Form and Style in the Arts

Other Books
by Thomas Munro:

Evolution in the Arts and Other Theories
of Culture History (1963)

Oriental Aesthetics (1965)

The Arts and Their Interrelations
(revised and enlarged edition, 1967)

FORM AND STYLE IN THE ARTS:

AN INTRODUCTION TO AESTHETIC MORPHOLOGY

Thomas Munro

The Press of Case Western Reserve University
in collaboration with The Cleveland Museum of Art
Cleveland and London / 1970

N
7430
.m84

PREFACE

Aesthetic morphology, the study of form in the arts, is a comparatively new subject, a branch of aesthetics. It is concerned with the description, comparison, and stylistic analysis of works of art, whereas other branches tend to emphasize theories of beauty and value in art, the creative process, aesthetic experience, or the principles and language of criticism. Its aim, as I see it, is to increase human knowledge and understanding of the arts. Toward that end, it seeks to be scientific in spirit, though making no claim to scientific exactness.

To analyze and describe works of art is, of course, no new undertaking. It has been done to some extent for many centuries, but usually as a part of art history or criticism. In historical writing it is subordinated to the tracing of chronological sequences and influences, whereas aesthetics usually organizes its discussions in some logical, theoretical order. In criticism the descriptive study of art is often subordinated to evaluation; its discussions tend to be subjective and personal. Art criticism has its own values, but does not necessarily provide any cumulative advance toward scientific knowledge. It is an aim of this book to provide some broad foundations for a future science of aesthetic morphology, as distinct from art history, art criticism, and philosophical aesthetics. Such a science should, however, remain in close touch with the older ones, exchanging insights and information with them.

It is not directly concerned with helping the reader to enjoy or appreciate art, although it may do so incidentally. Again, a treatise on the forms of art is not necessarily a work of literary art in itself. The potential reader, then, is warned not to expect aesthetic enjoyment from the following pages, which are abstract and theoretical, although dealing with materials which are fascinating in themselves.

Aesthetic morphology uses technical terms and concepts when these make for conciseness and clarity but does not, necessarily, attempt quantitative measurements. In future, there may be more need for exact measurement in aesthetics, but there is still a more basic need for a flexible taxonomy of art, a conceptual apparatus which can serve in descriptive studies of any art and period. This book attempts to provide one and thus to be of use to scholars in the field. It is not a panorama of art history or a survey of great works of art but a typological system for use in aesthetic theory.

The word "morphology," attributed to Goethe, was first applied in biology, and is still used more commonly there than elsewhere. Plants and animals have widely diversified forms, and these are described in biological morphology. Many kinds of human activity and product, outside the realm of art, such as laws and governments, machines and scientific treatises, also have different forms. These are systematically described in various sciences. Likewise paintings, poems, cathedrals, and symphonies have different forms, using "form" in the broad sense of "structure" or "mode of arrangement." The systematic analysis, comparison, and classification of such forms are tasks for aesthetic morphology. The morphology set forth here deals with all the arts, especially the visual arts, music, and literature.

Wherever there is form, there is also content or material—that which is formed, organized, or constructed. To understand the form, one must pay some attention to the material, and this can be described to some extent in psychological terms. In music, that which is formed consists of audible sounds which differ in pitch and in other respects. Painting organizes visible lines, colors, and textures on a surface. Poetry organizes words and meanings. The psychological materials and forms of art include, not only sensory stimuli which can be seen or heard, but also the culturally accepted meanings and close associations of these stimuli. Form, in a poem, includes the organization of word-sounds and of the images and ideas they tend to suggest in a particular language.

One task of aesthetic morphology is to observe and describe the components which are used in various arts, such as rhythm in poetry, melody in music, solid shape in sculpture, or perspective in painting. Another is to show how these are composed or built together to produce works of different types and

styles, such as Greek temples, Baroque operas, Elizabethan tragedies, and Abstract Expressionist paintings. Some of these modes of composition are explained under the headings of utility, representation, exposition, and thematic design.

Part One is concerned with the nature of art and methods of descriptive analysis. It goes on to describe the various ways in which a work of art can stimulate and guide experience, especially through sensory presentation, suggestion, mimesis, analogy, and symbolism.

Part Two is a survey of the elementary psychological components that enter into the arts, such as line, color, pitch, rhythm, desire, emotion, and conceptual thinking. (More complex developments of these, such as melody, orchestration, plot, and characterization, are described later in the book.)

The remaining chapters are devoted to a detailed study of the more complex types of organization, as in styles and modes of composition.

Because of the confusing ambiguity of terms often encountered in subjects dealing with the arts, special attention is given in this book to problems of terminology. Clarification of these is needed especially in comparing works of different arts and generalizing on features common to them. Such basic terms as "form," "style," "content," "exposition," and "harmony" are used in very different senses in different arts. There is need for a terminology applicable in all of them. Instead of coining new terms to describe the facts concerned, I have used existing words and meanings as far as possible, pointing out their special implications when applied to general characteristics of the arts.

An adequate, international terminology for describing types, styles, and trends should be especially useful to historians of the various arts and of civilization in general. A terminology capable of describing subtle differences between otherwise similar works of art, such as those by the same artist or composer, should be useful as the basis for improved notations, for the composition of dramatic or choreographic scripts. Such a system, defined in terms of morphology, could facilitate the achievement of desired nuances in production and performance. It should allow for the description of new or desired characteristics in art, as yet unrealized. It could help the performer in executing a work as the artist intended it, if he so desired. It could help a patron ordering a desired work of art, and help an educator in distinguishing various kinds of art. In the course of discussion we shall consider many possible developments which artists could pursue if they wished to do so.

The philosophic background of this book is in the traditions of empiricism and humanism. The generalizations made are based largely on observation of works of art in various media. The book emphasizes the roles of sensory perception and imagination in art, and of art as an object, stimulus, and guide of aesthetic experience. It does not conceive of art or creative inspiration as supernatural in origin, goal, or fulfillment. At the same time, it also recognizes the vast importance in art of non-naturalistic beliefs and world views.

As set forth in this book, aesthetic morphology pays little attention to problems of value or taste in the arts. It mentions changes in style and taste as events in history, but not to praise or disparage them. It proposes no definite rules or standards of value. It does not assert that any of the kinds of material, form, or style described herein is necessarily good or bad, better or worse, more or less beautiful or valuable than any others. This does not imply that all are equally good. In biology, the form of a cow and that of a cobra are described with equal care and objectivity. This is not because questions of value, in either art or biology, are unimportant or insoluble. It is because they involve many considerations other than purely morphological ones.

In my opinion, the value of a work of art depends in part on the persons and circumstances involved. It would be impossible, on the basis of the work alone and apart from its possible effects on human beings, to assign it a definite, permanent value. The problem of value in art is complex and difficult in itself, and deserves to be treated at length in its own right. I hope to do so in a subsequent volume. My general assumption is that there are many good kinds of art and many good ways of making or performing art. That which is better or best in a given case will always depend in part on factors outside the work itself. This is a moderately relativistic point of view.

No attempt is made, however, to exclude considerations of value entirely from this book. I do not claim that it is "value-free" or purely objective, and I have not tried to make it so. In some types of aesthetic inquiry the emphasis is necessarily placed on value. Elsewhere, it is placed on other aspects of art and experience. I believe that traditional aesthetics has suffered from too much haste in approaching evaluative problems without the necessary factual knowledge and without an adequate methodology. My purpose here is to help supply these needs. As I see it, a work of art cannot be clearly understood apart from some reference to the functions for which it has been made and used. I shall often refer to changes of taste

and to the aims and effects, aesthetic and otherwise, for which a certain type of art has been cultivated.

Critical evaluation often begins by identifying the work of art as belonging to a certain type or style: an English Gothic cathedral, a Shakespearean sonnet, a Romantic symphony. It then undertakes to describe the extent to which the work fulfills the accepted aims and requirements of that type or style. The critic then points out what other characteristics it possesses. Such thinking does not in itself constitute an evaluation, but it may be taken as a starting point for one.

This book will sometimes caution readers against assuming that a certain kind of art, described here, is necessarily good or bad. Nevertheless, it does tend to throw some light on the value of a work to know why it was made, and for what qualities it has been cherished or rejected in the past. Morphology, as an attempt at a descriptive account of works and types

of art, is thus relevant to evaluation and may be useful in it.

While the present book is devoted to form in the arts, it is not an example of "formalism" in aesthetics. That term usually implies an excessive emphasis on certain types of form and design as determining value in art, along with a tendency to minimize the importance of content, subject matter, associated ideas and emotions, moral effects and practical functions. Formalism in this sense is sometimes contrasted with social realism. Neither of these theories of value in art is advocated in the following chapters.

Limitations of space have prevented the inclusion here of many analyses of particular works of art. These are planned for a subsequent volume, and the present one is devoted to the theoretical foundations of aesthetic morphology. Numbers at the end of a chapter refer to visual illustrations which are especially relevant to the types of form and style discussed therein.

ACKNOWLEDGMENTS

The ideas proposed in this book were developed, to a large extent, in my courses on aesthetics in the Graduate School of Case Western Reserve University. These courses were attended, not only by graduate students, but also by members of The Cleveland Museum of Art and its educational staff. These various kinds of listeners contributed to the formation of the book, at least by relevant questions and critical comments. I had previously given similar courses at Columbia, Rutgers, and New York universities, and at the University of Pennsylvania. Through editing the *Journal of Aesthetics and Art Criticism*, and through giving lectures and courses in foreign universities, I became increasingly aware of the need for a comprehensive, systematic understanding of form in all the arts, and of how little had been written along that line. During the 1940s and 1950s, an actively interested public developed in America and other countries, with the aid of several national societies and periodicals devoted to theoretical studies of the arts. To the many friends and colleagues who cooperated in this effort, my cordial thanks are extended.

I have long felt a special debt of gratitude to Dr. Sherman E. Lee, Director of The Cleveland Museum of Art, for aiding and encouraging in many ways my teaching and writing in aesthetics. In the course of our long friendship, I have enjoyed the opportunity of learning many valuable things from him about Oriental art.

Behind the work of scholars and teachers, writers and museum curators stands the activity of philanthropists, trustees, foundations, government agencies, and their administrators. By helping to direct funds and efforts, they deeply influence the nature and quality of artistic and scholarly achievement. I have been fortunate, throughout my association with The Cleveland Museum of Art and Case Western Reserve University, in working with trustees and administrators who appreciated the values of education and research in the arts, and wished to develop them actively. Mrs. R. Henry Norweb, President of The Cleveland Museum of Art, is outstanding among such trustees.

My work with both Museum and University in Cleveland is brought to a focus in the joint publication of this book, for which I wish to thank both institutions. In particular, Dr. Merald Wrolstad, Editor of Publications for the Museum, has given valuable help in securing photographs and reproduction rights. Miss Dolores Filak has provided an expert typescript.

Throughout the years my wife, Lucile, has taken time from children, home, and music to share my theoretical interests and to aid my work in many constructive ways. To her this book is happily dedicated.

T.M.

SPECIFIC SOURCES

Several short passages in this book have been developed from previously published essays. Some of the basic ideas for these appeared in *Scientific Method in Aesthetics* (New York: Norton, 1928). Parts of my essay on "Form in the Arts: An Outline of Aesthetic Morphology" appeared in *Art in American Life and Education*, the fortieth yearbook of the National Society for the Study of Education, in 1941. In revised and developed form they appeared in the *Journal of Aesthetics and Art Criticism*, Fall 1943. "Style in the Arts: A Method of Stylistic Analysis" was published in its original form in that journal in December 1946. Parts of these two essays were further revised and published in a book of essays called *Toward Science in Aesthetics* (New York: Liberal Arts Press, 1956, later published by the Bobbs-Merrill Co. of Indianapolis. The Bobbs-Merrill Co. has been especially cooperative in this matter). My thanks are extended to all those who have aided in the development of the book through publishing successive parts of it or allowing the publication of copyrighted material in the present volume.

Cordial thanks are extended also to the many individuals and institutions, including museums and publishers, that have assisted me by supplying photographs, reproduction rights, and relevant information about the originals reproduced. They are listed below in alphabetical order, with roman numerals indicating color plates and arabic numerals indicating black and white illustrations.

Aero Photo, Paris: 85, 86.
Alinari-Art Reference Bureau: 6, 26, 29, 35, 50, 60, 77, 78, 79, 80.

Ampliaciones y Reproducciones "Mas," Barcelona: 58, 74.

Anderson-Art Reference Bureau: 2, 28, 40, 44, 45, 47.

Archives Photographiques, Paris: 87, 88.

Ashmolean Museum, Oxford, England: 67.

Biblioteca Ambrosiana, Milan: 23.

Bildarchiv Foto Marburg, Marburg, Germany: 49.

Mr. and Mrs. Vojtech Blau: VI, by courtesy.

Boston Museum of Fine Arts: 8, by courtesy.

Les Editions Braun et Cie., Paris: 1, by courtesy.

British Museum, The: 42, 66.

Chicago Natural History Museum, Section of Photography: 9.

Cincinnati Art Museum, from permanent collection: 55, by courtesy.

Cleveland Museum of Art, The: I (211), II (205), III (154), IV (42), V (84), VII (220), VIII (75); 5 (66), 10 (146), 17 (83), 18 (99), 70 (30), 75, 76 (60). (Note: numbers in parentheses refer to pages in *Selected Works: The Cleveland Museum of Art*.) Photographs 63, 64, and 65 are used by courtesy of the Museum and of Richard Godfrey, Photographer.

Corning Museum of Glass: 16, by courtesy.

Deutsche Fotothek (Grossmann), Dresden: 46.

Deutsches Archäologisches Institut, Rome: 41.

Gabinetto Fotografico, Soprintendenza alle Antichità d'Etruria: 43.

Photographie Giraudon, Paris: 33 (with special authorization of the City of Bayeux); 21, 34, 89, 90, 91, 92.

Solomon R. Guggenheim Museum, New York: 22, by courtesy.

Hirmer Fotoarchiv, München: 27.

Government of India; Copyright Archeological Survey of India: 25, 53, 72, 81, 83.

Kunsthistorisches Museum, Vienna, Dr. E. M. Auer, Director: 11, 12, 13, 14, 15.

Magdalene College, Cambridge; courtesy of the Master and Fellows: 19, 20.

Metropolitan Museum of Art, New York: 39, 73.

Münchow, Ann, Aachen, Germany: 61.

Museum of Modern Art, New York: 68, 71.

National Gallery of Art, Washington, D.C.: 51, by courtesy.

National Gallery of Scotland, Edinburgh: 7, 32, 37; from the Duke of Sutherland Collection, on loan to the National Gallery of Scotland.

Newark Museum, Newark, New Jersey: 59, by courtesy.

Österreichisches Museum für Angewandte Kunst, Vienna: 69.

Prähistorische Abteilung, Naturhistorisches Museum, Vienna: 24.

Rijksmuseum, Amsterdam: 52.

Staatliche Museen der Stiftung Preussischer Kulturbesitz, Kupferstichkabinett Berlin-Dahlem: 54.

Stockholm Museum: 36, 62.

Stoedtner, Dr. Franz, c/o Prothmann Associates, Baldwin, L.I., New York: 4, 30, 31, 38, 56, 57, 82.

University Library, Utrecht, Netherlands; Ms. 32 (Utrecht Psalter), f. 48v.: 48, by courtesy.

Worcester Art Museum, Worcester, Massachusetts: 3.

CONTENTS

PART ONE: WORKS OF ART AS FUNCTIONAL DEVICES

CHAPTER I: VARIETIES OF AESTHETIC PHENOMENA

CHAPTER II. MODES OF TRANSMISSION IN ART

PART TWO: THE PSYCHOLOGICAL COMPONENTS OF ART

CHAPTER III. COMPONENTS, TRAITS, AND TYPES

CHAPTER IV. DESCRIBING A WORK OF ART AS TO ITS PSYCHOLOGICAL COMPONENTS

PART THREE: MODES AND DIMENSIONS OF ORGANIZATION

CHAPTER V. SPATIAL, TEMPORAL, AND CAUSAL DEVELOPMENT

PART ONE

Works of Art as Functional Devices

CHAPTER I

Varieties
of Aesthetic
Phenomena

1. Types of form described in aesthetic morphology.

Modern aesthetics, as an empirical subject, is concerned with two main types of phenomena. One consists of *works of art*: pictures, poems, dances, buildings, symphonies, and others, distinguished according to form and content. The second consists of related human *activities,* modes of behavior and experience, both overt and internal; skills and responses to stimuli; processes involved in creating, producing, or performing art and those involved in perceiving, appreciating, using, enjoying, evaluating, managing, teaching, or otherwise dealing with it. The first group of phenomena is the special concern of aesthetic morphology. The second is the special concern of aesthetic psychology, aided by sociology, anthropology, and other humanistic sciences. The two groups overlap and can not be sharply separated. The performance of a sonata involves both activity and form.

Forms appear in all these kinds of phenomena: there are transitory and recurrent configurations in physical objects and events, in overt behavior and inner experience. Various sciences exist to describe these, but here we shall apply the word "morphology" mainly to the study of the forms observable in static and mobile art. In describing works of art we must refer to some of the ways in which they affect observers, to the social functions they were created to serve, and so on. In describing behavior and experience in the aesthetic realm, we must discuss them with reference to specific works of art. But the essential purpose and mode of organization, in both instances, places the major emphasis elsewhere. In aesthetic morphology, we tend to keep our attention on the products; in the psychology and sociology of art, on the people who make and use them.

"Form," in the broad sense of a *mode of arrangement,*[1] includes the physical and chemical structure of objects and events, as described in terms of the placement of atoms and molecules, as well as their outward aspects and appearances, as perceived or imagined. A scene in nature has a certain visible form for one observer, seeing it from a certain viewpoint and under certain conditions, and another form for a different observer. A painting of the scene has a somewhat different form, and a mental image of it, still another. A snow crystal has a highly regular visible form. The ticking of a clock has audible form, and so has the song of a bird. A football game or a battle has form, and so has a poem, a song, or a dance.

It is a task of aesthetic morphology to distinguish these various kinds of form in terms (a) of the elements, details, parts, materials, images, ideas, or other ingredients involved, and (b) of the ways in which these are interrelated, the brief or enduring structures and sequences into which they combine. Materials never exist and cannot be experienced without some kind of form. A rough marble block has one kind of

[1] "Form" is defined as follows in *Webster's Third New International Dictionary* (Springfield, Mass., G. & C. Merriam Co., 1961): "10a: orderly arrangement or method of arrangement (as in the presentation of ideas): manner of coordinating elements (as of an artistic production or course of reasoning); sometimes: a particular kind or instance of such arrangement <the sonnet is a poetical∿>." There are many kinds and degrees of order and coordination in art, even in some which have been mistakenly called "formless." The *Random House Dictionary of the English Language* (New York: Random House, Inc., 1966) defines "form," with a Fine Arts label, as "the organization, placement, or relationship of basic elements, as lines and colors in a painting or volumes and voids in a sculpture, so as to produce a coherent image; the formal structure of a work of art." We shall not restrict the elements of form to "basic" or "formal" ones, as opposed to "informal" or casual ones.

form, a statue another. Forms cannot exist or be experienced apart from some kind of material or content.[2]

Aesthetic morphology pays close attention to both form and content in works of art; to their interrelations and mutual influences. All art contains some of both. But in observation and in theory the emphasis can be placed on one or another at different times, as in showing how spots of a certain color can be arranged in various ways, or how a Romanesque church can be built of brick or marble. Some kinds of material are physical, such as bronze or sound waves, and some psychological, such as desires or emotions. Some kinds of form are organized in terms of logical implication, some in terms of spatial, temporal, or causal relationships. All of these and many other basic types of form occur in art, in countless variations which aesthetic morphology tries to analyze, compare, describe, and classify. Persons who have studied art only in a specialized way are often amazed to discover the tremendous variety of types and styles produced by different cultures, periods, and places in world history, and at the same time their underlying resemblances.

Aesthetic morphology describes the nature and varieties of form in the arts and, by extension, in other objects of human or natural origin, insofar as they are used as stimuli to aesthetic experience. A work of art, like a bird or tree, is an arrangement of diversified parts. It may be large or small, simple or complex, either static or moving and changing in a temporal process or cycle. Biological morphology has been defined as "the science of structural organic types"; aesthetic morphology aspires to be a science of structural artistic types.

In biology, morphology is sometimes understood in a narrow sense, as applying only to the externals of form, or to the structure of organs apart from their functioning. It is applied to anatomy as distinct from physiology, the latter of which deals with active functions and processes. We shall not think of aesthetic morphology as so limited, but as including the active, functional relationship of part to part and part to

whole, the operation of the whole form as a stimulus to perception and understanding.

On the other hand, we shall not extend it to cover all the diverse and far-reaching functions which art carries on in society. That study belongs rather to the psychological and sociological phases of aesthetics. Here we shall emphasize those aspects of structure and function which can be directly observed in the work of art itself, with some attention to its psychological and cultural setting but no attempt to analyze the latter in detail.

2. Difficulties in observing and describing works of art.

One difficulty in aesthetic morphology rises from the complexity, subtlety, and variety of forms in art They are often so elusive and intangible as to defy ordinary modes of observation. Plants and animals are made of living tissue, which can be cut apart with a knife and viewed in cross section under a microscope. Some art forms are as simple and tangible as an Egyptian pyramid. Some are as complex as a Gothic cathedral; as intangible as a Brahms string quartet; as full of cryptic symbolism as the Apocalypse. What can one say about the structure of art that will apply to things as different as these, each in its own way hard to analyze? Is there any common substance in them all? Are there any basic modes or principles of organization in forms so unlike? Analogies between works of different arts are often pointed out, but rather vaguely and abstractly. Architecture, it has been said, is frozen music. How can such metaphors be verified, translated into specific resemblances and differences, in such a way that any trained observer can discern them?

Another difficulty is to find words for describing art which will not imply evaluation, praise, or disparagement. If we start to describe a picture and call it "magnificent," "hideous," "clumsy," or "masterly," we are not describing but evaluating it. We are expressing our own personal, emotional responses to it, and projecting them upon the picture as if they were inherent properties therein. Such terms are irrelevant in morphology, as if one were to describe a lion by calling it "a noble beast." The description should be such that it could be accepted as true by observers of different tastes and standards, whether they like and admire the picture or not.

However, it is not easy to find words for describing

[2] The ontological status of "material" or "content," as related to matter, mind, universals, reality, etc., is a metaphysical problem with which aesthetic morphology, as an empirical science, is not primarily concerned. Such terms as "mental," "physical," and "psychic" can be used in aesthetics as convenient labels for classifying phenomena with no specific metaphysical implications as to the ultimate, inherent nature of such phenomena. The word "materials" does not imply physical substance when used in the sense of "psychological ingredients," as in gathering materials for a book.

the many varieties of form in all the arts. A great many of the words applied to art have been used with evaluative implications at one time or another, and may suggest them to some reader now. "Gothic," "Baroque," and "Romantic" have all been used as terms of opprobrium by those who did not like the kinds of art they understood by these names. In using them as descriptive terms, we should clearly indicate what observable characteristics are implied.

Another difficulty arises from past specialization in studies of the arts. Musical criticism has one terminology, literary criticism has another, and pictorial criticism a third. The vocabulary of comparative aesthetics does not yet possess enough descriptive terms which can be applied in any art. Hence it is necessary to use certain terms which now have only a narrow, specialized usage, and redefine them so as to be more widely serviceable.

One supposed difficulty in describing works of art can be dismissed at the outset as illusory: that is, the objection that every work of art is completely unique and hence indescribable in general terms. The simple fact that one can call two works "poems" or "sonatas," "Gothic cathedrals" or "Impressionist paintings" is enough to disprove the idea of their complete uniqueness. Every work of art is like others in some respects and unique in others. Whether their most distinctive traits can be described is another problem, which we shall deal with step by step. There is no reason to assume in advance, as some critics have done, that each work of art has a mysterious *je ne sais quoi* which makes descriptive generalization impossible, or restricts it to external trivialities.

3. Aims and uses of aesthetic morphology.

What good does it do to study the nature and varieties of form in the arts? To analyze the structure of a particular work of art, and compare it with others? To distinguish styles, and see how a certain style (such as Romantic or Baroque) can manifest itself in many arts? To understand how form in any art can be developed in any way the artist wishes?

It should be repeated that the aim is primarily intellectual and scientific. Its primary aim is not to increase the reader's enjoyment of art or his power as an artist. Yet it is a mistake to assume, as many do, that scientific analysis will decrease enjoyment, that one "kills" a work of art by "dissecting" it. The en-

joyment of automobiles, of plants, animals, or human beings is not necessarily decreased by some knowledge of their structure and operation. Many students find their interest in art and their enjoyment of it greatly increased by learning to perceive the complex subtleties of form and style, and to recognize major types and tendencies. On the other hand, there are some kinds of person for whom all systematic study of art is distasteful; they prefer to approach it in a more emotional way. Aesthetics, art history, and critical theory are not for them. Some artists are of this type but not all. Some profit by intellectual study and excel in it, as Goethe and Leonardo da Vinci did, while others find it dampening to creative imagination.

Analysis of form should be carried on, not merely through reading a book of general theory, but by careful observation and comparison of works of art which exemplify the principles, by going back and forth between concepts and examples to see the relation between them. If the generalizations are correct and applied in observation, they will aid the student to notice and to understand aspects of art which he might never have noticed by himself, and thus to enrich his experience.

The aim and task of aesthetic morphology is not merely to work out a few abstract definitions of conventional types of art, such as the epic, lyric, fugue, sonata, basilica, and the like, or merely to classify particular works of art under such headings. Much time has been wasted in fruitless argument over whether a certain piece of writing was really a novel or a romance, a tragedy or a comedy, and so on. Even when the classification is obvious and undisputed, it still falls far short of penetrating the full, complex nature of a work of art. Such a narrow approach to morphology proceeds from a narrow, inadequate conception of form in art. Form does not consist only in the obvious, conventional shell or skeleton, in which thousands of examples are alike, in the mere fact of being a sonnet or sonata. It includes the entire structure of each example, its peculiar selection of materials and its way of arranging them.

Greater attention to the individual form—to each particular work of art—distinguishes aesthetic morphology from the morphology of animals, plants, and molecules. In the older sciences, the individual is usually felt as unimportant, and the general type or law as all-important. Little attention is paid there to the unique aspects of any single tree, stone, or seagull. True, astronomy is especially interested in our sun, our earth, and our planets, because we live with them,

but it tries to see them as parts of a cosmic process. Man and the higher animals become attached to individual objects: to children, friends, toys, pets, weapons, houses, sentimental keepsakes, popular heroes and heroines, giving to each an extreme but relative, subjective importance which differs widely from one person to another. Science tries to avoid this personal bias and to emphasize the way in which particular objects conform to general types and tendencies. Yet it can, if necessary, analyze and describe a particular object or event within its field with minute precision, as in medical diagnosis.

Aesthetics, including the morphology of art, is interested in general types and tendencies, but also in particular cases as related to them. It studies the peculiarities of individual works of art more than botany studies those of individual trees. This is partly because, in the modern world, such emphasis is laid on the individual artist and on the outstanding importance of particular great works of art. Aesthetic morphology will itself be considered more important if it produces, not only a general understanding of form and style, but improved techniques for perceiving and understanding the distinctive nature of a particular work of art.

For those who appreciate and criticize art, the uniqueness of *Hamlet* and of each of Chopin's preludes is highly important: the subtle ways in which each differs from all others of its kind. Such differences between individual artists and their works provide the basis for all judgments of value and of greatness. One of the crucial problems of cultural history is why humanity produces great distinctive works at one time and place, and at another only stereotyped imitations. Yet what is the difference between *Hamlet* and the common run of Elizabethan tragedies? To satisfy the need of human thinking about works of art and artists, aesthetics must learn to deal with them as concrete individuals, in addition to dealing with them as examples of types and trends. The difference between one work of art and another can be approached as a problem of descriptive, comparative analysis, as astronomy describes the differences between Mercury and Saturn.

A general understanding of the varieties of form in art, derived from observation and reasoning, will aid in further observation. The fact of having encountered similar kinds of art or qualities in art before, of having singled them out for attention and given them a name and a place in the scheme of things, makes it easier to deal with them in a later situation. One is less bewildered, quicker to see how the present work of art resembles and differs from the previous ones.

Aesthetics is now at a stage somewhat analogous to that in which biology was in the early eighteenth century, before Linnaeus had worked out a system for analyzing the forms of plants and classifying them by species. Prescientific concepts of species and their interrelations were vague, inconsistent, and full of inherited myths and folklore. The same condition exists today in our thinking about the forms of art. As morphology and classification advanced in biology, they opened the door to all manner of far-reaching investigations on the nature and evolution of life. Often regarded as dull and plodding in themselves, they are indispensable to many deeper, more exciting lines of inquiry. Before distinguishing clearly the main varieties of form and style in art, we cannot go far in studying how they arise in the course of human history, how they can be used for human welfare. It is not enough to compare and classify whole arts, as in philosophical "systems of the arts." One must come down to intensive, detailed comparison of examples from different arts and different periods, to discover the main underlying types of form and their principal variants, which cut across the obvious but often superficial differences in medium.

Impatient to decide what art ought to be, we have in the past neglected to find out what it is. Impatient to decide whether we like it or not, we have failed to observe it systematically. We allow endless theoretical controversies to distract us from careful observation of the work of art itself. Aesthetic morphology calls the scholar or critic back to the concrete object in front of him. It invites him to see or hear it clearly and thoroughly for what it is. Through comparison of findings by many observers, it can build a tested body of knowledge about the forms and species of form in art. With this in hand, we can proceed to study how each kind of art operates in human experience: its functions and effects, actual and possible, under varying life conditions.

4. Varieties of art as related to social activities and functions.

The word "art," and its equivalents in other languages, have had many meanings in the last twenty-five hundred years. The ancient meaning, "useful skill," was very broad, covering such utilitarian "arts" as war, medicine, mining, and agriculture. It neither implied nor excluded aesthetic characteristics. In the eighteenth century, the conception arose of the "fine arts" (also called the "polite" or "elegant" arts),

those concerned primarily with the production of beauty and aesthetic pleasure. The others, more concerned with providing necessities and comforts, came to be known as "useful," "practical," or "industrial" arts.

The old meanings of "art" are still sometimes employed, as in speaking of "medical arts" or of a "bachelor of arts." On the whole the tendency has been to drop the word "art" in referring to mainly utilitarian or intellectual skills, and to refer instead to "crafts," "applied sciences," "technics," "engineering," "administration," "scholarship," and so on. This tends to restrict the word "art" to skills and products more concerned with aesthetic aims and values. However, it is recognized that no sharp line can be drawn between "artistic" and "utilitarian" skills. Many arts commonly classed as "fine" or "aesthetic," such as architecture and furniture designing, are also concerned with utility or fitness for practical functions. Painting and music can be adapted to utilitarian ends, as advertising or propaganda. Many activities regarded as primarily utilitarian, such as the making of armor and weapons, are sometimes devoted in part to aesthetic aims, to making the product visually attractive. A branch of a large industry may thus be classed as art. For example, "decorative ironwork," as in making ornamental gates and balconies, is called an art and also a branch of the iron industry.

Art still coincides to some extent with utilitarian technics, in spite of the modern trend toward separating them. This is true not only where artist and engineer intentionally cooperate to make a utensil or a piece of furniture both beautiful and useful; it occurs also where purely utilitarian aims incidentally produce forms which are later felt as beautiful, and are imitated for that reason. Often an aesthetic aim is indicated in a manufactured object, as by features which seem to have no other function than to satisfy in this way. If a tool, utensil, weapon, house, or garment is finished with ornamental details which serve no strictly utilitarian function, the aesthetic aim is evident and the product is classed as a work of art. The same may be true even if it is plain. Though lacking in added ornamentation, it may still be considered a work of art and a thing of beauty, because of the refined simplicity of its design. A severely functional tool is usually preferred by modern taste to an ornate one which was made to be beautiful, but the making of such tools is not usually classed as an art unless it is practiced with a consciously aesthetic aim and social function.

Literature as an art (*belles lettres*) overlaps many other kinds of verbal composition, both oral and written. It is hard to draw a line between literary writing and philosophic, scientific, or journalistic essays and treatises. Prose rhythm and euphony, vividly sensuous and emotive imagery, storytelling and imaginative accounts of personal experience, all tend to stimulate aesthetic contemplation.

Some skills are more strongly and commonly aesthetic in aim and function than others: poetry, music, and painting are more so than machine design, but this does not imply that the aesthetic qualities of an automobile are necessarily inferior to those of a painting or poem, or that industrial design as a whole is less worthy of respect than the "fine" arts because of its greater concern with utilitarian functioning. That belief has passed away with the age of aristocracy and with the general prejudice against useful manual work as unfit for a lady or gentleman.

The realm of art is now understood as including certain branches or phases of a great many different skills and industries, as widely separated as carpentry, city planning, horticulture, animal breeding, cosmetics, and even plastic surgery, where satisfactory visual appearance is at least one of the principal aims. It also includes aspects of those where satisfactory auditory effects are sought, as in music and speech. Cuisine and perfume, appealing aesthetically to the so-called lower senses, can be included as arts in spite of their limitation to psychologically simple stimuli.

It is no longer possible to restrict the realm of art to five, seven, or any restricted number of arts. Not only painting, sculpture, architecture, music, poetry, dance, and theater must be included, but scores of others, such as the cinema. If our view extends broadly enough, we must include as arts the execution of tattooing, featherwork, string figures, and many others which are absent or of low status in our own culture. It is no longer assumed that certain arts are permanently "major" and others "minor." Mosaic, a minor art for us, was a major art in the Byzantine epoch. Different epochs and peoples choose different vehicles to convey their major cultural expressions. However, literature, painting, sculpture, architecture, music, the dance, and theater are commonly regarded as major arts for civilization as a whole because of their widespread, perennial importance.

Since the term "art" alone has come to imply an aesthetic aim or function, the prefix "fine" is no longer required to distinguish the aesthetic arts from other skills. It is still used at times to distinguish the more strongly aesthetic arts, such as music, painting,

and poetry, from the more utilitarian arts, such as costume and furniture. But this is a distinction in degree only, since all the arts are by our definition recognized as concerned to some extent with aesthetic effects. The word "fine" has many confusing associations, especially the idea that "fineness" implies superiority. The term "fine arts" is sometimes understood as including poetry and music; sometimes as restricted to the visual arts, especially painting, sculpture, and architecture. Because of these ambiguities it is increasingly avoided in technical discussion, and the term "visual arts" is used when that specific meaning is intended.

5. Aesthetic and other functions of art.

One conception of art, derived in part from Aristotle's *Poetics,* describes it as a means to aesthetic pleasure. The concept of pleasure as the aim of art is hardly adequate today. A somewhat broader version of the Aristotelian, or technical, theory is to say that art is distinguished from other skills or products by its fitness or intended fitness for stimulating satisfactory aesthetic experience. To serve in that way is the function of art as such.

That is not its only function, however. It is often called upon to serve moral, religious, educational, or political ends. These are sometimes regarded as more important than the aesthetic ones. But they are not universal in art as a whole. Some sort of aesthetic appeal is more widespread and distinctive in the products classed as art. It is not necessarily successful. Even where the nonaesthetic aim is emphasized, as in religious and political propaganda, the product is not classed as "art" unless it also makes some attempt at aesthetic appeal. That appeal may serve to hold attention and create a generally favorable attitude toward whatever is advocated. This is also characteristic of advertising and other commercial art.

Of the many definitions of "art" in past and present use, some are strongly *evaluative*, implying praise or merit. To be a work of art in that sense, a thing must actually be beautiful, pleasing or high in aesthetic value. This criterion is still much employed, especially to distinguish some useful products—such as cups, chairs, and textiles—as "decorative art," worthy of a place in an art museum, from others of the same sort which are merely utilitarian.

The idea of beauty is less used today than heretofore in deciding what is to be classed as art, partly because of the difficulty of agreeing on what is beautiful. There is less disposition to say that a thing cannot be art unless it is beautiful. Many things classed as art today are not intended to be beautiful and are not so regarded. If a thing belongs to some recognized type of skill or product which is commonly regarded as an art, then the present tendency is to class it automatically as a work of art without trying to decide whether it is actually beautiful or satisfying. If it belongs to a class of things which are commonly made, performed, or used as means to aesthetic satisfaction, such as oil paintings, statues, temples, dances, symphonies, poems, novels, and dramas, it is regarded as a work of art whether or not it is so intended by the artist or performer, and whether or not it is satisfactory to the observer.

To *satisfy* is not the same as to *please*, although the two often coincide. Much art, especially at the present time, is not intended to be pleasant. Many artists disclaim any desire to please the public or to influence people in any way. But even art which is painful or disagreeable in some respects can be satisfying: perhaps as an honest, realistic account of disagreeable truths. As such, it may satisfy the desire of some observers to face unpleasant facts without flinching.

The word "art" is used here in a comparatively neutral, *nonevaluative* sense, regardless of individual merit or lack of merit. Such a neutral conception of art is useful in scientific discussion. An anthropologist can refer to the "arts" of a primitive people—their pottery, wood carvings, basketry, etc.—without having to show that they are beautiful. A psychologist can speak of "children's art," or the "art" of the blind or of insane patients, as something to be studied scientifically. Whether such "art" is good or bad, beautiful or ugly, is not always the main consideration. Such usage facilitates scientific study by allowing us to speak of "art" objectively as a name for certain types of cultural phenomena, under which many analogous skills and products of different cultures can be grouped for comparison. When "art" was used only in a laudatory sense, implying actual beauty or merit, it was impossible for aestheticians to agree on what to investigate. Hence it was impossible to start a systematic, empirical study of works of art in the same way that biologists study all animals, whether good, bad, or indifferent from the human standpoint.

Using "art" in a nonevaluative sense does not prevent one from evaluating works of art, or imply that one regards them all as equally good. A man can be called an "artist," and be so listed in city directories, simply because he practices a certain kind of occupation. He can be a bad artist as someone else might be

a bad doctor or lawyer. We may agree that his products are "works of art" in the broad sense, and then go on to say that by our standards they are extremely ugly, trivial, or harmful.

The same way of thinking applies to each particular art. In the old sense, nothing was recognized as "literature" unless it was rated as high in aesthetic value. About a new piano composition, the critic might say, "It's not real music." In the newer sense all piano sonatas are music, whether good or bad. One can easily recognize a verbal composition as prose or verse; as drama, fiction, or lyric. This entitles it to be classed as literature; whether good or bad is to be decided on other grounds. There is, of course, a minimum of skill required to produce anything that can be recognized as a novel or a piano sonata, just as a minimum of skill is required to practice medicine at all, even badly. To this extent the ideas of "art" and "artist" retain an evaluative element. But it is very slight, and it removes the whole perplexing question of specific value-standards from the general definition of "art," to be dealt with elsewhere in aesthetic theory.

The type of *form and social function* involved, rather than individual success or value, provides the main criterion for classing a thing of art. In many realms of science, things are classed and described according to their characteristic function or activity, their regular contribution to a joint result or process, the end to which they are adapted, whether the adaptation is successful or not. The function of a bird's wings is to help it fly, even though some wings are too weak or maladapted to do so. Such a function does not involve any conscious intention. A tribal dance to bring rain and an amulet to ward off evil spirits are both regarded as primitive art, regardless of their inability to achieve these ends. Both involve aesthetic appeal as well as utilitarian purpose. A very young child's drawing, in which he tries to represent a man, will be classed as a "drawing of a man" and an example of "children's art," in spite of its crudity and lack of resemblance.

A scientific diagram or three-dimensional model made to illustrate a mathematical concept may seem beautiful to someone. The same is true of a wild flower or a steel machine. The observer may place it in his room in such a way as to suggest that it be viewed aesthetically rather than scientifically. As such, it begins taking on the function of a work of art. But the making of aesthetically pleasing forms is not socially recognized as an art until it is practiced primarily for aesthetic reasons. For a product to be classed as a work of art from the social standpoint, it must belong to a type which is or has been *persistently made or performed by some cultural group as a stimulus to satisfactory aesthetic experience*. It is an undisputed fact of history that painting, sculpture, music, poetry, dancing, and many other skills classed as "arts" have been commonly produced and used for giving aesthetic satisfaction, whatever their other purposes or functions.

A *regular, established social function* is different from an occasional or accidental one. An oil painting may be used to patch a hole in a roof, but that is not its regular function. The occasional use of some bizarre device by a single individual, to produce an effect he considers beautiful, does not make such devices works of art. Tattooing is an art, not because we can prove it beautiful, but because it has been practiced and regarded aesthetically by fairly large social groups over long periods of time—e.g., by the Maori of New Zealand—even though it may not please or satisfy us today. It is fairly distinct from other arts in that it has developed its own materials, technics, forms, meanings, and social functions. In our culture, the cinema has gradually become an art distinct from that of stage drama.

There is no sharp line between artistic and nonartistic skills and products, but much overlapping and constant change, as new technics and media develop, and as old ones take on different functions in a changing world. A work of art can be, at the same time, a tool or machine, a work of science, of philosophy, of religious ritual, or of industrial engineering. These are all flexible and somewhat arbitrary manmade categories, corresponding to no fixed boundaries in the nature of things; they are ways of marking off different areas in human culture, as seen from different points of view, for study and management. To separate them too sharply in theory is to falsify their nature.

Many definitions of "art" imply special theories about the value and proper aims of art which are unacceptable to different schools of thought, and which could as well be expressed elsewhere. Discussion is facilitated, in aesthetics as elsewhere, by fairly neutral definitions of key words, which can be used by all participants. It is better for so basic a term as "art," which largely delimits the field of aesthetics, to be defined very broadly rather than so narrowly as to exclude important phenomena from consideration. It would be unwise, in the present underdeveloped state of aesthetics, to limit the concept of art with many debatable, detailed requirements. There is no good reason to specify that art must be made or executed by hand and not by machinery; that only the original

design of the artist, not a reproduction, is really "art"; that art must be made or performed by some particular technique, of some particular material, by the free imagination, with no thought of gain; or to make any other such restriction. All such limitations ignore the fact that humanity experiments with many different ways of achieving the same general ends, and that artists' methods and resources change from age to age.

The conception of art here endorsed, the "technical" conception, differs from that which defines art in terms of expression alone. As a knife is a device for cutting, a work of art is (among other things) a device for stimulating and communicating certain kinds of experience. Art is now described in anthropology as a kind of "psychosocial technic"—that is, a skill or device used for producing certain psychological effects on social groups as well as individuals. This does not deny the conception of art as expression, that usually preferred by artists. Through expressing his feelings, ideas, and attitudes in some artistic medium, the artist can influence other persons and communicate his experience to them. He does so whether or not he consciously desires and plans to do so. The conception of art as expression emphasizes the standpoint of the producer or performer, whereas the conception of art as a possible source of aesthetic satisfaction emphasizes that of the consumer of art. They are complementary and neither excludes the other. For some purposes and in some connections, it is useful to define "art" from the standpoint of the artist or the psychologist, in terms of expression rather than function: e.g., as the expression of an emotion "remembered in tranquillity." This aspect of art is less important in morphology, which is interested in the *product and its social functions*, rather than in how the artist created it.

One of the chief ways in which an artist arouses satisfactory aesthetic experience in others is to provide them with symbolic forms—literary, pictorial, or otherwise—in which he has expressed some of his own past emotions and other experiences, real or imaginary, and those of his cultural group. He expresses these and communicates them to others through the power of certain sensory images to convey meanings as a result of social usage. To the artist, this conception of art often seems more true and significant than any other. He may have little conscious interest in pleasing the public, or even try to shock and offend them. On the other hand, he may be much interested in his own emotions and the task of expressing them in some objective form. The public is little interested, unless he has something to communicate which seems worthwhile from the observer's point of view. Society will not long encourage or support his work unless it finds these emotional expressions somehow satisfying or useful. It may enjoy the work of an artist who has tried to shock and irritate even more than that of one who has tried to please. From the social and historical standpoint, the main reason why humanity patronizes the arts and pays the artist is because it finds his products valuable in aesthetic or other ways, not in order to give him the pleasure of expressing himself. The social effects of art are more important in determining its forms and functions than the desires of individual artists. In some kinds of art, especially the decorative and utilitarian, the concept of art as expression of emotion seems less relevant than it does in literature and music. Does a man who designs and makes a house or a table express and communicate emotion thereby? No doubt he enjoys his work, or has other emotions in the course of it; but so does the scientist, the doctor, or the lawyer, and all of them can arouse emotions in others. The role of the artist in arousing an aesthetic type of response, as he does through the visible form of the house or table, is more constant and distinctive.

The conception of art employed in this book is not based wholly, or even principally, on the individual artist's intention. Nor does it depend on any individual's actual feeling, desire, or satisfaction in contemplating a given work of art. As to the art of the past, there is often no way of knowing what the artist's intention was; it may have been purely religious or utilitarian. Even in the case of contemporary works, what an artist says or thinks about his own products does not necessarily conform with the facts. What he consciously intended to do may be very different from what his product actually is. He may not have intended the qualities for which critics and the public now like or dislike it. He may create an aesthetically satisfying product without intending to do so, or he may intend to do so and fail.

At the same time, however, it would be foolish to ignore the important role which conscious planning has had in the production and use of what we now call "art." This appears more clearly and persistently in social than in individual behavior. Functions and devices which are automatic and unconscious in the lower animal, such as protective coloring, become increasingly conscious and intentional in man. Without recognizing this fact, it would be hard to distinguish art from other human or natural products. People find in nature countless objects and events which please them aesthetically, such as songs, nests, flights, and colors of birds. These closely resemble some

works of art. One cannot clearly distinguish them from works of art in terms of their perceptible forms alone. Art constantly imitates selected aspects of nature and human life, even when the artist tries not to do so. All the forms of art have partial analogues and sources in nature. Everything human is a part of nature in the broad sense.

One basic difference between art and nature lies in the fact that the processes of art are comparatively conscious and purposeful, involving skills which are transmitted culturally. Sometimes artists try to create without conscious purpose, by spontaneous impulse, but the results are not usually classed as art unless they resemble some recognized type of art, such as an oil painting or a bronze statue. Naturally, this is an affair of labeling, ignoring the question of the aesthetic value of such spontaneous work.

Ordinarily, artists are not satisfied with purely natural or aimless products; they try to improve on nature and upon the scenes of human life, as by inventing new musical instruments and forms, or by recording aspects of the changing world in a more or less permanent way. Little by little, the arts have evolved a tremendous variety of aesthetic forms which differ in some respects from those of nature and ordinary life. To describe these in general terms is the task of aesthetic morphology.

Whether or not they are consciously so intended, the types of product and performance which are now called works of art are largely made and used as stimuli and guides to satisfactory aesthetic experience. This is their distinctive social function. The occasional rejection of that aim by artists does not refute the general facts of history.

We have referred to the arts as "psychosocial technics." As technics, or transmitted skills, they are akin to agriculture, metallurgy, and engineering. Being psychosocial, they are akin to law and education in serving the mental and cultural needs of social groups as well as of individuals. The number and variety of these needs, and of the kinds of aesthetic effect considered satisfactory, is now incalculable. They can not be reduced to any one type of content, form, or style. In defining "art" and "works of art" in a broadly comprehensive way, so as to distinguish them from other types of activity and product, we may point first of all to their methods (mainly conscious, psychosocial technics) and to their distinctive common function (that of stimulating and guiding satisfactory aesthetic experience). We can then try to discover the principal types of device which are actually made and used for aesthetic functions. How and of what kinds of material are they constructed, and how

do different types of form serve different aesthetic and other needs?

6. The concept of art. What is a work of art?[3]

We can now formulate a naturalistic, functional definition of "art" as follows: *Art is (1) skill in making or doing that which is socially used or intended as a stimulus and guide to satisfactory aesthetic experience, often along with other ends or functions; especially in such a way that the perceived stimuli, the meanings they suggest, or both, are felt as beautiful, pleasant, interesting, emotionally moving, or otherwise valuable as objects of direct experience, in addition to any instrumental values they may have. (2) Also, a product of such skill, or products collectively; works of art. Broadly, this includes every product of the arts socially recognized as having an aesthetic function, such as architecture and music, whether or not that particular product is considered to be beautiful or otherwise meritorious.*

Briefly, art is *skill in providing sensory and other stimuli to satisfactory aesthetic experience.*

The term "work" has different meanings. Many kinds of work are involved in art: countless different technical and psychological processes go into the conception, planning, execution, and (in the case of temporal forms) into the performance of art; still others into the appreciation and study of art by consumer, scholar, critic, and teacher. These are all important for aesthetics in general, but in morphology we deal mainly with the product. In speaking of a "work of art," we shall follow common usage in meaning the product or performance, the *oeuvre* or *opus*, and not the many other kinds of labor or *travail* related to it.

Works of art include static and moving objects such as pictures and fountains, processes or activities such as dances and operas, and also guides to such activities, such as dramatic texts and musical scores. Most works of art are directed primarily to the sight or the hearing of observers; some are directed to a lower sense, and some to two or more senses. The stimuli thus presented to sense perception are usually endowed by cultural usage with power to suggest more or less specific meanings, sense images, concepts, thoughts, desires, and emotions; hence with power to record and communicate varied experience from one

[3]This question is discussed at greater length in *The Arts and Their Interrelations*, by Thomas Munro, 2nd ed. (Cleveland: The Press of Case Western Reserve University, 1967).

individual or group to others, and to stimulate diversified, far-reaching apperceptive, affective, and other responses in a suitably trained and compliant observer.

A work of art operates by stimulating one or more of the sensory mechanisms of a human observer, as by sending variegated light to his eyes or changing sounds to his ears. The groups and sequences of images thus perceived have a tendency to stimulate further responses throughout the brain and nervous system, including the apprehension of meanings, based largely on previous cultural conditioning; also complex conative, emotional, imaginative, and rational processes in varying amounts and configurations. These responses vary according to the nature of the outside stimuli and also according to the nature and present mood of the observer. They can be pleasant or unpleasant, satisfying or unsatisfying. There is a common tendency for the observer to feel some of these responses as attributes of the object which stimulates them, and perhaps to regard the object as beautiful, ugly, or endowed with some other affective quality.

In this process, the work of art acts as a *connected group or sequence of stimuli*, and is thus able to *guide* a continuing process of aesthetic response. It is more than a single, initial stimulus, such as might be provided by a gunshot or flash of light, which starts a train of thought but does not keep on directing it. The words of a play or novel, the notes of music, the details of a cathedral provide a potential guide to an organized sequence of sensory and imaginative responses, which the observer can keep on making if he wishes, for several minutes or several hours.

7. Aesthetic as distinguished from other kinds of experience.

If an aesthetic social function is the main differentia of art, a scientific study of art should include a study of that function, and of what is meant by "satisfactory aesthetic experience" and similar expressions. It should include a study of the nature and varieties of aesthetic experience in response to art and to nature. It should include the relations between such experience and other ways of responding to art. These problems lead one into aesthetic psychology and value theory, and fall largely outside the scope of this book. Perennial controversies go on about the meaning of "pleasure," the kinds of pleasure and displeasure to be derived from art, and the extent to which

art is and should be aimed at pleasure, beauty, or some other value. Such questions do not form an essential part of the morphology of art, and can be given only brief comment here.

Aesthetic experience is a way of responding to outside stimuli, primarily through sense perception, but also with related psychophysical processes such as those of association, understanding, imagination, conation, and emotion. The specific nature of all these processes, and their relation to each other in the total configuration, is highly variable. For example, the conative-emotional response involved may be one of admiration and delight, or of irritated repulsion as in looking at an offensive picture, or a shifting blend of the two. The aesthetic response to a single object, such as a picture or a scene in nature, may be highly complex and diversified, including reverberations and shifting attitudes of the entire personality. It may be attended with active movements of the limbs and motor-muscular system, as in walking about a cathedral, or be almost entirely inward and imperceptible to another observer, as when one listens to music. One or another constituent function or process may be relatively active and dominant: e.g., at one time seeing, at another hearing. Sometimes inner fantasies or meditations receive a larger share of attention, as in reading a philosophical lyric. Thus there are countless varieties of aesthetic experience, no one of which can be singled out as *the* aesthetic response.

In general, aesthetic experience differs from other main types of experience and response, especially the practical, the investigative, and the fantasy-building types. These involve different attitudes toward the outside world. They can be taken toward art, or toward any other kind of object; they enter into all phases of everyday experience. They may be momentary or habitual. Briefly, the *practical* response or attitude contains a relatively strong element of planning, scheming, trying to think out means to future ends, rehearsing possible future actions. The *investigative* attitude is also one of problem-solving, but with less direct reference to action, or to decisions to act in one way rather than another. The investigative attitude is highly developed in philosophical and scientific reasoning. Both the *aesthetic* and the *fantasy-building* attitudes tend to lack this element of active problem-solving, either practical or theoretical. They are more compliant; the individual allows his experience to drift along with little or no inner, independent, voluntary, purposeful direction. *Aesthetic* experience is directed, more or less continuously, by a group or series of outside sensory stimuli, such as the colors of a sunset, the tones of music, or the words of

a printed page. In *fantasy-building*, attention shifts wholly or partly away from present sensory stimuli, so that the individual is more unaware of his surroundings as in waking or sleeping dreams; the sequence of images is inwardly rather than outwardly directed. Four men may look at the same house. One schemes how to possess it (a practical attitude); another wonders about the origin of its architectural style (investigative); a third contemplates it with interest and admiration but without any special problem in mind (aesthetic); a fourth looks away from it to dream of his childhood home far away (fantasy-building).

In ordinary life there is great overlapping and admixture of these attitudes, with countless intermediate degrees. They are distinct only in their extreme forms. Most people change frequently from one to another, in dealing with art or any other type of situation. An aesthetic attitude toward a picture in a shop window may change to a practical one as the observer comes to think of buying it. A practical attitude, as in using a tool to build a chair, may become partly aesthetic as one becomes aware of the form of tool or chair as something interesting in itself, something pleasing or displeasing in appearance. In listening to a symphony, one's attention may drift into inner reveries for a while, almost ignoring the music, then return for careful listening and a more definitely aesthetic type of contemplation.

Aesthetic experience of a highly developed, specialized type, as in the ability to sustain close attention and enjoyment throughout a long symphony concert, is largely a phenomenon of modern civilization and a result of intensive training. In ordinary life, and in the art activities of earlier cultures, the aesthetic attitude is and was more intimately bound up with other attitudes: with daily work, practical thinking, religious and other activities. Aesthetic enjoyment was then felt more as an integral part of these other activities, especially at the completion of periods of effort and planning. Even today, in the behavior towards art of a highly trained connoisseur, aesthetic experience is not necessarily a pure, distinct, specialized process. It is not necessarily better when it is highly specialized and detached from all other interests.

Aesthetic experience may itself include some kinds of problem-solving, as in reading a detective or mystery story, but there we are guided step by step by the author's reasoning, unless we put the book down and try to solve the problem independently, thus abandoning the aesthetic attitude. An *artist's* attitude is not purely aesthetic, except at certain moments of quiet contemplation; he has to spend much time and energy in *practical* thinking about his own technical problems; how to manipulate his tools and materials to produce the desired effect. A historian or aesthetician, in considering a work of art, is likely to assume an *investigative* attitude toward it, instead of regarding it with simple aesthetic enjoyment.

The aesthetic attitude is in some ways passive and compliant, in following attentively some series of outer stimuli, rather than pursuing a spontaneous course of thought or action. But it can be very active in apperception itself, as in struggling to distinguish complex forms in the outer object (e.g., in a symphony), or obeying the guidance of printed words to imagine scenes, events, and ideas.

In the pure and highly specialized type of aesthetic response, one feels no urgent desire to pursue any future goals or satisfactions. One is content to live in the present, and, in the case of a temporal form, to await its gradual unfoldment, except as the work of art itself causes us to think ahead, with hope or fear, perhaps, as in watching a drama, but with no sense of having to do anything about it. The yokel in the audience, who feels impelled to warn the damsel in distress or spring upon the stage and rescue her, has not learned how to assume an aesthetic attitude when that is appropriate. The critic at the play can hardly be purely aesthetic, for he has to plan what to write about it afterwards. Comparative freedom from distracting problems in aesthetic experience permits an agreeable sense of relaxation from ordinary tension, an exhilarating stimulation of other, less anxious tensions, and a more leisurely, extensive observation of the object than would be possible in the grip of some urgent personal need.

Practical and investigative perception tends to be more rigidly selective, less free to enjoy the whole range of presented stimuli, because of the need to pick out for attention those details most relevant to the problem at hand. An artist's attitude in seeing a landscape may be aesthetic at times, but becomes more practical as he tries to select, rearrange, and translate into paint on canvas a few aspects of the total scene before him. An expert restorer, looking at a painting to see where it needs to be repaired, is practical rather than aesthetic in attitude, though he needs aesthetic sensitivity as well. Aesthetic observation tends to be more free-ranging than practical observation, more sensitive to the whole array of details and configurations in the object, whether it is a work of art or of nature.

On the other hand, aesthetic experience is never entirely free from a conative element: from some kind of desire or aversion. In looking at a picture in a

museum, one may not want to possess or even to touch it; one may not be conscious of any wishful fantasy for an object represented (e.g., for the love of a beautiful person in the picture or story). Nevertheless, the very fact of sustained, keen interest in perceiving the object is a kind of desire or willingness to see or hear more. It is motivated in part by the power of the work of art to arouse, often unconsciously, emotive images in the observer's mind, and thus to activate certain areas of his conative structure. Desires can be symbolically satisfied or frustrated by a work of art. If one tries to restrict the concept of aesthetic experience to visual and auditory responses which are entirely detached from conative and practical activity, one ignores many valuable ways of enjoying art. Even in its most disinterested forms, it is never entirely detached from ordinary desires and activities; if it were, it would be completely unmotivated. There is no basic desire or aspiration toward pure beauty, distinct from the rest of human motives.

Some kinds of bodily activity, other than cerebral, are integral parts of aesthetic experience itself, or closely connected with it. Not all aesthetic response is limited to sitting and listening, or moving one's eyes across a page or picture. To perceive a garden, one must walk around it; to perceive a piece of jade or velvet fully, one may want to handle it; to perceive a perfume, one must breathe it in. Even in listening to music, the body undergoes many half-unconscious tensions and relaxations, changes in pulse and breathing, slight impulses toward movement, which if not inhibited by convention might lead to active tapping, dancing, singing, or marching. Even though concealed beneath an impassive exterior, such incipient motor-muscular responses can be an important part of the total aesthetic experience. They arouse and are felt as emotional-conative exhilaration, depression, tension, relaxation, firmness, gentleness, hesitation, and the like, as in the sense of being carried along by a powerful flow of sound in a Beethoven symphony.

When a man repeats in imagination a poem or song he has memorized, the process is a step removed from aesthetic experience, since no present sensory stimuli are guiding it. But it is closer to such experience than it is to free, self-directed fantasy, being guided by a memory image of sensory stimuli. Pleasant fantasies can be stimulated by a drug, or by some diseases. Such an agency may seem to fulfill the requirements of a work of art; but it does not guide the fantasy through specific sensory stimuli, and the experience is not purely aesthetic.

Aesthetic experience is not necessarily satisfactory or pleasant, whether caused by art or otherwise. Any of the four composite attitudes or types of response mentioned above can be pleasant, unpleasant, or intermediate, can be pervaded with agreeable or disagreeable feeling tone, can be dominated by a favorable, welcoming conative trend or a negative, rejecting one. Practical or investigative thinking about an object can become disagreeable when the difficulties are excessive and failure seems inevitable. It can involve positive desire for an object, such as a picture in a shop window, or aversion and desire to escape, as from an enemy sharpshooter. Free fantasy-building, as in daydreams, is usually pleasant because one chooses to think of pleasant images, but it can encounter painful ones at times, both consciously and unconsciously. Aesthetic experience also can be agreeable, disagreeable, or mixed, with any degree of ambivalence and mixed emotion.

Anyone with strong and definite tastes is sometimes disappointed and irritated by a work of art. This happens, for example, when a novel is slightly boring, and reminds one at times of some unhappy memory, but is on the whole entertaining enough to keep on reading. Ordinarily, if it becomes unpleasant enough, we close the book, or leave the theater, or turn our backs on the picture. Only schoolchildren, in a free country, are forced to study boring works of art, and then their attitude is rather practical than aesthetic, since it is motivated by the thought of future rewards and punishments. Some mixture of feelings toward a work of art is perhaps more common than complete, unalloyed pleasure. Of course, one may dislike and disapprove it in theory, and still enjoy the experience on the whole, or admire it in theory and be acutely bored by it. Excessive loudness or shrillness in music, or brightness and flicker in a motion picture, can be physically painful.

To satisfy the observer and to provide a satisfactory aesthetic experience, a work of art does not have to be beautiful or pleasant in the ordinary sense of these words. It may be ugly, shocking, disgusting, repellent; it may arouse the spectator to anger and resentment. These very effects may be deeply satisfying if he is in a state of mind to want and welcome them. This may be so when his inner desires are conflicting, perhaps unconsciously. The same object or experience may then please and displease him, satisfy and frustrate him, at the same time.

On the whole human beings, and indeed all sentient animals, like to repeat pleasant, satisfying experiences. They seek out the kind of object which tends to provide them. Purely natural phenomena, such as mountains, the moon, clouds, and rain, can give aesthetic pleasure to those who are suitably

endowed and conditioned. One cannot claim for art that it is always more beautiful or aesthetically satisfying than nature.

Though not always preferred or successful as a source of aesthetic enjoyment, art is specially devised and adapted for that purpose along with others. It has been successful often enough to be encouraged, patronized, and developed by countless generations.

8. Art which tends to attract and hold attention. Art adapted for marginal perception.

Any work of art must operate through stimulating and guiding sense perception, thereby stimulating and guiding other phases of a diversified psychophysical response. If it is to do so long, the observer must be somewhat willing and compliant. Also, the work must be able in some degree to attract and hold his voluntary attention; to maintain his willingness to continue perceiving. This we shall call "conspicuous art." The effect will depend somewhat, of course, on the observer's interests and attitudes and on surrounding conditions.

Attention is always selective; it means noticing some things and ignoring others. In a busy world, teeming with things which compete for our attention, art must compete also. If art is to have much chance of attracting and holding attention, there are several things which it must do. Some kinds of art do not demand close attention, and do these things to a less extent if at all. To hold attention does not make the work good. It is not necessarily bad if it does not do so. These are not rules or requirements for value in general. They are means to certain ends. There is a place in art for both kinds and each has its own aesthetic functions. The inconspicuous kind has been too much ignored in aesthetics.

To attract and hold close attention, the work of art must be *selective*. It must pick out for presentation a certain set of stimuli, limited in range, out of all the infinite profusion and change of possible sensations and ideas, thus giving us something on which our attention can be focused. A painting cannot do this and include all possible colors and shapes; a song cannot include hundreds of different melodies; a story cannot include a thousand different plots, situations, and characters.

Secondly, a way of making the selection clear is to *detach* the chosen materials from their setting or context in the environment, so that our attention remains more easily within the desired realm of space, time, or ideas. Merely taking a thing out of its normal context will help, as in taking a seashell from the beach and placing it on a table. The detachment is further underlined by surrounding the chosen materials with some kind of boundaries or limits, which tend to restrict attention from wandering. A frame does this for a picture; covers do it for a book; walls or hedges for a garden. The proscenium arch and the rise and fall of a curtain mark off the action on a stage from the action in the audience and from the world of "real life."

Such detachment from the outside world suggests and stimulates the assumption of a different attitude toward what is within. If we are used to taking a practical or investigative attitude toward things, the slight break from ordinary things may help us take an aesthetic attitude toward this limited, artificial realm. It gives us a sense of "psychic distance" from the ordinary world and from our ordinary selves. We are made ready to accept sensations, emotions, events which accord with the peculiar conventions of art, but which might seem preposterous or offensive as parts of everyday life: fairytale situations, exaggerated acts and speeches, exotic and highly colored passions.

A third means of attracting and holding attention is to *emphasize* and *intensify* what has been selected; to make it somehow more conspicuous and active than what lies without. The audience hall is dark and full of monotonous rows of silent, shadowy figures, backs of heads; on the stage are lights, colors, gestures, costumes, voices, conflicting actions. Even within the work of art, certain parts may be emphasized more than others. The spotlight falls on one or two characters; certain colors in a tapestry or themes in a symphony are accentuated by greater brilliance, loudness, size, purity of hue or tone, richness of ornamentation or texture, or in some other way. Some are dominant, some subordinate. Emphasis is not necessarily a matter of strength in the sensory stimulus; it may depend on emotional associations. Out of a quiet context, the whispered word "Liar!," "Fool!," or "Murderer!" leaps to seize attention. A twisted, nude body or a face contorted with frenzy attracts the eye when in front of a static architectural background. The emotive power of images varies considerably according to the individual, but there is also much agreement within a given culture.

Fourth, *variety and contrast* are essential for emphasis, and to hold the attention. If the environment is intense and conspicuous in the same way, the work of art will not stand out emphatically; it must be seen or heard in surroundings which are different from it,

and if possible less conspicuous. The same is true of relative emphasis among details within the work of art. If all the faces are contorted with emotion, if all parts of the tapestry are bright-colored, none will stand out as much as if some were subdued. Aside from differences of emphasis, variety and contrast tend to hold the attention, monotony and uniformity to lose it. When we find that all details within a field are similar we tend (other things being equal) to lose interest in it; we have seen and understood it, and can pass on to something new. When all the tiles in a floor are similar, we cease to notice them. Repeated, similar sounds, as of a motor while one is riding, soon pass from notice entirely unless recalled by some new event, as the stopping of the sound. This tendency is deeply embedded in instinct and practical experience. We have not the time or energy to notice all that is around us, the air we breathe or the steps we take. As much as possible is relegated to the automatic, semiconscious level, and conscious attention is left free to deal with matters which may need watchful handling, to deal with unexpected opportunities and dangers. So, in art also, we quickly take the repetitious for granted and look away to something else; but novelty, contrast, unexpected change, and even slight variations of the familiar tend to hold attention and revive flagging interest. On the other hand, extreme variety and constant, radical change in a work of art can produce a sense of confusion and repel the observer's interest.

Fifth and last of these basic requisites for attracting and holding attention is *internal organization* or *unity of form*. If the work is to guide a complex experience of some duration, sustaining interest throughout, there must be some continuity from part to part and moment to moment. The parts must cooperate in some degree toward a cumulative psychological effect, not be completely diffused and scattered. This is easy when the work of art is very simple and uniform throughout. A pyramid or an evenly tolling bell has considerable unity. But the more we introduce variety for the sake of sustaining interest, the more we risk confusion and the loss of interest on opposite grounds. If a reader loses the thread of a story he may never bother to pick it up again. To sustain long interest, we must do some of both: surprise and stimulate through variety of material and treatment, thus making it agreeably hard (but not too hard) for the observer to keep track of things; but we must reassure and aid him (but not too much) in grasping the work as a whole, by inner continuities, connections, and comprehensive frameworks.

The attention-holding power of art is not exactly proportional to these qualities; it depends on many variable factors. Much depends, as in all aesthetic phenomena, on the personality, present mood, and interest of the observer. The nature of what is selected for representation has much to do with interesting different kinds of person: whether the story or picture is about love or dangerous adventure may be more influential with adolescent observers than any abstract quality of form. The attendant circumstances are often important. If the environment is full of loud noise and excited movement, something calm and quiet like a Chopin nocturne may draw some listeners as a contrasting interlude. Here difference from the environment is more effective than emphasis. Because of such variables, one cannot say that any specific amount or degree is most effective in any of these qualities, or that any one quality is necessarily more important than the others. Some works of art contain much variety and little unity, yet succeed in holding the attention under certain conditions.

Some art is adapted to attract and hold the attention of the observer, to be conspicuous and highly interesting, while another kind of art is not. The latter is content to play a more subdued, *inconspicuous* role. The former kind tends to employ, in fairly high degree, all or most of the qualities just listed; the latter tends to reduce or avoid them.

How much and what kind of attention is desired by artists for their products? How much and what kind of attention do works of art attempt to attract and hold? How much and what kind do we ordinarily bestow on works of art? How much and what kind is it desirable to give, from the standpoint of maximum enjoyment?

There can be no single, specific answer to these questions, for many different kinds and degrees of attention are sought and given. One must not assume, as some theorists do, that it is always best to have our attentions held as firmly and sharply as possible, over a long period of time. No doubt some artists would be pleased to have the public held in fixed, unwavering fascination by their works, hour after hour; but they cannot expect this to happen always. When it does not, it is not necessarily a sign of failure in the work of art.

Many kinds of art are *made to be perceived marginally*, not with focused attention; to recede somewhat into the background or periphery of attention, while the observer carries on other activities. This function of art has been largely ignored by aestheticians. Consequently, they ignore the ways in which many kinds of art are adapted to appeal through inattentive, marginal perception.

Furniture, home and office accessories, interior design, landscape and garden design are often adapted to a marginal role as visible backgrounds for living. Even the façade of a great office building is commonly so perceived by those who live and work nearby. Some observers, of course, will want to observe it closely. But any item in such a background is likely to be examined carefully when first acquired, or by visitors, and then gradually taken for granted, seen only "out of the corner of one's eye." Seeing or hearing it repeatedly under similar conditions tends to deprive it of its power to attract and hold attention; we pass on to something new.

Some kinds of art are *made deliberately to recede into the background.* On the whole, easel paintings, freestanding sculpture, plays, films, and concert music are adapted to attract and hold the full, sharply focused attention for a while (in the time arts, for the full period of performance). Some ceramics and accessories, such as small rugs and cushions, are made conspicuous to serve as accents in a room. But behind and around these, one usually finds quieter areas, as of floor, walls, and ceiling, colored in a plain, solid, subdued texture or inconspicuous, repetitious design. If not, the whole room may be felt as "too busy and restless," with everything clamoring for attention at the same time.

As to how much "restlessness" in a room is desirable, tastes differ and change. The Victorian home seems fussy and overdecorated today. The Arab or Moorish interior is crowded with surface decoration, but this is often in strong contrast with the bare desert outside. Some clothing is made to attract attention, especially women's formal evening gowns and bright summer dresses for sport; in former times the nobleman dressed ornately, to show his wealth and rank. But other clothing, such as business wear for men and women, schoolchildren's garb, and the uniforms of nurses, nuns, and soldiers, is intentionally plain and inconspicuous. Monotony is not necessarily bad. Everything depends on how much attention is desired (for a soldier, it might be fatal), and what kind of impression one wants to make on the observer. Tastes differ as to how much perfume is desirable, in man or woman.

Within a complex work of art, such as an opera, some costumes are conspicuous, others not; in a film or play with music, the incidental music is usually subordinated. Subordination is a necessary counterpart of emphasis; one cannot have one without the other. What seems in one setting as a complete, independent work of art, e.g., a vase or painting in a shop, may have to be reconsidered as part of a larger whole, such as a room, as to how much attention it should attract. A costume which is admirable in the ballroom will seem out of place in an office or factory. Trends in taste sometimes call for the utmost in complexity and magnificence, as at the court of Louis XIV; in other settings, as a Quaker meeting house, they call for severe simplicity and plainness, for the reduction of all aesthetic attraction to a minimum, so that the mind will be left free to think of other things.

It must not be assumed, however, that the aesthetic power of art is weakened in proportion as forms become simple and unobtrusive. Those which make heavy demands on the attention, forcing us to break away for a considerable time from daily activities, run the risk of being ignored thereafter, as in a long play or novel which one does not care to see or read again. A very conspicuous picture, a very exciting, stormy symphony may fatigue the attention and be soon put aside.

Subdued, inconspicuous art, like a gently insistent person, may have a deeper effect in the long run because one can enjoy its continuous or repeated presence. One's conscious attention may be elsewhere, but one can be vaguely aware of a shifting sensory field or background of sights and sounds, tactile sensations, occasional tastes and odors. Some individuals are more sensitive to them than others, but all are affected to some extent by this marginal type of aesthetic stimulation, in which works of art can play a subtly powerful role.

Room decorations and furnishings in a sickroom are especially influential because the patient is hypersensitive and has little else to notice; but even healthy, busy people are affected by living in an ordered or chaotic, calm or excited, bleak or luxurious interior. Noise of traffic and conversation while we are trying to think affects us in one way; soft, steady, gentle music, in another. A work of art which is seen or heard marginally on many occasions, such as a church or garden which one passes daily, may have deeper aesthetic effect in the long run than another which is seen once only with undivided attention, such as a motion picture film. Thus the artist is by no means abdicating his powers when he deliberately subdues his work to fit it for a minor but persistent role.

Concert music is largely a modern phenomenon, involving high specialization. A few experts write, and others perform, difficult music, while the audiences listen attentively. Connoisseurs among the latter demand high development in the forms they come to hear: complex designs and subtle nuances of tone and rhythm; surprising modulations and variations; inter-

rupted, discontinuous progressions. Something of interest is happening every second to recall the wandering attention. Modern concert music is for the most part busy, intense, arresting, even in its relatively soft and slow passages; rarely permitting a frankly identical repetition; ever straining to avoid monotony and hackneyed effects, to say as many different, original things as possible in the time allowed. Long, clear, simple passages and leisurely repetitions are accepted in works of the old masters, in moderate amount, but are not to be overdone without danger of boring the audience, and not often risked by contemporary concert composers. "Streamlining" the classics for brief radio performance tends still further to eliminate slow, uneventful, and repetitious passages from concert music.

The radio, sensitive to many currents in popular taste, also presents at times analogous tendencies in music. Its managers realize that people often turn the radio on without giving it their undivided attention, conversing as they could not do in a concert hall, playing games, working, or dining. The radio does not strain and cajole incessantly to hold attention, but at times presents music adapted to marginal listening. One radio chain has presented a series entitled "Music for Reading" with the explanation that it aims to provide a "pleasant musical background for relaxation," to which one can listen while sitting comfortably at home and reading a book. Its guarantee *not* to distract or attract one's attention unduly is its chief recommendation. It is smoothly flowing, placid, and sweet, with few marked accents or dissonances. Many other popular radio programs are of this general type, without being so consciously designed for an inconspicuous role. They tend to be simple, repetitious, continuous, and fairly even in intensity. They avoid novel, surprising variations and contrasts. Familiar tunes, or new ones closely resembling them, are often preferred.

Music played by small orchestras in restaurants, hotel lobbies, and ship salons, while people talk, eat, drink, and move about, has long exerted a function like that of these recent radio developments. In Germany it has long been known as *Tafelmusik*. Ordinarily, such music is not written specially for the purpose, but consists of popular or semiclassical favorites. The adaptation to a subordinate role consists in the common tendency to play it in a regular, almost unaccented manner. This strikes concert musicians as mechanical and bad, but it is wanted under the circumstances.

Whether played by radio or directly, music so heard becomes part of the general background of experience, an auditory texture comparable to the visual texture of soft, subdued furnishings, but more shifting and evanescent. It is not purely sensory, for it tends to contribute a vague emotional atmosphere, and helps to set the rhythm and tempo of modern living. Concert music is often listened to in this way, especially over the radio, but is not always well adapted to such listening. Its close-knit texture, dramatic climaxes, and virtuosity seem to demand respectful attention, and keep it from sinking modestly into the background. In the long run, persistent needs produce appropriate types of artistic form.

Still another category of popular music, performed by orchestras and diffused by radio, television, and phonograph records, is dance music. Sometimes this approximates concert music, in that seated audiences watch a spotlighted orchestra while it plays recent tunes, with solo parts and sophisticated orchestration. But when it is really intended for ballroom dancing, it tends to subside into marginal attention, and to be adapted accordingly. The dancers' attention is no longer fixed upon the music, but upon each other, on the movements of the dance, on other dancing couples, and on snatches of conversation. At least in the American environment at present, music so played tends to become more steady in rhythm and continuous in melodic flow, more repetitious (beginning again without pause when the piece is ended), and more uniform in intensity. Loud or soft, it is more on a level than concert music. "Rock and roll" and related popular types tend to maintain a high level of loudness and a steady, fast, pounding rhythm. They are definitely accented, but tend to avoid climaxes or special emphases which would interrupt the flow and attract attention. Not all popular dance music is of this type. Some Negro, Cuban, and other exotic types are highly climactic, even orgiastic, in their original form.

Less marked in rhythm, less stimulating in timbre and melody, and hence more inconspicuous, is the traditional lullaby or cradle song. Aimed at inducing sleep (complete lack of attention), it is perhaps the diametrical opposite of most concert music. However, as we have already noted, such traditional types are often taken over into modern concert music and radically changed in the process. A berceuse of Chopin or a *Wiegenlied* of Brahms is not at all suited to put one to sleep, but rather to hold the attention; it is hardly less animated than other concert pieces, and retains only a trace of the soothing, slow monotony of its prototypes. But meanwhile, therapeutic technique in treating nervous cases makes use of deliberately soothing music for adults.

Many modern concert types, such as a "shepherd's song" or "spinning song," if traced back to their ancestry in folk music, would lead us to a kind of music which was not at all designed for conspicuous performance. The actual piping of a rustic shepherd in the hills of Greece is a solitary form of expression, to while away the long hours and commune with nature, as well as to quiet and reassure the flock in one's charge. It is simple, placid, and repetitive in the extreme. Work songs of rustic artisans, such as spinners, boatmen, and potters, likewise tend to be endlessly repetitive or periodic, and to stay on an even level of intensity, except when they call for sudden bursts of effort, as in sailors' chanteys to be sung in hoisting anchor and the like. In any case, they are not primarily designed to be heard by an audience. Hence they tend to form indefinitely continued series like those of a simple border in visual pattern, without concentrated development in a specified period of time. They are inconspicuous in that the participants' attention is partly or mainly on the task in hand.

In the field of religious music, the Gregorian chant occupies an intermediate position between concert music and extremely inconspicuous types. Traditionally, as we have seen, it was not intended as an object of aesthetic enjoyment for its own sake, but as a humble instrument of worship and ritual. Ostentatious virtuosity in performance was to be avoided, and likewise effects of rhythm, melody, harmony, or timbre which might tend to attract attention in themselves and arouse moods of sensuous pleasure and worldly emotion. Hence the traditional Gregorian chant remains comparatively simple and undeveloped in most components. Its lines are moderately slow and undulating, gently swelling and descending in pitch and loudness, but never working up to rich or violent climaxes. Its phrases tend to become softer at the end. Its themes are sad or joyful to suit the occasion, but are not elaborately varied or sharply contrasted. The rhythms are subtle and often fairly complex in their combination of a quantitative basis with slight accentuation, but never startling or exciting. By comparison with later church music of the Renaissance and Baroque periods, the Gregorian chant was definitely accessory in role and inconspicuous in type of design. Nevertheless, it is now performed by highly trained choirs that render its subtle rhythms and intonations with modest virtuosity, and before audiences that listen attentively. In an age when religious devotion is less intense and preoccupying, this musical accessory tends to assume a more conspicuous role in spite of itself, and even to enter the realms of concert hall and radio.

9. Perception, apperception, and projection as involved in aesthetic experience.

We have begun with the idea of a work of art as a man-made instrument for stimulating certain kinds of psychophysical response in human beings. It is somewhat like a finger touching the button of an electric machine, which activates far-reaching processes; but the human response is, of course, far more complex and variable than that of which any machine is capable. The stimulus can be a sequence of light waves striking the eyes, or of sound waves striking the ears, or of solid, liquid, or gaseous materials affecting a lower sense organ, as through taste or smell.

From such a stimulus, a wide variety of responses may occur, depending not only on the nature of the stimulus and surrounding conditions, but also on the nature of the percipient, his physical and mental equipment, previous conditioning, and present attitude. The same stimulus, such as a picture, may set off very different responses in different persons, or in the same person at different times.

Sense perception is a necessary and important phase in aesthetic experience. Perception differs from sensation in involving not only the activity of the sense organ and afferent nerves, but some interpretation, as in referring the sensation to an external object. Seldom, if ever (after early infancy), do we have a sensation devoid of all interpretation, or of recognition through comparing the sense-data with memories of past experience. But the amount and relative importance of the associative and cognitive phase vary greatly. In some perceptual responses the sense organ is alert and hyperactive, with comparatively little effort to understand the object or make inferences about it. At other times the focus of attention shifts partly away from presented stimuli to related memories, fantasies, concepts, and inferences, as in the mind of a lawyer who listens to a witness while rapidly thinking out what his next question will be. The term "perception" is sometimes applied to the awareness of mental images, as in dreams, but we shall understand it as implying some sensory activity. The awareness may be of events within one's own body, as in feeling a pain or other organic sensation.

In aesthetics, it is important to observe the nature and importance of the sensory factor in experience, as compared with the interpretive and other factors. In an extensive, highly diversified process the percep-

tual phase is that which is relatively close to the sensory operation itself, as contrasted with free fantasy and introverted thinking.

When the *interpretive* phase of perception is highly developed, active, and attentive, we shall call the process *apperception*. This term is defined by Webster as "perception of meaning" or "the process of understanding (as of a new percept) in terms of one's previous experience." Such understanding may proceed along with sense perception. Apperception is the activity of fitting new percepts into one's fund of previous memories, habits, desires, and beliefs. Cognition and reasoning play a varying part in it. Some apperception can take place with only a small amount of conscious attention, as when one is half asleep. But thorough apperception is effortful; it requires some interest and conscious motivation. A flood of sensory stimuli pours in upon us when awake and we select only a few of them for special notice.

Aesthetic apperception is apperception which occurs as a part of aesthetic experience: e.g., in looking at a picture aesthetically. It is only one part of such experience, and varies in relative importance therein, along with feeling, imagination, and other components.

There is no sharp line between sensation, perception, and apperception, but a difference in degree. A dog or an infant can see a picture or a printed poem, or hear a symphony; they sense it crudely and vaguely. An older child can perceive that the black printed marks make letters and words, and understand some of their basic dictionary meanings. He does not apperceive the poem as fully as a literary scholar who grasps its complex form of word-sounds, imagery, and subtle allusions. The total aesthetic response includes conative and emotional processes, of welcoming or rejecting, pleasure or displeasure, and the like.

In actual aesthetic experience, the various phases may occur in a merged, integral way, as parts of one total gestalt, more or less simultaneously. There may be no perceptible sequence with sensation coming first, then interpretation, then emotional and conative response. The object may be sensed, understood (e.g., as a gunshot), and responded to by a startled gesture, all in a flash. In responding to a work of art, the three phases may continue together for a long time, each influencing the others. Even the term "stimulus and response" is misleading, for it seems to imply that the aesthetic process is entirely subsequent to the sensory stimulation and caused by it. On the contrary, it is partly a continuation of certain previous attitudes and processes—e.g., expecting a certain kind of play as we sit down in a theater, feeling tense or

relaxed, happy or depressed. Such attitudes help predetermine, not only how we shall feel toward the actual sensory stimuli, but even how we shall perceive and understand them. Nevertheless, perception and understanding do a great deal to determine the emotional response and the nature of the gestalt as a whole. If we mistake a distant friend for an enemy, we feel and act differently toward him. We may misunderstand a poem as implying some offensive idea, become angry, then reread the passage and discover that no such idea was really expressed, and feel very differently about the whole thing.

Aesthetic apperception, especially of works of art, is sometimes strongly intellectual, as in reading a philosophical poem such as *Faust* or Lucretius's *On the Nature of Things*. It is usually less so in looking at a picture and recognizing what it represents, or in reading a popular love or adventure story. But in all these cases, there is an active attempt to interpret signs, to apprehend meanings, and to follow out lines of thought suggested by the object. The interpretations need not be true or correct; the meanings may not be the ones intended by the artist or established by social usage; the observer interprets the signs in his own way in relation to his own abilities and background of experience. He fits them into his previously formed personality structure. In aesthetic apperception his response is often a sequence of fantasies, guided by the outside stimuli, rather than intellectual reasoning or a search for true knowledge about the outer world. He allows the sensory data to suggest other images to his mind and contemplates these images aesthetically, as if they were present to his senses. Toward these he may assume a variety of conative, affective, intellectual, and other attitudes, as impelled by the work of art, his own interests, or both. He may love or hate them, try to analyze and interpret them, or simply regard them with passing interest. Insofar as suggested images and affects are directly suggested by the sensory stimulus, and are not remote parts of a train of private reverie, they act as *meanings* of that stimulus for the percipient. The word "orchid" may suggest to him a pleasant memory of one suddenly encountered in a forest. That affect-laden memory is part of the meaning of the word for him.

Aesthetic imagination or fantasy is an important factor in aesthetic apperception. Imagination may cut loose from the sensory stimuli entirely, to become for a while a spontaneous, inwardly motivated reverie; but then it ceases to be aesthetic. Aesthetic fantasy differs from free fantasy in being directed partly by the external, sensory stimuli, acting upon the individual's personality structure. Either fantasy or reason-

ing can be the most active, attentive phase in an aesthetic response, as long as it remains in close contact with sensation and is sensitive to the changing nature of incoming percepts.

We have seen that aesthetic responses tend to involve an affective or conative-emotional phase, and in addition the mechanism of projection, in which the affective responses are to some extent "objectified" or felt as qualities of the object-stimulus. All these various responses tend to merge and change in one diversified aesthetic experience of the object, as for example in listening to and enjoying (or perhaps being bored or displeased by) a symphony. One hears its sequence of tones, tries to organize them into heard patterns and categories (e.g., to recognize a rondo or a resemblance to falling raindrops), and at the same time feels them as exciting, soothing, harsh, lovely, monotonous, surprising, familiar, novel, or otherwise tinged with affective qualities. In actual aesthetic experience, and in most responses to art, the apperceptive phase does not occur distinctly and separately from the affective or evaluative phase. These and other phases occur in experience as indistinguishable parts of one complex configuration.

Nevertheless, they come to be distinguished, not only in psychological theory but in practice. Through education and self-discipline, one can learn to dissociate and partly inhibit projection, emotion, and conation in response to works of art and other objects. To do this for a time (not permanently) is a necessary phase in the development of a scientific attitude, and of critical objectivity in dealing with life's problems. Complete self-control along these lines is beyond the reach of humans; it would imply a superhuman, or perhaps inhuman, detachment. But to some extent it is achieved by all mature, intelligent, civilized persons. They learn to restrain or discount their personal feelings at times, for the sake of observing and thinking clearly in a particular situation, and thus ascertaining the facts of the case at hand.

In dealing with art, historians and aestheticians of the scientific type attempt to do this when necessary, in order to examine the nature of the work of art itself, apart from their personal feelings toward it. This, as we have seen, is necessary for a scientific morphology of art. It involves abandoning at times the aesthetic attitude toward art and substituting an investigative one. It involves maintaining and developing the apperceptive phase of aesthetic experience, while restraining the impulse toward full affective and projective response. This involves a temporary sacrifice of some aesthetic enjoyment for the sake of other values. One can be as objective as possible

toward a certain person or thing when circumstances call for it, and more warmly emotional at others.

The separation of apperceptive from affective responses becomes clearer as different individuals compare their experiences. Likes and dislikes, emotional attitudes, often vary independently of perception and understanding. In art, it is possible to agree on the sensory qualities of the object and on many of its meanings while disagreeing on its values and emotional qualities.

The mechanism of projection never disappears entirely from human experience, however. Philosophers have shown us that it occurs even in sense perception. In calling an object "red" or "sweet" we are projecting upon it, or attributing to it, our own sensations of redness or sweetness; we think of it as possessing such qualities in itself, but it does not. In fact, it becomes more and more difficult to find any intrinsic qualities, any noumenon, or object in itself, as we continue the epistemological analysis. Supposedly "primary" qualities like size, shape, and motion are said to be at least partly the result of our own sensory and intellectual experience, as are the "secondary" ones like redness and sweetness. Affects or "tertiary" qualities like the cheerfulness of a fire, or the solemnity and fervor of a religious painting, are not alone in being projected by human experience upon the outer object.

Strictly speaking, it might be more correct or cautious to say in each case, "I have an experience of . . ." instead of "the object is . . .," but this would make discussion intolerably awkward and subjective. Hence we go on attributing all manner of qualities and meanings to objects, instead of describing them as human responses or experiences. This leads to no trouble ordinarily, when people agree on their responses to similar sense-data. A very complex object or process can be described in terms of projected sense qualities or percepts, when people can agree on the meaning of names for such percepts, and on their applicability to the object.

10. Aesthetic objects and aesthetic forms. Individual and social aspects.

We have seen that aesthetic responses tend to be projected upon the external object which directly stimulates them. One's attention is directed to this object, and qualities derived from one's aesthetic response are attributed to it as if they were inherent properties. It is thus felt to be beautiful or ugly, charming, graceful, awkward, sublime, or the like. Even when

the observer is aware of his own feelings, of his state of bliss or boredom, he tends to attribute those feelings wholly or mainly to the object on which his special interest and attention are focused. He tends to credit or blame it for having caused the experience, and to ignore the part played in it by other factors such as his own desires, tastes, and present mood.

Anything regarded aesthetically—that is, as an object, stimulus, and guide for aesthetic experience—is an *aesthetic object*. Its physical basis may be anything perceptible in the outside world, a person or product, a work of art, a natural scene or event, a sound, taste, or odor. It is perceived as having certain sense qualities and traits of form; e.g., as being blue or red, round or square, sweet or sour, and also as having affective qualities such as attractive or repulsive, beautiful, noxious, fragrant, or delicious. Narcissus admired his own image aesthetically.

Aesthetic objects are *individual* and *social*, corresponding to the nature of the responses and attitudes which determine them. For the individual observer, a face or portrait toward which he feels aesthetically becomes, for him, an aesthetic object. It is a slightly different aesthetic object every time he perceives it, and even from one moment to the next, as he notices different aspects and feels differently toward them. It is, in part, the projection of a diversified, changing response. In actual experience most percepts are tinged with some affective quality. Heard music as a sequence of affect-laden, auditory percepts can be sad or gay, but not music as a mere sequence of sound waves or a set of black marks on paper.

Percepts can be socialized to some extent, and so can aesthetic qualities. Such words as "red" and "cold" are names for sense qualities upon which there has been a large amount of agreement; people experience them in similar ways and usually, though not always, can agree that a certain word is applicable. So, also, there is much agreement on aesthetic qualities in both nature and art. Insofar as people can agree in feeling that roses, bird songs, and Chartres Cathedral are beautiful, these become *social aesthetic objects*. The Rock of Gibraltar is a cultural symbol of strength and steadfastness. The moon as a social aesthetic object is that material satellite as it has been endowed with emotional meanings by countless generations of lovers, poets, painters, and storytellers: a very different thing from the moon as an object of scientific astronomy. Beethoven's Fifth Symphony as a social aesthetic object is that composition as heard, enjoyed, admired, and valued by thousands of concertgoers, in basically similar ways. It includes little of the physical conception of the symphony as a

sequence of measured sound waves; few of the audience can detect their specific frequencies. But it does include the firm, decisive tone of one theme, the flowing, gentle grace of another, the reassuring balance, unity, and strong conclusion of the whole.

This is not to ignore the fact of tremendous variation among individuals, groups, and generations in their aesthetic response to any given work of art or natural object. A social aesthetic object is always a changing, multiple-aspect object, embodying opposite and perhaps inconsistent qualities; it may be sublime to one generation, ridiculous to the next. But there is some agreement nevertheless; if not, there is no one social object in that case.

An aesthetic object has *aesthetic form*. This is the way it seems to the observer to be organized. Since his attitude is by definition aesthetic, the form of the object includes the affective qualities which he attributes to it. Insofar as the individual's aesthetic response is an organized configuration of psychophysical processes, it is projected upon the stimulus with some coherence. The statue is seen, understood, and emotionally felt as a whole with some degree and kind of organization. This may not be the whole form which the artist had in mind, and will certainly not be exactly as he conceived it. The uneducated observer may see Michelangelo's *Moses* only as a restless, muscular old man. One observer dislikes it as a reminder of his domineering father; another likes or dislikes it for more technical reasons. One notices only a few details of the statue, and fails to grasp its main, inherent structure; the other sees details and interrelations as the artist intended them. One ignores its mastery of sculptural art, the other appreciates it. But there is a kind of form and integration even in the naïve response, incorrect as it may seem to the connoisseur. Insofar as anyone sees, interprets, and feels toward the object in some definite way of his own; insofar as he is having a definite experience and not a mere jumble of incoherent impressions, his response is a *form* or gestalt. That form is partly attributed to or projected upon the object stimulus; it is the *individual aesthetic* form of the statue for the observer at that moment. For him it is affect-laden in a particular way.

Likewise the objects of social aesthetic experience have some organization and consistency, some persistent mode of arrangement in collective experience. In a particular work of art, this constitutes its *social aesthetic form*; the way in which society (or any group in its history) responds to it, thinks and feels toward it. Insofar as there is change and diversity in these attitudes, the object has many different forms.

Powerful individuals are loved and hated, made to symbolize the forces of good and the forces of evil. The conception of Mohammed, of Luther, of Savonarola in religious history, of Napoleon and Marx in social history, is not a merely intellectual one, but one endowed with intense, conflicting emotional and conative qualities which change from age to age. Great works of art are likewise the focus of continually shifting attitudes of praise and condemnation. These may be utterly diverse in one generation, as in the height of controversy over Wagner's merits or Courbet's; then may gradually assume a more consistent form, as they have toward Stravinsky's *Rite of Spring*. Scholars have interpreted the latter in certain ways; critics and the public have come to agree to a fair extent, for our generation at least, that it has certain values and certain limitations. Social attitudes toward it have settled into a relatively stable configuration which is expressed in terms of qualities, such as greatness, which are attributed to the work. This configuration is its social aesthetic form. The history of taste narrates the sequence of these forms, and so does the history of art insofar as it tells, not only how works of art and styles are made, but how they rise and fall in social esteem and are admired or condemned for changing reasons.

Social aesthetic objects include not only particular works of art like the *Odyssey*, but also types of art and elements in art, as emotionally regarded by social groups. Symbols of the universal "archetypes" described by Jung—e.g., the Hero, the Great Mother, the circular mandala—function as perennial objects of collective aesthetic and artistic experience. Religion, folklore, and the arts are full of emotive symbols, especially the erotic and sexual, which find ever-changing embodiments in new artistic forms and styles. The specific emotive power of a given image or symbol varies greatly, according to the culture pattern and the personality structure of those who regard it. The old king in fairy tales may be revered or rejected as a father image, or beheld with conflicting, ambivalent feelings. But such feelings are not infinitely diverse; they tend to assume one of a limited range of emotional attitudes, recurring through the centuries. As a social aesthetic object, the old king is not infinitely variable; as a rule, he is the hateful old tyrant, the wise and venerable protector, or both. But the range of feelings he inspires are very different on the whole from those inspired by other symbols, such as the clever animal whose exploits figure in countless fairy tales.

Historic styles of art also give rise to social aesthetic objects. What is Gothic or Baroque? Morpholog-ical analysis today gives a soberly objective answer in terms of stylistic traits. But in the history of taste, a style can be warmly admired in one age, fiercely detested in another. As a social aesthetic object, the Baroque is not merely a style, but a style regarded as magnificent or vulgarly overdecorated, sublimely powerful and rational or heavy, ostentatious, a hateful symbol of oppressive monarchy.

11. Aesthetic apperception, individual and social. Socially apperceptible forms.

Within the complex, diversified type of response called "aesthetic," we have seen that constituent factors or processes occur. Within the total aesthetic response, there is always a phase of sensory activity, the activity of one or more sense organs, with their related nerves and brain cells, which carry on the work of sense perception. There is, in many cases, an elaborate development of interpretation and understanding. It includes recognition and imagination as guided by the form of the object. This developed factor, as occurring within a diversified aesthetic response, is aesthetic apperception.

Although these phases usually occur in close integration, and not as separate processes, we have seen that it is possible to distinguish them in part, not only in theory but in practice. It is possible for the trained observer with scientific habits to perceive and apperceive with care and precision, while dissociating and restraining his conative-emotional responses to a large extent. This tends to substitute an investigative attitude for the aesthetic; but the emphasis can be on careful observation and analysis, rather than on problem-solving. One can try to apperceive a poem as fully as possible without raising any questions as to its authorship, sources and influences, psychological motivation, etc. One tries to grasp, not only the basic dictionary meanings of its constituent words, but their combined, cooperative meaning; to let one's mind follow out the trains of imagery and inference which they direct; to imagine the sounds of words and the pattern they construct; to grasp the relation between this pattern and the other ideas conveyed.

As the reader thus apprehends a poem, it becomes an *appercept* or *individually apperceived object*. He interprets the printed ink marks with meanings, projects upon and through them the products of his interpretive seeing and thinking. It becomes an apperceived form for him as he discerns its mode of organization, insofar as he attributes to the poem some

consistent interrelation of details, not only among the printed ink spots, but among the meanings and groups of meanings of the words they signify.

It is not a fully aesthetic object for him at the time, insofar as he is restraining his emotional responses. But he may be quite aware that this particular poem suggests certain emotional images and would probably arouse certain feelings in an observer who approached it in an aesthetic attitude. Awareness of these suggestions and potential effects may form part of the poem's apperceived form and be described accordingly.

Every work of art is experienced somewhat differently by each observer. No one can be sure of how another person apperceives it. But similar behavior toward it justifies the belief that there is often a basic similarity in the response of different individuals toward the same object. Thus we may call it social apperception, especially when the individuals cooperate in comparing their experiences.

The work of art as a *socially apperceived object* is the work of art as observed and understood by many individuals in a social group and perhaps throughout world civilization. It includes those features of the work on whose objective presence in the work there is a fair amount of agreement. This can be ascertained in regard to the *Divine Comedy* by reading the poem and authoritative interpretations of it. Some works of art are known to educated people the world over, and many more are commonly known within a large cultural group, as *Hamlet* is known within the Occidental world and the *Bhagavad-gītā* within the reach of Indian culture. Disputes arise on special points, such as the reason for Hamlet's indecision, but on the whole there is substantial agreement among authorities on the verse form and meaning of each part and of the whole. Dictionaries and grammars define the meaning and syntax of words and sentences. Teachers convey this accepted interpretation to students, changing it a little as the scholars change a point here and there, and passing it on through generations as a stable, enduring tradition, a constituent pattern in civilization. Whether people like and admire the work or not, they can agree substantially on its basic form and content. These will be somewhat similar even in translations. The established conception of *Hamlet* as a distinctive arrangement of word-sounds and ideas, and hence as an object of social apperception, can be accepted by people of widely different tastes.

Even where the work of art in question is new and unfamiliar, we can treat it as a potential object of social apperception. We can describe it as a *socially apperceptible form*, implying that it would probably be understood in a certain way by suitably educated people in a certain cultural environment. No work of art is completely different from all others. Words, patterns, colors, rhythms, chords recur in different combinations. As we noted above, certain ones take on enduring, widespread symbolic meanings, both conscious and unconscious. If the artist could not count on a public, even a small, sophisticated public, able to grasp his meaning to some extent, his powers of communication would be negligible. The artist in each medium inherits from his culture an apparatus for creative expression. It includes not only his basic vocabulary, palette, or notes of the scale, but also a vast array of traditional forms and meanings, concepts, patterns, and styles, simple and complex. From these he selects and rearranges. He adds fresh material from his own experience. It often seems to him quite new and strange, but is never completely so. It falls in part within the general scope of human experience, and is at least partly comprehensible as a factor in his art. A "new" work of art, then, is largely formed of images and meanings which are already part of the collective understanding.

Surveying the new work, one begins to recognize familiar ingredients and modes of arrangement. An educated observer, acquainted with relevant portions of his own social culture and hence with the symbols and meanings concerned, can predict approximately (never exactly) how they would be understood in this new combination by other educated persons in that culture, and to some extent by persons educated along similar lines throughout the world. A certain meaning can become international and intercultural. The cross in a religious context is understood as a symbol of Christianity not only by Christians but by persons of some general education everywhere. One can understand the hammer and sickle as a symbol of communism, whether or not one is a communist. The wheel as a Buddhist symbol of the Law is recognized and established in reference books on Buddhist iconology, and in encyclopedias in all civilized languages. With the extension of science and scholarship on a world scale, more and more symbols are understood in similar ways by educated people the world over.

To the extent that certain symbol-meaning relationships are thus established by social usage, they acquire a limited kind of *objectivity*. To understand them in a certain way is not purely a matter for individual choice or taste. If an individual fails to apperceive them in the established way, or refuses to do so, he can be judged wrong, incorrect, mistaken, as if he were to reject the common dictionary definition of a word. He can be said to have grasped only part of the

actual meaning, or to have misinterpreted the work of art. Such established usage is never completely definite or rigid; it is open to change by authoritative individuals or scholarly groups. It is more or less ambiguous, for the same symbol may imply different meanings. To some extent the context indicates which meaning is intended and is to be understood: a swastika meant one thing in American Indian art, another in Nazi German symbolism. But even in the same context, many symbols have plural, optional meanings, as in medieval Christian art. The symbols themselves may be intentionally unclear, producing an effect of mysterious vagueness. Many visual symbols are vague, and poetry is often ambiguous. But in proportion as humanity comes to agree on a stock of definite symbol-meaning relationships, and it is rapidly doing so, the interpretation of particular works of art becomes more objective (or intersubjective) and more predictable. The scholar can then say of a certain picture or poem, not only "This is what it means to me," but also "This is what it means." The latter implies no Platonic, absolutistic assumptions. It implies a generalization on social behavior: "This is what it means to contemporary, educated society. This is how most trained experts in the field explain it."

The *socially established* meaning of a symbol, or of a complete work of art, is not necessarily its popular meaning for the majority of individuals, for the "average citizen" or the "man in the street." There is some overlapping, but the definite establishment of symbol-meaning relations is largely the work of expert authorities, scholars, scientists, lexicographers, historians, and iconologists in various fields. They often base their definitions on popular usage, past or present, but the ordinary citizen is unaware of the vast stock of recognized cultural symbolism outside his own limited sphere of activity. A meaning may be known only to a few experts, and yet be established for a large cultural group in which they are recognized authorities. Such authority is not an arbitrary fiat, based on power or prestige alone. It expresses in part the reasoned judgment of experts, based on scientific techniques of inquiry and definition.

In aesthetic morphology, the observer has a difficult task in distinguishing, with regard to any particular art work, which of its meanings are socially established and which are more personal and private, derived merely from his own past experience. A picture of a church with a cross may remind him of one which he attended as a child, and of the people there. Such private associations would not be parts of the socially apperceptible meaning of the picture.

However, they might become so if, as a widely read author, he made these private associations part of the common culture. Thomas Gray thus publicized his memories and imaginings about a country church, and posterity established them in the English literary tradition.

When an aesthetician undertakes the morphological description of a work of art, he tries to apperceive it from a broadly social point of view, stressing those aspects and meanings which could be grasped by other observers. He has to interpret it in the light of his own "apperceptive mass," or background of funded experience, for he has no other; but he can try to stress the social element therein. To that end, he must make more use of standard reference works on art, and of interpretations by other writers, than he would if merely expressing his personal response, apperceptive or aesthetic. Direct observation of the work is basic and vital, but is not enough; it must be reinforced by supplementary information.

Another persistent difficulty in interpreting works of art arises from the fact that individual symbols as well as sensory details take on a different meaning in a new context. From a knowledge of their separate meanings, as stated in a dictionary or a book on iconography, one cannot be sure what they would signify together, along with other elements in a new work of art. A slight nuance of expression may change the whole import from serious explanation to parody and satire or vice versa. The more unified the work of art, the more its meaning must be grasped as an organic whole, not through mere listing of parts.

New symbols and meanings are constantly appearing in culture, and old symbols take on new meanings. Part of the meaning of a symbol may disappear from conscious recognition for a time, and then reappear. Primitive myths, folk tales, and rituals are full of images whose references to physical sexuality, violence, and acts of bloodthirsty cruelty were obvious and frankly recognized by primitive peoples. Later refinements of taste and morality so disguised and expurgated them as to exclude these meanings from civilized conscious recognition. Later psychoanalytic interpretation restores them to social consciousness: e.g., symbolic vestiges of patricide in myths of the slain and resurrected god, and of cannibalism in eucharistic rituals.

Unconscious meanings, as such, cannot be included as culturally established or socially apperceptible, no matter how universal they may be among humans. Such establishment requires conscious recognition. Morphological description should therefore be cautious about including new, debatable psychoanalytic

interpretations of a work of art. These should at least be distinguished from more verified meanings. But when a certain psychoanalytic interpretation is widely discussed by scholars (e.g., Hamlet's incestuous mother fixation), it becomes a part of society's stock of conscious meanings. It can therefore be mentioned as a socially apperceptible meaning of the play. When controversial, it should be stated as such, and not as a proven or adequate explanation. Likewise widely known facts and beliefs about the life of an artist, true or false, become socially attached to a work of art as part of its associated meaning. For example, van Gogh's portrait of himself with a bandaged head recalls his well-known self-mutilation.

12. Form in art as socially apperceptible.

A work of art as a socially apperceptible aesthetic object necessarily involves some arrangement or structure, and this is its *socially apperceptible aesthetic form*. Such form comprises the interrelation (a) of those aspects of the work of art which can be directly sensed, such as the sounds of music and the colors of painting; and (b) of those meanings or associations which are fairly well established in social usage, as contrasted with local, ephemeral, or highly specialized ones. It is intersubjectively perceptible and understandable. It is an arrangement which can be apprehended in approximately similar ways, not merely by exceptional individuals, but by considerable numbers of persons within a large cultural group; not necessarily by all persons therein, but by those with normal or superior psychophysical equipment and education in perceiving and understanding objects of this type.

The socially apperceptible form does *not* include the purely private, affective responses of individual observers, inaccessible to comparison with those of others. It does *not* include unconscious or purely individual symbolic meanings which the work may have had for the artist or may have for a single observer, unless and until these become conscious and socially recognized. Remote or occasional associations in the history of the work or the life of the artist are not included unless they have come to be socially regarded as integral parts of its established meaning. The socially apperceptible aspects of art are of special concern to aesthetic morphology, and will be emphasized in the present book.

To describe the form and function of a work, one may need to show how it is adapted for stimulating a certain feeling or desire in observers. Conduciveness to such an effect may be a comparatively objective feature of the work. One can describe the nature of a funeral march (e.g., the one in *Götterdämmerung*) as suited to a tragic scene and as tending to arouse tragic feelings. But whether any individual listener will or should actually feel so, and whether this funeral march is better or worse than others are questions which take us beyond the scope of morphology.

No work of art can be apperceived by all humans, or by all within a major social group: there will always be infants and blind, deaf, feebleminded, illiterate, or uneducated persons to whom it is inaccessible. Art is not unique in this. We do not expect everyone to see and understand the constellations as astronomers do, or plants as botanists do, but any adult with sufficient native ability can learn how by using the resources our civilization provides. A work of art may present many subtle and complex visual or auditory qualities, which only the acute and trained perception can discriminate; nevertheless, they are not denied when pointed out. The aesthetic form as an organization of such ingredients, while not universally apperceptible, is socially apperceptible in a limited way. Some works of art are very simple and obvious, and can be apperceived by the young and untrained—nursery rhymes, for example, although even these often contain subtle meanings which escape the young. Others, such as Chartres Cathedral and Bach's *Art of the Fugue*, require expert sense perception, knowledge, and connoisseurship. An individual's response to a work of art may not include a full or correct perception or understanding of the form as experts would apperceive it. This occurs, for example, when a young child or an uneducated adult sees a difficult play such as *Measure for Measure*.

In describing socially apperceptible form, one does not include how one feels toward it, or characterize it with strongly affective or evaluative terms such as "excellent," "mediocre," "great," or "tiresome." However, emotion and evaluation are not ignored in morphology. They may be part of the meaning of the work of art, as when a smiling face is apperceived as expressing happiness. The intent to please in certain ways may be expressed in the work of art itself, as in the prologues to many dramas. Fitness or intended fitness for certain aesthetic functions is often obvious in the form itself and in common interpretations of it, as in a clown's efforts to make people laugh.

In the description of a work of art, there is necessarily a good deal of personal, arbitrary interpretation and emphasis. Much as the observer may try to confine himself to aspects and meanings which any nor-

mal, suitably educated person would discern, he will inevitably see the object from his own point of view to some extent, and say what it means to him. But there can be an important difference in the amount of effort and in the gradual trend toward objectivity. Much purely individual feeling and association can be omitted in morphology which would rightly be stressed in the frankly personal, subjective type of criticism. The trend toward social objectivity and verifiable interpretation will progress as more and more different observers, all scientifically minded, study the same work of art, describe it, and come to agree on certain points. This task is much easier when evaluative issues are put aside for separate handling elsewhere.

13. Aesthetic and artistic objects. Aesthetic appeal. Aesthetic and nonaesthetic factors in a work of art. Unfinished parts and aesthetic relevance.

Any perceptible object or process, in nature, art, or elsewhere, is potentially an aesthetic object. It becomes actually so in being contemplated aesthetically by someone. It ceases to be an aesthetic object for him when he stops regarding it in that way. Many objects and types of object, such as the moon and flowers, often become aesthetic objects. Looking at any scene, such as the ocean in moonlight from the deck of a ship, one may suddenly feel toward it aesthetically. One becomes keenly aware of it visually and perhaps emotionally, as in imagining its vastness, loneliness, and hidden power. Toward a painting or film of the same scene one might feel in a similar way. The aesthetic attitude may quickly shift to a different one, as when the captain thinks practically about some problem of navigation. A person of aesthetic disposition tends to seek and prolong aesthetic experiences. Artists often regard them as possible materials for a work of art, and this is partly practical.

By definition, a work of art is a product of human skill. Its form is artistic as well as aesthetic (this does not imply that it is necessarily good). The concept of art excludes purely natural objects or events, however beautiful, such as wild flowers growing in their native habitat, unaffected by human skill. In a very broad sense, "nature" includes man and all his works, but that is not the sense intended here. Purely natural objects can have aesthetic form but not artistic form. It is a mistake to speak of "art forms in nature." When flowers are cultivated, improved by horticul-

ture, or even arranged in a vase, they become to some extent works of art and have artistic form.

Most objects and processes classed as works of art possess what is sometimes called "aesthetic appeal."[4] Like moonlight and roses, they are especially suited for stimulating aesthetic enjoyment and are sometimes capable of doing so. They are not necessarily successful in doing so; that depends partly on the persons who perceive them. An object may have aesthetic appeal or visual appeal without being beautiful or otherwise valuable. This is true of any painting, framed and hung on a wall, and of any symphony concert, however badly performed. Aesthetic appeal may be exerted in countless ways according to the medium, function, and style of the work concerned. As we have seen, it is often provided by differentiating and separating the work of art from its context, as in a drama performed on a proscenium stage; also by brighter lighting, conspicuous shapes and colors, loud sounds with definite pitch and rhythm, complex forms, representation of emotive objects, and the like.

Whatever operates to exert aesthetic appeal is an *aesthetic factor*, as in the words and gestures of a play. But other things which are integral parts of the performance may not be aesthetic factors, because they are normally imperceptible or irrelevant. The aesthetic effect of the whole would be much the same if they were different or absent. The backs of stage scenery are of this kind. They do not ordinarily have aesthetic appeal in themselves and are not aesthetic factors in dramatic art.

Having seen pictures or read stories about a certain kind of scene or event in life, one may have a greater tendency to regard it aesthetically. However, the opposite effect may occur. When a certain kind of object, scene, event, or idea is often treated in much the same way in art, it may cause only boredom or resistance to aesthetic contemplation. It may come to seem trite and hackneyed as in countless popular songs about moonlight and roses. Hence artists hoping to please sophisticated tastes usually try to find fresh subjects or to treat the old ones in a new way.

Regarded as a complete physical object or process (e.g., a statue or a musical performance) a work of art necessarily contains both *aesthetic and nonaesthetic*

[4] The word "appeal" is used here in a sense close to "plea" or "entreaty." "Aesthetic appeal" implies an effort or special fitness to satisfy aesthetically, but not necessarily actual aesthetic value. It implies a potential aesthetic stimulus for persons so constituted as to welcome it. As in the case of "sex appeal," it may be resisted or ignored. It is the offer or presentation of a stimulus, whether acceptable or not.

factors. The aesthetic factor is limited to those parts, qualities, and relations which can be perceived by normal human senses under comparatively normal conditions, or understood as established meanings or associations of those parts. It is limited to those aspects of the total work which contribute to aesthetic appeal. Most of the outside shape, size, and color of a freestanding marble statue is visible under normal conditions. It may also represent the god Apollo. Such images and meanings are parts of the aesthetic factor, but the marble inside an unbroken statue is not. Ordinarily, one cannot see the interior stone, and the visible form is not clearly adapted to making one imagine it.

If a statue, such as the Venus of Milo, is broken long after being made, some of the marble which was once invisible becomes unintentionally visible. The exposed surface may not be, at first, part of the aesthetic factor for most observers. But such breaks and rough surfaces may gradually come to be accepted as essentially characteristic of this statue, especially if its original form is unknown. It is now conceived and observed as if complete and so intended. Socially aesthetic form is not so much a matter of the artist's intention as of social attitudes and usages.

What is or is not to be regarded as part of the aesthetic factor is also a question of *aesthetic relevance*. A part or quality may be easily perceptible and a necessary means to the aesthetic effect, while not in itself forming part of the aesthetic object. For example, a broken, unsteady marble statue in a museum can be supported by an iron rod and clasp. This is obvious but easily disregarded by an experienced observer in contemplating the statue aesthetically.

In a musical performance, many slight sounds and sights occur which an experienced audience tends to ignore as irrelevant. The pianist may hum softly to himself and tap his foot; the conductor taps his baton on the music rack; some other musician moves his chair or turns a page. Someone in the audience coughs or whispers. These are nonaesthetic factors in the total auditory, aesthetic process.

The appearance and movements of the orchestra while playing a symphony are also parts of the total performance. They are parts of the total aesthetic experience of the listener and may add to or detract from his pleasure. But they are not parts of the aesthetic form of the symphony. They are extraneous, irrelevant factors in relation to the music as a work of art. In an opera, however, the appearance and movements of the singers (who are also actors) are more relevant. They contribute to the audiovisual form insofar as they are definitely controlled toward that end. The appearance of the orchestra and the back view of the conductor are usually irrelevant, even in opera. They are not shown in a way to attract attention during the performance.

In listening to an orchestra, people do not ordinarily recognize or pay attention to the exact frequencies, ratios, and overtones of all the tones they hear. Sounds come and go too fast and blend together almost indistinguishably. An expert in acoustics may grasp a few of them, but this is not considered necessary for the appreciation of music.

In some architecture, one can be fairly sure that certain parts were not intended to be seen and, if exposed, do not contribute to the aesthetic form. They are not artistic in themselves, even though they are parts of the work of art as a physical object and contribute to its strength. Let us suppose, for example, that a church or palace is closely hemmed in on both sides by other buildings, as often happened in Florence and Venice. The side walls were necessary to support the building, but were not finished on the outside. They were left in rough brick and stone, sometimes with drainpipes visible, to which drooping electric wires were added in later years. Demolition of the adjoining buildings has left these sides exposed. They are not necessarily ugly, and to some eyes may seem to have an interesting texture. But they are usually unrelated visually and aesthetically to the facade, which is the main aesthetic factor. Physically, the side walls are integral parts of the work of art and their construction was an integral part of the artist's task. From the inside of the house, one is aware of the side walls as supports and surfaces, but there is nothing inside to suggest the nature of their outside textures. They are only slightly developed artistically.

When we look at a painting in its frame, we ordinarily see only what is on the surface and visible under ordinary lighting, not what is visible only with a high-powered microscope or under X-rays or ultraviolet lighting. We do not see most of the canvas, wood, or gesso beneath the paint and varnish or the particles of wood of which the frame is made. A photograph of the painting under X-rays or ultraviolet is useful for certain purposes, but it is a different picture. It is usually made for scientific purposes rather than for direct aesthetic contemplation.

Some imperceptible parts of the work of art may be suggested to the observer's imagination by what he does perceive. A balcony or platform is sometimes cantilevered so far out from a building that the ordinary observer, accustomed to seeing supports, wonders what is holding it up, whether it is made of steel strong enough to bear the weight. A puzzling illusion of weakness, weightlessness, or defiance of gravity may be a part of the total aesthetic effect

conceived and executed by the architect. Suggested meanings play a large part in aesthetic form, but some suggestions are clearly contrived as parts of the form, while others are not. The latter are *nonaesthetic factors.*

It is not always easy to tell what is intended or aesthetically relevant; borderline cases occur, as in deciding just how much light should be thrown on a certain picture or how loudly and rapidly to play a piece of music. But quite extraneous details are often obvious, as when electricity fails and leaves a gallery in darkness, or when a performance is "drowned out" by noises outside a concert hall.

Many works of art are left partly unfinished, or left in ways which do not invite aesthetic attention. The unfinished parts are not necessarily bad or ugly. They may be imperceptible, or may have been so at first because placed where no one could see them. This is the case with statues originally placed in niches with backs concealed, then later taken down and shown in museums. An observer aware of the fact can easily disregard the back of the statue, if he wishes, or treat it as irrelevant to the aesthetic form. In other words, the unfinished back can be regarded as a *nonaesthetic factor* in the statue. It is relatively *nonartistic* also, by comparison with the front, but has some claim to artistry as part of the artist's whole conception. It contributes indirectly to the aesthetic effect by making the whole figure strong and easily fastened to the wall.

The question is further complicated when, as often happens, the artist deliberately leaves part of a statue rough and unfinished, even when the whole of it is to be seen, both rough and smooth. Michelangelo and Rodin did this frequently. In a sense, the "unfinished" part was finished from their points of view; it was shaped as much as they wanted to shape it. Its roughness, adjoining the smoothly polished parts, could suggest change and movement, a gradual emergence of the work of art from the rock, and thus a creation of life and order out of dead, crude, unordered matter. As contributing to such a scheme, the unfinished surface is part of the statue's aesthetic form, which is artistic as well as aesthetic. The same can be said of the sketchy, apparently unfinished parts of a portrait, which the artist wishes to contrast with the finished head and face.

14. *Appearance and reality.*

Is "aesthetic form" a mere illusion, a collective illusion if not an individual one? What, if anything, is

objective about it? Are we describing mere appearance and fantasies when we think we are describing a work of art? Empirical aesthetics makes no pretense of describing ultimate realities or things in themselves; appearances, fantasies, and illusion *are* its realities. But appearances are real enough *as phenomena* in a world of appearance, as actual events in the realm of experience.

The aesthetician can insist that physics and all other sciences are equally limited in this respect. The physical description of a statue or symphony, as we have seen, cannot claim to show it as it really is, but only as it appears and behaves when treated and observed in certain ways. The physical account is felt to be truer, closer to reality, largely because it can be more effectively verified by comparison with observed uniformities among phenomena, so that observers can be forced to agree in their findings.

The aspects of a work of art which appear in aesthetic experience, and are described as sense qualities or meanings, have their own status in reality as psychological phenomena. What goes on in people's heads is "objectively real" in this sense, though "subjective" in another sense. Aesthetic phenomena are not false or nonexistent. They are recurrent, more or less stable configurations in experience, in the apparent interaction between man and his environment, physical, social, and cultural. The illusion and the error come in attributing them wrongly to some supposed cause or underlying substance. It is a mistake to regard beauty as an inherent property of any external object, or on the other hand to refer it entirely to the perceiving mind. According to the naturalistic hypothesis, it is the product of an interaction between the two.

In art, illusions are consciously sought; the observer follows the artist's lead in trying to regard the representation as a real world in which he and others move and live. Aesthetics studies the nature and varieties of such illusion, and how they are produced by works of art. Sophisticated observers never quite lose track of the difference between appearance and "objective reality," i.e., between the imaginary world of the story or painting and the work of art as a sense object, part of the physical world about us. In aesthetic experience, we try to yield to illusion; in morphological analysis, to understand how illusion is produced. In later chapters, we shall consider the meanings of "realism" in art.

If affects and meanings occur, not in external objects but in human experiences, why not describe them as such? Why not stop talking about the apperceptible forms of art, and about aesthetic morphology? Why not reduce the whole subject of aesthetics

to a branch of psychology, and talk instead about configurations in perception, thought, and feeling? One reason is that aesthetic experience, like many other kinds of psychic process, *occurs largely as a projection* upon outer stimuli. It is felt or lived through *as if it were* the observation of pleasant or unpleasant qualities in some external object. In ignoring this projection, we would give a false account of the phenomena themselves. Our report will be more faithful in this respect if it continues to express its findings with reference to works of art as external objects endowed with perceptual and significant form. Hence the reason for a study of art in terms of morphology. Complex configurations in experience can be simply and easily described as traits of artistic form, which it would be laborious and cumbersome to describe in terms of mental processes. But both points of view and both modes of description are necessary for a thorough account of the facts. Morphology is not the whole of aesthetics. It should be supplemented by psychological and sociological accounts, describing the phenomena of art and aesthetic experience from these other points of view, with systematic reference to human individuals and groups.

15. Aesthetic forms in nature.

Can morphology discover aesthetic forms in nature, describe them, and compare them with those of art? As we have seen, phenomena of nature can become aesthetic objects, both individual and social, through the projection of aesthetic experience upon them. The moon as regarded by poets and lovers the world over is a social aesthetic object, and as such it can be analyzed and described from the standpoint of aesthetic morphology. By students of aesthetic phenomena who are not, presumably, under the moon's spell at the moment, or regarding it with emotion of any sort, the concept "moon" can be studied factually as an object-stimulus for certain recurrent emotional attitudes and ways of thinking. One can show how the visible form of the moon, its monthly cycle, its path through the heavens, its occasional eclipses, its dim reflected light have taken on diverse and contradictory emotive meanings through the ages: e.g., by association with the bow and the goddess of hunting, with lunacy, chastity, inconstancy, love, darkness, night, witchcraft, and the scientific exploration of space. A certain degree of organization is given to those social attitudes and meanings by the fact that

they are all focused upon the same natural object as symbol. "Queen and huntress, chaste and fair . . ."[5] "O! Swear not by the moon, the inconstant moon . . ."[6] "A savage Place! as holy and enchanted / As e'er beneath a waning moon was haunted / By woman wailing for her demon-lover!"[7] "Beautiful over the house-tops, ghastly, phantom moon, / Immense and silent moon . . ."[8] But in our own time the moon is coming to be associated more with space travel and scientific technology.

Many other objects in nature have thus taken on aesthetic social meaning and potency, which is capable of factual analysis: Orion, the sun, the Nile, Vesuvius, and the sea. As an aesthetic object Mount Olympus is still the home of the gods, although it has ceased to be so as an object of religious belief. The concept of a type or class of phenomena can also become an aesthetic object: flowers, animals, stars, clouds, waves, rocks, or trees. It is a worthwhile study to review these one by one from the standpoint of aesthetics; to examine their accumulated configurations of social perception, thought, fancy, and feelings; to see them as perennial stimuli to art and aesthetic experience.

There are, however, important differences between the aesthetic forms of nature and those of art, which make it hard to study those of nature by themselves. Nature or any aspect of nature, as a social aesthetic object, is not nature "in itself," or even nature as described by physical and biological science; it is nature as perceived, felt, and imagined by ordinary humans and especially by artists, who express and guide the aesthetic attitudes of other humans. It is nature, not "in the raw," but already partly transformed into art, or rather a composite residue of countless artists' work, of what these artists in all ages have felt, said, painted, and sung about nature.

How is one to study nature, apart from all art? Where is the borderline? The quest is harder than appears at first sight. We have already noted that many things, commonly regarded as natural, are partly changed by art: our domestic flowers have been transformed by horticulture; our parks, by landscape architecture; our horses, dogs, cattle, sheep, pigeons, and goldfish, by animal breeding. The human body and behavior have been the subject of artistic experiment since paleolithic times; there is art in washing or painting the face and combing the hair, in controlling the tones of the voice and the gestures of

[5] Ben Jonson, *Song: To Cynthia.*
[6] Shakespeare, *Romeo and Juliet.*
[7] Coleridge, *Kubla Khan.*
[8] Whitman, *Dirge for Two Veterans.*

the limbs. A gnarled branch is the product of natural, nonhuman forces, but it is only a step from admiring it to making abstract sculpture, which alters the shape a little to improve its design, or makes an entirely new one of similar qualities. Even the act of perception itself, as focused upon nature, involves some of the essential processes of art—selection and emphasis, detachment of certain details from their context in experience, endowing them with meanings from past association, and contemplating them in a single, interrelated gestalt.

To become definitely artistic the selected set of details, or something capable of suggesting them, must be externalized and made capable of stimulating aesthetic perception in others. This happens to some extent whenever we make a photograph from nature. A photograph of a blossom, a snow crystal, a cloudy sunrise, or a bird on the wing is not pure nature. It may be a work of art, the result of selecting a momentary aspect of some phenomenon, lighted in a certain way and seen from a certain point of view, then reproducing it on a sheet of paper for aesthetic contemplation. The medium (e.g., black ink or film) necessarily alters it somewhat. A phonograph record of bird songs in a garden is a selection of certain sounds as heard from a certain spot and reproduced with alterations by a mechanical medium. The moment we select any aspect of nature for closer observation, and still more when we try to preserve it for extended study, we find that it has ceased to be nature; we have transformed it in touching it, as Midas did in touching his children, who turned before his eyes to golden statues.

16. Particular forms and form-types.

All aesthetic forms include some imputed cultural meanings. They are partly established, predictable social modes of perceiving, feeling, and thinking toward works of art and other objects. An aesthetic form is not limited to the physical appearance of a statue or painting. It is also the record of certain ways of thinking and acting by people elsewhere, which have been attributed to the work of art as meanings. All works of art involve sensory signs and stimuli, capable of guiding apperceptive and other responses in the observer.

Important differences occur in art as to the nature of such sets of signs and stimuli, and as to the way in which social meanings are related to them. Works of art differ as to the extent to which they are bound up with some one physical object or set of stimuli. In some cases, the work of art is regarded as identical with a particular thing, such as a statue. The nature of that object is considered as a necessary, integral part of the aesthetic form. In other cases the work of art is conceived, not as bound up with any one object or event, but as more abstract and independent. On this basis, works of art can be roughly divided into several overlapping groups.

The main division is between *particular forms* and *general form-types.* A particular form is the form of a single work of art with its own individual identity, and usually with an exclusive proper name and designation: e.g., Beethoven's Sonata for Piano No. 23 in F Minor, Opus 57 (*Appassionata*). At the other extreme are general types such as the landscape, the oratorio, the comedy, the tragedy, etc., which are obviously abstractions. The main divisions are as follows:

I. *Particular aesthetic forms.*
 A. *Concrete aesthetic forms;* the aesthetic form of a certain physical object or group of objects, including its motions or changing appearances, if any.
 1. Of a static object.
 2. Of a mobile object; a simple or indeterminate action.
 3. Of a performance; a single, complex, transitory process.
 B. *Guidance or directional forms;* particular forms *independent of any one concrete object or event.*
II. *General form-types.*
 A. Historic styles.
 B. Recurrent types.

A *concrete* aesthetic form is most strongly bound up with some particular physical thing, such as a chair, or a group of things, such as a flower garden or a furnished room. It is conceived as the aesthetic form of that object or ensemble. Even the most "abstract" painting, in the sense of being nonrepresentational, is concrete as a particular physical object.

(1) The object or group may be comparatively *static*, motionless, enduring, as in the case of Rouen Cathedral, the Venus of Milo, or Leonardo's *Mona Lisa.* It exists as a concretion in space and time; as a more or less durable, fixed arrangement of material particles. We have noticed that the aesthetic form of the object is not the same as its physical form, but is that object as endowed with socially apperceptible meanings.

Even a "static" object presents changing visual aspects under changing conditions. Monet showed us

in pictorial form how many different aspects of color and light Rouen Cathedral assumed at different times of day and year. It can be seen from countless points of view: from any point around it on the ground, from inside, from its roof or the roof of a neighboring house; its builders never saw it from the air. Which of these aspects, and under what kind of lighting, are essential to it as an architectural form, and which are mere extraneous accidents?

As a socially apperceptible form, even a statue or cathedral is always more and less than the physical object which embodies it. It is that physical object as capable of being experienced in a variety of ways under different conditions. But it is not necessarily the sum of all possible ways of experiencing it, for some of these will be considered accidental or trivial. Some will appear most important: for example, certain aspects of the statue which are finished with special care and placed conspicuously. If the statue is placed so that no one can see it from above and behind, then that aspect may be held nonessential. But perhaps the devout sculptor foresaw that God and the angels might behold it from all points of view, as they see the hidden places of the heart. He may therefore have finished it with care in places not accessible to human vision. Later on, it is taken down and placed in a museum on a different level. Thus not only the nature of the physical object but changing attitudes toward it help determine its form as socially apperceptible.

What is the aesthetic form of the Parthenon? Different answers are possible. To the tourist, it is the visible form and associations of the present, partly restored (and perhaps incorrectly restored) pile of stones which bears that name. From the standpoint of art history, it is rather the conjectural form of the original building, with its sculpture and coloring intact, which archeologists have described for us. They disagree, so that concept must be described as having unknown or debatable features.

In painting, sculpture, and some of the decorative arts, great importance is attached to the "original" work of the artist, his own handiwork as distinct from reproductions. The former commands a much higher price and is given an honored place in museums. Heretofore, most reproductions of painting and sculpture have been so inexact that connoisseurs had reason for scorning them; they actually failed to present the subtle coloring and texture of originals. Now they are coming to be hard to distinguish from the originals, by ordinary perception. According to our definition of art, they are unquestionably "works of art." Aside from the sentimental value of thinking one has the "original," and from special, technical purposes, an exact reproduction can provide very similar aesthetic stimulation.

Painters and sculptors are coming to design for reproduction, as designers of industrial art have long done. Musicians compose and play for radio, television, phonograph records, and films. A similar trend occurred long ago in literature. Before the invention of writing, a poem was restricted in its audience to those who could hear the voice of the poet or speaker; writing extended it to a somewhat larger public of those who had access to manuscripts; printing gave it unlimited potential circulation. The result in all these arts is to free the artist's work from being tied down to a single, concrete physical object or event. He comes to think of himself as designing or composing for large-scale production. His painting is not only a work of art in itself but a design for color prints and perhaps for magazine covers and book illustrations. He may set a greater premium, as the public does, on his idea than on the actual paper or canvas on which it is first set down. As a particular aesthetic form, it exists not only in the original design but in all the later examples, which are no longer regarded as "mere reproductions." In industrial art, as in the making of automobiles, this trend has gone much farther. No preliminary sketch or model completely expresses the concept of a certain style of car; the design is completely realized only in the cars themselves, and is often revised in the course of mass production.

(2) The concrete object or group may be *mobile*. The trees and flowers in a garden move with the wind and sun, in a more or less indeterminate way. The water in a fountain or cascade flows in a more determinate, fixed path, but its movement is fairly simple, repetitious, and automatic, once the pipes have been placed and the water turned on. Windmills and weathervanes move in simple orbits and cycles. So do the parts of Calder's "mobiles." They require no art of performance, as a rule; no personal skill of execution each time they are to be seen. As in a statue, the skill is mostly in the initial construction; once made, the thing performs automatically, needing only maintenance, continuously giving off visual and perhaps auditory stimuli.

(3) *Aesthetic form in performance* is that of a single complex, transitory process, as in the singing of a song, the playing of a sonata, the execution of a dance, the recitation of a poem, the enactment of a play; one single instance of it, as a concrete event at a certain time and place. One may say of such a performance, "That was a work of art," even if it was

improvised, spontaneous, unrecorded, and afterwards forgotten. It was the skilled production of a set of stimuli to aesthetic experience; it was not a purely automatic routine; it had aesthetic form, both sensory and meaningful.

Examples can be found on the borderline between this type of form and the first two. A building, statue, or garden may be lighted up and decorated for some special occasion in a unique way, as with torches, lanterns, and banners. As a single historical event, it is a work of art. Leonardo and other Renaissance and Baroque artists were often called on by their noble patrons to devise such spectacles and pageants, especially for birthdays and weddings. They involved musical, dance, and poetic performances and the temporary illumination of familiar parks and palaces in a way that transformed their everyday appearance.

Directional or guidance forms are particular forms independent of any one concrete object or event, as in Beethoven's *Appassionata* Sonata. They are conceptual and partly abstract aesthetic forms, capable of partial expression in interchangeable sign-complexes (e.g., a printed score or text) and also in many different concrete performances. The sign-complex is a set of directions or guiding cues for the performer: the actor, reciter, singer, pianist, violinist, or dancer. The development of such forms is an application of the devices of spoken and written language. It gives the creative artist a wider audience and lets more people profit by his work. It provides a means for him to free his work from the narrow limits of a single transitory performance. A printed sign-complex can be reproduced in quantity and sent to the ends of the earth. Now films, phonograph records, and other devices can also act as guides to performers anywhere.

In a temporal art such as music, the "work of art" is not usually limited to any one performance. When we speak of "the works of Corneille" or "the works of Brahms," we denote no one stage presentation and no one copy of the text, but something more abstract and detachable. We refer to the complex arrangements of auditory and other meanings which are signified by the printed marks, and which can be performed an indefinite number of times. Any one performance of Beethoven's *Kreutzer* Sonata, on a certain evening in Berlin or Paris, inevitably contained many features which are not essential to the form as Beethoven wrote it down. The violinist played some notes a little flat, others sharp, perhaps a note which was not in the score at all; he made some longer or louder than the score directs; no two personal performances are alike. Such accidental, unintentional pecu-

liarities are not considered as essential parts of the *Kreutzer* Sonata, though they may recur in some musician's interpretation of it. A phonograph record preserves all that occurred at any one time, and hence comes to sound a little mechanical after frequent repetition; the nuances are more uniform than in "live" performances. Moreover, the sonata sounded a little different in each part of the hall; the sound waves were slightly different as they struck each person's ear. Obviously, a dance on a stage presents a slightly different sequence of visible patterns to each point in the auditorium. Each particular performance approximates the ideal, social conception of that work of art, with slight alterations, additions, and omissions. Even the composer never played or imagined it completely; for it keeps on changing as society reinterprets it.

All works of art and all aesthetic forms are directive to some extent: they serve to stimulate and guide the observer's apperceptual and other responses. But in those we are now discussing the directive function plays a major role. They are made, not merely to direct sensations and thoughts, but often to direct active, overt performance; complex sequences of muscular and motor activities. Such performance may be necessary to full appreciation. Such a work of art as an aesthetic form is briefly actualized, given full concrete reality only when it is overtly performed, so that sounds or visual stimuli are sent out to ears or eyes. The musical or choreographic score is seldom used as an aesthetic stimulus in itself; its directive power to dancers is its whole reason for being. This distinguishes visual directional forms from reproductions of painting and sculpture. In the former the printed signs are not intended to be interesting in themselves or to hold the attention as such, but to be used as a transparent medium, or a guide to thought and action. The color-print or plaster cast is intended to hold attention and interest for its own visual qualities, as well as for what it makes us think about.

In *directional form*, the essentials of the work of art are not completely bound to any one kind of visual or auditory sign; they are partly detachable as a set of meanings. Any one set of visual signs is dispensable; different kinds of sign can be interchanged. Their precise appearance is not essential. A poem can be printed in large or small type, black or red, roman, italic, or script, in electric lights, or in Braille type for the blind, to be read by touch. As to the actual psychological effect in apperceiving it, such difference in the sign-complex may make a good deal of difference in the total aesthetic response. But from the standpoint of literary art, the form of the poem is

regarded as essentially unaffected by the style of printing. It may be combined, of course, with calligraphy or decorative typography; but the result then is a different kind of art, partly visual.

A poem can be translated into another language without entirely losing its identity, and is commonly regarded as the same poem, the same particular form: e.g., as a German or French translation of the *Odyssey*. The linguistic medium is not entirely detachable and interchangeable, however. Insofar as specific word-sounds and nuances of meaning are essential to the form and inseparable from the original language, the work cannot be translated. This is the case with poetry, of course, more than with ordinary prose. Successful translation requires the help of a literary artist as translator, and produces a form which is partly new. Opinions often differ on how much of the original is preserved; but certainly many essential features of the *Odyssey*, such as the plot, incidents, characterization, imagery, even certain qualities of rhythm and meter, can be detached from the Greek and rendered in other civilized languages.

When most people were illiterate, literature had to be performed or read aloud by specially skilled artists, as music and drama are performed today. Now, through compulsory education, the rudiments of this art are widespread; most persons in a civilized country can read aloud for themselves. They can also, and usually do, read to themselves silently. This is itself a kind of private performance. A printed story may be all before one's eyes at once, like a picture; but its stimulative effect is not as automatic and immediate as that of the picture. One has to look at each phrase or sentence, one by one in the proper order, decipher its meaning, and fit it into what has gone before. The sound of the words is a part of this meaning, and the trained, sensitive reader of a poem can imagine it as he reads. More often, especially in reading prose. we hurry over it, and pay more attention to the other kinds of meaning; thus we do not, even mentally, give a full performance of the work. Highly trained musicians can read or write a musical score silently, and imagine how it would sound, thus giving it an imaginary performance like the ordinary silent reading of a poem.

In literature, spoken and written or printed words are to some extent alternative, interchangeable sets of signs, directing the percipient to think about the same ideas. In much prose, where the word-sounds are not especially important, the total effect of hearing the work or reading it to oneself is much the same; one can say that the essentials of the form have not been materially altered. But insofar as the word-sounds are

important, they are not a transparent medium or a merely arbitrary, dispensable set of signs, but an integral, quasi-musical part of the aesthetic form itself. If they are not heard or imagined, the form is not wholly apprehended.

Whether printed or spoken, literary forms are temporal and require special performance each time they are to be perceived, in order to activate their sensory stimuli. But this difference from static visual forms, like those of painting and sculpture, is relative. A painting is not necessarily easier to apperceive than a printed story merely because it displays its visual form automatically whenever the light falls on it. The picture also requires a temporal succession of steps in visual perception to be fully seen. In proportion as it is complex and subtle as to visual form and meaning, it requires active, skilled apperception on the part of the observer.

The particularity or individual identity of works of art is often relative and subject to gradual change. When a poem is translated, to what extent is it the same poem? When an "original" painting has been damaged and restored, no one knows how accurately, to what extent is it the same painting? Many of the world's most famous frescoes and oil paintings have been much altered in the course of history. It is only in recent years that exactly authenticated literary texts and musical scores have been carefully preserved. The older ones, and still more the early manuscripts, often vary in different versions and are full of gaps. Some writers and composers were careless proofreaders. Musical scores, even in the eighteenth century, often left much of the composition to be improvised by the player, especially the harmonization of the subordinate parts. Nuances of expression, volume, tempo, rhythm, etc., are often unspecified; so, in dramatic texts, are details of costume, staging, tone of voice, tempo, and gesture. Each performance is a concrete, full reality, with actors having a certain appearance and manner. Many of its details are held to be nonessential and optional, for the individual performer or director to decide about. The printed text, as filled in and amended by some editor, prescribes what he believes to be the essentials of the form. Tradition (e.g., how to act *Othello* or play a Bach fugue) helps to stabilize it. But it is always subject to some variation in performance.

Before writing existed, stories, poems, songs, and dances were preserved in the minds and habits of men, and handed down from generation to generation. There was oral literature, in the broad sense of that term, long before letters were invented. Its products were persistent, slowly changing patterns in

human memory, speech, and gesture, and were parts of larger, diversified culture patterns. The gist of many songs and folk tales spread from one culture area to another, assuming local names for the characters and local backgrounds. When the culture was stable, a folk tale or genealogical record could descend in fixed oral wording through many generations. Magic and religious rituals were sometimes handed down with careful precision. But without the crystallizing effect of written words, the form of a particular poem, song, or dance was often unstable and shifting, merging with others, or losing details and adding new ones. Floating masses of song and legend were gradually organized by successive bards, and were occasionally given fixed, particular form by great individual poets, as in the case of the Homeric epics. Unwritten folk arts are still living outside the centers of urban culture. Their temporal forms still tend to be fluid rather than sharply particularized. They reveal persistent themes and variable types, as in tales of clever animals. Fixed forms arise when some author sets down a certain version, as Kipling did in the *Just-So Stories* and Harris in the tales of Br'er Rabbit.

We have been noticing some of the general characteristics of art and of aesthetic form. But one should not exaggerate this generality or think of artistic forms as Platonic universals, independent of all concrete embodiment. From the standpoint of naturalistic science, they are always embodied in concrete events, and in the behavior of physical bodies. They exist, at least, as recurrent configurations in the behavior of human individuals and groups; in their ways of writing, talking, moving, painting, carving, etc., and in inner fantasies of such actions. When all concrete embodiments of a work of art are destroyed, and no one any longer remembers or performs it, it ceases to exist.

Turning from particular works to categorizations such as "Gothic," "epic," or "polyphonic," we encounter still more general aspects of form. These relate to types, genres, or species of form and we shall call such aspects of forms, *form-types*. They are built up through comparison of many particular works of art, and through generalization on their common and divergent traits. Some of them, such as "Baroque," refer to *historic styles* or groups of common traits among many works of a certain place and period. The concept of an individual style, such as the style of El Greco or Chopin, is less abstract and general, more bound down to a small group of particular works, than that of "Japanese style" or "medieval style." Some form-types are of *recurrent genres or species,*

such as "landscape," "portraiture," and "dance music," which can be found in many countries and periods. Some refer to *common factors in form*, or constituent modes of organization in art, such as "melody" and "perspective."

Aesthetic morphology is much concerned with these types of form and factors in form. It tries to build them up as concepts through careful, empirical analysis and comparison. Then it can use them as means to more accurate, selective description of particular forms. Aesthetic morphology tries to work out a systematic classification of all the principal types of form in art, to which any particular trait or example can be related.

The scientific description of a particular example is sometimes called diagnosis. In medicine this implies the recognition of a disease or other special condition; in botany and zoology it is a concise technical description of an individual (e.g., a fossil skeleton) or of a species or group, giving its distinguishing characters. In aesthetic morphology also, one needs to diagnose, identify, or characterize particular examples and groups: that is, (a) to show how they are related to certain form-types or species of art; how they fit into systems of form-types; (b) how they differ from other examples and types; their distinguishing characters. A work of art necessarily exemplifies many different form-types at once; it is always a combination of many different characteristics. It is, for instance, a piece of music, a work of the late Baroque style, partly homophonic and partly polyphonic, a string quartet, alternately slow and fast in tempo, etc. But it is also unique in certain ways, differing from other examples of these types or characteristics.

17. Analysis and synthesis in the study of form.

Any description of form, any attempt to perceive or understand it, must deal both with parts and with combinations of parts. It must at times pay special attention to the parts, details, or constituent qualities, and try to see how these are joined or merged in larger groups or wholes. This approach is one of *synthesis*. It applies to the task of observation and apperception, and to the task of description in words or other signs.

The study of form must also begin at times with the wholes or larger groups, and try to see how they are composed of smaller ones; of constituent groups or configurations and of small details. This approach is one of *analysis*, in the strict sense of that term,

although the term is sometimes made to cover both supplementary phases in the study of form.

In physics and chemistry, both analysis and synthesis can be executed as well as observed. One can actually break down a complex material into molecules, atoms, and perhaps electrons; one can build these up again into the same or another material. In biology one can dissect a living form and view its parts under a microscope. One can synthesize to some extent, as through introducing substances into a living organism; one can breed new species, but so far biologists have not been able to build a living organism from inanimate particles. Biological morphology is concerned, not so much with the atomic or molecular structure of plants and animals, as with how living cells are combined in subordinate systems like the bark, branches, leaves, and veins of a tree, or the bony, muscular, nervous, respiratory, circulatory, digestive, and reproductive systems of a horse. Their study follows both analytic and synthetic lines.

In the field of aesthetics, artists build up forms; critics and aestheticians dissect or analyze these, not so much by actual cutting or dissociation of parts as by throwing the spotlight of attention on particular details and characteristics in a work of art. In aesthetics at present, morphological synthesis is largely a process of observing and describing how details have been combined by artists into some existing form, or could be so combined.

Analysis and synthesis can be applied (a) to the study of a particular form such as a symphony, play, or picture; (b) to the study of an abstract form-type such as the sonata pattern, the Baroque style of architecture, the comic or the tragic. In all there is a set of characteristics, arranged in a certain way. Both approaches can also be applied (c) to the systematic study of form in art, as in the present book.

In learning to apperceive a particular, complex form such as a novel, symphony, or cathedral, it is helpful to take both approaches at different times. This requires several hearings, readings, or viewings of the work. One's first observation, if the work is very complex, is likely to be rather vague and sketchy, with a superficial grasp of the whole and attention to scattered details here and there. This can be developed into *complex, organic apperception* through focusing the attention systematically on one group of details or qualities after another; on how they are interrelated in larger and larger groups, and how these combine and cooperate to form the whole. It can be extended, if one likes, to a systematic comparison of two or more particular forms, to discover their similarities and differences.

A systematic treatise like the present one can begin with a study of the comparatively simple parts or ingredients which go to make up a work of art, then go on to discuss the various ways of combining them in a particular form or in a type or style. This is an abstract, synthetic approach, and on the whole it will be followed in this book. On the other hand, one can begin with complex types or styles and break them down into constituent parts and factors. This is abstract analysis. Each method has its advantages and disadvantages; the important thing is to do some of both sooner or later. As a rule it is easier to begin with the simple and work up to the complex; that is the usual order of exposition in any science. It provides one with concepts for use in analysis later on.

In analyzing small parts or details, it is unnecessary and impossible to go as far as ultimate particles or purely elementary, irreducible qualities or processes. Both analysis and synthesis can deal only with complexes, groups, clusters, or sequences; with smaller and larger configurations, included and inclusive.

Neither analysis nor synthesis, nor a combination of the two, corresponds exactly to the artist's order of steps in production. There is another type of procedure in art which may be called *genetic*. It covers the development of a particular work of art, corresponding to biological ontogeny, and also the historical evolution of styles, corresponding (with important differences) to biological phylogeny or the origin of species.

Both analytic and synthetic phases are involved in the *artist's* creative thought and execution; but he seldom follows either with rigid system and consistency. His order is rather from the vague to the definite than from the simple to the complex. He often begins with a vague conception of the intended whole work of art, or perhaps with a whole scene in nature as a model, then gradually alters and clarifies it, with occasional, irregular shifts of attention back and forth between details and combinations.

Aesthetic analysis is not limited to mere dissection or division of a work of art into *concrete parts*. It includes the recognition of such parts and how they fit together; but this is only one phase in the process. The other, and much more difficult, phase deals with *abstract factors*, qualities, and constituent modes of organization, such as line, color, melody, symbolism, representation, and design.

Any work of art can be divided, on fairly quick inspection, into its main concrete parts, and these into smaller parts. A play is divided into acts and scenes, with a cast of characters proceeding through them; a symphony into movements; a novel into

chapters. A cathedral can be divided into exterior and interior, nave, transept, apse, chapels, walls, roof, doors, windows, stories, towers, balconies, corridors, etc. In a statue, one can distinguish head, limbs, trunk, and so on, as parts of a human body; perhaps two or more human figures, animals, or other objects. Some pictures are divided into panels; some have one or more figures or objects against a landscape background, or within a decorative field. All such divisions are on a simple spatial or temporal basis. A movement of a symphony is a large, fairly long piece of music occupying a certain period. A church steeple is one three-dimensional part of the edifice, occupying its own space; the apse is another. Any of these parts can be further subdivided: the window into panes or bits of glass and strips of lead between them; the movement into sections, phrases, tiny musical figures, single chords; the novel into sentences and words; a painted tree into branches, trunk, and foliage. All this could almost be done with a pair of scissors, as when children cut the outlines of men and women out of a picture; in music one might cut sections out of a printed score. Even the tiniest definite part, obtained by such division, is still a concrete detail, comprising many abstract qualities.

It is a more subtle, intellectual type of analysis to distinguish such pervasive factors as melody and rhythm in music, color and design in visual art, plot and characterization in fiction and drama. Such factors run throughout the form, interacting in various combinations. They cannot be separated from each other in actual existence, but only in apperception and theory. In terms of them, different concrete parts and different works of art can be compared with each other.

Note: The following illustrations are particularly relevant to this chapter: Plates III and IV, and Figures 3, 5, 7, 11, 16, 17, 18, 19, 20, and 27.

CHAPTER II

Modes
of Transmission
in Art

1. Works of art as devices for stimulating and guiding apperceptive responses, and for transmitting accumulated cultural experience.

Works of art are man-made devices with many different uses. Their most distinctive use is that of stimulating and guiding satisfactory aesthetic experience. This they do through providing objects for sense perception, especially visual and auditory, which have the power of arousing specific responses of interpretation and imagination in the mind of a suitably trained and compliant observer. The sensory qualities of the stimulus are endowed with more or less definite meanings, mostly by cultural usage, so that an artist can count to some extent on making an educated observer understand them in a certain way, at least within the limits of a certain social environment. By this means he can convey to the mind of an observer some of his own past experiences, actual and imaginary; also experiences of other humans. By words or pictures, he can tell of Napoleon's defeat or of Satan's. Verbal and pictorial forms are so versatile, so capable of suggesting different meanings in different combinations, that an artist can make an observer think of something—e.g., a scene in heaven or hell—which is quite remote from anyone's direct experience.

Through education we train the young to recognize and interpret a vocabulary of signs and symbols, some of which (like the three Rs) are regarded as basic and required of all normal students. Others are more specialized and optional, as in chemical formulas and orchestral scores. General education in civilized regions now imparts a large and increasing stock of verbal symbols, spoken and written, as well as some ability to grasp simple musical and pictorial forms. Words, drawings, photographs, three-dimensional models, and other media having significant form can be used in both art and science; but each of

those realms has others more peculiarly its own. Once an individual has learned a basic stock of symbolic forms and the technique for learning more, he can use them in studying whatever he chooses of his cultural heritage, which is recorded and handed down in them. He can enjoy a great range of experiences in art and elsewhere: partly direct, as in perceiving or performing art; partly indirect, as in imagining how it would feel to take part in the events portrayed in art. He can increase his knowledge, his wisdom, his memory of actual and imaginary experiences, and his power to deal with new situations as they arise.

It was mentioned above that a work of art acts upon the eyes or ears of an observer somewhat as does a finger pressing the button of an electric machine; it starts off a long chain of diversified responses. But an electric machine has a comparatively small range of variation in its responses, while the human organism is complex and constantly changing. No two organisms are exactly alike. One can never predict exactly what a person's response will be to a given work of art. Much depends on his predisposition as determined (1) by his heredity; (2) by his personality, education, and special training; (3) by his present mood, attitude, and interest, which in turn are affected by his present surroundings. In aesthetic psychology, we investigate the effects of all these factors on the nature and varieties of the total aesthetic response.

In morphology we ignore most of these individual variations, and look mainly at the nature of the object-stimulus itself as a complex form. We look also at its power to communicate by affecting the apperceptive mechanism, not of any individual or peculiar type as such, but of large numbers of educated persons in a civilized society, insofar as they possess a fair acquaintance with established symbol-meaning relationships and some ability to use them in customary

ways for apperceiving works of art. Our generalizations about the tendency of a work of art to look or sound in a certain way, or to suggest certain meanings to the mind, must all be relative and approximate. It is taken for granted that, in any given case, some personal or momentary peculiarity might prevent the observer from apperceiving it in that way, and make his response very different.

We assume a certain receptiveness on the part of the observer with regard to the work of art. Its power to stimulate and guide him is usually gentle and easily resisted; it may even require his active cooperation, as in reading a book. Any resistance or distracting interest may make his response very different from what it would otherwise have been. The tendency of a work of art to appear or sound in certain ways, or suggest certain meanings, is uncertain and variable but none the less real as a general fact of social behavior. The letters C, A, T may not always cause one to think of a certain kind of household pet, but they tend to do so as a rule, for English-speaking persons with at least a rudimentary education. Aesthetics studies analogous tendencies in the more complex forms of art.

When an unfamiliar form (let us say a printed version of a Greek legend) acts upon the eyes, it causes a suitably educated individual to rearrange part of his stock of learned images and concepts into a form which is new for him. The legend is a cultural product, which has taken centuries in the building. It is a small part of the accumulated, distilled, and organized experience of mankind. When the peculiar sensory form (of printed words) in which it is embodied acts upon the senses of a new individual, it *transmits* to him (conveys through a medium) some of that cultural product. There is nothing mystical in the idea of such a transmission. Physically speaking, the only thing transmitted is an impulse to the nerves through light waves, which set up inner nervous processes. But the important fact from a psychological standpoint is the *specific arrangement* in which those physical impulses are transmitted. These arrangements are the cultural product which is transmitted, as the radio transmits a specific sound form through radio waves.

A work of art acting on a sense organ is not merely causing a rearrangement of old elements, previously acquired bonds of image and meaning, within the brain. It is contributing not merely a new form to old memories, but also fresh experiences. The object perceived may have sensory qualities never before experienced. The child who hears a Greek legend may already know the meaning of certain words—enough to let him grasp the main outlines of the story without help. But he is likely at the same time to hear

unfamiliar words; to ask and learn their meaning from teachers or dictionaries. Unfamiliar images will be suggested to him, as of the weapons a Greek soldier used. Thus the story, along with cooperating agencies, will add new elements to his fund of cultural experience. His act of rearranging his previous memories and knowledge into a new configuration is itself a new experience; not purely sensory but apperceptive, imaginative, and rational.

2. Presentation and suggestion as modes of transmission; as factors in aesthetic form.

The action of a stimulus on the sense organs and related brain cells is one continuous process. Sensation and interpretation are not separate events. But for purposes of psychological and artistic analysis it is important to recognize two somewhat different phases in the process. If we analyze a work of art in terms of how it is transmitted to the individual, we find that certain elements within it can be transmitted as direct sensory percepts, while other elements cannot be directly sensed, but must be built up by the individual from his own understanding, memory, and imagination, in accordance with clues in the outer stimulus. Direct stimulation of the sense organs is *presentation*. Traits of the object which can be thus directly sensed are *presented*. Stimulating or conveying experience through the power of these presented traits to call up associated images and concepts is *suggestion*.

Both these modes of transmission occur in all art. Every work of art presents some stimulus to one or more senses. All presented sense-data tend to suggest further images or ideas, mainly by association with past experience. Within a work of art, the modes of transmission operate as *factors in form*. We shall speak of them as *presented and suggested*, or presentative and suggestive factors. Both together are the *transmissional factors* in form. The presentative factor includes those elements, aspects, or qualities in the work of art which are or can be directly sensed by a normal human observer. The suggestive includes those which, as parts of the work of art, cannot be directly sensed, but can be called up to the observer's imagination through association with the presented factor.

In analyzing a work of art, it is not always easy to distinguish between what is presented and what is suggested. In ordinary experience we do not often attempt any such distinction. If we are looking at a

picture, and someone asks what we see there, we may reply that we see a tree, a horse, and a child who is happy because it has a new toy. As a matter of fact, what we see in terms of direct visual sensation is only green, brown, and other areas of various shapes and colors within a rectangular area. We recognize them as trees, people, etc., through interpretive perception on the basis of habit and association with previous similar sense qualities. The color areas, their peculiar hues, shades, shapes, and sizes, are the presented factors in the picture. Their attributed meanings as solid objects in deep space, and as people acting or showing emotion, are all suggested factors. Even the names of the presented qualities, such as "green" or "round," are suggested. The analysis of an aesthetic object into these two main types of factor is the first important step in the analysis of form.

The presented and suggested factors in a work of art or other aesthetic object are never radically distinct; they are not separate parts of it. Only through intellectual analysis do we distinguish what can be sensed from what can not. Even then there is some overlapping, for all our direct sensations are tinged with interpretations. Roughly speaking, an object or quality is presented when it is "actually there" to affect the sense organ physically, as contrasted with an imaginary one as in a dream or hallucination. When in doubt we sometimes check one sense with another, as in touching a thing to see if it is as solid as it looks; or we may summon another observer to corroborate our own impression. It is easy enough to make the distinction in extreme cases: when we read a story about Napoleon, we know he is not really present to our senses. But art includes many types of subtle illusion where the boundary between appearance and reality, or perception and fantasy, is more obscure. The technique of painting in lights and shadows to make a flat surface appear solid has deceived observers at least since the time of ancient Greece. One may think at first that a solid bunch of grapes is on the wall, but touching the wall will correct the illusion of solid shape; the solidity is recognized as a suggested quality, not a presented one. A carved and painted bunch of grapes in sculptural relief may look much the same from a distance, but on touching it or moving sidewise we find that the solid shape is "objectively real"—i.e., confirmed by repeated observation of different kinds and perhaps by different persons. Hence solidity is now to be classed as a presented quality, while other qualities of the supposed grapes are merely suggested.

In the previous chapter, we noted the difficulty of distinguishing theoretically between reality or physical existence on the one hand and mere illusion on the other. We noted also how the universal tendency to project our mental reactions upon an object, as if they were its inherent qualities, increases this difficulty. When art becomes deliberately illusionistic, its skills are devoted to concealing the difference between presented and suggested; to making the imaginary seem actually present to the senses. In a naturalistic painting of grapes, the form is not completely perceptible or completely imaginary, but a blend of the two. Careful psychological analysis is required to distinguish what we actually see from what we imagine and attribute to the stimulus. We do not directly see the grapes, or even paint on canvas or plaster; we see certain colors, shapes, and textures, and from them infer "grapes," if we are in a mood to accept aesthetic illusion. If not, we may infer "oil paints on canvas," as a true physical explanation of the sense-data. That "true" explanation also is suggested and not directly presented.

From a standpoint of strict psychological analysis, what is directly presented when we see a real bunch of grapes, a chair, or any other solid object? Actually, there is an image on the retina of each eye, slightly different because of our stereoscopic vision; we infer the object's solidity, size, and position in space from the nature of these images, on the basis of past experience. Even when the "real" object is directly seen, there is an element of conjectural interpretation in the percept; presented qualities are almost inextricably mixed with suggested or imagined ones, which accounts for our occasional errors and illusions in moving around the physical world. This applies to auditory sensations also. If someone nearby shoots a gun, we say, "I heard a gunshot." Roughly speaking, it is convenient to regard the whole experience as presented to the sense of hearing. By contrast, a newspaper account of it, or a blow on a bass drum, would merely suggest a gunshot. But on stricter analysis, it must be said that only the noise is directly heard; this is interpreted as a gunshot, perhaps because of a flash of light at the same time. It may actually be due to an automobile backfire.

When a symphony is played, a sequence of sounds is presented to the ears; it may suggest visual images such as falling water, as well as emotions, actions, attitudes. When a motion picture is shown on a screen, a sequence of different light and dark areas and perhaps of colors is presented. It suggests three-dimensional objects, scenes, persons, and stories. A piece of velvet can be presented to both vision and

touch. If it is shown in a glass case, or portrayed in a painting, it may suggest tactile smoothness and softness. A picture of a rose may suggest its perfume; the perfume of roses, presented to the sense of smell in a dark room, may suggest their appearance.

Both presented and suggested factors in art involve the transmission of individual and cultural experience. We have seen how the suggested ones may do so, as in a story of real or imagined events. Presentation also does so. The visible shape and color of a vase or textile design is partly the result of some individual artist's imagination and planning; partly a result of social experience which created that kind of vase or textile through a period of decades or centuries. Each creative artist transmits to posterity some of what he learned from previous art and civilization, together with new contributions of his own.

3. Presentation; presented or presentative factors in form.

In this connection, the verb "present" means to show or bring to someone's attention as an object of sense perception. A *presentation* is an act or process of offering something to sense perception, as distinguished from awareness by thought or association. Memory images and fantasies are sometimes said to be presented, but we shall limit the concept here to direct sensory experience.

A *percept* is a significant impression of an object received through the senses. Probably no sense quality is grasped by an alert, experienced person as a mere sensation, meaningless, crude, and pure. It is always somewhat interpreted and reorganized by the brain that receives it. In distinguishing presented factors from suggested, we do not imply that the former are pure sensations entirely devoid of suggested meaning. But there is a difference in degree which is highly important in the analysis of art. Greens and blues as seen in a picture, and as regarded for their immediate quality rather than as symbols, have a large amount of the sensory element in them, and relatively little of the suggested. They tend to stimulate sense perception rather than inner meditation. The concept of Greece, as apperceived or understood in reading a printed word, contains less emphasis on the sensory qualities of the letters and more on the images and concepts which they arouse in thought. The same is true of a picture. In looking at greens and blues for their own sake we are letting sensory qualities dominate our attention. In regarding a portrait as a human face expressing a certain character, we are shifting the emphasis rather to inferred meanings, interpretations of the sense-data perceived.

The word "image" is also used by psychologists in various senses. We shall understand it as meaning an object of sense, imagination, or memory, by contrast with a general or abstract conception. As such, the term includes both direct percepts and remembered or imagined representations of them. It also includes sensory objects such as words, which stand for abstract or concrete ideas. The retina of the eye is a sensitive membrane which receives the image formed by the lens. Even in what we call "direct" vision the outer object is, in a way, not seen directly, but rather through the medium of an image placed by the lens on the retina. In using the word "image" to cover both sensory presentations and products of imagination or memory, we shall distinguish them by such words as "direct sense image" and "mental" or "memory" image; also as "presented" or "suggested" image.

A *presentative factor* in a work of art is such even though it is not actually being perceived; even if it never has been perceived. It is presentative if it constitutes a *potential* stimulus to sense perception under the necessary conditions, e.g., of light and a normally functioning, adequately trained eye. A picture in a dark room still retains its presentative factors in a potential way. So does a statue or a nugget of gold while it is underground. So does a musical score which has never been played or heard. We can read it and distinguish the sounds which would be heard, if it were played, from the moods, actions, or natural phenomena if any which these might suggest. The former could be described as presentative factors in the music.

We must include among the presentative factors not only the individual sense qualities of the object but their *arrangement*, insofar as that too is directly perceived. In a series of red dots arranged as a triangle, we see not only the red dots but their linear arrangement in a simple pattern. Such a pattern is presented if we actually see it; suggested if we merely imagine it from a description. Some patterns of presented details, visual or auditory, may be so complex and difficult to perceive that no actual human has ever fully perceived them. Nevertheless, if it can be shown that such an arrangement is offered to the senses in such a way as to be perceptible with adequate ability and training, we shall still class it as a presented factor in form. This will distinguish it from

the conceptual description of such a pattern in a book. Invisible light waves and inaudible sound waves are constantly striking our senses, which no human sense can perceive, however trained. In aesthetics, we are concerned with phenomena which are at least potentially and conceivably perceptible by human senses.

Some kinds of sensory qualities are not to be included among presented factors, or in aesthetic form as an objective phenomenon, even though they are actually perceived in responding to a work of art. One of these consists of *private, inner stimuli,* not directly caused by the object under discussion. In abnormal mental states, hallucinations are seen or heard. They may be experienced as if parts of an outward form which the individual is noticing. But they are not objective or verifiable by other persons in looking at or listening to the same thing; hence they are not parts of aesthetic form in our sense. Mild examples of this sort of experience occur to normal people frequently, and one learns to distinguish them from objective appearances. Some diseases and medicines make the ears ring, or the eyes see everything as yellow. These are actual percepts, and may occur along with hearing music or seeing pictures. If a person enters from brilliant sunlight into a dim room, his eyes may be temporarily dazzled, and he will see streaks of light in a picture which are not really there. These are all in a broad way presented sensory images, but are not presented factors in aesthetic form.

Some details may even be objectively present in the object as a total stimulus, and be verifiable by other observers; and yet we shall not include them as presented factors in aesthetic form. These are aspects which arise from *accidental, attendant circumstances* or other extrinsic causes. For example, some ray of sunlight which falls on a picture for a moment is not part of the aesthetic form of that picture. The appearance of the picture under that circumstance is not planned and socially recognized as an essential element in its visible effect. On the other hand, as we have seen, it may be an essential part of architectural form to control the patterns of highlights and shadows on a façade at various times of day and under various conditions of illumination. A halftone reproduction of a painting contains small dots from the screen, which are visible and yet not included as essential to the form of the reproduction. But the Pointillist school of French painters used dots intentionally, and these dots are socially recognized as a more or less intrinsic part of the total forms and styles of their pictures. An injury to the surface of a picture is a presented detail, but not part of the

picture's original aesthetic form. The scratching of a phonograph record, or the bad tuning of a piano, is not an integral part of the musical form as written and readable in the score, although it may have a strong effect upon our total response to the music and enjoyment of it.

What kinds of experience, and of elements within the form, can be conveyed as presented factors? Only sensory images, their qualities, arrangements, and sequences. This excludes concepts, even the abstract name and idea of a color such as blue, which we may think of while looking at a blue object. But the word "blue" can be presented to vision, hearing, or touch. Rational inferences, desires and aversions, joys and sorrows, which are all parts of the material of art, can never be directly presented in or by a work of art. One's own thoughts, desires, and emotions are directly present in one's inner experience, but this is not artistic transmission. We may see on the face of an actual person or a portrait what we call the emotion of joy. We may say that we heard the joy of children at Christmas time or the sorrow of mourners at a funeral. But these emotions are all conveyed to us as suggested meanings. What is presented are the lines and shadows around a mouth, visible tears, gestures, or the pitch and timbre of voices. Presented images can be of any sense among the familiar five: sight, hearing, smell, taste, and touch. Tactile qualities of clothing and upholstery are presented to the skin. Some modes of experience now classed as sensory, especially the kinesthetic, arise directly from internal stimuli. These cannot be presented by an aesthetic form. They are presented images to the person who feels them, but cannot be objectively verified by the sense organs of other persons. Hence they can be conveyed only by suggestion. The appearance and sound of a struggling man may suggest to observers his kinesthetic experience of effort and tension.

As to which aspects of a certain art are presented and which suggested, the facts often differ according to the way in which it is experienced. When one performs a dance, certain kinesthetic and tactile experiences are directly sensed—feelings of muscular tension and relaxation, of the hard floor beneath one's feet. They are, broadly speaking, presented parts of the total experience. If the dance represents an eagle flying, that part is suggested and imagined. To an observer in the audience, only the visual appearance of the dancer's movements, along with the sound of music and footsteps, is presented. These may suggest the dancer's kinesthetic feelings and cause the observer to imagine them. They are, for him, suggested elements in the dance as an art form. If, by sym-

pathy, he feels rhythmic muscular tensions in his own body, they are presented or directly felt parts of his own total aesthetic response, but not socially apperceptible parts of the work of art.

4. Variable modes of transmission in literature.

When one hears a poem spoken aloud, the sounds of the words are presented to one's ears; they constitute a presentative factor in the literary form. But when the same poem is read silently to oneself, printed letters are presented to one's eyes; the word-sounds are imagined, suggested by them. The word-sounds (e.g., rhythm and rhyme) are then parts of the suggested factor in the form, along with the other meanings of the printed words. Literature can be classed as an art of auditory presentation, which it was originally, as an art of visual presentation, which it is coming to be more and more, or as audiovisual. When heard, word-sounds belong to the presentative factor in poetic form. Even when reading the poem silently, we may regard it as intended for speaking aloud, especially if it is dramatic in form. We may distinguish mentally between the factors intended as presentative and the other suggestions. Phonograph and radio performance tends to make literature again an auditory art.

In reading a musical score silently, we usually think of it as a set of directions for auditory performance and not as a visual form. Accordingly, we tend to regard the sound of the notes as presentative because they are intended to be heard, even though at the moment they are actually suggested, imagined meanings of the printed score. Other elements in music, such as the expression of emotion, are always suggested, either by the sounds themselves or the printed symbols for them. Music is seldom read silently except by experts; hence it is still regarded as essentially an art of auditory presentation.

Literature and musical scores can be presented tactually to the blind, as in Braille type. The tactile percepts suggest auditory and visual ones. They are not themselves regarded as integral parts of the aesthetic form.

The presented factors in aesthetic form may be directed to only one sense: only to sight, or only to hearing. The total experience of a person actually responding to that form may be much more varied. He may be watching the musicians, or talking with his neighbor about a picture. But, from the standpoint of morphology, the picture's form (as socially apperceptible) includes only such presented images as are recognized to be integral parts of it. Other types of form, such as opera, present stimuli to more than one sense at a time.

A sensory quality such as "red" or a simple relation such as "inside" can be either presented or suggested in art. One can directly perceive that a black dot is inside a red circle. But the words and concepts used to name and describe these sense-data can be only suggested.

5. Suggestion, expression, association, and meaning. Suggestive factors in form.

To *suggest* is to call something to mind through a train of thought or association of ideas. Suggestion is a mental process by which one thought leads to another. *Association* is a mental connection among ideas, especially one produced by learning. The word "idea" includes memory images of former sensory percepts, and also abstract conceptions and fantasies of things never perceived as such.

Most works of art contain both a presented and a suggested factor: that which can be directly sensed, and that which can be only called to mind by the presented factor through previous inheritance and conditioning. Both vary greatly in nature and relative emphasis.

The suggestive power of a presented image operates through the innate equipment and previous conditioning of the individual. His experience and education have made him sensitive toward that particular image, and have predisposed him to respond to it by thinking of certain other images and concepts. There is considerable variability, even within one individual, as to what he may think of on different occasions in response to a particular stimulus. Among different individuals, there is a chance for still more variability. But within members of the same culture, brought up with much the same sort of schooling, family environment, and traditions, there is a nucleus of similarity. Otherwise we could never understand each other's conversation or behavior.

The suggestive effect of an aesthetic object is not limited to arousing images and concepts in the mind. It may also include tendencies to act in a particular way, or to feel actual conative and affective responses toward the object. But these kinds of response need not be included in a morphological description. We are including mainly those responses made by apperception and consisting of images, concepts, meanings, inferences—either in isolation or as organized into forms. As we have seen, desires, emotions, and ac-

tions can be part of the suggestive content of a work of art. As such, they must be carefully distinguished from aesthetic responses made *to* the work of art. Music may express or suggest certain feelings, such as military enthusiasm, without arousing them in a particular hearer. Pictures used for advertising purposes commonly show the faces of people smiling and happy, to suggest that they are well pleased with the product advertised. We understand or apperceive such a pictured face as "expressing" joy and delight, but do not necessarily feel these emotions. Joy and delight are suggested parts of the picture's aesthetic form.

The word "express" has various meanings in aesthetics. One of them is almost synonymous with "suggest." But "express" tends to emphasize the role of the artist or performer, rather than the work of art as an independent object. When we ask, "What is expressed here?" we tend to answer by guessing at what the artist or performer was trying to express; which of his inner thoughts and feelings he wanted to externalize or communicate. *Expression,* in a musical composition or performance, is the use of means intended to reveal the thoughts and feelings of the artist, or those of some imaginary person or persons. To guess at the artist's actual thoughts and feelings is legitimate in some kinds of art criticism, but is risky in morphological description. We can seldom be sure what the artist means or intends to express. What he means may be very different from what his work actually suggests.[1]

In another sense, more useful in morphology, "express" refers to the object itself, not to the artist's intention. It means the quality or fact of indicating character or feeling, as in a facial aspect or intonation. Such expression is partly based on social usage, as in interpreting facial expressions and intonations. A face may actually express an emotion quite different from what the actor or portrait painter intended it to express. A purely accidental line, made by smudges on a wall, may look like a smiling face, and thus "express" joy or amusement. In such a broad and neutral sense, the word "express" means "to

manifest an emotion or type of behavior characteristic of some kind of person or thing."

It was noted above that the more *personal, private associations* which an object has for an individual are not parts of its aesthetic form. He may actually experience them in looking at the object, and they may seem to be intrinsic meanings of it. But they are not socially verifiable. One who sees a painted landscape may think of a similar place in which he lived as a child. Personal responses to a work of art may, in time, become part of its social meaning. A great writer may express his views about a work of art so forcefully that they become common property, and are often thought of when the work of art is mentioned. This is true of Lessing's comments on the Laocoön statue. Among English readers, Pater's interpretation of the *Mona Lisa* has become so widely known that his words are current cultural associations of that painting. They are not integral, firmly established parts of the picture's social meaning, but they are more nearly so than the purely private, unexpressed musings of an ordinary visitor.

Also to be excluded from objective form are trains of association in the observer's mind which are carried far beyond the direct, socially established meaning of the image in its present context. No sharp line can be drawn between the apperception of such meaning and the independent pursuit of further trains of thought along personal lines, not definitely guided by the work of art. One shades continuously into the other. Continuous paths are provided, not only by connections in the observer's mind, but by connections in the cultural fabric, which can lead him by an unbroken series of associations from any image or concept to any other image or concept, quickly or through a long chain of intermediate steps.

We shall make a distinction between social *meanings* and certain other kinds of suggestion and association. Social meanings are suggestions which are firmly and closely attached to a thing in cultural usage, rather than being loosely, occasionally, or remotely associated. There is a strong tendency for a thing to suggest its meanings, under suitable conditions; they are frequent, cogent suggestions, not mere random couplings as in a daydream. The bond is something one can count upon more or less in communication, whether artistic, scientific, or practical. Casual suggestions can become established meanings through constant, recognized association.

Not all firm, close associations are meanings. An idea may strongly suggest its opposite or some other correlative, as "hot" suggests "cold," and yet not *mean* it. A thing is said to "mean" something especially when the two ideas are considered about

[1] The term "expression theory" has been used in aesthetics in several senses, some of which imply a supernaturalist metaphysics. Plotinus and the Neo-Platonists conceived of true art as an expression of divine emanations. Romantic theory emphasizes the role of the artist in expressing "himself"—i.e., his inner life of thoughts, feelings, and desires. This is undoubtedly important in aesthetics as a whole, but not in morphology, where we are more concerned with the product—the work of art—than with the individual artist's mental processes which led to it. Art is also said to "express its age," which means its cultural milieu at the time. This is relevant to morphology in that its age does much to supply and alter the meanings and associations of art.

equivalent. Thus the idea "triangle" is about the same as "a plane figure having three sides and three angles." Linguistic symbols, such as the word "triangle," can in this way "mean" other symbols, such as the words in the definition; both sets of symbols have about the same connotation and denotation. A drawing of a triangle can have a similar meaning, though not necessarily an identical one. The concept "triangle" includes that term, word, or other symbol for it, together with its meaning; not all that it might suggest, but those suggestions which are considered by authorities in its field (geometry) to be basic and essential to it. In art, the suggestive factor is not limited to such definite meanings, but includes all images and ideas which the work of art, or any detail in it, tends through cultural association to bring to the minds of observers.

6. Suggestion by similarity; mimesis and analogy. Types of art based on them.

Psychology has long distinguished two basic types of association. Both give to certain images and ideas the power to call others to mind under favorable conditions. One is association by *similarity*, where images, concepts, things, or events are linked because of observed resemblances. The other is by *contiguity*, where they are linked because they have been experienced together. A single instance of contiguity, such as meeting a certain person in a certain place, may suffice to make one suggest the other thereafter, for the person who remembers it. Repeated, persistent contiguity in experience helps to link ideas strongly together in the minds of individuals and groups.[2]

Association often leads to theories, true and false,

[2] Modern objections to certain elements in eighteenth-century associationism do not invalidate the distinction between these two modes of association. It remains enlightening in its application to the arts. This does not imply a purely empirical or associationist theory of the origin of knowledge or of symbol-meaning relations. Previous association in experience cannot in itself be the ultimate cause or complete explanation of why one image or idea has the power to suggest or signify another. Such explanation raises a deeper problem with which this book will not try to deal. The power to recognize similarity and contiguity in experience is itself the result, in part, of innate connections in psychophysical structure among the higher cortical centers and sensory mechanisms. It is also, presumably, due in part to actual resemblances and causal connections in the outside world, such as those between sunshine, rain, and the growth of plants. Some psychologists (notably C. G. Jung) believe in innate, symbolic, archetypal images, derived from the racial unconscious and from past social experience.

of how phenomena are caused and controlled. People come to believe that they can influence or control a thing by acting upon other things which resemble or are often connected with it. J. G. Frazer, in *The Golden Bough*, showed how two types of primitive magic (imitative and contagious) were based upon these modes of association. At present, we are concerned with the modes of association as common processes wherein a certain image or kind of image in art acquires the power to suggest certain others.

They are not the only psychological factors contributing to this power; conative and emotional factors are also important. Great resemblance or contiguity among the ideas themselves may be less effective than intensity of personal, emotional attitudes toward them. Strong negative or conflicting attitudes, involving repression, may suffice to prevent conscious association between closely connected ideas, or send it into devious paths, as in unconscious erotic symbolism. But similarity and contiguity remain as important factors in determining all organization of images and ideas, in art and elsewhere.

Corresponding to these basic modes of association, we can distinguish certain types of suggestion and symbolism in the arts. Two or more of them often cooperate in the same work of art. The first includes mimesis and analogy.

Mimesis is suggestion through resemblance between two images: both presented, both imagined, or one of each. Literally, it means "imitation," but there are many kinds of imitation in art. "Pantomime" and "mimetic dance" are related names for certain kinds of mimesis in which suggestion is made through presenting gestures to visual perception.

Pictorial and sculptural representation operate largely through mimesis. A painting presents to the eye certain streaks of color, in certain shapes and textures; they may resemble the colors and shapes of trees, houses, animals, persons, etc. A statue presents a piece of some solid material, which may be shaped to resemble a human body or other object. In the back of one's mind are many composite memory images of what such objects look like. One often voluntarily "misinterprets" the streaks of color as to their true external cause, trying to "get the illusion" by perceiving them, not as paint on canvas or ink on paper, but as real scenes, real objects or persons. Certain arrangements of dark and light, especially with the lighter above, suggest the highlights and shadows made by an overhead source of light on a convex or solid object. Others suggest concavity.

Mimesis can operate through any sense. In music and with the human voice we can imitate other sounds. Imitative music can resemble a rainstorm or

the sound of horses' hoofs. Literature contains mimetic words, called onomatopoetic, such as hum, hiss, buzz, moan, and bark, which tend to call up the idea of a sound, not only through the meaning of a word but through resemblance to the sound itself. A particular perfume, such as that of roses, can be synthetically imitated, and so can the taste of oranges or the tactile quality of silk. But an image from one sense cannot clearly suggest by direct resemblance an image from another sense. There are many slighter, vaguer resemblances between percepts by different senses, however, which permit some amount of mimetic suggestion. A sound, a color, and an odor can be alike in being strong or weak, brief or long-lasting.

Mimetic relations can exist between two or more presented images or presented details in a work of art. The eye can discern that two lines in a picture have similar curves or angles, or different areas of similar color; the ear can discern resemblances between two or more chords, melodies, or rhythms presented successively in a piece of music. Such similarities provide the basis for thematic organization and design. The similar images in such a case may be presented, but the concept of similarity, and the recognition of just how alike or different they are, involve interpretation.

By representing two or more different things in such a way as to emphasize their visible similarities, a picture can suggest that they have other, deeper qualities in common. The curves in a woman's body can be likened to those of a willow tree or a vase; the coloring and texture of her skin to that of fruit and flowers, merely by juxtaposing these objects in such a way as to accentuate their likeness. The effect is somewhat like that of literary simile and metaphor, less explicit, so that unobservant eyes may miss the likeness, but vivid for those that grasp it. By juxtaposing two very different images, such as Mars and Venus, we may call attention to their difference as well as to the distinctive qualities of each. Juxtaposed objects in a picture, or ideas in a literary text, act as context for each other; each helps to call attention to certain aspects of the other and to restrict the range of its possible suggestions.

Mimesis is not necessarily exact imitation or literal, realistic representation. There may be any degree of resemblance between a presented image and the images it tends to suggest. A colored photograph or a seventeenth-century Dutch still-life painting is usually a fairly exact representation of some particular group of objects. Music may be devoted to imitating some natural sound as exactly as possible. But mimesis includes also cases of slight resemblance where the presented image is not a full and accurate copy but highly simplified, altered, "distorted," or "abstract." A child's "stick figure" of a man is visual mimesis and so is his picture of a face as a circle with two dots for the eyes, a line for the mouth, and another for the nose. The color red resembles blood and fire, and so may suggest these ideas even when presented abstractly, without accompanying details. A vertical line resembles an upright human figure; a slanting one resembles a falling figure; a horizontal one resembles a fallen, dead, or resting one. Such qualities of direction in line may convey the above associations through very abstract, selective resemblance. But when the resemblance is highly abstract and limited, it tends also to be ambiguous and vague. Red lines resemble many things besides blood; slanting lines resemble waves, vines, ropes, twisting drapery folds, among other things. Some slight clue in the context may be enough to indicate which association is intended: a boat in the picture may indicate waves rather than vines.

Many contemporary pictures have an intentionally slight and partial resemblance to outside objects. When they clearly resemble some particular kind of thing, but not exactly as it usually appears, we may call them "stylized" or perhaps "expressionistic." Pictures in which the resemblance is very slight, so as to make recognition difficult, are "semiabstract"; those with little or no definite resemblance to any object, as some by Kandinsky and Mondrian, are "abstract" or "nonobjective." However, any picture, any visual image tends to resemble something in the outside world, if only in a single trait such as blurred irregular shapes suggesting those of clouds, or geometric shapes suggesting those of machinery. Sometimes a verbal title helps to indicate such a resemblance, but often the artist prefers to leave it vague and slight, emphasizing rather the directly visible, presented elements in the form. In this trend, painting has consciously emulated music.

Musical mimesis is characteristically vague and abstract, only slightly resembling the nonmusical sounds it is intended to suggest. Without the aid of verbal titles and program notes, which act as context or attendant circumstances, the resemblance would often escape any hearer. This slightness of resemblance, or "distortion from nature," has not occasioned as much resistance from the public as it has in visual art, where naturalistic representation has been expected in our culture until recently. Music varies in degree of resemblance, some compositions being highly mimetic throughout (such as Rimsky

Korsakov's *Flight of the Bumblebee*), while others are so only in occasional passages (such as the "storm" in Beethoven's Sixth Symphony).

So far we have been considering similarities between art and phenomena outside of art. There is also direct sensory resemblance between one work of art and others in the same medium. However great its relative originality, every work of art imitates previous works in some respects. Every work belongs in part to some general style, such as Gothic or Impressionist. To the trained eye or ear, it recalls and suggests other works of similar styles, and perhaps other particular examples, in a few of its abstract traits of form or content if not fundamentally. Sometimes these borrowings or quotations from older works are explicitly acknowledged by the artist, but more frequently are not. In any case they become, for the experienced observer, part of the total suggestive effect of art. He discerns in Tschaikovsky certain traits of Wagner, in Paolo Veronese traits of Giorgione, in Virgil the influence of Homer. These may be quite transformed, so as to be without plagiarism or copying, but the significance of each work is increased for the knowledgeable observer by the sense of its relation to predecessors and successors in the history of art.

Analogy between images, things, or ideas is broader than mimesis. It includes all sorts of resemblance, especially those which are not directly mimetic or perceptible by the senses, but which involve abstract relations, behavior, attributes, effects, or attendant circumstances.

Analogy, or partial, abstract resemblance, can exist between images from different senses. Sounds, tastes, odors, tactile sensations can all be described as strong, weak, sharp, rough, harsh, mild, smooth, agreeable, disagreeable, etc. Applying to an image of one sense adjectives commonly used for another, such as "sweet melodies" or "sour notes," is somewhat figurative and metaphorical; it points out an attribute or psychological effect which two very different things have in common.

Similarities of behavior, action, or function, and those of inner character, mental or spiritual quality, also constitute analogies, even when direct sensory mimesis is absent. There is analogy of character and behavior in speaking of the wicked man as "spreading himself like a green bay-tree." The resemblance may be fancied rather than real, as in "Be ye therefore wise as serpents, and harmless as doves." These are *similes*, because the analogies are explicitly stated by the words "like" and "as."

A *metaphor* is a terse, compressed simile, usually omitting such words. It substitutes one kind of object or idea for another to suggest the analogy between them. Thus Shakespeare says, "Night's candles are burnt out" instead of "The stars are disappearing as burnt-out candles do." The latter version, an explicit simile, leaves less to the imagination and is prosaic rather than poetic. The image stated (candles burnt out) is the *vehicle* or literal content of the statement, while the unstated, latent content to which the vehicle refers (stars disappearing) is the *tenor*.[3] The implied analogy or other bond between them may be obvious or obscure, familiar or fresh and original, strained or natural. When Wordsworth writes, "This sea, that bares her bosom to the moon," he suggests to the reader's imagination two images, almost in simultaneous combination: a swelling movement in the sea, reflecting moonlight, and a woman literally uncovering her breast. At the same time the reader is made aware of the similarity between the two images, one stated (the sea beneath the moon) and one implied (the swelling breast).

Painters and graphic artists have produced effects somewhat like those of poetry through the visual presentation of images instead of verbal suggestion. There is an implied simile in juxtaposing two images in the same picture, as if to suggest a deeper similarity than meets the eye: e.g., a woman with a vase of flowers, a cat, or a serpent; a man with a lion or a pig. Combining a chrysanthemum and a sword in a picture dealing with Japan, or combining the words in a book about Japan (as did Ruth Benedict), suggests two opposite traits in Japanese culture: one analogous to the flower, the other to the weapon. The cultural traits, meant but unmentioned, form the tenor of this visual metaphor, whose vehicle is the picture itself. One can also class the two images as "symbols" of the cultural traits.

7. *Symbols, signs, and symbolism.*

Each of these terms is commonly used with several different meanings. Some writers define each in one particular way and reject other definitions as incorrect. We shall not try to narrow them down to that extent. The conflicting definitions are partly derived from different metaphysical theories, and these will be explained. Each of the current definitions points to a somewhat different kind of symbol, sign, or symbolism. Each can be distinguished by a

[3] See I. A. Richards, *The Philosophy of Rhetoric* (New York, 1936).

different prefix. None is wholly wrong, but it is well to indicate which kind one is referring to.

"Sign" is described by *Webster's Third New International Dictionary* as "a very general term for any indication to be perceived by the senses or reason." A sign may be a visible shape, sound, gesture, bodily action, or unit of language that means, designates, or denotes something or expresses a thought, wish, or command. Some signs, such as footprints and bird-songs, are recognized by animals.

Also very broadly, "symbol" is defined by Webster as a kind of sign: "an arbitrary, conventional, or non-natural sign, such as a character, diagram, letter, or abbreviation used in a particular field such as mathematics or music to represent operations, quantities, qualities, etc." A symbol in this broad sense, says Webster, "can apply to anything that serves as an outward sign of something else." Even broader is this: "A symbol is any concrete object made to stand for an abstract idea."[4] Defined in these ways, the term "symbol" has no mystical connotations and implies nothing about the value or religious importance of the meanings attached to it. Conventional signs and symbols pertaining to language are called, interchangeably, *linguistic symbols* or *linguistic signs*.[5] A sign or symbol of this sort may have one or several meanings. Ordinarily, an effort is made to avoid ambiguity by having each linguistic symbol mean as few different things as possible, but some ambiguity is unavoidable. For example, the punctuation mark used as a period can also be a decimal point in arithmetic.

A second type of definition narrows down the concept somewhat. A symbol in this sense is "a kind of sign, usually a perceptible object or image, which has, besides its obvious, primary, literal meanings, the power to signify or suggest one or more deeper, secondary meanings. These are usually abstract conceptions of qualities, conditions, beings, events, or institutions, which can not be sensed or adequately represented in purely sensory terms" (Webster). This kind of symbol is called *polysemous*, in that it has several meanings at the same time. (*Polysemia* is the ability of some words to assume new, different mean-

ings without losing the old. It is not the same as ordinary ambiguity, in which the meanings are often inconsistent alternatives.) Polysemous symbols have, in many cases, acquired their meanings from supposed analogies and historical associations. Thus the lion has, besides its literal meaning as an animal, the symbolic meaning of courage. The cross is, besides a wooden structure and an instrument for execution, a symbol of Christianity. The lilac in Whitman's poem, "When Lilacs Last in the Dooryard Bloomed," stands for new birth in the spring; the drooping star, for death. To call such an image a symbol implies further that it plays an influential role in the work of art, perhaps by frequent repetition or helping to connect other parts of the work. The bird in Keats's *Ode to a Nightingale* is emphasized as a symbol of joy and beauty.

We shall call this type of symbol the *figurative, polysemous* type. It does not imply, necessarily, either a mystic or a naturalistic philosophy. Its meanings are not specified as transcendental or supernatural in origin or reference, although they may be so understood in particular cases. It is "figurative" in using images, not only in their plain, literal senses, but also as figures of speech, tropes, metaphors, and similar devices in various arts. Symbols of this kind are commonly used in lyric poetry for aesthetic purposes. Some ambiguity is regarded in poetry as a potential means of arousing desired emotional reverberations through the suggestive power of imagery.

A third type of definition narrows down the concept of a symbol still farther. It specifies that the meanings of a symbol are on two or more levels of metaphysical reality. Some mystics and transcendentalists, who believe in a higher, supernatural plane of existence, define symbolism as "the representation of a reality on one level of reference by a corresponding reality on another."[6] A symbol in this sense does have mystical implications, which we shall examine later on. They are of special relevance in the field of art. One can use this sense in discussing mystical art to describe the significance of symbols for some writers such as Jung, and for some cultural environments such as that of medieval Christianity. This does not imply that one accepts the mystical world view or believes in the transcendental reality which this kind of symbol is supposed to indicate. We shall distinguish this type as the *mystic symbol*, from its use in mystical art and thought. Like the second type,

[4] R. P. Boas and E. Smith, *Introduction to the Study of Literature* (New York, 1925), p. 146.

[5] C. W. Morris uses the term "icon" for a sign (such as a straight line on a map) that signifies by sharing a property with what it represents (as a straight road). Thus a photograph, star chart, model, or chemical diagram would be an icon, while the word "photograph" and the names of stars and elements would be *symbols*. These distinctions, while valid, are unnecessary for our present purpose. "Icons" in this sense are included in this chapter under mimetic or analogic symbols.

[6] A. K. Coomaraswamy, "Symbolism," in *Dictionary of World Literature*, ed. J. T. Shipley (New York, 1943). Dante remarks that no object of sense is more worthy to be made a symbol of God than the sun (*Convito*, III, 12). One analogy, of course, is that both give light.

mystic symbols are polysemous and are often used figuratively in literature. Writers who use the term "symbol" only in its mystical sense, as the Jungians do, tend to exclude from it the ordinary linguistic and other conventional image-meaning combinations. Instead, they call these "signs."

We shall recognize three kinds of symbol. To summarize: (1) In its broadest sense, a symbol is anything that serves as an outward sign of something else; any *arbitrary, conventional*, or other *nonnatural sign* or other image, as used in fields such as mathematics, music, or literature to indicate operations, quantities, qualities, relations, etc. Those pertaining to language are *linguistic* signs or symbols. While the symbolic image or perceptible sign must be nonnatural, it may represent a natural object such as the sun, a tree, or a lion. (2) One variety of symbol, the *figurative, polysemous* type, has besides its obvious, primary meanings the power to suggest one or more secondary meanings. It uses images to stand for tropes, metaphors, similes, and abstract ideas which can not be adequately sensed or represented in purely sensory terms. (3) A variety of figurative, polysemous symbol, the *mystic* type, is regarded by some as having the power to suggest meanings pertaining to a transcendent spiritual level of reality, and hence to lead the mind upward to that level. This is called its *anagogical* meaning and function.

Symbolism is the practice or art of using symbols (in any sense of that word), especially by attributing symbolic meanings to things or by suggesting through sensory images things which can not be perceived by the senses. An example is the use of the nimbus around the head of a sacred or venerated personage in a picture, to indicate qualities, power, or degrees. (It may or may not be regarded mystically.) A more secular and naturalistic example is the use of mimetic and geometrical images in heraldry, to indicate the bearer's family, rank, and title.

Symbology is the study and interpretation of symbols in art and elsewhere. *Iconography* is the imagery which is used to convey an idea in art (especially visual art) or to represent scenes and personages. *Iconology* is the analysis and history of symbolism in art, including the identification of represented contents and the interpretation of general conceptions implied.[7]

[7]In another sense, used by some historians, "iconography" refers to particular, limited cases of representation and symbolism: e.g., a tree as symbolizing the "Tree of Life." "Iconology," in such a case, refers to broader, more general implications, through stylistic traits as well as representation, as in studying Gothic architecture and scholastic logic both as symbols of medieval culture.

Studies of symbolism in art have been greatly influenced in recent years by the psychoanalytic theories of Sigmund Freud and Carl G. Jung, especially the latter. Both emphasize the role of the unconscious in forming and organizing images in dreams, psychoses, neuroses, primitive religion, and various branches of primitive culture. Freud's theories emphasize the early history of the child in his family pattern and its effects in determining symbols in the imagination. Some of these are developed in the creative work of the mature artist, without full awareness of their source and latent meaning on his part. Symbolic representations of such a widespread situation as the Oedipus conflict are varied in art in countless ways. To some extent, they can be regarded as factors in a work of art, especially the manifest imagery of the symbols as dramatized in Sophocles' play *Oedipus the King.* As to the deeper suggestions, of which both artist and public may be unaware, such as the extent to which incestuous love of the mother and jealous hatred of the father are common in all generations, these are more debatable. Such ideas, when sufficiently publicized by scholars and expressed in dramatic performance or explicit reference to modern works of art, may achieve more objective status as socially apperceptible meanings.

Both Freud and Jung, especially the latter, dealt with another debatable issue, which is the extent to which patterns in behavior and imagination can be derived from the experiences of the human race and inherited by the unconscious mind of the individual. Jung built a large part of his system on the hypothesis that they can, and that this is the source of a great variety of myths and other symbols with multiple meaning. He distinguished between the *archetype*, as a basic, primitive, unconscious tendency to imagine and feel in certain ways, and the *symbol* itself. The former is comparatively blank and empty, a collective predisposition to imagine certain types of personage or situation, such as the great mother, the eternal child, or the hostile brothers. The latter is the archetype as filled in by the individual and varied in accordance with his own experiences and those of his cultural group. These give it distinctive sensuous imagery and meaning. Such symbols may be richly endowed with significant wisdom and drama for all mankind, as in the work of a great artist, or be neurotically distorted or mediocre.

The nature of any particular symbol or group of symbols in a work of art can be morphologically described with reference to the literal imagery (presented or suggested) and the meanings which are most strongly attached to them by long and widespread usage in one or more cultural fields. Jung and his

followers have amply demonstrated the fact that many symbols have been used in certain senses from time immemorial and in a wide variety of times and places. An example is the *ouroboros* or snake biting its tail, a variant of the mandala or circular image, which is said to symbolize eternal destruction and rebirth. Jung and his followers have defended his theory with countless examples of art, dreams, and other phenomena in which a basic, archetypal symbol is given similar meanings by distant cultures and individuals who could not possibly have communicated with each other. Many of these meanings are obviously expressed in ancient myths and artistic representations of them.

According to Jung, if an archetype or related symbol is subjected to excessive rationalistic analysis, realistic representation, or everyday use, it is said to lose its power and degenerate into an ordinary sign. Such a "degraded" symbol is called by Jung an *allegory*. But the word "allegory" is more commonly used in a broader sense, not pejorative, to designate a somewhat complex fictional story in words or pictures which has a generalized symbolic meaning or series of them, often referring to the moral or spiritual life of man or to sacred history on a cosmic scale. *Parables and fables* are shorter allegorical tales. A parable is usually simple and homely, referring to ordinary things but giving them a deeper meaning. A fable usually deals with animals, giving them human traits and showing their analogy to the weaknesses of man to emphasize a moral or practical lesson. The term "emblem" refers mainly to visible signs and symbols, such as objects, figures, or designs which suggest another object or idea by analogy or association. An emblem can function as a linguistic, figurative, or mystic symbol.

While mystic symbols usually have religious implications, which in Western art are mainly Greek or Hebrew-Christian, they are not individually confined to any one religion or to the sort of concepts emphasized in modern Western religion. The images and emotive meanings which recur in primitive and advanced religions throughout the world, and which mystics derive from archetypal sources, include many with their roots in the bloody and terrible rites and fears of prehistoric man. Examples are to be found in Hesiod's account in the *Theogony* of Cronos mutilating and dethroning his son Uranus, and in Goya's painting of a similar subject; other examples are those of Kali, the Hindu goddess of death, and the related archetype of the "Terrible Mother."

It is possible in morphological analysis to stop short of accepting all the multiple interpretations of a given work of art possible from the Jungian standpoint. While its analogies with other works and its possible derivation from certain archetypes are significant for study in important cases, the more controversial aspects of the Jungian approach should be set down for the present as on the margin of strictly morphological description. This includes the assumption of a collective unconscious, its inheritance by the individual, and the so-called dynamic, causal influence of the archetype on individual thinking.

From the standpoint of naturalistic psychology, symbolism is simply the use of symbolic images and their meanings in art and elsewhere; it may also refer to a system or combination of symbols. Symbols are peculiar, in the general class of signs, in that they have the power to suggest or call to mind other images and ideas, especially without direct sensory resemblance. They differ from the rest of that class mainly in the extent to which their power to call up specific, abstract meanings has become established, persistent, and predictable. To be classed as a social symbol, an image usually has to be recognized in a certain culture as having a certain meaning or meanings, and hence as "standing for" those other images, ideas, and real or fancied things to which they refer. However, an individual can have his own private symbolism, more restricted but somewhat stable, as in dreams and neurotic symptoms.

Ordinary experience and discourse, as well as literature and the arts, abound in the association and mutual suggestion of images and concepts by similarity, analogy, and contiguity. These are constantly being expressed in metaphors, similes, and other figures of speech. Only a few images become established symbols through being persistently used to suggest certain meanings and hence to represent them as tools of thought and action. Ordinarily, the symbol is a fairly familiar, easily recognized image or set of images. The idea or set of ideas for which it is made is usually more unfamiliar, difficult, abstract, or complex; hence the utility of having a simple substitute for it in reasoning, imagination, and behavior.

A symbolic image is usually easy to present or represent in art, visually or verbally. Its meaning may or may not be obvious and certain. When several symbols are combined in a work of art, the full reason for their combination is often obscure without some outside clue. At the same time, the images themselves may have another, more obvious organization as sensory details in a design or as elements in a literary story or situation. Thus, a symbolic work of art can be organized in various ways at once. The relationship among its deeper meanings may be only one of these

and the work may be grasped as a unity in some respects without understanding them.

8. Symbolism based on analogy.

Any image may become a *symbol* of its analogue, that to which it is considered similar, and also of the quality they are supposed to have in common. This is *mimetic or analogic* symbolism. An abstract idea as such cannot be a symbol: some sensory image (presented or imagined) must symbolize it. Thus, the owl or serpent symbolizes wisdom. A word, as a visual or auditory image, can also be a symbol.

In ancient mythology, the sky was compared to a father, fertilizing the earth through rain and sun; the earth, to a mother, bringing forth plants and nourishing animals. Gardens, valleys, and soft foliage are regarded as feminine, especially when walled in, protected and protecting. The mysterious correspondence of woman's menstrual cycle with the phases of the moon, in addition to the new moon's cup-shaped form and the weakness of lunar radiance by comparison with the masculine sun, combined to build a strong association between the moon and feminine imagery. The physiological connection between chastity and menstruation, pregnancy and lack of menstruation, helped to make the moon a symbol of the virgin goddess. But at the same time (such is the inconsistency of early symbolism) it could also be a symbol of fertility and maternity, as in the moongoddess Hathor, whose symbol was also the milk-giving cow. The notion of the "Milky Way" was based on a direct visual resemblance.

Symbols derived from ancient and medieval religion are frequently taken over into modern literature, both religious and secular. They figure prominently in the imagery, metaphors, and other devices of the poet. Thus a study of the career, migrations, and changing meaning of a particular symbol may lead through many different cultures, and provide an enlightening background for the interpretation of contemporary art. The meanings thus acquired by a symbol are often inconsistent or contradictory, because of the various comparisons and trains of thought in which it has been involved. An image can take on masculine associations at one time, and feminine at another, just as certain divinities (Siva, Kuan Yin, and others) change sex or become bisexual. Thus for Heine, in *Die Lotosblume Ängstigt*, the moon assumes an unusual masculine role, while the flower and the sun keep their feminine roles. (The German word for "moon" is masculine, unlike those in Latin languages.)

Flowers themselves are not necessarily feminine: that depends on which aspect of their nature is singled out for comparison. In the Egyptian *Book of the Dead*, the man's immortal soul is compared to the lotus, as rising out of the watery source of life into the sunlight of divinity.

> I am the pure lotus,
> Springing up in splendor
> Fed by the breath of Ra.
> Rising into sunlight,
> Out of soil and darkness,
> I blossom in the Field.

This symbolism is pictorially confirmed in one manuscript of the text, by a vignette of a man's head arising from a lotus blossom, which in turn arises from water.[8]

Analogy is a concept of the highest importance in art, philosophy, and science. Mental growth and learning in general proceed largely by constant comparisons among sensory and other experiences, through which we learn the recurrences and uniformities in nature and life. On this basis, we form habits of behaving similarly toward similar situations; of predicting and controlling events to secure our own and other persons' welfare. From uniformities and correlations in experience we infer causal relationship, and hence the possibility of control. The primitive tendency to infer causal interaction between analogous things led to many theories of the influence of heavenly bodies on human destiny, and consequently to attempts at control through magic and worship in which art was frequently involved. Science tests, corrects, and develops the rough and often erroneous hypotheses of primitive thinking in this respect into quantitative laws and exact numerical correlations. It extends these into remote fields of phenomena to show underlying analogies among them: e.g., between the weight of bodies on the earth and the movements of stars and planets, all of which exhibit gravitation. Thus the discovery of new analogies among phenomena tends to enlarge our knowledge, wisdom, and power.

Many such analogies were discerned and figuratively pointed out by art long before science measured and clearly stated them. Art is sometimes interested in their truth, but not always; often the artist

[8] R. Hillyer translation. See E. A. W. Budge, *The Book of the Dead* (London, 1938), pp. 263-64, "The Chapter of Making the Transformation into a Lotus."

and his public are content merely to contemplate examples of mimesis and analogy as something striking, picturesque, and fascinating in itself. Between remote ideas, they seem like tremendous leaps of thought. Artists continually try to reveal hitherto unobserved analogies through fresh literary imagery and new pictorial combinations; this is one road to originality. But the oldest, most traditional analogies have a way of reviving and appearing fresh when expressed with some slight novelty of detail.

One psychological function of analogies in art is the transference of emotional associations and attitudes from one image to another. By comparing an object, act, or person to something loved or admired, we tend to glorify and embellish it; by comparing it to something ugly, absurd, or contemptible, we tend to demean it. "The Lord is my shepherd"; Louis XIV is "the Sun-King." One's enemy is a rat, a hog, or a rattlesnake. Thus countless analogies, true or false, are asserted or implied in art as ways of characterizing things or persons, and of expressing emotional attitudes toward them. The resemblance may be supposed to exist in the nature of the things themselves or in one's feeling toward them, or both. Wit and humor in art make systematic use of such implied analogies, often with a demeaning or devaluating effect. In wit it is often malicious and accompanied by verbal mimesis, as in puns. Religion, politics, and propaganda use both glorifying and demeaning images.

9. Factors in analogic symbolism. Explicit and cryptic symbolism.

In the relationship of analogy (real or fictitious) there are always three elements to be considered. These enter into all forms of simile and metaphor, and into many forms of symbolism. Something (A), usually familiar, is compared with something less familiar (B) in respect to one or more characteristics (C) which they are thought to have in common. A and B are *analogues,* or things regarded as similar in this respect; C is the basis of analogy or alleged resemblance between them. Thus a shepherd (A) is like the Lord (B) in tenderly caring (C) for those in his charge.

The common quality is necessarily an abstraction. The term "analogy" is applied mainly to things which are very unlike in all but one or a few respects; hence to discover an analogy is to discern abstract, highly selective likeness, not obvious, concrete likeness. The

things compared may both be particular persons such as Julius Caesar and Napoleon, events such as the slaying of Christ and the slaying of Caesar, types of phenomena such as eagles, fire, lightning, gold, or abstract concepts such as personal intemperance and political rebellion.

When such a likeness has been frequently pointed out, one of the analogues may come to symbolize and stand for the other. Usually the more familiar, concrete, easily represented or imagined image (A) becomes the symbol, and the one which is more abstract or otherwise hard to understand or imagine (B) becomes its meaning or significatum. The symbol (A, the lamb) can thus mean or symbolize Christ (B). The total "meaning" of A may also include their common qualities (C, being a gentle, innocent object of sacrifice in vicarious atonement). If a picture of a lamb is shown, there is double use of the principle of similarity: mimesis to suggest the lamb, and analogy in the way the lamb suggests Christ as an object of sacrifice.

A well-known, conspicuous example of some trait or mode of behavior often becomes a cultural symbol of that abstract idea. Thus the person of Judas and his act of betraying Christ with a kiss become symbols of treachery. As an image, the "Judas kiss" then definitely means and symbolizes treachery. It may also tend to suggest, more indirectly and uncertainly, other supposed examples of treachery, such as Benedict Arnold within the area of American culture. To represent or mention someone in close proximity to such an accepted symbol is enough to suggest the alleged analogy: e.g., one can refer to a political adversary (or show him in a poster) along with Judas and Benedict Arnold. Verbal statement can make the analogy clearer as a logical proposition, but is usually less forcible psychologically.

Both A and B may be *explicitly* stated as in saying "The Lord is my shepherd." The rest of this psalm lists a number of C qualities, with the implication that they pertain to both images. Pictorially, analogy and symbolism are fairly explicit when A and B are represented as distinct but related ideas. For example, Christ may be shown in his divine person with a halo, and also as holding a shepherd's crook and a lamb. But often the main subject (B) of the comparison, that whose nature is to be characterized, glorified, contemplated, or vaguely hinted at, is not portrayed or mentioned at all. Only A may be given (e.g., the lamb), without explicit indication of C. The symbolism then becomes more or less *cryptic.* To be felt as such in art, its context must somehow indicate that the image has a deeper meaning, without specifying

what it is. Otherwise, the image is likely to be regarded as nonsymbolic: e.g., merely as a picture of a lamb and nothing more. If a slight, vague hint as to a deeper meaning is given, the symbolism is *semicryptic*. Uninformed persons may be able to understand the more obvious B and C meanings, such as Christ's gentle meekness, but not others. Instruction may reveal more difficult ones, such as the role of Christ as sacrificial lamb in the atonement. Poetic metaphors are often cryptic or semicryptic, even when the ideology is not mystical.

10. Suggestion through contiguity in experience; common or conspicuous correlation. Symbolism based on it.

The other main, primary basis for associating ideas is the fact of having experienced them together or in close succession, especially on repeated occasions and in otherwise dissimilar contexts. Clouds and rain often come together; day and night succeed each other regularly. Such pairs of things may be quite unlike and yet recur persistently together, or may be analogous in some respects, as clouds resemble rain in being moist. Contiguity and similarity often work together to connect two images. But we shall emphasize here those which are not markedly similar.

Persistent contiguity in nature and experience is usually taken as a sign of close causal connection. This is often misinterpreted by unscientific minds, and used mistakenly as a means of control, as in burning an enemy's fingernail parings in order to injure the man himself. But it does indicate some kind of underlying causal connection, and scientific techniques try to find exactly what this is. When two things, such as light and heat or gray hairs and conservatism, commonly occur together, both may be effects of some underlying cause or condition, even if one does not directly cause the other.

The appearance of common materials, such as wood, stone, leaves, iron, or fur, is associated with their tactile qualities and with visual images of connected parts, as of the trunk and branches with the leaves of a tree. The flash of lightning suggests the sound of thunder; falling rain suggests feelings of coolness and dampness. Living things are associated with their natural environment; camels, with the desert; fish, with the depths of water; lotuses, with the surface of water.

A familiar kind of suggestion in life and art is called the "expression of emotion," and we also speak of "facial expressions" and "expressive gestures." When we see a person raising the corners of his mouth and making the peculiar muscular configuration which is called a smile, we interpret it as meaning he is happy or amused, because human experience almost always associates that visual image with such emotion. That particular smile may happen to be caused by pain or by some accidental, unconscious mechanism in the person's face, but, on the whole, experience justifies our interpreting it as a sign of inward happiness or amusement. There may well be an innate predisposition in such responses. A very young infant so interprets a smile on the face of another person, and likewise interprets a frown as meaning annoyance or disapproval.

Such basic human associations are sometimes altered by the customs of a particular culture, so that a traveler in exotic lands does not know exactly how to interpret a smile, a laugh, or a tone of voice. Among young children there is less cultural variation. The higher animals also express feelings and desires in fairly definite, understandable ways. Young animals and children learn to interpret the parent's tone of voice as approving or disapproving before they can understand conventional words. People who cannot understand each other's languages understand that pointing to the month means hunger or thirst; placing the hand on some part of the body, with a certain facial expression, means pain. Later on, children learn to interpret subtler shades of meaning and attitude in conversation by slight nuances in the tone of voice. Many such auditory qualities come to have suggestive power through association with common expressions of emotion or other meaning. They can be detached and developed in formal musical expression.

Certain types of correlative are definitely *cultural* in basis. (1) Occupations bring together certain workers, tools, materials, actions; farming connects the plow, spade, and sickle with the earth, crops, sowing, and reaping. Formerly horses or oxen would be included; now mechanization is changing this correlation. Swords and shields, ships and sailors, pen and paper suggest each other. Crowns suggest royalty. (2) Words and other linguistic signs, as tools of thought and communication, develop systems of their own through grammar and syntax, such as "either . . . or" and "on the one hand . . . on the other hand." These pairs do not exactly mean each other, but are verbal correlatives. (3) Common connections in human products occur: e.g., walls, roofs, doors, windows in houses; cups and saucers; coats and sleeves; red, white, and blue in many national flags.

A presented line or other visual shape can have

suggestive power, apart from what it resembles. Most of us have drawn lines so often that, in looking carefully at one, we can imagine how it was drawn. We can, by the process of empathy, "feel ourselves into" the line, and imagine how it would feel to draw it. For one line, it seems that the pencil or brush must have been held firmly, with the arm rigid and a definite, forceful aim directing the movement. For another it must have been flaccid, weak, or uncontrolled. Such muscular attitudes are further associated with general traits of mood and personality, and hence even these may be suggested by abstract qualities of line. Of course, any inference of this sort about the actual production of the line is unreliable. Nevertheless, it may actually operate as a mode of transmitting suggestions through lines and other shapes. It can work together with the other functions of line (in imitating, symbolizing, etc.), or apart from them. Books on "art principles," "color theory," and the like often go too far in saying that a certain type of line or color has a certain emotional effect. Such effects are variable and much influenced by the formal and cultural context, as well as by the nature of the person affected.

Images and ideas correlated by contiguity may act as symbols of each other. This is *contiguous symbolism;* symbolism by *correlation in experience,* or by spatial or temporal connection among the events of existence. In this sense, a smiling mouth is a symbol of joy, pleasure, happiness, or liking. Breath is a symbol of life and the soul. But this symbolic relation does not always follow: black is not a symbol or meaning of white, summer of winter, or a roof of a wall, though each tends to call the other to mind.

When the frequent conjunction of certain phenomena is due to natural conditions and laws, rather than to human contrivance, they can be described as *natural correlatives.* As a rule they are causally and functionally related by common membership in some large, interacting system: e.g., the solar system or the human organism. They may be opposite phases of a periodic series, as in sleep and waking. Opposites tend to suggest each other through association in thought and frequent alternation in nature: day and night, light and dark, concave and convex, hot and cold, wet and dry, summer and winter, life and death, health and illness, love and hate, joy and sadness, war and peace. Obscure connections often link opposite or conflicting qualities in our minds, sometimes through our own ambivalent natures, which can desire and detest at the same time. Gold and gems turn to filth in dreams and fairy tales, rich costumes to rags, beautiful girls to horrible old witches, and fairy princes to frogs.

Other correlatives are fairly compatible or coexistent, such as infancy and helplessness, pain and disease or injury. Desires and their objects are correlated, as hunger and food, thirst and water. Organs and their functions are correlated, as the mouth with eating and talking. Each part of the body tends to suggest neighboring as well as similar parts: the face is associated with the neck and hair, the genital organs, with the legs and abdomen. More or less mimetic symbols are often substituted for the genital organs and processes in dreams and art. Neighboring bodily parts, or parts often connected in daily activity, are also thus substituted for them in the psychological mechanism called "displacement."

Primary sex characteristics are associated with secondary ones, and either tends to suggest the other. Masculinity is associated with a low-pitched voice, a rougher skin, broad shoulders, muscular strength, pugnacity and a desire for dominance, and direct and forcible methods of gaining ends; femininity, with opposite qualities. Secondary differences between the sexes vary in extent in different cultures and periods; modern feminism has reduced them greatly. At all periods, however, many men have liked to wear or carry accessories, weapons, and utensils which suggest virile strength by phallic symbolism and by association with power and violence. As boys they play with toys of this kind (e.g., toy swords and guns), and when older like to ride on spirited horses or in streamlined vehicles which suggest virile power by shape and motion, as well as actually increasing the rider's power and speed. Women have usually preferred garments and accessories suggesting softness, hollowness, delicacy, and yielding grace. Tastes of the sexes in art have likewise been differentiated. For both sexes, the appropriate type of costume and accessory acts as an extension of personality and a means to sexual and other ends. All are correlated with masculine and feminine traits of speech, movement, thought, and behavior which, taken all together, may be classed as tertiary sex characteristics.

These provide huge, antithetic systems of associated, affect-laden images. Any image or idea in one system tends to suggest others in it by direct correlation, and sometimes (according to context) its opposite by contrast. The sharpness of the antithesis varies greatly from culture to culture and period to period. In some, masculine and feminine are at opposite poles; in others, they coincide to a large extent. The polarity is now being diminished by modern rapprochement between the sexes, in which men and women are coming to dress, behave, and think more similarly, and to use and prefer more similar things. They receive more similar education and enter the

same professions. Still, the old associations persist to some extent in art and in life. Even when the sexes are more alike in actual life, we still contemplate works of art from periods when they were sharply differentiated, as during the recent Victorian age. Hence we understand, or unconsciously feel, the masculine or feminine tone in much associated imagery that is not specifically sexual in reference.

The juxtaposition in one work of art of images symbolizing both sexes at once may suggest, depending on details and context: (a) erotic relationship or struggle between the sexes; (b) stable family life, home, protection, and contentment; (c) fertility and long life, as in the Egyptian ankh symbol; (d) more abstractly, the cosmic process of strife and alternation between opposite tendencies (e.g., Mars and Venus as symbols of destruction and creation in Lucretius's poem) and their temporary reconciliation, balance, or union. These abstract, metaphysical implications are common in Oriental religious art, especially that of India. In Western art, masculine and feminine symbols are often combined, not only in the literal representation of groups of men and women, but in abstract forms and in representation of other subjects, such as still life and landscape. A tall, rigid wine bottle is placed near a bowl of soft flowers, a tall tree or telegraph pole near a pond or garden enclosed by shrubbery. Similar contrasts of shape and texture occur even in abstract painting. Music often combines (in opposition or union) masculine and feminine themes, as in a sonata form, where one theme is vigorous and decisive, the second gentle and graceful.

In relation to mimesis, we noticed how one work of art can suggest in this way others of similar medium and style. By contiguity also—that is, by spatial or temporal proximity of works of art or what they represent—one image in art can lead to thoughts of others and of details within them. Each scene and character in a well-known play or story suggests others, as each part of a natural form suggests related ones. Mention of Juliet leads to Romeo; and, if we linger on these names, to the feud of Montagues and Capulets and the whole sad story of ill-fated love. Abstract qualities are included: Faust suggests not only Margaret and Goethe himself, but the whole romantic movement and the modern "Faustian" attitude toward life which Faust has been made to symbolize. Thus, for the learned, art and civilization are one continuous fabric; art is continuous within itself and in contact with the rest of life. Not every point in art, however, is sufficiently well known so that allusions to it are readily grasped, even by

scholars in that art. Simple references to Homer and Shakespeare and their major characters are standard in Occidental culture, supposedly understandable by every college student, so that a modern writer can count upon their suggesting associated characters, events, and qualities: e.g., Penelope as a symbol of fidelity and patience.

For those who know anything of cultural history, including historic styles of art, any characteristic example of a style tends to suggest others, perhaps in a different medium, and their whole cultural background. A Gregorian chant suggests a medieval cathedral and the religious aspects of medieval life in Europe. Armor suggests its feudal, knightly aspects. A Greek statue suggests Greek life, perhaps not as it actually was, but as we now imagine and idealize it. In Rococo furniture and textiles, figures in Chinese costume suggested Oriental life and its exotic charm. In Debussy's *Sunken Cathedral,* a passage like a choral chant is used to call up a visual image of the edifice. Such lines of association can start the observer off on an endless course of reverie, far away from the present work of art. For this reason they are deplored by some critics, who urge more attention to the latter; still, we must recognize them as a powerful means of suggestion in and through artistic imagery.

Association through contiguity is not necessarily common in the sense of being frequently repeated in human experience. Association in one well-known, culturally established folktale or other work of art will suffice. This is *conspicuous* correlation. Thus the Trojan horse becomes a symbol of deception and trickery through its part in the capture of Troy. Religious stories, too, give rise to this type of association through contiguity. The footprints of Gautama Buddha, and the Bo-tree under which he sat, became his symbols in Buddhist sculpture. Through contiguity in the Christian epic, the cross and crown of thorns have become symbols of Jesus and the Crucifixion. Many saints and martyrs derive their traditional symbols or attributes from objects connected with their lives or martyrdoms: thus the wheel is a symbol of St. Catherine, the gridiron, of St. Lawrence. When iconoclastic trends forbid the representation of a deity as idolatrous, such concrete symbols are often used in its place.

Suggestion and symbolism based on contiguity can, like the mimetic or analogic type, be either *explicit, cryptic,* or *semicryptic.* They are explicit when a fairly clear indication is given as to A, the symbolic image (e.g., by portraying or describing it), to B, which it symbolizes, and to C, the connection or correlation between them. (If well known, C may be

taken for granted and the symbolism will still be fairly explicit.) Thus the "attribute" (A) of a saint can signify or symbolize that saint (B), not only through arbitrary convention, but primarily through their supposed historical association (C). The suggestion becomes semicryptic when little indication is given as to either B or C, and cryptic when none is given.

11. Suggestion through arbitrary symbolism; linguistic and other varieties of conventional symbolism.

The type of symbolism to be considered here is a special, civilized development of older types, differing from them generally in its greater definiteness and in its social function, which is mainly one of clear communication and the guidance of activity, both mental and overt. Linguistic and other conventional symbolism operates through a culturally established, specific bond between image and meaning, or between one concept and another. The arbitrary symbol may resemble the meaning, as in pictographs and onomatopoetic spoken words; but it usually does not. There is no resemblance between a tree and the word "tree," written or spoken. Linguistic symbols include written or printed and spoken words, letters, numbers, punctuation marks, and technical signs (such as those of chemistry). Many such symbols, in ordinary language and in religious iconology, have developed out of primitive tradition. They were originally based on association by similarity or contiguity, and this relationship between image and meaning may still be evident. Others are new, artificial products of arbitrary decision by authorities such as governments, academies, and learned bodies. Once adopted, they come to be associated with their meanings by contiguity and active use, as H_2O is with water in chemical manufacture.

As discourse becomes more scientific in spirit, it makes more use of arbitrary, consciously man-made symbolic devices as tools of communication and recording. It is less passive, less restricted to symbols which have been derived from observed or fancied analogies in the nature of things, or from unsought associations in experience. Man decides that a certain image *shall be* henceforth a sign or symbol for a certain meaning; that the two *shall be* associated by contiguity in educational experience and social usage.

Signs and symbols used in science and in the technological administration of practical affairs tend to be relatively clear and unambiguous: e.g., red and green lights and other traffic signals, or flag and blinker lamp codes in the navy. Ambiguity here would result in undesired confusion. Constant effort is made to sharpen up definitions and to standardize presented forms in such codes, so as to make them efficient tools for communication and the control of activity on a large scale. Their suggestive power is definite, with established meaning or signification, implying a specific connotation and denotation.

Other types of symbol, as we have seen, have a more vague and indeterminate aura of diversified, optional meanings. Mystic, prerational symbolism tends to perpetuate a small number of ancient, emotionally feared or venerated symbols, attaching to each a vague multiplicity of meanings. Rational, linguistic symbolism is more unemotional, practical, and intellectual, treating symbols (including words) as man-made devices which can be changed or redefined at will, for expediency in thought, action, and communication. It devises new symbols in great profusion, entire systems of them in each science and realm of management, so that each may have only one meaning or as few as possible. Yet there are so many meanings to be conveyed as civilization develops that most symbols have several possible meanings. At best, they can be made fairly definite within a certain realm of thought. The plus, minus, and multiplication signs are fairly definite in mathematics, though even there each has more than one shade of meaning. In cattle branding, a cross may stand for "Cross-bar Ranch" and denote a certain man's property. The circle can be a linguistic symbol for zero or the letter O, and also a religious symbol of the sun and solar deity.

The arts still use both ambiguous and unambiguous symbols, the former being on the whole more ancient and traditional. These are more diversified than science and technology in the kinds of symbols they employ and in the attitudes they take toward them. Literature uses very sharp and clear linguistic symbolism in printed letters and words. These are partly interchangeable with spoken words; tones of voice (e.g., rising at the end of a question) are also conventional symbols as well as expressive in other ways. Punctuation marks are partly equivalent to, and symbolic of, such inflections of the voice and their shades of meaning; both help to group words into phrases, sentences, and paragraphs for easy understanding. Literature and other arts are sometimes clear and unambiguous, sometimes deliberately vague and ambiguous.

All civilized languages, and many primitive ones,

have developed at least two systems of partly equivalent symbols: spoken words, written or printed words, and sometimes others of limited scope such as clicks in telegraphy, gestures for the deaf, and combinations of raised dots for the blind. The language of gestures or *mudras* in India is widely used among scholars and adepts, and contributes a symbolic element to dancing, painting, and sculpture. Symbols belonging to these different systems are not always exactly equivalent. Some complex scientific formulas are hard to put into spoken language. A spoken word may be ambiguous through sounding like another word, very differently written. Spoken words have certain overtones of auditory association, while their printed equivalents may suggest different words through visual resemblance. For fun, American schoolboys pronounce "Louis XI" as "Louis the Cross-Eye," and "Louis Quinze" as "Louis the Quince." Lewis Carroll joined "cabbages and kings." Such illogical associations among words play an important role, not only in puns, wit, and humor, but in serious poetry. Whether the effect is silly or serious depends on the type of image thus evoked, and its own emotive associations; also on the degree of incongruity. The Christian church, it has been said, was founded on a pun: the resemblance between the Greek words for "Peter" and "rock."

In spite of such partial differences, modern written and spoken languages parallel each other fairly closely, so that the written and the spoken form of a certain symbol tend to suggest each other. To read the word "wheel" suggests that sound of the English word as well as a visual image of a wheel. By this means, the auditory qualities of poetry can be imagined in reading it silently. For strongly visual, literate persons, the spoken word can suggest a visual image of the word, unless speech goes too fast. A picture of a wheel suggests both the spoken and the written word. In addition, each word can be defined in terms of other words, both written and spoken; i.e., a set of other words almost equivalent in connotation and denotation can be found, and we say that each "means" the other.

In painting, sculpture, and other visual representation, the internal use of linguistic symbolism is now usually avoided. It was common in early visual art to combine verbal with pictorial symbols, in Egyptian wall painting and reliefs, for example. By portraying the symbol mimetically, as in a painted or carved lotus, the visual artist can call to an observer's mind the same image which the poet suggests in a different way. Its visual form will thus be more vivid and concrete in the observer's mind; but its further meanings

can be equally ambiguous, equally surrounded by an aura of diverse associations.

Modern linguistic symbols—letters, words, numbers, etc., whether written or spoken—are mostly nonmimetic. Egyptian writing had to escape from the limitations of pictographs to achieve the freedom and power of arbitrary symbols in expressing abstract ideas. Some today, such as the hand or arrow for pointing a direction, are still mimetic.

In visual art, both arbitrary and mimetic symbols are still used. In some cases, a mimetic image was used originally to suggest a kind of concrete object it resembled. Later on, its meaning broadened out to include more abstract ideas associated with that object. The cross is mimetic in that it resembles the wooden cross used in crucifixion; but by contiguity and convention it has come to signify Christianity. A disc, or a group of lines radiating from a center, may represent the sun and its rays, or a chrysanthemum. Both come to suggest the abstract idea of power, and also the nation Japan, which uses this symbol. They also resemble a wheel, hence they may symbolize the Buddhist idea of the Law as a wheel, or the recurrent "wheel of rebirths." In the Amarna sculptures, they symbolize the flow of blessings from the sun god upon King Akhenaten.

Many symbols act through visual presentation. In the West, as well as the East, gestures and postures of the body may have definite symbolism, as in the case of military salutes and the polite observances of shaking hands and raising one's hat. Fascists and Communists have their own symbolic salutes. Auditory images, like bell and whistle signals, also act as symbols. So may presented tactile images such as the touch of a hand upon the forehead or shoulder. A national anthem such as "The Star-Spangled Banner" is an arbitrary musical symbol of the nation which adopts it. Association later strengthens that meaning.

As conventional symbolism develops along various scientific lines, it is organized into systems, such as the grammar and syntax of a language, the multiplication table, or the periodic table of elements in chemistry. Each symbol, and the concept for which it stands, tend to suggest others in the same system, and the whole realm of thought to which they apply. Their interrelation is not merely one of mutual suggestiveness; they are linked in systems of logical implication, and in the work of describing and controlling nature. They are not merely systems of symbols and ideas, but correspond in some degree to the structures of experience and nature. Even though their main functions from a scientific standpoint are cognitive and logical, they inevitably fall into other types

of mutual relationship, such as that of word-sounds. Rhymes, rhythms, and other likeness of sound among words of different meaning can link a set of words in ways which either supplement their meaning (as in poetry) or disrupt and confuse it (as in puns and witty word-play).

The bond between an image or symbol and its social meaning is a pattern in social behavior, a way of coordinating and controlling the acts and thoughts of many individuals. In primitive culture its function is mainly active and practical, as a means of expressing desires, issuing commands, indicating ownership, exerting magic power, and the like. In more advanced cultures symbol-meaning relationships are used not only in action, but increasingly as tools of abstract reasoning and as aesthetic objects. These various functions, often of the same symbol, may interfere with each other and produce confusion; perhaps intentionally, as in jest. In science, such confusion is reduced to a minimum by logical and other conventions regulating interpretation. In art, these conventions are used to some extent but not exclusively. Hence, in a work of art, there is sometimes consistency and sometimes conflict between logical and other ways of interpreting a given image.

Social bonds between images and meanings are more like roads or channels than links in a chain; paths along which thought is made to travel easily, through social education. Along such a road, it does not always travel equally well in both directions. As between two images, one may suggest the other, while the second does not suggest the first, or not as strongly. As a rule, symbolic sense images lead to their meanings, including abstract meanings; they are used as tools for that purpose. But the abstract meaning does not necessarily lead to any one symbol, except to the word or other sign commonly used as a name for it. The fish and the chrismon (a monogram of chi and rho) are early symbols of Christianity, and one so interprets them in art; but Christianity does not necessarily suggest these symbols.

12. Combined modes of suggestion.

Many works of art use two or more modes of suggestion; some use all of them, together or in different parts. The observer is seldom conscious of the difference between them, or of the exact source and psychological basis for the combined apperceptive and affective response which he attributes to the presented image.

Grünewald's *Crucifixion* uses all three modes of sug-

gestion in addition to a complex presentative factor. Among the presented aspects are the rectangular shape of the picture, its light and dark areas, its different colors (especially green, brown, blue, and red), the straight and curving lines, and various textures. Through mimesis these suggest wooden crosses, trees, foliage, rocks, human bodies, blood, and garments. Through common contiguity in experience, the flowing blood and facial expressions suggest pain and sorrow, with the aid of gestures such as wringing the hands. The letters INRI, fastened to the cross, are conventional linguistic symbols, initials of the Latin words for "Jesus of Nazareth, King of the Jews." All four modes of transmission cooperate to convey a complex set of meanings.

It is common practice today to go to a concert and read program notes or a printed score while listening to the music, or to a museum and read labels or a guidebook between glances at a picture. These methods involve, to some extent, combined modes of suggestion. Even a descriptive title below a painting tends to suggest a certain mode of interpretation.

All literature involves linguistic symbolism, in spoken or written words, as its primary mode of suggestion. The images and concepts which it thus conveys may suggest others: (a) through common correlation, as of "rose" with the perfume, soft petals, and thorny stem of the flower, or with bouquets and gardens; (b) through detailed or exact mimesis: "rosy" suggests a certain hue or tint, as in lips, cheeks, and sunsets; (c) through conventional symbolism, with specific meanings according to the context: e.g., again, in the case of the rose, the Virgin Mary, as in the rose window of a cathedral; the Tudor dynasty in England, whose emblem it was; Yorks and Lancasters in the Wars of the Roses; "sub rosa," as a symbol of secrecy; or (d) through verbal mimesis, with onomatopoetic words cooperating occasionally with these other modes of suggestion. Usually the sound of words is not interpreted mimetically, for it would lead the apperception astray into irrelevant associations.

Calligraphy ("beautiful writing") was highly developed as a visual art closely connected with literature, in China and medieval Europe. It combines all three modes of suggestion. In the first place, the characters for words or letters involve arbitrary symbolism. Secondly, mimesis enters in one or possibly two ways. The early stage of writing involves pictographs, or mimetic representation of certain objects by simplified imitations of them. Later, the ideas to be expressed become too complex and abstract to be visually imitated. More and more meanings come to be packed within a pictograph, so that it comes to suggest

symbolically other and perhaps very different meanings from those which it first suggested by mimesis. Even at a later stage, however, symbolic characters sometimes retain a trace of their early mimetic form.

In developed calligraphy, another kind of mimesis enters. The same character can be drawn in various ways, especially with a flexible brush. Similar brush strokes are used in pictorial representation. The same kind of line which is used to draw a drooping willow branch may also be used to draw the characters of a poem about willows. Another kind of line represents the jagged pine branch, and verbal characters can also be drawn with this kind of line. Their discussions of calligraphy show that the Chinese were aware of the resemblance between certain kinds of line in calligraphy and certain phenomena of nature, and that they carefully cultivated this element in the art. Such mimesis is of course highly abstract and simplified.

Calligraphy and drawing also involve suggestion by contiguity or common correlation, where a type of line suggests a type of physical gesture, hence the kind of physical, mental, and emotional condition which produced that gesture. The shape and texture of a line may thus suggest strength or weakness, firm decision or hesitation. Expert handwriting analysis is based upon the interpretation of such lines as indices of character and mood.

The occasional use of heavy black type in a printed text to give emphasis involves more than arbitrary symbolism. The slight shock of a more intense visual stimulus suggests intensity of feeling. So italics among ordinary type may suggest animation or a rise in excitement, through the sloping, cursive direction of their lines.

The combined use of mimesis and conventional symbolism is common in national emblems. In heraldry, a lion and unicorn are mimetically represented in the coat of arms of Great Britain. Other lions, a harp, a shield, a helmet, and a garter are also shown. Each of these has in addition an abstract symbolic meaning, referring to the descent and position of the British king. The mottos, such as "Honi soit qui mal y pense," refer, in arbitrary, linguistic symbolism, to a historical incident. The rampant lion of Scotland, also included in the British arms, suggests strength and ferocity through the common association of such qualities with the attitude called "rampant"—i.e., rearing up with forepaws extended. Red can suggest blood and fire by abstract mimesis; hence danger and revolution by common correlation. It can also suggest Communist Russia by arbitrary symbolism as well, according to the context, in flags or official insignia.

Human beings, animals, plants, and other natural phenomena are constantly used as symbols of abstract qualities or of deities or superhuman forces, e.g., the thunderbolt of Zeus, the hawk of Horus. The use of animals and plants as symbols of gods or ethnic groups goes back to primitive totemism. The use of a human or quasi-human personage to symbolize an abstract quality—e.g., a virtue or vice—is called *personification*. The same personal symbol can stand for many qualities at once; sometimes inconsistent ones, since the concept of a god or demon often represents a synthesis of several more primitive, local divinities. A nation may be symbolized abstractly or linguistically by its flag or crest, or concretely by a figure such as Uncle Sam or John Bull. Each star in the American flag suggests mimetically a star in the sky, and, arbitrarily, one of the states.

In the old-time silent films, use was constantly made of all three modes of suggestion. The presented lights and shadows on the screen suggested by mimesis the appearance of men, women, children, animals, rooms, objects, outdoor scenes, etc. The appearance of moving lips suggested by common correlation the sound of voices, words, exclamations; flashing pistols suggested audible gunshots. In the same way facial expressions and gestures suggested emotional attitudes, as of love, hate, fear. Printed words, occasionally flashed on the screen as "subtitles," clarified through linguistic symbolism the trend of plot and conversation. American flags, policemen's badges, etc., were also arbitrary symbols. Now, in the sound film, direct auditory presentation takes the place of most auditory suggestion. There is less burden upon the visible gestures to convey ideas and emotions in pantomime; hence they decline in emphasis, appearing as less extravagant, more natural. In observing either type of film, the public makes no systematic distinction between the various kinds of suggestion, but grasps them all as meanings of the changing images on the screen.

Mimetic suggestion operates mainly between images from the same sense: visual images directly resemble other visual images; sounds suggest by mimesis other sounds. Common correlation may cooperate to extend the suggestive range to images from other senses and to all manner of concepts. A painted portrait suggests the appearance of a person by mimesis, but that appearance tends to suggest many nonvisual images commonly associated with such a person: his age, sex, occupation, character, mood, or attitude, as well as certain tactile qualities, as those of smooth or bearded skin, armor or velvet. If the person is represented as singing, speech-making, or playing the violin, slight auditory suggestions are more likely. Some observers are naturally more auditory in their associations, others more visual.

13. Musical mimesis, analogy, and symbolism.

Musical sounds can suggest by mimesis other sounds, musical or nonmusical, like those of running water, a spinning wheel, marching feet, the song of a cuckoo, the clucking of a hen, or the blows of a hammer on metal (as in "The Harmonious Blacksmith"). Each of these may call up associated visual images, and perhaps tactile and kinesthetic ones, as of the appearance of a hen or spinning wheel, the coolness of a brook, the vigorous effort of hammering.

What is loosely called "program" or "descriptive" music usually involves two and sometimes three modes of suggestion at once or successively. First, we have noticed the role of abstract mimesis. Even music which is comparatively "pure" or nonprogrammatic is full of slight, vague resemblances to nonmusical sounds, perhaps unintentionally: to the wail of a baby, to laughing or quarrelling voices, the songs of birds. Each of these tends to evoke, usually without the hearer's knowing just how or why, a vague aura of correlated memories. Some of these are comparatively universal, as in associating grief or discomfort with an infant's cry, or the lightness and airy flight of birds with the high, clear tones of their song. Others are cultural or local: sounds which would express pain or grief in Europe express a different emotion in the Japanese theater. A low pitch tends to suggest the voices and hence the bodies and gestures of men or large, heavy animals; a high pitch, those of women, children, or small animals. Slow, steady rhythms go with slow physical movements, as in a stately dance or funeral procession; fast, broken rhythms suggest livelier dances, agitated or playful moods—all these suggestions, of course, subject to great variation according to the context. Speed and loudness suggest more tension, as a rule, than slowness and softness. A high pitch in music suggests visible height in space by common correlation, as with singing birds and also with the position of printed notes on the staff. (And to sing a high note ordinarily uses muscles higher up in the throat than a low one.) For these and other reasons, falling and rising pitch suggest falling and rising in space. A rapid, falling arpeggio can suggest a cascade; a rising one, a fountain; a trill or sustained alternation of notes, the shimmering and sparkling of light on water.

Some individuals and some cultural epochs are more sensitive than others to such correspondences

between the senses, and between different arts. The French Symbolists of the late nineteenth and early twentieth centuries were much impressed by them, and sought to carry over similar images and emotions back and forth between music, painting, and poetry. Debussy tried to suggest in music *Reflections in the Water,* a visual subject often painted by Monet. In *Goldfish,* he suggested by showers of light arpeggios and by quick, irregular changes in rhythm and melodic line the darting, shimmering movements of such fish.

The suggestions of instrumental music alone are usually vague, or follow paths not intended by the composer, without the aid of accompanying verbal titles and printed program notes. Experiments have shown this to be so even in the case of highly trained listeners. Insofar as the verbal aids are considered necessary, the entire composition is really a mixed form, combining words and music, though less integrally than in song or opera.

Military bugle calls involve arbitrary symbolism insofar as they convey specific commands, such as "Boots and Saddles." But there is also an element of mimesis and common association here, as there is in the Wagnerian *Leitmotiv.* "Taps" suggests relaxation and quietness by its tempo and melody; calls to action are faster, often with rising melodies.

Highly specific, arbitrary symbolism (except in musical notation) has never been a major device of Occidental music. It was more popular in the Baroque period than it has been since then. In Bach's chorale prelude *Durch Adams Fall,* he symbolizes the fall of Adam from a state of innocence into sin, by a falling seventh in the bass. Sin being conventionally symbolized by chromaticism, the sevenths are diminished. The chromatically winding middle part stands for the snake, another symbol of sin to which the text refers. In a cantata, Bach tries to convey the idea that a sinner has no firm ground under his feet by omitting the bass continuo, only the viola giving a "shaky foundation" to the music.[9]

A more general, variable type of suggestion from auditory stimuli was recognized as long ago as Pythagoras. It was he who applied the concept of "harmony," as a kind of unity and order in variety, not only to musical sounds but to relations among the parts of the soul and among the individuals in society.

[9] M. F. Bukofzer, *Music in the Baroque Era* (New York, 1947), pp. 283-92. Indicating "cross" by a sharp is a musical pun in German; likewise, spelling "BACH" by four notes of the scale.

This idea was later developed by Plato in the *Republic*. Greek philosophers realized that music can "imitate" or represent emotions, not in the way we now describe as mimesis, but through more abstract analogy. Simple, regular, vigorous, harmonious music, they believed, could not only suggest similar states of mind but help to induce them. Excited, irregular, complex music could suggest and arouse other psychological states.

Such correspondences are partially indicated by the expressive marks in a musical score, such as *grave, con brio, scherzo, con fuoco,* and *cantabile.* The whole design of a fugue may suggest, by abstract analogy, such qualities as firmness, confidence, and rational control in executing a task or completing a cyclical journey. Another, more romantic piece may suggest hesitation, lack of confidence, or uncontrolled passion. Such qualities can be further refined in the nuances of composition and performance. Medieval and Renaissance music moved a considerable distance toward definite symbolism, but this tendency has declined in favor of free, diversified expression.

14. Types of symbolism on the basis of cultural fields and attitudes. Mystic, rationalistic, and erotic symbolism.

We have distinguished several types of symbol and symbolism on a basis of different modes of association and suggestion: mimetic and analogic symbolism, symbolism by contiguity or correlation, and arbitrary, conventional symbolism, this last including varieties such as linguistic symbols, emblems, and insignia. Each of these is used in many different but overlapping cultural fields or subjects such as religion, science, commerce, government, war, and recreation. Large fields are divided in various ways: e.g., religion into Christianity, Buddhism, Greek polytheism, etc.; science into mathematics, astronomy, etc. Each subdivision of a field may have its own symbolism, as with heraldry, falconry, chess, bridge, and stock-exchange quotations. This provides a basis for classifying types of symbol and meaning in accordance with the fields wherein they have originated or are used. Thus we have chemical symbolism, heraldic symbolism, and Indian Buddhist symbolism. Each system is set forth in standard reference works on the subject: e.g., in books on Buddhist iconography, or on the symbols and attributes of Christian saints. Often a symbol is explained as having certain principal meanings in that field, as well as certain secondary or occasional ones.

A particular image or concept is often used as a symbol in several different fields, and in each of these it may have several meanings. Thus "H" can mean "hydrogen" in chemistry, and "Henri IV" on a French palace wall or piece of furniture. Dictionaries classify some of the various meanings of an ambiguous word, by prefixing the names of different fields. Thus Webster defines the word "nymph" as follows: "(1) *Gr. and Rom. Myth.* One of the inferior divinities of nature represented as beautiful maidens . . . (2) b. *Poetic.* A nymphlike maiden. (3) *Zool.* Any of certain insects in an immature form . . ." Sometimes such diverse meanings are historically related and have certain elements in common; sometimes use of the same symbol is accidental. In different fields or contexts the symbol tends to take on different emotional and conative associations, to become a different aesthetic object.

It was mentioned above that some symbols figure prominently in the widespread and perennial attitude toward life and art known as mysticism; hence, these are called *mystic symbols.* They are regarded, especially by mystical thinkers, not as colorless signs or tools of reasoning, but as objects worthy of respect and veneration, as keys to the understanding of deep spiritual realities beyond the reach of sensory observation. Mystic symbolism enters into many religions of the past and present. In a given religion, some worshippers may be mystical in attitude and others not; in art, philosophy, and daily life, some individuals are inclined to be mystical and others empirical or rationalistic. Thus, mysticism and mystic symbolism enter into the arts and into other fields, where they compete and sometimes combine with other kinds of symbolism and with other mental and emotional attitudes.

Love and sex, in both physical and spiritual aspects, constitute a major realm of human life and culture, a common theme of art; they also affect and penetrate all other main cultural realms to some extent, including religion, politics, and science. They have developed their own symbolism, based in part on primitive analogy, as we have seen, but further developed and refined in civilized arts. Thus *erotic* or sexual symbolism constitutes a major type of symbolism as to field and subject matter. Because of its importance in imagination and motivation, personality development and maladjustment, it is studied as a crucial type of phenomenon in psychology and psychoanalysis. It is widely prevalent in religious

iconography, and overlaps the subject of mystic symbolism, in that erotic symbols are often regarded religiously and mystically.

15. The interpretation of ambiguous symbols. Formal and cultural contexts. Mystic and naturalistic approaches.

From the standpoint of naturalistic philosophy, it seems true that no symbol has any one intrinsically correct meaning, whether according to the essential nature of things or to supernatural revelation. All the meanings of a symbol are attached to it by human experience and cultural usage. In course of time, new meanings are attached and old ones forgotten, although some may remain indefinitely. Some are local, others widely accepted. Many symbols in the arts have acquired innumerable meanings through long and varied usage. In general, it is impossible to define them exhaustively. Each is a set of radiating paths through culture, indefinitely long. All of these meanings are correct insofar as they are culturally established. Some are more strongly and closely attached to a particular image by authoritative usage, in a certain context or realm of discourse, than others. Hence, within that context, it is correct to assign such an image those particular meanings rather than others, if one's aim is to receive the intended communication and thus to apperceive the work of art most fully.

Among the questions relevant in trying to interpret symbolic art are these: What meanings were commonly attached to these symbols in the artist's time, place, and cultural environment? What ones did he attach to these and similar images elsewhere? What ones did he probably intend here, and what evidence exists for this hypothesis? What meanings do these images have today? Is there reason to think a deeper, truer interpretation is possible now than in his time?

No one type of symbolic meaning is always and necessarily on a higher level spiritually, is more true or profound, than others. A philosophic naturalist cannot agree with medieval mysticism that the sensory, literal, or obvious representational meaning is necessarily more superficial and trivial, the metaphysical or theological meaning more profoundly true or pertaining to a transcendent level of reality. It may be quite as true and important, quite as difficult a mental process, to diagnose a sensory image as a sensory image, within a perceptual scale as of colors or notes in the scale; or to recognize what kind of animal, plant, or historical personage is represented. One may

accept a certain religious or occult interpretation—e.g., the Incarnation—as true or correct in terms of cultural usage, without accepting the truth of any beliefs associated with that concept. One may agree that such an interpretation is traditionally regarded as referring to a higher spiritual plane than the simple, biological one, and yet question the actual existence of any such plane. In aesthetics as a whole, the mystical interpretation of mystic symbols is not necessarily more true or important in a particular case than the decorative, psychoanalytic, culture-historical, or other form of interpretation. Interpreters with different interests and intellectual backgrounds may properly interpret the same symbol in different ways. One meaning may be most correct and important from one point of view, in relation to a certain problem and context; another, from a different point of view. Such diverse interpretations may be supplementary rather than contradictory or mutually exclusive, and may all contribute to the fuller understanding of the symbol's total cultural significance.

What meaning or meanings may correctly be assigned to a symbol depends largely on the *context* within which it operates and is experienced. The task of narrowing down the countless possible interpretations of a highly ambiguous symbol is ordinarily performed by various kinds of cultural context. One is the immediate, *formal* context of the symbol in the particular work of art concerned, the images and meanings which adjoin it and the other relevant details in the picture, poem, or other work of art, as organized in a particular way. Another is the *general* context of culture and activity within which the work of art operates and is interpreted, the main field or fields of discourse concerned, such as astrology, alchemy, medieval Christian iconography, or Japanese Buddhist iconography. The work of art as a whole may belong to one such field, or the portion of it within which the symbol operates may refer to that field, as in a paragraph describing a Japanese Buddhist temple, within a story largely devoted to other subjects. Different parts may refer to different realms of thought, and thus indicate different contexts and specific interpretations for the various symbols involved. The cultural context of the symbol may include authoritative interpretations and rules for its exegesis within a certain setting. Thus a lion in a formal context which indicates the four evangelists will stand for St. Mark, on the basis of accepted principles of Christian iconography. Such contextual factors usually combine to indicate a particular meaning or narrow set of meanings as most cogent and appropriate.

Poussin's painting *The Realm of Flora* can be

apperceived on a literal, superficial level as a picture of several young and graceful men and women enjoying themselves on a summery day, surrounded by flowers. But this would leave unexplained the figure of a warrior falling on his sword or a chariot and its driver in the sky.

There is a double cultural context in this case: (a) the Greek and Roman tradition, as expressed in Ovid's *Fasti,* V, 183, and *Metamorphoses;* (b) the neoclassical, humanistic strain in seventeenth-century Baroque culture, as expressed in Poussin's original transformation of these sources. With the help of this context, one may recognize the warrior as Ajax and as a symbol of war (now abolished in Flora's realm). He dies as flowers bloom from drops of his blood. The goddess dances in the center, with her entourage personifying an ideal state of endless grace, beauty, joy, and pleasure, beneath the sun god's benign influence. Clytia, Narcissus, Hyacinthus, Crocus, and Smilax personify the origin of various flowers. This refers to Ovid's praise of Flora and his account of the flowers in her garden.

The various kinds of cultural context or milieu exist one within the other. At the center is the symbol in question; it operates within the formal context or work of art as a whole. This in turn operates within a changing, special field or area of culture, as marked off by professional, religious, or other interests and also by time and space. Many special fields, such as modern chemistry and Buddhist iconography, operate within the great, diversified milieu of civilized culture in general.

If the observer finds the symbol in isolation, he may be quite unable to decipher its true meaning. But the symbol is usually found within a work of art or part of one. This is ordinarily found amid other clues to the special field—e.g., Indian Buddhist iconography—in and for which the work of art was made. This may or may not be the one in which it now exists (e.g., an art museum).

What has just been said about the importance of the field and context in determining the meaning of a symbol requires some qualification from the standpoint of psychoanalysis. Freud and Jung both emphasize that a symbol may have meanings of which the person or persons using it are unconscious. Symbols of this sort, occurring in dreams and neurotic symptoms, are classed in this chapter as "unconscious" symbols. A certain archetypal symbol (e.g., the rose) can be widely used in varying forms. One may use a symbol, as in a work of art, without realizing its varied meanings in culture as a whole. To interpret such a symbol with reference only to its meaning in one particular context (formal or cultural) will fall

short of giving its full meaning. It might omit some meanings which are considered most important in culture as a whole, even though the artist and his public are unaware of them.

Here a relativistic policy would indicate selecting the meaning or meanings most relevant to the problem, field, or subject at hand. If one is writing about English Renaissance architecture, the meaning of "rose" as a heraldic symbol of the house of Tudor is probably most relevant. If so, there will be no use in encumbering the discussion with a host of comparatively irrelevant meanings from other sources.

16. Types of context. Their influence on the meaning of images.

Let us now consider again a traditional symbol such as the word "lotus" in poetry, or the representation of a lotus in painting or sculpture. Let us think of it first as detached from any particular work of art or cultural setting. We now perceive it as an isolated image and for the moment disregard any stylistic clues in the form of the visible symbol itself. As such, it has several possible contexts; it may refer to any of several different cultural realms and in each have a different set of meanings.

A. *Possible contexts of an isolated image.*

1. *Cultural fields or subjects:* main realms of thought and activity to which it may belong.

2. *Strong suggestions or basic meanings* in each field: alternative literal definitions; close associations, most strongly attached to the image in a certain field.

3. *Supplementary meanings and remote associations* in that field: established but less fixed, more variable.

The image "lotus" operates in at least three main cultural *fields,* which can be further subdivided. In the field of Greek history and legend, it has the following *basic meaning* or literal definition, according to Webster: "the fruit which served as the food of the Lotophagi, or lotus-eaters; also, the shrub bearing this fruit . . ." In ancient Egyptian and Hindu art, which may be considered one or two other fields, it means "any of several flowering water plants." In American horticulture, it means "any plant of the genus Nelumbo." To find the word "lotus" or a picture of one in a nurseryman's catalog or horticultural manual is a sign, through context, that it is to be understood in this last sense.

After defining "lotus" in the field of legendary Greek history, Webster goes on to give the following

additional information, which constitutes a set of *supplementary meanings:* "the fruit, and the wine made from it, was supposed to cause a state of dreamy content and complete forgetfulness of home and friends." It starts the reader on a path of association, or perhaps of study if he does not know the background of this allusion, which leads to Homer's account in the *Odyssey,* Book IX: "Now whosoever of them did eat the honeysweet fruit of the lotus, had no more wish to bring tidings nor to come back, but there he chose to abide with the lotus-eating men . . . forgetful of his homeward way. Therefore I led them back to the ships weeping, and sore against their will. . . ." The concept "lotus" in this field thus appears in a cultural setting provided (a) by the whole poem of the *Odyssey,* and (b) by Mediterranean culture in the Homeric age. It appears as the center of a vast network of cultural associations, of which some (the basic meanings and Homer's account) are most closely attached, while others ramify indefinitely into this cultural setting, as supplementary meanings and remoter associations.

In the field of Egyptian and Hindu art, as we have seen, the word "lotus" has a different basic meaning or literal definition, referring to a variety of flowering water plants. Behind or around this is a cluster of symbolic meanings. These vary according to the specific field of art and religion. As an Indian Buddhist symbol, the lotus flower "arising from or resting on the Waters, represents the ground or substance of existence, both that whereon and that wherein existence is established firmly amidst the sea of possibility."[10] This central meaning will suggest, to one familiar with Buddhist iconography, a further aura of secondary suggestions in that realm. Some are so well established as to be called "familiar but less essential aspects of the lotus symbolism." The lotus is "a metaphor of purity: growing in the mud, it betrays no trace of its origin." Some are more casual and popular: the lotus is "a thing loved and admired by all, and is used as a means of adornment, or lends itself to laudatory similes, as when we speak of lotus-eyes or lotus-feet." Thus by stages we branch out from the central meaning to a more indefinite group of associations in the religion, art, and everyday life of India.

Let us think of this potentially ambiguous image as part of a complete work of art. The essential problem of apperception here is to decide which of its cultural fields, and which meanings within those fields, are relevant in this context.

[10]Coomaraswamy, A. K., *Elements of Buddhist Iconography* (Cambridge, Mass., 1935), p. 20.

B. *Formal and cultural contexts of an image in a work of art.*

1. *The original cultural setting of the work of art:* that in which it was first produced or given its present form; the life and times of the artist or artists.

2. *The present cultural setting of the work of art:* that in which it is now shown or performed in general: e.g., twentieth-century Europe. Original and present settings may be the same, or very different. In a contemporary drama shown to a contemporary audience they coincide, except as class or regional factors may enter; in an ancient Hindu drama shown to a contemporary audience, they differ. In the latter case the social attitudes toward the object would differ from those in its original setting, and consequently the meanings and associations which were considered most important. The modern setting cannot alter the original artist's intention, but it can substantially affect (a) our understanding of that intention, and (b) the relative importance of its various qualities from the present standpoint. We are not bound today to interpret it exactly in the original way; we may be less interested in the early magical or religious aspects, and more in the decorative. The artist or artists who made or first performed the work are parts of its original cultural setting, and so are the persons who ordered, sponsored, or paid for it. Those who now exhibit, perform, enact, translate, edit, reproduce, study, enjoy, or use it are parts of its present setting.

3. *Attendant circumstances:* immediate, specific factors accompanying presentation of the work of art: e.g., in a museum, theater, concert hall, church, political ceremony, circus, or musical comedy; in a lecture on Oriental art or modern gardens. Such circumstances help determine what meanings of the image will be emphasized and considered most important at the present time.

4. *Total formal context:* the whole work of art in which the image occurs. This may be a short, independent lyric; but if the lyric itself is part of a large work such as a play or epic, this constitutes its total formal context. A piece of music may form part of an opera or cantata; a statue or painting may be an integral part of a temple or palace. Accompanying titles or text may be so closely integrated, so necessary to understanding, as to be considered parts of formal context. In an opera, the visual, musical, and verbal factors provide context for each other.

5. *Suggested (imaginary) cultural setting of the whole work:* a setting that may or may not be identical with its original, actual cultural setting. A Renaissance painting may portray a Biblical or Greek mythological scene; a modern story may deal with

medieval characters. Such an imaginary setting is seldom in exact accord with the actual facts of that period. It is an artistic creation, and part of the formal context. It may be a blend of ancient and modern; the ancient as seen through modern eyes or with modern touches. It is not necessarily uniform. A film (e.g., Griffith's *Intolerance*) or play may deal with several historical periods or geographical settings.

6. *Immediate formal context:* the portion of the work of art directly surrounding the detail in question, in space or time. For a word, this would be the phrase, sentence, paragraph, or stanza in which it occurred. In a statue, a lotus may appear as held by a god, or as part of the base for a Buddha or Bodhisattva. The immediate context may indicate an imaginary cultural field or background which differs from the prevailing one of the whole work: e.g., a character in an English play refers to the image in speaking of his Oriental travels.

Ordinarily, one approaches a work of art with some previous information about it, and about the circumstances under which it was created and is now shown. If not, one may acquire this during or soon after the process of listening, looking, or reading: e.g., by noticing the label under a picture or the name and date of an author or composer. This acts as a context to narrow down the possible range of interpretations of the work and of details within it. One places it in a certain cultural setting, both original and present: e.g., by realizing that a poem is a modern adaptation of a Greek legend.

A contemporary poem often includes references to several fields. One by James Joyce, T. S. Eliot, or Ezra Pound may contain a wide range of allusions, to Oriental religion, early Christian art, the Italian Renaissance, American city life, etc., all within the same poem. Its cultural setting is cosmopolitan; images from diverse cultural origins appear in the same work of art. One cannot, in such a case, classify the whole work as necessarily referring to a single cultural field or context: a certain image is to be understood against a background of legendary Greek history; one in the next line, perhaps, refers to the Florentine Renaissance. In regard to each image, one may have to ask what its cultural background, and hence specific meaning, are supposed to be. Other recent works are more homogeneous in their imagery; all details fit into the same imaginary world. One has no difficulty in placing Tennyson's *Choric Song from the Lotos-Eaters* in a setting of Homeric legend. From the title to the end, it deals with this branch of the lotus symbolism: "Falling asleep in a half-dream . . . Eating the Lotos day by day . . ." Where the work is studded, on the other hand, with images from widely scattered sources, it places a greater burden upon their context, and upon the reader's erudition, to interpret each correctly.

A mistake in the primary identification tends to start the observer on a wild-goose chase along irrelevant trains of thought. This can occur through misunderstanding linguistic symbols: e.g., through taking the word "lotus" in a Homeric context as referring to the water flower Nelumbo, and wondering how the ancients found it edible. A mimetic symbol, crudely or vaguely drawn, may be misread: a solar disk for a wheel or chrysanthemum. Physicians sometimes interpret contemporary nonrealistic painting and sculpture in their own terms: the "distorted" figure is taken as a case of goiter or elephantiasis. From there the interpretation proceeds in pathological terms, to show a morbid quality in modern art. A correct apperception of the mimetic symbol would include relating it to its cultural setting: in this case, to the interest of contemporary painters and their public in altering natural proportions so as to achieve some visual design or expressive scheme. In this context the main intended meaning of a particular curve may be, not "diseased, swollen," but "fitting into a curvilinear pattern."

Two kinds of clue are sought: *internal* and *external* to the work of art. When the observer strikes an ambiguous or obscure image, he may search in the immediate formal context, and if necessary elsewhere in the total form, for some key image or reference to indicate the field of reference, and hence the implied basic and supplementary meanings. Also, he may search externally in the title, preface, footnotes, or accompanying program notes for clues which, though not strictly part of the work of art, are provided along with it. Finally, he may study independent treatises, histories, and critical books about the cultural context, which may throw light on the meaning of the work in question.

17. The sequence of steps in individual apperception; primary and secondary suggestions from an image.

In the mind of an observer, how does a presented image set off a train of associations? It acts, through the sense organs, upon one set of preestablished but flexible bonds in the observer's brain and nervous system. It activates the set (complex in itself, though a small part of the whole) required to apperceive that

kind of image. If the observer so desires, he can at any moment arrest the train of thought thus started, or deflect it into some channel determined by his momentary interests. But if his attitude is aesthetic he will be relatively compliant, allowing the image and its context to guide his thoughts for a while. Not being forcibly deflected by any strong conative impulse, but rather impelled by interest in the image and its meaning, his apperceptive process will tend to spread out along paths of association which previous conditioning has made into good conductors for that kind of thought sequence. Such conditioning can result from previous intense, emotional experience, or from repetition, learning, and habit, as in educational discipline.

Sustained contemplation of one particular image, instead of passing on to others, tends to produce in the observer's mind a series of associations including inference, fantasy, and other types of psychic process. This series is not like ripples in a pond or sound waves in a room, for it tends to go along one line at a time rather than in widening circles. We must not think of it as a series of simple, unitary ideas, like beads on a string; it is a series of complex configurations, shifting and melting into one another, as the spotlight of conscious attention picks out and activates previously dormant memories and new percepts, combining them into ever-new, ever-changing forms. The area of association thus illuminated by conscious attention is only a small part of it; below are further reverberations on the unconscious level. In the case of aesthetic apperception, strongly focused on a present sensory stimulus, we must also think of the associations as largely projected on the stimulus, and felt as meanings of it.

If one were to diagram the path of conscious association in response to such a stimulus, it could seldom be shown as straight or continuous. It tends to dart rapidly from one direction, one basis or type of association, to another. A certain line of association or interpretation will be started, then abruptly arrested as futile. One then returns to the perceptible guide or starts on another associative path. The process may become fairly continuous and methodical in logical reasoning and classified lists, while the other extreme is found in pathological states where it skips about erratically. The order of steps is always somewhat variable, depending on the personality, education, and present attitude of the observer.

When an image has taken on many associations through long and varied social usage, it can arouse in the mind of an educated observer an endless train of cultural suggestions, group after group, as long as he wishes to dwell upon it with interest and an open, compliant attitude. Such a train of associated ideas will never, in itself, present a definite stopping place; it can always be prolonged a step farther. In practice, it is stopped by one's general sense of fitness and proportion in mental activity; by habits of self-control in pursuit of a goal. Having thought for a while about a particular detail, one becomes impatient to go on to the next, even though the former's possibilities have not been exhausted; one may return to it later, perhaps. But everyone has had the experience of coming upon an image, in a story or painting, so striking and suggestive that he is tempted to look away, or lay down the book and meditate a while on what it calls to mind.

The meanings of a work of art are usually too varied and far-reaching to be apprehended clearly all at once; one must travel gradually from one cluster of images or ideas to another. Perceiving another detail, one starts upon a different, though related, path of association. Occasionally, one has the feeling of a sudden flash of insight, as the total impact of many details in their mutual relationship becomes evident.

In a limited sense, the process of apperception is wavelike. The image arouses a first wave of response as soon as sensory activity begins. One's first glance at a presented image may be enough to permit recognition of it as the English word "lotus," made of certain letters; or as a picture of that flower. The word may at once suggest a visual image of the flower; conversely, recognition of the flower may call its name to mind. If the presented word is in an unknown language, or the pictured flower is unknown, one recognizes that fact; it is one way of interpreting the image. The shape of an unfamiliar visual sign may quickly arouse other first associations: e.g., a Chinese character may suggest bird tracks. This is the first stage in apperception. It can be quickly followed and corrected by the second stage if attention remains fixed. The percept may either be clarified or further complicated by additional sensory or associative details. Continued interpretive perception may follow the line begun by the first wave, or may change if that is found to have been mistaken.

When the symbol and context are familiar, the apprehension of primary and secondary suggestions can become almost instantaneous; one sees the cross at once as a symbol of Christianity. After thus quickly apprehending one or two sets of meanings, the mind may travel on to remoter associations or may turn back to contemplate another detail in the total form. One's first grasp of the meaning of a word or phrase is often vague and tentative, some-

times mistaken. Later words make one clarify in memory the previous ones; perhaps correct and amplify them. "Oh," one thinks, "that's what he meant back there!" If reading in haste, one tends to grasp only the first wave of suggestions from each word group as one goes along, or perhaps a few of the second. The next word group swiftly cuts across the train of associations from the previous ones. If less hurried, one goes back now and then for a fuller grasp of previous words.

18. Relative cultural strength among suggestions. Socially established meanings.

Indirectly, one's order of steps in apperceiving an image depends in part on the *relative strength or fixity* with which certain suggestions have become attached to the image through cultural usage. In any particular case, this can operate only through the individual's previous education and acquired habits of following such usage. In general, it is an objective phenomenon which helps to determine the apperception of all individuals in the culture area. When an image has many associations, some are always more firmly attached than others, more widely used and more likely to come to mind when the image is presented. These are *socially established meanings*. They have a high degree of cultural fixity with respect to the image, and are cogent in exerting a stronger influence upon the observer, to interpret the image in terms of them.

Considering the image as a social phenomenon, we can regard its various social meanings as divided into groups or levels, as to their relative strength and cogency. They might be diagrammed as radiating from the image in the cultural fabric. Closest to the image, and most firmly attached to it, are (1) its strong suggestions or *basic, social meanings and correlatives*, primary and secondary. One stage removed, and less cogent, are (2) the *moderately strong suggestions or supplementary meanings and correlatives*. Farthest, and ramifying out indefinitely, are (3) the *weak suggestions,* including some rare or highly specialized social meanings, and many ideas so tenuously associated as not to be meanings at all.

Other things being equal, one might expect *a priori* that the culturally strongest suggestions would come to mind first; the others, in order of strength. This often occurs, but not necessarily. In any given case some usually weak, remote association may acquire sudden strength, perhaps from unconscious causes,

and burst "without rhyme or reason" into the focus of attention. As shown by the Rorschach inkblot test, some persons are predisposed to bizarre, unusual associations. This may indicate an original mind, a neurotic one, or some peculiar emotional attitude.

After defining the basic meaning of a word, unabridged dictionaries and encyclopedias often go on to give an extended account, several lines or paragraphs long, of supplementary information required for thorough understanding. In the visual arts this function is performed by reference works in iconography. Still farther from the central image is an infinite succession of more remote, occasional, unusual associations. Without the aid of special context or predisposition, they are not likely to come to mind. Hence, for the artist, they are precarious and unreliable means of communicating. Among such remote associations are minor events and characters of history or fiction, or obscure literary references to the image in question. What Heine said of the lotus flower, or the details of Tennyson's poem on the Lotus-Eaters, are not quite minor or obscure, but are hardly common knowledge in our culture. An encyclopedia might cite such an association as an interesting sidelight on how the term had been used.

This tertiary aura of associations about any important symbol is on the borderline of objective aesthetic form and will hardly call for inclusion in a morphological summary. Yet its existence in general is a potent factor in the power of literature and other highly suggestive arts. The reader of a poem, if educated and sensitive to relations between ideas, is vaguely aware of the auras of meaning, both close and indirect, which are called up by each word and sentence. Literature which thus opens up a series of far-reaching corridors of thought, branching out from each major image, is called subtle, allusive, evocative. An observer who is experienced in a certain kind of art, whose mental background is rich in detailed memories of art and life, will keep encountering reminders of them in a new work of art, which other persons would miss. These include nuances of wording, unfamiliar literary and historical allusions, and expressive subtleties of style in painting and music.

Because of their commonness and obviousness, close cultural meanings often come to seem in art as banal, platitudinous, stereotyped clichés. The reader who grasps only the literal or dictionary meanings, and the artist who expresses and suggests only these, come to be regarded as lacking in subtlety and originality. Sophisticated taste wearies of the strongly fixed and overly familiar, seeking out instead the more unusual and surprising, the suggestion which involves

a leap into new territory, along untrodden paths of association. But the same kind of taste often welcomes an occasional return to the familiar.

Aestheticians whose training and viewpoint are logical or epistemological often exaggerate the logical aspects of aesthetic apperception and minimize its nonrational, affective ones. If one's habits of thinking and of interpreting signs are, as in childhood, not rigorously logical, one can more easily grasp the images of art in more primitive, sensuous, and emotional ways. Strictly logical methods would involve interpreting each symbol primarily in terms of its basic, accepted meaning as in a dictionary definition. On seeing a word, one would think first of its recognized, accepted connotation and denotation in the present context; then (and only then) go on to think of the word's more remote or occasional associations. But in ordinary aesthetic apperception some of these less logical associations tend to loom up powerfully, and dispute the priorities of ordinary thought. The nonlogical associations through mimesis and contiguity, such as puns irrelevant to the ideas concerned, are deeply rooted in childish and primitive mentality. They influence both conscious and unconscious thinking. This power appears in dreams, when recently-acquired, logical and precautionary habits of thinking are suspended and images succeed one another in fantasy through chains of association that are hard for the logical, waking mind to understand. To bring them into conscious recognition, one must often ferret out sensuous associations which seem on waking to be absurd, far-fetched, and adventitious.

Since art is only partially rational and logical, and contains a strong admixture of primitive fantasy, it often relies to a large extent upon these illogical, sensuous, and affective bonds of association. In asking which suggestions of an image are socially established, one cannot dismiss then as erratic or ridiculous; some are socially established in their own way, in and through art, quite as firmly as logical connotations are attached in rational discourse. Bonds which link them to the image and to each other may long antedate the logical bonds which link symbols and meaning in a concept, and may rest on stronger psychological connections. Strictly logical methods of interpretation often lead one into pedantically literal, factual, cut-and-dried explanations; they miss what artists and critics hail as the true, essential significance of the work. They may be clearly irrelevant in a particular case, when the context indicates that fairy-tale magic, weird fantasy, or whimsical nonsense is the governing principle, as in Lewis Carroll's "Jabber-

wocky." They are often irrelevant in Abstract Expressionist art. The context must be relied on to help select, not only specific meanings, but the whole basis and method of choosing meanings.

19. Apperception as tentative and gradual; static and temporal forms.

It was mentioned above that apperception of an unfamiliar work can never be complete in a flash. It is always a serial process, more gradual or piecemeal as the work is more complex and difficult. One may need to go over the work again and again, examining it in a different way each time. This is true, at least, if one's goal is thorough, accurate perception and understanding. To be sure, that is not the only way of responding to art. A glance may convince one that the work is not worth careful study. Also, it is possible to use a great work of art, not for sustained aesthetic stimulation, but as a springboard for independent thoughts and actions. In that case a quick, superficial glance may be enough, and one is off on original, unguided trains of thought. Many a poet has been thus inspired by a hasty, superficial look at a painting, seeing only what he chose to see there; many a composer has been inspired by some poetic line which took his fancy and has felt no need to read the rest. Such a response is only the most fragmentary beginning of apperception. A capable artist or critic will, at times, be satisfied with a hasty glance, while at other times he may stop for hours before a single work.

Some persons approach an unfamiliar work of art with rigid, preconceived ideas about it. Having heard something about the work or the artist, they have already made up their minds about it, often on the basis of secondhand information rather than direct experience of anything similar. On meeting the new work they do not trouble to examine it carefully or open-mindedly, but notice a few conspicuous features, then quickly classify and judge it. An experimental, tentative response, on the other hand, is plastic and flexible, widely exploring, going over and over the form from different points of view, to be sure of noticing whatever subtleties it contains, observing each detail in relation to various contexts and as fitting into various groups and sequences. Forming the habit of experimental observation, one learns to adjust one's apperceptive habits to new kinds of sensory effect, new meanings and arrangements. The world is flooded with unfamiliar kinds of art in every

medium from every past age and exotic culture; our own styles change so rapidly in divergent, unpredictable directions, that no fixed, uniform approach to them is adequate. It is well to develop techniques of experimental observation in each medium, to learn how to explore a strange but promising work of art, somewhat as if it were an unknown plant, animal, or machine.

Each chapter in this book describes a different phase in this exploratory process, a different kind of thing to look for. As we take them up, one by one, let us fit them into the general concept of a gradual development in powers of apperception, from the vague to the definite, from the blurred or fragmentary to the complex and organic. This is the normal sequence in learning to apperceive a work of art which is itself complex and organic. But it is not limited to such art. Even when the work is vague, naïve, disorganized or loosely organized, one can learn to see or hear it clearly and thoroughly for what it is, and to describe it systematically.

There is a difference between selective attention to the way things fit together and the impossible task of paying attention to everything at once. Attention is always a focusing of conscious awareness. In perceiving a complex form, it is impossible to be sharply aware of all details and interrelations in the same moment. *Highly developed, organic apperception* involves keeping all the most important details and interrelations in the back of one's mind—not too far back, since, recently noticed, they are fresh in the memory—while one's attention travels here and there. Attention to the whole means attention to the general, organizing features, and necessitates a temporary partial ignoring of many other features in the work. People differ in the ability to hold many things close to the focus of attention at once, to focus sharply on some, yet not entirely to forget the others.

The process of selective observation necessarily differs somewhat according to the type of art form concerned. In *static visual* art it is comparatively easy to look back and forth between the whole and the parts when the form is all displayed on one surface, as in the ordinary painting or sculptural relief. One can *see* all or nearly all of it at once, but one cannot clearly apperceive all the details in a complex picture at once—even a small one, as in a postage stamp. From a little distance, or with half-closed eyes, or with attention spread over the main outlines, one gets a general sense of the whole. With little change in position, a moment later, one can focus attention on a small detail, or trace a certain abstract factor such as linear pattern here and there. Looking at the same

detail, one can pay attention now to its shape, then to its color. It is comparatively easy to see how each detail fits into a small, immediate context, and this into a larger one. There is little strain on memory or imagination, since the whole form is spread out there before one. The problem is to change one's mode of seeing it from blurred, fragmentary perception, as a young child might see it, to complex, organic apperception, with sensitive grasp of all the major presented and suggested details and interrelations.

Sculpture in the round cannot be seen all at once, from one point of view, and still less so architecture. These are *multiple-aspect* forms. To see a statue thoroughly one must move around it; to see a cathedral one must move around and through it, tracing a devious path through aisles and balconies, and perhaps even upon the roof. To form a conception of the whole, even with the aid of many photographs, one must fit together all these aspects into some sort of organized, composite memory image; not a purely visual one, but one rationally explained and interpreted. A conception of so vast and intricate a form as the cathedral of Chartres can grow through years of observation and research. The formal contexts into which one must fit each symbolic detail are many and varied: the façade, the interior, the great portals, rows of saints and kings, rows of stained glass windows, gargoyles on the towers, and carved scenes from medieval life.

One's first conception of such a complex whole in art is necessarily vague and hypothetical, subject to revision later. Going back and forth between the whole and its parts or qualities in art is in some ways analogous to the deductive and inductive movements in logical thinking. In both, one advances with a general but tentative hypothesis to confront particular details; to fit them into it if possible, but if they refuse to be fitted in, one has to change the hypothesis. Meanwhile, and until one is ready to terminate the inquiry, one's apperception of the whole and of each vaguely, partly understood detail is *suspensive* or *provisional*. On first view, and perhaps on second and third, a certain part or quality seems to have a certain meaning, a certain raison d'être and role in the total form; but one has not yet fully studied out its relation to its context, immediate and general. One suspends judgment on it for the present, passing on to other parts and qualities, hoping to return with a clearer notion of the context; hence of its own significance therein. The process, however, may be much less intellectual and logical than it sounds when so described. What one has to do, in the case of music or abstract visual design, is primarily sensory; it is to

perceive as clearly as possible a complex auditory or visual arrangement and the role of each note, line or color therein.

In the fully *temporal* arts, with forms presented step by step in definite sequence, there is more need for developed powers of memory and anticipation. At any given moment, only a small part of the form—perhaps infinitesimal, as in rapid music—is there. The form speeds by us, and is gone, like a landscape seen from a train which never stops. To form a conception of the whole is to remember, while it goes, what went before; to imagine and expect what is to come, while remaining open to surprises.

In music, the phonograph is of great help in achieving thorough, complex apperception. One hearing of a symphony in actual concert, or a few at rare intervals, can never suffice. A painting or cathedral can be inspected at will: the whole and any part, as long and as minutely as desired. For the same effect in music, one must hear the form over and over again, and be able to stop the record at any moment, to repeat a certain passage. Music usually comes to us at a predetermined speed; we cannot slow it down at will, as in reading a book or strolling through a garden, for leisurely contemplation. To change its tempo much is to change its essence; though it may not be spoiled, it at least becomes a different work of art. But listeners differ greatly as to their speed of apperceiving music. Some can hear fast, unfamiliar, complex music and take in a good deal of it the first time; others never grasp more than the rudiments of musical form. For the latter, music is merely a hazy, floating texture of sound, more or less agreeable, gay, brisk, or sad, arousing sentimental thoughts, pouring in upon the ears without any definite structure. They cannot remember exactly what tunes they have heard before, or look ahead to what is coming next. They hear only the present moment, and that not very clearly. Others grasp short melodic units, and notice their recurrence. Only trained, expert listeners can discern the form of larger units in the first hearing, and follow the varied reappearance of several different themes. They can apperceive in large blocks, comparable to paragraphs and chapters in literature, and hear how these blocks gradually build a piece of musical architecture.

Printed texts in literature and musical scores, for those who can read them, facilitate apperception through allowing one to look quickly over the whole form, and to stop for careful study at any point. If one had to rely on the long unfoldment of a novel, play, or symphony in sound and gesture, with no means of stopping it in process, the task of analyzing it would be almost insuperable. Through visual,

linguistic symbolism, we transform these auditory arts almost into visual ones. We examine the score of a symphony almost as we would look at a Persian rug design, visualizing the form almost all at once, as if frozen into black dots and lines on paper. True, we cannot imagine all the sounds at once, but we can grasp their architectural framework, the main parts and interrelations. If a phrase or harmony sounds obscure, we can analyze it visually at leisure, and as through a microscope. A short poem can be actually seen all at once on a page. Its visible diagram of indented lines and stanzas, its lines of similar length or unequal as in free verse, can disclose at once a pattern of sounds which is slow to reveal itself in speech.

There is a danger here, however, in mistaking the visible symbols for the auditory form itself. When the sound pattern is important, there is no substitute for actually hearing it. Next best is to read slowly to oneself, imagining the sound as clearly as possible in every word or chord. One must resist the common tendency (acquired in daily reading of prose) to skip rapidly over most of the word-sounds and read large blocks of words at once, whole sentences and paragraphs at a time.

Only the general outlines of musical or poetic form, the bare skeleton, can be seen all at once in a printed text. The substance is essentially temporal and must be grasped in sequence, from the first step to the last. Whether by eye or ear, it must be apperceived in a gradual, tentative way. In an unfamiliar poem, each group of words suggests a set of meanings, perhaps vaguely at first, for one does not yet know their full context. Once a fairly complete unit of thought has been stated, the meaning of each phrase in it becomes more clear in memory than it was at first, even though the precise wording is forgotten. It would be too great a burden on memory and thought to hold our apperceptive process always in extreme suspense, always equally tentative. So the author feeds us, as a rule, ideas in partly separate groups—sentences, paragraphs, stanzas, chapters, acts—after each of which we can pause for mental breath.

20. *Reading a poem. The gradual apperception of meanings.*

A poem involves a set of presented images which are to be seen or heard in definite temporal sequence. In reading a European language, we begin at the upper

left and read along, word after word, line after line. Near and Far Eastern languages are read in different spatial and temporal orders. Each language has peculiarities of grammar and syntax which affect the reading order. In most languages, prose and poetry differ somewhat in word order, hence in order of apperception. The pattern of word-sounds may produce a different sequence from that of ideas. In this section we shall consider mainly the latter.

One of the functions of verse form—of printing poetic literature in separate lines, beginning with capitals and sometimes indented—is to show the reader at a glance that a special kind of reading and perhaps of thinking and feeling is appropriate here. Such traits of appearance are a part of the immediate formal context of each word and image. Rhyme and meter support this influence, in addition to their other functions. They invite careful attention to word-sounds, which are commonly blurred over in the fast, silent reading of prose. These factors hint that words are to be grasped, not quickly for their obvious, literal meanings only, but slowly and with some relaxation of strict logical and practical attitudes, to let their diversified suggestive power awaken deep reverberations in the mind.

One does not stop over every word. The rapid reader quickly fuses a group of separate symbols into a composite block of meanings, then moves on to the next. Even a leisurely reader, who stops to imagine along the way, will grasp the text in blocks of words, in phrases and sentences. Each of these in sequence will start a train of associations within his mind. But he is reading at a certain tempo, and will not stop long at any point. He will break off the train of thought before it has gone very far and pass on to the next image. A single touch on the piano key starts sound waves, which might reverberate a long time if we let them. But if we strike another string and let the damper fall upon the first, then the first series of waves is abruptly stopped. Each group of words, in starting a new train of thought, tends partly to arrest previously started trains. But not entirely, for their memory remains and accumulates to build up a composite meaning. This in turn acts as context and background to each new succeeding train of thought, directing it and assimilating it into an even larger form.

Images and ideas may be conveyed from the start in such a way that each is clear by itself, so that each can be clearly apperceived as read and succeeding ones fitted immediately into the cumulative group of meanings. But important key words are often postponed until well along in the passage. This is es-pecially true of verbs in Latin and German. There the reader tends to apperceive the earlier ones only partially, to hold them in suspense within his memory, vague or ambiguous as they may be, until he comes upon the clue which directs him how to narrow them down to relevant meanings and fit them together into a coherent whole. In some literature which aims to trick and surprise, he may be led to interpret and combine the earlier words in a certain way, yet find later on that all must be reinterpreted in the light of a different clue just provided.

When the representational meaning of a picture is obscure, as in Kandinsky's early, partial abstractions, a single detail may act as a key or catalytic for the whole. In his *Improvisation, 1913*, a cannon in a lower corner leads one to interpret vaguer shapes as an explosion.

In miniature, a very small poem is enough to show some of the tentative steps required in apperception. Landor's quatrain "Dirce" provides an example:[11]

> Stand close around, ye Stygian set,
> With Dirce in one boat convey'd,
> Or Charon, seeing, may forget
> That he is old and she a shade.

The title, "Dirce," suggests a Greek lengendary context; the original Dirce was a cruel Theban woman who came to a violent end. The first small word group, "Stand close around," arouses a vague, tentative image of a group of persons—we know not who or where they are—huddling about someone or something, as commanded. The next, "ye Stygian set," confirms the Greek legendary background and locates it specifically at the River Styx; the "set" being some group of undefined personages there—presumably spirits of the dead, or those who attend them. "With Dirce in one boat convey'd" clarifies the picture a little and gives it concrete form; those addressed are definitely spirits of the dead, being ferried in a boat across the river, and are told to stand around the woman Dirce. Through close cultural association, we think of the boatman Charon in this setting, almost before his name is mentioned. The last two lines explain the command as a precaution against possible amorous advances by the old man. In this context the word "shade," which usually has a different meaning, is quickly interpreted as "ghost." An obvious implica-

[11] It is included as a complete poem in Walter Savage Landor's *Pericles and Aspasia* (Boston, 1888), p. 272. Aspasia sends it to her friend Cleone with this brief comment: "Here are two pieces of verse for you. That on Dirce was sent me by Pericles; to prove that his Athenians can sport with Charon even now" [i.e., right after the plague].

tion is that Dirce must be very beautiful, to exert such allure under most unfavorable conditions.

All this is the literal, obvious, superficial meaning of the poem. Each word group requires a primary step, interpreting the printed or spoken linguistic symbols into English words; a secondary step, grasping their literal, general meanings, but in a suspensive, partial way until we know their exact context. A third step is the gradual fitting together of these meanings into a represented scene, dramatic situation, and incident—the command by an unknown speaker. We may leave it at that if we are literal-minded and content with a little imaginary vignette for its own sake. Or we may probe more deeply, embarking on a fourth step in apperception and asking what the poet's intention or deeper meaning may have been. Why did he issue this imaginary command and caution? It seems quite inconsistent with the legendary character of Dirce.

Here it is relevant to ask about the provenance of the poem itself, as a nineteenth-century English product. Classical and other fanciful names had long been used in lyrical addresses to contemporary ladies, especially in paying them high-flown compliments. This seems possible in the present case. It suggests that the one here called "Dirce" has recently died and that this is a brief elegy in her honor. Whether she is the original Dirce or another woman whom the poet wishes to liken to her, we cannot decide without some outside evidence. Nothing is said here about her being cruel or meeting a violent death. The imaginary situation and command form a partly cryptic metaphor, whose unstated but not too deeply hidden meaning is the poet's tribute to her beauty. An interpretation of *Dirce* can be inferred from the presented words in relation to established cultural contexts and traditions, to the common ways of interpreting such symbols.

Such an interpretation should remain tentative until one has consulted various critical comments, to see whether it is the accepted one in this particular case. Differences of opinion should be recognized, but each qualified reader is entitled to his own interpretation. Even an artist's explicit statement as to what he intended in a work is not necessarily final. He may have been partly unaware of his real meaning or have wished to conceal it.

21. *The transmissional schema of a particular form.*

In the following chapters we shall see many possibilities for selective observation: many factors in form

which deserve intensive study. Here we have been considering the modes of transmission in a general way, and it remains to add that any particular work of art can be observed and described from this point of view. Part of a comprehensive morphological analysis consists in describing exactly how, in this example, some or all of the modes of transmission operate.

A total work of art usually contains several constituent modes of arrangement, all more or less interconnected but forming somewhat distinct systems within the whole. Thus we might describe an animal as to its circulatory system and also as to its digestive and other systems. To designate such a constituent arrangement within a total aesthetic form, we shall use the word *schema*. It refers to the structure or mode of arrangement of a factor within the total work of art. A *trait* is any quality, characteristic, or relation in a work of art. In describing the transmissional *schema* of a particular work, we describe its whole form in that respect. To do so, we must mention several specific *traits*: for example, various detailed arrangements of presented qualities, of symbolic suggestions, etc., all of which in combination make up the transmissional schema.

As to the whole work of art, one may ask:

1. What is directly presented to the senses, and how? To which sense or senses? In other words, what is the *presentative factor* in this particular form?

2. What suggestions are conveyed as definite parts of the form? How? What is the *suggestive schema* of this form?

3. How are these two schemas *interrelated*? How and to what extent do the presented factors and their arrangements cooperate with the suggested?

On the basis of the discussion so far, it would not be possible to give specific answers to these questions. We have not yet considered the "what" of aesthetic form, the materials which are transmitted in and by it.

Description of a transmissional schema would involve some attention to the *comparative importance of presented and suggested factors* within the total form. This does not mean their relative value or beauty, but merely the extent to which each is utilized or emphasized as a mechanism for conveying experience. Obviously, some types of form, such as the novel, rely very little on any particular mode of sensory presentation. As long as the suggestions are conveyed, it does not much matter through what presented images they are conveyed: whether by one kind of type or another, by printed or by spoken words. Other kinds of art, such as textile designs, obviously place more emphasis on presentation, and

less on suggestion. In between are a host of other types and individual examples, such as pictorial representation, which frequently involves a more even balance between the two sets of factors.

We may now consider how presentation operates. Under what sort of conditions is the object to be seen or heard? Are there certain conditions of lighting, distance, and angle of viewpoint, from which the object is to be seen? There is a difference, for example, in mode of visual presentation between a sculptural relief, high in an architectural façade, and a garment to be worn upon the person.

There may be general conditions also under which *suggestion* is to operate. What type of education, information, or training in the interpretation of symbols is required to grasp the suggestions in this form? What is the cultural setting within which the suggestive images operate? What examples occur of the various kinds of suggestion noted above (especially mimesis, analogy, symbolism, and common correlation)? Which is most frequently and emphatically used? To what extent are definite secondary suggestions conveyed by the form as a whole, and by important details?

Any concrete part or detail can be analyzed as to its presented and suggested traits. Any small area of a picture will present one or more linear shapes, textures, values of light and dark, perhaps hues. In addition it may suggest, by mimesis or otherwise, other images or ideas. A small detail will not present complex visual design, and may suggest no specific meaning apart from context.

A preliminary survey of modes of transmission in a particular form should involve some attention to the details of *cooperation* between presented and suggested factors. For example, take any spot of color in a representational painting. It will have a purely presentative function, as a red spot. It will have a mimetic function as representing, for instance, a red textile, or possibly a heraldic symbol. Any such detail in a work of art can have a *double or multiple function*, as direct presentation and as stimulus to various kinds of suggestion. In looking at any given detail, one may then ask what are its various functions.

22. Summary of traits and types of form as to mode of transmission. Styles and trends in style.

The foregoing chapter provides one set of terms and concepts for describing, comparing, and classifying works of art and styles of art.

They can be distinguished, in the first place, according to whether the presentative or suggestive factor is most highly developed, most emphatic or conspicuous, as *dominantly presentative* forms, *dominantly suggestive*, or *intermediate* in this respect. Music is usually the first, literature (especially prose) the second.

It is hard to class a whole art under these or any other headings. Due allowance must be made for wide variations in style, both period styles and those of individual artists. But this is one way to characterize a style. One trend in the Romantic movement of early nineteenth-century Europe was toward more emphasis on suggestion in music, through mimesis and analogy, so as to convey specific emotions, visual images, and sometimes stories. One trend in recent painting and sculpture has been toward less emphasis on suggestion, and more on the presented factor, less on moral and literary factors, subject matter, and story-telling, and more on visual form and abstract expression. Literature is variable as to its emphasis on presented (word-sound) factors; poetry is highest in this regard, but always develops meanings as well as sounds.

The specific mode of *presentation* gives several categories for describing works of art. Again, we must be careful about placing a whole art under one category. As to *how many senses* are directly addressed, we can distinguish forms as *unisensory* (addressed wholly or mainly to one sense), *bisensory*, and *multisensory*. Music belongs to the first type; opera, ballet, and sound film, to the second; religious rituals with costumes, music, and incense, to the third.

As to the *particular sense* primarily addressed, some unisensory forms are *visual* (addressed wholly or mainly to the eyes); this includes most painting, sculpture, architecture, and decorative arts. Some are *auditory*, including music and the arts of speech (considered apart from writing). Some are *variable* in this respect, especially literature, which has become increasingly an art of visual presentation, especially in prose fiction and essays; drama is more characteristically auditory. When read silently, its word-sounds are suggested. Literature can be bisensory, presented to both eyes and ears at once, as when the printed text of a poem is flashed upon a motion picture screen while a voice is heard reading it aloud. Reading is thus taught to beginners, to help them associate both sets of symbols. One can follow a play or concert with printed text in hand. Opera, ballet, and sound film are *audiovisual*.

Some unisensory forms appeal to one of the lower senses. Perfume presents *olfactory* forms or qualities; cooking presents *gustatory* ones. *Tactile* presentation is developed in clothing, furniture, and the amatory

arts of classical, Oriental, and Renaissance culture. Attention to the appearance and odor of food makes cuisine a multisensory art.

Arts classed primarily as visual or auditory often appeal also to one of the lower senses. A form which does so in a definite, controlled way is bisensory or multisensory. The tactile qualities of clothing (e.g., as smooth or scratchy, soft or stiff) may be more important to the wearer than its appearance. Its odor, if any, is also important. But aesthetics and art history usually consider only the higher sensory aspects. The feeling of a sword handle, cup handle, or chair arm is tactile presentation; the weight and balance of the sword arouse direct kinesthetic sensations; so do the firmness and balance of a chair when sat upon.

In analyzing the functional and utilitarian aspects of form, we often have to consider such qualities. This is an integral part of aesthetic morphology. From this standpoint, a house or a suit of armor is far more than a visual form. Such classifications have to be somewhat flexible and variable according to the point of view and the aims of discussion. The appearance of a bell or musical instrument involves visual presentation, while its sound is auditory. These may be quite distinct, as in decorating a piano, or closely allied as in clockmaking. In this regard the latter is an art of bisensory presentation. In all such intermediate or variable cases, the essential problem is to describe the situation accurately, with due attention to social attitudes and usage as well as to the observable nature of the form, rather than to force it into some arbitrary category.

As to specific mode of *suggestion,* we have noticed many varieties in this chapter. The main distinction here is between forms which emphasize, or develop most highly, either *mimesis, analogy, common correlation,* or *conventional symbolism.* When two or three of these are used, they are forms with *combined* modes of suggestion.

Painting and sculpture usually emphasize mimetic suggestion; so do mimetic dance, pantomime, and dramatic gesture in stage plays or films. In addition, they often use common correlation, through the power of a represented facial expression, gesture, or other image to suggest images closely related to it by contiguity in experience. Painting and sculpture in medieval Europe and the Orient made great use of conventional symbolism, especially religious.

So did music and theater, as in *Everyman* and other plays involving personification and moral allegory. This has diminished in Europe since the Renaissance. There is wide stylistic variation in the visual arts as to emphasis on one or another mode of suggestion. Abstract painting, as in Kandinsky, reduces mimesis to a minimum, only vague resemblances remaining; but it often suggests abstract movements, tensions, blockings, relaxations, and other experiences by analogy and common correlation with the visual images presented. This is done also in abstract films.

It has been done much longer, with infinite variation, in music. As we have seen, music can involve all three modes of suggestion. Since Bach, it has usually omitted conventional symbolism, except in the linguistic symbolism of notation. Occasional cases occur, however. To include a snatch of the *Marseillaise,* as in Tschaikowsky's *1812 Overture,* is symbolic.

Literature is always based on conventional, linguistic symbolism. In addition, it uses other kinds of symbolism in suggested imagery. The images it suggests evoke others by mimesis and common correlation. There is occasional suggestion by mimetic resemblance between words and things signified.

In general, works of art can be compared as to their degree of *transmissional diversity* or *specialization.* There is high diversity in a religious ritual which presents stimuli to various senses and also conveys ideas by linguistic symbolism (spoken words), mimesis (dramatic enactment of the Eucharist, or the death and resurrection of a pagan god), conventional symbolism in ritual acts and gestures, and common correlation between such images and the emotions of ordinary life, such as mourning on Good Friday, joy at Easter. Here all four principal modes of transmission and several varieties of each are used.

Extreme specialization occurs when suggestion of all sorts is reduced to a minimum, and presentation is to one sense only, as in inconspicuous, purely decorative wallpaper. Even so, there is always some suggestive factor through the abstract properties of color and linear shape.

Note: The following illustrations are particularly relevant to this chapter: Figures 1, 3, 4, 10, 29, 32, 33, 34, 43, 49, 52, 54, 58, 68, 70, 71, 91.

PART TWO

The Psychological Components of Art

CHAPTER III

Components,
Traits, and
Types

1. Modes and contents of artistic transmission

The previous chapter, on *modes of transmission*, told of *how* art operates to transmit experience. The present one tells of *what* it transmits, what kinds of experience: in other words, the ingredients, contents, or psychological materials of art. Incidentally, in discussing the modes of transmission, we noticed some examples of content, as in the images of pain and grief suggested by a painting of the Crucifixion. We also saw that art can stimulate some kinds of experience directly, through serving as an object-stimulus of sense perception. Other kinds it can give only through arousing memories or fantasies in the observer's mind. Both kinds can be regarded as parts of the total content of the work of art.

The present chapter undertakes a survey of the ingredients of art from a psychological standpoint. For the description of works and styles of art, we need an adequate set of concepts to designate the various kinds of psychological material, as distinguished (a) from physical materials such as bricks or paint and (b) from the ways in which they are organized in the arts.

Ingredients and modes of transmission are partly dependent on each other. If the presentation is visual, it usually follows that there are visual ingredients in the work of art—e.g., the lines and colors in a painting. If it is auditory as in music, the sounds are presented ingredients in the form. When literature is spoken aloud, its word-sounds are likewise presented ingredients. When it is read silently they are suggested ingredients. In both cases they are usually regarded as integral parts of the literary form, especially in poetry, where they are more emphasized. Calligraphic writing and semipictorial arrangements of printed words on a page are not pure literature but mixed,

literary-visual works of art. Literary critics pay little attention to how literature is actually presented; they simply assume that the word-sounds of a poem are integral parts of it, and will remain so regardless of any change in the mode of presentation. The sound of the word "forlorn" can be so vividly imagined by a practiced reader of English verse that it is substantially the same ingredient whether imagined or actually heard.

There are other types of art whose mode of presentation is variable, and here again we must depend on social usage in deciding what to include as ingredients of the form. A drinking cup, a sword, a silk veil, can be regarded as purely visual forms in a museum case, or can be used, handled, felt, and thus be presented tactually. If one's interests in art are strictly visual, one will tend to minimize or ignore the objects' tactile qualities. But if one is interested in a fuller understanding of their nature as functional forms, such qualities will deserve attention. Even though the handle of a cup or sword is behind glass and untouchable by the public, one can imagine how it would feel to handle it. The visible smoothness or roughness suggests a tactile smoothness or roughness; the sword's large pommel and the way its grip would fit a man's hand suggest kinesthetic balance and wieldability. When the makers and users of the product commonly regard such qualities as important aesthetically, the student of art is justified in including them as established functional meanings of the form.

Even when the mode of presentation is relatively constant, as in painting and music, it is far from determining the whole content. The suggestive factor is usually capable of a wide range of variation, more or less independently. A picture may involve, beside the visually presented factor, suggested images derived from touch and other senses. When music definitely

suggests certain visual images with or without the aid of verbal titles, we can say that such images are part of the work's *suggestive content.*

In a literary narrative, many suggested images are attributed to imaginary persons in the fantasy which is aroused and guided by the words. "Color vision" is not felt subjectively and self-consciously as a sensory process, but as the particular colors of some imaginary thing: perhaps a green and gold dress worn by the heroine. If she is in a painting, one sees the green and gold and attributes them to an imaginary dress, usually at some place behind the picture plane. If she is in a story, the green and gold as well as the dress are imaginary; they are located in an imaginary scene, quite apart from the pages of the book. The kinds of imaginative experience aroused by art are often felt and described as qualities of imaginary things: the sound of voices in a waking dream propelled by the work of art; the taste of imaginary grapes and the scent of imaginary roses; the blueness of some fictitious mountain lake. In representing humans, the work of art may try to make us imagine, not only their sense qualities but their deeper traits of character, emotion, desire, belief, and thought; their devious actions and the motives for them.

Suggested traits of behavior and personality are among the main ingredients of art. They can be conveyed in an abstract, disembodied way, as in a snatch of plaintive music or a fragmentary line of verse: "Ah, woe, alas!" This is a suggested emotional image, detached and not referred to anyone in particular. In literature and visual art, such traits and feelings are usually attributed to particular persons, real or fictitious; they function in art as traits and experiences of these persons. Craftiness is a trait of Odysseus and hence an ingredient in the *Odyssey* as an aesthetic form. In lyrical poetry and sometimes in "asides" during a play or novel, the author speaks directly and makes his own feelings part of the form. Music, abstract symbols in a painting, and poetic lyrics are often vague as to whose experiences are being expressed. They arrange various emotional suggestions in an independent way, as free-floating images, or as arbitrary patterns very different from the ways in which emotions commonly occur. Thus one can, at will, arrange comic and tragic masks, swords, and dancing nymphs in endless alternation on a frieze, or gay and wistful tunes in a rondo. Such symbols of emotion can operate as ingredients in countless different forms.

In aesthetic morphology, one asks about each work of art what kinds of visual, auditory, or other image it offers directly to our senses and what kinds of image,

meaning, or train of thought it suggests to our imagination and understanding. What are the scenes and events it represents, the beliefs and attitudes it implies? One painting emphasizes dark color, another light; one emphasizes reds, another blues; one flat areas, another solid masses. One portrays nobility and luxury, another grim poverty; a third, ecstatic visions of heaven. One poem tells of childish innocence, another of crime and cruelty. One sculptural relief sets forth the Buddhist world view, another the medieval Christian. Whether made by the individual artist, by his social group, or both, such typical selections from life help determine the distinctive nature of a work of art, an artist, or an age.

A type of form such as the sonnet can be applied to, or embodied in, many different sets of poetic materials. The Shakespearean sonnets differ widely as to the images, concepts, and feelings contained within the essential form. The total form does not remain identical; it includes the specific arrangement of all these factors in each case. Both word-sounds and ideas contribute to the form as well as to the content. A certain type of object, event, or experience, such as peace or war, jealousy or loyalty, can be treated by dramatists and lyric poets in different contexts; it becomes an ingredient in different types of form.

Before discussing these complex factors, let us examine on a simpler level the psychological materials of which they are composed. A set of red dots can be arranged in a circle or a square. The dots can then be regarded as ingredients; the circle or square, as a mode of arrangement. Blue or green dots can also be arranged in a circle or a square. In this way, ingredients and spatial arrangements can be varied to some extent independently. Simple forms can be regarded as ingredients, as in a picture of a Dutch interior with rectangular floor tiles and a rectangular table top with circular plates on the table. Forms and ingredients cannot be completely detached, in details or in the total gestalt. Even in the smallest detail one sees both form and content. A single dot or brushstroke in painting has its own simple form, and so has a single tone in music. Jealousy as an attitude is an ingredient in *Othello.* As developed into complex motivation, it has its own form and it becomes a formative factor in the play.

A psychological ingredient is not exactly the same in different forms or contexts. A spot of red paint looks somewhat differently when surrounded by areas of yellow, green, or blue; it changes a little as one looks at it. The pleasure of a criminal in a successful crime is not the same as the pleasure of a child in rolling a hoop, although they have certain ingre-

dients in common. Psychic ingredients are not like indestructible bricks or atoms, to be shifted about from one form to another without internal change. But they do not change completely with every change of context; if they did, we should be hopelessly bewildered in every new situation. Familiar elements recur, and we respond in similar ways, with enough constancy to let us use the same words and concepts in discussing them.

It is one thing to perceive bitterness or sweetness directly and vividly, or to experience love or hate, ecstasy or terror, in what we call "real life." It is another thing to remember or imagine such experiences in response to a work of art. But it is not a totally different one. The "imaginary" experience is sometimes more vivid than the "real" one, and is in fact a real experience in its own way. There is enough in common between redness as a presented, perceived quality (as in a painting of roses) and redness as a suggested, imagined quality (as in a poem about roses) to let us use the same name for them and treat them as similar ingredients.

2. Contents in relation to form.

To say that a picture "contains" pain and grief is to use a figure of speech. It expresses a common tendency to project one's psychic responses on their outer objects. The picture contains pigments arranged so as to suggest these feelings, and the pigments are interpreted as such. As we have noted, the observer can so apperceive them without actually feeling the same ones in response. If a smiling face in a picture suggests that the imaginary person behind it is happy and likes what is going on around him in the imaginary scene, then happiness and liking are psychological ingredients in the picture as an aesthetic form. The word "pains" is a linguistic symbol of a certain kind of feeling. It appears in the presented form of the printed poem, Keats's "Ode to a Nightingale," in the words, "My heart aches, and a drowsy numbness pains/ My sense" That symbol has the power to suggest a mental image of pain, to one who understands English. To apperceive it does not necessarily cause any actual feeling of pain; whether it does or not is irrelevant in morphology. The concept of pain is a suggested part of the poem.

Form and content are not separate entities. Neither can exist, be perceived or even imagined, apart from some of the other. Even a cloud, a roll of thunder, or a vague mental image has some of both. It can be described in terms of what psychological ingredients are involved and how they are arranged: their size, shape, intensity, duration, emotional content, and so on. Form in art is always the form of something. That something may be called its content, materials, or ingredients, even though it is imaginary. "We are such stuff as dreams are made on." While form and content cannot be separated in existence, they can be distinguished in theory. In a particular case each can be described to some extent in its own terms, as a different aspect of the same complex phenomenon.

The psychic ingredients of art, such as tones and colors, joys and sorrows, never exist in a purely formless state or as pure abstractions, even in so-called abstract art. "Redness" and "loudness" cannot exist alone, but only as qualities of some concrete, phenomenal thing or event such as a flat red area of paint or a loud, high-pitched noise.

The conception of artistic content, stated in the present chapter, includes all the ingredients in literary composition: word-sounds, ideas, and emotions, when regarded as presenting or suggesting various kinds of experience and their objects in the outside world. "Form" includes the ways in which all of them can be arranged in a particular work—ideas and emotions as well as verbal sounds and patterns. In any art, the contents or ingredients are *what* is arranged; the form is *how* they are arranged.

"Content" in this sense is roughly equivalent to "psychological materials." But it is not the same as "subject matter," in the sense in which the term is commonly opposed to form. It is not restricted to the representational content of a work, such as the persons and events depicted in a painting. The psychological materials of the painting include the presented lines and colors, whether used in a purely realistic way or to build a design. The form of a portrait includes all the ways in which the suggested traits of physiognomy and character are arranged. The author of a historical novel may think of his "materials" in a narrow sense, as "raw materials," and as being limited to the records of facts and events which he reads in preparation for the work. But from a morphological standpoint his materials include all the words and meanings he puts into the book, some of which may be original with him. The complex arrangements are not so included.

The term "ingredient" is comparatively free from troublesome ambiguities. We shall use it as roughly equivalent to "psychological materials." "Psychological" refers here to the kinds of material that are studied by psychology. These can also be called "psychic," in the sense of "pertaining to experience."

This does not imply any supernatural, ghostly, or purely spiritual quality.

3. Life experience as the source of psychological materials.

In the physical materials of art there are many intermediate degrees between the completely raw or crude and the completely formed. Those used by the furniture maker are sometimes called "semiprocessed," as in the upholstery fabrics he puts on a chair. The writer inherits his language, including the current, emotional associations of words. A piece of brocade or tapestry can be regarded as a finished work of art by its makers, and as only semiprocessed by the furniture maker and interior designer.

Even when the physical materials, such as stone, are relatively crude, the psychological materials are usually much less so. The sculptor may have in his mind the conception of a human figure or an abstract design. He gradually shapes the stone to conform with it. Such mental images have forms of their own, which he alters in the process of construction. The psychological materials of a work of art may, indeed, be much more complex than the form built out of them. Those of Tolstoy's *War and Peace* were drawn, in part, from records of Napoleon's invasion of Russia and conditions among the Russian aristocracy and peasantry at the time. Colossal as it is, the novel includes a relatively small selection of these. Very often the artist draws materials for his work from previous works of art. Consciously or not, he selects details and modes of organization from previous works in his own or another medium. Thus Diaghileff used certain features of Mallarmé's poem for his ballet *The Afternoon of a Faun,* in addition to Debussy's music.

When a civilized artist thinks he is taking his materials directly from nature, he is approaching nature in ways which he learned to a large extent from previous art, science, and civilization. This is true of the landscape painter, for whom "nature" is exemplified by a wooded valley devoid of people, roads, or houses. He cannot forget previous landscape paintings even though he may try not to imitate them. Nature for the novelist or playwright may be largely human nature. He takes his materials, not only from previous literature, but also from his memories of real persons and places, motives, actions, and conversations. However lacking in artistic form, the words and deeds, appearances and voices of real people have their own

kinds of form. These have been produced in part by organic evolution, which gave to all humans their bodily forms, desires, and basic tendencies; in part by the individual heredity and local cultural influences which determine character. Human life today often seems chaotic in the extreme, but this is not for lack of forms within it. Rather, it is due to an overwhelming profusion of different forms, many in conflict with each other. Some artists like to portray it as such, to emphasize the perpetual struggle for power shown in the characters and acts of individuals. This itself is a kind of form.

The artist seldom if ever has to form the formless or build with elements of the utmost simplicity. He does not create his materials *de novo,* but finds most of them in the cultural traditions he inherits and the things he observes around him. His task is to detach a few materials from their previous contexts and *reform or reorganize* them in ways more congenial to himself and others.

The kinds of psychological material that occur in art, though extremely numerous, are not infinitely so. The same general types of experience recur again and again: the same basic themes of love and hate, joy and sorrow, birth and death; the same sounds of wind and rain, the same trees, sunsets, moon, and stars. Yet they are never quite the same in the lives of different individuals, or in the works of different artists. This is partly a question of form and partly one of materials. Slight shades of difference in either may give a total effect of uniqueness, at least on first acquaintance.

The psychological materials of art are all drawn from human experience, from man's interaction with the outside world and his moments of introverted meditation. They are, potentially, coextensive with all conscious and partly conscious human living. The humanist motto, *nihil humani alienum a me puto*, is increasingly true of the arts. It has not always been practiced, however. At times, art has tried to show only the good, the true, and the beautiful. But the art of modern centuries has shifted to the Faustian ideal of knowing all kinds of experience. It now turns the spotlight especially on the darker sides, those persistently glossed over by classical and romantic tradition.

There are still kinds of human experience which have not yet been treated in art, some kinds of advanced, scientific thinking and (at the other end of the scale) some very primitive and insane types of mental life. But there are none which cannot be used in art if people want to use them. There still remain vast potential areas and types of experience, surpass-

ing present human experience but to some extent imaginable, which have not yet been charted by philosophy, art, or science. Modern Western civilization has excelled the Oriental in developing empirical science and physical technology, but has neglected the mystical approach. Whether the religious assumptions of mysticism are true or false, Zen and Yoga produce types of experience which are highly valued by those who achieve them. Oriental art and medieval Christian art express and stimulate such experience, while modern Western art minimizes it. The content of art at any one time and place always falls short of expressing in full the life around it. As a rule, it expresses most fully the interests and attitudes of adults in the ruling, wealthy class. But again, these limitations are being outgrown.

In one way, art seems to go beyond the boundaries of human experience, to transcend all physical limits and show how animals, plants, gods, angels, devils, and inhabitants of other planets or the distant future think and feel. But this is, of course, only one kind of human imagining, and subject to all its limitations.

4. Physical and psychological materials.

These differ considerably in spite of their intimate connection. The former are commonly regarded as qualities of the latter. Red, for example, is regarded as a quality of certain pigments; middle C in the scale, as a phenomenon resulting from a certain frequency of sound waves. But this ignores the role of sense perception. In a naturalistic psychology, red is regarded as a product of interaction between the physical object or process and the human perceptive mechanism, which is also physical. Radical empiricists, following Hume, point out that we never perceive the external object in itself, only our own experience of it. We cannot assume that the physical material, stone, is the ultimate material of sculpture, or pigment that of painting. What physics and psychology tell us of stone is, in both cases, a record of human experiences derived from a certain type of phenomena. Aesthetic psychology is interested in physical materials and events (e.g., sound and light) from the standpoint of how they affect ordinary vision, hearing, and other modes of normal experience, while physics makes use of elaborate scientific devices to explore the inner nature of stone in terms of molecules, atoms, and electrons. On that basis it predicts what stone will do under various conditions and

modes of treatment. The artist is also interested in stone as a physical material, in regard to its potentialities for shaping into certain kinds of form; also its durability and other properties. But the aesthetic observer, as such, usually knows and cares little about those physical properties of stone which are not readily apparent to the eye and hand, or those properties of light and sound which are not apparent to the eye and ear.

An artist must know something about the technological properties of the physical material he uses as a medium or tool: of marble and chisel, paint on canvas or plaster, the acoustical properties of organ tones, the power of human limbs in dancing. But in morphology we are concerned mainly with effects and appearances. In aesthetic experience, as distinct from artistic production, we do not have to calculate and control the physical properties of the medium; we do not directly experience matter in itself, but only as it affects perception and thinking. This it does in various ways. One is through direct presentation, as in seeing and handling the marble of a statue. We perceive, not the marble in itself or as a physical assemblage of molecules, but something whitish in color, dull or glossy in surface, solid in shape, hard and smooth to the touch. These sensory qualities of marble function as ingredients in the aesthetic form of the statue.

Insofar as it is possible to imitate them exactly, as in a plaster cast with the patina of marble, the aesthetic forms of the plaster and marble statues may become presentatively identical. Most imitations do not reproduce the surface qualities exactly, and slight but aesthetically important differences remain. Sometimes perceptible differences between one material and another develop over a period of time. The plaster may crack or lose its artificial patina. Brass tarnishes and gold does not. All the presentative qualities of an object are not necessarily visible at the first or second inspection. In buying a work of art, one often has to consider its probable durability and economic value. In describing its aesthetic form, we may have to see how it looks four thousand years after it was made.

For convenience, we often describe a thing in terms of physical materials, even though they are not actually present. We may describe a color as "gold" even though we know that substance is not really there. Because it is familiar and easily recognized, we use the name and the concept of the color abstractly, apart from the substance itself. Likewise, we speak of hearing a violin solo over the radio, since violin tones

are reproduced with some fidelity, even if we know that no violin is directly audible. Artificial flavors and perfumes are described as "grape" or "violet" because of their sensory quality, regardless of their actual origin or chemical structure.

While the actual material may make little difference in the presented aspects of the form, ideas about it may affect the suggested aspects. Though gilded brass and solid gold may be indistinguishable to the naked eye, we think and feel very differently about them. Knowing or believing which is which in a given case produces a different train of associations, a different apperceptive process. In one case the object is interpreted as "cheap imitation, soon tarnished"; in the other as "costly, desirable, noble, enduring." One's attitude differs, in apperception as well as in evaluation; part of the meaning or suggestive power of a piece of real jade, ivory, or silk consists in ideas about its physical properties, historical associations, commerical value and prestige.

Other ideas about material can function as suggestions in aesthetic form, for example the strength and elasticity of steel. When a slender rod or cable apparently holds up a heavy weight in a bridge or building, we infer that it is not made of plaster, wood, or cotton, but of steel or some other powerful metal. We apperceive it as something with inner strength; its steeliness, with all that implies physically, is part of its meaning as an aesthetic object. As such, it may give suggestions of safety and security. Conceivably, other materials can be found to achieve these ends.

Often, though not always, the forms of art reveal and suggest indirectly the physical properties of the material out of which they are made. Artists often consciously try to make the form "express the material." Bronze sculpture, being usually more rigid than stone or clay, can rest upon a more slender base, e.g., a single ankle, without other supports. But here again, what affects aesthetic apperception is not the material itself directly, but associated ideas and images, derived from past experience, about the material of which we assume the object to be made. In literature the ink, paper, or (in recitation) the sound waves as such, play no direct, essential part in the form. Here the essential materials are obviously psychological, consisting of the auditory qualities and meanings of the words.

Comprehensive descriptions of art as a total area or branch of culture often include the physical materials and techniques used by the artist. These are important for some lines of study such as anthropology, but less so in morphology. Here we are concerned more with the product than with how it was made; with the appearance of the material rather than its physical constitution. But sometimes the apperceptible form can best be described in terms of material and technique, e.g., by saying that a statue is cast in bronze or drilled, chipped, and polished in marble. In the present age, physical materials are often closely imitated, and perceptible traits once produced by hand are achieved by machinery.

5. The psychological description of artistic ingredients.

Man has long been interested in analyzing his own experience and mental processes. He tries to observe, describe, explain, and evaluate them in many ways. Art throws penetrating light upon itself, as in stories about the lives and creative processes of artists. It also portrays a wide range of other types of behavior and experience, especially in representations of persons and events, but sometimes in theoretical discussions also. Plato's dialogues are works of literary art; they also contain much prescientific psychology. Modern psychology still finds in art valuable data and insights regarding various types of personality and behavior, as in the novels of Balzac, Stendhal, Tolstoy, Dostoyevsky, and Thomas Mann. Social and behavioristic sciences, e.g., economics, political science, anthropology, sociology, and psychiatry, throw light on selected areas of human action and experience.

For help in describing the ingredients of art, we can draw upon the psychological accounts of basic mental functions. What we call "experience" is the conscious, joint activity of some or all of these functions in dealing with the outside world.

These basic functions are comparatively universal among humans, but differentiated in recurrent ways such as those of age, sex, and education. According to the naturalistic world view, all the mental activities of art, including creation and appreciation, are special applications of these basic functions, utilizing physical mechanisms developed by the human species in the course of evolution.

Since all the psychological materials of art are drawn from human experience, a comprehensive survey of the basic ingredients in human experience will cover the basic ingredients in art as well. Both will consist of applications and developments of the basic functions, such as perception, emotion, and reasoning. These seldom if ever operate independently.

They combine in different ways, with different ones most active and dominating. At times, we are engrossed in listening and understanding, at other times, in desiring or reasoning practically, and so on. They are not to be conceived as distinct, unitary faculties of the mind, as in prescientific psychology, rather as varying configurations in the complex activity of one integrated nervous system. Certain constituent processes, such as emotion, are hyperactive at times, with attendant physiological disturbances, and almost inactive at others.

An account of the basic functions in general psychology tries to describe them, in a comparatively universal way, as a set of highly plastic mechanisms which can be directed and developed from birth along many alternative lines. They are applied to very different types of object, situation, and purpose. Art in general is one of these possible areas of development. It overlaps many others, such as religion, government, and industry. A huge field, art includes many different ways of exercising and developing the basic psychophysical functions. Painting appeals to vision, music to hearing. Productive artistry emphasizes free imagination and expression; the contemplation of art emphasizes perception and guided imagination.

General psychology views the basic functions as operating in human organisms in any common type of situation. Aesthetic morphology emphasizes their operation as stimulated by works of art or expressed and symbolized therein. This approach does not imply that artists themselves think or should think of their materials in psychological terms and classifications. Any systematic list of types and subtypes like the one here proposed is, on the whole, at the opposite pole from artistic ways of thinking. It is intended for scientific purposes, as means to the descriptive analysis of artistic form and style.

At the same time, however, it would be a mistake to suppose that artists never think and create in psychological terms. Literary artists, especially, have done so to some extent for millennia. Motivations and conflicts of desire are clearly analyzed in Homer and Euripides. Ancient Greek language and literature are rich in psychological content. Such concepts as vision and hearing, reason and emotion, desire and imagination, are not new or highly technical; they are parts of the ordinary language of educated people, and as such occur frequently in literature itself as well as in aesthetics and criticism. As psychological ideas become more widely diffused there is a tendency for artists, especially in literature, to think at times in psychological terms and to select and organize their materials on that basis. This has been especially true of literature affected by Freudian or Jungian theory.

6. *Basic psychophysical functions. General functional components in art.*

It was mentioned above that these functions are not separate "faculties" of the mind or soul. They are interlocking, almost inseparable phases of psychosomatic activity. Waking experience is a continuous process in which, as in a symphony, the various functions play their parts in close continuity, though not always in harmony. As viewed from within, it is an ever-changing configuration in which, at different times, one or another function dominates, not necessarily controlling the rest, but occupying the forefront of attention and channeling a greater or lesser share of the total discharge of energy. Progress is being made toward correlating different functions with different sets of brain and nerve cells and different activities among them.

A basic or general "function," in the present sense, is the characteristic action of any power, especially one of the elementary conscious activities or mental processes, such as seeing, hearing, perceiving, conceiving, imagining, and remembering. Each of these operates in many specific ways, as determined by internal or external factors or both. All of them are expressed in art. They all overlap and interpenetrate.

There is endless debate in psychology as to the nature of the basic functions and their typical roles in experience. Emotion, conation, imagination, and reasoning are sometimes called "functions," sometimes by other names. The word "will," emphasized by Schopenhauer, is now out of fashion. "Conation," "volition," and "motivation" are sometimes used instead in slightly varying senses. Twentieth-century definitions of all the basic functions differ from those of the eighteenth century (a) in stressing their joint action in complex configurations; (b) in stressing their physical basis and rejecting dualistic or idealistic explanations; (c) in denying the "atomistic" conception of experience as occurring in separate units, such as those formerly called "impressions," "ideas," or "sensations."

The present chapter follows recent theory in these respects, but proceeds to a further analysis of psychic phenomena than some gestalt psychologists approve. It is impossible to describe a complex psychological process or its expressions in art without referring to

some of the parts, specific qualities, and constituent processes which make it up.

For our purposes, the basic psychophysical functions can be roughly defined as follows:

1. a. *Sensation* is the kind of experience involved in immediate stimulation of one or more sensory organs or other sensitive parts of the body. It is a group of functions, including visual, auditory, olfactory, gustatory, tactile, and kinesthetic sensation, otherwise described as seeing, hearing, smelling, tasting, touching, and the sensation of muscular exertion. b. *Perception,* as narrowly defined, is sensation combined with interpretation; that is, sensation along with some inference or assumption about the cause or specific nature of the sensory experience. In a broader sense, perception includes the direct awareness of one's own mental images. c. *Apperception* is perception or apprehension involving a relatively large amount of interpretation.

2. *Conation,* the power or activity of striving, with or without a conscious goal, includes impulse, effort, desiring, willing, motivation, and volition. It may or may not involve emotion.

3. *Emotion* is (a) an excited condition of the organism, a departure from its usual calm, characterized by bodily changes in respiration, circulation,. and glandular action, as well as by strong feeling of some kind as in the conditions called anger, fear, disgust, joy, grief, and surprise. (b) Emotion is also understood as including milder, less intense feeling tones, moods, passions, and related phenomena.

4. *Memory* is the function of remembering or reproducing and identifying what has been experienced. It includes learning, retention, recall, recognition, and some aspects of motor habits and skills.

5. *Imagination* is the forming of mental images of objects not present to the senses, especially of those never perceived in exactly the same way; it is a mental synthesis of partially new ideas from elements experienced separately. It includes reproductive and constructive or creative imagination. Allied concepts are fancy and fantasy.

6. *Reasoning* is the drawing of inferences; the passage from data or premises to a conclusion; the forming or discovering of rational relationships of ideas; thinking with a view to the attainment of a conclusion believed to be valid. Reasoning includes both the act or process of exercising the reason, and the use of reasoned arguments with a view to convince or persuade. It includes conceptual thinking, reflective thinking, problem-solving, intelligent planning, judging, and inference. The word "thinking" alone is too broad for this concept, since it includes remembering

and imagining; "contemplation" and "meditation" are also vague in this respect.

7. *Kinesis* is bodily movement, including motor-muscular activity, the activity of efferent nerves; the impulsion and control, whether conscious or unconscious, of locomotion, movements of the limbs, head, and other parts of the body.

Corresponding to each of these *basic general functions,* or main recurrent phases in psychophysical activity, there is a *general functional component* in artistic form. This includes all manifestations or examples of that function in works of art; all direct stimuli to it or suggestions of it in the work of art, as presented or suggested therein. Corresponding to "sensation" is the *sensory component* in art. It includes all sense imagery, directly perceived or imagined, all presented sensory qualities, aspects, details, and arrangements, and all sensory percepts, such as redness in a flower. It also includes all suggested, remembered, or imagined sensory images, such as the quality "red" as designated by that word in poetry.

"Sensation" as a function is divided into the activities of the various senses such as vision and hearing, each of which is also a general function or subfunction. Corresponding to each of these in art is a general functional component or subcomponent: the visual, the auditory, and so on. The *visual component* includes all visual imagery, visual qualities, details, aspects, arrangements, etc., whether directly presented or suggested, perceived or imagined: all suggestions of visual experience or its products. The *auditory, gustatory, olfactory, tactile,* and *kinesthetic* components include (a) images and qualities presented by the work of art to each of these senses or discernible by it; (b) images and qualities derived from that type of sense experience and suggested by the work of art as an integral part of its form; and (c) descriptions or representations of that type of sense experience.

The conative function in experience and behavior has its counterpart in the *conative component*, in conation regarded as a component of form. It includes all suggestions and expressions in art of desire, aversion, effort, striving, longing, wishing, willing, welcoming, rejecting, and kindred attitudes or processes. These are found in literature as explicit statements: "I want," or "I do not want," and in countless variations; in visual art, as expressive gestures of desire, aversion, acceptance, and rejection.

The *emotional component* consists of all suggestions, expressions, and descriptions of emotional attitudes and feelings, e.g., of pleasantness, unpleasantness, fear, anger, joy, or grief, whether mild or intense, and

whether conveyed by words, facial expressions, mimetic sounds, or otherwise.

The term "affective" is sometimes applied to a combination of conative and emotional experience. Accordingly, art is said to have an *affective component.*

The *rational component* consists of all suggestions and expressions of reasoning and its products, such as concepts, beliefs, inferences, hypotheses, arguments, evidences, conclusions, and all manifestations of the ratiocinative or reflective process. The use of "rational" and "reasoning" here must not be taken as laudatory, as implying good reasoning or high mental ability. As a component in art, they apply to all examples of reasoning, in a broad sense of that term, whether correct and logical or incorrect and fallacious, true or false, wise or foolish, sane or insane. All these varieties occur as ingredients of art. Expressions of reasoning are, on the whole, clearest and most complex in verbal form, as in essays and theoretical discussions and arguments (Hamlet's soliloquy; Mark Antony's speech to the Romans). They are also conveyed in visual and other symbolism.

Kinesis, or the kinetic component, occurs in art as presented or suggested bodily movement, motor-muscular activities. It is presented visually in the dance and suggested in motion pictures, as well as in stories of physical action.

One can also speak of *memory* and *imagination* as functional components of aesthetic form, as in a play or story where someone remembers or imagines. But it is often more effective to describe these functions and their products directly in terms of the particular images and concepts, especially sensory, with which they deal. An image of something red can be considered under visual imagery whether seen, remembered, or imagined. We have already considered memory and imagination, under the heading of "modes of transmission," as phases in the apperceptive response and as stimulated by the suggestive factor in form. Imagination as concrete fantasy will be discussed again as stimulated by representational composition. The whole work of art is to a large extent the product of imagination in the artist, as well as a guide to imagination in the observer.

Mystics may urge that, in addition to sensory perception, allowance should be made for "extrasensory perception" and other alleged modes of communication with the outside world: for mystic intuition, revelation, clairvoyance, prophecy, supernatural trances and visions. The possibility that these may actually occur is investigated by procedures sometimes grouped as "parapsychology." In one way or another,

they must be carefully studied in aesthetic analysis, for they play an important role in the content of art. There is no doubt whatever of the reality of mystic experience as a kind of experience; there is no doubt that some people have strange visions and insights which seem to them as supernatural revelations of truth. The question is: what causes these experiences? The mystical type of personality is quite as real as the empirical and rationalistic. All such undoubted facts can be described phenomenally, without raising the metaphysical question of whether mystic experience is indeed a mode of contact with extrasensory reality, or is mere subjective illusion. It is not necessary to class mystic experience as a separate psychological function. Its ingredients, as actually suggested or presented in art, can be considered under other headings. There is always a large factor of sensory imagery in it (e.g., of light and music). Its meanings are largely covered by such functional categories as reasoning (to include conceptual thinking and inference), imagination, conation, and emotion. All accounts of mystical experience in art can be so described. Mystics claim to have types of experience different from those of ordinary experience but usually add that these are ineffable or inexpressible by ordinary means. The distinctive features of mystical art are concerned, not so much with ingredients as with modes of organization and beliefs about reality.

7. Diversified functional processes. Analogous components in art.

It was stated above that the basic psychological functions never occur in experience in an isolated, separate way, but always in some kind of joint activity. Likewise, their expressions in art occur in highly diversified configurations, wherein the distinctive nature of each function does not obviously appear. It is hardly accurate to call them "mixed" or "combined," for that implies a joining of different entities. By origin in an integrative nervous system they are organically connected. The events of everyday life do not come to us with their ingredients neatly labelled as sense images or emotions, or as compounds of desire and reasoning; neither do works of art. Perception is much influenced by expectation, desire, and feeling. It is practically impossible to have a conscious desire, an emotion, or a rational inference, or to express one in art, without bringing in sensory images, at least those of words. Most sensory images in art and life are *affect-laden*, tinged with emotion and conation.

Emotion is always connected with some conative attitude. Reasoning is impelled by some desire or interest, if only that of knowledge for its own sake.

We must also avoid the opposite error, of assuming that the psychological analysis of art and experience is impossible because the basic functions are completely merged and inseparable. If the basic functions always acted and changed in unison, we should never be able to distinguish them or their objects: e.g., if seeing yellow were always pleasant or always painful, or if love were inseparable from rational approval. We come to recognize their partial independence through observing how a certain response or configuration in one function can occur along with many different ones in other functions: how joy can accompany belief or disbelief, and sadness likewise; how the attainment of a desire can be pleasant or disappointing.

Individuals differ as to which of their psychic functions are most highly developed as abilities and most influential in character. Some are highly rational and some highly emotional; in some auditory imagery is most strong and sensitive, in others visual. To some extent, the functions can be separately trained and disciplined. Our total experiences differ likewise. Looking back on one, we can say that it contained a large and important auditory element, as in attending a concert. Of a dream, one can say that it contained little perception of the actual, external situation, but much visual fantasy with a peculiar emotional and conative tone, as of dread or elation. In such analysis we try to recognize the emphasis and peculiar configuration of the whole experience, which made it different from others.

What we find in works of art, likewise, is seldom a particular functional component in isolation. We find sensory images tinged with suggestions of emotion and desire and linked with beliefs and impulses to action. It is thus that "slices of life" are fed to us in drama and fiction, as inseparable combinations of different human types and tendencies. One can usually say about some passage in literature that here a certain component dominates, is most emphatic or conspicuous. This tends to give the passage as a whole distinctive character. There are poems replete with imagery from the lower senses and poems with little but abstract, philosophical meditation; there are chapters in drama where violent action keeps the stage in turmoil, and others where there is nothing but talk revealing suppressed envy, lust, or malice. In works of art, as in life experiences, we can speak of *dominantly sensory* configurations, or *dominantly conative, emotional, or rational* ones, implying greater

emphasis on one or another of these functional components in the total, heterogeneous complex.

Works of art, like individuals and experiences, differ as to their degree of variety and complexity. In some, a certain component seems to dominate so completely, while others seem to be so inactive that the essence of the whole can be summarized in terms of that one factor. This is a case of pure, uncontrollable greed, we say, or, here is the quintessence of pure, devoted self-sacrifice with no tinge of egoism. No doubt we oversimplify such cases; there is more beneath the surface than appears at first glance. Science, especially in psychology and psychoanalysis, is teaching us to look beneath the surface and to see the hidden complexities, partly unconscious, which are active there: the concealed, conflicting motives which, for good or ill, oppose the obvious, conscious ones.

Modern, civilized art, especially literature and the theater, expresses this growing awareness of the complexity and many-sidedness of human character and of the world we live in. Hence we often find in its forms a great diversity of psychological ingredients and an insistence upon the unique, inextricable blending of forces in every situation. This parallels the psychoanalytic, gestalt, and related trends in psychology, partly influenced by it, partly influencing it. But such awareness is not universal in art or in conceptions of the human mind and its place in the world. Primitive literature is highly abstract in a way, as primitive visual art is abstract in another way; the former seldom gives us really complex, diversified characters or situations. As a rule, these are reduced to a few simple, universal types of sex, age, occupation, and character. The characters are brave or cowardly, kind or cruel, stupid or crafty, faithful or treacherous, pious or impious; they seek food, or power, or women, or divine favor. Each is dominated by a certain motive and has few competing interests, little inner conflict. They seldom change much. No attempt is made to depict the phenomena of nature in great variety; only a few aspects, most relevant to man's interests, are singled out.

There are, of course, many intermediate steps between this early, extreme simplification of life and its opposite in modern art and science. Some art called "primitive" is rich and subtle in its differentiations within a certain area, in its musical rhythms, for example. Primitive society is complex in its own way, and so are its motivations. But insofar as art is actually highly specialized, small in range of ingredients, abstract and simplified in its pictures of life and the

world, morphology must describe it as such and not read modern subtleties into it. Incorrect as it may be, from the standpoint of modern psychology, to "atomize" experience or reduce it to the workings of a few fixed, oversimplified faculties, motives, and personality types, that is exactly what many works of art do. When their presented and suggested content is actually limited to a few detached, bare ingredients, arbitrarily schematizing the facts of life, let us so describe them. This should not prevent us, as psychologists or cultural historians, from realizing how they oversimplified or misrepresented real life and character.

8. Specific elementary components. Traits and types.

To describe the ingredients of art only in terms of basic, general functions does not take us very far. It is highly abstract and ignores important varieties within each function, e.g., those of color and linear shape within vision.

Projected responses of any psychic function, or traits discerned or felt by it in objects, include "qualities." Thus redness is a visual quality, cheerfulness an affective one, logical correctness a rational one. In its broadest sense, a quality is a property, attribute, or predicate which serves to identify or characterize a subject of perception or thought. Projected emotional qualities do not necessarily coincide with the real attributes of a thing. Since the concept of "quality" is extremely broad and vague, it must be subdivided into specific types.

In speaking of the "qualities of art" one risks confusion between those qualities which are contained in the form as ingredients and those which are felt by an observer in responding to it aesthetically. The quality called "beauty" is a suggested image in Byron's line "She walks in beauty, like the night. . . ." Whether it is a quality *of* the line or the poem is a question of evaluation. To avoid confusion, we have used the term "component" to designate the former type of quality: that with status as an ingredient in the aesthetic object.

We must also distinguish between such "qualities" as color or flavor and such "qualities" as red or pineapple-flavored. The former are more general and inclusive; the latter are specific varieties of them. Red is a kind of color, pineapple is a kind of flavor.

To make this distinction clear and systematic, let us call color and flavor *specific components* under the general component "sensation," or "sense imagery." "Vision," or "visual imagery," being comparatively broad and inclusive, we shall consider it also as a general component. "Red," "blue," and "yellow" are *specific component traits* under "color." To describe a thing by saying what components it possesses (e.g., shape, scent, or pitch) gives us only a vague idea of its nature. Reference to *traits* makes the description more specific and concrete, as in saying that it has circular shape, or the scent of lemon, or the pitch of middle C.

When two or more objects are compared in respect to some specific component used as a criterion, their difference in that regard is expressible in terms of *specific component traits*. If two apples are compared in terms of color, one may be described as red and another green; if they are compared in terms of visual shape (a specific component) one may be spherical and another oval (component traits). A component *type* expresses the same kind of distinction, but in the form of an abstract noun instead of an adjective, as in the class of things possessing "sphericity," "redness," "bitterness," or "dissonance."

The difference between "general" and "specific" components is relative, with many degrees of comparative breadth. It will not be necessary for our purposes to try to grade them exactly, but we shall see how some are included in others.

The term *attribute* is sometimes used in psychology as almost equivalent to what we are calling "specific component." An attribute in this sense is a way in which one sensation, image, or feeling can differ from another, as in quality, intensity, or duration. We shall regard as "components" those attributes which are most used and developed in artistic composition.

From the standpoint of the artist, such components as line, color, and rhythm are *means or resources* which he can develop into complex forms. They are also ways in which he can criticize and systematically alter an existing form to make it accord with his desires. A painter can begin with a photograph from nature, or a living model, and alter it in respect to linear shape, color, or texture. In this sense, some textbooks on art theory begin with short lists of "art elements," "plastic means," or the like, such as line, color, mass, and space, rhythm and rhyme, melody and harmony. These are usually far from adequate to cover the diversified range of components which are actually used, even in a single art.

The specific components and traits which we are now considering are comparatively simple and *el-*

ementary, in the sense that they represent about the farthest point in analysis to which it is necessary to go in aesthetic morphology. They are neither simple nor elementary in the sense of being ultimate units, atoms or indivisible particles of art or experience. They are not concrete things or events, but abstractions, discerned by intellectual analysis and comparison. In ordinary life, desiring and reasoning are highly complex mental processes. It is debatable to what extent one can analyze further a so-called ultimate sense-datum, such as red or sweet, but at least a process like the perception of space or color can be analyzed into constituent steps and factors, both psychological and physiological. Extended analysis along these lines is usually not worth while in aesthetic morphology. Many complex aspects of experience, investigated elsewhere in detail, can be accepted as primary data within this field.

"Color" and "pitch" are more specific terms than "sensation" or "sense image," under which they are classified. They are more generally used than "plot," "melody," "meter," and "harmony," in that they occur widely outside of the area of art as well as in it. All the attributes of sense imagery, conation, emotion, and reasoning which we shall class as "specific" or "elementary" components are to be found in almost every phase of human experience. Those to be classed as "developed" are more peculiar to the arts.

An attribute, according to the definition stated above, is any of the ways in which one sensation, image, or feeling can differ from another. *Intensity* and *duration* are two such attributes. These and certain other attributes are found, not only in sensations and emotions but in practically all phases of experience, and in the various configurations assumed by all psychological functions individually and in combination. They are so universal as to be called *general attributes of experience and its objects.* In describing the nature of a particular experience or of its objects or products, one can hardly avoid referring to them. One emotional or conative experience differs from another as to its intensity—how mild or vivid and excited it is—and also as to how long it lasts. These attributes can also be predicated of the qualities given to objects in experience: one story is extremely exciting, another mildly so; one perfume lasts for hours, another for a few minutes only.

Extensity, number, definiteness, change, and *texture* are also included as general attributes of experience and its objects. It will be found that these seven attributes are to some extent applicable to each function and its objects, including imagery from each of the senses. In some cases they are used, con-

sciously and systematically, in the building of artistic forms. The relative duration of notes and rests is important in music, for example. All these attributes are capable of such use when artists wish to use them, and hence are actual or potential components in aesthetic form. Under each, specific modifications or varieties can be listed as traits; e.g., "long" and "brief" are traits under "duration."

The set of concepts listed in the following chapters as specific or elementary components, traits, and types are not proposed as adequate for general psychology. That science has many ways of analyzing and describing different kinds of experience. The one proposed here is only a start toward the sort of apparatus needed for the analysis of art. It is not radically new or imposed from outside. For many centuries artists, critics, and historians of art have been thinking and writing about the arts in similar terms. What is attempted here is an extension and systematization of this vocabulary for application to any art.

It should not be understood in too atomistic a way. "Redness" and "angularity" are not completely distinct, eternal universals. They are man-made, linguistic devices for analyzing and comparing highly complex, diversified objects of experience. The phenomena they denote overlap and have no definite boundaries. Nevertheless, these devices will help us to explore one aspect of the infinite variety of art.

9. Component trait units and details. Concrete and compound details. Pure and mixed component traits.

A specific or elementary component such as color or pitch can be exemplified at many or all points of a total form. Any such example is a *component detail* or *unit.* A detail is relatively small; a unit can be of any size. All the leaves in a painting of a tree may contain units of color and also units of linear shape.

They also contain *component trait units:* each leaf may be a unit of the trait "green" or "yellow" under the component "color." At the same time, it may be a unit of the trait "elliptical" or "pointed" under the component "linear shape." Any component trait can be exemplified many times in a large and complex work of art, often in a different context. "Green" can appear at one point in a leaf, at another in a silk ribbon, at another in an emerald ring. In the first case it may be combined with the linear trait "elliptical," in the second with "wavy," and in the third with "round" or "oblong." Each presented trait can also

be combined with various suggested traits, as when green represents "leaf," "ribbon," or "emerald." Thus analysis discloses the varied combination of traits in different parts of a concrete subject or process. In music, a high pitch is sometimes combined with loudness and sometimes with softness, sometimes with a violin tone and sometimes with a flute tone, and sometimes with mimesis of a bird song or other natural sounds.

Any *concrete part* of a work of art, however small or brief, if perceptible at all, has many qualities. It necessarily embodies units or details of many different component traits. Any painted leaf in the picture will exemplify a certain color (including a certain hue, lightness, and chroma), a certain linear shape, a certain texture, etc. Any note as actually played in a symphony will have a certain pitch (its trait under the component "pitch," e.g., middle C), a certain timbre (e.g., violin tone), a certain loudness (e.g., mezzo-forte), a certain duration (e.g., a half note in four-four time, adagio), etc. Any word in a poem is a *concrete detail* which can be analyzed into many component traits. It is a linguistic symbol, written or spoken, involving a combination of visual traits (as letters) or auditory traits (as sounds) in addition to one or more suggested meanings. The meaning of the word "red" involves visual imagery and a certain trait under the component "color."

A concrete unit or detail, as existing in space and time, can be figuratively regarded as a *cluster of traits* (some philosophers call them "essences") exemplifying different components. As a concretion in existence, the leaf is in a way *compound*, a combination of different component traits, just as the whole work of art is. But it is less complex if it has fewer parts, less differentiation and integration, than the whole work of art. The word "compound" must be taken figuratively, since there is of course no actual compounding of separate substances as in a medical prescription. The experience itself, of perceiving a whole concrete object or event and at the same time feeling emotionally toward it, is usually felt as simple and unitary. The compound or composite aspect appears through the verbal and intellectual analysis of it. Reversing this process of analysis into qualities, one may conceive of the original concretion itself as an assemblage of more elementary traits.

In the same figurative sense one can apply the words *"compound,"* or *"mixed,"* to a single trait such as "fragrant" or "delicious," in which there is a blend of sense quality and affect. The words imply an odor or a taste which is pleasant and acceptable, and this in turn implies a joint sensory and conative-

emotional functioning. To describe the odor or taste merely as "orange" implies no such affective element. Many words, such as "sweet" and "harmonious," are ambiguous in this respect, being sometimes used evaluatively, sometimes not. In such cases, we must rely on the context to disclose exactly what trait, pure or mixed, is implied. Every civilized language contains thousands of words such as "questionable," "delicious," "melancholy," "plaintive," "cloying," "painful," "stifling," or "refreshing," which imply a mixed or joint response of two or more functions, projected upon some real or imaginary object and regarded as its traits. As ingredients in art, they are *mixed component traits*. Sometimes they can be referred largely, though not wholly, to some one dominant or emphasized functional component. Thus "fragrant," while implying pleasantness, refers primarily to the olfactory component. "Melodious" refers to the auditory.

In their literal meanings, "red," "blue," and "yellow" refer to purely visual qualities. "Angry" and "jolly" are emotional traits. "Intellectual," "dogmatic," and "illogical," as found in art, belong largely to the rational component. These words refer to comparatively specialized traits, although their context may link them with other functions. One passage in a detective story may be devoted entirely to visual description of a room; another, to an account of the detective's reasoning about a crime; yet another, to the criminal's rage and fear when discovered. Classifying an ingredient psychologically does not mean that it must be placed under one function only; some can be, but others must be listed under several, or as blends or joint products.

Most sensory traits can be either presented or suggested in art, if we include as works of art stimuli addressed to one of the lower senses, as in perfume. (There can be more form in a perfume than is commonly recognized). In an actual perfume, the trait "jasmine" can be presented; in a literary reference to the perfume, it can only be suggested. An exception is *kinesthesis*, which is sometimes classed as a sixth sense, pertaining to muscular sensations of effort and relaxation. Kinesthetic traits cannot be directly presented or perceived in a work of art, except to the performer. To the observer they are suggested, as by the visual appearance or sound of a leaping dancer or a wrestler. Emotion, conation, and reasoning can be only suggested. We cannot directly see or hear love or anger in a work of art, or in another person, but only the perceptible signs or expressions which suggest to us the conscious feelings behind them.

In ourselves, we can introspectively observe emo-

tion, desire, and thought, in a more direct way. What we call introspection or autoperception is a kind of direct experience though not immediately sensory. It includes remembered sense images. But all works of art require some sensory presentation and perception. Literature contains much representation of the inner stream of thought in imaginary characters, but it must always be conveyed to the reader or listener through a sensory medium.

Note: The following illustrations are particularly relevant to this chapter: Plates I, III, IV, VI; Figures 40, 41, 58, 78, 83.

CHAPTER IV

Describing a Work of Art as to Its Psychological Components

1. Elementary component analysis.

We are now in a position to consider both ingredients and modes of transmission in any particular analysis. Neither can well be studied apart from the other; both can proceed together. For example, in looking at a picture, we can set down under one heading those ingredients which are directly presented. These can now be further classified under the heading of general functional components (all visual, in the case of a picture), the specific or elementary components (hue, linear shape, etc.), and the traits (red, angular, dark, etc.) under which all the presented details may fall. Under the main heading of suggestive ingredients, another list can be set down. The ingredients suggested by a picture may include not only visual but auditory and tactile ones, not only deep space and textural qualities but conation and emotions, as in the picture of some tragic struggle.

Another way of classifying ingredients is to take a certain functional component such as visual images, and under it an elementary component such as texture, then list under the latter both presented and suggested examples of it. A painting will present one texture directly to the eye, perhaps in small dots of contrasting colors. At the same time, it may suggest another visual texture: that of flesh, silk cloth, fur, or foliage.

2. The need of selective apperception.

A preliminary survey of the object should be made before any minute analysis. After that a fairly definite order of procedure is useful in an early stage of study. The observer will need terms for describing specifically what he sees and for distinguishing what he sees from what he imagines, as well as for distinguishing the nature of the object itself from his personal feelings toward it. Having in mind the list of types in this chapter, the student is aided to search for and discover in the object traits which he might not otherwise have noticed. He should avoid letting his attention be monopolized by any one conspicuous detail, and should try to make his survey of the ingredients include all the main types involved.

A detailed analysis requires the process described above as "selective apperception." This includes the ability to narrow down one's attention to a certain few out of many presented details, ignoring all the rest for the moment. In the apperception of suggested ingredients, the same ability is requisite. One must be able, in reading a story, to notice one type of suggested material at a time, such as auditory imagery or practical reasoning.

A set of abstract concepts is not enough to equip one for the analysis of a particular work of art. Much concrete experience of art is also required. It can be organized under these concepts, which will then become full and active, not empty or merely verbal. To a person of little musical experience, the names of auditory components and traits will seem vague or meaningless. Such concepts must be vitalized by direct experience, perceptive and apperceptive, in which particular items of experience are explicitly noted as examples of certain types. This phase of experience is rather integrative than selective; it consists in assembling detailed ingredients under general categories and learning to recognize new examples of these types.

3. Selection of essentials. Estimates of comparative preponderance and activity among ingredients.

Even a much-abbreviated discussion of ingredients, such as that later in this book, may seem excessively long, but they are all in active use in the arts. Must one, in analyzing a work of art, have in mind all these concepts at once and be on the watch for examples of all of them? If so, the analysis of a simple form will assume alarming proportions. It is well, all the same, for a student to read through the whole list, and have it at least in the back of his mind without troubling to remember it in detail. Thus he will be more or less consciously on the alert for unfamiliar traits. In practice, in fact, the task of analysis quickly simplifies itself. It is usually obvious that all the presented ingredients in a certain work of art fall under some one category such as visual or auditory. The rest can then be ignored in that connection. Examining the suggested ingredients, the student will also discover that very few works of art possess anything like the variety theoretically possible. A short poem may contain only a few simple visual images and a single conative attitude toward them.

In practice, one soon develops the power of quickly recognizing which types of ingredient are emphasized in a particular case. One concentrates attention upon these and ignores or minimizes the rest. In a poem or story, as a rule, all visually presented factors can be brushed aside as absent or nonessential. Even a rough examination of the suggestive content of a story or picture suffices to reveal certain types of ingredient as *active and preponderant*. It may be obvious that a certain trait is frequently repeated, while others are infrequent or absent. One does not have to perceive the complex form of a painting to recognize that it has many spots of red in it, or that it is restricted to black and white. In reading most literature, one can easily see that the author has made much use of a few suggested traits, such as inner conflicts of desire and delusions of grandeur, and very little of other components.

The comparative *activity* of any component, trait, or type can be estimated in various ways. One can compare it with others as to the *number*, quantity, or frequency of the units or details embodying it. (E.g., Are there many repetitions of a certain symbol, such as the nightingale?) Secondly, one can compare it as to the *intensity* or energy of the units embodying it.

(Are the red spots more vivid than the blue? Is the violin part louder in a certain passage than the piano part?) Thirdly, one can compare it as to the *extensity* or *duration* of the units embodying it. (Are the red spots larger than the blue? Does the violin part last longer than the cello?) Fourth, one can compare it as to *amount of diversity*; of contrast or variation. (As to hue, are there many component traits, blue, red, yellow, etc.?) One such component may be so diversified while another is not. If all details are of one hue, as in a drawing made entirely in red crayon, hue tends to be less active in holding the attention. Attention may go rather to some component, such as linear shape, which is more varied. If the lines are simple and uniform, but there are many different hues, then the effect is reversed. When one voice is diversified in pitch while the other is a drone bass, the former tends to hold the attention, as in bagpipe music. All such estimates of activity are in terms of ingredients as such; and it should be repeated that mode of arrangement can substantially alter the relative degrees of activity.

As attributes of nearly all the main functional components, we have listed intensity, extensity, duration, and number. A first scrutiny of the ingredients of a form gives the basis for a rough estimate of which ones are most numerous or frequent, which ones most intense as stimuli, most extensive in size or area, most prolonged in duration. One may then decide to study with care the ones most active and preponderant from these points of view. However, details or nuances which are infrequent or unemphatic may deserve attention for other reasons: e.g., as unusual, original, or subtly expressive.

A total aesthetic form contains many *schemas*, whose descriptions will fit together into an account of the total form. The transmissional schema has been discussed. The *ingredient schema* is another: the particular set of ingredients included in a work of art. It should be stated, not merely as a list, but with some classification of the traits under various general and specific components. Also, there should be some estimate of the relative emphasis and activity among the different components and traits. Thus it may be relevant to say of a picture that it emphasizes color and texture but makes little use of linear or solid shape. Of two poems, it is significant to know that one contains more suggested emotion, the other more visual imagery. But it gives us a much clearer idea to say *which* colors, or which emotions, are used, and to what extent. A comparatively full account of the ingredient schema will specify the chief component

traits involved and the comparative emphasis on each. In the colorful picture, blue may be most active and emphatic, with red a little less so and yellow least of all. Nuances or slight variations in a particular trait (if any) may also be important.

4. Modes and degrees of ingredient diversity.

Works of art can be compared as to the approximate number of different components which they contain, and as to the amount of diversity within each component. As to any particular work, we may ask the following questions:

How many *general functional components* does it contain in a fairly active way, including both presented and suggested? E.g., visual, auditory, tactile, conative, emotional. (Shakespeare and Wagner use, as a rule, more than Holbein or Schubert.)

How many *specific elementary components* does it contain? E.g., under visual: hue, linear shape, solid shape, texture.

How many elementary *component traits* does it contain? E.g., under hue: red, blue, green. (Having a diversity of such traits tends to make a component active.)

How many slight *variations* of such traits, and how many different compound traits does it contain? E.g., light red, dark red, vivid red, dull red.

The ingredient diversity of a form can thus be described and compared, not only in a sweeping, wholesale way, but with reference to each of these modes of diversification. A form can be highly *diversified* in one of these and *specialized* or uniform in another. It can have comparatively few functional components, but many elementary components under those which it does have. The only active functional components in a picture or poem may be visual imagery. Yet it may have numerous different hues, shapes of line, mass and void, etc., thus being highly diversified in terms of this one component. Or the form may have many functional components, as in a story which includes all of them by suggestion. Yet there may be little diversification within any of these, or in any but one—perhaps the variety of emotional responses described. When two forms are thus diversified in different modes, it is difficult to compare them in terms of total ingredient diversity. But the estimate can be made in a rough and tentative way, for purposes of preliminary analysis.

5. Summary: a short list of general and specific (elementary) components, each covering a number of component traits.

a. *Sensory*:

Visual: Visual shape: line, area, surface, solid, and void shape. Position, direction. Number. Color: hue, chroma, lightness, brilliance, luminosity. Texture. Intensity. Duration. Change; movement. Velocity. Visual rhythm. Definiteness.

Auditory: Pitch. Timbre. Loudness. Silence; rest. Volume. Velocity. Extension; source. Duration. Rhythm; accent. Consonance; dissonance. Texture (auditory). Number. Definiteness. Change; movement.

Olfactory: Scent. Intensity. Extensity. Duration. Texture. Definiteness. Change.

Gustatory: Flavor. Intensity. Extensity. Duration. Texture. Definiteness. Change.

Tactile and related: Pain, hunger. Pressure. Friction; traction. Temperature. Humidity. Astringency; laxativeness. Surface texture. Shape. Intensity. Extensity. Duration. Change. Number. Rhythm. Definiteness.

Kinesthetic: Effort; tension; relaxation. Impulse; inhibition. Direction. Balance. Strength; weakness, fatigue. Rhythm. Velocity. Intensity. Extensity. Duration. Texture. Definiteness. Change.

b. *Conative:* Directional attitude. Release, inhibition, expression. Bodily location. Object-reference. Maturity. Sexuality. Mode of pursuit. Outcome. Ratio between desires and satisfactions. Relationship of desires in individual; among different individuals. Grouping; alignment. Strength, weakness; equality, inequality. Attitudes toward self. Intensity. Duration. Texture. Definiteness. Change.

c. *Emotional:* Expressive behavior; bodily change. Object reference. Conative correlate. Relation to satisfaction and frustration. Self-feeling. Hedonic tone. Organic condition. Intensity. Extensity. Duration. Number. Change. Definiteness.

d. *Imaginative:* Degree and mode of organization; relation to previous experience and to outside real-

ity; reproductive and constructive. Imagination and fancy. Sensory and other sources. Relation to other functions. Vividness; intensity; clarity; definiteness; abstractness and concreteness. Consciousness and sanity; existence and truth. Dreams, hallucinations, delusions. Communication and detachment.

e. *Rational:* Conceptual content; propositions; inferences, expressed or implied. Abstractness; generality. Explicitness; clarity, definiteness. Attitude; questioning or answering; affirmation or negation, belief or disbelief, proof or disproof; categorically or contingently; confidence, assurance. Intelligence. Strength, weakness. Transition; movement. Velocity. Direction. Duration. Extensity, scope. Degree of development; differentiation, integration. Conscious level. Relation to other functions, as closely merged or detached. To action: practicality, applicability. To perception. To fantasy. To conation and emotion. To evaluation, memory, knowledge. Degree and mode of logicality. Sanity and insanity. Relation to reality; existence; truth or falsity.

PART THREE

Modes and Dimensions of Organization

CHAPTER V

Spatial, Temporal, and Causal Development

1. Organization. Unity in variety. Development. Complication and simplification.

This chapter returns from the subject of *what* is organized in art to that of *how* this "what" is organized. The "how" was partly explained in the chapter on "Modes of Transmission." There we saw how the ingredients of a work of art are arranged in such a way as to stimulate perceptual, imaginative, and other responses in the observer. This involves organization in terms of presented and suggested factors in the work of art. Subsequent chapters surveyed and classified these ingredients: the psychological materials or contents of art.

Organization means, in this connection, the way in which the ingredients are combined and interrelated so as to have some degree of unity or internal coherence. It refers to the process of organizing or the condition of being organized. It implies some power of cooperation among the parts, though not necessarily complete harmony. It implies that the actions of a number of different units, such as workers in a factory or dancers in a ballet, have been coordinated so as to produce a single desired effect or set of effects. The functions of each are combined to some extent in the functioning of the whole, although conflicts and malfunctioning may occur.

The concept of *unity in variety* has been regarded in traditional aesthetics as one of the principal standards of value in art. To charge a work with "lack of unity" is often meant as condemning it entirely. However, there are many kinds of unity in art; many ways of organizing its materials. What appears to the conservative critic as a lack of unity (e.g., in Shakespeare or Debussy) may be an unfamiliar kind of unity. But many artists deliberately emphasize variety and leave the units of their work loosely scattered,

with an intentional air of disorder or casual freedom. They avoid all kinds of tight, formal unity as oppressive. Sometimes the artist wants to convey an impression of disorder and disunity, as in the ravings of a madman or the confusion of an unruly mob. But to do so consistently is itself a kind of unity.

Sculptural form has been reduced in some works by Brancusi almost to a single cylinder or oval. Pictorial form has been reduced by Malevitch, Reinhardt, and others almost to a single sheet of uniform color. Variety is thus reduced to a minimum. Art has long had a place for inconspicuous types involving either extreme uniformity or extreme, unorganized variety. But most art stays somewhere between the two extremes, including a variety of materials and seeking to unify them in some degree.

It would be hard if not impossible to find a work of art which did not possess some unity and some variety. The same can be said of natural objects and events. Every tree and every sunset has some of both. In art some variety is recognized as a means of holding the observer's interest, while some unity in the object helps him to perceive and respond to it in a unified, comprehensive, sharply focused way. Much variety without unity may seem confusing, hard to perceive together as a definite whole. It may soon become fatiguing and repellent. Much unity without variety tends to favor easy perception of the various elements, but may seem too easy. It may fail to hold the interest and attention of the observer. The exact effect of such conditions will depend, however, on the aims and context of the work. No trait in the object can be relied upon to produce the same aesthetic effect on all persons under all conditions.

This book is not concerned with the evaluative question of how much unity or variety a work of art should have. Artists, styles, and periods differ widely

on this point. We shall examine some of the different ways in which any desired amount of unity or variety can be achieved.

Here, in brief, are a few steps which help to produce an effect of unity in organizing a variety of parts. They will be explained more fully in later chapters.

a. One way to increase the aesthetic effect of unity is through making the parts more *similar*. This can be done with the presented or suggested factors or both. It can be done through having fewer different modes of transmission, fewer kinds of ingredients, or fewer dimensions and modes of composition.

b. Another way is to put the parts or units closer together in space, time, or both: that is, increase the effect through greater *proximity*.

c. A third is to *connect* the parts more thoroughly in space, time, or both, as by the string on which beads are strung. Connecting lines, masses, intermediate patterns, or prolonged sounds may have this function.

d. A fourth way is by *boundedness* or detachment from context in space, time, or both. This is done by picture frames and by the proscenium arch and curtains in a theater.

e. A fifth way is by conformity to an *overall pattern*, or schema, such as the sonata pattern or the Doric order.

Like organization, *development* can be a condition or a process. At any one moment, a work of art has a certain amount of organization and development along certain lines. As a process, development usually implies growth, becoming larger or more complex, as in the growth of a plant from a seed or in the evolution of animal life. Art as a whole has developed along various lines in various periods and places: e.g., toward increasing realism of perspective and anatomy in the Italian Renaissance.

With or without increasing complexity, something may develop in the sense of becoming more fit or efficient in performing its functions. Thus a man may develop a more effective mousetrap or a sweeter, more hardy apple which is not more complex than its predecessors. A scientist can find a key idea which will solve several problems at once, or a simple device which will do the work of several complicated ones. The artist develops his work from a germ-idea to a finished form, but this is not necessarily more complex than the preliminary sketch. It is usually more definite in the sense of saying more exactly what the artist wanted to say.

As increasing complexity, development involves two reciprocal phases: differentiation and integration. They are roughly equivalent to variation and unification. There is differentiation when the parts or qualities of an object become more unlike each other, or when more and more different parts are added, and also when the members of a group become more unlike, or when constituent movements, trends, or processes diverge from each other. If continued, differentiation produces more and more diversity, which may be felt in art as contrast. The opposite kind of change is increasing similarity or assimilation. It can produce repetition or homogeneity. "Monotony" suggests a tedious kind of uniformity. Multiplicity, having many parts or units, can be comparatively diverse or uniform. Thus one can add more and more characters (similar or dissimilar) to a story, more colors to a picture, more instrumental voices to a symphony. A fugue or a drama may become more complex as it goes along. Integration can be loose and partial or tight and thorough. New parts can be fitted into an existing framework as they are added, or a new mode of integration can be devised to include the old and new.

Complexity cannot be achieved without some of both reciprocating phases. Differentiation without integration produces an unconnected, miscellaneous, chaotic assemblage. Integration without differentiation produces a tight, simple uniformity. Some of both is required for high complexity. An Egyptian pyramid is a comparatively simple unity. A field on which miscellaneous rubbish and building materials have been scattered at random is differentiated but not complex. It can be loosely integrated by sorting out the different types of object and arranging them in some systematic way. The mechanism of a watch is complex and highly developed. Gothic cathedrals are complex and, as a rule, firmly integrated, but not always consistent in style.

As a process, one kind of development is called *evolution*. It occurs in organic life, in culture, and in art as a branch of cultural evolution. Artistic evolution involves a prevailing, long-range tendency to increasing complexity, along with adaptive modification and the origin of new types. Art as a whole has become more complex, as opera, sound films, and urban architecture suggest, but simple forms have persisted, and regressive or devolutionary trends toward greater simplicity often occur. Numerous examples of this can be found in Romantic music and poetry.

The opposite of complication is *simplification*. Various kinds of this occur. One is disintegration, a breakdown or weakening of internal cohesive forces. Another is the loss or elimination of parts, a trend away from multiplicity. This does not necessarily in-

volve disintegration. It is often practiced for the sake of economy, terseness, or other aesthetic qualities. Some recent trends in abstract painting and sculpture have emphasized simplification through eliminating representational content, complex design, and other features. Reactions away from complex form in art are sometimes linked with reactions away from classical rationalism and modern technological civilization.

In producing a work of art the artist does not necessarily go from simple elements to complex forms. He may do so, as in arranging bits of mosaic (*tesserae*) into a design. A painter may begin by selecting a scene in nature which is already fairly complex, and proceed by further selecting and eliminating details until his painting is considerably simpler than the scene. A story may begin with some historical characters and events, which the author changes to suit his purposes. He may complicate the story still more or simplify it by omitting some of the characters and events.

A finished work of art can be highly developed in some respects and undeveloped or slightly developed in others. A drawing in pen and ink can be complex in linear shape while lacking all variety of hue and solid shape. In perceiving and describing a work of art, it is important to notice the ways in which it is most highly developed.

of patterns. A "trophy of arms," consisting of different weapons or pieces of armor arranged in a group on a wall, forms a pattern or design according to its degree of complexity.

A work of art is made more complex by differentiation of parts and qualities along with some integration in a comprehensive series or pattern. If things or events exist or occur closely enough to be perceived together, yet without much definite order in space or time, one may call them a "scattering" or a "random distribution."

We shall use the term "series" to include any and all of these, whether or not the units are arranged in a definite spatial or temporal succession. If presented or suggested in a temporal order, they can also be called a *sequence*. If not, as when presented in a star pattern, the parts can still be apperceived in temporal succession, as determined by the observer. Such a group or pattern can be carried a step toward sequential form by being consecutively numbered or graduated in size, shape, or some other quality.

In twelve-tone music a "row" consists of the twelve chromatic tones of an octave, rearranged in a certain order and used as material for development. They form a "sequence" in the broad sense, but this term usually has a different, specific sense in music: that of a succession of repetitions of a musical phrase on different levels of pitch.

2. Series, groups, sequences, rows, patterns. Scatterings and random distributions.

One of the principal ways of developing a work of art, or the beginnings of one, is to produce a series of units (presented or suggested) which resemble each other more or less or which carry on a connected sequence of events. These can be organized in space, time, or both.

A *series* is a number of things or events which exist or occur in a certain order and are connected by a similar trait. It can be arranged in some order of succession. A group of things or events is *serial* if so arranged.

If one sees a number of flags displayed on a line of poles the same height, one may call it a *row* of flags. If the flags are clustered together in space, one may call them a *group*. If a number of things are arranged in a fairly definite spatial group or succession, involving somewhat similar parts and interrelations, a six-pointed star, for instance, one may call them a *pattern*. A *design*, in the sense used in this book, is a complex, thematic pattern or organized combination

3. Frames of reference: basic categories and dimensions in which art is developed.

A frame of reference is any systematic set of principles, facts, or ideas which serve to locate or identify a particular fact or conception and give it a certain meaning. Thus a point or figure can be oriented *spatially* with reference to two or three axes, intersecting at right angles in two or three dimensions of space. The path described by a moving object, such as a bird, a dancer, or an airplane, can also be so described. An event can be located *temporally* by reference to a system of seconds or smaller units, minutes, hours, days, and years. Our clocks and calendars are based on the rotation of the earth and its annual orbit around the sun. An event can be dated *spatio-temporally* as to the year (A.D. or B.C.), the day, hour, and second at a particular place on the earth. There are no absolute points or moments of reference, but for us on earth the solar system is fixed enough for most practical purposes.

Causally, an event such as Napoleon's defeat at

Waterloo can be located in the historical process as the joint result of many previous conditions, factors, and trains of events. Some of these, cooperating toward the defeat, were stronger than those combining to resist it. Opinions differ as to how completely any historical event can be explained along these lines, but the more we understand the previous alignment of factors the more we feel that we understand the outcome. It is always possible that some crucial factors have been overlooked, however.

It has been shown by Aristotle, Kant, and other philosophers that the human mind organizes its experience, including all sense perceptions, in terms of certain necessary modes or categories of thought. Among those frequently mentioned are space, time, causality, quality, quantity, and implication. There is still much disagreement on the exact list of categories, on whether they are a priori or derived from experience, whether they are purely mental or characteristics of the external, physical world, and so on. In aesthetics, we do not need to deal with these problems at length, but it does make a considerable difference whether we conceive of space and time as external realities or as purely mental constructs. The main interest of aesthetics is in how they are used in constructing, perceiving, and understanding works of art.

A broad category such as "space" covers many possible frames of reference, set up for specific purposes. For example, an ordinary scale map is set up in two dimensions, with distances in proportion to those represented on the surface of the earth. The spatial, temporal, and causal aspects of the arts are organized in many different ways.

All works of art, like natural objects and events, exist in three dimensions of space and in time. They have causal relations with other phenomena. But they are not all equally *developed* in these various categories. For a work of art to be developed in three-dimensional space means that it is differentiated and integrated in three dimensions, in ways which can be perceived or imagined. A perfect sphere of uniform color and texture, however large, has little aesthetic development in three dimensions: less so than a small statue whose parts jut out into space in different shapes, leaving hollows and empty spaces here and there. The sphere has a great deal of unity, but not enough variety to make it highly developed aesthetically. Likewise, the ticking of a clock is extended in space and time, but is too often uniform to constitute aesthetic development. Music is more highly developed in time by virtue of its variations in rhythm, pitch, and other components.

The various arts tend to choose different lines for maximum development, but there is some overlapping among them. Both sculpture and architecture are developed in three dimensions of space, but architecture develops interior spaces more. Music and drama are both developed in time, dramatic performance also in space. Within each art the artist has some latitude as to which lines of development he will emphasize. In choosing to carve a relief, the sculptor cannot expect to develop his work very far in the third dimension. Current styles and tastes tend to delimit further the range of options open to art at any one time and place.

Science tries to explore and describe the actual universe: man and the real world he lives in. It tries to do so as objectively as possible; to understand and describe the universe of space, time, matter, and energy as it is, or as nearly so as the human mind can achieve. Art, on the other hand, is usually quite willing to accept the more human, earthly, relative frames of reference, to represent things as they might look or sound to some individual observer, perhaps divine, but none the less individual and existing in space and time. Thus, we see the Trojan battlefield at times from the standpoints of Zeus, Aphrodite, and other deities above. Art sometimes tries to show things from the standpoint of an omniscient observer, *sub specie aeternitatis*, but more often it frankly expresses that of one human artist or observer, including his emotional attitudes as well as his position in time and space. It constructs its forms for presentation to equally human, limited observers, and to be clearly seen or heard from a certain range of positions. For the human mind and senses to grasp and enjoy them, works of art must not be too large or too small, too near or far, long or short, loud or soft, dark or brightly lighted, fast or slow. All presentative details are arranged in frames of reference which are relative to human observers. If they make us imagine a fanciful world and a nonhuman point of view, such as that of the gods on Olympus or of Dante in Paradise, that world must not be too completely different from our own, or we shall not be able to imagine and comprehend it at all. The idea of a truly omniscient, eternal, all-seeing, all-powerful deity has never been clearly represented in art, although some art has tried to symbolize it.

The basic "categories of the understanding" are not peculiar to the arts. They exist as modes of organization throughout human experience, including science, philosophy, and everyday life. From infancy we begin to organize our sense perceptions and causal inferences along these lines, though without being

consciously aware of them. We gradually become conscious of the categories, but only philosophers try to define and explain them abstractly and theoretically. Science uses them to formulate laws of nature and conceptions of the universe, as in astronomy and physics.

Dreams and waking fantasies, sane or insane, as well as normal, waking sense perceptions, are all organized to some extent in terms of these same categories. In dreams and other fantasies, however, the structures built within them are often vague and confused, at least as they seem in memory after waking. The events of a dream often seem to follow each other without any consistent spatial, temporal, causal, or logical order. The dreamer is here at one moment, there at another, doing something else. Things may happen with no apparent cause or effect, or with one which seems absurd after waking. Psychoanalysts tell us that significant parts of the dream are repressed, disguised, or forgotten on awakening. In normal, waking life, rational people try to order their experience consistently in space, time, and causality, so as to make a true and unified picture of the world in terms of which they can interpret new events and anticipate future ones. On awaking in the morning we reorient ourselves in space, time, and the causal situation of events and possibilities which we forgot in sleeping. We organize our plans and actions in terms of our apparent position in a spatio-temporal, causal environment.

The fantasies which representational art conjures up in our minds are necessarily organized to some extent in terms of the categories we employ in daily life. Otherwise they would be only blurred, chaotic jumbles in which we could not get our bearings at all. Stories, pictures, music, and other kinds of art arrange their images and suggestions in a somewhat orderly way within selected frames of reference. But the artist may intentionally leave the work somewhat vague and disconnected. He may wish to make us imagine the confusion of a dream, a fairy tale in which things happen by magic, or a psychotic delusion in which the patient misinterprets the causes of other persons' actions.

The basic categories apply to both the *presented* and *suggested* factors in aesthetic form. What we see or hear directly in a work of art is already organized in terms of certain categories. In apperceiving it, we tend to complete and interpret the presented factor, for example, in recognizing an incomplete sketch as a picture of a man. We grasp the suggested meanings and fuse them with the visible lines as a single, meaningful form. In reading or listening to a story, we apprehend the meanings of successive words and follow their guidance in imagining characters moving, speaking, and affecting each other in space, time, and causality. A motionless marble statue in the round can be presentatively much developed in space but not in time. It can suggest bodily motion somewhat, however, through the shape of the limbs and draperies. To perceive it part by part is a sequence of events in time.

Custom and convention, plus the nature of the medium, largely determine the categories in which each art develops its forms. Music is primarily a temporal art, and architecture one of space, but they can develop along other lines as well. If an artist wishes to do something unusual, he can make a sculptural relief whose parts move in rhythmic sequence, or a piece of music which is heard from different places in predetermined sequence. Such experiments have been tried, and many more are conceivable. It was long supposed that painting was essentially and permanently an "art of rest," a static, motionless art. But the desire to make pictures move eventually prevailed. First photography, and then painting, became potential "arts of motion," extensively developed in both space and time as the art of film or cinema.

4. Determinate and indeterminate traits.

To be "determinate" is to be definitely controlled, directed, or made in a certain way. Many traits in art are left indeterminate. For example, the printed text of a drama is a set of directions for speaking and acting. It is often limited to the dialogue, to the words and sentences each character is to speak, plus a few directions for entrances and exits. There may be no indication of where these characters are to stand and move, or of how fast or loudly they are to speak, or of their height and costume, or of the scenery and lighting. In these respects the dramatic text is indeterminate. For a performance it must be further determined, in part by the stage director and in part by the actors themselves, either by plan or on the spur of the moment. As a result, a new version of the text may be prepared, a dramatic script with indications of many details which had been left unspecified by the original author.

The Shakespearean plays have come down to us indeterminate in many respects, but over three centuries of staging and acting have established certain traditions, certain customary ways of filling in these details. The same is true of Baroque music. The

printed text of any poem can be read aloud or silently to oneself. Here again, the author usually determines it in respect to certain wordsounds and patterns of rhythm, as to rhyme, perhaps, but not as to pitch or speed. Punctuation and linguistic conventions help determine the intonation; for example, dropping the voice in pitch at the end of a declarative sentence, or raising it at the end of a question. In musical scores, the component traits are more definitely specified now than they were a few centuries ago.

In a static work of visual art, such as a painting or statue, accidents and environmental conditions may determine its nature in ways the original artist did not intend or specify. Age and weathering change the color and surface texture of mural paintings; they color the façades of architecture, adding unintended dark spots. Buried bronzes take on a patina which some prefer to the original texture. It is not to be assumed in morphology that the traits produced by the artist are necessarily better or worse, but it is significant to distinguish these if possible from the accidental ones. The former have more right to be considered as integral parts of the aesthetic form. The lighting of a statue is not ordinarily determined in advance, but the sculptor may make it so as to satisfy him in different lightings.

Whatever presented and suggested traits the art work has at a certain time, these are in a sense determinate; it is what it is, whether by design or accident. Often it is not necessary or possible to discover just what the artist intended or what the object's original nature was. But sometimes there is a great, important difference between the original state or version and a later one. Romantic taste in the eighteenth century favored ruins, sometimes more than new, white, perfect, clear-cut buildings. The difference here was so great as almost to make two distinct works of art: the original as intended by the artist and the present ruin, partly the work of nature or destructive human acts. There is also a significant difference between Shakespeare's *Julius Caesar* as originally performed and the same play as done in twentieth-century New York, in modern dress suggesting Nazi uniforms. There is a difference between the original *Iliad*, in which the Greek word-sounds were determinate parts of the form, and the modern English version. Sometimes the difference is one of successive stages in cooperative planning and production. An architect's preliminary sketches and blueprints do not determine the final appearance of the building in all respects. Ordinarily, they leave the interior design and furnishing as well as the landscaping and planting to be at least partly decided by others. On the blueprint, these are partly determinate if suggested in a vague, sketchy way, so as to indicate merely the location of shrubbery. Different artists or groups of artists may thus determine different parts and stages of the final form. At any one stage, some traits have been at least tentatively determined, others left undecided. The occupant of the house may finish the process with personal furniture and movable belongings.

All these examples are significant from the morphological standpoint, as raising anew the basic questions: "What does the work of art include? What traits should be mentioned in a description of it? What traits are essential, integral parts of it and what ones are mere accidents or transitory, superficial influences like the momentary falling of a beam of sunlight on a picture?" Often it is impossible to draw a sharp line. There is a central nucleus of comparatively essential traits and an ever-changing margin of nonessential, accidental, or optional ones. There may be two or more partly different works of art, or stages or versions of the same one.

Some works of art are never completely finished, especially in the arts of time or performance, where the final details of presentation were left indeterminate in the original version. Each generation, each performing artist or director, finishes it in a different way, according to the taste of the time and his personal inclination. Thus organization and reorganization, adaptation and development, are often continuing processes, even in the case of a single work of art which is called by one name and credited to a single artist. The work of later artists, publishers, editors, and others who revise it is not limited to filling in the details left indeterminate by the original one. In bringing out an edition of an old play or symphony, they sometimes change the original specifications inadvertently or in the belief that they are correcting errors. Any change in the original context may produce a partly different work, as in removing a statue from a high place on a church façade or palace roof and displaying it on the floor of a museum gallery, spotlighted for dramatic effect.

All works of art have the power to stimulate trains of thought in a responsive, educated observer. Each has a nucleus of more or less definite, determinate ingredients, presented and suggested. They tend to activate other trains of thought if inclination and circumstances permit. The lines which these secondary responses will follow are left more indeterminate, either unspecified or vaguely specified. Farther from the nucleus is a zone of still more indeterminate meanings and associations. Ambiguous words and

figures of speech, cryptic symbols, and obscure allusions form this zone, which is often possessed of considerable emotive power. Whether it is to be considered an integral part of the work of art or other aesthetic form is debatable; that depends on how definite and cogent the suggestions are from a social standpoint. Their determinateness may depend on the firmness of connections in nature and culture.

Any incomplete representation or description of a familiar type of object or event is likely to be completed by the observer from his own background of experience, correctly or incorrectly. A description of a parade with flags or a black-and-white photograph of one, showing the stars and stripes of the American flag without indicating the colors, may be completed in imagination by those who know it to be red, white, and blue. A description of a character in a story is always more or less incomplete. Certain traits are specified as relevant to the story, such as a tendency to lie or steal. Others manifest themselves in the course of events. Important characters tend to become more determinate as the story proceeds and fills in gaps in the representation. No story, in drama or fiction, can specify all the relevant traits in detail. The writer tells us a few and we fill in the rest from imagination. If an illustrator gets to work, he may fill in the visual details in a way which is different but equally appropriate to the story.

"Determinate" traits and relations in a form are also called "definite" in the sense implying clearly defined, not vague or accidental. We call a thing "indefinite" if it is hard to recognize or classify as belonging to a certain type. Thus a color can be indefinite if somewhere between a red and an orange; a shape, if approximately square but rounded at the corners, not quite circular. Cloud forms in the sky are often indefinite in the sense of being vague, irregular, and shifting, but scientists can classify them as cirrus, cumulus, etc. Paradoxically, the indefinite can itself be definitely achieved and determined in a work of art, as in Monet's carefully contrived reflections on rippling water, with vague hints of underwater foliage. It can suggest the transitory nature of all phenomena. *Vagueness*, a tendency to leave things indefinite, can be a definite trait of character.

Ordinarily, modern taste has welcomed increasing determinateness in works of art, on the assumption that an artist should say exactly what he means and (in the performance arts) how he wants his works performed. But there are many exceptions. Theatrical and musical directors are often glad to have considerable leeway for their own interpretations. Complete determinism impresses some people as dictatorial;

complete perfection in the finished product, as too perfect, cold, and lifeless.

Reactions of various kinds occur. One, practiced by Michelangelo and Rodin, is to give the product an unfinished look, as if the form were gradually emerging from the rough stone block. Another, practiced by Mozart,[1] is to give the performer a choice of various melodic and harmonic sequences, thus introducing a little surprise and indeterminateness. A third is to emulate games of chance, which achieve surprise and suspense through leaving important outcomes to a "throw of the dice" or the equivalent. Music of this sort (by John Cage, for example) has been called "aleatory." It provides some possible sequences, as in the variety of timbres in so-called concrete music. The score is arranged so that these can be presented in different orders, through chance or sudden impulse on the part of the performers or the audience.

Such extreme latitude for momentary impulse is in the romantic tradition and usually implies some confidence in the unconscious or nonrational sources of inspiration. Leaving much to chance in the construction of a work tends to restrict complex development, which (in art at least) usually requires careful planning.

5. *Quality and quantity; definiteness; regularity.*

In the previous chapter we considered a list of qualities and other traits, classified under various components. One picture presents light reds and dark blues, another, straight and curving lines. One piece of music presents violin tones, another, piano tones. A sunset changes from brilliant yellow to dark purple, a piece of music from slow three-quarter to fast four-quarter time. One story contains much description of pain and suffering; another, much description of pleasure and mirth.

Many of the sensory qualities discussed in this book have been studied scientifically, with the result that variations in a certain type can be graded according to a standard scale. If we find a bell and do not know its pitch, we can ascertain it by comparison with a set of tuning forks. Colors can be described with reference to a standard color chart. Physical heat is not the same as sensations of warmness and coolness, but there is a fairly high correlation between them in ordinary experience. The same is true of pitch as measured physically, in terms of vibrations,

[1] In *Musikalisches Wurfenspiel*, Köchel anh. 294 d.

and psychologically in terms of high or low audible sounds.

When we try to describe qualities in terms of standard units or scales, we approximate quantitative measurement. We run into difficulty from the fact that subjective images and feelings are much harder to measure than objective, physical traits. In experience, the two often seem identical and inseparable, e.g., the hot day and the feeling of heat. But they are not so, and often deviate widely; we may feel quite as hot on a cold day because of fever, heavy clothing, warm food, or exercise.

Art, especially literature, frequently tries to estimate degrees and intensities in both subjective and objective qualities. It estimates the extent, duration, number, dimensions, capacity, multiplicity of parts, and all other quantitative aspects of experience. Ancient art sometimes goes into great detail on the number, size, and cost of things as symbols of power and wealth, as in the *Iliad*'s catalogue of ships and in Egyptian tombs where monarchs boast of their victories and tributes. Primitive warriors enumerate the number of heads or scalps they have taken.

As science has forged ahead, transforming vague quantitative estimates into precise measurements, literature has tended more to avoid the latter. Visual art and music often try to avoid forms which are too obviously measurable; which look and sound too regular. This tendency shows itself in repeating a theme *almost but not quite exactly,* with slight or obvious variations.

Critics have counted the number of times a certain word or image is used by a certain author, and scientific computers have been used for research, especially to characterize and identify styles. A picture can be described as to the numbers, sizes, shapes, and colors of its parts. Many other aspects of art could be counted or measured, if it seemed worthwhile to do so. For everyday experience and conversation, and in the history and criticism of art, we are usually satisfied with rough estimates of quantity, as in the intensity of a sensation, the size of an object, or the speed and duration of a process. There is no standard scale for grading the intensity of an emotion or desire, and no standard unit for measuring it. Here again, we are usually satisfied in daily life with rough estimates such as "very," "slightly," "hugely," "calmly," or "passionately."

Art often undertakes to convey a quantitative impression of some quality such as beauty, honesty, or courage, as in comparing two persons or depicting them side by side; for example, in paintings of "The Judgment of Paris." Which goddess is most beautiful?

Much literary description, narration, and lyrical expression refers implicitly to some approximate scale of "more" or "less" in respect to the things or qualities named. Poets often prefer to suggest a large or small quantity by a vivid simile or metaphor. Thus Milton tells us that the fallen angels are "Thick as autumnal leaves that strow the brooks/In Vallombrosa."

Qualitative and quantitative development may proceed together, as when the painter adds more and more differently colored figures to his picture. He can develop his picture quantitatively, placing more and more similar figures on a larger canvas, with little qualitative variation. Or he can introduce more qualitative variation within a single small unit, e.g., more harmonic and orchestral coloring in a single short phrase of music. Analysis may tell us that this effect is due to the simultaneous sounding of more different tones and overtones, but to the ear the difference is more qualitative. In morphology we must guard against the tendency to confuse the elements or parts disclosed by analysis with the total qualities and configurations grasped in unanalyzed, sensuous intuition.

The artist is often more meticulous in determining the number, size, and intensity of the details he organized than the observer is in recognizing them. An architect has to be very exact in specifying the sizes and shapes of the parts and openings of a building, but the public is only vaguely aware of their mathematical relationships. The same is true of music. In both, the observer may get a total effect of firm, clear-cut regularity and crisp rhythm, or an opposite one, without realizing just what unitary traits and relations are producing it. Music has become more exactly measured and determinate in certain respects through the centuries. The introduction of *musica mensurata* in the late Middle Ages and Renaissance was only a partial step in that direction, especially as to bar lines, rhythm, tempo, pitch, and duration of notes. The metronome allowed the composer still further exactness in determining tempo. A musical score is now determined by the composer with some explicitness in many components, including dynamics (loudness). The pitch of each string in the piano is determined by the manufacturer and tuner in terms of the frequency of sound vibrations. But the listener is not expected or desired to grasp these quantitative relations as exactly as the composer specified them. Few listeners—even professional musicians—would be able to do so.

When the qualities and quantities in a work of art are comparatively uniform and repetitious, or when they differ by regular degrees and intervals on a

graded scale, the total effect of the work tends to be definite and regular. The intervals between tones on a piano are approximately fixed in terms of standard units. The colors in a painting may all be selected from a standard scale of hues, values, and intensities. The parts of a house may all be made of units of a certain shape and size or exact multiples of these, arranged at regular intervals, as in a row of windows. The parts of a design may all be easily recognizable as standard geometrical shapes such as circles and triangles. When the overall shape or framework pattern is regular and definite, the whole form tends to seem highly regular and definite. Such tendencies appear in early geometric styles of pottery, textiles, and architecture, and also in simple tunes on a lyre or other instrument in which the strings or pipes are tuned at set intervals. In more complex ways they persist in the classical phases of civilized art, and regressions to geometric style (as in Cubism) sometimes occur in advanced cultures.

In the classical styles of advanced civilizations, there is a tendency to combine regularity and definiteness in some respects with the opposite in other respects. Geometric forms are thus combined with *biomorphic* (irregularly curving or jagged) ones as in the architecture and sculpture of a temple. Houses are surrounded by shrubbery. The regular intervals in pitch on a piano may be slightly blurred here and there by a sustained pedal. A melody in which pitch intervals are highly regular may be very irregular as to rhythmic intervals. Baroque, Mannerist, Romantic, and Impressionist painting tend to blur the definiteness of parts by melting lines, colors, shapes, and melodic contours, and also by irregular, unbalanced composition. The two opposing tendencies may be evenly balanced, or one may dominate, as in city streets without trees or shrubbery. Modern geometrical interiors often make use of an Abstract Expressionist painting for contrast: the blurred with the sharp-edged, the "blot" with the "diagram" (as Kenneth Clark has described them).

6. *Space and time in the arts. Position, direction, and movement.*

Space and time on a cosmic scale occur in the arts as suggested concepts; man does not build concretely on that scale. They are conceived as infinite or finite, but in either case as immense, as containers of the whole universe, in which all nature and organic life exist and move. As such they were vaguely terrifying to ancient

man. They made him feel small and weak. He shrank from the idea of infinity and preferred to imagine a comfortably small, earth-centered cosmos. As civilization and scientific knowledge developed, and as interplanetary space was explored by telescopes, the idea of its vast expanses, peopled with stars and planets moving in regular paths according to immutable law, seemed less terrifying. Instead it brought a thrill of pride in man's intellectual power as the "lonely watcher of the skies"—perhaps the only thinking being who could see and know the universe.

Much of the art, however, is still devoted to making man feel comfortably at home on the earth. As his ancestors burrowed in the earth or hid in caves, he covers himself with snug protective roofs, shutting out the mysterious expanse above. He makes his tiny rooms attractive and reassuring with furniture and pictures in scale with his own small size. He fills the day and much of the night with activities fitted into his temporal schedule, not too long or too short, such as plays and films to be seen with companions, concerts to be heard, and storybooks to be read.

Space and time are not to be directly perceived or presented in the arts; we see or hear only the walls or objects between which empty space exists, and some of the changes which occur in certain periods. We perceive the ways in which artistic materials are organized and developed in space and time. These are mostly apprehended and emotionally felt in relation to ourselves as standing, sitting, or lying on the earth which holds us down, with the sky above and with man and his works going on around us at about the same level, or perhaps a little higher or lower. Differences in size and duration, in height or distance, movements and changes which would seem infinitesimal from the cosmic standpoint, loom up as striking and significant from the human standpoint. (E.g., the size of Cyrano's nose). They are perceived together and estimated in relation to normal human size and to the periodic recurrences which make up human life from hour to hour, day to day, year to year, birth to death, and generation to generation. All infinite space with its galaxies, all cosmic time with its infinite past and future, fade into the distant background of experience as attention is brought by the work of art to a luminous focus in the fleeting present moment. The space and time in which man's art and life are organized are not radically different from those in which the cosmos moves, but a very small section of the larger space-time continuum, as lived in and through by humans on or near the surface of the earth. As an aspect of ordinary, direct, visual experience, the earth is still comparatively flat, huge, and motionless; the

stars are still points of light in a vast, dark firmament which turns above our heads each day. The astronomical facts we learn and imagine more intellectually.

Nearby space, on earth and in the visible stars and planets, is the frame of reference in which we locate positions and directions in the arts. We observe and describe the shape and size of any linear contour, of any surface, of any solid mass or volume, any opening or enclosed region, with reference to a set of spatial axes or other coordinates such as the latitude and longitude lines on a globe. Scale, in a spatial sense, consists in the relative dimensions of things, the size or degree of the parts or components, as compared with analogous things. Thus it applies to the relation between a mile on the earth and a mile as indicated on a map.

Physical space has three *dimensions:* length, breadth, and thickness. To these time can be added as a fourth dimension, making spacetime a single continuum or inclusive frame of reference within which motions and directions can be perceived and described. Instead of using all three dimensions in our spatial frame of reference, we may arbitrarily simplify it into two or one. In plane geometry or in describing a flat pattern we usually consider only two dimensions. A picture frame or rectangular canvas, with its four sides at right angles, provides the axes. Its vertical sides are normally perpendicular to the floor. Sometimes we use only one dimension in locating points, as in the position of a train on a track between two cities. Spatial positions and directions are described in such terms as here and there, near and far, above, below, inside, outside, between, through and around, right and left, east and west.

In each dimension of space there are two or more possible *directions.* In one dimension, we can proceed forward or backward, outward or inward. On a two-dimensional surface there are more possible directions in which to move or look, and in a three-dimensional space, still more. The direction and magnitude of a course (as of an airplane) can be described in terms of vectors. Pressures, thrusts, and pulls, as in the structures of cathedrals or suspension bridges, can also be so described.

Direction is a developed component in both visual and auditory form. Specific traits of visual direction, especially in the position, shape, and movement of lines, areas, and masses, are described as vertical or upright, horizontal, oblique or diagonal, converging or diverging, straight or curving, receding or advancing. By association, horizontal lines tend to suggest immobility or rest; vertical ones, rigidity or upward

movement; diagonal ones, instability or swerving, slanting movements.

Any of these traits can be determined in a work of art by presentation or suggestion. They are usually fixed and apperceived with reference to a human observer, such as a man standing vertically on horizontal ground. Direction outward from the center of the earth is regarded as upward; the opposite as downward. The walls of a house are seen as vertical and rising; the roof as flat or pitched and pressing downward. Directional interrelations within a work of art can be arranged and observed without reference to man on earth, e.g., as concerning objects within a space capsule. Perspective, parallax, and scale are visual phenomena involving direction, which are carefully controlled in painting and architecture, in painting especially in the more realistic styles.

By analogy with rising and falling in space, successive musical tones can also be interpreted as rising and falling. Progressive differences in loudness can suggest approaching, receding, or sidewise movement in the source of a sound.

Time is a relation between events, with respect to which they are distinguished as simultaneous or successive, and as becoming, enduring, or passing away; as changing or permanent. It is usually regarded as an aspect of reality, differing from space in that the order of temporal succession is irreversible. It includes such relations as simultaneity and concomitance, before and after, while, during, between, longer, and briefer. A moment in time is analogous to a point in space. Temporal scale is analogous to spatial; we can represent the relative durations and temporal positions of events by much shorter or longer spatial ones in similar proportions. A time span is a period contained between any two moments. It can be subdivided infinitely, as a line in space can be. Speed is measured in terms of the amount of space covered in a certain time span.

Silence, as a period of time without noticeable sounds, is somewhat analogous to empty space. The role of one in music and theater is comparable to that of the other in painting. In Chinese and Japanese painting one often finds large areas of empty space, with trees or figures occupying only a small place in one corner. Such an empty area can suggest the peace and vastness of nature as seen by the Zen Buddhist. Some Buddhist music consists only of a few notes on the flute, representing perhaps the cry of a bird on her nest, and followed by a long, unhurried silence, after which a few more gentle notes are sounded.

Western music is impatient with long rests and

eager to resume the onward march of sound. Orientals have called it all "march music." Likewise Western painting and tapestry tend to fill the space available. Orientals regard empty space and silence, in the proper time and place, as something positive, not merely an absence of interesting stimuli. Space and silence can give elbowroom for the more insistent stimuli and also help one to relax the tension of searching for excitement. To the Buddhist they present a model for clearing one's mind of unnecessary sensations.

Human thought seems to have the power to "go back in time," that is, to imagine going back, and also to pause at any moment and to leap backward or forward at will. Art often appeals to this imaginary power. The act of remembering or foreseeing is really a distinct event. We remember the past, hope and plan for the future. Very primitive peoples have little definite conception of historical sequences, although they make a step in that direction by remembering long genealogies and imagining how the world began. Civilization has devised more and more exact means of measuring time, as by sundials, calendars, and clocks, The units range from light-years to small fractions of a second. Most of them are based upon the rotation of the earth and its revolution around the sun or on the phenomena of radioactivity. By these means, we regulate our daily activities and plan ahead. We organize the records of past happenings into historical sequences, as seen from the moving present moment.

Time as a frame of reference in art, as in ordinary life, is a way in which events are organized in action, perception, and thought. It is felt as a period during which some action, condition or process starts, continues, or stops. Events are mentally organized in terms of yesterday, today, tomorrow, long ago, in the distant future, and so on. In experience, time is inseparably bound up with the concrete rhythms of day and night, summer and winter, eating and sleeping, work, play, and rest. Through our ability to control and perceive the temporal relations of events, we can synchronize them precisely in art if we wish to do so, as in combining different voices in music. Art usually deals with fairly short sequences of events, fairly close to the present moment, actual or imaginary. Music presents a short sequence of sounds to the ears, which we follow from the standpoint of the fleeting present. We remember some of what we have just heard as more and more of it recedes into the past and try to organize it in memory into a sequence. On this basis, we try to anticipate what is soon to come, but are often partly surprised, since the composer usually gives us sounds which are partly like those we have just heard, but partly different. As we hear the same composition again and again, we can anticipate more accurately what is going to happen. The structure of a short poem or piece of music can be remembered almost as an instantaneous whole.

Persistent emphasis on the development of spatial or temporal relations is a basis for comparing the arts as spatial or temporal, arts of rest or arts of movement, static arts or performance arts. All arts exist and are experienced in both space and time. Even in architecture and painting, one must perceive different parts in succession, but in the static arts more of the important details and interrelations are spread out so as to be perceptible at a single moment. It is hard to perceive the comprehensive patterns of complex music because they are not aurally perceptible at any one moment. They must be distinguished in memory and imagination, or in looking at the score.

In producing or describing a form whose parts are moving, we must consider time as well as space. We must see that a certain point on the object is at a certain point in the spatial frame of reference (e.g., on a theater stage) at a certain moment in the temporal frame or time span. Thus locating the point or object in a sequence of moments, we plot the curve of its movements over a period of time. Theoretically, the form of a ballet is capable of exact description or direction by choreography, in terms of three spatial coordinates and one temporal. But the movements are so complex as to be hard to specify in any easily understandable notation.

Stable objects in the margin or background of experience help us to perceive and estimate the direction and speed with which other objects are moving and changing. In a theater, this contrast is provided by the proscenium arch or film screen and all the interior details, such as walls, loges, seats, of which we are vaguely aware in the semidarkness. Within the brightly lighted area facing us, we easily judge slight movements. If everything were moving and changing at once, confusion and dizziness would result. Even in a painting of active figures in a landscape, where the movements are merely suggested, there are usually some objects known to be stable and vertical or horizontal, such as trees and houses. If not, at least the frame or surrounding wall may provide this concrete frame of reference. Motion in a part is one way of emphasizing it. Thus a tiny insect crawling over a blank wall attracts our attention; we notice and perhaps anticipate its erratic path and speed.

Both spatial and temporal relations can be definite

or indefinite, clear or vague, regular or irregular. The same size, shape, or interval can be repeated more or less exactly throughout a form, or many different ones introduced. An effect of comparatively firm integration is achieved by subordinating all or most of the details to some comprehensive pattern in space, time, or both, e.g., to the basic form of a chair or a statue in space, a fugue or a sonnet in time.

7. Presentative development in two dimensions of space.

Certain types of form present to the eyes a highly developed arrangement of images in two spatial dimensions. The third dimension of space can never be entirely absent from such a work of art as a concrete object, but it is often undeveloped. Presentative temporal development is also lacking when no definite order is arranged for the perception of parts. Nearly all Western paintings, prints, drawings, tapestries, mosaics, and other pictorial works of art are mainly two-dimensional in presentation. They present a rectangular area of space, or sometimes a round or oval one, usually flat. Where the wall presents a curving surface, as in a dome or pendentive, the picture surface will actually be in three dimensions. But the arrangement of presented images may not be much affected thereby, except to include some correction of the distortions involved. When early Italian painting contains areas in gilt relief, or when modern oil paint leaves slight ridges or impasto, there is a slight incursion into the third dimension. But that step is usually not carried farther in painting or the graphic arts.

As a rule, Western painting since the early Renaissance can be looked at in any order of details; it is indeterminate as to time. True, some details such as an expressive face or a highly colored garment may attract the eye and draw it back frequently. A line or row of figures may draw the eye along it, but the perception of the form as a whole is not necessarily much affected by whether we look first at the center, then at the lower right hand corner, then at upper left, or in some other way. In any case, we tend to fit the different areas together into a single complex percept. We may view the parts of a picture in one order and organize it mentally as representing a different order of events. Two persons can view the parts in different sequences but end with similar complex percepts of the whole (e.g., a battle or a chariot race).

A painting usually contains many two-dimensional shapes and positions within rectangular boundaries. It makes a considerable difference whether one of them

is a little higher or lower, larger or smaller, farther to the right or left than its neighbors. Care is usually taken to place lines, spots of light and dark and of colors, at exactly the points intended on the canvas. Within the picture frame, the difference between a vertical and a slanting line has much to do with the effect of the whole.

Textile designs are usually developed mainly in two dimensions of space, and are indeterminate as to time. Many other kinds of decorative art are often developed in this restricted way. Metalworking, ceramics, woodcarving, enameling, and other arts can develop forms in three dimensions, but are also much used to ornament comparatively flat surfaces. Slight grooves or ridges on a flat panel are a step toward three-dimensionality, but again this step may be undeveloped, so that the principal elaboration of detail remains flat. A rug may have a deep pile and thick fringe; a piece of velvet may be cut so that certain figures are actually a little higher than their background, on the order of a sculptural relief. If so, the presentative development is not completely restricted to two dimensions, but it is often comparatively so.

The fact that a certain dimension is undeveloped or indefinite in a work of art does not make it unimportant or worthless in the total aesthetic effect. It is not implied that greater development always means greater value. Certain aspects may be slight and subtle, yet play an influential role in the object's total effect as actually experienced. Time and the third dimension are comparatively undeveloped in a piece of lace, although some parts may be thicker than others. If the lace is pinned flat on a museum wall, its main development of linear tracery is spread out on a two-dimensional surface. But lace is customarily made to be worn upon the person, as a veil or trimming on a garment. Each thread can be seen as a line or as a slender, flexible mass. As worn, it is constantly moving and is seen from different points of view. It falls into delicate, soft folds and, being full of openings, reveals further layers of the same textile with lights and shadows, and perhaps different textiles or the skin beneath. So perceived, lace involves not only three-dimensional arrangement but a temporal sequence of different images.

Such arrangements and sequences are indeterminate in time. No particular fall of light through the folds of the lace, and no particular order of moving the folds is indicated in the form itself. At the same time, the general consideration of movement and soft folding has been influential in making the form what it is. One reason why it is not often mentioned is that a similar consideration applies to nearly all the examples of the same medium. We tend to emphasize

rather the traits which distinguish one example or style from another. But there is a danger in so doing that we may miss some controlling idea, so obvious as to be taken for granted, which goes far to explain the total nature of the art. Such controlling ideas are often embedded in the general artistic conventions or modes of life of the people who make and use the object. They help determine how the work of art shall be used and presented to perception, and hence what its presented qualities shall be. These qualities, vaguely felt as essential to the type, may disappear if the object is differently presented. Such conventions are taken by the artist as a tacit assumption, a point of departure and a general guide throughout his work.

Pictures are usually more determinate than textile designs as to which edge shall be regarded as the top, which position is to be regarded as right side up and which is upside down. Some textile designs are so determined: not only pictorial tapestries, but those containing flowers or other pictorial units, and intended to be made into garments. Rugs and carpets can be laid on the floor or hung on a wall, but in either case there is usually no difference between top and bottom. The design is often symmetrical bilaterally and vertically. In prayer rugs the design is usually directional and intended to be pointed toward Mecca, but as a purely aesthetic object it can be pointed in any direction.

A ceiling painting tends to be more indeterminate or varied than easel paintings in this respect, in that observers may look up at it from various positions below. When the vertical position is determinate, as in traditional easel pictures, directions within the picture also tend to be consistently determinate. Trees, houses, etc., are to be seen right side up, and this involves related suggestions, as of weight and movement. In many abstract (nonrepresentational) paintings it makes less difference how the picture is hung. One may have to look for the artist's signature to infer his intention. If hung in the opposite position, it is not necessarily spoiled, but the suggestions of weight, flight, and tension may be reversed. Usually the artist prefers to have it viewed in a certain position, and takes steps to see that it is hung accordingly.

8. Presentative development in three dimensions of space.

No sharp line can be drawn between two and three-dimensional development. From the flat wooden panel with a few slight grooves and ridges, or the textile with design embroidered or appliqué, to the low relief and thence to the high relief—this series involves no new dimension, but a gradual increase in the size, conspicuousness, and organization of differences in height or depth. A sculptural relief presents details at several different levels or distances from the back of the slab. There may be three or four distinct levels from the lowest background to the highest foreground surface, or a gradual curving in and out. Such differences are presentative, actual, and tangible; not merely suggested as in perspective painting on a flat surface.

A statue in the round, as of a standing human figure, is sometimes regarded as a complete development of three-dimensional form. It may be a solid in the physical sense, having empty space all around it, and yet fall short of full three-dimensional development aesthetically. The latter requires a considerable amount of differentiation and integration in the third dimension, so that the statue presents a developed form from many points of view. Hardly any statue is intended to be seen from directly above or below, and hence development in those directions is hardly to be expected. But, to be fully three-dimensional as an aesthetic form, the statue or other object must present a sequence of developed aspects as one walks around it. Different yet continuously related visual forms then present themselves as the empty spaces, hollows, and protuberances fall into new arrangements.

Many archaic statues are little more than a high relief which has been cut out from its surrounding slab. Only the front is much developed, and that mainly in two dimensions, through grooves and ridges over its surface. When the figure is looked at from one side, it presents a rather shapeless, vague, or flat, undifferentiated mass, a mere thick edge. The same may be true of all aspects except the front view. This is not necessarily a fault; the statue may be intended to occupy a niche or other permanent position in a wall where only the front can be seen. It is simply a lack of full three-dimensional development. On the other hand, an object may be very delicate and fragile, an arrangement of threads, wires, or glass tubes; it may consist of columns of water, vapor, smoke, or fireworks, and yet be developed in three dimensions. The same is true of many freestanding primitive Japanese flower arrangements. A primitive Negro mask may have little or no development as seen from the back, but much from various angles in front and at the sides. The same is true of flower arrangements which are to be placed against a wall or in a niche.

Architecture and landscape gardening have achieved most of their development in three dimen-

sions of space. Architecture carries spatial development farther than sculpture does, in that it presents not only a mass to be looked at from various standpoints, but an interior space or spaces to be occupied by observers. The whole exterior of a freestanding building is comparable to a sculptured mass, seen in the large. In addition, a building encloses an area of three-dimensional space with its walls, roofs, and ceilings. The observer walks about inside that space, and wherever he stands he beholds a different arrangement of planes in front of and around him. But not all architecture develops three-dimensional arrangements to a maximum degree. The interior may be a mere box-shaped room or set of rooms, so simple and regular as to present a rather similar aspect from any viewpoint. Its area of space may be so undivided or so lacking in details to punctuate it at various intervals, that the beholder gets no vivid impression of spaciousness. Development of an interior space may involve division into constituent areas of different shapes and sizes, as by colonnades, partitions, screens, balconies, and the like. It involves the creation of vistas, different from different points of view, as down an aisle, obliquely into a transept, through an arch or window, or downward from a balcony. By such means, interior space is differentiated and organized. As always, fully organized development requires that it be also subordinated to some all-embracing schema, as in a cathedral.

A garden, natural or artificial, is usually open to the sky, except for occasional porticos and summer-houses. Most of its organization is usually in two dimensions, on the ground as a comparatively flat surface. It is concerned with the size, shape, and arrangement therein of paths, flower beds, hedges, pools, rows of trees, and similar objects. The garden is usually planned in terms of a two-dimensional map. At the same time, a garden or natural landscape necessarily involves the third dimension, as the objects within it rise into the air at different heights. The ground itself may differentiate into hills and hollows. There may be a series of levels, from the bottoms of pools and sunken gardens to the level ground, to the tops of low flowers and shrubs, and thence to the tallest roofs and tree tops. In other words, a garden necessarily exists in three dimensions. But it is not developed as an aesthetic form in three dimensions unless these intervals, sizes, and shapes along the vertical dimension are differentiated and organized.

This may occur, for instance, if a steep hillside is divided into a series of ascending terraces, or if plants and trees of different heights are so placed that one can look over the smaller ones to a rising series of higher ones. A large, complex, picturesque garden contains an infinite number of possible aspects and vistas, according to the points of view adopted. As one moves along a path, all the surrounding objects keep arranging themselves into different groupings. According as more and more of the possible viewpoints are considered, and a definite complex vista is organized from each one, the garden is more highly developed in three dimensions. Many Japanese gardens are of this type.

On a still larger scale a whole town, city, or large region can be planned as a development in three dimensions of space. This requires designing it not merely on a map, but in terms of a three-dimensional model to include, for example, hills and valleys, open meadows, ponds and rivers, high buildings, trees, elevated roads and subways.

9. Presentative development in time.

It was noted above that all art exists and is presented in time as well as in space, but that temporal development implies something more than this. A house or statue may be looked at part by part, in temporal succession, but it involves little or no determinate change during the process. On the other hand, music involves a high degree of presented temporal development, in that the sensory stimuli proceeding from its performance keep changing in a determinate way. The precise temporal order in which the different sounds reach the ear is highly important in determining the aesthetic effect. To a lesser extent, there is temporal development in a static visual form, such as a row of statues along a garden path, if a certain order for perceiving the parts is somehow directed and makes a considerable difference in the total effect.

The presentative spatial organization of music—the question of the place or places from which it comes or seems to come—is comparatively indeterminate as a rule. The composer seldom specifies it, although there are some exceptions. Music flowers elaborately in time through the differentiation of auditory qualities and of temporal intervals and durations. Differences in pitch, timbre, and other presented ingredients are such that very little development can be perceived in a single moment as in a painting. A single complex chord can be played by full orchestra, but that is a small unit in musical form. The ingredients in a simultaneous group of sounds can hardly be distin-

guished without comparing them with different ones before and after. Only through varied, extended durations and successions of tones and groups of tones does music develop into complex melody, harmony, rhythm, design, and expression.

Temporal relations can be explicitly determined in the musical score or literary text, or explicitly left indeterminate, as by the phrase "ad lib." When not explicitly determined, they can be enforced with any degree of definiteness by social custom and convention, as in raising one's voice at the end of a question.

Spatial considerations do affect both music and spoken literature, but rather as general, attendant circumstances than as distinguishing factors in form. To be perceived clearly, any sound must come from a place where it can be heard with the proper blending and loudness. Hearing is often assisted by the ability to see the lips of a speaker or singer, or the movements of a violinist. The acoustics of a theater are essentially a matter of controlling the reverberations of sound within a three-dimensional space, roofed or open.

Ordinarily, under modern civilized conditions, we hear music or spoken literature emanating from a place on about the same level as ourselves or a little lower, toward which we face. Sometimes the sound is highly concentrated, as from a single performer, or from a radio, phonograph, or other sound projector. The members of an orchestra are so numerous that they must be distributed somewhat from left to right, and we often hear their music as emanating from different points, although the conductor usually attempts to blend these different tones into one or at most a few composite sounds. In the theater, different actors speak from different parts of the stage. There the effect of blending is not so much sought after as the clarity of each individual voice. For that reason, the dramatist may specify with some definiteness that a certain speech is to be delivered from the left front part of the stage. This is a case of development in space as well as time. But ordinarily most of these spatial arrangements are left indeterminate by the dramatist, and are not considered as essential parts of dramatic form as literature. If we consider the play as finally worked out by the director or stage manager, it is a more highly developed form than in the pages of a book, for it includes fairly specific directions as to the movement and position of the actors.

Modern conventions, such as the practice of hearing music in a concert hall from chairs facing the musician on a stage, exert a profound influence on the nature of the form itself. Music to be heard in that way tends to be very different from music to be heard while marching, dancing, or working. For concert music, the audience tends to sit quietly instead of participating and is able to listen undistractedly to complex, finely differentiated musical forms. Aside from all modern developments, it is well to remember that both music and literature were originally auditory arts, with no visual notation, no stages, and no concert halls. They were sung, played, or chanted around a campfire, in the marketplaces, fields, and roads, or in the feudal hall where a wandering minstrel regaled the evening assembly. Their freedom from definite spatial requirements made them well adapted to the conditions of nomadic and pastoral life.

Literature can be spoken or chanted aloud, and as an auditory art is somewhat like music. It is presented as a temporal succession of sounds which differ from each other in timbre, loudness, pitch, and other qualitative respects. The spatial source of sound is usually not specified by the author. Both literary and musical form can be conveyed to the trained reader by the visual symbols, and in literature this mode of presentation (on a two-dimensional page) has become common. So has tactile presentation for the blind. The exact size, shape, position, and arrangement of the letters is not usually considered essential to the literary form. In music, visual presentation has not come to be a common substitute for hearing, and is mainly an aid to the skilled performer, composer, and critic.

In either of these arts, temporal development can remain within a small compass, or can extend into the long duration of a novel, epic, or symphony. In either art, there can be various degrees of definiteness as to the precise temporal order of details and constituent parts. There has been a historical development from the loosely organized suite of independent dances, which could be played separately or in different orders without destroying any important unity, into the sonata and symphony, where they fit into a more or less unified whole. A separate movement can be played alone and the order can be varied, but the sequence prescribed is ordinarily considered important. Some early compositions in the form of theme and variations are not necessarily to be played in any fixed order. Primitive music is often so repetitious that its parts, large and small, can be interchanged. It may have no definite beginning or end.

In literature, there has been a development from the primitive tale or legend into the loosely strung heroic cycle or anthology of narratives, and thence

into the fully integrated long epic or novel. An intermediate type is the anthology which is connected by intermediate links of running commentary, or by a single inclusive tale. Chaucer's *Canterbury Tales,* the *Arabian Nights,* and the *Decameron* of Boccaccio, are all examples of this type. There is a slight attempt at pervasive unity, but the constituent tales are more or less independent and detachable. The *Arabian Nights* is further complicated by the fact that some of the stories join into small sequences which are connected among themselves, one within another. We may judge the degree of development by the extent to which any such constituent part or group can be plucked out of its context without destroying essential order. Usually within a single story or within a single dance of a suite, there is fairly high temporal determinateness, but much less between the dances or tales as complex units. Since the Renaissance we have had another intermediate type in the sonnet sequence, where any constituent poem may be plucked out and read as a unit, but where there is some unity or development if all are read in a certain order.

10. Presentative development in two dimensions of space and in time.

In spite of its auditory origin, literature has been transformed by the printing press and mass education into an art which is largely visual in presentation. The spread of radio, television, and sound films has done much to revive it as an auditory art, and this trend may be carried further in the future. But there is a great deal in modern literature that is more adapted to visual than to auditory presentation. The habits of educated people lead them to read rapidly, taking in whole lines or paragraphs at a glance, and they become impatient of slow pronunciation, actual or imaginary. The form of literature itself becomes adapted to its intended presentation in letters on a flat page. Punctuation, italics, changes of type, arrangement of words on a page, are apprehended as to their meaning without the need of clearly imagining the significant changes in tone of voice, the pauses and accelerations, the rises and falls in pitch, which they have traditionally meant. These can act as alternative symbols, as in reading aloud; but in silent reading we tend to dispense with them unless there is some special emphasis on sound. Many visual signs are presented which are not intended to affect pronunciation. The educated person can read without even

mentally pronouncing many of the words. This is an age of rapid prose, in which we have little time to hear or even to imagine verbal sonorities. Much scientific writing, in complex symbols, chemical formulas, and mathematical equations, is hard to read or understand aloud. Often its visual symbols are international, while their pronunciation differs according to the language of the speaker.

In Chinese classical literature visual presentation was also important. It is still the only way in which a particular work can be understood in all parts of the country. The written language is universal among highly educated persons, while the same written character is pronounced in different ways in different places. Significantly associated with this fact is the great development in China of calligraphy. This involves qualitative development (e.g., shades, textures, and shapes of the brush stroke), but its principal development is usually in two dimensions of space and in time, over a flat surface of silk or paper. The characters can also be carved or cast in hard materials. They follow a definite arrangement in space, except for the nuances which an individual artist may introduce. They are to be perceived in a definite temporal order.

To a lesser extent, typography has become an art with us, usually as an adjunct to literature, but with its own conceptions of form. Much of its work, in arranging the shapes and positions of letters, is to facilitate effortless reading and to emphasize certain ideas. But it is also interested to some extent in the shapes and arrangements of letters for more purely visual reasons.

Painting is not always an art in which time is indeterminate. From early in the history of pictorial art, in Egypt and Mesopotamia, there have been series of pictures to be viewed in certain order. Each picture may present a stage in a victory, a procession, or the seasonal activities of workers. By viewing them in the proper sequence, one grasps the suggested continuity among them. Many mural paintings, including the *Odyssey* series in the Vatican at Rome and some by Giotto at Assisi and Padua, are in *picture-sequences.* So are the panels depicting the Stations of the Cross around the interior of a church, and many of the small pictures, especially of lives of saints, which often appear on the predella of a medieval altarpiece.

Chinese horizontal landscape scrolls involve temporal determination, in that they are to be viewed in a certain order, usually from right to left. As one rolls up one end of the scroll and unrolls the other, a changing yet continuous panorama of landscape is

disclosed. Sometimes the picture can be seen in either order; sometimes it works up to a climax in one direction and is regarded as less effective when reversed. But in any case, the picture is not to be unrolled entirely, fastened on a wall, and viewed all at once or at random. Once started on the sequence, one is expected to follow it on the whole, though one's eyes may rove around to some extent within the area disclosed. The horizontal sequence is thus more determinate in time than vertical or other sequences along the way. In Japan the narrative scroll, when involving a sequence of pictures representing successive incidents, was likewise to be viewed in temporal order.

All the types just mentioned have been static forms. In painting, calligraphy, typography, and printing, the object stays comparatively motionless, except as one turns the page or unfolds the scroll. Printing is sometimes mobile in electric signs and motion picture subtitles. Several important arts are mobile. The shadow play is one of the oldest of these, going back into remote antiquity in many parts of the world. It involves the presentation of flat silhouettes, either white or colored, as thrown by opaque or translucent objects between the screen and a light behind. Its great modern descendant is the cinema. All of these involve a temporally determined succession of moving, changing images on a flat screen.

Perhaps the most highly developed example of temporal determination in art is to be found in the modern motion picture, especially in the filming of animated cartoons with music and other sound effects. The most precise coordination is achieved between the sound track and the movements of figures across the screen. It involves the exact synchronizing of each step or gesture with a certain musical note or noise in the sound effect score. The presentation of the film to the public is also performed at a standard speed, so that the speed of each movement within it is determined in relation to the speed of projection.

Nonrepresentational shapes and colors can be effectively projected on a screen from front or back by means of motion picture film with presentative development in two spatial dimensions and time. This can also be done by the "clavilux," a keyboard instrument invented and used by Thomas Wilfred. (Smaller automatic models are also made). The clavilux projects colored lights directly on the screen without the use of a previously prepared film or sound track, and is thus capable of extempore performances. In either way, organized sequences of visual forms somewhat analogous to those of music can be produced. The forms may suggest movement in the third dimension and similarity to other things, or may be purely abstract. The art so produced has been called lumia.

11. Presentative development in three dimensions of space and in time. Four-dimensional development.

Many kinds of art are developed to a low degree in all of these dimensions: for example, the art of *cuisine.* The form of a modern dinner de luxe is a fairly complex cultural product, the result of long social experiment, tradition, and cultural admixture. Its qualities are addressed not only to the senses of taste, smell, and touch but also to the eyes, and auditory stimulation is not lacking at the feast or banquet in the form of music, conversation, and the clatter of dishes. All this may be highly indeterminate, impromptu, and apparently without conformity to any definite order. But the sequence of courses in a formal repast is determined with some exactness, from the appetizer through soups, entrées, meats, and salads to the final sweet dessert. It involves a conventional sequence in beverages as well, from the cocktail or dry wine to the liqueur and coffee. The appearance of foods and drinks is planned in relation to dishes, glassware, silver, flowers, and textiles; all are arranged in visual designs. Such a sequence is related to physiological conditions, as a way of sustaining appetite and enjoyment throughout the occasion.

We have noticed certain aspects of *gardens, architecture,* and *town planning,* treating them principally as examples of three-dimensional form with time indeterminate. But all of these also involve motion in time, both determined and undetermined. From the castle walls pennants waved and drawbridges rose and fell. Weathervanes turned upon turrets, bells swayed, pigeons fluttered in and out. Human beings, variously dressed, entered and left. Sculpture and sculptural reliefs, as seen under ordinary conditions in the ancient world, were subject to frequent change of lighting. They stood outdoors, where the sun swept daily overhead and cast a different set of shadows at every moment of the day and every season of the year. Or they stood indoors, where torchlight, candlelight, and sacrificial fires, together with fitful rays from the outside sun, produced a succession of flickering gleams and shadows over their surfaces. The cold uniform light of a museum makes sculpture appear as far more static than it used to seem. Still photographs of ballet, cinema, and theatrical performances tend to

make us think of these arts, too, as static. Shifting sunlight through stained glass, candles upon the altar, and torches fixed on columns, produce changing sets of presented visual traits and different arrangements of them in three-dimensional space.

Are such changing aspects systematically organized, or left to chance? If the former, then the building is developed in time as well as in space. Ordinarily they are not so organized, but in some cases temporal determination is achieved. This occurs wherever details are arranged so that the moving spectator will view them in certain order. Any building or garden may have a main entrance, then a path, corridor, stairway, or hall which the visitor is likely to traverse. Along the hall may be sculptured or painted panels which he is expected to see in a certain order. The interior of a Baroque cathedral usually provides the observer with a sequence of vistas from the entrance, leading to a climactic burst of sculptural ornament and illumination around the altar. The walled town of ancient and medieval times had a great gateway and a street which led therefrom to the marketplace, the king's palace, and the temple or cathedral. As a rule the visitor beheld the details of the town in a certain order on his first entrance, and the cathedral or palace came as a powerful climax. After that he might move around as he pleased, but the first memory of that sequence would be likely to remain in his memory of the town. Modern cities, when laid out with artistic planning (as they usually are not) sometimes involve a systematic approach, as from the water side or principal highway, between entrance pylons, up a broad avenue to a park with its arrangement of buildings and monuments. A planned city with traffic control is partly determinate in all four dimensions including time.

Any garden or outdoor scene presents, especially in temperate climates, a profusion of changes according to the weather and season. Leaves change from light green to dark and then to red and yellow (a qualitative change in hue and lightness). They also change spatially, as vistas obscured by heavy summer foliage reappear when autumn strips the branches. Winds blow the clouds and treetops in one direction and another. Rain, mist, and snow soften sharp contours and cover familiar surfaces. The great estates of aristocracy were not complete without the deer and peacocks moving slowly through the parks and over the lawns, the sheep and cattle in the meadows, the fishes swimming and rising in streams and pools, the cascades upon hillsides, the doves or falcons circling in the air.

All these display mobility in time, the changing aspects of a work of art. They are often simple and undeveloped, left to chance determination, irregular in their arrangement of details, by comparison with the great static development of these forms in space. Such effects tend to disappear when we make a schematic drawing or photograph of the object for technical analysis. They are presented in the actual experience of the object under normal conditions, but are commonly omitted and ignored in theoretical studies of art.

What of time in the observer's own movements toward these forms? In perceiving a garden, a cathedral, or even a statue, he must move for the sake of thorough perception. He must move not only his eyeballs, as in looking at a picture or the front of a statue, but his whole body, around the cathedral, along the nave, up the stairs, to the balcony railing. He must turn his head, look up, down, parallel to the walls and diagonally, if he is to see the diversified aspects which a cathedral form presents. The same holds true of perceiving a garden, a town, or any extensive outdoor scene.

To what extent is the temporal order of such perceptions determined? Obviously much less so than in reading a book or in listening to music. Ordinarily there is no one place to begin in looking at a building, a garden, or a town and no one necessary sequence of steps thereafter.

A garden may have many paths which turn, divide, and meet. Ordinarily, the stroller's progress is not restricted to any one sequence, and indeed the temporal sequence may be entirely indeterminate. But an intermediate stage is reached in many highly developed gardens, of which we have already mentioned the Japanese. There the visitor is free to follow a given path in either direction, and to take the right or left branch of a forked road as he pleases. But, once started on a particular path, he is likely to go along it for some time. A high development of garden art consists in arranging the sequence of views along each path so that they form a somewhat differentiated and unified sequence. This sequence can be reversible so that the path may be followed in either direction. The same is true of an avenue or approach in town planning: it may be so arranged as to make an orderly, differentiated sequence, either from outskirts to center or from center to outskirts of the town. Along a Japanese garden path, one may go from the dwelling house over stepping stones in a little brook, up a wooded slope, around a bend with a view of a curving bridge, around another turn with its view of

mound shaped like a mountain, past a waterfall in a grove of birches, and so to the rustic tea house. Returning, one sees the same vistas from a different angle and in opposite sequence; but either order provides some amount of continuity, variation, contrast, and perhaps a climax.

We have noted that a garden or landscape design is in some respects a mobile form. Some of its movements are indeterminate. Where and when a particular fish will turn in the brook, when a particular leaf will turn yellow or a flurry of snow descend—these things are not subject to human determination. But within broad, flexible limits even such effects as these can be included in an organized scheme. A bank of shrubbery can be so planted that it will present a sequence of different colorings, from the pale green and pink of the cherry blossoms through the deeper red of azaleas, through the vivid hues of summer to the red maples and chrysanthemums of autumn. Every vista in the garden can be so arranged as to how it will appear at various stages of the year's recurring cycle. The foaming cascade of water on mossy rocks can be placed with forethought in a spot where other things are dark and static. The movement of red carp in a stream, though indeterminable as to small details, can yet be circumscribed within the limits of that stream, and considered in relation to red foliage, a curving red lacquer bridge, and the sinuous lines of willow branches. The fall of snow upon the garden can be foreseen, and so can the withering of deciduous leaves in the winter. Unfading moss can be placed instead of grass upon a miniature lawn, and dark green pines or hemlock arranged for contrast with the snow.

It was mentioned above that even architecture, supposedly the most static of arts, has its mobile aspects, but that these are usually undeveloped. For example, an architectural façade is subject to variations of light and shadow, at different times of the day. Highly developed architecture takes account of these changes, and makes them somewhat determinate. It arranges its orientations, projections, and recesses so as to produce a certain effect of cast shadow at any hour of the day. The architect may wish to avoid an effect of unsteady bending in the columns, or confusion in sculptural ornamentation. As the use of indirect artificial lighting at night becomes more common, the possibility of controlling both exterior and interior lights and shadows is extended. France has recently led the way in cleaning and lighting its public buildings, inside and out.

Mobile structures for transportation, such as boats, carts, and chariots, are among the oldest and most universal of human products. They are not included within a narrow conception of architecture. But architecture in a broad sense as "the art or science of building" may be taken to comprise mobile as well as stationary structures, especially those large enough for people to enter, work, and even live inside. Any conception of architecture which omits the modern transatlantic steamship (rather a compact and highly developed temporary city than a single building) is an extremely limited one. Much of the genius that went in other days into building static edifices now is turned, under the stress of our restless urge for travel, into vehicles of transportation. We have the railroad train with its pullman cars or *wagons-lits*, compressed and highly organic machines for mobile living. We have the automobile with its tiny yet commodious and minutely differentiated interior, and the trailer, adapted as a mobile home or commercial establishment on wheels. We have the airplane, furnished with rooms for sleeping, eating, and all the necessaries for living during a period of days at a time. The space capsule is following that example. These are our most elaborate developments of architectural form as a mobile art in four dimensions, three of space and one of time. Yet, by comparison with the immense variety of movements of which a bird in the air is capable, the movements of these and other humanly made machines are not yet highly complex or differentiated.

Turning to minor visual arts, we may notice in passing the forms produced by *fireworks,* and by neon and other kinds of *electric lighting.* Though rather simple so far, they exceed all other arts in luminosity: in the intensity of colored light as seen directly at its source. Technical methods are rapidly endowing neon lights with the necessary variety of hue and flexbility of construction, so that they may become a vehicle for complex visual form as well as of mere advertising letters. In Japanese cities, this medium was quickly turned to considerable decorative use. The characters of the Japanese language are elaborate and patterned in themselves. When illuminated in large size against a night sky, when made to change and combine with abstract decorative patterns, they enter the realm of temporal as well as spatial form. As yet, the three-dimensional aspect has not been much developed. Fireworks are even more luminous and mobile. The ascent of a skyrocket in a line of fire against a dark sky, its successive bursts and showers of red, green, white, and gold sparks, its fiery streamers darting out in all directions, entitle it to consideration as an art in time and three spatial di-

mensions, in spite of the brevity and simplicity of its usual course.

Certain contemporary artists, especially Calder, have devised mobile sculptures, designs of metal, glass, and other materials, whose parts are to be seen in motion. Usually each part is suspended so as to have its own limited orbit, which combines with others to produce a complex four-dimensional form. Sometimes the motion is rather indeterminate (e.g., as the parts are blown by a current of air), and sometimes more definite as in a machine. Such forms have been influenced by the recent tendency to look upon machines themselves as aesthetic forms, whether stopped or in motion. There have been similar trends in past ages. Hero of Alexandria made mechanical clocks, puppets, and other forms, which were moved by steam and water power. They were regarded as artistic amusements, rather than as purely utilitarian devices. The Arabs made automata with rich materials and careful craftsmanship, as clocks and table fountains.

The principal "time arts," music and literature, usually leave their spatial aspects indeterminate, but not always. Even under the conventional restrictions of a modern concert hall, the composer sometimes indicates a slight spatial determination. In Beethoven's *Lenore Overture,* an instrument is to be heard offstage. Such effects of timbre, as of muffled softness produced by distance, can however be artificially produced, and the actual spatial location is hardly essential to the musical form. In Wagner's opera *Parsifal,* chanting is to be heard from above the stage, by choirs of singers in a dome.

Such occasional effects are surviving vestiges of the antiphonal conception of music, in which space was more important. (An antiphony is an anthem, psalm, or musical composition sung alternately by a choir or congregation divided into two parts.) This mode of organizing music into responses from groups at different points in space was common in the medieval cathedral, where it fitted into the architectural setting. Detached choirs of singers or instrumentalists were sometimes placed at remote parts of the cathedral, as in high balconies across from each other. Antiphonal music occurred likewise in the Greek drama from primitive times, as groups of actors entered chanting from opposite sides of the stage. There is a substantial trace of it in the oratorio, a form popular into the early twentieth century, with its choirs of singers grouped in space according to the pitch of their voices. In highly developed antiphonal music, as in the cathedral, the hearer is within the music, whether he himself participates or not; he is surrounded by,

and hence may feel himself a part of it, in a way impossible under the spatial arrangement of a modern concert hall. There, only the player in an orchestra is literally surrounded by music; the audience is not only more passive but detached, observing from a distance. Stereophonic phonographs and records detach certain voices in symphonic music from each other, making them sound more distinct as if coming from different sources.

A ballroom dancer, like a musician in a chorus or orchestra, not only participates in but is spatially surrounded by the work of art. But the observer of a ballet or solo dance in a theater sees the dance as an aloof spectator. Except insofar as the audience floor and balconies are wide and high enough to provide slightly different points of view, or when an arena stage is used, the spectacle is usually seen from in front and center, as in a picture frame. It is arranged mainly for the benefit of persons on the orchestra floor or pit and in the lower tier of boxes; those higher look down on the heads of the dancers. The result is a radical difference in the form of the dance, from what it is when spectators surround the dance or move among the dancers. In the ritual pageantry of mass in a cathedral, the procession moves through the congregation to the altar, then back again at the close. Modern theater conditions circumscribe the development of dance form in space, although enriching it with control of lighting and other factors. Acrobats in a circus, especially trapeze performers, develop their otherwise limited art more extensively in three-dimensional space.

The stage play, the marionette show, and pantomime are all presented in three dimensions of space and in time, with some amount of determination in all four dimensions. We tend to think of the first two dimensions as vertical and horizontal, right and left, up and down. The third (as suggested in painting) is then depth, near and far. In ballet, the presented aspects are organized in four dimensions. On a horizontal stage as seen from in front, the form is highly developed as to movements (1) between right and left and (2) between near and far. In the vertical dimension (3) it is more restricted by gravity. The dancers can leap, bend, stoop, or lie on the floor, but only within a small range up and down. Within this range they can achieve an intensive development of subtle, expressive gesture and posture. But the upper part of the scene is usually filled only by the backdrop and other static properties. Some designers have realized this limitation and sought to escape it by constructing various levels upon the stage, on which the actors may move up and down. Ramps and balconies along

the back and sides of the stage, stairs and platforms near the center, are moderately effective toward this end. Any deep arrangement on the stage may look differently to spectators at the right and left sides of the audience; hence the arrangement is often somewhat indeterminate as far as its presentation to various eyes is concerned.

The modern proscenium stage, while imposing some restrictions on movement in three dimensions, has produced an intensive utilization of the remaining opportunities. Slight gestures and even facial expressions may be counted on, through the aid of efficient modern lighting, to reach hundreds of spectators, and hence to become definite factors in form. Moving silhouettes and costumes can be placed in front of a backdrop or group of other actors, with the assurance that they will be seen against some part of it, in the relation of figures to background—a relation which cannot be determined when the audience surrounds the actors. Efficient acoustics and the art of diction cooperate to provide a clearly organized set of auditory stimuli in time. On the stage, a voice can be heard as definitely coming from one side of the stage and from one actor's mouth or another's, so that spatial development is auditory as well as visual. Opera carries out this joint development of visual and auditory forms along many lines and in all four dimensions, though not always with uniformly high development.

It is characteristic of our age that increasing numbers of people are spectators of the arts, rather than participants in it. The widening gulf between the work of art upon a theater stage or museum wall and the detached onlooker applies to some extent in popular games and sports as well. Thousands now watch baseball or football games who never play these games. The game, as played by skilled professionals according to accepted rules, takes on to some extent the attributes of an artistic form in three-dimensional space and time, to be perceived as an aesthetic object. Our conception of art will be narrower than that of the Greeks if we exclude from it all athletics, games, and sports. To what extent they are, as now practiced, art rather than mere skill or commercialized entertainment is a question into which we need not enter at present. But it is worthy of notice in the present connection that millions of people, especially the young, spend their time voluntarily at the practice or observation of activities which involve a fairly high development of motion in time and three dimensions of space.

Some sports, such as swimming, diving, yachting, and flying, do not always involve any definite game or set of rules. The performer may execute a specialized type of movement in three dimensions, perhaps with as much speed as possible, but with speeds and orders of movement more or less undetermined, subject to his present whim. The observer watches these with an eye to the degree of speed, grace, and agility displayed. Flying in military formation involves complex four-dimensional coordination. When the event is a race or competition under established rules of procedure and fair play, it takes on more the attributes of an established cultural form. Who shall stand where, who shall move first and how, in what order the other participants shall act: in a baseball or football game these are elaborately determined within flexible limits. The same is true of tennis, polo, fencing, and boxing. Their degree of determinateness in space, time, and causality helps to take them out of the category of mere feats of strength or aimless scuffles.

What is undetermined in them and what distinguishes them as games is the competitive element. Unlike a dramatized version of a battle or duel, the game (if honest) is not determined in advance as to who shall win, or as to the precise moves at any moment. In fact, although the moves are in some ways minutely determined at every second of play—in the sense that there are many things one must not do, and comparatively few things permitted—yet the range of indeterminateness is sufficiently wide to allow either side to gain at any moment by some unpredicted turn of luck or skill; thus keeping up suspense and uncertainty as to the future course and outcome of the whole activity.

By comparing these various kinds of presentative, space-time organization, especially in the visual arts, we have distinguished the following types:

1. Those in which presentation and perception are largely restricted to one viewpoint and hence one main, highly developed aspect or vista. These are static, *single-aspect* forms. Most painting is of this type. Some change in the observer's position in viewing it is possible, and also some change in conditions of presentation such as lighting, position of picture, etc., but these are usually not determined or counted on to produce significant, desired changes in the form.

2. Those in which the form is developed and adapted for perception from many viewpoints and under different conditions, as of lighting and movement. Sculpture in the round, architecture, decorative clothing, ordinary gardens, and many other arts may belong to this type. They provide *many-aspect* forms, but these forms are usually not strictly or elaborately

determined as to nature and sequence. The forms are static or indeterminate as to sequence of aspects and possible changes.

3. Those in which the form includes many different aspects, to be seen from one or many viewpoints, all or most of them being determined rather strictly as to nature and temporal sequence. These include the arts of performance, such as ballet and cinema, where the sequence of changes must be managed in a certain definite way in order to produce the desired effect. Here the spectator usually stays in one position while the work of art changes and sends out different stimuli. Some highly developed landscape design involves determinate change in the landscape itself as well as determinate movements by the observer, as in following a path.

12. Suggestive development in space and time.

Any ingredients and any way of organizing them can be suggested to the imagination and understanding. Among the arts, literature has the greatest range and variety in this respect. In exchange, it sacrifices much in the way of sensuous vividness.

Through spoken or written words, literature can help us to imagine a rug design as developed in two dimensions of space, a house in three, a sonata in the dimension of time, or a ballet in four dimensions. All the arts have, to some degree, the power to suggest other ingredients and modes of development in addition to those they present. Thus, the work of art may comprise two structures, one presented and one suggested. These may coincide to some extent or differ radically. Even if both are developed in the same frames of reference, the structures produced therein may differ. If a piece of music entitled "The Shepherd's Flute-song" is played on a flute, the presented form (actually played) resembles the one it suggests (that of a shepherd playing somewhere else). The suggestion is mimetic. However, if we read silently or listen to the quiet reading of a story about a battle, the presented arrangement (that of the printed or spoken words) will differ radically from the suggested one (the imaginary battle). Here the suggestion is through linguistic symbolism.

Theoretically, literature can suggest an organized form in any degree of complexity. In practice, to describe a very complex form in sufficient detail to let us imagine it clearly may strain the patience and imaginative powers of a reader. It would be hard to describe in words a long, complex symphony in such a way as to make it vivid in detail, even to a musically trained hearer. Yet it is not completely impossible. To convey an imaginary conception of a cathedral in great detail would be easier by means of a motion picture film than by words alone. On the other hand, if we want to suggest how some character thinks out an abstract, theoretical problem, it might be easier to do so in words.

Literary descriptions of scenes and processes are usually much less complex than the medium would permit. Very exact, detailed description, narration, or exposition is apt to slow down the story and lose the reader's interest if much prolonged. But authors frequently describe in great detail some crucial situation, scene, or episode, for the sake of emphasis and understanding. In a detective story, the author may describe minutely (in four dimensions) where each character in a room was standing at the moment of a murder and what he was doing or saying when the shot was fired. Some writers like to make us imagine a landscape setting in great detail; some, the appearance and manner of a character. A long play or story may represent some episodes in detail and then skip rapidly over others to the next important situation. Thus different parts of a play, story, or poem can be compared as to the extent to which they build up complex suggested forms in space, time, and other frames of reference.

A motion picture is presented in two dimensions of space plus elapsed time; a stage play, in three plus elapsed time. Both also build suggestive sequences of scenes and actions which the spectator is to imagine as taking place far away in time and space from the actual present moment. If he is reading a story, he imagines the events as far away from the present presentation—that in which a printed book presents letters to his eyes. In watching a film or stage play, one knows the action depicted is separate and far away, but tries to merge the fantasy with the present presentation, that is, to project one's fantasy upon the situation here and now on the stage or screen in front of one. While knowing in the back of one's mind that the two are different, one tries to get the illusion and suspend disbelief for the time being.

Thus, the presented and suggested sequences may coincide or overlap to a varying extent within the observer's aesthetic experience. In analyzing the work of art as an objective form, it is necessary to recognize their distinct and often very different natures. While fixed in his chair at the theater, the film observer may be instantaneously transported, not only back to ancient Rome, but back and forth from one place and time to another, always there to watch

another important episode. Thus the film escapes from the presentative limitations of the stage play, allowing the suggestive form to be much more independent of the actual here and now, as well as from dialogue and gesture. Its potential range in suggested spatial and temporal development is infinite. For this gain, as usual, it sacrifices other resources.

In a more limited way the Chinese hand scroll, the newspaper "comic strip," and other picture sequences can also suggest movement in three-dimensional space and time, thus building up an imaginary sequence of events which is more or less different from the presented one. In the Chinese landscape hand scroll, the imaginary movement is primarily that of the spectator himself as projected into the imaginary landscape. As from a bird's-eye viewpoint, he may fly as slowly as he wishes past the hills and valleys, turning now and then to follow a mountain path on foot, up to a temple or cottage. In the Japanese narrative hand scroll, as in the modern comic strip or other picture sequences, the observer may do some of the moving, but the emphasis is on the actions of imaginary characters whose figures recur in successive scenes, representing the same or different locations.

European painting in the Renaissance and Middle Ages often represented different stages in a story in one picture; not as a sequence of distinct pictures. "The Rape of Europa," as treated by Francesco di Giorgio and later by Paolo Veronese, was a favorite subject; another was the stations of the cross in the ascent to Calvary. Usually, in such a picture, the suggested temporal sequence is not quite so clearly determined as in a sequence of separate pictures. One tends at first to interpret the picture as a simultaneous scene. Later, one perceives the recurrence of figures, perhaps along a winding road. This type of picture went out of fashion when taste came to favor the single vista, as it would appear from one point in space at one moment of time, under one set of atmospheric conditions.

The presented arrangement of sensory stimuli (in the hand scroll, from right to left) provides a framework into which the suggested one is fitted. The hand scroll and comic strip are both comparatively static, but can be moved at will. The speed as well as the exact path traced by the spectator's vision is indeterminate. In a play or spoken narrative the presented arrangement is determined in the process of performance, and the imaginary sequence of events is fitted into it. A long, slow sequence can thus be telescoped into a short and rapid one. It can indicate the passage of years between the enacted episodes or suggest that the represented action took much longer in

life than it does on the stage. The suggested temporal sequence may differ from the presented one, not only in speed and total duration but in the duration of episodes and the intervals between them. The narration may begin in the midst of the story and then go back to an early stage. Whatever the order of actual presentation (in narrative or drama) the spectator gradually fits the imaginary events together into the suggested sequence in which they supposedly occurred.

Since Heraclitus, at the latest, philosophers and poets have been impressed by the irreversibility of time; by its inescapable, all-consuming, onward march. Cronus, says Hesiod, ate his children. Such qualities, attributed to time, belong rather to the processes which happen in time. Time itself is a pure abstraction, one of the dimensions in which things exist, move, and change. Most processes are not exactly reversible, but many are partly so. One can organize a nation or a work of art and then dissolve it, but the result will not be exactly as it was in the beginning.

Some art emphasizes the temporal aspects of experience and of the processes around us: presentatively in music and ballet, suggestively in literature. It can stress their brevity or long duration, their sudden or gradual change. Drama and fiction tend to organize their materials in two kinds of temporal sequence. One is the order in which details are presented and suggested; the other, that in which the imaginary events of the story are supposed to have occurred. One occupies elapsed time, the period during which apperception of the form occurs. The other is imaginary time, the period or periods during which the events of the story are represented as happening. The two coincide if one tells or acts the story in the same order as that of the supposed events themselves (*ab ovo*). They diverge when one begins *in medias res* and then reverts, as in the flashbacks of a film or novel, to supposedly previous events. This is not completely unrealistic; it dramatizes the power of thought to leap at will from a fleeting present to a remembered past or an imaginary future.

It is impossible to represent or imagine the reversal of time itself, but one can easily imagine the reversal of any sequence of events in time. By reversing a motion-picture film, one can represent an old man as becoming a youth, a child, and a baby. One can imagine turning the clock backward, as by H. G. Wells's "time machine," and finding oneself in a street of ancient Rome, watching the chariots pass. A still more radical reversal of the sequence of events is imagined in Hindemith's *Hin und Zurück*, where

events proceed up to a certain point and then reverse themselves approximately to the starting point.

The rhythms and tempi of life are subject to some cultural and individual variation, but on the whole they are determined by the cycle of the seasons and that of day and night, work and rest. The tempo of music, spoken drama, or motion pictures seems fast or slow in relation to the standards set by the human pulse, normal respiration, and the speed with which visual or auditory images can easily be grasped. But habit and custom have much to do with our attitudes toward time in art. The tendency today is to speed things up, to cram as much action as possible into a short interval, as in abridging plays and novels for phonograph or television presentation.

We have now noted the arts which achieve most definite and highly developed suggestion of events in time and three spatial dimensions. Many other arts build up suggested forms in a more limited way. For example, it is commonly said that music can suggest "spaciousness," as that of a vast cathedral or forest interior, and movement in space, as that of a march, dance, or combat, and doubtless it can for many individuals, by one sort of association or another. But such suggestions by music alone are always comparatively vague and simple. They are not necessarily established meanings of music, or definitely predictable responses even in the musically trained listener. Clear verbal titles or directions, such as "Forest Murmurs," may cooperate with vague musical hints to convey a more definite suggestion of space. Being a time art, music can more effectively suggest a temporal order of events, which may run parallel with the presented order or may vaguely seem longer than the presented duration. It may express with some clarity a sequence of inner emotions, moods, and volitional states in the individual. It can begin with a passage which suggests hesitation, melancholy, and agitation, then change to a mood of brisk, assured gaity. Such a sequence may be continued with recurrence and variation of these moods, and with still others added, so as to suggest a fairly complex series of psychic events. But the conceptual vagueness of most musical expression prevents it from achieving highly developed suggestive form without the aid of words.

Pictorial suggestions of space differ widely. There are slight suggestions of deep space in paleolithic cave painting, as in overlapping figures of animals. Neolithic painting is comparatively flat, and so is early Greek vase painting. Hellenistic painting, as in the *Odyssey* series, achieved a high degree of three-dimensionality with perspective, atmosphere, and modeling of figures by highlights and shadows. Byzantine and early medieval taste went back to comparative flatness; then the Renaissance and Baroque redeveloped three-dimensional representation. Again, at the end of the nineteenth century, Gauguin and others returned to comparative flatness.

Strictly speaking, hardly any picture is completely flat. Differences in lightness and color alone will suggest advance and recession, figure and ground, as in a black line on white paper or a light red spot on dark blue. The bare outline of familiar figures, normally solid and scattered in deep space, will suggest the third dimension even when one is above another. But the spatial suggestions of what we call "flat" painting are on the whole simple, vague, and indeterminate by comparison with the classical Baroque of Poussin. Abstract Expressionist painting also varies in this respect; some of it is vague, some definite, in three-dimensional suggestions. Nonrealistic styles of painting have achieved very complex spatio-temporal arrangements, as in the Christian and Tibetan Buddhist conceptions of heaven and hell. The Cubists undertook to show in one picture how an object looks from different points of view, and the Surrealists combined objects and events in one picture which could not occur together in reality.

Temporal suggestion is not lacking in static pictures, in sculpture, or even in architecture. Critics have long recognized the effects of "movement," "tension," "struggle," "thrust and counterthrust," which are conveyed through the association of kinesthetic with visual images. The lines and areas of decorative art, the masses and contours of sculpture, and all these factors in painting, can produce vivid suggestions of movement. Abstract Expressionist painting does this without the aid of definitely mimetic suggestions. The movement may be interpreted as being in one dimension, in two or in three, in addition to time. We speak for example of the "swirl" of lines in an arabesque, or of the diagonal movement of masses backward and forward in a painting by Tintoretto. Some kinds of movement are suggested by kinesthetic association and empathy, and others by mimetic representation of an object in the act of moving. When we see a picture of a man in the act of raising his sword to strike, or a horse with its forelegs in the air, or a tree bent over in the wind, the suggestion may be so strong that we say "I can almost see it moving." But however vivid, such suggestions of movement in a painting, statue, or cathedral are not to be classed as developed arrangements in time. The movements suggested are usually very brief and simple. They include

the descending of the sword or the horse's leg a little way, or the straightening of the tree. After that, they do not specify the next movement or guide the imagination in a definite, complex way, as would literature or cinema.

13. Suggestive development in causal relations.

The details of a work of art are developed causally by giving clues to their interrelation which can be described in terms of "why," "because," "therefore," "consequently," "in order that," "in spite of," "with the result that," or words of similar import. In literature such words can be used to explain an event or condition or to ask for an explanation. "Why so pale and wan, fond lover?" Without words, as in a picture or pantomime, gestures and postures may suggest a particular causal relation with the aid of the context. Causal relations can be only suggested or inferred, never directly presented.

Temporal forms such as pantomime can present a series of events and thus clearly suggest a chain of causes and effects or the wish to discover one. A strikes B to get his money and B resists; others come to the aid of A. Story plots in narrative and drama usually emphasize causal relations among characters, desires, and actions. A static picture or sculpture is more limited to representing a single moment, although a transitional gesture can be suggested. Without the aid of a verbal title it may fail to show exactly what is supposed to have occurred and why.

A work of art is at least partly self-explanatory when its main causal relations are explicitly set forth in words, as in the denouement of a mystery story, but one can still ask why the author wrote as he did. Pictures can be almost self-explanatory when the situation represented is causally obvious, especially when accompanied by a verbal title such as "The Creation of Adam." Many works are causally problematic in that they tend to raise questions as to causes and effects but do not answer them or provide enough evidence to make the explanation obvious. Hamlet's hesitation is a classic example. In painting, a well-known example of emphasis on causal relations is Leonardo's *Last Supper,* which shows the dramatic effect of Jesus' words, "One of you shall betray me," on the various disciples. But the explanation is far from obvious. Why did Jesus say this, and why did Judas betray him? What specific, psychological effect on each disciple lies behind the various gestures and facial expressions? Causal explanation is a never-ending process, or one which has to be arbitrarily ended in life and in art. One can always ask "Why?" or "What effect will this have?"

In life and in art, apparent causal relations are often deceptive. One man may lie dead and another stand near him, holding a dagger. But, as in detective stories, our tendency to blame the second may be erroneous; the death was caused by someone else, or by disease or accident. Suggested explanations in art are often oversimplified, in attributing a complex train of effects to one factor. "Is this the face that launched a thousand ships/ And burnt the topless towers of Ilium?"

Some modern plays and novels emphasize the complexity of causal relations, thus adopting a more scientific attitude. Others, as in the contemporary French "new novel," tend to obscure causal connections. Things may happen and be seen or heard by the imaginary characters without being understood, as a merely accidental flow of images across a screen or through someone's mind.

In general, causality is the relation of cause and effect, or that between regularly correlated phenomena. A cause is that which determines a result or change: the necessary antecedent of an effect, which brings about its existence or condition, or helps to do so. Philosophers have distinguished several relations commonly regarded as causal: for example, a relation between events or things in the same time series, such that when one occurs the other necessarily follows, or that when the latter occurs the former may have preceded.

The statistical principle of correlation has been useful in describing obscure and complex relations among phenomena. Two sets of phenomena can be only slightly or not at all connected through direct influence. Neither can be called *the* cause or effect of the other. Yet it may be that both are causally connected as results of the same cause. It may be that a process involves several interacting factors, and we wish to discover what influence exists between a certain pair of them. Two factors may have no direct causal relation, but happen together at times. Any of these relationships may be described, with whatever exactness is permitted by the data, in terms of positive or negative correlation. A negative correlation may suggest, but not definitely prove, that one factor tends to counteract the other or that their necessary conditions are opposite. The degree of cogency involved in causal relations can be measured or estimated in terms of statistical correlation, as in explain-

ing the fluctuation of prices. Such thinking involves both the causal and the quantitative category.

Even when measurement is impossible, we often estimate the comparative strength of two or more factors. Some of these may reinforce, while others counteract, each other. Such a problem arises in asking why Rome fell, or why tastes in art change as they do.

The ultimate nature of causal efficacy, as in gravitation, remains a mystery. Empiricists argue that the supposed "laws of nature" are only generalizations on recurrent sequences among observed or inferred phenomena. In aesthetics, as usual, we can avoid most of the scientific and metaphysical problems involved in causality and think instead of how causal suggestions are developed in the various arts.

In speaking of the order of nature and of the universe as a cosmos, philosophers assume that all phenomena are somehow connected causally. Any work of art has some obvious causes and effects. Its nature can be partly explained by the artist's aims and actions. It can affect the observer's sense organs. Any presented or suggested image can lead one to imagine related causes and effects. As to a painted landscape, one may infer that the greenness of the trees and grass is due to warmth, moisture, and fertile soil. A phonograph record of piano music suggests the pressure of the musician's fingers on the keys. Such causal relations are so common and pervasive as to be usually taken for granted without special notice. They are comparatively external and do not necessarily bring out the most important and distinctive traits or values of a particular work of art. At the same time, some other causal relations may be essential to the plot or controlling idea of the piece and hence deserve to be emphasized in descriptive analysis. In a drama these are usually concerned with the motives and purposes of the protagonists and the immediate reasons for their success or failure.

Causal development may be carried on to any desired extent by adding more and more sequences of causes and effects, and also by analyzing each event more intensively as to the various cooperating and counteracting factors it involves. Step by step, after his father's ghost charges murder, Hamlet satisfies himself as to the truth of the charge, but he cannot (or at first will not) understand his mother's attitude toward the slayer. His impulse to revenge is paralyzed by obscure, conflicting motives.

Most epics, dramas, novels, and short stories involve an emphasis on causal organization in developing plot and characterization. All desire and aversion, love and hate, ambition and renunciation, have causal

aspects, especially as they lead to effort, struggle, and conflict. The observer becomes aware of contending forces, of suspense, as one or another seems to prevail, of the step-by-step progression toward a feared or hoped-for conclusion, as in *Oedipus the King.* If there are gaps or inconsistencies in the causal sequence, one may feel them as weaknesses in the structure or as problems to be solved. The psychologically-minded modern reader is not satisfied with actions which seem inadequately or implausibly motivated, "out of character." He is not satisfied with a radical change of status (peripety) on the part of one person or faction, without some hint as to the steps which led to it.

Causal sequences have direction. Besides proceeding in space and time, they lead from one effect to another. They can be retraced, as by a detective or historian. Art tends to simplify them, as if they were a row of falling dominos, whereas science discerns a plurality of causes and effects at each step.

In some Greek tragedies the outcome is said to be "inevitable." This does not mean that a modern observer, if caught in a similar predicament today, could not extricate himself, but rather that if we assume a world as conceived by the Greek playwright—one of divine order, inherited curses, predestined fate and punishment—then no other ending seems possible. Likewise some music is called "inevitable," a Bach fugue in strict counterpoint, for example, which seems to proceed inevitably toward a certain final cadence. Each phrase seems to determine the next phrase; each note, the next note.

Such "inevitability" is partial and relative. A different ending would really have been possible, if the artist had decided to try a surprise ending. Such endings do happen, in fugues and even in ancient tragedies, e.g., where a god descends *ex machina* to prevent an "inevitable" ending which seems, for one reason or another, unacceptable. Established styles in any art, reinforced by the whole cultural context of beliefs and attitudes, tend to develop habits of expectation in observers as well as rules of procedure for the artist. Having seen events A and B lead so often to C, we regard this sequence as inevitable. But such rules are not always coercive. Today we are more used to unusual twists in plot and character; we are less surprised by surprises. But it remains a fact that some kinds of music suggest the inexorable working out of a preconceived plan or premise, while other kinds suggest a world of loose indeterminacy where anything can happen.

When music fits into a play, as in Wagner's music dramas, it tends to reinforce plot, characterization

and emotional tone, thus acquiring causal significance. For example, the recurrence of a leitmotiv may give a clue to how a certain character is thinking and feeling, and hence to his acts and motives, or the sources of his power. Music takes on causal aspects from its context in words and actions. Pure music, as in a Beethoven symphony, may oppose and alternate two themes in such a way as to suggest conflict between two emotional moods, perhaps one of vigorous hope and the other of depression. This may seem to symbolize the struggle of man against fate or creative against destructive powers. Abstract Expressionist painting achieves analogous effects by emotive shapes and colors and by suggestions of thrust and resistance. But many abstract forms, in both music and visual design, have little or no definite causal suggestion. One can always project one's own attitudes into the form by empathy; but in morphology we must ask what clues to causal relation exist in the work of art itself.

Causal relations in art or elsewhere can be suggested by the relationship of parts within a static, concrete object, as viewed in the light of our past experience. When we look at a Gothic cathedral and realize how the piers support the vaults, how the buttresses support (or seem to support) the outward-thrusting walls, we are interpreting what we see in terms of cause and effect. We imagine a cooperative balance of forces in static equilibrium. When we look at the portals, balconies, windows, choir, and altar and realize what functions they were intended to perform in ritual and symbolic instruction, we are again interpreting them causally. The building as a whole suggests the activities for which it is intended. The adaptation of means to ends, in all utilitarian art, is an adaptation of possible causes to desired effects. Part of the aesthetic response to any utilitarian object, such as a sword or silver bowl in a glass case, is to realize how and to what extent its parts *could* (or could not) cooperate in achieving the intended functions of the whole.

It is the apparent causal relations within the work of art, rather than the actual or scientifically possible ones, which usually concern us most in observing a work of art. We (the observers) are concerned with how things seem to operate in an imaginary situation, into which we can project ourselves with enough belief to experience the desired illusion. If the causal sequences are too incredible, we may find this impossible. We can often accept a highly fantastic, fairy-tale world, such as that of ghosts and magic, if it is consistently organized in its own way. Or the artist may, for his own reasons, introduce apparent inconsisten-

cies and impossibilities, as in the dream of a lunatic or the sudden derailment of a train of causal inference by puns and other wordplay.

Othello builds up a complex structure of conflicting causal factors, including some which are shown as actually operating and some which are inferred on questionable evidence by the tragic hero. Of the former type is the development of Othello's jealousy and suspicion, partly as the result of Iago's hints. Of the latter type is Desdemona's alleged infidelity, which Othello infers from evidences such as the handkerchief. We see how certain forces and events combine to produce the tragic outcome, how certain traits in Othello cooperate with later events, how certain counteracting forces are too weak to prevent the catastrophe. This network of cooperating and counteracting forces operates as a frame of reference in which we can locate any particular event as caused and causing.

Causal suggestions in art vary greatly as to definiteness and determinateness. Romantic poetry often expresses a vague mood which the poet cannot explain or will not. "This grief hath no reason." Even to characterize the mood as "grief" makes it somewhat definite, while its causes remain obscure. Music can suggest mystery and vagueness or a sudden change with no apparent cause. A roof or balcony may seem unsupported even if it is not. This may suggest unstable equilibrium, with some doubt as to what will happen next. In architecture suggestions of stability are usually wanted, even though the opposite is often preferred in music, painting, and literature. In amusement parks, however, a room may be tilted to make it feel unstable.

The lack of direct causal relation between two sequences of events, or the lack of a particular kind of relation, may be as important as the presence of one. To Othello, the reason for Cassio's possession of the handkerchief is vitally important. Is it due to an unfaithful love for Cassio on Desdemona's part, or to another chain of events? In life and art, we are constantly trying to interpret other persons' motives and explain their actions. Those charged with guilt may try to show their lack of responsibility for the crime.

In life and art there are also many kinds and degrees of causal influence. No two events in the same time and place, involving the same group of persons, can be completely unrelated causally. No one event can be the sole cause of another, or the sole effect. Causal influence proliferates in all directions. In some it is strong; in others, weak. Lady Macbeth's influence on her husband was strong, but she was not the only cause of his crime. As we study causation more

thoroughly in life and history, we try to estimate its nature, direction, and intensity. We discover countless intermediate degrees between being the sole cause of an event and having no influence on it, that is, between absolute necessity and absolute indeterminateness. An event or sequence of events may tend at the same time to cause a certain outcome and also to prevent it. A man's appearance and behavior may arouse contradictory, ambivalent feelings in a woman, and hence impel her toward contradictory actions. The question is, which will be the stronger influence? In the exact sciences, such degrees of influence are measured or estimated in terms of correlation and probability, but in life and art we usually rely on less exact, more subjective and unreliable methods.

14. Implicative development.

Implication is closely related to causality and may be regarded as a species of it. It differs from other kinds of causality in being more concerned with relations among words, concepts, propositions, and inferences than with overt actions and events. The concept "triangle" implies by definition "a plane figure having three sides and three angles." The basic definitions, axioms, and postulates of geometry imply a series of more specific theorems, such as the one which states that the sum of the interior angles of a triangle is 180°. No action or obvious cause and effect is apparent here. But words, concepts, propositions, and inferences can be regarded as persistent, social ways of saying, thinking, believing, and feeling. Acceptance of one statement tends to cause acceptance of certain others, and rejection of still others, by persons who reason according to the rules of logic.

Some Platonizing philosophers have conceived of a great hierarchy of universal ideas, existing eternally and independently, interrelated by implication and inclusion, graded from the most inclusive at the top to the most specific at the bottom. The whole science of mathematics, and indeed all science, was once conceived as a single huge, implicative system, built on a set of definitions and self-evident first principles. Now there are many alternative systems of mathematics itself, some non-Euclidean, based on different premises. Many scientific theories are inconsistent with each other.

Empiricists tend to think of implication as a manmade category of thought, derived from human experience. From this point of view it is closely related to causality and inference. When we say that democracy implies equal opportunity, we are referring to a cultural association of ideas and other phenomena, not to any a priori connection. When we say that one proposition implies another, we mean that *if* we accept the first as true and if we reason logically, then we must accept the second as also true. The antecedent mental actions compel the consequent ones. Many propositions about which we reason are generalizations about cause and effect, for example, that a certain drug will have a certain effect on the normal, adult human organism under specified conditions. As a syllogism, this implies that it will have that effect on X, who fulfills these requirements.

In art, implicative development is most employed in literary exposition, as in the essay, the treatise, the meditative lyric, and occasional passages of expository writing in other literary types. Not all exposition is to be classed as art; some of it is purely scientific. Other examples are accepted as literary art because of their aesthetic traits: notably, the more poetic dialogues of Plato. Many of these are focused on the general implications of some concept such as beauty, love, pleasure, or justice, as distinct from particular examples of them. Conflicting views and arguments about it, usually leading to the victory of one, give the discussion a dramatic quality. "'What is truth?' asked jesting Pilate." Francis Bacon took this as a starting point for a soliloquy of his own in essay form. But much literary use of implication is limited to a sentence or two, in which an implicative relation between two or more ideas is suggested vaguely or clearly, truly or falsely, perhaps with deliberate flouting of truth and logic for some aesthetic effect. In saying "Beauty is truth, truth beauty," Keats took poetic liberties with the implication of both terms.

Without words, implicative relations can be suggested, but as a rule less definitely. To say that a lion is a symbol of courage is taken as meaning that the concept "lion" implies the concept "courage."

15. Development by addition.

Addition and division are very general, flexible methods, which can be applied to building complex forms in any frame of reference. They occur in biological and social evolution and in many other realms of phenomena. Increasing complexity can be achieved by either of these methods or by both together. They are widely used in the arts.

The method of *addition* consists of adding or assembling more and more parts or units. It can be

illustrated as follows. Beginning with a certain unit—a red circle on a white sheet of paper, say—one may draw several others at random on the same sheet. The addition is external and extensive, in that new units are placed outside the previous ones, or perhaps overlapping them, but not within the old ones so as to divide them into smaller parts.

Such addition can be developed in one dimension of space, as in making a horizontal row of circles, or in two as in scattering them over the sheet of paper. It can be in three dimensions, as in a scientific model of wooden balls connected by rods at different angles. It can be carried on in time, as in adding one melodic phrase after another, or one line or stanza of verse after another. It can be in space and time, as in adding one posture or movement after another in a ballet. One can build a mobile sculpture by adding one pendant unit after another. In terms of cause and effect, as well as time and space, a story may continue indefinitely through adding successive exploits of the hero. Primitive heroic cycles thus string together a long series of tales, in each of which the hero conquers a different enemy or monster, or performs an apparently impossible task.

Differentiation of the units can be performed along with addition or later. In adding circles one can make them a little larger or smaller, more or less elliptical or incomplete, lighter or darker, more orange or more purple. A larger difference is called a *contrast,* as in adding to the red circles a square or star-shaped figure or one intensely blue.

Any number of units can be assembled without much integration, but this produces a mere agglomeration of units or loose succession of events, rather than a complex form. Analogous phenomena are seen among some simple forms of animal life, in the way many individual organisms coalesce into a shapeless mass with little or no interdependence. (In a *colony* they are separate organisms; in a *coenobium* they have a common membrane. In a *coenocyte,* algae or fungi combine to form a single, large cell). In higher forms of life, instead of independent organisms, we see a number of interdependent cells, varied and specialized into different forms and functions, cooperating by means of a nerve system or other unifying factor. Man admires this complexity and often emulates it in art.

Countrywomen used to bring together for a quilting party bagsful of odd bits of cloth, more or less different in shape, size, color, texture, and pattern. These they would sew together, sometimes into a "crazy quilt" with no definite pattern, sometimes into a pattern of stars or flowers, with scraps of similar color and texture placed at regular intervals. So, too, a number of folk tales, different in origin and characters, would be organized into a connected sequence, as in Chaucer's *Canterbury Tales* and Boccaccio's *Decameron.*

One unifying device is especially appropriate to the method of addition, in which the relation of units of a common framework is often loose and indefnite. This consists in linking individual pattern units to each other by means of *connecting units.* The latter may resemble or differ from the units they are to connect. For example, a row of large, detached medallions may be connected by small medallions or small rectangles. To be connecting, they must be intermediate in spatial or temporal position between the units to be connected. They may be in actual contact with the latter, like bridges, or like strings which tie them together. They may be almost in contact, so as to suggest connection, and lead the observer's eye from one to another. If they overlap or penetrate one or more of the units to be connected, their connecting effect tends to be stronger. For example, in complex rug patterns it is common to have large units joined by certain lines (often representing vines or stems) which extend continuously from the interior of one unit to that of the next, and perhaps throughout the whole series. Sometimes there are so many such lines, and so many interpenetrations among the pattern units themselves, that the units tend to lose their separate identity and become merged in a continuous arabesque or texture. In connecting complex musical pattern units, it is common to have one or more tones or voices prolonged continuously from one to another.

The most fundamental way of unifying is that of *subordination to a common framework.* In the method of division we begin with such a framework in the original pattern. It is easy to maintain subordination to it as division progresses. In the method of addition we may or may not have a framework, or any conception of one, at the start.

More and more complexity can be achieved by grouping a number of units into a form or pattern of intermediate size, then a number of these patterns into a larger one, the large ones into still larger, and so on.

16. Development by division.

This method proceeds within a given unit in space, time, or both. It is mainly internal and intensive. A

circle can be divided into sections by radiating lines and smaller circles, thus making a wheel-shaped pattern. The rim can be subdivided into tiny, pearl-shaped circles. Complex designs of this sort are common in Byzantine and Persian textiles. An outline of a bird can thus be subdivided into head, wings, legs, and beak, then each of these into smaller units such as feathers. These can be differentiated in size, shape, and color from each other.

A musical phrase can be divided by substituting different notes of short duration for a single long note, two eighth notes or four sixteenth notes, for instance, for a quarter note. The development section of a sonata can be prolonged by subdividing the subject and varying each of its parts, independently and in different combinations. A short story such as that of Joseph in the Old Testament can be developed into a series of novels such as Thomas Mann's *Joseph and His Brothers*. Each main part of the short, original version (such as the episode of Joseph and Potiphar's wife) can be dwelt upon and expanded into a series of detailed incidents, conversations, meditations, descriptions, and explanations, as seen from the standpoint of different characters. Instead of adding more main events, simultaneously or successively, one can analyze each event and situation more thoroughly as to their internal structure and causal relations.

In addition, the newer parts are placed outside the older ones in space or time, thus producing extensive multiplicity. In division, they are formed inside the older ones, as parts or included units. If continued this produces intensive multiplicity, as in embryonic development.

17. Combined method.

There is no conflict between the two methods. Development can proceed along both lines, simultaneously or at different times. We then have a *combined* method, addition *and* division. Sometimes one or a few important parts are intensively developed by division for the sake of decorative emphasis.

More and more internal division of a part or of the whole eventually produces parts too small or too short in duration to be adequately perceived or understood under ordinary conditions. If still more division is desired along with maintenance of clear perception, some enlargement of size or duration then becomes necessary, at least for the part to be further subdivided, and perhaps for the whole form.

On the other hand, more and more external addition leads eventually to the point where the whole is too large to be manageable or to be perceived and enjoyed as a single object or sequence. The whole or some of its parts may then have to be cut down in scale. Much depends on the nature of the art and how its products are to be used and perceived. The form of a city or even of a single building can obviously be more complex than that of a medal without becoming cumbersome. Such a form, while too large or too long-enduring to be fully perceived on one occasion, can be experienced part by part on different occasions.

Either addition or division, or the two combined, may achieve the same result. It is hard to tell from the product which method of development has been pursued. Addition alone tends to produce a somewhat diffuse, weakly organized arrangement, but this can be corrected by rearranging the units according to some comprehensive framework. Division alone, if it begins with some definite pattern, tends to maintain that pattern and hence to preserve an overall unity. It tends toward a somewhat tight or repetitious integration, but this can be reduced by loosening the framework and introducing more variety among the units.

18. Undevelopment.

Change in a direction opposite from growth is less often considered in the arts than development. Yet it sometimes occurs, in the work of an individual artist and as a long-term trend in the history of styles. For one reason or another, artists or their patrons may wish to reduce the complexity of the product, perhaps to make it please a younger or less educated public. Regressive, devolutionary trends occur at times in the history of an art, or in several arts at once. They may manifest themselves as a desire for more simplicity or for a softer blending of neighboring parts, as in a change from "linear" to "painterly" style. Sharp, detailed contour lines around each object and its parts become unwelcome.

In general, undevelopment proceeds along lines opposite to those of development. Instead of addition, we have subtraction and elimination of parts or traits. Instead of clear division and subdivision of parts, we may have a tendency to melt or overflow the demarcations. Flowing color may dissolve the sharp outlines; rich harmony and orchestration may dissolve the melodic lines. Previously distinct things run to-

gether into larger, variegated wholes. Such changes in themselves do not imply undevelopment or simplification on the whole, for they may be accompanied by complication along other lines. Undevelopment is the breaking down or loss of complexity; hence it involves a loss of parts or of divisions between parts, and also a tendency to soften or weaken the comprehensive framework of the whole. But undevelopment, like development, can be limited to certain aspects of the work of art. The elimination of one kind of growth may clear the way for others. Thus Kandinsky gradually omitted representational details such as trees and cannon from his paintings, but substituted other kinds of development such as expressive line and color.

19. Realism and unrealism in various frames of reference.

Works of art are often described as realistic, naturalistic, truthful, or lifelike. Others are called unrealistic, fantastic, idealized, or stylized. All these terms have different shades of meaning. Critics disagree on what makes a work of art, or a style such as that of Giotto, realistic or the opposite. Sometimes "realism" is used as a standard of value, with the implication that art should be realistic or is better when it is so, and sometimes realism is avoided and condemned.

Whether or not a work of art will seem realistic depends in part on one's conception of reality, of the facts about what is represented or described. It depends on one's beliefs about what actually exists, has existed in the past, or would be possible or probable in future. This conception may not embrace all reality in an abstract, philosophic way; it may be limited to a particular fact, such as the appearance of someone's face. But realism is also conceived as the expression in art of general truths about the world and man. One must have some idea about the facts concerned, so as to decide how the work of art conforms with them.

Whether art will seem realistic or not depends also on one's experience with other works of art and how people regard them. Even when people agree on the things represented, they sometimes disagree on how truthfully the work of art portrays or describes them. When people are used to a certain way of representing landscape or the human figure, it may seem realistic to them, whereas it seems highly stylized to someone else. It can be realistic in some ways and not in others. No one can portray all reality in a work of art, or represent anything with complete fidelity in an artistic medium. People in different times and places are especially interested in different aspects of the world, so that accuracy in representing these gives an impression of realism in general, even if other aspects are omitted or altered.

In one sense of "realism," a portrait or landscape is called realistic in proportion as it resembles the actual appearance of the person or scene depicted. This is visual realism or naturalism. Music is called realistic if it has even a slight resemblance to other sounds in nature or human activity, such as a brook, a chariot race, or a steam locomotive. This kind of realism depends mainly on sensory mimesis; it is sometimes called "surface realism" or "literal realism." This is not easy with conventional instruments. Literature and theater may involve suggestions as to the mood and character of a person by accurately reporting his behavior, talk, gestures, and facial expressions. Even if the person is imaginary, we may feel that the representation is realistic if it conforms to our ideas of how people in general, or people of a certain kind such as adolescent girls in a modern American city slum district, are likely to act, think, and feel.

All art involves some departure from the usual appearance and behavior of things, if only from the fact that it must select and emphasize some characteristics while omitting others. To a large extent we accept these differences as recognized conventions of the art or medium, as ways of calling attention to selected aspects of a subject, rather than as misrepresentations of it. Persons used to seeing a photograph or motion picture film in black and white are usually not bothered by the lack of color; they accept it as a convention of the medium. But savages who have never seen one are said to have difficulty in recognizing the objects in it: the small size, flatness, lack of color, and other differences baffle them. In modern civilization we are accustomed to new, experimental media, each with its own conventions, as in the rapid change of viewpoints in cinema. Even young children in an urban environment can learn quickly to accept them and to get the illusion of seeing real people moving and talking. From its earliest beginnings, art has adopted certain conventional simplifications, as in representing figures by linear outline alone. To hear the actors in a play or opera talk in verse or song involves a considerable break from ordinary speech, but is easily accepted as adequately natural.

All historic styles in every art have their own conventions. Impressionist painting emphasized sunlight

reflections, and in that respect was visually realistic. But to do so it had to sacrifice some realism in representing the sharp, linear edges and spatial positions of things. A Chinese landscape of the Sung dynasty may seem highly stylized to someone accustomed only to academic European landscapes. The latter have come to seem to him like nature itself. But to someone brought up in China the opposite may be true; his own kind of stylization may seem more realistic, as portraying the inner reality of natural objects, such as the spirit of a weather-beaten, old pine tree. Various types of perspective in Persian and ancient Indian painting are soon accepted by the connoisseur, not as mere "distortions" or incorrect versions of realistic perspective, but as having their own kinds of realism. For example, they tend to show in one picture how a scene and objects in it look from different points of view.

To the modern observer, medieval pictures of heaven and hell with angels and devils flying through the air seem fantastic in the extreme. The same is true of sculptured Hindu deities with many arms. They are indeed so from the standpoint of modern, scientific naturalism. But one must not assume that they were intended as mere flights of fancy. Before the age of science, no sharp line was drawn between fact and imagination. The people who made and those who observed these works of art probably believed that spirits more or less like these actually existed. Mystics claimed to have seen them in visions. No one knew exactly how they looked; supposedly, they could assume different visible forms. The traditional ways of representing them were felt to be as close to the truth as humans could get, and could be regarded as symbols, not literal representations. Thus, in a general way, traditional religious images might express and conform with current religious conceptions of reality.

The sizes and shapes of visible forms in art are usually such as can be taken in fairly easily by the naked human eye, either from a single vantage point or by moving around to such positions as can be taken without great time or effort. Most pictures are to be looked at upon a wall, in front of the beholder and on a level with his eyes or a little higher, or sometimes in a book within his hand. In any case, the size and scale of the picture will tend to be large or small according to its probable distance and position in relation to the eyes of the beholder. Buildings and the sculptural or other decorations on their walls are usually adapted to the viewpoint of someone on the ground or floor, or perhaps of someone walking along a balcony. As seen obliquely from below, the arrangement of a group of figures in relief may seem very

different (because of parallax) from that which it presents on a level.

Furniture, garments, and utensils are devised in size and shape to fit the human body and its movements. In the realm of art there is literal truth in Protagoras' dictum that man is the measure of all things. Not only judgments of value—whether a thing is *too* large or too small, too straight or too curving—but even the more purely perceptual judgment of *how* large or small it is, how straight or how crooked, are made in terms of how it appears to humans. The Greeks understood that a column which is actually straight will not look straight; they organized their temples from the standpoint of psychological as well as physical space. A work of art is large or small in relation to its context in human experience, and in the total perceived situation. A picture is large or small in relation to the wall or the page of a book. A detail within it is large or small with relation to the whole picture, so that in a postage stamp a difference of one millimeter may seem enormous. In looking at the small, nearby picture, we adjust the focus of our eyes, and adopt for the moment a new set of standards as to what consitutes large or small, near or far.

Positions and directions in *space* are described and mentally measured from the standpoint of the observer. Spatial relations are organized in terms of lines and conical vistas radiating out from the observer in all directions, especially forward along the ground to the horizon and upward a little into the sky, with occasional turns to right, left, and downward. The erect position of man upon the earth determines whether objects in such a vista will seem upright, recumbent, or falling. Intervals between objects are perceived as arranged along one of these receding vistas away from the observer. Things are above, below, in front of, or beside one another as they appear to him. He forgets that men on the other side of the earth are standing in the opposite direction. His viewpoint may be somewhat fixed, as in looking into the imaginary space of a painting, or he may shift his position from time to time as in walking through a garden or cathedral. Most of his total visual experience is a succession of such forward-looking, overlapping vistas in different directions, along with cumulative memories of previous vistas and expectations of those to come.

These he may fit together into a composite conception of an object or interior as seen from all sides. In the course of a novel or motion picture he may be made to assume a number of different imaginary spatial viewpoints in succession and to imagine a process at various moments of time, or as it would appear to different persons at the same time. This will

approach the standpoint of an omniscient observer—that from which, according to medieval thinking, God beholds the universe.

We sometimes speak of distorting space or changing time, but of course we can really do neither. In art and elsewhere we constantly rearrange our conceptions and memories of what happens in space and time, as observed from our individual points of view and from the general standpoint of man on this tiny, whirling sphere. Even in trying to be as factual as possible, as in writing history and biography or describing the workings of the solar system, we find it necessary to eliminate most of the data concerned, to select this and rearrange that, so as to bring out what seem to be the most important facts and express them in an understandable way.

Art is much more free than science to rearrange the data of experience from a frankly personal, local, momentary point of view, including the interests and feelings of the artist. But art also tends to express in some degree the prevailing conceptions of reality at the time, which are increasingly those of contemporary science. Hence it makes a changing compromise between the personal and the impersonal, the subjective and objective points of view. It portrays the spatial and temporal relations of things, now with emphasis on what they really are in scientific terms, and now with emphasis on how they seem to mortal, earthbound humans. Thus Thomas Mann, in *The Magic Mountain,* makes us realize how swiftly the years seemed to pass in an isolated mountain sanitarium. People who experiment with drugs, like Aldous Huxley, tell us of the illusions these produce, such as that of time "standing still" and of being transported "out of this world" to a higher level of reality. We have already noticed the important difference between elapsed or presentational time, as in the performance of a play, and suggested or imaginary time, as in the events of the story enacted.

The quality of realism in art depends also on the treatment of *causal* relations. Causes and effects in art may seem to be much like those in ordinary life or very different. Reality may be conceived as an orderly process where things happen in accord with natural law, or as subject to the disruptive power of magic and miracles, demonic possessions, and sudden metamorphoses, as in Ovid's book of that name. A story in which sailors are turned into pigs and back again (as in the *Odyssey*) is fantastic by contemporary standards. But there are many intermediate types between magic and natural law. Many a story builds up a general atmosphere of naturalness, only to have a single weird, inexplicable event break through with

strong suggestions of the supernatural or preternatural.[2] Even these do not imply a total lack of causal relations, but the existence and power of some agencies not subject to ordinary natural laws, and therefore able to produce effects not possible by natural methods. If the events are explicable as insane delusions, psychological realism is restored.

If the existence of supernatural agencies could be proven to the satisfaction of science, the conception of "nature" would have to be expanded to take them in. If superhuman powers exist, they are a part of reality and of nature in a broad sense. Many types of action are on the borderline between the recognized processes of nature (such as radio communication) and those which most scientists consider unreal (such as telepathy and mind reading). Art is free to imagine any of them as real.

Most events and conditions of life which come to our attention can be explained, at least in part, as examples of the recurrent natural processes and tendencies which science describes. The phenomena of eating and sleeping, being born, growing old, and dying, are familiar examples of regular causal sequences. Even exceptional, "unnatural" ones, such as a sudden, premature death, can usually be explained as due to the unexpected intrusion of some other set of factors, natural enough in its own way. Accurate films of undersea life seem fantastic to those of us who have never seen these regions in reality.

Extremely unusual forms and juxtapositions in visual art, as in Salvador Dali's picture of the limp watches, can give an effect of unrealism and the preternatural even when they are not impossible. It is an easy step from there to things which are impossible in our world, such as centaurs, giants as large as mountains, and incongruous hybrid creatures. But such images can occur in dreams and hallucinations, as well as in art. This makes them, in a sense, natural when so explained. A story can realistically describe a person's nightmare. But dreams and insanity are in some ways intermediate realms between that of normal daily life and that of total unreality. Much art is called "fantastic" which diverges from the normal only in a few important details. In fantastic art, things may coexist which do not and perhaps could not coexist in nature, such as a man with a bull's head or wings. Unsupported, heavy objects usually fall. Hence a picture of a roof in the air with no supporting walls looks unrealistic unless otherwise explained. Transparent walls and machines are unrealistic unless

[2] As in Henry James's *The Turn of the Screw.* These are also explained as due to insanity.

the context explains them. Transparent or cut-away walls were a common convention in early Renaissance painting, and transparent machines are used today in mechanical production illustration. When so explained, they do not produce an effect of free fantasy or weird unnaturalness.

As to *implication,* a sense of realism can be produced by having concepts and propositions mean about what they usually mean in a certain context. It can be produced by making inferences follow approximately logical steps, at least when the persons concerned are supposed to be reasonable. Suddenly illogical inferences, totally incorrect meanings in the given context, can destroy the appearance of realism. Thought and speech then seem out of touch with the realities of the situation. But if the speakers are shown to be insane or in a joking, punning mood, psychological realism is preserved along that line. We recognize that people might actually think and speak in this way.

As contrasted with the surface realism of visual and auditory resemblance, another kind is called "symbolic," "poetic," or "figurative." In this sense, a work of art is considered as realistic even though it does not resemble or accurately describe its literal subject, provided that it symbolizes or otherwise expresses some important religious or philosophic truth. This may be a truth about human nature on an earthly plane, as in the fables of Aesop. These are fantastic in making animals talk and think like humans, but they are psychologically realistic in pointing to common human traits. People of different religious and philosophic beliefs naturally differ as to what kinds of art are symbolically true and realistic.

Such beliefs have, of course, changed profoundly in the course of cultural evolution; they differ greatly among various groups and individuals today. This applies not only to comprehensive theories of ultimate reality, but to opinions and impressions on a more limited scale. Artists, like other people, disagree on how just or unjust the present capitalistic system is, or how much poverty and misery exists among the masses, or how oppressive or benevolent owners and officials are. They disagree on how rational or irrational, kind or cruel, human nature is in general. Accordingly, they differ as to what is true in art. Is art which shows the evil side of life more true and realistic than that which shows people as happy and virtuous? If the artist represents only one man or a small group, critics ask whether this is typical of the whole class represented, such as laborers or landlords.

An artist's products tend to reveal, consciously or unconsciously, his conceptions of the world and his emotional attitude toward it. Some of Kafka's stories show how the world appears to a neurotic or psychotic individual. Some who like the world and the social order, or at least see some hope for its improvement, create idealistic and reformist works of art. Some, who regard the world as hopelessly bad, dream of perfect heaven, while others portray the life around them savagely, with extreme ugliness and evil. Philosophers, as well as artists, disagree as to whether this world is controlled by a divine, benevolent Providence, by a blind cosmic will, or by inanimate physical forces. Metaphysical idealists tend to conceive reality as fundamentally good, true, and beautiful. Ugliness and evil are, to them, illusions which can be transcended by rising from the sensory to the spiritual level of thought. These opposing world views involve beliefs about the facts and the values of life, including the qualities of human experience.

Art is one of our chief sources of knowledge about primitive and ancient conceptions of the world and man. Sometimes it states explicit myths about creation and the present rules of heaven and earth, as in Hesiod's *Theogony.* Sometimes a world view is implicit or vaguely hinted, as in the conception of a divinely established moral order in Greek tragedy. It is often hard to tell exactly what ancient thinkers believed about the nature of things, for they blended observation and reasoning with imagination. Only as the scientific attitude developed, in spite of many long setbacks, did the rigorous quest for factual truth diverge from poetic fantasy.

An objective estimate of realism in art should indicate what conception of reality is taken as a criterion, that of contemporary science or that of some past age or foreign culture, or perhaps one held at the place and time the work was produced. It should indicate what aspects of reality are being considered, and what scientific or religious beliefs about them. A work of art can be physically and biologically realistic but psychologically unrealistic, or the opposite. Since we have no certain knowledge of ultimate reality, we have no certain standard for deciding what conforms with reality. But for all practical purposes there is enough agreement today to make sufficiently clear distinctions between fact and fantasy. Few educated persons in contemporary Western culture now believe in demonic possession as an explanation of insanity. Magic and witchcraft, creation *ex nihilo,* and most primitive forms of religion are excluded as operative principles wherever the scientific world view prevails.

Certainly, we have no right to assume that present scientific beliefs are wholly true. Past ages were equally sure of beliefs which later turned out to be

false. A hundred years from now, many of our present beliefs about the world and man may seem fantastically untrue, and the art which expresses them will seem accordingly unrealistic.

20. Naïve and scientific conceptions of reality as expressed in art. Primitive and childish attitudes.

Primitive conceptions of man and the world tend to be egocentric and ethnocentric. Each individual regards the world from the standpoint of himself and his kinship group, from their position in the history of culture and in terms of their own special interests. So small a part of reality comes within the purview of a primitive group that it amounts to a misconception of the whole, as in the story of the blind men who fingered different parts of an elephant. Such conceptions are naïve and unrealistic by contrast with that of modern science. So, in some ways, are the conceptions held by young children in our own culture. They, too, are self-centered and family-centered at first, although education soon gives them broader scope.

Ancient thinkers enlarged the conception of space and time through astronomy and the calendar. They worked out the complex geocentric theory, attributed to Ptolemy, which regarded the heavenly bodies as moving around the earth. In Dante's vision, these were on concentric crystalline spheres. His conception was also anthropocentric in regarding human history as the focus of divine attention and the scene of the Christian epic, from Creation to the Last Judgment. Later on, the vastness of the universe in space was discovered, first through the Copernican or heliocentric theory and later through the discovery that our solar system itself is only a small part of one galaxy. Likewise the vastness of the universe in time was discovered and its history extended backward through the long evolution of life. Astronomers pushed human vision ever outward to more and more remote galaxies, from which it takes light millions of years to reach us. Man and his works seem less important by comparison with so vast and impersonal a cosmos, although they are not necessarily so to man himself.

The scientific conception of the physical universe in space is now taught in simple terms to civilized children. But for most adults the experience of life is still rather narrowly centered on themselves as individuals and their own close circle of relatives and friends. It seldom becomes fully geocentric, in a sense

implying world-wide scope. Temporally, too, they do not see present events as part of a long historical and evolutionary sequence. The conceptions of physical science remain, for most of us, somewhat remote and artificial. We accept them as true because we are taught them in school, but we do not and can not conduct our lives entirely in terms of them. Only seldom do they break into our daily lives, as when we read of space travel or of the strange, microscopic world of viruses and electrons. We continue to see the world mostly from our individual positions in life. For everyone, it is said, the sky is an inverted bowl of which he is under the exact center. No one, even the scientist, can be scientific in all his thoughts and personal relations; such an attitude would be inhumanly cold, objective, and impersonal. Each of us must look, think, feel, and act from the standpoint of his own brain and ego, at least in his personal life. However unselfish our decisions may be, we must look out upon the world with desires and aversions, prejudices and preferences. We must, to some extent, project our feelings into the outside world, regarding people and their acts as good or bad, lovable or hateful, beautiful or ugly, not as mere biological, sociological, or psychological phenomena.

Thus the naïve human, emotional, egocentric conception of reality persists along with the scientific in the minds of educated modern adults. The two are not radically inconsistent, and we manage to adjust them to some extent, to introduce a little science into our personal relations and a little humanity into our scientific thinking. One is narrowly limited, the other aspires to seeing things with godlike objectivity. The human viewpoint stresses the local, immediate, and unique, the things and events on or near our own scale of size and duration. Science stresses the general, widespread, enduring aspects of things, the enormously large and the infinitesimally small, the millions of light-years and the thousandths of a second.

The naïve human conception—even that of the young child or primitive savage—is not wholly false. Its chief error is the assumption, on the part of each individual or group, that its own viewpoint, its own interests, its own history and character, is the only one or the only important one. But it is true and realistic in representing his own little world, in the jungle or cradle, as self-centered and family-centered. Things do arrange themselves for him in terms of his own body and its position in space-time. Their causal system is the way they satisfy or frustrate him. Science can never prove it false unless he tries to affirm it as universal. If he tries to impose it on others, he

will probably suffer. But the world of naïve experience, individual and social, is not completely replaced or invalidated by that of scientific experience. Both are equally real as mental phenomena. Both have their ground in matter and in ultimate reality, whatever that may be.

There is no ground in science for supposing that science can replace art, or (as Hegel predicted) that philosophy will replace it. The fact that science has to eliminate naïve and primitive conceptions from its own realm does not mean that art must eliminate them too. It may do so when it wishes to, but it also has an important function in preserving them as part of the total cultural heritage, not as doctrines demanding belief, but as achievements of past reason and imagination. They are to be preserved, not only as sources of direct aesthetic satsifaction in art, but for the true insights they provide, in recording how the world has looked at various times to man on his small planet and to the individual in his passing moment of space-time.

To the young infant it may seem as if he were omnipotent, or as if his cries alone were enough to get satisfaction. Miraculously, someone attends to his wants. Later, he can get things by asking for them politely and behaving so as to please his elders. Still later, he must use effort, skill, and intelligence to get things in a frequently hostile or indifferent world. He must develop a realistic understanding of causes and effects, means and ends, in trying to satisfy his desires. Some individuals go through all these stages and adapt their methods accordingly; others remain on a childish level or regress to one when frustrated, relying on some imaginary parental substitute. Insanity is said to involve a "flight from reality" through hallucinations and delusions, perhaps as a result of inability to face the facts and act accordingly.

As a child grows older, society usually forces him to abandon the purely egocentric viewpoint, and to compromise with those of the groups or individuals with whom he comes in contact. He is asked to put himself in the place of others and sympathize with their hurts and desires. There are many people in the world; one cannot have everything one wants; things are not necessarily true because one thinks they are; but there are ways of finding out facts and getting some things done. Most adult individuals stop short before going far along the way. Their experience is still ordered mainly in egocentric terms, but they have given up the infantile extreme of egotism. Such a man is able to think and feel to some extent from the standpoint of his family, his town, church, business, or social class, and on rare occasions (such as a

war) from that of his nation as a whole, and still more rarely from that of humanity. All these stages and attitudes are represented in modern drama, film, and fiction.

A significant difference exists in art between the authentically naïve, either primitive or childish, and the imitations of naïve art by modern, sophisticated adulst. The latter we may call quasi-naïve or, in some cases, pseudo-naïve. Imaginative regression to primitive and childish ways of thinking and feeling, as well as to primitive social conditions, have often occurred in the history of the arts. They were especially popular in the European Romantic period, as for example in the stories of Chateaubriand and some poems of Wordsworth and Blake. Later examples are Lewis Carroll's *Alice's Adventures in Wonderland,* Kipling's *Jungle Books,* some of the drawings of Paul Klee, and Schumann's musical *Scenes from Childhood.* Works of this kind are sometimes produced for the enjoyment of children, sometimes not; in either case, they tend to include sophisticated forms and ideas which adults can appreciate on a higher level. They also tend to eliminate much purely naïve detail which might seem tedious or incomprehensible to the modern adult or older child. They are intermediate between the naïve and sophisticated, rather than mere imitations of the former.

Some types of contemporary art lean rather toward the scientific attitude and use scientific concepts as starting points. So-called science fiction, such as that of Jules Verne, H. G. Wells, and a host of recent followers, is one of these. Here the scientific element is variable and often slight, consisting mainly of imagined future inventions and their consequences. In the novels of Emile Zola and the "naturalistic" school of nineteenth-century France, it was more seriously devoted to representing individuals and social situations in a strictly factual way, but with emphasis on the evils usually glossed over by classic and romantic fiction. "Naturalism" in this sense implies a more thorough kind of realism than that of mere visual appearance. It is rather literal than symbolic in its mode of representation.

The naïve type of *qualitative* development appears in a relatively small amount of definite, subtle distinction among qualities, and among shades of difference in the same quality. Naïve painting tends to repeat broad contrasts of color without determinate subtleties of hue, shade, tint, or texture. Naïve music lacks controlled subtleties of pitch, rhythm, dynamics, and timbre. (Some modern tribal music is far from naïve or genuinely primitive.) Subtle gradations occur in naïve art, but more or less at random.

The verbal expressions of young children and the oral literature of very primitive peoples do not describe objects with much discriminative detail. (Homer was not primitive.) Words are lacking in genuinely primitive language to express very subtle distinctions. Concepts are broad and loose, only slightly analyzed into varieties. Things are good or bad, pretty or ugly; they hurt or feel good. Again, this is not true of modern tribal peoples. Many of these have finely discriminative terms for qualities within their own realms of experience, such as the different tracks which animals leave on the snow.

The naïve attitude is prone to unconscious projection; one attributes one's inner feelings and attitudes to outside objects. Little attempt is made to distinguish the subjective from the objective, experiences of the self from attributes of external reality. Things or persons which hurt or thwart the self are, simply, bad; those which satisfy and please it are good, kind, friendly. Objects are called beautiful or ugly without realization of the part played by the individual's own mood and personality in determining these responses.

The modern, sophisticated writer can, when he wants to, distinguish a wide range of qualities in experience and in the outside world, employing for that purpose a rich vocabulary of nouns, adjectives, adverbs, similes, and other figures of speech. He can find the mot juste for precisely characterizing a vague, faint sensation or mixed emotion, as in the prose of Marcel Proust and Henry James. He can describe his own inner feelings and those of imaginary persons. He distinguishes in higher degree between illusion and reality, and recognizes prejudices, neurotic tendencies, or social ideologies for what they are. (No one does so perfectly; all these differences are in degree.)

Many traits of art which are called distorted, fantastic, or unrealistic are actually trends from the naïve viewpoint toward various kinds of realism. Certain aspects of Cubist, Futurist, and Surrealist painting belong in this class. They undertake to represent, in the same picture, different aspects of an object or different moments in a process, which could not possibly be seen together by a single observer.

We tend to judge realism by comparing art with our past experience of the usual sizes, shapes, numbers, positions, movements, and speeds of things in ordinary life. Are some of the persons or objects rep-resented impossibly larger or smaller than others? Do common movements, such as walking, proceed in a film at the usual speeds, or are they artificially retarded or accelerated? Do flowers open with unnatural speed, or dancers leap more slowly than gravity would permit? Do animals talk and think like humans? Fantastic treatment of the size of persons is developed in Swift's *Gulliver's Travels*. Much depends on the medium through which objects move. In swimming under water, bodies move slowly and rise with ease. No doubt in exploring the moon and planets we shall find natural types of motion which would seem fantastic on earth.

There is an important difference between what is possible but so far unknown, such as Gulliver's tiny people, and what is completely impossible by the nature of things. A round square is impossible, a contradiction in terms. A living organism occupying only two dimensions is impossible because of the requirements of matter and life. No person can be in two places at the same instant of time—or at least, so it seems today. But many things which seemed impossible in the past are now realities: human flight, for example. Ancient myths of human-like creatures with wings, tales of flying carpets and flying wooden horses in the *Arabian Nights*, all seem fantastic from the standpoint of modern science, not because they tell of people flying, but because the flight is done by magical or supernatural means. Through dreaming of things impossible at the time, such as human flight, art nourishes the desire to achieve them, and this sometimes leads to making them real.

Civilization preserves and will preserve, as stimuli to varied experience, both realistic and unrealistic art. It preserves the naïve and primitive side by side with the scientific, the insane with the sane, the world of dreams with that of alert sense perception. The study of unscientific and prescientific conceptions of reality is an important field for science to study. In art itself, it is not necessary to state how realistic one's production is, or to adhere consistently to one conception of reality. But in the morphological description of art, as well as in evaluative criticism, the degree and type of realism are important facts to observe and estimate.

Note: The following illustrations are especially relevant to this chapter: Plates IV, VI; Figures 18, 23, 30, 31, 33, 34, 42, 44, 46, 48, 52, 59, 60, 61, 62, 71, 73, 74, 76, 81.

CHAPTER VI

Developed Components

1. Their nature and uses.

Chapter Four of this book classified the basic psychological ingredients of art under a list of general and specific elementary components. Under each component there are a number of elementary traits and types. For example, under "pitch" are all the particular frequencies of sound in nature and human activity which are perceived as more or less "high" or "low," as in the tones of different bird songs and in the tones of a harp or pianoforte. "Middle C" is an elementary trait under the component "pitch." "Hue" is an elementary visual component, covering "red," "blue," and other elementary hue traits.

In Chapter Five, "Spatial, Temporal, and Causal Development," we considered some general ways in which the elementary components and traits can be built into more complex forms. The most important of these for the study of form in the arts, we saw, are space, time, and causality. They constitute frames of reference within which the details of art and of life experience are differentiated, combined, and developed.

The present chapter combines these two approaches to consider how the elementary components can be combined and organized in various frames of reference, producing *developed components*. An example is "melody," which results from a combined development of pitch and rhythmic relations among a number of tones arranged in temporal sequence. "Plot," in drama, fiction, and narrative poetry, involves the temporal, spatial, and causal development of motivated actions, desires and aversions, emotions, reasoning, and other elementary components. A developed component includes one or more elementary components, and usually several of them. A developed component trait or type, such as a certain kind of literary plot, includes several elementary traits or types, such as particular kinds of desire and emotion.

Elementary components are to be found in all areas of human experience. Developed components are to be found chiefly in the arts, but not exclusively so. Plots and characters occur in ordinary life situations as well. Life and art imitate each other. But on the whole a developed component is a conscious, technical procedure, evolved in a certain art or group of arts as a means to achieving certain specialized aims. "Orchestration" occurs in music. "Perspective" occurs in various ways in painting, architecture, stage design, and landscape design.

In general, developed component traits and types are more complex than elementary ones. The pitch of a single tone is more elementary than the changing pitch and rhythm of a melody. But none of them is purely elementary. Perceiving, desiring, and reasoning, even in their simplest forms, are highly complex, diversified processes. A percept or perceptual quality, such as blueness, is not an atom of experience; artistic production is not a mere assembling of atomic units. A developed component is not a distinct part or self-enclosed system in a work of art; it is one among many overlapping methods of organizing the ingredients employed. The main difference between elementary and developed traits in art is not so much one of general complexity as of the extent to which the resources of human invention have been organized and developed along consciously artistic, technical lines.

Developed components, traits, and types provide the artist with organized devices which are usually on an intermediate level of complexity. While more complex than the elementary ones, they are less so than the work of art as a whole, in that the latter usually includes several developed components. (A symphony includes melody, harmony, orchestration, dynamics, and others.) They are less inclusive than the "modes of composition" which we shall consider in later chapters.

The role of developed components in a complex work of art is somewhat analogous to that of the

various constituent systems in a complex machine or a living organism. The form and functioning of an automobile includes the structure and cooperation of the combustion engine, ignition, cooling system, transmission, differential, steering gear, brakes, etc. The form and functioning of a highly developed animal is described in terms of its bony, muscular, nervous, digestive, reproductive, respiratory, circulatory, glandular, and other cooperative systems, each complex in itself.

Some examples of what we are calling "developed components" have been distinguished under various names for thousands of years. Aristotle, in the *Poetics,* discusses the nature and interaction of plot, characterization, color, form, rhythm, language, emotion, action, rhythmical movement, spectacular equipment, song, diction, metaphor, and thought. Calling these "parts" or "elements" (*merê*) of a play, he distinguishes them from the quantitative parts such as prologue and episode. Likewise, under the name "developed components," we shall distinguish them from the concrete parts or quantitative sections of a work—e.g., the "acts" in a play, "chapters" in a novel, or "cantos" in a long poem.

There is not, and cannot be, any complete and final list of developed components. Countless different concepts of this sort are used in reference to different arts by scholars of different times and places. New ones are constantly being devised to describe and deal with new developments in one art or another.

The tremendous recent growth of cinema as a combined art, leading to the sound film in color, has brought with it a new set of terms for producing, analyzing, and discussing it. These include some derived from the older terminology of theater art in general, such as plot and dialogue, along with others more or less peculiar to cinema, such as montage, editing, continuity (in specific senses), animation, incidental music, and sound effects. Photography as a whole can be regarded as a component distinct from acting, scenery, and dialogue, even though the whole film is photographed. "Technicolor" or some analogous term refers to developed color effects. Usage in respect to such terms is constantly changing.

How are these terms and concepts used? Primarily, in planning and executing the product: in the technical and creative side of the cinema industry. This has become so huge and diversified, employing so many specialized types of expert, that names are needed for each craft or subdivision of the process. The distinctions among photographers, sound effects men, actors, and scene designers are analogous to those among photography, sound effects, acting, and scenery as developed components in the film as a work of art.

This raises again the question, often asked of aesthetic theorists, of whether a knowledge of such technical terms is necessary for an artist, whether artists really think in these terms or need to do so. The answer is that they are not strictly necessary; many artists do not think about them, especially in primitive periods and in the simpler, more individualistic arts such as drawing and singing, where little complex organization or specialization of personnel is required. A primitive bard could use and develop plot and characterization, meter and melody, without knowing these names or their equivalents in any language; without consciously directing his thoughts along these lines. But as art becomes more consciously purposeful and technical, and as thinkers in other fields discuss and criticize it, these terms and newer ones are in demand. Philosophers, patrons, officials, and professional critics need technical terms to praise this aspect of a work and disparage that. Plato distinguished between the "imitative" aspects of a work of art and the moral ideals it expressed. Aristotle used technical terms to distinguish between the requirements of a tragedy and those of an epic.

In a society such as ours, where complex art is produced and actively discussed, there is a tendency to analyze it more and more explicitly. Thus a critic may say of a new film that its plot is hackneyed, its dialogue banal, but that its montage and color effects are magnificent. Where such distinctions are commonly made, artists tend to make them too. They originate some in the process of technical work and borrow others from current usage. Large-scale, collective organization multiplies them. In aesthetic morphology, we try to avoid the evaluative issues and implications, and to sharpen up the factual distinctions involved. Whether or not we desire to evaluate a film, we must pay some attention to its developed components if we wish to perceive and understand it fully. One who notices only the action in a Shakespeare play, ignoring the verbal music, the characterization and all the rest, cannot be said to have experienced it fully. The study of developed components, like that of other factors in art, should help us know what to look for in the many kinds of art we encounter.

Many volumes have been written on some of the components mentioned in this chapter. Usually definitions of them and descriptions of their use in art are mixed with rules and value judgments as to how they

should be used, e.g., what constitutes correct, beautiful, or agreeable chord progression or color harmony. We shall take some note of changes in taste and style along these lines, but shall not attempt to evaluate any particular traits or types.

2. Their special importance in the time arts and in complex space arts.

Analysis in terms of developed components is more necessary and revealing in music and theater arts than in static painting and sculpture for psychological reasons. The notes and chords of music, the words, rhymes, and rhythmic feet of spoken verse, flow past our ears in such great numbers at high speed as to prevent close attention to them as individual units. It is impracticable to describe a long, complex symphony or poem in terms of elementary component traits—the pitch of each note and chord, the timbre of each rhyming syllable, and so on. To describe them individually would be interminable and unprofitable. The ears and mind tend to grasp them in groups and sequences of moderate size, such as, in music, melodic phrases and chord progressions; in poetry, metrical lines and grammatical phrases and sentences. These are *developed component units*. The same condition exists in looking at a motion-picture film. The individual pictures come and go so rapidly (several each second) that we cannot stop to notice each in detail as to hue, linear shapes and the like, as we could in a static painting or drawing. We perceive them rather in "shots" or connected sequences of intermediate length.

In general we tend to perceive the time arts in temporally developed groups and sequences of intermediate duration and complexity. We try to grasp each developed unit as a whole in its rapid flight, and also to fit it into larger sequences and patterns. Each developed unit, such as the musical phrase, is moderately complex and heterogeneous in symphonic music. It contains trait units of several developed components, merged into a single changing wave of variegated sound. It may contain, at one and the same time, one or more units or parts of units in a melodic, a harmonic, a metrical, and an orchestral sequence.

With a static, printed score of music or text of verse in front of one, it is easy to fix attention on a single tone or letter, as one would notice a single curve or dot of color in painting. Units of this size can be described in terms of elementary component traits. Such microscopic analysis may or may not be

very significant in characterizing the work as a whole, and it quickly grows to vast proportions. Morphology requires a general understanding of the relation between elementary details and the form as a whole. Developed components provide the necessary links between them.

Painting, sculpture, and the smaller decorative arts can be complex enough in their own ways, and we shall see how developed components function in them. But they usually present a simpler problem for perception in that the details are relatively few and the whole form stands before one's eyes with little or no change, as long as one cares to look at it. A statue in the round presents different aspects as one moves around it, but one can return to see them over and over. The same is true of a printed work of literature. Under such conditions analysis in terms of elementary components becomes more possible and more significant. Pictorial form can be profitably analyzed in terms of presented and suggested traits of shape, color, space, texture, and their associations in human experience. However complex a single, static picture may be, it is simple in one respect: there is only one picture to deal with, not many thousands, as there are in a motion picture film. In the film analysis of any one picture or short sequence is only the beginning.

3. Developed component traits and types.

In discussing elementary components, we observed that a number of traits and types could be classed under each. Under "linear shape" are "straight," "curving," "angular," "jagged," "wavy," and many others. "Angularity" is an elementary component trait, and lines possessing it constitute an elementary component type. Any particular angle in a picture is an elementary trait unit of that component.

Analogous concepts are needed in dealing with more complex developments. If "melody" is a developed component, any specific variety of melody is a *developed component trait*. Melodies are sometimes distinguished as "scalewise" and "chordwise." Scalewise melodies, which (in traditional music) tend to avoid long leaps in pitch and to follow some definite key or keys, constitute a developed component type. Any particular example of a type or trait is a unit.

By definition, a developed component is somewhat complex, involving a number of elementary component units and some variety of elementary traits. Instead of "developed component traits," one might

say "trait complex." But, for brevity, we may assume that a developed trait is necessarily a cluster or sequence of somewhat differentiated elementary traits. It may be of considerable length, as in the highly developed melodies of Tschaikovsky, Rimsky-Korsakov, and Brahms. Such a melody cannot be fully described in terms of any one trait such as "chordwise."

The same is true of the developed literary component "characterization." Any particular character or group of characters, such as Achilles or the Olympian gods in the *Iliad,* can be taken as a unit or group of units under that component. But the character of Achilles does not appear all at once. It is shown by successive actions and speeches, which bring out different traits—e.g., valor, pride, sulkiness, devotion to Patroclus, and the like. The character of Achilles is a *developed component trait complex,* involving all his traits as thus demonstrated. In some respects he represents a type, the epic hero; in others he is unique, and very different from Odysseus and Aeneas.

The fact that characterization is developed through acts and speeches illustrates the general fact that all components, all traits, both specific and developed, tend to overlap and merge to some extent. It is possible to separate them; a protagonist may act or speak in some way which does not exhibit any particular trait of character. Action can be developed more or less in isolation, and so can sensuous imagery. But in highly developed literary form there is a frequent tendency to kill two or more birds with one stone, to make each concrete part of the work, each passage in the play or epic, carry on two or more component developments. The various components are combined in different ways in different parts of the work. In one scene of a play there may be little action and much revealing dialogue; in another, the opposite. One can usually trace the course of each developed component throughout the work, interacting with others to build the total form.

4. Component sequences and progressions, elementary and developed.

Analogous to the elementary component sequence is the developed one. Both are most definite when developed temporally: that is, when details are presented in a certain chronological order or arranged in a static way so as to be perceived in a certain order. A miscellaneous group of marks on a piece of paper, differently shaped and colored but scattered at random, is not a sequence. But if a set of marks is shown in succession, or placed in a row so as to be seen from left to right, it constitutes a sequence. The sequence may be quite irregular, as in "2,1,6,6,3," or "red, blue, yellow, yellow, black." If it manifests some persistent trend or change from one order to another, it can be called a *progression.* (Neither this word nor "regression," below, imply judgment of value.) A row of triangles increasing or decreasing in size is an elementary sequence, and so is a succession of tones increasing or decreasing in loudness. A sequence which reverses a previously established or expected trend can be called a *regression.* Some progressions and regressions are highly regular and based on arithmetical or geometrical measurement, especially in the decorative arts (e.g., in an architectural moulding or textile border), but most are irregular and approximate.

Any sequence of units containing different traits of some developed component is a *developed component sequence.* A symphony may contain successive changes in orchestration: first a passage for strings only, then one for strings and woodwinds, then one for these plus brasses, then one for brasses and tympani only. That is a developed sequence in the component "orchestration." It is mainly a development of the elementary component "timbre," or "tone quality." Each passage is a compound unit, containing a certain orchestral trait complex. (It will usually contain developed melodic, harmonic, and rhythmic traits which form concurrent sequences in these other components.) The sequence will be progressive if it shows some approximate trend or direction, such as a tendency to bring in more and more different orchestral choirs and thus to enrich the tone quality of the musical texture. Thinning out the texture by decreasing the number of orchestral traits would then be regressive. Most developed component sequences involve some development of two or more elementary components. Thus to change from violins and flutes to cellos, double basses, and bassoons involves a lowering of the range of pitch variations in addition to changes in timbre.

Two or more developed components often reinforce each other in producing some combined effect, such as working up to a climax. Toward that end, the passages involved may contain a progressive enrichment of orchestral coloring, plus increasing loudness on the whole, plus accelerating tempo, plus suggested agitation by rhythmic irregularities. Ordinarily, such concurrent progressions (elementary and developed) do not proceed at a steady, even pace or all together. They coincide in part and diverge in part, with occa-

sional pauses and regressions. If the differences and divergences dominate, the effect is, of course, to weaken or prevent any combined progression, at least for a while. A gradual tendency toward cooperation among the components can itself be the dominating trend.

The analogies in literature and other time arts are fairly obvious. There is often a discrepancy between words and deeds, dialogue traits and action traits, in the development of characterization. Honeyed words and professions of friendship, such as those of Iago toward Othello, may for a while accompany malicious acts, or malice may appear in the dialogue itself behind the mask of friendship. For a while the characters of Othello and Iago are not made evident, but they gradually become so through a number of elementary progressions—the increasing credulity, jealousy, and suspicion of Othello, the clever treachery of Iago, unrestrained by pity or loyalty.

In general, a trend toward either integration or disintegration, self-control or lack of it, can be regarded as a progression in the developed component "characterization." It can be a brief episode or a dominating pattern of the whole work; it can be continuous or interspersed with pauses and regressions.

Progressions differ as to the number and diversity of components participating actively. Thus a gradual rise toward a climax may occur only in and through dynamics (as increasing loudness) while the other components remain on a steady level. Or all can participate, thus producing a combined diversified component progression.

5. Specialized and diversified component development. Relation to various arts and styles.

In the chapters on ingredients it was shown that different arts, styles, and works of art differ as to the nature and number of elementary components they employ. Some are relatively specialized, some diversified in this respect. All works of art contain at least a trace of more than one elementary component, but many of them develop only one to any great extent. Thus a pen-and-ink artist may specialize in line and develop it into complex form. There will be some contrast of light and dark, and perhaps of hue, between ink and paper, but the artist will not necessarily develop this by emphasis on variations.

As to developed components, the history of cinema shows a progressive diversification. For several decades, films were silent and limited to blacks, whites, and grays. Then sound was introduced, and later color. "Sound" came to include several developed components, such as dialogue, commentary, incidental music, and nonmusical sound effects. The development of one component may tend to diminish another. Pantomime was emphasized in the old silent film, but declined with the coming of spoken dialogue.

On the whole, greater diversification of components permits more complexity of form, but that will depend on how much they are developed and integrated. Ordinarily, a symphony is of course more complex than a folk song. But a work of art which specializes on one or a few components may achieve intensive complexity by much variation within a restricted range.

Development of more components does not necessarily make a work of art better or worse. It offers opportunities and raises problems for the artist in handling a wider range of resources. It raises problems for the observer in appreciating what is done with them. An oil painting is not necessarily better than a pen-and-ink drawing, or more complex, but it has a greater potential for complex development in a wide range of aesthetic effects.

In some arts, such as architecture and opera, the nature of the medium, product, and functions have traditionally favored a wide range of components, especially where luxurious ornamentation is called for. In others, such as drawing and calligraphy with brush and ink, all factors favor subtle development wihin a narrow range. In literature there has been especially great variety in the range of suggested components. On the whole, artistic evolution has provided a wider and wider range of potential means for the artist in each medium, so that he may choose for himself whether to specialize or diversify.

Various *styles* within the same art may differ widely in this respect. One important way to distinguish styles in any art—either individual styles or major period styles—is to notice which components, and how many of them, are developed and emphasized. The extent to which any component is developed depends, as we have seen, on the number, variety, and integration of the units containing it. But without much development along those lines, a component can be emphasized by making it conspicuous, large, intense, or pervasive. This in itself is a kind of development. Thus melody can be emphasized in a musical composition by making it comparatively loud and sustained, especially in the treble voice, and usually dominating the chordal accompaniment. Much of Schubert's music is of this sort; more so than

Wagner's late works. With less emphasis, melody can receive the principal development by many variations and by great activity in appearing and reappearing within the musical texture. Either kind can be called melodic music. Since Wagner's later works, there has been a frequent tendency to minimize or blur melodic line; to subordinate it on the whole to harmonic and orchestral effects and to emotional expressiveness.

The history of painting since the Renaissance has included a partial trend from emphasis on linear and suggested solid shape (as in Botticelli and Signorelli) to nuances of light and color (as in the Venetians and Impressionists). In coloration the emphasis shifted for a while from decorative surface pattern (as in the Byzantines and Fra Angelico) to atmosphere, involving nuances of light, local color, reflected color, and aerial perspective. In drama and fiction the emphasis has shifted somewhat from overt action and plot to more subjective, psychological developments, as in the "stream-of-thought" novel, and to sociological developments as in the literature of social protest.

As against all these trends, there have been countermovements, especially in recent years. Many radical issues and divergent tendencies in style can be basically stated in terms of which components are used, which ones emphasized and developed, and how and to what extent. Some recent styles deliberately avoid or minimize components such as three-dimensional representation in painting and plot or story interest in fiction, which have been traditionally regarded as fundamental necessities. To eliminate certain ones is to rely more heavily on others for the total effect. Each individual artist and each particular work selects certain components and develops them in somewhat distinctive ways. But an overall tendency to eliminate components previously emphasized, with an effect of drastic simplification as in much "abstract" visual art, is a significant trend in style.

Styles in each art are roughly distinguished by a general tendency to use, develop, and emphasize a certain range of components. They overlap considerably in this regard, and there is much variation within a given style among particular artists and their works. Even within a particular work some parts may emphasize one component, some another. This is one way in which art differentiates in the course of evolution. On the whole, music of the classical style in Europe (late seventeenth and eighteenth centuries) tends to steady meter and dynamics and to long, clear-cut melodic lines, as well as to restrained emotional suggestiveness, subordinated to musical design. Orchestration is comparatively simple, with many passages marked "tutti." Romantic music of the early nineteenth century tends to more irregular meters, rhythmic phrasing, tempi, and dynamics, and often to shorter, more irregular melodic lines. There is more dissonance, with richer and more varied chord-progressions and frequent modulations, and richer orchestration, with many passages for one or a few choirs of instruments. Harmonic and timbre development often blurs the clarity of melodic line.

6. Architectonic components. Conflicting attitudes toward them.

In each art certain components have been traditionally regarded as fundamental, as providing the necessary basis and framework for aesthetic form. In the visual arts linear shape, surface shape, and solid shape have been so regarded. Color, light, texture, and others have usually been treated as somewhat accessory. The essentials of the form, it was supposed, should first be outlined in terms of shape; then the outline could be filled in, if so desired, with subordinate components. Linear shape has actually been fundamental to many arts for millennia, as in Chinese painting and calligraphy with brush and ink. It was a late and sophisticated reaction to attempt, as in some Baroque and Impressionist painting, the gradual subordination of line to light and color along with the melting of line and solid shape.

Somewhat analogous changes of attitude have occurred in music and literature. Melody, as involving developments of pitch and rhythm, has usually been fundamental in European music. The early Gregorian chants were mostly in unison, without instrumental enrichments of timbre. In some kinds of tribal music, the rhythmic pattern of drumbeats is fundamental. Harmonic and orchestral enrichments usually came in later as fitting into the patterns set by melody and rhythm. Recent music, however, has often tried the experiment of dispensing with melody, or at least with firm, complex, continuous melodic development. Instead, the shifting, chromatic textures of tonal and atonal chord progression, enhanced by orchestral coloring, themselves determine the form.

Fiction and drama have traditionally considered action and plot as constituting a fundamental framework. Characterization, verbal music, scenery, local color—all have usually been fitted into that framework, however much prized and cultivated for their own sake. By contrast, as we have just observed,

much recent literature has subordinated plot and action or even (as in Beckett) eliminated them as completely as possible. What remains may be only a loose succession of sudden impulses, scattered, fragmentary images, detached events, and momentary fantasies.

As against the conservative charge that works deprived of the traditional, firm, architectonic outlines are "formless," it is now commonly recognized that form can be achieved in other ways. The formative potentialities of color, texture, and other once subordinate components have not yet been fully realized. Some artists wish to avoid complex form, or at least firm, obvious, monumental types of form. In fiction a vivid stream of thought can be a substitute for action and a kind of internal action in itself. It can involve many psychological components and be as firmly organized as the artist wants to organize it. Here, too, there has been some tendency toward irregularity or very loose organization.

7. Selective apperception. Components and their functions in a particular work.

The ability to analyze a work or style of art in terms of developed components requires some effort and practice. It is often useful to look or listen for one component at a time. One can focus attention on a certain component and follow it throughout its manifestations in different traits and trait units.

Many untrained listeners perceive little else but obvious, tuneful melodies in a symphony. The more highly trained listener can, if he wishes, hear a whole piece of music with attention fixed mainly on the rhythmic variations, then mainly on the orchestration, and so on. This is one kind of selective apperception. By thus focusing attention on one component after another, the observer can approach a fuller grasp of their interaction and thus of the work as a whole. Few if any observers can grasp all the components clearly at once, in the first experience of a complex work. Many never achieve a full, clear, organic apperception of such a work, especially in the time arts. They perceive rather vaguely, with attention only on a few obvious aspects of the work which interest them most, such as melody or plot. Accessory features such as verbal music in poetry, subtleties of characterization and symbolism, pass them by unnoticed. Only the careful student of music, who will listen to the same composition many times with score in hand, can approach full perception of so complex a work as Brahms's Second (B flat) Concerto for Piano

and Orchestra. Before the phonograph was invented, the public rarely had an opportunity to hear such a work repeatedly, in close succession. Now it is comparatively easy to do so. It is easy, of course, to read a piece of printed literature over and over, but to do so in a systematic, selective way requires some effort.

In symphonic music, one can listen one or more times for melodic lines, including counterpoint and polyphonic developments, then for harmony, chord progressions, and modulations, then for changes in meter and rhythm, and so on. In a film, one can watch for plot, then for characterization and dialogue, then for color and photography. After looking and listening selectively to the course of several components through the work, one can try to follow several or all at once. There is no one right order for selective apperception, but it is often advisable to begin with those most emphasized or most dominant in the form as a whole. In music it is usually a presented component, such as melody; in literature, a suggested one, such as plot or verse form.

It is not enough merely to look, listen, and understand in a superficial way. One must go on to ask just *how* each developed component is used in this particular work, and in each main part of the work, and what are its changing roles and functions in relation to the other components and the total form. A component or component trait is seldom if ever regarded as an end in itself. It is a means to some joint effect, a cooperative factor in a larger organism, even in a very small, simple work. Even a very subordinate, undeveloped component may play a definite part in the whole and deserve some attention.

8. Developed auditory components and component traits.

Music is, of course, the principal field for development of auditory components. Literature also develops them to some extent in presentation and suggestion, especially in the case of rhythm and timbre. Their presentative development is mostly in the qualitative and temporal frames of reference. Visual art can suggest sounds, as in a picture or pantomime of a boy singing, but it does not develop these auditory suggestions to any great extent.

Let us remember that, when literature is read silently, all auditory components are suggested, and all visual components also, except those pertaining to the appearance of letters and other presented visual symbols. All visual and auditory components can be

suggested in literature. The possibility of direct, spoken presentation still stimulates the development of auditory components, more so in poetry than in prose, and more so in music than in either. Poets in our age have to reconcile themselves to the fact that their works will be read silently for the most part, not heard aloud. This has tended to discourage emphasis on verbal music in poetry, and to discourage poetry in favor of prose. But even in silent reading, one can pay careful attention to suggested word-sounds.

Music and literature both require visual means of expression for recording and communication, because of the evanescence of sounds. Unlike paintings and statues, sounds do not remain for inspection once they are made. Consequently, both music and literature tend to become partly visual rather than purely auditory arts. Both composer, critic, and theorist may become eye-minded in dealing with music, sometimes partly confusing the visible, symbolic score with the auditory form. The very word "literature" comes from the Latin word for "letter." Literature as an art has been defined in terms of letters, books, and writing. We almost forget that "literature" was highly developed as an art long before there were any letters or books, that it was originally, and still is to a large extent, oral and auditory. Printed words come to convey meanings directly to the mind, not through the intermediate suggestion of word-sounds. The latter become more or less dispensable accompaniments of the form, rather than essential components within it. That process has gone a long way in civilized literature, but less far in music. For trained musicians and musicologists, and especially for the writers of books on the subject, music has become increasingly visual. It is they who produce music theory, principles of harmony and the like, with the result that much of this writing treats music from a visual point of view. It is much concerned with how music is to be "spelled," written down in terms of a consistent system of notation. This can distract from open-minded concern with how music sounds, and hamper free extemporizing in serious music. Some kinds of jazz music involve much free extemporizing on a given theme and use the printed score chiefly as a point of departure.

In many devious ways, visual thinking comes to exert an influence on the nature of music and literature. Those musical effects which are most easily and clearly written down are favored, and others neglected. Irregular, slight variations in all components—fractional intervals in pitch, slight rhythmic syncopations, instruments of mixed timbre—are common in exotic and folk music. They are hard or impossible to write in our notation, so they are omitted or left to individual interpretation, which usually stays fairly close to the written score. Components such as pitch and loudness, which are hard to symbolize in literary text, tend to be neglected in literary composition, although they were integral factors in primitive literature. Rules and methods for the notation of music are emphasized in the training of the performer and composer, sometimes aiding and sometimes cramping the development of his musical imagination. Students learn impersonally; performers learn from the score music which they have never heard. This makes our musical styles very different from those of most exotic peoples (including India, where music has had a high development), who learn even complex music directly by ear, voice, and hand. The phonograph and sound film are helpful in recording and studying music directly, including the exotic and primitive, without the intervention of printed notes. So far they have not been used much in composition, but probably they will be in the future.

9. Auditory rhythm development.

This occurs in both music and literature, especially verse, but along somewhat different lines. In the chapters on ingredients, auditory rhythm was described as a specific or elementary component. In comparatively simple forms, it occurs throughout the sounds of nature and of human activity. As a steady, persistent succession of beats or pulsations, separated by intervals of comparative rest or silence, the rudiments of rhythm are heard in waves and tides, in the beating of the heart, in breathing, in walking, in the hammering of a woodpecker or a carpenter, in the ticking of a clock, in birdsongs and sometimes in human speech.

The beats are usually distinguished from the intervals by comparative loudness, i.e., as accents or stresses, and by quantity or duration. Thus the succession can be one of "loud, soft, loud, soft" or of "long, short, long, short" or of both combined. The loud can be long or short. Some rhythmic effects can be secured by alternating any pair of contrasting auditory traits, such as high and low pitch or the timbres of piano and violin. Even in its comparatively elementary forms, rhythm is thus a combination of different auditory traits

Development consists, here as elsewhere, in the systematic differentiation and reintegration of these beats and intervals. In auditory presentation (musical

and literary), it occurs mostly in the qualitative and temporal frames of reference. Causal and implicative suggestions are also introduced, especially in literature. Certain types of rhythmic change suggest changing actions. Developed auditory rhythm includes systematic accent, meter, tempo, rhythmic phrasing, rhythmic counterpoint, and other devices. These are developed auditory components.

10. Pitch development.

This includes several complex ways of sounding tones of different pitch, together and in succession. Scientific knowledge of the physical basis of pitch, in sound waves of different frequency, has helped in the artistic management of that elementary component. But in art we are primarily concerned with the perception of pitch as a kind of experience; it would be a mistake to base alleged laws of harmony entirely on mathematical ratios of sound.

In modern Occidental art, pitch development has been mainly confined to the art of music, including musically sung or chanted literature. Nonmusical sound effects, as in the cinema, control the pitch of sounds in different ways. We have noted the tendency for spoken language and literature to fall in pitch at the end of a categorical or imperative sentence and to rise at the end of a question. But intonation is not highly developed or determined in Western literature. Conventional intonations in speech vary considerably among the European languages, especially Swedish, French, Spanish, and English. It is hard to preserve such traits in translation. In Chinese and some other "tone languages," differences in intonation are a necessary part of communication. In those languages the rise and fall of the voice help to distinguish words or different ideas that would otherwise sound alike. Since pitch variations are determinate there in sounding each word of poetry, the problem arises of how to alter them in producing melody, without changing the meaning. Significant pitch variations are sometimes used by the Oriental poet to produce further aesthetic effects, approximating those of music.

Pitch is developed, along with other components, into scale, key, tonality, modulation, and melody (as combined pitch-and-rhythm development, polyphony, chord relations, chord structure, and chord progression). These are still highly important in music, both traditional and avant-garde; but for reasons of space we must postpone detailed discussion of them here.

Chord relation cannot be sharply distinguished from the other developed auditory components. It is intimately bound up with melody, in that the various "parts" of chords and their progressions tend to fuse horizontally as well as vertically, into melodic lines. Whenever harmony is conceived in terms of two-, three-, or four-part writing (e.g., of soprano, alto, tenor, and bass), it may organize itself contrapuntally as well as in vertical chords. In modern writing for the piano and other instruments, many of these horizontal continuities are melted and scattered. One principal melodic line, corresponding to the old *cantus firmus*, often remains. It too may break and dissolve at times, during strong emphasis on chords or other components, but it is almost impossible to avoid the tendency for the top or other emphasized tones in a chord progression to join together in a suggestion of melodic line. Discussions of both chords and melodies are subject to the same considerations of scale, key, modulation, tendencies of active tones, cadences, and the like.

In addition, chord relations are much affected by rhythm and timbre. The effects of chord progressions are vitally influenced by whether a certain chord comes on an accented or unaccented beat, at the end or the middle of a rhythmic phrase.

Timbre and the different nature of musical instruments have also helped to determine the use of chords. Pianistic harmony tends to be much more percussive and more free and extended, with wide skips and floating chromatic figuration, than does music for a single sustained, slow-moving human voice. Progressions which would be difficult or strained and cumbersome for the latter sound easy and natural for the former.

11. Timbre development in music; orchestration.

The word "orchestration" refers literally to the arrangement of music so as to be played by the various instruments of an orchestra. When music is written, not for a full orchestra but for a smaller group of instruments such as violin and piano, the word "instrumentation" is often used. These terms are not regularly applied to music for human voices, although voices are a kind of instrument. Music for a group of voices is called *choral*, but voices are often combined with other instruments, in large and small groups. We shall understand both "instrumentation" and "orchestration" as covering both animate and inanimate instruments when special attention is given to their vari

ous timbres. (Respighi used recordings of bird voices orchestrally.)

As a technical study, orchestration deals with the construction, operation, range, timbres, and combination of musical instruments and with the writing of musical scores for them. Among the techniques imparted under this heading are the distribution of the parts to emphasize those considered most important in each passage, the differentiation of timbres through contrast and blending of various groups, and the expressive effects of different timbres.

The traditional concert orchestra includes four or more groups of instruments: the strings (first and second violins, violas, violoncellos, contrabasses), woodwinds (flutes, oboes, bassoons, clarinets, piccolos, English horns), brasses (horns, trumpets, cornets, trombones, tubas), and percussives (tympani, cymbals, triangles, gongs, etc.). Harps, pianos, harpsichords, and some other instruments, though using strings, are often classed separately. Stringed instruments use tense strings, to be bowed, plucked, struck (as in the piano), or blown upon as in the aeolian harp. Most wind instruments use a column of air which is made to vibrate by a reed or by the lips. Percussions use a membrane, plate, metal rod, or other device. The piano is in a way percussive, but is not usually so classed.

From our present point of view, the important distinction is not between types of instrument or technique, but between the types of timbre they produce. These are usually named after the instrument or (in voices) the age and sex of the singer. Not only is there a difference between individual singers as to range of pitch and timbre, but each instrument (including voice) has certain traits of timbre. A soprano part differs as sung by women or boys. The difference between "legato," "staccato," and "pizzicato" on the violin is partly one of rhythm and partly one of timbre. The human voice is potentially one of the most versatile of all instruments.

In describing traits of timbre in music, one can use not only specifically musical terms, but also those referring to timbre in general, as an elementary component. Thus a voice may be described as light, heavy, shrill, guttural, harsh, strident, clear, pure, delicate, strong, raucous, hoarse, whining, trembling, commanding, and the like. While many of these are not intentionally produced in singing, they may be sought in drama and occasionally in opera, for expressive effects.

Orchestration has been greatly developed in recent years, in popular as well as in symphonic music. But it is still not commonly regarded by theorists as one of the main components of musical form. These components are commonly listed as harmony, melody, and rhythm. They are often misleadingly described as if independent of the kinds of timbre involved. As a part of music, orchestration has been regarded as extraneous to the basic structure. The music is composed, often without express consideration of timbre or instrument (which usually means that it is written as if for piano or voice). Then it can be "arranged" or "transcribed" for any instrument. Instrumental timbre is then regarded as a "medium," external and separate, through which is to be presented a musical form complete in itself without reference to it.

This involves an underemphasis on timbre as seen in the light of its recent development. The actual harmonies, melodies, and rhythms of past European music have been basically influenced by the types of instrument used—voices in chorus, organ, harpsichord, violin, etc., each with its peculiar qualities of accent, resonance, surviving or quickly dying tone, fixed or variable pitch, comparatively pure or mixed timbre. At the same time, changes in taste and in culture generally have led to the development of certain instruments such as the piano, which is peculiarly suited for solo virtuosity before a large audience. Some kinds of music could only have been composed for certain instruments. Certain kinds are easily performed on one instrument, hard or impossible on others. Some instruments are especially conducive to a polyphonic, others to a chordal style, some to a rapid, crisp succession of notes, others to slower and more expressive singing tones.

Alfredo Casella, an early twentieth-century composer and theorist, remarked that harmonic sensibility itself was then reaching a new, qualitative conception, that of *tone color*.[1] Long after Casella wrote, the range of tone colors used by avant-garde composers continues to increase.

If we recall that effects of differing timbre are produced mainly by the number and character of the overtones mixed with the fundamentals in a total sound, the nature of timbre is closely connected with that of harmony or chord structure itself, which is likewise an audible blending of tones of different pitch. The thorough analysis of harmony leads directly to a consideration of timbre. Richness of timbre is associated with a growing taste for sensuous values as distinct from intellectual and formal ones, the latter being associated in theory with melodic line and chord progression and with visual line and shape. Gregorian music was plain and simple in timbre; the

[1] *The Evolution of Music* (London, 1924), p. xx.

modern orchestra has steadily developed that component.

The orchestra developed under more secular auspices. Each instrument possessed not only its general type of distinctive timbre (e.g., violin tone), but also a wide or narrow range of further possible variations in timbre (e.g., the bowed or plucked violin tone; the harpsichord tone with different keyboards). In recent years many unfamiliar instruments and timbres have come into Occidental music, some new, some revived or borrowed from Oriental and primitive sources.

When musical form in general entered a more vertical, chordal period, instruments also joined into more completely blended combinations, with greater sensuous richness at the cost of polyphonic clarity. Outstanding characteristics of early nineteenth-century orchestral music were, first, a great emphasis upon the strings, which almost always carried the main melody and shaped the principal chord progressions (with percussions and winds in a subordinate role for accentuation and accompaniment); second, a tendency to write long passages for all or nearly all instruments together (tutti). Subsequently Berlioz, Wagner, Rimsky-Korsakov, Richard Strauss, Debussy, Ravel, Bartok, and Stravinsky continued to separate these uniform, total blends and often to reduce the dominance of strings. Brasses and percussions rose in importance. Passages for the whole orchestra (tutti) were less prolonged, reserved usually for occasional emphases. Orchestration became more open, extended, diversified in time. If all instruments were playing together, certain ones would be strongly dominant at a certain time, soon yielding this eminence to another choir. Brief solo passages, for a single instrument, occasionally flashed out (as in *Schéhérazade*) with all the rest soft or silent.[2] Many different combinations were heard, sometimes in quick succession, each composed of a very few choirs or perhaps only two. These might be comparatively similar, as the bassoons and cellos, or in marked contrast, as the flutes and harps or the oboes and kettledrums.

A simultaneous combination of different timbres we shall call a *timbre blend.* Several violins together make a highly uniform blend; violins and violas make one which is slightly less so; piano, voice, and violin make a highly contrasting blend. The difference between the tone of a single instrument or voice and that of many similar ones together is not essentially one of loudness. The whole violin section playing together may play more softly than a single instrument. The difference is sometimes described in terms of "volume." We shall include it, however, under the general heading of variations in timbre.

A simple, directional trend or sequence of timbres is a *timbre progression:* for example, from violin to flute to cello to bassoon. An *orchestrational progression* is a succession of complex timbre blends. One type of orchestrational progression would be: from strings and oboes to brasses and percussions, and thence to a passage for whole orchestra. A timbre blend is analogous to a chord; an orchestrational progression to a chord progression. A movement or a whole composition can be analyzed and described in terms of the succession of different timbre blends it involves, and the duration of each in terms of measures. This is *orchestrational analysis.*

Much of the effect of orchestration depends on its relation to other components, especially to harmony, melody, and dynamics. The question is not only what choirs are playing, but with what relative loudness, which choir carries the main melody, and so on. These are questions of compound musical effect, of cooperation between components.

Recent music has evolved a greatly increased variety of both blends and progressions in timbre. It has raised instrumentation as a developed component to a much higher position of importance in relation to harmony and melody. The development of the phonograph, sound film, radio, and electronic technology has presented new problems in the analysis of musical timbre. The scientific knowledge utilized in these mechanisms, involving not only sound waves but electric, radio, and light waves, has been applied in the realm of music partly for the reproduction of tones originally produced by the voice and traditional instruments of the orchestra, partly and increasingly for invention of new kinds of sound, not previously used in serious music.

Mechanical sound production is rapidly outgrowing its early imperfections, its unwanted hums and scratches, its omission of desired overtones. It is approaching accurate reproduction of whatever sounds are transmitted to it. Much study and aesthetic analysis of music is now based upon phonograph records. In listening to a "violin record," we are not hearing tones from a violin, but tones from the phonograph mechanism. These may, however, be almost indistinguishable from the original violin tone. In other words, a characteristic timbre which we call "violin tone" is now being produced, not by a violin but by an electric machine, just as the characteristic texture

[2] Such music has been called "white," from the blank appearance of the score in such passages. That term is also applied to a sound or noise which contains many timbres and pitches, as white contains a mixture of hues.

of oil coloring is now being reproduced with ink in color prints.

Electronic sound production can imitate the timbre of any instrument by the artificial mixing of overtones, so that the timbre which we call "violin" or "pipe organ" can be directly produced through it, not reproduced, without having a real violin or organ play into or through at all. Even so, people may continue to call it violin or organ timbre. In the second place, science can *originate new timbres* (yet unnamed) in any number and of any type desired, again through the mixing of overtones. Through the use of radio tubes or transistors, a kind of belltone or guitar tone can be produced which will sustain or increase its volume instead of dying away at once. New names or symbols are now being devised for new timbres which gain established usage. A particular timbre has been intimately connected with a certain instrument, heretofore the sole means of its production. Thus "timbre development," as a component in form, was inseparable from the process of using certain orchestral instruments. In the future these may be to an increasing extent abandoned, replaced by more powerful and flexible, easily operated mechanisms.

Contemporary "concrete music" is so called by contrast with the supposed abstractness of music written for the pure tones of standard instruments. A great variety of sounds, many of which had previously been regarded as mere noises, are produced on instruments specially devised for that purpose, or reproduced phonographically from natural sounds such as thunder, artificial noises such as traffic, and the strange sounds which can be produced by electronic machines such as computers. These sounds are arranged in definite sequences or left in part to chance and sudden impulse as in aleatory music. Computers are also made to work out formulas for the combination and sequence of the sounds.

One result of the "concrete" approach has been to exalt timbre development to an unusually high status among musical components, at the expense of meter, melody, and chord progression in the traditional senses. Whether the music thus produced will satisfy the critical public remains to be seen. Much depends on the nature of the timbres employed, and these can be intentionally harsh or mellifluous. The former are often preferred as more appropriate to the present world situation, just as visual forms are preferred which a previous generation would have considered ugly.

Many of the sounds produced in contemporary experimental music can not be written in our traditional notation. Yet there is a growing need for written directions to performers. Hence efforts are being made to develop a new and adequate system of notation. As in ballet choreography, this encounters serious obstacles.

12. *Timbre development in literature.*

In phonetics, the word "timbre" is applied to the distinctive resonance of a spoken sound, especially a vowel, as determined mainly by its overtones. It is distinct from pitch, intensity, and loudness. The human voice, in singing or in ordinary speech, has a wide range of timbres and can change from one to another easily and quickly. Without instruction or purpose, the infant constantly modifies the timbre of his voice by altering the shape and tension of his mouth, lips, and vocal cords. In a culture these modifications are brought under control to express meanings and emotions.

In literary art, they are further developed into a component of auditory form, presented or suggested. The range of different timbres available for this purpose is determined mainly by the nature of the spoken language in which the piece of literature is composed and which the written language symbolizes. Each language has its peculiar set of vowel and consonant sounds, usually somewhat constant in spite of varieties of pronunciation due to differences of region, class, and other environmental influences. They are suggested by written syllables and words, so that a sequence of letters can evoke a sequence of different timbres. Some vocal tones resemble the sounds of certain musical instruments, but most of them are distinctive; the specific vowel sounds and the slight explosive, humming, or clicking sounds of consonants have no exact counterparts in orchestral timbre.

The comparison with music is further complicated by the fact that every human voice has its own peculiar, variable timbre in addition to the fixed timbres of the words it is speaking. It is childish, mature, or aged, male or female, strident, hoarse, or clear, soprano, alto, tenor, or bass. It is nervous or relaxed, firm or quavering, and constantly changing with successive moods. These traits are perhaps more similar to those of musical timbre than are the established vowel and consonant sounds of literature. The more diversified arts of dramatic speech and singing embrace both kinds: established word sounds and "tones of voice." For example, a dramatist may direct that a certain character (such as Beckmesser in

Die Meistersinger) is to have a harsh or whining voice, or that a certain speech is to be so delivered. The writer of fiction may remark that certain words were spoken "gruffly" or "pleadingly." In singing, especially dramatic singing as in opera, the voices are to some extent determined with respect to several kinds of timbre. They are to be soprano or baritone, for example, and young or old; in addition, they speak the word-sounds of a certain language. From this fact arises part of the difficulty in writing or translating the libretto of an opera: certain word-sounds are hard to sing at the desired pitch, or in the tone of voice desired for dramatic reasons.

Aesthetic theory has been slow to recognize and adopt a clear terminology for the description of timbre in literature. Some accounts of the elements in literature group together, rather indiscriminately, all the effects of word-sounds as distinct from content, meaning, or ideas. "Word-sounds," thus broadly conceived, include rhythm and meter. In the present section we are considering only one kind, that involving timbre development.

The most definite, emphatic way of developing timbre in Western literature is through *rhyme.* It is developed only in verse or poetic prose. Even accidental, occasional rhymes are usually avoided in prose. The commonest type is *end rhyme,* which exists between the terminal sounds of two poetic lines or verses. It involves a partial, but not complete, similarity between terminal sounds beginning with an accented vowel, as in "go" and "throw" or "madly" and "sadly." According to English convention, the accented vowels must be preceded by different consonant sounds, or by a consonant in one and not in the other. Similarity of unaccented vowels, as in "kindly" and "gladly," does not constitute rhyme by this definition. If the sounds are identical, as in "eight" and "ate," they do not form a rhyme in the conventional sense. French allows end rhymes produced by similarity in sound between the consonants before the rhyming vowel, as well as between the last accented vowel and successive sounds (e.g., "deceiving," "receiving"). Each of two or more rhyming words or sets of words is called a "rhyming member." It may include two or more short words, as in "helmet" and "well met." Words which are similarly spelled but differently pronounced, like "though" and "rough," are occasionally used as "eye rhymes." Unrhymed verse, especially in iambic pentameter, is called "blank verse." The "heroic couplet," popular in the eighteenth century, is also a combination of certain rhythmic and timbre traits; it is a rhymed couplet in iambic pentameter.

A *rhyme scheme* is a developed trait of rhyme, an arrangement of rhyming syllables. It can be brief and limited to a few such sounds or developed into a complex pattern. A simple type of rhyme scheme, or rhyme sequence, is that of couplets as in go, blow, high, sky (aabbccdd), etc. Another is the alternating sequence (ababcdcd) as in go, high, blow, sky, red, blue, said, true. Several such sequences of different types can be combined in one complex rhyme scheme. A *rhyme scheme progression* is a change from one rhyme scheme to another, or a definite sequence of such changes. A simple progression of this sort occurs in the conventional Petrarchan sonnet, where the rhyme scheme of the octave (abba) is succeeded by that of the sextet (usually cdecde or cdcdcd). From abab to cdcd (as above) is not a change in rhyme scheme, but merely an indication that the second set of rhyming syllables is to be different in timbre although similarly arranged.

Internal rhyme is that occurring between sounds at other places than the ends of lines, between one terminal sound and one or more elsewhere, or between two or more sounds inside lines. They may be between words of different lines or of the same line, and they may occur at regular or irregular intervals. If at regular places in successive lines, they tend to divide the lines and to sound like end rhymes. Rhyme in general often occurs, unintentionally, in prose or casual conversation, as in saying, "He spent every cent of his money." Prose writers tend to avoid it as distracting one's attention from the meaning without providing any compensatory development.

Similarities in timbre between nearby words in a literary passage, verse or prose, are not to be ignored even if they fail to qualify as "rhyme" in the accepted sense. "Rich" and other commonly disapproved varieties are used by some contemporary poets, but rhyme in general has declined in the twentieth century, in favor of free verse. Occasional rhymes are sometimes scattered irregularly in otherwise free or nonmetrical verse. Free verse usually lacks end rhymes and other regular, definite rhyme schemes. But that does not mean it is necessarily devoid of timbre development. By the subtle arrangement of occasional internal rhymes and other repetitions and variations of timbre traits, it can produce its own kind of verbal music. This may include similarities not usually classed as rhyme, such as the occasional repetition of exact words ("Break, break, break") and of unaccented vowels ("kindly, sadly, warningly, tenderly").

Alliteration is one of the common ways, other than rhyme, of developing verbal timbre. It consists in re-

peating the same letter or sound, especially a consonant, at the beginning of two or more nearby words. More broadly, it can include the repetition of any vowel or consonant sound in nearby words, other than by rhyme, including those in the midst of words as well as those at the beginning. Alliterative poetry is a type in which alliteration is systematically emphasized, as in early Teutonic poetry, most of which lacked end rhymes. It usually had four accented syllables to the line, the third alliterating with the first, the second, or both. (Here again, the development of rhythm and that of timbre combine to form a compound type.)

Assonance includes both rhyme and alliteration when broadly defined as the repetition of verbal sounds. As such, it is roughly equivalent to "word-sound development" in general. It refers also to a special type of rhyme used in verse in early Romance languages. We shall use the term to designate all those repetitions, variations, and contrasts of vowel and consonant timbres which are not included in rhyme or alliteration. Progressions can occur in assonance also, as when Keats, in the "Ode to a Nightingale," gives first a group of words which repeat certain vowel sounds (such as long *a* and short *u*) and certain consonants (d,s), then passes to other sequences of timbre traits.

13. Loudness development; dynamics.

Loudness in general is an elementary component, present to some degree in all audible sound. Softness is its opposite: a low degree of loudness. Silence is a complete or relative absence of audible sound. (One person, or one group of musical instruments, may remain silent while others are heard.) As a physical phenomenon, loudness is accurately measured in terms of decibels. In art, relative or apparent loudness is often more important than the exact physical power. If preceding sounds have been very soft, as in a whispered conversation, an emphatic word or distant shot may sound very loud.

Some amount of loudness, usually varying from moment to moment, is present in all auditory presentation, as in music and spoken literature. *Dynamics* implies some amount of systematic development of this component, a careful grading, that is, of relative loudness in successive passages and as between one voice, instrument, or group of them and others in concurrent sounding. Like other components, dynamics was not precisely determined in early musical

scores, being left more to the taste of the performer, but during the last two centuries it has been increasingly determinate.

We have already considered one systematic use of degrees of relative loudness, under the heading of rhythm. We saw that accent, including metrical stress and occasional accentuation, can arise from variations in loudness or force. In other words, one role of the specific component "loudness" is to help in the development of rhythm. But it has another role as well. Over and above the quickly alternating, often slight variations which contribute rhythm to a succession of tones, there may be a more pervasive, general rise and fall in loudness. These are called, in music, *crescendo* and *diminuendo*. *Crescendo* is usually indicated by the sign \diagdown or the abbreviation *cresc.* This is relative to the loudness of the immediately preceding passage; it implies nothing definite as to the physical amount of loudness to be produced. The dying reverberations of a single blow on a temple gong can hold the attention for several seconds.

Somewhat more specific are the gradations indicated as fortissimo, mezzo forte, mezzo piano, and pianissimo. But even these are estimated in relation to psychological as well as physical considerations. It would be easy to measure physical loudness with an audiometer and to specify in music the exact amount of loudness desired, in terms of standard quantitative units (decibels). This would be analogous to the exact determination of tempo and duration secured by means of the metronome. So far the art of music as a whole has not attempted such exactness, although it is becoming necessary in the scientific control of phonographic and sound film recording and radio or television broadcasting. One reason for avoiding exact specification is the great variety of conditions under which a given piece of music may have to be performed. A degree of loudness which would give the psychic effect "fortissimo" in a small room would be scarcely "forte" in a large open-air gathering, and what is "pianissimo" in the former would be inaudible at a distance outdoors without amplifiers.

Specifications of relative loudness have been made with increasing care and detail in modern musical notation. It has always played, however, a rather subordinate and accessory part in musical form as a whole. One of its principal uses is to suggest degrees of emotional excitement. The louder passages express on the whole more intensity of feeling, as a scream or shout does in ordinary life, but a sudden diminuendo in music or in speech may have a similar effect. When the form is diversified, as in opera, such emphasis is used with more restraint so as not to drown out the

words. In any case, very great or sustained loudness soon becomes fatiguing, as does extreme brightness in visual art, with loss of definite emotional suggestiveness.

A second use of dynamics is to help organize and mark off the compound parts of music: its phrases, periods, and movements. A gradual and continuous rise and fall of loudness, over a series of measures, can help to link it into a more or less balanced whole. A continuous crescendo or diminuendo throughout a sequence will likewise help to build it up into a climax or suggest a gradual dying away. If one sequence is loud and the next soft, or vice versa, the two stand out in contrast.

These are simple and obvious ways of using dynamics in the service of melody, harmony, and meter, to reinforce the divisions and cadences which have been constructed basically in terms of those components. Romantic music tends to find such obvious integration monotonous, and to distribute its louds and softs with less regular conformity to melodic phrasing. This may suggest wild or capricious impulse and emotion breaking loose from rational patterns. Dynamics is then more essential to the total effect desired, and is usually more explicitly scored.

The traditional means of demarcating phrases and other compound units are often weakened or eliminated, with the result that the units themselves tend to become more nebulous. In such cases dynamics can play an important part in the basic construction of the form.

Specific traits and types of loudness and softness are indicated by the single marks *ff, mf, p,* etc. A developed trait would include a more complex arrangement of different loudnesses and softnesses, crescendos and diminuendos. Beginning very softly and working up to a climax of loudness is a familiar dynamic scheme. It may be symbolized as pp → p → mf → f → ff → fff. Another is the sudden *sforzando,* coming unexpectedly in the midst of a calmer passage. Such changes can be developed into fairly complex orders of their own, and from one type of order, or dynamic scheme, progression can be made to another. For example, one passage or movement can be even, gently undulating in dynamics, the next, full of sudden outbursts and dyings away.

Written literature hardly ever develops this component very far. The loudness with which any sentence, line, paragraph, or stanza is to be read aloud, or imagined, is ordinarily left to the reader. Of course, a story or poem may say that a certain sound (e.g., of rain or wind) was loud or soft, or that certain words were shouted or murmured. But that does not mean that the words of the story or poem are to be spoken with corresponding loudness. Certainly, literature does not make systematic use of variations in the loudness of performance, as does music. As with timbre development, spoken drama sometimes takes a few steps along this line. Thus a dramatic script, or literature written as if for that purpose (often without any intention of actual performance) will sometimes give the stage direction "Suddenly screaming," "In a low whisper," or the like, in parentheses before a speech. Dramatic reading of a poem may endeavor to enhance its emotional effects by appropriate crescendo and diminuendo. But these are slight and almost indeterminate uses of loudness, in comparison with musical dynamics.

Silence can play a positive role in drama, and to some extent in instrumental music. Its significance depends on the moment in the action at which it occurs: for example, in tensely waiting for an expected intruder at night, or in the silence of an accused person when given a chance to defend himself. Other sounds than the one expected may proceed as usual or may stop together. In music, *rests* of different duration play a positive role in the development of rhythm and melody. A hushed pause in the midst of music, as in *Parsifal,* can be impressive as a contrast.

It was mentioned above that silence is a more important part of some Oriental music than it is of ours, being analogous to empty space in architecture. Occidentals tend to be impatient of silences in music; they expect to have something happening almost every second. Silences in Western music are usually few and brief, comparatively trivial pauses in a torrent of sound. The Buddhist attitude, expressed in certain types of Chinese and Japanese music, is on the whole more quietistic, more introspective, avoiding instead of craving constant external stimulation. It treasures the unchecked, slow dying away of each reverberating stroke upon the gong (symbolic of the passage of an individual life, and not to be unduly halted, as if by a damper). It treasures the long, quiet intervals between bell strokes as a way of escape from the noisy chatter of cities in the long silences of nature, only occasionally broken by the sound of a bird or waterfall.

14. Auditory texture development.

Auditory texture is a very general attribute of sound, to which pitch, rhythm, and timbre may contribute.

Automobile traffic has a characteristic sound as heard from a distance; so has the sound of many women's voices in a restaurant, the sound of cattle or sheep in an enclosure, frogs in a swamp, or surf pounding on a seashore. Some sounds are confused, blurred, as a result of many differences in pitch, timbre, and rhythm which blend vaguely, so that no one voice can be heard distinctly. Other sounds of nature and human activity are clear, plain, and open, as when a single bird cries aloud in a meadow, or a carpenter hammers a nail in a quiet neighborhood.

Some music can be described as thick and complex in texture, some as thin and simple. This will depend in part on the number of instruments and the variety of tones they are sounding together. Some music is crowded, densely packed with different tones; some is open, with only one or a few instruments playing. Some is tense, effortful, straining against difficulties; some is easy, relaxed, free-flowing, as if meeting no obstacle.

A tendency to one sort of texture may be persistent in a certain style, whether of a period or an individual. Late nineteenth-century orchestral music was on the whole comparatively dense, rich in tone color, and moderately dissonant. The work of a single composer, or even a single composition, may contain strongly contrasting textures. It may vary, suddenly or gradually, from thin to thick or vice versa: from open and simple to tightly, intricately woven. This is frequent in Wagner's music dramas. When definite melodies, keys, and chord progressions diminish, there is often greater reliance on broad effects of musical texture in which all the components play a part. Highly developed orchestration is an effective means to textural contrast between thickly blended passages and thin, open, simple ones, as in Debussy's *Afternoon of a Faun.* For a blurred, confused texture, much differentiation in small details of rhythm and pitch is also effective. The contrast of broad musical textures is analogous to that of broad visual textures in painting, architecture, and landscape design. To change from one developed, sustained type of texture to another is a *textural progression.*

15. Developed visual components.

In returning to the visual components of art, let us begin with some basic facts already noted. Visual components are, of course, presented in the visual arts, including the combined arts of opera and theater. They can also be suggested in the visual arts,

as when a painting represents a scene in nature. They can be suggested more or less definitely by other arts, as when musical mimesis of bird songs calls to mind the appearance of birds. Tastes, odors, and tactile qualities can, by association, call to mind the appearance of the things which usually present those lower-sense traits. All visual traits and components can be suggested in literature.

Visual ingredients can be *developed*, as we have seen, in various frames of reference, in one, two, or three dimensions of space, and in time and causality. Different arts, styles, and works of art develop selectively along one or more of these lines.

Visual ingredients may or may not be developed in time. In this they differ from auditory ingredients, which are always transitory. Some visible objects in nature are quickly evanescent, such as lightning, sunsets, the flight of hummingbirds. Others stand relatively changeless and motionless, long enough to be closely inspected in detail. The visual arts are likewise variable in this respect. A painting, statue, or building, especially if shown by fixed, electric light, is relatively static. A ballet or motion picture, on the other hand, is like music or spoken drama and therefore easily synchronized with these arts; it presents a rapid flow of changing visual images which we tend to grasp in groups and sequences of intermediate size and complexity. In the static visual arts, especially in comparatively simple forms such as those of some Egyptian sculpture, it is often convenient to perceive, analyze, and describe in terms of elementary component traits. There may be few or no highly developed ones. In the visual arts which are highly developed in time, such as ballet and cinema, there has been more tendency to think, produce, perceive, and analyze in terms of developed components.

Other things being equal, it can be assumed that spatiotemporal development, including speed of performance, usually leads to greater complexity of form than static, spatial development. There will probably be more details and more differentiation of them in a motion picture film than in a still painting. But there are different kinds of complexity. The multitude of details in a motion picture film may all be relatively crude and insignificant, devoid of subtlety in either the presented or suggested factors. A still picture, on the other hand, can develop its own kind of complexity through nuances of line, color, spacing, representation, emotional tone, symbolic meaning, and other constituent factors, far more than most films provide with all their millions of momentary "frames." The very fact that the painting will remain fixed for long, careful scrutiny, over and over on suc-

cessive visits, may encourage a painter to strive for these nuances.

In the static, visual arts there is wide variation as to which components are developed and to what extent. Some can be adequately analyzed in elementary terms, while in others developed components call for recognition. Taste often calls for relatively simple forms in both painting and sculpture. There has been a strong trend of this sort in recent years.

16. Linear development; drawing; delineation; line progressions.

Terminology is lacking for a clear distinction between developed and undeveloped line. It is lacking also in the case of several other visual components. In painting and sculpture, line and color can be fairly well described in terms of elementary traits and types. Film art consisting of "animated" drawings and paintings—developed in time—is comparatively recent. Other temporally developed visual arts, such as the dance, have not provided concepts of sufficient generality for our purpose. Most names for the linear aspects of art fail to distinguish between simple and complex types.

However, the distinction is not entirely unrecognized, and words can be found to express it. In one sense of the word, "line" is the general style and arrangement of a work of art in regard to its outlines and contours. The word "drawing" (in French, *dessin*) is often used in this sense. The critic may say, "The drawing in this picture is good, but the coloring is bad." *Delineation* is drawing in outline, as distinguished from that by means of colors, lights, and shades. *Draftsmanship* is developed skill in drawing. We shall use the terms "drawing" and "delineation" to mean the complex development of line as a component in visual art, whether used for representation or otherwise. They refer to either the process or the product.

A particular line may be a concrete thing and also a compound visual image. A pencil line on paper includes not only "line" as an abstract attribute, but also some color, degree of lightness, etc. A line of chalk on a blackboard is a streak of dull white, with a certain width, texture, surface shape, etc., in addition to its linear shape. That streak can be developed in various ways. We can develop it as to linear shape by extending and differentiating its curves or angles. We can add a loop, another and another of the same shape; we can cross it with other lines, straight and

curved, horizontal, vertical, and oblique. We can unify these linear diversities in some way, as in a regular pattern, or in the representation of a house or tree. The color and texture can remain the same dull white, with no definite mimesis of solidity or depth. This is linear development. We can start with any simple visual image, however indefinite, and begin to elaborate it in terms of any developed component we choose. We can have, as a result, a picture which is highly developed in terms of one component, but of low development in all others. The other specific components must be there, to be sure, and may be varied a little from place to place. An etching or a pen-and-ink drawing must have some color (counting black as a color), some darks and lights, and so on. But all these other components may remain comparatively simple, vague, or uniform.

Line development may take place in any or all of the four spatiotemporal dimensions. We can have a line whose development is almost wholly in one dimension, as in a straight line or slightly curved one which is continuous in some places and made of dots and dashes in others. Its development can be in two dimensions, as in a flat, decorative arabesque over a plane surface. It can suggest advance and recession into the third dimension, as in the drawing of a box or stairway in perspective. Drawing is developed temporally in the animated film cartoon, for instance, where a curved line changes into a straight one, and moves from left to right. In observing the movements of nature (tree branches, waves, etc.) we see change and differentiation of linear shape. In a ballet or pantomime, the total form involves change in many components. There is temporal development of line in the way the contours of the figures shift, combine, and separate into groups, in orderly sequence.

Neither line as a visual attribute nor its development requires that there shall be any definite lines in the sense of isolated streaks (e.g., of pen or pencil), grooves, or ridges. Line, as we have seen, can occur as a boundary or edge surrounding a silhouette or mass, or separating two contrasting color areas. It may consist of somewhat discontinuous images in a row or sequence, as in a line of footsteps in snow or of spots on a carpet. These elementary component types of line can be developed, as in some complex paintings, through the fact that the shape, size, and direction of these contours are not left to chance but controlled, diversified, and organized in their own right. "Drawing," in the same sense, can be done without any sharp-pointed instrument, and may consist in the way broad streaks of color or of light along arms, legs, and draperies are definitely organized in terms of linear

shape and direction (as in Tintoretto or El Greco). This may be done with whole solid masses, as of human limbs, tree branches, or snakes, as in Michelangelo's *Expulsion from Eden.* It is not to be identified merely with the shape of their edges or contours but also with the main total direction or series of related positions which they trace.

The term "line" or "linear shape" may refer to an elementary visual component, but also can be applied to its developed forms. "Drawing" and "delineation" refer mainly to developed types of line, such as the *arabesque.* This is a kind of ornamentation used in drawing, painting, textiles, mosaics, sculpture in relief, and other static visual arts, and characterized by intricate patterns of interlacing lines. It may be abstract, geometric, and angular (as in much Egyptian Islamic decoration) or curvilinear and flowing. *Bentwire drawing* uses sharp line of comparatively uniform thickness and texture. It is contrasted with *calligraphic line,* which varies expressively in width, light-and-dark, and texture, as when made by a brush with varying amounts of ink and pressure.

Any particular example of the use of a certain trait or type is a detail or unit: for instance, a single Celtic interlace design in an illuminated medieval book which repeats that kind of design with variation on successive pages. If the units are to be seen in a certain order, that introduces temporal development, and the units constitute a sequence. If there is gradual change from one type of arabesque to another, the sequence is a delineative or *developed line progression.* A sequence of linear shapes may proceed on the whole from the simple, regular, abstract, and geometrical (e.g., triangles and squares) to the complex, irregular, and representational (as in decorative drawings of animal forms). The arrangement may be made in *space,* as on a wall from left to right; or in *space-time,* as in an abstract film or a piece of mobile, abstract sculpture in relief.

Among the historic styles which have emphasized linear development are Greek vase painting, Chinese and Japanese drawing, painting, and calligraphy, Persian and medieval European painting and calligraphy, as well as many individual styles, such as those of Botticelli, J. L. David, Ingres, and Aubrey Beardsley.

17. Surface shape development; modeling.

This kind of development can occur on one flat surface of an object, such as a slab or wall carved into relief, or the ground of a garden which is planted with flowers, shrubs, and trees of varying height. It can be achieved through embossing, repoussé, cameo, intaglio, or other techniques of raising or lowering parts of a flat or curving surface, such as that of a silver vase. If the presentative development is carried out very far in the third dimension, it tends toward high relief and sculpture in the round. Engaged columns and statues are intermediate.

The development of surface shape consists in diversifying and interrelating various parts of a surface, as in contrasting flat and curved, convex and concave, smooth and rough areas. Some may be geometrically regular, formed as parts of a sphere or cone, and some irregular, formed as gradual undulations or jagged peaks and crevices. A relief can be highly regular, as when the distances of all points on the surface from the background, or of the most accented points, are restricted to certain magnitudes at regular intervals in a series. For example, the height of all projections and the depth of all hollows may be either one inch from the background, two inches, or three inches. Most reliefs are more irregular than this, making gradual transitions in height, as in the raising of an ear or the hollowing of an eye socket.

The possibility of raising the projections to any desired height has given rise to certain types of relief, based on relative distance from the background and the extent to which parts are modeled in the direction of freestanding figures. These alternative lines of development produce various traits and types under the developed component *surface shape modeling.* In high relief, half or more of the circumference of objects represented projects from the background. In low relief there is little projection and no complete detachment. Hollow relief leaves the background in the same plane as the highest parts of the objects represented. An *intaglio* has a design or figure cut below the surface of some hard material so that an impression from it gives a representation in relief.

Actual modeling, carving, or casting in relief is presentative insofar as variations in surface shape are perceptible to the touch as well as to the eyes, and as they appear somewhat differently from different points of view (more so in high than in low relief). Instead of being presented, modeling can be suggested by pictorial mimesis, as in Raphael's *Madonna of the Chair.* Thus it constitutes one of the chief developed components in painting and the graphic arts, especially in the Hellenistic and Renaissance periods. An emphasis on modeling rather than coloration was characteristic of much Florentine Renaissance painting, such as that of Signorelli. Such painting was much influenced by classical sculpture.

Suggested surface shape development is produced with the help of other components, notably highlights and shadows, linear contours, and the power of certain color arrangements to suggest advancement and recession. (Cool colors often tend to suggest recession and warm ones advancement, but this is not uniformly true.) In a black-and-white photograph of a sculptural relief, the presented surface development of the latter is only suggested. Instead of merely imitating an actual carved relief, the painter or draftsman can, by properly arranging his lines, hues, lights and darks, represent desired hollows and projections on an imaginary surface, such as the features of a face, the curving planes of a human figure, the folds of drapery, or the slopes and vegetation of a field. A row of figures, trees, etc., against a wall or landscape may be pictured in much the same way that a high relief is modeled, with sky and far-off land as a background plane, and objects shown as standing out at various distances from it. In such cases, the modeling of an imaginary set of surfaces has been developed in the third dimension, until it merges with the arrangement of solids in deep space. In Giotto, Andrea del Castagno, and some other other painters of the early Renaissance, the represented space is usually shallow, seeming to end against a solid wall or uniform color area but a few feet in from the actual picture plane. Figures seem to be modeled, and to stand out from this background, somewhat in the manner of a sculptural high relief.

A statue in the round and the exterior of a building may involve three-dimensional developments of surface shape. The building is a series of four or more wall surfaces and a roof surface, each of which can be variegated with recesses and projections. The statue presents a continuous curving surface to the eye, as one walks around it, and this surface may be consistently modeled into similar and contrasting shapes. But insofar as visual art presents or suggests full three-dimensionality, it can also be described in terms of solid shape development.

A *developed surface shape progression* is a progression in space or time of somewhat complex and different surface shape arrangements. A row of carved coats of arms on a wall is a spatial series unless some order of perceiving them is indicated; if such an order exists, there is also a temporal sequence. If it changes in some directional way, as in working up to a climax in a royal coat of arms, it is a progression. The temporal arts, such as ballet and cinema, again offer the possibility of developing this component in time and space. Ballet emulated Greek vase painting in Nijinsky's version of *L'Après-midi d'un faune*. It was danced as if on a flat screen with emphasis on angular line and surface shape, but little depth. A film can easily offer a sequence or progression of photographs of reliefs or of actors posing as if they were sculptural reliefs.

18. Mass-and-void development.
Solid shapes and empty spaces.
Perspective.

These are often discussed in art criticism as "mass" and "space." One speaks of the arrangement of masses in a picture and of the arrangement of spatial intervals between these masses. One speaks of solid masses and of openings in architecture, and of both as systematically arranged. These are simple, easy words to use, and it is only for the sake of precision, to avoid confusion with other senses of these same words, that more cumbersome terms are used as the title of this section. When the meaning is clear, we can speak of "mass development" and "space development." But "mass" is often used in another sense, in regard to art. A mass of color or of darkness, in this sense, may be quite flat, whereas we are thinking now of solid, three-dimensional masses only. "Space" is also an ambiguous word to use, for it can mean a general frame of reference in which all ingredients are arranged, as well as a special type of ingredient.

The "development" of mass or solid shape here referred to includes not only the modeling of a single shape, but also the systematic arrangement of a number of solids. The two are sometimes hard to distinguish. This is so in regard to the various parts of a naturalistic human statue (head, limbs, trunk, etc.). One may regard them as solids joined together, or as modeled variations in the surface of a single solid (the whole body). If the parts are marked off with some clarity, as by the grooves and ridges of a primitive Negro carving, they tend to appear more clearly as distinct solids. If an object has all or several of its surfaces interrelated by systematic modeling, it tends to appear as a solid, three-dimensional mass, more definitely than one which has only a single surface developed, even though both are solid masses in regard to their physical nature. An intermediate type is the Assyrian statue of a bull god, consisting of low reliefs on three faces of a solid block.

To visual experience a solid is a three-dimensional object which is bounded and limited on all sides, so that one can move around it or imagine oneself as doing so. It is more or less opaque, or at least not

purely transparent. Thus it arrests and reflects the light and is seen as an object in its own right. A window glass, which is almost invisible and through which one looks directly at the outer world, is not a solid from the standpoint of visual form; neither is the film of varnish over a painting. Static masses of liquid, on the other hand, such as wine in a glass, are solid objects from an aesthetic standpoint. A cloud, a puff of smoke, a cascade, or a fountain is a mobile solid in this respect.

Solids and voids are opposite or complementary ingredients in visual form. The presence of either precludes the other, as far as ordinary vision is concerned, although we know from a physical standpoint that all solids have interstices, and that "empty space" on this earth contains air, vapor, flying particles, and light waves. One kind of void is a three-dimensional area where there is no perceptible solid to obstruct the view. This is sometimes called "negative space." It is the realm of space around a solid and between solids, through which one looks to the sky or to some mass or opaque surface beyond. If there is a series of free-standing solids, there must be a series of voids as spatial intervals between them. If there is a void of a definite shape, it must be surrounded or bounded by solids, opaque surfaces, or other limits to the vision. Translucent mist, smoke, falling rain and snow may appear as intermediate between voids and solids, and so may clear water as it appears to a diver.

A statue in the round, like all other physical objects, is three-dimensional, and if it is visually developed as such it will present somewhat different, interrelated aspects from every point of view as one walks around it. These may consist only of slight hollows and projections, as in a represention of a human head. The development will then be rather of surface shape than of solid shape. One can start developing solid shape by enlarging the projection, as of a bent arm or leg, so as to detach it considerably from the rest of the body and invite attention to it as a distinct, solid shape in its own right, largely surrounded by empty space. If an elbow is bent away from the trunk, while the hand returns to rest upon the hip, an opening or void is produced. Several such partly independent, partly different solids and voids, visible from different points of view, provide a start toward mass-and-void development. It can be carried indefinitely farther along many lines: e.g., by combining several figures in the same statue, as in the *Laocoön.*

The idea that a statue should be made so that it could be rolled downhill without damaging any part was severely restrictive, to say the least, and has seldom been fulfilled. It would reduce the statue almost to a column without a capital. Many Renaissance statues have few large projections or openings, but sculpture from the seventeenth century to the present has often emphasized them, as in the works of Bernini, Canova, Barye, and Henry Moore.

The developed arrangement of solid shapes and that of intervening voids can be considered as one single component, *mass-and-void development,* rather than as two distinct ones. In developing either the artist tends to develop the other also. Masses can be systematically arranged at spatial intervals, that is, with voids between them. Voids or openings cannot be systematically shaped and arranged except through bounding them by solid objects or opaque walls, which act as intervening masses. The blue sky looks like an opaque dome above. Solid masses, being material and tangible, usually receive emphasis; it is they that are consciously arranged, while the intervening voids arrange themselves more as incidental results. But this is not necessarily true. "Clay is moulded into a vessel," said Lao-Tse; "the utility of the vessel depends on its hollow interior. Doors and windows are cut in order to make a house; the utility of the house depends on the empty spaces." The arrangement of openings in highly developed architecture is not left to chance.

It was mentioned above that a void can be two-dimensional, as in the spaces between lines of printing or between streaks of color on a canvas. If the blank surface is white, our attention tends to focus on the streaks of ink or paint which differentiate the surface. We are apt to regard these streaks as constituting the whole form of the text or picture, and to regard the remaining white areas as "empty." If the blank surface is red or black, and the streaks are in some contrasting color, then we regard the remaining red or black spaces as empty. But whatever their color, they are filled by a physical material, paper or canvas, and present an opaque surface of a certain color to the eye. To arrange streaks of ink or paint on a white surface is to build up a color-form consisting not only of these streaks, but also of the white areas which remain between them. Together, they constitute figure and ground. Both can be active factors in the form. An oil painter usually has to paint his white areas white and not leave them to the changing color of bare canvas.

When a flat surface has some areas cut out bodily, as in a stencil, an iron grill, or a windowed wall, the resultant spaces can more truly be called empty. Here, however, we are no longer dealing with a purely two-dimensional form. The masses are arranged mostly in two dimensions, are thin and undeveloped

in the third; but the voids extend farther out behind them, to whatever opaque surfaces lie beyond. These are usually indeterminate and changing, so not considered as parts of the form, which is conceived in terms of masses and openings.

An empty, three-dimensional space can be marked off or bounded with any degree of definiteness. The interior of a cubical room, with all its walls, floor, and ceiling intact, is highly definite and regular. It remains so if we pierce its walls with small windows, especially if there is glass to indicate the wall plane. But even if the windows are open, our eyes supply an imaginary continuation of the wall plane to complete the boundary of the room. This is true of doorways and arched openings as well. The walls of a Gothic cathedral are said to be "diaphanous." A great deal of the enclosing walls may be removed without destroying entirely the identity of the enclosed cubical space. We may take away one wall, as in a theater stage or a chapel attached to a cathedral. We may take away the roof or ceiling, as in the theater stage, and make stairway openings in the floor. The more we remove the boundary masses, the more we tend to make the room space indefinite, until finally it remains but a vague suggestion.

In a garden, a pergola or trellis is fairly definite, although it may have no walls, for the eye and imagination supply walls between the columns and a roof plane overhead. Underneath, one feels almost that one is in a room. That sense is present, but more vaguely, in a garden space, which is enclosed by hedges but has no suggestion of a roof overhead. A three-dimensional void has been definitely determined in two of its dimensions, and partly in the third by the vertical hedges. If the hedge is tall and even, we may imagine a roof plane directly overhead, or else feel only the blue sky and the clouds above as limits to the height of the room. The hedge can be partly removed or replaced by vaguer boundaries, such as paths and rows of low plants, until little or no sense of enclosure remains. In a dense, old forest of tall trees, the effect of enclosure is strong. It becomes more indefinite and vanishes as the trees thin out near a clearing. It is produced not only by the ceiling of branches overhead, but by the trunks beside and around one; irregularly scattered near at hand, they appear to merge in the distance into an almost solid wall.

Anything approaching a row or line of solid objects may be grasped, through integrative perception, as a plane, as a boundary between two three-dimensional areas in space. Two dots may be perceived as indicating a line; two trees or stones as a boundary to separate one plot of ground from another. Very slight and irregular continuities of this sort may operate to produce a perceptible though very indefinite effect of division in the spatial field of vision. Thus, in gardening and landscape painting the slightest suggestion of boundaries may be enough to make us perceive a space as divided into sections. Two or three rocks and bushes in the midst of a field, or even the long shadow of a tree, may make us divide that field into foreground and background. They punctuate not only the ground surface but the space above it, helping us to organize it as a vista into two different voids, near and far, of definite size and shape, instead of one large and vaguely defined region. Let there be another such punctuation still farther away, as by a distant road or the beginning of a hillside, and we divide the vista once more, into foreground, middleground, and background. Let there be a noticeable object near the center (say a haystack or a human figure), and again we tend to divide the total area of space, this time into subvistas, right and left.

The typical high Renaissance portrait is an imaginary vista into space, with a large figure in front and center. To right and left are subvistas into landscape. Each of the vistas may be divided into foreground, middleground, and background. Thus a fairly complex arrangement of masses and voids can be produced, without having any of the voids clearly and completely marked off by solid boundary walls. Developed landscape painting and picturesque gardening often achieve high complexity of a subtle and flexible type by careful elaboration of rather slight clues to spatial arrangement.

Architectural form has been limited at times by neglect of "void" or empty space. Some Renaissance architects conceived a building mainly in terms of its façade, especially when only the front wall was easily visible, as along the canals in Venice. This tended to reduce architecture to a two-dimensional art, or to an art of large sculptural relief on a single surface. Even when all four walls were visible, if the building was conceived only from the outside, its development could be limited to that of a series of four surface planes. To be sure, there would be rooms behind them, but often boxlike and undeveloped.

The great cathedrals such as Amiens, on the other hand, made a high development of interior space, dividing and subdividing it by rows of piers, intersecting vaults, and openwork partitions into many distinct, connecting voids and vistas. Areas of three-dimensional architectural space are for the most part much more definite and regular, more clearly and completely bounded, than those of gardening and

landscape painting. The artist can determine not only the form and location of the partitions and the shape of its openings, but to some extent what should be visible through these openings. Through a certain doorway, one is to see a colonnade immediately ahead, and through it a vista down the transept or into a sunny cloister garden. Modern architects, such as Frank Lloyd Wright and Mies van der Rohe, have emphasized interior rooms, vistas, door and window openings, outside paths and gardens, in their conceptions of architectural form.

Differentiation as a phase in development can occur in regard to both masses and voids. Examples and series of either can be of any shape and any size, within the range of human power to perceive them. A series of either, or a combined series of masses and voids, can be similar, varied, or contrasting in shape, size, or both. For example, a colonnade in which the columns (masses) were of exactly the same height and width as the spaces (voids) between them would be extremely regular. So would a series of connecting rooms (voids) of the same size and shape, separated by uniform walls or colonnades (masses). Contrast would be introduced if some rooms were cubical and some domed or barrel-vaulted. Occidental doors and windows are mostly rectangular, while traditional Chinese ones are more varied in shape. Painting suggests more irregular shapes in masses and voids: the masses of human figures, pieces of furniture, utensils, fruit, trees, animals, houses, clouds, and so on, and the voids between these (e.g., between two dancing figures) and among the parts of a single object (e.g., the branches of a tree). In spite of their irregularity, there can be definite resemblance and contrast among them.

We have seen how temporal development can be achieved in all spatial organization, through arrangement into vistas to be seen in a certain order. The motion picture has led to further development in terms of mobile form. A sequence of changing, contrasting vistas can now be suggested to the stationary spectator, with masses and voids of different shapes, some close-ups and some distant shots, some bounded by a near obstruction and some opening out to far horizons.

The word "perspective" is sometimes used in a sense close to that which we are calling "mass-and-void development." Thus we speak of a picture, a garden, or a building as having "interesting perspective," as if perspective were one of the components in the total form. The color and modeling of the picture are good, we say, but the perspective is bad. Certainly considerations of mass and void are included in the

study of perspective, but so are many other components. Much perspective is concerned with line drawing, especially with the apparent convergence of lines in the distance. It may also be concerned with atmosphere, color, and light, as in so-called aerial perspective.

The discussion of perspective in Western art has been largely concerned with techniques for representing accurately, on a flat surface, the appearance of a three-dimensional scene, as it would appear to a single observer at a single point in space and a single moment in time, under certain conditions of lighting. Definitions of perspective as a means to that end, through utilizing converging lines, overlapping forms, diminution according to distance, etc., refer only to one kind of mass-and-void development. We should also examine unrealistic representations of scenes in deep space, as in Indian Buddhist (Ajanta) painting, utilizing so-called multiple perspective. We must include "forced perspective" and other deliberate alterations of natural appearance for aesthetic ends, as on Baroque theater stages. We must include vistas in a park or garden, as when an avenue of trees and statues opens up toward a lake and row of hills in the distance.

These and other lines of development can be brought under the concept of "perspective" only if that concept is defined in its broad and literal sense, as a "looking through" voids or openings, between bounding masses to the bounding walls beyond. As a developed component in art, perspective also implies the systematic, more or less complex arrangement of such voids and masses for aesthetic ends.

Ballet, theater, and cinema, once again, provide opportunities for elaborate temporal development of this component, through successive groupings which may progress in definite directions. In ballet, the presented masses are of course the bodies and costumes of the dancers. Cinema permits, by suggestion, the opening up of almost limitless perspectives and sequences of them. And let us remember that garden art (landscape design) is not purely spatial, but allows the control of many changing vistas through the year.

19. Light development; notan, chiaroscuro, illumination, luminescence. Developments of lightness and luminosity.

One of the differences in presented visual traits is due to actual differences in the intensity and quality of

lighting, direct or reflected. It includes (a) those due to differences in the light-reflecting properties of different materials under the same lighting, or to local colors, as in a black and white cloth, which remain somewhat different in lightness under changes of illumination. Gold, silver, and glazed mosaic, as in Byzantine art, reflect much light. Some materials glow in semidarkness, but ordinarily there would be no difference between black and white in complete darkness; (b) differences due to reflected, indirect lighting, as between a painting or textile seen in a dimly lit room and the same one seen under bright sunlight or electric spotlight; and (c) differences in direct lighting—radiance, luminosity, or luminescence—as seen from the source or from a directly transmitting material such as a glass window, clear or stained. Various degrees of intensity are perceived as reaching the eye through air, fog, film, or other transparent or translucent material, clear or colored. Such lighting can be raised in intensity to any desired or tolerable degree, as in electric lamps and neon tubes.

The second group of developments involves more *suggestion and representation,* in addition to presented visual stimuli. It includes (a) the pictorial representation of differences in local, inherent lightness (i.e., value or brilliance), as in a Japanese painting of a girl with black hair, white skin, and light blue kimono; (b) the representation of reflected light, with highlights and cast shadows, as in a painting by Rembrandt or Monet or a scene illuminated by an unseen source; and (c) the representation by ordinary pigments of direct sources of light, as in a painting by Rembrandt or van Gogh of a lighted torch, lamp, sun, moon, stars, or lightning.

It was noted above that a picture made with ordinary pigments on paper or canvas, which looks under ordinary lighting as if it were giving out direct light, is sometimes called luminous or luminescent. This is an illusion and should be distinguished from a work which is really luminous, such as a stained glass window on a sunny day or a neon sign. Sculpture can suggest luminosity by visual shape, representing rays of light as in Bernini's *Ecstasy of St. Theresa.*

The third group includes *suggestions* of light or dark by *nonvisual* means, such as music or literary imagery (e.g., Dante's description in the *Paradiso* of the "light that moves the sun and the other stars").

Differences of apparent lightness or intensity which are due mainly to the local, inherent differences in materials are graded in a scale from black to white, with many intermediate grays. Each hue, such as red, can be presented in different lightnesses (values or brilliances) from very dark to very light.

Their systematic development in art, through differentiation and integration, is sometimes called *notan,* from the Japanese term for dark and light. This kind of *lightness development* was favored in traditional Chinese and Japanese painting. Western painting has favored the representing of illumination from a specific light source by highlights and shadows, a technique called *chiaroscuro,* from the Italian for light and dark. This way of developing light-and-dark variations was highly developed by Western painting in the Hellenistic period and from the Renaissance to the twentieth century. In early Renaissance painting it was used mainly for modeling, to give the illusion of solid figures and also for decorative arrangement of light and dark areas. Later it was used for more realistic and dramatic effects of strong illumination in contrast with deep shadow, often overflowing linear boundaries, as in Tintoretto, Bassano, and El Greco.

Shade can be understood broadly as meaning any degree of lightness, or one of the lower degrees of lightness as distinguished from "tints." It can have a more specific meaning, as a low lightness caused by cutting off rays of light. In this sense, it is the comparative darkness produced in an area by an opaque body between it and a source of light. Thus we say that something is "in the shade." In a *shadow,* the area of shade has more or less definite limits and shape, as determined by the intensity of light, the opacity of the intervening object, and the clarity of the atmosphere. It is usually an image resembling in silhouette the shape of the opaque object. The architectural study of "shades and shadows" includes the control and arrangement of all these effects: e.g., the use of black and white stones and the planning of shady areas for relief from the sun.

When notan or other developments of light and dark are used to represent actual illumination, as if in a lamplit room or a sunlit forest (i.e., for depicting the sources and reflections of light and the shadows cast by opaque objects), then the resultant form includes *both* lightness and luminosity. Degrees of lightness are *presented* to the eye: light and dark grays, tints and shades of other colors. These resemble and *suggest* degrees of luminosity in the outside world. In painting, luminosity is thus developed as a suggested factor, and great effort has been expended upon it by such artists as Rembrandt, Turner, and Monet. Notan and chiaroscuro can thus be regarded as including the development of both lightness and luminosity, but as using only lightness in direct presentation.

The representation of reflected lights and cast shadows is rare in traditional Japanese and Chinese painting, from which the word "notan" has been de-

rived. As was mentioned above, notan refers to the kinds of light and dark arrangement common in Japanese art. Those include the directly presented contrast of dark and light areas, or of intermediate grays, as by ink on white paper, whether or not they represent anything in nature. Areas of black, white, and gray can be arranged on a piece of cloth to make an abstract design. In a pictorial representation, these areas may imitate certain materials. These are variations in lightness which represent the local, intrinsic light-reflecting power of various substances, but they are usually not representations of cast shadows or gleaming highlights from a particular source of illumination.

In any case, the development implied by the term *notan* consists partly in the fact that degrees of lightness are selected with some regularity from a qualitative scale, partly in the fact that they are arranged with some definite order in space. They can be developed mainly in one dimension, as in a ribbon or narrow border design, with a complex arrangement of varied and contrasted dark and light areas. They can be developed in two dimensions, as over the surface of a flat painting, print, or photograph, in a suggested third dimension, as in a painted landscape, or in a presented third dimension, as in a polychrome statue or a church of black and white marble. The ballet, motion picture, and other mobile arts develop notan also in time, although the word is not often used in these connections. What we are calling notan is regarded in the motion picture as a part of "camera art" in general, of "photography" as a component distinct from the plot, acting, sound effects, and other developed components in the total form. It may be decided that the picture must not be too dark or too uniformly light, but varied in shade, with important objects such as faces clearly illuminated. Some films attempt thematic arrangements of moving light and dark areas. Such systematic developments, whether representative or decorative in aim, and whatever evaluative rules and standards are adopted, constitute "notan" as distinct from the elementary component "lightness."

Notan cannot be entirely separated from *drawing* or *delineation*. Any definite area of light or dark will have boundaries. The effect of notan can be built up entirely from sharp lines, or even from dots, as when a number of black lines or dots close together, or crosshatched lines, give the impression of an intermediate gray area. Separating them a little gives the effect of a lighter gray; packing them closely, of a darker. When they are fairly small, numerous, and close together, the eye tends to perceive them not as distinct lines but as shaded areas. Even a single line, broadening here and narrowing there as in Chinese calligraphic drawing, can involve systematic development of dark and light, and even suggest cast shadows, without the existence of any broad areas of darkness. Notan achieves clear development when a two-dimensional area is divided into sections and spotted in an orderly, complex manner, with due attention to the distribution of each shade from very dark to very light.

Notan is also closely bound up with coloration. Lightness is regarded as an attribute of color as well as of light. Any color area can be considered as to its degree of lightness; any combination of color areas, as to the way in which it involves a systematic arrangement of lighter and darker colors. Notan is not confined to pictures in monochrome or black, white, and gray, such as ink drawings, etchings, and ordinary photographs. In other words, light development in art is sometimes chromatic, sometimes achromatic. But when difference of hue is present, it tends to attract the attention so strongly that the light and dark arrangement (if any) may be unnoticed.

Differentiation of lights and darks can be carried out to any degree. In Japanese prints, and in much other Oriental art, there is frequently a tendency to limit greatly the number of shades used. The picture is deliberately constructed out of this set of lightnesses; out of a black and median gray against white, perhaps, or out of three grays at about equal intervals on a scale of lightness. There are few if any areas of intermediate shading between them. Modern Western painting, in its pursuit of realistic representation, has tended to use a much greater and more irregular variety of shades and tints, with innumerable soft, melting transitions, in order to represent the modeling of solid objects and the gradual suffusion of light in a natural scene. It has organized these shades more loosely and incidentally, as a means to representation rather than design. There is no necessary conflict between these methods. A painting can use few or many shades for abstract design, representation, or both, and at the same time develop notan systematically through the grading and spatial distribution of these shades.

If notan is a developed component, any particular way of using and developing it is a *trait or type* under that heading. An example in a picture would be restriction to black, white, and three intermediate grays at equal intervals on a scale of lightness. A *notan progression* is a progression in space or time of different notan arrangements: for example, in a motion picture film, a succession of complex scenes differ-

ently lighted and proceeding on the whole toward greater contrast of light and dark, or from prevailing gloom to prevailing sunshine.

Lighting and *illumination* imply the development of luminosity as directly presented, rather than as imitated in pigments or other reflecting materials. A cathedral may use both: notan in stones, wood, and metal of different lightness; luminosity in torches, lamps, and windows.

Regarded not merely as a building but as a synthesis of arts, the cathedral achieved a tremendous multiform development. It made systematic use of illumination, in the first place through candles upon altars and before niches. Their points of light glowed through the whole interior, emphasizing important places in the architectural setting. Their flickering yellow rays were reflected from the glistening surfaces of mosaic and gilded paintings. Torches fixed on columns sent more intense and wavering gleams, mixed with smoky shadow, up into balconies and ceiling vaults. When stained glass windows developed in the Gothic cathedral, daylight illumination changed from a mere pale suffusion of outdoor sunshine through narrow openings, to a vast and complex interplay of multicolored radiance. Dull surfaces of stone were a foil to emphasize the intense luminosity of the window areas. At every hour of the day, in different weathers and in different seasons, these changed in source and intensity of light, transforming the total aesthetic effect of the interior.

Now we are gradually coming to make use of the potentialities of electric light in analogous ways. This is done in secular as well as ecclesiastical architecture, in domestic and theater interiors, in store windows and showcase displays, in museums and expositions, in parks and gardens. Exteriors of important buildings and monuments are studded with lamps and flooded with indirect illumination. Gas-filled tubes are shaped into advertising signs of intense and luminous red, green, blue, and yellow; they are drawn along the contours of buildings and organized into moving pictures and designs. In place of the uniform glare of electric bulbs, there is coming into being a more varied, subtle kind of illumination, through indirect reflection and through the softer diffusion of light by translucent glass and plastics.

Theaters have long made use of direct, reflected illumination through footlights (at first candles, torches, and lanterns, then gas and electric lamps) and spotlights upon leading actors and musicians. They have long known the dramatic effect of contrasting full illumination with the mystery and gloom of a dark stage, or a stage partly lit as from a hearth or

candle. Now they employ more powerful batteries of electric lights, controlled by switches offstage and spotlights in the balcony, involving many colors and gradually stepped up or down in luminosity. Strange new effects with infrared and ultraviolet light, upon surfaces chemically sensitive to them, are being tried. The cinema is taking over many of these effects and adding others.

Direct lighting is distinguished from *indirect* in that the former sends most of the light from the source directly to the area which is to be seen, while in the latter the light is reflected from a ceiling or other external object. In *cove* lighting, the lights are concealed in recesses. In *diffused* lighting, the light goes through a diffusing medium before it reaches the area to be illuminated. In *flood*lighting, a large area is illuminated more or less uniformly by light from a distance. In *spot*lighting, on the contrary, a part of the area is illuminated more brightly than its surroundings by a concentrated beam from a distance. In *strip* lighting, several tubular lamps are arranged in a line to make a continuous strip of light. Many European cathedrals are now lighted in several different ways. By night, interior illumination is seen from the outside through the windows, in contrast with indirect lighting of the exterior. By day, sunlight comes through the windows and combines with candlelight to illuminate the interior, leaving many regions in shadow.

These varieties are main *component types* under the developed component "lighting" or "luminosity development." Any particular variety under one of these would also be a developed component type, but of a more specific sort. For example, under spotlighting, one subtype would be a steady white glare of high luminosity; another would be a spotlight changing from very soft to medium bright, and from blue to green. Any particular effect of spotlighting can be described or specified (as in stage directions) in terms of component traits. They may involve not only degrees of luminosity, hue, lightness, and saturation of color, but also spatial organization (as to the source of light and the extensity of its diffusion), and temporal organization (as to systematic changes and successions in any of these respects). A compound description of a certain type of illumination can thus be built up in terms of several elementary component traits and modes of development.

A *lighting progression* is a progression in space or time of different developed lighting arrangements, for example, in an electric advertising sign using a succession of different arrangements of colored lamps, differing in luminosity as well as in hue and shape.

It was mentioned above that the art of *fireworks* is notable for development of intensely luminous spots and streaks of color in contrast with a black sky background. Fireworks are arranged sometimes with considerable complexity, as in "set pieces," pyrotechnic displays mounted on frameworks. The most elaborate skyrockets present, not only a fairly complex arrangement of different colors at any single moment, but a progression in time of such arrangements. Parts move in all directions, and sometimes lead up to a visual climax of extreme luminosity, along with an auditory one of loudness. Of less luminosity are the spectacular displays produced by projecting changing, colored lights on moving water, steam, and smoke, as in fountains and cascades.

20. Color development; coloration; color schemes and progressions.

The development of light and of color in art are intimately connected. As we have just seen, the development of lightness and luminosity is not restricted to achromatic effects—to black, white, and gray. Although notan and chiaroscuro have been much used in black-and-white media, and although illumination can involve a contrast of white lights with gray shadows, yet these may be combined with variations of hue and saturation as well. The distinction between "light development" and "color development" is not a fundamental one. Nevertheless, it does correspond to a real distinction in the practice of art.

As in the case of line, the word "color" is used indiscriminately to mean either the undeveloped or the developed state of this component. In the latter sense, it refers to the general scheme and tone or the combined, pervasive effect of color areas in a work of art or of nature. For this sense, we shall use the term *coloration,* by analogy with "delineation." Thus one speaks of "protective coloration" in animals and plants, referring to a comprehensive mode of using, arranging, and combining colors for a certain function. Whereas "color" may refer to a single spot of red, "coloration" will imply a fairly complex development, especially one with emphasis on differentiation and integration. One may speak of the coloration in a certain Rembrandt painting, such as the *Night Watch,* or of the typical coloration of Rembrandt's late paintings in general, citing subtly graded nuances of brown and yellow with occasional notes of red and green, representing the soft play of light (especially artificial, as in torches) over different textures of wrinkled skin, hair, cloth, and metal. This would be a *developed trait* or trait complex under the component "coloration."

People sometimes describe a picture as done in "bright, cheerful" colors, in "dark, depressing" ones, or in "harsh, garish" ones. Such terms as these suggest controversial assumptions about the emotional effects of colors, and should be treated with reserve in objective description. We are on safer ground in speaking of a "warm" tonality in coloration. This association rests on widespread experience, as of red and yellow with fire and sunshine.

A color combination is sometimes called a color harmony. As we have seen, this term also is risky in morphology because of its evaluative associations. It is often used in a restrictive way, as applying only to certain color combinations which are regarded as "going well together." Others are condemned as clashing, discordant, etc. As in music, tastes have changed in recent decades, so that combinations once felt to be discordant or inharmonious may not now be felt in that way.

Any systematic selection and combination of colors is a *color scheme.* This is a developed component, roughly equivalent to "coloration." Two rooms in a house may have different, developed traits in this component, one being decorated in silver with pale tints of blue and rose, the other in shades of brown, russet, and gold. A simple color scheme can also be described as a *color chord,* by analogy with music. A color chord is any group of two or more colors, juxtaposed and visible at about the same time, but not completely blended over the same area, or present in areas too small to be seen individually. A number of small dots and streaks of different colors, which blend into a single texture as in an Impressionist or Pointillist painting seen from afar, do not make a color chord. The areas do not need to be directly contiguous, but must be close enough to be easily seen together, as in parts of a single painting or flower bed.

A specific color is described as having a certain hue, chroma, and lightness. In painting and many other visual arts, it is not necessary to specify as to its luminosity or luminescence, because (a) most pigments on paper or canvas do not (like phosphorus) radiate light directly, and (b) the amount of reflected light which falls upon them is not ordinarily determined with exactness. But if one is considering a chord of colors in luminescent tubes or fireworks, this component also may have to be considered. In describing a chord of any sort, it is often necessary to indicate also the areas and relative positions of the

several colors, if only because their visual effect tends to differ according to their context.

The term "color chord" tends to imply, by analogy with musical chords, that the constituent colors have been selected from some scale or scales with definite intervals, as in the so-called color triad. Such a chord can be described in terms of the hue, chroma, and lightness of each of its constituent colors. Some artists work in this way, but many painters and decorators prefer to choose and blend their colors by direct impulse or trial and error, paying no attention to scales or formulas.

Some painters become attached to a certain color scheme and repeat it over and over with variations, so that it becomes a characteristic of their individual styles. A certain color scheme may be characteristic of a period style: e.g., gilt and silver with ivory and pastel tints in French Rococo.

A *color sequence* is a somewhat continuous, connected series of colors, especially one arranged in temporal order. A row of colors on a single surface may be regarded as either a color chord (if it is to be seen simultaneously) or as a color sequence (if to be seen in temporal succession). A *color chord progression* or a *color scheme progression* involves a more definite sequence of related color combinations, especially if tending in a certain direction. If a series of rooms in a house is to be seen in a certain order, and if they are differently decorated, each in a distinctive color scheme which has something in common with the others, they form a color scheme progression. The color schemes in some of the rooms and houses in the park at Nymphenburg are related as examples of German Rococo and in other ways.

When temporally developed, a color scheme sequence or progression may involve actual change and succession. A colorful sunset is a rather indefinite progression of color chords. Their constituent colors are mostly very luminous, but do not belong to any one definite scale; they merge and change from one to another continuously. At any moment, the sunset presents a different combination of shapes, hues, saturations, lights and darks, and luminosities, especially when playing on clouds or mountains. It grows progressively darker, although sometimes momentarily lighter in certain places.

Color scheme sequences and progressions of a more definite, organized kind are presented in the color film and in the art of lumia. They occur in theatrical spectacles, dramas, ballets, etc., as when a scene decorated in a certain color scheme (including stage setting, furniture, costumes, makeup, and lighting) is followed by others in different color schemes. In a ballet or color film, one scene may be on the desert with almost uniform sunlight on sand dunes, with a few costumes in dark reds and browns, as in *Lawrence of Arabia*. The next may be in a ballroom with variegated artificial lighting, officers' dress uniforms and ladies' gowns in lighter, more intense hues and textures, silver, flowers, and glass. This provides a color scheme sequence. Others of note are contained in *Henry V, War and Peace, My Fair Lady,* and *Dr. Zhivago.* In a ballet one scene can be in mainly light, cool colors, with minor warm, dark notes, the next in the opposite scheme. Hues, chromas, lightnesses, and luminosities can all be individually repeated, varied, and contrasted. A long ballet or a full-length feature film gives time for many changes of color scheme, including returns to previous schemes.

When we turn to the probable effects of color combinations in painting, textiles, or stained glass, we find that all these factors vary widely according to the constitution of the individual pair of eyes involved, and according to attendant circumstances such as the kind of illumination (e.g., morning or afternoon, north or west, sunny or cloudy). Leaving out all question of beauty or pleasantness, it is hard to generalize very definitely about the perceptual effect of a certain color combination in art. It is hard to predict, for example, how much glare, halation, or blurring of one color into its neighbors will occur in vision. It is hard to predict the nature of afterimages in looking from one color area to another, what afterimage, that is, will blend with the direct perception of the second area. Something is known about the "subtractive" effect of opaque objects, in making the illuminated side of the object appear different in color from the other, and from its cast shadow. But in the perception of nature and art such tendencies are always modified by a number of other variable factors.

It is easy to make practical applications of the color solid. One can select from it a group of colors which are regularly graded in terms of one, two, or three attributes. The selection can be as exactly regular as one desires, from equal intervals and corresponding positions on the color solid. This will produce a certain type of development, namely, orderly variation in the qualitative frame of reference. It is a means of achieving one kind of regularity and unity, simple or complex, in visual form. If understood in this light, as mere instruments or possible modes of achieving regularity, the various "set palettes" and "color systems" proposed by theorists (e.g., Munsell and Denman Ross) are unobjectionable. They are comparable to the regular gradations of pitch in the

musical scale. Just as the standard scale of the piano is a regular selection out of an infinite number of tones and scales, so any regular series of colors can be selected arbitrarily. Specific combinations, roughly comparable to musical triads and other chords, can be chosen out of such a scale of colors. A picture can be limited to a restricted color scale, just as a piece of music can be written in the key of C. The scale can be made complex by including many intermediate gradations of color. From the very fact of such regularity in the initial selection of colors, any work of art containing them will be sure to have some amount of unity and complexity in the qualitative frame of reference, though not necessarily in the spatial or temporal. This will occur even if the colors are splashed on at random. In the same way a young child or a kitten, playing on the white keys of a grand piano, cannot help producing a sequence of tones with some unity and variety in terms of scale and key.

The artist can go on to attempt systematic effects of "balance" by including in his composition equal shares of complementaries, equal areas of high and low saturation, light and dark, etc. Any such effect may be modified by the different amounts of emphasis on different areas through their positions in the whole arrangement. If he wants a total effect of great or little contrast, high or low intensity, etc., he can proceed methodically to secure it. He should remember, though, that the psychological effect of certain colors when seen separately is not the same as when they are seen together as a chord or in temporal sequence. Contrasting colors, especially, seem to change in close contiguity or succession. The systematic notation and classification of colors give both artist and psychologist something definite to experiment with. One can test the effects of certain colors, chords, and sequences on different types of person under different conditions and be fairly sure that one is talking about the same kind of physical stimulus.

Color chords can be compared and estimated as to the *extent of contrast* within each, and between any two chords. For each hue, there is one other hue (its complement) which contrasts most strongly with it. Other hues contrast with it in proportion to their distance from it on the circle of hues. Hues very close will appear as variations of it, as blue-green to green. Hues moderately close to it (as orange to red) may appear either as variations of it or as contrasts, according to the context of other colors. In a chord of three or more colors, alike in all but hue, there will be a maximum of mutual contrast if they come from points at equal distances on the color circle. However, there are other ways of securing contrast, as when

two complementary areas are strongly emphasized while the other colors are close to one or more of these on the circle.

Since colors may vary in three different ways (or four, including luminosity), the nature of the variation or contrast between any group of colors may be roughly described on this basis. Two colors which differ in only one attribute or component form a *one-way* (or *one-component) contrast*: for example, a light, highly saturated red and a light, highly saturated blue, or a light, highly saturated red and a dark, highly saturated red. Two which differ in two components form a *two-way* contrast: for example, a light, highly saturated red and a dark, highly saturated blue. Two which differ in three components form a *three-way* contrast: for example, a light, highly saturated red and a dark blue of low saturation. In certain cases it may be necessary to compare in terms of luminosity also, as when differently hued electric lights in a display are also of different luminosities. This introduces a fourth possibility of similarity or contrast.

It must not be assumed that the total effect of contrast is in proportion to the number of ways in which the colors differ. Having both colors of high saturation tends to increase the effect of contrast between the hues. But, by having the various components in mind as possible ways of securing either similarity, variation or contrast, the artist can organize a group of colors systematically in any way he chooses. The observer, likewise, can more clearly grasp the nature of the relationship thus produced.

The term *color balance* is applied to a distribution of colors, as in a painting, which tend to merge into a neutral gray when rotated on a disk in areas proportional to those of the colors in the work of art. The colors are said to be balanced in lightness (value) when the gray produced is a median gray. Degrees of balance or imbalance can be produced experimentally by using different hues, saturations, areas, or spatial distributions of certain selected colors.

The advance of color theory as an objective, scientific study has been persistently confused by introducing evaluative rules and judgments. Denman Ross arranged the colors of the spectrum in a number of "set palettes," each composed of colors chosen by regular gradation on a basis of hue, brilliance, warmth, and coldness. These palettes, he said, are analogous to the keys of music, and modulation from one to another is possible. By following his system, said Ross, "we get a very perfect system of Value and Color Balances; appealing equally to reason and to our love of Order and Harmony." Such an appeal expresses a neoclassical world-view and is rejected by

most persons of a romantic or experimental turn of mind.

Coloration can be objectively defined as any systematic way of interrelating a set of different colors in the same object or process. Then we can go on to say that a balanced or regular color scheme is one kind of coloration among others, one developed component type under the general head of coloration. An unbalanced or irregular color scheme is another type, with equal claims to theoretical consideration. The systematic development of color can aim at this type as well as at its opposite.

Tests of preference—e.g., as between two different color chords—can be conducted with some objectivity when the results are stated as differences in taste, and not as proof that one is better than another. Some tests appear to indicate that when people find a set of colors "goes well together," it is because these colors are similar in at least one attribute, i.e., in one elementary component, in hue, lightness, or chroma. If colors (or other images) differ in many ways, they may give the effect of unrelatedness, incongruity, or disharmony. They may be hard to perceive together, and thus unpleasantly confusing to persons who like what is easy to perceive all at once. But some kinds of person prefer juxtapositions which are lively and clashing or bizarre and puzzling. Different styles of art, aiming at different expressive effects, call for different color combinations as means to these ends. What people like in color is much influenced by fashions and circumstances of the moment: e.g., by elite standards of what is fitting in dress for business, church, summer resorts, or costume balls. The empirical study of such attitudes toward color can be greatly aided by reference to an objective system for classifying and describing colors.

21. Visual texture development.

The word "texture" is derived from the Latin for "weaving." The textile arts produce a multitude of distinctive textures: some plain, some ribbed, striped, mottled, or patterned; some rough to the touch, some smooth and satiny. Even if one does not touch a rough, hairy, woolen surface, it can suggest a tactile image of roughness. Woven ribs and cut velvet involve some presentative development of surface shape. Some other textures are produced by variations in color alone.

The concept of texture is applied especially to areas which contain a large number of different trait units of color, line, surface shape, light and dark, or other elementary components so small and close together as to be hard to distinguish individually from a distance. Unless examined closely, these details tend to merge into one composite quality, a certain *texture trait*. Examples of this kind of texture are called "variegated," "rich," "dotted," "interlaced," "sculptured," "woven" (even if actually painted or printed so as to resemble woven cloth), diapered, checkered, crosshatched, imbricated, lacy, cloudy, grained (as in varnished wood), and the like. A piece of textile may contain a complex all-over pattern of flowers, animals, arabesques, landscape vistas, or otherwise, in which the details are so small as to be noticed only from close at hand. Yet even from a moderate distance, it may present a general, vague effect of being intricately patterned.

The idea of texture is not limited to these minutely variegated types. They are often contrasted with the opposite, with some sort of plain, uniform surface, e.g., of burnished gold, satin, white paper, or pigment of a certain hue, saturation, and brilliance. Plain textures are one kind of texture. "Visual texture" in general is the visual quality of an area as perceived vaguely or from a distance, rather than in separate, distinct details. (We also noticed the difference between open, clear, simple passages in music and close-packed, variegated ones, full of tiny differences in pitch, timbre, and other components.)

Developed visual texturing differs from "texture" as an elementary component in being systematically extended, differentiated, and integrated. A certain textural trait can be repeated with variations and contrasted with others. This is not especially characteristic of Western painting, but is highly developed in Persian miniatures, especially those in the sixteenth and seventeenth centuries. Matisse often uses this method. The picture plane is divided into areas of different size and shape, and each is treated in a way which contrasts with adjoining areas. Some represent mosaic patterns on a floor or wall; some represent a grassy area with flowers; some reproduce the pattern of a rug; some are plain blue or vermilion, representing a garment, and so on. Certain texture traits may be repeated here and there. To emphasize the complex design thus produced, other components such as realistic chiaroscuro are sacrificed. A picture so organized is a *texture trait complex* in respect to this component.

Temporal development, with texture trait *sequences and progressions,* occurs when different traits or

groups of traits are shown in succession, as in a film. Thus the striped shirts of sailors, the hard, metallic luster of polished machinery, the dancing wavelets of a calm sea, and the scudding clouds overhead, can all be presented as successive images (e.g., in Potemkin).

A carved stone wall, seen from a considerable distance, may present no distinct details in any one component, but a peculiar rough, weathered, vaguely patterned texture which is produced by the color of the stone, the shimmering highlights and the shadows, the modeling of hollows and projections, masses and voids between them, the whole being blurred by intervening atmosphere. The same details, seen more closely, would resolve themselves into distinct constituent parts and arrangements. Impressionist and Neo-Impressionist painters, such as Seurat, often juxtapose small spots or streaks of different colors to produce a scintillating, opalescent texture. Some surfaces in nature present a blurred, irregular surface whether seen from a distance or close at hand, or even with a microscope: a piece of veined onyx, for example, or a mossy boulder. A number of parts, all somewhat indefinite and irregular in texture, can be contrasted, repeated, and arranged in definite groups. An architect may decorate the inside or outside of a building by a horizontal row of alternate, contrasting blocks, to form a stringcourse. A painter may juxtapose, for contrast, the textures of rough woolen cloth, burnished steel, flesh, hair, and leaves, against a marble wall. Textural development might consist, in this case, of representing these differences fairly definitely and of repeating and varying each type of texture, in different combinations, e.g., steel in one place beside the flesh of a hand, or in another beside wood, glass, or leather. An interior designer can organize in one room such textures as wood, stone, leather, metal, silk, wool, porcelain, glass, paper, paint, plaster, and living plants.

Since texture is a compound component, the effort to develop it systematically leads to its analysis into other components which make it up. A given texture such as that of a mossy oak tree trunk resolves itself on analysis into certain component traits of color (e.g., dark grayish, greenish brown) or line (e.g., irregular vertical streaks) and of surface shape (the corrugations of the bark). Accordingly, one could vary it in terms of any of these components: as to color, for example, by juxtaposing it with a tree trunk of light silver-gray unstreaked with green; as to line, with bark of horizontal lines like that of the white (paper) birch; as to surface shape, with smoother bark like that of the cherry. Systematic development of tex-

ture could resolve itself into a joint development of each of the various specific components involved in it.

22. Kinetic and kinesthetic developments.

Complex temporal and spatial developments of bodily motion are presented in ballet and other types of dance, and also in pantomime and theatrical gesture. The same developments are represented in the cinema, sometimes with even greater fullness. Instead of being restricted to one point of view, as in a theater seat, the observer of a motion picture film is rapidly transported in imagination to different aspects of a complex action, such as a ballet, a tennis match, a football game, or a battle.

Complex movements of animate and inanimate objects are suggested with little or no temporal development by static painting and sculpture, as in a Rubens battle scene or a drawing of floods and whirlwinds by Leonardo. Sculptural or pictorial representation of bodily effort and struggle, as in the *Laocoön* and Pollaiuolo's *Hercules and Antaeus*, tends to suggest the idea of inner, kinesthetic sensations on the part of the struggling persons. George Bellows's *Stag at Sharkey's* is a vivid representation of prizefighters in action.

Such art can also arouse similar but milder muscular responses in the observer himself, through sympathy and empathy. Those watching a combat often tense and relax their own muscles and breathe more rapidly, along with the combatants. Mental images of tension and relaxation, strength and weakness, are often among the suggestive factors in a work of art.

Music develops the suggestion of both kinetic and kinesthetic images to a high degree. It can suggest movements and energies such as those of a storm or an approaching and receding band of musicians. Increasing loudness, accelerating tempo, rising pitch, more irregular and jerky rhythms, more dissonant harmonies and unresolved cadences—all these, together or separately, can suggest various forms of motion and struggle in nature and human life, perhaps followed by periods of relaxation, calm, rest, and peace. In these suggestions, the kinetic images of physical movement, thrust and counterthrust, conflict and cooperation, are often intimately blended with kinesthetic ones—that is, with images of how it feels to be engaging in such action or inaction. Beethoven, Wagner, Tschaikovsky, and Hindemith all use this component of music, especially with full orches-

tra. As a time art, music can suggest a long and varied sequence of such images in determinate order, abstractly or with definitely programmatic representation. Literature and the theater arts do so with more explicit, representational meanings.

Static drawing, painting, and sculpture can also build up complex suggested forms along this line, either by mimetic representation or by common association in experience between certain visual traits and certain types of action or inaction, effort or quiescence. By the nature of the line and color, with or without representational significance, Chinese and Japanese painters have for centuries conveyed diverse kinetic and kinesthetic imagery: the Chinese tending more to stately calm and balance of forces, the Japanese at times to tense, irregular interplays of energy, as in Hokusai's drawings. Van Gogh stressed agitated color and brushwork in his later works, whatever the subject.

Contemporary Action Painting further develops this approach with little or no representation. It emphasizes expressions of the artist's movements while painting, together with the feelings behind them. Abstract Expressionism frequently suggests tension, relaxation, movement, effort, advance and recession, thrust and counterthrust in various directions. Kandinsky, chief founder of nonobjective painting, did the same just before and during the First World War, as in *En Gris*. Even in purely abstract art, suggestions of tension, relaxation, advance, and recession are often combined with emotional and conative associations derived from life experience. They are not conceived as merely physical phenomena. *En Gris* has strongly erotic suggestions. Tension may suggest anxiety, moral struggle, fear, or indecision. Such a meaning may remain vague and doubtful or be clarified by the context, verbal title, or other outside factors. Suggestions of tension, confusion, and destruction in contemporary art are often linked by artists and critics with present wars and threats of war.

Contrasting traits in developed kinesis and kinesthesia are often combined in the same work of art, as in making one character powerfully dominant or effortful, the other passive and compliant or yielding to greater force. In a "Deposition from the Cross" the limp body of the dead Christ contrasts with the vigor of those who take it down. All of these attitudes are expressed in facial and other bodily configurations. Masaccio's *Expulsion from Eden* and Michelangelo's *Creation of Adam* and *Last Judgment* are examples. Suggestions of power and mastery on the part of man are characteristic of some Baroque art, such as that of Rubens, and to some extent of modern Western civilization as contrasted with early Buddhist and Christian quietism.

Classical architecture tends on the whole to suggest a firm, simple equilibrium of forces, such as that between the weight of the roof and the support of the columns. The contending figures in the pediment sculpture are fitted firmly but dynamically into their triangular spaces. Gothic architecture tends toward a more complex, extended equilibrium of diversified thrusts and counterthrusts.

The dance is not a purely visual art of movement; it is certainly not one to the dancer, who feels it intensely from the inside as an art in which her limbs and muscles are coordinated in executing a complex sequence of actions. Insofar as she is expert and the outside observer is perceptive, he tends to imagine some of her kinesthetic sensations. These differ from dance to dance, from one performer to another, and from one style of dancing to another. The traditional "classical" ballet emphasizes gravity-defying lightness and delicate grace of movement *sur les pointes*. Isadora Duncan, Martha Graham, and many other twentieth-century dancers have avoided these traits as a rule.

Kinetic and kinesthetic traits can be analyzed and described from various points of view. As related primarily to physical movements in space and time, they can be distinguished in terms of direction and vector, as parallel, cooperating, or opposing. In terms of released power, energy, and causal influence, they can be compared as strong or weak, active, quiescent, yielding, dominant or submissive. They are centrifugal or centripetal, explosive, cohesive, or disintegrative. They attack, press, resist, repel, collapse. Also, as we have seen, art endows such movements with biological, emotional, conative, and moral associations. One force seems to struggle to reach, grasp, dominate, and penetrate, another to welcome, accept, resist, reject, or flee. Together, they form a complex situation or configuration, describable in such terms as harmony or conflict, equilibrium or disbalance and confusion, inhibition or release, rational control, growth and progress, or decline and fall. Temporal and causal sequences of such images can be continuous or discontinuous, onward-rushing or hesitant, groping, pausing, fumbling, recklessly pursuing. In drama and fiction as well as ballet, different characters thus interact, some to reinforce and some to frustrate each others' efforts. Such action moves slowly and indecisively at times, and at other times rushes toward a climax.

*23. Linguistic style as a
developed component of literature.*

The concept of style in art is defined in various ways. In this book it is used mainly in a broad, inclusive sense, covering all the components and ways of organizing them in all the arts. As applied to literature, it includes not only the choice and arrangement of words but also the design and subject matter, the emotional and intellectual content, the story and characters (if any), the pattern of ideas and word-sounds, and all morphological aspects of the literary work. Style in this sense will be discussed in later chapters.

In literary criticism the term has been used more narrowly, with reference only to the verbal, linguistic aspects of literature, as distinguished from its content of ideas and emotions and from the larger modes of organization. To restrict the term "style" to these aspects is inadvisable in aesthetics. It tends to obscure the other kinds of style which pervade every aspect of literature, and which literature has in common with all other arts. Instead of "style" in the narrow sense we shall use the term *linguistic development.* As a *developed component* in literature, this includes several subcomponents, especially (a) vocabulary; (b) grammar; (c) syntax; and (d) word-sound development. Characteristic ways of using and combining these linguistic devices cooperate with other components to produce a historic style in the larger sense: the total, interrelated set of traits which distinguish the work of a certain author, people, or period.

Under the heading of *vocabulary,* one may ask what kinds of word are most used and emphasized. Is there a tendency to use very bookish, abstract, technical, scientific or philosophic terms, so as to give a generally "highbrow" or intellectual effect, as contrasted with a "lowbrow" or "middlebrow" effect? Are different types combined in a systematic way, to produce a certain combined effect? Is there much use of foreign or dialect words and indicated pronunciations? Of words known mainly to a special group or occupation, such as sailors or physicians? Of polysyllabic, erudite words when simple ones could be used? Is erudition carried to pedantry or ostentatious display of learning? Is the *mot juste* for a certain idea usually chosen, or are there many confusing, misleading terms? Are difficult words carefully defined or explained? Is the vocabulary on the whole characteristic of an upper or lower class? Is it simple, plain, colloquial, everyday, conversational, popular, concrete, and mundane? Is there a tendency to high-flown, artificially poetic diction? To farfetched figures of speech? To distinctively masculine, feminine, or childish expressions? To slang, argot, or cant, characteristic of a certain nationality or type of person? Is there much use of words commonly regarded as vulgar or obscene, as in the so-called four-letter words? Is there much use of neologisms, words recently coined and not yet in common use?

Each language and culture attaches certain associations to certain words and types of word, which are not fully explained in dictionaries. In English, for example, a persistent emphasis on words of Latin, Greek, or French derivation tends to give an air of bookish, intellectual refinement, and by association an air of belonging to the conservatively educated upper class. This is traceable in part to the aristocratic, Norman-French element in English since the Conquest. An emphasis on Anglo-Saxon words tends to give an air of plain, down-to-earth, matter-of-fact simplicity, of directness and concreteness, suggesting the language of the kitchen, market place, or workshop. Most vulgar words in English are of Anglo-Saxon or Germanic origin. Similar ideas can be expressed in technical, scientific terms, derived from Latin or Greek, without vulgarity. Many poetic and intellectual terms are also Anglo-Saxon. The associations just mentioned are variable and easily counteracted by other factors in the context. Many English writers use both types of word without thinking much about their origins. Some recent writers have used more Anglo-Saxon ones, partly as a revolt from conservative tradition.

As to *grammar,* one may ask whether the writing is on the whole correct or incorrect according to current accepted rules and standards. To what extent and with what effect? This applies to the declensions and conjugations of words, to tenses, case endings, active and passive voices, singular and plural forms. English has long shown a tendency to simplify language by abandoning many inflections. It is less complicated with them now than Latin, Greek, German, or Italian. It changes rapidly; new words and locutions from popular and technical usage are quickly adopted by dictionaries and scholars. Expressions considered incorrect in one generation are often approved by scholars in the next. Extremely meticulous obedience to tradition may give an air of pedantry and stiff conventionality. Occasional minor violations

are widely tolerated, especially in casual conversation, and are even sometimes cultivated for humorous or stylistic effects. Very ungrammatical speech or writing tends to suggest ignorance, lack of education, a background of the streets and slums. Hence an author may wish to use it for purposes of characterization.

In grammar, it is also important to notice which parts of speech are most used and how they are arranged and emphasized. Some writers use mostly nouns and verbs, which often suggests a bare skeleton of thought, confined to basic actions and objects. Others, by many qualifying adjectives, adverbs, and modifying phrases, give an air of subtlety and microscopic accuracy in expression, or perhaps of exaggerated fussiness in making fine but unnecessary distinctions. The effect depends in part on the situation, on whether or not it seems to call for fine distinctions at the cost of slowing down the pace of action and discourse.

Syntax and grammar are not sharply distinguished; the former is more concerned with organizing words, phrases, and clauses into sentences, paragraphs, and larger units. It is concerned especially with predicative, qualifying, and similar word relations and, in general, with achieving orderly combinations of words. It often reveals patterns of group and individual thought.

In analyzing literary form one should notice whether the sentences are prevailingly short or long, simple or complex, with few or many subordinate clauses and phrases. Does the main verb come quickly, or is it postponed with an air of suspense, requiring close attention by the reader? Long, involved sentences with the verb or participle at the end were the pride and affectation of German scholars until recent years. Now they have more respect for short, simple sentences and use more imported foreign words. As to any piece of literature, one may ask whether it tends to alter the customary order of words and, if so, to what extent and why—to fit poetic meter or to emphasize certain ideas, for instance. Wordsworth tried to substitute natural, common speech for high-flown poetic diction, but was not consistent in this respect.

Word-sound components, such as rhythm and euphony, which we considered above in relation to verse, are important also in prose as factors in linguistic style. Short, simple sentences not only divide a train of thought into short, discrete units, but also tend to make the rhythm of discourse somewhat choppy. Many prose writers tend to avoid them or to use both short and long sentences. Extended, complex sentences can develop subtle rhythmic patterns in prose, without shifting over into meter or rhyme. Like long, sustained, rhythmic phrases in music, they can give an effect of nobility and stately grandeur, especially when made up of appropriate words and lofty ideas. They are characteristic of Sir Thomas Browne, Gibbon, and later prose masters in the Neoclassic era. Successive sentences rise to main and secondary peaks at different points. Prose in the romantic style is often excited, jerky, and irregular in rhythm. Avoidance of verbal sequences which are hard to pronounce (such as starch, choke) tends to make a style smooth and consonant. Occasional alliterations and internal rhymes, at rare intervals, can move it toward poetry, but many writers prefer the opposite effect. Hemingway popularized the curt, clipped speech of men of action in times of emotional crisis. Prose in the grand manner is likely to seem antiquated and pretentious at the present time. Many writers cultivate a simple, direct, conversational or journalistic style as more suited to prosaic ideas in an age of democracy and social tension.

All the linguistic components just mentioned can cooperate to help produce a distinctive literary style, such as that of Shakespeare, Milton, Byron, or Walt Whitman. Goethe used many different styles. In *Ulysses,* James Joyce plays with a great variety of historic styles in English prose, using them with virtuosity and sometimes with conscious disregard of their appropriateness to the ideas and actions concerned. At one point in that book, the sequence of linguistic styles constitutes a progression in accord with historic stages in literature.

Within each of the major civilized languages there are many sublanguages characteristic of different regions, social classes, age levels, and occupational and other types. They overlap, and a single person may speak several in different contexts. They involve a somewhat different choice of words and of grammatical and syntactic construction. A physician often speaks a technical language to other physicians, but has to use a colloquial one in talking to his children or to friends in other occupations. An author may choose to write persistently in one style, as Henry James did, or to combine several, as Dickens did. Mass media of communication, such as film, radio, and television, tend to destroy local peculiarities. Joyce tried to invent a new sublanguage, and sacrificed ease of communication in that attempt.

24. Imagery as a suggestive component in literature; developed metaphor and symbolism.

Imagery in general includes the use of images from all the senses. The term can be broadly defined to include all ways of using them in art. But it is also defined more narrowly, as excluding the word-sounds in which the literary work is expressed. It refers to the other kinds of sensory image which words can suggest, as in the power of the words "lightning" and "thunder," or their equivalents in other languages, to suggest certain visual and auditory images however the words may sound. The fact that huge numbers of images recur in many languages, though signified by different words therein, makes translation possible. It is harder and often impossible to preserve the word-sound patterns. One cannot always find the exact equivalent of a certain image or idea in different languages, and this makes exact translation difficult.

The power of words to suggest specific sensory images varies greatly. Some words, such as "relationship," do not arouse any, except perhaps the appearance of the letters when the word is pronounced. "Lightning," "blue sky," and "blood" do so more strongly, but much still depends on the context. In a textbook on physics, the reader may be asked to consider lightning as an abstract concept, a type of phenomenon, rather than to imagine it vividly. Literature, especially poetry, tends to encourage an imaginative response. It tends to emphasize the sensory and affective meanings of words, rather than their purely intellectual or practical ones. But this, too, varies greatly from one writer to another.

Some writers and some period styles of literature tend to emphasize sense images more than others do. Some emphasize certain kinds of imagery. John Keats, in *The Eve of St. Agnes,* uses images from all the senses including olfactory and gustatory ones, in reference to perfumes, foods, and drinks. Such writers are described as "sensuous." Others, such as John Donne, use many abstract, intellectual concepts, as in discussing metaphysics and religion; such writers seem less interested in the sensory qualities of things or in sensuous reveries about them. Some writers emphasize specific images related to sex and physical love. This is more and more common in present Western literature, and it is also common in the popular

literature of the Far and Near East. Dante and Milton made extensive use of Biblical and astronomical images; Homer's *Iliad* resounds with clashing weapons and the cries of battling warriors. Some writers use fresh, unhackneyed images; others, old ones which have lost some of their power to stimulate interest and fantasy in the reader.

It is hard to find a more far-reaching basis for characterizing an author or a period style than the degree of emphasis on imagery of a certain kind, and the way in which it is used. This depends partly on the sense or senses and partly on the cultural realm from which it is derived, which may be the Old Testament, Greek mythology, or modern industrial life. The emphasis on a certain kind of imagery tends to express a certain interest and attitude on the part of the author, a certain set of values, and a certain social and educational background. By associating certain things with ugly, evil, disgusting images and others with beautiful, noble, serene ones, an author can express his philosophy of life, as T. S. Eliot does in connecting modern civilization with images of dirt and decay.

There is significance, not only in the nature and relative number of sense images employed, but also in the ways of organizing them. Among these are *simile, metaphor,* and *symbol.* We have considered these briefly as "modes of transmission," ways in which an image or idea acquires the power to suggest another, as through similarity or contiguity in experience, through analogy (real or fanciful), or through cultural convention. They will be considered again under "Expository Development." Here we should note them as possible ways of linking together and organizing images and concepts on a large scale: for example, in complex systems of religious symbolism and in extended similes and metaphors, as in the poetry of Edmund Spenser.

As a functional part of a work of literature, an image is not an isolated thing, however interesting it may be to contemplate for its own sake. It tends to call others to mind, some vaguely and some cogently, some by established definition, some by common human experience, and some by previous connection in art or other realms of culture. Certain images are highly ambiguous, others not. The context usually helps to select and reinforce certain channels of association. To link certain images and concepts as members of a metaphor or other literary trope, to predicate one of another or to point out an alleged resemblance or difference between them, may function as a means of characterizing and explaining

them; hence as a step toward intellectual organization.

In combining a set of literary images, the author may or may not intend a deeper meaning, a metaphysical or moral affirmation. Some kinds of literature attempt to avoid these and to focus attention on sensory similarities and contrasts for their own sake. But it is hard for the author to avoid expressing some affective attitude toward the images he employs and some conception of their status in reality. Thus Walt Whitman's long lists of images tend to build up a conception of democratic American life and an expression of the poet's far-reaching love of man and nature.

Developed literary imagery, as distinguished from the use of single images, involves the manipulation of linked clusters and sequences of them, organized and interrelated in various ways. Often the poet develops an emotional conception of something by adding simile after simile, metaphor after metaphor, as Keats does in the "Ode to a Nightingale." Here he contrasts two opposite conceptions, one of the dreary, actual world of ugliness and misery, the other of a realm of ideal beauty, symbolized by the nightingale. Each is developed as a trait complex, an image cluster, and the poem alternates them until a climax is reached. To go from one type or linked cluster of images to another is a *developed image sequence*. It is a *progression* if the changes tend persistently in some direction, as the imagery of Dante's *Paradiso* ascends by definite steps toward the divine.

25. Emotional development. Combinations and sequences of affective traits and types.

In the chapters on ingredients we considered some of the basic emotions, such as joy and grief, anger and mirth, as elementary traits and types. There and in the present section, we are not concerned with the emotions aroused by a work of art in the observer, but only with those suggested in the work of art itself. We noted that the two may or may not be similar; an observer may recognize that a picture suggests joy, without feeling the same emotion in response to it.

In life and in art, the emotional component of experience assumes many different forms, such as mild or intense moods of elation or depression, pleasant or unpleasant feeling tones, and enduring sentiments of love or hate. Seldom, if ever, does it occur in isolation, as pure emotion apart from all other mental

processes. It is usually combined with desiring something and with being satisfied or frustrated. It is often directed toward certain outside objects and stimulated by them. It may function as a preparation for action without issuing as action. At times the emphasis is on the mood or feeling itself, rather than on any such associated factor.

A single image is affect-laden when it suggests a certain emotional trait or type. Thus a picture or description of a weeping woman in a painting of the Crucifixion suggests grief. A musical chord progression in a certain context may also suggest that emotion, as in the opening chords of Tschaikovsky's *Pathétique* Symphony. An emotion often occurs in art in a simple, elementary way, as a single, passing mood or allusion, without much development.

Like other components, it can be developed through variation and contrast. An entire complex work of art may be dominated by a single emotional tone or tonality, expressed in all its details. This may or may not be relieved by contrasting ones. A considerable amount of development is possible within the limits of a single emotion or set of related emotions, by multiplying images and concepts which suggest various aspects of it. Something of the sort is done in Milton's *L'Allegro,* and a contrasting group is assembled in *Il Penseroso*. Many short lyrics, including some of Shakespeare's sonnets, develop a single mood. The same is true of many shorter musical works, such as Chopin's Preludes, Nocturnes, and Etudes, Mendelssohn's *Songs without Words,* Schumann's *Scenes from Childhood,* and others.

Certain recurrent types of emotional tone have been traditionally associated with certain "styles" or "manners," as in speaking of the grand manner, the heroic style, the sublime, bombastic, pastoral, lyrical, satiric, and others. Each of these implies certain traits in addition to those of emotional tone. The pastoral, for example, usually deals with country life and idealized representations of peasants, shepherds, shepherdesses, flocks, and herds. In mood, it is predominantly calm, simple, happy, and serene as in Beethoven's Sixth *(Pastoral)* Symphony. There is room within the pastoral tone for a good deal of variation, as between dancing and quiet musing, storm and sunshine.

Different emotional tones are often contrasted in the same work of art, especially in long temporal forms such as dramas, novels, and symphonies. Shakespeare often makes a different emotional tone preponderate in successive acts of a play. The first half of *The Winter's Tale* is in a tragic tone; the second, in a pastoral one. Within an act, one scene

may be solemn and the next given over to slapstick buffoonery as comic relief. Even a single one of Shakespeare's sonnets, brief as it is, may contain a strong emotional contrast and progression of tone, as in the change from depression to elation in the sonnet "When in disgrace with fortune and men's eyes." Each tone is developed with illustrative images to form two opposing clusters, which constitute two complex traits under the component "emotional development."

Long musical works—sonatas, symphonies, and chamber works—usually emphasize different emotional tones in successive movements. The change from *allegro con brio* to *adagio* or *grave* involves not only tempo but emotional expression. Moods akin to wit and humor are indicated by the terms *giocoso* (jocular, facetious) and *scherzo* (a jest). A change from major to minor mode may suffice to change a gay, *scherzando* type of agitation into one of fear and confusion. A single minor or diminished chord or sudden dissonance may suggest a brief "darker mood" in the midst of a tranquil passage. Tschaikovsky's *Pathétique* Symphony is dominated by the tragic mood, but contains some lengthy passages with lighter emotional coloring. Even in a single painting, two or more strongly opposing moods may be expressed in different characters and groups. A Crucifixion may include the agony of the crucified figures, the grief of the mourners, and the busy indifference of the soldiers, some of whom cast lots for Jesus' garment.

The temporal arts, of course, are more able to indicate changes, as from one emotion to another or from one degree of intensity to another in the same emotion. It is common in tragedy to show the hero at first in various moods of self-confidence, gay or masterful, then to plunge him slowly or suddenly into deeper anxiety, struggle, and despair. *King Lear* is an example. Such terms as "gay" and "grave," "bright" and "somber," applied to visual art, can be used to characterize both the visual, presented aspects, such as a certain choice of colors, and the mood they express. Dark shadows throughout a film, as in *The Informer,* tend to suggest a somber mood.

26. Wit and humor.

These terms apply to a variety of phenomena, especially in the literary, visual, and theater arts. They are psychologically complex, variable traits and types, involving developed emotional and conative attitudes. They often express mirth, convivial merriment, and a comic spirit, but not always. They can also hide a serious or hostile attitude, a desire to hurt and injure someone mentally. This is especially true of wit.

Besides their emotional and conative motivation, wit and humor involve certain types of method and device. Wit is often achieved through playing on words, as in puns which wreck a train of serious, logical, or practical thought. Both wit and humor tend to arouse laughter by juxtaposing incongruous images. This may be at someone's expense, as often in wit, or it may express a more kindly amusement at common human faults and troubles. This is more true of humor. Both may express a light-hearted, irreverent attitude toward subjects which are often taken seriously. By suddenly releasing inhibitions on thought and speech, as in risqué jokes and unintended double meanings, they may produce an explosive effect whose outcome is laughter.

Different individuals and cultures vary as to what they consider ludicrous. In a savage or barbarous culture, people sometimes laugh when a man runs against a hidden sword and kills himself unintentionally. A trick or practical joke may seem only cruel to the object of it or to sympathetic observers. Wit can be mentally cruel when it tends to hurt the feelings of a weak and sensitive person, such as a child or cripple. It can be grim and cynical in meaning regardless of its effect on others. Sarcasm often results from saying the opposite of what one really means, as in complimenting a stingy person on his generosity or a coward on his courage.

There are several kinds of irony, with various emotional associations. One occurs when a character unknowingly refers to something important which the reader or the audience already knows about. Another is like sarcasm, but gentler and less malicious.

Both wit and humor tend to demean or devalue someone or something. They do so by suggesting an analogy, perhaps far-fetched, between something ordinarily taken seriously, respected, or even worshipped, and something of a lower order which is ordinarily treated with familiarity, contempt, or mild condescension. This incongruity tends to ridicule the former and diminish its prestige or dignity. If the person or idea thus devalued is taken very seriously (e.g., as an object of religious worship), such ridicule may arouse shocked resentment. Even so, the comparison may be recognizable as witty, especially if it involves a surprising twist in the usual meaning of words. Favored targets for wit in a democratic society are the excessively pompous, haughty, dignified, solemn, and pedantic individuals and traits. Persons who do not have these traits can join in laughing at

such a person's discomfiture, or at jokes behind his back. Wit and humor thus have a conative aspect in satisfying some persons' desires while frustrating those of others. One who wishes to talk seriously is frustrated by a pun which throws the conversation off the track.

Types of art which often involve wit and humor are the *caricature* and *parody*. The former, especially in visual art, tends to exaggerate in an absurd or repulsive way some traits of appearance, manner, or behavior on the part of an individual or group. It can be playful or hostile. A parody, especially in literature, imitates or mocks a well-known work of art or style in a way somewhat like that of caricature, usually with alterations which tend to make it seem a little ridiculous.

In theater arts, wit and humor often play an important role in comedy, but the concept of comedy involves other specifications as well. Tragedy, too, may involve wit and humor, usually in a subordinate way.

To deflate false pretensions to wisdom or virtue may be a constructive social function. Clowns and court jesters have been tolerated for this purpose and also for relieving tensions in the high and mighty by poking mild fun at them and suggesting that they cease taking themselves too seriously.

Wit is often concise and sparkling, compressed into an original pun or metaphor. Brevity is said to be its soul. Humor can be more leisurely, diffused through a whole story or picture which undertakes to show some of the comic aspects of life. What it devalues may be human nature in general, by showing that certain faults and weaknesses are universal. As such it is kinder and more philosophic than wit which focuses on a certain individual, class, or social group. To devalue man in general or some particular man, as an example of the all-too-human, is not necessarily a real detraction from their value. It may relieve them of an artificial strain in trying to be more dignified, rational, or prudish than they can be or need to be. A humorist may intentionally deflate himself or his own cultural group in a small way by emphasizing their milder foibles—but usually not their worst crimes and vices, for these are hard to take lightly.

In an aristocratic society such as that of the Elizabethans, and for that matter early in the twentieth century, much wit and humor was devoted to belittling servants and others of the lower classes, or (in America) recent immigrants, Negroes, and other minority groups. To portray their amusing dialects, mistakes, and awkward ways gave a comfortable sense of superiority to the wealthy, successful, and aris-

tocratic. Now, under different social conditions, such humor is more likely to be resented and avoided. One is more free to ridicule oneself or one's own group, if only to show that one is not too thin-skinned. The ability to laugh at oneself is recognized, in some cultural contexts, as a thing to be proud of. But much self-ridicule, like much self-praise, can be an overcompensation for a sense of insecurity. A tendency to belittle weaker persons and indulge in frequent wit at their expense is often a protective screen to cover one's own weaknesses. Cervantes' gentle ridicule of decadent feudalism helped to end the feudal era. Voltaire, Molière, Swift, and Shaw satirized the high and mighty, the pompous and hypocritical, in their day.

Much wit and humor on a popular level, including that in the Elizabethan dramas, features playful insults, practical jokes, and risqué anecdotes aimed by one character at another. They abound in crude, physical images, such as those of Falstaff's fatness. On a higher social level, as in George Bernard Shaw's comedies, they deal more with social attitudes, false assumptions, and prejudices. To introduce primitive crudities in a polite comedy of manners is to heighten the effect of incongruity and the sudden shock to conventional attitudes.

The most successful defense against pointed wit and derision, for those who wish to maintain the spirit of the jest, may be to return all thrusts with equal or greater force, as Falstaff does. Continued, such exchanges can develop into long passages of repartee and mock hostility. They can hide an undercurrent of rivalry and, if carried far, burst into genuine anger and conflict. When wit and humor become too pointed, too malicious, their underlying tone is no longer light-hearted, but it often pretends to be, and on an upper-class level may take on an air of extreme politeness. Continued banter, especially between men and women, often takes on a sexual tone as a sort of amatory fencing, preliminary to serious lovemaking, in which each side can partly reveal and partly conceal its desires and intentions without committing itself too far or fast.

The defensive function of wit and humor, in evading or belittling unwelcome ideas, appears in "black" humor, of which "gallows" humor is one species. It is found in the grimly cynical jokes of soldiers under fire (as in Bruce Bairnsfather's cartoons during World War I). These can help one resist the emotion of terror, to make light of danger or disaster, and thus to endure the frightful things around one. Any kind of art can have this function to some extent, when it

represents evil in a way which shows man's power to transform and control it in terms of some artistic medium.

Wit and humor develop to their fullest in literature, especially in dramatic dialogue. They also find considerable scope in drawing and painting, as in the caricatures of Daumier. Music alone cannot convey them clearly, but can reinforce them in drama, as by supplying appropriate sounds which suggest laughs and jollity, clownish thumps and squeaks, or playful dialogue. Wit and humor are expressed in Moussorgsky's *Pictures at an Exhibition,* with the aid of program notes referring to the pictures. Pantomime is well suited to humorous imitations and burlesques, but also to expressions of love, grief, and pathos. From sympathetic amusement at someone's shortcomings or minor mishaps, it is but a step to pathos and pity for what seem to be serious troubles.

27. Conative development; motivation, desire, and purpose.

It has been remarked above that conation (volition, desire, effort) is closely bound up with emotion in life and also in art. Where a strong emotion is expressed there is usually a conative situation, conscious or unconscious, to help explain its cause. Positive, pleasant feelings tend to accompany strong conscious desire and satsifaction of desire, but not necessarily so; negative, unpleasant ones usually but not always accompany frustration and privation. Psychoanalysis reveals the great complexity and variability of conation, the largely unconscious nature of its operation. If a vigorous appetite or active quest for something is pleasant as a rule, so that anticipation is sometimes better than realization, it can also be said that "hope deferred maketh the heart sick." If there is a conflict of desires within the individual, such a desire to seize or hurt and a desire to be loved and respected, satisfaction of one tends to frustrate the other and to bring, at best, a mixed emotion. Very easy, repeated satisfaction tends to become automatic and devoid of feeling.

Modern literature deals more with mixed, complex desires and feelings, on the whole, than does ancient literature. The interest in psychology and in changes of character has increased.

Both simple and complex, conscious and unconscious desires are commonly expressed along with emotions in literature and visual representation. But many desires are almost or completely unemotional, and these also find their way into art. They include the routine satisfaction of most basic physical needs, such as those of air, food, and sleep, as well as the persistent, enduring hopes and ambitions, aims, and policies of life which motivate human effort through the years.

Since conation and emotion may develop along somewhat different lines, or at least appear separately in art, it is well to regard them as different components. A lover's desire for his beloved is a conative trait; his moods of hope and despair, joy and gloom in quest of that object are emotional traits. All may at times give way to their opposites; all may be strong or weak, mild or intense, brief or lasting. Conation may develop along with practical reasoning and purposeful planning, or it may be impulsive, spontaneous, unplanned.

Conative development can be found within a single individual in the growth of a dynamic personality, a set of needs and desires based on his innate endowment, which grows and expands into wider ranges of habits, tastes, and attitudes, always in adaptation to his physical and cultural environment. Being more selective than life in general, art often picks out a certain motive as characteristic of an individual, such as Macbeth's ambition or Othello's jealousy. It may disregard most of his other desires because they are not distinctive and do not advance the story.

Motivation is usually simplified in art, as judged by realistic standards, but is less so in modern literature than in ancient and primitive. Artists are now more aware, not only of internal conflicts and mixed feelings, but of the way an individual's desires may change from year to year and moment to moment. They do not assume that, because he belongs to a certain sex, class, religion, or occupational group his attitudes are like those of all others in it. Conative traits and tendencies are thus conceived in a more pluralistic way, but the artist often tends to focus on one moment, aspect, or factor in their complex interaction.

Art also develops conation in terms of the relations between two or more individuals. One character may hold the center of the stage for the most part, as in *Tom Jones* or *Faust,* and be the only one whose wishes and aversions are analyzed in detail. All others may appear chiefly as related to him: as aiding, obstructing, or neutral to him, as similar to him or different. But usually there are two or more, perhaps a numerous cast of developed characters, as in the Shakespearean plots. Each has a set of desires and

aversions, hopes and fears, which interact with those of others in a sequence of shifting configurations. A and B cooperate and help each other; A and C want the same thing, which only one may have, and hence are rivals. B and C want different outcomes, and struggle against each other. D helps E and F thwarts G, without intending to, while pursuing other aims. Minor figures in the background take different attitudes toward the various protagonists. The various desires and characters may typify general types and principles: e.g., one the established order, another, rebellion against it; one cruel selfishness, another, self-sacrifice and Christian humility.

Motivation usually comes quickly into the open and develops rapidly in the drama, especially through dialogue and action. In the novel it may do so or be slow and meditative, with long interludes for the author to talk of this or that while describing the landscape. In a work portraying battle scenes and dramatic moments, such as Jacques-Louis David's *The Oath of the Horatii,* painting can suggest a variety of conative-emotional traits—in this example the bold ardor of the youths, the exhortation of the old man, the fear and grief of the women. In pantomime these suggestions are developed temporally. Abstract painting and sculpture, in suggesting physical thrusts and counterthrusts, tensions and relaxations, can also hint at related desires and conative attitudes.

Music, in its own way and with more temporal development, suggests kinesthetic efforts and countereffforts, rests and moves in a certain direction. It thus arouses associations of conscious effort, desire and attainment, the struggle between conflicting forces, as in Beethoven's works of the middle period. Even the conflict between good and evil can be hinted, as in Richard Strauss's *A Hero's Life,* through contrasting themes in a grand, heroic mood with the harsh, rasping, bickering tones of hostile critics and the gentle tones of the loving helpmate. Such effects in music are much aided by verbal clues in the title or program.

28. Developed action; motivated behavior; plot.

Any movement of a body, animate or inanimate, is a kind of action. The wind acts on trees, and waves act on rocks. The simplest types of life act in ways conducive to survival; the higher types, with conscious purpose and desire. All these kinds of action are suggested in various arts. Many primitive dances represent the typical movements of different animals, as in hunting their prey. These are organized into complex patterns of gesture and sound. Any random movement of a human body is action, even the automatic rhythms of breathing and unconscious reflex movements while asleep. These too may find an occasional place in art.

What we mean by "action" in a play or story, however, is usually *motivated action,* behavior impelled by some desire or conative impulse, on or near the conscious level though not necessarily completely conscious. Fully *developed action* in this sense is a combination of developed motivation with complex movement, as of one or more individuals while walking, talking, working, playing, eating, making love, worshipping, or fighting. Like rests in music, the sleep or deathly stillness of a body can fit into a sequence of actions, though not fully active in itself. It is not developed action merely to want something, however intensely, or to feel a strong emotion inwardly. One must externalize the desire in some overt, expressive gesture, posture, speech, or facial change, or in significant inaction when movement is expected. Dance and dramatic action represent the conscious deeds of humans impelled by various desires, which often lead them into physical and mental conflict. They do so by presenting visible movements resembling those of imaginary characters. Fiction can only describe and narrate action.

Motivated action is developed into *plot,* which (in the broad sense) is any comprehensive arrangement of action in a story, play, or other temporal work of representation, such as a narrative scroll. "Plot" connotes especially a certain kind of arrangement, that involving a well-defined complication and resolution, but many looser ways of organizing action can be included under that name. The total action of a complex story consists of a sequence of incidents and situations.

29. Developed speech; dialogue and monologue.

A *dialogue* is a conversation between two or more persons, usually dealing rather persistently with some definite topic or topics and exchanging ideas about them. A whole literary composition may be written in dialogue form (Plato's dialogues), and yet deal so technically with erudite subjects as to be, in effect, an essay or treatise. The dialogue form preserves to some extent the appearance of free discussion between persons with different views. The text of most dramas consists almost wholly of dialogue, perhaps with bits

of narration and a few stage directions, but as presented on stage or screen it includes other components such as action and setting. Dialogue occurs as a component in the novel, short story, and many types of verse, usually interspersed with narration and comments by the author. He may or may not appear as one of the conversing characters. Opera merges dialogue with music in song. Purely instrumental music sometimes gives the impession of a dialogue, as when violin and piano alternate short passages in which each takes the leading voice by turns. Differences in pitch and timbre may suggest a man and woman conversing.

A *monologue* is a speech of some length delivered by one person alone. It may be addressed to others present or spoken as a soliloquy, such as that of Hamlet. In the latter case, it may be addressed to himself or to no one in particular; he may seem merely to be thinking aloud. A long spoken prayer is a monologue but hardly a soliloquy if addressed to an imagined deity. Long soliloquies by sane persons in actual life are so rare that their occurrence on the stage is a conscious, conventional departure from realism. Many lyrics take the form of a monologue by the poet, which may or may not be addressed to any particular person. Browning's short, dramatic monologues convey, through the mouth of a single imaginary speaker, a complex story and a set of characters. Some are soliloquies, some addressed to an imagined listener, as in "My Last Duchess."

Speech is a kind of overt action, and a most important kind. It is distinctively human to the extent that man is the only animal that invents symbolic sounds and transmits them culturally as a means of communication. Stories can be told without it, as by pantomime or picture sequences, but with limitations. Speech proceeds rapidly and conveys much with a few symbolic sounds. It can influence and accelerate action, expressing the inner thoughts and feelings of characters, or it can become a substitute for other forms of action, practiced for its own sake. Speech can explain and implement other action and motivation in a play or story. But it is not only a means of communication. It can mislead the listener and obscure or falsify the facts. Action and speech do not always coincide; they often diverge and conflict, as when a character says one thing and does another. Speech can be a means of concealing or partly concealing one's inner thoughts, emotions, and intentions; it can lead others to misinterpret one's acts. A soliloquy, being supposedly private and unheard, is expected to tell the truth insofar as the speaker understands it.

Because of the divergences between speech and other forms of action, it is well to regard them as different components which may conflict or reinforce each other. Speech is a developed component when it is complicated and organized in some artistic way, as in a lyric monologue or a dramatic dialogue. As a component in drama or fiction, one of its chief functions is to express the desires, beliefs, purposes, and emotions of individuals, thus helping to exhibit character and advance the plot. All literature is speech or a written substitute for speech; but as a component of literature speech consists of passages which are supposed to be spoken aloud. Even a mental soliloquy, such as that of Mrs. Bloom in Joyce's *Ulysses,* may function as a kind of imaginary speech.

Many *types* of dialogue recur in literature, such as the love scene, the verbal argument or quarrel, the trial, the passage of humorous banter, and the philosophic discussion. Each example can be described in terms of developed component traits and perhaps progressions. A courtroom trial is a long, formalized sequence of dialogues, usually leading to a decision by jury and judge. Many Platonic dialogues progress to a victory for Socrates in philosophic debate.

In analyzing a dialogue or monologue, it is usually important to notice *who* is supposedly speaking, to whom, when, where, and under what circumstances. What is the origin, direction, and target of the speech or part of one? This relates it to the context of character and action. But often the speaker and the one addressed are unspecified, especially in meditative lyrics.

Many developed components often enter into dialogue, such as linguistic style, emotional and motivational development, imagery, and rhythmic development. Dialogue can expand to take in the whole of a work of literary art, or be only a minor, occasional factor, as in an incidental quotation within an essay.

30. Ideology.

The term "ideology" refers to the manner and content of thinking which is characteristic of an individual, group, class, or culture. It is a more or less systematized set of concepts, beliefs, theories, standards of value, moral and political principles, mental habits and tendencies of thought, permeated with emotions and desires. Even the most primitive or uneducated adult has some sort of ideology; the more highly educated think theirs out and organize it logically to some extent, but never completely so. Most Western

philosophic and scientific theories try to be as rational as possible. In most persons emotional attitudes and a will to believe contend with logic and practical wisdom. Every individual derives most of his ideology from the social and cultural group in which he is raised and educated. Many continue to think throughout their lives along the lines in which they have been conditioned; many (especially in free, diversified cultures) dissent from the inherited patterns of thought in some degree and work out somewhat original ones for themselves. Marxist art criticism stresses the influence of the class and social order (e.g., feudal or bourgeois) to which an artist and the characters he represents belong. It emphasizes the role of economic conditions on standards of value. Many individuals are not fully aware of how extensively their feelings, beliefs, and utterances express a certain ideology.

As a developed component, "ideology" includes the more conceptual, rational, intellectual factors in human experience and behavior as portrayed in art, but it is not limited to these. ("Rational" refers here to how people reason, not necessarily implying correct or wise reasoning.) Prince Hal, in *Henry IV, Part I*, exhibits a ruling-class ideology to some extent, but is atypical in his youthful misdemeanors and the amount of rough banter he permits to Falstaff. Later, he becomes more dignified, responsible, and typical of the ideal prince and king.

In art, ideologies are seldom developed as logically and systematically as in Plato's dialogues, Montaigne's essays, and other thoughtful works by philosophic minds. Most of them are echoes of what others have said and are only slightly rationalized. On the whole, people usually believe what they want to believe, or what their desires and conditions of life impel them to believe. Dante's ideology is his own personal version of medieval Christian doctrine, presented as a truthful picture of the universe and of the relations between God and man. It is influenced by the feudal system, with its hierarchies and conflicts, during which he lived. An artist's social, religious, and moral attitudes may be expressed in the kinds of character he portrays and in how he portrays them, for instance, whether with sympathy and admiration or in the worst possible light, with seeming approval or disapproval of their conduct and success or failure, or in his expression, through them, of his own belief or disbelief in the rightness of the present social order.

Modern literature recognizes the great variety of individual beliefs and attitudes which exist even within the same class and culture, none of them being necessarily right. It takes more account of change in human ideologies in response to environmental and other influences. Different ideologies are often contrasted, as in Thomas Mann's *Magic Mountain,* where a long, intermittent dialogue takes place between two intellectuals with different world views, a Jesuit and a Freemason. Traditional ideologies are often subjected to attack today, especially those reflecting an aristocratic or bourgeois point of view and those accepting the belief in divinely established, absolute moral laws. This is done not so much by logical argument as by showing the disintegration of characters who accept them but find them inadequate in the modern world. There are also sporadic attempts by artists as well as philosophers to build up a new, democratic ideology for the twentieth century.

31. Characterization.

This component has to do with the representation of character and personality in humans or imaginary beings such as gods, or in animals with humanlike traits. Even plants and flowers are sometimes endowed with humanlike feelings. Characterization is especially important in drama and fiction, but enters also into painting, sculpture, and to a less extent into music.

Characterization involves a combination of many specific traits. The character of a man can be suggested by his appearance, voice, and manner, by what he says and what he does in relation to other people, and by the similarity or difference between his speech and his conduct. Some art undertakes to describe his innermost thoughts, desires, and feelings, which may or may not correspond with the self he presents to the outside world.

The portraits of Rembrandt characterize by showing, not only those inborn traits of physiognomy which distinguish one individual from another and the common marks of youth or age, but also more subtle nuances which indicate the personality and mental attitude behind the face. Some of the late self-portraits of Rembrandt emphasize the signs of age, disappointment, and vicissitude. Houdon's portrait statues of Voltaire, Rousseau, and others bring out traits which seem distinctive and important in each case. When the character is known to us from other sources, we tend to project what we know into his portraits.

Much painting and sculpture, even when devoted to portraiture, does not try to reveal an individual personality. It shows the man or woman, god or

goddess, as an example of a type, usually an ideal type of the perfect deity or noble. This is a partial characterization, but of limited scope. Not only the shape and expression of the features, but also the shape and posture of the body, may combine to suggest a certain ideal. Some Egyptian portrait statues were highly individualized, showing the marks of experience and the strain of great responsibility, although most were of generalized and somewhat abstract types. Representations of lesser humans and animals were often more realistic, but even here the usual emphasis in ancient art was on occupational types: the hunter, fisherman, farmer, scribe, or soldier.

Little individual attention was paid to persons of low class in the art of aristocratic societies; they were treated mostly as inferior types performing menial tasks. In and after the Renaissance they were shown in more detail, especially in Flemish, Dutch, and German painting.

No static, visual representation can penetrate very deeply into individual character. Pantomime can do more through imitating significant movements and changes of expression. But one can never be sure, from the outward appearance and movement, of just what thoughts and feelings lie underneath, since people learn from infancy to hide these at will beneath an impassive expression or an artificial smile. Physiognomy, like speech, is not a trustworthy guide. Some vicious criminals have angelic faces and some good citizens have diabolic ones.

Music cooperates with dialogue and action in the opera, to build a total impression of character, angelic or diabolic. Some composers, such as Elgar, have tried to portray individuals in pure instrumental music, but this remains a tour de force. At most, without a verbal aid, one can hint at a few such traits as sprightly animation, heavy dignity, volatile emotions, or calm serenity; the sum total remains a thin abstraction.

Spoken drama can deal with abstract types such as Everyman, or create as unusual and complex an individual as Faust. Even Faust has come to symbolize a type: that of modern man with an insatiable desire for change and new experiences. The spoken drama labors under the difficulty just noted, in that neither speech nor movement on the stage can easily reveal the subtleties of character. All must be simplified and underlined, to be perceived and understood from a distance. But Euripides showed what could be done within these limitations. The film with its close-ups and its power to enact inner fantasies has added resources. In the novel, above all, the author can analyze character as long and as deeply as he wishes, displaying the stream of conscious and semiconscious thoughts as if they were obvious to any eye or ear. He can make his characters act and speak significantly in ways which would be impossible on stage or screen, and also describe them in his own terms or those of science. He can see and show them with all reserves and barriers down, both mentally and physically naked to the world.

There are several possible stages in the development of characterization. First is the stage just mentioned, where men, women, gods, and animals are shown as mere examples of a few broad types. Ancient drawings and paintings are mostly conceptual in this respect. Then comes the portrayal, especially in drama, of individuals who are more than examples of types. Achilles, Odysseus, Penelope, Medea, Orestes, and Oedipus depart in some respects from the accepted norms for their sex and status. They have flaws and virtues of their own. The protagonists in the great ancient epics and tragedies are realized in a fairly solid, three-dimensional way, through a multiplicity of traits revealed in different circumstances. At the same time and in the same work, minor characters are less fully realized, some remaining as mere supernumeraries, others (such as the chorus) being characterized en masse as a section of the public or a group of nameless, moralizing onlookers. The third stage of development expresses the modern historical, sociological, and psychological interest in change, individual and cultural. Characters are shown as changing gradually or suddenly and as often inconsistent. Their inner lives are portrayed in terms of a "stream of thought" or a dialogue with oneself. Still more recently, there has been a regressive trend in various arts back toward abstraction and simplification, with *personae* as mere masks, walking robots, or empty shells devoid of real personality.

32. Environment; setting and background; enveloping action.

In art, this includes the whole physical, historical, and cultural milieu, within which a character is represented or a story told. Modern historical writing, biography, and social science have tended to give increased importance to environment in the making of characters and the course of events.

Even when apparently of only decorative interest, as in the architectural and landscape backgrounds of Renaissance portraits, the represented environment

may be significant, in this case as showing a wish to appear in affluent, aristocratic surroundings, or perhaps as a hero in battle. It is well known that, in the seventeenth and later centuries (for example, in the paintings of Poussin and Claude Lorrain), the interest in parklike scenery often outweighed that in human figures, which then became smaller and less distinctive. In the nineteenth century, pure landscape became an absorbing interest in itself, inspiring countless pictures of wild nature and commonplace urban or rustic scenery—the physical environments of ordinary human life.

Environment, as a developed component in drama and fiction, including epic poetry and modern cinema, can be divided into the *physical* and the *social or cultural*, the latter including the historical context of events at a certain time and place, real or imaginary. The physical environment of the *Iliad* is largely on the shore and near the walls of Troy. The cultural epoch is one of warlike feudalism and heroic, aristocratic ideals. Religiously, it is one of Olympian polytheism. The enveloping historical action is the siege of Troy, with memories of the seizure of Helen and the gathering of the Greeks under Agamemnon. Most stories in any medium have some such combination of environmental factors, realistic or fantastic. These cover the whole conceivable range of physical and chronological locations and of real or imaginary worlds, from those of magic and the supernatural, as in the *Arabian Nights* and *Paradise Lost,* to the grim social realism of Zola and Gorky. Often, especially in plays, the physical background is only vaguely indicated in the text, but the stage setting can augment the desired emotional tone, as in the wild, stormy settings for the opening scene of *Macbeth* and for that of Lear's madness. The stage director may present it abstractly or with visual realism. Often the historical and cultural background is only vaguely implied, and must be inferred from the characters, dialogue, and actions. As the story unfolds, one becomes aware of the kind of world in which it is supposed to happen. When it is of an unfamiliar sort, supplementary interpretations are almost indispensable. Unless one has read something about the intensity of feudal loyalty in medieval Europe and Japan, it is hard to understand the motivation of *The Cid* or of *The Forty-seven Ronin.*

In any case, a thorough analysis requires some attention to the various kinds of background in a complex work, to their mutual relations, and to the characters and events which they help to bring into relief. As to the consistency and credibility of characters and motives, it makes a great deal of difference to know that the story is an episode in the Wars of the Roses, or in a battle between good and bad magicians in the *Arabian Nights,* where almost anything can happen. Even when the background is abstract and supposedly universal, as in *Everyman* and *Pilgrim's Progress,* the dialogue soon shows what kind of world is conceived as enveloping the action of the story. One significant variable is the extent to which human characters are shown as making their own decisions and controlling events, or, on the contrary, humbly seeking to obey established authority or suffering when they disobey. In *David Copperfield,* Dickens portrays a naturalistic social setting in which some amount of deserved success is possible. *Uncle Tom's Cabin* portrays one in which a good life is almost impossible for the slave. Some of Kafka's stories, such as *The Trial,* show the protagonist (typifying man) as helpless in the grip of a malevolent "system" which he cannot escape or communicate with.

The rise of evolutionism in the nineteenth century, with its conception of the environment as selecting the fittest and eliminating the unfit in each generation, coincided with increasing emphasis on the social environment as determining characters and events. Taine and Marx were leaders in this trend, which had great influence on literature. Both stressed the role of cultural factors in determining character and success or failure. Freud stressed the influence of early family environment on the young child.

33. Developed components as distinct arts within a combined art.

We have noticed that a certain component often functions in several different arts, and that, within a given art such as painting, two or more components (e.g., drawing and coloration) may be so closely merged that it is hard to distinguish them in a particular case.

On the other hand, they sometimes tend to develop as separate arts, using different materials and techniques, and performed by different, specialized artists. This has occurred in the history of many arts, especially those whose products are in great demand and those where a complex, diversified product is wanted. The result is often a division of labor somewhat like that of modern industry, even when all work is done by hand.

The medieval, illuminated book is one example. Many an ancient book had been written out by hand, illustrated with pictures, and decorated here and there—all by one versatile artist. Calligraphy, drawing,

coloration, and perhaps binding had been planned and executed by a single mind, usually under the influence of some official or patron who was not an artist himself. It was then a solitary art like poetry. During the period of its highest development in the late Gothic and early Renaissance, the making of illuminated books had become a fairly large-scale enterprise with division of labor among several groups of specialists, usually working in close proximity in some monastery or in the urban workshop of a master artisan. Specialized skills were in demand, so that each type of artist might continue working along his own line on one product after another. Apprentices performed the simpler, more menial tasks. One brother was recognized as a good manuscript writer and kept busy on that phase; another was a good draftsman in outlining initials and marginal decorations; another was an expert colorist; still another was good at applying and burnishing gold. Bookbinding was a separate art. A very luxurious binding might be ornamented with gold, precious stones, and bits of stained glass.

When the various techniques and components diverged into separate arts, especially when performed in separate workshops, there was an obvious risk of diminishing the unity of the whole. This could be overcome by the firm hand of a directing artist, but there was often considerable divergence. For example, as the pictorial section of the page became more realistic in the early Renaissance, it gave an illusion of depth and of being "a hole in the page." Some consistency was lost between this and the flatter areas of writing and marginal decoration. That this disturbed some observers is shown by the efforts to bring the marginal decoration also into three-dimensional form. Eventually, many artists preferred to have the pictures and the writing (or printing) on separate pages.

Architecture has long fostered a diversified set of arts, crafts, and utilitarian industries. These continue to multiply. One cannot exactly equate the "components" of a building, in a morphological sense, with constituent skills such as designing, stonemasonry, stained glass making, and woodcarving. Sometimes they correspond and sometimes not. One craft may attend to several components.

The same situation exists in the cinema, the "film industry." It includes a long list of specialized occupations, some of which can be classed as "arts" (e.g., acting, scene designing, costuming, and makeup) while others are utilitarian skills such as electrical wiring. The fact that a certain component of the total product, such as "Technicolor," "editing," "mon-

tage," or "animation," is performed by a specialized group of workers indicates that it is conceived as a somewhat distinct component. It also tends to encourage further independent procedure by those in charge of that component, with a growing consciousness of their distinctive aims and methods, their own standards of excellence, whatever product is being made. This has been true of color photography, sound recording, and incidental music.

Even more distinct are the constituent arts within the older arts of opera and ballet. The singer and the dancer remain in the spotlight but are supported by a growing cast of workers behind the scenes: one group or individual writing the libretto, one writing and orchestrating the musical score, one writing the choreography, and one designing scenery, one costumes, one the lighting effects.

Many other arts, such as poetry and painting, remain more solitary throughout, though not always or necessarily so. When they do, and when a single mind manipulates all the components, it is less likely (other things being equal) to think in terms of components at all. The artist may move from one to the other without being aware of it, regarding his creative work as one undifferentiated process.

34. Framework and accessory components.

Styles in the arts differ greatly as to the prominence accorded to various components. The very fact that action and plot have dominated so many epics, plays, and novels is a challenge to the would-be innovator: can he not write a story with little or no plot or action? If realistic perspective and three-dimensional modeling have been the foundation of painting for centuries, is it not time to eliminate them entirely? Such thoughts as these have motivated a large amount of avant-garde experimentation in recent years. Sometimes the innovation satisfies the public for which it is intended; often the traditional methods return in slightly different form a little later.

Whenever the spirit of the age and the main stylistic trend call for an emphasis on rational, structural unity, there is pressure toward reemphasizing certain components which are especially adapted to this end. They are potentially most capable of organizing a total form and clearly interrelating its parts, although not always so employed. We have called them "architectonic components." Line and solid shape are of this kind in the visual arts, rhythm and melody in music, action and plot in storytelling. With these

alone, one can build a strong and varied framework for the total form. Without them, and relying wholly on such components as coloration in painting, dynamics and orchestration in music, emotional tone and imagery in fiction, the result may seem formless, weak, diffuse, and shifting to those who are used to firmer frameworks. Some will prefer it so, at least in certain arts. Architecture is usually required to seem as well as be firmly built and organized. Where would calligraphy and typography be without clear, legible outlines? How much music has been written without some recurrent, rhythmic beat?

The leading roles in organizing form can pass, to some extent, from the normally architectonic components to others. From its prehistoric beginnings the art of painting has usually relied on line to sketch the main, basic framework of the picture. Afterward, a colorist might fill in accessory details of shading, modeling, and color within the areas thus delineated. This custom persisted in some degree even during occasional trends to "painterly" coloration, as in the seventeenth century, when melting colors and soft shadows blurred the outlines. Some Baroque painters sketched directly with paint-filled brushes. But it was not until the Impressionist movement of the late nineteenth century that definite line was commonly avoided by many innovators, and rich color (organized in terms of light reflected by various materials) was assigned the main task of organization. Even among the Impressionists there were exceptions. A preliminary outline may be completely covered over, and yet have served to organize the whole. Direct painting in color, without preliminary linear sketching, is common in contemporary abstract art.

Characterization has often replaced action as the framework component of a play or novel. Overt action can be reduced to a minimum, as in Goncharov's novel *Oblomov,* and the main development (perhaps a disintegration) can take place within an individual mind. But this is unusual.

Even when emphasized, the framework components are not necessarily most important in the total aesthetic effect. Often they are the least original, for certain conventional ways of using them have descended through centuries. The distinctive and original features may be achieved through accessory components such as coloration, orchestration, and emotive imagery. It is well known that many of the Shakespearean plots, the main outlines of the action,

were derived from other writers. Within such a framework the dramatist could build a new, total form, enriched with various accessory components such as verbal music, emotional tone, and characterization. The plots of Italian operas and of Gilbert and Sullivan's musical comedies are not the most distinctive features in these works. The music and comic poetry are fitted into the framework provided by action and plot.

In analyzing a work of art it is well to recognize, not only which components and traits are most emphasized and developed, but also which ones do most to provide a framework for the whole.

35. *The developed component schema; developed component analysis.*

Early in this chapter, it was mentioned that a necessary phase of morphological analysis is *selective apperception.* It is impossible to perceive or comprehend all the developed component traits in a diversified work of art at once, on first acquaintance. After one or more preliminary experiences of the whole, without systematic analysis, it is useful to look or listen for one component at a time. Afterward, one can listen again to the whole composition at once, trying to grasp the interrelation of all components.

After such study, one can try to summarize in words the distinctive nature of the work examined, as to its use of developed components. This will constitute its *developed component schema.* To be briefly noted under this heading are (a) the relative emphasis on various developed components; (b) the elementary components out of which they are built; (c) the spatiotemporal and other frames of reference in which they are developed; (d) their various roles in helping to build the framework or fitting in as accessories; (e) the principal developed traits under each, including those most highly developed through repetition, variation, and contrast; and (f) the extent of cooperation and reinforcement, or of conflict and apparent inconsistency, among the main components.

Note: The following illustrations are particularly relevant to this chapter: Plates I, II, III, IV; Figures 4, 9, 21, 26, 27, 31, 32, 40, 48.

CHAPTER VII

Modes of Composition

1. Their nature in general.

The four "modes of composition" described in this chapter are additional ways of organizing and developing components and component traits in various arts and frames of reference. They can be used in a simple, rudimentary way or developed with great complexity. They are used extensively in the arts of civilized peoples, and some of their beginnings are found in early prehistoric art. Every work of art involves one or more of them. They serve different kinds of use and enjoyment in human life. As factors in a work of art, they contribute to its total organization and functioning.

Four such modes will be described: *utilitarian, representational, expository,* and *thematic.* It is not implied that these are the only modes of composition in the arts, but as here defined they are inclusive enough to cover the main varieties of form and style in the arts, past and present. They are used to some extent in all the major arts, although to a different extent in different periods.

Under various names, and with various shades of meaning, the modes of composition have long been recognized in art criticism and aesthetics. Some arts (such as furniture making) are called "useful," "practical," and also "decorative." Sculpture and painting are called "representational" arts. The concept of "themes" and "thematic development" is widely used in music theory. The term "exposition" is applied to a kind of literature. As we shall see, the kinds of form to which they refer are much more widely distributed. This fact is now obscured by the practice of calling similar phenomena by different names in different arts.

Since the expression of feeling is so widespread a function of art, and since form in art is almost always expressive in some way, it may seem that "expression" should be recognized as another mode of composition. But the very fact of its universality in art indicates that it is not a distinct mode of composi-

tion. All four of the modes considered in this chapter are, or can be, expressive. Some of their expressive aspects have been considered under the heading of *modes of transmission,* in terms of suggestion and the suggestive factor in art. Presented sensory images of any kind can suggest or express emotion. The varieties of emotion, conation, and related components which are thus expressed in art have been discussed under the headings of *psychological ingredients* and *developed components.* They can enter any mode of composition.

No art can be classed as a whole under any one mode of composition; every major art includes more than one of them. An essay or a story can contain some exposition of an abstract subject, along with thematic and representational arrangements. Painting and sculpture can represent concrete objects and also explain abstract ideas. A desk or wardrobe can be utilitarian and also contain carved representations of animals, flowers, or human figures.

No distinctions can be made among these four modes of composition and of form in art. They overlap and change from age to age. Any kind of art can be used for a utilitarian function at some time, and any kind may be used at other times for aesthetic contemplation only. Thus representational art is often made and used as a device for magic or religious purposes, as in the statue of a god to whom one may appeal for victory in war. Expository art often sets forth general conceptions with the aim of using them for practical purposes. The aim of decorative design may be utilitarian: e.g., to sell a product as in modern packaging. In this chapter, we shall think more about observable differences in form than about the countless variations in specific aim and function. At the same time, we shall call attention to some of the main social functions for which each type of form has been made and used.

Some arts tend to specialize on one or two modes of composition. Thus music has comparatively little representation or exposition, but much thematic de-

velopment. An art may emphasize one mode of com-position for a time, then another. Particular styles in art can be described, in part, in terms of emphasis on a certain mode. Representation was featured in many arts during the Renaissance. It is less emphasized in painting, sculpture, and the useful arts today.

The modes of composition are not mutually exclu-sive. Two, three, or all of them often coexist in the same product. A work of art can be composed in several of these ways at the same time. The same details, the same traits, can be organized in several ways at once within a work of art, just as the same human individuals can be organized simultaneously into political, religious, economic, regional, racial, oc-cupational, and other groupings.

One can analyze and describe any work of art as to the modes of composition it contains. As combined in a single work of art, they constitute a special type of *factor*: the utilitarian, the representational, and so on. These are *compositional factors*, as distinct from components such as pitch and harmony.

Development in the modes of composition can be achieved in various ways. One of these is to add dif-ferent compositional factors, more and more parts and component traits under each, thus following the method of addition. These can be different incidents, emotions, colors, melodies, or the like. Some one compositional factor usually provides the basic frame-work for holding these together. Another way, fol-lowing the method of division, is to analyze more intensively within one or a few compositional factors, one or a few parts and components. Thus, in a story, instead of adding more characters and events, one can describe a single character in great detail, including the mental steps leading up to a single action on his part.

Although a work of art may contain several com-positional factors, they are seldom of equal impor-tance within it. One particular mode may be empha-sized and clearly dominant, highly developed and influential in determining the nature of the whole, while others occur only in rudimentary, incidental ways. Some works of art are mainly utilitarian, some others mainly representational, and so on. Any work of art is likely to contain at least a trace of more than one compositional factor.

2. Utilitarian composition; utility as a compositional factor.

Utilitarian composition consists in arranging details in such a way as to be instrumental (or at least appar-ently or intentionally instrumental) to some ulterior purpose or use, over and above serving as an object of aesthetic contemplation. This aesthetic function is by definition characteristic of all art, but in addition the kind of art called "utilitarian" is adapted to serve, guide, or influence action. The word "action" refers here primarily to overt bodily action, movement, pos-ture, or direct preparation for it. Such art is used in the ordinary business of life, including work, rest, and play, as distinguished from quiet aesthetic observa-tion, dreaming, and reverie. Utility in this broad sense is fitness for some use over and above being looked at, listened to, or thought about. It may be adapted for influencing the mind, character, attitudes, or be-havior of those who observe it, as through education, social reform, or psychotherapy. A house is utilitarian in being made, not only to be looked at, but to be lived in. A knife is to cut with, a cup to drink from, a coat to wear. A map is to guide one in travel and other long-distance activities.

Utilitarian forms and functions are not necessarily humble, menial, or merely practical in a narrow sense. The greatest cathedral is utilitarian in basic form, as a sheltered place for meeting and worship.

It is not implied that a work of useful art is adapted *only* for such utilitarian functioning. If a product is purely and exclusively utilitarian, it falls entirely outside the realm of art in the aesthetic sense. A drainpipe underground, or the inner mechanism of an electric motor, is not itself adapted as an object for aesthetic perception, although it may indirectly serve aesthetic ends. Someone may consider it beautiful. But a palace, a decorated porcelain bowl, and a gown of silk brocade are all suited for both aesthetic and utilitarian ends.

Utilitarian composition is sometimes called "func-tional," in a narrow sense of that term. Thus a chair or building is called "functional" when its emphasis is strongly on fitness for active use as contrasted with "useless" ornamentation for aesthetic reasons only. The utilitarian structure may itself have decorative, thematic qualities. A "functional" style of furniture or architecture tends to rely on these for aesthetic effect, rather than to add "nonfunctional" ornament. In the same way typography can be "functional" if wholly or largely devoted to facilitating reading and understanding rather than to decorative line and lay-out.

From a psychological and social standpoint, art has a function if it serves only as a stimulus to aesthetic perception and enjoyment. What seems to be "use-less" ornamentation may also have a social function as a symbol of the owner's status. As broadly defined, the functional is not antithetical to the decorative or

aesthetic. A work of art may have utilitarian, aesthetic, moral, political, and other functions at the same time.

Insofar as a thing is organized in a utilitarian way, its form can be described in terms of fitness for some active use in addition to the limited activity required in looking, listening, understanding, and appreciating. This implies organization in the causal frame of reference. If one asks about a utilitarian form, "why is it constructed in this way?" or "what is its principle of organization, its rationale?", the answer is in terms of specific means to ends and of cooperation among parts. One answers, "so that it will do this and that" or "as a means to this end." One can so describe, not only the thing as a whole, but each of its utilitarian parts, traits, and internal arrangements. To do so is to give its *utilitarian schema*. Each detail is as it is because being so makes it cooperate with others toward the function of the whole. We can say that of the blade and handle of a knife, of the legs and seat of a chair, and of each moving part in a machine.

Some complex types of useful art are made to exercise many interrelated functions, to serve many ends, at once or at different times. In architecture and automobile design, these are called the *program* of this type of product. Each room in a house may serve a different set of uses, such as dining, cooking, bathing, or sleeping, and be equipped with devices adapted to each. At the same time, they may all have "eye appeal" or qualities intended to seem beautiful. A modern automobile has a complex program; each part is intended to serve the general aims of rapid, economical, safe, comfortable transportation, along with visual attractiveness. But in the house or car, a certain part or trait may serve one set of ends and not the other. We may then say that the utilitarian and decorative schemes do not coincide in these respects, perhaps even that one impedes and conflicts with the other. A sharp, uncomfortable projection on the back of a chair may fit into the decorative design but not into the utilitarian program.

An object is not necessarily composed in a utilitarian way, just because it happens to be used in a utilitarian way. Such a use may be adventitious, extraneous, and not evident in the nature of the form itself. One may use a chipped flint scraper as a paperweight, or recite a nursery rhyme as a magic spell to impress savages. But neither the shape of the one, nor the sounds and meanings of the other, is systematically and directly relevant to such use. One can say, of course, that certain characteristics of the object fit into a utilitarian scheme which was not foreseen by its maker. But it would be farfetched to include in a description of the aesthetic form of an object or process all the possible uses to which it might conceivably be put. In morphology, emphasis should be placed on the main, socially established functions which the form is especially adapted to serve.

What are the kinds of use or function to which utilitarian form in art can be devoted? They are infinite in number, including all the diverse activities of human work and play, food-getting, sex, bodily protection and shelter, warfare, religion, government, transportation, communication, education, research, and technology. Among objects now commonly recognized as works of art (especially from primitive cultures) there is a tremendous variety of intended uses, practically coextensive with the whole business of life. Whenever we take a utilitarian process or device and embellish it in some way so as to have aesthetic appeal in addition to its utility, we produce a work of utilitarian *art*. Or we may begin with an abstract design and develop it into a commercial trade mark. The embellishment can be superficially added or an integral part of the utilitarian form. With emphasis on the embellishment, such art is often called "decorative." Whether it is actually beautiful is another question.

We can recognize a form as utilitarian without knowing exactly what its artist intended. In most cases, especially in ancient or primitive art, we have no definite information on what he had in mind. The function must often be inferred from examination of the form itself, plus a general acquaintance with the cultural environment in which the form originated. Sometimes the data, even from the artist himself, are highly misleading. When utilitarian composition is definite and highly developed, this is usually evident in the form. The analysis of form should not rely too heavily on extraneous information as to how the object was used, but concentrate primarily on what can be directly observed in the form itself. The intended function of an arrowhead is comparatively obvious from the visual and tactile qualities of the form (shape, hardness, sharpness), without any supplementary information save a general understanding of the hunting methods of primitive man. We are justified in assuming that a particular arrowhead was made for this purpose, even though we have no specific knowledge about its maker's intentions. On the other hand, some details observable in the object may indicate another use. Some ancient Chinese jade knives and axe heads are so thin and fragile as to make them obviously unsuitable for the usual work of knives and axes. We are justified in inferring that they were made for some other use, possibly ceremonial.

Functional adaptation is not necessarily planned or

consciously intended. In the plant and animal world, adaptation or fitness was observed by philosophers for centuries before Darwin. The eye is intricately fitted for seeing, the hand for grasping, the wing for flying, the coloration of some animals for protective concealment. The dancing and plumage of certain birds has a function in sexual selection. Theologians pointed to such intricate fitness in nature as an evidence of "design," or purpose. By analogy with human artifacts, they attributed it to the conscious planning of a divine creator. Darwin and later biologists undertook to explain it otherwise, by nonpurposeful evolutionary processes. But as far as the directly observable nature of the forms is concerned, what an archeologist sees in an arrowhead is much like what a paleontologist sees in a fossil leg bone: an object whose nature is to be understood in terms of its fitness to cooperate in a larger mechanism, adapted to a fairly definite set of functions which we now regard as useful.

To be described as utilitarian, a device does not have to achieve its ends or perform its functions successfully. A typewriter which has a broken part and will not write is still a typewriter. The airplane designed by Leonardo da Vinci, which probably did not and could not fly, was nevertheless a "flying machine" in terms of the functional arrangement of its parts.

Often the human artist has not been clearly aware of the real biological utility of his product, of how it actually contributed to survival. Uppermost in his mind may have been some direct use which we now consider superstitious and ineffective. He may have thought to please the gods or avert evil magic, as in countless taboos. Some of these, such as dietary laws, are now seen to have had hygienic value. Some supposedly magical potions were actually medicinal. Magic and religious rites have at times enhanced the prestige of rulers and strengthened group solidarity. Now, from the standpoint of aesthetic morphology, we are interested not only in the real utility, but also, and at least as much, in the *apparent*, superstitious one. It is to be classed as a use and a function in describing the product, even if quite ineffective. Dancing with magic rattles to make the rain fall, averting the evil eye and warding off disease by amulets, making crops grow by placing statuettes of the earth goddess in the field—these are all utilitarian functions. The means are often quite ineffective for these ends, but are to be understood in terms of *intended fitness* for them. The intended, ineffective use may have had a more direct and obvious influence on the nature of the form than did the real, indirect utility, if any.

The utilitarian form of any artistic object or process can thus be described in terms of either actual or supposed fitness for certain uses, and for entering into a complex of human activities concerned therewith. That of a ceremonial axe or dance is to be described in terms of its immediate uses, and also of the part it played in a larger complex of ritual, regardless of how ineffective the whole complex may now seem as a means to its intended results. Although we are not primarily concerned with the artist's intention, it is impossible at times to understand utilitarian forms unless we know something about the ways in which artists usually regarded them, what specific ends they sought, and what kinds of art they considered effective in achieving them.

Several types of visual art have been mentioned as having utilitarian aspects: furniture, weapons, utensils, garments, amulets, dances, and rituals. Some are static, such as a building. In some (e.g., an axe), the object is moved as a whole. In some, various parts are moved with respect to each other. Armor does this to some extent, and vehicles to a greater extent.

Auditory forms, such as music and spoken literature, can also be utilitarian in structure and emphasis, although this fact is less commonly recognized. A bugle call or drumbeat, in army drill and war, is a brief musical composition devised and used for a specific end in the world of action. One form of call is to make soldiers get up in the morning; another, to send them to bed at night; one to make them advance, and another to make them retreat. Music which is written for marching or for dancing has a purpose in the world of action and is adapted to it in certain ways, such as rhythm. A war song, a love song, a work song, a lullaby: each of these has an aim in action, and is somehow adapted to it. To tell how it is adapted is to describe its utilitarian structure.

Words, whether spoken or written, are commonly put together for some utilitarian purpose, to get something done. Much writing is utilitarian in this sense, but most of it is not classed as art. An advertisement or a business letter, used to secure sales and purchases; a lawyer's brief, used to persuade a judge or jury; a civil law, act, or edict; a railway timetable; a guidebook for travel; a manual of instructions for operating a machine—all these are verbal forms, composed so as to guide or influence action. So is a prayer, a hymn, or a letter of appeal to some divine or human agency, insofar as it asks for something to be given, or for success in some enterprise. So is a

speech or sermon urging people to act in a certain way. Religious objects and practices are utilitarian when definitely adapted to such ends as acquiring health, salvation, prosperity, or success in war and agriculture. A mathematical treatise is utilitarian when adapted for use in engineering. Whether or not these types of verbal composition are classed as art, they can be analyzed in utilitarian terms as means to expected functions. To be classed as utilitarian *art*, as we have seen, they must also have some adaptation to aesthetic functions.

A landscape in Italy may be painted for aesthetic reasons, with no utilitarian purpose or adaptation whatever. But if it is incorporated in an advertising poster, with the words "Visit Italy" printed below, the whole poster takes on utilitarian form and the picture itself is given a utilitarian function. Political cartoons and other forms of propaganda usually reinforce the pictorial effect with words. But even without words, the active end may be evident. A poster on hygiene can show two pictures: one of a ruddy, plump, and smiling child, drinking milk and eating cereal, the other of a pale, thin, sad one, without the milk and cereal. A war enlistment poster can show a man in uniform, smiled upon by a beautiful girl, who turns her back on a man in civilian clothes. A revolutionary mural can show in one panel a worker scourged by capitalists; in the next, the same worker triumphant, having overthrown the oppressor.

3. Representational composition.

This consists in the arrangement of details in such a way as to suggest to the imagination and understanding a concrete object, person, scene, situation, or group of them in space. Some representation goes farther, suggesting a sequence of events in time in which these persons, objects, or combinations of them seem to move, act, change, and affect each other. Representation tends to arouse and guide a fantasy in the mind of a suitably educated and compliant observer who is willing and able to follow it. As a set of stimuli it may involve, not only the several images themselves, but their interrelation in space, time, and causality. It may thus include a suggested interpretation and explanation as well as an arrangement of sensory images.

Representation does not include all the fantasies which a work of art may suggest to an observer. It does not include those which he constructs by free

association based on his own personal, distinctive experience. These, as we have seen, are not to be classed as objective parts of the work of art. Only those are to be so classed for which some fairly definite cue or direction is given by the presented factors in the work of art, together with their established meanings. The observer is, of course, free to depart in reveries or other trains of independent thought at any moment, and no disparagement of such departure is implied. No sharp line can be drawn between these and the apperception of representational form in the object; but a rough distinction must be made in theory between what is, and what is not, actually represented.

Representation differs from exposition in emphasizing concrete objects, particular persons, scenes, situations, and events, rather than highly generalized, abstract concepts and relations. But this distinction, too, is only partial. Representation can make use of some abstract ideas in explaining the nature and interrelation of the things to be imagined. Visual representation then becomes visual conception. One can represent a type or class, such as "lion," by portraying an example of it with emphasis on traits regarded as typical or characteristic of members of the type, e.g., as a "lion rampant" in heraldry. Some kinds of representational art go a long way toward the abstract and general, in idealized statues of the gods, for instance, or in allegorical plays and stories, such as *Pilgrim's Progress*. Here the individual characters are important mainly as examples of types. To represent a character psychologically may require some exposition of his general attitudes and behavior patterns.

In recent painting and sculpture there are many intermediate stages between sharply individualized, concrete representation and purely abstract, nonobjective or nonrepresentational form. Morphological analysis can try to indicate roughly how much representation there is in a particular case, as compared with other compositional factors. The term *semiabstract* or *highly stylized* can be applied to works in which some resemblance to outside objects is barely recognizable in a vague, incomplete, or much altered way. At the other extreme is highly realistic or naturalistic representation, as in a portrait which is an exact, photographic likeness of someone's face.

A distinction is sometimes made between "abstract" and "nonobjective" painting in that the former may be based on a real or imagined concrete scene or object, from which so many details have been omitted that it has no definite, mimetic suggestion. The "nonobjective" painting does not start or finish with any such image or concept from the out-

side world. The artist simply lays on certain lines, colors, textures, etc., and develops them into nonrepresentational forms somewhat after the manner of music. Neither purely abstract nor nonobjective art suggests anything definite by mimetic representation. It often has a vague resemblance to some outside phenomena such as clouds, vines, or crystals.

As to mode of transmission, there are two main types of representation: mimetic and symbolic. In *mimetic* representation, the presented set of images (arrangements of lines, colors, sounds, etc., which are directly presented to the eye or ear) resembles the set of images which it calls up in imagination. In the *linguistic-symbolic* type, especially literature, whether spoken and heard or written and read silently, the presented images are words or other conventional signs or symbols. They usually do not resemble the images which they suggest, except in primitive pictographs. Representation is not the same as mimesis or imitation, since it can be conveyed through nonmimetic, symbolic expression. Mimesis can be limited to a single pair of similar images, whereas representation involves composing many details. Although literary representation thus differs from pictorial and sculptural representation, each can, in its own way, build up a concrete fantasy somewhat like that suggested by the others.

When representation is mimetic, the response to it tends to be, to some extent, a voluntary illusion. It is rarely a complete one, except perhaps in "wax works" which are made as exact imitations of individuals in real clothing. In viewing most art, even the most illusionistic *trompe l'oeil* painting, the percipient is well aware that what he imagines is not real, that the picture of a man is not a real man. The differences are obvious, and it may require some effort and experience to discern the resemblance to something real. One tends to project upon the presented object one's imaginary conception of that which is represented, to blend or identify the two, as if the portrait were really a smiling human face, or the actor actually Agamemnon. One tries to see the white marble statue somewhat as a living human figure, the painted landscape as a real one, visible as if through a window. At the same time, one remembers that it is a work of art and perceives it in part as such, without expecting a perfect imitation. Some very naive persons actually confuse the two, and wish to shoot the actor who portrays a villain. At the other extreme are persons who can not or will not enter into the game of make-believe; they will not yield at all to the illusion or empathize into the work of art. They keep sharply aware of the difference between

subject and object and refuse to practice that necessary act in experiencing representational art, which Coleridge called "a willing suspension of disbelief."

Music can represent, by a sequence of mimetic sounds, the sounds of a storm, a battle, or a chariot race. By common cultural association, these tend to suggest also the visual appearance of such an event. Musical mimesis is usually not very realistic, being produced by musical instruments, and there is less tendency to illusion than in realistic painting. When orchestral music is very realistic, one can imagine it as music, and also as the sound of a spinning wheel, a chariot race, or whatever else it represents. A phonograph record of orchestral music is really a representation of that music, and (if it is programmatic) of something else besides.

When representation is linguistic-symbolic, as in a printed story, the fantasy is detached from the presented letters. One's attention is divided between these symbolic stimuli and the fantasy built up in one's own mind of the things and events described. One's mind is partly "carried away" from the presented symbols to the inner world of imagination which they foster and direct.

Literary representation includes *description, narration,* and *drama.* The last two, and sometimes the first, represent a sequence of events in time. Description may suggest the changes of thought and character in a person, as well as his appearance, voice, and movements.

The representation of certain objects, scenes, or events in a work of art is called the *representational content* or *represented subject matter* of the work. (The terms "content" and "subject matter" are also applied to all the ingredients of a work, presented and suggested, as distinguished from the way these are organized into form. They are also applied to the expository content, if any.)

Representation in art is seldom, if ever, an exact reproduction of anything outside the work. Some selection and changing emphasis, some alteration and elimination, are almost inevitable in the mere fact of using an artistic medium.

One's apperception of representational form is strongly affected by one's cultural background and experience of art, especially if it is mainly of that same art and style. One learns to perceive in accordance with certain conventions. This includes supplying from imagination some of the details which are lacking in the work of art and mentally organizing the presented or suggested details into some familiar configuration. Expecting to find a certain familiar grouping or sequence, one perceives it as actually having

that form. How much of this activity on the observer's part should be called imagination and how much included in perception itself, is open to debate. Certainly it is related to the different ways in which people describe the same work of art, some feeling it as highly distorted or stylized and some as realistic. In perceiving for the first time a picture from a distant culture in an unfamiliar style (e.g., a Chinese landscape), one may find difficulty in recognizing what it represents. After more experience of that style one tends to find it, if not realistic, at least a normal, understandable way of representing things, somewhat like a new system of shorthand. Young children learn to follow the continuity of plot in a motion picture film without difficulty, in spite of many breaks from one point of view or set of characters to another.

These are the most common types of representation, classified on two bases: (a) the mode of transmission and sense addressed; and (b) the amount of determinate mobility, with temporal development.

A. Visual mimetic representation.

1. *Static.* Here the presented parts of the form are, on the whole, motionless or devoid of determinate motion.

a. *Static pictorial representation* includes that which is produced by drawing, painting, engraving, and other media. (It does not include the whole arts called by these names, for they involve other modes of composition.) Most of them involve a two-dimensional surface, usually flat, rectangular, and bounded by a frame. On that surface, lines and color areas are spread in such a way as to resemble in some degree an object or scene in space. Pictorial representation is subdivided into figure painting, portrait, landscape, still life, etc., according to the kind of object portrayed—the "subject" of the picture. By colored lantern slides they can be presented (usually with heightened luminosity) on a screen. Pictures are made in sand, by tattooing, and in other media by various cultures. Natural forms, such as insect markings and discolored rock surfaces, sometimes involve pictorial mimesis, usually rather indefinite. *Single* static (still) pictures are distinguished from *still picture sequences* which tell a story when viewed in the determined order. These are found in the modern newspaper "comic strip" and in some early Renaissance paintings, as of lives of the saints, often in a predella attached to larger panels. The Bayeux Tapestry is a still picture sequence. A still picture representing one scene or situation in a story or in history is an *illustration.*

b. *Static sculptural representation* includes representation in which perceptibly solid objects are presented to the eyes, as well as that in which a presented surface is actually modeled in low or high relief. By such means, sculpture can imitate the appearance of other three-dimensional things, such as human figures, groups, and (in relief) landscapes and architectural vistas. Many dolls and other toys can be classed as static sculptural representation. Some of their parts can be moved by the user in most instances. Natural forms, such as clouds, fungi, flowers, tree trunks, and crystals, can be somewhat representational in a similar way. Analogous to the still picture sequence is the *sequence of panels in relief*, portraying successive situations in a story.

c. *Other varieties.* One kind of dramatic representation is static: the *tableau vivant*, in which actors are arranged in groups, costumed and sometimes masked so as to represent a dramatic situation. *Dioramas* represent the actors by small figures with a background. Theater *scenery and staging* involve some pictorial representation, as in backgrounds. They use "properties" such as furniture to represent imaginary scenes, as in a king's palace or a forest. Chinese and Japanese *flower and garden* art involves some representation, usually as a minor element. A small mound may represent Fujiyama. A small garden, or even a miniature garden on a tray, may represent a large garden or a natural landscape. A twig in the group represents a tree, a pebble a cliff, and so on. Flowers and leaves in a container may be arranged to represent a scene by a brook, or the ascending levels of a mountain. Representation is involved in such cases only when a considerable number of details are arranged systematically to suggest a fairly complex image or combination of images other than the one presented.

2. *Mobile.* Here the presented parts of the form have determinate motion and temporal development. The objects represented may be static, as in a motion picture of a cathedral.

a. *Mobile pictorial representation.* This class includes the *cinema* as its principal medium. Films may be made directly from real scenes and actors in motion, or from series of drawings, paintings, and even solid figures such as puppets in different positions, to give the illusion of movement and action on the screen. In any case, a succession of pictures is shown, which usually represents a connected series of events, a story. We have seen that the Chinese *landscape scroll* and the Japanese narrative scroll are in some respects mobile pictorial arts. They are moved by rolling and unrolling, and present an orderly series of views to the eye, as of a boat trip down a river or a

sequence of events in a story. The *shadow play* is another ancient art, analogous to the cinema. It uses small, opaque or translucent colored silhouettes, which sometimes have movable parts. A translucent screen is placed between them and the audience, and a light behind them. Their shadows appear upon the screen and act out a story, with or without verbal or musical accompaniment. Television represents action photographically on many distant screens at the same time. Some fireworks, especially "set pieces," are representational.

b. *Mobile sculptural representation.* Marionettes and puppets (other than shadow figures) are perceived as solid figures, carved or molded and costumed, which move before the spectator's eyes across a stage, usually a small one. As a rule, they have movable parts. The terms "marionette" and "puppet" are sometimes interchangeable, but the former is now applied mainly to the type which is moved by strings or wires from above, and the latter to the type moved by hand, usually from below. In Western countries, most marionettes and puppets have been small and used in recent times mainly for children's entertainment. Dolls and other toys are sometimes mechanically moved. In Japan much larger puppets are used, with several men to operate each one. The former use of this medium for serious adult drama, for tragedy, political satire, and poetic fantasy, is occasionally revived. In much mobile sculpture there is little or no representation, although some suggests leaves and plants moving in the wind.

c. *Visual dramatic representation*, especially by live actors on a stage. The word "visual" distinguishes this type from the auditory element in spoken drama and from written dramatic literature. The actors represent imagined characters in stories supposedly happening in other times and places. The visual element in dramatic acting includes *pantomime*, which may rise to the status of an art in itself, capable of telling a whole story without sounds, by significant gestures, postures, and facial expressions. The early, silent motion pictures were photographic reproductions of pantomime with the aid of scenic backgrounds and short verbal, printed texts or "subtitles." These helped explain the action and contributed bits of dialogue. Some amount of pantomime remains in the spoken drama and the sound film, to reinforce the verbal text. Cinema is twice removed from the imaginary story, being a photographic representation of the actors who represent it.

Closely akin to dramatic action is the dramatic or *mimetic dance.* Not all dancing is representational. It may be a decorative spectacle of moving shapes and colors, with strong kinetic and kinesthetic suggestions. In the mimetic dance, the actor represents some character or type of character, or perhaps an animal or plant, or a natural phenomenon like the rain or lightning. He portrays this person or thing and its attributes. If it is an abstract type, he may portray an example of it. Sometimes he acts or dances out a story, perhaps the story of a successful deer hunt. Groups of dancers together may enact a more complex story, as in the Russian ballet. Costumes and scenery contribute to the visual forms.

d. *String figures* are highly developed in some primitive cultures, with limited mobility. (*Cf.* Western "cat's cradle.") *Folded paper* and many other media are also occasionally used.

B. Auditory mimetic representation.

1. *Musical mimetic representation.* This type of music is often called "descriptive." The sounds presented suggest through resemblance another kind of sound, such as a brook or a thunderstorm. By building up a succession of such resemblances, music can imitate the sound of a waterfall, or even narrate the events of a battle. Such representation is usually vague and often unintelligible without the aid of a verbal text, title, or program; hence it is commonly described as "program music." But not all program music is representation. Some tries to convey a moral, religious, or other abstract conception. There is some mimesis in a great deal of instrumental music: an occasional suggestion of ocean waves, a bird song, a clock ticking, wind in the trees. Representation implies, not such isolated traces, but more comprehensive arrangements in which the imitative effect is systematic. To be called representation, however, it does not need to be exact and literal. The resemblance can be abstract and subtle, aiming to convey the essential quality of the phenomenon represented, or perhaps to be atmospheric, as in Debussy's *Afternoon of a Faun*, rather than obviously imitative. Musical representation has found especial favor among romanticists. There are many examples to be found in modern music as well as in primitive and exotic.

2. *Nonmusical sound effects (mimetic).* These have risen to considerable importance in the sound film, radio, and television, especially as backgrounds for narration and drama. Their usual aim is to strengthen realism and sometimes to heighten emotional tension. Common types are the sounds of traffic noise, wind, rain, thunder, shooting, crowds talking or screaming, wild animals in swamp or forest,

machines and electronic devices. In experimenting with such sounds, the inventors produce new timbres which are sometimes accepted as musical.

3. *Verbal mimetic representation.* The term *onomatopoeia* is applied in rhetoric to the use of words whose sound resembles the thing referred to. Such use is almost entirely confined to incidental details, and very seldom becomes a mode of composition. It is noted here as a theoretical possibility, but a limited one.

C. *Literary (linguistic-symbolic) representation.* Here the presented stimuli are words, either visual or auditory. Early writing was mostly in pictograms, which bore some resemblance to the thing, person, act, or event represented. Literature so transmitted could be partly classed as a kind of picture sequence. In modern writing mimesis is rare, fortuitous, and usually outweighed by conventional usage. The desired suggestion does not depend on resemblance. Conventional meanings of the symbols are relied upon (including punctuation marks), and these are composed by proper arrangement of the symbols. The words usually do not move, but the speaker's voice presents them in determinate order in reciting aloud; the silent reader moves the pages and looks from line to line in determinate sequence. Literary types of representation, defined with reference to *word-sound* schema, include narrative verse (epics, ballads, descriptive and narrative lyrics), dramatic verse, narrative prose (fiction, history, biography, novels, short stories, tales, anecdotes), and dramatic prose.

1. *Description.* This term is applied chiefly to literary representation of a comparatively static object, scene, or person, or to a momentary aspect in some changing one. However, it is sometimes applied to that of temporal processes also, as in speaking of some author's "description of the Battle of Hastings." It is most commonly visual, as in describing the appearance and visible movements of something or someone. But it may also include other sense qualities: how the waterfall sounded, or the person spoke, the feeling of the air, the taste of the wine, or the scent of the garden. These can all be blended in one compound image of how the subject would present itself to direct experience. It is not limited to sensory qualities. One can describe a person's character, his inner emotions, desires, and habits. One can generalize about him, fit him into abstract types and tendencies.

2. *Narration.* Here the subject represented is more definitely temporal and mobile: a connected process or sequence of events. Someone (the author, an unknown person, or an imaginary character) tells in words what happened or is happening. Prophecy narrates what will happen. Narration differs from dramatic enactment on stage or screen where the story itself seems to unfold in the presence of the audience. But short passages of narration often occur in the midst of dramatic action and dialogue, just as bits of dialogue may occur in the midst of a long narration.

3. *Dramatic text.* This is usually in written form, consisting largely of dialogue printed as if to be spoken, plus directions for action, costuming, setting, lighting, etc. When read silently, it is a kind of literature, different on the whole from description and narration. Any of these three types may provide the dominant structure of the piece, while the others may enter as subordinate modes of organization. The silent reader imagines the dialogue as spoken and the action as performed, perhaps as it would be in real life, perhaps as it would appear on the stage, perhaps a little of both. Some dramatic texts are intended and adapted for stage performance; some could not be fully acted on stage as written (e.g., *Prometheus Unbound* and *Faust, Part II*). Some could be adapted for the film.

D. *Combined types.*

1. *Dramatic enactment,* including reproductions of it in film, television, etc. This may include all the static and mobile types listed above, whether visual or auditory, mimetic or linguistic-symbolic. Presentation is usually bisensory (audiovisual). It ordinarily includes some action and pantomime, dialogue, costuming, scenery, and other component arts. Stage plays usually have little or no music, but sound films usually have a considerable amount of incidental music and other sound effects, especially when no one is speaking or in a tensely emotional scene.

2. *Opera* is a kind of dramatic enactment, including all the above, but with music a main and almost constant feature. Some operatic music is representational, some not. Wagner increased the emphasis on representation and expression. Interludes of ballet are often provided.

3. *Marionettes, dance,* and some other types mentioned above are often presented in combination with others: e.g., marionettes with spoken dialogue from behind the scenes; ballet with representational pantomime, costumes, and scenery (representing characters, events, and settings in an imaginary story).

4. The *illustrated and illuminated book,* a major art in the Middle Ages, combined verbal (linguistic-symbolic) representation with static pictorial representation. Some but not all of the texts were narra-

tives. Even when they were nonrepresentational, the pictures could represent the characters of the Bible stories. In the late Gothic and early Renaissance much free, representational decoration developed in the margins, often with little relation to the text. Most modern, illustrated books and magazines are mechanically reproduced.

4. Expository composition.

Art is expository insofar as it arranges details so as to set forth, explain, or suggest general relationships, as of causal or logical connection, abstract meanings, pervasive conditions or qualities, common or underlying principles. It is not concerned wholly with abstractions, but when it deals with concrete particulars it does so mainly to show how they illustrate general conceptions, problems, beliefs, laws, tendencies, values, or ideals. Expository art expounds, explains, interprets, or raises questions. Sometimes it points to a mystery which seems to be inexplicable, to a problem for which no answer has been found.

The greatest development of rationalistic exposition occurs outside art, in philosophic and scientific theory. But exposition occurs also in art: chiefly in literature, but to some extent in other arts as well. Its most familiar variety in literature is the *essay*, in which an abstract topic such as love or honor, or a particular person or thing, such as Napoleon or the Parthenon, is analyzed, discussed, explained, and theorized about in a somewhat abstract and general way. An essay is a partial approach to a philosophic, scientific or other theoretical mode of thinking. It retains enough of the characteristics of art to permit its being classed as literature or "belles lettres." It is somewhat informal as to logical order; it often lays stress on verbal style, and it tends to use picturesque, poetic images and allusions. It may involve some representation through description and narration of significant examples, but it does not emphasize the stimulation of fantasies for their own sake. Even in the familiar, personal type of essay, where the author tells how he feels or thinks about something, there is a tendency to generalize: "I like," or "I hate" this or that sort of thing. Other types introduce more objective evidence and systematic argument.

Most essays are fairly short; a book-length exposition is usually called a *treatise.* But some long, philosophic writings have been called essays, such as John Locke's *Essay Concerning Human Understanding.* Some essays are in verse, such as Pope's *Essay on Man* and *Essay on Criticism.* In a highly rationalistic pe-

riod, such as that of Pope, the conception of poetry admits a strong flavor of rational, theoretical discussion. But today, as a rule, the stronger that flavor is, the greater the tendency to express the ideas in prose. Many *lyrical* poems are mainly expository. They try to express, often in obscure metaphors, the poet's conception of the world, of life, beauty, love, or death, of God or nature, of his own soul and its mysterious inner life, and his emotional attitude toward such things.

Much *visual* art, such as the Hindu sculptures of the Dancing Siva (Siva Nataraja), undertakes to convey theological, metaphysical, or moral conceptions through symbolic images. Sometimes the meaning of these is cryptic, sometimes clear to those sufficiently educated in the culture concerned. A great deal of medieval and Renaissance painting expresses Christian belief through symbolism. The symbols may be conveyed in a visual, verbal, or musical medium. An allegory such as *Everyman, Pilgrim's Progress,* or the *Divine Comedy* uses a symbolic narrative or dramatic representation to convey religious and moral teachings.

A single symbolic image such as a cross or wheel is not enough to constitute expository *composition.* There must be some systematic development, involving a combination of related symbols and meanings, so as to build up a fairly complex set of general ideas.

Before written language evolved conventional letters, it used pictures, called *pictographs* or *hieroglyphics.* A pictograph such as that of a hawk, when considered by itself, is an example of mimetic suggestion. It can be developed into a pictorial representation, as by filling in realistic details or combining the hawk with other objects so as to depict a scene in space. One can show the hawk as standing on a tree branch, with clouds behind and the ground beneath. One can also arrange the hawk with other hieroglyphics to make a verbal text. This can tell a story or expound a moral principle. The picture of a hawk can be placed beside one of a large feather, a small lion, a hand, a noose, and some geometric figures, in such a way that they do not combine into any concrete scene in space. Each detail is understood as having a conventional symbolic meaning different from the one which it suggests by resemblance, referring to perhaps an abstract idea to which it has no resemblance whatever. The whole group of linguistic symbols, consituting a passage in pictographic writing, may be composed in any of the ways possible in literature. They may produce representation of a literary type, describe a scene, or narrate the myth of Osiris in hieroglyphics.

A set of symbols may be put together in a nonrep-

resentational way to produce an expository discourse on virtue or an astrological formula. Again, the representational meaning of the individual details will be superseded by the new linguistic meaning which each has taken on, and by the new combined meaning of the whole arrangement. Concrete images and abstract concepts will be knit into a complex of generalized relationships. For example, it may be pointed out that obedience and piety bring happiness in this life and the life to come, or that future events can be foretold from a certain configuration of the stars. Thus the individual details in a work of art can be representative and mimetic, while their combined mode of composition can be expository. (As in the Egyptian *Admonitions of the Harper*).

Another example is that of *heraldic coats of arms*. Here again, there are pictorial, mimetic details: perhaps an eagle, a shield, and a helmet. In the coat of arms of a certain British king, there is a shield divided into quarters, in which appear lions, a harp, and fleurs-de-lys. On either side are a large lion and a unicorn. Above are a certain kind of helmet and crown, and a crest with a small lion. Around the shield is a garter with a motto, and another motto appears on a scroll below, with roses and shamrocks nearby. These details are pictorial, except for the verbal mottos. They could be combined into a single representational picture. All the animals, the shield, helmet, and crown, could be shown in a consistent scale of sizes, and arranged in perspective as a group of objects on the ground, as a concretion in space. But instead, scale and spatial arrangement are arbitrarily determined, on a very different principle. This principle is symbolic and *expository*. A motto may express the ideals and attitudes of the family. The composite meaning is to set forth the rank, descent, and rights of the person to whom this coat of arms belongs.

One who understands the language of heraldry can interpret such a form as defining the status of that individual in the social hierarchy and in the history of its family connections, as explaining his origins in the past and his present rank. This set of meanings is not a concretion in any one area of space and time, but a network of more generalized relations. It is not a picture of the British king as an individual human, but a demonstration of how certain abstract powers, ranks, and honors come to a focus in him as a noble personage. The same set of meanings could be conveyed in words, in a piece of literary exposition. Here it is conveyed through *pictographic exposition*. As such, it is intelligible to those who cannot read words, and is accordingly effective in a feudal period when few people are literate. Moreover, it conveys a complex

set of ideas vividly and succinctly, with the added effects of decorative form.

Pictographic exposition is common in the iconography of religious symbolism. Of this type is the "Tree of Jesse," often shown in medieval windows and illuminations: a genealogical tree setting forth the descent of Christ from "the root of Jesse." Any genealogical tree is a piece of expository composition, perhaps in addition to other compositional factors. So is any scientific diagram, one, for example, showing the descent of the modern horse from Eohippus, or the evolution of the sword or the helmet from earlier forms. So is any chemical, physical, or mathematical formula. Where the line shall be drawn between art and science is not the essential problem at present, but rather the type of thinking which finds similar expression in all these varied forms, some using mimetic and others nonmimetic symbols.

Music sometimes tries to express abstract ideas, especially moral, religious, and philosophical. Some of Beethoven's late compositions have been interpreted in this way. Without the aid of words, such as those in the Ninth Symphony, attempts at exposition in instrumental music are likely to be vague and open to widely different interpretations. A descriptive title, a verbal text or program, can help to convey the intended abstract meaning.

The structure of expository composition in the arts varies considerably, in relation not only to the medium employed, but also to the kind of thinking it expresses. It can approximate philosophy and science in attempting a high degree of rationality and logic; indeed, the early stages in philosophical thinking are often combined with expository art. Verbal exposition then tends to follow a series of explicit steps in demonstration or investigation. In the less rationalistic, more mystical types of expository art, the parts combined may consist mainly of symbolic images which, when put together, tend to suggest a general conception or to hint vaguely at some hidden meaning. This kind of expository art can be *cryptic* or *semicryptic* in that important parts of the explanation are not expressed.

5. *Thematic composition; decoration and design.*

Thematic composition consists in repeating a certain trait or set of traits, exactly or with variations, and sometimes also in contrasting it with one or more different traits and integrating the set of units thus produced. This last is done by connecting them with each other or subordinating them to some comprehensive

pattern, conception, framework, or pervasive trait. *Repetition, variation, contrast, and integration* are thus the main constituent phases in thematic composition. Repetition and integration tend to produce unity; variation and contrast tend to produce diversity. Both together tend to produce complexity.

Thematic composition does not necessarily serve any ulterior purpose or active use, as in utilitarian form, or represent anything either by mimesis or linguistic symbolism. It may or may not do so. It does not need to explain any abstract ideas or suggest any problems. It can be adapted mainly or wholly to serve as an object, stimulus, and guide for satisfactory aesthetic perception. In this it may or may not be successful. Such a product, in the visual arts, is often described as "pure form," "pure decoration," or "pure design." In these arts, the term *decorative* is closely related to what we are calling "thematic." But it is seldom applied to music or literature in this sense. The concept of thematic composition, as here defined, is applicable to any art and is therefore preferable in comparative aesthetics. All the arts employ themes and thematic relations.

Simple, indefinite thematic relations occur everywhere in nature, wherever a resemblance between parts is observable. More or less complex, definite designs also appear in nature, as in flowers, snow crystals, the shapes and markings of some animals, and the songs of birds. Both simple and complex thematic arrangements occur in human products other than art, as in buildings, tools, and machines devised for purely utilitarian purposes. They may be incidentally produced without any artistic intention, and yet be apperceived aesthetically. Artists often start with some such nonartistic design and alter it to their own taste or to the requirements of a particular task at hand.

Thematic composition is the most universal and far-reaching of all the modes. It can coexist with any or all of them, using the products of utilitarian, representational, or expository art as its themes and patterns, or it can proceed and develop alone, apart from any of them, as pure design. No work of art can develop far without including some thematic relations among its parts.

Even when abstract and separate from other modes, as in much instrumental music, thematic form is not entirely separate from the rest of life. All the recurrent forms of nature and culture, inanimate and animate, the cyclical motions of sun, moon, and tides, the growing, striving, clashing, cooperating and dying of plants, animals, and humans on this planet or elsewhere, are variously symbolized in terms of themes and theme repetitions, variations, and contrasts.

Throughout life we find ourselves borne along on vast underlying physiological processes of breathing, pulse, and digestion. We are swept through alternating cycles of appetite and satiety, desire and indifference or aversion, activity and rest, tension and relaxation, excitement and repose. One moment we feel alone in the universe; the next, pushed on with the crowd. Sometimes we grow in power and scope to high plateaus and climaxes of relative success; at other times we fail or weaken, slowly or suddenly. All these recurrent types of process have their analogues in thematic series of visual, auditory, tactile, and kinesthetic images. When these are presented or suggested in combination with products of the other modes of composition, they can help organize, reinforce, and intensify those products. In isolation, as designs of abstract sounds, shapes, or colors, we can sometimes feel their relevance to archetypal powers and situations, vaguely because of their ambiguity, but emotionally moving nevertheless. We can fill these in with concrete details if we wish—perhaps with tales of individual heroes and their exploits—or be content with grasping and feeling them as abstract, expressive forms in their own right.

The word "theme" is differently defined in different arts, usually in such a way as to be applicable only in a certain art or type of art. For an adequate definition in aesthetics, terms restricting the concept to one art should be avoided, and the emphasis placed instead on more basic, widespread characteristics.

In this book, a *theme* is understood to be *a presented or suggested trait or combination of traits which is repeated or capable of being repeated, exactly or with variation, as an organizing factor in a work of art.* It may or may not be contrasted with others. It may be simple or complex and may involve few or many components. A trait or combination of traits in any component may function as a theme.

The term "theme with variations," as used in music, refers to a certain recurrent framework type. It involves a simple melody, usually harmonized and sometimes orchestrated (as in Richard Strauss's *Don Quixote*). It is then repeated any number of times with variations. These are usually organized as more or less distinct units. They all preserve some resemblance to the distinctive character of the original theme, although contrasting traits may be introduced

in a subordinate way. The "short melody" which constitutes the theme can be fairly complex in itself, as embracing several measures, figures, and perhaps whole phrases. Some or all of the variations tend to be more complex as well as different in other respects. The first or *theme-establishing* unit, together with the variation units, may constitute a whole musical composition or a fairly long part or "movement" in one.

The first unit, as well as the others, is compound in that it contains several developed components such as melody, harmony, meter, other rhythmic development, and perhaps orchestration. The "theme with variations" as a whole is a complex, compound, auditory thematic sequence.

The terms "series," "serial," and "sequence" are all used in various senses in music theory. The first two are sometimes restricted to music in the twelve-tone scale, in the tradition of Arnold Schoenberg. Such music is called "serial." "Sequence" is commonly used to mean the repetition of a melodic or harmonic figure or phrase at different positions in the scale. For reference to all the arts, it is necessary to define these terms more broadly. A series usually includes three or more units. A set of numbered playing cards thrown down at random is a series because of its numbering. Several dissimilar small objects in a row from left to right are a series because of their portions.

A *sequence* is a series whose units are presented or suggested in temporal order. A *thematic* series or sequence consists of units or statements of a certain theme or themes.

Several kinds of musical unit, which can be regarded as types of theme in a broad sense, are often called by other names. Some are very small, perhaps comprising only a short figure of three or four notes, as in the opening of Beethoven's Fifth Symphony. Such a theme, repeated with variation, is often called a *motive, motif,* or (in German) *Motiv.* Wagner used the term *leitmotiv* for a comparatively short but expressive sequence of tones, associated with a certain character, mood, idea, place, action, event, or image. However short, any distinctive motif can be treated thematically, and successive units of it will then constitute a thematic sequence.

The process of varying a motif, as in rhythm, key, mode, tempo, or instrumentation, has been called motivic play.[1] Together with phrase grouping, says

W. S. Newman, it "concerns the connective tissue that binds the musical skeleton," as knitting and sewing do for fabrics. It occurs especially in the development section of a sonata allegro movement, but to some extent in all developed musical form.[2]

A small motif and successive variations of it constitute a *thematic motif sequence or figure sequence.* At the other extreme of size, a whole composition or one of its movements, such as the *Adagio* of a symphony, can be repeated *in toto,* exactly or with variations. These will constitute a thematic sequence of larger units.

In a complex design some themes and series are more emphatic and influential than others. These are *main* or *principal themes* or subjects as distinguished from subordinate or minor ones. The principal themes of a symphony, or of its first movement, are usually called the first and second subjects. This suggests a literary analogy, but it has the disadvantage of obscuring the fact that the so-called "subjects" are one kind of theme. Like the theme of the "theme with variations," the subjects of a sonata allegro movement are somewhat complex and compound to begin with, but can be repeated in still more complex, compound forms. However, they are often taken apart, and the parts thus produced (such as compound figures or short melodic phrases) are separately repeated, varied, and recombined.

Going a step farther in analysis, we must distinguish between *compound* and *component* themes and theme units. This distinction is not made in traditional music theory, but is necessary in order to bring out the analogies between thematic relation in music and other arts. A component theme is one restricted to a single component or a small group of them. Any compound thematic sequence in music can be theoretically analyzed into component sequences, e. g., into a rhythmic sequence (ignoring pitch, dynamic, and timbre variations), a pitch sequence (ignoring rhythmic and other variations), and so on.

Even a single tone, such as middle C on the piano, can be regarded as a compound thematic unit containing a certain pitch, a certain loudness, a certain

[1] See W. Newman, *Understanding Music* (New York, 1953), pp. 7, 128 ff.

[2] R. Reti brings out the wide scope of thematic structure in music, including motivic variation. "We call *motif*," he says, "any musical element, be it a melodic phrase or fragment or only a rhythmical or dynamic feature which, by being constantly repeated and varied throughout a work or a section, assumes a role in the compositional design somewhat similar to that of a motif in the fine arts." *The Thematic Process in Music* (New York, 1951), p. 3.

timbre, and a certain duration. Each of these traits can be treated as an elementary component theme, such as the pitch of middle C, and repeated with or without variations. To play middle C a little higher or lower on the violin, as in a vibrato, is to vary it according to pitch. This may or may not be accompanied by variation in other components, such as loudness or timbre. A compound sequence is produced by varying the original tone simultaneously in pitch, duration, loudness, and timbre (as in playing it first on the piano, then on the violin).

The fact that very small thematic sequences are often ignored in music theory is connected with the fact (already noted in regard to developed components) that temporal art forms usually proceed very rapidly, making it hard to distinguish small units. Instead, the listener must try to grasp them in the larger groups and sequences which are produced by the developed components and modes of composition employed.

In painting, the visual motif which constitutes a theme can be any component trait, elementary or developed. It becomes a theme when it is repeated with variation. Any spot of red is a potential theme if it is large and emphatic enough to attract attention. It is treated thematically if other spots of slightly different red occur elsewhere in the picture. To place several spots of blue nearby is to produce contrasting thematic series.

"Repetition" implies more than one occurrence of a trait or set of traits. They may occur at different moments in time, as when one repeats a word or a melody, or at different points in space, as when one repeats a curving line or a yellow circle in a rug design. The repetition of a trait in various parts of an object or process is equivalent to *similarity* between those parts with respect to the trait in question. To say that blue is "repeated" in several spots implies that the spots resemble each other with respect to their blueness. To say that a certain melody is repeated with variation in several passages of a sonata implies that the passages all involve the main, distinctive features of that melody. In other respects, the passages may be very different.

Thematic development, if continued, tends to involve some differentiation and some integration. Differentiation is achieved (a) through *variation*, which implies a relatively small amount of change or difference among the examples of a certain trait, and (b) through *contrast*, which implies a greater difference. Red is an elementary trait under the component "hue." It can be taken as a theme and repeated with

variations—e. g., made a little lighter or darker, more bluish or more yellowish. Each red spot in a picture is an *elementary trait unit* of that theme. All the red spots together constitute an *elementary thematic series*. Arranging them in a star-shaped pattern is one kind of integration.

Blue contrasts with red, and several blue spots make up a thematic series in contrast with the red one. Contrast implies more difference than variation, but there is no definite boundary between them. To be felt as contrasting, the traits concerned must be of the same general kind, similar enough to be compared. Red and blue are contrasting hues; joy and sadness are contrasting emotional states. Red and angular are both visual. But red, fragrant, 4/4 time, sadness, and Corinthian are too different to be contrasted unless some connecting link is provided.

The tolling of a church bell is an undeveloped type of musical form. Each stroke contains certain traits of timbre, pitch, and loudness. They are repeated with slight, indeterminate variations, over and over. The successive strokes constitute a repetitive thematic sequence. It could be developed by introducing systematic, distinct variations and contrasts in pitch, timbre, and loudness, as in a carillon. In a room whose walls and ceiling are painted a uniform pale green, that color is a rudimentary or potential theme. There will be variation if different greens are introduced, and contrast if some red or orange areas are added, as in pictures, pottery, or textiles.

The *suggested* factors in art can also be organized thematically, as in the characters and events of a story or play. Examples of wisdom and folly, fortune and misfortune, pride and humility, virtue and vice, love and hate, happiness and misery, are contrasting pairs of themes, each of which can be repeated with variations. The Eucharist leitmotiv occurs in *Parsifal* as an auditory theme and also as a suggested mood and concept. Suggested events may take place in imaginary time and be linked by imaginary causal relations. The alternation of grave and gay passages in music produces a contrasting thematic series in the suggestive factor. The total design in any art includes both presented and suggested themes, series, and patterns.

Any component trait or compound set of traits, any concrete object, event, or part of one, which occurs with sufficient emphasis and clarity to be perceived and recognized, can function as a theme. A trait which is stated only once in a composition, or more than once but vaguely, weakly, or at such wide intervals that the resemblance is not easily noticed, can be regarded as a rudimentary or potential theme.

To develop it thematically, the first step may be to repeat it exactly or with variation, closely enough in space, time, or both to make the similarity perceptible. Each example of it is a *unit* or *statement* of the theme.

Two or more units (e.g., of red or of a diminished seventh chord) constitute a rudimentary thematic *series*, or, if developed in time, they become a *sequence*. Thematic composition on a large scale involves the interrelation of many different units and large series containing smaller ones. One statement of a certain melody, or a recognizable part of one, is a *developed theme unit*. So is a single motivated action in a drama, e. g., a lie told to save one's reputation. It can be developed as a varied sequence of similar lies, and still farther by contrasting these with instances of telling the truth. They will form a developed thematic sequence in the component "action."

Countless degrees and varieties of thematic development are to be found in the arts, from the very simple and rudimentary to the ultracomplex. We shall understand a *design* to be an example of high or moderately high thematic development, usually involving a number of parts and components with some variation, contrast, and integration. It is a complex or moderately complex thematic composition. Exact resemblance or repetition is not enough to make a design; some unity in variety is needed. The term "design" is sometimes limited to industrial or utilitarian products such as furniture. In the sense used here, design can occur in any art. That term can refer to a complete work or a major part of one, especially one which involves several components and contrasting thematic series, integrated by a framework pattern. The first movement in Brahms's Concerto for Pianoforte No. 2 in B♭ (Opus 83) is a complex musical design in itself. So is that concerto as a whole. Any one of Shakespeare's sonnets, as a whole, is a poetic design in which the sonnet pattern is filled in with a distinctive set of word-sounds and meanings. In aesthetics, "design" does not imply either "purpose" or "drawing," as it does in other contexts.

We shall use the term *pattern* to designate a comparatively simple framework, series, or other thematic arrangement, especially when used as part of a more complex framework or design. For example, some of the lines in a textile design can be arranged in star-shaped patterns, and others in patterns of concentric circles. A pattern may emphasize one component and one thematic series, as when three separate lines in a picture combine to approximate a triangular shape. The figures in Leonardo's *Madonna and Child with St. Anne* are arranged in a roughly pyramidal pattern.

As a whole the picture involves many components. A minuet is one kind of conventional pattern in music and another in the dance. Though belonging to different arts, the two kinds of minuet have some traits in common, such as rhythmic development.

Thematic development, including the production of more and more presented units and series, can proceed in one, two, or three dimensions of space and in time. The complex development of design in various arts will be discussed in a later chapter.

Some thematic series are temporally determinate: that is, they are arranged so as to be perceived in a certain order. This is true of most designs in music, literature, and theater art, and in some Chinese and Japanese scroll paintings. Sometimes, as noted above, the order of presentation and perception is left to chance or to the momentary impulse of the performer or observer. This is true of "aleatory" music and of occasional cadenzas and passages marked *ad lib.* in otherwise determinate forms. In most static pictorial and sculptural forms the order of perceiving thematic series is only loosely determined if at all. Thematic series in music and poetry are normally irreversible without radically changing the design and the total effect, as in playing a film or tape recording backwards.

Almost any trait or set of traits, such as red and blue, high and low pitch, love and hate, can be organized in accordance with any mode of composition. They can function as parts of a utilitarian, a representational, an expository, or a thematic form, and of several or all of these at once.

Details arranged according to any other mode of composition may also function thematically. The curving shape of a vase may adapt it for a utilitarian function and also form a design. Reds and blues, curves and angles, may represent flowers and sides of a house while also forming a design of lines and colors. A poem can form a design of word-sounds while generalizing about life, love, or other expository subjects.

Any sense image or configuration of them, any emotion, desire, concept, belief, or other possible object of perception or thought, can be taken as a theme and used in thematic composition. Mutability, the idea (tinged with sadness) that all joy must have an end and all things of beauty pass away, is a common theme in lyric poetry. Keats's *Ode to a Nightingale* is an example. Some lower-sense qualities, such as tastes and scents, can be used thematically. A banquet involves a contrast and sequence of several kinds of taste, each of which may be varied somewhat. Some late nineteenth-century writers, notably Huys-

mans, considered the possibility of a "symphony" of tastes and odors. One obstacle is the fact that the lower senses in man are usually incapable of perceiving very complex forms such as those of music and painting.

Temporal repetition often suggests *spatial* repetition. The musician is likely to associate a musical form with the score in which it is written down, and to visualize the various statements of a melodic theme as occurring at various places in the score. Conversely, spatial repetition often suggests temporal, as in looking at the several parts of a complex visual object in succession, one after another. It is hard to perceive many of them in the same instant. Sometimes, as in sculpture and architecture, the nature of the form prevents us from seeing it all at once. Thus, even though the various repetitions of a theme are actually simultaneous, existing all together as physical objects, we may experience them successively, perhaps as a vague whole to begin with, then as one part or constituent grouping after another. If they are spaced at fairly regular intervals; the temporal succession may seem regular and metrical; if the size or spacing is a little varied, the effect may be similar to rhythmic variation in music and poetry.

This connection between thematic repetition and rhythm often holds true of the artist's work as well. A primitive potter decorating a bowl encircles it with curving incisions or brush strokes, feeling each as a separate action in time, and perhaps accompanying his work with rhythmic singing. The resultant series of marks has temporal, rhythmic associations for him afterwards, and so it can have for others who look at the bowl. By the process of empathy, the observers may project their own imaginary movements into the static form.

This strong and common association, between auditory rhythm and the repetition of visual themes, has led many writers to use the word "rhythm" for what we are calling "thematic relation" or "thematic repetition." Such use is misleading. In this book, "rhythm" refers to an *auditory component*. There is need of the term in that specific sense, in the analysis of music and literature. The concept of thematic relation covers a much greater variety of effects in art, simple and complex, including some in which the analogy to auditory rhythm is remote. In music itself, rhythm is only one kind of thematic relation.

In modern Western culture, the art which has tended most strongly to specialize on thematic composition, apart from all other modes, is instrumental music. When it is purely thematic, it lacks any definite utilitarian, representational, or expository signifi-

cance. Ordinarily, the tone of middle C and the triad C-E-G have no such meaning or nonaesthetic function. Neither has the sonata, fugue, or symphony as a conventional pattern. Most music is adopted mainly as a guide to satisfactory aesthetic experience. Of course, like anything in art, it can be used for other purposes: e. g., to make money or educate students. Any work of art may suggest something outside itself. Middle C may be made to symbolize moderation, or a symphony, harmonious cooperation. But such associations are indeterminate and not universal or necessary.

Among the visual arts, textile design, as in a Persian rug, is often elaborately developed along thematic or decorative lines, without representation. Certain curving lines and spots of color may combine into medallions, borders, and other patterns of intermediate size and complexity, and these combine into the total rectangular design. The rug as a whole, as a three-dimensional fabric, may have utilitarian fitness while the visual form on the surface is purely thematic. Even the surface design may serve a utilitarian function, as when it is adapted to serve as a prayer rug, pointing to Mecca.

The specific nature of thematic composition within a particular work of art—the various themes used, the manner and extent of their variation, contrast, and integration—constitutes the *thematic schema* of that work. In most cases, it involves relations with other compositional factors therein.

6. *Types of design in various arts.*

One of the most significant ways of distinguishing and classifying types of design is in terms of the sense or senses primarily addressed, e.g., as visual, auditory, or audiovisual. This implies related distinctions among types of trait which can be presented in a certain art and those which can be only suggested. It also implies distinctions as to the kinds of pattern and design which can be presented in each art, and those which can be only suggested. Attention must also be given to the frames of reference employed, to whether the development is mostly in two or three dimensions of space or in time.

A. *Visual, static, surface design.*

Here thematic development is presented mostly in two dimensions of space, with little or no determinate change or movement. It can be presented on a flat, curving, or polyhedral surface. The components

presented are especially line, color, and texture, sometimes with slight variations of surface shape, mass, and void shape. There may be a little presentative development in the third dimension, as in low sculptural relief, but with emphasis on surface arrangement and little extension forward or backward. "Static" refers to the presented factor only, and has nothing to do with possible suggestions of movement, as in a picture of a battle. Certain kinds of surface design are distinguished on a basis of which components are emphasized. An arabesque is a kind of design involving intricate linear development, with or without representational meaning. In it the temporal order of perception and the nature of thematic series are more or less indeterminate and variable. Three main subdivisions of visual, static, surface design can be distinguished:

1. Strip design: long and narrow as in ribbons, borders, and architectural mouldings in low relief. It is extended mostly in one dimension, lengthwise; units of design may be indefinitely repeated or prolonged in either direction. It can be developed by addition, in producing more units to right, left, or both, or by division, in increasing the size and inner complexity of each unit: e.g., in a row of heraldic designs. Strip design accepts a definite boundary in the second dimension; it is held in above and below but can expand sidewise. Internally, it is adapted to the area between the two boundaries, as between the edges of a moulding or border. Conventional types include the fret, wave, egg and dart, and guilloche. Varieties appear in one or more of the following ways:

First, as to the dimensions in which presentative development occurs: whether it is actually flat or slightly three-dimensional. In the latter case, actual differences in surface or solid shape are present and are systematically arranged as in mouldings, picture frames, lace, repoussé, jeweling, and embossing. Secondly, in terms of suggestive development. A design which is actually and presentatively flat may be suggestively three-dimensional, giving illusions of solidity, depth, or apertures, as if by cast shadows. These may be realistic or stylized, vague or precise. Thirdly, as a result of the presence or absence of representational development. Strip design may be purely abstract, nonrepresentational, or more or less developed in the direction of pictorial or sculptural naturalism. The representational factor, if any, may be presentatively flat and realistic through linear outlines alone. This tends to involve some three-dimensional suggestion, but it may be slight, without the use of shadows or perspective. Strip design is sometimes highly realis-

tic as in Chinese and Japanese hand scrolls. It may emphasize either a pictorial or a thematic, decorative framework.

2. Bounded-area design. This is limited within a given two-dimensional area and is usually related internally to the size and shape of the area marked off, as to a rectangular or circular frame or border. This tends to distinguish it theoretically from an arbitrarily severed portion of a strip or allover design, but in practice there is a good deal of overlapping between these types. (Some of Degas's paintings seem arbitrarily cut off at the side). An additive approach may appear in the random scattering of units within the area, without definite relation to the boundaries.

Designs of the bounded-area type may be presentatively flat or three-dimensional. Design in painting is usually of the former variety; sculptural relief is of the latter. Some paintings approximate reliefs through the use of high impasto or raised, gilded areas. Some textiles involve a slight three-dimensional development through the use of embroidery, appliqué, cut velvet, and other techniques. Suggestively, many textiles are comparatively flat, as in prayer rugs. Most paintings are suggestively three-dimensional.

The relation of design to representation is especially important in the bounded-area type. Where pictorial representation is highly developed as an imaginary scene in space, it tends to provide a framework within which thematic relations can be developed as an accessory factor to any desired degree of complexity, in terms of line, color, solid shape, texture, and other components. Each compound unit, such as a house or human figure, can then function in design as well as representation. The design factor is strong and complex in medieval and Persian manuscript illumination, within a representational framework.

When the framework is thematic or decorative, as in most Persian carpets, the main units are repeated and arranged arbitrarily to make a pattern, rather than merging into a single scene in the interests of representation. In such a framework, some or all of the individual units may be representational (e.g., as flowers or animals) or nonrepresentational (e.g., as a row of circles). The outline of a small unit such as a flower may provide a subordinate representational framework—e.g., for stem and petals.

Paintings of the types called abstract, nonobjective, or nonrepresentational differ considerably in these respects. Some are completely nonrepresentational, and some suggest scenes or objects in a highly simplified, partial way. Some incline toward representation in the constituent units, the framework, or both (e.g., as

vaguely suggesting clouds or undersea life), some toward a more purely abstract design in both respects. In some the thematic relations are so slight and simple (e.g., repeated vertical brushstrokes) as hardly to constitute a pattern or design. They often differ from conventional, formal ornamentation in being comparatively asymmetrical, irregular, and free-flowing, suggesting moods, attitudes, and tensions which may also function thematically. Some are tightly geometrical, as in paintings by Mondrian.

Utilitarian objects, such as buildings, chairs, robes, and boxes often provide the frameworks for design in bounded areas. The back of a chair or an inside wall in a house may provide a rectangular, circular, or oblong surface for decoration, its size and shape helping to determine the size and shape of themes and patterns therein. These can be representational, thematic, or both, as in a woven scene of figures in a landscape, used to upholster the back of an armchair.

3. Allover design is unbounded in two dimensions, with a tendency to indefinite repetition or prolongation in two dimensions and four directions. There is a tendency to additive method as to the series of units, and a tendency to division within each unit, as in a spot pattern of complex medallions in a textile. Termination is usually arbitrary and sudden rather than prepared; it comes when a piece of cloth is cut from a bolt, or when the edge of a wall or box is reached. The internal decoration of that area does not tend to be as thoroughly adapted to the outside shape of the wall or box as when that shape is treated as a bounding area. The proliferation of a design tends to flow from one side to another of the box or other object, ignoring its edges and corners. Thus an allover design may completely cover a solid object, such as a vase or an enameled metal figure, as if a decorative textile were pasted over it. The framework thus presented is not flat, but is treated much as if it were flat, its solidity and surface variations of shape being ignored. Painted and mosaic surfaces of architecture, on inside and outside walls, are sometimes treated in this way.

A common feature of allover design is to arrange the units on two coordinate, intersecting systems of lines (horizontal and vertical or diagonal) and not along a single main axis as usual in strip designs. Conventional types are spot, stripe, scale, interlaced, flowered, figured, and scenic patterns. Allover design is much used in dress fabrics, upholstery and drapery fabrics, wallpaper, linoleum, and wherever the design is to be adaptable for further use in products of variable size and shape.

This type of design can be flat or three-dimensional, both presentatively and suggestively. Lace, wire filigree, and similar products may be intermediate between flat and solid, developed mostly, that is, in two dimensions. It may be representational, abstract, or intermediate between the two. Like strip design, allover design is usually decorative rather than pictorial in its comprehensive framework. It tends to repeat units, over and over, in various directions on a given surface, flat or curving, as long as room is available. Individually, these units are often pictorial and realistically three-dimensional as in scenic wallpaper, but they are repeated and contrasted to make a somewhat regular design instead of being merged into a single scene. In highly realistic examples, the boundary between units is obscured so that they seem to merge continuously. In a room thus papered on four walls, the design may seem at first like a realistic landscape, until one perceives that a certain complex theme of trees, figures, houses, etc., is exactly repeated again and again without conspicuous separations. The individual units are often of the bounded-area type, including strip designs, border details, and the like.

B. Visual, static, solid design.

This type is three-dimensionally presented; it has considerable extent in thickness or depth as well as in length and breadth. It is not merely spread over a solid object, as in the varieties of allover pattern just mentioned; the thematic units themselves consist of different solid parts, thematically arranged, as in an arcade or colonnade or in a row of similarly costumed figures. Thus there is more use of solid masses, voids, and surface shapes than in static surface design, in addition to line, color, and texture. Usually the temporal order is not definitely determined.

1. Exterior design, as in architecture when viewed from the outside, and as in sculpture, utensils, jewelry, furniture, etc. The object may present many different designs as seen from different points of view, as opaque, solid parts fall into different arrangements through parallax, overlapping, and partial concealment by other opaque parts. High three-dimensional development is lacking in solid objects placed so as to be seen from only one point of view or a narrow range of them, such as a statue fixed in a high niche. Primitive Negro sculpture tends to divide the figure into definite solid parts by grooves and ridges; these parts present variations on one or more solid themes, such as the cylinder, pear shape, cone, or sections of one.

An armchair may also present a series of cylinders

in the legs and arms, contrasting with flat, curved planes in the back and seat. In the statue, we have a representational framework; in the chair, a utilitarian one. Other common varieties of three-dimensional design are found in vases (in thematic relations between the curves of the body, neck, mouth, and handles); in weapons, especially the rapier with its swept hilt, a slender, curving mass of steel; in flower arrangements contrasting the shapes of stems, flowers, leaves, and stones; and in decorative ivory plaques. Some of these types permit indeterminate or slightly determined kinds of motion, as in lace and in gold earrings and other pendants which move with the wearer.

2. Interior design, surrounding or partly surrounding the observer, as when he is inside a building, room, garden, or enclosed city square. The Gothic cathedral is highly developed in this respect, presenting different patterns of ribbed vaults, clustered piers, horizontal balconies, windows, sculptures, and paintings as one moves around and changes the angle of vision. Again, the temporal order of perception is only partially determined.

3. Combinations of the two, as in the connection between exterior and interior designs in the cathedral. The rose window contributes to the design of the façade as seen from in front, contrasting with the columns, arcades, and towers. It also contributes to the interior design, adding luminous color, as one looks backward toward the inside front wall after entering. A palace surrounded by a park also combines exterior and interior designs. In the park, one is outside the palace and may move around it, noting the thematic relations between the various sides and roofs. One is also surrounded by landscape design, which may be geometric, baroque, picturesque, or diversified. Movements occur in it, as from the wind, but are mostly indeterminate. Dioramas and stage tableaux can also combine inside with outside views. As one looks into the structure from in front (e.g., an animal habitat group with landscape setting), one is outside it, yet can be led to imagine being in it and surrounded by it. Some dioramas are realistic, dealing with human, animal, or plant groups; others present thematic arrangements of non-representational forms in deep space.

4. Intermediate between surface and solid design is *sculptural relief* which varies as to the amount of three-dimensional development. When the relief is very low and applied to a flat panel, it tends to be perceived as static surface design within a bounded area. When high and partly detached from the background, as in modeling an elbow in the round and

opening a space between it and the rest of the figure, it approximates static solid design.

C. Visual, mobile, temporally developed design.

1. Mobile surface design. This type comprises visually presented thematic development in time, as well as change and motion in determinate sequence, mostly in two dimensions of space. It includes motion pictures, shadow plays, and lumia or mobile color, all presented as flat images on a flat or curving surface. The shapes thus presented may be representational or nonrepresentational, with or without three-dimensional suggestions. We are not concerned here with the representational aspects, if any, for their own sake, but only with the ways in which they may provide thematic materials, units, and series, as in a filmed version of a ballet. Some films are abstract, presenting geometrical and other types of shape and color in rhythmic movement.

Intermediate between static and mobile surface design are the Chinese and Japanese pictorial hand scrolls, which are usually unrolled so as to bring one or more continuously changing pictures into view. The temporal order of viewing is thus flexibly determined, from right to left. As in strip design, the form can be indefinitely prolonged sidewise, but is held in by a boundary at top and bottom. Vertical scrolls, by contrast, are comparatively short and are usually unrolled all at once to be seen as wholes. The handscroll is obviously not as mobile as a marionette play or ballet. It does not move of its own accord, and the viewer or someone else must move it, but some mobility is characteristic of its conception and performance.

2. Mobile solid design presents actually solid figures (not merely represented ones) in more or less determinate motion. It is developed in three dimensions of space and in time. Examples are found in dance, especially ballet, in marionettes and other mobile sculpture, in acrobatics, especially trapeze performance, theatrical skating and swimming, fireworks, and decorative waterworks. Not all examples of these arts are highly developed thematically. Some are mere feats of strength or agility, but all can be developed along thematic lines by rhythmic motion, by repetition and variation of certain movements, by decorative costumes, and the like. In mobile sculpture such as that of Alexander Calder, air currents propel the suspended parts, which are usually nonrepresentational, into changing arrangements. Their movements are limited in range. Speed is usually indeterminate.

Some mobile sculpture is operated by a motor and is hence more determinate in speed.

D. Auditory design.

This is aurally presented in more or less determinate temporal sequence. It may or may not be combined with mobile visual design, as in ballet. It usually lacks much spatial development, although exceptions occur, as in music with antiphonal relations between choirs at different positions in a church or concert hall.

1. Musical design, one of the two main subdivisions, is based on thematic development of rhythm, pitch, timbre, consonance and dissonance, etc., and of developed components such as melody, tempo, meter, dynamics, chord structure and progression, and orchestration. Conventional types of framework pattern are the theme with variations, the rondo, fugue, suite, sonata, symphony, and symphonic poem. Musical design is most highly developed through the use of instruments and human voices having relatively pure and constant pitch and timbre, each with a certain range of variations. Many sounds of nature and human activity are commonly regarded as nonmusical noises, largely because of much larger admixtures of overtones, but sometimes because of excessive loudness or monotonous uniformity. These have been traditionally regarded as unfit materials for music, but recent composers have experimented with them as potentially musical. Any sound or noise can be treated as a theme, repeated, varied, contrasted with others, and organized into a series.

2. Word-sound design is one of the two main factors in literary design, the other being formed of suggested ideas, meanings and associations. Word-sound design is presented aurally when literature is spoken, and thus resembles music to some extent. It differs in different languages, some of which (e.g., Chinese) involve much determination of pitch, even in prose conversation. In Western languages, word-sounds are developed especially in verse and through the use of meter, rhythmic phrasing, rhyme, assonance, and alliteration. Literary prose develops them to a less extent, with more irregularity and flexibility. Pitch and tempo are usually indeterminate, although convention regulates them in part, as in dropping the voice at the end of a sentence. Poetry tends to demand slower reading than prose, to allow clear perception of its form and content.

3. Verbal-musical design, as in song, oratorio, and opera, is a combination of musical and word-sound themes and patterns. Either may dominate, or the suggested meanings (as in a story) may provide a framework for both.

E. Audiovisual design.

This type involves some temporal change because of the evanescence of sounds. To correlate the visual factor thoroughly with these requires some change and movement in the visual images also.

1. Audiovisual surface design, of mobile visual patterns combined with music, word-sounds or both, is found in motion pictures and shadow plays with incidental music and spoken verses.

2. Audiovisual solid design is produced by combining mobile solid patterns with auditory ones, as in dance and ballet with music. The music may or may not provide the main framework. All the varieties mentioned above under "solid design" are frequently accompanied by music, especially as types of theatrical entertainment such as group figure skating. This helps to coordinate the movements and elaborates the total perceptual content.

F. Types of design based on suggestive thematic development.

The foregoing list distinguishes types of design mainly on a basis of presentative development, according to the sense primarily addressed and the way in which the presented factor is developed in space, time, or both. Representational and other suggestive factors have been mentioned incidentally.

It should be emphasized, however, that such factors are capable of elaborate thematic development. These may include kinesthetic tensions and relaxations, as suggested through abstract or representational painting and sculpture. Suggestions function thematically in literature, music, and visual art.

To some extent these can be regarded as subdivisions of the presentative types just listed. For example, "bounded area design," as in most paintings, may or may not involve thematic development of symbolic meanings. A tapestry may contain heraldic figures which symbolize the union of two noble families in marriage. Perhaps a lion and a fleur-de-lys are repeated alternately in the border, and joined at the top and center. Such repetition, contrast, and integration involves the visual images along with their meanings and associations.

In literature, especially prose, thematic development is mostly suggestive. References to ideas and emotions such as war and peace, joy and sorrow, selfishness and unselfishness, and every type of image derived from the senses, can be arranged into patterns

of any desired complexity. Of course, it is through presenting the visible or audible stimuli to such ideas that the author arranges the ideas themselves, inviting us to think of them in certain combinations and sequences. Closely interrelated as they often are, the word-sounds may be formed into one set of patterns (e.g., a stanza built of alternately rhyming, metrical lines), while the ideas are arranged in another. The two sets may or may not correspond.

The distinction is fairly obvious when poetry is read and heard aloud, for then the presented stimuli are radically different from the meanings attached to them. The word-sound music may be so insistent that we tend to ignore the pattern of ideas. When the poem is read silently to oneself, all the word-sounds are imagined and not heard. This makes them harder to distinguish from what we are calling the "pattern of ideas." Broadly speaking, the suggested word-sounds deserve to be included among the "ideas" or "meanings" which the printed words call to mind. Be that as it may, it is important for the study of design in literature to distinguish word-sound patterns (heard or imagined) from the patterns formed by the other meanings of the words. In prose, such as the novels of Thomas Mann, two or more conceptions such as health and disease, science and mysticism, life and death, are often contrasted at great length so as to form thematic series. These have little or nothing to do with the patterns formed by word-sounds. In the realm of ideas, too, the writer can develop his ingredients in a certain frame of reference which does not correspond with the tempo of reading.

7. Compositional factors in a single work of art. Ways of interrelating them.

So far, we have been considering the modes of composition as to their nature in general, as four different ways of developing form in the arts. We have noticed in passing that two or more modes of composition may coexist in the same work of art. The same work can be both utilitarian and thematic, or expository and representational. Some kinds of art—notably the cathedral—combine all four modes in a single example. Most modern works of art specialize on one or two.

Where two or more modes of composition exist in the same work of art, they interact as *compositional factors*. So regarded, the four modes are: the utilitarian, representational, expository, and thematic or de-

sign *factors*. In analyzing a work of art one may need to describe two or more of them, showing how they are interrelated in that particular case. One factor may be dominant, determining the general outlines of the form, while others play subordinate roles. The relations among compositional factors in a work of art are its *compositional schema*.

A chair is a type of utilitarian form, adapted for work, rest, dining, or other functions. An armchair is one of its many subtypes. It can be analyzed and described in terms of its utilitarian schema: that is, the cooperation of parts and qualities toward the intended fitness for use. It can also be analyzed in terms of its thematic schema.

Even if made without any aesthetic aims or decorative development, a chair can hardly avoid having some rudimentary thematic relations. It will usually have four legs, a seat, and a back, plus arm supports in the case of the armchair. The legs may consist of four slender cylindrical rods. This in itself establishes a thematic series in the component of solid shape. The rods may be varied in shape, the front two a little different from the back two, for reasons of support and convenience. The seat and back sometimes form another series of two thin, broad, flat, or curving masses. These two series contrast with each other and are integrated in the total form of the chair. A simple design results, whether so intended or not. In this case, the design or decorative development is not something added, extraneous to the utilitarian factor, but coexists with it. Recent taste in furniture and architecture has favored this kind of form, with little "nonfunctional" ornamentation but appealing aesthetically through the utilitarian structure itself.

This kind of thematic relationship occurs also in representation. The human body has two eyes, two arms, two legs, and the female two breasts as well. Hence any sculptural imitation of the body has several rudimentary thematic series. When the body is twisted and the arms and legs are bent into angles, an additional series of angular masses is formed. This produces a simple design without sacrificing realism. Some artists, and some periods in the history of taste, are satisfied with such extremely simple thematic arrangements; others wish more development.

Another kind of thematic development is more distinct from the utilitarian factor. The artist may paint or carve flowers on the back of the chair. He may alter their proportions for the sake of design in ways which do not contribute to utilitarian fitness. This is a more superficial kind of decoration or embellishment. Some amount of conformity between the fac-

tors can be maintained by making nonfunctional ornament follow the outlines of the basic framework and stay within the boundaries set by its main parts. The outlines of the flowers and stems can repeat certain lines in the basic, utilitarian structure of the chair.

Thematic development, as in the case of the statue, may not follow the outlines of realistic representation. One may add nonrealistic colors or alter the proportions of the bodily parts (as in primitive Negro sculpture) to bring them into thematic relation.

When two or more compositional factors are closely merged in a work of art, each detail tends to function in two or more of them at once, and thus to fulfill two or more different roles. This is the *plural functioning* of a part or unit. In a painting of a garden, a single spot of red may represent a rose and at the same time help to build up a series of red spots as part of a design. If a red rose is part of a coat of arms, it may function as the emblem of a certain noble family. The widely curving buttresses of a Gothic cathedral help to build a design of contrasting masses and also help (or appear to help) support the wall.

A Gothic cathedral is characteristically developed in all four modes of composition. It is, first of all, a utilitarian structure, a meeting house. It is adapted to hold a large number of persons, to protect them from inclement weather and unwelcome intrusions and to facilitate worship and other activities. Its walls, piers, buttresses, roof, and openings provide this utilitarian factor. Its representational factor usually consists of a cruciform ground plan and of the many sculptures, both inside and outside, of divine personages, saints, kings, queens, bishops, angels, imps, devils, animals, and other beings, both natural and supernatural, and also of paintings on walls and altarpieces, pictorial tapestries, and the like. Parts of the mass and other ceremonies (e.g., the Eucharist) are quasi-dramatic and representational. They are also expository. Almost every part and aspect of the cathedral symbolizes some religious, ethical, or historical idea. Taken all together, they combine to set forth the medieval Christian theology and value-system, as well as a conception of past and future history. Moreover, the cathedral is an ultracomplex visual design of pointed spires and arches, circles (as in the rose window), clustered piers and arcades, and designs of multicolored, luminous stained glass. Its thematic relations extend from the shape of the whole to the minute details of glass and of wood carving in the choir stalls.

Music is often utilitarian and representational, in addition to its thematic structure. When it is adapted for ballroom dancing (an active use), that fact is discernible in the music itself, in a very regular beat, a suitable tempo, simple melodic lines, and other devices. Representational passages often appear in the midst of otherwise purely thematic music, as in the storm in Beethoven's Sixth (*Pastoral*) Symphony. Dukas's *Sorcerer's Apprentice* is narrative throughout.

The combination of *expository* with thematic composition can be illustrated by Wordsworth's *Ode on the Intimations of Immortality*, a meditative lyric. Here the expository factor is devoted to setting forth the poet's theory of a previous life, after which "Our birth is but a sleep and a forgetting." Thematically, the poem is developed in terms of auditory components such as meter, rhyme, rhythmic phrasing, and euphony, as well as in thematic handling of the suggested images and ideas.

Literature, like painting, can express two or more contrasting ideas, such as "sacred and profane love" or "poverty and riches." Both arts can introduce concrete examples, but literature can go farther in theoretical, intellectual analysis, as in an explanatory essay or meditative poem. The various references to a certain idea build up a thematic series, and two or more series can be interwoven to make a design. Any case of regular, step-by-step logical inference or inquiry takes on thematic aspects, if not of contrast, at least of repetition, variation, and integration by a comprehensive pattern. The theorems of Euclid are an example, and Plato's dialogues combine thematic form with dialectical reasoning.

When three or four modes of composition are highly developed, as in the cathedral, one can say that the work of art is highly diversified in this respect. It has a high degree of *compositional diversity*. Other types of art are more *specialized* along one line of composition. Some are almost purely decorative, containing mere traces of other modes. Some paintings, like photographs from nature, are mainly representational. But they are almost certain to contain some rudiments of thematic structure, if only from the presence of two similar trees, two windows, or two men in similar clothing. Sometimes the artist is content with these; at other times he undertakes to emphasize and develop these accidental resemblances and contrasts.

There are many intermediate types between the extremes of diversity and specialization. Some cups involve, besides utilitarian form, decoration through gems and incised patterns, but no representation and no definite expository meaning. Some are decorated with letters which spell texts from the Bible or the

Koran, thus involving exposition but not representation.

The various factors in a diversified form can operate as distinct *objects of apperception*. An observer can focus his attention on each constituent mode of composition in turn, grasping the same set of ingredients first in one way, then in another. He sees the same details from various points of view, in accordance with these modes of arrangement. From the utilitarian standpoint, he sees a royal coat of arms as an instrument. He asks, what is it for? How does it work? What does one do with this and that part of it? One purpose is to identify the king's property and servants. From the representational standpoint, one asks, what is it a picture of? What kind of animals are these, and what are they doing? From the expository standpoint, he asks, what general ideas does this convey? What assertions or claims does it imply, as to the rank, descent, and power of the person owning the coat of arms? (A fleur-de-lys in the British arms, for example, would imply a claim to French noble descent and feudal privilege.) From the thematic point of view, he asks, what design does this make? How do its lines and colors fit together as visual details in a decorative arrangement?

Another way to regard the compositional factors is as various possible modes of procedure for the artist. Any work of art could, theoretically, be altered and developed along any of four or more different lines. Let us say that we are building a throne. We can make it along utilitarian lines, as an armchair. We can try to make the shape decorative as well as serviceable, by seeing that more of its masses and surfaces are thematically related. Then, if we like, we can introduce representation by carving a lion's head in relief on the back of the chair, and fashioning the legs and arms of the chair like the legs of a lion. These details will also constitute applied decoration. We can add expository meaning by carving a motto around the border of the back of the chair. We have now made a beginning in all four modes of composition. Suppose we choose to develop the chair further along representational lines. This would involve, perhaps, making the chair more and more like a statue of a lion, as in some primitive thrones. Or it might lead to covering the chair with many small scenes in relief, with human figures as legs of the chair, and so on.

The result, of course, might well be to sacrifice some of the chair's utilitarian fitness by making it uncomfortable, unsuited to the primary utilitarian function of the chair as a thing to be sat upon. Thus development of one mode of composition often requires, or seems to require, partial sacrifice of others. If an artist sets out to combine two or more modes of composition in the same form, he may find it hard to do them at once without conflict. He may find himself restricting one, holding it within limits in order to do a certain amount of the other also. He may feel that the resultant form is a compromise between competing sets of aims or values. Let us say that he wishes to paint a realistic representation of a group of figures. He would also like to make a design of their linear outlines. But if he makes that design very definite and complex, he may find the figures no longer realistic, no longer producing the kind of representation he desires. However, the development of one mode does not necessarily require sacrifice of others. Some works of art achieve high development in two or more without mutual interference; the two factors reinforce each other.

8. Persistent compositional types. Their relation to styles.

Many kinds of artistic product and performance, based on one or another of the modes of composition, descend through millennia as parts of traditional culture. In each, one or more modes compose the basic outlines of the piece. Some of these descend with little change through many different cultures and periods in remote parts of the world; others change and diverge in adaptation to different cultural and physical environments. Some are short-lived. Some types of architecture and of dress tend to differ widely in cold climates from those in hot ones. But certain kinds of knife, hatchet, mallet, cup, bowl, hat, and cloak, widely used today, are much like those of former ages aside from changes in material and manufacture. The basic conception of a human figure in paint or stone remains fairly constant; so does that of an adventure story or a love song. A myth is a persistent type of story, a representational type. In addition it usually has expository significance, as in attempting to explain the origin of some natural phenomenon.

Persistent compositional types act as enduring frameworks and points of departure for the artist. They epitomize, in somewhat generalized form, the contribution of previous cultural invention toward a solution of persistent human problems. With their aid, the artist does not need to begin at the beginning in each generation; he can take as a starting point that

this is the way, or one tested way, at least, to make a house, a love song, or a war dance. The cumulative, concentrated experience of cultural millennia in dealing with each particular type of situation is set before him as a partial guide and model. As determined by his own creative powers and the extent to which his environment encourages them, he can imitate some past solution mechanically or alter and develop it in some partly new way.

Much of what is commonly called "creative" is only partly so. It is never completely new, from the ground up, but can be more or less original by comparison with the previous condition of the type concerned. The words "creative" and "original" are usually meant in a laudatory way, but from the standpoint of morphology we can interpret them in a more objective, roughly quantitative way, as indicating that the artist in question has done relatively much to alter and develop the types, techniques and ideals which he inherited.

These are some persistent compositional types:

Utilitarian: the chair, cup, dwelling, castle, temple, hat, cloak, shoe, sword, vehicle, map. Verbal rules (often in verse) and pictorial diagrams to guide the craftsman, farmer, hunter, fisherman, soldier, or builder. Dance music, work songs, sailors' chanteys.

Representational: the painted or sculptured human or animal figure; the portrait head in paint or sculpture; the landscape and still life. Subject types in various cultures and religions, such as the Holy Family, Nativity, or Crucifixion; incidents from the life of the Buddha; Gautama in various postures and gestures. In literature, the epic, tragedy, comedy, novel, and short story. Mimetic dances representing totem animals.

Expository: the essay, treatise, and meditative lyric in literature. In visual art, the Tree of Jesse and Siva Nataraja with symbolic details. Myths of creation in various religions.

Thematic: the fugue, sonata, and symphony as musical types; the Elizabethan sonnet in verse; the arabesque in visual ornament.

Any such type can remain fairly constant in its general outlines while undergoing many successive changes in style. Individual artists, periods, and cultures may treat it differently in detail while leaving the basic framework recognizable. The armchair as a persistent compositional type has been treated very differently in ancient Rome and China, in modern France and England since the Renaissance, and in contemporary plastics and tubular metal. Much the same can be said of the dwelling house and of a woman's dress as basic types. Stylistic fluctuations in the latter have been traced in detail as to length, waistline, and silhouette, but the essentials of the type persist throughout.

9. Basic frameworks and accessory details. Their relation to compositional factors.

We have seen that one way to achieve integration, along with as much variety in detail as may be desired, is *conformity to a comprehensive pattern or framework*. The conformity may be complete and rigid or approximate and loose. The framework is a kind of general outline or skeleton of the work of art. Within it, and more or less conforming to it, are the *accessory details*. Even though covered and somewhat concealed or modified by the details, some evidences of a framework or determining conception usually remain.

Compositional types derived from all four modes of composition serve as frameworks for particular works of art. Each type is conceived in terms of certain characteristic parts and interrelations. Accessory details are arranged within them. Each compositional factor provides the basic framework in some cases and is then to be called the *basic framework factor*. In other cases it plays an accessory role, providing supplementary details to be fitted into the framework.

The framework and accessory factors in a work of art can be related in either of two ways. They may be mostly derived from the same compositional factor, or from different ones. In the former case, we tend to regard the work as "purely" this or that: e.g., purely decorative, with no hint of representation. Having them from the same compositional factor tends to heighten the effect of unity and consistency along one specialized line. Having them from different ones makes for variety; it suggests to the reader different attitudes and modes of thought.

The essay provides a characteristically expository type of framework, especially when organized so as to explain or interpret some abstract subject. Usually the writer takes up various aspects of the subject, one after another, ending with some generalized conclusion. If his mode of thought remains expository throughout, including the treatment of concrete examples as data or evidence for a thesis, one may say that the accessory details are in the same compositional factor as the framework. Some essays, such as those of Montaigne, have many representational pas-

sages—concrete examples, anecdotes from history and legend, and personal reminiscences. These often do more than help explain the subject. They invite attention for their own sake as examples of literary narrative and often have a very tenuous relation to the main subject.

The sonata is a thematic framework, and is characteristically developed in terms of smaller thematic series, part within part. Each of these can be treated thematically on its own level of size. A sonata or symphony can be built throughout in terms of thematic composition alone. In so-called pure music a composition does not represent anything, explain anything, or serve any utilitarian purpose. The accessories and framework are then consistent in this respect. On the other hand, the composer is quite free to introduce a representational passage at any time, or to try suggesting an abstract conception, or to adapt a part of his music for some practical use, such as an academic procession or a wedding march.

We have noted that a cathedral is primarily a meeting-house, a *utilitarian* type. To provide for a large assemblage in one hall, certain kinds of wall, roof and roof supports, doors, and windows are needed. This recurrent type serves as a basic, conceptual framework for many particular cathedrals and other churches, all somewhat different in detail. Within the utilitarian framework, accessory details are inserted. Many of these are also utilitarian, such as the piers, vaults, and buttresses; others are representational, such as the statues and tympanum reliefs around the portals. Many are expository, and nearly all fit into some thematic series. Small decorative details are usually organized within a utilitarian part as a subordinate framework—e.g., a window or portal—instead of overflowing from part to part.

An opposite relationship appears in the Statue of Liberty in New York harbor, perhaps a distant descendant of the Colossus of Rhodes or some other anthropomorphic lighthouse. Here the basic, overall framework is *representational*: a colossal statue of a goddess holding a torch aloft. The flame of the torch can be illuminated from within, making the statue serve as a lighthouse; but the inner structure necessary for this function is not visible from outside. The interior is hollow, equipped with stairways and devices for its utilitarian functioning. The utilitarian factor is thus inserted within a representational framework to provide accessory details.

The *portrait* is a traditional framework type in the *representational* mode: it consists as a rule of an individual head (with face emphasized) and shoulders.

Other parts of the figure, costume, background, and accompanying objects are optional. Within this abstract conception, any particular portrait fills in accessory details, usually in such a way as to bring out peculiar traits of physiognomy and personality in addition to traits of sex, age, fashion, and (especially in aristocratic societies) of social class and wealth. They may be realistic or idealized. Such details are of the same compositional factor as the framework. But the portrait framework may be treated and filled with details in a nonrepresentational, thematic way. Certain features may be omitted or stylized to form a semiabstract design, carried out in the lines and colors of the costume and background.

Let us take for example a Persian miniature painting which contains a picture of a rug as if seen from above, with all of its pattern showing. It also shows a tile floor and a pool in the same way, while human figures and the wall of a house are seen from the side. In spite of these departures from realistic perspective, the parts combine to make a scene in space, with human figures against a background. The basic framework is representational. The accessory details are both representational and thematic, with design emphasized in the picture of a rug and other highly ornamental areas.

Then let us take for contrast an Indian rug containing many small details. Here the relation is reversed. Most of the individual details within the central field are representational: a hunter on horseback, an elephant, a small house, several trees and plants, and other animals. But they do not combine to make a concrete scene; instead, they are arranged as separate units in a comparatively flat design, surrounded by a nonrepresentational decorative border. There is no consistent viewpoint in the representation of details; no placing of one figure behind another; no gradation in scale; no continuity of represented action from one to another. The basic, general framework is *thematic*, forming a decorative pattern, while some of the details are representational. In some Persian rugs, on the other hand, the framework is representational in depicting a flat, highly stylized garden. They are usually symmetrical, vertically and bilaterally, as the gardens themselves were.

A painted landscape in Western style may contain much thematic detail, as in the similar outlines of curving trees, winding paths, hillsides, and clouds. Again the basic framework is representational, the accessories both representational and thematic. This relation is often reversed in printed textiles and wallpaper of the eighteenth and early nineteenth centu-

ries. A whole landscape in color, diminished from the ordinary size, is treated as a unit in a "repeat pattern." It is stated identically, again and again at uniform intervals, perhaps in alternation with one or two other motifs, such as portraits or grotesques as if in sculptural relief. Here the details are representational and thematic, the overall pattern thematic, including perhaps an alternating series of contrasting motif units, vertically and horizontally.

Musical representation is less common than visual, but even here different relations among the compositional factors can be found. We have already referred to Beethoven's Sixth (*Pastoral*) Symphony, whose general framework is thematic, but which introduces a mimetic representation of a storm at one point. Other passages in it may be taken as thematic or as representing country songs and dances.

By contrast, Richard Strauss's *A Hero's Life* is organized as a story throughout; it has a representational framework. With the aid of program notes, it dramatizes the life story of a hero: his early years, his early struggles against enemies, his tender, loving helpmate, his carping critics, his great battle, his victory and peaceful retirement. Within this framework, the composition is replete with thematic development, producing a musical design which could be grasped as such without reference to any dramatic meaning. Honegger's *Pacific 231* also has a representational framework: the starting of a locomotive, its full speed, and its gradual stopping.

The essay and treatise may be utilitarian as well as expository. Many are guides for doing or making something: how to wire a television set, or how to travel on foot through Brittany. If they are only this, they may not qualify as literary art, but some of them are developed also along aesthetic lines. Isaak Walton's *The Compleat Angler* was mentioned above as an example of such diversified composition. The framework is utilitarian: how to fish. But instead of sticking to that subject exclusively, the author often shifts to brief anecdotes and conversations in dramatic form (representational), to bits of verse (thematic word-sounds), and to expository bits on the values of life and numerous other topics only distantly related to fishing. No doubt some particular guidance in fishing is sacrificed for these digressions, but they help to give the work its compositional diversity and its status as literature.

Jonathan Swift's *A Modest Proposal* is mock-utilitarian, pretending to argue in defense of cannibalism as an economic and philanthropic measure. This hides another, sincerely utilitarian proposal: that something else be done to alleviate the misery of the poor.

Conversely, Thackeray's novels, such as *Vanity Fair*, have narrative, representational frameworks, but they often interrupt the story for expository digressions on general topics, such as London society and the qualities needed for getting ahead in it.

By such alternation and contrast, the author can build up a thematic sequence, regular or irregular. Thus Shakespeare often alternates scenes of action and dialogue, advancing the plot, with more static scenes of exposition, meditative soliloquy, or lyricism. The latter tend to slow up the action, relax tension, and avoid a premature denouement.

Thomas Gray's *Elegy Written in a Country Churchyard* is composed in rhymed quatrains which make a *thematic pattern in terms of word-sounds*. The meter is iambic pentameter, and alternate lines have end rhymes (abab). Each line is somewhat unique in its details of timbre and rhythm. Such a pattern gives one kind of thematic framework to the whole. If we take the word-sound pattern of the first quatrain as a complex theme in the auditory factor, all the others can be regarded as variations on that theme. They introduce different sets of suggested, auditory traits.

In addition to the series of word-sounds, there is one of *ideas*: of suggested meanings, images, and concepts over and above the auditory patterns of the verse. It begins as descriptive representation: the sights and sounds of twilight in the churchyard. But it soon shifts to exposition: "The paths of glory lead but to the grave." This is discussed for several stanzas, and near the end the method shifts again toward representation.

The series or pattern of ideas does not necessarily correspond exactly with that of word-sounds; in fact, it seldom does. That of word-sounds may be highly regular; the other, very irregular. Whether the arrangement of ideas is consistently representational (as in the *Iliad*), largely expository (as in Wordsworth's *Ode on the Intimations of Immortality*), or mixed and variable (as in Gray's *Elegy*), it may wander freely over the framework of metrical word-sounds as if on a trellis. Some conformity is usual between the various patterns which go to make up a total design, but not complete conformity.

Since compositional types overlap and vary considerably, it is not enough in morphological description to classify a work of art under only one of them. Not only do thousands of sonatas differ from each other within the conventional sonata allegro pattern, but that pattern itself has undergone much variation in respect to its major outlines. Beethoven treated the form of the sonata very freely, shifting slow and fast movements about, making unusual modulations,

changes of meter and tempo, and the like. A compositional framework is often a very tentative, flexible, preliminary conception, especially in the present age of radical experimentation. In Impressionism, the basic Western conception of a landscape changed radically, becoming more often blurred, soft, and shimmering, with indefinite shapes and distances half obscured in mist. Something was retained from the traditional concept of landscape—e.g., an imaginary view into outside space as through a window—but much was discarded, such as the emphasis on grand, parklike vistas. Here a style trend altered the basic representational framework-pattern.

It is not to be assumed that the framework is the most important part of a work of art, or that "accessories" are of minor importance because they are "conforming" or "subordinate." Either may be deemed more important in a particular case; but as a rule the conventional framework is the least original. After ten million armchairs have been made, there is no special achievement in merely making one more; it can be done in mass by mechanical reproduction. One looks for both utilitarian and decorative innovation rather in what the artist has done with and within this familiar pattern. Distinctive traits, and therefore room for differences in creativeness and value, are to be found in accessory development rather than in the general framework employed. Many of the greatest artists have been content to use a traditional framework type and to create within its limits. Sometimes, but not often, they create new frameworks too.

10. The compositional schema;
description of a particular work of art
in terms of compositional factors.

For describing the compositional schema of a particular work, these questions are relevant:

(a) What compositional factor or factors provide the basic and most comprehensive framework or frameworks? What is the schema of each, including its main parts and ways of combining them, as expressed in terms of component traits and frames of reference?

(b) Which compositional factor or factors provide the accessory details? Are they the ones which provide the framework or different ones? What is the schema of each?

(c) What are their principal interrelations, as of cooperation and reinforcement or conflict and divergence? Are they loosely or tightly integrated? Do important units function plurally, in two or more compositional factors at once?

Note: The following illustrations are particularly relevant to this chapter: Plates I, III, IV, VI; Figures 2, 3, 5, 8, 9, 10, 12, 13, 14, 15, 16, 19, 22, 23, 24, 26, 28, 30, 52, 53, 59, 60, 61, 62.

CHAPTER VIII

Historical
Aspects of the Modes
of Composition

1. Changing relations among the modes of composition. Differentiation and specialization in art and science.

There has been a persistent trend in art away from relatively *undifferentiated* types, containing at least the rudiments of two or more compositional factors in a single work, toward more *differentiated* ones, specializing on a single factor. This trend is part of the general process of cultural evolution, which includes both differentiation and reintegration. It is closely bound up with the tendency to increasing division of labor, along with increasing specialization of knowledge and technical skill.

That all branches of culture do not evolve at equal rates of speed is well known. Knowledge in the physical sciences and technology based upon it, as in engineering, medicine, agriculture, and war, have far outstripped the evolution of the arts and other humanities. One aspect of this cultural lag is that many relatively undifferentiated types of production still persist in the arts. These include types involving two, three, or four compositional factors in a single work of art, whereas such types in other areas of culture have shown a stronger tendency to divide into specialized forms.

The theory has been advanced of an undifferentiated primitive art, the religious dance drama with music, from which more specialized types of art emerged by subdivision. That theory is plausible, but we can not assume that *all* primitive arts and technics were contained in that undifferentiated type or in others of similar scope. It is probable that some comparatively specialized types of product (such as chipped stone points) existed from the beginning of culture, that a few diversified activities arose along with them, especially around important magico-religious

rituals, and that modern arts are descended from both kinds.

Ancient civilization made no clear separation between art, philosophy, and the beginnings of science. The work of Pythagoras and his followers combined mathematics, ethics, musical harmony, and mystical ritual. Hesiod's *Works and Days* is at once a handbook for the farmer and husbandman, a lyrical poem about nature and country life, a discussion of political and ethical questions, and advice on magic and religious observance. It contains myths and legends of the gods, some with expository meaning as in the myth of Pandora. It is developed along utilitarian, representational, expository, and thematic lines. Plato's dialogues are at the same time dramas (representational), philosophic (expository), and to a less extent utilitarian as guides to rational conduct, social and individual. Lucretius's *On the Nature of Things* is poetry, philosophy, and science. It has a double framework: thematic as to its verse form, expository as to its arrangement of ideas. These explain, in accordance with Roman Epicureanism, the nature and origin of the universe, the origin and nature of man and other animals, the psychology of sensation, emotion, and thought, social evolution, and the progress of the arts and other technics.

From the time of Aristotle on, there was a tendency to separate the sciences from art and from each other, but this was blocked by many obstacles, including the decline of science and rationalistic philosophy from the early Christian era to the Renaissance. The Renaissance produced some specialists in art, some in science, and some who combined these approaches, notably Alberti and Leonardo da Vinci.

Gradually, in succeeding centuries, *pure science* emerged as a specialized pursuit, devoted mainly to the discovery and exposition of knowledge and

theory. It developed rapidly along that line. *Applied science* and the technology based upon it followed another specialized course, devoted to utilitarian means and methods. To a large extent, both science and technology eliminated representational art and decorative design from their products. What had formerly seemed a rich, harmonious combination of these modes now came to seem a distracting encumbrance. Who today would call for tools, weapons, furniture, and houses to be heavily ornamented with human and animal figures? Who would write advanced scientific treatises in verse?

Later, the rise of the novel and short story in prose involved elimination of verse and hence of thematic word-sound frameworks. The epic, poetic drama, and other types combining representation with verse declined, leaving verse more limited to lyrics. The lyric remains comparatively undifferentiated, often combining a thematic word-sound framework with brief expository, representational, or utilitarian developments. Much musical development, on the other hand, has been almost wholly thematic. Along instrumental lines, freed from close attachment to verbal text, dance, or ritual, it has at times abandoned all its former utilitarian, representational, and expository functions. At the same time, the individual composer has been free to revive these traditional factors in his work when he felt so inclined.

Pure science today is, in certain respects, the cultural descendant of ancient expository art and of undifferentiated types combining exposition with other modes. Scientific *technology* is the descendant of primitive utilitarian technics. Pure science and technology have contributed to each other along the way. The utilitarian and expository factors in art, when developed more and more highly along specialized lines, tend to leave the domain of art almost entirely, abandoning nearly all attempts at aesthetic appeal. Even representation becomes at times a kind of scientific technology when the utmost accuracy is desired, as in the portrayal and description of a galaxy, an ultramicroscopic virus, or a criminal sought by the police.

Only thematic composition has, to date, shown little tendency to develop along scientific lines. Even here, there have been premonitions of such a tendency, as in the production of new musical and visual designs by scientific devices such as computers.

In recent centuries there has been a strong tendency for utilitarian composition to become more scientific, for technics and technology, such as those of medicine, to abandon their ancient magical and religious devices, and rely more wholly on the naturalistic ones of applied science. In so doing, they depend less upon the arts as utilitarian devices. Some kinds of representation also follow this course, as in medical and mechanical illustration and diagramming. Exposition, as it develops intellectually, has a tendency to become pure science or philosophy and to abandon the attempt at aesthetic or literary appeal.

These trends away from art in the various modes of composition are not complete, however. All four modes retain one foot in art, though reaching over the border into science. Medicine is still an art when applied to plastic surgery for improving a person's appearance. Philosophic and scientific exposition is still written at times in literary prose with aesthetic appeal. An automobile is a work of utilitarian art, aimed at both utility and beauty.

2. Reintegration in the arts. Continued spcialization and elimination.

What of reintegration? Is the differentiating, specializing tendency in complete control? No; opposing tendencies are still at work. There are many different kinds of reintegration. One is that between different arts, as is the case in opera or the color sound film. This is a combination of different arts and techniques in a framework of dramatic representation. Another is between different modes of composition. When music is active throughout, as in opera, it provides an auditory thematic framework, running parallel to the story of the drama and more or less integrated with it. In some operas, especially those of Italy through Verdi and Puccini, the emphasis on melodic design is strong and makes the music somewhat independent, in the sense that it can stand on its own feet without words or dramatic action. In the Wagnerian opera, music becomes more intimately fused with plot and characterization to support the representational framework. It retains a strong thematic structure of its own, however.

The tendency to reintegrate modes of composition is evident in twentieth-century "functional" design, especially of utilitarian, industrial form types which also appeal to aesthetic taste. These are found in clothing for men, women, and children, in architecture and interior design, furniture, utensils, in accessories such as telephones, vacuum cleaners, kitchen and bathroom fixtures, typewriters, radio and television sets, and in vehicles intended for personal use.

Women's taste plays an important part in making their decorative development profitable. In the nineteenth century, the industrial revolution led to a temporary dislocation between the engineering (utilitarian) factors in production and the aesthetic ones. The latter often diverged into separate bypaths of elaborate, cumbersome ornamentation, as in Victorian upper-class homes and costumes. In the twentieth century, manufacturers have found it profitable to bring the engineers and artists closer together in designing products which will be acceptable from both points of view.

The decorative (thematic) element in such products is now mostly nonrepresentational. To make an object visually attractive it is no longer considered necessary (as it often was in the Renaissance) to cover it with pictorial or sculptural representations of humans, animals, flowers, landscapes, gods and goddesses, cherubs, or grotesque figures. This means that only the utilitarian and decorative factors are reintegrated; the representational is largely omitted. The decoration is often comparatively simple, relying on the functional framework for its basis and stressing large areas of plain color and simple shape, though using elaborate designs for sportswear and festive occasions. The juxtaposition of differently colored and textured objects in a room allows the occupant to form as complex and unified a design around him as he wishes.

The history of painting since the Renaissance displays a more persistent tendency to specialization and elimination. From early Christian times, through the Middle Ages and well on into the seventeenth century, both painting and sculpture had been loaded with symbolic meanings, mostly organized along expository lines to set forth the principles of Christian belief. This expository content was held in literature also, as in Dante's *Divine Comedy,* and in architecture and decorative art, as in the cathedral and its complex windows. After the Council of Trent the tendency to proliferate allegorical meanings was discouraged and gradually declined, giving way to a more straightforward, undistracted interest in the representation of man and nature. Exposition flourished along scientific lines, as in the work of Galileo and Copernicus. To a large extent it moved away from art, with the exception of a few brilliant essayists such as Montaigne, Bacon, and Diderot. Painting retained a strong interest in both representational and thematic development, as in the monumental landscapes and figure compositions of Poussin, Rubens, and Vermeer.

In the last half of the nineteenth century painting became somewhat more naturalistic in eliminating artificial, formal patterns. It often sought for casual, intimate views of nature, as in the works of Courbet and the Impressionists. This involved some decline in thematic complexity, but it was balanced by the new use of vigorous coloring. In Cézanne, Renoir, and Seurat, pictorial form rose again with the aid of color, to complex, monumental heights. Some of the Post-Impressionists, such as Matisse and Picasso, used bright, flat color to build new kinds of unrealistic design. But once the trend of painting toward elimination had begun, it moved irresistibly on. The late nineteenth-century style leaders were satisfied with eliminating most of the story interest from pictorial representation, substituting still life subjects and local, everyday scenes devoid of strongly romantic or dramatic associations. This placed the burden of positive appeal more exclusively on visual form and on the thematic factor.

Avant-garde painting carried the trend to extremes in the twentieth century by eliminating all or nearly all representation. In the generation of Kandinsky and Mondrian nonrepresentational painting found its own line of development, which was mainly thematic at first. Later it emphasized the expression of impulse and mood.

A distinction was made, but not universally accepted, between "abstract" and "nonobjective" painting. Both were practiced by Kandinsky. The former began with some representational image and eliminated more and more of its details until nothing recognizable as such remained. The latter began with no representational starting point at all, but manipulated lines, colors, and other components for their purely visual and expressive qualities, as a sort of frozen music. As the twentieth century wore on, many abstract painters and sculptors proceeded to eliminate design and thematic development also, leaving only simple areas and impromptu brush strokes. The reaction against complex form was strong in drama as well as in painting and sculpture.

An extremely simple form can suggest or express some sort of feeling or affective attitude—e.g., an irregular brush stroke or splash of paint applied by sudden impulse, apparently without plan or purpose. As such, it may not fully exemplify any of the four modes of composition, but it will inevitably contain the germs or rudiments of one or more. If the artist decides to complicate it by adding another line or spot, or by extending the one he started with, he will tend to produce a simple thematic series. Whether he wishes to or not, his work may also hint at some

resemblance to outside objects, such as a cloud or vine, and thus make a step toward representation.

The modes of composition are ways of developing more or less complex forms in some artistic medium. Extremely simple, abstract forms, such as a single straight line on a canvas or a single word or bell tone, involve comparatively little composition. Such works, approaching the ultimate stage of elimination and simplification, are common in contemporary art. Many of the characteristics of highly developed form in past and present art do not appear in them.[1]

Returning to the history of poetry after Dante and Milton, we can observe the increasing tendency in that medium also, to minimize exposition and representation. Both are still strong in the poetry of Browning and Tennyson, Whitman and Baudelaire. But in the twentieth century poetry tends to focus on short lyrics, especially those with a subjective, personal approach. Mallarmé tried to eliminate much of their usual, objective content. Now little narrative or drama is written in verse, much in prose. Fiction and drama continue to foster exposition and representation.

The emphasis on elimination is strong in contemporary writings on art, sometimes even as if there were a virtue in merely leaving out. Indeed, more than one artist has tried the experiment of painting or writing with a blank canvas or an empty sheet of paper as the final result. But it should not be supposed that, when something is eliminated from one art or group of arts, it is lost to art and civilization forever. In the first place, the elimination may be only temporary; styles have a way of bounding back to a previous extreme or to some place between the two. In the second place, what is rejected by one art may be welcomed and fostered by another. Realistic pictorial representation, rejected by avant-garde painting, has persisted in dominating the cinema. It includes the perennial components of plot, characterization, dialogue, pantomime, and setting, in addition to new contributions of its own. Abstraction has made little headway there so far.

Meanwhile, expository pictorial representation has continued along certain lines which were favored by Leonardo and by the anonymous illustrators of ancient texts on plants and animals. It tries to explain, not the supernatural world, but nature and man. It often serves science. To draw and color an anatomical or medical illustration or to illustrate a text on botany, with little or no attempt at aesthetic appeal, would probably not be classed today as "art," but as science or technology. Unintentionally, it might qualify as art in some respects. Anyone is free, of course, to pick out an example of it and admire it as beautiful, but that is not its main intent or function today. The same can be said of production illustration, which aids in the manufacture and assembly of complex mechanisms (such as airplanes) by diagrams, three-dimensional drawings, and transparencies. It is both representational and utilitarian. Educators in every field sometimes find a pictorial illustration useful along with verbal exposition, to help convey a difficult, abstract idea. The cinema is also widely used for expository purposes in education. All these phenomena illustrate the way in which a certain kind of composition, formerly accepted in the realm of art, can be rejected by that field but hospitably welcomed elsewhere, especially in science and technology.

By contrast with science, which now specializes on exposition and utility, the realm of art is much more diversified. It perpetuates many undifferentiated, multipurpose types which try to satisfy different needs and interests at the same time. It also perpetuates a tendency to personal, emotional, subjective, and often mystical kinds of thinking, of a kind which science tries to eliminate from its own work. But the opposite, more rationalistic type of thinking is also widespread in the arts today, especially in literature and drama.

3. Technics and technology in art and science. The role of aesthetics.

The meaning of "technics" and "technology," as used in the social sciences, is often misunderstood. A *technic* is a skill or skilled activity, including the necessary tools, the ability to use and perhaps to make them, and the ability to transmit them to successive generations. As broadly conceived, technics include, not only material tools and processes, but psychosocial ones also, such as laws, economic processes, educational and psychiatric methods. The arts are also a kind of psychosocial technic, or rather a large group of different technics, which have in common the function of stimulating and guiding satisfactory aesthetic experience.

[1] See, for example, the account of "minimal art" in Gregory Battcock's book of that name (New York, 1968). The frontispiece is Ad Reinhardt's painting "Untitled," a uniformly black rectangle. Sculpture follows analogous lines when reduced to a simple geometrical shape such as a cube or cylinder.

One kind of art, or factor in art, is also adapted to serve as an instrument in some sort of overt action, as a means of achieving nonaesthetic ends. This is utilitarian art. It differs from other kinds of utilitarian technic which do not have an aesthetic form and function. Some of the devices and procedures of magic and religion, as we have seen, can be classed as utilitarian in that they are attempted means of achieving earthly ends such as victory in war and success in hunting or agriculture.

Not all the technics of art are utilitarian. Each of the compositional modes has its own changing set of methods and devices. They all use the technics of exact science at times; there is a chemistry of paints and a mathematics of architecture. Notation is a technic of music. Each instrument, including the voice, has its own special technics. Versification is a technic of poetry. All the factors in art which were described in the chapter on developed components can function as technics from the artist's point of view.

Technology is generalized knowledge and theory dealing with technics. It consists of rules, maxims, and prescriptions as to how to perform some kind of technical process successfully. These rules are, at various times, based on magic, religion, natural science, or a combination of these activities and world views. Technology is organized and subdivided with reference to different realms of activity, such as medicine and law, and to the kinds of method and device employed therein.

Homo sapiens has always had some kind of technic, so far as we know. Even Neanderthal man had fire. Chipping flint into various kinds of tool involved considerable skill. But technology, as a more rationalized, conceptual process of generalizing on past experience, must have come much later. At first the two were hardly distinguishable. But gradually, through language and demonstration, man learned how to explain to the young certain fundamental technics for survival. He learned to do so in a systematic way, as a set of customary methods for dealing with the recurrent needs and emergencies of life. He could explain how to shoot an arrow at a deer, and how to aim at a vulnerable spot. Women taught girls how to gather wild food and to prepare meat for eating.

Science did not originate technics or technology, but has transformed them radically. The arts are technics which, on the whole, applied science has not radically altered so far except in a few complex industries such as architecture and cinema. Each art has its own technology; musical composition, prosody, and color harmony all have theoretical aspects. These are derived in part from prescientific tradition, but have been influenced and developed by scientific thinking.

Aesthetics includes a highly generalized study of certain aspects of artistic technology. It is concerned not so much with details of practice as with aims and methods in general. The trend toward science in aesthetics has been strongly resisted by the various antirationalistic movements of the nineteenth and twentieth centuries, especially Romanticism, but has made some progress. That trend does not necessarily involve logical proofs or exact measurements. It does involve an attempt to think out the ends, means, and values of art, in general and in particular cases.

4. Magic, religion, and naturalism as related to the modes of composition. Their different conceptions of reality.

In previous chapters we have noted how particular traits and types of art express, and are causally related to, different conceptions of reality. Here we shall observe some general, historical relations between conceptions of reality and modes of composition in art.

It is not the business of aesthetic morphology to study in detail the historical environments of art or to explain historic changes in style, but some reference to these is useful in explaining the varieties of form. Some knowledge of the cultural context is especially necessary in interpreting symbols, which are often highly ambiguous when viewed in isolation. Cultural contexts are also significant parts of the provenance of styles. They help determine the basic conceptions of historic styles in all the arts.

One's conception of reality, whether passively accepted from tradition or explicitly reasoned out in philosophy, tends to affect one's attitudes toward art. It often finds expression through the modes of composition. If one is setting out to control something with the aid of art, as in the utilitarian mode, it makes a great deal of difference whether one believes that human and natural phenomena are controlled by minor spirits, powerful deities, or constant physical processes describable in terms of regular laws. Whether one's aim is to cure a disease, to win a battle, or insure a bountiful harvest, one tends to adopt methods accordingly, by magic, prayer, or material technics, or perhaps by all of these together.

In viewing representational art it may make a great difference whether one believes in the reality of spir-

its, and, if so, whether one conceives of them as anthropomorphic or theriomorphic, as monstrous and terrible or benign. The stories one tells, the pictures and statues one creates, will tend to express one's conception of the reality behind everyday phenomena, and of what follows the death of the body.

In expository art likewise, a belief in supernaturalism will lead to attempts at setting forth the nature of the spirit world and its relation to man on earth. Theories of creation and seasonal myths, symbols of the gods and metaphysical doctrines—all will be called upon to explain reality as it is understood to be.

Thematic design and decoration will often be lavished on those objects and ideas which seem to be most important in the light of these conceptions of reality. Ornate temples and ecclesiastical vestments often occupy such a high status. If one believes that the physical universe and the present life are the only realities, one will tend to direct one's attention, desire, and fantasy toward things of this world. All of these tendencies, of course, are subject to exception, and countless intermediate paths lie open.

An important distinction between magic and religion was made by James Frazer in *The Golden Bough. Magic* implies a belief in the power of humans, or of some specially gifted humans, to control the spirits or hidden forces behind phenomena, and thus to achieve one's desires. It implies that the spirits are relatively weak, though usually stronger than man, and that they can sometimes be controlled by humans who possess the secret knowledge, spell, charm, amulet, wand, spoken formula, or other necessary means. These are magical technics, usually employed for utilitarian ends. As in the *Arabian Nights*, a particular object such as Aladdin's lamp may give control over a particular jinn or spirit, good or bad. Magical power is thought to be innate in some individuals. The magical command may be directed toward a spirit, as in expelling demons, or toward natural phenomena directly, as in telling the rain to fall.

Religion, in Frazer's sense, implies a belief in more powerful spirits, good or bad, which can not be controlled by humans. Toward these, as toward a powerful earthly ruler, humans must adopt an attitude of pleading and propitiation, so as to induce the great spirit or spirits to grant one's desires. As in dealing with any great noble, humble people often ask the aid of an intercessor, such as a priest or the soul of some deceased holy person, to plead on their behalf.

Both magic and religion involve supernaturalism, as a belief and as a way of trying to achieve one's ends. They involve a belief in supernatural or preternatural beings behind phenomena, who must be dealt with somehow to achieve success in earthly desires. Magic and religion involve many traits beside the ones just mentioned. They are not merely ways of achieving one's earthly desires, but this is the trait that concerns us most at present.

Magic, religion, and naturalism are not three distinct, successive cultural stages. They have coexisted to some extent throughout human history, although they rose to power in the order named. It is more accurate to speak, in the present discussion, of three different types of *technic and technology*. Where magic relies especially on spells, charms, amulets and the like, religion often relies on temples and churches, hymns and rituals of worship, prayers and sacraments, statues and paintings, gold and jeweled reliquaries.

When these are persistently made or performed by social groups for utilitarian ends they are a kind of utilitarian technic. They are artistic insofar as they are adapted to serve as objects of aesthetic perception by spirits or humans. Their aesthetic and utilitarian functions are sometimes evident in the product itself, as in written spells and prayers. In the magical spells, these may be explicit formulas of command, to be accompanied by specified actions; in the prayers, they tend to be humble requests. Either may express a desire for good hunting, rain and plentiful crops, healthy offspring, victory in war, or the like.

Organized magical practices appear to be at least as old as the paleolithic cave drawings and sculptures of animals in Southern France and Spain. These are said to have been intended as means of insuring success in hunting. Thus magic apparently arose within the hunting hordes and prehistoric villages before the time of agriculture and of strong, stable rulers. Power was gradually vested in petty chiefs, shamans, and councils of elders, who could be overthrown with comparative ease.

There is also evidence of a prehistoric belief in future life and other beginnings of religion, as in burying a chief's weapons with him. But the radical change in attitude and approach to which Frazer refers was apparently connected with the formation of larger social and political units, by conquest or otherwise. It was associated with the emergence of moderately powerful kings, long before the first dynasties of Egypt and Sumeria. Throughout the world this political change from magic to religion was slow and gradual; the two are usually blended to some extent in primitive cultures and on the lower educational levels of advanced cultures. Aspects of both magic and reli-

gion can be discerned in the use of totem poles, cere-
monial masks, decorated ancestral skulls and sculp-
tured fetishes. Magic in a simple form occurs when
someone makes a small clay figure of an enemy for
symbolic destruction, then sticks pins in it or burns
it. It occurs when someone drives nails in a wooden
fetish figure to remind the local spirit of one's de-
mands, and then hurls it on the rubbish pile if disap-
pointed. The art involved in these actions may be
very simple indeed. Many modern superstitions, such
as the belief in lucky numbers, are survivals of magic.

The *myth,* as in Persephone's annual capture and
detention in the lower realm and subsequent release,
is a persistent compositional type involving three or
four modes of composition. Its basic framework is
representational, a story, but it may have expository
significance in explaining seasonal phenomena. Its en-
actment is partly utilitarian, as a means of influencing
these phenomena for the benefit of man. Any partic-
ular representation of it may involve thematic embel-
lishment. Ritual dramas with hymns and dances, such
as those of prehistoric Greece and Rome, are a mix-
ture of magic and religion. In acting out the death
and rebirth of the sun and other gods each year, they
are intended to help make the sun actually return;
thus they involve some imitative magic even though
dealing with powerful gods.

Representational art produced for magical pur-
poses is usually not very realistic. The Lascaux cave
drawings of animals surprised the world with their
vivid depiction of anatomy and movement, but they
are still exceptional. Often the magical representation
of a spirit is highly stylized. This is not necessarily
due to any lack of technical ability. It may have been
due to fear of the realistic figure or to a general ten-
dency toward abstract, decorative symbolism. In any
case, realism was usually not considered necessary for
magical purposes.

The belief in magic still holds a footing throughout
the earth, especially among comparatively unedu-
cated people. But religion arose after magic on the
whole and has usually tended to drive it out or absorb
it. Ikons, amulets, rites, and sacraments administered
by humans can be supposed to have a direct, apo-
tropaic effect on evil spirits, though deriving their
beneficent powers ultimately from the great gods,
who may delegate some of their powers to minor
priest-magicians. Religion has usually but not always
continued the process, begun in magic, of delegating
the chief responsibility for dealing with spirits,
whether by command or inducement, to specialists in
such matters. The aid of Christian priests, with cross

and holy water, was often invoked to drive out de-
mons from the sick and insane.

Few if any social groups have relied entirely on
either magic or religion to sustain life and satisfy
earthly desires. If any have done so, they have prob-
ably not survived long. Throughout their evolution,
humans and their animal ancestors have relied to
some extent on *naturalistic* methods, which grew di-
rectly out of prehuman modes of getting food,
warmth, and shelter, defending oneself and family,
and attacking enemies. Those methods which survived
and developed, such as chipping flints, methods
which have been transmitted as acquired skills to later
generations, are naturalistic technics. Some of these
developed into utilitarian arts and, later, applied sci-
ence. The technology of science tends to replace both
magic and religion as the principal way of seeking to
control phenomena so as to satisfy earthly desires,
individual and social.

Naturalism as a kind of primitive technic means,
simply, trying to satisfy one's desires through directly
controlling the perceptible phenomena of nature and
human nature, as in hunting or agriculture, as con-
trasted with working through the supposed medium
of incorporeal spirits. In primitive cultures, naturalis-
tic technics are frequently accompanied by magical
and religious practices, on the assumption that they
reinforce each other.

The technics of modern applied science are natural-
istic in that, not assuming the existence of spirits,
weak or strong, they do not find it necessary to deal
with spirits in order to control phenomena. They pro-
ceed more directly to deal with the phenomena them-
selves—e.g., food, enemies, disease, care of children,
social customs—with tools and methods derived from
an empirical study of causes and effects within the
realm of nature. Examples of naturalistic utilitarian
technics are the bow and arrow, the plow, the sword,
printing, machinery, sailing ships, steam engines, sci-
entific agriculture and animal breeding, medicine,
law, public education, and the use of atomic energy
in peace and war. Some of these, such as printing,
may involve an aesthetic factor and thus qualify as
utilitarian art.

Not until the time of Epicurus is naturalism ex-
pressed as a reasoned philosophy of life, including a
disbelief in incorporeal spirits. The Epicureans be-
lieved in gods, but held them to be made of atoms
and to be uninterested in human affairs. Hence there
was no use in trying to control earthly phenomena by
efforts to coerce or persuade the gods, through art or
otherwise. Not believing in Heaven or Nirvana, philo-

sophic naturalists did not claim that they could help one achieve it after death.

The philosophical developments of all three world views are relatively modern. Magic was elaborately developed in sixteenth- and seventeenth-century Europe into what we now call a pseudoscience. But in prehistoric times all three existed in more or less rudimentary form, not so much in reasoned theories as in unanalyzed customs, emotional attitudes, and inherited patterns of behavior. The three methods are not radically inconsistent in practice, though they may be in theory. People do something for themselves in a naturalistic way, such as putting first wine and then olive oil on a wound, while at the same time uttering a magic spell and a prayer to the gods for recovery. This combination was used in ancient Egypt by the followers of Imhotep. As religious technics developed greatly at the expense of magic in early and medieval civilization, those of science developed at the expense of both after the revival of science in the Renaissance. Modern naturalism is based on science. It is also connected with the rise of the middle class and of democracy and liberalism in the eighteenth and nineteenth centuries.

The three types of method imply different beliefs about the nature of reality, as to the kinds of force or agency which govern events and conditions in the world. Religion tends to explain the universe in terms of one or a few powerful gods, with or without minor spirits such as angels. One god such as Brahma or one race of gods such as the Olympians may be in complete control, or different ones may be engaged in perpetual struggle, as in Zoroastrianism. Religion does not necessarily deny the existence of minor spirits or even insist that they are under complete control of the higher gods. Some are conceived as rebellious, wandering demons, banshees, trolls, or malicious ghosts, against whom either magic, religion, or both may be the best protection.

Naturalistic technology, as developed by applied science, is analogous to magic in one respect: that is, in assuming that man can at times directly control the hidden forces behind phenomena. But they differ essentially in that science has learned ways of testing its methods experimentally to improve them and eliminate the unsuccessful, and also ways of discovering new facts and thus constantly increasing its knowledge and power. Applied science bases its attempts at control on generalized knowledge and theory about the facts and persistent tendencies of nature, including human nature.

Being convinced by experience that no verbal incantation or prayer can transform lead into gold or a frog into a prince, naturalistic technology ceases to try. Later, science finds out why such miracles are impossible. In magic and religion, an unsuccessful method can persist almost unchanged indefinitely, being relatively unaffected by failure in practice. Success is taken as confirmation of its fundamental rightness, whereas failure is taken as a sign that one made some mistake in executing the formula, committed some sin, or offended some god. Innumerable failures do not necessarily accumulate into evidence against the supernaturalistic approach, although they have done so when a primitive culture was beginning to disintegrate in competition with science. More often, when one religion fails, its adherents turn to another, as from Baal to Jehovah. The manifest superiority of naturalistic technics in war, locomotion, and machinery tends to force their acceptance, and in some cases to force an abandonment of supernaturalism. But that does not necessarily follow; they can persist on different levels of thought in the same individual. A North American Indian can manage a motorboat with skill and use the white man's medicine while still invoking the shaman's magic at other times.

All three types of method can motivate artistic production in various media, but they do not always do so. Each tends to foster certain attitudes which may influence the kind of art produced, but this is subject to wide variation.

Magic is, on the whole, less strongly inclined than religion to develop costly, difficult, complex kinds of art. Often it employs no art at all. One reason is that it does not assume the need of pleasing weak spirits by the means which art can provide. It often places great reliance on natural objects and regards them with intense emotion—such things as oddly-shaped stones or pieces of lava. The shaman's kit of magical implements may contain nothing but a few bits of shell, gravel, dried snakeskins and other animal parts, hair and nail clippings, and the like.

Any person, however ugly and stupid, any locality, plant, or animal may become the abode of *mana* or supernatural power for a short time or indefinitely, and thus have enormous potentiality for good or ill. Some mana is positive, some negative. The belief called animism, commonly associated with magic, imagines humanlike attitudes, benign or malevolent, in many kinds of natural phenomena. A boulder, rolling down hill and killing a man, may have done so intentionally. The dances, chants, and gestures of the shaman are often extremely simple and undeveloped, from the standpoint of civilized art, but this is not

supposed to affect their magic power. Mana is usually conceived as impersonal, though perhaps capable of assuming human, animal, or monstrous form at times. In any case, it is not easily represented or described. Primitive peoples are often afraid of wild, ungoverned, uncontrolled spirits in the world about them, which may be antagonized and turned against one for violating a taboo. Some tribes forbid their women to make representational art, such as humanlike figures on a bowl or blanket, for fear that these might come to life and be malevolent. Cultures dominated by the magical attitude lack the stimulus of believing that the gods will be pleased and influenced by artistic excellence, or that the minor spirits with which they deal can be coerced or influenced by it.

Magic usually flourishes mostly in primitive groups living on the hunting, pastoral, or agricultural village level. These are primarily nomadic or seminomadic, though sometimes remaining a long time in one place. Even in the sedentary village they are somewhat unstable from generation to generation. Such peoples usually cannot build large, heavy, monumental types of art such as temples and statues of stone or metal. Writing was invented in the neolithic stage, but tales of magic were long transmitted orally. From the age of magic we find many small, portable objects finely finished, such as stylized stone and wood sculptures of animals (often totemic), ceremonial arts of personal adornment such as painting and tattooing, masks, and costumes for transforming the normal personality. These, in addition to rhythmic drum beats and group dances, are used to bring about a trance condition in which adepts commune with dreaded spirits of ancestors and totem animals.

On the primitive level, neither magic nor religion finds expression in expository art to any notable extent, but this is due to the lack or scarcity of abstract terms and intellectual concepts rather than to supernaturalism itself. Both magic and religion achieve complex exposition in advanced civilizations, often hand in hand when their adherents see no conflict between the two.

As late as the seventeenth century, erudite and massive tomes were published on alchemy, astrology, cabalism, chiromancy, necromancy, and other so-called occult arts. (Here "art" means "useful skill.") They combined exposition with utilitarian technics. It is an oversimplification to call these subjects "pseudosciences," although their technics and assumptions were mostly false. They were rather a transitional stage from magic and primitive religion to natural science, a transition long delayed by surviving elements of mysticism and folklore. They involved ingenious combinations of mystical philosophy with bits of prescientific observation, especially regarding the planets and chemical elements. The results were occasionally expressed in pictorial and poetic form, as in the strange books of Robert Fludd, Paracelsus, Nostradamus, and others. The essence of magic persists in the long attempt to control natural phenomena directly for utilitarian ends such as turning baser metals into gold, finding the universal solvent and the elixir of youth, predicting and guiding human events by the position of heavenly bodies at the time of one's birth, choosing a propitious date for enterprises, and calling up spirits of the dead. In such highly developed magic, elements of Neoplatonic philosophy and of Roman, Jewish, and Christian religion were mixed with diabolism, witchcraft, and the black mass. The North European tradition of magic and diabolism found expression in the Faust legend as treated by Marlowe, Goethe, and others. (This is not magical art, but art representing magical practices.)

Religion has been far more productive than magic as a stimulus to the arts, including all four modes of composition. One reason for its favorable attitude toward art is its assumption that the best way to gain important ends in this life and the next is to ask the gods for them. To get them one must please or propitiate the gods. No one can be quite sure of what will please a particular deity, but it is commonly assumed that whatever pleases earthly potentates will also please the gods. This opens the door to attempts at doing so by means of art. No other cultural factor has equaled religion as a stimulus to artistic production and performance. It has provided a strong motivation for artistic efforts and inspiring subject matter for creative representation.

Yet one must not suppose that religion is always favorable to art. That depends on one's conception of the gods and of their probable desires and interests. Such conceptions vary according to the general cultural level. Some people have supposed that the gods would be most delighted with cruel human or animal sacrifices, with the scent of roasting flesh ascending to their nostrils, or with bloody self-mutilation. At other times and places the hermit's life of prayer and poverty, far from art and other amenities, relying on manna from heaven for daily sustenance, was considered the best path to divine favor. Most of the world's great religions have gone through periods of asceticism and iconoclasm, wherein all art was condemned as wasteful, sensual, a provocation to crime and war. Both religious and secular leaders have warned their people against selfish requests and mercenary offerings to the gods. "Bring no more vain oblations," said

Isaiah. Prayer and worship, it was said, should be an unselfish outpouring of the heart in thanks for blessings already given, a loving communion with Deity and an expression of obedience and repentance for past sins and shortcomings. If the worshipper was to ask for anything, it should be forgiveness and spiritual enlightenment. But splendid gifts to God and church were often accompanied by requests for tangible benefits. At the same time, practical men kept up their efforts at success by naturalistic means as well. "Put your trust in God," said Cromwell, "but mind to keep your powder dry." Voltaire added that God is always on the side of the heaviest battalions. Even when religious faith and zeal were at their height, men did not rely entirely on artistic tributes to the gods as means of gaining their ends.

Likewise, it must not be supposed that hopes of divine favor were the only, or always the main incentive to art. From prehistoric times, no doubt, some individuals enjoyed making art, and many more enjoyed perceiving it, enough to motivate some amount of art production. But certainly the hope of divine rewards in this life or the next has been an added, strong incentive. Just as ulterior aims in giving gifts to humans are often concealed for fear of seeming too mercenary, so the selfish element in religious giving and sacrificing may be hidden by a mask of piety. One can only speculate on what the quantity and quality of art would have been without this motive. The historical fact is clear that most of the world's art which is recognized as great has had some religious orientation.

In some of the most highly developed religious art of the past a utilitarian motive is not explicitly avowed, but can be reasonably inferred from the cultural context; for example, in the architecture of Luxor, Borobudur, Angkor Vat, the Parthenon, and Chartres. In relying on art as a kind of utilitarian technic, religion assumes that the world is controlled by a personal spirit or spirits who can think and feel somewhat as humans do, though on a much higher plane. Such beings, it is hoped, can appreciate and reward fine achievements in art and the sacrifice of wealth, time, and labor required to make them. Advanced religion thus tends to assume a high level of aesthetic taste and discrimination on the part of the controlling spirits, along with a generous attitude in rewarding artistic merit. Even the solitary tumbling of a little, hunchback juggler could please the Queen of Heaven if offered as the best gift of his art.

As a stimulus to representation, religion provides subject-matter of unparalleled richness for the artistic imagination to work upon: the host of gods, goddesses, devils, demigods, satyrs, nymphs, and monsters, vaguely conceived by primitive poets and portrayed in visible form by successive generations of artists; the scenes of heaven and hell, creation and temptation, sin and redemption, incarnation in human form, and all the colorful iconography of advanced religion, accepted not merely as beautiful and glamorous, but as profoundly important in determining man's destiny. Polytheism is more inspiring to the representational artist than absolute monotheism, because its conceptions are more easily visualized and understood in human terms. Monotheism, as conceived by the metaphysicians, tends to become too abstract and impersonal for ordinary humans to understand, communicate with, or represent in art. Christian artists, from those of the Catacombs through Giotto and Dante, were dissatisfied with a purely impersonal, abstract monotheism or pantheism. They helped to create a new pantheon from the saints, angels, archangels, the Holy Family, and the Holy Trinity, which partly compensated for the lack of minor gods explicitly recognized as such. Dante even provided a colorful hierarchy among devils, imps, fallen angels, and spirits of the damned.

In principle, the artist was not to claim the credit for "creating" his work, which came from God, but only to do the best he could with the gifts and opportunities Providence had given him. But in fact, from the Renaissance onward, the artist was increasingly praised or blamed as creator of the work. He was given increasing freedom, subject to his patron's wishes, to treat traditional religious subjects in new ways.

Wherever an accepted body of religious belief provided some stability and continuity of thought, philosophic exposition became more systematic. With St. Thomas Aquinas, such exposition made great advances, including a combination of Christian and Aristotelian principles: the former for spiritual matters, the latter for temporal. The theoretical content of advanced religions was expressed in words by philosophers and by some literary artists such as Dante. In visual art it was expressed by the sculptors, book illuminators, stained glass makers, tapestry weavers, and other medieval artists who transformed abstract theology into visual iconography and decorative design. They preserved much of its expository content in the form of complex visual symbolism expounding Christian theology, eschatology, sacred history, metaphysics, and ethics. In the hands of secular philosophers such as Descartes, Christian philosophy became increasingly rational, logical, and friendly toward mathematical and physical science.

As a stimulus to thematic, decorative composition, religion has so far exceeded magic that no detailed comparison is necessary. To some extent, the lack of great surviving works of art inspired by magic is due to the suppression of irreligious magic by the church. To some extent it is also due to the fact that magical technics were mostly temporal and ephemeral, consisting of spoken or chanted spells and ritual gestures. But there are more fundamental reasons.

What kinds of culture and social situation favor a high development of complex decorative art? Such development tends to occur intensively at focal points in the cultural scene and its activities, where strongly cherished values are located or symbolized. It occurs in and around images or objects with concentrated emotive power: images regarded with special veneration, awe, hope, fear, or pride, and which therefore constitute crucial symbols and epitomes of the value system of their culture. For the Christian Middle Ages, images inviting decorative enrichment were provided by the figure of Christ and his associates at various stages of his career, and especially by the crucifix, regarded as a holy ikon with thaumaturgic powers, by the altar and the church around it, and especially by Rome, regarded as center of the church (although the Holy Land might have rivaled it if the Crusades had succeeded). Minor focal points were provided by relics of the saints and by hand-made copies of the Scriptures and other religious writings, ornately decorated. These were housed, when possible, in finely executed covers, resplendent in gold and gems. Buddhism too has its gorgeous housings for the relics of Gautama.

European culture from the Middle Ages through the Baroque period developed an unsteady alliance between church and state and a double hierarchy of sacred and secular power. The secular hierarchy cherished the castle, palace, and city hall, the coat of arms, richly decorated armor and weapons for man and horse, luxurious furniture, garden art, court costumes, and jewelry for men and women. These could indicate high status, amounting at times to that divinity which "doth hedge a king." Great inequality of wealth and power, as in feudalism and absolute monarchy, has favored the intensive development of decorative art by and for the privileged classes. It is often concentrated on the types of status symbol just mentioned, in addition to magnificent entertainments in the form of music, dance, and pageantry.

Where wealth and power are more diffused, as in a modern democracy, there is a tendency to diffuse and level the arts of decoration. Cheap, standardized products are made available to all at low cost by sci-

entific technology, and there is much resistance to concentrated expenditures for private enjoyment. Public institutions and vehicles of locomotion are favorite areas for enrichment through visual design, but democratic culture tends to be less strongly focused in this respect.

Primitive magic has its focal points, its objects, places, persons, and actions which are taboo and strongly endowed with mana, friendly or hostile. But as a rule they are ephemeral, because primitive culture usually lacks the stability and continuity of urban civilization and because small social units, weakly governed, do not as readily come to a focus by projecting concentrated emotional attitudes upon a certain image, place, or action. Modern magic has, in the Western world, usually been condemned and attacked by the church or confined to the rural areas and lower classes of society. What religion can do in ornamenting its focal points is exemplified by the temples at Delphi, where the Greek city-states were able for a while to suspend their chronic quarrels and join in worshipping the same gods with magnificent arts and rituals.

5. Varieties of naturalism in art.

What of naturalism as a stimulus to the arts and to various modes of composition? It was mentioned above that naturalistic technics are not new. Throughout human history, and indeed throughout organic evolution, man and his ancestors have depended in part on such methods for survival. In coming to believe in spirits and in trying to coerce or persuade them by magic or religious art, man did not cease employing naturalistic methods also. All art involves some naturalistic technics, at least to the extent of employing a physical medium, perceptible by one of the senses. Much of it goes farther, as we have seen, in trying to control, represent, or explain the phenomena of nature and human nature without invoking theories of supernatural causation.

What we describe in art as thematic form, decoration, pattern, and design is not foreign to natural science, which discovers and describes such modes of organization in nature as well as in human affairs. Snowflakes and other crystals exhibit highly geometrical, regular patterns; plant and animal structure and behavior exhibit also the more biomorphic, free-flowing types of thematic series and pattern. Science describes these from the standpoints of mathematics, physics, chemistry, biology, psychology, and sociol-

ogy. What we have called "development by addition and division" occurs in protozoa and in human societies. Aesthetic morphology discovers in music, painting, and sculpture thematic structures analogous to those which science finds in nature.

There is no reason to suppose that the extension of science and the naturalistic attitude farther into art will obstruct the creation of designs therein, or try to impose excessively rigid, geometrical patterns on artistic materials. The modern vogue of geometrical styles in art, as in Mondrian, Cubism, and the hard, bare "pipe-and-slab" style of early twentieth-century architecture, exemplify only a primitive, limited application of scientific ideas. Art has hardly begun to draw upon the resources of science for thematic materials and patterns of a more biomorphic type, in styles more suited to the expression of human impulse and emotion. When romantically-minded artists try to escape from science and rationalism, they often serve as avant-garde explorers on behalf of science, by calling our attention to psychological phenomena—expressions of the human mind—which science will explore more systematically later. This is true of present experiments with "psychedelic" drugs.

Art and science are drawing closer together in some respects, even though both artists and scientists are more conscious of the differences and though some—especially artists—try to go as far as possible away from the forms and mental processes of science. This is true of Action Painting, Zen, Surrealism, and other latter-day romantic, antiscientific movements in art. Science is expanding its own approach to explore and understand these movements as psychological and social phenomena.

Naturalistic aesthetics is not hostile toward the apparently irrational aspects of art; it has no desire to abolish them or substitute for them the logical, quantitative forms and methods of the old, exact sciences. Insofar as other, nonlogical forms and methods are held to be valuable in art, naturalistic science can consistently attempt to stimulate and liberate them. Ever since the Romantic movement, and increasingly in the twentieth century with the aid of psychoanalysis, the sciences dealing with human nature have moved away from the methods based on mathematics and physics to work out more subtle and flexible ones. These are not unsympathetic to art arising from the realm of unconscious impulse, desire, and dream.

"Naturalism," in the narrow sense commonly applied to art, is only one variety of naturalistic thinking in the broader, philosophic sense. It flourished especially in the European late Gothic and Renaissance, as a reaction from the supernaturalism and otherworldliness of Romanesque and early Gothic art. That variety of naturalism, as a stylistic trend in painting and sculpture, specialized on accurate representation of the visual aspects of objects, persons, and places, in terms of anatomy, perspective, suggestions of movement, and later of local colors and luminous atmospheres. It tried to base visual representation on the data of visual observation rather than on tradition, faith, and fantasy. The "nature" which the Renaissance artists observed and described was not nature as wild and untouched by man, but nature and human nature as partly transformed by Greek and Roman art, which was then being rediscovered. It was, on the whole, civilized, parklike, neat and orderly. The human figure was shown well and fashionably dressed, or else nude in statuesque poses, monumentally grouped. This moderate, refined type of naturalism seemed at first not inconsistent with Christian subjects and Christian feeling, although extremists like Savonarola protested. The High Renaissance and Baroque, as in Titian and Rubens, created a new visible pantheon of Christian deities, saints, and angels, made fleshly and sensuous after the manner of pagan gods and goddesses. They were naturalistic in anatomy and landscape backgrounds. Even the pagan element was naturalistic in this broader sense. As time went on, the fervidly religious element diminished (with a few exceptions such as El Greco) leaving the new, neoclassic naturalism to dominate the field and generate a still more sensuous, worldly variant in the Rococo. Thereafter, religion played a minor part in motivating and guiding new pictorial styles.

The history of major styles after El Greco is one of competition between several varieties of naturalism. Pictorial naturalism became a little more severe and Roman in Jacques-Louis David, suave and linear in Ingres, coloristic and dynamic in Delacroix, sober and unflattering in Courbet. Though Courbet represented the visual world with accuracy in some respects, he was outdone in other respects (light and color) by Monet. Some later styles are naturalistic in still other ways.

History had shown that, for the time being at least, religion was not indispensable as a stimulus to art. Under favorable conditions the direct enjoyment of creating, performing, and experiencing art could provide an adequate motivation. As to subject matter for representation, there was the fascinating, infinitely varied world of life on earth—human, animal, and plant—as well as that of inanimate forces, such as storms and floods, which Leonardo loved to draw. Naturalism as a philosophic world view, in the tradition of Epicurus, was slow in reviving, but as a kind

of attitude and interest for the artist it stimulated not only representation but the other modes of composition also.

Leonardo's versatile genius combined the spirit of pure science, manifest in his studies of natural phenomena, with that of utilitarian technics, which he reveals in inventions which amazingly anticipate modern applied science. Both were combined with the artistic approach as expressed in realism and fantasy. Leonardo turned his back on magic and showed little interest in religion. He treated religious subjects, such as the *Last Supper*, in a naturalistic way. Machiavelli's *The Prince* was a pioneer analysis of contemporary political conditions, together with a practical handbook for the ruler and would-be ruler. The new interest in portraiture combined visual naturalism with more sensitivity to individual personality, which paralleled the psychological insight of writers like Boccaccio, Chaucer, Francis Bacon, Shakespeare, and Montaigne. Naturalistic visual decoration was often based on naturalistic representation. Any blank surface or empty area seemed to call for enrichment in terms of human and animal figures, flowers, trees, and landscapes. This included the façades and inside walls of architecture, the surfaces of pottery, furniture, shields and helmets, court clothing, textiles, jewelry and goldsmithing (as in the work of Benvenuto Cellini). Music was in tune with the new naturalism in its emphasis (a) on more sensuous, emotional tone through melody, harmony, and orchestration; and (b) on developing its partnership with secular literature through the madrigal and opera.

Naturalism, in a narrow sense, persists in the novel through Zola up to the present. There it consists in an attempt to represent not only the appearance but the inner workings of human life and social behavior with scientific truth and depth, including the evil and unpleasant aspects as well as the good and beautiful. Movements in painting and sculpture after Courbet have often been regarded as breaking away from naturalism, and have been given other names such as "Impressionism," "Post-Impressionism," "Cubism," "Futurism," and "Surrealism." This variety of names does justice to the explosive era of specialization on divergent lines which has persisted up to the present. It also satisfies the wish to believe that each of these short-lived movements is quite original, revolutionary, and independent of science. The debt of some of them to science, as in Seurat's Pointillism, is well known. But all of them are in line with naturalism in the broad, philosophic sense.

Painting through the Impressionists, including Manet, Monet, Cézanne, Renoir, and Seurat, continued to represent selected aspects of the visible world about it. More recent movements have avoided literal, superficial naturalism, but do not, on the whole, involve serious expressions of religious faith. (Rouault is an exception.) While avoiding or distorting the ordinary appearance of things, they deal with actual types of experience, as when the Cubists and Futurists combine different aspects of an object, or different moments in an action, in one static composition.

There is method in the apparent madness of Surrealism, Dada, and other recent movements which try to express the irrational and absurd. Whether intentionally or not, many works of this sort are influenced by the wide public interest in psychoanalysis and psychiatry, in dream life and unconscious symbolism, in automatic writing and unplanned, unanalyzed impulse, in the sudden revelations of Zen, in the "absurdity" of life as proclaimed by Existentialism, and in the psychoses of schizophrenia and paranoia. Some works in these styles express the widespread mood of disillusionment with modern civilization and its anxieties.

This is not to say that artists in these movements are intentionally acting as propagandists or scientific investigators; usually the opposite is true. But, even if unconsciously and against their wills, they are often influenced by current psychological and social thinking. They provide relevant data for psychologists to interpret. As the psychiatrist can describe in words how the world looks to a psychotic patient, so the painter can, if he wishes, represent certain aspects of that imaginary world in visible form. Many paintings by psychotic patients are significantly similar to those by normal contemporary artists. This is not derogatory to the latter or a sign that they, too, are psychotic. It is a sign that both are dealing with similar psychological materials, although in different ways. The scientist deals with those materials in still another way. Subjective phenomena, normal and abnormal, can be treated by the representational artist in words or pictures, by the abstract painter in expressive line and color, and by the composer in music along the lines opened up by Romanticism over a century ago. They can be causally explained in verbal composition by the essayist. From the standpoint of psychotherapy, they can be discussed in utilitarian terms of possible control or redirection.

The philosophy of naturalism, in the broad sense, is not committed to favoring so-called naturalistic art, in the narrow sense of sensory realism, the reproduction of surface appearance in art. It is not committed to favoring artistic expressions of naturalistic philosophy. On the contrary, it tends to favor the production, study, and enjoyment of any and all kinds of art, including expressions of magic and religion as

well as those of unrealistic fantasy. All are products of the human brain and nervous system in various cultures, periods, and individuals. Nothing human is alien to the science and art of naturalism. Mystical and mythical art, old or new, is encouraged by naturalism as leading to deeper self-understanding on the part of humans, and also to the possible enhancement of aesthetic experience in contemplating it. This does not imply belief or disbelief in the existence of the things represented.

The question is often raised as to whether artistic representations of a myth that the artist does not accept as true can be good or great: in other words, whether art today can equal the art of the past which assumed the truth of magic or religion. Such evaluative questions do not concern us here, and there is too little evidence to support a definite answer. But art has already produced many examples of myth and fantasy in which the artist did not believe as sober fact: for example, the music dramas of Richard Wagner, the tales of Edgar Allan Poe, the etchings and late, nightmarish paintings of Goya. Ceasing to believe in religious tenets as historic facts or binding rules does not necessarily destroy their aesthetic appeal or the desire to deal with them in art. The power of religion to inspire and enrich the arts may even be increased by detaching it from questions of truth and moral authority, as in our present attitude toward Greek and Roman mythology. When the Romans lost faith in their own inherited religion, after a period of conflict in which the victory of Christianity was decided, they did not permanently reject artistic expressions of the old religion in literature and visual art. The classical tradition remained alive during the Middle Ages, and in the Renaissance it not only regained and surpassed its old prestige, but developed new powers of inspiring the arts. It is still a major constructive force in Western culture.

It is said that humanity has not ceased inventing new myths, including some beliefs now accepted by science. It remains to be seen how mythical these are in the sense of being false. Also to be seen is the extent to which false myths, and myths in which the artist disbelieves, can nevertheless inspire good art.

6. The modes of composition as related to psychosocial attitudes and types of experience.

It would seem, at first sight, that any phenomena as widely distributed as the four modes of composition must be significantly related to common human motives and attitudes. This is true to some extent, but the relationship is not a simple, constant one; many other variables affect it.

Utilitarian art must always be somehow motivated, in part, by the practical attitude of mind. It is one expression of man's unending struggle to satisfy his desires in the realm of action. Here the artist has to be especially practical in adapting his available means to the specific end desired.

The representational mode in art is analogous in some respects to the mental process of fantasy-building. Awake or asleep, man dreams of other times and other places, of other humans, gods, devils, wild beasts, or monsters, of what he and other men have seen and done, or would like to see and do. Artists communicate their fantasies in stories and pictures, while other people follow their guidance in building similar fantasies.

Expository composition expresses another typical human desire: to know and understand things in a general way, and to state and communicate one's beliefs and problems in symbols or other understandable forms. There are persons, usually somewhat intellectual in type, who like to explain ideas through art, and others who receive these explanations with belief or disbelief.

Thematic composition seems related to the widespread love of beauty and harmonious form, whether plain or simple or complex and ornate.

It would be an easy step to suppose that each mode of composition, as embodied in a work of art, tends to arouse analogous aesthetic responses in the observer. But this would greatly oversimplify the facts. The human mind is far too flexible and variable to obey any such neat formula. Whatever the artist's mental process may have been in making the work of art, others can perceive it in accordance with their own individual tastes and interests; they do not have to repeat the artist's process. As we have observed, a jeweled sword or cup in a museum case may arouse a fantasy of how it would feel to use it, or an aesthetic enjoyment of its combination of design with functional fitness. Even though a practical motive operates in the production of all utilitarian art, that motive may lead to very different means and methods in different cultural environments. It may lead one artist to design an automobile and another to spend his life in prayer and worship, in the hope of achieving Heaven or Nirvana.

Representational art usually does tend to arouse some sort of fantasy in the observer, or at least an attempt to recognize what is represented. But this is not the whole story. A utilitarian motive often dominates in the mind of the observer, as in hoping to propitiate a king or god. A modern scholar, studying

an ancient statue, may be much more interested in its material and technique than in what it represents. He sees that it is obviously a statue of Hermes, but his mental process in experiencing it is rather one of investigation than of fantasy. Likewise the response of an observer to expository art depends largely on his own interests. An example of symbolic art may stimulate one observer to intellectual inquiry, another to mystic contemplation of the work as a key to transcendental truth.

As to thematic composition also, the process of organizing materials in that mode is not the same as that of perceiving it. The perception of a complex design is often vague, superficial, marginal, or fragmentary, with more attention to *what* is ornamented than to the ornamentation itself, as in a reliquary or an actor's costume. The production of thematic form is widespread in nature, as in flowers, crystals, plankton, viruses, and other plant and animal structures. Such form is not necessarily produced by the human imagination; it can be, from the scientific standpoint, unpurposeful, automatic, and mechanical.

Some utilitarian and representational art is now commonly regarded as ineffective and useless for the ends it was originally made to serve—especially, as we have seen, that which relied on magical or religious means such as masks, fetishes, amulets, dances, spells, and rituals before a statue. Its production, perception, and use for those ends has declined, but in many cases it takes on a new kind of function, as in decoration or performance for aesthetic reasons. The mental processes of both artist and appreciator toward such art tend to change accordingly.

When exposition declines in art but flourishes in science, this suggests that people are now more satisfied with the scientific way of explaining things, at least in certain fields. The old myths and allegories no longer seem adequate, in method or content, to explain the universe of astronomy, physics, biology, and sociology. We do not go to Dante for information about the stars and planets. To most readers the *Divine Comedy* is now a book to be read as a story, as a complex design of words and ideas, and as an explanation of the medieval attitude toward the universe, ethics, life, and history. Most of us apperceive it from the standpoint of a naturalistic society in the twentieth century.

The same works of art, the same types and styles of art, not only change their values for different ages but change their meaning also. They take on new meanings through the perspective of history, while some which had seemed important at first recede into the background. To a large extent, science and technology have taken over the former tasks of utilitarian and expository art because the present age believes they can perform them better. But in some realms this has not happened or is happening very slowly. In the field of individual psychology, science still looks with great respect to the novelist, poet, and playwright for insights which psychology has not yet achieved. Here art and science work together, each giving something to the other. Psychoanalysis adds meaning to *The Bacchae* and *The Brothers Karamazov*, through explaining these works more deeply than their authors or contemporary critics could have done.

When a type of art is no longer trusted to carry out the tasks originally expected of it, that type is not necessarily discarded. If it held an important place in some past epoch, it automatically qualifies for a place in cultural history. We want to know some things about it in which its originators were probably not interested. We want to know how it fitted into its cultural pattern and into the sequence of stylistic changes which constitutes the evolution of art.

Such studies endow the art of the past with new associations, based on historical contiguity. Recent studies in the history of art have tried to link styles more closely with their social and cultural backgrounds. Some historians, especially followers of Marx and Taine, have regarded social factors as powerful causal agencies in determining the nature of styles. They further point out that an artist's social status, the sources of his income and prestige, the ideology which he inherits from his class and milieu, may all be implicit in his works while he himself and his public are not clearly aware of them. The sociological art historians tend to regard an artist's works as expressing his social background and motivation at a certain moment of history. As symbolized more or less unconsciously in his works, they argue, the social factors which helped to shape him operate as meanings of those works. Unconsciously, the artist (like the philosopher and theologian) tends to glorify and strengthen the social system upon which his well-being depends. Less often, he may try to undermine it, and in that case his revolutionary, class-struggle sentiments will also appear as meanings of his work.

What concerns us most here, from the standpoint of morphology, is that historical associations tend to endow styles and works of art with certain powers of suggestion. To what extent should such associations be classed as integral *meanings* of the work? In this book, we are reserving the term "meaning" for ideas which are very closely bound to the presented images in the work of art. These include, not only the dic-

tionary meanings of the words and the iconography of the symbols, but also other firmly established cultural interpretations. Some, but certainly not all, historical associations deserve to be called "meanings." Some are too occasional and variable.

It is impossible to draw a sharp, accurate line between what is and what is not a meaning of a work of art. One must draw such a line somewhat arbitrarily and change it from time to time as different ideas are attached or detached by changing cultural attitudes. The social background of Baroque art is definitely suggested, not by all seventeenth-century art, but by those works which obviously show the results of royal magnificence and power, such as the palace, parks, furniture, paintings, fountains, and statues of Versailles. Such works were clearly adapted to serve the tastes and further the grandiose ambitions of the Bourbon kings.

Let us take "formalistic" to mean "emphasizing thematic development, visual or auditory form and design" as opposed to "emphasizing moral and social content." To what extent, then, is formalism connected with the decadence of capitalism? The antithesis between formalistic and socially conscious art is a variant of the old antithesis between "art for art's sake" and "art for its moral and social consequences." Whatever one's preference between these two may be, and whatever one's alignment as between communism and capitalism, it is no easy task to show that either approach to art has been definitely linked with the decline of capitalism. Is capitalism really declining? To what extent, if at all, is formalism a sign of decadence? Are not Persian carpets, the fugues of Bach, and the symphonies of Brahms, as formalistic in their ways as Kandinsky's abstract paintings are today? May not a communistic state decide, consistently with Marxist philosophy, to develop some kinds of formalistic art as a means to the education and enjoyment of the workers?

Many kinds of art which, in an earlier day, were limited to the privileged few, and were consequently regarded as status symbols, are coming within the reach of all citizens in a prosperous democracy. This is more and more true of the utilitarian arts and conveniences of modern living. A more sophisticated democracy in future will probably demand access to all types and styles of art, formalistic and otherwise.

"Art for art's sake" and "art for social content" are supplementary, not contradictory. There is room for both. In a free society, some artists will want to occupy themselves with technical problems of material, form, and style, while others will want to express themselves on social problems. Each type of art will find an interested public. However, a more fundamental conflict is at stake here, one between different moralities and social systems. It is being fought out in all the media of communication and in the field of action. Art has been, and will be in future, active on both sides of the conflict between old and new in social philosophy. Thus engaged, it will need to make use again of all the modes of composition.

Note: The following illustrations are particularly relevant to this chapter: Plate V; Figures 2, 3, 9, 11, 17, 23, 43, 49, 62, 85–92.

CHAPTER IX

Complex
Recurrent Traits
and Types

1. Concise description; selecting important traits for emphasis

Scientific description of a particular object or phenomenon usually tries to be concise, selective, and systematic, pointing out in a few words or other symbols its most significant aspects. This is done in a biological account of a newly discovered plant or animal. Accounts of particular works of art vary greatly in this respect, some being concise and objective, others personal, diffuse, and rambling.

One way in which the description of a work of art can be made concise and brief is to select its most *distinctive and important* traits for emphasis, ignoring or minimizing the rest. Selecting "important" traits involves some amount of evaluation, but not necessarily a comprehensive judgment of the work's aesthetic value. Here it implies "most worthy of study and of emphasis in description." As we have noted, it is impossible to exclude all evaluation from science; any choice of subjects to investigate and describe is somewhat evaluative. But the things most worthy of study may be the worst things from other points of view. In studying works of art it is often important to emphasize traits which are regarded as faults, weaknesses, or signs of decadence. But one can focus attention on certain traits as a step in research without raising questions of general value.

Another way to condense a descriptive account is to use appropriate technical terms with broad significance. A single term of this sort can imply a number of important facts about the work to be described. To begin with, it can locate the work in a certain type or genus. Such words as "realistic," "romantic," "Gothic," and "polyphonic" can all be very informative as applied to a particular work. But many such words are ambiguous and need precise redefinition.

In any field the description of a particular object or event usually includes the procedure, devised by classical logic, of locating it within a certain genus or certain genera, then differentiating it from others therein. To locate the object in a genus describes it in certain broad respects, as in saying that a work of art is a portrait or a sonata. To place it within one of several species under that genus describes it in some additional respects, as in saying that the sonata is one for violin and piano. By classing it under more and more species and subspecies we tend to bring out its distinctive features.

In biological and other highly developed systems of taxonomy, the relations between different genera and species are definitely established, so that a certain example can be classified under them in an accepted, convenient order. Knowing the characteristics of each genus and species, we can fairly easily decide under which one it belongs. But this is not true in dealing with works of art. Aesthetics has no accepted system for classifying examples, types, or styles. One can easily place an example under various headings: e.g., as ecclesiastical, Gothic, and utilitarian; but there is no recognized order for doing so, and no way of being sure that one has taken account of the object's most distinctive and important features. It is often hard to decide which basis for classification to use in a given case. No one way, no particular kind of trait, is always the most important. Which to emphasize will depend on one's interests and special problems at the time. If some practical use is contemplated, as in education or psychotherapy, traits which promise to be most useful along that line will seem to deserve first consideration.

In this book we have considered a number of bases for describing and classifying works of art, such as "mode of transmission," "sense addressed," "spatio-

temporal dimensions," "developed components," and "compositional schema." This last heading can also be stated as "basic framework type." It calls attention to the fact that two or more modes of composition are often involved in the same work of art. A useful way to start describing the work, then, is to say that its basic framework is utilitarian, representational, expository, or thematic. "Works with utilitarian basic framework" (or otherwise) will then provide a first genus for classification. "Main stylistic affiliation" (such as Gothic) is a second possibility. After that one can proceed to mention traits which most definitely distinguish the work in question from others of this framework type and style.

2. The use of evaluative terms and concepts in describing art.

The use of evaluative terms is not descriptive in the strict sense and is to be avoided in morphology. To call a picture beautiful is to evaluate it rather than describe it. But there is an element of factual description in many evaluative terms. To rule out all terms which have been applied in praise or derogation of art would leave all too few. Many names of styles, such as "Gothic," "Baroque," and "Romantic," have been used as disparaging epithets at one time or another. Scholars are now trying to redefine them more objectively for historical and other factual studies. The same is true of many general concepts such as "ornate," "sentimental," "grandiose," "unbalanced," "dry," and "crowded." Each of them has implied a fault or disvalue when used by persons who dislike the kind of art to which it is applied.

Each can also imply a value, however, when used by persons who approve that kind of art, either in general or in some particular situation. To call a picture, a building, or a sculptural relief "unbalanced" implies that considerably more of its actual or represented substance is at one side than at the other. There may be definite reasons for this arrangement, aesthetic or otherwise. To call a picture "crowded" implies that it has an unusual number of figures or other details within a small area. Such a term can be applied descriptively without raising the question of whether the arrangement is *too* crowded, *too* full of details. In each case, one can indicate that the term is used to point out certain observable traits and perhaps to make comparisons of more and less, but without expressing a value judgment by the writer.

It is possible to say that Goethe's *Sorrows of Werther* is "sentimental," in the sense of "marked by feeling, sensibility, passion, or emotional idealism," without either praising or disparaging it. Yet, for some critics, to call a story or a painting "sentimental" is to damn it completely. Whether one likes or dislikes sentimental stories, and what constitutes excessive or undesirable sentimentality, is not our main concern in morphology. But sentimentality and other affective qualities may be objectively described as component traits in a work of art.

When A is said in a story to admire B and feel that she is good and beautiful, the images and concepts implied by these words are integral parts of the text. One cannot fully describe the story without mentioning how they function in it. The supposed beauty of Helen, the valor of Achilles, the craftiness of Odysseus, the patience of Penelope, all have a certain objective status as suggested images and meanings within the works of art in which these characters play their parts. They are socially established as imaginary traits of certain imaginary characters in the fictional realm of Greek legend. Like the anger of Achilles and the filial piety of Aeneas, they can all be accepted as component traits in aesthetic form, and included in descriptive accounts of the epics concerned.

Judgments of value as expressed in a work of art, such as Keats's line "A thing of beauty is a joy forever," are ingredients to be described along with other conative emotional and rational suggestions, as to their roles in the poem as a whole. This does not imply that the poem itself is necessarily beautiful. One can even go farther and agree with the Neoclassicists that some Greek statues suggest noble simplicity, repose, restraint, symmetry, and balance, thus exemplifying the classical ideal of beauty. At the same time, one can dislike this kind of sculpture and give it a low rating on other grounds.

3. Simple and complex traits. Complex recurrent types.

Some traits and types are comparatively simple and elementary; they involve one specific component or a very few. "Red" and "loud" are simple traits, while "red pictures" and "loud music" are simple types. To classify a work of art under such a heading locates it very roughly and may serve as a start toward description, but the type is so broad and inclusive as to provide little clue to the work's distinctive features, if

any. Under special circumstances, it may be important to know that a picture is red or a piece of music loud, but other kinds of trait are usually considered more significant.

A *developed component trait,* or a group or sequence of such traits, usually needs a number of words to describe it. This is true, for example, of the trait called *fugato* in music, and of "tragicomic" in drama. These are complex traits. The former refers to a musical passage somewhat in the style of a fugue but not necessarily part of a strict, fully developed fugue; it involves the relations between two or more melodic lines, which in turn involve traits of pitch, rhythm, and perhaps dynamics and timbre. "Tragicomic" implies a combination of tragic and comic factors, usually with the tragic predominating, and this in turn may involve emotional tone, plot, character, and other developed component traits. In both cases a single word connotes a group of such traits.

To describe a work as an example of a certain art or branch of art, such as an epic poem, a landscape painting, or a sonata for violin and piano, tells us at once a number of things about it, including the sense usually addressed, the general nature of the presentative factor, and the basic compositional framework, whether thematic, as in the sonata, or representational, as in the epic or landscape. These terms refer to comparatively complex traits and types. Each implies a number of specifications, including the ways in which developed components such as melody and harmony are used in the sonata, how plot and characterization are used in the epic, and how drawing and perspective are used in the landscape. A single word, as the name of such a type, can serve to characterize the example in several ways at once. No single word or simple phrase is enough to characterize a sonata, a reliquary, a painting of the Last Supper, a Buddhist stupa, a tragicomedy, or a statue of the dancing Siva.

The term "sonata form" (sometimes called the "sonata allegro form") refers to a conventional pattern for one movement of a whole sonata or symphony. It often occurs in the first movement and involves two contrasting themes or subjects stated first in different keys. Its main parts are an exposition, a development of one or both subjects, a recapitulation of both in the original key and usually a coda.

So defined, the sonata form is a *complex type.* Its definition requires a comparatively large number of specifications, referring to a set of developed, interrelated traits. It is a conventional framework type under the heading of thematic composition. It does not imply any judgment of value. The sonata is a

recurrent type, exemplified by many particular works in successive periods.

What we are calling a "complex type" is also known as a *genre*—originally a French term derived from the Latin *genus.* Broadly, a genre in art is any kind of artistic production characterized by a certain style, form, or content. In this sense, tragedy and comedy, epic poetry, odes, and sacred hymns, have all been called genres. Ancient Greek distinctions among several of these concepts were implied by the list of nine Muses or inspiring goddesses, each of whom presided over a certain kind of art or science, such as the epic, choral dance and song, tragedy, lyric poetry, and astronomy. In a narrower sense, "genre painting" is a type which takes as its subject matter some scene from ordinary, everyday life, especially of the lower classes, and treats it in a realistic, informal way. It is contrasted with monumental, classical, idealized painting in the grand manner, as of noble or divine personages in a symmetrical arrangement.

In previous chapters, we have used the word *schema* for a combination of traits of a certain kind in a particular work of art. Thus the "ingredient schema" is the particular selection of components and component traits found in a certain work, including the relative emphasis placed on each. The sonata form as defined above enters into the *compositional* schema of a piece of music. It constitutes a certain kind of thematic composition which occurs with variations in many musical works.

To say that a movement of a certain symphony is written in sonata form is only a start toward describing its thematic framework. By "compositional schema," we understand a more complete description as to its compositional development, thematic and otherwise. A reasonably full account of the compositional schema would include some characterization of the specific themes and variations, keys and key relations employed.

4. The lyric as a complex recurrent type.

The *lyric* is a complex recurrent type of ancient lineage with many varieties. It is highly diversified as to modes of composition and otherwise. Originally, the term referred to a poem used for singing and thus combined with music, especially for the lyre. This association has persisted, and many lyrics are actually sung, while others are intended rather for silent reading.

Most lyrics are comparatively brief and involve a fairly definite pattern of word-sounds, usually including rhyme. A number of Walt Whitman's are in free verse and comparatively long. Conventional patterns in English include the sonnet, rondeau, and ballade. The basic framework of word-sounds is a thematic pattern. Within it, ideas and images may also be arranged thematically. There is often a refrain in which whole lines or short stanzas are repeated. Otherwise the lyric is extremely variable, and in this respect it has not followed the common tendency to specialize on some one compositional factor. The accessory factors, developed within the word-sound framework, can be representational, expository, utilitarian, or any combination of these.

The representational factor may be a description of a person, real or ideal, or of a scene in nature, perhaps including sounds as well as sights, as in the sound of birds or cataracts. It may describe the poet's own feelings and desires, likes and dislikes, joys and sorrows. It may narrate a brief experience of himself or someone else, as in Wordsworth's "The Daffodils." The narrative ballad is developed into a story, usually compact and emotional, often with a pathetic ending. Coleridge's *Rime of the Ancient Mariner* is an example.

An expository factor may consist in philosophizing or generalizing briefly about life, God and man, the soul, nature, happiness and misery, the evanescence of beauty, love, and pleasure, or about any conceivable topic, perennial or ephemeral, serious or comic. The poet may give questions only, answers only, or both.

Songs of work, war, dancing, convivial drinking, and similar topics are often adapted for actual singing while engaged in these activities. In primitive times, they often had a seriously utilitarian function, as in coordinating movements and in urging the listener to renewed efforts.

In a more recent, sophisticated age, all these modes of composition are sometimes imitated for purely aesthetic purposes and sometimes in a spirit of parody, wit, and humor. When the poet exhorts his readers, "Gather ye rosebuds while ye may," or "No, no, go not to Lethe," or even "Sleep, baby, sleep," the ostensible meaning is utilitarian in trying to direct some sort of action; the real intent is aesthetic, and the lyric may be classed as mock-utilitarian. Other examples are mock-expository, as in Aldous Huxley's comic but profound *First Philosopher's Song.*

There are many subtypes of lyric, some referring to the kind of occasion or circumstance under which the poem is supposed to be written or spoken, such as the elegy, the serenade and other love songs, the commemorative ode, and the epithalamium. The hymn suggests a religious or patriotic setting; the dramatic monologue and soliloquy, a theatrical one.

Other subtypes are distinguished on the basis of psychological subject matter or emotional tone, such as nature lyrics, laments, meditative lyrics, addressed monologues (to some individual, real or imagined), lyrics of wit and humor, imagist lyrics, and lyrics of worship. Some lyrics are comparatively objective, describing external facts, others subjective, in revealing the inner life of one person, perhaps the poet himself. Some are highly personal, some impersonal or even cosmic in scope.

5. Recurrent types of visual form: geometric, biomorphic, and classic.

There are two opposite poles in the organization of form. One is the ideally complete order, regularity, and unity which are found in geometrical conceptions of the triangle, pyramid, and other typical figures. As actually drawn or printed, these figures are never quite perfect, but they contain relatively few irregularities or variations. At the other pole is the conception of something utterly chaotic or amorphous, disorderly, miscellaneous, formless, and shapeless. Again, such a condition never actually exists in nature or in art, for all phenomena display some vestige of form and cohesion, even if it is no more than the passing shape and texture of a cloud. But clouds, mossy textures on rock, and many other phenomena have comparatively little regularity, definiteness, or unity as objects of perception. Other types of natural and artistic form can be roughly graded between these two extremes, although there are so many different modes of organization that the amount of regularity and order possessed by any one example will always be debatable.

Thematic composition includes this range of gradations in regularity and order. "Design" implies a fairly high degree of complex unity; but the term "thematic relationship" is broad enough to include cases where only occasional, fragmentary theme recurrences appear. Far from being able to measure the degree of regularity and order in a thematic relationship, we still lack terms to indicate even roughly its approximate position on the scale.

Geometric is a term applied especially to pottery

and textile ornamentation, and by extension to all design. It implies an extremely high degree of regularity and order in certain respects. It implies that themes and theme units, especially in line, consist wholly or mainly of simple, regular figures of the types discussed in elementary geometry, such as straight lines, angles, arcs, triangles, squares, circles, diamonds, stars, etc. These units are prolonged or repeated, usually along rectilinear axes, into zigzags, meanders, bands, chevrons, plaids, and other simple framework patterns, still close to the group of elementary geometric figures. Geometric design can be curvilinear as well as rectilinear. Straight lines predominate, but many designs called geometric contain arcs, circles, waves, spirals, guilloches, or other tight and simple curves.

Much primitive art of the geometric type is nonrepresentational, or seems so to the ordinary observer. But it may be a much-simplified descendant of more naturalistic types and may still have a representational or symbolic meaning for those who know and use it. Thus a wavy line may signify water; a triangle, a wigwam. In other geometric art the representational meaning is made obvious, as in a circular Eskimo mask with the facial features clearly drawn.

Contrasted with "geometric" art is the free-wandering, irregular type of curve or zigzag which is associated with blowing drapery or lightning. These are sometimes called *naturalistic,* but that word is ambiguous. It is sometimes defined as "closely resembling nature; realistic." As such, it implies that the work of art in question represents nature accurately, and this tells us nothing specific about the themes or patterns thus produced. We have noted the geometric forms in nature, such as crystals, honeycombs, and certain flowers. Accurate pictures of these are geometric as well as naturalistic. But many natural forms present flowing, irregular curves to the eye, with occasional jagged peaks and zigzags: wind-blown trees, flower stems and leaves, vines, many types of animal and human bodies, rivers, ocean waves, sand dunes, and undulating cliffs and mountain ranges. Since these predominate in the observed shapes and movements of living organisms, they are called *biomorphic.*

In art, the biomorphic type of line has usually occurred in forms which undertook to represent natural phenomena with some fidelity, especially those of life, as in late Greek sculpture and drawing. When art undertakes a drastic simplification of natural forms into abstract patterns or conventional symbols, it sometimes approaches the geometric, as in Cubism.

But biomorphic design is not necessarily realistic or representational. Free-flowing lines for purely decorative reasons occur occasionally, especially in romantic periods. The French *Art Nouveau* of the early twentieth century favored them, and so did much German Expressionism. Kandinsky combined biomorphic lines with geometric ones for their quasi-musical expressiveness.

Strictly speaking, it is wrong to imply that free-flowing, irregular, variable curves are non-geometric. Geometry as a science studies all kinds of curve and can plot and measure any curve or zigzag, however frequently it varies its direction. But usage in art associates "geometric" with the simple, regular types of figure, including the parabola and ellipse, and not the more complicated curves of analytical geometry and statistical graphs. Biomorphic shapes are not, as a rule, examples of any particular geometric type; they are irregular and variable. One can describe some of them by comparing them to natural forms which they resemble: as, "wavy," "willowy," "jagged," or "serpentine."

Even without the aid of scientific measurement, the eye is able to distinguish approximate degrees of regularity in curving and rectilinear shapes. It can distinguish a line or series of lines which repeats a certain arc or S shape uniformly from one which has the irregular waviness of vines, clouds, rivers, and billowing drapery folds. It can distinguish a rectilinear zigzag or meander, with uniform lines and angles, from the unevenly bristling zigzags of lightning or of pine twigs on a branch. The regular (or approximately regular) series can be called geometric; the apparently irregular ones, biomorphic or naturalistic.

The two types are distinguished, not only by the shape of linear themes, but also by the proportion and arrangement of parts. Thoroughly geometric design tends to have important parts (motif units) about equal in size or varying in regular proportion, so as to be half, twice, or three times as great as some other, for instance. It often subdivides the given area or volume in fairly regular proportions, so that field and border of a rug, neck and body of a vase, or head, limbs, and torso of a statue, are in multiples of some common unit or module. It tends toward symmetry of pattern: bilaterally, vertically, or both. Biomorphic design, on the other hand, tends toward incommensurability, real or apparent, toward the avoidance of regular proportions and arrangements, of exact symmetry.

In all these distinctions, the appearance and not

the mathematical fact is the main criterion. Biomorphic units may actually be commensurable and exactly proportional in size and arrangement; yet if the ratio is not simple and obvious the effect in aesthetic observation may be one of irregularity, Geometric units, in primitive design at least, are seldom exactly uniform or evenly graded in size. Even if so intended, they usually vary a little because of freehand techniques and rule-of-thumb measurements, and often so much as to give perceptible unevenness. Moreover, a series once begun in a regular way may be impulsively dropped and begun again in a different way. For such reasons, primitive design tends to be less exact in its regularity than modern geometric designs, produced by machines and precision instruments. Critics may then praise the early design for its "vitality," as a result of these slight, almost accidental variations. Machine-made designs can also be so constructed, if the designer so chooses and the consumer demands it.

The concept of "geometric" is not limited to linear figures such as those discussed in plane geometry. It includes the typical shapes of *solid* geometry: cubes, spheres, cones, pyramids, cylinders, and so on. Designs wholly or mainly made of these, or of close approaches to them, are called geometric. Cubism in sculpture and painting was strongly geometric in tendency, a reaction from the romantic extremes of vague diffusion which had been reached in Impressionist painting and the sculpture of Rodin. The ancient Egyptian and Mayan styles of architecture are geometric, not only because of their linear contours, but because of the pyramids and columns which they use prominently. Sections of cones, pyramids, and other geometric figures can appear on sculptural reliefs, or in paintings imitating them, thus building up geometric designs (for example, in Cubist sculptures by Lipchitz, and paintings of mechanical themes by Léger).

A limited kind of complexity is found in African Negro sculpture, where a certain theme or themes in solid mass and surface texture is contrasted with others—e.g., a swelling, bulbous shape with a pointed one—to make a static design. This is usually based on a human or animal body or face as a framework. It is usually developed frontally and somewhat rigidly as a symmetrical design in three dimensions of space. The contrasting series tend to interlock in firm unity. Line and shape vary from the tightly geometric to somewhat more relaxed, archaic curves, but seldom become freely biomorphic. Surface textures vary from the rough to the finely polished, ribbed, or grooved.

When we turn from linear and solid shape and size to *color and texture,* including light and dark, hue, and saturation, the term "geometric" becomes less directly applicable. However, geometric linear pattern has tended to accompany certain kinds of color and texture. When shape is strongly geometric, color areas and textures often become comparatively flat, plain, and uniform, definitely bounded by hard, sharp, linear edges.

However, a tendency for geometric effects in one component to accompany similar effects in others is far from universal. Actual historic styles often show considerable diversity in the use of components, using some in a much more geometric way than others. This can sometimes be traced to the use of certain materials and techniques, to the essential nature of the medium chosen, which may invite a geometric treatment in some respects and a nongeometric one in others. Houses made of wattling, with thatched roofs, or with hand-trimmed logs and boards, cannot assume a flat, smooth surface texture as easily as those of marble, but either type of house can be made geometric in its general shape. In many cases, artists working in a certain style deliberately avoid extreme consistency of type; they deliberately introduce biomorphic elements to balance and contrast with geometric. Sophisticated textile designs, as in the French brocade and the Japanese kimono, often introduce blurred, shadowy, or watery textures to contrast with knife-edged precision elsewhere.

What might be called the *geometric attitude,* if consistently applied, manifests itself not only in the shape of lines and solids, but in their texture. Geometric lines (not only as edges, but as streaks of pigment, grooves, ridges, etc.) tend to be hard, sharp, bold, firm, and unwavering, to approximate perfect straight lines, circles, and parts thereof as closely as the artist's technique and materials will permit. Archaic or semirigid line can be a little more rough in texture, as with Matisse, or extremely hard and sharp, as in the "bent-wire" lines of severe Greek vase painting. The geometric attitude is shown in the hard, uniform, metallic surface of a modern automobile or refrigerator.

The classical attitude toward the texture of line often manifests itself in the brushstrokes of Giorgione and in those of Sung Chinese landscape, different as these are in many respects. It consists of a balance between control and freedom, as shown in moderate

variations of texture. Line goes less often to an extreme of sharpness or of softness, but moves part way in either direction as the situation demands. The classical calligraphic line of the Orient (not in Han, but in the riper Sung examples) manifests itself in writing and painting in a constant variation of texture, as the brush holds more or less ink, thinner or thicker ink, or is pressed down more or less heavily. One continuous line may be, in various places, slightly more narrow or broad, dark or light, sharp or blurred. In Giorgione and the later Venetians, the sharp lines of most early Renaissance art give place to various types in various parts of the picture. Sometimes they are sharp and clear, to define important contrasting areas in full illumination, sometimes soft and melting. The latter tendency progresses as we go from the early Venetians to Tintoretto and the final style of Titian. It is dominant in Rembrandt, Delacroix, and the Impressionists.

What has just been said about the texture of lines applies also to the areas of *light and color* which the lines surround. Instead of merging gradually from one shade or hue to another, the areas of geometric design are usually contrasted with some sharpness; each is of a certain shade and hue which marks it off from its neighbors. Most often, only a few different hues or shades are used in the same design; one particular set is repeated in different units without great variation. Extreme regularity and definiteness occur in the realm of light and color, as in that of shape. Light, color, and texture can at least be strongly *metric*, if not geometric in being chosen from definite steps and intervals on a scale and from a definite list of obvious types or degrees, just as geometric shapes are chosen from the list of typical figures studied in geometry.

The deliberate choice of rough, irregular, variegated surface textures in characteristic of Romanticism or a tendency toward it. As Baroque design becomes more violent or casual, its shapes and color areas tend to melt more continuously into each other, overflowing definite boundaries. Color areas and streaks of light interpenetrate each other, producing rich, mottled, iridescent surfaces. In European painting this tendency is well on the way in Rubens, Constable, and Delacroix, and rises to its culmination in the Impressionists, especially Monet and Renoir. In van Gogh it becomes less realistic but more excitedly expressive, as a final flare-up of violent nineteenth-century Romanticism. The more quietly pastoral romantic type appears in landscapes by Monet and Sisley and in the Japanese tea bowl, with its rough, irregular surface glowing softly in dull, mossy greens and reddish browns, congenial with the rustic setting and relaxed mood of the tea ceremony itself.

6. Varieties of biomorphic line and pattern: archaic, classic, Baroque, romantic.

The biomorphic type of line itself includes many degrees of variation, many steps away from the geometrical extreme. A line can be moderately supple and flowing, with constant slight variations in direction, and yet not go to the other extreme of confusion or utter irregularity, as in the scattering of leaves on the ground by a storm.

Archaic or *semirigid* line is one step away from the strictly geometric. Straight lines relax a little into broad, flat curves of dissimilar length and width, as in tree branches or bending wires. Figures stand stiffly or lunge, sway, and flex their muscles, as in early Greek pediment sculptures. Drapery hangs in tight parellel folds, or curls like the falling hair into scalloped ridges. Arcs flare out into asymmetrical spirals, parabolas, and ellipses. Lines meet at intersections which are almost angular, but rounded at points and sides. Precise rows of units scatter into different positions and directions over the surface. Line and pattern of this type we associate with archaic sculpture and painting, Greek vases of the black-figured period, the reliefs at Aegina, and the Apollo of Tenea.

The lines of many paleolithic, ice-age cave drawings and figurines approximate this type. So, on a more sophisticated level, do those of certain Byzantine mosaics. They suggest a *hieratic* quality derived from solemn, priestly rituals. Such lines are common in Carolingian and Celtic miniatures. Being intermediate between the geometric and biomorphic, they incline in Romanesque sculpture toward the former, and toward the latter in Gothic. Chinese reliefs of the Han dynasty, and sculptures of the Wei, use archaic lines. They are associated with considerably more detailed and realistic representation than is common in geometric design. As compared with freer types of line, they are sometimes called "severe," "austere," "precise," and "strict." These are associations which archaic design often has for the modern observer, although it is doubtful whether they were intended or felt in archaic periods. "Archaic" is not an adequate name for it, meaning simply that it belongs to an early, conventional stage of too advanced a style to be called primitive. This is true of Greek art in the

sixth century B.C. Such design is often described merely as "conventionalized" or "stylized," but these are also too vague for the purpose. "Semirigid" comes nearer to expressing its essential nature.

A little more regularity and variation in curves produces the type of line and solid shape called *classic*. It is more flowing than the archaic, with a hint of free wandering, but also of flexible restraint and systematic organization. A garment hanging in soft folds, or a banner waving in a breeze, displays curves which are approximately similar and rhythmic in succession. Following an individual line, one finds it as a rule fairly long and continuous, changing direction more rapidly and constantly than archaic lines do, swerving into deeper convolutions like the outlines of a woman's body. It does not suggest capricious, random, spasmodic movement, but stately progress or dynamic equilibrium. The movements of a flag in a gentle wind result from the action of an air current on a cloth of even texture, held firmly at one side. A vine grows along a supporting surface, upward toward the sun; its shape plots a previous course of progress as continuous as possible in relation to the interacting inner and outer forces. The classic line tends to suggest life and movement in which freedom of impulse and emotion is tempered by a fundamentally controlling force, purpose, or underlying trend.

Classic line and pattern are best known in middle and late Greek sculpture and vase painting. They appear in Phidian sculpture and in red-figured Attic vases, gradually breaking up and accelerating the linear flow as they enter the Hellenistic period. Hellenistic designs are often too full of irregular, crowded details to be called "classic." That term implies more restraint, simplicity, and repose. Classic lines and patterns occur in T'ang and Sung Chinese painting and sculpture and in the arts of the High Renaissance in Europe. In India they occur in Gupta sculpture. What we are calling here the "classic" type of line is similar to what Hogarth praised as the "line of beauty." But today one would hardly claim that this or any other type is always the most beautiful.

The difference between the classic and the less regular types of biomorphic design is not only one of linear shape, but of proportion in size and arrangement. The main parts of a classical design tend, more than archaic design does, to be proportioned as multiples of some common unit. Distances between main focal points in the design (such as eyes, chins, tops of heads, knees, and elbows in a group of figures) tend also toward regular proportion. Lines connecting them are likely to produce a framework pattern of

some regularity, even though this does not show in the finished product—a network of diagonals about some principal focus. Definite mathematical formulas are often discoverable. Classic design tends to combine a basic regularity and rational order in the general framework pattern with moderate freedom and irregularity of details. It is a balanced combination of unity and variety which may incline toward calm simplicity or dynamic alertness.

Between the classic line and the extreme of chaotic irregularity, one can roughly distinguish a few other types or stages. *Baroque* design, as in Rubens, inclines toward comparatively wide, sweeping, swirling or radiating curves and slashing zigzags, suggesting explosive power or violent feeling, the churning of heavy masses. Mannerist design is characterized more by patterns, somewhat asymmetrical and eccentric, in tight restraint, unstable equilibrium, or flung apart. Analogies with European Baroque are found in some late Roman art and in Kamakura Japanese sculpture. Here the Dionysian element, repressed in Apollonian art, surges restlessly against its classic bonds of moderation and repose.

The recurrent types of design can be compared in terms of the so-called art principles of academic art education, especially balance and proportion. These principles are no longer accepted as universal standards of value, but they are discernible attributes of classical design and hence noteworthy from a morphological standpoint. Romantic artists, on the other hand, tend to avoid them in varying degrees.

Balance, in this connection, implies an actual or apparent balance of weights between right and left side: a balance which tends to be obvious and symmetrical in geometric design, concealed in ripe classical design, and verging toward disbalance in the more extreme examples of mannerist and romantic. *Proportion* may be understood as a matter of "nothing in excess," as a general quality of measure, or as a definite numerical ratio, a regular mathematical proportion between sizes, distances, and intervals.

Romanticism in design is associated to some extent with avoidance of regularity, definiteness, and order. It is not self-consistent, but prone to change and experimentation, and is thus hard to summarize briefly. It tends on the whole to avoid geometric precision, and also the restrained, stately curves of classic form. At times it is indistinguishable from Baroque exuberance, flying into melodramatic swirls, twisting, writhing, and darting in every direction, as in Delacroix's *Death of Sardanapalus.* This is the heroic, *Sturm und Drang* type of romanticism. At other times, romanti-

cism is extremely placid, mild, and quiet, as is seen in the gently rolling meadows of an English landscape by Constable. This is the *pastoral* type of romanticism, expressing the ideal of simple life in tranquil, rustic surroundings. It finds expression in Chinese and Japanese garden art, the tea house with its apparatus and ceremonies, and related styles of painting and flower arrangement. In line, it tends toward the diffused and indefinite, with tiny, irregular shapes blurring into a rough texture, or else toward wide, flat, horizontal curves, as in Dutch landscape. Any and all types of linear detail may appear in romantic design, including the tendency toward lack of uniformity or of definite theme repetition. They may suggest, not rational plan or control, but accidental scattering, that of violent disruption or carefree informality.

7. Suggestive effects of various types of line and design.

All the types and subtypes just mentioned can occur in either abstract or representational design, in purely decorative line, in illustrative painting, or in the contours of utilitarian objects, such as clothing, chairs, and vases. The names of each type tend to suggest, to anyone familiar with art history, numerous characteristics over and above mere degree of regularity in line. These suggestive tendencies result partly from association with certain types of subject matter and function in historic styles of art, partly from the power of different kinds of line to suggest the kind of bodily movement, tension, and psychological attitude which is commonly involved in making them.

It is hard to differentiate abstract types of line, especially the nongeometric, without bringing in some of these associations. Hence we tend to distinguish these types, not in terms of linear shape alone, but also in terms of kinesthetic and emotive images which they tend to suggest. We speak of geometric lines as "severe," of classic line as "stately," of Baroque line as "powerful, swirling," and so on. Some of these associations are comparatively basic and universal, since they depend in part on common physiological factors in the process of drawing and perception. Others are more accidental and nonessential, depending on some peculiar use or subject matter with which the line has been connected at a certain time.

A particular kind of line, shape, color, or design will not necessarily have the same associations in all

works of art under all circumstances. A slight change in context and accompanying factors may radically change its suggestive effect. Its effects may differ somewhat from one individual or one culture to another, but within a certain culture and period style the suggestions are to some extent similar and predictable. To that extent it is reasonable to include them as possible meanings of a work of art within a specified context.

Some theorists of the origin of geometric art connect it with the origin of written language, and the need to simplify realistic pictures into abbreviated pictographs, the ancestors of our letters and other conventional symbols. But that would not explain the tendency to geometrize all visual art, linguistic or otherwise. Some theorists connect it with certain primitive techniques, such as that of weaving, whose rectilinear crisscross of fibres naturally leads to geometric ornament. This is probably correct, but would not wholly explain the geometric character of design in other media, equally old, such as painting on pottery. Modern machine and factory techniques are also conducive in many respects to mass production of simple geometric forms, and this fact may have some relation to the recent tendency in that direction of industrial design and Cubist painting and sculpture.

Geometric design in ancient art is historically bound up with the development of rational thinking along lines which ultimately led to science, especially with writing, counting, and measuring. In Egypt, it grew along with surveying; in Babylonia and Mayan Mexico, with astronomy. These and the great architectural projects of the early empires involved careful diagramming of relative sizes and positions. It is not surprising that geometric design appeared in works of art, such as temples and palace gardens, which were directly connected with these enterprises. They suggest a direct aesthetic joy in clean-cut, evenly proportioned forms, and also a sense of their magical potency. Early civilizations attributed magical power and mystic, symbolic meaning to numbers and geometric figures. The gradual discovery of their universal mathematical properties, and their applications to land dimensions, the calendar, the movements of heavenly bodies, must have been fascinating and awe-inspiring. One can imagine how early artisans, for the first time possessing fairly clear concepts of certain typical figures and numerical proportions, must have delighted in repeating them with controlled precision. To draw a perfect square or circle and divide it into even parts may have seemed to them vaguely as expressing human power to understand, control, and

create in a new way, surpassing the crudities of their more primitive ancestors.

How different the feeling of modern romanticists toward geometric design, and even toward the milder degree of disciplined regularity involved in classicism! Some romanticists dislike both types as symbols of repressive formalism, and seek in wild nature the opposite extreme. Some associate geometric and archaic decoration with a romantic ideal of primitive life as free and unconventional. (No doubt it was so, to the visiting Parisian, far from his own social restraints and unbound by those of his hosts; but tribal life is far from being wholly free to those who grow up in it.) Gauguin's art combines a romantic primitivism with a deliberate use of severely archaic and sometimes geometric line. He associated this with the primitive culture and environment in general, not omitting occasional hints of fear and mysterious concealment. Modern folk design, as in Slavic and Greek peasant embroidery, is often geometric or severely archaic; much of it is descended from Byzantine traditions.

The associations suggested by a certain type of design vary considerably according to whether one links it up (a) with one's conception (true or false) about a kind of people who used such design; or (b) with the type of image it suggests through kinesthetic and other physiological bonds. The latter is a more universal kind of association, based perhaps on a more direct and unprejudiced visual experience of the design itself, rather than on its historic and literary associations. By this latter type of association, geometric design strongly tends to suggest an extreme of rigid discipline and cold, chaste severity. By the former, it may suggest anything from South Sea tropical landscape to the Bohemian life of modern Cubist painters.

Certain arts have persistently shown a tendency to retain geometric framework, while others more easily assume a fluid, mobile form. Architecture is an outstanding example of persistently geometrical framework. In part, this is due to physical materials and techniques. Stone, brick, wood, and steel invite geometric shapes, whereas the plant forms of garden art, unless constantly restrained, insist on assuming sinuous, romantically irregular curves. In part, the geometric tendency of architecture is due to functional requirements. Most buildings must be strong and fairly rigid, and as a rule geometric shapes most readily insure these qualities. In part, it is due to suggested associations: a bank or government building is usually intended to suggest by its appearance ideas of strength, firmness, and rectitude, again effects most easily achievable through a geometric framework.

To take another set of examples, the shape of the book and of its lines of type remains conveniently geometrical, while jewelry and costume, more intimately connected with flowing bodily lines and movements, run through all the gamut of possible shapes again and again. Painting and sculpture have occasional geometric tendencies, as in Cubism. But, more often, they have clung to a fairly naturalistic, biomorphic type, oscillating between classic and romantic, after the first steps away from primitive geometricality have been made. On the whole, arts or types of art which undertake to display, imitate, or express the activities of life and nature, or to fit closely the contours and movements of living bodies, tend toward the biomorphic and away from the geometric in form.

On the other hand, types of art which undertake to provide a firm basis or background for human life tend to stay closer to the geometric. This would include architecture, city planning (e.g., in the gridiron and wheel patterns for laying out streets), and certain types of furniture such as tables, desks, and bookcases. Lounging chairs and hammocks, on the other hand, tend to fit the body's curves and softer textures. Exceptions to these generalizations abound, as in the wavy lines of some suburban roads. In each art there are constant oscillations of style, slight or extreme.

8. The combination of geometric and biomorphic elements.

Two or more arts sometimes combine to produce a single form containing geometric and biomorphic elements. Architecture and sculpture did so in the Greek temple and the Gothic cathedral; architecture and painting, in the Florentine church; bookmaking and pictorial illustration, in the modern book or magazine. On such occasions a fundamental contrast ensues which challenges the artist's power to integrate, and which provides the differentiation necessary for complex, organic development.

Interior design and decoration is a diversified art which makes use of several constituent arts, some geometric as a rule, some the opposite. Walls, doors, and windows in the Occidental house are almost always rectilinear and are often echoed by geometric moldings, wainscotings, fireplaces, etc. The people inhabiting these static frameworks present the contrast of irregular, mobile curves. This type of line may be

echoed in growing plants, flames and smoke in the fireplace, the smoke of tobacco, the forms of goldfish and other household pets. Furnishings occupy an intermediate position: many forms are static and geometric, while others are more often biomorphic, such as statuettes on a shelf and brocade designs in upholstery. The recent geometric trend reduced many marginal types to severely geometric shape, e.g., armchairs, lamps, desk utensils, ash trays. Eighteenth-century Rococo forms, on the other hand, flowered in curving profusion over ceilings, walls and floor coverings, chairs and utensils.

To soften a little the rigid geometry of architecture, the realm of plants, trees, and foliage provides its wealth of biomorphic forms. Curving paths reinforce it. Indoors, textiles, paintings, and small sculpture, abstract or representational, can perform a similar function. The result, if integrated, is combined, diversified form.

It is an essential characteristic of classic design, as we have seen, to combine elements suggesting life and movement with those suggesting order and firm control: not the lifeless order of the crystal or the slave's submission, but the tense equilibrium of the reined-in chariot horse and its driver. An effective way of suggesting this equilibrium of opposing forces is to combine geometric (or at least comparatively rigid) lines with biomorphic ones in the same design. The essential qualities of each are brought out more strongly by the contrast. Their union suggests controlled animation rather than dead rigidity on the one hand or capricious impulse on the other. Genuine integration goes beyond merely scattering together objects of both types, as in the ordinary domestic interior. Such integration is achieved in the Parthenon and many other buildings by irregular, curvilinear sculpture in pediments, friezes, or elsewhere, and in the Renaissance by mural paintings as well. In easel paintings of the Renaissance and seventeenth century, the geometric themes are often provided by architectural backgrounds, whether exterior, as in street or garden scenes, or interior, as in the larger compositions of Titian, Velazquez, and the Dutch genre painters. In textiles, wallpapers, and other types of flat design, it is common to have a geometric framework of stripes or crossed lines, over which arabesques or naturalistic foliage, garlands, ribbons, or animal forms may wander freely.

It is possible for a single curved line in itself to suggest controlled, orderly movement. But by separating the elements of static firmness from those of life and motion, then interweaving them again in a single design, we symbolize more vividly both the opposition and the compromise involved. Moreover, we can easily vary the relative emphasis on the two elements. A little more extent and heaviness in the geometrical element, a little less swirl in the curves, and we verge toward the severely classic or archaic. This occurs in the Quadriga or four-horse chariot within a circular medallion, a Byzantine textile motif. A little more in the opposite direction, and we verge toward the Baroque or romantic. El Greco and van Gogh achieved powerful suggestions of restless, fantastic agitation by bending and slanting even those architectural frameworks on which we customarily rely as comfortably firm and rigid. A very slight shift in the relative amounts of regularity and irregularity often makes a tremendous difference in the net effect, especially where we are accustomed to expecting a certain amount. In architecture, we expect so much geometric rigidity that a very slight curve in the main structural outlines, or a slight increase of curves in the ornamentation, is apt to seem like a radical trend toward the Baroque or romantic. (Gaudi's church in Barcelona goes far toward biomorphic form). In women's clothing, on the other hand, where flowing curves and soft textures ordinarily predominate, a slight shift toward plainness and straightness may appear as "severely classic" or "trimly tailored."

Any of these basic types of line and pattern can be developed into complex design, with the possible exception of the pastoral, simple-life variety of romanticism. There all complex organization is consciously avoided, or at least ostensibly avoided—perhaps concealed in order to produce a studied effect of simplicity. Complex organization, regarded as a product of rational control, is congenial to the classical ideal, but even there, the desire to pare away nonessentials, surplus ornaments, often leads to a final effect of austere plainness. The Baroque spirit is given to piling up complex structures for the sake of grandiose display of power and wealth, and for the joy of building and expressing oneself in the grand manner.

Complex development in certain respects can be achieved along purely geometric lines. Egyptian Islamic decoration, in carved wooden panels, stone and plaster designs in mosques and palaces, affords some notable examples. Often large sectional designs are purely rectilinear, lacking even the simplest arc. Ancient Egyptian and Mexican design also developed geometrical form up to fairly complex levels, with more use of simple curves. Early Gothic design is comparatively geometric and comparatively simple, but the late, flamboyant stage flares out into com-

plex, wavelike or flamelike traceries of archaic, semi-rigid curves.

9. Recurrent types of design in music and literature.

The visual types just considered have their analogues in auditory design in music and literature. Sounds as well as visual images can vary from the extreme of definiteness and regularity to the opposite extreme. "Romantic" in music and literature implies a trend in the latter direction, and "classic" an intermediate, balanced, or combined type.

It is significant that music can be scored in visual notation, or at least that comparatively regular music can be so diagrammed. What is the musical staff, with five treble lines, five base lines, and an imaginary middle C line between them? It is similar in function to the horizontal lines on a piece of graph paper, for symbolizing quantitative differences. In a simple statistical graph we have a pair of axes or coordinates at right angles to each other: the A and the B axis. With reference to these we can symbolize the relations between two factors in a set of changing phenomena: for example, rises and falls in price over a period of years. Moving from left to right along the horizontal axis, we go, for instance, from the year 1913 to the year 1963. Moving upward, we go from lower to higher prices. Notes on a musical staff also indicate temporal succession by their arrangement from left to right. By their position up or down, they indicate level of pitch. Both temporal duration and level of pitch are indicated fairly definitely, the former by vertical bar lines and by whole note, half note, dotted note, and other symbols in relation to a specified metronomic speed of beats, the latter by halftone gradations on the scale, with the aid of sharp and flat symbols. Standardized tuning and tempering of instruments further determine pitch on scales with fixed intervals of whole or half tones.

Gregorian chants had a semirigid, archaic type of melodic line, restrained and simple, without division into equal measures. When medieval music made an approach to such measurement, about 1100, the result was called *musica mensurata*, measured or mensurable music, in distinction from the older "plain song." Later, the term "meter" was narrowed down in music and poetry from its literal sense of "measure" in general, to mean measurement applied to rhythm, that is, division into a specified number of long and short or strong and weak beats. Broadly speaking, modern music in a traditional European style is metric or measured, not only in regard to the strength and duration of beats, but in regard to tempo and pitch. Both of these components are commonly specified in numerical quantities, or in symbols translatable into them.

The possibility of scoring and thus directing the performance of music has tended to make traditional Western music comparatively regular and definite, especially since Palestrina. The pitch thus changes by regular intervals, instead of wavering and wandering between the notes of the scale, and notes of definite pitches are combined into chords. Slight, unspecified sharps and flats are condemned, as a rule, especially in singing, although slight deviations of pitch are permitted to the singer and violinist in certain circumstances. Trained listeners object to "sour" and "off-pitch" notes of a sort which is common in Oriental music. The clear "ping" of harpsichord music and the relative purity of Baroque organ tone as compared with nineteenth-century romantic tone facilitate complex, neoclassic design.

Unless the metric succession of beats proceeds with steady regularity, the performer may be criticized for uneven rhythm. Such aspects of Western music, which can well be called "metric," are analogous to the "geometric" aspects of visual art. In contrast, both the melodic line and the rhythmic pattern of much Oriental music are biomorphic. Fractional intervals are commoner, and rhythmic beats are less regimented into uniform bars. Slight waverings in pitch and meter are accepted in music as one accepts them in the song of birds and the wailing of winds—as characteristic of life and nature, not as incorrectly "off pitch" or "off beat."

In Western musical design, as well as in visual, there are countertrends. As exact precision of pitch and rhythm have become easier, through mechanical aids, public taste has reached a little away from it. The romantic spirit of much nineteenth and twentieth-century music has favored relaxing the strictness of both pitch and rhythmic meter. It has favored permitting the violinist, cellist, or singer occasional slight liberties with pitch, in sliding up to or down from a note, and in oscillating the finger that holds down a string. It has favored increasing liberties with rhythm, from the modest "tempo rubato" of Chopin to the wild primitivism of "hot jazz." Recent "concrete" and "electronic" music go even farther at times in mixing and blurring timbres, pitches, and meters. Charles Ives makes some instruments and groups

in the orchestra play almost independently at times.

As in visual design, means have been found to combine metric and nonmetric elements in the same work of art, thus producing a compromise or balance which may vary from the neoclassical (as in Haydn and Mozart) to the romantic (as in Schumann, Wagner, Debussy, and the earlier works of Stravinsky). A single melodic line can strike an intermediate degree, between simple, repetitious ups and downs, louds and softs on the one hand, and extremely diffuse, aimless wandering on the other.

As in visual art, one can separate and contrast the two types. The base can be, as it often is in modern jazz, mechanically regular, thus providing a regular framework for the biomorphic traceries of the treble. Certain voices in the orchestra can be extremely regular in both meter and pitch, while others follow more erratic paths.

Dynamics, timbre and orchestration, chord progression—these other components in musical design have not been satisfactorily reduced to exactly measured regulation. The structure of chords is a development of pitch, and as such capable of numerical expression as comprising tones from one to seven in the octave, as first or second inversion, as dominant or diminished seventh, etc. But the development of the orchestra and its greater importance in romantic music of the nineteenth century have tended to blur exact pitch through complex orchestration and the multiplication of simultaneous overtones, especially in dissonant chords and chord progressions. Dynamics are indicated by rough comparative terms, such as "pianissimo," "mezzoforte," and so on, but their nuances are left to personal interpretation.

Verbal design, especially in verse, has shown some tendencies parallel to those of music. The classical system of measuring feet and lines in terms of quantity—of long and short syllables—was severely metric in theory, though usually applied with some flexibility in the composition of verse. The difference between long and short syllables could, theoretically, be exactly measured and regulated. That between strong and weak syllables in accented verse was harder to measure, for the relative loudness or force of an accent cannot easily be specified in quantitative terms. In the actual reciting of verse, accents are greatly varied, to emphasize important ideas as well as for thematic development of rhythm. The tendency of modern verse, both "free" and formal, has been on the whole toward freedom for unusual, nonmetric patterns of rhythm. Corneille's rhythms are spoken at

the *Comédie Française* with more variation than would appear from the printed text.

So it has been, too, in regard to rhyme. Timbre in word-sounds became partly metric when rhymes were organized in set schemes such as the terza rima of Dante and the Shakespearean sonnet. They were metric in being governed by some numerical formula. The heroic couplet is comparatively geometric in its simple regularity, from the standpoint of rhyme scheme as well as from that of rhythm. Pitch and several other components remain indeterminate in both verse and prose.

Prose is the ordinary language used in speaking or writing; the term is used also of a kind of literature which is not organized into poetic meter or definite rhythm. It is nonmetric and somewhat irregular in regard to rhythm, timbre, and all other components. Intermediate types are (a) rhythmic prose, which has a little more thematic development of rhythm than ordinary prose has; and (b) free verse, which usually has somewhat more, along with division into lines of uneven length. Inasmuch as prose is, in a sense, more natural—the form which words assume when not artificially patterned—the "back-to-nature" impulse of Romanticism sometimes carried with it a tendency to favor prose rather than verse. Other factors in Romanticism cling to verse as more congenial to emotion and fantasy. Wordsworth consciously associated Romanticism with the move away from artificial verse and toward the language of the common man. Walt Whitman and the twentieth-century free-verse poets, as continuations of this nonmetric tendency in literature, maintain strong affinities with Romanticism. Many Romantic poets, such as Burns and Heine, favored the simple, short, rustic type of song, which involved a move away from complex metric pattern but not an avoidance of meter.

Again the difference between romantic, classic, and geometric is relative. In verse, a slight shift toward simplicity or freedom of rhythm can seem extremely romantic, if people have been used to much stricter forms. Prose is, on the whole, the language of science, commerce, and conversation on prosaic subjects. Prose, and even free verse, are not necessary for the expression of romantic sentiments, and not always devoted to it. English poetry of the Romantic period was written for the most part in fairly regular patterns. These gave way to extreme irregularity in the free verse of Whitman, which is in its way a culmination of the Romantic movement.

Prose can be classic in effect, when slightly rhythmic and cadenced. When people are used to very

prosy prose—to speeches, stories, and articles which make no attempt at all at organization of word-sounds—then a slight development of rhythm in that medium may seem very formal. A contemporary reader is likely to derive this effect from reading the prose of John Donne, Thomas Browne, or the King James Bible. Though much less metric than ordinary verse, they are much more metric than ordinary prose. Hence they strike one today as formal, elaborate, and (in their stately, extended periods) as classic.

Rhyme is scarce in primitive verse, but a simple, repetitive meter and melody are common, as in American Indian chants. As the simple triangle or zigzag is repeated over and over again in a Navaho rug, so a simple insistent theme of strong and weak beats, with a few ups and downs of pitch, will be repeated over and over again in the tribal chant. So, also, a few definite gestures, often boldly angular, will be repeated in the dance which goes along with the music. In a Polynesian tribe, long genealogies and catalogues of ancestral exploits are remembered with the help of mnemonic rhythms, which tend to impress the modern, uncomprehending listener as tedious.

As in visual art, primitive geometric design in music and literature is almost never completely exact in its repetitions. Whether intentionally or not, each repetition may be a little different. Primitive art is free from the stereotyping effect of scientific, mechanical methods of reproduction. Usually it is free from definite patterns or written texts to be followed. Slight, often unconscious variation from unit to unit of a theme tends to give each design a suggestion of vitality. Pitch and tempo change slightly in ways that would be unlikely under the rule of tuning fork and metronome. Suddenly and surprisingly, the whole design may shift from one theme to a very different, but still simple and geometric one.

Primitive music is devoid of long, sustained, developing melodies and of rich harmonic textures. It remains undeveloped in most components, and on the whole lacks differentiation. However, some complexity is possible in geometric music. It occurs notably in African Negro rhythms, where a variety of drums and other percussion instruments may develop into a sort of counterpoint, sometimes with the aid of simple flutes, bowed strings, and human voices. Each instrument may repeat an intrinsically simple pattern of beats over and over, or with slight change. But if each plays a different rhythm, and all interlock through landing together on occasional strong beats, a limited kind of complexity results.

Note: The following illustrations are particularly relevant to this chapter: Plates I, II, VI; Figures 6, 21, 23, 24, 27, 28, 29, 30, 31, 32, 35, 36, 37, 38, 39, 40, 41, 48, 49, 61, 62, 63, 66, 73, 74, 75, 81.

CHAPTER X

Style
and Stylistic
Analysis

1. Styles as complex recurrent types.

The term "style" is currently used in two different senses in the field of art. The chief difference between them rests on whether a style is defined in terms of some particular historical provenance. When it is not so defined, "style" is roughly equivalent to "complex recurrent type," as discussed in the previous chapter. A style in this sense is not limited to any one period, place, or people in history; it may occur in many times and places. To combine the two ideas, one may call it a *recurrent stylistic type*. Epic, tragedy, satire, and many analogous types are sometimes called "styles" in this sense. Thus critics and historians write of the epic, heroic, lyric, and sublime styles, and of the pastoral, satirical, and comic styles. ("Satiric," in the sense of "containing satire," is not to be confused with "satyric," as descriptive of an ancient Greek type of play having a chorus of ribald satyrs.) "Pastoral" means portraying or expressing the life and surroundings of country folk, especially shepherds and shepherdesses, in an idealized or romanticized manner. It is applied to poetry, theater, painting, and music. A trained writer can usually express himself in any one of several styles. Thus an author may intentionally write and an actor act in the "grand manner" or in a slapstick, burlesque, or low-comedy style. A text intended by the author to be in the grand, sublime, or lofty style can be burlesqued, parodied, caricatured, or "hammed" in performance. Through exaggeration, it may become grandiose or bombastic, or it may be intentionally delivered in an incongruous, clownish style.

In literary criticism, as we have seen, the term "style" is often restricted to the choice of words and to details of grammar, syntax, sentence structure, and rhythm or lack of it. These refer mainly to the general pattern and medium of expression rather than to the content of ideas and emotions or the subject matter represented. When thus restricted, literary style is conceived as being concerned with the shell or garment rather than the substance of art. Style in this sense is a developed component of literature.

We shall understand the concept of style as including any kind of trait, whether of form or content. Thus to write in a scholarly, erudite style, as contrasted with a popular or juvenile style, tends to involve certain kinds of idea, of attitude and subject matter, as well as of words and sentence structure. A particular stylistic type can be defined in terms of any trait or set of traits which are emphasized therein, such as a prevalent mood, conative attitude, or emotional tone. Thus critics distinguish the "humorous," "witty," "didactic," "lyrical," "jocose," and "pathetic" styles. Music makes use of analogous concepts, as in the "scherzo," conceived as a sprightly or somewhat humorous composition or movement.

"Satire" is a stylistic type which can pervade an entire composition or only part of it. A play or novel can have a satirical strain running through it as a developed component trait, perhaps in the words of one character. Satire is close to wit and humor, but more polemic and often savagely biting. It can be comic or tragic; mild satire is a common element in comedy. In general, satire holds up human faults, vices, and follies to ridicule and mockery, sometimes with implied suggestions for correcting them.

As we saw in the previous chapter, many names of complex types are used in an objective sense and also with favorable or unfavorable connotations. Thus "grandiose" can mean, simply, "in the grand manner"—that is, impressive because of unusual majesty, grandeur, breadth, and power, or imply an absurd affectation of grandeur through exaggerated pomp

and pretense. "Bombastic" implies a badly grandiose mode of speech or writing, pretentiously inflated, out of proportion to the ideas involved. Both these terms have acquired unfavorable connotations, but in a more neutral way they may refer to details within a work. It implies no disparagement of a play to say that some character or speech within it is grandiose or bombastic. An entire work may be intentionally written in one of these styles, as a tour de force.

Stylistic types such as these have been defined and practiced for centuries in the drama and theater. They refer, not only to the literary text, but also to costumes, gestures, facial expressions, and tones of voice, all of which combine to make a character or scene exemplify them. From this, they are easily carried over into pictorial representations of theatrical and other subjects. Thus a bombastic, ranting actor may be a subject for caricature. This in itself is a complex type, implying an intentional exaggeration or distortion of the subject's appearance, speech, or manner so as to belittle or demean him, perhaps in a kindly, humorous way and perhaps as derogatory satire. Not only a picture but a literary portrayal of someone can be called a caricature in this sense.

The same term, as applied in different arts, will naturally take on somewhat different meanings. "Tragic," "comic," and "pastoral" are like most of the others just mentioned in applying primarily to literature and drama. They are extended more abstractly into visual art and music. "Tragic" and "comic" are commonly understood as referring mainly to the outcome of a plot and the related emotional tone; tragedy has a sad ending for the hero or heroine, comedy the opposite. Those who base their usage on Aristotelian poetics tend to distinguish tragedy from the merely sad or pathetic, and comedy from the merely happy or amusing. Genuine tragedy, or at least classical tragedy, is then conceived as requiring a plot with "magnitude" and a hero with nobility, inspiring some respect and sympathy, but brought down by a "tragic flaw." A story can be pathetic, or express pathos, if it is sad without rising to heights of grandeur, dignity, or magnitude. In a feudal culture the lower classes are usually regarded as incapable of real tragedy; their sufferings are then shown as merely pathetic or even ridiculous. In the eighteenth century the concept of tragedy was extended to the middle class, and now it has no definite class limitation.

To call a picture "tragic" usually implies that it depicts a tragic scene with appropriate expressiveness in representation, coloring, and other factors. The Crucifixion is often regarded as a tragic scene even though its protagonist is not a tragic hero in the classical sense,[1] but it has magnitude and inspires sympathy. Music and abstract painting may qualify as tragic in the broad sense, even though they lack a definite story or characters; that is, by conveying a tone of sadness or mourning along with dignity, nobility, or majesty, as in Beethoven's funeral march in the Sonata, Opus 26. Likewise, music can be pastoral, as in his Sixth Symphony, when it suggests a mood of calm or gay relaxation and enjoyment in the country. When applied to poetry and drama, such as the "bucolic" poetry of Theocritus and Vergil, it usually calls for more explicit representation of rustic scenes and characters—shepherds, shepherdesses, and their flocks in pleasant meadows.

In the mind of anyone familiar with art history, the mention of a well-known type tends to call notable examples of it to mind, such as those just mentioned. Oedipus and Macbeth are typical tragic heroes, while Odysseus and Aeneas are typical epic heroes. Not only epics, but also ballads, odes, and prose tales glorifying the exploits of noble heroes with appropriate imagery and word-sounds are said to be in the heroic style.

2. Style and provenance. Period and individual styles.

This second sense is preferable on the whole for distinguishing "styles" from other types of art. A style in this sense is *an interrelated set of traits which is characteristic of the art produced in a certain place and period, by a certain social group or individual artist.* Style in this sense is definitely linked with some historical *provenance*—chronological, geographical, social, or individual, or perhaps all of these. Works from that source are said to manifest the style in its most authentic, typical, pure, or highly developed form, although imitations of it or similarities to it may be found elsewhere. Such a style is called a *historic* or *period style.*

The "provenance" (or provenience) of a style or work of art is sometimes conceived in terms of place alone. We shall understand it as including period and people also. "Provenance" may include the artist, nation, or ethnic group which, in a certain age and re-

[1] Jesus had no flaw, according to Christian doctrine; his death was not a downfall but a sacrifice, and not permanent.

gion, originated the style or produced it in some especially notable way.

The basic idea of historic style, that significant differences exist between the art of different peoples and periods, goes back at least to Greek philosophy. Plato writes in the *Republic* of the various "harmonies" in singing, naming them in terms of peoples or geographic regions, and discussing their supposed effects on mood and character. Thus the Ionian and Lydian, he says, are called "lax," "effeminate," and "convivial." Vitruvius compared the Doric, Ionic, and Corinthian styles of architecture, now sometimes called "orders." His name for what we now call a "style" was *genus* or type—the same term now used in biological classification. Neither he nor Plato emphasized historical origins. Medieval writers compared under various names what we now call the Romanesque and Gothic styles of church architecture. Those of the Renaissance compared the so-called "Greek" (Byzantine) and Roman styles of painting. Some traits of the latter descended from Hellenistic Roman art to Giotto and Masaccio.

During the Renaissance there was increasing interest in the individual from various points of view, including his appearance and personality. Individuals were shown in art with increasing discrimination, and the artists themselves were compared in terms of individual *maniera*. Historians compared the arts of ancient Greece and Rome with those of modern times, at first to the disadvantage of the latter.

Most of these early references to style, in various terms, had a strongly evaluative intent; they were concerned with praising one kind of art, or the art of some one person, time, or place, at the expense of another. This is true of Winckelmann in the eighteenth century and of Hegel in the nineteenth, although both did much to advance the knowledge of historic styles. It was only in the later nineteenth century, in France and Germany, that a conscious trend toward scientific objectivity in the analysis of styles made important headway. Present aesthetic morphology is in that line of descent. Scientific aesthetics asserts that no historic style is to be assumed as right or best. Taine declared that each can be described objectively as biologists describe a plant or animal: as a historical phenomenon, a way of seeing or hearing, thinking, and creating, which flourishes at certain times and places under certain conditions. The morphologist is not especially concerned with historical relations, sequences, environments, causes, or effects, but some reference to these is almost unavoidable in the description of styles.

A clear, basic definition of any historic style requires two sets of ideas, two meanings of the name by which the style is known. One refers to a certain *provenance*, the other to a certain set of *traits in art* which are regarded as characteristic of it. Either may be mentioned first and specified most fully in the definition. The Merriam-Webster *Third New International Dictionary* (1961) thus defines "Impressionism" first as a historic style: "a theory or practice in painting esp. among French painters of about 1870 of depicting the natural appearances of objects by means of dabs or strokes of primary unmixed colors..." It then defines the term as a recurrent type, not restricted to any one provenance: "the depiction of scene, emotion, or character (as in literature) by the use of detail that is sometimes brief and essential but ... is intended to achieve ... effectiveness more by evoking subjective and sensory impressions (as of mood and atmosphere) than by recreating or representing an objective reality." A similar meaning in music (as a recurrent type) is then listed: "a style of musical composition designed to create vague impressions through rich and varied harmonies and timbres."

Impressionism changes gradually into Neo-Impressionism in the Pointillist techniques of Seurat and Signac; into Post-Impressionism in the solid shapes and deep spaces of Cézanne and Renoir in their late periods. All these painters vary considerably in the course of their lives, especially as to the emphasis placed (a) on the purely visual as distinct from represented subject matter; and (b) on reflected sunlight and color as distinct from clarity of outline, shape, and space composition. How far such variations can go without passing the limits of Impressionism is still debatable. To understand Impressionism historically and chronologically, one should see what went before as well as what came after it, especially the naturalism of Courbet, much of which survived in Impressionism, and the rich coloration of Rubens, Constable, and Turner, all of whom contributed to it. Some would say that these earlier masters had pre-Impressionist or proto-Impressionist traits, and this applies to some Hellenistic as well as modern painting.

A thorough study of nineteenth-century French Impressionism would lead one to investigate its cultural environment. What of the previous advances in photography and the science of optics? One might examine changing attitudes toward nature: how, in contrast with Renaissance and Baroque landscape, French Impressionism emphasized a rather peaceful (not grand or wild) kind of rustic scene: intimate

views of quiet meadows, country lanes, small gardens, ponds with boats and water lilies, often with well-dressed women and children enjoying the summer weather. They give a mood remote from arduous labor (as in Millet's *Man with the Hoe*), and also from dramatic actions and magnificent buildings. Monet's paintings of cathedrals and palaces tend to subordinate the buildings to surface reflections of light and color. The mood suggested is often one of relaxation and quiet happiness without profound thought, anxiety, desire, or effort; a mood like that of a bourgeois family on a holiday trip.

A comparison of Impressionist painting with previous styles (e.g., of Dutch landscape) shows considerable overlapping. The soft, flowing, "painterly" character of Impressionism links it with "Baroque," as Wölfflin defines the latter. In some respects, Impressionism can be regarded as a recent outgrowth of the Baroque tradition. In other respects (e.g., the Baroque expression of power and grandeur) they are very different. This illustrates how a stylistic tradition can divide as it descends through time, portions of it merging with others.

3. The definition and classification of historic styles. Stylistic identification of particular works.

Like the concepts of complex recurrent types, those of historic styles are useful in morphology as means of concise description. Like the names of recurrent types, a single word such as "Impressionist" or "Gothic" is enough to characterize a work of art in many respects at once. In addition, that word can help to locate the work in the history of art and of culture. It is not the main task of aesthetic morphology to trace the chronological and causal sequences among works of art, but some knowledge of their provenance can throw light on their meanings and functions.

Doubt and disagreement on the meaning of style names make it hard to apply the name to a particular work. A name such as "Romantic" or "Baroque" implies several traits in combination, and a work of art may involve some but not all of them. Scholars disagree on what traits each name implies, and which among these are most essential. Hence it is hard to get agreement on what examples are most typical.

In spite of all these difficulties, one of the most significant ways to describe a work of art is to show how it exemplifies one or more historic styles as cur-

rently defined, how it conforms to these in some respects and differs in others. It would be useful in morphology to have a long list of concepts of historic styles, covering all the arts and art-producing periods through the world, with each style clearly defined in terms of traits and provenance. No such list is now available.

A style of art can flourish throughout a large area—a continent, a hemisphere, or the entire world; this is an *extensive* style. To be extensive means that examples of it are widely distributed, not that it is the only style in that area. A style can be limited to a certain tribe, clan, or small village; this is a local or geographically *restricted* style. The geographical relations between two or more styles, or examples of the same style, are often historically important. This is especially true when stylistically similar examples come from widely separated places, such as the Egyptian and Mayan Empires.

A "period" is a certain time span in history, especially one which is marked off by some notable event such as the end of a dynasty. In chronological duration, a style can be brief or long-lived. The Greek orders of architecture have been extensive as to both space and time, but only some parts of that life were creative and original. The rest has been imitative. Recent painting has produced many short-lived styles. A combined space-time description indicates the style's duration in a certain place or places. It may be long-lived in one place and short in others. Similar styles may flourish in environments which are remote from each other in time as well as in space. A dormant style may revive with a new burst of creativity, as Greek styles did in the Renaissance.

What we are calling "people" takes many forms. In general, it is the group or individual who produced the style. This raises problems as to cause and effect, especially when a style is partly derived from foreign sources. What previous styles influenced it and what later ones did it influence? The people concerned may be designated in various ways: politically (e.g., British); racially or ethnically (e.g., Negro or Polynesian); religiously (e.g., Islamic or Buddhist); in terms of social classes, such as nobles or peasants; in terms of sex and occupation, such as male or female dancers; in terms of age, education, and mental level, such as children or adults, intellectuals or illiterates; and otherwise. A combined description can be made in all three frames of reference for an individual artist as well as a group: e.g., El Greco's youthful style before going to Spain.

A clear and detailed account of many historical

styles would open the door to systematic *classification* of them and to the recognition of *substyles* as divisions or variants of the major ones. On a basis of provenance, the styles of Botticelli at various periods of his life are substyles of fifteenth and early sixteenth-century Florentine style, which is a division of Renaissance style in general.

Discussions of style are often rendered vague and confusing by failure to specify, in sufficient detail, what one means by the name of a certain provenance. It is not enough to say, "in the Florentine style" or "in the fifteenth-century style" unless the context indicates more clearly what is meant. Florentine art has had, of course, many styles at different times and even in the fifteenth century.

In speaking of *individual* artists and their styles, such terms as "Chopinesque," "Raphaelesque," and "Miltonic" are commonly used. They are applied to examples of the artist's own work, as in saying that a certain passage in a sonata is "typically Chopinesque." Also, they are applied to the work of later artists, as in saying that some of Titian's works are Giorgionesque. One or more traits of the earlier master may appear in altered form in the later, as Giorgione's coloring is incorporated in the work of Titian and later Venetians.

Some romantic philosophers, in glorifying the nature and creative power of the artist, have argued that every style and every work of art is "unique." Following Plato, they say that each true artist receives a direct inspiration from heaven, and owes nothing essential to the art of the past. If this were true, there could be no period styles and no enduring traditions like those of Greek architecture and sculpture. There could be no general morphology of art. But the falsity of that belief is obvious as soon as one begins to compare actual works of art. Each artist takes something from the artistic traditions and cultural environment he inherits, and, if he is creative, he adds to them or alters them in some significant way. His work will have certain generic traits of style in common with that of other artists, and certain more or less distinctive ones. His individual style or styles will help to make up the styles of his cultural group at a certain time.

It may take many years for an artist to develop what he and posterity will regard as his own personal style, his distinctive self-expression. Even so, it will necessarily involve a selection from one or more past traditions, along with his more original characteristics.

Because some styles in all arts persist through generations, or revive after temporary declines, it is important to distinguish between original examples and later imitations or adaptations. The latter are not necessarily forgery or plagiarism; some are frankly copies or reproductions. But expert scholarship, monetary value, and other considerations call for care in distinguishing the genuine, authentic works, "of the epoch," from the later versions. This is most notable in visual art, especially painting, where a great premium is placed on having the original work of the master. To a lesser extent, but with important aesthetic implications, experts study old manuscripts of music and literature to decide whether all is in the handwriting claimed. Some of it may have been altered or inserted by a later hand.

For the most important decisions, a purely visual, morphological inspection of the work is not enough, so the aid of science is invoked in the form of x-rays, ultra-violet photographs, chemical analyses, and studies of carbon radiation. These may date and place the object with some assurance—for example, by showing that the clay in a certain vase is found only in a certain region of China, or that the paint, canvas, or varnish found in a certain painting was not used before 1600.

In other cases the visual or auditory acuity and historical knowledge of an expert may suffice to infer the provenance of a work on a basis of style alone. He has learned to identify the work of a certain artist with a certain set of traits. Then, seeing a work with similar traits, he attributes it to that artist. This is often correct and confirmed by other evidences. But it rests on the assumption that the works previously attributed to the master were actually his. To use stylistic evidence for it may be arguing in a circle. The assumption may rest on questionable information as to where and when the early pieces were found, or on vague descriptions of a work of this sort in early documents. Analogous problems arise in determining the authenticity of musical and literary manuscripts by stylistic analysis. The modern critic may say, "Mozart would never have used that modulation," or "that Hellenistic phrase was unknown in Sophocles' time." Hence, using his conception of the style of the early master, he rules out exceptions to it as proof of a different origin. But not infrequently the current conception of an early style must be revised in the light of new discoveries. Rembrandt painted and Bach composed in many different ways in the course of their careers.

4. Difficulties involved in the relation between traits and provenance. General stylistic analysis.

A carefully developed conception of a historic style will refer to a certain provenance and also to a set of traits as characteristic of that provenance. This will imply a statement about historic facts, whose truth is an important consideration from the scientific standpoint. If someone speaks of "the Impressionist style of landscape painting, as in the Byzantine mosaics at Ravenna," the historical error is obvious. But less flagrant misstatements are common in the discussion of styles. A concept of style containing historical errors is a poor instrument for morphological description and may lead to further errors.

The names and definitions of historic styles have not, as a rule, been the result of empirical study and logical reasoning. Style names and meanings have been associated more or less fortuitously through centuries of discussion along many lines. Some of them referred originally to historical phenomena far removed from those they now suggest. "Romantic" referred to "Roman," to the Romance languages, and to medieval verse tales written in those languages; then to some of their traits, such as a profusion of characters, incidents, and events, not conforming with classical rules. Only in the nineteenth century did it come to stand for a certain movement in late eighteenth- and early nineteenth-century literature and other arts. It still refers at times to that historical movement and at other times to certain abstract traits and types wherever they may occur. "Gothic" referred at first to a semibarbarous, migrating people on the borders of the Roman Empire, and much later to a style of architecture, especially in the medieval churches of Northern Europe. Old and new associations, different conceptions of traits and of provenance, mingle in the modern meanings of these terms.

In some cases, as we have seen, the name of the style referred primarily to a certain provenance, to the art of a certain period, place, and people (as in "Louis XV style"), without restriction to any particular kind of art. Later on, it came to mean also a certain set of traits, supposedly characteristic of that provenance. In other cases, the style name referred primarily to a certain type or set of traits (as in

"Rococo"). Later on, it came to mean especially a certain provenance, of which those traits were supposedly characteristic. "Rococo" is derived from *rocaille*, a kind of ornamentation made of rocks and shells, popular in eighteenth-century France. Later it spread to cover all French visual arts of the mid-eighteenth century, during and shortly after the reign of Louis XV; then still farther to include certain types of visual art, music, literature, and theater from all parts of Europe in the mid-eighteenth century. Thus literary critics refer to the "Rococo wits" of eighteenth-century England.

Such changing associations were at first rather loose and casual, but in the twentieth century attempts were made to use the style names more precisely. This led to oversimplified generalizations about the history of art, and to confusing definitions of particular styles. Attempts to correct these and achieve a clear, true statement of the facts can be described as *general stylistic analysis.* They can not be adequately done by studying only abstract concepts, words, and meanings, or only particular works of art. The names must be tentatively applied to particular works of art, and checked with verifiable information about the provenance of these works. Hypotheses about the correlation of certain traits and types with certain periods, places, and peoples must be tested empirically, to produce more reliable generalizations about historic styles.

We have noticed the definition of "Impressionism" as a style of painting, practiced by a group of French painters in the late nineteenth century, which represented shimmering sunlight on colored objects out of doors by juxtaposing small strokes of contrasting colors. But the idea of an "impression," as a quick, incomplete, perhaps superficial observation of something, applies to several different kinds of painting. It was applied to painting of much the same provenance which emphasized, not sunlight and color, not small, contrasting brushstrokes, but quick glimpses of rapidly changing aspects in the passing show about us— race-horses, ballet dancers, strolling crowds in a park at twilight, and the like. Whistler and Degas exemplified this kind of Impressionism; Whistler called attention to it by using a butterfly as symbol. The coloristic type, exemplified by Monet and Sisley, achieved a longer, wider vogue among artists, critics, and the public, whereas Degas and Whistler remained as isolated individuals. Little by little, the term "Impressionism" was limited to Monet's kind. The shift in meaning as to traits is obvious, but the difference in

provenance can best be described in terms of individual artists.

A new question of provenance arises, however, when coloristic Impressionism lasts on through several generations to the present time, even leading to "Abstract Impressionism" in the 1950s. As a long-lived style, its "period" is almost a century; but within this one can distinguish Impressionism "of the epoch," as in a painting of water lilies by Monet, from late, conservative, *retardataire* Impressionism as in Ernest Lawson. However, the wider meaning still persists in its own right, especially outside painting. Debussy's preludes for piano are often descriptive, as the titles indicate—e.g., *Reflets dans l'eau* and *Jardins sous la pluie*. At the time, artists in different media often tried to convey the same "impression" by different means. The term "Impressionist" was applied to music of this type, and also to literature which sought to describe fleeting images, as in some passages by Mallarmé, Verlaine, and Proust.

To take another example: the origin of the name "Baroque" is lost in obscurity. At one time it was thought to have come from the Portuguese word for "irregularly shaped pearl," which seemed consistent with its later meaning. At another time it was traced to the formula for a type of medieval syllogism, and at another to the Italian artist Federigo Barroccio. Whatever its origin, it expanded to connote certain traits in painting, sculpture, and architecture, such as an emphasis on large, heavy, swirling masses, bizarre and irregular, unbalanced compositions, grotesque and extravagant imagery, dynamic opposition of forces, elaborate ornamentation, powerful tensions and contrasts. Until the twentieth century Baroque art, in this sense, was generally condemned as excessive. At the same time, the term became attached to a certain period in European art, especially the seventeenth century, along with the years just preceding and following it.

Early in the twentieth century, the Swiss art historian Heinrich Wölfflin did much to stimulate an interest in theories of art history and especially in the concepts of "classic" and "Baroque" style. The former he associated mainly with the Italian Renaissance (fifteenth and sixteenth centuries); the latter with seventeenth-century European. Besides defining the provenance of "Baroque" in this broad way, he redefined the concept in terms of a new set of five traits. Since he did not clearly restrict these traits to any subdivision of seventeenth-century European art, his book[2] gave many readers the impression that *all*

seventeenth-century European art possessed them, or at least all that was worthy of consideration. By contrast, he redefined "classic" or "Renaissance" style in terms of five traits antithetical to them. Thus he proposed a sharp, multiple antithesis between the two styles and supported it by analyzing photographs of many examples. Where the classic is linear, said Wölfflin, the Baroque is painterly (with soft, flowing colors, textures, and shadows, blurred contours, etc.). Where classic is "planar," the other is "recessional"; where one is "closed" the other is "open." Sixteenth-century art is "multiple"; that of the seventeenth century is "unified"; one is "clear" and the other "unclear." The book was hailed as important for its positive contribution: it did point to certain widespread contrasts between the two centuries. But it ignored or minimized some important negative instances: for example, in the art of Poussin, Velazquez, and Vermeer. Many works of these and other seventeenth-century artists fail to exhibit all the so-called Baroque traits; many sixteenth-century works (e.g., late paintings of Titian and Tintoretto) do exhibit some of these traits.

Philosophical historians, especially those in the German, Hegelian tradition, led the way in pointing out a supposedly all-inclusive *Zeitgeist* in each period of cultural history. Some applied Wölfflin's formula to music and literature, thus identifying the "classical Renaissance" with the period 1400-1600 as a whole, and "Baroque" with the 1600's. "Typical" examples of each were easily found, exceptions easily ignored. This implied a homogeneity in each of the periods which more critical, empirical historians denied. Each period, it was later shown, contained some of both sets of qualities. It was thus untenable to define "Baroque" in terms of a specific set of traits and, at the same time, in terms of the large provenance which Wölfflin had included. .

The meaning of "Baroque" remains somewhat confused in spite of many attempts to correct it, partly because of inadequate attention to the theoretical problems involved in defining styles. When the set of traits implied by a style name are found to be *not* as characteristic of a provenance as had been supposed, what can be done to correct the situation?

When generalizations about a whole, large provenance are called for, there are ways of making them with reservations. One can say, for example, that Wölfflin's five Baroque traits occurred *especially*, or in a more fully developed way, in the seventeenth century, but less fully and frequently in the sixteenth, and with somewhat declining force in the early eighteenth.

If we assume that there is no one right, permanent meaning of a word and that words and meanings can

 [2]*Principles of Art History: The Problem of the Development of Style in Later Art* (New York, 1932). Translated by M. D. Hottinger from *Kunstgeschichtliche Grundbegriffe* (first ed., 1915).

be adjusted to serve human uses, there are two main possibilities. One approach is to define the style name, tentatively, in terms of a certain provenance, then to examine the arts of this provenance and describe their main distinctive traits. Large periods, places, and peoples can be divided and subdivided, together with the styles and substyles actually found therein. The other approach is to define the style name in terms of a set of traits and look around to see where, in what provenances, this set of traits can be actually found. The two approaches supplement each other and can easily be combined.

In either approach, so large a provenance as "Renaissance man" or "the Baroque age in Western art" should be subdivided into smaller parts, one or more of which may exhibit a certain set of traits with some consistency. In terms of the frames of reference discussed above, this can be done as follows.

The large provenance called "Baroque"—late sixteenth, seventeenth, and early eighteenth-century art throughout Europe—can be divided first *chronologically*. In terms of *period*, we can detach some of the late sixteenth- and early seventeenth-century products which seem to be significantly different from the later ones. Thus there has been a tendency to class Tintoretto and El Greco, formerly regarded as "High Renaissance" or "Baroque," under the concept of "Mannerism." This involves minimizing the traits of these artists which had formerly placed them with the Baroque, and emphasizing others such as anxiety, bizarre composition, strained postures, elongated necks, exaggerated muscles, and the like, now to be called "Mannerist." In literature, some of Shakespeare's "dark" plays, such as *Hamlet*, have also been linked with Mannerism.

Secondly, the realm once wholly assigned to Baroque can be divided as to *place*, into northern and southern. Thirdly, as to *people*, it can be divided in terms of religion into Protestant and Catholic. (Flanders was mainly under Catholic influence; Holland, under Protestant.) Combining these modes of division, we deal with smaller units of provenance, such as "southern, Catholic Baroque in the last three quarters of the seventeenth century." Thus cutting down the field, one may expect to find fewer contrasting, fully developed styles, with more similar influences throughout, in spite of individual variations. A few individuals, such as Rubens, will loom up as typical of it. Southern Catholic Baroque is infused with the emotional enthusiasm of the Counter-Reformation, expressing itself in large, bold, magnificent ornamentation.

On the other hand, there has been an opposite trend in theories of art history toward extending the provenance of a few conceptions of major historic styles. Instead of emphasizing the names of local, individual, or short-lived styles, such as those of the Louis XV period, or of Chippendale, Lully, Tiepolo, Dryden, Pope, and Delacroix, one tries to group them under a few major, extensive headings such as Baroque, Rococo, and Romantic. This involves minimizing differences in place and people, while emphasizing instead the supposedly common, unifying spirit of each age. Chronological, ethnic, and religious grouping becomes important, but without sharp boundaries, since it is recognized that the spirit of the age manifests itself a little earlier or later in different places.

Inevitably, as one tries to make a concept like "Baroque" cover more and more space and time, more and more different arts, ethnic groups, and individual leaders, it becomes harder and harder to find important common traits of style within it, clearly different from those of other peoples, times, and places. One is forced to minimize the individual peculiarities of distinctive artists like El Greco and John Donne, stressing instead their resemblance to contemporaries and the roles of other men more typical of the age. Trying to cover all the visual arts, literature, and music, one must omit from the general definition of "Baroque" specifically visual traits like "large, sweeping curves," "heavy ornamentation," and "strong contrasts of light and dark." One must also omit specifically auditory terms like "complex melodic structure" and "strong contrasts of timbre and dynamics." The concept tends to limit itself to conative-emotional suggestions and abstract ideas which can be expressed or symbolized in a variety of media, such as "restless striving for power." Such a general definition can, of course, be accompanied by reference to the different ways in which it is exemplified in special fields.

5. Recurrent stylistic types in widely separate periods and cultures.

The rapid development of advanced art criticism and historiography during the past century has embraced the arts of all regions, periods, and major cultural groups since paleolithic times. One consequence has been the increasing interest in comparing the arts of widely separate provenance. This has called attention to many striking resemblances, not only where a long-lived tradition such as that of Greek architecture has survived and spread throughout the world, but in cases where any direct influence, importation, or diffusion is unlikely.

In trying to describe works of art from a distant provenance which resemble some of the more familiar

Western and Near Eastern styles, historians often describe them in terms of style names from our own culture. Excavations in southwest Asia have disclosed ancient examples of sculptured heads which seem remarkably like those of Gothic Europe, and these have been described as "Gothico-Buddhist."

This sort of cross-cultural comparison has been widely practiced, so that many of the names of major Western styles have been applied far outside their original provenance. In Japan some Kamakura statues of guardians, noted for their heavy, swirling shapes and suggestions of powerful energy, have been called "Japanese Baroque." Examples of Indian sculpture from the Gupta period have been called "classic" because of their spirit of calm repose and their balance of inner strength with surface decoration; of realism with idealization, the natural with the supernatural— all traits which Western historians have found in "classical" Greek art of the fifth century B.C.

The similarity among clay pots of the neolithic and other sedentary village cultures in various parts of the world is very striking, especially as to painted or incised decoration in a geometric style. Pottery of the "geometric" style in different regions, some of it centuries or millennia apart in time, is much more similar on the whole than that of later stages, in which evolutionary differentiation has occurred.

Some of the pastoral poetry of Theocritus, Anacreon, Bion, Moschus, Horace, and Vergil, as well as the story of *Daphnis and Chloe*, parallels certain aspects of European eighteenth-century Romanticism, especially in portraying the life of shepherds and shepherdesses in a fanciful, idyllic way. Rustic scenes are idealized as a welcome escape and regression from the restraints of urban civilization. Primitive life is shown, as it was by eighteenth-century Romanticists, as happier, more beautiful, healthy, and innocent than modern city life. In Japan, the art of flower-arrangement underwent a change from "classical" formalism to "romantic" Moribana naturalism. The trend was toward more free, relaxed arrangements like those of nature itself, not only in flower arrangement but in landscape and garden design. The "picturesque garden," a conscious expression of the Romantic movement in eighteenth-century England, was much inspired by prints of similar gardens in Japan and China.

Some style names, such as "Louis XV," are so firmly attached to one provenance that their application to a remote or world-wide field would be unlikely. But even here, as we have seen, some ambiguity exists; for a "Louis XV chair" is not necessarily "of the epoch"; it may have been made in America yesterday. In this sense, then, the style name is not firmly restricted to the reign of Louis XV; it may include objects made anywhere at any subsequent time. But at least, in such usage, it is assumed that the essentials of the style were established for all time in that particular time, place, and period; all others are mere imitations.

In the case of "romantic," on the other hand, it is not assumed that all examples of it throughout world history are imitations of the one European style. Many occurred before the European Romantic movement, or far beyond its influence. Some have been given indigenous names, and it is only from the modern Western point of view that a Western name for them is considered fitting. In Occidental writing, "romantic" is commonly defined in both ways, one of which ties it down to a certain trend or movement in Europe and America during the eighteenth and early nineteenth centuries. When defined as a historic period style, it can include all the following traits and more: an emphasis on freedom of individual impulse, imagination, emotion, and expression as opposed to rational control, measure, restraint, logical methods, fixed rules, and authoritarian discipline; the love of ceaseless change and new experience (as in *Faust*); the revival of interest in medieval life and art, not for its authoritarianism but for its supposedly glamorous chivalry and otherworldliness, and also for its mysticism, witchcraft, magic, and weird midnight scenes, as in the "Gothic" novel; a return to handicrafts as opposed to modern industrial machinery; a love of country life and unspoiled nature as opposed to city life and courtly formality; glorification of the simple life, the noble savage, the child, the peasant, and primitive man; love of exotic color and excitement, as in scenes and stories of the Near East; subjectivism, introversion, idealization of dream life, insanity, disease, sadism and other neurotic symptoms; release of intense passions and sentimental attitudes, even at the cost of life; irregular, often blurred forms, as of darkness and fog; a belief in the glorious role of the artist as mediating between the realms of sense and spirit, necessity and freedom; a belief in the inherent tendency of man and all living things to strive forward toward higher forms of life, and perhaps in the divine, animate character of the universe as a whole. Wordsworth, Coleridge, Shelley, and Goethe are typical of those Romanticists who inclined toward pantheism or metaphysical idealism. This carried with it in poetry a feeling of oneness between the artist and nature, as contrasted with observing and describing it from a distance.

Not all of these traits occurred in the work of any

one Romantic artist, and some are contradictory. They appeared in many different combinations. All of them appeared in close proximity in Europe from the time of Jean-Jacques Rousseau until after 1840. Some of them, such as the emphasis on art for art's sake and freedom of self-expression for the artist, are still alive and influential in the modern world.

It is only in the sense of *single-period style* that romanticism can be described in terms of many traits. As a *multiperiod style or recurrent type*, it must be stated much more briefly and abstractly, so as to provide a common denominator for all the period styles throughout the world which seem to deserve the name "romantic." But this attempt arouses controversy all along the line of descent from the time of Schiller, Goethe, and the Schlegels. According to Goethe as reported in Eckermann's *Conversations* with him, "Romantic art is sick art." Goethe found more artistic health in classical Italy, but he retained some romantic traits until the end. Rousseau's theory of the social contract and Adam Smith's laissez-faire are not universal traits of romanticism.

The crucial question is: what shall be regarded as the essential, universal, necessary traits of romanticism, wherever and whenever it occurs? On that point there has always been disagreement. Jean Paul asks,[3] "Wherein does the romantic style differ from the Greek?" Not, he answers, in modern irregularity, or in the mixture of tragic and comic, or in exaltation of spirit, but in the element of *expanse*. "Romanticism is beauty without bounds—the beautiful infinite, just as there is an exalted infinite." Homer is romantic at times; the late Greeks, less so. Old Norse and Hindu poetry are romantic; so are the Christian temple, Christian chivalry, and Christian romantic love. But every century, Paul concludes, "is romantic in a different way," just as Northern and Southern romanticism are different.

Certainly the arts of many advanced cultures show at times a trend to individual freedom of impulse, emotion, and expression as opposed to rational or arbitrary rules, as well as a love of wild nature and country life as opposed to urban formalities. These traits are akin to what Nietzsche called "Dionysian," though with significant differences. They appear, again with variations, in Chinese Taoism and Ch'an Buddhism, later in Japanese Zen. For want of a better name, the common element in all trends of this kind may still be called "romantic."

The observed recurrence of cultural traits in art and elsewhere is interpreted by some philosophers of history as an argument for the belief in universal parallelism, immanent determinism, or cultural orthogenesis. This is a variety of evolutionism derived mainly from Hegel. It maintains that human culture everywhere follows and must follow much the same paths, though at different speeds and with minor differences. Without going to the other extreme of trying to explain analogous styles entirely by diffusion or influence from one people on another, one must admit the obvious fact that similar inventions in art and elsewhere have been frequently made by widely separate peoples. It is not the task of aesthetic morphology to explain them causally, but to describe them objectively and in detail. This should lead to an improved nomenclature of styles and recurrent types.

Another theory of history maintains that civilization, including the arts, proceeds in cycles, with similar forms of art and thought recurring endlessly. Wölfflin hinted briefly at a theory of this sort in remarking that the change from "classic" to "Baroque" might have happened many times. Such a theory would shift the meaning of both terms from single-period styles to multiperiod styles or recurrent types. "There is classic and baroque," he said, "not only in more modern times and not only in antique building, but on such a different ground as Gothic." High Gothic is like "classic" in being linear, planar, and tectonic, while late Gothic "seeks the painterly effect of vibrating forms." It has recession, movement, overlapping, softness, obscurity, and other typically Baroque traits.[4]

6. The relation between historic styles and persistent compositional types.

In discussing the four modes of composition, we noticed a number of persistent or recurrent *framework-types* based on each of them. Many have come down through millennia, retaining their basic forms and attributes. Examples of persistent utilitarian types are the axe, knife, sword, and helmet; the house, temple, fort, and palace; the cloak, hat, shoe, and glove; the chair, table, bench, cup, boat, and wagon. Persistent representational types include the sculptured human or animal figure, the drawn or painted portrait or landscape, the story of love or adventure in verse or prose, the story of creation, the

[3] "The Nature of Romantic Poetry," ch. 22 in the *Vorschule der Ästhetik*, 1813; *Collected Works*, Weimar, 1935. Quoted in O. Strunk, *Source Readings in Music History* (New York, 1950), p. 744.

[4] *Principles of Art History*, p. 231.

mimetic dance, the epic, ballad, and drama. Expository types include the essay, the allegorical story, the symbolic picture, the diagram (as in the Indian yantra). Thematic types include the fugue, the sonata, the arabesque, and the sonnet.

None of these is a historic style in the sense of being definitely bound up with a single provenance. Each of them has been produced in various periods and places and by various groups and individual artists. While the basic outlines of the type persist, they are altered and combined with different traits from time to time and place to place. Each enters into various historic styles, and provides a basis for applying that style to an old, familiar type of product. It is characteristic of a historic style to treat certain persistent types in a somewhat distinctive way. A compositional type so treated is a *stylized compositional type*—e.g., a Corinthian temple; a Romanesque crucifix; a Romantic sonata.

The persistent compositional type often acts as a starting point or skeleton for the inventive activities of the artist. Even those artists known as style leaders are often content to use and build upon a traditional basis of this sort. To improve a utilitarian type along utilitarian lines might take practical, mechanical abilities they do not possess. They may not wish or dare to improve religious art along doctrinal, expository lines. Many painters and musicians have been content to work from traditional religious concepts: e.g., as to the persons present at the Crucifixion. Often they are not allowed to do otherwise, and this of course limits their scope for stylistic innovation. At other times an artist will attempt a drastic alteration of the traditional type itself, as in Walt Disney's "animated cartoons" and other cinematic innovations, derived in part from theatrical and pictorial sources. Bach accepted traditional thematic types and enriched them. Modern engineers have developed the functional aspects of automobiles and household appliances while calling upon artist-designers to "style" them. In these various interactions, style as an aesthetic factor is sometimes restricted to surface decoration, while at others it extends throughout the whole conception.

A major historic style such as that of the European Romantic period can be described in cross section, showing how it treats different persistent types, in different arts, in a somewhat consistent way. Certain essential traits and attitudes of the style, such as the love of nature, the simple life, and individual freedom, are expressed in a great variety of forms and media. Lyrics of rustic life, childhood, and peasantry by Wordsworth and Blake are emotionally in tune with Schumann's musical *Scenes from Childhood*, with the love of thatched cottages and woodland paths, and with paintings of them by Dutch, German, French, and English landscapists.

Like compositional types, some styles also descend as traditions through the ages, dormant at times and at other times revived. When in favor, such a recurrent stylistic type as classicism tends to express itself in various arts, attitudes, and ways of thinking, feeling, and acting.

Another way to view the history of styles is to follow the career of a certain compositional type such as the armchair. It would lead us through styles as diverse as the throne of Knossos, the curule chair of the Romans, the straight-backed Gothic chair with pointed-arch tracery, the tall and richly carved, upholstered armchair of the Louis XIV period, the dainty, curvilinear chairs of Louis XV with gilded wood and delicate silk brocade, the Chippendale mahogany version of Chinoiserie, and the modern upholstered armchair with springs. The chair undergoes Romantic influence in several respects, including the return to simple forms and handicraft methods, using inexpensive materials, as in the Morris chair.

The archetypal image of a fight between man and beast, or folk hero and monster, is far older than its representations in Sumer and Babylon. By way of Theseus, Siegfried, St. George, David, and Jack the Giant-killer, it has come down to the time of Picasso, who often styles it in terms of the modern bullfight or the ancient Minotaur.

As a rule, a style is more short-lived; a compositional type may live on through an endless series of styles. The compositional type is often determined in its basic outlines by nonaesthetic, functional considerations. The style is more concerned with additions and alterations for aesthetic reasons, though not necessarily with more ornamentation, for it may prune this away in quest of severe simplicity. All these generalizations are subject to exception. Some compositional types are ephemeral. They vanish when the conditions disappear which called for them and produced the demands which they tried to satisfy. Witness, for example, the greaves and cuirasses of armor and the amulets, spells, and charms of ancient magic. While they flourished, they changed in style along with the current styles in other works of art, as in the Maximilian style of armor in the sixteenth century.

Historic styles usually find their most congenial expression in a few compositional types and materials. The Louis XV style was thoroughly adapted to the furniture and decorative arts of the old regime in France, to the requirements of the salon and boudoir in an age of concentrated wealth and luxury, exotic

importations, and exquisite craftsmanship. Armor was on its way out except for decorative and ceremonial purposes. The intense religiosity which helped to motivate the cathedrals had declined.

The power to assume new styles and to stimulate experimentation in them is a sign of the continued vitality of compositional types. History is strewn with the wreckage and fossils of obsolete, discontinued ones. Most of the types listed at the beginning of this section undertake to satisfy perennial interests, needs, and desires. They often fail to do so completely; hence, there is a frequent effort to improve them functionally as well as aesthetically. This means changing the basic type more or less. Each of the types mentioned above is flexible enough to permit considerable stylistic variation from age to age, place to place, or people to people.

7. The extension and distribution of styles. Revivals and reproductions. Monotechnical, polytechnical, and whole-culture styles.

Some styles live on long after the artists who originated them are dead. They travel far from their first location. So few buildings exist which are Greek or classical in date that we usually assume a building in "classical style" to be a modern adaptation. In painting, sculpture, and the decorative arts many ancient objects exist, and it is often important to know whether one is "authentic, of the epoch" or merely "in the style of."

Such distinctions often have to be made in the case of stylistic *revivals, reproductions,* and *adaptations.* The prefix "neo-" has proven useful in distinguishing "Neoclassic," as a modern revival of certain Greek and Roman traits, from "Classic," in the chronological sense. Since much-loved ancient styles are frequently revived, we may have to reckon with a succession of Neoclassic, Neo-Gothic, Neo-Baroque, and other styles. Each can be an authentic style for its own place and period, not a mere imitation, if it adds something new and departs a little from its traditional source.

The situation is different with regard to modern reproductions and adaptations of past styles. Here we must distinguish between "an original Chippendale chair" and "a twentieth-century chair in Chippendale style." In the latter case the word "Chippendale" implies a set of traits like those of the original work, not actual provenance. In many cases, adaptations are made in the modern piece, to modern taste and tech-

nology. Thus we have "Girder Gothic" in a New York skyscraper; the "Gothic" being perhaps restricted to a few ogive ornaments and spires at the top. A chair in the Chippendale style may have all the traits which are said to constitute the style, and be recognizable as a reproduction only through certain nuances of materials and technics known only to experts. "Gothic Revival" or "Classical Revival," in architecture, implies no exact imitation or intent to pass for a building of that epoch, but rather a use of certain selected features (such as windows or columns) from the original style, perhaps in a very different context.

The question often arises whether a style which has lasted on with many changes from generation to generation should be called by the same name, perhaps with the prefix "neo-," or be given an entirely new one. The desire to be thought original is a motive for using a new name and minimizing indebtedness to the past. On the other hand, philosophic historians like to recognize genuine continuities and analogies in the history of the arts. Both methods are followed. The revival of classical Greek and Roman styles in the Renaissance is recognized in the name itself, signifying rebirth. But the differences are also great, and the historian is entitled to emphasize them if he so desires, as by saying "Florentine," "Venetian, "Quattrocento," or "naturalistic" instead of "Neoclassical" or "Neo-Hellenistic."

It was mentioned above that no style is "unique." None is the expression of only one age. Some are more distinctive than others. Every style resembles others in some respects, and every long-lived style is in constant change. Some traits persist, entitling it to be called by the same name for a while; others decrease, disappear, give way to new ones. The Gothic style in general is long-lived and far-reaching. Early, severe Gothic appears in twelfth-century churches in Burgundy and Normandy. Later Gothic combines rib vaulting, pointed arches, and flying buttresses to make a skeleton framework over large inner spaces. (These features had previously appeared separately.) The High Gothic period lasts roughly from 1250 to 1400, and the stage of late, Flamboyant, Perpendicular, and other features from 1400 to 1500. Meanwhile it spreads eastward to Germany and Austria, southward to Spain and Italy, and northwestward into England, always with distinctive local or national features. Flying buttresses have been atypical and scarce in Italy.

While the main, original flowering of the Gothic style ends with the victory of the Renaissance, a comprehensive history of its career will not ignore the occasional persistence and revival of selected Gothic

traits up to the present time. It will not ignore the application of the term "Gothic" to the macabre Gothic novel, the artificial ruin and grotto, the "back to handicraft" movement, the picturesque garden, and other Romantic variants of the style. Partial merging with classic features at one time and with romantic ones at another is characteristic of the history of a major style. A style is never a tightly integrated, exclusive whole; its constituent traits can always be dissociated and combined with traits of other styles, where the will and means permit.

A long-lived style is an ever-changing complex of traits, and a geographically extensive one is different in different areas. In applying its name to a particular work of art, and thereby classifying it under that heading, one may have to limit the concept with several specifications. A church may be a thoroughly typical example of some subdivision of the Gothic (e.g., English Perpendicular) and not of Gothic as a whole, or of French early Gothic.

These are some ways in which a style can develop in magnitude:

(a) *Chronological*: by actively persisting or recurring through a long period of time, as in the case of the Greek architectural orders. Active duration means not only that examples or descriptions of it are preserved and studied, but also that it is practiced by artists and used or enjoyed by patrons or the public. Some styles are mere ephemeral fads, here today and gone forever tomorrow. Large numbers of these indicate a dynamic but fickle, unsettled cultural condition. Having many styles which persist or revive does not necessarily indicate a stagnant culture, for the styles may be creatively developed and adapted to new conditions while retaining their basic identity.

(b) *Geographical*: over large areas of the world, during long or short periods of time. Modern rapid communication, trade and travel facilitate wide geographical extension. This involves some spread through the peoples residing there, but not necessarily through all the peoples or all parts of any one people. Many styles are cultivated by wealthy patrons or intelligentsia over a wide area, while remaining almost unknown to the masses.

(c) *Social, ethnic*: active spread of a style through larger numbers of different peoples, political units, socio-economic classes, occupations, religious groups, ages, and sexes. Some kinds of art are made by lower-class workers for the aristocracy, some by peasants for city people, some by women for men or children. In any of these respects, a style may be restricted or extensive. In a modern, consumer-oriented democracy, different segments of a population have more opportunity to develop and satisfy their own tastes in

art. They may produce artists to satisfy these tastes, or persons from other parts of society may try to satisfy them by production or importation. There has never been a period in history when the tastes of children of all ages and both sexes received such careful attention and stimulation as at present, when so much in the realm of popular art was produced to satisfy them. Sumptuary laws, restricting certain costumes and enjoyments to restricted classes, are almost a thing of the past. Popular art, as in newspaper and magazine stories and illustrations and on radio and television, is cheap enough to be enjoyed by almost all, at least in the more prosperous democracies.

(d) *Arts and media*: A style may be limited to a single art and a single medium such as Gregorian music or stained glass. Such a style is *monotechnical.* A *polytechnical* style is one which spreads through several arts, as Gothic did through architecture, furniture, sculpture, calligraphy, book illumination, and others. It may spread even farther, throughout the culture of the time. Such a style is called a *whole-culture* style. Romanticism affected all the arts of its time in varying degree. Some, such as music and poetry, it affected more than others, such as architecture and sculpture. It spread beyond the arts, affecting even science and philosophy, as in the development of evolutionism in biology and of Romantic Idealism in Fichte, Schelling, and Hegel. It affected economics and industry, as in Adam Smith's individualism, and politics through encouraging revolutionary liberalism.

Romanticism arose in several of these fields at about the same time; the new spirit was in the air. But other styles persisted as Romanticism rose. Early Romanticism was a lonely, minority trend. The movement in its prime attracted many of the greatest artists and their critical admirers, but Neoclassical works were still produced. Late Romanticism was, in some places, permeated with conservative, reactionary, and escapist attitudes although Victor Hugo, Walt Whitman, and other leaders continued to preach social liberalism. Late Romanticism was also tinged with neurotic sadism and homosexuality. Romanticism changed so much throughout its career that one must define it very broadly to apply the same name to all its stages and substyles. In historical retrospect, we tend to emphasize the roles of those artists and trends which have since been ranked as most important, and to forget that other, very different styles may have been more highly esteemed by critics and public at the time.

The four possible kinds of extension just described are independently variable. Development may occur in one but not in others. They cut across each other,

and all should be considered in summarizing the extension achieved by a style.

The style of an *individual* artist is a period style on a very small scale, no matter how great he is. Many artists have different styles at different periods in their lives; thus Picasso's works are divided into "Blue Period," "Cubist," and others. The style of an individual artist in one example of a certain medium, at a certain period of his life, is perhaps the smallest in extension with which art history has to deal.

"Distribution" refers especially to the places at which examples of the style are found today, as in the case of stone tools or potsherds of a certain type. Study of the strata in which they are found throws light on the time of their production. Usually, in early cultures, artifacts did not travel far and the place of discovery corresponds more or less with the place of manufacture. But there are some surprising evidences of large-scale importation and exportation, even in paleolithic times. Amber, copper, flints, and stone tools were carried to great distances. Some anthropologists today use the term "horizon" to mean a cultural area or stage of development exemplified by widely separate artifacts having stylistic or other similarities. It is also applied to the period indicated by a certain level of cultural development in an excavated area.

Today, of course, the products and performances of many arts travel throughout the world: not only durable artifacts, but orchestras, ballet companies, domesticated plants and animals, films, and television programs. The place, time, and people of origin may or may not coincide with those where the work is most enjoyed and used. Javanese "gamelan" music can retain its national style in a foreign country. On the other hand, Greek and Roman architecture has been domesticated and adapted to local needs and conditions in all civilized areas, especially for public buildings.

8. Stylistic and nonstylistic traits. Essential and nonessential traits.

To decide on the definition of a historic style and on typical examples of it is a highly selective process. It involves selecting certain traits as being *possessed in common* by a considerable proportion of the works in a certain art and provenance, enough to qualify them as typical of that period, place, and people. Also, the traits selected should be somewhat *distinctive* as a group, not common in other periods, places, and peoples. Such traits are *stylistic*. It might be im-

possible to find a group of traits which were present in all the works of that provenance. One could not expect to find many traits which were individually unique, but the concept of a historic style implies that as an interrelated set of traits they are somewhat distinctive. At least, they differ on the whole from works of nearby provenance in space or time. To select such traits empirically requires extended comparison between examples of various styles.

Among the numerous traits of any work of art, many are *nonstylistic* in being common to many styles and not especially typical of any one. Such traits are, for example, the use of stone in sculpture and of columns in architecture, the representation of human figures in line drawing, and the use of duple or triple rhythm in music. A distinctive way of treating one of these might be stylistic. As a rule, those traits which make the framework of a persistent compositional type are nonstylistic. The fact that a work of art is a portrait, a landscape, a cup, or a temple is not stylistic. Such facts merely indicate a kind of outline within which many different styles might develop.

The *haboku* or "flung ink" way of painting a landscape in Japan is stylistic. In the history of a persistent compositional type such as the landscape painting, the stylistic traits are those which distinguish one way of treating it from another. The mere fact of representing trees and mountains is not stylistic. The fact of painting landscapes with brush and black ink is stylistic in a very broad way. It characterizes most Chinese and Japanese landscape painting as distinguished from most Western landscape painting, but there are exceptions on both sides. Some Far Eastern landscape is colored and some Western landscape is done with brush and ink. Traits which may be stylistic for a very large, inclusive provenance or for a complex recurrent type are not necessarily so for a smaller one. The fact of being painted quickly yet purposefully, somewhat abstractly, in rough, broad, somewhat blurred and simplified strokes, in such a way as to give a total, immediate impact, is stylistic for the "flung ink" landscapes of Sesshu. In Europe, the fact of using many colors is not peculiar to any one style, but the fact of juxtaposing small strokes of contrasting color to represent sunlight reflections out of doors is a stylistic trait of Impressionism. The other sense of the word "impressionism," that of recording quick, partial impressions of a scene in a somewhat abbreviated way, occurs in Oriental flung-ink landscape and also in some Western works (e.g., some landscape sketches by Constable, Turner, Whistler, Manet, and Monet).

Styles overlap in many respects, so that one must often say, "This trait is emphasized in Style X, but it

appears occasionally in Styles Y and Z also." The particular traits into which a style or a work may be analyzed are seldom, if ever, completely distinctive and unique. Each can probably be found somewhere else. What is more likely to be distinctive is the combination of several in one complex, unified, developed form.

Stylistic traits, like all traits which go to make up aesthetic form, are aesthetic traits. They are capable of being directly presented to the senses or suggested to the imagination and understanding of the observer. The physical materials of which an object is made are not, as such, aesthetic or stylistic traits. Their appearance or tactile qualities may be so, but not those properties which require scientific analysis to discover. The physical and chemical properties of the clay from which a vase is made can be distinctive and revealing as to its provenance, but they do not appeal directly to aesthetic apperception. Indirectly, they may lead to stylistic traits, as in making possible a certain shape, color, or texture.

Techniques also, the means and methods by which a work of art is made or performed, are not necessarily aesthetic or stylistic. Style is concerned with traits which can be directly perceived or inferred. The technique employed in a particular case, such as chipping, drilling, or rubbing a stone to produce the desired form, often leaves observable, distinctive traits, and these can be stylistic. But if the technique is so completely obscured in the finished product that one can learn about it only from outside information or physical analysis, it is not stylistic. There are many doubtful, borderline cases, however. Often the best way to describe an observable trait is in terms of the technique which has been used to produce it. But that trait may sometimes be produced by other means, as in color-print reproductions of painting.

Technique and aesthetic form can be so completely merged in playing the violin that it is almost impossible to separate them. Even here, however, one can separate means from ends to some extent. The preliminary practicing, exercising the fingers, learning the positions of the hands and how to execute certain marks in the score—these are not parts of the style, but their results, as heard directly or as reproduced by radio or phonograph, may qualify as aesthetic and stylistic as well as technical. The Impressionist way of painting in small, contrasting brush strokes close together is often called a technique, but it produces a distinctive, directly visible texture in addition to representing sunlight. As such it is an aesthetic, stylistic trait. The chemical materials and methods of making oil paints are among the techniques of modern painting, but are not stylistic. An oily appearance may be so. The use of oil paints by early Flemish painters was stylistic for a while, but soon became common throughout Europe.

The traits which combine to make up a style are not of equal importance. (Once again, importance is not the same as value.) Certain ones are usually recognized as constituting the "essence" of the style, its sine qua non, so that a work which lacks them can not be classed as an example of the style, or at least as typical of it. The emphatic use of pointed, ogive arches in the interior vaulting of a church, in the doors and windows, and in the exterior development as in niches and arcades, is generally considered as an *essential* trait of Gothic style. A definition of Gothic in architecture would list several traits, such as comparatively thin walls and large windows filled with stained glass, clustered piers, high vaulting, steeply pitched roofs, spires, gargoyles, Christian symbolism, hierarchical designs, and other features related to feudal and ecclesiastical organization. As to which of these are more or less essential, there would be some difference of opinion among authorities.[5] One would have to approach the question by asking how frequently and emphatically each trait occurred in examples recognized as Gothic, and how often it occurred in other styles. Flying buttresses are so conspicuous and characteristic of French Gothic cathedrals that one is tempted to rank them as essential to the style, but they are seldom found in the few Italian examples of Gothic. Therefore, one could not rank them as essential to Gothic style as a whole, only as typical or frequent in French Gothic.

[5] Thus Paul Frankl quotes John Ruskin (in *The Stones of Venice*) as listing the characteristic elements of Gothic as follows: savageness, changefulness, naturalism, grotesqueness, rigidity, and redundance. Later, he quotes Hans Jantzen as finding "this specifically Gothic element in a quality of the composition that he calls *diaphanous structure.*" He adds that Gothic has never been more concisely and profoundly defined than in Jantzen's words: "Space as Symbol of Spacelessness." Dr. Frankl's own conception of "the essence of Gothic" emphasizes "the cultural and intellectual background insofar as it entered into the building." The function of the building is to provide a place for the cultic art, and the essence of church Gothic is "the form of the churches of the twelfth and thirteenth centuries as the symbol of Jesus." (P. Frankl, *The Gothic*, [Princeton, 1963], pp. 559, 785, 787, 826 ff.) (This emphasizes a suggestive, symbolic trait). Otto von Simson agrees with Jantzen in emphasizing the "porous" Gothic wall. "Light filters through it, permeating it, merging with it, transfiguring it." Also, he adds, there is a unique relationship between structure and appearance. "Here ornamentation is entirely subordinated to the pattern produced by the structural members, the vault ribs and supporting shfats." (O. von Simson, *The Gothic Cathedral* [New York, 1964], pp. 1–5.)

A *typical example* of a style is a work of art which exhibits, more or less prominently, all or most of the traits recognized as essential to that style. Sometimes a particular example is regarded as the criterion for a style. Thus the Parthenon is taken as the model and yardstick for deciding whether any building is typically Doric. Examples of a style may be compared as to how purely or consistently they embody it. Some are more typical than others. Many of the most admired cathedrals, as well as medieval works in other media, contain a mixture of styles. In the cathedral, this was partly due to the time consumed in building, in which tastes changed. But even in designing a church or furnishing a room to be finished all at once, styles are often mixed for the sake of contrast. A mixture of styles can itself be a style.

It is important in morphology to describe whatever different stylistic factors are present, as to their individual nature and their interaction with other factors. The main structure of a cathedral may be Gothic, while much of the interior and some exterior ornamentation may be Renaissance or Baroque. As a rule, the more different styles are present and emphasized in a work of art, the less it will be typical of any one of them. It may be called an *atypical* example or a *hybrid, mixed,* or *transitional* example of several at once. Most of the great historic styles contain some trace of more than one ancestral style. The Gothic cathedral often contained classic as well as northern, Gothic, and Germanic features. Pagan textile design in North Africa gradually merged with Christian features in the Coptic style.

Mere individual whims and mannerisms are not usually listed as stylistic traits, but a trait which seems trivial at first (such as pointillism in painting) may gain significance through being persistently repeated and used as a means to more important effects. Traits which are not essential to a style but occur sometimes therein can be regarded as more or less characteristic or consistent with it. If fairly frequent and distinctive they are *optional* or *variable* stylistic traits. Gargoyles are frequent but optional in Gothic architecture. The stages of Gothic from early to late and of its developments in different places, such as "Flamboyant" and "Perpendicular," are *variants* or *substyles* of it. A trait may be essential to one of these but not to Gothic as a whole.

When a certain mixture of styles wins considerable acceptance and is practiced and repeated over a fairly large space and time, people tend to feel it as more unified and consistent than they did at first. Through repeated observation, one may come to accept apparently conflicting factors as a moderate contrast.

When conditions favor diversity and rapid change in styles, any work of art is likely to exhibit traits of two or more styles at once. These may not be radically different styles; one may be a subdivision of another. Thus Sienese and Florentine painting of the fifteenth century differed somewhat from each other, though not entirely, and both were subdivisions of the broad class, "Italian Renaissance style." When a style is broadly defined, as a recurrent trait or as characteristic of a very large provenance, it covers many different substyles and examples. Early Romantic art in Europe was linked with a social-revolutionary movement toward individualism, as in Adam Smith, Robert Burns, and Shelley, but this is not true of all Romanticists.

Artistic types and styles are in a constant state of change. In this they resemble biological types; both evolve, but artistic types change much more rapidly on the whole. They merge and overlap, divide and coalesce again into new syntheses. The speed of stylistic change has been accelerating ever since the Renaissance, and especially since the Romantic movement glorified the original, independently creative artist. Contemporary artists of the avant-garde are usually eager to create entirely new styles, owing nothing to the past. Their friends and patrons encourage this attempt. Whether or not the resulting individual style is really new, its adherents tend to ignore and deny its resemblance to other styles, old and new. Artists usually dislike labels and classifications, except those they originate themselves, as in manifestos. They reject most efforts to place them in stylistic categories. The neutral observer is under no obligation to accept their own ideas about their work, however, and he may see their stylistic affinity with other artists far more clearly than they do.

It is usually impossible to define a style adequately in terms of the complete presence or absence of certain traits. One finds that examples of other styles possess them in slighter degree; hence, one's definition must be in terms of *more and less.* The same difficulty arises in classifying works of art. Example 1 has more of the essential traits of Style X than does example 2, or it has a few of them in more fully developed, emphatic form. In either case, stylistic description requires comparative estimates of extent or degree. It is well known that some Romantic (or proto-Romantic) traits are present in Shakespeare: for example, the multitude of characters, actions, and subplots which violate Neoclassical rules. J. S. Bach is comparatively Romantic at times, as in his *Goldberg Variation No. 25.* "In its somber reflections," said Wanda Landowska, "all the restlessness of the

Romantics may already be discerned. This richly ornamented adagio whose feverish intensity is translated into poignant chromatics overwhelms us." Jacob van Ruysdael is a seventeenth-century proto-Romantic in some of his landscapes, especially *The Jewish Cemetery*, with its murky, stormy lighting, its broken trees and ruins. In all these cases, one can also find non-Romantic traits, or traits not emphasized in the romantic movement at its height. But even in the works of such "typical" Romanticists as Keats, Byron, Delacroix, and Chopin there are non-Romantic traits, such as classical subjects, firmly patterned, metrical rhythms, and complex rhyme schemes. Byron's use of heroic couplets and his ironic, often cynical wit link him with Pope and the Rococo style in spite of his Romanticism.

Nuances and other subtle traits are more apt to be considered essential to an individual style such as that of Rembrandt, than to an extensive historic style such as Gothic or Romantic. To define the extensive style broadly enough to cover all the desired examples and variants, one usually has to reduce the definition to a few rather obvious, general traits. Some essential traits of an individual style may be obvious, while others are slight, personal variations of the extensive style. This is true of Hobbema's in relation to seventeenth-century Dutch landscape style in general.

Sometimes a versatile artist such as Picasso or Stravinsky produces in many styles, essentially different, but at the same time he can maintain certain personal traits in all or most of his work. Picasso tends to use bold outlines and strong contrasts of shape and color in different styles. Stravinsky tends to use many dissonances and strong contrasts of rhythm, orchestration, and dynamics.

The personal traits of a highly original artist often appear in the copies or adaptations of other artists' work, which he sometimes makes for his own enjoyment. When van Gogh copies Millet, he is almost certain, intentionally or not, to put something of his own force and agitation into the product.

The absence or minimizing of a trait which has been common in the art of a certain locality may function as stylistic. Even though it can not be directly perceived, its absence can be noted and felt as important, like any neglect of a common custom. This is especially true when the trait in question has been highly valued and emphasized by neighboring or immediately preceding styles. One can hardly tell the story of European visual art in the late nineteenth and twentieth centuries without mentioning the numerous features, admired in previous generations, which were gradually *omitted*. Courbet's "natural-ism" avoided classical ideals of beauty and monumentality, as well as Romantic emotionalism. Monet's Impressionism weakened or eliminated definite contours and solid shapes. The Postimpressionists, Cubists, Expressionists, Futurists, and others abandoned visual realism in favor of pure design and expression. The abstractionists (Kandinsky, Malevitch, Mondrian, and others) eliminated all or most of the representational factor. Symbolism for mystical and expository purposes had been eliminated in the Renaissance and Baroque periods. Design and definite development are avoided in the work of some contemporary "action painters." What remains? Often only a few rudimentary themes and vague suggestions of motion, effort, and feeling. The aim of such works, it is said, is to stimulate the viewer's imagination rather than to offer him a finished work.

Analogous trends in other arts have been noted in previous chapters, such as the frequent elimination of plot and characterization in drama and fiction, and in architecture the elimination of cornices, columns, pilasters, sculptural ornament, and other classical features. Much recent poetry dispenses with rhyme and meter; music, with traditional melody and harmony. Schoenberg often dispensed with keys and tonal modulations.

The elimination or minimizing of one set of traits is usually accompanied by the addition and development of others, which partly compensate for the loss. But there has been an overall trend of considerable breadth toward a net simplification of the forms of art, especially by rejecting traits derived from conservative traditions. In describing recent trends in various arts, historians and critics often begin by telling of what has been left out, as if that were a positive trait instead of a negative one. Omissions and eliminations are often described in terms of positive values, such as "economy" and "freedom from the tyranny of the past," as if the forms of past art were now felt as onerous burdens or morbid growths. If long continued, such a trend would approach a vanishing point.

9. Stylistic traditions and factors in a work of art. Mixed and transitional styles.

When recognizable elements of an early style persist or die out and reappear through long periods of time, they constitute a *tradition*. The style of a great individual may endure as a tradition for centuries, always more or less recognizable while undergoing changes in

detail. Thus the traditions of Michelangelo, Raphael, Rembrandt, Shakespeare, and Beethoven have been influential long after their deaths. Those of Dutch and French landscape painting in general were carried on in eighteenth-century England and nineteenth-century America.

A stylistic tradition which persists throughout successive generations in a heterogeneous culture will necessarily interact with others and enter new syntheses. As such, it is a *stylistic factor* in later group and individual styles and in particular works of art. Thus we speak of an "Italianizing tendency" in the work of some early Flemish painters such as Memling. That tendency can also be noted in Bach and Mozart. Dürer's wood engravings contain a Gothic and a classical, Renaissance factor, especially in certain works such as the *Apocalypse* series. Classical and Hebraic factors interact throughout Christian art, as in Dante and Milton.

When the dates of artists, works or styles compared are known, a continuing change in the same direction can be described as a *trend*. Different trends in the same or different periods can be compared, as in the movement toward naturalism in the Renaissance, and the one toward abstraction in painting of the mid-twentieth century.

In the history of many styles there is a temporary plateau, often exemplified in the work of some outstanding leader, in which a completely balanced, integrated combination of stylistic traits appears to exist without change. Before it, there may be a phase of groping experimentation, and after it, a phase of gradual turning toward something new. Purists tend to look from one plateau to another, ignoring the transitions between them. Nevertheless, these transitions exist, and they often take the form of hybrids, mixtures of traits from two styles which appear more purely and separately elsewhere. Sometimes the two fail to coalesce enough to satisfy those who demand extreme unity; sometimes they succeed.

It has been said that there is no such thing as a transitional style, but this is based on the erroneous theory that all styles are unique. If we call a work "transitional," this does not imply that it lacks a style of its own. In one sense of the word, all styles are transitional, since none endures forever without change. All are in process of evolution and tend to change somewhat from one year to another, especially in recent Western civilization. Many styles shade gradually into succeeding styles; some give place to different ones by radical reaction or by reversion to an earlier style.

To decide whether a work is actually "transitional"

between two styles requires some outside information about historical trends and sequences at the time the work was produced. One must know the approximate, relative date and place of the work and of the styles between which it seems to fall. In the work itself we can only see traits of two or more styles, loosely or firmly integrated.

As an example of a relatively unified hybrid, one may point to the substyle of French and English Rococo known as Chinoiserie. The tiny, ornate curves and asymmetrical ornamentation of Rococo are there, and also certain features borrowed from late (Ming and Ch'ing) Chinese porcelains and textiles. The two are often smoothly blended in a compound style more eighteenth-century French than Chinese. In such cases one may discern two or more *stylistic factors* in Chinoiserie as a whole and in any particular example of it. The problem for morphological analysis is then to trace these factors as they may appear, perhaps completely merged in some areas and distinct in others. The insistence on multiple, tight curves and the use of gold and pastel tints in furniture and textiles is more French, the use of mahogany in Chinese Chippendale more English. One should also ask how both are related to the underlying compositional framework, which is often utilitarian as in a chair. Chinoiserie was a short-lived stylistic factor, though it spread widely during its vogue. In retrospect, it does not seem to have been definitely transitional toward any later style. It soon gave way to Louis XVI and Empire, which were themselves rather composite, since both included Roman motifs from Herculaneum and elsewhere.

A style or group of styles which seems more essentially transitional is that which flourished briefly in Italian and German painting during the early fifteenth century, and which continued the use of gold along with increasingly realistic human figures. (In German it is called *Prunkstil.*) Gold backgrounds, raised halos, and the like tended to prevent the illusion of the third dimension, which more naturalistic painting with highlights and shadows tried to convey. The attempt to combine both sets of traits produced a comparatively unified effect in certain pictures by Fra Angelico, Gentile da Fabriano, and the Sienese, but somewhat less unity in such Germans as Conrad von Soest, Conrad Laib, the Master of the Heiligenkreutz, and the Master of the Frondenberger Altar. Soon, in both countries, the irresistible pressure toward visual naturalism swept away the remnants of medieval gold in favor of consistently three-dimensional modeling, perspective, and natural coloring. In view of the Byzantine style which preceded it and the consistently

Renaissance styles which followed it, this brief gold-with-naturalism style can be regarded as transitional.

10. Quantitative estimates; obvious and subtle traits; nuances. Microscopic and macroscopic approaches to stylistic analysis.

Although no exact measurement of most aesthetic traits and types is possible at present, rough estimates are constantly being made in art history and criticism. These can be tested and refined by continued comparison. They can be limited to nonevaluative judgments.

Estimates are made as between two or more styles: for example, that Louis XV furniture is usually more curvilinear than Louis XVI, more given to wide and sometimes complex, asymmetrical interweaving of curving planes and contours, as in chair legs and in plant forms used in textile design. As between two Louis XV chairs, one may be more curvilinear than another. Scholars in literature have counted and compared the number of times a certain word, phrase, image, or grammatical construction is used by various artists and in various periods. Such statistics are used as evidence for judgments of authorship and authenticity. Without resorting to mathematics, it is easy to show that images of a certain kind are favored by a certain writer, as in Milton's predilection for images of astronomical vastness, power, and grandeur. On the whole, dissonances are less used by Renaissance and Neoclassical composers, such as Palestrina and Rameau, than by recent ones such as Stravinsky and Schoenberg. In the Renaissance, Don Carlo Gesualdo employed them more than most of his Renaissance contemporaries did.

Quantitative comparison of very slight *nuances* in particular works often assume great importance in judging its style and provenance. Is it a typical example of Style A, or transitional between Styles A and B? Is it an authentic example of the work of a certain artist, or a later imitation or adaptation? The decision in such questions often rests on a combination of different kinds of evidence: only partly on stylistic evidence, including knowledge or belief as to what traits are limited to works of the artist, place, or period in question. Significant nuances of style are to be found in the slight gradations of tone in Rembrandt's paintings, representing light and shade, material textures, character, and facial expressions. Those of his followers are, on the whole, less subtle. Long experience may lead a connoisseur to say, of a piece of

music, that Haydn would not have used such long, complex phrases or as many dissonances as this one contains. He may say of a painting that Monet would not have used such definite, sharp outlines in the same period in which he used soft, Impressionist coloring. Sophisticated, cynical wit is more common in Pope than in Burns or Keats.

Comparative estimates of particular traits can be made between works by the same artist, as in saying that *The Night Watch* is one of Rembrandt's most complex compositions, or that Goya's late, demonic style involves more images of horror than his early paintings of Spanish holiday scenes for tapestries. Renoir's late paintings are, on the whole, more given to rich blends of colors, while Matisse and Picasso both prefer flat areas of comparatively uniform color. Combining many such comparisons can provide the data for broader generalizations on individual and period styles.

Subtle traits and differences occur in all the components and modes of organization discussed in this book. They occur in the selection of certain ingredients, in the suggestive factor, in causal, spatial, and temporal relations, and in the interrelation of various compositional factors.

The morphological description of any work of art can be limited to *obvious* traits and differentiae. The obvious ones are bold, conspicuous, easy to perceive, gross and manifest; the slight and *subtle* ones (nuances) are slight, sometimes faint, infinitesimal, rapidly fleeting in the time arts, as in the delicate gradations of timbre in operatic singing. The nuances call for a high degree of sensitivity in sense perception and in apprehension of suggested meanings and allusions. The subtle traits are not necessarily better than the obvious ones, but they are often given more weight in deciding on the authenticity of a supposed masterwork. In reviewing a musical or dramatic performance, critics assume that almost anyone could sing or play the notes or speak the words. The important differences between performers are felt to lie in the nuances of tone and execution.

In some cases the bold, obvious effects are the most distinctive and important ones. This is true in much of Matisse's work. But a work which is bold and obvious in some ways—e.g., in having large areas of intense, uniform, contrasting color—may be subtle in others. The color harmony may be unusual; the effect of each color area on its neighbors may be hard to grasp at first sight. In other cases—e.g., in some of Mallarmé's poetry—nothing is very obvious, or what is obvious may seem trivial. The poet's main intention reveals itself slowly, between the lines.

In Chinese landscape painting of the Sung and later dynasties great emphasis is placed by artists and critics on brushstroke. The large, comprehensive design and representational framework of the whole, which are likely to impress a foreign observer most strongly, are taken somewhat for granted and often adapted with slight change from earlier pictures. One must look closely at the way individual leaves, twigs, rocks, or distant waterfalls are painted: sometimes with a faint, blurred film, sometimes with a firm but changing, calligraphic line, sometimes with a texture of tiny dots, streaks, and smudges.

Subtle effects and slight differences, stylistic peculiarities of a certain artist at a certain time, may show themselves in any aspect of the form. They may be utilitarian, in an obscure but effective adaptation to function, as in the comfort of a chair or the balance of a rapier. They may be representational, in a kind of stylization which brings out seldom-noticed aspects of nature, or thematic, in unusual rhythmic variations.

One does not have to choose between noticing the obvious and the subtle. One usually begins with the obvious, with a general, superficial view of the whole, and then singles out certain areas and aspects which seem to call for closer scrutiny of nuances. The subtle ones are not necessarily separate from the obvious, or more small or faint. They often consist in the way an artist executes the large, conspicuous things. In literature, significant nuances occur both in word-sounds and in their suggestive power. In prose they may occur in the use of long, complex sentences and in a slight tendency to recurrent rhythm which falls short of obvious meter, as in Thomas Browne and Gibbon. In either prose or verse they are found especially in typical choices of words, images, and metaphors, in the length and rhythm of sentences, and in the suggestive power of ambiguous words and phrases.

Traits of an individual artist's style are often to be found, not only in the way he executes the obvious things, but in small details as well. The approach of some critics to stylistic analysis, and also to evaluation, is comparatively *microscopic;* this is often true of Bernard Berenson. That of some others may be called *macroscopic.* One critic focuses attention on the way an eyebrow is painted in Flemish portraits, the other on the general outlines of the composition, the subject matter, expression, or color scheme. Bernard Berenson called the attention of scholars to many significant differences in minutiae, which proved to be important in deciding questions of authenticity and attribution.

In teaching elementary history and appreciation to children or adult beginners, one tends to stress the macroscopic approach, so as to help them recognize broad differences of style as between main periods, nationalities, and outstanding artists. For one who knows these and wishes to continue his studies, the interest tends to shift to microscopic details, as in distinguishing the styles of two or more similar artists within the same period and local school, or perhaps that of the master from those of his pupils and assistants. If all use much the same general selection of materials and forms, the emphasis in evaluation also tends to shift more to small details. In painting, this may require an actual microscope, focused on individual brush strokes to compare the *touche* and *écriture* of different artists. In music, it may focus on particular tones, chords, or modulations, with the question "is this really characteristic of composer X?" May the present score contain a printer's error or an editor's alteration? In music and poetry, unsigned manuscripts are occasionally found and attributed to a well-known artist because of certain obvious similarities of style, but closer scrutiny may show discrepancies in small details. Anyone who produces art during or shortly after the life of a great artist is likely to show some stylistic similarities to his work. Expert analysis tries to weigh both similarities and differences, and to estimate the importance of both.

11. Particular stylistic analysis.

Reference has been made in this chapter to "general stylistic analysis" as dealing with conceptions of styles. There the aim is to improve the definitions, the names by which they are designated, and the relations between them. *Particular* stylistic analysis, on the other hand, emphasizes the nature of one or more complete, individual works. It studies these in relation to conceptions of style. It may analyze one work of art at a time or several.

A series of such analyses is *monotechnical* if it deals with examples of the same art, or *bitechnical* if it deals with works of two different arts. One may compare a picture with a poem or a piece of music as to the extent to which they both manifest Baroque style. Comparing two works of the same compositional type in the same art and medium, but of different styles (e.g., a Dutch and a Chinese landscape) helps to bring out the stylistic differences sharply.

Analysis is *intrastylistic* if it compares two works of the same style, such as a Romantic poem and a Romantic sonata. It is *interstylistic* if it compares

two works of different styles, such as a Neoclassic and a Romantic picture, or a Neoclassic picture and a Romantic poem.

It was noted above that the concept of any historic style, when adequately thought out, has two parts: one referring to a set of traits, the other to a certain provenance. One must consider both traits and provenance in asking whether a certain style name, such as "Gothic" or "Impressionist" really fits the work of art at hand, and if so how and to what extent.

Using concepts of historical styles in particular analysis can help to fit any work of art into the long, vast pageant of art history. Morphology can help the historian by providing more effective concepts of style. We can hope to understand a work of art more deeply by seeing its relation to the great cultural heritage of contemporary civilization. This contains, not only countless works of art, but concepts of traits, types, and styles occurring in them. Such ideas as "classic" and "romantic," "realistic," "thematic" and "expository," do not refer to the past alone. They remain as active forces today, not only as ways of interpreting the past, but as ways of understanding present civilization and of planning, making, and evaluating new styles of art.

The scholar in art history will usually think at once, on first viewing a work of art, of some stylistic affiliations it seems to have. He can regard these ideas tentatively, as hypotheses for further testing. He can then examine some current definitions of these styles in order to choose which ones to use during analysis. If no satisfactory definition is available, he can change an old one or propose a new one; the main requirement is to state clearly the meaning of each style name applied. In the course of analysis, other style names may come to seem more appropriate than the ones first thought of.

The principal task of analysis thereafter is to compare the work or works at hand with the specifications of the style or styles being considered. The aim is to ascertain the points of *conformity and nonconformity* between them. These can be described in stylistic and other morphological terms. How and to what extent does Work A fulfill the requirements of Style X? As to essential traits? As to nonessential, optional, or variable traits? How and to what extent does it fulfill the requirements of Style Y? How and to what extent does Work B fulfill these requirements? On the basis of such comparison, one can generalize as to how and to what extent the work or works analyzed are typical or atypical of a certain style or styles. If not typical of any one, are they

intermediate or transitional between two or more styles?

The detailed stylistic affiliations of a particular work of art are its *stylistic schema*. They include the principal ways in which it conforms to one or more historic styles, and the principal ways it does not conform: i.e., ways in which it differs from the usual conception of the styles and from works regarded as typical of them.

To describe a work of art as to its provenance, through giving details as to its place and time of origin and of the persons who produced it, requires more information than can be derived merely by perceiving and analyzing it directly. Even if the work contains an explicit statement to the effect that it was produced at a certain time and place by a certain artist, that statement is subject to verification. False or groundless claims are often made. All statements in the analysis implying facts about provenance should be carefully weighed as to their logical grounds. For example, to say "This is a typical black-figured Attic vase of the sixth century B.C." or "This painting is evidently not by the hand of Rembrandt himself" implies an assertion about the actual provenance of the piece. Both rest upon assumptions (true or false) as to the styles of art actually produced in that provenance. Direct stylistic analysis is never enough to establish provenance. To make an assertion about provenance on the basis of style alone, however correct it may be, usually rests on arguing in a circle. It is more cautious to word one's conclusion somewhat in this way: "This piece possesses all (or most) of the traits required to make it typical of Style X. Many (or all) works of this style are known on other grounds to come from provenance P. Stylistic analysis thus supports the inference that this piece comes from that provenance."

One is free, of course, to add other, nonstylistic evidence which supports or weakens that inference: for example, scientific analyses of the materials and techniques used in the piece; reports and photographs by archeologists indicating where similar works have been found and beliefs as to their origin. Stylistic evidence can be a highly useful implement for ascertaining historical facts and corroborating beliefs about them, but only if it is not corrupted by unverified assumptions based on previous misinformation or invalid reasoning.

Useful stylistic analysis can be conducted without raising any questions of actual provenance, authenticity, authorship, or the like. Through purely stylistic analysis a reproduction (photograph, color print,

hand-made copy, plaster cast, translation, phonograph, or radio broadcast) may be found to possess many essential characteristics of a certain style. The fact that the work is a reproduction or imitation may be quite obvious, needing only a brief note to that effect. The provenance of the original from which it is made may then be more important. In other cases only minute, extended scrutiny will disclose the significant nuances which help (along with other evidence) to establish the conclusion that the piece is or is not from the provenance supposed.

A frank, obvious reproduction, as in the color plates of a book, has a double provenance: that of the original work from which the photograph was made, and that of the color plate itself. In analyzing it one may find it worth while to point out the differences. The stylistic traits of the original can be only roughly conjectured from the reproduction, which always differs from the original to some extent. Both can be analyzed in terms of stylistic traits: e.g., the colors in the reproduction may be darker or more bluish than those of the original.

In music, one cannot be sure of the nature of a work by hearing it as played on a phonograph record by a certain performer. Here there is a double risk of departure from the original, as conceived by the composer. The performer may play it with more sentiment and rhythmic variation than the score indicates, and the recording may distort it in other ways.

Note: The following illustrations are particularly relevant to this chapter: Plates I, II, IV, V, VI, VII, VIII; Figures 2, 6, 7, 15, 16, 21, 22, 26, 29, 30, 31, 32, 35, 38, 40, 45, 47, 50, 52, 57, 63, 68, 70, 71, 73, 75, 86, 90.

CHAPTER XI

The Interrelation
of Factors in a Work
of Art

1. The morphological description of a particular work. Summary and application.

We have now surveyed the principal types of psychological ingredient from which works of art are constructed, and some common ways of organizing them in various arts. The latter have been grouped under six main headings: elementary components, modes of transmission, frames of reference, developed components, modes of composition, and styles. These have been described in general terms as widespread cultural phenomena, and a few of their countless varieties have been noted.

By way of illustration, we have noted their occurrence in some particular works of art. This chapter will take a closer view of the particular work as a subject for descriptive analysis, but still in somewhat general terms. Paradoxically, it is true that "the particular work of art" is a general concept, standing for a certain type of phenomenon, and applicable to countless examples. It differs from art in general as a branch of human culture, and also from a particular art such as music. The only way to describe a particular work, or any other concretion in existence, is in terms of the traits and types it combines. This includes how and to what extent it combines them, how it acts under various circumstances, and how it is related to other phenomena such as human vision.

Every work of art which is developed beyond a rudimentary stage contains a selection from the types of ingredient and organization which we have surveyed. Its ingredients can be described as traits of certain elementary components—e.g., as red and blue under the component "hue." These are combined within certain frames of reference into transmissional factors (presented and suggested). Often but not al-ways, they are combined into developed components such as melody, and into compositional factors such as representation and design. The relative emphasis and development along any of these lines can vary greatly. While the resultant factors may be almost inseparably merged within a particular work, they can be distinguished to some extent for purposes of theoretical analysis.

The *comprehensive schema* of a work of art includes all its constituent schemas: transmissional, component, compositional, and stylistic. It is the total way in which this particular work selects and organizes certain ingredients. This is not the form or mode of organization only, apart from content, for the choice of a certain content or set of ingredients can also be a distinctive feature of the work. It is not the verbal description of the work in English, French, or any other language, but a set of facts involved in the work which the verbal description summarizes. It is the total structure of the work as involving and combining certain psychological materials. A description is never absolutely complete, but it can be full enough for all practical purposes.

Careful perception and description by one individual can be compared with accounts of the same work by other individuals. This will gradually produce an intersubjective or socially verifiable body of empirical knowledge about the contents, forms, and styles of art. This morphological approach, however, will not yield all the knowledge which we need about art and related types of experience. It must be supplemented by other approaches, especially the psychological, historical, sociological, and evaluative.

Since the time of Francis Bacon, it has been widely recognized that an ultimate aim of science in every field is to benefit humanity through the knowledge

and control of nature, including human nature. Empirical aesthetics, including the morphology of art, joins in this aim and effort. Art is one of the means by which human nature is actively influenced, for better and for worse. At the same time it is a phenomenon of human nature and experience which needs to be better understood, with all its potencies for good or ill. To observe and describe works of art as objectively and accurately as possible may be a means of eventual benefit to human beings. But these considerations do not imply that one should always have a practical aim in mind in aesthetic researches. It is often advisable to keep them in the back of one's head, meanwhile seeking knowledge about important phenomena without being assured in advance that each inquiry will have an immediate, practical worth.

It was mentioned in a previous chapter that there is no limit to the number of descriptive statements which can be made about a work of art, especially a complex one such as an opera, novel, ballet, or cathedral. Each note or rest, each rhythmic beat and instrumental timbre, each syllable and comma, each bit of stone or glass, could be described ad infinitum, without adding anything of great importance to our understanding of art. It is desirable in morphology, therefore, to simplify the description of particular works through selecting and emphasizing those traits which seem most important for the theoretical inquiry at hand. We have no definite, a priori standards of general importance.

In describing a particular work one should try, not only to make the description fairly short, but to say those things which will be most enlightening and significant about the work in question. How can this be done? No particular traits, ingredients, or modes of organization stand out a priori as always most important by the nature of things. One of the outstanding characteristics of art is its inexhaustible variety; in each art, each style, each particular work, somewhat different things are selected and emphasized. We are not necessarily looking, in morphology, for the best or most valuable traits. Different kinds of traits will stand out as most worth studying at a particular time and place. Aside from questions of originality, one scholar may be interested in what kinds of art have been most influential socially. Another will ask to what extent each work expresses its age and culture. A third will be interested in its relation to cultural evolution in general. But these questions take us outside the field of morphology and into that of history.

2. The analysis of simple and specialized forms. Formalism, Expressionism, and related styles.

Any style and any work of art, actual or possible, can be analyzed and described in morphological terms. Such a description is never complete. But none is essentially intractable to analysis or description, provided that adequate conceptions of content, form, and style are employed.[1]

This applies to both simple and complex works. However slight may be the positive features of a simplified work in form and content, it can be described in morphological terms for what it is. Its principal lacks and avoidances can also be noted by contrast with what is usual in previous works of similar type and provenance. One can try to interpret it, perhaps, as a symbolic rejection of traditional forms and values. Its own value or lack of value is another question.

Much recent art, as we have noticed, has been of the simplified, highly specialized type, especially in avant-garde painting, sculpture, and music. One of the most distinctive traits of Abstract Expressionism and its predecessors in the twentieth century is negative. It consists in the number of things which they avoid or eliminate, things which have usually been present

[1] Solomon Fishman remarks in *The Interpretation of Art* (Berkeley, Calif., 1963, pp. 151-2) that Tachisme and Action Painting have been intractable to analysis and critical apprehension. Roger Fry, he says, was a formalist, subordinating vision to design, rationality, and order. Fry, says Fishman, denied formal quality to works which resisted intellectual analysis and explication. He thought of form in terms of universal, classical principles and was unsympathetic to van Gogh's Expressionism, Picasso's "sur-realism," and abstract art. Herbert Read, on the other hand, says Fishman, is romantic in holding that art has no limits, in affirming that "Art is everything that can be imagined and expressed." Historically, these statements are justified, but Fry's limited conception of form is not true of all form analysis, or of aesthetic morphology as set forth in this book. In the broader sense of "mode of arrangement," form in art includes all the irregular, irrational, and chaotic aspects of Expressionism, Tachism, and Action Painting. It is not limited to classical styles and principles. Intellectual analysis and explication are not limited to such styles or to works of art governed by reason and order. The artistic expression of a passionate, impulsive, Dionysian personality, or one pervaded by internal conflict, is quite as susceptible to intellectual description as the opposite type. Whether a highly intellectual person is capable of fully appreciating and evaluating such art, as a more romantic critic such as Read might do, is another question.

in the arts concerned. In describing such works, critics often stress these omissions as if they were positive values: e.g., the lack of representation, of story interest, of realism, of decorative ornamentation, and of definite design. Some abstractionists, such as Kandinsky and Mondrian, retained very definite thematic relations and complex designs, but others omitted even these.

The question arises, then, of what remains. We have no reason to assume that some new, important element or quality must have taken the place of what was left out. Sometimes there is actually very little to be analyzed or described. If the work is one which seeks only to stimulate the observer's imagination, what is there in it which does the stimulating, and how? Insofar as there is anything presented to the senses or suggested in a socially apperceptible way, it can be observed and to some extent described. Certainly, this may not exhaust the suggestive content of the work, which may include an aura of ambiguous associations, too vague to be described, and different for every observer. Sometimes, even here, the nature of the marginal suggestions can be vaguely hinted in words by a sensitive, sympathetic observer. If not, or when the limit is reached, one can simply note the fact without claiming to have told the whole story.

Where much has been left out that traditional art provided, there is some danger that the friendly critic may imagine new, compensatory factors in the work where none exist. He tends to feel that persons who do not see the mysterious *je ne sais quoi* are merely blind, deaf, or aesthetically insensitive. To such unconvinced persons, on the other hand, it may seem that he is merely indulging in an independent fantasy, not a genuine response to art. Such disputes are hard to settle, and controversial areas of this sort will long persist in aesthetics, however objective it tries to be.

In many highly simplified works, however, such as Malevitch's famous *White on White*, one can usually find one or more vague, rudimentary themes and variations. The absence of common, traditional developments may be significant as suggesting an attitude of rejection and revolt. Usually there are suggestive tendencies such as (in a painting) tensions, thrusts and counterthrusts, spatial relations and movements in and out, rising or falling, expanding or contracting. There are hints of moods and feelings, such as vigorous attack or scattered, jerky flows and zigzags, as in the works of Jackson Pollock. There are moods of black depression, as of today's "angry young men." Spots like those of Chinese "flung ink" painting suggest explosions or sudden, unplanned impulses, perhaps attempts to convey the essence of a scene in as

few brush strokes as possible. Slight approaches to representation may persist, as when an Abstract Impressionist painting calls to mind part of a Monet pond with water lilies. Often hints of geometric design remain, as in Mondrian's late work, or in contrast, biomorphic traces of plant or animal life, dripping liquid, the human body, and detached erotic images. What is called "abstract art" is thus often only semiabstract.

Another difficulty rises today in the path of descriptive analysis. This is the antipathy of many artists toward the attempts of critics to psychoanalyze them or their works. The Freudian, Jungian, Marxist, and other twentieth-century approaches to art point out what seem to their exponents as obvious examples of symbolism, whether consciously so or not. Freudians find erotic, sexual symbols, Jungians find transformations of the archetypes, and Marxists find the influence of social status and class struggle. But, however convincing theses interpretations may be to scientists and the general public, many artists today continue to find them derogatory. They vehemently deny that their works "mean" what the analyst thinks they mean, and critics opposed to psychoanalysis agree with them. Again, this is an area of persistent controversy for aesthetics, but not necessarily a permanent one.

3. The order of steps in analysis.

No particular order is necessarily best. The order to be followed will depend to some extent on one's special interests at the time. If one is especially concerned with the role of color in different styles of painting, one may wish to begin with that component in describing a particular work. If one has no special interest, but wishes to report an experience of the work as it actually occurred, one may begin with the details which first caught one's attention. If the work is temporally developed, as in music and drama, one may describe it in the order of presentation, from the opening tones or words to the end. But this might not bring out the main frameworks and constituent patterns very clearly. They are not evident at the start or all at once, and usually not until near the end of the performance. A morphological analysis has something more to do than simply to report an aesthetic experience; it should reveal the inner structure and distinctive features of the work as a whole. To recognize these, one should perceive the whole form one or more times before starting to analyze it.

One possible aim in describing the work would be to see how clearly the verbal account can make a reader imagine it without ever having perceived it directly. However, one must not expect too much along that line. No matter how exact the verbal description, it will always be discursive and at several steps removed from direct, intense, intuitive apperception. The work of art has one set of traits and functions; the description of it, another set. The morphological description is not itself a work of art or a copy of one. It does not need to have any aesthetic appeal. It is, instead, a step in empirical observation and conceptual thinking about a work of art, for the sake of rational understanding. It differs from the work of art as the botanical description of a tree differs from the tree itself.

While allowing for the need of flexibility, one must also recognize the need, especially for students, of having some fairly systematic method as a starting point. One logical order of steps is based on the principles of taxonomy, as in biological classification. It begins with certain very broad classes and subdivides them step by step, as into kingdoms, families, phyla, genera, species, subspecies, and so on. To describe a newly discovered plant or animal one tries to locate it first in a fairly broad category, then in smaller and smaller subdivisions. A related method of defining concepts was worked out in classical logic: this was, to locate the concept first within a *genus*, then differentiate it from others within that genus. Epic and tragedy are literary genres or genera. They differ in certain respects, as Aristotle showed. The *Iliad* and the *Aeneid* are both epics, and each has certain differentiae within that class. Within the genus "tragedy," classical and modern tragedy can be regarded as two species: Sophocles' *Oedipus the King* in one and O'Neill's *Anna Christie* in the other.

One great difficulty in thus classifying works of art is the lack of agreement on any definite system of classes. In this book, some steps have been made toward an aesthetic taxonomy by indicating a number of broad concepts which can be used as genera, as well as some species or subtypes within each. Any work of art can be placed among a number of different classes in different respects: e.g., as music for the violin with respect to instrumentation; as a sonata with respect to its thematic framework; as Romantic with respect to style.

By classing a work of art in a certain genus which has a recognized meaning and denotation, one tends to locate it roughly within the total fabric of nature and culture, perhaps also in some special field of thought such as botany or aesthetics. But if that genus is a diversified one, such as "drama" or "chamber music," merely classing a work under it does not give us a very clear idea of that work. The next step is to indicate some of its *differentiae*: one or more respects in which the work differs from others in that genus. Dramas are divided as comedies, tragedies, etc.; comedies as farces, comedies of manners, etc. Dramas can also be divided as being in verse or in prose. To say that a drama is a comedy in verse, we class it under two genera. We differentiate it from other comedies in prose and from tragedies in verse. We narrow down the conception by making it more specific. The same concept, such as "comedy in verse," serves as a differentia, to distinguish that kind of drama from others. It also serves as a genus, species, or subspecies, within which we can distinguish farcical comedies in verse, comedies of manners in verse, and so on. Ideally, one might wish for these subdivisions to be mutually exclusive and systematic. In the arts, they usually overlap. There is no agreement as yet on which are genera and which are species.

The more we classify a certain work under various types and distinguish it from others in each of those types, the more we tend to sharpen the description, to characterize the work more fully and clearly in its generic and distinctive traits. We realize how and to what extent it is "unique." Any work of art will share with others its membership in certain types. But some are comparatively unusual as among the few works which combine a certain set of traits. Certain combinations may be very unusual, almost unique as far as our present knowledge goes. The Taj Mahal is not the only ornate mausoleum, but few if any resemble it in complexity and delicacy of ornamental stonework and also in its formal, landscape setting.

Unless some special order is called for, it is usually well to start with very broad, generic concepts, especially those (like "sonata" and "temple") which imply complex traits and types. From these one can work down to more and more specific ones, looking more and more carefully for those which tend to bring out the work's peculiar features. Both genera and differentiae are important for a thorough description, equally so, perhaps, although in different ways. The broad concepts help us to get our bearings, to see the work in its cultural context of recurrent types and historic styles. But in modern times the interest of scholars and the general public has been more and more directed toward the personal, individual traits of style. People want to know what is distinctive and original about a work, not merely to class it as an example of this or that common type. It does not tell us much to say of a work by Chopin that it is a waltz

or concerto; many other composers have used these framework types. A nocturne or a mazurka is less common. But critics and historians want to find out what distinguishes a particular mazurka by Chopin from all other compositions of its type, from those by other composers and from others by Chopin himself.

In the previous chapter, we described the traits of a work of art as either *obvious* or *subtle*. The subtle ones are often called *nuances*. The obvious ones include those traits which are large, bold, conspicuous, intense, or emphatic in a particular work, as well as its broad outlines and perhaps its basic framework as a whole. In some kinds of art, such as billboards and posters to be seen from a distance or in passing, practically all the traits will be fairly obvious. Nuances would not be perceived under the circumstances. The same is true of national anthems and hymns for mass participation. But even here, nuances may be observed in a particular performance by trained singers.

The nuances, as we have seen, can be slight differences in the way the obvious or basic things are executed. But there are styles of art which persistently emphasize nuances, especially those which can be seen or heard carefully under the circumstances, as in an easel painting on the wall of a museum or a living room. Of this type are coloristic paintings such as those by Rubens and Renoir, with rich, varied textures; also delicate Chinese brush drawings with expressive, calligraphic lines. Of this type, also, are German *Lieder* calling for sensitive changes in emotional expression and in the contrasting timbres of piano and voice. Nuances of rhythm occur in the way a poet introduces slight variations in the length and accent of syllables. Obvious traits, too, can be distinctive, especially by contrast with previous styles which emphasize nuances. Thus Picasso startled eyes accustomed to soft Impressionism with his bold, heavy outlines and flat color areas.

A connoisseur in a particular art, undertaking to describe a work, is likely to ignore the broadly generic traits and go directly to the distinctive nuances. These he detects, not only through careful perception of the work itself, but also through mentally comparing it with composite memories of similar ones he has seen or heard in the past.

On the whole, the approach in the following outline is analytic. It goes from the more generic to the more specific and individual, with a summary at the end. It goes from the general framework and stylistic affiliation to details of development, from the form as a whole to its main parts and dominant traits, and thence to minor details: from the macroscopic to the microscopic. In the previous chapters of this book we have been following a synthetic order on the whole, from the elements to the more and more comprehensive ways of organizing them. The present chapter reverses that order, showing how we can take a single, concrete whole and analyze it into constituent factors.

Neither the analytic nor the synthetic approach in morphology, as we have seen, necessarily corresponds with the artist's approach in composing the work. He may go back and forth between the two or follow some quite different, independent course. In any case the task of morphology is not simply to repeat or reverse the artist's procedure. The two have different aims and methods. In this book we are much concerned with the artist's products: only incidentally with his aims or methods. As a rule, he thinks more in terms of concrete objects, such as paints and canvas, pianos, chairs and houses, trees, men and women as individuals. Aesthetics, including morphology, deals more with abstract qualities and their interrelations.

The following outline is adapted primarily for the use of students of aesthetics, art criticism, and art history. It should be used flexibly, in accordance with the nature of the work to be analyzed. Not all the points or questions listed need to be covered in any one analysis. Many can be omitted at a glance as being irrelevant in a particular case. Those covered can be dealt with in any order.

4. An outline for the descriptive analysis of a work of art.

A. *Preliminary information* (from outside sources and obvious, general nature of the work). Sources or authorities for this information; how certain or reliable, if any question exists.

1. *Art, material, or medium* (e.g., music for piano; oil painting; poem or drama in English; film with sound and color). Original or reproduction. Language used, if a work of literature; original or translation. If a translation, what changes of form, as from verse to prose.

2. *Artist or artists*, if known: author, painter, composer, designer, performer, or group of them.

3. *Title* or brief classification, as for a library card, museum label, or footnote reference.

4. *General provenance*, if known: place, nationality, approximate date of composition, publication, or first performance. Changes in condition of the work since then, if any (as in a ruin or restoration). Present

location and condition of original if this is a reproduction.

5. *Other* relevant information, in brief.

B. *Brief morphological description.* (Sufficient when only a short account is desired. Section C of this outline may then be omitted.)

1. *Stylized compositional type* to which the work belongs: e.g., Doric temple; Romantic song; Gothic book illumination.

2. *Basic compositional framework type. Utilitarian*: e.g., temple, chair, helmet, verbal guide, music for march or dance. *Representational*: e.g., epic, tragedy, tale of adventure, statue, portrait or landscape painting. *Expository*: e.g., essay, meditative lyric, symbolic diagram. *Thematic*: e.g., rug design, sonnet, sonata. How developed, as to

a. *Transmissional* schema. Sense or senses primarily addressed. Nature and interrelation of presented and suggested factors.

b. Main *compound parts* and their subdivisions; parts within parts. How interrelated.

c. Brief account of how the work exemplifies the basic *framework type*; how it is developed in terms of that compositional factor.

d. Implied conceptions of *reality*: e.g., naturalistic, supernaturalistic; magical; anthropomorphic or pantheistic religion.

e. *Accessory* compositional factors involved; compositional types exemplified in addition to the basic one. Extent to which they are developed.

f. Main *distinctive traits* of the work, other than stylistic. Distinctive ways of developing and combining the compositional factor or factors; ways in which this work notably differs from others of the same type or types.

3. *Stylistic affiliations*: historic style or styles in which this work is treated.

a. Main *stylistic traits* which identify it as an example of a certain style or styles (period, national and/or individual; extensive or restricted). Relation to a certain provenance. Ways in which the work *conforms* to current definitions of the style or styles in question, or to other, proposed definitions.

b. Ways in which the work does *not* conform to the definitions of the style accepted here. Traits which distinguish it from other examples of this stylized compositional type.

c. To what extent is it *pure or mixed, typical or atypical* of this style or styles? If more than one style is present, are they merged or separate in the work?

d. Main *stylistic relations to its provenance and cultural background*, as evident in the work itself.

Implied conceptions of reality and value as related to current beliefs and attitudes of its time. How these are expressed or suggested.

C. *Detailed analysis of various aspects of the work.* (For use when a more thorough study is desired. Comments under these headings should amplify, not merely repeat, those made under §B.)

1. *Transmissional schema.* Organization of ingredients according to modes of transmission, in various frames of reference and dimensions.

a. *Presentative* schema, including frames of reference involved. Sense or senses chiefly addressed.

b. *Suggestive* schema, including frames of reference and dimensions.

c. *Interrelations* between presented and suggested factors.

d. Relation of these schemas to the compositional schema.

2. *Compositional schema*: further organization of ingredients by one or more modes of composition.

a. Schema in the basic framework mode, or modes if two or more are about equal. Types and traits especially developed in this mode; from what components and kinds of trait it is built. Main stylistic traits of this compositional factor, as present in the work being analyzed.

b. Its main lines and degrees of development, including spatial, temporal, and causal; frames of reference and dimensions in which development occurs.

c. Schemas in other compositional factors; framework-accessory relations among them; their distinctive emphases and developments. Degree of compositional diversity or specialization. Of cooperation or conflict.

d. Are the various compositional factors similar or different in style? Cooperative or conflicting? How?

e. Main compound parts and their subdivisions; how related to the compositional factors and to each other.

f. Relations of these compositional factors in the work to outside reality, or to beliefs about its nature. Degrees and types of realism or the opposite. (E.g., in representational painting and sculpture within the utilitarian framework of a cathedral).

3. *Component schema.* Organization of ingredients according to elementary and developed components and traits. Frames of reference and dimensions involved.

a. Amount and nature of component diversity: presented and suggested.

b. Presented components and traits, elementary

and developed, in order of emphasis and develop-
ment. Frames of reference involved.

 c. Suggested components and traits, elementary
and developed, in order of emphasis and extent of
development. Frames of reference involved.

D. *Selective summary*. Outstanding generic and dif-
ferential traits of the work in terms of the following:

 1. Compositional schema, including implied con-
ceptions of reality and value. Relations among differ-
ent compositional factors, if more than one.

 2. Stylistic schema, including relations to prove-
nance.

 3. Transmissional schema, including relations be-
tween presented and suggested factors.

 4. Component schema, elementary and/or devel-
oped.

 5. Relations among the above, especially as to dis-
tinctive traits and extent of unity in variety.

PART FOUR

Development
Through Various
Modes of
Composition

INTRODUCTORY NOTE

1. Review and prospectus of the following chapters.

The nature of the four modes of composition and their interrelations in various arts were briefly sketched in Chapter VII. This was followed in Chapter VIII by an account of some historical changes in them, including the tendency of some to develop along scientific lines. The subject of the four compositional modes was then dropped for a while, so as not to delay unduly an introduction to the nature of style and an application of all these concepts to the descriptive analysis of particular works.

In view of the fact that little has been written on the general nature of the modes of composition in world art, it seems well to return to them at this point for a more detailed study. The preliminary account of each in Chapter VII will be reviewed and expanded with special reference to its variants in the styles of different periods and cultures. In the last four chapters we shall also consider some of the ways in which each mode has been used to build more or less complex, diversified forms. This will suggest certain possibilities for future development.

2. Simple and complex development in art.

As applied to art, "development" usually means increasing complexity, as in the growth of a plant or animal, or a condition of relatively high complexity. One can speak of art as having developed on the whole, or in certain respects such as visual realism in the Renaissance. This meaning of "development" is close to that of "evolution."

In this sense, the arts have developed on the whole since prehistoric times, but they have also shown simplifying trends or undevelopments at various times and for various reasons.

The term "development" is also applied to changes which do not necessarily involve increasing complexity. It can mean "increasing definiteness," in the sense of becoming clearer, more explicit, fully realized, actually usable or available. Thus an artist's conception of a work may develop from the vague to the definite: from a rough, unclear, incomplete sketch or germ idea to the finished product, including all that he had more or less consciously wanted to say.

Modern technology has developed complete utilitarian products as simple as the Johansson gauge block, used for precise measurements in machine construction. Technology tries to develop maximum efficiency along certain specialized lines through eliminating unnecessary parts, motions, waste, and friction. In all arts, comparative simplicity and economy in producing a unified aesthetic effect are often sought. The Japanese haiku, a very short lyrical poem, is one example.

In such cases, however, the simple but highly evolved form is usually part of a highly complex culture pattern in which it cooperates with others, simple and complex. In this it is comparable to a single mathematical symbol, such as that for "plus" (+). To understand the haiku or the Johansson gauge, one must know something of its cultural context. The surgeon's scalpel is only one of many specialized instruments and groups of instruments which are employed in one complex, technical profession.

Many ancient examples of utilitarian art such as palaces, temples, ships, weapons, and vehicles, were

large and complex, loaded with heavy, ornate, cumbersome parts but comparatively undeveloped as to functional efficiency. The same can be said of seventeenth-century court costumes as compared with elegant dress for men and women today.

In the history of a major compositional type, such as the wheeled vehicle, one can often observe trends toward complication and trends toward simplification, at the same time or alternately. More and more different desires for services and qualities to be satisfied by the same product, such as a house or automobile, constitute an ever-expanding, utilitarian program. But working to restrain this is an ever-present wish to eliminate superfluous parts, reducing the initial cost and the cost, labor, and inconvenience of maintaining an efficient product.

The realm of art includes countless degrees and varieties of development in different frames of reference, from the extremely vague or chaotic to the ultracomplex and highly organized. Elaborate groups of public buildings, operas, films in sound and color, and other complex forms exist side by side with extreme simplicity in certain kinds of building, such as the pyramids of Egypt, and in some kinds of modern clothing, utensils, painting, and sculpture.

The basic framework of a work of art may be constructed in accordance with any of the four modes; occasionally it is built with two or more about equally. Whichever mode provides the basic framework, one or more of the others may enter as accessories. As determined by the artist's desires, by cul-

tural pressures and other factors, the basic framework itself may be developed to any extent, with or without development of the accessories.

We shall consider some cases in which development occurs in the compositional factor of which the basic framework is made, and others in which the main development is in accessory factors. For example, the palace is a persistent type of basic framework in the utilitarian mode. It can be developed in that mode by adding or changing parts which make it serve more effectively as a palace: e.g., by being stronger, more comfortable, or adapted to more different conditions, activities, and uses. It can also be developed in the representational mode by adding carved statues and reliefs beside the entrance and along the roof, and in the thematic mode by interrelating these sculptures as variations of contrasting themes such as Venus and Mars. A particular unit may function in more than one mode, as when a statue serves as a column to support an entablature: e.g., the caryatids of the Erechtheum in Athens.

Even when the development is primarily or mainly in the framework factor, it may incidentally involve some accessory development. Merely by adding rooms with rectangular windows to a house, we necessarily develop the thematic series of rectangles established by the previous windows and doors. A design can be formed by thematic relations between the utilitarian parts without adding any nonutilitarian ornamentation.

CHAPTER XII

Utilitarian Development

1. Aesthetic and utilitarian factors in a work of art.

One reason for using the term "utilitarian" instead of "functional" was noted in Chapter VII. Mainly, it is to avoid the false implication that the aesthetic aspects of a work of art are nonfunctional. This is an essential point, since a functional conception of art (sometimes called "technical") is held throughout this book. The aesthetic factor in a work of art, which may include the whole work, serves the function of stimulating satisfactory aesthetic experience in observers. It may not succeed in doing so for all observers, but that is its function nevertheless, just as the utilitarian function of a slide rule is to aid in calculation, even though some persons can not or will not use it.

As used in this book, the term "utilitarian" does not imply "menial" or "narrowly practical." The type of active use concerned may be of the highest cultural value.

It was shown in previous chapters that any work of utilitarian art contains these two factors: (a) its utilitarian factor, by which it is fitted or supposedly fitted for some active use, and (b) its aesthetic factor, by which it is fitted or supposedly fitted to serve as an object-stimulus for aesthetic experience. They may or may not coincide. Possession of an aesthetic factor constitutes it as a work of art. The word "supposedly" implies that, to qualify as utilitarian art, the product does not have to be successful or efficient in carrying out either function. This opens the door to include as utilitarian art (a) works of magical and religious art which are not now regarded by science as effective for the active uses intended (e.g., to bring success in hunting), and (b) utilitarian works of any kind which may not now be considered beautiful, but which were regarded aesthetically by the people who made and used them.

What we are calling the "aesthetic factor" or "aesthetic appeal" is called "visual appeal" when addressed to the eyes. It can be achieved by any mode of composition or a combination of them. It can exist in natural objects or in human products not intended as works of art.

Some attempt at embellishment is likely to be made when the utilitarian product is to be directly, closely, and repeatedly perceived by persons with influence, under conditions favoring an attentive aesthetic or critical attitude. Such conditions often occur in watching or performing rituals and festivals, or when relaxed and comfortable at home or in one's garden or tea house, or where feminine taste is influential.

Those objects or activities tend to receive aesthetic development which have a prerogative status in the culture concerned at the time, for their practical importance or as symbols of strong conative attitudes in the group. They act as foci of intense or persistent hopes, desires, ambitions, achievements, satisfactions, perhaps as objects of worship, veneration, admiration, or gratitude, or as respected guides to social or individual conduct. The cathedral and related types of art held that position in medieval culture, together with such associated types of utilitarian art as ecclesiastical vestments, utensils, reliquaries, and illuminated manuscript books. Shrines and structures to house relics and statues of the Buddha held a similar position in the Far East. In modern Western civilization similar prestige, though for different reasons, is held by the automobile, airplane, and other vehicles.

The aesthetic and utilitarian factors are comparatively distinct when the former consists largely of nonfunctional or "useless" ornamentation applied to the surface, as in pasting a small picture on a lampshade. They are comparatively integrated when every perceptible part in the utilitarian factor also functions aesthetically, and every aesthetic part contributes to the utilitarian fitness. The handles of a bronze vessel may represent gazelles with arched backs, which echo the curves of the vessel. A clay vase can be developed in utility by making it more watertight, or by making the handles stronger and more convenient for pouring

liquids. It may be developed in representation and design by painting a scene from the *Iliad* on one side, as in many Greek vases. The aesthetic factor is not necessarily limited to that painting; it may also comprise the thematic relations of the vase's curving contours, and their relations to the lines of the painting. To decide how much unity exists between the two factors, one should also ask whether the painting has some other kind of utility, e.g., in a religious or civic ceremony. The utilitarian factor is not necessarily limited to the basic physical functions. Many vases are made expressly for ritual purposes.

Even when the two factors are closely merged, as in so-called functional design in modern furniture, where few or no purely decorative traits exist, the observer can focus his attention on one or the other. When the two are distinct, either may be developed while the other remains undeveloped, or the two may be developed along different lines.

An intermediate type occurs, in which some non-utilitarian ornament is added, but is made to carry on thematic series established by the utilitarian form. For example, in a circular bowl several smaller circles may be concentrically painted so as to reinforce the visual circularity of the rim itself, as seen from above. A step is made toward integrating the two factors more closely if the rim is painted and glazed in such a way as to protect it from chipping, so that the added circle is utilitarian as well as thematic. Many works of utilitarian art are intermediate in the sense that some but not all the perceptible details function in both factors.

Naturalistic utilitarian devices made by primitive and ancient peoples often combine the aesthetic with the utilitarian in a simple, undifferentiated way, but one cannot expect all examples of a particular utilitarian type to do so. Among thousands of prehistoric stone tools, pots, tobacco pipes, or spearheads one or two may be selected here and there as works of utilitarian *art* in the aesthetic sense. The others were, presumably, made and used or thrown away if defective, for purely utilitarian reasons without much attention to their appearance. In some advanced civilizations, on the other hand, the ideal of "functional design" has become fully conscious and deliberate. This is true of Japanese utilitarian art, in which plain, humble utensils and containers of wood or rough pottery, whether intended for a modest farmhouse or a noble's garden teahouse, are commonly made with attention to design as well as utility though lacking nonfunctional ornament. For other objects, such as a court kimono, where concentrated design is thought to be appropriate, the aesthetic factor is developed with extreme complexity and richness. It often involves stylized representation and symbolism as well as design.

2. Supernaturalistic technics. Utilitarian development through magic and religion.

How can one distinguish the utilitarian factor from the aesthetic in magic? The utilitarian factor is expected to perform the essential part of the task, to be most active and indispensable. It is often a certain precise wording of a spell, which is doomed to failure if not repeated exactly, or it may be a certain gesture, talisman, or amulet, or a certain place or person endowed with positive or negative *mana* with respect to the effects desired or feared. It may or may not have any aesthetic appeal to the human observer.

In religion also, as Cain and Abel found to their cost, the acceptability of the offering is not necessarily proportional to its beauty or the reverence with which it is presented. It may depend simply on what a particular god demands. The god of a pastoral people may prefer an animal sacrifice; that of an agricultural people, a vegetable one. But in religion, especially an advanced polytheism, the aesthetic factor is more likely to coincide with the utilitarian or be an important part of it, since the god is expected to be favorably inclined toward the donor by a fine and costly work of art in his honor. The donor is often clearly identified in a painting, so that his pious generosity may not be overlooked.

In both magical and religious art, as we have seen, the utilitarian factor is often concealed or obscure. We may know, or have reason to think, that the work was used for some utilitarian purpose, but that purpose and the way in which the work was expected to achieve it may not be indicated in the work itself. From a technological standpoint, the essential steps in the process are missing. It is therefore hard to trace their development, if any. We may have before us an apparently ordinary, natural stone, a crude carving, or a magnificent temple full of statues of the gods, and still have little clue as to how it was supposed to operate, nothing analogous to the sequence of mechanical operations set in motion when one turns on the ignition of a car and activates the starter.

The process may be conceived as somewhat analogous to the ways in which humans and animals

think, feel, and act in similar situations. As a father gives commands to his child by speech or gesture, as a mother bird calls her young, so a magician can order the rain to fall. This assumes the reality of causal influence on outside events by sensory stimuli or even by silent thoughts, without direct physical force or with only the threat of it. It is easier to imagine the process if one conceives the rain as somehow alive or inhabited and directed by a humanlike spirit. This is the essence of primitive animism or hylozoism. It is also easy to imagine the change to a religious attitude of propitiation and inducement when attempted coercion fails, as it does in dealing with strong rulers. Female animals and children have usually had to rely at times on inducement, in dealing with the stronger adult males.

The imaginary processes assumed in both magical and religious types of utilitarian technic are partly psychological—projections into the outside world of mental phenomena and modes of control with which man has become familiar as a result of his own organic and cultural evolution. It took a long time for science to correct this projection and to realize that most physical phenomena are not directly controllable by thought, speech, or gesture alone. Since the technics of magic and primitive religion are partly mental in their supposed operation, they may be thought to have more chance of success when the phenomena to be controlled are themselves partly mental. This is the case not only in mental diseases, neuroses and psychoses, but to some extent in all diseases, insofar as the patient's mental and emotional attitude can weaken or strengthen his resistance. Dramatic temporary cures can thus be made in removing hysterical symptoms which appear to be organic. Through faith in friendly magic and religion, the hunter and the warrior, the lover and the ruler, can all become more bold and perhaps more likely to succeed.

When the supernaturalistic technics fail, likewise through a mistaken belief in the ubiquity of spiritual powers, faith in them often persists through lack of adequate methods for the experimental testing of hypotheses. Continued faith in spite of frequent failure has kept them alive, postponing the rise of science for millennia but fostering the development of the arts. Though magical and religious arts came first, on the whole, aesthetic development spread to the secular areas of culture also. This was facilitated by the close alliance or merging of church and state in theocratic governments.

Early naturalistic technics, such as the building of houses and canoes, were permeated by the sense of supernatural presence, potentially benign or baleful. They were frequently combined with magical or religious rites to drive away evil spirits and secure protection by good ones. Throughout the evolution of culture to the present day, survivals of magic have persisted along with developed forms of religion and applied science. Types of utilitarian art expressing all three approaches can be found on advanced as well as primitive levels of civilization. It is harder to illustrate the supernaturalistic developments because so large and important a part of them was deliberately occult or cryptic, unwritten or kept secret for initiates. A complex ceremony may have used only the simplest verbal or material devices, or none at all. Nevertheless, there has usually been some material or perceptible vehicle to carry the supposed occult influence, and many of these have survived.

Magic in general has been divided into several main types, of which we have already noted the *imitative* and *contagious*. Both are included under *sympathetic* magic, which assumes that like affects like, that a desired result can be brought about by imitating it or naming it in spells, and that things which have been in contact influence each other after separation. A distinction is also made between *apotropaic* magic (for driving away evil powers) and *propitiatory* (for appeasing and conciliating, as when a hunter asks pardon of the animal he is about to kill). *Divination* is a method of acquiring occult knowledge, especially about the future, often accompanied by magical rites to invoke the aid of spirits. Some divination, as in the oracle at Delphi, depended on the physical and mental condition of the priestess, who could see the future and advise accordingly (often cryptically) only at certain times. In Rome divination was an approved magic art in the form of *augury* (inspecting such omens as the flight of birds or the entrails of sacrificed animals). It also took the form of observing portents through *astrology*. *Necromancy* or communication with the dead for magical purposes was often aimed at foretelling the future, as in the Biblical scene of the Witch of Endor. *Thaumaturgy* or wonderworking includes alchemy, jugglery, and tricks performed by demons. *Incantation* is the speaking or singing of spells or charms, words or formulas with magic power, or the performing of magic rituals. Magic which seeks the assistance of demons, as by sorcery, witchcraft, and diabolism, or which tries to kill or injure someone, is *black* magic. It was condemned by the Christian Church, whereas *white* or natural magic as in legerdemain and some kinds of prescientific experiment, was usually though not always permitted.

Sorcery and *witchcraft* included dealing with demons, especially the non-sanctified, wild, amoral earth spirits such as the witches in *Macbeth*. Some major deities of ancient religions have descended in cultural status, becoming minor spirits, devils, or demons in later ones. The traditional Devil of medieval witchcraft, with hoofs, horns, and a tail, recalls the bull god of ancient Babylonia. Feared in the Middle Ages, he has become a ridiculous or playful figure, as in Halloween masquerades. Voodoo in Haiti combines some elements of primitive witchcraft with primitive and advanced religion.

The following are common types of magical device which are sometimes developed aesthetically:

Visual: amulets; talismans (often carved symbols of a heavenly body, constellation, or planet, made under conditions favorable to receiving its influence); fetishes (sculptural and other); rings, garments, wands, weapons, mirrors, crystal balls for prophecy, circles and other geometrical diagrams; numerical and other signs such as those of the zodiac; masks; costumes, gestures; ritual enactments of desired or feared events.

Verbal and auditory: spells, charms, curses, formulas (often in syllables meaningless to the uninitiated); bull-roarers; chants, hymns, prayers, and rituals, especially of a diabolic sort as contrasted with those addressed to a deity. Black magic, as in the "black mass," was often a blasphemous mockery and ridicule of the orthodox mass.

Frazer's theory of magic took from psychology the distinction between analogy and contiguity as grounds for the association of ideas. We have already noticed how these two modes of association gave rise in primitive times to false beliefs about the world, such as the myth of the sky (male) fertilizing the earth (female) to bear crops and young. These modes are still active in poetic metaphor and symbolism. In supernaturalistic technology, reasoning by analogy leads to imitative magic: to the belief that one can make it rain by shaking a rattle, filled with gravel to sound like rain, and at the same time pouring water out of a jar upon the ground. Reasoning by contiguity leads to contagious magic, as in the belief that one can kill a man by burning his hair or nail clippings with appropriate spells. It leads to a belief in the sanctity and the potency of relics of the saints, bits of the "true cross," and the like. On the primitive religious level, reasoning by analogy has also led to the belief that a picture or statue of a god may have some of the powers and tendencies of the god himself, so

that worship of the ikon may incline the god to a favorable mood.

When such means and steps are used by primitive magic and religion, development along these lines may take the form of further speculation about the ways of controlling or placating spirits. In time they may lead to complex myths like that of Demeter and Persephone and to complex theological and metaphysical systems involving representational and expository art. There is reasoning by analogy, more highly developed than in early imitative magic, in the belief that acting out the return of Persephone will bring back the sun and summer each year. There is reasoning by contiguity in the belief that the king's touch will cure scrofula, or that touching the bone of a saint will protect from evil spirits.

In all magical and religious devices intended for overt action—that is, aside from the purely subjective ones—there is necessarily some perceptible product or performance to act as a vehicle for the command or plea, invoking supernatural aid for the ends desired. This vehicle may be solidly material, as in a carved stone fetish, or visual as in a ritual gesture, or audible as in a spoken incantation. It may or may not qualify as a work of art. It will necessarily have some form and that form will be capable of development. That there was great development in the perceptible forms of magic is evident from historical records, but we lack sufficient examples in various media to illustrate successive stages in all parts of the world. The more advanced forms of magic tend to merge with, and to borrow material from, contemporaneous religious arts and technics.

Ovid (*Fasti* VI. 155-162) describes a Roman apotropaic rite, performed for the protection of an infant named Procas. Children, he explains, were in danger of harm in the night from bloodsucking vampires in the form of owls:

> She [Crané, a witch] touches the doorposts three times in succession with a spray of arbutus; three times she marks the threshold with arbutus spray. She sprinkles the entrance with water (the water contained a drug). She holds the bloody entrails of a pig, two months old, and thus speaks: "Birds of the night, spare the entrails of the boy. For a small boy a small victim falls. Take heart for heart, I pray, entrails for entrails. This life we give you in place of a better one." Having killed the sow, the witch placed the vital organs in the open air and forbade those attending the rite to look upon

them. Then a whitethorn branch was set in a small window which furnished light for the house. After that the child was safe and the color returned to his pallid face.[1]

The words "I pray," suggest a religious attitude rather than a coercive one, but the rite as a whole is typically magical. As to development, one must distinguish between the rite itself and a verbal account of it. Burriss speaks in another example of "Cato's directions for inducing a broken bone . . . to come together."[2] The directions prescribe a short sequence of acts to be repeated, beginning "Take a green reed, four or five feet long; split it in the middle and let two men hold the pieces against the hip joints." Such generalized instructions are (within the realm of magic) examples of what we now call "technology" as distinct from the technics or acts and devices themselves. In many examples of literary fantasy the magical and religious expressions are obviously not intended as actual statements of the artist's belief or actual methods to be followed with a view to achieving some end. But our concern in this study is with the forms of art, and it is a common procedure in art to represent supernatural events and ideas in which the artist himself does not necessarily believe. The divinations asked by Macbeth and practiced by the witches, or the magical tricks performed by Mephistopheles in *Faust,* are parts of representational compositions, whereas Cato's words are composed in utilitarian form. A literary form containing images and concepts of supernatural characters and events can be developed along utilitarian, representational, expository, or thematic lines, or all of these in combination, to any degree of complexity. The passage quoted from Ovid is in the form of a generalized narration, although it might easily be put into action.

The Atharva-Veda hymns of ancient India contain a number of poems on different levels of artistic development. Some purport to be charms for various practical ends; some are pleas or poetic prayers to a god or goddess. One, analogous to the "directions" of

Cato, is entitled "To a Magical Plant, That It Heal a Broken Bone."[3] In magical form, it concludes, "Join thou together hair with hair, join thou together skin with skin. Let blood and bone grow strong in thee. Unite the broken part, O plant." Another charm, "To Grow Hair," is likewise simple, concrete, and direct in its commands. Similar medical charms have been found which date from ancient Egypt, where they were used in connection with prayers to Imhotep (legendary founder of medicine), often along with physical medications.

A little more highly developed as poetry is a "Charm against Sterility," also from the Atharva-Veda.[4] It is so developed in that the simple command is elaborated and diversified with vivid metaphors and similes which reinforce the conception of the events desired.

As arrow to the quiver, so let a male embryo enter
 thee.
Then from thy side be born a babe, a ten-month child,
 thy hero son.

Bring forth a male, bring forth a son. Another male
 shall follow him.
The mother shalt thou be of sons born and hereafter
 to be born.

With that auspicious genial flow wherewith bulls
 propagate their kind,
Do thou obtain thyself a son; be thou a fruitful
 mother-cow . . .

May those celestial herbs whose sire was heaven, the
 earth their mother, and their root the ocean,
May those celestial healing plants assist thee to
 obtain a son.

Why should a magical charm, in words or otherwise, be developed in poetic form? Many were left in the barest prose or even in nonsense syllables, from the belief that these would be as efficacious. As to those which are developed, one can only guess at the reason. It would depend somewhat on the mentality of the speaker, and also on who or what is to hear the charm and what effects are wanted. Aside from any possible effects on spirits, there are advantages for

[1] E. Burriss, *Taboo, Magic, Spirits* (New York, 1931), pp. 58-59. Also from the *Fasti* (II. 571-582) is the account of a magical rite intended to silence an enemy. An old woman, surrounded by a group of girls, places three pinches of incense in a mouse's hole under the threshold as an offering to the spirits of the dead. She then utters a spell, turns black beans in her mouth, and winds woollen threads around a dark, lead image of the slanderous person. She takes a fish, pierces it and sews it up, saying, "Hostile tongues and enemy lips have we bound."
[2] *De Agricultura* XLX.

[3] Translated by R. Griffith, *The Hymns of the Atharva-Veda* (Benares, India, 1895).
[4] *Ibid.*, p. 29. Another from the same source, developed in philosophic breadth as well as in poetic imagery, is the "Charm against Witchcraft."

humans in verse form. Verse is more easily remembered in an age when few can write, and relevant imagery also impresses itself on the mind. Poetry may have a more reassuring air of supernatural authority than simple prose. Also, as we have just noted, poetry may be written in the form of a magical charm, a religious prayer, or any other traditional type, for its aesthetic value alone. Oberon's speech to Titania, as he squeezes the flower on her eyelids, is in the form of a magical command by a spirit. The context, formal and cultural, lets us know that this is a literary fantasy and not the record of a real attempt at magic.

Much the same can be said of utilitarian religious art. There is reason to believe that some poems from the Atharva-Veda can be taken at their face value as to magical or religious intent, although later editors have altered them to some extent. It seems unlikely that one would be written as a modern Western poet might compose an ode or poetic prayer to Aphrodite, for purely aesthetic reasons and not as an expression of sincere belief in that goddess. From reading "To Varuna," especially in English translation, one can be sure that it is in the form of a utilitarian religious composition, a prayer to the god for benefits, but not that it was actually so intended and used. The realm of art is a realm in which fiction, fantasy, dramatic enactment, and make-believe flourish on every hand. Without sufficient study of the context one can never be sure that a character, a speech, an action, or a story means exactly what it says or seems to mean at first sight. The first three stanzas of the hymn to Varuna are as follows:

This laud of the self-radiant wise Aditya shall be
 supreme o'er all that is in greatness.
I beg renown of Varuna the mighty, the god exceeding
 kind to him who worships.

Having extolled thee, Varuna, with thoughtful care
 may we have high fortune in thy service,
Singing thy praises like the fires at coming, day
 after day, of mornings rich in cattle.

May we be in thy keeping, O thou leader, wide-ruling
 Varuna, lord of many heroes.
O sons of Aditi, for ever faithful, pardon us, gods,
 admit us to your friendship.

Another hymn to Varuna, from the same source, praises that god for his "mighty deed of magic" in meting the earth out with the sun as with a measure.

This "most wise god's mighty deed of magic" keeps the rivers from flooding the sea. There is a prayer for pardon and restored affection: "cast all these sins away like loosened fetters, and, Varuna, let us be thine own beloved." Here let us note that magical powers are attributed to a god, not practiced by men. A deed of divine magic may be called a miracle. That term suggests a departure from the usual laws and processes of nature, which only a god or one of his agents can make. Varuna is here extolled as creator and organizer of the universe, a concept which indicates advance in religious evolution. Human magic, as in a love charm, is not abandoned but reinforced by a prayer to Varuna: "expel all thought and purpose from her heart. Deprive her of her own free will and make her subject unto me."

Desire for the love of another person is one of the oldest and commonest motives of magic and prayer. In magic it has led to the sickness or death of countless persons—Lucretius was one of them, according to the legend—who drank poisonous "love philtres" intended for that purpose. Prayers for the same result can be simple and terse to the point of crudity, as in asking, "Oh, God, make her love me." But the same utilitarian approach can be developed as literary art by stating it in terms of colorful, emotive images which express the lover's feeling and the desired consummation more intensely and fully, and also by an organized, thematic sequence of word-sounds. All this is done in Sappho's "Ode to Aphrodite," which is a prayer and a highly developed work of art. Here the lover entreats the goddess to say, "What does thy wild spirit crave so dearly?/ Tell me, and proud though she be who charms thee/ Yet will I win thee her heart . . . Now though she fly thee, she soon will pursue thee, . . . Lady, provide me/ My spirit's desiring, and in battle-station/ Stand thou beside me."

Innumerable love songs in poetry and music have, of course, been written to reluctant maidens, real and imaginary, begging them to relent. But most of them in modern times have been neither magical nor religious, but naturalistic in approach.

The perceptible work of art, as a vehicle for the supernaturalistic effort, may develop in such poems as these along any of the modes of composition. We have just noted some obviously utilitarian examples. In others the main development is representational, as in a painting, statue, mask, costume, or a story of a god, or in a ritual enactment of some process for the purpose of influencing similar events. In still others the main development is expository, and we turn to a

history of magic for a relatively modern, highly civilized example.[5]

It must not be supposed, however, that all modern magic was diabolical or anti-Christian. To many intellectuals from the sixteenth century through the nineteenth, it seemed in accord with both science and Christian doctrine to probe into the secrets of physical nature as a realm apart from theology. The boundaries of what we now call science were not yet clearly drawn, and such erudite studies as astrology and alchemy, combining some observation of nature with mystic lore from antiquity, seemed more promising as "natural magic" than purely physical measurement. De Givry quotes Nicolas Valois, a fifteenth-century alchemist, as saying "The good God granted me this secret through my prayers and the good intentions I had of using it well; the science is lost if purity of heart is lost." Magicians of this sort employed the written name of God as a magic symbol, avoided all appeal to evil spirits, and worked out a secret, symbolic doctrine which remained almost unchanged for centuries.

Their ultimate aims were left in cryptic symbols, but it is known that the power of turning baser metals into gold was one goal. Beyond this, they aimed to penetrate the mysteries of life and the formation of matter.[6] They were accused of trying to rival the Creator in power, but so were the scientists. Alchemy openly sought the "Philosopher's Stone," but added that it was not a stone but animal and vegetable, with a body and spirit. The secrets of alchemy and astrology were linked by a connected symbolism for the elements and heavenly bodies. The study of both was compared to the attack on a mighty citadel of secret knowledge, with many paths of ascent, some right and some wrong.

In the seventeenth century especially, a number of learned volumes were published, purporting to explain the secret doctrine in some degree, with the aid of elaborately engraved pictorial diagrams. These are highly developed as expository art while also utilitarian in ultimate aim. Among the authors and illustrators are Heinrich Khunrath, Mylius, Jean d'Espagnet, Nicolas Flamel, Libavius, Elias Ashmole, Salomon Trismosin, Basile Valentin, and Robert Fludd.

The analogy between the microcosm (man) and macrocosm (universe) is a common symbol, as in that of human science as the "sedulous ape" of nature. The dragon biting his own tail symbolizes the resurrection or renewal of things after destruction or in the midst of decay. Mercury holding a caduceus and Saturn with a scythe, cutting off Mercury's legs, mean the maceration of common mercury with salt and vitriol. Adam (man) is analogous to the sun or gold; Eve (woman), to the moon or silver. Male and female principles are combined in the Hermetic Androgyne. Man and woman are bound to the macrocosm by chains. The initiate is advised to "Pray theosophically and work physico-chemically." In the seventeenth century the Ptolemaic and Copernican astronomies are still portrayed as in conflict.

Contemporaneous with the alchemists were the humble "puffers," prototypes of the modern chemist, who spent their time on groping experimentation. Lacking the glamor of mysticism and aristocratic support, they were somewhat despised though actually on a truer path to science.

Today, Jungian psychology finds archetypal images throughout the symbolism of alchemy and astrology. Alchemy seems dead, but astrology still has a small following among educated as well as uneducated people, as a way of predicting the future and a guide to fortunate actions.

3. Changing roles of art in advanced religions.

In the later evolution of religious thought, the following tendencies have occurred in various cultures:

As to *aims,* there has been a shift from naïve requests for worldly, material goods—from an emphasis on wealth, power, prestige, bodily health and the like—to requests for spiritual guidance, faith, and resistance to temptation. The emphasis changes from benefits for oneself to those for others. The change can be sincere or hypocritical. On the part of the poor and lowly, as in Rome of the first and second centuries, it can be due in part to increasing despair at

[5] G. de Givry, *Witchcraft, Magic, and Alchemy.* Tr. by J. Locke (London, 1931). Fig. 79 on page 107 of this book shows a set of symbolic diagrams and accessories for evocation of the Devil in sorcery, from the book *The Magus* by F. Barrett (London, 1801). One accessory is a tripod for burning perfume. Fig. 92 shows a more artistically developed set of "Paraphernalia of sorcery used by Henri III in his Satanic Operations." They include two silver-gilt, obscene statues of satyrs holding bowls for oblations and a golden cross containing an inlaid piece of wood, supposedly from the "True Cross" and used for profanation. The sorcerers, de Givry comments, had illustrious patrons. Even in Devil worship, they could claim to have substituted one religion for another in the Faustian search for superhuman power.

[6] de Givry, pp. 347, 366.

the possibility of improving their status in this world, and also to an increasing sense of the enormous, almost unbridgeable gap between the smallness, weakness, and sinfulness of man and the perfect goodness, omniscience, and omnipotence of the God of monotheism. Also, it becomes evident to disillusioned minds that naturalistic technics are more effective in attaining the goods of this world, while one may still hope that supernaturalistic means can achieve those of the life to come.

In religious literary art, such as lyrical prayers, the emphasis shifts to expressions of thanks, humility, love, faith, and obedience, often without definite requests for further blessings except perhaps for spiritual growth, forgiveness of sins, restoration to divine love and fellowship. One pleads for salvation of the soul from damnation or (in Buddhism and Hinduism) for Nirvana and liberation from the chain of rebirths. An artistic plea for blessings after death is an extension in time of the plea for blessings in this life. Both are utilitarian art, in the sense of art which is instrumental to some end beyond direct aesthetic satisfaction. This is true of art which is devised to influence either divine or human observers. Some religious art is made and used to elevate the mind of a human observer to higher spiritual levels. This is its *anagogic* function.

While seeking to deal rightly with supernatural things, advanced religious art is mindful also of life on earth. Part of its utilitarian message is to lay down explicit rules for human conduct. In this it not only seeks to restrain man's aggressive and sensual impulses, even to the point of praising universal celibacy; it also teaches man to obey the temporal, political powers while warning those powers of their duty to rule justly. In this way, and also by preaching humble acceptance of one's allotted status in life, it tends to reinforce the feudal and imperial hierarchies of its time.

Religious art has found literary expression in verbal prayers, often developed along lyrical lines as well as in rhythmic and metaphorical prose. The prose sermons of John Donne are examples, these being addressed more to a sinful people than to Deity directly but often leading to prayers for absolution and guidance. From the time of the Gospels and St. Augustine, Christian literature developed in all four modes of composition. The utilitarian appeared as a guide for moral conduct, thought, and feeling, as warnings to the sinner and promises of reward to the virtuous. Explicit rules were given in the Ten Commandments and the Sermon on the Mount. Exposition was provided in interpretations of the theologi-

cal, metaphysical, and eschatological basis for belief in the moral law and obedience to it. The Gospels are largely narrative and representational. Christian literature developed along this line in Dante's *Divine Comedy* and Bunyan's *Pilgrim's Progress,* but in both cases it offered explicit moral guidance. In Dante it became highly thematic as to its arrangement of word-sounds and as to its diversified, firmly integrated arrangement of ideas. Literature cooperated with music in hymns of worship and in poetic prayers and litanies throughout the year. To the visual arts it contributed an inexhaustible heritage of stories from the Bible, the Apocrypha, and current legends suitable for illustration in every visible medium.

The pictorial and sculptural arts contributed richly to the development of moral guidance from the Middle Ages through the Baroque. Most obvious and forceful in their moral lessons, perhaps, were the great *Last Judgments,* notably that of Michelangelo, with their graphic portrayal of the punishments of vice and the rewards of virtue.

Among the persistent types of religious art with strong utilitarian development, as either framework or accessory, are the following:

(a) *Visual utilitarian framework types,* such as temples, churches, altars, baptismal fonts, ritual and funerary vessels and utensils, reliquaries, costumes, incense burners, bells, gongs, chalices, sacrificial and ceremonial knives, urns, sarcophagi, and monuments.

(b) *Visual representational types* such as pictures and statues of gods, spirits, angels, demons, and saints. Mortuary figures, portraits on mummies, figures of servants, horses, dancers, food, and other equipment for the dead in after life. Ritual enactments, dramas, dances, ceremonies, depicting divine and diabolical scenes and personages. Sacramental gestures with symbolic and thaumaturgic significance.

(c) *Visual expository types:* mystic, symbolic art other than representational; abstract symbolic designs.

(d) *Literary and musical forms:* prayers, litanies, hymns of worship; collective and individual expressions; lyrics, sermons. Mystery and miracle plays. Prophetic utterances; reports of supernatural visions; revelations of the will of the gods; oracles; ethical precepts and codes put forward as divinely ordered; sacred histories believed edifying. Guidebooks for the afterlife (e.g., the Egyptian and Tibetan *Books of the Dead*).

What kinds of development have occurred in the utilitarian arts of magic and religion? Their prestige has depended on changing beliefs about the nature of the universe, and about the most effective way for

humans to satisfy their desires. As we have seen, one of the basic assumptions of magical technology, that things are governed by weak spirits which can sometimes be controlled by man, has been largely replaced in many parts of the earth by the religious belief in strong spirits which can not be so controlled. Vestiges of magic persist, but on the whole civilization has come to depend for its earthly goods on a combination of religion and naturalism, especially the latter.

The religious faith in strong spirits endured for millennia, during which it inspired an unparalleled development of art. It was long reinforced by the additional belief that the gods (or the God of monotheism) would be favorably influenced by the best works of art which man could devise. But both beliefs were subjected to attack. In repeated iconoclastic and ascetic revolts, religious art was denounced as idolatry, sensuality, extravagant luxury, and an incitement to war and crime. The result was usually a temporary slump in art production, followed by a vigorous revival as dominant social forces returned to the belief that religious art could help them get the ends they most desired. It was again proclaimed that art for the glory of God and His Church was right and divinely favored.

In the long run, the prestige of religious art was undermined by two new tendencies. One was toward a thorough monotheism, conceiving of God as an abstract, impersonal, creative force, perfect, omniscient, and omnipotent, and hence beyond the power of any human artist to represent. This weakened the belief in good and bad minor spirits, angels and demons, as well as in all the miraculous occurrences that art had loved to represent. The other adverse tendency was the revival of naturalistic science and philosophy, developed by the Epicureans and revived in the seventeenth and eighteenth centuries, especially by Diderot in the French *Encyclopedia*. This further undermined the belief in personal spirits and the art which represented them, and also the belief in the utilitarian efficacy of religious art and mysticism as ways of getting things done.

The rise of naturalism also hastened the decline of magic as a serious mode of thought and action among urban intellectuals in Europe after the seventeenth century. With it went the old beliefs in the Devil as a major spirit, in the host of minor spirits good and bad whose aid could be secured, in the influence of stars on human destinies, and in the power of mystical alchemy to penetrate the secrets of the universe. In all these matters, science gained the ground by practical successes and by arguments.

Both magic and religion retain considerable pres-

tige in the realm of art as subjects of fantasy in literature and pictorial representation. In painting and the graphic arts, one has only to think of Goya, Blake, and the illustrations of Doré for Dante and the Bible. In literature and drama, the continued popularity of *Macbeth* and *A Midsummer Night's Dream*, of the Grimm fairy tales, the King Arthur legends, and the Faust legend as treated by Marlowe and Goethe, all attest the love of young and old for imaginative escapes from contemporary realism. In treating religious subjects other than the Hebrew-Christian, Western artists take it for granted that belief in the existence of the old gods is dead and no longer even controversial. But as psychology and anthropology probe more deeply into the mental and social significance of religious history, art is again inspired by new ways of treating religious subjects in a way combining realism and fantasy. As in Mary Renault's *The King Must Die*, the myths and legends of primitive Greece and Rome are retold in obviously fictional forms, yet with insight gained from modern theories as to how real persons and events may have provided the starting point for collective myth-making in actual historical settings. Robert Graves, in *King Jesus*, and others have approached the Christian story in a similar spirit, but here it is more difficult to avoid controversy over what is fact and what is fiction.

While noting this continued vitality of magic, witchcraft, and primitive religion in the twentieth century, we should realize that it is no longer on an actively utilitarian basis. Comparatively few present-day intellectuals regard these types of art as genuinely powerful, effective ways of getting things done in this world. They are treated mainly from the standpoint of imaginative fiction, and the basic frameworks of the art produced are usually representational. Sometimes they combine an expository factor, a discussion of magic and religion in general, with aesthetic appeal.

In the descriptive analysis of past art one must recognize the importance of supernaturalistic types of utilitarian form. They still function as suggested meanings and modes of organization in art, even when their practical value is no longer believed in.

4. The cathedral as a type of utilitarian framework. Its various modes of development. Social influence on architecture.

Strictly speaking, a cathedral is a bishop's church, so named from the bishop's official chair; it is the princi-

pal church of a diocese. But the term is now broadly applied to any large, important church, especially one of Gothic style in medieval Europe.

In either sense, it is one of the most complex types of visual art devised by man, especially if one includes as integral parts of it the sculptured figures within and without, the interior furniture such as choir stalls, the stained glass, the metal grilles, the high and subordinate altars, the fonts and pipe organs, the sacristy, treasure room, and cloister, the ecclesiastical utensils, costumes, and other objects fixed or movable. One is tempted also to include in the cathedral as a living institution the rituals performed there, the music, the words and gestures of the mass, the priests in their splendid vestments, the acolytes with crosses or incense burners, and the crowd of standing, walking, or kneeling worshippers.

The cathedral is outstanding as a persistent compositional type which maintains a utilitarian basic framework along with development in all four modes. It is *utilitarian* as a church. It is *representational* in its figures and stories of divinities, saints, kings, martyrs, imps, and animals, in wood, stone, or glass, and *expository* in its elaborate symbolism of religious ideas and beliefs. And it is *thematic* in its countless sequences and patterns of line, mass, void, texture, color, and light.

The cathedral is a highly evolved descendant of ancient temples, basilicas, and north-European halls of wood with steeply pitched roofs. Its physical base is naturalistic and firmly on the ground, while its lofty spires reach toward heaven, symbolizing the aspiration of the soul. In keeping with this physical orientation it combines a set of naturalistic functions (primarily those of a covered meeting house) with a set of supernaturalistic functions (primarily those of worship and guidance on the road to salvation). These are combined in providing a physical, formal, aesthetic basis for cultic rituals.

At its height of activity in the Middle Ages, the cathedral with its adjoining structures provided facilities for a number of specific functions. It was at once an auditorium, a hall for worship and sacramental rites, an art museum and library, a sanctuary from pursuers (in theory at least), a center for the ecclesiastical government of a bishopric, a school, a concert hall, a store-house for costumes, treasures, and reliquaries, and sometimes a studio for artists. It might be also a temporary dwelling place for ecclesiastical personnel of high and low degree. In the Romanesque age, its predecessors had often served as forts to resist armed attack, but in the later Middle Ages it could risk thin walls and fragile glass windows.

Even more diversified in some ways were the huge monasteries like La Grande Chartreuse, near Grenoble, which housed a more or less permanent group of monks with individual cells, kitchens, refectories, chapels, libraries, studios, gardens, live stock, and rooms for manufacturing beverages or other products for sale. Although highly developed on the utilitarian side, they were less so than the cathedral as works of visual art. Likewise, one might say that a modern city hotel, a transatlantic ship, or an organized group of hospitals or university buildings is still more complex and diversified as to naturalistic, utilitarian forms and functions. But, again, none of these equals the cathedral in complexity of aesthetic development. None contains its great interior vistas and its ultracomplex design of masses, surface shapes, and luminous colors. Large modern buildings are often mere oblong boxes, divided and subdivided into thousands of smaller boxes by thousands of partitions, as in a honeycomb.

One reason why the cathedral inspired rich and concentrated aesthetic development was because of its prestige and prerogative status in medieval society. It was the place where all classes of society met and joined in activities of the highest possible concern to all. It was the focus for intensely emotional attitudes, for the highest hopes of people in an otherworldly age, when the possibility of eternal damnation seemed real and urgent, and the Church the only sure protection from it. In an age when towns were growing in wealth and freedom, when guilds of artists and craftsmen enforced high standards and were paid a living wage and treated with increasing respect, when bishops and their cities vied with each other in religious art for the glory of God, the cathedral was the logical place for supreme magnificence. Monarchs were not yet powerful enough to draw equivalent amounts of wealth and artistic ability into their castles. Secular life was often ruggedly military. While life was increasingly secure within the towns, it was not yet safe between them. Social pressures still forced much medieval life within or near the town walls. One could not, as safely, build large, expensive, unfortified buildings over the countryside. Good roads and fast communication were lacking.

The cathedral's extraordinary complexity, including diversity and integration in both the aesthetic and utilitarian factors, is causally related to these social conditions. The age of the cathedral was an age of great inequality of wealth and power among the various social classes. They formed, supposedly, a double hierarchy of Church and State from the lowest monk and serf to the Pope and Holy Roman Emperor, although this ideal form was never perfectly attained.

Within the religious hierarchy, the right of the Pope to be supreme was generally accepted in the West. Symbols of rank in both ladders, such as coats of arms of noble families, abound in the church interior. The many designs in glass and sculptural relief persistently repeat the hierarchical conception through placing the most important personages, divine and human, on the highest level or in central position and enlarged in scale.

Concentration of wealth and power, including power to commission works of art, and concentration of people in cramped, walled towns, both favored the concentration of different functions in a single building or group of buildings. This is not necessarily the most efficient way to perform the subordinate ones, such as education and handicrafts. In fact, when the rise of kingdoms and the spread of royal military power ensured more security outside the city walls, architectural construction rapidly expanded there. In many small towns, such as those along the Loire, the military type of chateau, grim and almost windowless, gave way as the cathedral itself had done in previous centuries, to thinner walls, more and bigger windows. It opened out into parks and gardens, hunting lodges and unprotected summer houses. The cathedral and the fort split, figuratively speaking, into many different, separate, specialized types of building in city and country—into schools and universities for an increasingly secular education, into monasteries and small local churches. The bourgeoisie, increasingly prosperous, followed Jacques Coeur in building splendid residences. Town halls for local government rivalled the main church in size and dignity.

Why have more cathedrals not been built in modern times? We need not infer a decline of architectural ability. Among the many reasons are, not only the decline of faith in otherworldly values, but also the increasing diversification of cultural activities, each demanding its own kind of building for greatest efficiency. Thus we have, instead of a few huge cathedrals and chateaux, a great variety of public buildings including neighborhood churches, theaters, schools, banks, museums, libraries, government buildings, and the rest. Each is temporarily adapted to serve a certain range of social functions, but is soon obsolescent as more services and more efficient means are called for. Democracy and widespread distribution of purchasing power decrease the demand for enormous private palaces and stimulate the production of small, cheap, but efficient apparatus in small houses widely scattered through the open land.

Universal, free, public education diminishes illiteracy. Cheap textbooks, magazines and newspapers, radio, and television bring educational and cultural opportunities to the poorest class. They diminish the need for teaching in pictorial forms, as in the cathedral, and for elaborate symbolic visual exposition to convey the essentials of religious doctrine.

The splitting of the cathedral into many specialized, smaller types of building has not preserved its aesthetic character or (so far) been followed by equal developments of complex design in architecture on a smaller scale. The contemporary emphasis has been on more efficient utilitarian forms, not entirely devoid of aesthetic appeal, but without the enormous concentration of thematic design in any one building or type of building. The emphasis has been rather on large numbers and mass production of semiprocessed materials. Simple forms are repeated over and over. Many buildings are flimsy and quickly obsolescent, torn down to make room for more efficient ones. New suburbs, shopping centers, towns, and cities spring up, almost overnight. This is a kind of development, not without its advantages, but producing no single type of unit analogous to the cathedral as visual art.

5. Naturalistic utilitarian technics, physical and psychosocial.

There are several ways to classify the principal kinds of naturalistic skill which man has devised since the origin of culture. Most of them follow a roughly chronological or genetic order, although the order of succession varies much from place to place. The most general tendency, perhaps, and the one which causes historians to call it a "progress" or "advance," is that of increasing efficiency and power, of labor-saving methods and increasing assurance of accomplishing one's aims, at least in certain fields. This is complicated, however, by the fact that each invention, each breakthrough to greater power and efficiency, leads to new desires for more and better products and enjoyments, so that man is perpetually dissatisfied. Higher standards of life in certain respects are achieved at the cost of lower standards in other respects, and of grave maladjustments through the uneven growth of technology. There are always people who try to use the new power to dominate others. This makes historians and philosophers hesitate to call the whole history of culture a "progress" in the evaluative sense as they did in the nineteenth century. But there is little room for doubt that technological change has achieved huge advances in physical power

and efficiency as compared with man's limited power to control them wisely for the benefit of all.

What has just been said applies especially to the arts. They have made some use of applied physical science, as in the machinery used in architecture and motion pictures. Scientific ideas have influenced the arts in many ways. It was once hoped that science and rationalism would quickly improve the arts, but that hope was disappointed. A main contention of the Romantic movement was that art must depend more on free individual feeling, intuition, imagination, and impulse than on reasoning, logic, and rules. The issue is not yet decided, but the Romantic attitude is still powerful in Western art and aesthetics.

Most if not all the kinds of technic listed below are utilitarian. Many of them are artistic technics also. Neither art in general nor science in general constitutes a separate kind of technic; both are scattered widely through many kinds of method and device. Any technic can be developed scientifically; more and more are gradually being reorganized in this way. In most of the technical types mentioned below, there are subtypes devoted to artistic treatment of the products and processes involved.

One way to classify the main kinds of technic is in terms of stages in cultural evolution. These were distinguished by nineteenth-century evolutionists as savage, barbarian, and civilized. The invention of certain technical methods was regarded as marking the change from one level to the next higher. That of settled agriculture and metallurgy was identified by some anthropologists with the rise from savagery to barbarism; that of writing, with the rise of civilization. Efforts were made to show that people in a certain stage had about the same technics throughout the world, but at different times. Such stages were said to exist in some of the visual arts, as was shown, for instance, by a change from realistic drawing to stylized, symbolic decoration. But sometimes realism seems to come first, and sometimes abstract stylization. The theory of universal stages met with strong objection from early twentieth-century anthropologists, who found great diversity in different parts of the world. While one cannot distinguish clear-cut, universal stages, there are partial similarities in cultural evolution everywhere. Somewhat similar inventions have been made in many different places at about the same times.

A related mode of classification, and another criterion of technical advance, is that of the *material* chiefly used. The old three-stage theory (stone, bronze, iron) must now be amplified into stone,

wood, copper, bronze, iron, steel, reinforced concrete, glass, paper, plastics, and so on. But not all of these have led to as far-reaching a cultural transformation as did bronze and iron. There has been an increasing tendency to import desired materials instead of adapting the product to what is near at hand, and still more recently to invent and manufacture the kinds of material wanted, such as plastics and synthetics. This gives greater freedom in inventing any kind of physical form and encourages foresight in planning forms, materials, and functions. The introduction of a new material has not, of course, eliminated the old ones; we still use a great deal of stone, rough and smooth. But it has often brought about a great increase in the power and wealth of the groups possessing the new materials and related technics.

The source of *physical power* is another basis for technical change. The earliest was human, bodily energy. Afterward, though in variable sequence, came fire, domesticated animals, wind, water, steam (from burning wood, coal, oil, etc.), petroleum, electricity, and atomic energy from fusion and fission.

A more complex base for classification is the type of *end or function* and of *means or device*. We have just been considering the differences between magical, religious, and naturalistic technics as to both means and ends. All three have been used for basic, material ends such as food and health, wealth and power, and all three use the arts as means. But religion tends to use the arts more consistently, and in its more advanced forms to aim at otherworldly, spiritual goods, including those of a future life. Naturalistic technics tend to use the arts more for the enjoyment and instruction of humans in this life, and to use them only where aesthetic appeal seems appropriate. They often avoid aesthetic appeal and specialize on achieving the most efficient means to a particular function which is possible at the time.

The great development of naturalistic utilitarian technics has called for many other ways of classifying them in terms of ends and means. We have noted that most of the earliest technics were comparatively undifferentiated. That of chipping flint was used to make various kinds of tool and weapon, some of which (points, scrapers, hand-axes, awls, etc.) could be used for many different purposes. Clubs, bows and arrows, and spears were used for both food-getting and fighting; so, in a later age, were the horse-drawn cart and chariot.

The technics of ancient civilization, both naturalistic and supernaturalistic, were gradually differentiated into an increasing number of specialized occu-

pations such as those of priest, scribe, soldier, sailor, farmer, government official, physician, merchant, artist, artisan, entertainer, and servant.

In modern times different cultural areas, industries, applied sciences, or branches of technology produced different sets of apparatus and procedure, as in medicine and surgery, meteorology, law, jurisprudence, and education. Within each metier, as practiced by inventive minds, ideas and desires for new methods and functions multiplied. Experts in each metier foresaw and partly achieved ways of improving the work of that metier and its relations with others. Artists imagined such inventions and portrayed them in verbal or pictorial fantasy, as in the tale from the *Arabian Nights* of the flying wooden horse, and in Jules Verne's trip to the moon. The multiplication of different technological areas provided occupational bases for classifying the technics and apparatus employed: e.g., those of law, banking, medicine, aviation, enameling, and rug weaving. In most areas, there was also an evolutionary diversification of rank, at first on grounds of birth, later on grounds of ability. These included the managerial and professional level, the levels of skilled and semiskilled workers, and those of the unskilled or menial laborers.

Military technology, including weapons, defenses, tactics, strategy, and logistics, is said to have developed more steadily than any other branch of culture. Bugle calls and march music belong under this heading. Officers have usually worn somewhat ornate, artistic dress to show their status, especially on parade. Flags, banners, armor, swords, and shields have been elaborately decorated, some in types of art intended to frighten the enemy. But for the most part war has been a grim business in which neither side could afford much aesthetic enjoyment. Magic and religion have been extensively used to bring victory. At times they have encouraged those who used them (such as Joan of Arc) or discouraged their enemies enough to turn the tide of battle. But on the whole there can be little doubt that naturalistic methods were more potent. Failure to keep up with the advance of naturalistic technics in this field brought rapid danger of conquest. Those used are both physical and psychosocial. The latter are directed largely toward sustaining morale and the will to resist in one's own army and at home, while weakening them in enemy countries. Art can be a powerful instrument in all these undertakings.

The varieties of utilitarian technic can be classed as *physical*, *biological*, and *psychosocial*. These categories overlap, and a single occupation may involve all of them. A physical technic such as coal mining deals mainly with inanimate materials. But there is something mental and something social in all physical technics. At least, they involve thinking and planning in the effort to satisfy desires, and some communication in transmitting them to the young. All psychosocial technics involve some physical materials, at least in the brains and nervous systems of those who exercise them. Also, in many cases, they involve paper and ink, written and spoken words and numbers. But there is a difference in emphasis.

Besides the more wholly material skills such as metallurgy, which deal with inanimate objects, there are *biotechnics* dealing with living forms, as in agriculture, animal husbandry, medicine, horticulture, and applied genetics. The biotechnics overlap the psychosocial technics, for mind and society depend on life and life depends on material organisms. Broadly speaking, one might class as psychosocial all the technics aimed at providing a healthy and versatile physical basis for life and thought, such as defense against enemies, preserving and cooking food, providing clothes and shelter, and caring for the young. But the term "psychosocial" is now used in a narrower sense, for technics dealing mainly with mental and social phenomena and directed toward mental and social ends. "Mental" here includes all psychological processes, such as the sensory and perceptual, the conative, emotional, imaginative, and rational.

Some Oriental technics such as those of *yoga* are mainly psychic, but seem to have little social quality, since they often involve escape from social contacts. Even these are physical in striving for control of one's own body and desires.

The arts are psychosocial technics, even though they use some physical materials such as paint and paper, and even though (as in architecture) they minister to both mental and bodily needs. They are psychosocial in that they are learned, transmissible skills, used to a large extent for stimulating and guiding certain kinds of conscious experience in individuals and groups. They are means of recording, communicating, and developing man's social heritage of culture, including the products of moral and intellectual as well as aesthetic evolution. According to naturalistic humanism, psychosocial technics are or should be aimed at improving the quality of experience for all humans, at attaining a just and liberal social order, and at supplying man's basic needs more easily and efficiently through mechanization while stimulating free individual enterprise and creativeness in artistic and other cultural lines. Modern psychoso-

cial technics rely on devices for the exact observation of phenomena, for free experimentation and expression of ideas among individuals and groups. However, they can be used for selfish, aggressive, and oppressive ends by those who wish to do so.

Psychosocial technics include not only methods of thinking and communicating ideas, as in writing and logical reasoning, but the physical devices used in thinking, writing, and organizing social behavior. Thus they include, in addition to spoken and written language, the calendar, alphabet, sundial, and clock, Arabic numerals, the printing-press with movable type, the telescope and microscope, book-keeping, the telegraph, telephone, radio, and television. Psychosocial technology includes the theoretical and scientific formulation of principles in the use of all these. Ethics and aesthetics are prescientific branches of psychosocial technology.

Aesthetics includes a highly generalized technology of the arts. It is not itself a technic, but a theoretical subject which discusses ends and means, forms and functions, values and disvalues in the arts and related types of experience. The active skills and instruments used in practicing all the arts are psychosocial technics, as in oil painting, violin playing, and versification. These can also be called "aesthotechnics." But not all the arts are utilitarian, only those artistic skills and products which are adapted to serve other functions in addition to aesthetic stimulation. A *work* of art, in the sense of a product or performance, is a psychosocial technic or, more strictly, a *technical device.* The devices and skills required in making and using them are all roughly classed as technics.

Education, as a systematic process of training the young in desired folkways and transmitting to them the cultural heritage of the group, is a very broad, almost all-inclusive institution, comprising a vast range of psychosocial and other technics. It includes the practice, appreciation, and history of the arts, and can become an art itself, as in the methods of Froebel and his followers.

The technics and technology based on modern, applied science are sometimes used for physical ends, as in atomic bombs, but these are usually coupled with psychosocial ends, such as political power and freedom. They become more definitely psychosocial in radio, television, phonograph records, educational texts, and motion picture films. In all of these, their means and methods tend to become more mechanical, automatic, large-scale, industrial, and impersonal. Heavy burdens have been shifted from the backs of men and women to machines. Mechanization is already extensively used in many arts, especially the so-called mass media just mentioned.

Even the product of a solitary artist, such as a poet or painter, can be reproduced or recorded and widely distributed by mechanical means. This does not mean that the forms and contents of the arts are becoming equally mechanical, although some philosophers have expressed fears along this line. There are also counter-movements from the romantic point of view, as in Abstract-Expressionist painting, where an effort is often made to avoid suggestions of machinery, geometry, logic, symmetry, rational planning, and other common traits of applied science. That the rapid mechanization and automation of nearly all utilitarian fields will spread farther with the aid of science, for better or worse, there can be no doubt.

That all kinds of technology will eventually support moves toward peaceful, international cooperation is the hope of humanists. Pessimists are mistaken in blaming present troubles on science or technology, for these are only implements. Psychosocial technology does not lack the knowledge or professional skill to maintain world peace, but these are helpless without the will to use them on the part of powerful groups. In the meantime, antipathy toward science and technology is a common feature of twentieth-century art. It carries the prestige of the romantic tradition through the past two centuries, reinforced by new fear and disappointment over the apparent failure of science to bring lasting peace and justice.

6. Naturalistic utilitarian art in visual media

Utilitarian art is naturalistic when it does not rely for success in its utilitarian functions on the aid of spirits or other supernatural agencies, when it is so organized as to help in directly controlling the phenomena of nature and achieving human desires in this life. Such a work of art may be used in connection with a supernaturalistic technic: for example, by carrying an ornate shield into battle and also wearing an amulet or praying that the shield will protect one. The shield itself is a naturalistic device. In a cathedral, the physical structure and fitness to serve as a sheltered meeting place are naturalistic, while the symbolic meanings and specific uses (sacramental and ritual) are mostly supernaturalistic.

As we have seen, the aesthetic and utilitarian factors in a work of art may be closely merged or quite distinct and loosely assembled. A certain type of utili-

tarian factor may be associated with a certain type of aesthetic factor over long periods of time, or the two may diverge and develop differently. The two may appeal to very different interests, one to a severely practical attitude and the other to a more aesthetic, sensuous, or imaginative one. Circumstances may hold them together for a while, focused on a single type of product, but it is not surprising that they often separate. The history of the aesthetic aspects of utilitarian art is closely related at times to that of utilitarian technics in general, while at other times they follow separate paths. There are periods in which certain utilitarian types persist almost unchanged for centuries—e.g., the pottery bowl—while artists of different times and places decorate them in countless different styles. In other periods the utilitarian factor changes fairly rapidly, while the aesthetic one lags behind or joins in current style trends with little concern for its utilitarian basis. This may happen either in response to urgent practical needs, as in war, or as a result of strong social interest in practical invention, as in modern American culture.

The tremendous modern development of naturalistic technics and technology has proceeded mainly along utilitarian lines, often with little or no concurrent aesthetic development. Yet, like all specialized modern developments, it can be traced back to less differentiated types. Many of its notable antecedents are pervaded with supernaturalism and also with a strong aesthetic factor. Greek conceptions of technology in visual, tangible products were personified in Hephaestus (Vulcan), who created armor and weapons combining use and beauty, and also in Apollo and his Muses, who fostered both beautiful and useful skills in other realms. Prometheus and Daedalus personified useful invention, including the use of fire and mechanical devices, but their stories carried a warning against presumptuous efforts to rival the gods in power. The fear of punishment for *hybris* operated to discourage naturalistic technical innovations and to perpetuate reliance on humbly religious ones.

Nevertheless, Hellenistic Greece was on the verge of rapid mechanical progress when it was conquered by the Romans, whose technical genius was more in the fields of law, road building, and imperial government. Archimedes, Ctesibius, and Hero of Alexandria had produced automatic pumps, water organs, water clocks, and steam engines involving mechanical principles capable of far-reaching development. They paid some attention to aesthetic factors also, as in Hero's little dancing figures for summer gardens. Some of their inventions were musical instruments; others

were decorated with human, animal, and floral motifs. Some were used to make temple doors seem to open of their own accord. Some of these types of utilitarian art, called "automata," were made and used by the Arabs in the Middle Ages, and paintings of them from the fourteenth century exist.[7] They included ornate water clocks and lavabos. Mechanical table fountains, made in medieval Europe, were elaborately gilded and enameled, with small bells which jingled when wine or perfumed water ran through their small pipes and tanks. As in the Chinese invention of gunpowder, little serious, practical use was made of these mechanical devices.

The Industrial Revolution of the late eighteenth century, which began in the English textile industry with mechanical devices for spinning and weaving, spread rapidly throughout other technical fields. Among its far-reaching social and cultural effects were the gradual substitution of machinery for human and animal power, the introduction of large-scale mass production, and that of large-scale capital in financing private enterprises. Eventually, these tendencies transformed society as a whole, especially in its economic, political, and military aspects. The Industrial Revolution was itself a resultant of many cultural trends, including the centuries of scientific development which had recently put astronomy, physics, mechanics, chemistry, and some parts of biology on a scientific footing. These were not immediately applied to practical technics; indeed, it was well along in the nineteenth century before this was systematically done.

One of the areas most easily conquered by machine methods was that of heavy industry, including the manufacture of semiprocessed materials and parts to be assembled, such as woollen thread and cloth, wooden planks for carpentry, clay chimney pots, steel rods and plates for steam engines, and rails for railroads. Not being intended or adapted as aesthetic objects, they made less demand for artistic treatment than the finished products, such as houses, chairs, and dresses. Little attention was paid to the aesthetic aspects of the machines and factories which turned them out.

When Ruskin, Morris, and other champions of beauty protested against the grimy streets and clouds of sooty smoke defacing the countryside, their plea

[7]There is a manuscript book of *Automata*, by Al-Jazari, from Mesopotamia in 1315. It is described as *A Book of Knowledge of Ingenious Devices*. Both the mechanical devices and the pictorial diagrams for making them are examples of utilitarian art.

was usually for a return to handicraft methods, rather than for a further development of machine technology along more beautiful lines. Sometimes the proud owners of an early locomotive or steamship tried to improve its appearance with glistening paint and an ornament or two. These products were likely to attract attention as they moved through the countryside. For the lower and middle classes, machines were soon successful in turning out simple, stereotyped products at low price and in great numbers, such as the "Road-rail, pig-lead, fire-wood, iron-ware, and cheap tin trays" of which John Masefield speaks in "Cargoes." In some fairly important products for the home, such as cast-iron stoves, a few traditional ornaments were introduced, such as classical garlands and cornucopias in relief. These showed little attempt at original forms appropriate to the function of the stove as a heating device. In more ambitious attempts at combining use and beauty, a few complex machines were covered with elaborate Gothic or Neoclassical ornamentation. Machinery was evolving its own, new kinds of design, destined later to attract aesthetic attention for their own sake; but these were not taken seriously at first. Some notable exceptions were the Crystal Palace, the Brooklyn Bridge, and the Eiffel Tower, in which some basic structural features were themselves made to function decoratively.

On the whole, the mid-nineteenth century was a period of dislocation between art and engineering, the pursuit of beauty and that of use. The quest for utilitarian efficiency, economy, and power made enormous strides, while that of use combined with beauty groped and wavered. Painting and poetry followed a very different quest for beauty, far from machine technology, often into romantic dreams of the far away and long ago.

Meanwhile, prosperity was increasing the demand for utilitarian art in the home, church, and office as well as for some to be worn on the person. In these places it was on view at close range and often criticized by feminine taste on grounds of beauty and fashion. It commanded high prices for products on the luxury level, and here "machine-made" became a term of opprobrium. Fine, hand-made things were symbols of high socioeconomic status. The spread of machine methods and forms suggesting machinery met with determined resistance in realms where high aesthetic quality was expected, and for which high prices could be charged. One cannot say that utilitarian art was entirely neglected during the Victorian period, but it did remain conservative in style, on the whole, and far removed from the turmoil of mechani-

cal technology. In 1900 a considerable amount of transportation, both of persons and of goods, remained in horse-drawn vehicles. Hand methods and traditional styles still dominated such important branches of utilitarian art as domestic architecture, interior design, furniture, utensils for personal use, clothing, cosmetics and coiffure, packaging and preserving of foods, photographs, books and other printed products (in spite of the printing press). Machine-made and mechanical contrivances for the home or office such as sewing machines and typewriters were being introduced. The telegraph, telephone, automobile, and motion picture were in their early stages. Improved oil lighting, gas, and electric lamps came in quick succession.

7. Industrial art in the twentieth century.

This century has brought (a) a wide demand for improving industrial design in harmony with utilitarian function, and (b) a large-scale introduction of mechanized equipment for the home and office. The latter includes a wide range of kitchen and laundry equipment, operated by small electric motors, many with fractional horsepower. It includes electric washers and dryers for clothes and for dishes, refrigerators, stoves, power mowers for the lawn, electrified tools for carpentry and metalry, electric typewriters and copying machines, bathroom equipment such as electric shavers and water heaters. Automobiles have almost eliminated the horse, except for sport, in technically advanced communities. Private airplanes are becoming more common. Phonographs, radios, and television sets are common household furniture, not restricted to the luxury class of homes.

The widespread introduction of products requiring mechanical operation by untrained persons in and around the home has had several far-reaching effects. Efforts have been made to increase the ease and safety of operating them, especially in automobile and kitchen appliances, but they are still far from being foolproof. They need frequent repairs and servicing, which makes the owners increasingly dependent on repair and maintenance men. Some are intentionally made so as to wear out or become obsolete in a fairly short time, by comparison with old-fashioned, nonmechanical tools and furniture. Competition impels the manufacturers to keep improving, or at least changing, the appearance as well as the efficiency of the product, so as to make the purchaser buy a new

one soon. This leads to rapid style changes in utilitarian art, much like those which are occurring in other arts.

Now that machine technology has begun to make its peace with art and shown its adaptability to a great variety of uses, including domestic, family, and personal ones, the demand for more efficient, better-looking appliances grows at accelerating speed. Countless new gadgets appear on the market each year, many of them designed with expert care by engineers and artists in cooperation. In a free, consumer-directed economy, competition is rife. Advertising stimulates new desires in addition to selling a particular manufacturer's wares.

In this competitive process, as we have seen, two opposite pressures are at work. One is toward simplification through eliminating unnecessary, friction-causing parts. This tends to make the device less expensive to make and maintain, and less difficult to operate for persons without technical training. There is also a certain type of aesthetic appeal in extremely simple, efficient devices, each perfectly adapted to its intended function. But, this pressure is somewhat counteracted by one toward complication, through making each device do more things, serve more connected uses, as in an automobile or kitchen mixer. Some new features are normally invisible and nonaesthetic, such as the down-draft carburetor. On the other hand, the streamlined shape, the colorful upholstery, and the durable paint on the body do function aesthetically. The passenger car for individual or family use receives more critical attention on aesthetic grounds than the truck or tractor, and hence is more carefully developed along that line.

A great and ever-increasing variety of styles in utilitarian art is now offered to the public. Persons with conservative tastes may buy a phonograph or television set in so-called traditional style, which may be an adaptation of Chippendale or French Provincial. The mechanical parts are then usually concealed within a visible shell whose appearance in no way resembles that of the mechanism beneath. Many persons with fairly radical, vanguard taste in some kinds of art tend to favor a traditional style in the living room, dining room, and bedroom, on the ground that it is more comfortable and homelike, while at the same time they are willing to accept a more modern, machine-age type of design in the kitchen and bathroom. There the protective shell itself tends to become smooth, metallic, or enameled, uniform or slightly variegated in color, and geometric in design. In both kitchen and bathroom, this makes for easy cleaning

and durability as well as for a distinctive kind of aesthetic effect, a style now vaguely known as "modern," akin to sculptural Cubism and the painting of Mondrian. It is often praised for "clean, strong, smooth, restful lines and planes," by contrast with the "restless, fussy, dirt-catching forms of Victorian England." In outdoor construction, large areas of fairly bright, varied colors are favored along with white, silvery chrome and luminescent lettering. This new style has spread to several types of utilitarian architecture, such as the gasoline filling station, which were formerly left without much aesthetic development.

The art of interior design has developed along utilitarian as well as decorative lines: the former, through more careful analysis of the aims and functions of a room. The proposed ideal of an efficient "machine for living" aroused objections through suggesting a hard, cold, steely kind of efficiency. This would be inefficient from the humanistic standpoint. The modern home or hotel room demands a softer, more comfortable setting for the kind of life most people desire. But for true efficiency one must distinguish and allow for individual ways of life and for the many different functions which go on in a well-equipped modern home. Most of us no longer need a "drawing room," but many do desire a library, a dining room, a powder room, and a "rumpus room" in which strenuous children and teenagers can play without damage to delicate materials. A "living room" for the family is less specialized. For each of these functions a different set of architectural specifications, fixtures, and movable furniture is needed. The arrangement may be as important as the nature of the individual units. Considerations of health and happiness are influential in thinking out such functional ends and means in a way combining realism with idealism and imagination.

In these new kinds of utilitarian art, the main factors involved have reached a new integration through combining engineering technology with artistic design, under the practical direction of large corporate management. The aesthetic factor tends to express or harmonize with the spirit of the age—to some extent with that of machine industry and scientific technology—even if it does not literally portray or reveal the underlying mechanisms.

Extreme functionalists in modern industrial design call for visible forms, as in a house or chair, which directly reveal or express the main outlines of utilitarian structure. This attitude runs counter to the spirit of Rococo and other traditional styles which delight

in concealing the structure. They often cover it with ornamentation which differs radically from the underlying structure and material, and which takes no special delight in utilitarian efficiency. The curlicues of Rococo furniture and interior design often seem to be as artificial as possible, to develop the aesthetic factor independently, with little regard for the basic framework. Yet they can be psychologically functional as an expression of wealth and status.

It would be easy to expose, perhaps in glass containers, most of the inner mechanisms in the new household apparatus to the view of persons who live, work, and sleep among them. Some men (few women) who like machinery for its aesthetic as well as its practical aspects wish to have these inner workings uncovered and visible, as in home-assembled radio sets, electric lathes, and jigsaws for basement hobbies. Transparent covers or no covers at all can easily be arranged. Glassed-in clocks of this sort, made in France, with gilt mechanisms and musical chimes, were popular early in the present century. But since then the number of mechanized appliances in and around the home, run mostly by gasoline or electric power, has increased enormously. If their operating parts were all visible or audible, going at different speeds in different directions, the total effect might soon be confusing. Continued resistance to very obvious mechanization in the home is to be expected. But an appliance (e.g., a television set) can suggest its functions and its basic inner structure by its outward appearance, yet remain unobtrusive.

8. Geometric and biomorphic functionalism.

The extremely geometrical style in architecture and furniture, which was hailed in the 1920's as expressing the machine age to perfection, is not necessarily functional. If one function of an armchair is to provide comfort, it is not functional to have a vertical board or a sharp edge or point in contact with the body while resting. "Pipe-and-slab" architecture was mistakenly assumed to be functional, partly because it dispensed with some traditional features such as cornices and Grecian columns. But it lacked many utilitarian features necessary for the physical, psychological, and social well-being of the humans who lived in it. For some purposes, the most efficient utilitarian forms can be biomoprhic or otherwise nongeometrical, as in animals, plants, and soft cushions.

A trait or style such as "geometrical," while seeming to be justified and praised on utilitarian, functional grounds, may actually win acceptance rather for aesthetic reasons. Geometrical forms, as we have seen, tend to suggest hard, cold, logical precision, durability, strength, and permanence. Biomorphic forms suggest not only life, change, and softness, but the irregular, flowing shapes of clouds and rivers. Each appeals to certain kinds of taste, the former more to masculine, the latter to feminine, but with many exceptions. Each type dominates in certain styles and periods, when it spreads throughout many kinds of art. But each tends to seem more fitting in certain kinds of product, the geometric in mechanical forms made of steel or other hard materials, where resistance to wear and pressure is desired, the biomorphic where soft, yielding, irregular, pliant forms are preferred, as in women's clothing, bedroom furniture, drapery, flowers, and foliage. An increase of static, hard, geometric forms in the home, as in the outside shell of an electric refrigerator, tends to stimulate a desire for some contrast and relief elsewhere, in the shape of household plants, trees, and shrubbery near the house, and sometimes pet birds, goldfish, or other animals.

Aesthetically, machine forms can have their own direct appeal. Potential themes for design, simple or complex, are often provided unintentionally in the building of machines for purely utilitarian purposes. The outlines of a cogwheel, the cylinders of a piston, electric wires and cables, luminous bulbs and tubes, have all fascinated artists as well as engineers. Color is sometimes used to distinguish them and avoid confusion in handling them. In the nineteen-twenties and thirties, bits of machinery were exhibited in art museums for their aesthetic quality and used as subjects by painters, sculptors, and photographers. Hard industrial landscapes and fantastic figures to express the machine age were in vogue, in ballet and film as well as the static visual arts. The machine as a symbol of modern Western culture was sometimes shown as admirable, powerful, clean, and beneficent, a servant of man; sometimes as enslaving and brutalizing him. The negative associations grew in strength as the blame for war, atomic weapons, and the standardization of life in a dead routine was heaped on the machine and its creator, scientific technology.

Utilitarian buildings and furniture which directly served consumers in the higher income brackets, such as banks and executive offices, tended in mid-century to work out experimental contrasts and compromises between these two extremes. The main, utilitarian outlines remained fairly geometrical or classic, while

contrast was provided by richer textures in curtains, upholstery, grained wood, and mottled stone, with an occasional burst of irregular shape and color in large, abstract paintings. The combination could suggest prudent conservatism along with up-to-date progressiveness and youthful vigor.

When a certain kind of shape and color becomes popular for utilitarian reasons, acquiring thereby certain favorable associations, people tend to use it elsewhere, perhaps in places where it has no utilitarian function. This has been the case with so-called streamlining, whose primary function was to diminish wind or water resistance as in automobiles, airplanes, submarines, torpedoes, rockets, and other missiles. It has real utility there and sometimes even in other objects, such as automatic pencils, where no such resistance is to be encountered. But it has also been followed where such a shape is not especially useful, as in chairs, slowly moving trailer homes, and office buildings in the form of skyscrapers. The modern streamlined product is in the long tradition of prehistoric spears, arrows, and boats, the obelisk, the Siva lingam and other phallic monuments, the cathedral spire, and (still farther back) the forms which nature gave the fish and bird. From all these associations it has come to suggest, abstractly, some kind of onward movement, progression through or into something with maximum efficiency. Such suggestions can operate as parts of the aesthetic factor in the product, whether or not they have any other actual utility there.

9. The planning of cities and larger communities.

Utilitarian visual art rises to its greatest heights of complexity in urbanism, that is, city and community planning. This includes the designing of streets and highways, diversified neighborhoods, and large geographical regions. Here, too, there has been a dislocation between the utilitarian or engineering factor and the aesthetic, artistic one. Enough is left of some ancient and medieval cities to qualify them as works of art, utilitarian frameworks for certain kinds of human living that also appeal to aesthetic vision. They may also appeal to hearing with a multitude of bells. But as cities outgrew their walls and spread out into the countryside, and still more as the automobile called for more and more roads to connect them, the forms of most cities have been increasingly chaotic. Urgently needed utilitarian facilities for traffic, water,

gas, electricity, and the like have taken priority. Their building, maintenance, and constant increases have demolished or defaced the early visage of the city, while attempts to beautify the result have been half-hearted. It has long been realized that planting trees along the roads, prohibiting billboards, and opening up a few vistas will not produce a genuine integration between efficiency and aesthetic appearance. More drastic changes require giving adequate power to public-spirited city planners, and in a democracy this often meets with strong resistance from political and economic groups whose interests are threatened.

A thorough and balanced approach to urban planning calls for scientific and philosphical consideration of the various ends to be sought; the kinds of human life to be fostered in and by the physical setting. This demands the cooperation of different kinds of expert knowledge and ability, not only in traffic regulation, which is often given most consideration, but also in sociology, public health, ethics, education, recreation, and many other fields. A town must, as a rule, be divided into zones for different activities, such as industry, commerce, government, and residence on different socioeconomic levels. Schools, shops, churches, parks, playgrounds, and other facilities must be distributed throughout the community.

It is necessary that such moral and social ends as health, education, and welfare be given priority in modern city planning, but this does not require neglect or merely perfunctory, superficial treatment of aesthetic aspects. It is possible to have the artistic point of view represented in basic planning and large-scale alterations; it is not limited to questions of local detail. Such utilitarian considerations as climate, topography, and industrial needs will usually determine the basic framework of a city, but within this the city can flower as a complex work of utilitarian art. This requires that an aesthetic as well as a practical view be taken of industrial and commercial areas as well as of parks and public buildings, that slums be eliminated and all residential areas persistently raised in quality as conditions permit. Cities such as Paris, Florence, Venice, Madrid, and Kyoto, which are works of utilitarian art as well as places to live and work, have shown that expenditures for beauty can be economically profitable as well as means to better living for both residents and visitors. Even where utilitarian ends must dominate, it is often possible to achieve them along with artistic ones, as integral parts of the same project. There are places in every city, such as memorial statues, buildings, and monuments, where artistic aims can be allowed to take the lead.

10. Commercial and financial devices with developed aesthetic factors.

Of great importance in modern socioeconomic life are the many kinds of printed paper used as media of exchange. Most of them serve as money or the equivalent, such as the paper notes or bills for various amounts, engraved and printed by the national government, or the postage stamps used for mailing letters and packages. These are usually developed as works of graphic art, whereas most coined money consists of small, metal discs with designs and numerals in sculptural relief stamped on both sides. Engraved certificates of ownership of stocks are issued by corporations, and similar certificates for bonds by corporations and government agencies. All are designed by graphic artists.

Their primary functions are utilitarian rather than aesthetic. Even the pictures, ornamental lettering, and other decorative factors usually serve by their complex, fine details to prevent counterfeiting. The nature of the designs on modern coins is somewhat limited by the need to stack the small discs firmly in a small space, and also by the need to mill the edges to prevent clipping and filing.

In addition to these utilitarian functions are some of a more aesthetic, psychological nature. There is a common desire to make such objects seem important and desirable as symbols of a nation or a corporate institution. In the modern world of commerce and finance they are notable as means and symbols of wealth, power, success, and efficiency. They are regarded as things to treasure and keep securely or to exchange for other precious things. As such they are focal points of interest and effort in modern civilization, somewhat analogous to the magic and religious icons used as means of gaining one's desires in previous ages. True, they are seldom examined with care from an aesthetic point of view except by specialists, but even a casual glance at them can give an effect of richness and monumental stability. The idealized representation of national rulers, heroes, shrines, and other symbols, such as Mount Vernon or the Statue of Liberty, may contribute to the total effect of dignified beauty, stability, and reliability, besides helping to distinguish notes of different value. The small space available for postage stamps and coins has posed artistic problems. Details can not be reduced in size beyond certain limits without becom-

ing indistinguishable to ordinary vision. They must remain comparatively simple and bold, and yet postage stamps often represent an extensive scene or complex building in considerable detail.

The lavishing of such care and artistry on bits of paper and metal symbolizes the respect of capitalistic society for money, private property, profits, and income therefrom, and for free enterprise and rapid communication. This is in marked contrast with the medieval attitude, in which both interest ("usury") and profit making ("engrossing") were often regarded as sinful or criminal.

11. Art for persuasion and inducement. Propaganda, advertising, oratory, therapy, and education.

The production of desired attitudes in both gods and humans has been a common function of art throughout its history. To gain one's ends through propitiating the gods is a supernaturalistic technic, but art has also been used to develop a religious attitude among humans. It is supernaturalistic when used to reinforce a plea for divine blessings, but naturalistic as a means for influencing human emotions. From time immemorial, art has been used for missionary purposes, for proselyting and converting people to religious faiths, and for producing attitudes of mystery, devotion, awe, and reverence in the believer during ceremonies. The dim but strangely colorful light of the cathedral, the rituals, hymns, vestments, paintings, and sculpture which surround the worshipper, can all contribute to these attitudes.

The term *propaganda* once referred mainly to the work of religious missions in "propagating the faith." Now it covers any systematic effort to spread ideas or policies, to help or hinder any effort or doctrine, including clandestine hints and rumors. It does not, necessarily, imply that such ideas and methods are good or bad. Both sides use propaganda in wars and elections.

The psychological fact that music and other arts have power to move or quiet the emotions was discussed by Greek philosophers and poets, and has long been used for religious and secular purposes. Band music, flags and banners waving, soldiers marching in uniform and pretty girls in bright-colored dresses applauding, all help to set the tone for political and social speeches in both democratic and dictatorial countries. Such devices tend to create a favorable at-

titude toward whatever is advocated in the speeches, although a stubborn dissenter may feel otherwise. They are used to praise patriotism, loyalty, and obedience to the established order and also movements to abolish or reform it. They are used to spread hatred for one's enemies and to arouse a warlike attitude in soldiers.

In isolation, the artistic means used may not be utilitarian. Music and flags are not necessarily propagandist. They become so when incorporated in a composite form which is used to influence feeling, thought, and action. They can arouse mass emotions of excitement and enthusiasm in general. *Oratory*, an art in itself, directs and focuses the crowd's attitude toward some particular action to be taken. It organizes all the aesthetic stimuli into a cooperative work of utilitarian art. The technology of oratory, especially legal and political, was explained in ancient treatises on rhetoric.

It was mentioned above that *advertising* and *commercial art* are influential in a consumer-directed, competitive society. They help to stimulate the demand for, and the production and sale of, certain types of industrial product and service rather than others. By generous payments to artists in different media, these arts attract persons of cleverness and talent who develop them along both aesthetic and utilitarian lines. The strictly utilitarian factor is the message or sales talk, the appeal or advice to buy or support something. If the message is treated artistically, or accompanied by an aesthetic factor, it becomes utilitarian art.

Let us remember that the aesthetic factor may be composed of artistic forms which in themselves are not utilitarian. They may have no direct, internal reference to the utilitarian aim or message. To subordinate that aim is often considered more effective, especially in dealing with intelligent, sophisticated people, than to harp too much on what one is trying to sell. On radio or television, an entire symphony concert may be played with no mention of the commercial sponsor except for brief announcements at the beginning and end. An advertising poster may be almost wholly nonutilitarian, a purely representational picture such as a landscape which, it is hoped, will attract favorable attention for its own sake. But if the name of a certain brand of product is conspicuously printed somewhere on it, not only these words but the whole poster, as a verbal-pictorial form, becomes utilitarian. Regarding the poster aesthetically, one may wish to ignore or eliminate the words, thus treating it as purely representational. As to the symphony

concert, one may ignore or try to ignore the brief reference to the sponsoring company. The music will probably have no intrinsic relation to the advertising message, but, if we refuse to recognize that symphony and message are being treated as a single utilitarian device for this occasion, we shall be missing an important social phenomenon. It would be easy enough to compose a song or jingle in which both words and music sing the praises of the product advertised. This is commonly done, but often fails to make a favorable impression on the kind of buyer sought. Hence the advertiser may prefer to ride on the coattails of the composer. For the advertiser the essential, connecting link is the favorable association to be formed, perhaps subconsciously, between his product and something which the potential buyer is likely to feel as admirable and desirable.

Whether a loose assemblage of this sort, for commercial purposes, is good or bad art is another question. It is utilitarian art in our present, nonevaluative sense of the term, and it is not fundamentally new. What is relatively new is the adaptation to commercial ends instead of religious or political ones. The basic type of form, in which something advocated is closely juxtaposed with something already pleasant to contemplate, is ancient and psychologically similar whether the thing advocated is good or bad, noble or trivial. Religious propaganda combines ideal pictures of gods, angels, and happy souls in heaven with sermons urging faith and obedience. Political propaganda is factional and partisan. The speaker associates his own candidates and policies with images of happiness, peace, and prosperity, those of the opposition with images of misery, trouble, proverty, and corruption. To form a pleasant association with a certain belief or attitude may be equivalent to forming an unpleasant one with its opposite. In medieval painting, sin is associated with devils and hellfire, while in modern advertising the failure to use a certain cosmetic is associated with images of unpopularity and social ostracism.

One distinctive feature of modern advertising and other commercial art is the amount of scientific research and experimentation employed to make it efficient. Large sums of money are spent by commercial groups and advertising agencies to secure the aid of psychologists and other experts in discovering the effects of certain kinds of art and other sensory stimulation on certain kinds of observer. The main purpose, of course, is to discover and predict what kinds of stimulus will tend to produce the desired attitude in the kind of person one wants to influence. Such

researches are not limited to works of art, but many of the advertising devices used have traits in common with art, such as the presentation of thinly disguised erotic and other emotive symbols. Filmed images too brief to be consciously perceived are sometimes presented to the eyes or ears to see if they have made any effect.

Another kind of study, related to the psychology of art, is the classification of potential buyers of a certain product, such as *greeting cards,* into types. The choice of a certain kind of greeting card to send one's friends and relatives is said to be a means, not only of expressing one's own self-image, but of impressing the recipient in a certain way. Some people like to show themselves as severely restrained and formal, some as loving and sentimental, some as witty and sophisticated, and so on. Concealed erotic symbols also affect their choices.

Advertising and other commercial arts use a great variety of forms and media, both outdoors and indoors. Those outdoors include *billboards* and *posters.* The former, usually large and conspicuous, are prohibited in many localities as disfiguring the countryside, especially along major highways. Moving, mechanical figures attract attention. At night, electric signs made of tubes filled with neon and other gases outline words and pictures with glaring luminescence. Their task is to attract and hold the attention of hurried travelers long enough to convey their message, willy-nilly. When the billboard is near a high-speed automobile highway, this must be done very quickly by a bold, simple form. Advertising messages have been written in the sky by airplanes with smoke or vapor, and suspended on giant signs from balloons. They have been blared from loudspeakers by moving cars and planes. Certainly, there is little attempt at art in many of these forms.

Among the commonest types of indoor commercial art are *magazine and newspaper layouts* with pictures (drawn or photographed) and text. Here the advertiser may count on somewhat more leisurely inspection, and therefore risk a longer, more complex form. Such advertising is carefully adapted to a certain type of reader as to age, sex, education, and socioeconomic status. Some, in the luxury magazines, is frankly addressed to motives of status seeking, snob appeal, and sex appeal, as in hinting that all persons of the upper class or smart society folk use a certain product. Radio, television, and motion picture film advertising may be long or short, but it runs the risk of losing its audience if too long. It is often in the form of a very short dramatic skit or a snatch of simple melody with words in praise of the product advertised.

The preparation of shop window and interior store *displays* of goods for sale, sometimes with clothed lay figures, is another highly developed commercial art. One of the most popular and profitable commerical arts in recent years is that of *packaging.* The covers, boxes, and bottles of almost every product sold directly to consumers have been redesigned in recent years, to make them more attractive and tempting, sometimes to make the amount contained seem larger than it is. Plastics have been extensively used. New names suggest that the product is improved. In a few cases, the public has shown a stubborn preference for the antiquated cover to which it has become accustomed.

Persuasion or inducement can be attempted by pictorial means, as in juxtaposing two pictures, one of which shows a person before taking a certain medicine, the other afterward; one gaunt, pale, and sad, the other hale and hearty. Words may or may not be used to reinforce the message. The implication is that certain steps produce, or would have produced, desirable results; hence the picture functions as an attempt to influence and guide conduct. One picture alone may suffice, as in most caricatures. To portray a certain person, e.g., a politician or enemy leader, in easily recognizable form, yet as ugly and detestable, can be a symbolic denunciation of his policies and a call for their rejection.

The same advice can be given in purely verbal terms. Those responsible for it may resort to logical argument, supported by expository development, as in explaining just why a certain policy is harmful or a certain product superior. Here the aesthetic factor will consist of literary developments such as imagery, metaphors, and thematic arrangement of word-sounds. Mention has been made of Izaak Walton's *Compleat Angler* as an example. Though utilitarian in title and basic framework, it achieves artistic development also, not only in the way the practical instructions in fishing are themselves expressed, but in supplementary stories, dialogues, poems, and historical references interspersed in the text. Being of considerable length and systematic organization, the *Angler* can be classed as a utilitarian treatise, even though its author seems at times more interested in gossip and literary bypaths than in his main subject. A short verbal guide to some kind of action would usually be called an essay. Most essays are mainly expository, but some consist of directions or advice on where to go, what to do, and how to do it.

Several other persistent literary types are frequently utilitarian. The *letter* is extremely variable in form and content. It is a common medium of communication between individuals or groups, usually with no claim to artistry. Extemporaneous letters between individuals, like ordinary conversation, are often representational in recounting events and describing persons and places. Between scientists in the seventeenth century, when other means of international communication were few, they were sometimes highly technical along expository lines. Commercial and industrial institutions, politicians and administrators of all sorts often send out letters giving orders and instructions which may be classed as utilitarian, e.g., in ordering goods from a wholesale merchant or in urging their constituents to vote in certain ways. Some are from one individual to another, some are impersonal and circular in form, as in a letter "to whom it may concern." Of all these, few make any claim to artistic quality. On the other hand, letters from noted literary artists, even the most informal and spontaneous, are often classed as literary art when collected in book form after their deaths. According to the author's personality and favorite subjects of discourse, they may hold to one mode of composition or skip at will from one to another. Here, again, we may class as utilitarian art those which contain some aesthetic appeal along with an effort to persuade or induce, to influence or guide someone toward a certain course of action.

A familiar variety is the *love letter,* which normally contains an attempt to win or strengthen someone's love for the sender, to persuade him or her to act in a certain way. This may be reinforced by stories or lyrical passages of any sort, ad lib. Some letters are in verse, with the added appeal of verbal design. An opposite type of letter which fulfills the requirements of utilitarian form is that of Joan of Arc to the Duke of Bedford, commanding him to leave France with his army and threatening him if he does not.

Sermons are usually on religious or moral themes, and exhort a congregation to greater faith, obedience, and virtue. The preacher may denounce the congregation for its sins and confess his own shortcomings. In either way, a sermon can become highly emotional, rhetorical, and powerful as literary art, as in those of John Donne. Being a lyrical poet, Donne spoke in rhythmic cadences and striking images in sermons as well. Some of his poems are sermons in verse, and he alternated easily between verse and prose.

Broadly speaking, a sermon is a kind of *speech* if orally delivered, and the composition and delivery of sermons has been treated as an art. Being usually religious in its aims and assumptions, it is commonly supernaturalistic in tone. Speeches on other subjects are usually called by other names, such as orations or addresses.

The high development of *oratory* as an art in ancient times was partly due to the inability of most people to read, partly to the lack of professional lawyers and the need of citizens to plead their own cases before a public audience. Oratory was one of the few arts considered worthy of the highest nobility. It was practiced by kings and generals as well as actors and scholars. Radio and television have brought it again into prominence. Ancient treatises upon this art emphasized the logical and eristic requirements as well as the literary, especially regarding the sequence of steps in a convincing argument. Like the letter, a speech can be on any subject, with or without pretensions to literary art. It is often devoted to political issues, and is utilitarian in urging a course of action. Other speeches are commemorative or elegiac, as in a funeral oration, but even so they often end with a call for those living to remember and emulate the virtues of the deceased.

Music is much used today as a *therapeutic* device for treating mentally disturbed patients. Calm, quiet, gentle music is used to produce a tranquil mood, and joyous music to lift them from depression to happiness. Those who can learn to sing together may find it easier to cooperate on other lines. But for all these activities a choice is usually made from pieces of music already composed for other purposes, perhaps for purely aesthetic ends. When music is expressly adapted for therapeutic ends, when it is somehow rearranged, transposed, or developed as an aid in treating certain mental symptoms, we can feel more confident in classing it as utilitarian music.

That classification is obviously justifiable in the case of *work songs,* such as sailors' chanteys. Many of these have apparently grown out of the work itself, where they perform a function in helping to coordinate movements, as when several men pull on a line. Others have arisen out of corn husking, cotton picking, and similar agricultural activities. They may aid morale through giving a sense of group solidarity and harmony. The words may or may not refer to the activity.

Special types of music for use (in German, *Gebrauchsmusik*) have evolved in many other social activities, notably military march music, ballroom dance music, cradle songs, wedding and funeral marches, and incidental music for various kinds of

ceremony. These are all more or less naturalistic, and as such different from the music used for magical spells or divine hymns. All these types may, at times, be contemplated aesthetically without further use, but they are utilitarian in having also a socially recognized nonaesthetic function, that of influencing action in some way.

A clearly utilitarian type of music is the *bugle call,* formerly used for giving orders to troops beyond the sound of one's voice. In military action, bugle calls are now largely replaced by other means of communication, but they are still used in ceremonies and in the peaceful routine of army camps. A bugle call is a short, distinctive bit of melody, sounded on an instrument with high, clear, piercing tone, and understood as meaning a certain command. One, much used in the age of cavalry, is "Boots and Saddles." "Reveille" is sounded in the early morning, and "Taps" means "go to bed" for those not on duty. It is also sounded in final tribute to the dead at military funerals. Calls to fast action are sometimes characterized by fast tempo and rising pitch; those for stopping, by slower, falling notes.

Not only bugle calls, but drum taps, bagpipe music, and many other military types are mainly utilitarian, or were so in their original usage. Their function was to stimulate the desired emotional attitude in soldiers at a certain time, as well as to communicate an order. In the former respect, they are not yet fully replaced by modern fast communication.

Educational art is highly diversified. To some extent it overlaps commercial art, in that both attempt to stimulate interest and liking toward certain kinds of object. Schooling today relies more on inducement and effective presentation to arouse interest and effort than it did a century ago, when the fear of corporal punishment was a common incentive. As in advertising, pictures and diagrams are combined in textbooks to convey information clearly and simply for the age and educational level of the students, and to arouse a desire to learn more and use one's information actively. Encyclopedias for youth contain a great variety of scientific illustration in addition to maps and reproductions of fine art. Medical and anatomical illustrations are sometimes made in semitransparent layers to show the parts of the body at different relative depths. Motion picture films and film strips in color, with or without synchronized commentary and music, as well as specially prepared radio and television programs, develop the audiovisual side of educational practice.

In many of these devices, the boundary between art and non-art, or between art, science, and other

subjects, is hard to draw. Even in explaining to children an abstruse scientific subject such as rockets and space travel, some artistic development is found useful, as in combining colored pictures (painted or photographed) with diagrams and typographical headings which are easy to read and understand.

12. Mock-utilitarian types. Partial imitations of utilitarian types for aesthetic functions.

Not all music with a name implying a utilitarian function is really utilitarian in form or intended for such use. Many so-called cradle songs are not intended or adapted to put a baby to sleep; many waltzes are too fast or rhythmically irregular to guide a ballroom dancer. To call them by utilitarian names may, however, serve an aesthetic end by suggesting images of a certain sort and putting the listener in an appropriate mood.

To call these "mock-utilitarian types" is not derogatory. The artist's right to assume a temporary role in his work is not in question, or the propriety of imitating one mode of composition in another. Resemblances to a utilitarian type may be justified on aesthetic or other grounds.

Such partial imitations are common in literature and visual representation. When the poet writes, "Gather ye rosebuds while ye may," or "No, no, go not to Lethe," he is literally making a command and trying to influence and guide someone's action. But anyone familiar with the customs and conventions of poetry understands that he is speaking in a figurative sense. His command is rhetorical and lyrical, issued mainly or wholly for aesthetic apperception and not as a command or guide in action. Such ostensible commands are given, sometimes at some length and in complex form, where there is no intention to exert an influence—e.g., in "Break, break, break/ On thy cold grey stones, O Sea."

A man may have on his desk or shelf, as an ornament or paperweight, a small model of a spinning wheel, a ship, an airplane, or some other utilitarian device. In analyzing it from the standpoint of morphology, one may wish to note the forms and interrelations of its parts in utilitarian terms, and also, perhaps, in terms of representation and design. It may be that wheels which turn in the full-sized product, as in an automobile, are immovable here as parts of one solid piece of metal. The function of the model may be mainly aesthetic. If it also acts as a paperweight, this function is very different from that of the full-

sized product, and does not require the same internal construction.

13. The utilitarian schema.

Note how the form observably reveals or is adapted to the following. Also the extent to which supplementary information is required for an answer to these questions.

A. *Functions:* For what aims or uses in the realm of action is this work of art employed or intended? Is there a complex program involving many specific ends or functions? How are aesthetic functions related to utilitarian ones?

B. *Mode of operation*: In general, how does it work, or how is it presumably intended to work, as a means to these functions? What is the role of each main part or trait therein? How are they expected to cooperate?

C. *Conditions of operation* (actual or imaginary) under which it is supposed to work. Other agencies which it is supposed to use or work with. Principles of causation assumed. Expected sources of power. Factors it is supposed to influence or control, as means to ends, and how this is to be done. Intermediate steps expected.

1. *Conceptions of reality* assumed: supernatural or natural. Types of thinking involved: e.g., magic, religious (polytheistic or monotheistic). Prescientific or scientific conceptions of nature and natural laws. Naïve (juvenile or primitive) or sophisticated (adult, civilized, prescientific, scientific, etc.) as to conception of causal factors involved. (E.g., adult, urban, monotheistic religion, relying on miracles but not magic.)

2. *Type of natural force and law* relied upon: physical, mechanical, chemical, biological, sociological, psychological.

3. *Socioeconomic* setting of manufacture and of intended use. (These may differ). Primitive hunting tribe; urban industrial, etc.

D. Utilitarian *framework* and relation of parts thereto:

1. Is the utilitarian schema developed into a definite framework of its own (as in a sword), or is it fitted into a framework provided by some other mode of composition (as in a representational picture adapted for advertising purposes)?

2. In either case, what are the main parts of this framework? The main subdivisions in each of these?

3. How do they cooperate or fail to cooperate, as means to the effective functioning of the whole? How would they cooperate under the conditions assumed?

E. *Effectiveness.* Probable effectiveness of the work of art for the ends directly sought. Probable incidental effects sought or unsought, with which its use would be attended (especially psychosocial).

F. *General type and degree of development,* as to

1. Definiteness; differentiation of the whole from other forms; adaptation of means to functions.

2. Complexity; differentiation and integration of parts. Parts clearly articulated, interlocking, cooperating, or vaguely assembled.

Note: The following illustrations are particularly relevant to this chapter: Figures 2, 8, 9, 10, 11, 12, 13, 14, 15, 16, 17, 18, 19, 20, 21, 22, 23, 24, 39, 49, 59, 62, 72, 77, 90.

CHAPTER XIII

Representational Development

1. Motives and subjects for representation in various arts.

Why do people represent things in the arts? For many different reasons, of course. Only a few can be briefly mentioned here. The motives which impel representation do not necessarily appear in the products or warrant consideration in morphology. But indirectly they may do so. The original functions which a work of art is called on to perform contribute meanings to it, and these are apperceived as suggested factors in the total aesthetic form. This is true even when those functions have ceased to operate, as in the case of ancient religious art. Conscious desires tend to motivate the invention of artistic and other functional devices in modern civilization. By now, technology has become systematic and farseeing. In primitive cultures, however, as in organic evolution, the form and function often come first, the conscious wish for them later.

Various motives predominate in different periods and cultures. The desire to represent a certain subject in a certain way arises from the social and cultural conditions of the time, interacting with the personalities of individual artists, rulers, and patrons. In a comparatively free, civilized, democratic society, the tastes and interests of individual artists have much weight. But even there, the representational artist is usually under some pressure to choose subjects and styles which will satisfy influential critics and patrons. The group which influences him the most may be one of dominant power and wealth in the social order; it may be drawn from revolutionary circles hostile to that order or seeking to overthrow it; it may be an aesthetic vanguard, more or less indifferent to social issues. Lower classes and ethnic minorities, different age and sex groups including adolescents and children, are now more able to express themselves in art, and to help support art which satisfies them, than were analogous groups in earlier periods.

We noted in a previous chapter that primitive magic was sometimes favorable to representational art, sometimes not. It often used nonrepresentational objects thought to possess *mana*. Imitative magic in a prehistoric, hunting tribe often involved pictorial and sculptural representation of the kinds of animal hunted, as in the paleolithic caves of France and Spain. Humans engaged in hunting or in ritual dances connected with the hunt were sometimes portrayed. The dances themselves were largely mimetic. From the same era come nude female figures, some pregnant, which were doubtless intended to increase fertility. People represented something in order to gain power over it, to obtain and use it or destroy it in accord with their desires.

The production of an image representing some living being, even though highly stylized, can give the illusion of actually creating life. Hence the fears and taboos which have surrounded the practice of representational art in some primitive cultures, especially by women, since women seem by nature able to create living humans. The beings thus created, it is feared, may be hostile ones. Souls of the dead were also feared and precautions were observed in representing them. Highly civilized forms of supernaturalistic philosophy have perpetuated the belief that artists can indeed, with divine aid, create forms able to mediate between the worlds of matter and spirit.

Religion, as we have seen, was on the whole more favorable than primitive magic to the imaginative portrayal of gods and minor spirits, so as to propitiate the benign and ward off the malevolent ones. Human ancestors were represented, in sculpture and in decorative skulls and masks, to be likewise honored and placated. Major works of art in the early empires tended to support the status quo through idealized representations of rulers and high officials, who were often shown as patronized by deities. In these kinds of representational art a utilitarian motive was prominent: that of securing divine favor and the satisfaction of desires in this life and the next. They brought in this life, if not the satisfactions asked for, at least

those of wish-fulfilling dreams and reassurance. They also brought a satisfying sense of sympathy and solidarity with other members of one's social group, through common objects of worship and hope.

Art in all these forms was not practiced only for ulterior ends. One may also assume an innate tendency in the human species to enjoy exercising its powers of sense perception and to seek or make satisfying objects for the senses to focus on. It is not unreasonable to suppose that representation in art springs in part from some innate predisposition to imitate phenomena which interest one. Many lower animals show this tendency. Making mudpies and scratching pictures on the sand are almost universal as types of children's play. Young children will imitate the barking of dogs and flap their arms as a bird flaps its wings. They pretend that they are adults and imitate their elders' activities at home, at war, and in the hunt. The doll and the wooden sword are perennial aids to active, imitative play.

For a child, making pictures can be a means to normal growth of personality, a means of thinking out clearly the nature of things in his widening range of experience and of making his reactions to them conscious and rational. Some persons like to contemplate familiar subjects and familiar ways of representing them, while others like unfamiliar ones which make apperception difficult and challenging. Representations of the persons, animals, houses, tools and weapons, vehicles and other objects around one are usually enjoyed by children, both in making them and in playing with those made by others.

For adults, the making and contemplation of nude figures seems a natural and easy extension of the sexual instinct. It can be merely a fantasy substitute for frustrated physical desires, or an artistic supplement to their satisfaction. The essential difference between a soldier's "pin-up" photograph and Goya's *Maja Desnuda* is not necessarily that one is more erotic than the other. The Goya is the joint product of a certain woman's beauty, an artist's genius, and many centuries of artistic evolution from which the artist learned how to treat a common subject with uncommon style and nuances. The ascetic tradition insists that genuinely aesthetic experience is disinterested, free from desires, but that is debatable. Both the photograph and the painting can be works of representational art, and both can be, to some extent, sexually motivated. Each can be motivated by the artist's desire to treat his subject in the best possible way as judged by his own standards of value.

To some extent, all the motives just mentioned

have survived into modern times. Magical, religious, and propagandist types of art still survive. But more secular, hedonistic motives, always present in some degree, have come to the fore in modern centuries. In Hellenistic Greece and imperial Rome, there was a growing tendency to desire and cultivate art for the Epicurean ends defined by Horace: that is, for the earthly pleasures and benefits to be received directly from it. From the Renaissance until recent years, this motive has led to idealized representations of youth, beauty, health, happiness, games and sports, heroic adventures, and the joyous occasions of love, marriage, and convivial friendship. Even battles were commonly shown as glorious. The personages involved might be gods or humans; the styles might be neoclassic, romantic, or naturalistic, but in any case the prevailing moods and the conceptions of life implied were on the whole positive. Representations of this sort, like religious dreams of heavenly bliss, all involve imaginary wish-fulfillment, especially when actual achievement is impossible. Fantasies of unfulfilled desires and ideals can also motivate practical efforts to conceive them clearly and to achieve them. Since most imaginations are weak and poorly equipped, those of artists are in demand as guides and leaders. They make it easy for the rest of us to identify ourselves in fantasy with imaginary characters of all sorts, including some in whose bodies, racked with pain and fear, we would not willingly stay forever. By empathy we project ourselves into imaginary situations and live through stories more blissful or exciting than our own. The public demand for such representations helps to motivate their production by artists.

The desire to preserve tokens and reminders of cherished but evanescent phenomena such as infancy and childhood, holidays and weddings, happy family gatherings with several generations present, has far exceeded the number of artist-painters available and has aided in the great development of cameras, motion pictures, and mechanical devices for color printing. The contemplation of images with pleasant associations from the past can be a revival and reliving of partly lost experiences, a recapture of their meaning and flavor. Art can develop them along certain lines, but does not necessarily increase their value, which may be mainly that of subject matter.

In more obscure and complex ways, the opposite kind of art is also wish-fulfilling: that representing examples of hellish torment, earthly misery, pain, and evil. It has been used to teach a moral lesson of what to avoid, as in pictures of the Last Judgment. But it

can also be exciting for its own sake, especially as involving dramatic conflict.

In all types of culture, stories are told to the young as devices for moral and practical education in the folkways and history of the group, and hence as guides to success in life by current standards. Art depicting failure and frustration has been increasingly favored in the twentieth century. Its nature and motives differ from those of ancient tragedy, which stressed nobility of character and moral problems in the relation between men and gods. Many different motives impel modern realistic, tragic, and pathetic art, among them a desire for deep understanding and true, frank portrayal of life as it is, not as idealized by either classic or romantic art. Another is the desire, often unconscious or unadmitted, to live dangerously in fantasy, violating both moral and prudent inhibitions. Thus, some persons enjoy acting out in fantasy their unsatisfied desires for rebellion and destruction.

On the whole, the basic subjects of artistic representation have changed comparatively little in the past thirty thousand years, but the styles and means of representing them, the aspects emphasized and the ways of developing them into complex forms, have changed tremendously. Man still enjoys representing himself in all his great and increasing variety, as he is, was, and may be in the future. Next to portraying himself, man likes to portray his natural surroundings and the artificial ones which he has made himself. He was slow in coming to look admiringly at nature for its own sake, but gradually came to depict with growing accuracy his earthly environment, animal, vegetable, and mineral, the physical world of land, sky, and water, of towering trees, of plants beneath his feet. At first, he did so only as a background for human protagonists: then with growing interest in nature itself. From tame, parklike nature he went to wilder nature, with courage increasing as he purged it of dangerous animals and spirits. From palatial architecture as a background he went to humbler cottages and tavern rooms, then to the poorer city streets which have almost supplanted nature with their grim tenements, asphalt jungles, and glaring electric signs.

During the nineteenth and twentieth centuries, there arose in Western painting and sculpture a revolt against all representation. It appeared first as a tendency to choose uninteresting, common, or trivial subjects and to lavish all one's care on the style, form, or manner of treatment. Sometimes it appeared as a tendency to specialize on some one aspect of nature, such as colored light reflections, ignoring all the rest. Just before the First World War, style leaders in painting were making "abstractions," first with little repre-

sentation, then with none at all. Attempts were made to transfer this style to other arts, but with varying success. Literature and theater arts have remained stubbornly representational, though often unrealistic. Architecture had always been largely nonrepresentational except for the statues and pictures attached to it, although the architectural style of a building may imitate that of another building or architectural period. Representational ornament gradually disappeared from the exteriors of architecture and furniture. Literature found it hard to hold attention without some representation, but this was often subordinated to word-sounds and formal patterns. Walter Pater had predicted the trend away from representation in saying that all art aspires toward the condition of music (music had long been mainly nonrepresentational).

The romantic tradition, as expressed in the slogan of "art for art's sake," demanded and achieved (in principle) unlimited freedom for the Western artist in a democratic society to experiment as he pleased with form, content, social protest, erotic stimulation, or anything else which interested him. The lines of experimentation and of personal expression in painting and sculpture spread out widely. Some artists chose a certain type of stylized representation, some pure abstraction. On the whole, when representation persisted in these arts, it remained simpler than in the Renaissance and Baroque. Distinctive effects were sought through rigorous selection, avoiding many previous lines of development. A growing public came to like some kinds of nonrepresentational form in visual art.

Unconventional movements in the visual arts arose in rapid succession, some realistic, some abstract, and some devoted to whimsical, absurd, or startling representations. In many cases, the dominant motive seemed to be negative: an aversion from all past styles of art, even the primitive ones which had satisfied many a short while ago; a desire to flout and caricature all art, producing what some described as "non-art." But this was hard to do, since clever "non-art" was quickly accepted in the fold of recognized, respectable art.

2. Hidden factors in representation. Symbolism and allegory in this mode of composition.

In the chapter on Modes of Transmission, we noticed how images in nature and in art take on symbolic meanings in addition to their obvious, literal ones.

These are determined partly by the hereditary structure of the human organism and partly by association in experience. The meanings attached to a particular image by different individuals vary considerably, but certain kinds of image-meaning complexes, called archetypes, recur widely in the dream life and behavior patterns of individuals in remote parts of the world, as in folklore and civilized art. Some of these symbols stand for unconsciously conflicting impulses and attitudes of desire and aversion, love and hate. Directed in infancy toward parents and others in the family circle, these feelings may later be transferred to different objects and persons.

An emotional attitude toward a certain symbol may express a complex motivation which the individual concerned does not fully understand. The attitudes involved are shown in tendencies to enjoy and repeat the contemplation of a certain symbolic form, to dislike and avoid it, or to feel ambivalently toward it. Insofar as the artist and his audience have similar attitudes toward a given set of images, whether consciously or not, his work tends to arouse a sympathetic response in them. As Freud remarked, the unconscious of the artist can speak to that of his public.

Man's basic physiological and conative inheritance, reinforced by primitive elements in his cultural inheritance, impels him to feel a strongly emotional interest in certain types of image, especially those involved in physical sex, violence, and destruction. This gradually spreads to related types of interpersonal attitude and action, as in the Oedipus conflict and other situations involving a mixture of erotic desire with hate and violence. It gives to images of lust and cruelty, sadism and masochism, a power to fascinate and inspire libidinous contemplation in art. Insofar as the cultural milieu of artist and public disapproves and condemns the display of such images in art or everyday life, the artist is under pressure to inhibit and disguise it. Various cultures and periods differ greatly in the nature and severity of such restrictions. In some circles practically none remain. The conception of obscenity, and the taboos against supposed examples of it, have been much relaxed in recent years, but they still retain a considerable emotive power, even for persons who consciously flout them. They often operate in art through the conscious or unconscious acquiescence of the artist, who accepts and introjects them along with other factors in his cultural heritage. Even against his will, he usually finds it wise to conform or compromise with social convention in some degree. Society usually permits at least a veiled, symbolic allusion in art to forbidden images and attitudes, and even puritanical observers may feel an ambivalent pleasure in contemplating them, in spite of their conscious disapproval.

In accord with prevailing cultural and moral attitudes, art tends to develop more or less disguised representations of the forbidden subject matter, as between the extreme of libidinous realism found in pornography and the suggestive asterisks of a Victorian novel. The motives and processes of artistic creation are, as Freud showed, in some ways analogous to those of dreamwork during sleep. In both, there is a tendency to wishful fantasy, to partial repression and dislocation of elements in the fantasy and to elaboration of the disguise. If the artist is inspired by a dream to write a poem or paint a picture, he will perform a secondary process of selection, elimination, and reorganization, adapted to his conscious aims and current social standards. The representational form which is finally presented to public view may show clear evidence of the partly repressed fantasy which inspired it. However, the conscious imagination of a gifted artist often clothes his fantasy with so heavy and complex a disguise that its original nature is almost undiscernible in the finished work.

From the standpoint of morphology, the main fact to be noticed here is the way in which a disguised, partly censored and reorganized fantasy can operate as part of the total, present meaning of the work of art. That meaning changes from age to age. The meaning of a long-lived work of art is not purely intrinsic and objective; it consists to a large extent in the changing ways in which people interpret and regard it.

Since the interpretations by Freud and Ernest Jones, Hamlet's mother fixation has been recognized more widely by scholars in the field as an influential motivation in the play, partly responsible for his hesitation to act and for his emotional outburst against his mother. It was basically present in the play when Shakespeare wrote it, but is now more socially accepted as an objective factor in it. There are two manifest stories in *Hamlet,* a play within a play. The former consists of the short enactment of the crime which Hamlet presents before the King and Queen. It is a distinct unit within the comprehensive framework provided by the manifest plot, and helps us to understand that plot by reviewing the events which led up to the start of the play. Hinted obscurely at first, then more and more clearly, is a third sequence of events consisting of Hamlet's emotional relations with his mother and father before and during the action of the play. Psychoanalysts and biographers of Shakespeare speculate upon still another relevant sequence: that of his own changing inner life and relations with

other persons. This last sequence, one may conjecture, must have helped to determine the nature of the play, but it is not an integral part of the play as an objective form.

One should not assume that either artist or public would, if freed from all inner and outer restraints, prefer to represent the tabooed imagery in all its naked, brutal realism. Many different motives can incline the artist to prefer a disguised, refined, and somewhat censored version. As Romanticism demonstrated, there is an aesthetic power in mystery, obscurity, concealment, forbidden fruit, and hints of secret guilt and shame. That power tends to vanish in the cold light of day. It fades in the dry light of a scientific report, as in a psychiatrist's case history of the same types of fantasy. Artistic elaboration, through the techniques of representation and design, can add immeasurably to the aesthetic appeal of the basic fantasy. That appeal can last for centuries while the appeal of crude pornography and physical violence diminishes through repetition of the same simple, elementary materials.

Whether or not the subject is tabooed, many observers will prefer a work of art which is not entirely obvious at first sight, one which does not merely call each spade a spade, but offers something in the nature of a problem or puzzle to be unraveled. Most detective stories are of this sort. They involve at least two sequences of events: one, the events leading up to the crime; the other, those leading to its solution. The latter is usually presented first.

For various reasons, then, artistic representation often involves two or more different stories, one within the other or both along parallel lines. Both stories may be explicitly told, or one may be explicit while the other is concealed. One story may be manifest, as in the conscious aspects of a dream, the other latent, as in the dream's unconscious meanings.

The rudiments of plural representation can be found in countless pictures, short stories, plays, and poems involving a *double entendre,* especially of a risqué, erotic nature. These are often but not always intended as witty or humorous. They may arouse laughter by suddenly touching upon the disapproved subjects and thus releasing a usually inhibited response. Irony, satire, and serious lyrics also make frequent use of double meanings. The erotic or other hidden meaning is usually conveyed through a symbol or metaphor involving mimesis or some other kind of analogy. This can be verbal, as in Gustav Falke's "Strand-thistle." It can be visual, as in Kandinsky's painting, *In Gray.*

3. Subjects and objects.
Frameworks and modes of development.

It was explained in Chapter VII that representation often occurs together with one or more other compositional factors, that it sometimes constitutes the basic framework of the whole and is at other times an accessory factor. The present chapter will emphasize its use as a basic framework.

Representation can be developed in various ways. In terms of the number and interrelation of objects, the following types or stages can be distinguished: (a) representation of a single, isolated object;[1] (b) representation of two or more objects interrelated as a scene or situation; (c) an incident involving a change or new event, thus comprising more than one situation; or (d) a story, comprising more than one incident.

Representing a dynamic situation tends to suggest an incident or story of which it is a part. The represented scene or situation can provide the main framework of the whole. Instead of developing it internally, one can add other details to complicate the scene in space, or one can add them temporally to make an incident or story. An incident involves a temporal sequence of at least two scenes or situations, one before the main event, and one during or after the event: e.g., a man is walking along a path, and he is hit by an arrow, and lies wounded. Through combining incidents in temporal and causal order, we produce a story. This can become the main framework. More and more stories can then be combined to produce any degree of complexity desired.

The artistic means most commonly used for representation are as follows: presentation through painting, sculpture, dance, pantomime, film, television, musical mimesis, verbal presentation, tactile presentation as in Braille type and some sculpture; suggestion by any of these means. Architecture, furniture, jewelry, and other arts occasionally represent other objects, thus emulating sculpture. Literature has usually gone farthest in representing traits of thought, feeling, and personality. In representing a single individual, it often begins by describing his appearance, voice, movements, etc., then goes on to his traits of mind, attitude, and character.

[1] The word "object" here includes persons, animals, deities, and other natural or supernatural beings.

Since representation is a worldwide, perennial type of art and factor in art, it is practiced in countless ways according to the prevailing style and technique, and according to the interests and attitudes of the artist. As usual, any particular type can be described in terms of its components and component traits, elementary and developed, its way of organizing them in terms of space, time, and causality, and its relation to other compositional factors. Line, shape, and color are the most common visual components.

That which is represented in art is called, rather confusingly, either a "subject" or an "object." We shall understand "general subject," in this connection, to mean the realm of existence, thought, or action treated. The general subject of *Macbeth* is the effect of unrestrained ambition in a context of Scottish history and legend. The term "subject matter" is used rather loosely as equivalent to "content" or "materials" and contrasted with "form." It includes the ideas discussed in an expository essay. In representation, it covers not only what is explicitly shown or described, but also the literary and historical associations of that material, all as distinguished from "form."

By "object" of representation, we shall understand any particular thing, person, event, process, or combination of them which the work of art tends to suggest to a beholder's mind. Thus Macbeth as a person is one of the objects represented in the play. Other objects of representation in various arts are: a star, a mountain, a bird, a tree, a cooling breeze, a bell tone, a flash of lightning, a person or character. A particular thought or percept as a mental act or process can be represented through narration or description. The object can be a concrete example of a type, and as such can call to mind the concept of the type itself. A primitive drawing may represent a man: no particular man or kind of man, but a visual conception of man or men in general. A portrait of George Washington as he looked at a certain time is more specific, concrete, and individual. Both are objects of representation. To call a picture of a man or animal a "figure" suggests that it is being regarded as a visual object rather than for any possible traits of mind or character.

Many simple, pictorial representations (such as portraits) consist of a figure and ground. The latter may be left blank and indeterminate as to distance and ingredients, or developed in its own right into a complex object or scene. Both are developed in the *Mona Lisa.*

The representation of any isolated object can be developed internally, by division. Its outlines then become the main framework of the whole composition. Thus, an early Flemish portrait of a single face can be made complex without introducing any outside object, by painting eyelash hairs, tiny wrinkles, highlights on forehead and jewels, and slight differences in skin color in various parts of the face. The contour of the face is the basic framework of the whole, unless the background too is developed in some way. Likewise a scene or situation, such as a moment in the Crucifixion, can be painted or verbally described in any amount of detail without introducing any great changes or long temporal sequences.

Development of the ground is optional. In a picture it may be left blank, in white, gold, or a color. When a single object is represented, the framework can be provided by the supposed shape and appearance of the object or by its sound or other sense qualities. These can be presented or suggested. The representation of two or more objects close together (as on the same page of a book) may fall short of depicting a scene unless some spatial relation between the objects is indicated.

A freestanding statue, large or small, usually shows the figure in isolation, sometimes with a slight suggestion of scene, such as a rock, tree stump, or broken column. The actual physical setting is usually indeterminate. Even if the statue is intended for a certain place, it can be moved to a different one. Some statues are definitely adapted for a certain niche or other permanent setting, thus being parts of a larger framework.

To represent a single object, or even to imagine it clearly, one must detach it to some extent from its previous surroundings in nature and experience. One tends to relegate its context to the margin of perception and thought, perhaps as a vague, inconspicuous background. This tends to give the object a more distinct identity and to facilitate the focusing of attention on it without distraction. However, it is impossible to represent an object (human or otherwise) very thoroughly in complete isolation. Its nature is manifested largely in its relation to other things or persons, in the ways in which it affects them and is affected by them. Having detached the object from its ordinary context in nature and experience, one may then wish to show it in a more significant, artificial, selective context. This may or may not be a single situation. It may consist of references to many situations and events, all of which reveal something important about the thing represented. Thus a man may be characterized by his attitudes toward many different women at different times. Opinions change

as to what relations with other things are most important. Ancient art often indicated the superior status of a god by giving him large size and a high, central position.

4. Realistic and unrealistic representation.

We have discussed in a general way the question of how a work of art is related to outside reality and to current conceptions of it. That question is applicable to all four modes of composition, but it arises most often in regard to representation. With that aspect of it this section is concerned. Whether the work is visual or literary, whether it represents an object, scene, person, situation, or story, people like to argue about whether it is realistic or the opposite.

From the Renaissance to the early twentieth century the assumption prevailed in Western culture that a work of representational art should be essentially "true to life" or "true to nature," while also improving on nature to some extent both morally and aesthetically. Consequently the value of the work was thought to depend largely on the extent to which it thus combined realism and idealism. This applied especially to bodily anatomy, posture and movement, and also to perspective, contour, scale, and coloring. In storytelling and characterization, visual or verbal, it applied to the motives, feelings, moral principles, and beliefs which were expressed or exemplified.

The extent to which a work of art is realistic or the opposite is often controversial. It depends not only on the meaning of the term but on which aspects of the work one is considering, and on one's conception of the facts represented. What Soviet writers regard as "social realism" is regarded by noncommunist writers as slanted toward a favorable view of communist society, and exaggerated in condemning all others. Opinions differ on how true to life or to actual social conditions a story is. But if realism is identified with naturalism in the Ibsen-Zola type—with an accurate portrayal of actual kinds of person doing ordinary things and speaking ordinary language—then it can be distinguished from works of fantasy and high-flown diction, as in Blake's *The Book of Urizen* and Tennyson's *Idylls of the King.* Wordsworth, in some of his poems, used language which he, but not all his readers, accepted as the speech of ordinary life.

Representation in art has been persistently concerned with the sensory aspects of things. The question whether it is realistic or not involves the relations between such aspects as occurring in art and in the outside world. Realism implies a comparatively high degree of similarity between them, of "verisimilitude," that is. This does not imply literal truth, as in a story based on actual past events, but sufficient likeness to perceptible things and events for the observer to imagine them as actually existing and happening.

Artistic truth, in the sense of conformity with commonly observable phenomena, is often called "naturalism." (This may refer only to surface appearances, and does not necessarily imply philosophic naturalism.) Naturalism is then distinguished from "realism," conceived as truth in representing the more intangible, imperceptible qualities of things, especially their spiritual, mental, and moral essences. "Realism" in that sense tends to deal with abstract concepts and with supernatural powers, imperceptible by humans and impossible to represent by sensory mimesis. Representation of this sort verges toward exposition.

In another sense, both "naturalism" and "realism" imply the use in art of ingredients and forms like those which are commonly perceptible in nature and ordinary human life. Art is then considered more realistic insofar as its constituent forms are regularly perceptible, as in the case of an eclipse, not extremely rare or dependent on improbable circumstances. The outcome of a story which depends on a single coincidence can be realistic, since coincidences happen; but it is not realistic if it depends on a long, unlikely series of marvelous coincidences.

To philosophic naturalists, any representation seems unrealistic which implies a strong reliance on supernatural or preternatural agencies. It did not seem so when people believed that these were always, actually close about them. The representation can be realistic on the whole and yet contain some elements of the preternatural, such as the witches and their magic in *Macbeth.* Dürer's engravings of the *Apocalypse* combine much naturalistic anatomy and perspective with supernatural elements, such as winged spirits and a humanlike figure with columns for legs. Hints of the weird and uncanny may be introduced in the midst of an otherwise naturalistic work, as in the stories of Edgar Allan Poe. The ancients moved easily back and forth between the natural and the supernatural, making the gods intervene in human quarrels. But as art becomes more thoroughly naturalistic, accepting on the whole a world view which excludes belief in spirits, magic, and miracles, an occasional exception tends to stand out with stronger contrasts, as in the voice of Hamlet's murdered father.

It is impossible for humans to represent things in a

way which is totally different from the phenomena of ordinary human experience. Even when the subject is supernatural or preternatural, as in gods or devils, it is usually conceived with some human or animal traits of appearance, feeling, speech, or behavior.

Art is regarded as highly unrealistic when things are made to appear and behave in ways which would be impossible according to present beliefs, as in the transformation of Daphne into a tree, or the turning backward of time, as in H. G. Wells's *The Time Machine.* But such a work of art can be realistic in other respects. A little more realism is attained when the events portrayed are, according to our views, possible though not probable. There is nothing inherently impossible in a story about a race of giants, each with a single eye, but it is hardly likely in terms of present biology. What strange forms of life may exist on other planets we can only surmise, but a detailed description of such beings, if they exist, could be actually realistic no matter how fantastic it seemed to be from the human point of view.

Representing something in a certain way may be deliberately fantastic as a stimulus to active flights of imagination. On the other hand, it may imply a belief that the things represented (as in an ancient map) actually do or did exist in that way. Unrealism can result from ignorance and misconception or from a deliberate attempt to alter the appearances of things or imagine them as other than they are. The motive may be wishful thinking or propaganda, or perhaps a wish to influence public feeling and action by showing social conditions as better or worse than they actually are.

Complete realism is impossible in art, primarily because art is always and necessarily selective. Neither painter nor photographer can show a natural scene in all its profusion of ever-changing qualities. Complete unrealism is likewise impossible, primarily because of the limited number of psychological ingredients and modes of organization which the human mind can observe, understand, or manipulate. There must always be some resemblance to the outside world and ordinary experience. Between these extremes is an inexhaustible range of possible combinations.

All representational art is comparatively realistic in some ways, unrealistic in others. Different components can be differently treated in this respect. A painting can be realistic in bodily contours, unrealistic in coloration and perspective. The dialogue of a play can be realistic in imitating the dialect of a certain ethnic group, such as the American Negro before the Civil War, but unrealistic in the ideas and motives attributed to persons of that type. By gradually increasing and emphasizing the rare, atypical, unrealistic aspects of his work, the artist can gradually transform it into something quite fantastic on the whole, as in *The Tempest* and *A Midsummer Night's Dream.* At each step of the way, problems await him in adjusting the realistic and unrealistic elements, as if they were contrasting themes, and in giving each its intended share of temporary credibility, as an imaginary conception which the observer can and will regard for the moment as if it were real. Great complexity can be achieved through a careful interweaving of the realms of sober fact and fancy, of the possible and impossible, the probable and improbable, the accidental and the inevitable. An effect of realism or the opposite is partly the result of apparent causal, temporal, and spatial consistency among the details represented. In part it depends also on the apparent consistency between the work of art as a whole and the way things seem to happen in the outside world.

Montage is a special kind of representation, used especially in cinema, in which separate, heterogeneous pictures or film shots are combined so as to be visible together as a composite picture or sequence. Usually they remain somewhat distinct, as in showing together a sleeping man and also what he is dreaming about, or the same man at different times and places. The juxtaposition is often intended to suggest a total impression or state of mind, as of crowding, confusion, or multiplicity and rapid change.

The method has spread to other arts, so that bits of music or verbal text (such as newspaper headlines) can be combined at once or in rapid succession. The product is not strictly realistic, in that one never sees or hears the elements thus combined in actual life. But it may give a truer impression of a total process or condition than any single, realistic picture.

A somewhat similar effect is produced in painting by Analytical Cubism and Futurism, through combining in a single form several aspects which could not possibly be seen at once. Some contemporary film directors insist that they are not aiming at even this limited amount of realism. "I want to make the audience remember," they say, "that this is a *film,* not a picture of real happenings."

5. Characterization: the representation of character and personality.

As we have seen, characterization is a developed component in many arts and in various modes of composition. It can be used in the representation of one or

more persons, in isolation or in a particular setting. The emphasis can be on outwardly observable traits or on thoughts, desires, and feelings. Such representation can be developed indefinitely in terms of the nature of a single individual, including some reference to his relations with others, but without showing him as engaged at length in any particular scene, situation, or story.

All characterization is suggestive. That performed through the meaning of words is almost wholly so, whether it deals with a person's appearance and other externally perceptible traits or with his inner life. When an actor's spoken words and visible gestures imitate those of an imaginary person, the presentative factor is conspicuous. The same is true of the lines, colors, and surface shapes in a painted or sculptured portrait. One can directly sense them as presented component traits, but to interpret them as representing a particular man or kind of man involves mimetic suggestion.

The emphasis in characterization can be on an individual's nature and behavior at a certain time and place. This is usual in drama and in visual portraiture. It can be, instead, on different moments or periods in his life, in chronological sequence or as detached episodes. When the chronological order is emphasized, the form tends toward biography, history, or storytelling. A third procedure is to generalize about the person without emphasizing any particular time, place, or sequence. What sort of person was Napoleon? How does he compare with Julius Caesar? This sort of characterization tends to become more conceptual and expository: an essay rather than a representation. One usually refers to certain moments, actions, or events in his career which seem especially noteworthy, as dramatically colorful, as revealing the main, distinctive factors in his personality, or as significant in relation to his time, milieu, and achievements. Details regarding other moments or aspects of his life might be as true but less characteristic and less revealing, as in a photographic snapshot made at random.

A *person* is ordinarily understood to be a human individual of either sex and any age or type, or sometimes as a quasi-human being such as an angel, demon, or animal with humanlike attributes. A *personage* can be an individual human, especially one of high rank such as a king or ambassador. In another sense it is any being, realistic or fantastic, which fills a humanlike role in art. The talking serpent in the Garden of Eden is a personage. Trees and flowers feel and speak in fairy tales. The Latin word *persona* means a mask worn by actors. As on the stage, an individual in real life can display many different selves or aspects in different kinds of situation. These may be as different as Dr. Jekyll and Mr. Hyde, or as similar as the ways a man acts and talks at home and in the office. Psychoanalysts emphasize the fact that we build up different *personae* to show the world, perhaps to show what we would like to be or think we are. They are means of adjustment between the ego and different phases of its environment. In that sense, all of one's *personae* may be somewhat different from one's underlying, enduring personality structure. Artistic representation often undertakes to show this overlapping plurality of selves.

The term *personality* is now used in an inclusive sense, comprising both conscious and unconscious, manifest and hidden traits. *Character* refers especially to the moral aspects of personality, and in this sense a man or woman is called virtuous or vicious, reliable or irresponsible, strong or weak. In a larger sense, especially referring to the drama, "character" is about the same as "person." The characters of a play or story are its *dramatis personae*, especially those who are somewhat individualized as distinct from groups of nameless bystanders. To *personify* is to represent or symbolize an abstract quality, activity, or thing in the form of a person. Thus Athena personifies wisdom and the city of Athens; Hephaestus, fire and crafts; Artemis, the moon.

Pictorial and sculptural representation deals primarily with visible traits as combined in personal appearance, including facial configuration, dress, and posture. It may or may not include expressive ones—those suggesting inner traits of character, attitude, and mood. Pantomime and other theater arts often concentrate attention on a character such as Harlequin or Falstaff, portraying him through visual or audiovisual means. Some portraits are sharply individualized but rather impassive, giving little clue to mood or character. This is true of Holbein's, as a rule. His line drawings pick out and stress nuances of individual physiognomy and thus seem realistic, but most of them show little or no distinctive feeling in the person represented. This may be due in part to the wishes of his noble and wealthy sitters. It is natural for the subject of a portrait to show the artist his favorite *persona*, and in the case of aristocrats this was often one of aloof serenity or haughty disdain. The artist may or may not wish or be allowed to bring out what he thinks is the subject's underlying personality.

Rembrandt's portraits (many of himself or his plebeian models) are comparatively expressive in the sense of suggesting inner traits of mood and personality. The extent to which any single picture can do

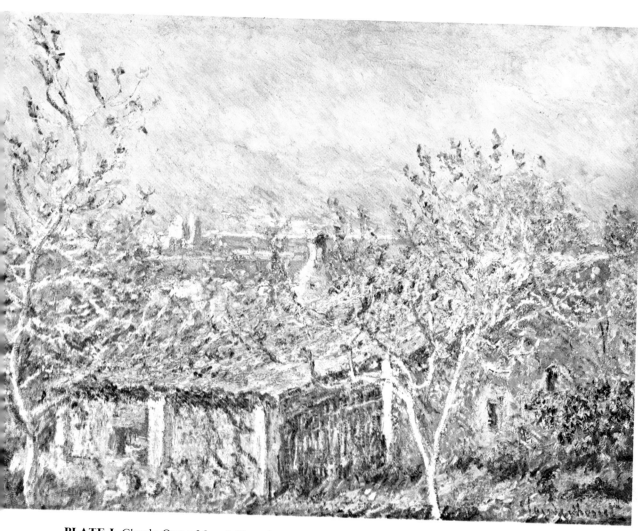

PLATE I. Claude Oscar Monet, French, 1840–1926. *Antibes.* Oil on canvas, 1888. The Cleveland Museum of Art. Gift of Mr. and Mrs. J. H. Wade. 16.1044.

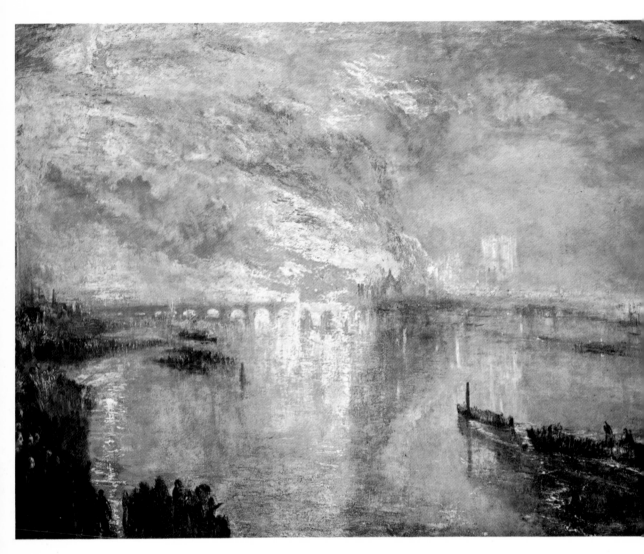

PLATE II. Joseph Mallord William Turner, English, 1775–1851. *Burning of the Houses of Parliament, 1834.* Oil on canvas, 1835. The Cleveland Museum of Art. John L. Severance Collection, 1936. 42.647.

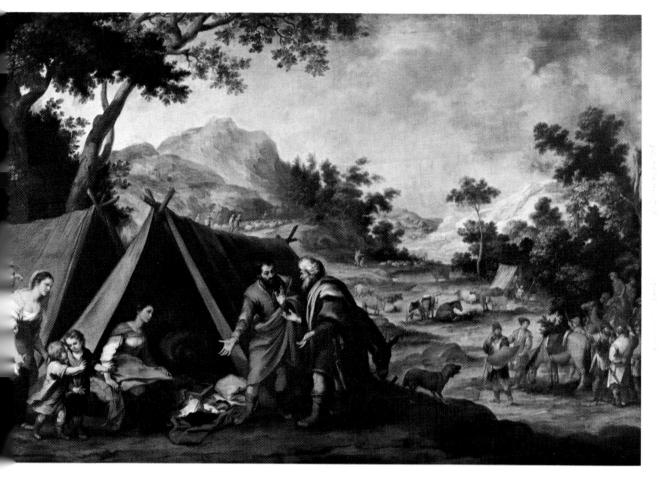

PLATE III. Bartolomé Esteban Murillo, Spanish, 1617–1682. *Laban Searching for his Stolen Household Gods in Rachael's Tent*. Oil on canvas, ca. 1665-1670. The Cleveland Museum of Art. Gift of the John Huntington Art and Polytechnic Trust. 65.469.

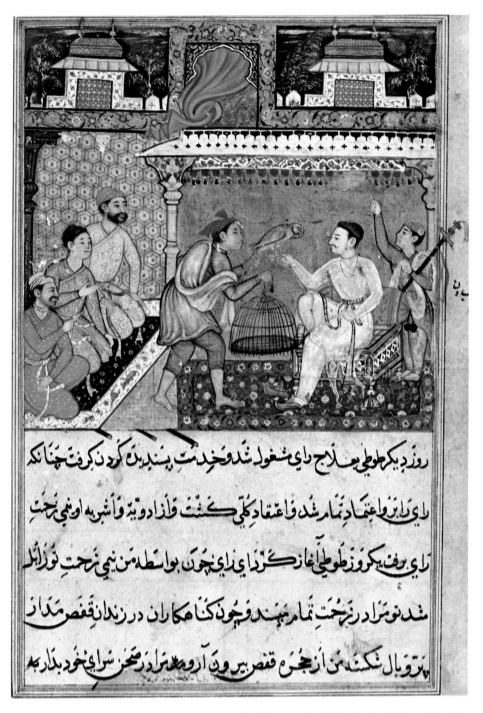

روزی دیگر طوطی مصالح رای مشغول شد و خدمت پسندیده کرد و ذکر گفت چنانکه

رای را باور و اعتماد تمام شد و اعتماد کلی کنت قلاده ادویه و اشربه او نبی رحمت

رای میفرمود یکروز طوطی غاز گردای دای چون بواسطه من نبی رحمت نورانله

شد نو مراد و رحمت تمام پسند و چون گناهکاران در زندان قفص مدار

پر و بال شکسته من از چون قفص پریدون و از محن سرای خود بدار به

PLATE IV. Manuscript of the Tuti-Nama by Ziya al-din Nakhshabi: Folio 36v. *The Fowler Presents the Parrot to the Emperor's Vizier.* Artist: Basawan. India, Mughal, early reign of Akbar, ca. 1560. Color and gold on paper. The Cleveland Museum of Art. Gift of Mrs. A. Dean Perry. 62.279.

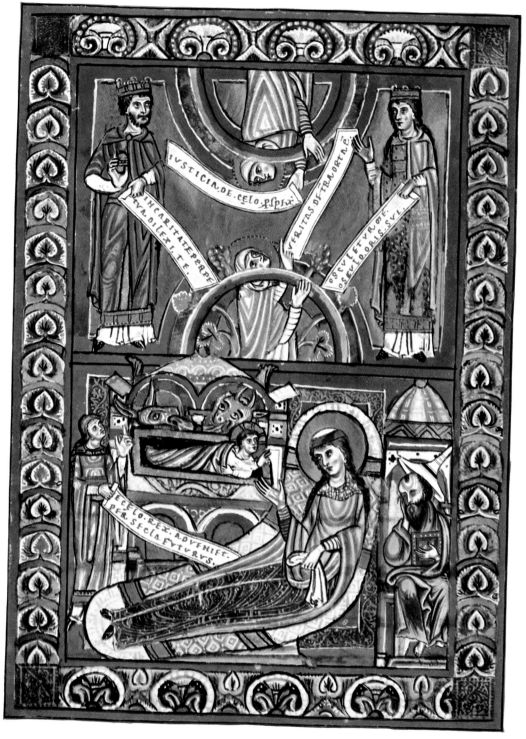

PLATE V. Co-worker of Hermann von Helmarshausen. Single Leaf from a Gospel Book (now Trier MS, 142). Recto: *The Nativity*. German, Saxony, 1170-1190. Tempera on vellum. The Cleveland Museum of Art. Purchase from the J. H. Wade Fund. 33.445.

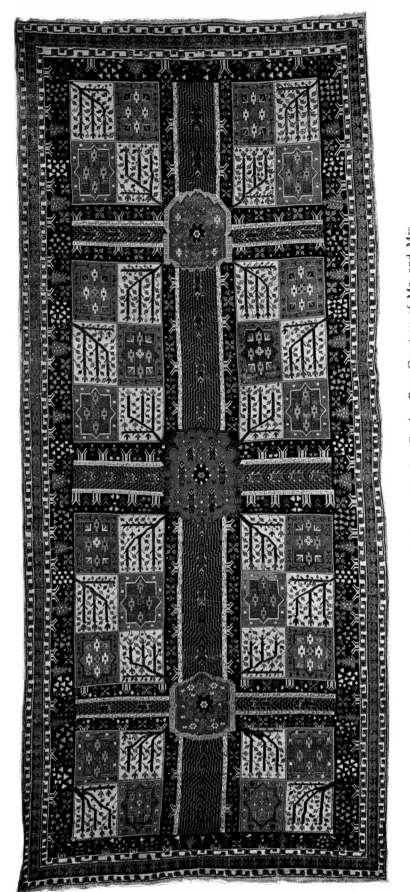

PLATE VI. *Eighteenth-Century Persian Garden Rug.* Courtesy of Mr. and Mrs. Vojtech Blau.

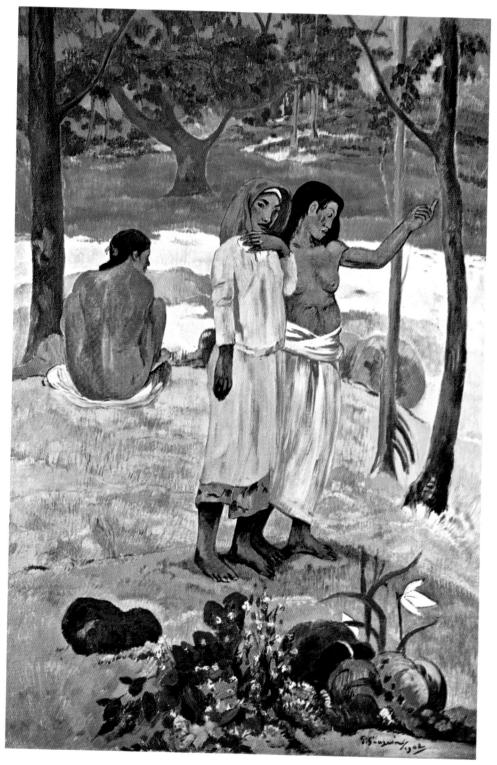

PLATE VII. Paul Gauguin, French, 1848–1903. *L'Appel.* Oil on canvas, 1902. The Cleveland Museum of Art. Gift of Hanna Fund. 43.392.

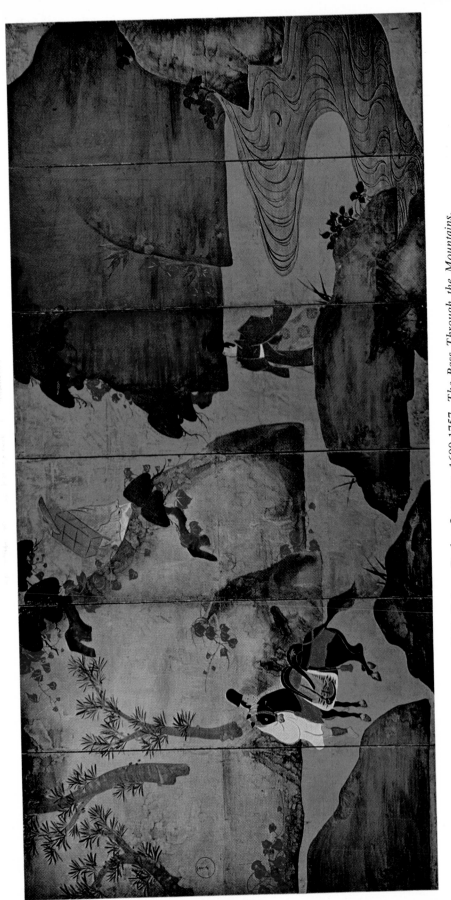

PLATE VIII. Fukaye Roshu, Japanese, 1699-1757. *The Pass Through the Mountains.*
Six-fold screen, detail. Tokugawa Period. Color and gold on paper. The Cleveland Museum
of Art. John L. Severance Fund. 54.127.

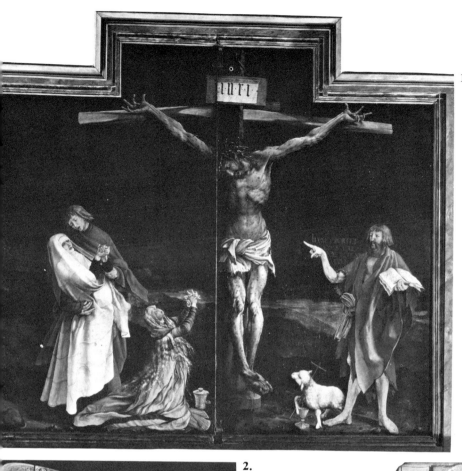

1.

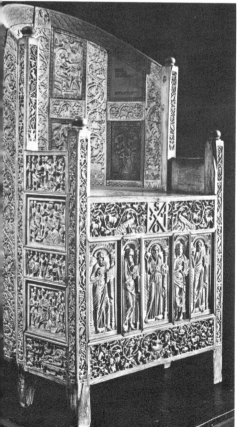

1. Matthias Grünewald (1460–1528). *Isenheim Altar, Crucifixion,* 1513–1515. Musée d'Unterlinden, Colmar, France. **2.** *Bishop's Throne,* 5th century. Ivory. Ravenna, Italy. **3.** Egyptian: *Prince Arikharer Slaying Enemies.* Meroïtic, A.D. 25–41. Worcester Art Museum, Worcester, Mass. **4.** Assyrian: *Assurnasirpal Hunting Lions.* British Museum, London.

2.

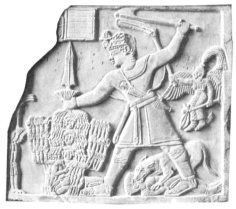

3.

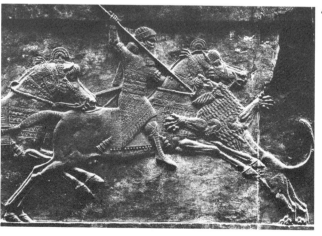

4.

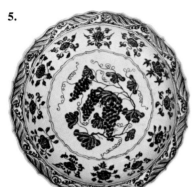

5.

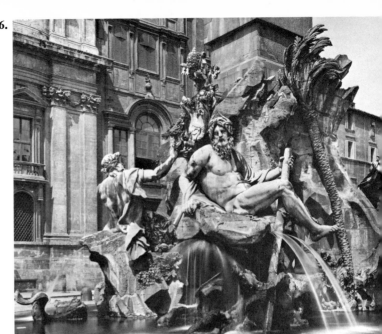

6.

5. Chinese: *Dish,* Ming Dynasty, early 15th century. Porcelain with underglaze decorati
Mohammedan blue. The Cleveland Museum of Art. Anonymous gift. 53.127. 6. Gianlo
Bernini (1598–1680). *Fountain of the Four Rivers.* Rome, Piazza Navona. 7. Giovanni B
Tiepolo (1696–1770). *The Finding of Moses.* Duke of Sutherland Collection, on loan
National Gallery of Scotland, Edinburgh. 8. Honoré-Victorin Daumier (1808–1879). *"You Ha*
Floor, Explain Yourself, You Are Free." One of a series of portraits of judges of the
Defendants. Lithograph, 1835. Museum of Fine Arts, Boston. Babcock Bequest. 9. Tsimshian In
Shaman's Rattle. Chicago Natural History Museum. 10. Jamnitzer workshop. *Goldsmith's Scales.* Ge
Nuremberg, ca. 1565–1570. Gilt bronze. The Cleveland Museum of Art. Purchase fro
J. H. Wade Fund. 50.382. 11. Benvenuto Cellini (fl. 1540). *Salt Cellar of Francis I of Fr*
ca. 1540. Gold, enamel, and precious stones. Vienna, Kunsthistorisches Mus

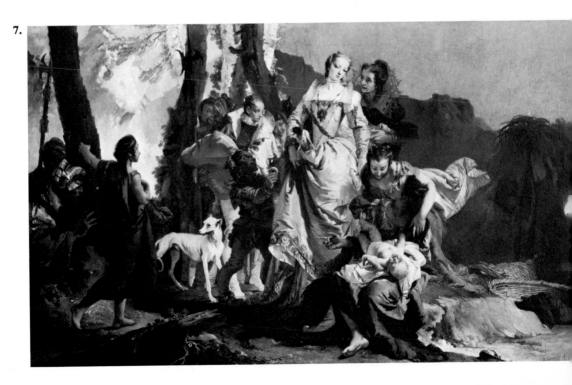

7.

8.

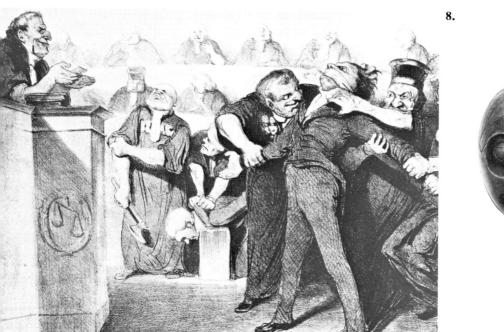

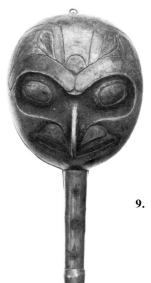

9.

10.

11.

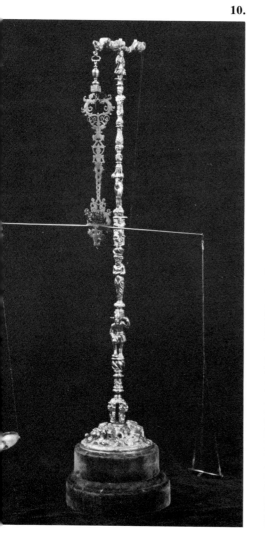

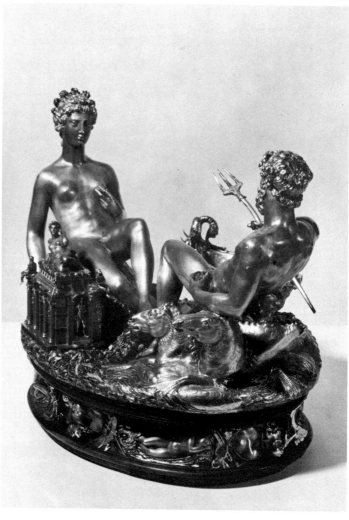

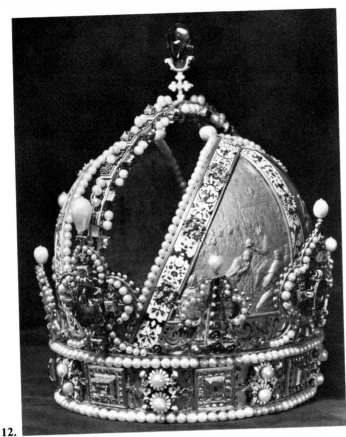

12.

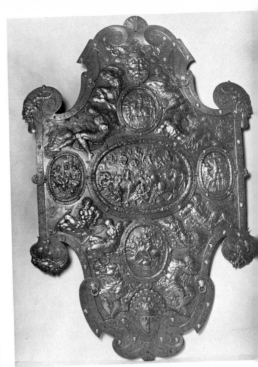

13.

15.

14.

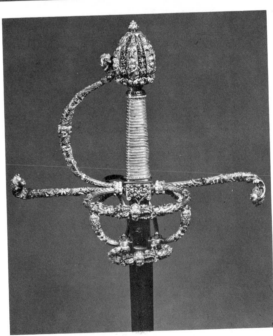

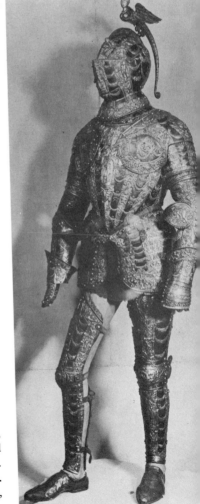

12. *Crown of Rudolph II of Hapsburg,* 1602. Precious metals, enamels, and gems. Vienna, Kunsthistorisches Museum.
13. E. Libaerts. *Pageant Shield.* Antwerp, 1560–1565. Vienna, Kunsthistorisches Museum. **14.** A. Piccinino and others. *Hilt of the Sword of Archduke Ferdinand of Tirol.* Vienna, Kunsthistorisches Museum. **15.** L. Piccinino. *Armor of Alessandro Farnese.* Milan, ca. 1570. Vienna, Kunsthistorisches Museum.

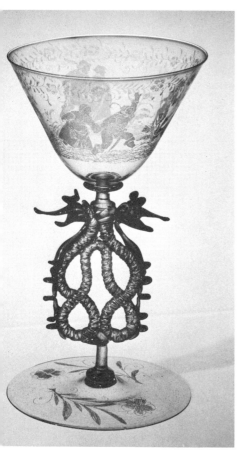

16.

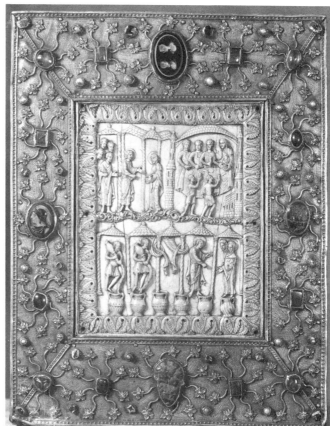

17.

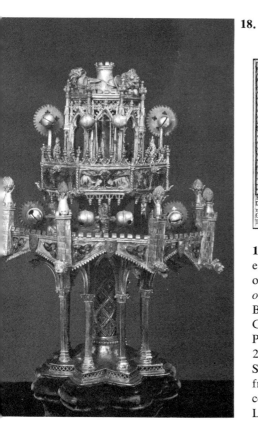

18.

19.

20.

16. *Glass for Wine*. Venetian style, winged, diamond-point engraved. Netherlands, late 17th century. Corning Museum of Glass, Corning, New York. **17.** *Reliquary in Form of Book*. Liège, 11th century. Ivory. Frame: Germany, Brunswick, second half 14th century. Silver gilt. From the Guelph Treasure. The Cleveland Museum of Art. Purchase by the John Huntington Art and Polytechnic Trust. 2225.30. **18.** *Table Fountain*. France, late 14th century. Silver gilt and enamel. The Cleveland Museum of Art. Gift from J. H. Wade. 24.859. **19, 20.** *Trade Cards* (early commercial art). Late 17th or early 18th century. Pepys Library, Magdalene College, Cambridge, England.

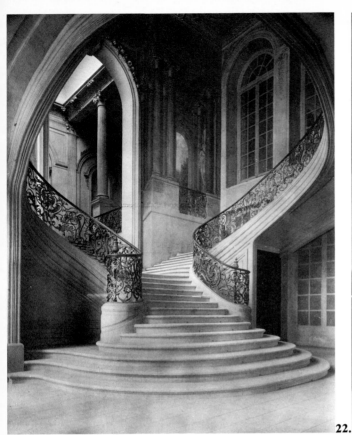

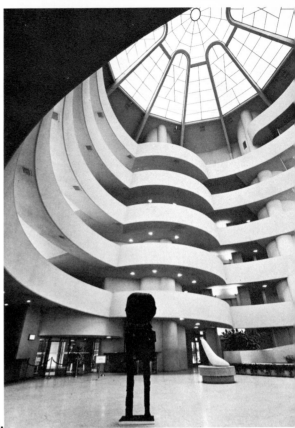

22.

21.

21. *Grand Stairway of Honor in the City Hall.* Nancy, France. 22. Frank Llo
Wright (1867–1959). *The Solomon R. Guggenheim Museum.* New York. Interi
1959. 23. Leonardo da Vinci (1452–1519). Drawing, *Giant Crossbow.* Pen a
wash. Milan, Biblioteca Ambrosiana (Codex Atlanticus, fol. 53v-b

23.

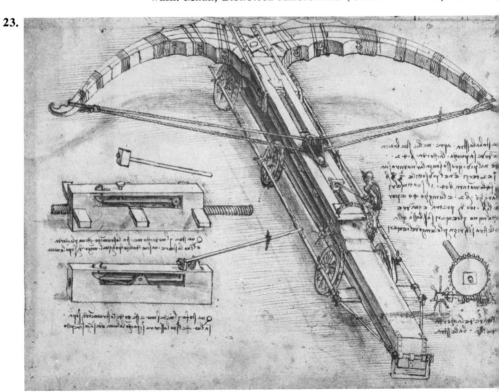

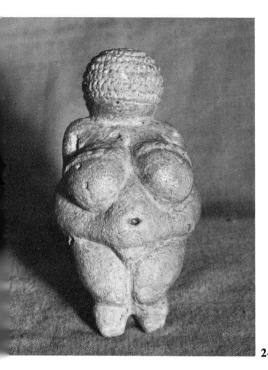

24.

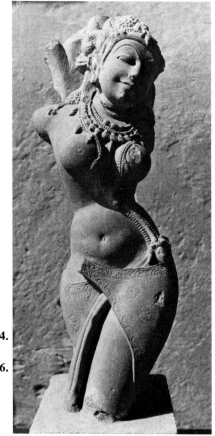

25.

24. *The Venus of Willendorf.* Austria, Upper Paleolithic period. Collection of the Prehistoric Division in the Natural History Museum in Vienna. **25.** *Tree Goddess.* From Gyaraspur, Madhya Pradesh, India, 11th–12th century. Archaeological Museum, Gwalior. **26.** *Venus of Cyrene.* Museo delle Terme, Rome. **27.** Hellenistic: *Jockey.* Bronze, late 2nd century B.C.

26.

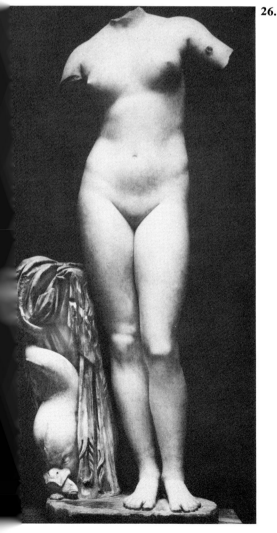

27.

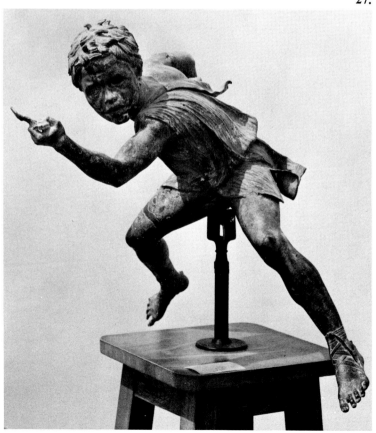

28.

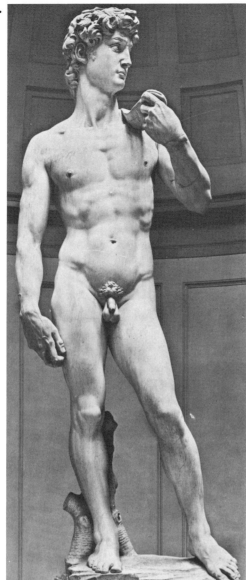

29.

30.

31.

32.

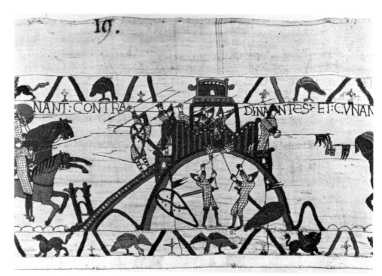

33.

34.

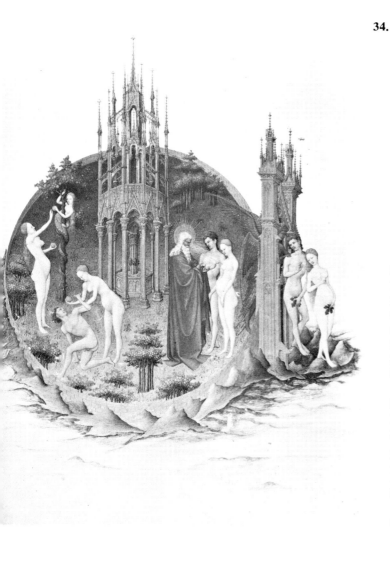

28. Michelangelo (1475–1564). *David*. 1504. Academy, Florence. **29.** Ancient Roman: *Old Shepherd*. Rome, Palazzo dei Conservatori. **30.** *The Palace and Garden at Fontainebleau*. Perspective bird's-eye view by A. Francini, 1614. **31.** *The English Garden,* Munich. Map by Rickauer, 1806. **32.** Rembrandt (1606–1669). *Self-Portrait*. Duke of Sutherland Collection, on loan to the National Gallery of Scotland, Edinburgh. **33.** *The Bayeux Tapestry. (Tenture de la Reine Mathilde).* Conan, Duke of Brittany, offers keys of city to William. 11th-century embroidery. Town hall, Bayeux, France. **34.** Pol de Limbourg (fl. 1416). *The Earthly Paradise*. Musée du Condé, Chantilly.

35.

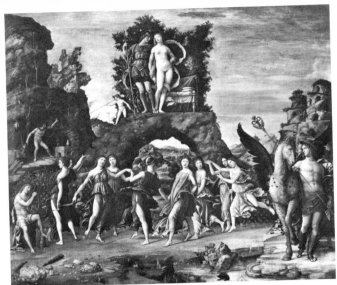

36.

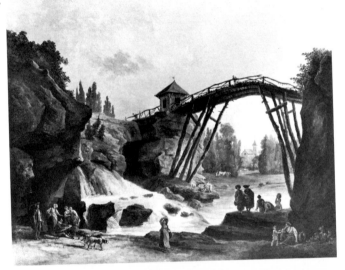

35. Andrea Mantegna (1431–ca. 1506). *Parnassus*. North Italy, ca. 1455. **36.** Hubert Robert (1753–1808). *Landscape with Wooden Bridge*. Stockholm Museum. **37.** Titian (1490–1576). *Diana and Actaeon*. Duke of Sutherland Collection, on loan to the National Gallery of Scotland, Edinburgh. **38.** Filippo Brunelleschi (1377–1446). *Piazza Chapel*. Santa Croce, Florence, 1430–1433. **39.** Japanese, 19th century: *Wedding Set: Outer Robe*. Silk, dyed and embroidered. The Metropolitan Museum of Art, New York. 37.92.10. Gift of Mrs. John D. Rockefeller, Jr., 1937. **40.** Ancient Roman: *The Sacrifice of Iphigenia*. Mural, Pompeii. National Museum, Naples. **41.** *Birth of Helen*. Scene from a farce: Zeus breaking the egg of Leda. Apulia, 4th century B.C. Vase painting. Museo Archeologico, Bari, Italy.

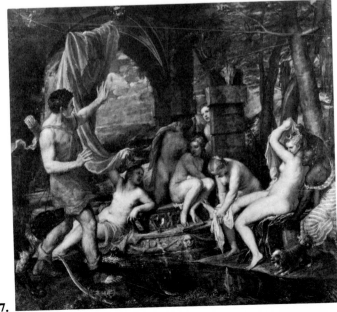

37.

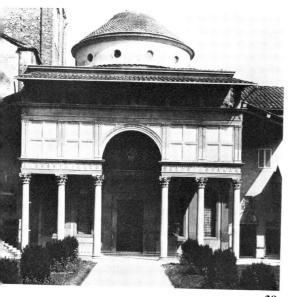

38.

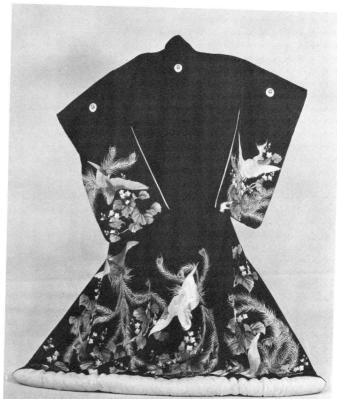

39.

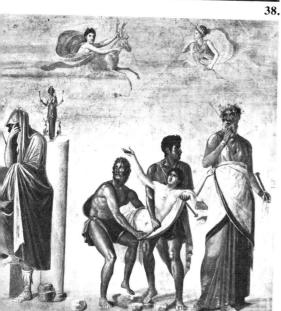

40.

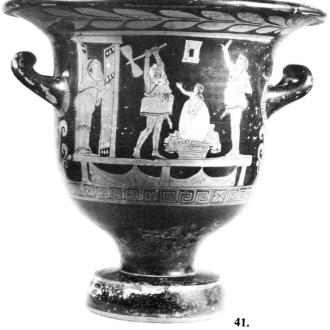

41.

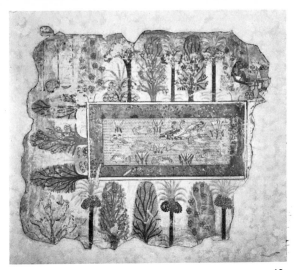

42.

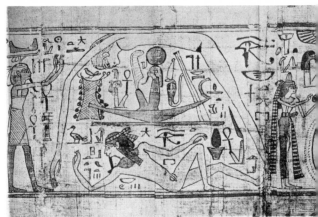

43.

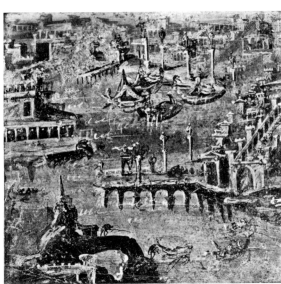

44.

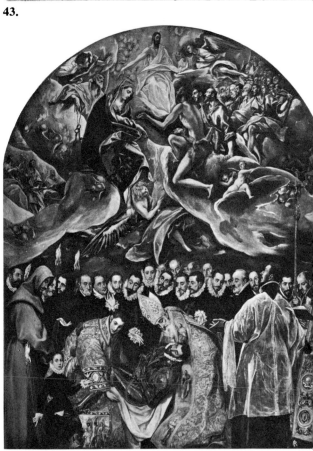

42. Egyptian: *Pond with Trees*. British Museum. **43.** Egyptian (New Kingdo⟩
 The Solar Boat Supported by Nun, the Primordial Ocean. Drawing on papy⟩
 Bibliothèque Nationale, Paris. **44.** Ancient Roman: *View of a Port from Sta⟩*
Pompeian. National Museum, Naples. **45.** El Greco (1545–1614). *Burial of the C⟨*
 of Orgaz. Church of Santo Tomé, Toledo, Spain. **46.** *The Nativity*. Ikon, Novg⟨
 School, 15th–16th century. Moscow. **47.** Filippo Lippi (1406–1469). *Virgin ⟩*
Child. Pitti Gallery, Florence. **48.** Utrecht Psalter. 9th-century illumination. Ab⟨
 The Last Judgment. Below: Angels smiting enemies of Israelites. University Libr⟩
Utrecht, Netherlands (Script. eccl. 484, fol. 48v). **49.** Egyptian: *King Akhenaten* ⟩
 his Daughter under the Rays of Aten. Detail of relief on altar in Tel el Ama⟩
 ca. 1360 B.C. Bildarchiv Foto Marburg and Ernst V. Hülsenh⟩

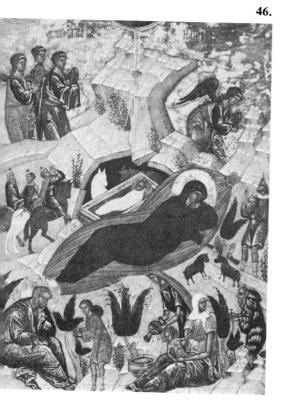

46.

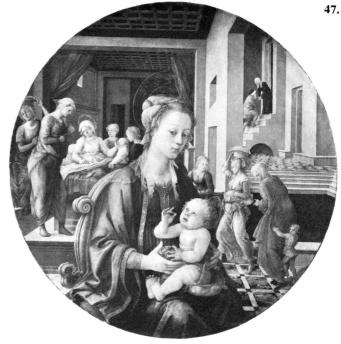

47.

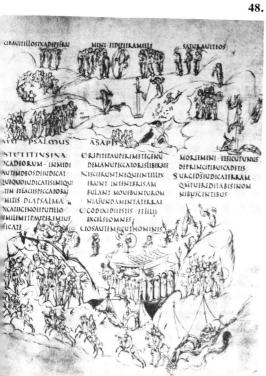

48.

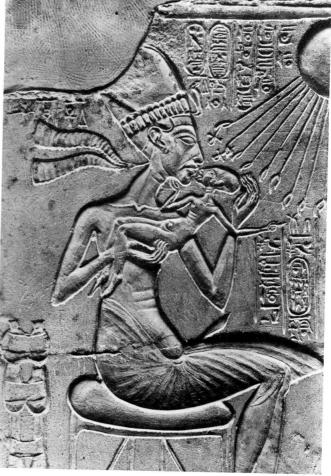

49.

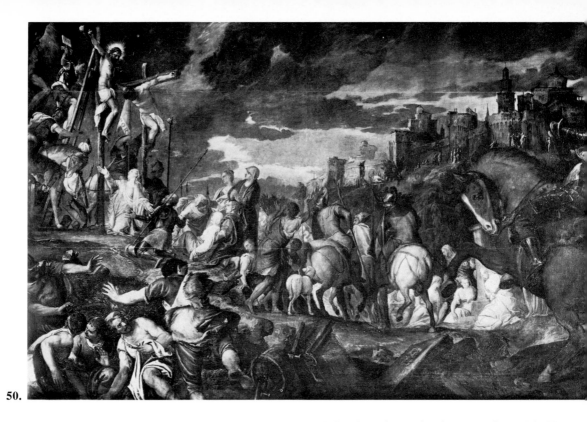

50.

50. Paolo Veronese (1528–1588). *Crucifixion*. Academy, Venice. **51.** Tintore
(1518–1594). *Worship of the Golden Calf*. The National Gallery of Art, Washingt
D.C. **52.** Indian: *The Dance of Siva*. Chola Period, South India, 12th century. Bron
Museum of Asiatic Art, Amsterdam. **53.** *Worshipping the Wheel of the Law*. Re
from the stupa at Madhya Pradesh, India. Sunga Period. Indian Museum, Calcu
54. Albrecht Dürer (1471–1528). *Melencolia I*. Engraving. **55.** Persian: *Pecto
Representing Eternity in Androgynous Form, with His Sons Ormaźd and Ahrim
Receiving the Barsom. Luristan, 1200–900 B.C. Silver. Cincinnati Art Museu

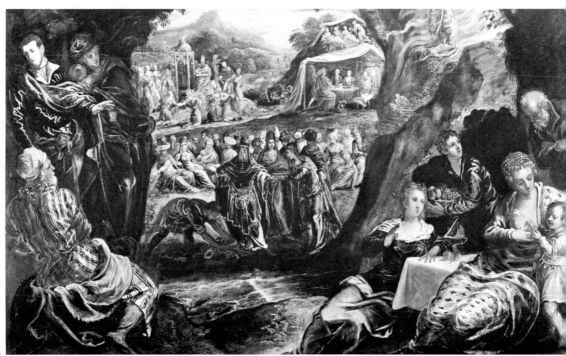

51.

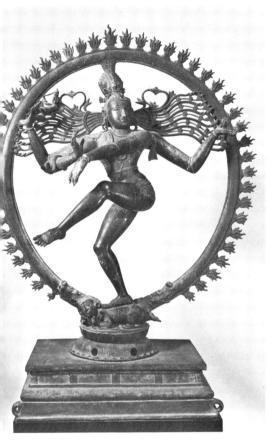

52.

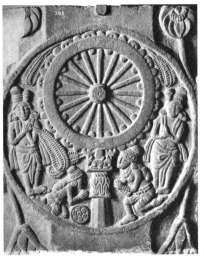

53.

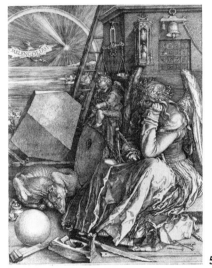

54.

55.

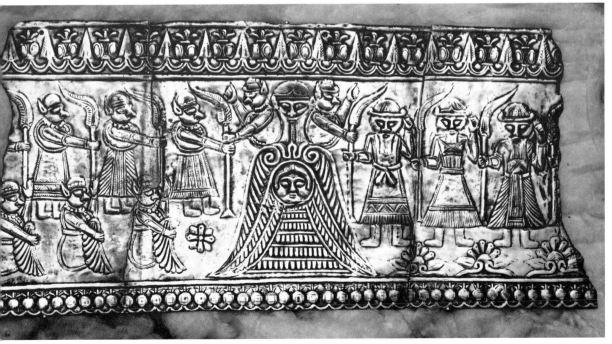

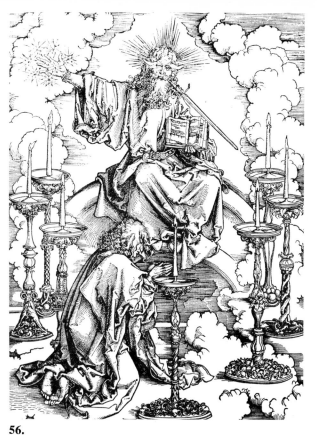

56.

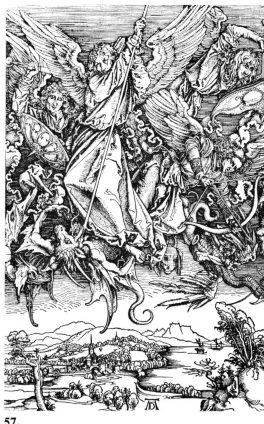

57.

56. Albrecht Dürer (1471–1528). *The Apocalypse: Calling of John.* Engraving. **57.** Albrecht Dürer. *The Apocalypse: St. Michael and the Dragon.* Engraving. **58.** Francisco Goya (1746–1828). *Saturn Devouring His Son,* ca. 1818. Prado Museum, Madrid. **59.** Tibetan: *The Wheel of Existence,* symbolizing transmigration. Buddhist Tanka. 18th century (?). Scroll painting, tempera on cotton. The Newark Museum.

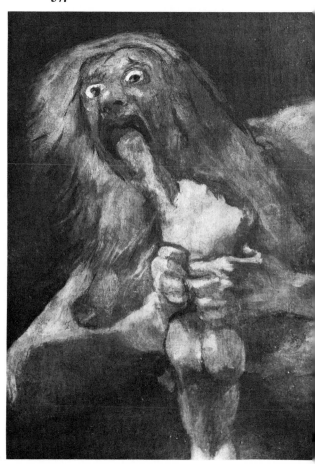

58.

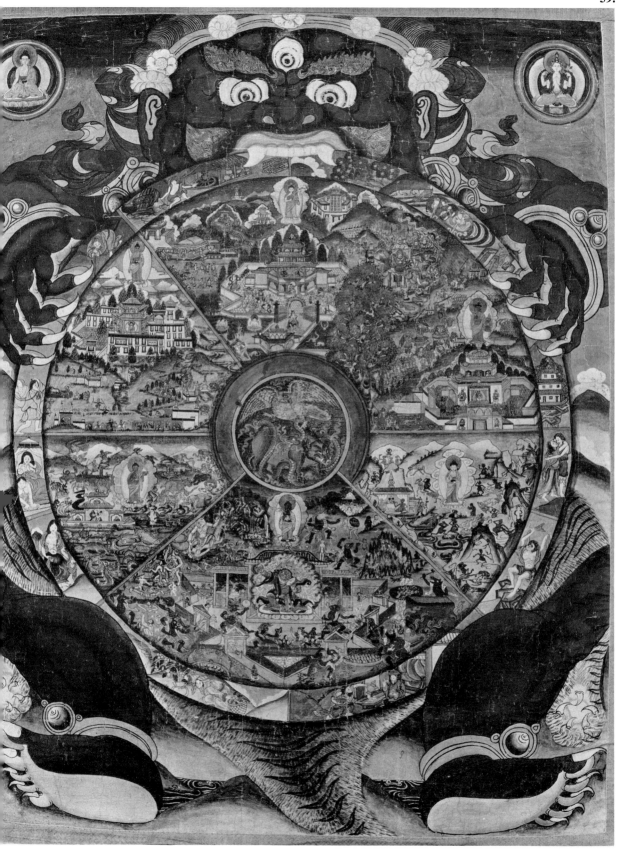

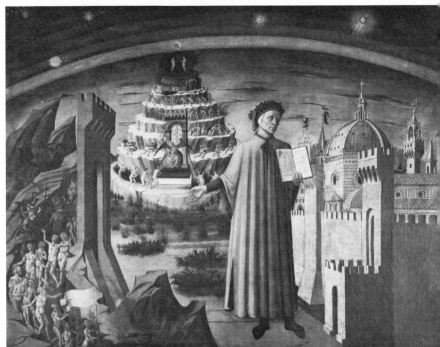

60.

62.

61.

60. Michelino (fl. 1435?). *Dante and His Book, with View of Florence.* Uffizi Gallery, Florence. **61.** Textile with representation of a *Quadriga.* 7th century (?). Cathedral, Aachen. **62.** Russian: *The Last Judgment.* Ikon. National Museum, Stockholm.

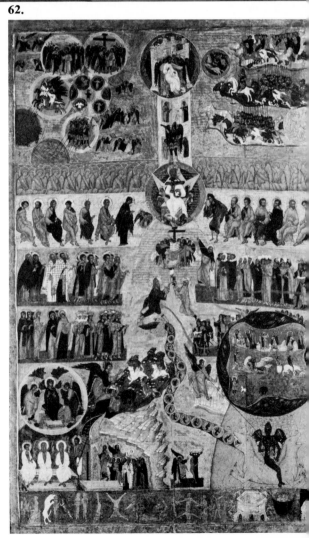

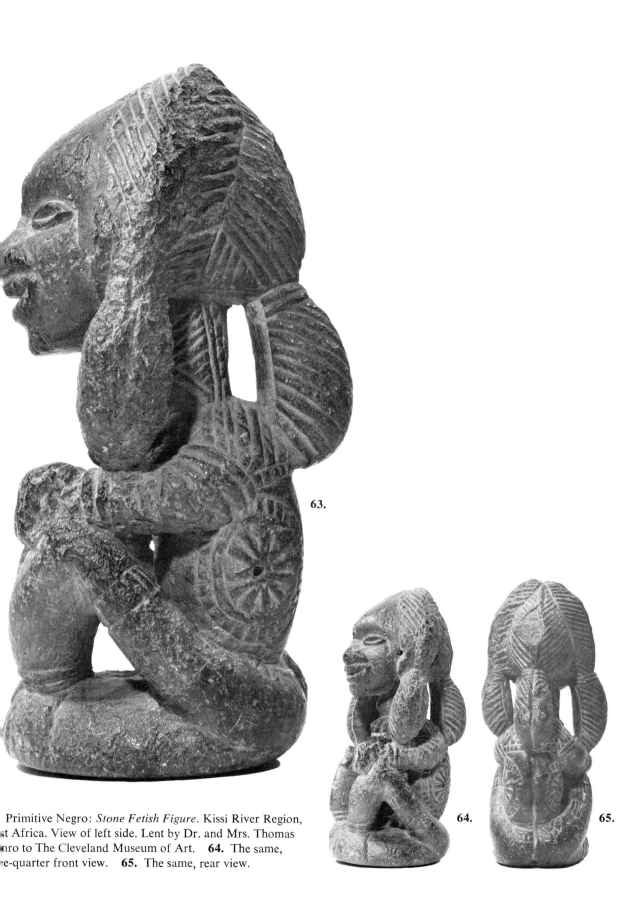

63. Primitive Negro: *Stone Fetish Figure*. Kissi River Region,
[Wes]t Africa. View of left side. Lent by Dr. and Mrs. Thomas
[Mu]nro to The Cleveland Museum of Art. **64.** The same,
[thre]e-quarter front view. **65.** The same, rear view.

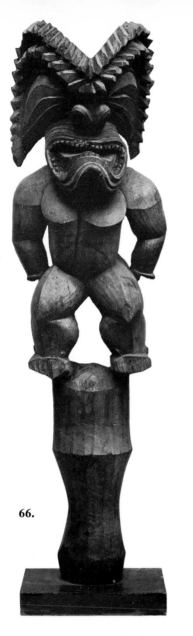

66.

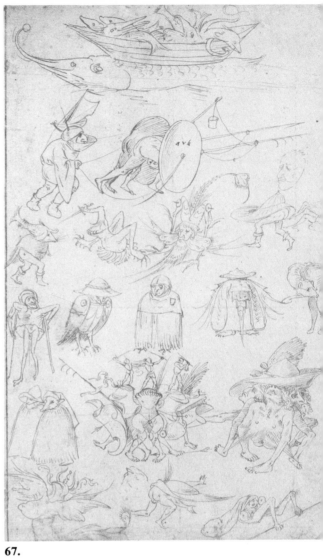

67.

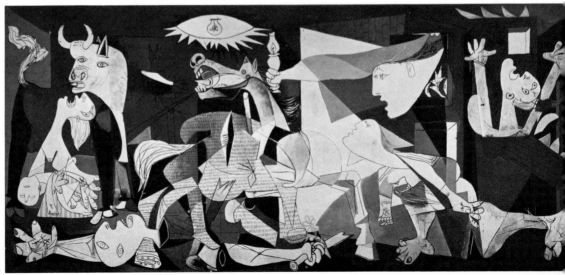

68.

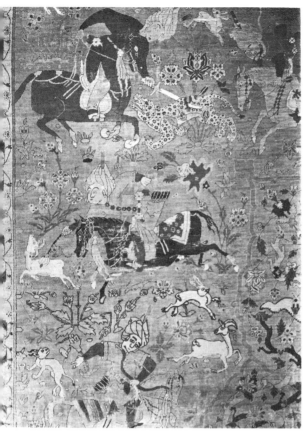

70.

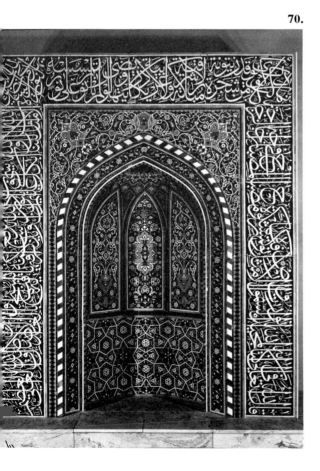

71.

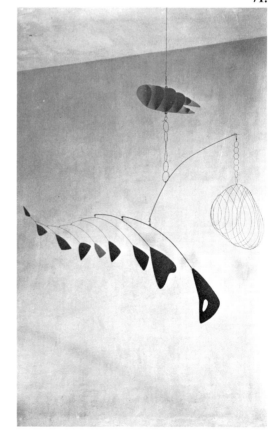

66. Hawaiian figure, wood, *Figure of a God*. British Museum. **67.** Hieronymus Bosch (d. 1516). *Study of Monsters*. Drawing. Ashmolean Museum, Oxford. **68.** Pablo Picasso (1881–). *Guernica*. Mural, 1937. Oil on canvas. On extended loan to the Museum of Modern Art, New York, from the artist, Pablo Picasso. **69.** Persian: *Hunting Carpet*. Kashan, 16th century. Designed by Sultan Muhammad (?). Silk with metal threads. Österreichisches Museum für angewandte Kunst, Vienna. **70.** *Mihrab and Frieze*. Faience mosaic tiles. Isfahan, Iran, first half 16th century. The Cleveland Museum of Art. Gift of Katharine Holden Thayer. 62.23. **71.** Alexander Calder (1898–). *Lobster Trap and Fish Tail*. Mobile. Collection of the Museum of Modern Art, New York. Gift of the Advisory Committee.

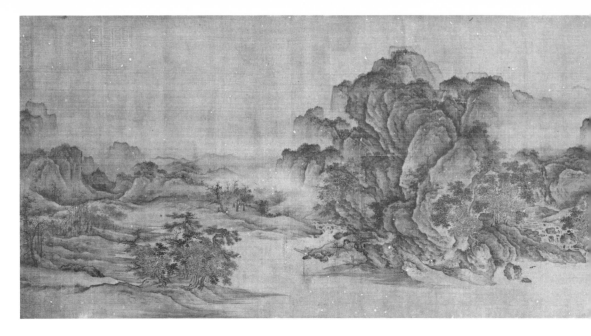

72.

73.

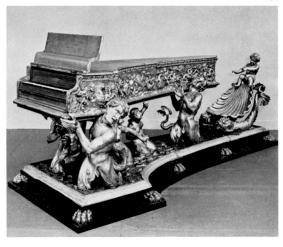

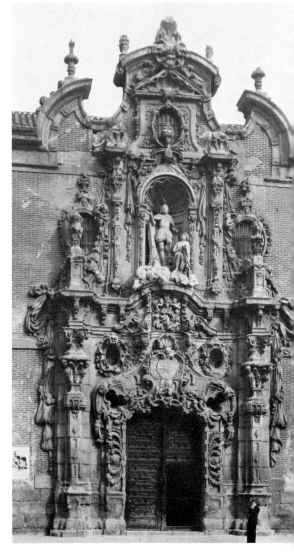

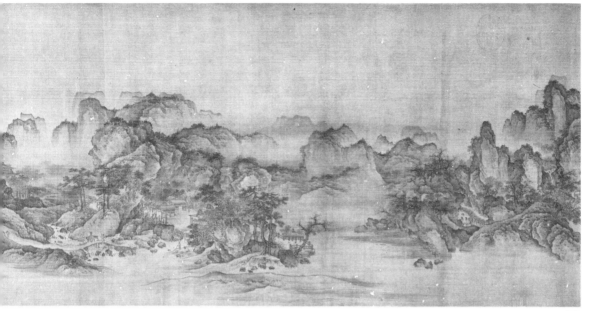

75.

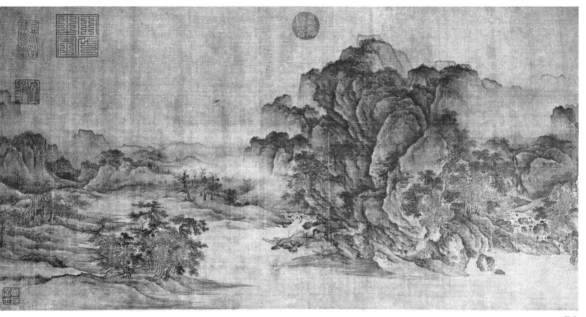

76.

Indian: *Taj Mahal,* ca. 1634. Agra, Uttar Pradesh, India. **73.** *Harpsichord.*
ian, 17th century. Supported by tritons, with gilded procession. Figures of Galatea
d Polyphemus playing a bagpipe. The Metropolitan Museum of Art. 89.4.2929. The
sby Brown Collection of Musical Instruments, 1889. **74.** Pedro Ribera (d. 1742).
spicio de San Fernando (Municipal Museum), Madrid. **75.** *Streams and Mountains
hout End.* Northern Sung Dynasty, ca. A.D. 1000. Chinese handscroll, ink on silk,
ail. The Cleveland Museum of Art. Gift of the Hanna Fund. 53.126. **76.** The
e, detail of climax.

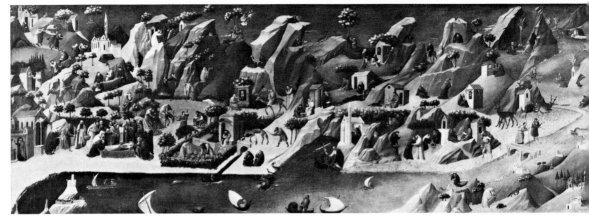

77.

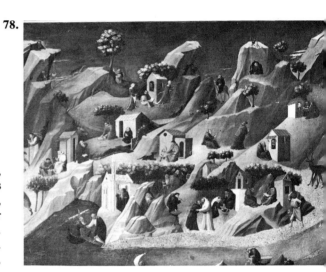

78.

77. Tuscan School, end of 14th century, *Hermits of the Thebaïde*. Large section as seen from a distance. Uffizi Gallery, Florence. **78.** The same, smaller section as seen from close at hand. **79.** Vittore Carpaccio (ca. 1490–1520). *The Arrival of St. Ursula.* Academy, Venice. **80.** *Grotto in Boboli Gardens,* Florence. **81.** *Lingaraj Temple.* Bhuhaneshwar, Orissa, India, ca. A.D. 1000. **82.** Chidambaram: *The Temple.* East Gopuram, India, 1100–1300.

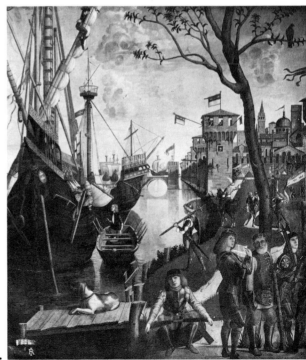

79.

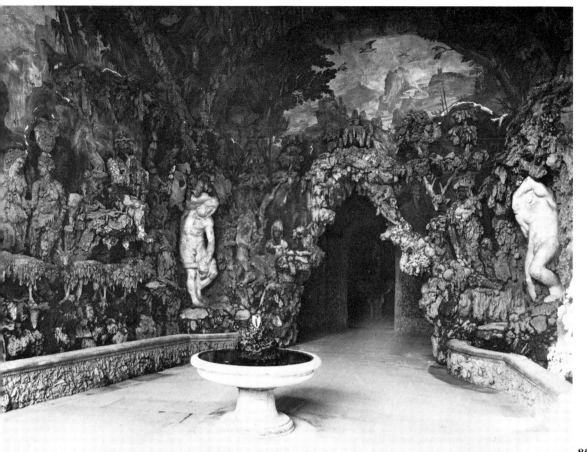

80.

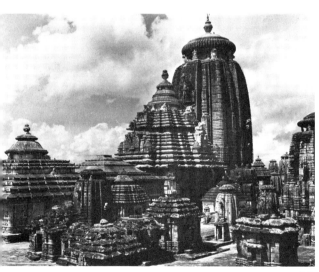

81.

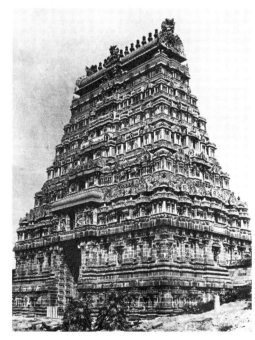

82.

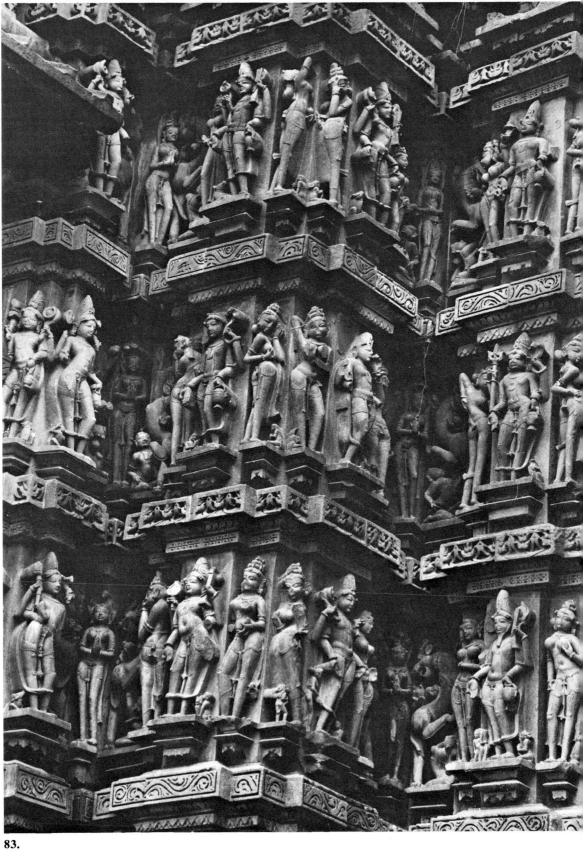

83.

83. Khajuraho: *Kandarya Mahadeva Temple*. Detail of exterior decoration. Ma[
Pradesh, India, ca. A.D. 1

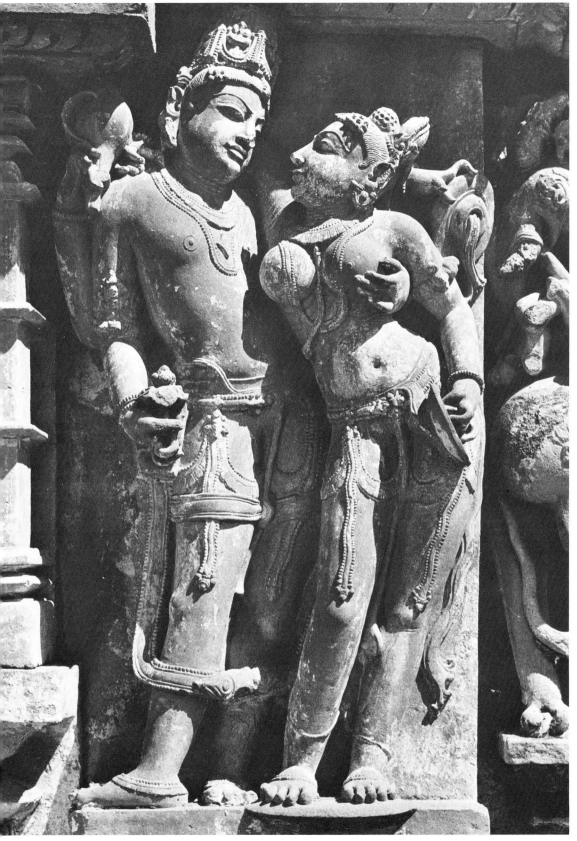

84.

Khajuraho: *Vishnu and Lakshmi as Lovers*. Detail from Viswanath Temple.
hya Pradesh, India, 11th century.

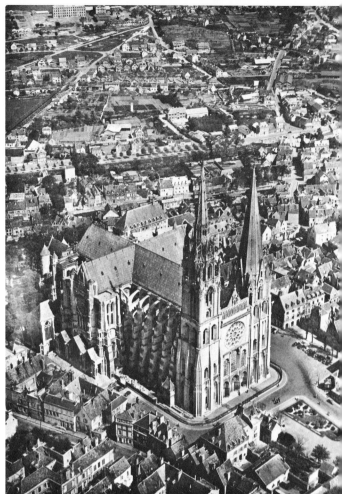

85. *Chartres Cathedral,* 1194–1260. Aerial front view, distant. **86.** *Chartres Cathedral.* Aerial rear view, distant. **87.** *Chartres Cathedral, Facade.* Ground level, at medium distance.

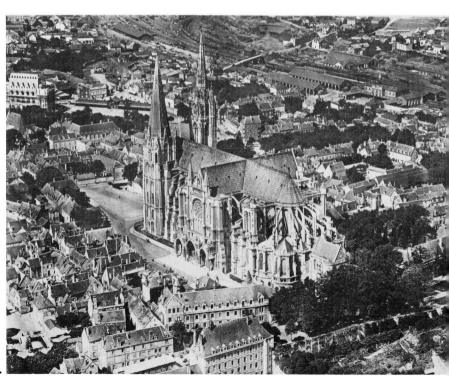

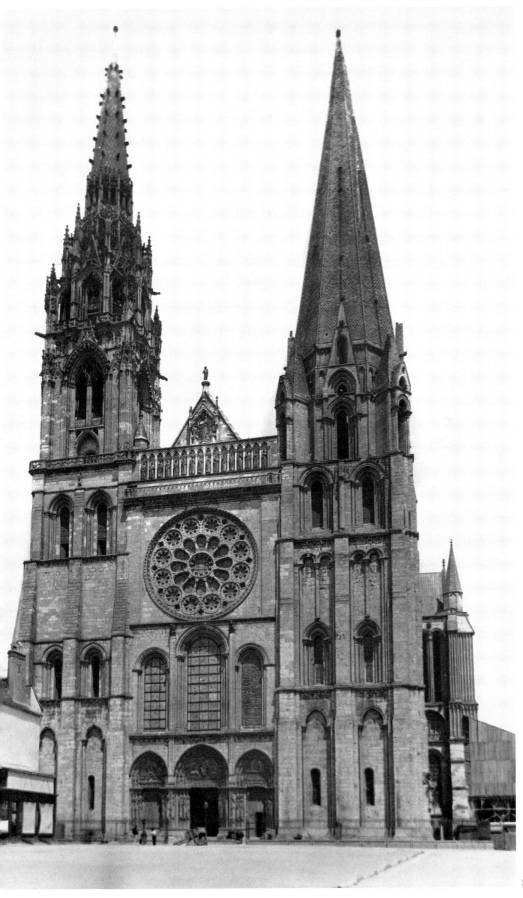

87.

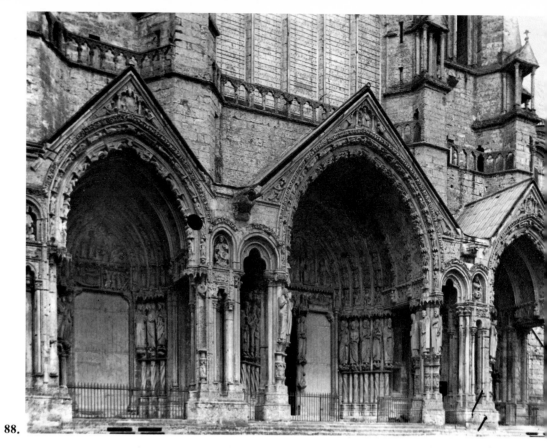

88.

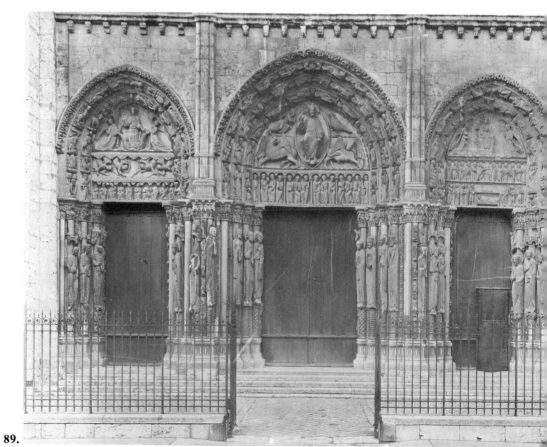

89.

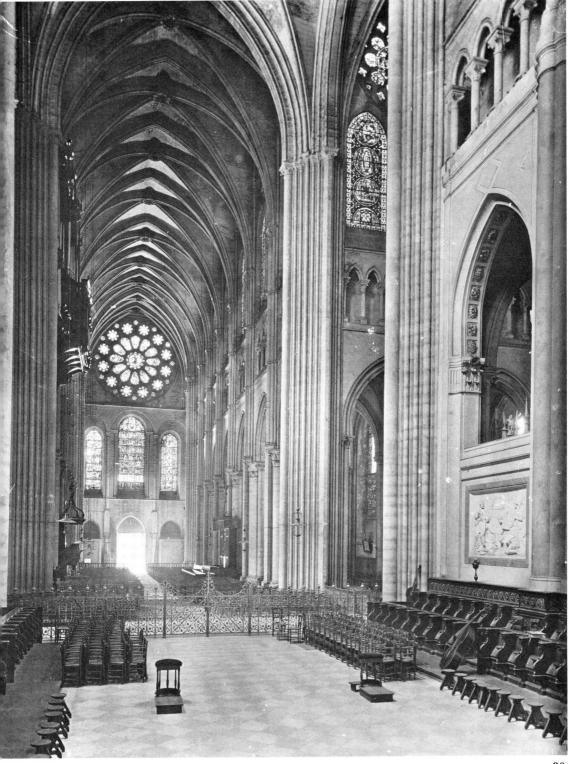

90.

Chartres Cathedral, North Portal. Ground level, from moderately close.
Chartres Cathedral, Royal or West Portal. Ground level, at short distance.
Chartres Cathedral, the Nave as seen from the Choir.

91.
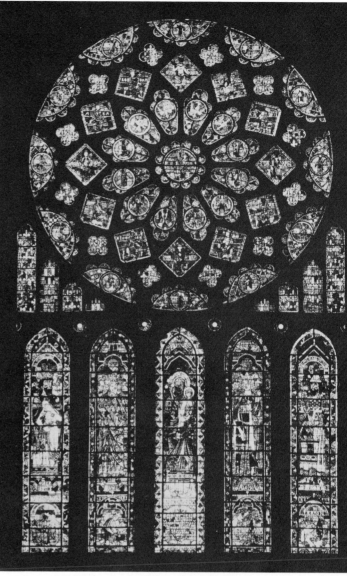

91. *Chartres Cathedral, North Rose Window: Glorification of the Virgin,* 13th century. **92.** *Amiens Cathedral, Signs of the Zodiac,* lower basement, 13th century. Ground level, from close at hand.

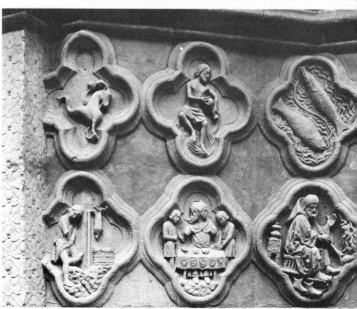

92.

this is limited, however. It can show facial configurations commonly associated with vigorous youth or tired, disappointed old age; it can show a frank, outgoing attitude or a somewhat cryptic one as in the *Mona Lisa*. But these may not be deeply characteristic of the person.

A portrait (in painting or sculpture) can be expressive in other ways than by suggesting emotion on the part of the person represented. The artist may suggest emotion in a more general way through qualities of line, color, shape, and otherwise, even if the person's face remains impassive. The drapery swirls of Baroque sculpture and the agitation with which van Gogh painted houses, trees, and rocks as well as human beings are expressive, but not necessarily of any feeling in the person or thing represented. Observers may attribute the feeling thus expressed to the artist himself or to the work as a whole.

Instrumental music has a very limited power to represent individuals without the aid of words such as titles, libretti, or program notes. It can suggest abstract types of action and feeling, and these in turn can suggest different types of personality, as in the light, quick step and high-pitched, lilting voice of a happy young girl or the heavy tread of tired soldiers. But to individualize such traits as those of a particular person—as of the composer himself or an imaginary character—is not easy. Music cooperates effectively with words and gestures in building more definite characterizations in opera and film.

Characterization in the drama tends to show itself through speech and behavior in general, rather than through what a person says about himself or what others say about him. The fact that people dissimulate and hide their emotions, perhaps appearing to be kinder or happier than they really are, is widely recognized. Cordelia, in *King Lear*, by refusing to declare her filial love, makes it seem that she has none. Through a long sequence of connected actions, the dramatist can show the subtle, individual peculiarities of each character as brought out by different situations and pressures. Narrative representation, as in the novel, is usually less dependent on action and dialogue for characterization, more on the author's own comments or his power to describe, as omniscient observer, what is going on in each person's mind.

The difficulty of directly revealing character in drama through ordinary conversation has led to various expedients, more common in the past than in an age of dramatic realism. One is the *aside*, a short comment supposedly not heard by other characters, but often revealing to the audience the speaker's thoughts and feelings. A *monologue*, delivered at some length by one person, may be an ordinary speech. A *soliloquy* is usually a kind of monologue, ostensibly spoken by the person alone, to himself or as an expression of his inmost thoughts, addressed to no one in particular. It may be an internal dialogue as expressing different desires or parts of his nature.

In general, characterization has become more complicated as part of the total process of artistic evolution. This includes more understanding representation of (1) the *complex* nature of human personality: the many functions and tendencies, innate and acquired, which it combines and organizes; its conscious, preconscious, and unconscious levels; (2) its *variation* from one individual, group, culture, or period to another: the many types and individual differences which occur in relation to age, sex, organic predisposition, and social environment, including a wide range of normal, neurotic, and psychotic types; and (3) its constant *change* within each individual and group: the normal life cycle of the human individual and the many deviations from it, as in cases of arrested or unbalanced development; typical and atypical patterns of growth and decline; brief, rapid, cyclical changes in a given individual, as in the daily alternation of work, play, and rest; specific changes of mood as resulting from internal or external causes; stable and volatile, impulsive types of personality.

While characterization in art has become more complex on the whole, it does not always emphasize complexity, change, or diversity. There is still a demand in art for simple characters, broadly sketched as examples of a single type, such as "boy," "girl," "man," "woman," "house," "tree," and "dog." These are common in art intended for children and for adults with naïve aesthetic tastes. They also occur in art for sophisticated adults, where characterization is deliberately minimized in favor of some other component, as in Post-Impressionist, Cubist, Fauvist, and Surrealist painting. In drama, the contemporary "theater of the absurd," as in works by Beckett and Ionesco, often uses characters who are flat abstractions or whimsical caricatures. Even in plays and novels where the leading characters are intricately analyzed and deeply revealed, as in *King Lear* or *War and Peace*, it is common practice to fill out the cast with a background or context of less developed, minor characters or anonymous groups. These may be important collectively. In *Cyrano de Bergerac* they provide different samplings of Paris life in the seventeenth century, toward which the protagonist displays the varied facets of his exuberant personality. In general, the evolution of characterization is shown in the ability of artists to conceive and portray com-

plex, variable, highly diversified persons when they wish to do so. This occurs more in drama and fiction than in visual art, especially in leading characters. One or two complex protagonists are often surrounded by a graded hierarchy of less and less fully realized figures, increasingly flat, vague, or shadowy as they fill more brief or unimportant roles in the story. Pictorial analogues to these occur in compositions with many figures by Tintoretto, Veronese, and Tiepolo, and in Rembrandt's early biblical scenes.

The criteria for judging realism in characterization differ greatly from age to age and culture to culture. Many kinds of character which seemed to ancient artists to be based on fact now seem fantastic, at least to a modern who accepts a scientific view of things. These include gods and demigods, angels, devils, imps, magicians, witches, saints, and other beings possessing supernatural or preternatural powers for good or evil. These are not always sharply characterized; indeed, they are often said to be outside the range of human understanding, but the attempt is commonly made from the standpoint of current beliefs and ideals. Prometheus as a Titan, friendly to man, was characterized by Aeschylus. Oberon and Titania, as rulers of the fairy kingdom, were given both human and superhuman traits in *A Midsummer Night's Dream*. Vishnu and Krishna had many characters in their different manifestations. The characterization of a divine or saintly personage, as in *The Imitation of Christ*, expresses not only current ideals but conceptions of what is real and possible. Insanity was commonly traced to demonic possession.

Degrees and varieties of unrealism in art can be distinguished in terms of how common, probable, possible, or impossible a certain kind of character seems to be. The monotheistic conception of God as omniscient, omnipotent, and perfect in goodness can not be realistically represented as a single character. The Jehovah of the early Hebrews, with his tribal favoritism, his angers and resentments, is closer to human nature. So are the Olympian gods of Greece, with their special interests and activities such as handicrafts and message bearing. Their faults and quarrels are all too human. Their immortality and miraculous powers are far beyond present human attainment, but steps can be made in those directions. Flying through space, distant communication, and the transmutation of elements are actualities of naturalistic technology, and more are being rapidly achieved. Some living individuals are known to have supernormal mental ability along certain lines, such as musical memory, chess, and mathematical calculation. Other human or superhuman types, which do not exist at present, may con-

ceivably emerge through biological mutation or eugenic control. Education and cultural fostering may produce individuals in future generations who far excel us, even without changes in the genes.

The portrayal of a god or goddess in primitive religion is usually rather simple. He or she personifies a single natural force or phenomenon, such as sky or earth, rain or lightning, or a single human process or activity, such as agriculture, war, or childbirth, or perhaps a set of several related ones. He or she may be a patron or protector of humans in that activity. We do not expect to find inner conflicts or inconstancy in the more primitive conceptions of deity, but they do occur among the Homeric deities, who have mixed feelings and quarrel with each other. As religious syncretism advances and a single god is made to combine the attributes of several earlier gods or local heroes, he is often portrayed with symbols of many attributes, such as the fire, drum, skull, and snake of Siva Nataraja. In the more advanced stages of religion, philosophic minds understand that the picture or statue is not meant as an actual likeness of the god, but as an aid to understanding and worship.

The earliest pictorial and sculptural representations extant, produced in prehistoric times by paleolithic artists, are conceptual, schematic examples of a few common types, such as cattle, hunters, and dancers. Early neolithic drawings of men and animals are often extremely simplified and barely recognizable. They are symbols of types rather than visual representations. This has been explained as a trend toward writing and away from the realism of paleolithic cave drawing, and also as showing a decorative interest. The subsequent history of visual characterization involves representing examples of more and more types, which are in many cases subdivisions of previously recognized types. Most Egyptian reliefs and wall paintings of persons, divine and human, emphasize the types to which the persons belong, even if an individual is named. Only those details may be given which are necessary to indicate the type, such as a king, soldier, tribute bearer, oarsman, fisherman, woman grinding corn, or the like. Variety develops partly through more and more subdivisions, such as tribute bearers from different countries. Strikingly individual portraits occur but are somewhat rare. Gradually, individual differences within a major type are recognized. Achilles differs from the usual warrior hero in being sulky, resentful, and uncooperative at first; Odysseus, in being crafty, resourceful, and persevering. In a strongly hierarchical society, status and occupational role were more important than personal idiosyncrasies.

In later centuries, Platonizing philosophers disparaged individual, local, and transitory qualities as mere illusions or "accidents," and stressed instead the eternal types. To show gods and nobles as serene and impersonal was to emphasize their lofty character as above the wear and tear, the wrinkles and blemishes, the passions and frustrations of ordinary life. Hellenistic art was more individualized, as in the famous statue of an old market woman. Rome deified its emperors and idealized their portraits.

Jungian psychology points out a list of archetypal patterns in folklore and civilized art, such as the great mother (in benign and terrible aspects), the eternal child, the old wise man, the god, the devil, and the shadow or dark brother. These are regarded as innate, abstract, empty predispositions in imagination and art, which each culture and individual artist fills out somewhat differently. From them arise the recurrent types of character in folklore, such as the Cinderella type, the dragon fighter, the sleeping beauty, the cruel stepmother, and the crafty animal.

Certain stock characters recur widely in the drama and fiction of different peoples. Many of these types are based on social class and occupation, such as the soldier and physician, the gentleman and his valet, the lady and her maid. Others involve common personality traits, as in the irate father, the ingenue, the henpecked, deceived husband, the braggart, the sly, thieving servant, and the virtuous wife. Modern types, and new names for old ones, are distinguished as the vampire, the gold digger, the butter-and-egg man, the tired businessman, the virtuous prostitute, and the like.

Many recognized types are based on famous historic and fictional characters: the Napoleonic type, the Oedipus and Hamlet types, the Joan of Arc, the Gretchen, the patient Griselda, the Don Juan and Don Quixote types. With any of these as a starting point, the modern author can proceed to show how a particular character differs from most examples of the type, or from the common conception of it. One way to do so is to combine several different types, not usually found together, in the same individual: e.g., Sherlock Holmes as the intellectual, scientific, musically cultivated, upper-class detective. To show how an individual belongs to more and more types which do not usually coexist is, in effect, to differentiate him from most other members of each of these types. It is to make him more and more unique.

In life or in art, a character can never be unique in all respects; he would be literally inhuman, an incomprehensible monster. Even so strange a being as Caliban has traits in common with other simpleminded, earthy, bestial humans. Most characters in drama and fiction exemplify some recognized psychological and occupational type, such as the intellectual or the man of action, the sweet young ingenue or the hardened woman of the streets. But here again, there has been some tendency to stress the deviant traits of members of any type, in order to avoid stereotyped, hackneyed writing. The plot and descriptive comments may bring out atypical, personal traits, perhaps only in degree, which distinguish an individual from others in the same category: e.g., the intellectual chorus girl; the prizefighter with aesthetic tastes. In reality, of course, each individual belongs to many types at once, and can be typical or deviant in relation to each of them. Some deviant types, such as the virtuous prostitute and the effeminate young man, are themselves recognized, persistent types in life and art.

The relation of a character to various recurrent types is often questionable from the standpoint of realism. Even when the story does not say so, people tend to regard a character as being supposedly typical of the group to which he is said to belong, e.g., a group based on race, color, or religion, as in Othello or Shylock. Even if the author explicitly states that the character is not intended as typical, some readers will insist on regarding him so. In the early, silent films, it was often taken for granted that Mexicans and Indians were criminals or wantonly aggressive. This was corrected in part by showing examples of different kinds of Mexicans and Indians. Middle-aged parents in America are commonly portrayed as tyrannical, possessive, and restrictive toward their children and as enemies of young love. Hence the common inference that all of them are so, and the cultural tendency to make the conventional middle-aged parent a symbol of such traits. On the other hand, in a free society there is some tendency to correct apparent oversimplifications, not necessarily for theoretical reasons, but to avoid a stereotype which may have become tiresome. Whatever the character or plot, people like to discuss whether all women, all Americans or Frenchmen, all big businessmen or all adolescents, are really like the one portrayed. An artist can portray a deviant individual such as Don Quixote or Hamlet without asserting that there are any others like him, but critics and the public tend to rank the work of art as great precisely on the ground that it *is* symbolic of some larger type or tendency in human nature. All great works of representational art are said to be symbolic in one way or another. Recognizing the broad, symbolic implications of Don Quixote, we tend to call other men with tendencies to naïve, impractical, exaggerated idealism "Quixotic." Names of

real or fictional characters such as Faust, Confucius, Judas, and Byron are thus adapted and used to describe other persons and traits.

Plot may seem consistent or inconsistent with any or all of the other factors in the story. If the author characterizes a certain person in a certain way early in the story—e.g., as extremely selfish and cruel—then makes him suddenly act in a very different way, the audience may protest. Authors who wish to give an effect of psychological realism attempt to prepare in advance for such a radical change by indicating adequate causes for it, perhaps by letting it be seen early in the story that this is the kind of person who is subject to radical changes and inconsistencies of behavior. Our conception of human nature has been widely extended by modern discoveries in anthropology and cultural history, revealing the tremendous diversity of behavior, thought, and feeling in different periods and cultures.

Increasing philosophic naturalism, including an interest in visible and mental phenomena, helped to motivate individualized characterization in the arts, along with particularized representation of animate and inanimate things and places. Euripides showed this interest and power of character analysis to a notable degree. So, in essay form, did Plutarch. They helped to develop characterization from the more abstract and general to the more concrete and particular. The Renaissance revived and advanced this tendency, and characterization remained a leading component in Western (including Russian) art through most of the nineteenth century. Outstanding along this line are Leonardo, Rembrandt, Velazquez, Cervantes, Shakespeare, Houdon, Stendhal, Dickens, Balzac, Tolstoy, Dostoyevsky, and Ibsen. Goya could reveal individual character sharply when he chose to do so. At other times, as in his bullfight pictures, he was content to show bull and toreador types in various aspects, and in the background the nameless crowd with individuals blurred together.

From a scientific standpoint, personality has been explored and described in general terms by various branches of psychology, including psychoanalysis and social, cultural, and individual psychology. What is called in science "individual psychology" has usually been more concerned with types of person, especially neurotic, than with individuals for their own sake or for their aesthetic interest. It tends to emphasize the general categories under which individuals can be classed (e.g., the hysterical and obsessive types). Its analysis of a particular individual is often limited by special theoretical or practical problems. Characterization in civilized art tends to be more free and diversified, noting any traits which seem interesting, distinctive, and significant.

To some extent, the scientific and artistic approaches to characterization have developed together, each accepting certain insights from the other. The debt of psychology to art is exemplified in such terms as "Oedipus complex." That of art to psychology and medical science is shown in the novels of Thomas Mann, especially *The Magic Mountain* and *Dr. Faustus*. But long before the rise of scientific psychology, literary artists were building complex, imaginary characters based on previous art and on their own observations of life. These called attention to traits and tendencies which psychology later found to be widely recurrent.

In the case studies of individual psychology and psychiatry, we find scientific examples of highly generalized characterization. They are simplified in reducing the description to a few traits which are most relevant to the purpose at hand. Case X or Mary Y is described mainly as an example of a type, such as "schizophrenic." The scientist tries to see through and beyond individual peculiarities, to discern the basic causal mechanisms which recur in all examples of a type. Such descriptions usually lack aesthetic appeal and fall outside the realm of art, but it is not impossible to develop them aesthetically. This is done through providing more specific details so as to build up a fuller, more "three-dimensional" portrayal of the individual. He is shown, not in isolation or by conceptual analysis alone, but in a context of life, usually in relation to other persons engaged in emotive situations and actions. He is made to show his nature in many ways, not merely in those few which lead to a simple diagnosis or basic classification, such as "tubercular" or "paranoid." Thomas Mann makes extensive use of scientific and philosophic resources for characterization, but supplements them with many descriptive details which a scientific specialist would consider irrelevant. He interrelates them systematically by showing how, in his opinion, bodily disease can lead to supernormal kinds of psychic sensitivity, including mystical experience.

Characterization tends toward science when it emphasizes traits which may serve to describe and explain an individual personality in abstract, theoretical terms, such as "normal," "neurotic," or "psychotic;" "impulsive" or "inhibited." It arranges its descriptive terms in some logical or theoretical order. Artistic characterization, on the other hand, is usually more diversified and apparently unsystematic, although the artist may have a systematic plan in mind. It can be made to reveal itself incidentally through behavior,

including speech and action, which is both significant of underlying personality structures and inviting to aesthetic contemplation. It can be expressed in vivid images and symbolic examples, rather than in technical terms or abstract, explicit concepts.

Scientific case studies of individuals have often been motivated by practical considerations, such as the pursuit of criminals or the diagnosis and therapy of mental disturbances. The Bertillon system of exact bodily measurements and standardized photographs was devised to aid police in identifying suspected criminals. It produced highly exact, systematic, visual and verbal representations, adapted for utilitarian rather than aesthetic functions. Fingerprints are now used for this purpose, along with precise verbal descriptions, as of height, weight, coloring, moles and scars, mannerisms, and relevant character traits such as "dangerous" or "fond of gambling." A poster of this sort, devised by the police, is an example of representational composition. It can guide visual imagination and recognition. It may have a high degree of diversity and unity. In the hands of a literary artist, its ingredients can be rearranged for aesthetic appeal, as by Truman Capote in his highly realistic and factual crime story, *In Cold Blood*. Graphs have been made of individual voices to show their distinctive character.

Other varieties of the scientific approach to characterization are adapted to the analysis and evaluation of any sort of person, or of any normal person beyond early childhood who can understand and use a certain grade of vocabulary. These are known as rating scales, personality profiles, and the like. While personal evaluation is always somewhat subjective and arbitrary, a step is made toward science by dividing and subdividing the problem into various aspects of personality and behavior. Different persons are asked to rate the subject (real or fictional) in regard to social adjustment, cooperativeness, emotional stability, variety of interests, extroversion or introversion, linguistic or mathematical ability, auditory acuity, and so on. As to each criterion, the subject can be rated from One to Ten, or as high, low, medium, or the like. A composite rating in terms of many such criteria is called a "profile." It may have practical uses, as in choosing persons for employment or promotion.

Obviously, the whole mode of thought and expression here is radically different from those common in the arts. The appeal is cognitive and practical rather than aesthetic. But in substance the various approaches to characterization may cover somewhat similar ground. Those of psychology tend to stress

overt behavior and commonly used criteria of value. Those of art are often the same, but in highly developed literature they tend to be more intuitive, imaginative, sensitive to nuances, mixed feelings, ambivalent attitudes, motivated actions, and unique combinations of these. They make more use of narrative and dialogue. So-called science fiction sometimes combines the two modes of characterization.

In either artistic or scientific characterization there is usually a gradation of emphasis on different traits, as to the degree to which they are deeply, permanently ingrained and influential. Some one characteristic, such as Macbeth's ambition or Iago's malicious treachery, is often made to stand out. But verisimilitude is sought, especially in the leisurely art of the novel, by adding other traits, changes, minor inconsistencies, perhaps hesitations and inward conflicts, to make the character seem more fully three-dimensional. Shakespeare and Stendhal often did this, but Dickens's characters are on the whole simpler, more completely good or bad; each acts more uniformly in accordance with a certain type.

The genesis of human personality has in recent years been traced in terms of organic and cultural evolution, as well as with regard to individual growth, maturation, and senescence. The mysterious realm of the unconscious, almost uncharted before 1900, has been partly explored with resulting light upon the various levels and phenomena of individual personality. Instead of being largely rational, the ego is now seen as impelled, often in different directions at the same time, by inner forces over which it has less control than had been supposed. At the same time it is recognized that some persons are comparatively simple, homogeneous, and consistent inwardly and outwardly; others, the opposite. Social environment can force some persons into a uniform mould and arouse in others far-reaching spiritual conflicts.

All persons change in the course of years in ways that are variants of the stages in a normal life cycle. Some age more rapidly than others, on the whole or in certain respects. Admirable characters are corrupted and bad ones suddenly reformed, for no very obvious reasons. Some persons remain for years on the verge of insanity, or subject to terrible emotional pressures, but do not break down. Others seem to have little innate ability to resist adverse pressures or overcome obstacles. Neither art nor science understands these phenomena very thoroughly as yet. The phenomena themselves have been described to some extent by psychologists and illustrated in concrete images by artists.

In fiction the author is at liberty to make his char-

acters interact without his explicit intervention. He can pause for personal digressions as Thackeray and Trollope liked to do, and in his own right analyze his characters, their problems and environments. A certain character can persistently express the author's own attitudes, or these may be divided among several characters. A character can analyze and explain himself in speech, and the story may prove him right or wrong, frank or hypocritical, self-understanding or self-deceiving. Speech is a kind of action, but not necessarily to be taken at its face value. Moreover, the actor and the stage director can make it mean different things.

The recent tendency to avoid or minimize plot, action, and other common components in representation may coincide with greater emphasis on characterization and more detailed development of it. However, this does not always happen. Any component may be emphasized. In some styles of painting and sculpture, the portrayal of character is highly developed, while in others it is sacrificed to visual effects of form and design, as by Cézanne and Matisse. This can happen even when an individual face provides the ostensible subject and framework.

Along with the recent reaction against representation in painting and sculpture has come a partial reaction against all complex, detailed characterization. In keeping with the drastic simplification and surrealist fantasy of other arts, recent drama and fiction often cut it down to abstract stereotypes and caricatures intended to satirize the evils of civilization and of life in general. Psychoanalytic fiction and drama tend to emphasize the role of unconscious factors in personality, while the sociological approaches stress that of the social order and its inherent class conflicts.

6. The representation of a scene or situation.

Representation can be developed by combining two or more objects into a scene or situation. A *scene*, such as a landscape with figures or a city street, involves some spatial connection among the objects, so that they seem to be existing together in one area and to be perceived together in a single field of vision. A group of figures in front of a landscape background can thus combine to form a scene, whereas a group of separate, detached pictures on a page, even if dealing with related subjects, as in a Sears Roebuck catalogue, does not do so. The spatial connection does not have to be realistic; it can be of souls and demons in Hell. It does not have to be completely integrated;

a few sketchy strokes of brush or pencil may suffice to make the grouping recognizable and indicate its outlines.

While primarily visual, a scene may be represented in terms of several components: e.g., a battlefield after the battle as a scene of grim desolation; a peasant dance as a scene of carefree youth, rhythmic motion, joy, and mirth.

A *situation* may be manifested as a scene, but it is not necessarily visible. As a configuration among factors of some sort, it is usually temporary and of either short or long duration. Most of the situations represented in art involve human or other sentient beings with different and partly opposed desires and emotional attitudes. Inanimate factors also contribute to make a situation, as when drouth and famine cause suffering and social unrest.

Some scenes and situations are comparatively static; others are dynamic, mobile, and dramatic. There can be a situation of complete inactivity and torpor in a small town on a hot afternoon, followed by a state of alarm and excited movement as robbers approach. A situation can be immobile but tense in restrained emotion, as in the moment after a challenge to a duel. Any situation can be described in words; not all can be represented pictorially. The situation may consist entirely of concealed and partly unconscious, conflicting desires within individual minds in a family group. Usually in such a case at least a few outward expressions exist.

Paintings and sculptural reliefs of scenes are often comparatively static in both presented and suggested factors. Take, for example, a Cézanne still life of apples and dishes on a table. They are not actually moving or shown as if moving. This does not exclude the possibility that relations of color and shape may suggest, to a sensitive observer, slight advances, recessions, and tensions among the objects portrayed. The same is true of many landscapes in painting, photography, or relief. They are organized suggestively in three dimensions of space, but the rocks and vegetation they portray do not represent actual motion. Other landscapes, though immobile as paintings, represent things as actually moving, as if the appearance of waves on a beach or trees in the wind were stopped and frozen forever at a certain moment. This may suggest what the next movement would be, as when the wave crashes or the running deer takes the next step. The observer may tend, through empathy, to identify himself in imagination with certain objects, whether these are represented as moving or not. In the landscapes of Rubens and van Gogh, expressive brush strokes tend to suggest inherent power and im-

manent movement in houses, hillsides, and tree trunks as well as kinesthetic tensions and relaxations, desires and emotional qualities, as in the gloom and threatening force of an impending storm. Pantheistic poets such as Wordsworth felt all nature as endowed with life and feeling.

A group of represented figures, divine or human, may be organized in two-dimensional space only, or with slight suggestions of a third dimension, of movement, or of psychic change. An extremely static quality in anthropomorphic figures tends to suggest eternal, monumental grandeur instead of mutability in time and space. It is found in hieratic arrangements such as those of Egyptian gods and Buddhist mandalas, with many Buddhas and Bodhisattvas arranged in circles and squares so that they do not clearly represent a natural scene. Hieratic representation of this type was common in Byzantine painting also, but gave way in the Renaissance to the portrayal of dramatic scenes and situations in deep, naturalistic space. These were occasionally found in medieval pictures, but were less highly developed. The Italian Renaissance developed them in terms of linear and atmospheric perspective, scale, overlapping, viewpoint, and other devices. Also included was the naturalistic representation of solid human and animal figures, trees, clouds, vegetation, architecture, ships, and water at rest or in motion.

Sculptured relief was occasionally able, as in the Ghiberti doors in Florence, to represent a scene in deep space. This was done under considerable difficulty, since actual cast shadows, by lamps or sunlight at different times of day, tend to interfere with the suggested solidity of objects and their apparent regression in space. A monochrome surface also lacks the aid of color variation in suggesting perspective.

Some of the objects commonly portrayed in Renaissance perspective were humans, animals, and supernatural beings moving in relation to one another or in parallel directions, as in Michelangelo's *Last Judgment* in the Sistine Chapel. This gave the illusion of a mobile, dynamic scene or situation, involving causal as well as temporal development, often with conative attitudes among the characters. Movement was usually motivated, as in a scene of hunting, love, or battle. Such a situation is dynamic and dramatic. Scenes of this kind were produced in the *Laocoön* sculpture of men struggling with serpents, in Leonardo's *Last Supper*, and in Rodin's group *The Burghers of Calais*. Even an expressive look, such as that of the dying Caesar toward Brutus, may indicate a dramatic situation. When characters in a picture seem to pay no attention to each other, as often happens in a

Picasso group of acrobats, one kind of dramatic unity is lessened; but instead, the picture may suggest a situation of mutual indifference and apathy, each character being shut in with his own thoughts. This, too, can be dramatic in its own way.

Much of the ingenuity of European painters and sculptors until the twentieth century, following the tradition of late Greek and Roman art, was devoted to representing motivated action and dramatic situations in the static visual arts. Drawing, painting, and sculpture served to illustrate and intensify in vivid images the situations described in Biblical and Classical literature, hence the long-accepted motto *Ut pictura poesis*. This did not mean that either art was necessarily the handmaid of the other; each had its distinctive potentialities, and later on the differences between poetry and painting were emphasized. Part of the task of the visual artist was to choose a moment, and a configuration of active figures in that moment, which would forcibly suggest several successive moments in a dramatic action, usually at a climactic or significant point in the story, a "pregnant moment." He could represent characters in such a way as to suggest the thoughts, moral traits, and ideals implied by their actions.

Mobile presentation, as in fiction and the theater arts including cinema, still further extends the possibility of representing many scenes, situations, and stories in a single comprehensive framework. (It will be remembered that literary narrative is mobile whether read silently or heard aloud; it presents a constantly changing sequence of verbal stimuli.) Drama, as contrasted with epic poetry and prose fiction, tends to compress and intensify action and emotion, and to move quickly from one situation to another. The novel, being susceptible to slow, deliberate reading, gives more opportunity for the deep analysis of a complex situation, as in Marcel Proust and Henry James. A main situation in drama is seldom static very long, but its general outlines can persist through many incidents while the details change. This may be true of an enveloping situation, such as the long siege of Troy, or of a particular one such as a husband's persistent jealousy. An unjust social situation can last for centuries. These facts can be described by distinguishing between inclusive situations and subsituations, subordinate or transitory ones, that is, included in the larger framework.

Because of the importance of situations in drama and fiction, aesthetic theorists from Gozzi to Goethe, Schiller, and Polti have discussed the number of possible ones. Gozzi, a Venetian and author of the play *Turandot*, found thirty-six, but later writers have

listed many more. The number depends on how one names and classifies them, as well as on how wide a survey one makes of world literature. Each of Polti's is named abstractly, sometimes in terms of a single incident or trait characteristic of one of the protagonists, such as "Madness," or a single crucial incident, such as "Discovery of the Dishonor of One's Kindred." Each main type of situation is divided into several variants, depending on the types of character involved and their attitudes or actions. Thus "Supplication" includes "Fugitives Imploring the Powerful for Help Against their Enemies" and "Hospitality Besought by the Shipwrecked." The list could be expanded indefinitely by recognizing combinations of complex, ambivalent, or changing attitudes in terms of modern psychology. Most of the conventional types refer to some complication which is resolved in the rest of the story.

One should notice the situation with which a story begins, that with which it ends, and others along the way. No complex story, such as the *Odyssey* or *Medea*, can be adequately described in terms of a single situation or motive.

7. *The representation of incidents and stories.*

An *incident* is an occurrence or short sequence of events, having a form of its own somewhat distinct from the events which preceded and followed it. The word is applied especially to happenings which are somewhat unusual, not matters of regular routine. As contrasted with the larger continuum of events of which it is a part, an incident is usually regarded as of minor importance and perhaps as unexpected or unplanned, but important events are sometimes also called by that name. The assassination of a king by a foreign citizen may create an international incident. An incident involves at least a slight change of situation for those directly concerned and perhaps for many others in a widening circle of repercussions. It involves some temporal or causal connection. Except in cases regarded as magical or miraculous, an incident is usually shown as causally continuous with previous and subsequent natural events, but these may not be represented in detail.

No sharp line can be drawn between "incident" and "story." A short series of events containing one or a few changes in situation may be called by either name. In this discussion we shall understand an incident as one of the smallest and simplest compound

units of which a story of any length can be composed. It is "compound" in combining several component traits, e.g., of action or kinesis, motive or conation, and perhaps of emotion and reasoning. It may be represented visually, verbally, or otherwise.

A *story*, then, is a series of causally related events involving at least one incident or change of situation and usually more. The events may be overt actions, thoughts and experiences, or both. Stories deal mostly with particular persons and actions at particular times and places, rather than with collective actions or general trends and conditions, but all of these may be included to some extent.

The word "story" can be applied to the events themselves, real or imaginary, or to the representation of them in some artistic medium. A story is usually but not necessarily fictional; one can tell the story of the discovery of America. But stories which lay claim to factual truth are usually called histories or biographies. Historical and biographical novels are a combination of fact and fiction. They often strive for accuracy in describing general conditions, major social trends, types, and historically well-known individuals, but are frankly imaginative (though not necessarily contrary to fact) in describing less famous persons, conversations, and detailed events. Histories and biographies are usually less able to give these. Hence an account of events which features them, however truthfully, is apt to read like fiction. A historical novel usually gives the impression that its characters and events are similar to those which actually occurred at the time and place.

To qualify as a story, a sequence of events must be internally connected to some extent in terms of persons involved, place, time, and causation. This provides some unity of action, but no specific type or degree of unity is implied in the definition. An author may deliberately produce an effect of partial disunity and discontinuity, as in telling of a dream or of psychotic thoughts and ravings. Even this would have some continuity as such. Any degree of inner continuity can be provided by retaining or returning to certain characters, scenes, objects, motives, conflicts, moods, and kinds of action throughout successive situations. Some diversity in all these respects is also customary.

To be a story, the series of events must have some approximate limits in space, time, and action. It must be somewhat detached from the total context of previous, concurrent, and subsequent events, real or possible. This context may remain as a separate, enveloping background. The story must have a time span,

long or short, and a beginning, middle, and end. This is not a law or rule, but a composition not possessing these traits would probably not be called a story. It does not imply that the events themselves were sharply detached. An author may wish to emphasize that things went on after the end of the story in much the same way as before and during it. Most stories have a fairly definite scene or locale and one or more fairly continuous action threads. That is to say that one or more characters pursue a certain course of motivated action throughout most of the story. Meanwhile, other characters may pursue a different but related course, so that the action threads oppose or reinforce each other.

A story can be represented through verbal narration, dramatic text, or a combination of both, as literature to be silently read. It can also be directly enacted on stage or screen as a work of theater art. Ordinarily the dramatic text provides the main framework of the story in the form of a play which is suited to guide speech and action. Narration and drama do not necessarily represent a story, although they usually do; they may only build up an active situation without incidents or changes. Narration may recount detached incidents which do not combine into a story.

Although we commonly speak of "presenting" a play, it is impossible to present it completely, in the strict sense of "present." Like most works of art, it contains presented and suggested factors: the former comprising those images and configurations which can be directly sensed, the latter comprising all the meanings and associations which they tend to stimulate in the minds of a willing and suitably educated audience. Thoughts and motives in the minds of the characters can be only suggested by the presented sights and sounds. In a stage enactment, one sequence of events is presented by the actors for the audience to see and hear. As this sequence proceeds, the audience interprets it to some extent as one occurring in the lives of a different set of persons at another time and place. The presented, enacted process and the suggested, imagined one are merged to some extent by the audience's projection of its illusions and guided fantasies upon the actors on stage. This aesthetic response, as a willing suspension of unbelief, is seldom complete; the audience experienced in such matters is well aware that the make-believe activity is not the real one it pretends to be. The actress portraying Desdemona is not really killed. The enactment of her murder is real as such. The supposedly real event is imaginary. It is the subject or material of

the story, that which the story or play represents. It can be only suggested; even if the persons represented really lived and the events occurred as enacted, they are suggested factors in the play.

A person may enact himself, and in this sense any sequence of externally perceptible events, such as a coronation or a revolution, can be directly presented to onlookers. A juggler may perform his tricks before an audience. This belongs under the general heading of theater art, but it contains no representation unless the performer tries to suggest someone else or some events (perhaps his own previous actions) other than what he is doing now. Someone represented in a play may appear in person at the end of it, but even so, he is different from the imaginary character represented therein.

8. Persistent types of story sequence in various arts.

Many persistent literary types are devoted mainly to narration. They are defined in various ways. We shall understand their names in the following senses, except where a special meaning is indicated.

The classical *epic* is a long narrative in verse, usually dealing with heroic deeds and adventures over a comparatively long time. It may cover large areas of space, as in the *Odyssey* and *Aeneid*, and involve many persons, major and minor. Its usual setting is that of war and it often involves the intervention of gods, oracles, and other supernatural agencies. It is serious in tone, dignified, and comparatively unified. The epic usually begins with an invocation to the Muse and employs extended similes. The Greek tragic drama, usually in verse, is distinguished from the epic by Aristotle as representing a comparatively simple, unified action, occurring in a short time and one locality. By extension, any long story of heroic deeds, in verse or prose, can be called an epic. Often it results from the combination of many older tales and cycles of tales involving heroism or cleverness.

A *ballad* is a shorter narrative in verse, usually with a refrain and suitable for singing. It often tells a sad, romantic, or sentimental story. The *dramatic monologue*, as treated by Browning in *My Last Duchess*, is concise and stresses character. It has only one direct speaker but implies a listener. It combines dramatic and narrative features. Though very different in tone and subject, Mallarmé's "The Afternoon of a Faun" is also a dramatic monologue in form. Keats's "La Belle Dame sans Merci" is in the form of a brief drama in

verse, a conversation between the knight at arms and an unspecified inquirer. Coleridge's *Rime of the Ancient Mariner* begins as a dialogue but soon becomes a narrative of preternatural events. Victor Hugo, Tennyson, and Masefield wrote short verse narratives of different kinds, short and long. Stories of failure, with mediocre or contemptible protagonists, are usually in prose, but T. S. Eliot has introduced bits of narrative and satirical description in such poems as *The Hollow Men* and *The Love Song of J. Alfred Prufrock.*

The *novel* is defined in various ways. Broadly, the term is now applied to any long, prose narrative, but in a narrower sense it is restricted to those which do not rely on supernatural agencies, magic, or miracles to explain events, and which pay some attention to psychological and social factors. Dickens's *David Copperfield* is an example. A *tale* or *romance* is a narrative in prose or verse, usually involving love and adventure, and characters and events outside of and different from those of ordinary life. It may or may not introduce supernatural agencies, magic, marvels, and legendary events. In this sense the ancient prose narratives, *Daphnis and Chloe* (attributed to Longus) and *The Golden Ass*, by Apuleius, are prose romances rather than novels. Lady Murasaki's *The Tale of Genji* (11th century) is on the borderline. It has much psychological analysis but introduces supernatural elements here and there.

A *fable* is a short story, usually dealing with marvelous or supernatural events and pointing to some useful or moral precept. *Fabliaux* are short stories in verse, usually dealing with lower-class characters and coarse humor in a somewhat cynical way, especially in regard to women. A *fairy tale* involves minor supernatural beings and magical events, usually in prose and based on folklore. An *allegory* is a long or short story in narrative, dramatic, or pictorial form which symbolizes abstract ideas or beliefs, usually of a serious religious, philosophic, or moral kind.

The term *short story* can be applied to any brief prose narrative, especially one which is compact and fairly complete as to incident and characterization. An *anecdote* is an extremely short narrative, usually in prose and recounting one simple incident or situation; sometimes it is only a witty play on words. An *extravaganza* is a very free literary fantasy in prose or verse, narrative or dramatic, often involving burlesque, parody, or whimsical exaggeration. The term "fiction" is now usually applied only to *prose* narratives, long or short. This includes novels and short stories, tales and romances, but not epics or ballads.

Verse is easier to memorize than prose. It is more characteristic of the age when literature was performed and transmitted orally by traveling bards and minstrels, although such literature was written down in later times. Verse was used especially for tales involving an emotional account of noble characters and heroic deeds. Prose can achieve these results, but is also used for stories of commonplace events, common people, and ordinary life.

Fiction and drama are both concerned with representing stories, but fiction emphasizes *narration*, in which one or more characters tell in words what has happened, is happening, or will happen, including what various persons do and say. It usually includes some dialogue, or direct quotation from characters, perhaps in dramatic form. In *dramatic enactment*, the presentational framework is usually set by action and dialogue. Pantomime by itself can enact a story. Narrative passages may occur in drama, but usually in a brief, incidental or accessory way as part of the dialogue.

When a dramatic text is read silently, the reader imagines the action and speech, but they still provide the main *transmissional framework*. The *supposed actual framework* consists of the events in real or imaginary life outside the work of art, which the transmissional framework calls to the reader's or observer's mind.

Exceptional types occur, as when the narrated portion of a play is more inclusive. A character may start telling a story, but what he is about to tell is then enacted. He may sit in the light at the start, at the side of the stage; then the curtain rises and the light shifts to a group of characters enacting the events he was about to narrate. This gives a detailed dramatic framework within the simple, inclusive, narrative one. The narrator may be a character in the play, perhaps as he was years before, or an author reading a story which then comes to life. Narration and drama may thus alternate.

In addition to the verbal types of narrative and drama, several other arts and media are commonly used for representing stories. Among them are the *still picture sequence* and the *sculptural sequence*. A single picture, drawn, painted, or photographed, can suggest an incident or story indirectly as a sequence of events preceding or following the situation directly shown. Different places in a single picture can show the same person or persons, supposedly at different moments in a story, performing different actions. This type was popular in the Middle Ages and early Renaissance. The sequence of still pictures, now most

employed in the newspaper comic pages, gives more scope for representing successive moments in a story. Temporal order is determined by the convention of looking at the pictures in a spatial order as from left to right on the top horizontal line, then the same on each successive line down. One famous example of the still picture sequence is the Bayeux Tapestry, which tells the story of the Norman invasion and the Battle of Hastings. The Apocalypse tapestries at Angers are narrative on the whole, but do not tell a single, continuous story; they are illustrations for a book which is partly narrative in the present, past, and future tenses.

Examples of the *sculptural sequence* are commonly found in reliefs of the Stations of the Cross, placed in chronological order around the interior of a church, and in many sculptural friezes in temples. The Parthenon frieze of a procession represents a dynamic situation or continuous process.

In the *dramatic or mimetic dance*, in *pantomime*, in *marionettes, puppets*, and *shadow plays*, and most of all in the *film*, actual presented motion allows great scope and means for acting out a complex story in temporal order.

Instrumental music without the aid of words is relatively weak in storytelling. As representation, it is usually rather abstract and generalized. However, it forms an active supplement to words and visible actions in dramatic enactment, as in opera, and also in dramatic monologue by a solitary speaker. The attempt to tell long stories in music alone is rare. In such works as Richard Strauss's *A Hero's Life*, which ostensibly do so, the audience needs the help of printed program notes or other verbal aids for detailed interpretations. Hence the term "program music." Even with this aid, the effect remains somewhat generalized—a typical process rather than the acts of a particular man. Program music is sometimes called "descriptive," but instrumental music does not describe in the usual sense. It can suggest other sounds by mimesis, and these auditory images (as of a storm or battle) can further suggest characters, scenes, situations, and incidents. But experiments have shown that, without verbal aids, most ordinary listeners do not agree on the representational meanings of music. Expressive music is something else. Without developing representation, instrumental music can express or suggest a great variety of moods and emotional attitudes. But here again, the expressions of feeling are usually somewhat vague to the listener not equipped with a program or a score containing specific directions.

In verbal storytelling, all the elementary components may be included, most of them suggestively. The developed components most used for this purpose are: motivated action, which may be further developed into plot; dialogue, characterization, diction, setting (physical, social, and cultural), emotional tone or mood, and viewpoint.

On the basis of which components or component traits are most emphasized, persistent types of story are distinguished: for example, action stories, love stories, ghost stories, detective stories, mystery stories, and horror stories. Types are also distinguished in terms of the intended function, such as didactic or moral tales, or in terms of the kind of person addressed, such as children's stories.

9. Story frameworks and compound factors.

Action, or motivated movement, usually gives one of the principal frameworks. It may or may not be developed into plot. If action breaks out of automatic routine or disrupts a static situation, it tends to produce an incident and, if further developed, a story. Action in drama and fiction is somewhat analogous to action drawing in the pictorial and graphic arts, and to linear development as a visual component. Both dramatic and narrated movements usually involve a change in pose or linear contour as well as of location. Melodic line in music is also related to visual line and action. All of these developed components are architectonic or especially form-giving.

There are kinds of story in which *characterization* gives the main framework. Meditative, analytical authors such as Henry James and Proust often dwell upon the psychology of an individual and emphasize it throughout the work. There may be little overt action, that little serving mainly to reveal different facets of personality. Particular actions at different times may not be clearly bound together into action threads or plots. If a static situation persists or recurs, as in Chekhov's *Uncle Vanya,* it may consist largely in the way different characters affect each other personally: attracting or repelling, irritating or soothing. Attempts by one or all to break away are ineffectual. Goncharov's Oblomov, in the novel of that name, outdoes Hamlet in paralysis of will; he spends a good deal of his time on a couch, thinking of things he should or might be doing. A particular character or group of characters may be shown as typical of the whole social situation or of people in a certain region

or ethnic group. Local color, folkways and traditional modes of thought and behavior in a certain setting may thus predominate over action in building a story.

The component which gives the basic framework is not necessarily the most important or emphatic in the whole. From the standpoint of interest, originality, and detailed development, the accessory factors may stand out while the framework is merely a scaffolding to support them. In the musical comedies of Gilbert and Sullivan, the plots are regarded by many critics as rather banal and trivial. The humor, light music, and versification receive more development and more attention from the public. Yet the plot, such as it is, provides the main framework of the whole.

The analysis of story form, as of other artistic types, requires attention to the relations among components. What is the relation between framework and accessory components? Between action, plot, characterization, dialogue, geographic and cultural setting, stage scenery, and music, if any? As to each, one may ask whether it is emphasized for its own sake or used only as a means to developing some other component.

Characterization may be consistent or inconsistent with plot and action. If the author wishes realism, he may have to show how certain apparently incredible, unmotivated acts were really motivated by hidden traits of personality. But he may forego consistency of character entirely, deliberately making his characters do incredible things for the sake of fantasy or humor. The great modern interest in human personality and individual differences has resulted in many literary works (such as the novels of Balzac, Stendhal, and Dostoyevsky) in which character is one of the main factors. Plot can be merely a means of setting the protagonist in motion and showing how he behaves under different pressures. In Dickens (e.g., *The Pickwick Papers*) hosts of minor characters, not vitally concerned with the plot, are developed a little as distinct individuals and exhibited for their humorous, pathetic, hypocritical, or other traits.

The persistence of a certain desire or conative attitude in one or more characters tends to unify a story and draw together various action threads. Desire for the Golden Fleece helped to motivate the quest of the Argonauts; the Holy Grail is a focal point in *Parsifal*. Such a concept as the Grail is a symbol, originally mystic and supernatural. As a factor in aesthetic form it is compound, involving visual imagery and emotional associations based on unconscious archetypes and Christian legends. Likewise the persistence of a certain dominant mood or emotional tone can serve to hold together the parts of a story. Two or more such moods can be contrasted as in *Parsifal,* where Christian asceticism, humility, and piety dominate some parts while pagan sorcery and sensual pleasure dominate another. Such contrast serves to heighten both emotional tones.

Dialogue as a story component is of the highest importance in spoken drama on the stage. It is only a little less so in cinema (where it competes with action and local color) and in fiction (where it competes with indirect narration). It cooperates to a varying extent with other components. In Plato's dialogues it is one of the dominant factors and occasionally gives a touch of dramatic or narrative form to the composition, but Plato is interested more in exposition by dialectical means than in telling a story, and dialogue is a means to that end rather than an end in itself. Plato represents few characters, incidents, or situations except that of discussion between Socrates and others. Voltaire, Oscar Wilde, and George Bernard Shaw emphasize dramatic dialogue, at times for witty wordplay, at times for theoretical disquisition, and at times to advance a plot. Shakespeare uses dialogue for many purposes: not only to advance the plot and characterization, but to generalize in brief expository passages and to develop the musical, thematic relations of word-sounds. Dialogue is commonly used to show the nature of a person as educated or illiterate, aristocratic or plebeian, native or foreign in accent, boastful or modest, gentle or quarrelsome.

One of the many resources which cinema offers to the storyteller is the ability to present (not merely describe) as many different *physical settings* as he wishes. He can linger at one spot in a desert, forest, or city street, move through it at any speed, or shift rapidly from one place to another. He can subordinate all other components for a while to the visual effects of scenery in color, or can use the setting as an adjunct to action and character, for example, in showing how the slum tenement of one person and the flashy, ostentatious palace of another express their tastes, influence their conduct, and help to mold their character. To show each episode in a story as happening in a distinctive environment can reinforce the other components, whether the total effect desired is one of realism, fantasy, or otherwise.

When several arts cooperate as developed components in representing a story, each of them tends to form its own framework or set of frameworks. They vary greatly as to relative influence. Each of the pictorial illustrations of a novel has its own framework as a picture, but in sequence and in subject matter they tend to conform to the verbal text of the narrative, especially when this emphasizes action. Each pic-

ture selects a scene, situation, or incident from the story and conforms on the whole to the verbal specifications for it, although the pictorial artist may exercise considerable freedom in imagining its details. The order of insertion in the book is usually fitted approximately into the order of the printed text. This does not mean that the verbal component is necessarily more valuable, but that it has more influence in determining the arrangement of details. It acts as main or basic framework while the illustrations act as subordinate or accessory frameworks.

Much the same relation occurs in the opera: the dramatic text or libretto provides the main framework of action and dialogue while the music, ballet divertissements, costumes, changes of scenery and the rest are fitted into it and conform on the whole to its specifications. In short compositions the relation is sometimes reversed. The music of a song may be composed first and provide its own, firmly organized framework, to which the lyricist modestly conforms. In opera the libretto usually comes first, but words and music, composer and librettist, tend to influence each other. In any case, there must be some conformity between the two component arts, in order that the syntax and syllables of the text will be singable, and so that the orchestra and singers will proceed synchronously. When the emphasis in operatic music shifted from design to expression, as in Wagner, there was still more tendency for the libretto to determine the main outlines of musical sequence, even though the music was considered more important by composer and public.

In the hands of a powerful and imaginative illustrator, such as William Blake or Gustave Doré, pictures tend to develop their own complex, self-sufficient frameworks. This is especially true in the case of Blake, who (like Wagner) created in two of the participating arts. Yet even there the verbal sequence tends to determine all the other sequences.

10. Varying degrees of emphasis on factors in representation.

In describing a work of representation, it is not enough to say what factors are included; one should note the relative extent to which each is developed (by presentation or suggestion) and the relative emphasis placed on each, as by greater size, intensity, position, contrast, complexity, or other means. In a painting of apples on a table or figures in a landscape, or in a story of struggle for power, certain compo-

nents and certain component units are usually emphasized. It is hard to avoid this, even when the artist tries to keep things at a dead level and attract only marginal attention. A bright red, solid apple or an apple with contrasting colors tends to attract more attention than a flat, dull, gray-green one, and a large figure in violent action tends to be more emphatic than a small, quiet one. Likewise in a complex story, some characters play leading roles and others subordinate ones.

In ordinary perception we keep shifting our attention to different points and areas in the total perceptual field, to various objects, sounds, and perhaps odors and tactile stimuli. A work of art provides us with a prearranged set of graded emphases. These tend to make us perceive the work of art with degrees of attention corresponding roughly to the degrees of emphasis in the work itself. At the same time, we are free to redistribute our attention differently, in accord with our own inner impulses, interests, and purposes. In looking at a painting, statue, or building, one can easily focus one's attention on a spot which the artist left inconspicuous. In the temporal arts this is more difficult. Complex groups of stimuli come to our sense organs with such speed that we have little time to rearrange them, and we tend to accept the prearranged hierarchy of emphases, at least in the first hearing or reading. Afterwards it is easier to seek out the subordinate details, such as minor characters and events whose full import was not clearly grasped at first.

Selection and emphasis are made on many different bases: for example, of (a) a shape, gesture, speech, or action which seems most interesting, significant, or emotionally moving; (b) one which seems most typical of the kind or class, thus helping the observer to recognize it as a member of that class, such as a deer, a pine tree, or an angel; (c) one which helps to distinguish an example surprisingly from other members of the class; or (d) one which helps to explain a situation or develop a plot, as by showing the effects of previous actions and pointing to their further consequences.

In drama and fiction, the leading characters are traditionally called *protagonists*. This refers to the importance of their roles in the story at hand, though not necessarily in the world at large, for a king or god may appear only once, in a static pose, while a slave or beggar gets most of the dialogue, action, and characterization. In the art of aristocratic ages, lower-class characters seldom received much respectful treatment, although they often appeared at length in comic parts. Modern protagonists may include a

youthful hero and heroine, a villain and sometimes a villainess, but it is not essential that some of the characters be good and others bad. Even in Greek tragedy, the conflict was sometimes between characters more or less equally good, but all in the grip of fate and set against each other by powers over which they had little or no control. Having characters in strong contrast morally is one way of arousing sympathy, identification, and suspense on the part of the audience, and these aesthetic responses are often desired; but it is also possible to have the audience identify with all or none of the characters or with different ones in succession.

In Greek tragedy, the protagonists were few but gradually increased; they stood out in contrast with the more impersonal chorus, which might express the attitude of anonymous citizens or of humanity in general, observing and moralizing on the actions. In opera, the star parts exemplifying young love are usually given to soprano and tenor voices; baritone and bass parts often go to villains or to elderly kings or fathers. Traditionally, prominence in a narrative usually goes to active characters, whether active for good or ill: to persons with strong desires (such as Don Quixote or Becky Sharp) who keep events in motion. In modern stories a relatively inactive character may be emphasized, as aloof or above the battle. Shakespeare, Balzac, and other modern masters of the complex plot brought in more secondary characters than appeared in ancient drama and fiction and developed them more as individuals. There were some important secondary characters in the Greek and Roman epics, such as the faithful Achates, but the spotlight was on the principals most of the time. Secondary ones such as Polyphemus and Circe in the *Odyssey* or Dido in the *Aeneid* loom up as protagonists for a while, mostly through their relation to the hero, then fade out of the story. In Shakespeare, especially the comedies, both main and secondary parts are often given definite characters. The youthful lovers are sometimes more stereotyped than unusual characters such as Lady Macbeth, Falstaff, and Prospero. On the other hand, while Helen plays a symbolically major role in both Troy and Faust legends, as the "face that launched a thousand ships" and the object of many men's desires, she is seldom developed very far as a human personality.

In a work as vast and complex as Tolstoy's *War and Peace,* one can grade the many characters into primary, secondary, and tertiary levels. The same can be said of Balzac's characters in the *Comédie Humaine* as a whole. Both these writers avoid confusion by maintaining a certain scheme of relative importance on the whole, but this is flexible and the emphasis shifts frequently. Napoleon is important on the plane of world politics, but not in the context of Russian peasant life, and even as monarch he cannot cope with a Russian winter. Unlike the painter or sculptor of a static form, the novelist or dramatist can keep shifting the hierarchy of importance for contrast, as the composer shifts it among voices and orchestral choirs.

At or near the bottom of the hierarchy, in a complex play or narrative, one may find vague images which are individualized only slightly or not at all, such as a waiter who fills a glass and then disappears forever. They form inconspicuous parts of a changing background as the story proceeds. Many persons in it are not individually characterized, but are merged in the collective image of a passing crowd, a group of bystanders, listeners to a speech, or dancers at a ball. Like the spectators at a bullfight in a Goya painting, they tend to recede into the background of attention, even if one occasionally waves his hat or shouts applause. Individuals from this level appear as examples of types, such as a policeman on his beat who plays no active role in the plot. At any moment, though, an individual or group may change from a merely passive, background role to an active, individual one, as when a demagogue arises from the nameless crowd. The crowd itself may turn from sullen inertia to revolutionary violence.

An obvious kind of relation between action threads is that of mimesis, as in plays where a love affair between two young aristocrats is paralleled in part by one between their servants—the gentleman's valet and the lady's maid. In a traditional play expressing aristocratic society, the former is emphasized; the latter can be a somewhat comic parody of it, though not unsympathetic. The first or main action thread is developed more in detail, with fully realized characters, emotionally accented scenes and a final climax. The minor action may be, not only a weaker echo of the main one, but different in emotional tone, perhaps humorously awkward, sly, and scheming while the main action is lofty, elegant, and sentimental. Each brings out the other's nature by contrast.

Scenes and physical settings differ in importance according to the nature of the story and the author's interests. In a story of travel and adventure, the localities are often described in some detail. For centuries drama was limited in theory to a single time and place, at least as to the main, presented action; events far away and long ago could be described or narrated, as in *Oedipus the King.* Shakespeare used little scenery. Certain scenes stand out in memory, such as the storm in *King Lear,* but mostly through the words

and movements of the actors. The cinema can bring out important scenes with the greatest realism or with decorative brilliance. In *War and Peace,* the Russian winter is more than a static background; it is shown as a determining factor in history.

Material objects, together with their scenic backgrounds, appear in almost every type of story. People desire, think, feel, and act, not only toward other people, but toward the inanimate things around them; things such as furniture and houses, works of art, clothing, utensils, jewels, weapons, books, food and drink. Some of these are natural, such as rivers, trees, and waterfalls; some artificial, such as necklaces and automobiles. They figure in a great variety of roles and with different degrees of importance. Among the least emphasized are those which form the familiar background of daily life—the tables, chairs, dishes, and garments which people see and use so often as hardly to notice them. A painter may include some of these to build a physical setting for a picture of everyday life, such as a Dutch kitchen, in which no one object has outstanding importance. On the other hand, a single, inanimate object may play a significant role in a story in various ways. It may be a mystic symbol such as the Tree of Life, or an abode of *mana* such as a sacred spring. It may be an object of individual or partisan desire and contention, as in the quest for the Golden Fleece. It may be a bit of evidence in judgment such as Desdemona's handkerchief, a symbol of ideal character such as Penelope's loom, or a status symbol such as the Samurai's sword or the modern automobile or mink coat. The sword of Damocles has acquired from legend a broader human meaning, as a symbol of the dangers threatening men of power and wealth. The central role of an object may be indicated in the title of the story, as in *The Ring and the Book, The Picture of Dorian Gray, The Eustace Diamonds, The Moonstone, The Gold Bug, The Purloined Letter,* and *The Castle.*

Among the factors which can operate at different levels of emphasis are *ideologies,* cultural beliefs and attitudes. We have noticed how a belief in magic or some particular religion can occupy the foreground of attention: magic in *The Arabian Nights;* religion in *The Divine Comedy* and *The Mahabharata.* Magic not only dominates the witches' scene in *Macbeth,* but helps to motivate the hero's action through his belief in their prophecies. It figures prominently in *The Tempest* as well. But Shakespeare expresses no definite religious beliefs of his own, and does not emphasize religious characters on the whole. Wolsey figures more as a political than as a religious figure. The background of Thomas Mann's *The Magic Mountain* is not only physical, the mountain sanitarium for tuberculosis; it is also one of medical science and the ideologies (religious and rationalistic) held by patients there. In Pasternak's *Dr. Zhivago,* the Marxist ideology pervades the background, though not entirely shared by the protagonists.

Religious and metaphysical assumptions profoundly influence the explanation of events in a story. For example, the so-called Nemesis action shows, again and again, how a man's evil deeds live after him and, though he rises to great power, will bring him to an untimely end. This can be explained as the punitive action of a personal goddess, Nemesis, or as a law decreed by the Fates, as the judgment of an almighty God, or as an impersonal law of the universe. Some naturalists, such as Epicurus, reject this determinism and all divine intervention. Others substitute a materialistic determinism based on heredity, social environment, or both. Some insist that the individual will is free to decide actions, in spite of these predisposing forces. Skeptics such as Fielding show the clever, likable, unscrupulous trickster enjoying his gains and escaping without much punishment. Psychoanalysts lay great emphasis on infantile experiences in determining one's later personality development, normal or neurotic. Marxists, on the other hand, lay greater emphasis on the social environment in which an individual grows up. These various theories are applied in drama and fiction to explain, and sometimes to justify or condemn, a mature individual's conduct.

Ideologies are influential also in determining the conceptions of ideal character which are glorified in story form as well as in painting and sculpture. Such characters as Odysseus and Penelope, Gautama, David and Solomon, Socrates, Mary and Jesus, Joan of Arc and the Christian saints exercize a tremendous influence on art as well as on morality. Characters regarded as evil, such as Satan, Judas, and Brutus, are held up as types to avoid. Modern civilization has tended to idealize the successful man of affairs, the statesman, military leader, inventor, physician, and even a few artists such as Rembrandt and women such as Florence Nightingale. Devotion to the ideal of feudal loyalty dominates *The Cid* and *The Forty-seven Ronin.* The ideal of the faithful wife who prefers death to dishonor dominates *The Rape of Lucrece.* These ideals, attitudes, and assumptions not only influence characters, motives, and plots; they provide a cultural background for the action, which is to some extent bound up with scenes and persons, to some extent independent.

The importance of jealousy as a motive in modern

social life has been expressed in countless examples of the "eternal triangle." Yet jealousy is not actively felt in all cultures. It is causally related to the growth of private property and the emphasis placed on bequeathing rank and wealth to one's descendants, and hence to the desire for assured paternity.

11. Chronological divisions in a story.

These produce compound units of different sizes, in succession or one within another. Each may be made more compound by including more and more components, characters, actions, or other factors. Some are inherent in the structure of a story, as in the periods before and after a man sustains a sudden gain or loss. Some are more or less arbitrary, introduced to avoid continuous passages of excessive length. We have considered their relation to developed components, compound factors, and frameworks. Now we reconsider them as successive parts or cross sections in the flow of events.

These common types of divisions and units can be inherent, arbitrary or both: this is true (a) of the acts and scenes in a stage play; of plays in a trilogy or other sequence, such as Wagner's cycle of music dramas, *The Ring of the Nibelungs;* (b) of sections, chapters, numbered parts or "books" in a novel; of cantos in an epic; of movements in narrative music; and (c) of sequences in a film, each containing episodes which contain different "shots." There is less definite division into successive parts in the cinema, partly because it is customary to show the whole work without a pause.

When definite breaks occur, as in intermissions between the acts of a play, there is usually an attempt to make them coincide with breaks in the story or moments of heightened suspense, to sustain interest. Another aim is to produce parts of approximately equal length, so that readers or audiences may rest or move around and get refreshments if they wish, or at least have time to consider what has happened before passing on to the next events. Many of the divisions which are now standard practice have been introduced by modern editors and managers.

Among the more inherent chronological divisions in a story are some we have already noted in another connection. They often but not always coincide with the arbitrary ones just mentioned. *Situations,* as we have seen, are temporary configurations among the factors in a story. Each usually involves one or more

characters, motives, and objects. But this is not always true: Robinson Crusoe was alone during the early part of his stay on the island. Later, his man Friday was introduced, which complicated the situation. A situation may be a stable equilibrium, static, enduring, calm, and repetitious, or it may be unstable, shifting rapidly and perhaps violently. When civil strife continues and the situation is not under government control, it is called "liquid." A quickly changing situation can be regarded as an incident. A situation lasts while the arrangement of forces within it (physical, psychic, or both) is not substantially changed. It is not necessarily an even balance; one factor may control others, at least for a time. Most dramatic situations are largely overt and behavioristic, but there are also internal, largely psychic situations, such as an unresolved conflict between two impulses in the mind of an individual.

Incidents and episodes. Incidents, as we have seen, are brief events or changes of situation; movements from one situation to another. The term is applied to events which are somewhat unplanned or unexpected and not extremely important. A single, unitary act of one person or group, or a happening which affects them in an unusual way, may be called an incident. Eating one's breakfast in a habitual way is not an incident in this sense, but having an unexpected guest there with surprising news would provide one.

Long, complex stories are often divided into *episodes,* each involving a number of incidents and having some continuity. When a long story contains several fairly distinct shorter ones, each of these can be regarded as an episode. In Greek drama, the period of action and dialogue between two choric songs was an episode; now the term is loosely applied to any somewhat distinct sequence ·of events within a story, whether narrative or dramatic.

General conditions and long-range trends. These are more comprehensive and enduring than incidents or episodes. General conditions include parts of enveloping situations which persist while others change: for example, a contrast between poverty and riches. The slow, gradual decline of a family (as in Mann's *Buddenbrooks*) is a long-range trend.

What has been said above about degrees of emphasis among the parts applies also to the divisions just noted, both arbitrary and inherent. Some are major units, others minor or very trivial. Major situations and events result from decisive, far-reaching changes, climaxes in a struggle, suggestions of intense emotion, or violent actions. They underline the main contours of the plot or action, the story proper as distin-

guished from backgrounds, interludes, minor digressions and divertissements, comic relief, and local color.

12. Motive forces and causal agents; types of causal interrelation.

We have noted the general importance of causality as a frame of reference in explaining events, real or imaginary, and in organizing the details of a work of art. Causal relations are described in such terms as "because" and "therefore," "to avoid" and "in order that", and also in describing the specific causes and effects of an action or incident. They appear in simple form in pictorial and sculptural representations of a dramatic situation such as Leonardo's *Last Supper* and Michelangelo's *The Expulsion from Eden.*

In complex plays and narratives, they are more highly developed. Causal relations can be explicitly pointed out by the author or a character, as when Gloster says in *Richard III:* "Now is the winter of our discontent / Made glorious summer by this sun of York." Characters interpret themselves, their actions, and the events and conditions around them in terms of cause and effect; the audience also does so, but perhaps in a very different way. Dramatic irony occurs when a character says or does something which we, the audience, know he would not say or do if he knew what we know, being in possession of facts which he has not had the opportunity to learn.

All planning and expectation of future events assume some general causal principle and some ideas about the conditions involved here and now. Many of these are expressed in popular proverbs, such as "Man proposes but God disposes" and "There's many a slip 'twixt the cup and the lip." Both of these imply that, however well we plan and however sure the outcome seems, the unexpected and the unwanted may occur. This bit of worldly wisdom underlies the plot of many plays and novels. It is illustrated again and again by the unwarranted confidence of some protagonist at the start (e.g., Oedipus and Lear) and his disillusionment at the end, but also by more cheerful plots in which early fears are proven ungrounded and blessings come unsought, as in the Persian fairy tale of "serendipity," the gift of finding pleasant, valuable things not sought for.

The main types of causal explanation and planful effort in representation are like those in other modes; they derive from the general world view and cultural outlook of the persons concerned, real or fictitious.

Basically, they can be distinguished as supernaturalistic and naturalistic, the former including magic and religion. In an age and place where magic is believed in, people explain things and strive to gain their ends at least partly on that basis. They do so on a basis of religion at a later stage. But in every period and culture, people also think and plan to some extent on a naturalistic basis. It is customary to attribute the comparatively ordinary, routine achievements to one's own efforts, as in catching fish where fish are plentiful, but to attribute any sudden, unexpected stroke of good or bad luck to the intervention of some good or bad spirit. Even the most religious people do not attribute every event concerning them to the direct intervention of a god or devil; they combine naturalistic with supernaturalistic explanations without recognizing the difference until philosophy points it out. It is also argued that even one's regular successes, such as daily bread, are due to a benign Providence, while persistent bad luck is due to some guilt or omission on one's part. Divine interventions are frequent and direct in the *Iliad;* less so in the *Odyssey,* which has led some scholars to assign a later date to the latter. The tales of the *Arabian Nights* differ greatly in age, and the later ones are said to be on the whole more naturalistic; they make less use of magic and the supernatural. As Western science extends its influence, naturalistic explanations and modes of planning are increasingly prevalent in representational art. This parallels the trend in utilitarian composition, as shown in the previous chapter.

Another distinction between types of causal agency and explanatory principles is that between the *personal* and *impersonal.* Both occur throughout the history of literature. The impersonal may be conceived as natural or supernatural. On the whole, ancient causal explanation is conceived in terms of individuals and their desires, which are assumed to be like those of humans even when the causal agency is thought of as superhuman. A human, a god, a devil, or a witch wants something, is friendly or hostile to someone. The devil wants Faust's soul; the bad fairy imposes a curse because she was not invited to the wedding. There is also a more impersonal explanation in primitive thought and art. This is in terms of *mana,* vaguely conceived as a sort of spiritual energy or magical power which may inhabit a person, a place, or a thing for a short time or indefinitely. The causal assumptions implied in polytheism are largely personal. They attribute greater or lesser powers to countless varieties of gods, demons, angels, imps, and fairies, good and bad. In *A Midsummer Night's Dream* it is a dispute between the Queen of fairies, Titania, and her

husband the King over possession of a serving boy, which gives the main framework of the play. Similar quarrels appear in the foreground or background of the Homeric and Virgilian epics, especially that between Zeus and Hera. But the Greeks and Romans also believed in a power higher than that of the Olympian gods, sometimes personified in the Fates (Moirae or Parcae) and sometimes conceived abstractly as Fate or Destiny. Monotheism, as explained by modern Western philosophers, became comparatively impersonal, especially when combined with pantheism or panpsychism. Even in Dante, it led to a somewhat impersonal or superpersonal vision of "The Light that moves the sun and the other stars."

Stories based on a naturalistic world view also employ both personal and impersonal agencies. The more naïve and popular kind of naturalistic tale attributes actions, causes, and effects mostly to individual wills and personal qualities, good or bad. If the role of chance and luck is stressed, this constitutes a more impersonal factor. The belief in jinxes, hexes, lucky stones, and the like is a survival of magic. At the same time, modern naturalism has led some writers, such as Ibsen and Zola, to stress the power of vast, impersonal forces, biological and social, impinging on the lives of individuals and shaping their destiny regardless of plan or merit. Instead of Fate or Providence behind the scenes, we are vaguely aware of heredity and environment as pervasive forces, shaping the individual and his destiny for good or ill. Society, the present social order, custom and convention, vested interests, the weight of tradition, hidebound authority, "the System" or "the Establishment"—all these concepts are invoked, especially to explain the failure of merit and the success of crookedness or favoritism.

Implied but seldom discussed at length in art is the metaphysical question of the freedom of the will as against inner and outer factors which obstruct success. (This is emphasized in *Paradise Lost*.) The rise of evolutionism in the nineteenth century led to stories emphasizing organic heredity as a determining factor in life. Evolution and heredity could both be interpreted in a mechanistic way, as leading to a sort of fatalism which minimized the individual will. They were also explained with the emphasis on chance variation along Darwinian lines. In either way, they fostered a pessimistic view of the ruthless struggle for existence and the survival of types which were "fittest" in a biological but not a moral or aesthetic sense. Some stories of the twentieth century, e.g., by Jack London, emphasized the supposed occurrence of "atavism" or retrogression by humans to a bestial level.

To summarize: varied combinations of these causal factors are developed into the following types of explanation:

(a) Events are due mainly to human wills, which are conceived as free, but with occasional intervention by the gods.

(b) Events are due mainly to Fate or Destiny, with humans as mere helpless pawns or puppets (theistic or mechanistic fatalism).

(c) Events are due mainly to Divine Providence, but with human wills free and able to err.

(d) Events are due mainly to organic inheritance, but with power of human wills to influence them somewhat.

(e) Events are due mainly to human wills, which are free and able to surmount adverse conditions as in the self-made man. The power to make decisions and identify with an effort higher than oneself is shown as a distinctive trait of man.

(f) Events are due mainly to social environment, including the family pattern in infancy and good or bad influences in later life, wealth and poverty, high and low cultural levels, the class struggle, walls of prejudice. Success for the individual from a bad environment is hard but possible.

Artistic treatments of these ideas are mainly in concrete, individual examples even when the author is influenced by general theories. Individual characters, particular problems and solutions function as symbols of religious, philosophical, or scientific beliefs and attitudes. The story verges toward exposition if it emphasizes general, theoretical discussion.

13. Transmissional frameworks and supposedly actual frameworks.

A *transmissional* framework is the way in which details are arranged in a work of art for presentation and suggestion to an observer. For example, in a realistic painting, visible details are usually presented all at once on a flat, rectangular surface, so that some of them can be seen and interpreted almost simultaneously or in any order the observer wishes to follow. If they are so arranged as to suggest by mimesis a landscape in perspective, he can interpret it accordingly and imagine that scene in deep space, as if through a window. The way in which he is led to imagine the arrangement of details in that landscape,

as being at different distances from him, containing solid objects, cast shadows, etc., constitutes the *supposedly actual framework*. It is the way in which the represented landscape is to be imagined as existing in space. There is no sharp division between the two kinds of framework. In one case we are thinking mainly of the process of suggestive transmission; in the other, of the nature of what is suggested. In some kinds of art they differ widely.

In the temporal arts, the transmissional framework is the *spatiotemporal order of presentation and suggestion*. In the enactment of a play, one sees the movements of the actors and hears their voices in a certain spatiotemporal order, as coming from the stage. One also apprehends the meanings of these sensory stimuli in approximately the same order, though as organized groups and sequences, not as single images one at a time. They gradually build up an imaginary conception of different characters: not the actors as such but the persons they represent, who are saying and doing things in an imaginary present that is supposedly elsewhere in space and time, perhaps in Rome in the first century B. C. This conception is the *supposedly actual order*. The two kinds of order or framework are very different also in reading a novel silently. One perceives the printed words, paragraphs, and chapters in the transmissional order determined by the author with the aid of established customs and conventions for reading the language employed. But any chapter or paragraph may "flash back" to a supposedly earlier, supposedly actual event.

The difference between the two kinds of order varies greatly in relation to the art and medium used and to the subject, style, and other factors. In saying that a picture "stays on the wall" and does not give the illusion of a view through a window, we are implying that there is very little difference between the two orders. When there is no perspective, the presented lines and colors and the represented figures, if any, are perceived as being about the same distance from the eye. The observer's empathy and fantasy may, if he wishes, push them back in space, but the picture does not strongly guide or influence him in doing so.

Insofar as representation is developed at all, there must be some difference between the two orders. Some amount of otherness, of psychological difference between what is directly seen or heard and what is imagined in response to it, is essential to this kind of composition. When pictorial representation is very slight, consisting only of vague, semiabstract

forms ambiguously moving or standing in space, the supposed actual order is accordingly vague and indeterminate. The transmissional order may be quite emphatic and definite, all visibly spread out before one, but what it makes one imagine may be quite indefinite, hardly deserving to be called a framework. When representation is emphasized and highly developed along realistic lines, the difference tends to be great. The observer then may have the illusion of seeing only the supposedly actual framework, and may almost cease to be aware of the transmissional one. In watching a stage play, the illusion may be so strong as to constitute a state of rapt attention, in which one identifies with the fictitious characters and events portrayed and almost forgets that one is in a theater seat, here and now.

However great the difference, the supposedly actual framework is necessarily inferred to a large extent from the transmissional one. It will not be completely so, for each observer contributes something of his own to what he perceives and imagines. But in any case, he cannot directly perceive the supposedly actual framework. The transmissional one, whatever medium is employed, must tell him what to imagine and in what spatiotemporal order. The transmissional order is always selective; it shows only part of the events which are supposed to occur. In highly stylized or semiabstract representation it shows only a few of them, and one is expected to imagine the rest.

The *total representational* framework is a combination of the transmissional and supposedly actual orders. It includes the total order of things and events to be imagined and the total of artistic ingredients, presented and suggested, by which the work of art undertakes to stimulate and guide them in the observer's mind.

Instead of having only one transmissional framework, we may have (as in an opera) several cooperating ones in which words and music, scenery, costumes and the rest join in helping the observer to imagine the drama supposedly unfolding on the stage, thus transforming it as if by magic into another set of persons, elsewhere at another date in history.

This is not to say that the observer does or should yield to this illusion completely. There are values in surrendering entirely to it and others in maintaining an active contact with the present. The latter type is especially sought in listening to opera, especially by persons who have seen a particular opera several times. The drama, including all the representational and illusionistic factors in the work, may then seem less important than the quality of the music as per-

formed by particular persons on the stage here and now. The same is true in all the representational arts, such as painting. If the total form—of a picture, let us say, by Renoir—contains a definitely representational factor and hence a potential invitation to imagine an actual scene of bathers in a rustic landscape, the observer is under no obligation to comply with it fully or yield entirely to the illusion. He may, instead, prefer to focus his attention as much as possible on the presented factor alone (e.g., lines and colors), or on this along with a few abstract suggestions.

The various frameworks involved in a complex, diversified work of art do not necessarily cooperate or coincide. In some late medieval books of hours and other illuminated manuscripts, the illustrated scenes conform only roughly to the order of the text. Even the form of one single illustration on a single page may contain divergent elements, such as a deep landscape with figures, a flat, ornate initial letter, some calligraphic writing, and a border with elaborate linear arabesques interspersed with tiny animals, flowers, and fruit on a flat ground. Without complete illusionistic unity, however, the elements of the page may harmonize in spirit, as in all referring to the beauties of nature and of decorative art.

14. Their use in representing an object, person, scene, or situation. Description and narration.

Verbally. Literary description is a kind of verbal composition which undertakes to give an idea of something which exists, has existed, or can be imagined, by specifying in detail its characteristics and their interrelations, and perhaps also its relation to other things. It can mention changes, movements, actions, or sequences of events, and thus approach narration. Some of each may be included in the other, but if the emphasis is on successive events, the work becomes predominantly narrative. In description the emphasis is more on static or enduring traits, or on traits mentioned without reference to any systematic temporal order.

Description is sometimes contrasted with explanation as being somewhat superficial, as not showing underlying causes or motives, but this implication is not necessary. We shall understand "description" as including explanation if the latter deals mainly with a particular object, person, scene, or situation rather than with general topics; in the latter case it becomes

exposition. As a kind of representation, it tends to stimulate sensory imagination as to how the thing looks, sounds, feels, etc., rather than logical or theoretical associations. But it is not necessarily limited to sensory images. A thorough description of a person may characterize his tendency to think, feel, desire, and dream in certain ways. The description of a complex object, such as a cathedral, or of a complex personality or a social entity, such as Rome under Hadrian, may introduce some narration. The visitor to a cathedral may write to a friend of how he walked around it and inside it, viewing different parts in succession under different lighting. The description of a person may recount some of the author's experiences in dealing with him, significant things that person did and said.

Much depends on the order in which the various events and traits are noted. The biography of a man or the history of a cathedral tends to be predominantly narrative, and aspects of it can be dramatized. Pure description helps one imagine and understand the object, without necessarily following temporal order. It is thus more free to list characteristics in order of their importance. One tends to mention general impressions and outstanding characteristics first, then to fill these in with details, examples, exceptions, fine distinctions, and comparisons.

Visually. Here let us distinguish between a still picture, a picture sequence, a three-dimensional model, and a motion picture film. We have already noted how a still picture on a flat surface, in a certain transmissional order, differs from the scene it represents (i.e., a certain supposedly actual order).

In Egyptian and some other ancient styles of painting, a rectangular pond is often shown as surrounded by trees. Perpendicular to each side of the pond is a row of trees, shown as if lying flat on the ground, their bases toward the pond. This transmissional order is interpreted by some moderns as due to mere ignorance of perspective and by others as a positive stylistic trait. It is characteristic of young children's spontaneous drawings. We may assume that the artists and the public knew that the trees were actually erect. They interpreted the arrangement in terms of the supposedly actual order, and perhaps were not insensitive to the decorative qualities of this arrangement. The practice of showing in one picture aspects of objects which could not actually be seen at once occurs in Persian miniatures. In Analytical Cubist painting, it occurs as a conscious departure from conventional perspective.

Sequences of still pictures, to be viewed in a cer-

tain order, are used as "production illustrations," to explain the structure of a machine and guide a mechanic in assembling its parts. (This involves utilitarian development.) In one kind of illustration the parts are shown as if exploded or separated in space, but at correct positions in relation to each other. "Phantom" drawings appear as if one could look through a steel container at the parts assembled therein. Three-dimensional models are used in teaching physiology as well as mechanics. Some are made of colored plastics (or formerly, of papier maché) in sculptural form, with removable layers and organs; some are in flat, transparent sheets with pictures to be superimposed. This technique has been called "transvision." By such means, the actual spatial and causal relations of the object can be described and explained: e.g., the way in which the heart pumps blood through the arteries and veins.

In the cinema as a temporal art, the actual sequence of steps in a cyclical process such as the circulation of blood can be still more clearly suggested by motion picture photography or animated drawings in color. The form of a cathedral can be shown as a sequence of images, a visible record of the changing perceptions of an observer walking around, in and out, up and down the building. In this case the sequence of photographic images displayed (the transmissional order) gradually builds up a visual conception of the cathedral as a complex, static form (the supposedly actual order). It may or may not correspond with the sequence of observations made by the traveler, or with any possible sequence of movements on his part. "Lapse time" and other types of slow-motion films are used to give the illusion of natural movements occurring at unusual speed. Thus one can show a flower as budding and opening in a few seconds; or a hummingbird as flying slowly.

15. Their use in representing a story. Narrative, dramatic, and cinematic forms.

A set of still pictures can be arranged so as to represent the various aspects of a complex, static object such as a temple, a changing scene in the Piazza San Marco, or a series of views along the Rhine. These can suggest a narrative if the viewer is asked to look at them in a certain temporal order. They can easily be developed along narrative lines if the indicated order of viewing is made to represent a certain sequence of events, such as the movements of the person who

made the pictures. In titles or spoken commentary he can say, "I saw this," and "then I saw that." In a sequence of static pictures such as that of the newspaper comic strip, convention dictates a certain order of viewing. The sequence of supposed events can be indicated by having the same characters appear in successive pictures in about the same places but in different attitudes. In one, a policeman reaches for his gun, in the next he fires it at a fleeing criminal, and in the third the criminal is lying on the sidewalk. Printed words issuing from the characters' mouths make the meaning clear to any literate mind.

As in this example, the indicated order for viewing the pictures often coincides with the *suggested actual order of events*. This is comparatively easy to grasp, even for very young viewers. But the other method, in which the two orders diverge, allows more variety and is fairly easy to follow for those used to seeing dramatic films. A few words of explanation may be needed, such as the familiar "Meanwhile, back at the ranch . . ." Thus two or more action threads can be maintained concurrently by alternating scenes, characters, and actions. The art of still picture sequence, which is at present more popular with children than with adults, has been much influenced by cinema techniques. In cinema, the text arranged for presentation on the screen (in transmissional order) is called the *scenario* or *screenplay*. This distinguishes it from the novel or stage play (if any) on which it is based.

The difference between the transmissional and supposed actual orders in story representation was recognized by ancient poets and critics, especially in regard to the Homeric epics. After short invocations, both the *Iliad* and *Odyssey* begin *in medias res* ("in the midst of things"). This means that the narration of the story (transmissional order) begins with an episode supposedly well along in the actual order of events, perhaps even near the end. The *Iliad* opens with Apollo sending a pestilence on the Greek army because of his anger at an insult to his priest, Chryses, during the siege of Troy. The *Odyssey* opens with its hero, twenty years after leaving home, detained on his way there by the nymph Calypso. In both cases, as usual when this method is used, the poet has to explain later on what had previously happened. This is sometimes called the "retrospective exposition," but it is not exposition in the sense used in this book.

The other method, called *ab ovo* ("from the egg"), is more strictly chronological. It begins with some event in the distant past which can be regarded as the actual start of the chain of events to be narrated. (If it had been followed out to extremes in the *Iliad*, that

poem might have started as far back as the legendary birth of Helen from an egg, as the result of Leda's union with Zeus in the form of a swan.) This method, of course, is likely to strain the reader's (or hearer's) patience in waiting so long to reach the main action. Hence the beginning *in medias res* is usually followed to some extent, especially in dramatic treatments of a long chain of events, as a means of capturing the observer's interest by plunging him quickly into an exciting episode.

In this method, the transmissional order differs considerably from the supposed actual one, whereas in the *ab ovo* type they run approximately parallel. Strictly speaking, these Latin terms apply only to the ways of beginning a story. But either method can be maintained throughout the story: the one called *in medias res*, by reverting many times to the past to pick up a few previous events at a time. We shall use the term *divergent construction* for the type wherein the two orders differ widely; *parallel construction* for that in which they run more or less together in approximately chronological order. Scott's novels usually begin at or near the start of one of his chains of causation, but he soon finds it necessary to pick up another chain. He treats these chains or action threads in parallel fashion at times, and at other times brings them together.

A compromise between the two methods can be made by having the story begin at the beginning, in terms of actual order, but with an event which is arresting in itself and quickly followed by others suited to hold the attention. One problem when the story begins *in medias res* is to supply the necessary information about previous events without slowing down the main action and interest excessively. Ibsen was adept at this, and was said to present only the "last hour" in the story, weaving in the necessary information almost imperceptibly. This dispensed with the usual parlor maid and manservant who summed things up at the start of conventional nineteenth-century dramas. Both methods are still used.

In addition to *retrospection* or looking back over past events, a story may introduce *prospection* or foresight. Future events (in terms of supposed actual order) can be narrated by prophecy, as in Cassandra's warnings. A mere plan or dream of some desired or dreaded event may be only a detail in the present action. Fully developed prospection implies a fairly definite account of events to come. This method of storytelling was common in an age when the belief in real prophetic powers, mystic visions, and divine communication through dreams was more common than

it is now. In Book III of *Paradise Lost*, God predicts Satan's fall and the punishment of man. In Books XI and XII, the angel Michael predicts future history at length. Prophecy is also exemplified in *Prometheus Bound*, the Messianic books of the *Old Testament*, and the *Apocalypse*. When it comes early in the story, it can help to organize all the rest of it, since remaining events may show the prediction coming true or, perhaps, avoided by some adequate action or outside interference. One difficulty in this type of story is that prediction of the end may rob the telling of suspense, but it can be treated as an uncertain hope or doom hanging over the protagonists until the final outcome.

With respect to prophecy, science has accomplished some things formerly regarded as supernatural, as in predicting the movements of heavenly bodies, the weather, economic trends, hereditary traits, and the progress of certain diseases. Accordingly, prediction is finding its way back into art on a scientific basis.

In multiple-action stories such as those of Shakespeare, with several concurrent action threads, it would be impossible to pursue an exactly chronological order. One has to go back and forth between them, picking up each about where it was left before. This is true of history writing also. Of course, one can have two groups of actors at opposite sides of the stage, both talking and acting at once. This has been tried but is usually avoided as confusing. The multiple-action story usually includes many actions and incidents, some of which are supposedly happening at the same time in widely separate times and places. The transmissional order here is the order in which various parts of the total action are enacted, narrated, or otherwise represented.

Since most modern novels introduce several action-threads, it is hard to find one in which the transmissional and actual orders coincide entirely. An approach to this is made in such a simple framework as that of *Robinson Crusoe*, which is mainly concerned with the adventures of the lonely protagonist. Short stories often start at the beginning and proceed in approximately continuous chronological order. One reason is that they have so little verbal space in which to skip about and develop different action threads. However, many short stories can be analyzed into brief, partly distinct actions, separately treated. One is O. Henry's "The Gift of the Magi," in which each partner in a devoted couple sells, without the other's knowledge, a prized possession so as to get a gift for the other. Doing so prevents each, for a while, from

using the other's gift. Their mutual discovery of this provides an ironic, surprising coincidence which unifies the story at the end.

Surprise endings often result from the disclosure of hitherto unknown or concealed facts and events. *Detective* and *mystery* stories are prominent in this category. The transmissional sequence in these is typically concerned with the investigation and discovery of some past event, such as the nature of a crime and the identity of the criminal, or the place where a treasure is buried. The first part of the supposed actual order is unknown to some or all of the protagonists. The transmissional order in a detective story usually begins *in medias res* with the discovery of the crime. The detective and others involved proceed to develop several alternative, hypothetical solutions, throwing suspicion on one person after another, most of whom are shown to be innocent. The suspense and surprise, if any, consist in making the reader guess wrongly, so that a character he had not suspected is finally found guilty. There is an element of conflict in the unknown criminal's effort to avoid detection. But this formula is now so familiar that the reader may suspect the right character merely because he seems least probable. In any case, the disclosure at the end brings to light the hitherto concealed sequence of events, revealing a dramatic event in retrospect and adding another in the capture of the guilty person. Variants of the familiar type are provided by having additional crimes committed after the story begins, or telling the reader at least part of the secret at the beginning.

The narrative or fictional arts, including the epic, novel, and short story, have had an advantage over the stage play in their ability to leap quickly, through the power of words to guide fantasy, from one place, time, or set of actors to another. This, of course, facilitated the development of complex, multiple-action stories in those media. The artist could arrange and rearrange the transmissional framework at will, to achieve whatever values he sought, and through it represent much the same sequence of events.

This provided an almost inexhaustible number of possible devices for retelling an old story in a somewhat new way. If the ancient playwright complicated the plot too much, he was apt to confuse his audience. This is one reason for the practice, later expressed as rules in the "three unities," of restricting the transmissional framework to one locality, one day, and one main action thread. But these restrictions did not apply to the narrative portions of the play. A narrator was free to tell, as part of the action and dialogue on stage, of other acts by other persons in other times and places. He was free to report in some detail violent actions such as Medea's murder of her children, of which the direct enactment was tabooed. The bit-by-bit revelations in Sophocles' *Oedipus the King*, by Tiresias and others, gradually build the true picture of Oedipus's unintended crime years before. In form, this tragedy is one of the prototypes of the modern crime detection story. The transmissional framework, as enacted, includes the narrated or recounted portions. As a whole, it diverges widely from the supposed actual order of events.

Shakespeare went much farther in providing multiple action threads for direct enactment on the stage, farther than either the Greeks or the seventeenth-century French had gone. His lack of realistic stage settings was perhaps an advantage in this achievement, for the audience could easily follow him from one imaginary setting to another. As the settings became more realistic and elaborate in later years, they also tied the playwright down somewhat, because of the time consumed in changing them from one scene to the next. This shifted the advantage back again to the fiction writer. The nineteenth-century French and English novelists profited greatly from the change. Not until the advent of the film was dramatic enactment once more freed to diversify its transmissional order ad lib, diverging widely from the supposed actual sequence.

Additional problems have arisen in writing for the radio and television. Members of the audience are apt to tune in at any moment of the presentation, ignorant of what has happened in the story. From their standpoint, frequent retrogressive explanations all along the way would be desirable. An approach to this is made in presenting operas over the radio, when the announcer summarizes the previous events before each new act. But many listeners object to frequent breaks in continuity; they want constant, exciting action with few or no pauses or long monologues in the manner of Wagner's Gurnemanz. Alternations between narration and enactment are also difficult for the naïve listener to follow. In adapting a long play or novel for abridged performance in a few minutes, one finds it necessary to summarize long passages and give only the high spots by direct presentation. Much must be reduced or omitted: e.g., the leisurely pace of Dickens; the frequent shift in Proust between what a character says or does and what he imagines or remembers.

In general, it can be said that transmissional order in the film is the *showing order*, the order in which

images are projected on the screen. In fiction, it is the order in which events are narrated. Supposedly actual order in both is the order (spatial, temporal, and causal) in which the events are imagined as happening. Neither of these will necessarily conform to the order of writing, planning, acting, or photographing. Chapters are often written and shots photographed in a sequence quite different from that of final presentation and from that of the supposed events themselves.

The most distinctive achievement of the film, as to representational form and technique, is not the introduction of sound and color, for they were present in the old-time stage play and are now present in television. Even the basic fact of presenting images in motion on a screen to represent dramatic action is not the most distinctive feature, for this can be used to reproduce a stage production. Early film plays were indeed made in that way, with the camera fixed in one position facing the stage or turning only a little from side to side. To see a film thus made affects the modern observer strangely, as if he were being held in one spot and prevented from moving around to see different actions in different places. The distinctively cinematic revolution, impossible without the motion picture camera and projector, was the change produced by cutting and editing the film, fitting together shots of different scenes and moments, as in Porter's *The Great Train Robbery*. By this means the observer is transported in imagination from one scene and moment to another and enabled to see the most revealing and significant events as if he were present at each. He can easily keep track of different action threads, different groups of characters, different settings and situations. Through flashbacks, fadeouts, and other technical devices, he can move at any speed, slowly or in a flash, from any place and any moment of imaginary time to any other. Thus he can be quickly and easily brought up to date on the supposedly previous events. He can be inside a character's mind, seeing his fantasies, or in the minds of several who, in the actual framework of events, are ignorant of each others' thoughts.

All this provides the motion picture dramatist with means for the development of story form which were previously available only to the fiction writer, and then only through the sensuously weak device of words. He was further limited by the ability of the reader to imagine as the words directed him. Pictorial illustrations for a novel can be of some help in this connection. The film director can make each shot extremely vivid in itself, can diversify the shots in countless ways, and can join them in a complex unity which is comparatively easy to grasp.

Even for educated adults, it is often hard to keep track of the many characters in a novel by Dostoyevsky or Tolstoy, in the Japanese *Tale of Genji* or the Chinese *Chin P'ing Mei*. The characters are not only numerous; each may have several names—formal, informal, and honorific. Many are not clearly described; they enter briefly and are not seen again till long afterwards. But in the film even minor characters can be given a distinctive manner and appearance, and be associated with a certain place and incident. Monumental effects of city crowds or snowy mountains give place in a second to intimate close-ups of a single face, bringing out expressive nuances which would have been imperceptible in a stage play. There is little continuous narration; everything is translated into action of some sort. Even when a character narrates a brief passage, we can look from him to his listeners, to see what effect his words are having on them. Speeches and songs, as well as actions and expressions, can all be subtly expressed and built into complex unities. In these potentialities, representation in the film is obviously indebted to the older arts of painting as well as to literary narrative and stage enactment. It inherits many of their great resources while potentially avoiding their limitations. Whether these resources will be fully exploited depends to a large extent on the ability of future artists.

True, the art of the novelist still has some advantages: he can dwell at length on subtleties which would be hard or impossible to translate into cinematic imagery. He can follow a more leisurely pace than is usually demanded in either film or stage enactment. He can dispense with almost all overt action, relying on character and inner, psychic events, whereas the drama on film or stage usually relies heavily on action. The reader, too, can follow his own tempo, without being hurried along by a motion picture projector.

16. Plot as the organization of motivated actions in a story. Action threads; multiple-action plots.

The word "plot" is used in several senses: sometimes as including the whole arrangement of main events in a story. We shall use it in a more restricted sense, as referring only to the *supposedly actual order* of events in a story and, within that, especially to the pattern of *actions*. As such it is theoretically distinct from characterization, emotional tone, local setting, and other factors in the supposed events, although

these factors overlap to some extent. Plot and character are especially likely to be closely interwoven; one cannot thoroughly describe the plot of *Othello* or *Macbeth* without attention to the character of their protagonists. But they can be distinguished in theory.

Plot is also theoretically distinct from the transmissional order of arrangement. Both are types of framework, but one can take a certain plot and arrange it for transmission in many different ways. The plot, in this sense, is gradually revealed by the transmissional order of enactment or narration. It is the pattern of actions in the events which the work of art makes us imagine. The actions of the players on the stage do not constitute the plot; they represent it and suggest it to the audience's imagination, but their own actions are quite differently motivated and organized as parts of a performance in which each actor strives to play his role adequately.

It was mentioned above that "action" in a story implies more than physical movement. It also implies motive, which may be conscious and purposeful, vague or definite, unconscious and impulsive, general or specific. Action is often but not necessarily emotional. Speech and even thought can be regarded as kinds of action, and we say, "his mind was active in spite of his injury." But in theater art "action" is usually conceived as overt behavior; there would be no action in this sense, and no plot, if the characters merely stood and thought. Hamlet reveals some of his thoughts and feelings in speech, especially in soliloquy, which is an effective device when imaginary communication to others in the play is not called for. Hamlet's inaction when action seems to be called for is itself a kind of action. Dramatic action can be comparatively active or passive, aggressive and initiating or passive and quiescent. It can be systematic and continuous or spasmodic, rambling, desultory: in short, like any kind of action in life. A brief, particular action is an act or deed.

An *action thread* is a more or less distinct, continuous sequence of causally connected actions. It is given some continuity through the persistence of a certain character or characters having certain motives, desiring some object or a succession of related objects, usually with minor changes of end and means in response to changing circumstances. Thus Macbeth's ambitious quest for power is more than an action; it is a thread or chain of actions, running through the play like a red thread in a textile. It is manifested in a succession of words and deeds which are related to various persons and situations encountered along the way.

In a complex story with several action threads, each is dropped at times to bring others into view, then resumed. The causal connection is not necessarily clear, complete, or realistic. It may consist partly of magic or miracles. The motive, means, and persons involved in a certain action thread may be fully evident from the start, may be disclosed later on, or may remain a partial mystery. A certain action thread may lose its identity as the characters concerned enter different pursuits and alignments, and new threads may enter in the course of the story. This is especially true of biographical novels such as Romain Rolland's *Jean Christophe*, where the hero changes and meets different situations, different friends and adversaries, on his way through life. An action thread usually involves some perseverance, but even persistent lack of it can be a kind of action.

Plot, as a developed component in both fiction and drama, may result from the interrelation of two or more action threads. This can be done through prolonging them through a long series of incidents and situations, connecting them in conflict or cooperation, enriching them by the differentiation of characters and motives, and in other ways.

A plot may be developed along thematic lines analogous to those of music. A *single-action* plot, with only one main action thread, is somewhat analogous to homophonic music, with one main melodic line. A *multiple-action* plot is comparable to polyphonic music, but is ordinarily less distinct and regular. The threads which are interwoven in a plot are usually not of equal importance and the succession of events does not follow any regular pattern or set of rules, at least in modern stories.

One of the commonest ways to develop a plot is to diversify the conative and emotional relations among the characters, as to specific desires and aversions, dominance and submission, success and failure. This process may begin with a problematic situation among the chief characters and their desires. Thus *A* may love *B*, while *B* prefers *C* but is under pressure to take *A*, and develops a somewhat ambivalent attitude toward both *A* and *C*, both of whom change somewhat in the course of the story. A *plot-producing* situation or incident usually generates conflicting attitudes and actions. The plot of *King Lear* develops from the mistaken judgment of an old man as to which of his daughters loves him most sincerely.

Plot is the commonest type of story framework; the most usual way to integrate other factors such as characterization and emotional tone. It is not universal, however, Many stories have little plot or developed action; the author may be content to produce a character study through a series of events or situa-

tions in which little happens overtly. He may rely on a touching picture of a pathetic character under hopeless conditions, or on witty dialogue to reveal the shallow mentality of an aristocratic milieu, or on a series of detached, humorous events which do not lead anywhere. He may construct a plot so slight and stereotyped as to call for little attention, while lavishing all his inventiveness on local color and earthy speech. Even when plot provides the main framework of the whole, it is not necessarily original, unusual, or noteworthy; it can be mechanical and conventional while the distinctive development occurs in other components.

17. Types of plot in terms of levels and trends in fortune. Complication and resolution.

The most common basis for constructing plots is that of the rising or falling fortunes of a person or social entity, such as a family or state. "Good fortune," in this connection, may refer to any kind of desirable event or condition, as conceived by the characters of a story. Its opposite is bad fortune or misfortune. Good fortune may be conceived as requited love and happy marriage or as power, wealth, rank or status, success, security, or other worldly advantages desired by one or more of the protagonists. It may be conceived in terms of spiritual goods such as moral virtue, holiness, and religious enlightenment, as when an ascetic such as Saint Anthony successfully resists temptations. Different kinds of fortune may be represented in the same story and the same individual, as in one who gains the world but loses his own soul (like Marlowe's Dr. Faustus), or in one who "makes a fortune" in the popular sense but finds only unhappiness as a result. Different characters may disagree on the true meaning of good fortune and success. The attainment of Heaven, Nirvana, or blessed poverty on earth can be regarded as the highest type of good fortune. But most stories involve an attempt to achieve some kind of worldly good in the shape of external objects or conditions. As a rule, good or bad fortune is shown to result from right or effective action rather than from mere luck, chance, or favors received without effort or merit.

We have noted the recurrence in story form of the so-called Nemesis action, whereby a person rises to great power and wealth, perhaps through evil or foolish deeds, then displays *hybris* or presumptuous pride and incurs the wrath of the gods or fates, who bring him down with a crash. Oedipus and Aegisthus, Mac-

beth and Richard III are classic examples. The Nemesis action is expressed in Christian thought in the words, "He hath put down the mighty from their seat, and hath exalted them of low degree," and also in the many pictures of the "Wheel of Fortune," derived from the Roman goddess Fortuna, which shows kings and popes rising on the wheel to eminence, then hurled down with its descent. The concept of Nemesis is not dependent on any particular religion or causal explanation. Even if one does not believe that such retribution is just or inevitable, one may rejoice (perhaps through envy and malice) at seeing the fortunate brought low in life or in art. Their fall is potentially extreme and dramatic when shown in a comparatively static, hierarchical society, as in the case of Mary Stuart, Charles the First, or Marie Antoinette, but it can be moving also in a democracy, where people are often fickle toward their leaders, as in the case of Parnell in Ireland.

The traditional term for extreme changes of this sort is *peripety*. While applied mainly to falling fortune on the part of the protagonist, as in a tragic ending, it can also be applied to the opposite type, where the change in fortune is for the better. The latter also gives rise to many variants, such as the *Cinderella type*, "from rags to riches," and the type often identified with the "American Dream," in which the home town boy makes good by his own honesty and industry in a just social order. Thousands of conventional plots are summarized in the formula, "boy meets girl, boy loses girl, boy gets girl." Any of these plots can be treated in a popular, stereotyped way or with as much intellectual and artistic sophistication as the author is willing and able to achieve. Plots in which a sympathetic hero or heroine achieves success and happiness are *success stories*.

Partly similar to the Cinderella type are many stories of folk heroes and religious founders, persecuted in life and perhaps unjustly executed, yet rising to divine status in heaven. Contrast and dramatic change can be shown in either falling or rising, and the latter tends to satisfy the wishful fantasies of persons who identify with the hero. Peripety can be quick and sudden or gradual, exciting for a moment or suspenseful over a longer period.

Another traditional type of plot is that of *recognition*. It involves the correction of a case of mistaken identity, due perhaps to a voluntary disguise, to the identical appearance of twins, or to the kidnapping of an infant who is then brought up by peasants or Gypsies. The plot usually begins with the incidents causing mistaken identity, while recognition and action appropriate to it are the culminating incidents.

There is naturally an emotional appeal in the reunion of lost relatives or friends, and this is enhanced in a social order where much depends on hereditary wealth, rank, and family connections. It was commonly believed in Shakespeare's day that an infant of noble birth, raised by strangers in humble circumstances, would show his or her innate nobility as an adult. As in *A Winter's Tale*, the child's recovery could solve complications of love and status between persons of apparently different social classes. Recognition usually brings a rising fortune trend to the person recognized and to his friends and relatives, but it may be the opposite, as in identifying a criminal in disguise.

Ordinarily, it is the final rise or fall of the protagonist or leading character which determines the type of plot. A protagonist in the modern sense of the term can be either male or female, but is usually male. His rise or fall carries with it that of his women. In some of Euripides' plays, notably *Medea*, a woman is the leading character. If there are several leading characters of almost equal importance, they can all be loosely described as protagonists. The antagonist, in Greek drama, is the chief opponent of the protagonist, but this meaning is seldom used at present. In drama and epic poetry, the leading character (male) is usually called the hero; the female lead is the heroine. Protagonists, heroes, and heroines are usually somewhat sympathetic in the sense of inspiring sympathy, admiration, or liking. They are often imperfect, however, and in both Greek and Shakespearean drama the "tragic hero" is conceived as having a flaw (such as excessive jealousy or ambition) which leads to his downfall and makes the fall seem credible. The protagonist is seldom entirely bad in fiction or drama. Most authors and most audiences prefer to imagine a hero and heroine who are not too hard to sympathize with. It is easier to build up suspense in awaiting the uncertain fate of one with whom we can willingly identify ourselves, at least in part. Many great tragic heroes, such as Othello, would be judged as morally bad by civilized standards, but inspire enough sympathy so that we feel some pity and terror in their downfall. A downright villain such as Iago tends to arouse little or no sympathy. He is a protagonist in the broad sense but not a tragic hero. Stories called "picaresque" tell of the fortunes of likable rogues, male or female, with whom it is easier to sympathize. Often they do no great harm to other likable people, but rob the undeserving rich and give to the deserving poor, as Robin Hood is supposed to have done.

In case there are two or more important characters in opposition to each other, the rise of one tends to bring the fall of the other, at the same time or later. This produces an effect of *mixed or contrary* fortune trends. But usually one character is emphasized so much that his rise or fall is taken as determining whether the story will seem to be dominated by rising or falling action. Whether he is sympathetic and likable or not is not necessarily the controlling factor here. We may despise him throughout the story, and yet feel drawn by the plot to pay him constant attention: even, perhaps, to identify with him to some extent while hating him at the same time. He is, perhaps, more fully portrayed psychologically; his words and deeds are set forth in great detail.

For purposes of morphological description, the *levels* of fortune can be roughly distinguished as follows: (1) very high; secure; "on top of the world"; with main desires completely satisfied for the present; (2) moderately high; partially successful and encouraged but insecure and dissatisfied; (3) moderately low; in the grip of adversity; set back and worried but not completely defeated; and (4) very low; defeated or frustrated; killed, outcast, or thrown to the bottom of the ladder.

From the worldly, naturalistic standpoint, death can be regarded as the complete, final defeat and frustration. It prevents any later enjoyment of values. But in stories death is often not so regarded. It may be proclaimed as a glorious victory for the dead hero and the cause for which he gave his life. Moreover, it is regarded by many religious and philosophical creeds as the entrance to a higher, better life for one who has lived well on earth. Dante's *Divine Comedy* goes into great detail about the levels of Hell, Purgatory, and Heaven reached by different souls, largely as a result of their behavior on earth. Their fortunes in the next world are shown as often the reverse of those they enjoyed in this one. Through Purgatory they may rise. Whether the death of a hero will be regarded as a downfall will depend on the beliefs of the author and his public on such questions, and also on how the hero is shown as meeting his death, whether nobly or ignobly. The desire for death in preference to certain other losses or evils (e.g., the loss of one's beloved) is often expressed by story characters. Death as portrayed on the stage, as in *La Bohème* and *Cyrano de Bergerac*, is often treated with all the beautifying resources at the author's and the actor's command. To die for love, country, or both is commonly regarded as eminently fitting. It can provide a powerfully climactic ending.

The *action and changing situation* at any one time, as affecting the protagonist, may fall into one of these types: (1) *Smooth success*: unimpeded action

toward goals. (2) *Complication*: entanglement, rising difficulty, danger, and tension through fall or threatened fall of fortunes or through new desires, ambitions, necessary tasks; hence increasing difficulty. (3) *Resolution*: gradual or sudden ending of struggle; falling tension, difficulty, danger, or resistance; disentanglement. (This may be through rising fortunes and attainment of desires, partial victory, achievement with elimination of difficulties, liberation, or gaining strength. It may also be through falling fortunes, gradual downturn, weakening of will or ability to persevere.) (4) *Mixed motion*: up and down at once in various respects, for the same character or more than one in alliance; e.g., rising spiritual condition along with material loss; willing and noble renunciation of previous desires. (5) *Complete success and victory*. (6) *Complete failure and defeat*.

In charting the graph of rising and falling fortune as found in a particular character, one can usually discern *turning points* and *crises*: that is, moments or incidents involving a definite change of trend. These may be sudden or gradual, major or minor, temporary or final. They are not always recognized as such at the time by the character concerned or the reader. Later events may reveal in retrospect how sharp and decisive they were. Just before and after an obvious, recognized crisis (e.g., gain or loss of a battle or duel), it is natural to expect a heightened level of emotional intensity, followed by some relaxation. Such heightened moments are *accents*. The most extreme point in such intensity, whether of joy or grief, love or anger, is a *climax*. It is usually approached by gradual steps, in order to build up increasing tension. (The word "climax" is derived from the Greek for "ladder.") It usually coincides with final, relatively complete success or failure, victory or defeat for the hero and his allies, if any. A very complex story, such as the *Odyssey*, may have several climaxes of different kinds, major and minor.

One of the most common types of plot is the *C-R* or *Complication-Resolution* type. These are its usual main stages, in terms of changing fortune-trends:

(a) *Previous history*. These are the relevant conditions and events which took place before the opening situation, and which are deemed important enough to be recounted at some time during the story as a means to understanding its main incidents. Some plots dispense entirely with this stage.

(b) *Opening or preliminary situation*. This is the way things were just before the complication began. It may have been a quiet level of equilibrium, confidence, and calm before the storm, of unimpeded work and play, or of pride and pomp on a high level or hopeless misery and poverty on a low one.

(c) *Inciting force*. Something happens which will eventually be recognized as a turning point, perhaps the first of many. It marks the beginning of a complication for better or worse.

(d) *Main complication*: from inciting force to main turning-point or crisis; obstacles and difficulties mount up, perhaps with minor turning points and changes in trend on the way.

(e) *Main turning point*: an incident, recognized now or later as marking the decisive change in the hero's fortunes, for better or worse.

(f) *Resolution*: from main turning point to denouement. Continuation of the trend begun in *e*, perhaps with minor turning points and temporary reversals.

(g) *Final incident and resolved situation; denouement*: final status of success or failure, victory or defeat, satisfaction or frustration.

(h) *Subsequent events*: often omitted from the story or briefly summarized.

The following are some common varieties of the C-R plot, in terms of fortune trend within a single action thread:

(a) *The U-type plot*: Starting on a relatively high level, the protagonist encounters complication (difficulties, obstacles, losses, partial defeats); his fortunes descend to the main turning point, after which resolution in the form of success proceeds, gradually or suddenly, to a denouement on a more or less high level. This type can be symbolized as CRu (complication with upward resolution). It includes many varieties of "success story." *David Copperfield* is an example.

(b) *The arch-type plot* (not to be confused with "archetype"). Starting on a relatively low level, the protagonist encounters complications such as new opportunities, false hopes, temporarily rising fortunes, difficulties apparently solved but leading to more serious ones, illusory successes and partial victories. After the main turning point, resolution occurs in the form of failure, defeat, and descending fortunes to a relatively low conclusion. This includes tragedies, failure stories and others ending in frustration, disappointment, and sadness for the protagonist and his allies. It can be symbolized as CRd (complication with downward resolution), as in *Macbeth*.

(c) *The mixed-motion plot* (CRm). This type involves diverse and indefinite trends and resolutions. The ending is a mixture of success and failure from the standpoint of the protagonist; his fortunes have risen in some respects, fallen in others. His antagonists may have risen or fallen about as much as he has. *Paradise Lost* is of this type.

(d) It is possible to have a partial, rudimentary plot

with no resolution at all, only complication (C). Beginning on a relatively high or low level, the protagonist encounters incidents and situations which seem to portend a change in fortune. After many ups and downs, perhaps, the story ends with his fortunes about the same as they began, still in a state of indecisive complication. Many modern writers prefer this type as more true to life on the whole, in spite of its lack of contrast.

(e) A similar type is CRC. Beginning in the midst of complications, the protagonist's fortunes seem to be in process of solution, but the complications are renewed and the story ends with him again entangled in them. The complications may be either favorable or unfavorable to his interests; whichever they are, the temporary resolution is or seems to be the opposite.

(f) In the *pendulum-swing* type, which can be symbolized as CRCRCR, etc., complication and resolution alternate an indefinite number of times, ending on either phase. This type is found today in series of short stories or chapters, presented over radio or television or in popular magazines. A new chapter of the hero's or heroine's adventures is provided in successive installments, as in the so-called soap operas. Its ancestors (as to form) are the heroic cycle and other series of tales involving the same protagonist and perhaps certain recurrent minor figures. He successfully overcomes each set of complications except, perhaps, a final one in which he meets his death as did Hercules. The complications often consist of apparently impossible tasks to be done, insuperable adversaries to be defeated. The chapters may be so loosely strung together as to constitute separate stories rather than a single plot; this depends on the amount of continuity in characterization, main and enveloping actions, emotional tone, and other components. Heroic or pathetic cycles of this sort are sometimes an intermediate stage on the way to the organized, complex epic, in which the individual tales become episodes within a framework plot. In primitive cultures the clever animal (such as Br'er Rabbit in the Uncle Remus stories) is a favorite hero.

A story which remains throughout on a uniform or undulating level of high or low fortune, ease or difficulty, success or failure, satisfaction or frustration, will be lacking in plot but can be varied in other ways. It can have variations of character, mood, emotional tone, incident, dialogue, and thematic development. The hero can rise and fall slightly, as by magic, divine favor, or serendipity, enjoying unsought pleasures and suffering unavoidable misfortunes with no effort on his part. The problem in such a story is to sustain interest without much contrast or suspense.

The main stages and plot types just listed refer primarily to the supposed order of events. As we have seen, the transmissional order—in literature, the order of narration or dramatic enactment—may or may not coincide with it. From a knowledge of the main stages in the supposed actual order and of the plot type to which they belong, one cannot infer what the transmissional order will be. That is for the artist to decide. He may, for example, find a historical or newspaper account of a sequence of events, narrated in chronological order, then rearrange them freely to form his play or novel. The historical events may fall into the arch-type (CRd) category, but this does not imply that he has to put the complication first. He may begin with the denouement, with the turning point at which the hero's fortunes began to fall, or anywhere else in the actual sequence, then flash back to the beginning. He may proceed straight ahead after selecting a starting point, or skip back and forth in time. Whichever transmissional order he selects, he will usually make the outlines of the actual plot emerge gradually. The nature of the supposedly actual order may suggest to him that a certain transmissional order would be most suitable for his purposes. If the former is very short and simple, he may prefer to tell it straight ahead in chronological sequence.

Whatever type of plot is used, or if there is no definite plot, the transmissional order will have its own sequence and divisions. It may begin with some sort of prologue or opening situation, narrated or enacted. Then will follow the main and final sections of the transmissional sequence, which may deal with any part of the plot. A plot concerning the rival efforts of two gangsters may end with the slaying of one. This constitutes a final downturn in his fortunes and, within the limits of the story, a final upturn in his rival's. But a narrative or dramatic presentation may begin with a detective and a newspaper reporter entering the scene of the slaying. In answer to questions, perhaps, the detective first tells of the fight just ended and how it began; then, on further questioning, he goes back to the beginning of the feud and its fluctuating trends of fortune for each rival.

18. Further relations between plot, situation, and character.

Some types of incident and situation are "plot-producing" in that they tend to complicate life and disturb established relations between people. Authors tend to place them at or near the beginning of the supposedly actual order of events, although fresh

complications can occur throughout the story. The nature of the opening situation, whether calm or agitated, has been changed by the introduction of a new element, such as the arrival of an unexpected guest bearing good or bad news, the overhearing of a confidence or the discovery of an incriminating letter. When this is offered as the beginning of a story, it seems to call for some development or complication, to be followed by a resolution, satisfactory or unsatisfactory to those concerned. In this it is somewhat like the statement of opening themes in music, ending on an unresolved chord which seems to call for further development and resolution. The artist is not obliged, in either case, to satisfy the reader or listener by giving him the expected, and perhaps desired, resolution. Both kinds of ending are common in the arts. The opening scenes of *Hamlet*, in which his father's ghost arouses his suspicion of the murder, are obviously plot-producing. Any unproven charge of crime against a respected person in high position is likely to complicate things and to call for a definite resolution one way or the other.

Many kinds of situation are obviously fitted to act as resolutions; they finish certain lines of action, close doors, and remove the causes of doubt or dispute. Nora's slamming of the door as she leaves forever in *A Doll's House* is of this kind. Most of the stock situations recognized by dramatic theory tend to be the complicating sort: e.g., the "meeting of the rival queens." Such situations recur endlessly in life, in drama, and in fiction. The "rival queens" today might be a business executive's wife and mistress, brought together by the wife's overhearing of a confidential telephone call. Such a confrontation is likely to come early in the transmissional order, although it may be near the end of the actual order.

All the recurrent types of story situation, as defined abstractly in terms of the bare outlines of action and attitude, are susceptible to countless varieties of treatment. They may come at almost any moment in the actual or transmissional orders, although placing them at an unusual stage in the plot may raise unusual problems for the author. Since life is always more or less continuous, Nora's slamming of the door could be taken as the start of another drama. The overheard confidence may clear up a misunderstanding; the rival queens may sit down and arrange things amicably, much to everyone's surprise. It is a common device of modern authors to take a type of situation which is traditionally complicative and treat it as a resolution, or vice versa. For the mistreated wife or husband to leave home and break up a

marriage can thus provide the beginning of a better life for both.

Changing social and cultural conditions alter people's attitudes as expressed in drama and fiction; what disturbs and complicates life in one period may not in another. In some cultures, the discovery that a girl has borne an infant out of wedlock is welcomed by her prospective bridegroom, as proof of her ability to have other healthy children. In the main Western tradition her loss or threatened loss of "honor" was usually an inciting cause of many complications. In stories with happy endings, it could be taken for granted that marriage or betrothal was the normal resolution of doubts and dissensions, and that the couple would live happily ever after. Now a marriage is at least as likely to be the beginning of complications in a realistic story, thus confirming the popular saying, "Needles and pins, needles and pins; When a man marries his trouble begins."

The recurrent types of situation are not only capable of being moved about at will in the plot as a whole; they are capable of being treated with different psychological and social meanings and emotional tones. Acts and attitudes traditionally regarded as sinful and wicked may be justified in countless ways. Their results, instead of being regarded as terrible, tragic, or pathetic, may be treated as comic. The Lord High Executioner is a burlesque figure in Gilbert and Sullivan's *Mikado*.

The total aesthetic effect of a play or narrative is not merely the result of using a certain incident, situation, or plot; it is the combined result of these and of all the other components used. A tragic story can be easily turned into burlesque or parody by exaggerations here and there, plus the use of a flippant, humorous manner of speech and gesture. Another determinant of the aesthetic effect is the psychological and cultural context in which the work is presented.

19. Emotional tone in relation to plot. Pace and tempo. Accents and climaxes.

Emotional tone is the prevailing mood and conative attitude in a work of art or part of one. It is one of the suggested components in artistic form. Any or all the other components in dramatic enactment, such as action, dialogue, gesture, posture, lighting, costume, and scenery, can help to express a particular mood, such as mourning, anxiety, or gay abandon. As in ordinary life, so in dramatic enactment, louder tones

of voice, quickened speech and faster motion tend to suggest increasing excitement. Other component traits such as frowning or smiling, laughing or weeping, cooperate to give the tone a definite character. A prevailingly fast or slow *tempo* throughout the enactment, or suggested by short or long sentences in a narrative, tends to produce a certain *pace.* This may change significantly in the course of the plot, as in the acceleration leading to a climax, followed by slowing down after it.

Often a certain character will express a certain range of moods throughout the play; that is part of his character and contributes to the general mood, perhaps by provoking others to an opposite attitude. The general mood or emotional atmosphere at a particular time may be consistent, shared and maintained by all those present, or diversified, a mixture of opposite feelings. Sometimes a certain general tone is maintained throughout a play or novel, as in the air of slowly gathering fear and gloom which pervades *Oedipus the King* and the rapid, boisterous merriment which pervades *The Merry Wives of Windsor.* As such, emotional tone and tempo are unifying factors. They can be limited to a certain act or scene, serving to unify that part and contrast it with others, as in the gravedigger scene in *Hamlet* and the knocking at the gate in *Macbeth.* As in music, a whole section of a play could be marked *grave, largo, agitato, scherzo,* or *allegro con brio.* These imply a slow or fast tempo as well as a certain mood.

Emotional tone as a suggested component in a work of art is not the same as emotion or mood in the beholder's response, such as the pity and terror which tragedy is expected to arouse. The two may or may not be the same; a tragedy may arouse only boredom or derision in some spectators.

The type of plot and the position of a scene within the plot have a good deal to do with the emotional tone expressed. The final catastrophe may bring fear and unhappiness to the protagonist, if he is able to feel at all, and the same to his friends and allies, but the opposite to his antagonists. The arch-type plot is associated with a "sad ending"; the U-type with a "happy" one. But, as we have seen, this is far from invariable. Any type of plot and any moment therein may conceivably be combined with any sort of emotion. The author who wishes to surprise his audience with something out of the ordinary can easily find an excuse for combining a final downturn in the action with a happy emotional tone. The protagonist and his friends realize, perhaps, that to lose what they have been struggling for was a blessing in disguise, that

their victorious adversary was really their best friend. But to this it can be answered that such an ending is not really a catastrophe, except in the bare outlines of action. Psychologically, it is an upturn and the plot is mixed. For a protagonist with strong guilt feelings, who unconsciously wishes to suffer as a penance, a successful (U-type) plot can be a catastrophe. It was mentioned above that modern psychology and anthropology have discovered so much diversity in human nature that hardly any sort of emotional response or behavior can be ruled out as utterly inconsistent with fact. The contemporary author who does not feel obliged to make his characters act realistically can easily justify the most unlikely, extravagant combinations between action and emotion, if not by appealing to psychiatric case histories, then by turning his work into a comic burlesque or parody, such as those of Gilbert and Sullivan. He may use a plot which seems appropriate to serious drama, if not tragedy, and turn it into light comedy or farce by jokes, banter, amusing satire, fantastic costumes, and rippling melodies. On the other hand, psychologically sophisticated writers such as Marcel Proust and Henry James can, without resorting to violent catastrophe, show how pleasures conceal or become frustrations, thus producing a bittersweet or tragicomic mood.

An arch-type plot is not necessarily sad, even when the hero is sympathetic. Much depends on his character, the nature of the final fall, and how seriously it is taken by himself and his friends. The slight discomfiture of a lighthearted character who joins in the laughter at himself can be comic in spirit. The hero may be a clown in a farce and his downfall (symbolized by slipping on a banana peel or being knocked down with slapsticks) may be shown as an occasion for mirth. Primitive comedies and rough horseplay were often cruel toward the weak and unfortunate. The injury or death of the loser could seem laughable. The tendency to sympathize with an unsuccessful protagonist—even an unheroic and unworthy one—has evolved as a part of humanistic culture. At the same time, one may laugh in a kindly way at his slight mishaps or at our own. This applies not only to audience response but to the stories themselves. Modern writers present as worthy of sympathy or derision characters who, a few centuries ago, would have been condemned without mercy.

Increases in emotional intensity and duration are used to provide minor accents along the way, e.g., a slight embarrassment at a *faux pas,* a slight amusement at a familiar joke. Such rises and falls in intensity and quality of feeling may be placed anywhere in

the plot, perhaps for the sake of surprise or to indicate emotional instability on the part of a character. But ordinarily, other things being equal, the main emotional accents will come at or near important turning points. The impact of the first inciting force is usually received with some heightened feeling, positive or negative as it seems to bear upon the hero's fortunes. As in life, encountering an unexpected difficulty tends to shock us out of quiet routine and make us think, fast or slowly, what to do. Emotion at such moments tends to accompany an increased awareness and anticipatory set for action. But the expectancy of trouble or difficulty affects different persons differently. Some it depresses or makes anxious or afraid; some it challenges and exhilarates by calling forth their best reserves of vital power.

The main *climax,* near the end of the play or novel, is normally a moment of high intensity in emotional expression, perhaps the highest of all the accents. Again, it may come at various stages in the action, sometimes at the main turning point; but if this comes too soon, it may diminish suspense and lead to an *anticlimax* or disappointingly weak ending. The traditional place for an emotional climax is after about four fifths of the action, or sometimes even later. An audience can be held in its place a little while for discussion after the action is finished; a novel reader is perhaps more likely to throw the book aside when it no longer promises to be interesting.

Following the main climax, the rest of the story is a *postclimactic descent.* It can be used, if the author so wishes, to reduce tension among the characters and to bring the imaginary action gradually back toward everyday reality. It gives time, also, to reflect briefly on the meaning and importance of the outcome; perhaps to moralize a little in general terms. "Good night, sweet prince . . ." or "After life's fitful fever he sleeps well."

In the *Odyssey,* there are two different, major climaxes, both near the end: one of anger and revenge in the killing of the suitors, one of joy and love in the hero's reunion with his wife. Both are determined as such by the pattern of the plot—success after long frustration and delay on the journey home—and by the sympathetic portrayal of the hero as contrasted with the suitors. (This does not mean that all readers will like him and rejoice at his success; Dante did not, for theoretical reasons.) The emotional force of a climax is heightened by a gradual, step-by-step increase in suspense and intensity, as opposed to sudden, quick success or failure. In the U-type plot it can be heightened by partial defeats and failures along the way, which seem to portend disaster. In the arch

type, as in *Macbeth,* it can be heightened by partial victories which deceptively promise final success.

20. *Tragedy and comedy in various arts. Success stories and failure stories.*

The concepts of tragedy and comedy have held an important place in the philosophy of art since the time of Aristotle. The former is the principal subject in what remains of his *Poetics;* it is briefly contrasted there with epic poetry and comedy. As we have seen, "tragedy" and "tragic" are used in various senses. Literary scholars are inclined to use them in a fairly narrow sense, based on Aristotle, while more common usage has extended them widely. In the latter, somewhat popular sense, any play or narrative can be called "tragic" which has a sad ending, especially through the final misfortune, suffering, loss, or death of a sympathetic (likable or admirable) hero or heroine. Any story of the arch type, with the final downfall of a sympathetic protagonist, treated in a serious, dignified way, is a tragedy in this sense.[3]

By the same token, any play or narrative with a happy ending and a U-type plot, including the final rise in fortune of a sympathetic hero or heroine, is a comedy in the broad sense. The word "comic" retains a strong suggestion of the funny or ludicrous, but a "comic opera" or a "comedy of manners" is not necessarily so; the term there implies mainly a happy ending and a dominantly cheerful emotional tone. Aristotle said that tragedy shows people as better than they are, comedy as worse than they are. The meaning of this is not exactly clear, and his explanation of comedy is obviously incomplete, but it seems to associate comedy with satire, as in Aristophanes' caricature of Socrates, and with what we describe today as farce or slapstick comedy. An urbane comedy such as those of Oscar Wilde, G. B. Shaw, and Schnitzler does not necessarily show people as worse than they are. It may show some as worthy, others as unworthy, some as happy at the end of the story, others as unhappy. Comedy, in this sense, is close to the sense implied by Dante in calling his poem a comedy. We find all sorts of personages in *The Divine Comedy*—the damned and the elect, angels, devils, saints, and deity, but the ending for those who follow

[3] Some Greek plays with happy endings are traditionally classed as tragedies: notably Euripides' *Helen, Alcestis,* and *Iphigenia in Tauris.* Today they can be called comedies, but not in Aristotle's sense of that word. They do have magnitude and noble heroes.

the right path is a happy one. The conception of history implied is of the U-type; man has fallen from a state of innocence and bliss into sin and evil, the "darkness of the soul," but there is a way out which Dante finds through the aid of Beatrice.

Scholars who do not like the extremely broad, loose definition of "tragic" sometimes use the terms "pathos" and "pathetic" instead. These do not stand for any particular type of plot. They imply sorrow, suffering, and melancholy: a sad or pitiable condition. A pathetic character is usually conceived as somewhat weak or humble as compared with a tragic hero. Pathos is a kind of emotional tone which can be treated as a developed component in any kind of story, as well as in lyric poetry and music. "Tragicomedy" is a type combining tragic and comic elements, usually but not necessarily with the tragic ones predominating.

The classical conception of tragedy, based on Aristotle, retains considerable influence today. This does not include the Renaissance and Baroque misinterpretation of Aristotle as having laid down the so-called rule of the three unities (of place, time, and action). As we have seen, this is now generally rejected, but it is a fact that many Baroque playwrights followed it to some extent (notably Corneille and Racine); hence it has some significance for descriptive morphology.

What does survive with more vigor today is the classical conception of tragedy as implying a certain kind of hero or protagonist. The tragic hero is not merely an unsuccessful or unhappy man; he is a great man, both in social rank or status and in character. In struggling against his fate and meeting death, exile, disgrace, or other downfall, he shows some nobility and grandeur in spite of the "tragic flaw" which leads him into error and catastrophe.

The plot in typically tragic drama is of the arch type or an approximation thereto. Sometimes only a part of it is shown, as in Aeschylus's *Prometheus Bound*. (Earlier and later parts were shown in other plays.) Prometheus was a Titan and thus superior to ordinary men, belonging to a race which had been conquered and expelled by the Olympian gods. He had shown grandeur in defying the gods and bringing fire to man, but in this he had also committed the offence of *hybris* or presumptuous pride by threatening the supremacy of the gods. Icarus and Phaethon fell through a similar excess of ambition. Moderns are inclined to admire this offence to some extent, but the Greeks feared it as invoking divine wrath. Other types of flaw, crimes against human and divine law, were patricide, matricide, and incest. Retribution for such crimes could be imposed by destiny through several generations, as in the curse upon the House of Atreus. The heirs might suffer as Orestes did, through the sin of an ancestor. This would be a flaw or weakness even if not a moral fault. Nevertheless, their actions could be tragic insofar as they exhibited magnitude; these were no sordid, petty misdemeanors. The hero's fate was such as to inspire pity and terror, and sympathy for his downfall and the errors which led to it, such as one could not feel for a man entirely bad or lowly. His fall could go farther since it started from a higher level. The play represented the development of a conflict between him and a force which finally proved more powerful, such as that of fate, society, or the piling up of adverse circumstances.

In addition to these specifications as to character and plot, the classical tragedy had a certain emotional tone: lofty, serious, and dignified. There was little room for comic relief or for any minor actions; tragicomedy was frowned upon though sometimes approximated. Verse form contributed to the elevated, heroic tone.

Since the eighteenth century, the classical conception of tragedy has been altered with respect to the nature of the tragic hero. (Lessing and Diderot were leaders in this movement.) The change, accepted by authors and critics alike, has reflected the change from an aristocratic to a democratic cultural setting. Instead of conceiving the tragic hero as necessarily of high rank and status in society, he could be of middle or low class and still have greatness of character, sufficient to give his actions and his fate the necessary magnitude. The ending of a tragedy need not be entirely sad; an ideal of noble action and feeling has been set, whereas the common, popular "tear-jerker" may be filled with intemperate grief over the sordid frustrations of trivial or mediocre people. The downfall of such a person may be pathetic, according to this definition, but not tragic.

A story of ignominious failure can be called a *failure story.*[4] The protagonist can be noble or ignoble, admirable or contemptible as judged by the standards expressed in the work of art, or by those of the critic. The protagonist's action leads to his frustration and fall, but it may or may not inspire pity, terror, or sympathetic sadness. A failure story can be tragic, comic, or tragicomic; it can be a satire, burlesque, or parody.

This conception of a failure story is antithetical to that of a "success story," and the difference is some-

[4] See T. Munro, "The Failure Story: A Study of Contemporary Pessimism," *Journal of Aesthetics and Art Criticism,* XVII (December 1958 and March 1959), pp. 143–68, 362–87.

what analogous to that between arch-type and U-type plots. However, the term "success story" has in recent years taken on derogatory or ambivalent associations, implying that the apparent success of the protagonist is false and meretricious, even if he and his friends are happy about it. These associations are a part of the twentieth-century trend to pessimism and rejection of modern scientific, technological civilization. They include especially a rejection of the common type of success story wherein the poor but honest, industrious young man wins fame and fortune in this supposedly just social order. The background and ideological assumptions of the conventional success story have usually been those of a capitalistic, free-enterprise system, and the attacks upon it have often come from critics who prefer a communist, socialist, or fascist one. But this connection is not necessary. Communist, socialist, and fascist states tend to develop their own kind of success story, intended to show that real success is possible only there. Critics from the free-enterprise democracies tend to reject that assumption and to favor books like *Dr. Zhivago,* which shows the failure of an admirable character to succeed or be happy in a communist state.

If we understand the concept of "success story" in a literal way, without these recent associations, it applies to many perennial classics such as *The Odyssey, The Tempest, The Aeneid, David Copperfield,* and *Tom Sawyer.* In this neutral sense, any U-type story with a happy ending, based on the final rise in fortune of a sympathetic hero or heroine, is a success story. "Sympathetic" refers to the way in which the hero is represented and regarded within the structure of the story itself, e.g., by his friends and allies. A puritanical or excessively moralistic work may repel the modern reader, while at the same time its hero is represented as an ideal and as worthy of sympathetic admiration.

The term "success story" corresponds with one meaning of "comedy," just noted. But there are many kinds of success and of beliefs as to what constitutes true success by the highest standards. Accordingly, there are many kinds of success story, not all of them being devoted to false or meretricious achievement. In some the achievement is obviously slight, playful, and trivial. Similarly, some kinds of failure and of story about failure are serious, grim, and violent; others are no more serious than failure to catch a certain fish.

The great variety of stories in drama and fiction throughout the world can not be adequately classed under the few headings mentioned by traditional literary theory. It is no longer assumed that the emotional tone of comedy must be light and amusing. Any kind of moderately happy ending, with satisfaction rather than frustration for the sympathetic protagonists, is enough to qualify a story as comedy in the broader sense.

We now distinguish between "high comedy" and "low comedy", the former being that dealing with characters, actions, ideas, and emotions regarded as on a higher intellectual, moral, or aesthetic plane. The "comedy of manners" and the "comedy of situation" are classed as high by comparison with slapstick farce. The classical and Shakespearean kinds of tragedy are "high tragedy," and the modern failure story of comparatively ignoble, despicable, or merely mediocre characters, actions, and emotions can be appropriately called "low tragedy." Failure in general is not to be classed as necessarily ignoble. As in the case of success, it depends on what one has tried to achieve and how, on what one's motives and methods have been and how one accepts the result. To describe one kind of tragedy and comedy as higher does not imply that the higher is better as art.

A serious story about despicable characters can be taken seriously as a work of art. Such characters are not to be merely despised, condemned, or ridiculed. The rise of deterministic theories of conduct, as opposed to the doctrine of free will, has inspired many stories which seek to show that crime and insanity are the results of heredity, environment, or both, that the individual is not responsible for his acts and should be pitied or helped rather than censured. Since moral principles are also in dispute, the final success of a so-called criminal may be shown with satisfaction by a particular artist, or his downfall shown with regret, especially when he symbolizes revolt against an unjust social order.

The practical approach of modern ethics tends to weaken the force of attempts at tragic art. It leads both artist and audience to feel that the protagonist's fate was not "inevitable" in the way assumed by classical tragedy. His failure could perhaps have been avoided by more knowledge and ingenuity or by a juster social order. As evaluations of ancient tragedy, such considerations are irrelevant in morphology. But the belief in an inevitable working out of destiny, including an inherited curse upon a family, is part of the total meaning of the classical tragedy. It is important as a factor in unifying the work and in providing an emotional tone of impending, inescapable doom. For these reasons it deserves attention in descriptive study. A modern audience can, as a rule, accept it imaginatively as part of the ancient world of fantasy

which is represented. A modern writer of tragedy may be so conscious of his disbelief in destiny as to be unable to include it effectively within the dramas he creates. A modern beholder of these works may feel the lack of "inevitability" as a weakness, and infer that real tragic art in the present age is impossible.

It is more directly within the field of morphology to compare and analyze the differences between old and modern tragedy, including such works as those of Eugene O'Neill. While the factor of supernatural determinism may be absent in the latter, and while many moderns insist in theory upon the freedom of the will, much remains in life and art of more naturalistic kinds of partial determinism. Many individuals and groups can truthfully be shown as condemned beyond any likelihood of escape through inherited physical and social evils which correspond in practice to the ancient belief (Hebrew as well as Greek) in inherited sins and curses. It remains to be seen how future dramatists and novelists can deal in art with their tragic aspects.

The words "tragic" and "comic" are sometimes applied to pictures, statues, and music. This involves the same ambiguities we have noted in regard to drama and fiction, but to an increased extent. In these other arts as well, the terms may be understood in senses close to those of classical tradition, or more broadly. In the popular sense, any work of art with a deeply sad but dignified emotional tone may be called "tragic." "Comic," as we have seen, retains its special association with "ludicrous" or "funny," which is not far from Aristotle's idea that comedy shows people as worse than they are—worse, at least, in being open to ridicule. In this sense, we speak of the "comic strip" of newspaper cartoons, which are usually though not always intended to be funny. "Comic" is seldom applied to visual art or music in the broad sense which includes anything with a predominantly happy tone and ending.

The use of "tragic" in these other arts tends to keep some vestige of the classical conception of tragedy: that is, of nobility and grandeur in spite of misfortune and suffering. Not everything sad is tragic in this sense, but only the sadness of a person who is noble in character if not in rank, and whose sufferings are concerned with lofty, not trivial or sordid things. The question is, then, to what extent and how these suggestions of classical tragedy can be conveyed in music without words, in painting, and in sculpture.

The most obvious and easy way, perhaps, is through direct association with dramatic or fictional tragedy, as in opera. In "*Siegfried's Funeral March*"

from *Götterdämmerung*, the close association of the music with a certain hero and his downfall is explicitly established. It is verbally reinforced in more general terms in Beethoven's funeral march "On the Death of a Hero" in the piano sonata, Opus 26. But even without such words, it is possible to suggest through musical means alone the abstract qualities of grave, solemn, dignified sadness, e.g., through the rhythm and tempo suited to a slow, stately procession appropriate to the burial of a great man, along with melodic and harmonic development in the minor mode. Certainly music can strongly reinforce the tragic or comic qualities of drama, but by itself it remains, as usual, somewhat vague in its representational significance. In the visual arts likewise, suggestions of tragedy or comedy are usually more definite when based on the visual representation of some subject actually used in tragic or comic literature, dramatic or otherwise. These can be conveyed through mimesis in pantomime, drawing, painting, and sculpture. Many specific representations of characters and scenes from the tragedies and comedies existed in ancient visual art. The *Laocoön,* with its reference to an incident in the siege of Troy, has some of the elements of classical tragedy although its expression of intense emotion might have been considered excessive. The deaths of Niobe and her children are in the same category: with tragic elements, but on the whole pathetic rather than fully tragic. Rodin's *The Burghers of Calais* has nobility of characterization and situation in persons of a middle class. Rouault's *The Old King* represents a type of character somewhat like that of Lear, with dignity, but bent and weakened beneath his crown by age and troubles.

What pictures deserve to be called "tragic" will again depend on one's definition of the term. If the Crucifixion is a tragic scene, then tragic portrayals of it abound in Renaissance art, notably in the works of Tintoretto and El Greco. But Christ was not a tragic hero in the exact traditional sense, and the Crucifixion was not a final downfall. Nevertheless, depictions of this scene are usually made *as if* tragic: that is, with a noble and dignified protagonist meeting torture and death with dignity. In medieval and Renaissance art the story of the birth, suffering and death of Christ filled a role for Christians comparable to that of the tragic hero for the Greeks, as well as to that of the seasonally dying, resurrected god in many cultures.

The task of illustrating scenes from tragic and comic literature has appealed to many modern artists, including Tiepolo, Delacroix, Doré, and David. One can find in their drawings epic and tragic scenes from

ancient history and legend, also from Homer, from Shakespeare and from Goethe. Romeo, Hamlet, Macbeth, and Lear are favored tragic heroes. Falstaff is at first a comic one, but later on a pathetic one. Part One of *Faust* is regarded as a tragedy; Part Two is hard to classify, but has elements of comedy in the Dantesque sense of a happy ending through the saving power of Mary and the angels.

Even in abstract painting, certain elements in the tragic spirit can be conveyed through color and shape alone, because of the established associations of certain visual traits with certain feelings in Western culture. Thus black and other dark, somber colors and horizontal or drooping shapes, as in a weeping willow tree, have been traditionally used to suggest grief and mourning. Dignity and stateliness can also be suggested in abstract visual art. Again, however, the suggestive effect is rather vague without the aid of definite representation or specific context.

21. Viewpoints, vistas, and aspects in various arts.

Literally, a *viewpoint* is a position in space from which one can look at something. What one sees from there is variously described in psychology and art. With reference to the visual activity involved, it can be called a visual percept. With reference to the objects of vision, as a certain selection and configuration of the external stimuli, it can be called a *field* of vision, a *scene* or *vista*. The word *perspective* implies, in a literal sense, a vista through or into deep space, but can also mean a way of giving an illusion of such a vista in art. The word *panorama* suggests a broad expanse of scenery, as from a tower, while "vista" suggests a deep but somewhat narrower view, as in looking through a window or valley toward a far-off scene. The landscapes of Claude Lorrain represent deep, wide vistas toward a far horizon, irregularly bounded on each side by buildings, docks, hills, trees, and the like.

To normal human eyes, space appears as an approximately cone-shaped region, with the apex at the observer. While he keeps his attention fixed on a point straight ahead, things above and below, right and left, are visible only within this region; one cannot see straight up or down or backward. Of the things very near us we can see only a small area right and left, above and below. Things seen too closely become blurred. Of the things much farther away we can see a larger expanse. This is connected with the fact that anything such as a road, an airplane, or a person seems larger as it is closer to our eyes. As it recedes into the distance it seems to cover a smaller and smaller part of the total field of vision, until it vanishes completely. Having two eyes a little apart, we can see partly around things and estimate their volume and distance.

While one's attention is fixed on a point straight ahead, one can usually see that point and things near it with the utmost clarity. Things far from it are more vague and blurred, being seen with marginal vision. But one can pay mental attention to something on which one's eyes are not exactly focused. One can look "out of the corner of one's eye."

Some small areas in the margin of vision at any time are normally "blind spots." Fortunately, vision need not be focused on any one point. While keeping one's head motionless, one can move one's eyes and the focus of attention at will, anywhere within the cone-shaped region. By moving from place to place, by comparing what one sees with what people in other places see, and by using such instruments as the microscope and telescope, one can greatly refine and extend the total area of visual experience.

A scene or a single object, such as a cathedral façade, will present different *aspects* when seen from different points of view or under different lighting and atmospheric conditions. One cannot see directly all the sides and surfaces of a solid, opaque object at once, but one can see some directly and some indirectly as in a mirror. Some styles of painting, such as Cubism, represent different aspects of an object on one flat surface, to be seen simultaneously.

Some viewpoints and vistas are *actual* (i.e., presentative). Others are *suggested* to the imagination through art. The latter are supposedly actual. One assumes an actual viewpoint in looking at a picture on a wall at eye level, a few feet away. Artists usually adapt the size and form of their work to the actual viewpoints from which they expect it to be seen. For a good view of some of the mosaics in Santa Sophia, one must climb to a high position and look from a distance. Pictures made to be seen on a distant wall or ceiling tend to be large, with a few large figures and bold contrasts which will carry well, as in Michelangelo's ceiling frescoes. Easel paintings are suited to be shown in a house. Album paintings and hand scrolls can be seen as closely as a book; hence, they often contain very small details. Holbein's painting, *The Ambassadors*, represents a skull when seen obliquely; but in front view the skull is distorted.

In addition to the actual viewpoint and vista involved, a picture may suggest *imaginary*, supposedly

actual ones. The observer is made to imagine, perhaps, that he is standing on a hill, looking down over farms and houses. Thus we speak of a "bird's-eye" or airplane view of a town. Some Chinese landscapes are called "frog's-eye," because the point of view is close to the ground, looking up. In a stage play or film, one sees and hears the presented images from one's seat in the auditorium as an actual viewpoint. One is led to imagine, perhaps, being inside a garden or a prison.

Much Western painting from the Renaissance onward suggests a vista through a nearby window, which the picture frame helps to mark off and detach from the actual space around the observer. Western artists have shown great freedom and stylistic diversity in treating this imaginary view, making it shallow or deep, wide or narrow, realistic or fantastic, full of miniature detail (as with Patinir) or broadly simplified (as with Manet). In a Cézanne still life, the vista may be only a view of a table top with fruit and bottles. Ceiling paintings often give the illusion of looking up high into space. In a still photograph, the suggested viewpoint usually tends to coincide with the position from which the camera was pointed.

Although "viewpoint" refers primarily to vision, there are other kinds. The position in space from which one hears a sound, or a sequence of sounds as in a concert, may be called an auditory viewpoint or an actual *hearing point*. We also try to recognize the source or direction from which other stimuli affect our sense organs, as when a cold wind or an odor comes from the left. The relative source of sound can be suggested, as in Schubert's *Moment Musical* which suggests the passing of a group of musicians.

Hearing is analogous to vision in that we can focus our attention on one sound or a few selected sounds out of many which are reaching our ears at once. We can shift from one sound to another at will, as in listening to an orchestra and paying close attention first to one group of instruments, then another, and then to someone whispering behind us. A trained listener can pay attention to a single component such as rhythm, perceiving the others more marginally. Hunters and jungle warriors learn to notice soft, distant sounds and ignore louder ones near by.

By further extension, we speak of the different mental "points of view" from which different persons regard ideas. That of an artist toward his work is not the same as a critic's or a dealer's. People are sometimes prejudiced by self-interest toward proposed legislation. This kind of viewpoint is not primarily sensory; it involves one's whole personality, past experience, desires, beliefs, and present mood in interpreting or evaluating something. Persons belonging to a certain social class or psychological type, or to a certain religious or political group, are apt to regard things in a characteristic way. This is close to what we have called an "ideology." Such a "viewpoint" may involve a predisposition to certain moral, aesthetic, intellectual, and practical assumptions and attitudes. Differences of age, sex, class, education, occupation, and the like all tend to accompany different points of view toward life, oneself, and the world. These may be called "character viewpoints" or emotional predispositions. Although not mainly sensory, they may involve a tendency to perceive and interpret sense objects, including art, in a certain way. Dealing with the world from a certain habitual viewpoint tends to make people's thoughts and actions more uniform and predictable. Carried to extremes, it may freeze them into rigid patterns, but one can learn to guard against this and to look at things sometimes from other persons' points of view. Anthropology and literature, especially in the novel, can help us do this by making us imagine how things look to others.

It is impossible for a human to be completely objective. All of our perception and judgment is basically determined by our position on the earth and under certain conditions of light and climate, as well as by the nature of our bodily equipment and cultural environment. The mathematical and physical sciences try at times to escape and eliminate particular viewpoints in their generalizations, thus viewing things *sub specie aeternitatis*. At other times they are content to recognize the inescapable relativity of our thinking and to guard against assuming that our prejudiced views are purely objective or universal. Absolute, as opposed to relative knowledge, has been attributed by some philosophers to the divine nature, but certainly for humans some limited viewpoint is unavoidable in all perception, thinking, and willing.

The relativity of viewpoints is not merely negative or restrictive. Particular viewpoints and personal attitudes are ways of organizing experience and dealing with our earthly environments. They accomplish in advance a large part of the work which art finishes. The artist finds nature, human life and its products, the styles and techniques of art, already organized in countless ways when he begins his work. These ways are all pervaded with personal viewpoints, individual and social. If they were not provided for us by cultural accumulation, we could not learn so quickly—even as children—to view things in a civilized way. Art in each new generation begins by accepting some of this biological and cultural heritage, but selects and rejects from it, while adding new discoveries and interpretations.

Different kinds of viewpoint play important roles in artistic representation. They are somewhat like the "frames of reference" or categories which we examined in Chapter V. Each one is a potential way of selecting and organizing for the use of other persons a limited selection from the data of experience. This can be done mechanically, as in pointing a camera at random through a window outdoors. A painter or photographer can also bring his mental viewpoint into play in selecting and rearranging the same vista. As a developed component in art, viewpoint is useful as a framework for arranging in space, time, and causality whatever details the artist wishes to incorporate. To do so from a single viewpoint helps to augment the consistency and unity of the whole. To introduce different viewpoints, by the same or different persons, produces variety. All perception and imagination in ordinary life involve one or more viewpoints. Even in dreaming, one seems to be at a certain place or a succession of places, looking at or listening to other persons or objects in view.

We tend to see the world through the viewpoints, perceptual and mental, of different artists. The artist arranges his presented details so as to suggest certain aspects, vistas, or fields of vision. If we wish to, we can follow his lead in imagining things and events from the viewpoints he provides. These may be realistic, perhaps direct accounts of his own experience, or the opposite. They can be his own, consistently maintained, or he can ask us to imagine the same events as perceived and interpreted from the viewpoints of different persons. This is common in telling a story: the narrator assumes the viewpoint of one character and then another.

Artistic representation sometimes uses definite viewpoints, sometimes not. The effect of not doing so may be vagueness and confusion or a somewhat universal, abstract, timeless, mystical quality, as in Byzantine mosaics. The more definite the viewpoint, as if in real, earthly space and time, the more the work of art tends to emphasize the here and now, whether real or imaginary, the distinctive, transitory experiences of a certain human individual. An emphasis on individual viewpoints in literature often involves extended reference to individual psychology, to how the personalities of different individuals color their observation and interpretation of facts.

The *development* of suggested or imaginary viewpoint as a component in representation involves increasing definiteness and differentiation. The work can be made to suggest several different viewpoints, of different individuals and groups or of the same under various conditions. Each can be clearly indicated for what it is and clearly related to the others. Ways of using imaginary viewpoint may be compared in these respects:

(a) *Whose* viewpoint is one led to assume in imagination? A particular individual's, as in a story, or a somewhat common, generalized one, as in viewing a painted landscape? If individual, what kind of person or personage? Man, woman, child, animal, supernatural being? In a dialogue, what characters are supposedly speaking, and to whom?

(b) *When?* In what historical period, if any? Remote or recent past, future, or present? Time in relation to events of the story: e.g., in childhood or old age of a character; in flashbacks to an earlier time?

(c) *Where?* In a house or garden? City or wilderness? In the air above or under the sea? In Heaven or Hell? Where in reference to scenes perceived? (E.g., as if in Japan, looking down from a roof diagonally.)

(d) *How?* Under what conditions and with what aesthetic effects? Vision only, hearing only, or several senses? Involving character, mental and emotional predisposition? Realistic or not, as to what could normally be seen, heard, or shown under the conditions specified? Is the viewpoint that of a limited, human observer or an "omniscient" one? Does the same individual change his attitude, as from sane to insane or from sober to intoxicated? Does the use of viewpoint help to build up a certain kind of imaginary world, as if seen through the eyes of a young boy, an old woman, a scientist, a criminal? Is the total effect comparatively impersonal and objective?

22. *Viewpoints in sculpture.*

Differences exist in this respect between sculpture which is freestanding, in the round, and that which is in relief. In both types, there is a difference between actual and imaginary viewpoints.

Toward freestanding sculpture no particular, actual viewpoint is usually predetermined; one does not have to look at a statue in the round from any one point of view. Some one or more aspects may be most highly developed, such as the front view of a standing figure, and this naturally draws the observer to a point from which he can best see the aspects which interest him most. But the sculptor is free to develop all aspects of a statue in the round, and that is one of the chief resources of his art. A statue so developed can present an infinite number of slightly different aspects to the observer insofar as he can walk around it and perhaps even see it from a little

above or below. Not all sculpture in the round can be seen from so many actual viewpoints, of course. A statue may be fixed on the roof of a building where it can be seen only from below, perhaps from a little to the right or left. Such restriction in the range of possible viewpoints tends to influence the size, shape, and proportions of the statue. One would not, for example, rely heavily on small, delicate nuances of surface shape and texture, while these might be more effective in a small ceramic figurine to be placed on a nearby mantel shelf.

Sculptural reliefs differ in size and shape. They vary from low to high in relief. Some, such as coins and medallions, are to be seen from close at hand. This is also true of gems cut in cameo or intaglio form. Others, such as the Parthenon friezes, are placed fairly high up on a wall and hence to be seen from a range of positions below. The Ghiberti doors in Florence are seen from close at hand, more or less at eye level. This determines the angle of vision and makes it possible to achieve some perspective into deep space, comparable to that in a painting of figures in landscape. Such a perspective involves an imaginary viewpoint and vista. Insofar as certain parts stand out in high relief, it makes a difference whether one sees the composition from a little to the left, right, or center; a little higher or lower. It makes a difference where the changing shadows fall. The sculptor takes this into account in arranging details so that these variables will not destroy the vista he wishes to suggest. A small range of different viewpoints is suitable for perceiving the presented form and imagining the relative sizes, shapes, and positions of figures as intended.

When a statue in the round is developed on all sides and can be adequately seen from any side, no particular imaginary viewpoint is determined. If it suggests a mental image of a living body, this image tends to be fused with the visual image of the statue itself. One may voluntarily accept the illusion that the marble face is expressing feeling and about to speak. This kind of response differs from that in looking at a realistic bas-relief. There, as in looking at a realistic painting of figures in a landscape, one tends to place the imaginary vista behind—perhaps far behind—the actual surface of the carving. The imaginary vision is led "out there." Such an illusion of real depth and distance is hard to achieve in a monochrome stone or metal relief, and the observer may refuse to make the effort, being content to see the relief more as a single, variegated, decorative surface.

If a statue in the round is engaged or fixed in a niche, the effect is of course to restrict the possible range of actual viewpoints, and perhaps to make one imagine the represented personage as there also, standing in the niche. The visual percept of the wall or façade as a whole tends to compete with any tendency the observer may have to imagine the statue as a living personage, human or superhuman.

A freestanding statue in the round, if humanlike in size and proportions, can have a fairly strong illusionistic power for the common observer. This increases somewhat in proportion to the degree of visual realism, which reaches its height in the "waxworks" found in amusement parks, lifelike in flesh color, wearing real garments, and sometimes even moving and speaking. Many regard them as real, living persons. But since this amount of illusion, while amusing to the crowds, is not welcomed by most artists and connoisseurs, it is avoided in serious, monumental sculpture. Some "psychic distance" is sought. Not only is realistic polychrome avoided, but also extremely realistic size and position. A statue is usually made larger or smaller than life and placed fairly high on a pedestal, which takes the imaginary personage represented out of our ordinary space. If shown as motionless, he is outside our ordinary temporal processes also.

23. Indefinite and plural viewpoints in drawing by children and adults. Varieties of perspective.

Unguided pictorial representations by young children usually lack a definite, consistent, imaginary viewpoint. The viewpoint implied in them is comparatively undifferentiated, containing the germs of many possible lines of development. Vague hints of several different viewpoints may be combined in one picture. As composite memory images they are conceptual and schematic, expressing the residue of different, separate observations of the kinds of object shown and perhaps of previous dreams, waking fantasies, and associated emotional experiences.

In the drawing of objects, including humans and animals, the juvenile schematic type is additive in assembling parts, each part being more or less distinctly conceived and executed, often as if from a different viewpoint. The human figure is drawn in separate steps, rather than in a continuous, inclusive contour. First comes a large rounded face as a rule, then eyes and mouth, then separate limbs, sometimes added as a fringe without intervening neck or torso. Each part is the result of a partly separate memory image and

constructive impulse. The integration of the parts thus drawn is usually weak and indecisive. The scale of comparative sizes is determined mainly by the relative importance of each part or object in memory and interest; thus, the expressive head or face is large. The gables at both ends of a house are commonly drawn in one picture. A conceptual drawing is based on the knowledge that they both exist, rather than on present observation or memory of how the whole house looks from one point of view. Drawing of the continuous contour or silhouette develops gradually.

The drawing of such contours identifies most of the Ice Age cave drawings of animals as made by adults. But the tendency to include and emphasize the best-remembered or most characteristic aspect of a thing persists in many styles of adult art. The side view of a bird or quadruped is usually the most characteristic, easily recognized aspect. The front view of a human figure may be best remembered by a child, but sex organs and actions such as running or shooting an arrow are often shown from the side. Many prehistoric drawings of men and women are in profile.

In the schematic type of drawing, different objects or parts of objects are often shown as if from different viewpoints. The eye in a profile face is often shown as if from in front, even in the comparatively sophisticated drawings of the adult artists of ancient Egypt.

The early schematic type of drawing by young children tends to show opaque objects as if transparent; the outline of the one behind is visible. Prehistoric cave drawings also do this; sometimes many pictures, made at different times, are superimposed. In children's drawings, several figures in a scene, supposedly at different distances, may be shown as standing on one horizontal line (the standline or groundline), expressing a concept of the ground on which they all stand. The sky is at the top, the ground at the bottom; figures may be shown in a row or with distant ones above. Later, two or more distinct standlines or registers may appear. Young children differ considerably in ability to select significant aspects and postures in active figures, as in a group of boys at play, and also in ability to organize the units into some connected view.

Even with inconsistent viewpoints, a scene may be organized to some extent. One way of representing a scene with roads or paths, trees, and houses is to show the roads as if from above, with trees and houses definitely placed as on a map, but with each tree and house shown as if from one side. A road may thus be bordered with two fringes of trees. As in the Egyptian pictures mentioned above, the bases of all the trees touch the road on opposite sides. The trees are seen as if lying flat on the ground but extending in opposite directions away from the road. A house is often shown conceptually, as if partly transparent so that furniture can be seen from the outside. A furnished room may be shown partly as from above, looking down on rugs, but with tables and chairs as if from the side.

Such examples of plural or multiple perspective, when produced by children or primitive adults, are sometimes labelled as "wrong" or "incorrect." They have their own raison d' être, however. Maps made by adults show most of the terrain as if from above, but small pictures of buildings, local activites, and the like are often added as if seen from the side. A picture which combines what seems to be the most important, interesting, significant, or beautiful aspect of each object in a scene is sometimes preferred over one which arbitrarily forces all of them into a single, realistic vista. Much Postimpressionist painting has revived some kind of multiple perspective.

The drawings produced by an individual child over a period of years tend to develop through a typical *sequence of stages:* (1) the scribble stage; (2) early schematic stage; (3) developed schematic stage; (4) transition to single-viewpoint realism; and (5) developed single-viewpoint realism. This last appears gradually, if at all, in several respects such as continuous silhouette, solid modeling with light and shadow, realistic anatomy, action, perspective, textures and atmospheres. Most persons do not develop their drawing ability beyond an early stage

Several theoretical problems arise in the study of these phenomena. They lie beyond the scope of morphology but may be noted in passing. One is the extent to which the development of an individual artist recapitulates that of art in general. Another is the question of how much the artistic development of individual children, along lines which seem universal, normal, and innately predisposed, is really due to cultural influence. To what extent does the tendency to single-viewpoint realism, which is obviously influenced by adult art in civilized Western centers, occur in other cultures where adult art has never developed that type of realism?

In noticing how early and exotic styles of art differ from the main Western academic styles, people often attribute the difference to the fact that artists in those days did not know how to create in the correct, academic way. As to perspective, it was assumed that artists would have preferred to draw in the single-viewpoint, Renaissance way if they had been able to.

It is well to recognize that other ways of organizing an imaginary scene in space have been used throughout the history of pictorial art. In some of them, viewpoints are plural but definite and highly organized, with aesthetic functions not achievable through our academic, single-viewpoint method. That is not to say that this method was consciously considered and rejected in favor of others. Apparently no strong need was felt for the Western style of visual realism, at least until it became fashionable in some parts of the Orient to imitate Western pictures directly. Until then, Oriental artists were apparently satisfied with their own traditional aims and methods.

One function of the plural viewpoint or multiple perspective, as we have just noted, was to combine in a single picture different, significant aspects of things which could not be simultaneously perceived in actuality. Another, emphasized in Persian miniatures, was to permit a maximum of intensity and contrast in color areas for decorative purposes, without blurring and darkening their edges by shadows. In recent years, effects of this sort have appealed to the Cubists, especially Picasso and Braque. In other words, indefinite and multiple types of perspective have been revived by certain individuals and schools, though none has dominated painting as the Renaissance type did for several centuries.

As to the paleolithic cave drawings, mentioned above, it may well be argued that their usual lack of definite viewpoint is part of the generally primitive, unevolved condition of their art, rather than being a conscious expedient. Most paleolithic drawing had no definite boundary such as a frame or rectangular wall or canvas; it was freely spread over the irregular, natural surfaces provided by the cave. Definite limitation of the picture area facilitates the clear conception of a vista, as if through an opening. When representation is on a curved or irregular surface such as an animal bone, this helps to determine the form of the drawing and prevent the suggestion of a deep imaginary vista.

Plural viewpoints have been definitely organized in various ways. They are involved in the complex, symbolic decoration of Chou dynasty bronzes and in Pacific coast and island art: notably, Chilkat blankets and British Columbian wood carvings. Objects are commonly displayed as if split and flattened out, showing both sides, so that one sees both eyes of a bird, for example. These had magical functions. We have already noticed how some children's drawings involve two or more imaginary viewpoints: one as from above, producing a maplike ground-plan, the other as from the side, to show the most characteristic aspects of trees and houses. This kind of perspective is common in Persian carpets showing a rectangular garden as if from above, surrounded by flattened-out rows of trees and flowers in various directions. Persian miniature paintings of the sixteenth century tend to show rugs, ponds, and floor tiles as if from above, but human figures as if from the front or side.

Vase painting, as in late Greek and Ming Chinese, tends to use indefinite and plural viewpoints. As one turns the vase or moves around it, thus changing the actual viewpoint, one may see a series of different groups and scenes as if from the same position. For example, several fights between Greek and Trojan warriors will be shown as if from the side, where the action is most visible. Sculptural relief on vases likewise tends to use different viewpoints, as in the Minoan Harvester Vase.

Buddhist Indian paintings in the Ajanta caves provide complex examples of multiple perspective. A wall may depict a scene with many different figures and other objects, supposedly at various distances. These will appear as if seen from several viewpoints, sometimes as if the observer were moving, sometimes as in a mental conception of particular scenes without definite spatial interrelation. Each is shown as if remembered or imagined in one of its most interesting or significant aspects. In general, Oriental art tends to practice and to justify in theory the conceptual rather than the directly visual approach in painting and sculpture, on metaphysical and moral grounds. Different vistas can be loosely integrated with the aid of expository and decorative factors, if not into a single vista.

Japanese paintings and prints of figures in architecture, as in illustrations of the Genji story, commonly assume an imaginary viewpoint from diagonally above, as if one were looking down from a low roof into a courtyard or through a transparent wall. This device was also used in the early Italian Renaissance; it provides a useful way of showing what is going on inside and outside of a house at the same time. The building is often reduced in scale.

Sung Chinese handscrolls in horizontal strips often use a continuously changing viewpoint, as of a person traveling down a river or through the air and inspecting a continuous stretch of scenery. This may be from ground level or somewhat above, so as to see receding ranges of hills and also small waterfalls, men and cattle walking, small buildings, and bridges. Some paintings make the observer feel close to an intimate scene of life on the ground; some give him a majestic, all-seeing range of vision, as if from Heaven.

Much Byzantine, medieval European, and Oriental painting, as well as mosaics and reliefs, presents a hieratic arrangement. This is consistent with an imperial or feudal social order and a theocratic ideology. In such compositions there is no attempt at a definite spatiotemporal viewpoint; on the contrary, every effort is made to transcend that way of looking at things and to suggest the universal, eternal, timeless, or infinitely recurrent. Such compositions, mainly flat, are suited to the expression of mystic visions, earthly and heavenly hierarchies. Scale and centrality are determined by the supposed rank and importance of the deities and other personages shown. Some objects are shown large, others small, regardless of distance. Pictorial style can develop indefinitely along this line, with highly evolved technique and organization. In Europe, it flourished in the Byzantine and Romanesque periods and gradually died out in the late Gothic and Renaissance.

The Renaissance painters clung for some time, however, to vestiges of the plural or indefinite viewpoint. A favorite among these was the scene containing many figures, as if in a single vista, but revealing themselves on close inspection to be the same group at different moments of a story. This was done by repetitions of faces, costumes, and actions, and by arrangement in spatial sequence in such a way as to suggest a temporal one. Examples are by Botticelli, Piero de Cosimo, Francesco di Giorgio, and even as late as Paolo Veronese (in *The Rape of Europa*).

24. The development of single-viewpoint realism (or naturalism) in Renaissance painting.

Much of the formal development of Renaissance painting can be summarized as the gradual achievement of realistic, single-viewpoint perspective: that is, the ability to represent a scene as if perceived as a whole from one point in space at one moment of time under one set of atmospheric and lighting conditions. Painting thus accepted a new "law of three unities." This involved the gradual elimination of traits inconsistent with that kind of visual realism, such as indefinite and plural viewpoints in space and the inclusion in one picture of events supposed to happen at different moments of time.

Steps were made toward single-viewpoint perspective in Hellenistic painting, such as that made in Rome by Greek and other artists during the first two centuries A.D. Realistic figures, solidly modeled in highlight and shadow, were placed in urban and land-scape backgrounds in some Pompeian and later examples. These represented backgrounds are usually shallow, often stopping at a nearby wall, but occasionally recede for some distance into a harbor or hillside view. Vistas through city architecture, as in Boscoreale, are illusionistic but lack precise convergence of receding lines. The highest extant development of deep-space painting in the ancient world is that of the *Odyssey* series in the Vatican. Here the landscape opens out into comparatively vast proportions, with controlled variations of atmospheric lighting and coloring and a fairly consistent adherence to one suggested viewpoint. This development is comparable to that of Baroque landscape. How far it went we do not know; it was soon abandoned in favor of the Byzantine approach.

The early Renaissance revived some traits of visual realism, especially in anatomy and drapery. Giotto and Duccio showed solid figures in shallow space with occasional symbols of buildings and landscape as in isolated trees and rocks. Gold backgrounds gradually gave way to somewhat more realistic ones. Masaccio, Uccello, Alberti, and others gradually developed the various features of realistic perspective, including the overlapping of opaque figures, consistent scale, and the imaginary cone-shaped (or megaphone-shaped) vista into space, with the apex at the eyes of the observer. The convergence of parallels toward the horizon and the gradual diminution in size of more and more distant objects proceeded in a way which was opposite and complementary to the conewise extension of the vista, reaching out from the imaginary viewpoint. This viewpoint was more and more definitely located, usually a little above ground, as in the eyes of a standing or seated adult in real space. Objects and surfaces seen obliquely were carefully foreshortened.

The systematic representation of receding vistas was reinforced by such means as these: contrasts and alternations of light and dark, of hue and of texture; punctuation of the main areas depicted by objects of familiar size and shape, to indicate scale; zigzag recession of continuous lines, as of paths, shadows, shorelines, housetops, etc., to lead the eye back and forth; aerial perspective, with blurring of distant objects as if by mist or heated atmosphere. Such vistas were unified by light from a single source, as in a sunset, or by a clearly explained combination of lights, as from windows, lamps, torches, fires, or lightning.

The expansion of the imaginary vista into vast proportions was not a major concern of the Italian Renaissance, whose main interest remained in human and superhuman personages and their doings. Patinir,

van der Goes, and other early Flemish masters did expand the distant view, but on the whole in miniature detail, without aerial perspective. It was left for the Baroque to carry this expansive trend to its limit, as in Bruegel's *Winter, the Return of the Hunters* and the monumental landscapes of Claude and Poussin. Throughout the late Renaissance and on into the eighteenth century there was conflict between the advocates of a strict adherence to the supposed laws of scientific optics and perspective and those who favored a freer sort of illusionism. In ceiling paintings the latter often retained and further developed a plurality of viewpoints, ingeniously merged together so as to appear as a single, vast concourse of heavenly beings, flying hither and thither overhead. Many a Renaissance and Baroque painting which seems at first sight to be strictly organized in terms of a single viewpoint reveals, here and there, departures from that method in the interest of a more free and expressive illusionism. Even painters who now seem strictly academic asserted at times the artist's right to alter, emphasize, and rearrange details, either to tell the story better or to build a better design.

In the nineteenth century two other phases of the single-vista style were carried to new heights, thus further revealing its great potentialities. One was the depiction of very transitory, momentary configurations in the objects shown, as in photographic snapshots. These include Degas' ballet dancers and racehorses and Whistler's twilight park scenes. The other was Impressionist coloring, which likewise emphasized the momentary, evanescent aspect of the scene. Monet emphasized a distinctive set of light conditions in each painting. These developments were partly consistent with the single-vista concept, but often edged away from it in weakening the definiteness of the imaginary viewpoint. Also, they tended to diminish the size of the vista from the grandly monumental to the casual, small, and intimate.

While the single-viewpoint style achieves a comparatively high degree of visual realism, there are psychological factors which prevent it from completeness in that respect. Some of them pertain to the nature of optical focus. Normal human vision, being stereoscopic, does not look out from one point alone, but from two eyes. Looking partly around a solid object, they give a strongly three-dimensional percept which can not be fully equaled in a single flat picture. Hence the popularity of stereoscopic devices using two photographs taken through lenses a little distance apart, and various kinds of viewing apparatus to merge them into a single, apparently three-dimensional scene.

Also, our eyes tend to shift their focus often in looking at a real scene, as part of the larger process of shifting attention. When attention rests on a certain object in the field of vision, it tends to bring out that object with more clarity than others, often with a greater effect of solidity. Such differences can be represented in a painting or photograph of a scene, by emphasizing a certain part and making it seem more three-dimensional by means of highlights and shadows, advancing and receding colors, and the like. Cézanne thus brings out one or two apples in a still life, making others seem more flat and blurred. This can give a startling effect of realism at first, but again it differs from ordinary vision in that the spot representing a focus of attention must remain at the same place in the picture, the rest being permanently more flat, blurred, or neutral in coloring. When we focus our vision on a part which the painter has blurred, it does not seem more sharp and solid, but more definitely blurred. Early Flemish painting tended to make all the details of a picture comparatively sharp and clear, thus losing the effect of blurring in the distance. The Impressionists often blurred the whole picture, making it hard to bring out any object with special clarity.

None of these differences between art and ordinary experience is to be taken as necessarily undesirable. The human eye and mind have great powers of adapting to various kinds of stylized representation, so as to feel many of them as realistic enough if that is wanted. But by the end of the nineteenth century, avant-garde painters and critics had tired of the whole task of achieving more visual realism in a still picture. They went off on other tracks while the cinema was showing that it can easily excel in one kind of realism, that of shifting the imaginary viewpoint and focus of attention. By moving the camera from one spot to another, it can give the spectator an illusion of moving his own attention here and there. Stereoscopic devices have been tried even here, but do not seem to be much in demand.

25. Complex developments of pictorial viewpoint and vista.

One of these is the *still picture sequence.* This type is mainly *additive.* Different units, each a scene in itself with one or more viewpoints, are added in space, time, or both. Addition in time has produced the cinema, with its rapid succession of imaginary vistas.

As mentioned above, the handscroll type in China

was devoted mainly to landscape; in Japan, to narrative. It was unrolled and rerolled so as to present from right to left one long picture or a series of detached ones. In landscape, a single scene could be prolonged indefinitely without breaks, to suggest a continuously changing viewpoint and vista. Some highly complex scrolls, such as *Streams and Mountains Without End,* were partially divided into connected subvistas as in looking through a gap between nearby hills to more distant, higher ones. The transitions between them could be gradual and continuous. One's imaginary visual perception in viewing the scroll would go from right to left and also in and out, from near to far and back again, in a gentle, irregular succession.

In some landscape scrolls and more often in the narrative ones, the horizontal strip is definitely divided into scenes, separated by vertical lines or empty spaces. This is helpful in telling a story, since the same characters reappear in successive situations and episodes. The division produces a detached, as distinguished from a continuous, type of addition and extension into space. The development is temporal also, in that parts are to be seen in a certain sequence.

When each of the detached scenes, or each part of a continuous strip, is subdivided into smaller parts (subvistas), the mode of development is by *division* as well as addition. This joint method can produce a highly complex total form. In a narrative scroll, each scene can be subdivided into many figures, horses, ornate costumes, houses, and actions such as fights and conflagrations.

Comparable though somewhat different types of development are to be found in the early Renaissance predella pictures of lives of saints, often attached to a large altarpiece (e.g., by Duccio). These are usually detached from each other, but in combination illustrate important events in someone's life or martyrdom. Each may have one or more viewpoints. The arrangement may be central, around or below the main picture. The modern popular "comic strip," featured in American newspapers in the twentieth century, tended at first to retain the same viewpoint in picture after picture, but now imitates the cinema in inserting close-ups, oblique shots, and contrasting vistas in successive pictures. Here the temporal order is indicated by the convention of proceeding from level to level as in reading a book: from top left to right, then along the next to top line, and so on.

In the Occident, the still picture sequence has usually involved separate, detached pictures. Sometimes they are placed together in a strip of frieze, sometimes on the walls of a room. (E.g., the Bayeux Tap-

estry, the St. Ursula series by Carpaccio, the murals by Benozzo Gozzoli in the Medici-Riccardi Palace, and Giotto's sequence on the life of St. Francis in Assisi.) Many such series are used and given temporal sequence as illustrations in a book, such as the *Book of Hours of the Duke of Berry,* by Pol de Limbourg. Individually, the pictures are complicated by elaborate subdivision into central panel, borders, initial letters, and the like. They tend to be loosely integrated as sequences, relying on the text of the illustrated book to give continuity. Words explaining an event in a story are sometimes inserted. A book-length story can be told entirely in pictures.

One still picture sequence, notable for the complexity and variety of its individual pictures, is the *Apocalypse* series of wood engravings by Albrecht Dürer. The Biblical book which it illustrates is not entirely continuous in itself, being a series of prophetic visions, but those who know the book can fit the pictures together accordingly. Although the book-size pictures are not large in themselves, most of them contain details of almost microscopic smallness. Each is organized on the whole in Renaissance style, as a single vista into deep space, but each is differently divided into two or more subvistas: e.g., between two large, opaque masses at the sides, left and right of a large central mass, above to a heavenly scene and below to an earthly one, and so on. Subvistas to far-off, miniature scenes of extensive landscapes combine to give a simultaneous effect of vastness and close-up detail. Naturalism and supernaturalism are combined by juxtaposing lifelike human figures and houses with supernatural scenes of deities, angels, and miracles.

Another way of complicating the plural vista, without dividing the work into separate pictures, is the *alcove cluster.* Here the represented area is roughly divided into apparent niches or alcovelike compartments, irregularly placed and vaguely marked off by lines, walls, or cloudy strips. The shapes, sizes, and apparent distances are also dissimilar as a rule. As in the Ajanta cave paintings, each alcove is apparently filled with a distinct group of figures: princes, nymphs, animals, Bodhisattvas, angels, deities, souls, or the like. The alcoves are not merged into a single vista; each group is in its own space, but they may be loosely related as details in a story. The subjects are usually supernatural, as in the mystic visions of El Greco and William Blake. Tintoretto often uses this method. Complex Byzantine ikons, such as Nativity scenes, are commonly so divided.

Ceiling paintings provided an opportunity for sophisticated developments of the plural vista, especially during the seventeenth and eighteenth centu-

ries. Michelangelo had divided the Sistine ceiling into separate compartments, with supplementary figures of prophets, sybils, and others. The scenes contained in these compartments were organized by different imaginary viewpoints, and no attempt was made to interrelate them as parts of a single, comprehensive vista, as in the *Last Judgment*. In moving around on the floor beneath, with eyes on the ceiling, the observer frequently has to change his actual viewpoint a little, to see a certain group right side up. During the late Renaissance and Baroque, many palaces and churches were decorated with ornate ceiling paintings, depicting Christian or Roman mythological scenes, each organized as a single, comparatively unified composition. Many of these contained a hidden plurality of gradually shifting viewpoints of which the casual observer would be unaware, so likely was he to be overwhelmed by the number, size, and variety of superhuman figures charging and soaring above in many directions. The more careful observer might appreciate tricks of illusionistic perspective, as in a quadriga, or four-horse chariot, which seemed to be charging toward the observer wherever he stood on the floor.

A comparatively simple way of developing the single vista was practiced by Georges Seurat in his large canvas, *The Models (Les Poseuses)*, in the Barnes Foundation, Merion, Pa. One is made to imagine looking toward the corner of a studio, in front of which three models (or three views of one model) are placed. On the right-hand wall are small pictures; on the left-hand wall, filling it to the intersection with the wall and the floor, is part of another large painting by the same artist, *Sunday at the Grande Jatte*. Enough is shown of its right half to give the illusion of looking through a park with men, women, a child and a dog at various distances from the eye. Thus there are two imaginary vistas, one included within the other. The transmissional order is the whole, flat painting, *The Models,* as it actually hangs upon the wall; the picture plane covered with small, variegated spots of paint in the Pointillist style. The supposedly actual vista is, first, the view toward the models and the studio corner, including the large painting of the Grande Jatte, which one can imagine as another flat picture plane covered with paint. But one can also accept this second illusion and see the large painting as a vista through the park, thus detaching it from the studio corner and projecting it outward in imaginary space. Each of the two large pictures is organized in its own way as a design with human associations. The studio-corner view is a scene from the artist's Paris, with nude models and garments flung about casually.

By way of contrast, the park view is a scene from bourgeois Paris, with families stiffly and formally dressed for a Sunday outing.

Single-viewpoint painting was carried to heights of complexity in the Renaissance and Baroque, by such men as Bruegel, Hugo van der Goes, and Lucas van Leyden in the north; and by Filippo Lippi, Raphael, Tintoretto, Poussin, and Claude Lorrain farther south. This was accomplished not only by taking in a larger total vista with more figures, houses, and distant mountains (as in Bruegel's *Winter, the Return of the Hunters*). It also involved a systematic variation and integration of details throughout the vista, except for a few comparatively empty spatial intervals to mark off different groups.

It involved, in varying degree, two kinds of *division* and *subdivision.* One of these proceeded *transversely,* cutting across the total vista with gaps, shadows, walls, roads, rows of plants, or the like, thus dividing it into *foreground, middleground,* and *background.* Each of these could be further subdivided into two or three smaller sections. In each area thus formed, the details could be varied and linked together by their significance in the story (representational) and by thematic relations as part of the total design.

The other kind of division was *radial* or *longitudinal:* division into subvistas reaching out from the imaginary viewpoint in various directions, e.g., to right and left of a large, opaque object. (This is favored in portraits such as the *Mona Lisa.*) Fanning out into the distance, radial subvistas could proceed along both sides of a wall from somewhere near the imaginary beholder, or down two streets, or through two open doors or windows.[5]

The two kinds of subdivision were often combined in the same picture. Whether one or both were used, the lines of division were usually irregular, partial and sketchy, not continuous as in a geometrical diagram. A wavering row of stones or bushes, separated by long spaces, could function as a "line" for this purpose. Spaces otherwise empty were often punctuated by recognizable objects at various distances. In the van der Goes *Adoration of the Kings*, a ruined wall in middle distance acts as background for the principal figures, while openings allow subvistas left and right to distant scenes. The total effect is often similar to that of the alcove clusters just mentioned, but here all the alcoves and subvistas are definitely integrated in the one main vista. Outstanding examples are by Tintoretto, as in the *Miracle of the Loaves and Fishes,*

[5] See the circular picture by Filippo Lippi, *Madonna and Child.* Florence, Pitti.

the *Gathering of Manna,* the *Worship of the Golden Calf,* and other Biblical paintings.

It is hard to provide material for interesting subdivision in the sky part of naturalistic landscapes. Claude Lorrain, the Dutch landscapists, Constable, and Turner relied heavily on clouds and treetops in this respect. But fantastic subjects as in Dürer's *Apocalypse,* with its many heavenly scenes, are easily adapted for this purpose. The same can be said of Tintoretto's sketch in the Louvre for his *Paradiso.* Here one grandiose vista opens out as in an amphitheater, with divinity at the far end and various groups of the blessed on both sides and in the nearby center. Tiers of clouds and unfilled spaces loosely separate the groups. These are of different sizes, which help the eye to relate them to each other and to a few outstanding individuals. Oblique, curving, and zigzag progressions lead the eye back and forth within the central vista.

26. Trends in pictorial viewpoint as related to cultural change.

Some of the main stylistic changes we have been considering appear in historical retrospect to be connected with major social and cultural changes. Without assuming any specific causal relationship, we may regard these associated trends as secondary suggestions of different kinds of pictorial representation: in other words, as expressive effects of different kinds of viewpoint. On the whole, the development of the single-viewpoint type of visual realism seems definitely correlated with the Renaissance trend toward a more naturalistic world view and toward empirical science. It shows an interest in making and recording clear, sensory observations of the natural and human phenomena around one, as affected by man's optical equipment and by the results of turning it toward this or that configuration in the outside world. The record of an individual experience, actual or possible, is sought. In the single vista, the human observer sees things as contingent on, and determined by, his own chosen viewpoint, usually on the earth, at a certain moment in the flux of phenomena. By walking a little, he can radically change the forms which external reality presents to him. He tends to feel less passive, more powerful than in regarding the monumental, timeless groups of superhuman beings portrayed in hierarchical styles of art. Those had been associated with absolute monarchy, feudalism, obedience, and a

sense of the common man's inferiority. Visual realism, on the other hand, is associated with a rising middle class in revolt against a disintegrating feudalism, with increasing freedom of thought and experiment in science and philosophy.

The new techniques of Renaissance art gave to painters so inclined (such as Tintoretto and Veronese) the power of creating vast supernatural scenes inspired by contemporary pageantry and theatrical brilliance. Parklike, spacious landscapes such as those of Claude and Poussin were silent invitations to an imaginary journey toward far horizons. It is significant that the development of the single vista on a vast scale coincided with the epoch of worldwide exploration and colonization. But the magnificent kind of humanism associated with the grand Baroque monarchies was later supplemented and eventually superseded by a more modest, domestic, intimate kind of humanism, first as in the interior scenes of De Hooch and Vermeer, later in the Barbizon school and Impressionism. The spectator, however humble, can imagine himself as part of the scene, and the scene is not too far from his own experience to seem credible.

Another cultural trend associated with single-vista realism was the interest in transitory, evanescent phenomena, to which we have already alluded. These had been considered inferior, seductive, and potentially evil by Platonism and Christian doctrine, but reviving Epicureanism stressed the beauty and pathetic charm of mutability. The poet's advice, *carpe diem,* led away from monumentality in art and toward Monet, Debussy, and Proust.

We have noted how some phases of Postimpressionism and Cubism revived the plural viewpoints of earlier styles, as in showing at the same time different aspects of an object (e.g., a head or guitar) which could not in reality be so perceived. Futurism also emphasized abstract suggestions of motion in a still picture. What has been called "juvenilism" in Klee, Picasso, Loren MacIver, and others is in line with this trend, as in segmental drawings of the human figure and interior views of a house, showing floor and all walls. Abstract Expressionism characteristically avoids a definite, single, imaginary viewpoint.

The rise of single-viewpoint perspective in the Renaissance was connected with the rise of modern science in general, and was indeed a part of that rise, especially as theoretically explained in the rules and diagrams based on the science of optics. By the same token, the decline of that kind of perspective in late nineteenth-century art was connected with the reac-

tion against science, reason, and empiricism which was a part of the Romantic movement. As the antiscientific movement in the arts grew in strength toward the end of the nineteenth century, it was manifested in many ways, including a rejection of Renaissance perspective and a revival of several common features of primitive art. One of these ways was to flatten human figures and landscape backgrounds, as in the paintings of Gauguin; this involved a rejection of the carefully acquired ability to model figures in realistic light and shadow. Another was rejection of the concept of the picture as a window into outside space and as an invitation for the spectator to project himself into it for an imaginary journey. "Paint it flat; don't try to make the wall disappear"—this was the new doctrine, along with praise for primitivistic distortions of shape, size, and color.

Time has shown, however, that the empirical, scientific attitude is not necessarily bound up with the single viewpoint in art. It can be directed into any way of observing phenomena, any kind of experience, any way of reorganizing the data of experience into potentially valuable forms. We have noticed the recent development of scientific, technical illustration in the tradition of Leonardo's mechanical and anatomic drawings. These apply a conceptual, schematic method, but in a far more complex way than that of juvenile and primitive drawing. Through the centuries, this kind of drawing and painting has been gradually detached from the realm of "fine art," as usually defined, because its chief aims are not aesthetic but intellectual and practical. Modern *production illustration,* as in devices for showing a mechanic how to assemble or repair a complex mechanism, makes constant use of different viewpoints, which it clearly distinguishes and interrelates. It goes freely back and forth between these and realistic single vistas in producing imaginary cross sections, transparent metal coverings, exploded views, and isometric (unforeshortened) projections. These are used in education, advertising, and scientific research. They often have aesthetic aspects, as in explaining the structure of an automobile for the prospective owner.

During the First World War and to some extent in the Second, *camouflage* was developed on a large scale. This is significant here as an attempt to disrupt or blur the clear, accurate, unified perception of an object or scene in space, such as a large cannon or machine-gun emplacement, and thus to conceal it from enemy view. It is also applied to uniforms for jungle wear. Its methods are thus the opposite of those which characterize the developed single vista, especially by obscuring typical contours, textures, colors, lights, and shadows.

27. *Viewpoints in literature, especially narrative.*

Pictorial and literary viewpoints have influenced each other through the centuries. The nature poetry of the eighteenth century was partly inspired by previous landscape painting, and poetry in turn pointed out aspects of nature for the painter to represent. A partial synthesis of the two has been provided by the theater arts of staging and dramatic enactment, but these were comparatively limited and inflexible until the advent of the film, which potentially combines many of their resources.

Toward a work of literary art, one's *actual* viewpoint may be relevant, as in the difference between reading a story quietly at home alone and hearing it read aloud in a theater. But usually the author does not specify an actual viewpoint or mode of perception, and his work can be apperceived under many different circumstances.

Suggested visual viewpoints, which naturally play an important role in painting and other visual arts, function also in literature. They are often combined with emotional attitudes, as when the poet tells not only what he sees in nature but how he feels toward it ("Silent, upon a peak in Darien") or when he describes it in affective terms as lovable, terrible, or sublime ("Flow gently, sweet Afton"). A suggested viewpoint (i.e., emotional attitude) may be directed in literature toward any kind of sense image or configuration in the outside world, or even toward oneself, as in the case of a person with a strong sense of inferiority or guilt. The field of observation may include sounds, odors, or tactile qualities, described as attributes of represented objects. (Keats's "Ode to a Nightingale," or *The Eve of St. Agnes*). A lyrical poem can be extremely brief and simple, without enough representational development to qualify it as a story, and yet represent an incident or sequence of events in narrative form as seen from a certain sensory and emotional point of view. This is usually the viewpoint of the poet in retrospect. (For example, Wordsworth's "The Daffodils"—"I wandered lonely as a cloud . . .")

In speaking of literary viewpoints, character viewpoints and the like, we are of course extending the term far beyond its literal, visual meaning. A "viewpoint," in the broad sense explained above, can in-

clude the whole psychological and social makeup of an individual or group, as applied in perceiving, interpreting, evaluating, or feeling toward something. In assuming an attitude toward some important issue, such as whether to join in a revolutionary movement, an individual may bring to bear all his innate predisposition, training, and previous experience. Milton did so, not only toward the Puritan revolution in England, but also toward his imaginary character, Satan, as a symbol of the arch-rebel against absolute monarchy. But many viewpoints in literature are expressed toward relatively simple, concrete, mundane matters, as in business competition, marital disputes, and tastes in food or clothing. Literary viewpoints are sometimes called "perspectives," with special reference to the imaginary speaker.

In studying the role of suggested viewpoint in a work of literature, it is relevant to ask again these questions about the work as a whole and any passage in it: (a) *Whose* viewpoint is being expressed or demonstrated? How many individual viewpoints are there? *Who* is supposedly speaking or thinking? Whose attitude is being described or narrated? (b) *To whom or what* is he speaking? (E.g., to a person, flower, animal, deity, the sun, or all nature?) (c) Under what *circumstances?* In what mood or condition is he supposed to be? (E.g., meditative, elated, depressed, friendly, resentful, excited, or calm and objective?) The work may or may not be clearly determined, varied, or unified in these respects.

As in pictorial composition, viewpoints in a literary work may be vague or definite, single or plural. A definite, individual viewpoint or combination of them helps to guide the reader's understanding of a complex story and to respond selectively with empathy. The development of viewpoint as a developed component in literature often takes the form of making it more definite, consistent, and differentiated. This is especially characteristic of writers with a logical or scientific turn of mind. Some of these wish to bring out, by contrasting viewpoints, how subjective and prejudiced are people's attitudes toward life. It is shown, for example, that two witnesses of a crime or accident may give contradictory reports of it, as to the events themselves and who was to blame. A somewhat indefinite viewpoint, on the other hand, is maintained by some writers as a means to an air of mystery and mysticism. A definite, individual viewpoint may, throughout a story, be comparatively colorless and objective, devoted entirely to the straight reporting of facts with no evaluation of them. However, the narrator of a story or describer of a scene, whether he is the author himself or one of his characters, does have the power to slant his account in favor of one side and against the other. Like the Greek Chorus, he can express a traditional attitude toward the persons, conditions, and actions concerned, making them seem good or bad, right or wrong, beautiful or ugly, typical or exceptional. The story may make it clear that the imaginary teller is a Roman soldier stationed in Palestine at the time of Christ, seeing, hearing, and understanding only that which one actually could under those conditions. The mental attitude which would be typical or credible in such a person, as well as certain individual traits, can be suggested throughout, as in Browning's *My Last Duchess*.

A story may be told in the first, second, or third person; in one of these throughout (usually the third) or from a succession of personal viewpoints. In the first person one says, "I saw this" and "I heard that." In the second, a prosecutor charging a defendant may say, "You did this" and "then you did that." In the third, one says "A did this" and "B said that." The viewpoint of a single person may be different at different times, e.g., one viewpoint in childhood, another as an old man; one when under special stress or duress and another when free and tranquil.

Sometimes an unusual kind of narrator is chosen, as in Walter de la Mare's *Memoirs of a Midget*, to show how the world looks and feels from that point of view. Without making a certain character actually narrate the story, one can make him the chief protagonist, through whose eyes and personality the reader sees most of the events. Thus a deer is the protagonist whose viewpoint dominates the story, *Bambi*, and Oscar Wilde's *The Happy Prince* is told from the standpoint of a statue and a bird. The viewpoint of a certain character, or that of the author in his own person, may provide the main framework for a long and complex story. Thus the story of Scheherazade, in which she saves her life by telling a story, is made to include a thousand other stories, more or less. Many of these include series of other stories so that the relationship becomes hard to follow and somewhat irrelevant to the content of individual plots.

One of the commonest types of literary viewpoint is that of the supposedly *omniscient observer*, who is able to see and report events which happen simultaneously in different parts of the world, and who can directly know what is going on in people's minds. This may be the author himself behind the scenes, not representing himself as a person, and hence naturally able to know what all of his characters are doing and thinking. A story told as if by an omniscient observer may be one without any single, definite, sustained, individual viewpoint. It simply skips from one

place to another and from one brief, individual viewpoint to another, without explaining how the author can be aware of them. This is commonly accepted as a quick and easy way to tell a complex story. If the omniscient observer is identified as a particular person, the question may arise of how any mortal observer could have this power.

Some ancient and medieval tales do suggest a divine or supernatural teller. The *Apocalypse* and many other prophetic visions are narrated as if dictated to the writer. In long poems, it was common practice to begin with an invocation to the Muse, calling upon her to inspire the song which then ensues. (Lucretius begins with a tribute to Venus.) Thereafter the pretense of a supernatural narrator is usually abandoned while the omniscient viewpoint is maintained without explanation. It is easy then to transfer the viewpoint to some particular character for a while, as in Odysseus's account of his wanderings and misfortunes as told at the court of a friendly king. Dante begins the *Divine Comedy* in the first person singular, but frequently puts short passages into the mouths of certain characters, especially Vergil and Beatrice.

Narration as distinct from dramatic form implies an indirect way of representing a story: not as a set of directions for speaking aloud and acting out the events portrayed, but as verbal accounts of what happened, arranged so as to help the reader imagine the events themselves in temporal and causal sequence. As we have observed, the order of narration or enactment can differ from the supposed order of actual occurrence. Narration is more free than drama to suspend the action and introduce passages of exposition or other digressions, perhaps as directly expressed by the author. In drama, the author does not usually speak in person, except in an occasional prologue or epilogue. He may put his own viewpoint into the words of one or more characters.

In the narrative forms, the author may be speaking directly as such, and yet the text may represent him as another, quite different person, such as a traveler from a distant land. By this expedient, writers with independent minds have put dangerous thoughts into the mouths of supposedly remote, inaccessible foreigners, thus escaping some of the risk involved. Notable in this respect are such philosophic tales as Voltaire's *Candide* and *Zadig*. Here the fictitious adventures are lively, whereas in More's *Utopia* and Bacon's *New Atlantis* the narrative framework is slight, the expository development massive.

The chief types of literary representation in which narration dominates and provides the main framework are the epic and the prose narrative, long or short. For the present, we may disregard the differences between prose and verse. We have already noted the various ways of classifying prose narratives. There has been a recent tendency to class all prose narratives as "fiction," all long ones as "novels," and short ones as "short stories." This raises the question of how to classify such conventional types of fiction as the romance, fable, extravaganza, allegory, and philosophic tale, which are variable in length but distinctive in psychological content and mode of organization. One solution is to restrict the term "novel" to long prose narratives which involve comparatively realistic explanations of cause and effect and which emphasize psychological and sociological analyses of character and plot. *The Golden Ass* of Apuleius, one of the few surviving long prose narratives of antiquity, could not be classed as a novel on this basis because of its extensive use of magic, but Murasaki's *Tale of Genji* could be so classed in spite of some supernaturalism, because of its keen, realistic, and far-reaching characterization.

We are concerned at this point only with the role of viewpoints in these various kinds of narrative. Those in which the gods are active characters, as in the Greek and Roman epics, and those where magic figures prominently, may occasionally assume the viewpoint of a supernatural or preternatural being. (In *The Golden Ass* a man who has been changed into an ass recounts his experiences in that form.)

Certainly the modern novel, in the restricted sense of that term, because of its tendency toward a naturalistic world view and its emphasis on psychology and sociology, has developed viewpoint to an extent unequaled in previous literature. This line of growth was clearly anticipated in Madame de Lafayette's *The Princess of Clèves* and in *Don Quixote*, where burlesque, fantasy, and extravaganza are given a naturalistic explanation in the Don's delusions. The modern novel has made full use of the special power of narration to deal with inner, subjective experience. It has created a tremendous variety of imaginary viewpoints, attributed to individual characters, to the narrator as personal or omniscient, and to the social groups and classes which are made articulate in such symbolic figures as Rob Roy, Oliver Twist, Uncle Tom, Jean Valjean, and Père Goriot. In some of these the imaginary narrator is sharply focused in one individual; in some he is divided among many participating characters; in others he is vaguely present behind the scenes in the all-seeing eye and conscience of the author. Sometimes his "stream of thought" is addressed to no one in particular.

The development of viewpoint, like that of other components, can be intensive rather than extensive. Without distributing that role to many different characters, the author can see, hear, think, and feel at length and deeply through the eyes and mind of one. Given a lengthy narrative, such as *War and Peace*, he can do both. Here are some further possibilities for differentiating viewpoint: (1) Different characters can tell different parts of the story, as in separate chapters (e.g., Sholom Asch's *The Nazarene*) or in an interchange of letters (Gide's *The Counterfeiters*; Rousseau's *Julie*). (2) The same events can be narrated several times as from the standpoints of several different persons, as in Browning's *The Ring and the Book*. On a smaller scale, Edgar Lee Masters does this in some of the lyrics in *A Spoon River Anthology*. (3) Stories can be included within stories ad infinitum, each with its own narrator. This has resulted from the combination of many folk tales of heroism and adventure, first in a loosely strung heroic cycle and later in an integrated epic such as the *Odyssey*. (4) Without changing the individual viewpoint, the author may attribute to one character many different attitudes on different occasions: e.g., as a child and as a man; before and after an emotional experience. Marcel Proust, in *Remembrance of Things Past*, develops a single, autobiographical viewpoint to colossal proportions. With himself as the narrator here and now, he relives in memory innumerable persons and events as experienced by himself in previous years.

28. Viewpoints in dramatic enactment: on stage and in the film.

In a stage play the actual viewpoints in space and time of those in the audience are highly important. The spectator must be in his seat when the curtain goes up, and the location of his seat makes a great deal of difference. In the age of aristocracy the best ones were reserved for the king or duke and his immediate entourage. The arrangement of seats was hierarchical. In the remoter seats, or standing in the noisy pit, one might have difficulty in seeing and hearing. The actors played directly to the persons of quality; when complex Baroque scenery was developed, spectators at the side or high up might see it in a distorted way. Now efforts are made to insure good sight and hearing to everyone, but some seats are still much better and more expensive than others.

These differences are especially important where three-dimensional presentation with parallax exists, that is, in viewing ballet, marionettes, and other performances where the aesthetic effect depends in large part on the actual point of view. Persons in an upper balcony see the dancers or actors partly from above, which may distort the intended composition of figures even though an effort is made to play to all the house. Different levels and ramps on the stage help considerably, and some spectacles are so replete with actors, dancers, costumes, and moving scenery that everyone has much to see and hear. Problems concerned with actual viewpoint have been much on the minds of experts in the various theater arts: in architecture, acoustics, lighting, amplification of sound, and mechanical devices for rapid change of scenery and properties.

To be sure, a dramatic text can be read silently while one is alone at home, and, as in reading a novel, one can imagine the successive scenes at any speed: not merely the stage settings, but the supposedly real scenes they represent. A text in dramatic form is, however, under one serious handicap for silent reading as compared with a novel: it relies on printed dialogue and stage directions, lacking the wealth of interpretive and supplementary comment which a narrative can give. To read it silently deprives it of the vivid and elaborate sensory stimuli provided by enactment. Shakespeare's text is strong enough to compete on these terms, but most printed plays are not.

In watching a stage performance, the actual scene which a spectator perceives from his seat in the darkened auditorium coincides to some extent with the scene which he is led to imagine there. He tries to imagine that the scene before him is in a Renaissance garden, watching Romeo make love to Juliet who stands in a balcony above. He is well aware that he is actually in a modern theater, in a certain city, day, and year, but willingly suspends his belief in order to get the illusion as fully as possible. The necessary stimuli to give him that illusion are out there on the stage; without them he might achieve it only vaguely. In order to make him imagine another fictitious scene in the same place and thus continue the story, the setting, dialogue, and action must be changed, and perhaps some of the actors too. To apperceive the enacted story, he must be provided with a succession of scenes and acts. If realistic and complex, the setting can not be easily and quickly changed. Increasingly complex, cumbersome, inflexible stage settings tend to restrict the play to a few changes of scene. This can be overcome in part by playing some scenes in front of the curtain while the change is made out of sight, and also by using a revolving stage with different settings quickly available, and by blacking out

part of the stage while the action is proceeding in a lighted part.

Among the most drastic expedients to insure maximum vision and hearing from all points in the audience is abandonment of all complex staging: a return to the Elizabethan stage with few or no stationary furnishings. When the proscenium type of stage is kept, each spectator has his own single vista into it, through groups of actors and perhaps up and down ramps and balconies. Another such expedient is to abandon the proscenium or front-view stage entirely, and substitute the arena, central platform, or other type in which the spectators encircle the performers, seeing and hearing them from a great variety of viewpoints, that is to say, from indeterminate, multiple viewpoints, perhaps even from nearby treetops and rooftops. This type of plan is adapted to kinds of performance in which no particular viewpoint is necessary for adequate perception, as in a church ceremony, a circus, athletic contest, pageant, or skating carnival. It was often that of the primitive, wandering theatrical group, and was used in the beginnings of the Greek drama. The ancient device of a runway into the audience is still used in modern burlesque and in large fashion shows. These modes of arrangement tend to restrict the performance to simple actions which can be seen and understood from many points of view at once. The performers may be somewhat self-centered, ignoring the crowd, or wheel about frequently to face different ways and give everyone a front view occasionally. One problem here is that persons in the encircling audience can see the rest of the audience beyond the actors, and this may interfere with the illusion, that is, with the representation of imaginary characters and actions.

The most revolutionary device for achieving rapid change and differentiation of viewpoints is, of course, the motion picture camera. It is democratic by contrast with the Baroque theater, not only in the kind of plays it presents, but in that most seats are equally good and sold at about the same price, and also in that a film and projector can be easily transported and shown wherever and whenever electricity is available. In the Baroque theater, the audience (especially the humbler spectators) had to watch the brilliant spectacle from afar. The arena theater brings them all fairly close to the actors by encircling the latter, but at some aesthetic sacrifice. The cinema leaves the spectators in different seats, with fixed and different actual viewpoints, all facing the screen as their ancestors faced the proscenium stage. It presents them all with a rapid flow of visual images on the screen, which suggests to them a rapid succession of imaginary viewpoints and vistas. Thus it gives to dramatic enactment the power of quick, unlimited change, vastness, and complexity in the imaginary vista which had formerly been exercised only by the literary narrative. In some respects it excels the latter, in that it presents vivid, colorful images to the spectator's eyes and ears instead of being limited to the often paler, weaker stimuli of words. It takes in and combines the several resources of photography, drawing, and painting, through direct color photography or animated cartoons, in addition to the resources of speech, action, scenery, and music on a large and intensified scale.

At present, the film has many points of weakness in comparison with the older arts it incorporates. An inherent, inescapable weakness is its lack of living, flesh-and-blood, human actors, and by the same token its lack of spontaneous variations in the nuances of facial expression, speech, and gesture. Once filmed, the performance is frozen. But the importance of these limitations is debatable. Connoisseurs of pictorial art feel the inferiority of film color to that of a great painting; those of music feel the difference between film sound and the actual sound of an orchestra. But film technique is rapidly overcoming some of these weaknesses. In the meantime, no one can deny the tremendous liberation and scope it has given to the visual imagination, by taking us in fantasy to every part of the earth and under the sea. The faults most often attributed to film art are concerned with the quality of the story, the words, and the acting. But these are not inherent or necessarily permanent; they depend on the quality of the humans using this powerful instrument. The film takes us much closer to the actors than we could normally get on the stage, in close-ups of their facial expressions, their slightest movements, and their voices (as in the color film of *La Bohème*, presented by La Scala Opera Company).

History gives ample evidence that great artistic resources and techniques do not necessarily produce great art. Some limitations may impel the artist to a more intensive development within the limits he accepts. The limits of staging and the lack of mechanical equipment in Shakespeare's time helped to channel his ability and that of his associates into the best possible use of words, both written and spoken, and such actions as could be easily performed on a simple stage. The Elizabethan theater gave a challenge to the poet to develop dialogue, song, character, and plot to the highest degree, and his merits were rewarded. The color film in sound today is like the full orchestra: it takes an exceptionally versatile genius to use its re-

sources to the full. But meanwhile, some worthwhile things are being done with it, including the creation of original types of form.

Some early films were made of conventional theatrical performances, from a fixed point in the audience. (One of Sarah Bernhardt and a supporting cast in *Queen Elizabeth* was so produced.) This, of course, did not utilize the distinctive resources of the new medium. Historians credit Porter's *Great Train Robbery* (1903) with being one of the first to introduce the essentials of cinematic form. This short film depicts a simple incident involving the holdup of a train while the telegrapher in a country railroad station tries to summon help. In true film technique, it flashes back and forth between the train, the robbers, the station, and along the way, providing a sequence of brief shots from different points and angles. Among the obvious advantages of this method are, first, that it can give the spectator only the high spots of the action, omitting unnecessary and possibly tiresome details; secondly, that it can provide a greater variety of visual experiences; and thirdly, that it permits arranging the transmissional order (the sequence of shots projected on the screen) in accordance with the supposed actual order, to any extent desired. Since the supposed actual order usually takes place in different places at the same time, it would be impossible to film it in chronological order from one fixed point.

Since Porter's day, the resources of film technique along these lines have been greatly augmented, partly by mechanical devices which facilitate photography from different points and angles, from a stationary or a moving camera; partly by giving greater freedom to the editor to cut and rearrange the film in a different order from the one in which it was photographed; and partly by montage and similar devices for combining elements from different shots on the film at once. The moving camera can give the spectator an illusion, almost impossible in stage plays, of being in rapid motion himself, as in an airplane or a bobsled. The rapid sequence of short, different shots, with accompanying speedup of action, can select the tense moments and eliminate the slower parts, thus giving a total effect of fast pace. On the other hand, the director is free to slow the action down to any leisurely speed, as in a saunter through the country. A relatively short passage in slow motion is often enough to give the illusion of a long period.

By shifting rapidly from one person, scene, or aspect to another, the film can tacitly suggest comparisons and contrasts between them, significant analogies and symbolic acts. In this way, one can suggest hidden or unconscious meanings. The contents of a sleeping dream or waking reverie, as subjectively felt, can be more easily and vividly suggested by the film than by any other present medium. By images instead of words, or by words and images, the drama can be shifted back and forth between the outer and the inner world. The film can easily portray the bewildering discontinuity and strange distortions which some dreams possess, and which constitute their own reality as psychic phenomena.

Motion-picture viewpoints can be personal or impersonal, either as if through the eyes and mind of a particular character or through the all-seeing eye of an omniscient observer. As in literature, the eye is never really all-seeing; it sees only what the artist makes it see, but that is far beyond the power of any human eye. Most films use an impersonal viewpoint, with occasional personal vistas. The transition from one to the other can be imperceptible. Seeing a boy's room, for example, we can be made to notice things which would most interest a boy who enters it; we see the boy handling these things; then, through his eyes, we notice something characteristic of these objects. The illusion of the all-seeing eye and the all-understanding mind can be communicated to the spectator, with a resultant illusion of greater power, speed, and excitement. Both the personal and impersonal viewpoint can be so limited as to leave unnoticed or misunderstood certain important facts, as in a mystery story; or, the impersonal eye can see things which the characters ignore.

Film technique combines some of the advantages of different kinds of pictorial viewpoint. As in the single viewpoint of Renaissance painting, it can suggest a view through a window or a telescope, organizing a vast panorama as if through the eyes of one superhuman beholder at a single moment of time. But it can separate immediately into plural viewpoints and vistas, showing how the same things look and feel to different observers. Thus the Japanese film *Rashomon* shows how the same crime appeared to, or was reported by, several different characters vitally concerned in it. *The Cabinet of Dr. Caligari* and *The Last Laugh* are experiments in representing how the world looks to a madman, an intoxicated man, or someone else in an abnormal condition. Things seen can be distorted, blurred, or whirling dizzily. But the film is equally capable of recording exact appearances with a maximum of objectivity, for scientific purposes.

The rapid oscillation in a film between various ac-

tion threads, characters, settings, and the like facilitates merging a great variety of them into one organized unity. The multiple-action multiple-character story, as of Shakespeare, Hugo, Balzac, Tolstoy, and others, is often hard to follow. Repeated reading may be necessary for a young reader to recall the characters. The film can aid the process of identification by repeated, close views of the same person and repeated explanation, in visual as well as verbal terms, of what is going on; yet these shots can be so short and fast that no great expenditure of time is required. Comparatively young children today often surprise their elders by perceiving and understanding in a flash incidents on the screen which would have taken much longer in a stage play or printed narrative in the nineteenth century.

When the narrative approach is desired, as when an explorer describes what he saw and heard in some exotic region, the film can be easily adapted to a more subordinate role. The speaker can tell his story in person if he wishes to, and at the same time he can show in color how the country and its people look. In subdued sound he can give a background impression of its folk music and the chatter of its crowded marketplace. The small film and film projector can be taken into the home to record events of interest only to family and friends.

For films of major importance, as for stage plays, the theater as a locale for presentation still has advantages. In attending a theater one is normally predisposed to accept the illusions of art to an unusual degree. One tends to detach oneself more thoroughly from ordinary life and perhaps to attain a state of rapt attention with almost complete forgetfulness of self. In that state the illusion of a different reality can be extremely vivid.

29. The representational schema.

A. Type of representation involved, especially as to *mode of transmission and general development*.

 1. Art or medium; apparent materials.

 2. Mode of presentation; sense addressed.

 3. Mobility; extent to which presented movement is determined (as in motion pictures; marionettes).

 4. Modes of suggestion: mimetic; symbolic; common association.

B. Types of *subject* and their cultural backgrounds.

 1. E.g., isolated object or person; scene or situation; incident or story.

 2. E.g., Greek deities; mythological setting.

C. *Representational frameworks*.

 1. Is representation fitted into basic framework provided by another mode of composition, or is it developed into a framework of its own? What is the specific nature of this framework? (E.g., statue of a man; a caryatid; a rug design.)

D. *Transmissional and supposed actual frameworks*.

 1. In what order (spatial, temporal, causal, etc.) are the represented things and events supposed to exist or occur?

 2. In what order are they presented or suggested in the work of art?

 3. How do these coincide or diverge?

E. *Plot development*, if any. Of what kind, as to:

 1. Fortune trends; complication and resolution.

 2. Number of actions involved: main and subordinate.

 3. Emotional tones involved; tragic or comic type.

 4. Transmissional arrangement of plot stages.

F. *Presentative development as related to suggestive*.

 1. E.g., in theater art, what is enacted, played, shown? (Speech, gestures, costumes, lights, music.) What is suggested only? (By narration or otherwise.)

G. How are *viewpoints* determined and developed?

 1. Actual viewpoints in relation to suggested.

 2. Vague and indeterminate or definite?

 3. Plural? Single? Changing? How rapidly?

 4. Personal or impersonal? Abstract or individualized?

 5. Whose? Where? When?

 6. Organized into series? How related to plot?

 7. How elaborately is each developed? (E.g., vast single vista in painting.)

 8. With what secondary suggestions? (E.g., of imaginary journey through space.)

H. How *complex* is the representation, as to:

 1. Multiplicity of parts and factors. (E.g., multiple-action plots.)

 2. Their diversity or differentiation.

 3. Their definiteness.

 4. Their integration by resemblances and common frameworks.

I. How *realistic* or unrealistic is the representation?

 1. Literally?

 2. Figuratively?

 3. Perceptually? (E.g., as to visual viewpoint.)

 4. In relation to scientific probability, from standpoint of sciences concerned?

J. What *components* are most developed? How do they cooperate in building up a consistent representative schema? (E.g., does color function in representa-

tion or only decoratively? Is there inconsistency between plot and characters?)

K. *Cultural and psychological* background of representation; general type and degree of development, as to:

1. Subjects, characters, incidents, plots, etc., represented.

2. Naïve or sophisticated conceptions of reality, viewpoint, causality, space and time, human behavior, etc.

3. Subtle differentiation of qualities (through words, images, etc.).

4. Integration of diverse elements.

Note: The following illustrations are particularly relevant to this chapter: Plates I, II, III, IV; Figures 3, 4, 7, 8, 23, 24, 25, 26, 27, 28, 29, 30, 31, 32, 33, 34, 37, 40, 41, 42, 43, 44, 45, 46, 47, 50, 51, 52, 56, 57, 60, 62, 67, 68, 71, 75, 79.

CHAPTER XIV

Expository Development

1. Exposition in art, philosophy, and science.

Exposition was defined in Chapter VII as a mode of composition which arranges details so as to explain or interpret something in terms of general characteristics, causal principles, interrelations, tendencies, or values. It may interpret or evaluate some fact, condition, concept, theory, or belief, such as goodness, truth, beauty, evolution, gravitation, democracy, or the relation between the diameter and circumference of a circle. It may describe how certain kinds of person or thing behave under certain conditions. It may suggest a problem or mystery such as the nature of God or the Trinity, for which no adequate explanation is considered possible. It may include some reference to concrete examples, but as means of explaining or supporting a general conception, rather than for purely sensuous or imaginative reasons. Its appeal is usually somewhat intellectual, to satisfy a desire to know and understand, but in art it is not purely intellectual or cognitive. Its images and meanings tend to involve an aesthetic appeal as well.

Exposition may undertake to characterize an individual, but not (as in representational composition) with emphasis on his appearance, manner, and actions at a particular time and place. It tries to explain him by emphasizing his inner motivation and fundamental, controlling traits. It tends to stress his relation to general types and trends, his habits of thought, his persistent desires, attitudes, and actions and the reasons for them, his merits or demerits and enduring characteristics. But exposition and representation are often so closely blended as to be almost inseparable: in Proust, for example, where the narration of a small incident or the description of someone momentarily seen is often coupled with a generalization on how and why men or women of that kind tend to act, feel, or speak as they do.

Different kinds of exposition occur in art, philosophy, and science. In art it can be transmitted through visual, auditory, verbal, or other presented sensory stimuli. In literature it is a common feature of the essay and meditative lyric. In visual art, it is common in pictorial and sculptural representations of religious subjects.

Typical parts of a highly developed expository composition are: (a) the sensory signs or symbols presented, such as printed or spoken words, numbers, lines, or colors, and their primary, linguistic meanings; (b) the main problem, phenomenon, mystery, being, concept, condition, or situation to be interpreted; (c) some past interpretations, beliefs, or attitudes regarded as inadequate; (d) the proposed interpretation or characterization; and (e) arguments or examples illustrating it, undertaking to demonstrate its truth or value and to support its acceptance. These parts may be arranged in any temporal, spatial, or logical order.

In art, philosophy, or science of a rationalistic or naturalistic sort, all these parts tend to be stated *explicitly* unless obvious and taken for granted. In art pervaded by a *mystical* attitude, exposition tends to be more symbolic or metaphorical. This may involve omitting some of the parts mentioned above or touching upon them in a vague, obscure way. The exposition is then *cryptic* or *semicryptic*, depending on how much is expressed or left obscure.

The expository factor in a work of art usually coexists with one or more of the other compositional factors. It may provide the main framework, as in the essay, but ordinarily it is conveyed by some other mode of composition which serves as a vehicle. A number of illustrative anecdotes (representational) are scattered through Montaigne's essay "Of Cannibals." It begins with narration: "When King Pyrrhus invaded Italy, having viewed and considered the order of the army the Romans sent out to meet him . . ." A little later comes this bit of exposition: "Our utmost endeavors cannot arrive at so much as to imitate the nest of the least of birds, its contexture, beauty, and convenience; not so much as the web of a poor

spider." The main framework of the whole work is expository.

On the other hand, exposition may fit as an accessory into a utilitarian, representational, or thematic framework. In Gray's "Elegy Written in a Country Churchyard," the word-sound framework is metrical; the framework of ideas is representational (a scene and incidents). Into them such expository bits as this are fitted: "The boast of heraldry, the pomp of power,/ And all that beauty, all that wealth e'er gave,/ Await alike the inevitable hour./ The paths of glory lead but to the grave."

In a Gothic *Tree of Jesse* window, the main framework is representational and thematic, as a pictorial design. The exposition of Christ's ancestry on earth is fitted into it. Reference to this descent and to the Incarnation provides a mystical element in its meaning. A related type of visual art in the Middle Ages is the *tree of consanguinity*. Here the expository factor is more generalized and nonmystic. Within the symbolic tree (related to what we call a "family tree") are the figures of men and women with labels to indicate types and degrees of kinship. Those on the left side cannot lawfully marry those on the right. The diagram has an expository function in explaining the concepts of consanguinity and incest. It has also a utilitarian function in regulating marriage and the inheritance of rank and property, which were highly important in medieval society. The arrangement is hierarchical and bilaterally symmetrical, as in much medieval design.

In ancient civilization, as we have seen, the modes of composition are often comparatively undifferentiated. Expository factors are sometimes combined with others in a single work of art, with no attempt to separate them consistently or to eliminate the others. This is characteristic of the works of Hesiod, Plato, and Lucretius. They contain enough exposition on practical and philosophic matters to qualify them as early science or protoscience. But their development of such aesthetic factors as imagery, word-sound patterns, description, narration, and dialogue is enough to qualify them also as literary art. These would be regarded as out of place in modern science, except for educational purposes.

In the evolution of culture, some branches of expository thinking and expression, originally joined with art, have tended to develop in a specialized way along rationalistic and naturalistic lines. Both usually involve empiricism, or reliance on sensory data; but rationalism has been at times dogmatic in its own way, resting its faith in supposedly self-evident, a priori assumptions. When it pursues a specialized course along these lines, exposition tends to become philosophic or scientific and to separate itself from art, including representation, utility, and design. In the West, this specialized development was far advanced in the writings of Aristotle, Epicurus, and Euclid. Their writings tend to sacrifice aesthetic appeal to the aim of conveying knowledge and wisdom about the universe and man. More or less undifferentiated types of art involving an expository factor still persist in various arts, especially lyric poetry.

2. Mystic and rationalistic exposition. Figurative and cryptic symbolism. The myth.

Some works of art express a mystical, supernaturalistic world view, as do the poems of Blake, and some a rationalistic or naturalistic one, as in Shakespeare and Balzac. Expository development in art proceeds at times along mystic-religious lines, at times along naturalistic, empirical lines, and at times with some of both, even in the same work. Mystics then regard it as proceeding on different levels of reality and truth.

Mystic exposition in visual and literary art involves the assumption of all mysticism that communication with a higher spiritual level of reality, and perhaps with deity, is possible through methods other than sense perception and reasoning. Those methods are said to include supernatural visions and messages, inspired and automatic writing, trances, and various forms of extrasensory perception. Mystic exposition does not aim at completeness of explanation. It holds this to be impossible for man in dealing with religious mysteries; also, many mystics believe that human attempts at such explanation may be presumptuous, impious, and dangerous. Some make no attempt at communicating their supramundane experiences to other humans by ordinary sensory means. Others believe, and say in their works, that such communication has been divinely ordered and is possible to a limited extent, especially through the use of symbols. These include visual images and literary figures of speech which can, according to the mystic, hint obscurely at the nature of ineffable things and give the reader or observer a vague idea of the subject which is better than none at all.

Rationalistic exposition, whether in art or science, in a literary essay, a pictorial diagram, or a philosophic treatise, undertakes to explain or interpret something clearly; perhaps not completely, but

as fully as required by the purpose for which it is composed. It relies mainly on logical reasoning and empirical data. It assumes on the whole that such explanation is possible, useful, and morally justifiable, and also that there are no fixed limits to what man may rightly seek to understand. It tends to use plain language or technical terms when necessary, rather than figures of speech such as metaphors and emotive symbols.

Naturalistic exposition is usually rationalistic in method. It is further characterized by a naturalistic world view, which does not recognize the possibility of attaining true knowledge of the outside world through mystical, transcendental sources. It does not explain things in terms of supernatural, incorporeal agencies such as gods, angels, devils, and spirits of the dead. Its emphasis is on observable and material causes. But an artist can, like Shakespeare, be comparatively naturalistic or skeptical in his own philosophy and yet express in art fantasies of magic, miracles, and other supernatural events.

Figurative exposition, as in lyric poetry, is less concerned as a rule with maximum clarity and fullness of explanation than with producing an aesthetic effect, often through metaphors and other figures of speech in addition to thematic factors, and through pointing out unfamiliar, striking analogies between otherwise different things. It can be rationalistic or mystic, naturalistic or supernaturalistic.

Cryptic symbolism has been justified and cultivated by mystics under the name *Imago ignota*. The obscure was accepted as a self-sufficient goal, as explained by the German poet Gottfried Benn: "The writing of poetry is the elevation of things into the language of the incomprehensible."[1] The "unknown image" is a pattern of words, shapes, or colors that has no apparent relation with normal phenomena of the mind or the outside world. Such images and their incomprehensibility itself symbolize the mysterious, unknown, and unformed: the secrets of the cosmos which man cannot fully understand.

A major aim of mysticism is to achieve a state of oneness or union with something outside and greater than oneself, this something being usually conceived in supernatural terms. The sense of oneness is said to involve a felt loss of, or escape from, one's own self and its limits, and thus from self-conscious feelings and attitudes. In this it is said to constitute a return from the previous alienation of man from deity.

Such aims and effects do not always constitute so-

[1] J. Cirlot, *Dictionary of Symbols* (New York, 1962), p. 149.

cially apperceptible parts of the work of art itself, and so may not need to be included in morphological description. They are integral parts of the work of art when definitely expressed there, as in an ode or prayer asking for union with the god, or when the anagogic function of a certain type of art is socially recognized, as in an Indian *yantra*. This is a geometrical diagram consisting of interlaced triangles, which the adept contemplates to attain spiritual insight.

Some but not all these types of mystic symbolism are expository in the sense of this book: only those whose form can be functionally described as means or intended means to the attainment of understanding. They seek to give, directly or in symbols, some insight into the nature of things or of some particular type of being or phenomenon. This is the aim of much mystical art, but when the main goal is to clear the mind entirely by eliminating all thought, knowledge, sensation, and desire, as in extreme forms of Buddhism, neither expository art nor any other kind of art is needed.

Rationalistic and mystic exposition resemble each other in several ways. Both can undertake to inform and instruct the reader or observer on matters of general import. Both undertake at times to predict the future and help him guide his actions. Mysticism does so by prophetic visions and inspired speech or writing, supposedly based on supernatural revelation as in the *Apocalypse* of St. John. Science does so by describing general laws and causal relations, verified by observation and experiment, so that a man may know what to expect if he acts in a certain way under specified circumstances.

Both make extensive use of *analogy*, but in different ways. Primitive religion observes certain resemblances, especially between human life and the outside universe, for example, between the Milky Way and mothers' milk as white. It infers a personal, causal connection: that the Milky Way comes from the sky goddess, Nut. The life-giving rain proceeds from the sky god, who impregnates the earth mother and causes her to bring forth plants and animals in their season. Such theories are implied in primitive symbolism and explicitly stated after the invention of writing. The analogies thus noted are not completely false; there is a real resemblance between milk and the Milky Way, but primitive thought exaggerated it into a false cosmic generalization. Science excludes such generalizations, but art does not, since factual truth is not one of its essentials. In art, even a slight, far-fetched analogy may have aesthetic appeal, whether or not it is given a deeper symbolic meaning.

In science, a perceived analogy between two otherwise remote and dissimilar phenomena may suggest a regular causal connection, but this remains only a speculation or hypothesis until verified by further observation and experiment. One such analogy is that between an apple falling to earth (as an example of gravitation) and the earth itself as a mass obeying the same law. One of the earliest scientific generalizations was the Pythagorean theorem, which asserted a universal correspondence among right-angled triangles: the square on the hypotenuse being equal to the sum of the squares on the other two sides. This is a demonstrated analogy, based on reasoning more than observation, between all right-angled triangles, whatever their size, location, and physical embodiment. All the generalizations of pure science can be expressed as analogies and recurrences between certain kinds of perceived, conceived, or imagined fact or phenomenon. A scientific "law" is simply the exact description of certain recurrent regularities in behavior among phenomena, which seem unvarying as far as present experience indicates. As science enters the more complex fields of psychology, sociology, and aesthetics, it discovers more and more tendencies and approximate regularities which can not, at present, be described as absolute, invariable laws. They depend on too many independently variable factors. Nevertheless, it is often enlightening to recognize even an approximate regularity in phenomena of great concern to man, such as the causes of health and disease, peace and war, happiness and misery, the experience of beauty and ugliness. To what extent, philosophers of history ask, are the rise and fall of civilizations such as that of Rome a regular, cyclical, inevitable recurrence? While science cannot prove any simple, definite answers to such questions, it can and does formulate theories which, though speculative at first, can be gradually rendered more probable through analyzing and interpreting empirical data.

Scientific exposition expresses modern man's curiosity and desire to discover more and more truths. It concentrates much of its effort on the frontiers of knowledge. It tends to express its thinking partly in words, numbers, and other common linguistic symbols, but increasingly in sets of symbols devised for use in a special field, such as biochemistry or symbolic logic. In exposition intended for the education of young or beginning students or for the general public, it often reverts to quasi-artistic means, such as pictorial illustrations, three-dimensional models, graphic charts, and informative diagrams. These are intended to arouse and hold interest while imparting simple explanations.

It was mentioned above that philosophic exposition has developed into the pure and applied sciences, the former being more concerned with knowledge for its own sake and the latter with utility. The sciences overlap and cooperate so as to approach the condition of a single huge, growing system of knowledge and theory. This includes many gaps, unsolved problems, and conflicting theories. For specialized research and exposition, it is divided and subdivided into special fields and inquiries, interrelated through allowing somewhat independent treatment. The report of a single, small research, experiment, or exploration may constitute a distinct piece of expository writing, such as a monograph. Treatises and textbook surveys cover larger areas.

One of the principal differences between scientific exposition and that of mystic-religious and romantic art is that the former tries to avoid ambiguity in symbols, while the latter often welcomes it as a positive value. In science, a particular sign or symbol should ideally have one meaning and no more. Actually this is impossible. There are so many overlapping ideas in modern civilization, increasing at so rapid and accelerating a pace, that there are not and could not be enough words or signs to go around. To multiply them would be hopelessly confusing. So we have to rely very largely, in science as well as ordinary discourse, on the particular context in which a word is used at a particular time, to indicate its intended meaning. Mathematical terms have comparatively little ambiguity, but some remains: e.g., the term "infinity" has various meanings.

What does mystic symbolism try to explain, in and through expository art? At times it offers no definite explanation at all, in the modern, rationalistic sense of that word. It merely presents an image or set of images which seem to have a meaning deeper than that which meets the eye, perhaps a suggestion of something strange, profound, weird, benign, or terrible. To interpret such a form, we must lean heavily on associated information about the cultural context of the work and the meanings actually given there to such a set of symbols in mystical art.

Much of this transcendental meaning would come under such modern headings as theology, eschatology, cosmology, and ethics, but these names imply a somewhat rationalistic division of thought which did not exist before Aristotle. In ancient culture, such realms were not clearly marked off from each other or from the concrete images of divine and diabolic spirits, scenes of heaven and hell, myths and legends, all of which were conceived more along representational than expository lines. Primitive religion was

not clearly distinguished from what we now call magic and devil worship, all of which made use of mystic symbols. As dramatized in the *Bacchae* of Euripides, the worship of Dionysus involved much that would be regarded today as diabolical. In medieval Christian art and in Buddhism, Hinduism, and other advanced religions of the East, much the same basic subjects were interpreted by means of images: at first by concrete, personal images of gods, heroes, saints, animals, nature spirits, and monsters, then gradually by the abstract theories attached to them, as in the conception of Siva as symbolizing the cosmic process of construction and destruction. Incidentally, all the principal phenomena of the universe became the subjects of speculation and of partial explanation by appropriate symbols—birth, love, old age, and death; pain and pleasure; the relation between gods and man; the illusions of desire and ambition; the way to avoid them and achieve heaven or Nirvana. Some of them were also the subjects of rationalistic and naturalistic philosophy, especially in Greece by the Epicureans and in India by the Carvaka school, but these were overwhelmed by the strength of mystic religion in the East and West.

Ancient and medieval mysticism did not, as a rule, formulate either its problems or its answers explicitly—not, certainly, in the abstract, impersonal way that science formulates them, as in asking why the planets have elliptical orbits. An answer often came first, as in assuming that the orbits must be circular because the circle is a perfect figure, hence appropriate for divine creation. Early philosophers had to explain (or explain away) the primitive explanations which had been current since prehistoric times, and which obstructed open-minded observation and reasoning. When Agamemnon's fleet lay becalmed at Aulis, it was taken for granted that the reason might lie in some god's anger; hence the priest's advice to sacrifice the king's daughter seemed credible. By the time of Euripides, this belief was coming to seem unreasonable as well as cruel. Yet the traditional religion still cherished countless beliefs of this kind, which it sanctified in mystic rites and symbols.

The *myth* is a persistent type of story, expressed in verbal, pictorial, dramatic, or other media, and capable of development in various modes of composition. Primarily representational and narrative, it was often developed along thematic lines as in the verse of Homer and the Greek dramatists. Its ritual enactment, as of the Orphic and other seasonal myths, had a utilitarian function in bringing back the sun each year to make life possible on earth.

It was also expository. Some nineteenth-century theories of the myth exaggerated its explanatory function; this indeed was only one of its functions and often implicit. But the recurrent myth of the god's death and descent into the underworld, like that of Persephone's annual captivity, had obvious explanatory significance; it helped to explain the cause of winter and summer, the death and rebirth of vegetation through the reinvigorated sun. It was this causal theory which, to a large extent, motivated the artistic composition and the annual enactment. Likewise the myth of Prometheus, as dramatized in Aeschylus's *Prometheus Bound*, explained the origin of the arts and crafts, man's rise in power and civilization, and the gods' hostility toward that presumptuous rise.

By the fifth century B.C., the development of rationalism in Greece had gone a long way. It was applied to the vexing problem of why the gods, as portrayed in poetry, were so often immoral, cruel, and dishonest. This was discussed through the speeches of actors and choruses, briefly and as if incidentally, in terms of particular characters such as Agamemnon and Iphigenia, caught between their own moral sense and the cruel, unjust demands of deity. Plato carried it still farther in attacking the poets' conception of the gods explicitly. In his *Laws*, the mystic symbol is almost dissolved by rationalism; in his *Phaedrus* and *Timaeus*, the undercurrent of mysticism rises to flood level. The farther back we go toward primitive thinking, at different dates in different cultures, the less we find exposition of abstract subjects as a conscious, purposeful, systematic undertaking; the more we find it, if at all, as incidental to a representational framework such as a myth or drama. The abstract meaning on a naturalistic level comes out by implication; on a transcendental level it is often obscure, as in what we know or can guess of the Orphic mysteries.

There must have been conflict and hesitation in the minds of many artists as to whether the gods would resent and punish any attempt at revealing divine mysteries through clear exposition, as they resented Prometheus's gift of fire to man. One expedient was to keep the revelation of mysteries restricted to the initiate, as at Eleusis. This was a well-kept secret, whose public utterance was punishable by death.

After the career of rationalistic naturalism in the writings of Aristotle, Epicurus, Lucretius, and their followers, the Greek-Roman world was again overwhelmed by a flood of mysticism from Persian, Hebrew, and other sources, culminating in the Hebrew-Christian triumph under Constantine. Late Persian mysticism was expressed in Mithraism and Maniche-

ism. That of the Old Testament, as in the books of Daniel and Ezekiel, flowed into early Christian mysticism as exemplified by St. John's Revelations and the Gospel of St. John the Evangelist. But mysticism and its arts, with or without a developed expository strain, flourished in advanced religions throughout the world, not only in Asia, but also in Central America.

Whether by diffusion or independent invention, symbols such as the Tree of Life are found in most of the civilized, art-producing regions of the earth at analogous stages in cultural evolution, though at widely varying dates. Among their meanings there are usually some in common, such as the conception of the world tree as a bridge between the earthly and the heavenly realms, on which the gods travel back and forth, and hence as a symbol of the connection between body and spirit. Any account of ancient Brahman, Buddhist, or Hindu culture must include some reference to its elaborate iconology of mystic symbolism in art.

There are differences, of course, such as the common acceptance in Asia of the doctrines of reincarnation and that of different avatars or personal manifestations of the great gods. Innumerable local gods and demons were gradually merged, as in the West, into separate manifestations of a few supreme deities, especially Brahma, Vishnu, and Siva. The lack of any vigorous, persistent tradition of science or philosophic naturalism in the Far East helped to keep the mystical tradition alive in art and thought until the present time, though not without a certain hardening into fixed forms, especially in India since the Middle Ages.

3. Symbolism in expository art; in literature, visual art, and music. Heraldry, astrology, alchemy.

The present section is concerned with the use of symbols in expository art. Though used in other modes of composition also, they are especially important here. Several kinds of symbol are widely used and developed into expository forms.

In Chapter II on the Modes of Transmission, three kinds of symbol were distinguished as follows: (1) In its broadest sense, a *symbol* is any arbitrary, conventional, or nonnatural sign, such as a character, icon, diagram, letter, number, or punctuation mark, abbreviation, or other image, used in a field such as mathematics, music, or literature to represent operations,

quantities, qualities, or relations. Those pertaining to language are *linguistic* symbols. Although the symbolic image or sign is nonnatural, it may represent a natural object such as the sun, a tree, or an animal. (2) One variety of symbol, the *figurative, polysemous* type, has besides its obvious, primary meanings the power to suggest one or more secondary meanings. It uses images to stand for abstract, metaphorical, or hypothetical ideas which can not be adequately sensed or represented in purely sensory terms. (3) A variety of figurative, polysemous symbol, the *mystic* type, is regarded by some as having the power to suggest occult meanings pertaining to a transcendent spiritual level of reality, and hence to lead the mind upward to that level.

In Chapter II we also noticed several varieties of symbol and symbolism, including the analogic, mimetic, linguistic, mystic, unconscious, rationalistic, explicit, and cryptic. They differ as to the relation between symbol and meaning, as to actual or intended functions, as to the ways in which they are regarded, and as to the cultural fields in which they are used. These last provide them with different contexts which help to determine their meaning in a particular case.

The term "occultism" refers to a belief in hidden, mysterious, supernatural or preternatural powers and supposed ways of controlling them by humans. It also refers to a widespread cultural field and tradition, concerned with efforts to control these powers. It dates from primitive times and includes a variety of beliefs and practices involving magic and mysticism, such as alchemy, astrology, and necromancy. It includes certain areas of belief and practice within many of the world's great religions. Occultism is supposedly esoteric, hidden from public knowledge. It is expressed to some extent in symbolic art, especially in the more cryptic varieties. This involves the so-called language of occultism and mystic symbolism, in which certain images and forms are understood as having socially established meanings: e.g., that the *ouroboros* or snake biting its tail symbolizes self-fecundation, the self-sufficiency of nature, the continuity and cyclical revival of life after dissolution.

Opinions differ about the origin and value of these widespread symbol-meaning recurrences. Jung and his followers in psychology accept the mystical doctrine of their transcendental status and origin as archetypes in the racial unconscious. This theory is rejected by naturalism, but the recurrences are too common in the art of all civilizations to be ignored. Insofar as occult symbolism is actually understood and practiced by artists within a certain cultural field, it can

be used by the naturalist as well as the mystic to interpret that art, at least to the extent of showing what it meant to the people who made and used it. There is no doubt that many symbols, such as the Tree of Life, were used with approximately similar meanings in different cultures and periods throughout the world. Some of them probably spread by diffusion, some by independent invention. Occult symbols and meanings were certainly used and understood by many European artists and their educated patrons until recent years. To this extent they should be included in the morphological description of works of art.

Occult symbolism tends to be more or less cryptic in having hidden meanings besides the ovbious, representational ones. These are some of the motives for such obscurity in expository art:

(1) Fear of the unknown and mysterious; of supernatural and preternatural powers as malevolent; of taboos against mentioning them by name or literal description (e.g., the Furies; Yahweh); fear of punishment for revealing divine secrets.

(2) Belief that supernatural things, even when revealed to the initiate as in dreams, visions, and divine messages, are ineffable: that is, impossible to describe or explain adequately in words, pictures, or other images.

(3) Special taboos in various arts and cultures, such as that against graven images as idolatrous; also, that against erotic art, which tends to arouse sensual impulses; inhibitions against explicitly describing, representing, or explaining matters of physical sex in art.

(4) Romantic love of mystery, vagueness, secrecy, and hints at unutterable things: strange sins, aberrations of nature, darkness, the weird, uncanny, and frightful. As fear of them declined, they came to seem pleasantly exciting.

(5) Romantic distaste for clear, frank, rational expression as destructive to beauty and other aesthetic values, to love and other delicate emotions, and to understanding of higher, spiritual realities. Dislike of the coldness or offensiveness of "calling a spade a spade" in common terms or in those of science, as in physiology and psychology.

(6) Romantic egotism in the artist and his admirers; belief in the vast importance of self-expression on his part, especially when too abstract or unrealistic to be understandable by the general public; desire to shock and mystify the bourgeoisie.

All mystic symbols in art can be regarded as linguistic insofar as they employ the so-called language of occultism. But this is not to be confused with the use of ordinary linguistic signs and symbols in the nonmystical sense.

The essential differences between the various types of symbol are in the meanings and suggestive powers conferred upon them, rather than in the images presented. Many images recur in all three of the types of symbolism defined above. The hand with pointing finger, reduced to its simplest outlines, is used in typography to call attention to a certain word or line of print. On a sign or wall, it directs the traveler. This is *linguistic* and utilitarian. Ordinarily, the linguistic sign is not regarded with much interest or aesthetic feeling for its own sake, although it may be developed artistically; it is usually a mere device for conveying an idea which may be important or trivial, emotive or prosaic. In a suitable pictorial context, a pointing hand may acquire a *mystic*, religious meaning, as in a saint who points to heaven, or a *figurative*, secular meaning, as in the picture of an officer who points to his flag in battle.

Linguistic symbols are used throughout the arts and elsewhere in civilization. They are not peculiar to expository art, although exposition of a rationalistic type is especially dependent on an adequate vocabulary of clearly defined words and other conventional signs in explaining abstract, theoretical subjects.

In literature, especially lyric poetry, there is a strong reliance on the figurative, polysemous type of symbol, usually in the form of metaphors and similes. Most works of this sort, in modern centuries, have not been definitely mystical. The use of figurative symbolism in pictorial art was common through the seventeenth century and has persisted to a less extent until the present time. Much of it has been expository.

Countless types of image which recur in nature and in the human imagination are used as mystic and figurative symbols. Among them are these: (a) natural objects, animate and inanimate, such as the sun, moon, stars, and planets, lions, apes, fish, and serpents; mountains, rocks, rivers, trees, flowers, water, temples, palaces, weapons, armor, cups and vases, books and statues; (b) monsters and hybrid creatures, such as dragons, sphinxes, centaurs, and mermaids; (c) places, such as dark forests, swamps, and cities; (d) figures of personages, individual and typical, humans, gods, demigods, and heroes such as Hercules, Adam, Krishna, Persephone, and Beatrice; (e) sounds, voices, thunder, lightning, bells, music, spoken words; (f) actions and gestures, such as the dance of Siva, ritual movements and mudras, postures, ceremonials, sacrificial rites; (g) odors and tastes; the taste of honey or bitter wormwood, the smell of incense;

(h) conditions of nature, seasons, weather, day and night; (i) stories, myths, allegories, parables, visions, fables; (j) mathematical and other abstract forms, such as the circle, triangle, pyramid, point, sphere, square, and combinations of these such as the Hindu yantra; (k) numbers such as three and seven; (l) hierarchical arrangements such as a series of steps or levels; (m) breaks and intentional irregularities in a product, to avoid presumptuous attempts at perfection.

By contrast with words and pictures, music has proven a very limited means of symbolic exposition. Since the time of Pythagoras at least, music and its power to affect the emotions have been regarded mystically, especially as an aid to ritual and song in causing an elevation of the spirit. Its semimagical powers and spiritual values were explained largely in terms of number, as in the Pythagorean theory of harmony. St. Augustine's treatise on music emphasized its numerical relations, which seemed to him valuable in much the same way that Dante glorified the number nine. The sensuous pleasantness of music was much less respected by medieval philosophers than its abstract symbolism; St. Augustine distrusted it on ascetic grounds. The supposed "music of the spheres," of which the Psalmist could say, "The heavens declare the glory of God; and the firmament showeth his handiwork," was usually conceived as silent. "There is music even in the beauty, and the silent note which Cupid strikes, far sweeter than the sound of an instrument." So wrote Sir Thomas Browne in *Religio Medici*; and, he added, "there is music wherever there is harmony, order, or proportion; and thus far we may maintain the music of the spheres." Music in this abstract, intellectual sense was analogous to the regular, recurrent, cyclical movements of the heavenly bodies.

Well into the eighteenth century, attempts were made to use specific musical sounds as a kind of language, e.g., a group of three notes to mean the Trinity, or a passage in rising or falling pitch to signify rising to heaven or falling into hell. Beethoven attempted a kind of exposition in his Ninth Symphony, but felt the necessity of resorting to words (Schiller's poem on joy) to express his ideal conception of a free, happy, peaceful humanity.[2]

Doubtless music could have been developed along

the lines of a definite language by attaching specific meanings to specific notes, chords, and types of sequence. But the pressure in the Renaissance and later was too strong in the opposite direction: that is, toward freeing music from such ideational burdens, toward creating and enjoying it for more purely sensuous and emotional qualities, perhaps as a relief from the heavy weight of intellectual meanings which literature and painting have had at times to bear. Literature and painting themselves have usually followed the same course in recent centuries, avoiding elaborate symbolic meanings. But it is easier in those arts than in music to introduce symbolic meanings when desired in a particular case.

Mystic symbolism in art was naturally at its height in those cultural epochs when mysticism as a world view and a way of life was flourishing, before it had been seriously undermined by the rise of scientific rationalism and naturalism at the end of the seventeenth century in Europe. Naturalistic science and philosophy regard all kinds of symbol and meaning as man-made products of human experience, through the interaction between man's evolving physical apparatus and the outside world. It is not necessary to postulate for any of them a transcendental origin. When we speak of the "power" of a symbol or other factor in art to suggest a meaning, we are speaking of a power conferred by humans on a certain product of experience. No image or percept has a certain power or meaning by the eternal nature of things. No particular meaning of an image such as the sun, the wheel, or the number nine is *the* correct meaning, except in the sense that it is commonly so accepted in a certain social group or field of culture.

Pythagoras, at the beginning of philosophic speculation, turned the minds of mystic thinkers to the analogy between numerical ratios, musical harmony, and ethical harmony. Plato further developed this combination and added an emphasis on "divine madness" as one source of art and spiritual ascent. He enriched the symbolism of mystical philosophy with some of its most dynamic images, as in the myths of the Cave, the Sun, and the Charioteer. They were later combined with the Biblical stories of Adam, Eve, the Garden of Eden, the serpent, Cain and Abel, the flood, Samson, Goliath, and others to form the Western heritage. The Neo-Platonism of Plotinus diminished the rationalistic strain in Platonism and exalted the mystical, as in the use of the sun and its radiance to symbolize God and his emanations, penetrating the soul of the true artist. The infinite mind, according to this tradition, expressed itself in the cosmos and in history. The persons, events, and

[2] Some critics interpret other late works by Beethoven as expository in this way, but they are not widely understood so. See J. Sullivan, *Beethoven, his Spiritual Development* (New York, 1927). Sullivan calls the Quartet in F Major, Op. 185 a summary of the great Beethovenian problem of destiny and submissiveness (p. 255).

images of the New Testament were reinterpreted in Neo-Platonic terms, as in the Logos doctrine of St. John the Evangelist. For example, the relation between the logos or word and its concrete embodiment was symbolic of the Incarnation. "In the beginning was the Word . . . and the Word was God, and the Word became flesh and dwelt among us." For over a thousand years after Constantine, the minds of Christian intellectuals and mystics were busy multiplying the meanings of every incident and image in the Bible.

The process of discovering hidden, deeper meanings in the Bible and throughout nature was a prolific inspiration to artists to arrange the visible symbols of them into works of art. It turned attention away from naturalistic representation to symbolism in art and justified the production of art as a means of executing God's will, thus avoiding the charges of idolatry and sensuality. But at the same time, it loaded the imagery of art in all media with more and more theological and moral ideas, often far-fetched and controversial, until a turning point was reached in the Council of Trent, which discouraged excessive symbolism.

By that time the rebirth of science was on its way. But Platonism and Neo-Platonism also flourished in the Renaissance, long obstructing science. For a time the burden of symbolism became more complex than ever, as in Michelangelo's heroic effort to combine classical with Biblical symbols in the Sistine Chapel.

While a large amount of medieval Western symbolism was Christian and in line with ecclesiastical doctrine, not all of it was so, and some of it was outside the pale of organized religion. Of this last an extreme form was diabolism or Satanism, allied with sorcery and witchcraft. Under the patronage of occasional diabolists among the nobility, it inspired clandestine works of art, mostly short-lived. In mockery of the mass, it substituted symbolic rituals of its own, with desecration of the church and altar as opposed to consecration. The Witches' Sabbath, as described in the Walpurgisnight episode in Goethe's *Faust*, is one of many expressions in art of this tradition, derived from pagan rites in the north and south. The Devil's cloven hoofs and tail relate him to the ancient bull gods of Babylonian religion. Some ancient deities, worshipped in their time, have thus descended from divine to diabolic status, thereafter, in some cases, to become amusing, playful images like the little imps of Halloween decoration. In this descent, their symbols lose most or all mystic meaning. The decline of belief in a powerful devil paralleled the gradual change in Western religion from a strict dualism of good and evil toward monotheism and the conception of God

as a loving father, who may tolerate evil for the present but is not seriously threatened by it. Variations on this theme are found in the treatment of Satan or Lucifer as archrebel by Dante and Milton.

Several extensive branches of medieval thought developed their own mystic symbolism. Their relation to the Christian church was variable. Though usually professing Christian faith, they were often charged with witchcraft. Chief among them were *astrology* and *alchemy*, now commonly scorned by science as mere superstition, but then aspiring toward knowledge and power by occult means. They flourished through the seventeenth century and inspired innumerable drawings, paintings, book illustrations, and verbal texts. The two lines of study were allied and overlapping, employing many symbols in common. These were combined to build pretentious structures along utilitarian and expository lines. The utilitarian motive in astrology, derived from ancient magic, was the desire to predict the future for individuals and nations, and to advise their actions from knowledge of the benign or baleful influences playing upon them at every moment from the stars and planets. The aim of alchemy was, not only to transmute the baser metals into gold, but to achieve other, greater powers, such as a knowledge of the relation between matter and spirit, of the "elixir of youth," the "philosopher's stone," and other profound mysteries.

Since the universe is one, the alchemists believed, with man as a microcosm or small analogue to nature (the macrocosm), the symbols and meanings drawn from all realms of thought were interrelated and consistent. Symbolic pictures show the alchemic hermaphrodite in which the male part is symbolized for astrology by the sun and the female by the moon, or, in alchemy, the man by gold and the woman by silver. While the astrologers inspected the heavens, the alchemists experimented with their ovens and retorts. Their methods were more mystical and magical than scientific. Every part of the oven, and each familiar chemical process, was given a symbolic meaning, as in the maceration and dissolving of gold and its "resurrection" in a precipitate. The "Great Work" of alchemy as a whole was symbolized by a castle with many entrances, some real and some deceptive, through which the aspiring adept sought to pass. Man in the center of the cosmos was symbolized as the "sedulous ape" who learned by observing and imitating nature, but in practice this ideal was long obscured by reliance on magic and mysticism. Until after Copernicus, the physical universe was conceived in Ptolemaic fashion, with the earth at the center: its surface as a circular mandala, peopled with animals

and plants. Around it were concentric spheres (pictured as circles) which contained the various heavenly bodies.

Cabalism was another phase of medieval occultism, emphasizing the hidden symbolism in the Jewish and Christian scriptures. It set the scholar at work counting letters in a name and searching for "key verses" with which to foretell the future. Such methods were often combined with those of astronomy and alchemy wherever some possible hint of supernatural revelation might be found. The prestige of astrology among serious scholars waned in the seventeenth century as scientific astronomy developed, and especially as the Copernican or heliocentric theory of the universe triumphed over the Ptolemaic or geocentric. Symbolic pictures of the time show the two systems in combat among the constellations.

Also of artistic interest are the many illustrated books or types of natural phenomena, such as lapidaries, herbals, and bestiaries. These kept alive a tradition in the study and classification of natural forms which had flourished among Greek and Arabian scientists. Empirical fact was largely sacrificed to moral and religious symbolism. A familiar example is the pelican in Bosch's *Ars Symbolica* as the bird which tears open its breast to feed its young, thus symbolizing Christ's love for mankind. Similar concepts were illustrated with fanciful pictures of fabulous animals such as the dragon and basilisk, and plants like the mandrake, taken from travelers' tales and popular legends.

The confluence of innumerable symbols and meanings during the early Roman Empire, from a confusion of rival cults in the Near East and Egypt, overwhelmed the decadent rationalistic philosophies and the efforts of the emperors to merge them all into one imperial religion, with or without the deification of the emperor himself. An example of this effort is shown in a type of statue combining a number of symbols, formerly peculiar to the gods of different religions. Hadrian's unsuccessful attempt to bring the Jews into line, accepting Jupiter as Jehovah, was only one of many failures. But the triumph of Christianity under Constantine, followed by the Council of Nicaea to establish an orthodox canon, introduced some order in the chaos by eliminating masses of pagan and heretical ideas. The focus of attention was now located in the Old and New Testament as the primary source of divinely authorized symbols, and every character and incident therein was given a plurality of meanings, literal and figurative.

"St. Thomas," says C. H. Grandgent, "gives us a clear discussion of the scope and method of allegori-

cal explanation." Two different processes were used.[3] (a) Concrete things were taken as symbols of abstract concepts. Thus the four letters of Adam's name meant that his descendants would occupy the four regions of the earth and the elect be gathered from the four winds. (b) Persons and events of the Old Testament were said to foreshadow the New. Thus Adam, Jonah, and Samson prefigure Jesus in the detailed episodes of their lives. St. Augustine's *Exposition of the Revelation of St. John* declares that "we have taken heed and have sought under his bountiful guidance, to explain according to analogy: for the revelation of Jesus Christ is bestowed upon our ears, that heavenly secrets may be manifest to our hearts."

The triumph of Christianity, with the adoption of an orthodox canon and ecclesiastical organization, both simplified and complicated Western symbolism. The simplification was in excluding a vast amount of non-Christian interpretation or narrowing it down to specific Christian applications. Thus the cross, an ancient symbol with many variants, could mean the Tree of Life, the world axis, the ladder by which souls reach heaven and gods descend to earth, the relation between earthly and heavenly, the joining of spiritual (vertical) and worldly (horizontal) principles, fire, suffering, martyrdom, and countless other things. Some were peculiar to a certain variant such as the Egyptian looped or ansate cross, which stood for health, happiness, the combination of male and female, active and passive, the extension of life.

Christianity narrowed the meaning of most types of cross to the single instance of Christ's agony and sacrifice, together with the Christian church, its doctrines and activities. But at the same time a vast number of new symbols and reinterpretation of the old arose from the practice of making all the characters and events of the Old Testament prefigure, and thus symbolize, those of the New. Thus Jonah became a symbol of Christ as one who was sacrificed (by the men on the ship), who descended into the realm of death (the sea monster), who was resurrected, and who points the way to salvation.

It is impossible to draw a sharp line between the mystic and the nonmystic or merely figurative use of polysemous symbols in art. Long after mysticism has declined as a living faith on the part of the artist and his public, artists continue to employ the ancient myths and archetypal images for their aesthetic value, even as transformed in modern dress and modern idioms. The aesthetic functions of mystical exposition have been taken over to some extent by figura-

[3] C. Grangent, *Dante* (New York, 1921), pp. 251, 254.

tive exposition in poetry and visual art. From the standpoint of the modern mystic, the loss by myths and archetypal symbols of the primal strength they had when accepted as supernatural is great and irreparable. But some compensation is found in the enrichment of secular poetry and painting, including the naturalistic treatment of religious subjects in the high Renaissance and Baroque.

In its day, the mystic type of symbolic exposition was no doubt more susceptible to artistic treatment than rationalistic exposition is today. Its loss of prestige has resulted largely from disbelief in the kinds of explanation it offered, and disbelief in the reality of its supposedly anagogic, supernatural powers. This involves a far-reaching shift of confidence from the mystic to the naturalistic way of explaining phenomena and of attempting to control them. For most explanations, modern man trusts to science and the philosophy built upon it; for control, he trusts to scientific technology, always with some risk to himself. In becoming scientific, exposition has lost or voluntarily sacrificed much of the aesthetic appeal which prescientific exposition derived from its use of vivid imagery, both mystic and naturalistic, and from the primitive method of explaining things in terms of personal spirits. To make up for this aesthetic loss, it claims far greater truth in exposition and greater power in utilitarian control.

4. Complex expository composition in terms of mystic symbols. The theory of universal symbolism.

How did symbols function in the development of mystic exposition? Ordinary linguistic symbols, such as words, functioned there as in the other modes of composition, insofar as the medium was literary. Words could serve in both mystic and secular poetry. But whereas the poetry of naturalism and rationalism sought on the whole for clarity and definite, limited meaning in each word and sentence, that of mysticism tended to be more obscure and allusive; to hold up for the observer's rapt contemplation emotive images, each of which had many meanings, interpenetrating and coalescing in a single emotional experience. Whereas rationalistic exposition tended to develop along logical lines in defending a thesis or expounding a complex subject step by step, mystical exposition tended to avoid conceptual analysis and logical sequence. It often presented its meaningful images, verbal or pictorial, in a simultaneous arrangement, as in a stained glass window or a book illumination.

At other times it presented them allegorically, in narrative sequence as in *Pilgrim's Progress.* In the Apocalypse, St. John presents them in approximately narrative sequence, as successive visions, with pauses for the elaboration of a single vision such as that of the Four Horsemen.

The tendency to avoid plodding, logical order in exposition is characteristic, not only of religious mysticism, but also of secular lyrical poetry, especially that of Romanticism. Lyrics include many short forms in which the whole conception is conveyed almost in a single flash and also ballads, which recount a short story with a moralizing refrain. The dramatic allegory, also in story form, has been an effective vehicle for exposition, as in the symbolic play *Everyman.* In plays not suited for enactment, such as *Faust* (Part Two) and *Prometheus Unbound,* the author can present a temporal sequence of symbolic characters and events including fantastic or supernatural ones, which will gradually build up a complex philosophical conception. In Lucretius's poem *On the Nature of Things,* Venus and Mars are more than figurative images. Lucretius was a naturalist, and did not believe in these Olympian deities as commonly conceived, but as personal symbols of the eternal cosmic process of creation and destruction, somewhat analogous to the Hindu Siva; his allusions to Venus and Mars help to make his poem a work of art, not a mere text on primitive science.

A powerful influence in medieval art was the doctrine of *universal symbolism,* which is attributed largely to St. Augustine, Origen, and Clement of Alexandria. It taught that everything in the universe, in nature and in human art as well as in the Scriptures, was like the handwriting of God in his benevolent plan to guide and educate mankind. The vast scope thus given to symbolic thinking might well have swamped the intellectual scene with an embarrassment of riches, had not the Christian scholars persistently sought to organize the multiplicity of symbols into some kind of system, or rather, to discover the unity which God had placed there.

A key idea in that direction, as we have seen, was the theory of man as microcosm, implying that everything in the earth, the starry heavens, hell, and purgatory had its analogue in the human body, mind, and soul. Another was the theory that everything comes in series and belongs to several common rhythms, based mainly on analogy. Numbers, colors, odors, tastes, notes of different pitch, pointed objects, hollow containers, mountains, valleys, forests, plains,

rocks, and water constitute separate series. Each member of a series can be considered as to its physical or observable nature, its function, and its spiritual meaning. Thus, it is said, the sword, iron, fire, red, Mars, and a rocky mountain all belong to one "symbolic line," signifying a desire for spiritual determination and physical annihilation.[4]

Most of the symbols employed in mystical art are ambiguous. Each may stand for several related ideas, and only the context will show which is meant. The archetypes as such, according to Jung, are empty forms or innate predispositions to organize experience in certain very general ways. Each individual and each cultural group fills in a selection of archetypes in somewhat different ways in terms of its own experience. There is no fixed limit to the number of ways a circle can be experienced. It can be drawn with countless variations and interpreted accordingly: now as a wheel turning, now as the wheel of the law; now as a lotus blossom, now as perfection or cyclical recurrence, and so on. Usually there is some basic idea in common among all the variants. It is hard to show that any interpretation is definitely wrong, since an archetype can mean so many things; but one can often show, with the aid of reference works on iconology and symbology, that in a certain context it usually has a certain meaning.

While each symbol may have several meanings, it is also true that several symbols may stand for the same idea, as a unifying analogy between otherwise dissimilar images. Each object in a series has a "dynamic tendency" to join, in thought and art, with corresponding members of other series. Each object can be interpreted on several levels, e.g., those of its sensory qualities, its utilitarian functions, and its transcendental meaning.

Furthermore, says J. E. Cirlot in explaining "symbolic syntax,"[5] individual symbols tend to appear in clusters, leading to symbolic compositions which may be arranged in time (as in stories), in space (as in pictures, emblems, and graphic designs) or in both (as in dreams and dramas). The way a symbol is oriented is significant, so that fire pointed downward means erotic life and when pointed skyward it means purification. A basket changes its meaning when placed on the head. Combinations of symbols have a cumulative meaning, so that a crowned snake signifies the crowning of instinctive or telluric forces. A group of simple symbols in an emblem may be concordant, as in a heart enclosed within a circle from which

flames radiate. These, it is said, signify the Trinity: the heart is love and the mystic center; the circle is eternity and the flames are purification. A Medusa's head in the center of a symbolic space means destructiveness. The vertical position of the image is important in that higher elevation means spiritual superiority, as when the Egyptian uraeus or snake image is placed on the forehead to mean the spiritualization of inner force.

Individual symbols may be related in four ways: successively, when beside each other without combination or interrelation; progressively, when they represent different stages in a process; compositely, when their juxtaposition causes mutual influence and a complex meaning over and above the sum of their individual meanings; and dramatically, when different, complex groups of images and meanings are synthesized. Discords and oppositions may appear, but on the deepest level, in the infinite, "the apparent diversity of meaning merges into Oneness." Hence the combination of apparently hostile symbols, as of the material and spiritual, good and evil, does not necessarily imply a radical dualism. It is easy to see how, on this basis, thousands of different, complex emblems were assembled, each with some expository meaning and also a thematically organized design.

Mystical exposition is sometimes short and simple, but sometimes extremely complex, as in the symbolism of the *Divine Comedy* (verbal) and the Cathedral of Amiens (visual). When it is complex, we can distinguish in theory two constituent lines of development: (a) the *composition of symbolic images*, including metaphors and similes, and (b) the *composition of meanings*.

Both involved a vast amount of multiplication, largely as a spontaneous process of cultural evolution, performed by various peoples in different periods. In Europe, as we have seen, the number and variety of images available for symbolic use was hugely multiplied by the doctrine of universal symbolism, so that even the humblest being or imaginary creature was accorded a significant place in the divine scheme of things. Every word and idea, every sound, shape, and color, was made available to the artist for religious and moral use. These included presented images, addressed to any of the five senses, and also their suggested literal or primary meanings: e.g., that of "lamb" as a young sheep. These together made up the "symbol" as conveyed in visual or literary art.

There was also a composition of *meanings*, especially the secondary, "deeper" ones. These were multiplied as theologians and philosophers attempted through the centuries to interpret the innumerable

[4] J. Cirlot, *A Dictionary of Symbols*, p. xxxvii.
[5] *Dictionary of Symbols*, p. iii.

symbols contained in the Bible, in human history (including such stories as the *Aeneid,* which Dante regarded as historical), and all of physical nature.

As in all art, the composition of these varied ingredients into works of art was a process of selection, emphasis, and organization. The execution of the process, however divinely inspired, was necessarily a physical one of manipulating a sensory medium which could stimulate the perceptual mechanism of an observer. It could be complicated in any way and to any extent which was favored by the artist and his patrons, within the limits of the materials and techniques available. The artist could assemble the desired symbolic images, each with its literal meaning, in two dimensions of space as in a painting, in three dimensions as in a statue or building, in time as in music and poetry, or in four dimensions as in a mystery play. Dante chose to assemble his in the form of a poetic narrative, and thus with a representational framework.

The arrangement of the secondary meanings, which are the most important from a theological standpoint, coincides only in part with that of the symbols. It coincides in that each symbolic image with its literal meaning is placed before the reader in a certain spatial or temporal order. In the *Divine Comedy* the order is one of temporal succession within imaginary space, from the first moment when the poet finds himself "midway upon the road of this life" within a dark wood, to the final, beatific vision. If equipped with the necessary knowledge for its fourfold interpretation, the reader proceeds throughout the story apperceiving the deeper meanings one at a time, but with a cumulative memory of those already received. When he reaches the end of the story, that is the end as far as the narrative sequence of symbols is concerned; but if he has understood and remembered correctly, he will retain, not only a memory of the story in temporal order, but a conception of the divinely established and directed universe as something fundamentally eternal, changeless (unless God wills it otherwise) and distinct from the particular journey which Dante and his guides made through it. This conception, combining deeper meanings of all the symbols noted en route, will be the main, expository factor in the work of art as a whole. That whole will be something more than the sum of the individual meanings: something closer, it is hoped, to an understanding of the fundamental mystery of the Trinity and its relation to the world and human life.

The cathedral is a static, spatial framework for presenting Christian symbols. Here they are displayed simultaneously for the most part, although each observer receives them in a somewhat different way. But they all contribute to an understanding of the universe—material and spiritual, past, present, and future—as conceived by medieval Christianity.

The composition of mystic symbols on a comparatively small scale is illustrated in the many works of art which seek to characterize some human, divine, or saintly personage by combining his or her image with a set of symbols or attributes. Some of these are related to the personage merely through historical contiguity, as in the griddle of St. Lawrence which indicates the manner of his martyrdom. Others are based more on supposed analogy.

Thus, in Psalm 23 the singer characterizes the Lord by likening him to a shepherd. "Shepherd" is here the main symbol and "the Lord" is the mystery to be interpreted. This is done by expanding the initial metaphor ("The Lord is my shepherd") into a cluster of symbol traits, most of which amplify the image of a protecting shepherd. There is also a second theme and character in the situation. The Lord is not characterized in his own ineffable nature as an unapproachable being in heaven, but in direct relation to *me,* the singer. The second line is "I shall not want," and the last lines revert to his own blessed present and future state under divine protection. In many intimate lyrics, both sacred and secular, part or all of the characterization is of oneself, perhaps in relation to someone else, divine or human.

In certain emblems of the Virgin Mary, she is shown surrounded by a number of symbolic objects, implying that each resembles her in some respect. The symbolism is semicryptic in that the grounds of these analogies are not explained in the picture, but most of them are fairly obvious and familiar in Christian symbology. Thus Mary is like the sun and moon as a source of light. She is like a closed garden (*hortus conclusus*) as to her virginity. She is like the rose, the cedar of Lebanon, the fountain of living waters, the star of the sea, and the tower of David. Taken all together, these build up a partial characterization. The details are representational, but they are not arranged to make a realistic scene. The objects are diverse in their literal meanings, and their arbitrary arrangement in a symmetrical pattern calls attention to the deeper expository meaning of the whole.

In Indian sculpture, the nature of Siva is set forth in representational statues of the Nataraja type. The god is performing his cosmic dance, which symbolizes the rhythmic process of the universe. This constitutes the statue's expository factor. Siva is portrayed in a lithe, graceful, energetic dance posture, surrounded by symbolic objects referring to his various activities

and exploits. The fire symbolizes destruction and regeneration. The small fires around him are held in by a circular mandala, which suggests their control in a perfect unity. The god stands on a dwarfish monster, symbolic of the evil he has conquered, while the goddess of the Ganges recalls a myth in which he saved humanity by swallowing the river. Siva's dance is a spontaneous expression of his inner nature, not performed for the sake of any onlooker or for any ulterior purpose.

A more abstract, geometrical type of Indian mandala is the Shri Yantra, a linear diagram which functions as an aid to concentrated contemplation and insight. It is one of many circular forms, such as the wheel of existence, the lotus, rose, calendar stone, and zodiac. The components of the yantra are all concentric, suggesting an expanding center. The central point is said to stand for the irradiating point of primordial energy. Surrounding it is a pattern of nine triangles within a circle of lotus petals (symbolizing regeneration) and a triple circle. The serrated border of straight lines is said to symbolize orientation in space and existence in the material world, while the figure as a whole suggests the longing to bring order into chaos, integration into the diverse and diffused.

Albrecht Dürer's engraving, *Melencolia No. 1*, has a representational framework: a fairly realistic scene in deep space wherein a winged woman sits in a dejected attitude, loosely holding a compass. The symbolic nature of the whole is suggested by the unusual and somewhat incongruous objects scattered around her. They do not seem to make sense on a literal plane. Several of them are related to science, which suggests an expository meaning; but why is a bat flying above, and why is a winged *putto* seated nearby? One clue is given in the title of the picture, which the bat is holding.

To interpret this complex picture, some information is needed on the symbolism of the details and of the scene as a whole, in the context of German Renaissance culture in 1514. Erwin Panofsky has supplied this.[6] In the first place, Panofsky tells us, the infant symbolizes activity, the woman, theory. The two realms are dislocated here. The melancholy expressed is of a peculiar kind, common among artists and deeply felt by Dürer himself. The melancholy temperament was regarded at the time as being akin to genius and influenced by Saturn in astrology. Saturn's influence was regarded as malevolent on the whole, but favorable in that he was the patron of philosophers. In the context of Greek mythology, as in Hesiod, he was a cruel father, dethroned, imprisoned and castrated by his children; he was associated with old age, misery, and death. But the Renaissance humanists glorified him, associating him with crafts and geometry. Melancholics were gifted in mathematics but not in metaphysics; they felt inadequate in being unable to reach the philosophic level described by Plato as the realm of the divine ideas. So the figure of Melancholy here is characterized as winged and cowering, provided with the tools of art and science yet brooding in idleness, despairing at being shut out from the highest realms of thought. Dürer felt himself to be a melancholic; often dejected, he longed for absolute beauty and for an understanding of higher mathematics, so as to grasp the eternal ideas of perfection. But he had found that subject an insufficient clue and no other was adequate. Hence he felt a derangement between theory and action. Science can take one part way to perfection, but not all the way. The distant rainbow is a symbol of unattainable perfection; the bat, of darkness, evil, and failure.

The Apocalypse or Revelation of St. John, complex and closely set with vivid symbols, has been a prolific inspiration to visual artists throughout the Christian era, including Dürer. Many changes of style can be followed through the long list of pictorial illustrations of its separate visions. Among the most noted are the Spanish Commentary of Beatus of Liebana on the Apocalypse, written about 780 and copied many times. The manuscript is painted in a terse, bold, graphic style, flat as in most book illuminations of the period. In Emile Mâle's opinion, it influenced much sculpture in the portals and capitals of southwestern France, notably at Moissac. One of the pages represents Christ in majesty, accompanied by the four winged figures. Around him are the twenty-four elders in a large circle, seated on thrones with crowns on their heads. Each holds a cup and a viol while angels fly overhead. The fourteenth-century series of tapestries at Angers, which originally comprised eighty-four scenes (fifteen are missing) is in a monumental style, in a rich tonality of rose and blue.

Perhaps the most celebrated illustration of all is the early fifteenth-century *Adoration of the Lamb*, by the Van Eyck brothers, in Ghent. Here one of the outstanding scenes of the Revelation is developed in a style which combines the miniature quality of early Flemish painting with the monumentality and spatial depth of the early Renaissance. It is bilaterally symmetrical, suggesting unity, and combines a multitude of symbolic details concerned with Christ's sacrificial death and worship—in the center, the Lamb with a cross, the dove overhead, the fountain of life around which angels kneel, with catechumens and other human types nearby, all shown against a background of natural beauty with a hint of the City of God near the horizon. Here the visual realism of the

[6] E. Panofsky, *Albrecht Dürer* (Princeton, 1945), Vol. I.

early Renaissance is achieved at the cost of omitting many fantastic images from the text.

Dürer, at the end of the fifteenth century in Germany, produced a series of wood engravings of the Apocalypse which strove to follow the text more literally, even in such fantastic images as St. John devouring the book. He represents even the most fantastic symbols, as of angels, devils, and monsters, with surprising realism as well as ornate linear design and miniature landscape details. Each picture is firmly organized as a different design.

The framework of St. John's Revelation is partly narrative, but only within the individual scenes where incidents take place; the scenes are not linked in temporal order. The whole is a *rhapsody,* a highly emotional, ecstatic literary work combining different kinds of expression. It is in the tradition of several Old Testament books depicting visions of miraculous, divinely inspired incidents, such as marvels in the heavens, fires, storms, earthquakes, wars, monsters, pestilences, revolving wheels, and direct words of God, usually denouncing the wicked and prophesying the dire punishments which await them. Each scene in the Revelation is complete in itself, and they fit together to connect Old Testament prophecies of the Messiah and Last Judgment with New Testament fulfillments. Many scenes are adapted from earlier visions in the books of Ezekiel and Daniel, thus carrying on the mystic, apocalyptic tradition in Hebrew thought.

The expository factor is the explanation of world events, present and future, as a warfare between the forces of evil (the Beast, the Woman of Babylon, and their allies) and the forces of Christ and the Saints. The victory of the latter, after the horrors of the Day of Wrath, is assured. The seven visions are arranged thematically in time, so as to form a complex, symmetrical design in which the fourth is the center and foundation, while the others work toward it or build upon it. The mystery of divine prophecy is revealed in the sacrificial role of the Lamb that was slain. After the seventh angel sounds his trumpet, salvation is announced in the fourth vision: "the Kingdom of the World is become the Kingdom of the Lord, and of his Christ, and He shall reign for ever and ever." The Woman arrayed with the Sun and her Child are saved from the devouring Dragon and caught up to God; her child will rule the nations. But the Beast with ten horns and seven heads wars with the Saints until the final victory.

Many of the symbolic images in the Book of Revelation are explained to some extent in the text. In the Prologue the author sees seven golden candlesticks and, in the right hands of a figure "like unto a son of man" he sees seven stars. These are cryptic at first,

but the figure explains that "The seven stars are the angels of the seven churches: and the seven candlesticks are seven churches." This makes the symbols partly explicit, but in mystic symbolism there is always the certainty of further meanings. The symbolism of the sealed book and its gradual unsealing is fairly obvious as meaning a revelation of secret knowledge. Full interpretation of any mystic symbol is impossible, but in the semicryptic type at least a clue is given.

Later in the Apocalypse (following the vision of Ezekiel) there is a vision of four living, winged creatures full of eyes before and behind: one like a lion, one like a calf, one with the face of a man, and one like a flying eagle; all saying "Holy, holy, holy: the Lord God Almighty." This identifies them as on the side of the saints, but their strange appearance is not explained here. Later Christians, however, called them the four Evangelists. A possible further meaning is given by the number four, which has its own general, occult symbolism as related to the square and other four-part divisions in implying firmness and stability: for example, in the four elements, seasons, points of the compass, stages in the life of man, and corners of a building. This is not true of the four horsemen (Captivity, War, Famine, and Death), whose meaning is explicitly indicated; but these form a foil to the "four living creatures" and reinforce the pattern of the whole. Partly analogous symbols with opposite meanings, implying strife, are often juxtaposed in mystical art.

Francesco Colonna's *Hypnerotomachia* (Venice, fifteenth century) is the story of a dream, a complex narrative involving an expository combination of archetypal symbols. It is the story of a mysterious journey for a secret purpose, full of obscure symbolic allusions. Linda Fierz-David comments on it as follows:[7] "Three conceptions are blended in one in the *Hypnerotomachia:* the humanistic conception of the revival of classical culture; the courtly conception of the love of women as a task; the alchemical conception of the transmutation of matter."

5. Fourfold meaning as a method of interpretation.

The theory that each important symbol had a *fourfold meaning,* and that interpretation is to follow a fourfold method, was a product of gradual evolu-

[7] L. Fierz-David, *The Dream of Poliphilo* (New York, 1950), p. 12.

tion.[8] It appears in fully developed form in the *Divine Comedy,* not merely as a way of interpreting the images which happened to occur to the poet, but as a conscious, systematic principle of organization, a basis for choosing images to convey the complex meanings desired. To the modern reader it seems anything but simple. He is accustomed to one meaning for each image or concept, or at most to an occasional ambiguity or metaphorical double meaning. To be told to look for no less than four in each major image throughout a lengthy work, many of them based on what seem today like far-fetched analogies, gives a first impression of laborious pedantry. But it is quite in accord with the spirit of medieval art and metaphysics, and it represents in some respects a simplification. Even though the number of potential meanings of a symbol can still be regarded as infinite, the *Comedy* as a particular work is easier to grasp because (a) a limited number of major symbols is used throughout, and (b) four specific types of meaning are attributed to each.

The four types of meaning resulted from four methods of symbolization and sources of knowledge: the literal, the allegorical, the moral or tropological, and the anagogical. In the last three, the image was regarded as conveying an insight and aiding in the soul's progress. Every fact or event in nature or scripture was thought to convey four kinds of truth. The literal kind, as in the common nature and appearance of a rock in ordinary experience, included the standard meaning of words and descriptions of or casual associations with them. There were three symbolical interpretations, of which the allegorical included truths in relation to humanity as a whole, including Christ as head of humanity. The tropological applied to the moral lesson which could be learned from any event, as in the story of the blind leading the blind. The anagogical was knowledge of ultimate truth, independent of time and space.

Thus the symbol of the rock may stand allegorically for Christ, the Rock of Ages; morally, as an example of what each soul should be, as Christ said of Peter; anagogically, as the foundation of the heavenly kingdom. Every natural object tells allegorically of the life of the *Logos* on earth, morally of the inner life of man, and anagogically of the life in glory. Several interpretations are usually possible under each heading, and there were elaborate guides for this pro-

cess. The literal story of Abraham's sacrifice of Isaac signifies allegorically Christ's sacrifice on Calvary; morally, the sacrifice inevitable in a life dominated by divine will; and anagogically, the complete self-giving which takes place in eternity, in union with God.

The allegorical subject of the poem, says Dante in his letter to Can Grande, is man, who, by merits or demerits in the exercise of his free will, subjects himself to justice for reward or punishment. The necessity of divine justice is contrasted with freedom of human action. Good works without faith and morality without religion, says Dante, are not enough for salvation. His subject was the soul's journey from a state of misery to one of bliss. Except that time and space do not exist in that final experience of the infinite, the journey can itself be regarded as a fourfold story, in which the poet's personal life, its analogue in the history of humanity, and the allegory of Christ's earthly life and suffering, all proceed together. One can read it on the literal level only, as many do, or on all four levels, each of which is said to give a different, complementary insight into reality and a moral lesson for the soul. On the literal level, the story of Dante's life is given against a background of nature; the allegorical story of humanity, against one of scripture; the tropological, against one of reason. The anagogical or heavenly level is one to which man can be raised only by grace.

The sun and his messengers, as the most complete physical symbol of God, who leads men aright on every road, form another organizing center of the symbolism. Dante makes the rose symbolize, in various places, himself as a type of Christ, Christ himself, and Mary, "wherein the Word Divine made itself flesh" (*Paradiso,* XXIII, 73-75). Dante's personal life (literal) is made an allegory of humanity, which in turn symbolizes progress in insight; the Sun, as physical symbol of Deity, leads upward to the Beatific Vision of the "light which moves the sun and the other stars," the anagoge of the whole journey from the misery of the Dark Forest (in the grip of evil and far from God) to the bliss of the Garden of Paradise.

The number nine, says H. F. Dunbar,[9] is fundamental in the symbolic pattern of the *Comedy.* It is identified with Beatrice, who also symbolizes theology and leads Dante through the *Paradiso.* Their first meeting was in the ninth year of his life and her death was on the ninth day of the ninth month of the year of the century "wherein the perfect number was com-

[8] It is associated especially with Philo of Alexandria and Peter Lombard. The latter distinguished four sources of knowledge: nature, reason, revelation, and grace. Dante's *Letter to Can Grande* is a short, clear exposition of Dante's use of it.

[9] H. Dunbar, *Symbolism in Medieval Thought and its Consummation in the Divine Comedy* (New Haven, 1929), pp. 30 f.

pleted nine times." Dante continues, in the *Vita Nuova,* "if three is the sole factor of nine, and the sole factor of miracles is three, namely, Father, Son, and Holy Ghost, who are three and one, this lady was accompanied by the number nine to give to understand that she was a nine, that is, a miracle whose root is the wondrous Trinity alone."

Thematic variations on the numbers three, nine, and one recur throughout the work, as in the Trinity, in the three main realms through which the journey proceeds, and in the interlocking, rhyming tercets of the verse form. Such thematic treatment builds up a complex design which is closely integrated with the representational and expository frameworks. Thus, nine good forces are opposed by nine evil ones. The former are the Trinity, the three blessed ladies of heaven (Mary, Lucia, and Beatrice), and three of the good of earth (Matilda, Statius, and Virgil). The evil ones are Lucifer's three faces, three accursed ladies of hell (Medusa, a Siren, and Circe), and three beasts of earth (leopard, lion, and she-wolf).

The intended climax of the *Divine Comedy* is certainly in the last few lines of the *Paradiso:* from the narrative standpoint, as the end of the journey and glorious culmination of the soul's quest; from the religious standpoint, as a supreme revelation of the Trinity itself, nothing higher than which could be conceived. From the expository standpoint, it is the complete explanation of the cosmos, "all properties of substance and accident in one volume; the divine essence become intelligible form." Yet from the purely human, literal, dramatic standpoint it has seemed to many readers a somewhat disappointing anticlimax. The *Inferno* has always been the favorite of the general public, in quest of entertainment on what the mystic regards as the lowest, most literal plane of interpretation. It contains the element of conflict in the highest degree, with the fascination of different kinds of sin and picturesque punishment. Its characters are all too human, whereas those of Paradise are more abstract and impersonal. This was inevitable from the nature of the subject matter, the conceptions of divine, angelic, and saintly character to be expressed. Dante clearly recognizes the shortcomings in his account of the Beatific Vision, and explains them in the manner common to most visions of the sort: the inadequacy of memory to recall and words to express. "Thenceforward what I saw/ Was not for words to speak, nor memory's self/ To stand against such outrage on her skill." But he asks for power to describe at least one sparkle of the radiance from the "three orbs of triple hue" which seemed to change as his understanding of it improved, although

it was actually changeless. An attempt at this point to describe or explain in detail the nature of God would no doubt have seemed to Dante inevitably belittling, hence his attempt is limited to a few brief hints.

The nearest thing in visual art to the complexity of Dante's vision is certainly the cathedral. We have noticed it in previous chapters as an example of compositional diversity: as containing highly developed utilitarian, representational, expository, and thematic factors, all closely integrated in the Gothic cathedrals at their best. In its utilitarian aspect it was a meetinghouse and hence hollow, a cavern, shell, or womb, female and protecting, a symbol of Mother Church. It was primarily a place of worship and ritual. But it was functional in many ways, not clearly differentiated from each other. Each of these functions made the whole building or one of its inner parts symbolic in one way or another. Its concern with beautiful forms made it stand for earthly as well as spiritual beauty; to the bishop of the region it was often a symbol of the wealth, prestige, and generosity of his diocese. The separate chapels or balconies for worship by noble families, the heraldry displayed, the distinctive vestments and ceremonial roles of different ranks in the clergy, all reflected the hierarchical society of medieval Europe, political and ecclesiastical.

The representational aspects of the cathedral are familiar, as in the rows of statues engaged in portals and on higher levels, portraying not only divine personages, angels, saints, imps, and demons but kings and queens, knights and scholars, animals and plants—all standing for symbolic types in the worlds of nature, history, church and state, hell and heaven. Indoors, pictorial and sculptural symbolism was continued in the carved choir stalls, around the altars and tombstones, in stained glass windows, and sometimes on the walls. Events of history, real and imaginary, were narrated with moral and eschatological emphasis. Other familiar symbols in the cathedral are the cruciform ground plan, the rose window in honor of the Virgin, the wheel windows repeating that universal archetype as in the vision of Ezekiel, and the skyward-pointing spires.

Many artists have tried to illustrate the *Divine Comedy* or parts of it in pictures, but the result is often, as in the drawings of Gustave Doré, representational and fantastic rather than expository. This can be said of the painting by Michelino, called *Dante and His Book.* It gives a compressed picture of the three regions, with tiny figures in each, and with the poet holding his book in the foreground; but there is little to explain his symbolic journey or his conception of the cosmos as a hierarchy of levels, from the extreme

of evil at the bottom to the extreme of goodness at the top.

6. Oriental mystic symbolism.

In the Far East, one of the most complex types of expository painting is the Tibetan Buddhist *tanka* or hanging scroll, depicting the *Wheel of Existence*. This persistent form type is a diagram of the Buddhist conception of the world as ever-changing, unreal, and illusory. It implies that, as the wheel revolves, each individual goes from one body and one realm of experience to another until he attains release. As a demonstration of the eternal round of rise and fall from low to high estate and back again, and of the illusory nature of pride, rank, and ambition, the Wheel of Existence is comparable to the medieval *Wheel of Fortune* derived from Roman pictures of the goddess Fortuna, which shows kings and prelates falling off the wheel as it turns downward. [10] But it is far more complex, both visually and symbolically. Both emphasize the mandala or circular framework which signifies (among other meanings) circular movement and unity in diversity. Both pictures involve all four modes of composition.

The Wheel of Existence represents a huge, ferocious monster, holding with his jaws and limbs a disc which symbolizes the endless cycle of life. It is divided as in a wheel. Between the spokes and on the hub and rim, many small, symbolic figures of men, women, children, animals, gods and devils, forests, palaces, and mountains are displayed. Their arrangement produces a symmetrical design of lines and colors, with suggestions of deep space in each compartment. The utilitarian factor is the moral counsel of the Buddhist law: to free oneself from the bondage of desire, to accumulate merit and thus to attain Enlightenment.

There are many versions of this type, of which the oldest known is in an Ajanta cave. The one illustrated here is in the Newark Museum. [11] The monster is the demon of impermanence in the Indian version and judge of the dead in the Tibetan one, with the third eye of spiritual insight in his forehead. In spite of his ferocious look, he is the counterpart of Avalokites-

vara, the Bodhisattva of compassion, and assumes his appearance to emphasize the frightfulness of clinging to worldly desires. At the hub of the wheel and thus the core of rebirth, a hog, snake, and bird symbolize the daughters of desire: greed, lust, hatred, wrath, ill will, and delusion. A band around the hub in most versions shows humans going upward to happier rebirths and downward to worse ones. From highest to lowest, there are six ways of life or rebirth, each in a separate region on the wheel: those of the gods, the titans, man, beasts, tantalizing ghosts, and hell. In some versions there are paths from one region to another, including a possible but arduous escape from hell.

Upper left, in the Newark version, is the human realm with people engaging happily in typical activities of work and play, worship and ritual. Next to the right is the realm of gods and titans. The gods enjoy delights but are still bound by the wheel to delusion, and even they may fall. They are endlessly driven by jealousy and lust for power. Clockwise, the third realm is that of tortured spirits who suffer from unsatisfied, passionate cravings. The food and drink they try to swallow turn into knives and flames. Fourth and lowest among the regions is that of cold and hot hells, where sinners suffer as in Dante's *Inferno*. Six standing figures of Avalokitesvara, one in each realm, show his compassionate roles there. For example, a sword for the militant titans means divine wisdom cutting the bonds of delusion. The outer rim of the wheel symbolizes interdependent conditions of rebirth, as in (a) a blind woman with a stick, meaning ignorance; the condition under which human life develops; (b) a potter modeling clay. The wheel here signifies man's formative activity, by which he shapes his character and future life.

7. Exposition through figurative symbolism in lyric poetry and visual art. Mystic and rationalistic varieties.

Figurative symbolism, as defined above, includes all modes of suggestion wherein a certain image has one or more secondary meanings in addition to its obvious, literal ones. The image can be verbal, visual, auditory, or otherwise. It can be mystic or nonmystic, cryptic or explicit. Some kinds of figurative symbolism are neither definitely religious, in the sense of expressing the beliefs and attitudes of a religious group, nor definitely mystic, in implying the possibility of making contact with a higher, spiritual world

[10] This appears as one of the drawings in the *Hortus Delicarium*, a twelfth-century book by Herrad of Landsperg.

[11] See the account of it by E. Olson in *Oriental Art*, IX, 4, Winter 1963, p. 204 ff. See also L. Waddell, *The Buddhism of Tibet*, 1899; E. Kenton, *The Book of Earths* (New York, 1928).

by means other than sense perception. They tend to reflect a naturalistic, rationalistic attitude: not necessarily a conscious philosophic belief or a purely logical way of thinking, but certainly an interest in things of this world for their own sake and not only as symbols of something else, as well as a tendency to explain ideas clearly and explicitly.

The Shakespearean plays are, on the whole, neither mystic nor religious, but they are full of significant metaphors and similes, many implying generalizations on human life and character. Portia's speech in *The Merchant of Venice* develops this simile: "The quality of mercy is not strained,/ It droppeth as the gentle rain from heaven/ Upon the place beneath." The next few lines continue the exposition. There is exposition also in the series of metaphors in *Macbeth,* beginning "Sleep that knits up the ravell'd sleave of care."

Several of Shakespeare's Sonnets are more consistently expository, within a thematic framework: notably, numbers LIV ("O, how much more doth beauty beauteous seem"), LXIV ("When I have seen by Time's fell hand defaced"), CXVI ("Let me not to the marriage of true minds/ Admit impediments") and CXXIX ("The expense of spirit in a waste of shame/ Is lust in action"). Representation, which dominates the plays, is a subordinate factor in these lyrics.

In lyric poetry and visual art the juxtaposition of two or more images which do not ordinarily come together is often enough to suggest an analogy or other significant relation between them. Thus the words "Chrysanthemum and Sword" have been used to symbolize Japanese culture. To put such objects visually together in a picture may also suggest their interrelation. A chrysanthemum and a sword are so obviously different that one tends to interpret them in terms of contrast rather than analogy: the one as standing for the peaceful, artistic, beauty-loving side of Japan and the other for its military side. "Weimar and Potsdam" have a similar meaning as applied to Germany.

Incongruity among the images and ideas of a work of art can be significant as a violation of the normal and expected order of things. It may point seriously to an evil, or humorously to a slightly demeaning analogy. An example of the former is Sarah N. Cleghorn's satirical quatrain: "The golf links lie so near the mill/ That nearly every day/ The laboring children can look out/ And see the men at play." Its terseness makes it slightly cryptic, but for anyone aware of child labor as it used to be, the implication of social injustice is obvious.

On the other hand, Aldous Huxley's "First Philosopher's Song" is humorous in comparing man to an ape—a comparison often seriously made by Renaissance alchemists. But here the human mind is first admired for its power to jump over gulfs of thought and to link "Analogies between tree and tree," then ridiculed as "still umbilical to earth."

As we have seen, the expository factor in art often appears, not as the main framework or most obvious, highly developed part of the work, but in a few accessory details. Prolonged exposition, especially when dealing with highly abstract, intellectual generalities, may soon tire the average reader. Artists often prefer to cut it short and insert it casually among more concrete images. Even so, the expository bits may be important key ideas, significant for an understanding of the whole. Such an expository statement often occurs near the end of the piece, as a moral or conclusion: e.g., in *The Rime of the Ancient Mariner,* "He prayeth best, who loveth best/ All things both great and small." In Mallarmé's "Afternoon of a Faun" the poem's general thesis and controlling idea comes near the halfway point: "that we/ Falsely confuse the beauties that we see/ With the bright palpable shapes our song creates." Both of these bits of exposition come in poems which are, on the whole, representational.

When expository ideas are emphasized and developed in importance by comparison with the rest of the work, the representational details may be considered as examples of them, or as ways of demonstrating them by analogy with the events narrated. This is the case with Aesop's fables, where the moral is emphasized. "The Shepherd-boy and the Wolf" ends with the moral "Liars are not believed even when they tell the truth," and "The Dog and the Shadow" ends with "Those who grasp at the shadow are likely to miss the substance." All the ancient civilizations developed wisdom literature of this sort, mostly in the form of detached proverbs and maxims without elaboration in story or expository form.

As to degree of explicitness, literary exposition varies widely between two extremes. On a line from left to right, we may put first the extremely cryptic type, in which metaphors and symbols are given with little or no clue to their secondary meanings, so that we must rely heavily upon their cultural context for help in interpreting them. Next comes the semicryptic, with a little more help in the work of art itself. Then comes the explicitly figurative; in this the text makes considerable use of symbols, metaphors, or similes, but in a rather obvious way implying no hidden meanings. Still farther to the right, and usually in prose, is the essay, developed along more or less ra-

tionalistic lines but with considerable use of imagery. Of this type are the essays of Cicero and Montaigne. Some of Plato's dialogues are also in this category while others are more mystical and symbolic. As a philosopher, Plato explains his symbols to a large extent, as in the myths of the cave and charioteer, but further meanings can be found in them. In the essays of Cicero and Montaigne there is less symbolism; the imagery consists mainly of illustrative details, anecdotes, and examples to support a thesis. Finally we reach philosophic and scientific exposition, in which there is little or no use of metaphors or figurative symbols. Most of Aristotle's works are of this type. Epicurus intentionally avoided fine literary style as an obstacle to clear thinking.

A distinction can be made, in theory at least, between prose exposition which qualifies as literary art and that which is over the border in philosophy or science. Literary exposition, whether good or bad, tends to develop one or more types of aesthetic appeal such as verse form, vivid imagery, picturesque metaphors and similes, representational frameworks and digressions, rhythm and euphony of word-sounds, and the like. Philosophic and scientific exposition tends to avoid such means of aesthetic appeal unless they are necessary to the exposition itself. It pursues some particular task of exposition steadily and persistently, without attempting to hold and satisfy the reader's interest by other devices. On this basis, Plato's *Phaedrus* is literary art as well as philosophy, while his *Theaetetus* is more consistently expository and prosaic. Those writings attributed to Aristotle which have come down to us make little attempt at aesthetic appeal. (It is said that some others were more literary). His *Poetics* begins and continues as logical exposition:

> Our subject being Poetry, I propose to speak not only of the art in general but also of its species and their respective capacities; of the structure of plot required for a good poem; of the number and nature of the constituent parts of a poem; and likewise of any other matters in the same line of inquiry. Let us follow the natural order and begin with the primary facts. Epic poetry and Tragedy, as also Comedy, Dithyrambic poetry, and most flute-playing and lyre-playing, are all, viewed as a whole, modes of imitation. But at the same time they differ from one another in three ways, either by a difference of kind in their means, or by differences in the objects, or in the manner of their imitations.

Scientific prose, in the exact sciences, is now expressed mostly in technical signs and equations. But in other sciences and in writings by scientists for the general reader, plain prose is still required, as in these lines from the Introduction to Charles Darwin's *The Origin of Species:*

> In the next chapter the struggle for existence among all organic beings throughout the world, which inevitably follows from the high geometrical ratio of their increase, will be considered. This is the doctrine of Malthus, applied to the whole animal and vegetable kingdoms. As many more individuals of each species are born than can possibly survive; and as, consequently, there is a frequently recurring struggle for existence, it follows that any being, if it vary however slightly in any manner profitable to itself, will have a better chance of surviving, and thus be *naturally selected.*

In classing the *Theaetetus,* the *Poetics,* and Darwin's *Origin of Species* as comparatively lacking in literary appeal, we do not imply that they are badly written or aesthetically unsatisfying. Some readers find an aesthetic value in clear, concise, logical exposition, without the usual devices for aesthetic appeal, which is more satisfying to their taste than expository poetry. Such responses vary according to the individual. What makes a work artistic and (if in words) literary, is not its actual aesthetic value but its membership in a class of products which are socially used and recognized as having an aesthetic function. We recognize it as such, not only by information about its actual and intended use, but also by its adaptation to an aesthetic function through possessing some of the common devices for aesthetic appeal, just mentioned. The examples quoted are not entirely lacking in such appeal—e.g., Darwin's prose is simple but rhythmic. "Animal kindgom" is a metaphor. In all such matters, it is a question of degree.

On the whole, though with many exceptions, mystic exposition leans toward cryptic or semicryptic symbolism; rationalistic exposition leans toward explicit prose. The rise of naturalistic rationalism in the West helped to bring about the decline of mystic symbolism, but not to the extent of discouraging all figurative poetry. There remained a vast midregion of poetry and literary prose in which symbolism and metaphor could flourish, all the more through being less restricted to Christian doctrines, through turning again for materials to the rich, inexhaustible phenomena of nature, earthly life, and human personality.

Classical mythology was religious in a broad sense, but could be used in art for its beauty without complicating questions of belief and doctrine. Figurative poetry, released from the fourfold method of interpretation and other fixed systems, was free to use metaphor and symbol to express any desired idea, and to revel in the excitement of discovering fresh analogies.

Some expository lyrics of the Neoclassic period are almost lacking in symbols as well as in deliberate obscurity; they expound a general thesis in plain, abstract propositions. Alexander Pope, in his "Ode to Solitude," states his thesis in the first stanza: "Happy the man whose wish and care/ A few paternal acres bound,/ Content to breathe his native air/ In his own ground." This he develops through listing the merits of the simple life, close to the earth.

Joseph Addison's "Hymn" illustrates the fact that religious art can be rationalistic and still use figurative symbols. Here the conception expressed is that of seventeenth-century deism, with its belief in a clockwork universe of rational order, divinely created but without miracles or mystery. "The spacious firmament on high,/ With all the blue ethereal sky,/ And spangled heavens, a shining frame,/ Their great Original proclaim/. . . And all the planets in their turn,/ Confirm the tidings as they roll,/ And spread the truth from pole to pole/. . . In Reason's ear they all rejoice,/ And utter forth a glorious voice,/ Forever singing as they shine,/ 'The Hand that made us is divine.'" The jingly rhythm of the short, rhymed couplets contributes to a mood that is far from mystical. The author expresses a mood of joy and confidence, full of admiration for the world of order and beauty which science has disclosed. Music (the "music of the spheres," which may be silent to our sensuous listening) is one of the component symbols.

Another type of pictorial art which emphasized symbolism was the *emblem*. In the Renaissance the emblem was commonly an engraved and printed page with a number of symbolic images, decoratively arranged to form a pattern such as might be used for the title page of a book. As a rule, they were not combined as a single scene in space, but small vistas and three-dimensional figures were often represented. The emblem as a visual design could be fairly complex, but the composition of meanings did not always involve a higher synthesis. In 1531 Andrea Alciati published an influential work called *Emblemata,* and Henry Green, in a book about him (London, 1872), lists more than three thousand other books on the subject. Although these made use of symbols which had been treated mystically, such as the world tree,

the circular enclosure, and the woman with boat, waters, bees, and phoenix, the attitude of artists and collectors toward them was rather aesthetic and "profane" (i.e., secular) than religious.

From the fifteenth century onward, the astrology and alchemy, the lapidaries, bestiaries and herbals of the Middle Ages and the art they inspired, were gradually superseded by astronomy, physics, chemistry, zoology, and botany. The ancient questions regarding the origin of the universe, the plant and animal world, man and civilization, were answered in new and gradually more convincing ways by science. Leonardo da Vinci's drawings of human anatomy, the flight of birds, and the movements of wind and water in storm and flood—these were harbingers of scientific exposition in their devotion to the aim of showing how things work in nature. He also made diagrams of his utilitarian inventions, such as the airplane. But even in the seventeenth century, artists could still treat astronomical phenomena in the spirit of Biblical tradition. Milton's great Protestant epic, successor to Dante's in justifying "the ways of God to men" and in explaining "Man's first disobedience, and the fruit/ Of that forbidden tree whose mortal taste/ Brought death into the World, and all our woe," marked the end of an epoch. It made extensive use of astronomical images as a background for the grandiose, aerial battles of loyal and rebellious angels. Shelley's spirits stayed closer to earth, and already in his life the grand manner was declining, together with the belief in a universe created and peopled by myriads of gods, angels, and demons. The evolutionary answer to the question of the origin of life and man was being formulated by Lamarck and others. As science invaded each successive field of phenomena, the artists tended to retreat from it. The old, artistic explanations seemed weaker, more purely imaginary, now that they could no longer be believed as facts. The scientific explanations seemed to most Romanticists ugly and depressing, but they had destroyed the glamor of the ancient myths and symbols.

"Fresh woods and pastures new" remained, however, and the ones most favored by Romanticism were those of imagination and feeling: the inner world of subjective experience and the relations between individual personalities. Even nature, the hills and lakes, the flowers and birds, were treated mainly from the standpoint of a sensitive wanderer who projected his feelings upon them. Some artists, such as Wordsworth, Shelley, and Goethe, substituted a vague, impersonal pantheism for the personal theism of Dante and Milton.

The Industrial Revolution was spreading ugliness

and poverty, and many poets voiced nostalgic regret for the old values. Thus Wordsworth begins an expository sonnet with the lines, "The world is too much with us; late and soon/ Getting and spending, we lay waste our powers;/ Little we see in Nature that is ours;/ We have given our hearts away, a sordid boon!" He then proceeds to amplify this antithesis between the lost values of nature, emotion, and classical beauty on the one hand, and on the other the small compensation, the sordid, illusory benefits which man has gained from the modern world. "This sea that bares her bosom to the moon" is a vivid metaphor, descended from archetypal symbols for the female aspects of nature (sea and moon), whereas the howling winds, Proteus, and Triton illustrate the more masculine forces.

Wordsworth developed his Platonic philosophy in the *Ode on Intimations of Immortality from Recollections of Early Childhood,* especially the doctrine of the pre-existence of the soul before its birth in this life. "Our birth is but a sleep and a forgetting;/ The Soul that rises with us, our life's star,/ Hath had elsewhere its setting,/ And cometh from afar." We retain some heavenly qualities in childhood, but gradually shades of the prison-house close about us. This and the sonnet quoted above set forth a gloomy conception of adult life in this world. Keats does likewise in the "Ode to a Nightingale," in which the bird symbolizes the ideal world of joy and beauty as contrasted with the actual world of ugliness and misery. Elsewhere he expresses a simplified optimism in the familiar lines, "'Beauty is truth, truth beauty,'—that is all/ Ye know on earth, and all ye need to know."

A later poet, Matthew Arnold, expresses in "Dover Beach" in explicit metaphors the regret of his age at the current loss of faith. The sea is again a symbol, at once explained as "the sea of faith," and compared with Sophocles' use of it as the analogue of human misery. The imagery, though full of symbolism, is nonreligious and devoid of any definitely mystical suggestions. It is impossible to say that mystic meanings are not present, for any image at all can be interpreted mystically by the doctrine of universal symbolism. But this again is a question of degree. The tone of this poem is one of regretful agnosticism. Arnold's use of figurative symbols follows a common scheme. The sea is the principal symbol (S). It is amplified by others to form a cluster of four S images (S^1, S^2, S^3, S^4), describing its calmness, its darkness, the roar of receding waves, and the sadness of their sound. The referent (R), to which the sea is compared, is faith. It, too, is amplified into a cluster of explicit, secondary meanings (R^1, R^2, R^3, R^4). These are the ways in which R is analogous to S: namely, that it was once at the full; that it is withdrawing and retreating; that this is drear and melancholy; and that the loss of faith leaves the world in the dark without joy, love, and other values. At the end is a short simile in which "we here" (R) are likened to ignorant armies (S). Images of darkness, anxiety, and futile movement connect this with the main, expanded simile. The brief call for "truth to one another" sounds a momentary, contrasting note of love and hope.

Not all of modern lyrical poetry has been pessimistic, of course. John Masefield's "Sea-Fever" (1902) uses the sea and related images to suggest "the vagrant gipsy life" and a robust, masculine joy in the sailor's life. Victorian poets were happiest, it seems, when they could reconcile in some degree the fundamentals of Christian faith with the new world of science and machinery. Change and evolution were hailed for a while as progressive. Tennyson and Browning accepted this view at first: Tennyson with the confident vision in "Locksley Hall" of "the wonder that would be" when "the kindly earth shall slumber, lapt in universal law." "Forward, forward, let us range,/ Let the great world spin for ever down the ringing grooves of change." Browning, in an early poem, expressed a naïve optimism in the song from "Pippa Passes." Six reasons for happiness are given in the beauties of a spring morning in the country, leading to the conclusion "God's in his heaven—All's right with the world!" Both of these poets became more pessimistic later.

On the other hand, Wordsworth found ample cause for joy in his pantheistic view of nature, far away from "the world." It is expressed in *The Prelude,* in the account of a vision during a nighttime mountain climb, which seemed to him to reveal "a majestic intellect, its acts/ And its possessions, what it has and craves . . . the emblem of a mind/ That feeds upon infinity . . . a mind sustained/ By recognitions of transcendent powei,/ In sense conducting to ideal form,/ In soul of more than mortal privilege." His friend Coleridge expressed a persistent loyalty to the symbolic tradition, reinforced by his studies of German thought: "In looking at objects of Nature while I am thinking, as at yonder moon dim-glimmering through the dewy window-pane, I seem rather to be seeing, as it were asking for, a symbolic language for something within me that always and forever exists, than observing anything new." [12]

[12] See R. Warren, *The Rime of the Ancient Mariner* (New York, 1946), pp. 135, 141. The general idea of the poem is that of a crime against nature, as symbolized by the shooting of the Albatross.

8. *The interpretation of cryptic symbolism in poetry.*

The Symbolist movement in French literature and painting after 1880 was much concerned with general ideas, which it sought to convey through sensuous imagery. It emphasized the mysterious and metaphysical, and the unity of the arts and senses. It hinted at strange sins, neurotic desires and decadent attitudes, such as masochism, sadism, and diabolism. Moreau, Rops, and Aubrey Beardsley expressed these in pictorial form. The symbolism is often semi-cryptic. Paul Verlaine begins "Clair de Lune" with an explicit metaphor as symbol; a variant of the ancient *hortus conclusus:* "Your soul is a sealed garden, and there go/ With masque and bergamasque fair companies/ Playing on lutes and dancing as though/ Sad under their fantastic fripperies . . ."[13] The reference is evidently to the personality of an exquisite, world-weary type of individual, but all the details amplify the symbol without explaining exactly how "your soul" resembles it. In another lyric, "Il pleut doucement sur la ville," Verlaine asks a psychological question: "Tears fall within mine heart,/ As rain upon the town:/ Whence does this languor start,/ Possessing all mine heart?"[14] The answer, psychologically revealing, is that "This grief hath no reason . . . I know not why,/ (Neither for love nor hate)/ Mine heart is desolate." In more prosaic words: it is a common experience to feel depressed and sad without being consciously aware of any cause for it. "Tears" are the principal symbol. Falling rain, while likened to them by a simile, is also a symbol of relief from the mysterious, psychic pain which causes them.

The dangers of explicit statement as fatal to love as well as poetry are pointed out by William Blake in true Romantic fashion. The speaker in "Love's Secret"[15] told his love "all his heart," which only frightened and repelled her. Then a mysterious traveler "took her with a sigh"—silently and invisibly, like the gentle wind.

William Blake was a creative mystic and dreamer, a visionary and at the same time a courageous realist in diagnosing the evils of the modern world. He was a versatile artist who expressed his imaginings in po-

etry, drawing, painting, engraving, lettering, and book designing. He was a Romanticist in his opposition to Neoclassic rationalism in art and elsewhere, and also in his revival of the ancient art of myth-making. Though religious and moral in his own way, he was far from being an orthodox Christian. His work abounds in mystic symbolism, both traditional and original, cryptic and explicit. Especially in *Songs of Experience,* he bitterly satirized the cruel hypocrisy of the rich and pious. He used traditional symbols in unusual ways, which are sometimes hard to interpret.

Blake's short poem called "The Sick Rose" has been variously interpreted. Let us examine it as an example of figurative symbolism and lyrical exposition. It is not explicitly religious or mystical, but can be so interpreted.

> O Rose, thou art sick!
> The invisible worm,
> That flies in the night,
> In the howling storm,
>
> Has found out thy bed
> Of crimson joy;
> And his dark secret love
> Does thy life destroy.

There are two main symbols: the rose (S^1) and the worm (S^2). On the literal, obvious level, one is a flower and the other a small, creeping animal. These are their primary, literal meanings (PM^1, PM^2). Together, they represent a common, garden situation: a worm eating a rose. Each of them is developed into a cluster of metaphorical images as specified in the poem: a group of S^1 traits and one of S^2 traits. These are not literal meanings or common associations of the two main symbols. The explicit S^1 traits are (a) sickness; (b) on bed of crimson joy; (c) being destroyed. The S^2 traits are (a) invisible; (b) flies in night; (c) in howling storm; (d) dark secret love; (e) destroying.

The symbolism is cryptic by comparison with most modern lyrics, in that each symbol group contains some unexplained, literal incongruities. "Bed of crimson joy" is metaphorical. Most of the images in the S^2 group are obscure as literally applied to a worm. This suggests a hidden, secondary meaning (X^1) for the rose group and one (X^2) for the worm group, and also one for their combination (X^1, X^2).

In cryptic poetry as a rule, the secondary meaning is not wholly incongruous with the primary, literal meaning of the symbol. The lamb is appropriate as a symbol for Christ, not only because they were both sacrificed as atonement, and because they were asso-

[13] Tr. by Arthur Symons.
[14] Tr. by Ernest Dowson.
[15] Not always called by this title. See G. Keynes, ed., *Poetry and Prose by William Blake* (London, 1939), p. 86.

ciated in the Bible, but also because they have traits in common such as innocence and gentleness.[16] Goats as well as sheep were sacrificed to atone for the sins of the people, but the concept "goat" has too many inappropriate associations in our culture to make "goat" or "kid" suitable as a symbol of Christ.

One established meaning of "rose" is the Virgin Mary and another is the Tudor coat of arms, but the context here would make both interpretations incongruous and implausible. Among the established, symbolic meanings of "rose" is the idea of woman in general. Linked with crimson, it suggests passion and loss of innocence through sexual experience, as in the "scarlet woman." "Worm" is commonly phallic and masculine in its associations. It is also associated with evil, ugliness, and corruption, as in Shakespeare's lines, "But let concealment, like a worm i' the bud,/ Feed on her damask cheek." That the love of man for woman should be secret, invisible, violent, destructive, and corrupt is an understandable idea. But what of flying in the night and the howling storm?

Turning to Cirlot's *Dictionary of Symbols,* we find that "rose" is traditionally a symbol of completion, achievement, and perfection, as in the garden of Eros, the paradise of Dante, and the emblem of Venus. But "red" as applied to it was given by alchemists the meanings of sulphur and passion. "Wind" is "air in its active and violent aspects," believed in Greece to possess evil powers. "Storm" is creative intercourse among the elements. "Night" is associated with death and black. "Worm" is defined by Jung as a libidinal figure which kills. It is associated with death, biological dissolution, and "crawling, knotted energy."

Combining these ideas, we come close to Blake's conception of the "fallen" garden of experience, where innocence is lost, the waste land of this world. In destructiveness, the worm is comparable to the "tyger, burning bright," which destroys the lamb. A tiger, being divinely made, is beautiful and not wholly evil. Innocence must learn to cope with the world and even join forces with it to some extent. This applies,

perhaps, even to the lowest forms of life. Darwinism, a few years later, was to tell of the struggle for existence and the survival of the fittest. But Blake had little sympathy with the scientific approach.

The sexual suggestions of the poem are so strong that it is not surprising to find most critics accepting them as basic secondary meanings. The poem is taken as symbolizing one kind of erotic situation in which a violent, corrupt, male force destroys a weaker but receptive female being. She does not realize her danger, Hazard Adams notes, but receives her attacker with joy; hence the imaginary speaker tells her of her "sickness."[17]

The poem partially characterizes the male force in general by likening it to a worm; the female by likening it to a rose; her destruction, by likening it to the worm's destruction of the rose. From this standpoint the explicanda are the two abstract, sexual natures, for it is usual in symbolic expression to explain something general, abstract, and little understood in terms of more familiar, concrete images which serve as analogues. But the two symbolic images are also explicanda. They and the poem as a whole need explanation, and this is provided in part by the secondary meanings just noted. When two ideas or groups of ideas are juxtaposed in the same work, suggesting that the things they stand for are analogous or otherwise connected in reality, each can throw some light upon the other. Light is thrown on the nature of destructive love by comparing it to a worm eating a rose, and light is thrown on the meaning of "rose" and "worm" by showing what broader, deeper, human meanings they can have when combined in this context.

Is this the whole meaning of the poem? The emotive force of this small, highly compressed pattern of symbols and of "knotted energy" may lead one to expect something more profound, surprising, and dramatic than the meanings just noted. As we have seen, the mystical view of such questions is that no verbal, rationalistic interpretation of an archetypal image can exhaust its potential meanings. In the present case, a long list of critics have offered additional suggestions. Hazard Adams compares several of these and adds his own interpretation.[18] He warns that "at-

16"To be fully effective," says C. H. Grandgent, "an allegory must suggest something more than a plain statement could convey, and it must be so constructed that the literal and the symbolic meaning, while each pursues a coherent and intelligible course, are connected by an inner necessity. Nothing is more exasperating or more puerile than an attempted allegory in which the relation of reality to emblem seems arbitrary and external. This is the defect of much latter-day symbolism. Impenetrable until a key is provided, it reveals itself as trivial the moment the door is opened." C. Grandgent, *Dante* (New York, 1921), p. 271.

17H. Adams, *William Blake: a Reading of the Shorter Poems* (Seattle, Wash., 1963), pp. 20, 246.

18*William Blake,* pp. 325-26. For example, he quotes Leone Vivante (*English Poetry,* London, 1950) as saying, "Blake's dominant idea is that the fundamental reality shares the nature of light and love even in things abject and cruel. In the poem, 'The Sick Rose,' the destructive 'worm' is depicted by its 'dark secret love'; which intrudes in an infinitude of joy, enhanced in and through the infinite of its more visible quality (cf. 'crimson'). The perpetual tragedy in nature's womb is contained in the little poem."

tention should be paid to detail, to perspective, to related images in Blake's other works, and to symbolic conventions in literature," so as to avoid treating the poem only as an "allegory" addressed to what Blake called the "corporeal understanding." Adams comments that the worm, while suggesting the biblical serpent and the phallus, "resembles also the serpent boy Orc in Blake's prophetic books, image of revolutionary violence, who sinks into conservative tyranny.... The worm is inside the rose, a Genesis serpent, which indicates what Blake calls the selfhood—spiritual apartness—suggested by Eve's action in the garden." The bed of love becomes the bed of sickness. But "in Blake, sexual relations are part of a large system of analogies. The rose is in danger of falling into the state of diabolical or inverted marriage, where corrupted selfhood feeds on its own body like a worm in a rose."

Philip Wheelwright suggests that "Here, epitomized in the rose, is an implicit judgment about the sickness of the created world."[19] Louis Untermyer sees in the poem an example of Blake's continual emphasis on the union of opposites—"innocence and experience, good and evil, flesh and spirit, the marriage of heaven and hell." Evil, from experience of the world, cannot be avoided; it must be recognized and understood. "To fight it is vain; it must be joined to goodness and merged with it." Blake's imagination, says Untermyer, pits the tiger (experience) against the lamb (innocence) and finds them equally beautiful as framed by the "immortal hand and eye."[20]

Certainly, the morphological analysis of a symbolic work of art should not stop short on the literal level of interpretation; nor should it rest content with assigning a conventional secondary meaning to each symbol, on the basis of custom and convention. It is always likely that the whole means something different from the sum of its parts or in addition to that sum. As we have seen, the worldwide traditions of occult symbolism provide a partially objective language, containing a vast store of symbol-meaning combinations which were understood and used by certain esoteric groups, and these are now being disclosed by scholarly research. Jung's theory of archetypes is enlightening in this connection. It offers much that the naturalistic scholar can accept without endorsing the supernaturalistic assumptions which usually accompany it. For information about the deeper meanings which have been attached to sym-

bolic art, aesthetics must depend to a large extent on the knowledge of actual usages provided by iconologists in the type of symbolism concerned.

Certainly there is no sure way to recognize what secondary meanings are integral parts of a work of art. If we rely too heavily on symbolic conventions as completely objective language, we soon discover them to be far more ambiguous than in Dante's time, when a "fourfold meaning" was often enough. It is not enough to point out Jungian archetypes, as in Coleridge's "Kubla Khan" or Blake's "The Garden of Love." Original artists tend to give their archetypal images distinctive, personal variations, as when Blake distinguished between the garden of innocence and the "fallen" garden of experience.

One good approach, made by several of the scholars just quoted, is to see how the author uses a certain image in his other works, as well as how it is used by other writers of his time and place. But even this leaves much room for conjecture and debate, for an original artist will follow no such usage exactly. One is justified in cautiously following the Freudian, Jungian, and Marxist lines of interpretation as they seem to coincide with observable facts. They include a study of the author's personal life and social background as a clue to what he may have meant, consciously or unconsciously. Sometimes these different modes of interpretation corroborate each other, sometimes not. Rather than attribute too many of one's own ideas with assurance to the author, it is well to leave some details frankly problematic for the present. In these ways the boundaries of what may justifiably be called the "objective meaning" of a work of art—i.e., the combination of its socially established, verifiable meanings—can be gradually extended, revealing more forms and contents for aesthetic morphology to include in its descriptions.

In modern civilization, mysticism and figurative symbolism have been largely replaced by empiricism and rationalism as ways of learning about man and the world and expressing the knowledge and beliefs thus acquired. One result has been to discourage mystic symbolism in the arts, especially in expressing conceptions of the physical universe, the origin and nature of life and man, and the history of man on earth. In dealing with these problems, there has been a tendency for thought and expression to follow scientific methods and thus to leave the realm of art. This has encouraged the writing of expository essays and treatises which set forth more naturalistic conceptions of reality. Some of these qualify as works of literary art, while others belong rather in the field of science or philosophy. Meanwhile, the decline of reli-

[19]P. Wheelwright, *The Burning Fountain* (Bloomington, Ind., 1959), p. 298.

[20]L. Untermyer, ed., *A Treasury of Great Poems* (New York, 1942), p. 602.

gious and other occult subjects in painting and sculpture has been paralleled by the growth of naturalistic expression in these arts and also in the film, in landscapes and realistic representations of human life. Much of this has contained no prolonged expository development, but short expository passages are often to be found in the midst of representational art, expressing various intellectual attitudes, sometimes with regret at the loss of old values and disparagement of the kind of world produced by scientific technology.

The decline of mysticism in art and other realms of thought is still far from complete, however. Significant modern works of art are occasionally inspired by the mystical world view, as in the poetry of T. S. Eliot and the painting of Rouault. At the same time, critical and historical studies of past art have come to look upon the mystical expressions of past ages and distant cultures with increasing respect. The revival of interest in symbolism and mysticism is supported by the psychology of Jung and Freud. Although Freud was himself a naturalist, his discovery of the importance of symbolization in dreams, primitive culture, and artistic expression tended to stimulate many different ways of explaining these phenomena. Jung was more sympathetic to mysticism and supernaturalism.

While mystic symbolism in strictly religious art has been declining in vigor during recent years, figurative symbolism in a broader sense has retained or increased its vigor in several arts. We have observed some examples in lyrical poetry, some with a slightly mystical tinge and others definitely naturalistic in ideology. The Symbolist movement in nineteenth-century French poetry and painting involved much subtle, obscure exposition, as in the works of Mallarmé and Redon. The strong Postimpressionist trend toward the purely visual, and toward eliminating both representational and expository subject matter, tended to discourage both mystic and naturalistic symbolism. But critics inspired by psychoanalysis find significant symbolism in many recent works, such as Picasso's *Guernica*. The "theater of the absurd," which emphasizes satirical thrusts at the contemporary world, is full of obvious symbolism for expository ends. Symbolic images such as the Dynamo and the Bomb have replaced the older ones in the minds of many contemporary artists, but are used in somewhat traditional ways to express emotional conceptions of the world and man.

In the visual arts, other ways are found to express through symbols general ideas, especially satirical commentaries on modern civilization. The emotive impact can be strong even though the ideas expressed are vague and unsupported. The famous *Fur-lined Coffee Cup,* in the Museum of Modern Art in New York, is an example of the conscious juxtoposition of incongruous ideas: here as a caricature of modern technological functionalism. Somewhat similar, but with the added satire on civilization as suicidal, are the "self-destroying machines," one of which was made to explode in the yard of the same museum. Deliberate incongruity is characteristic of the Surrealist movement of the early twentieth century and especially of Salvador Dali, as in his painting of the limp watches. In their suggestions of irrationality ("paranoia"), they continue the romantic revolt from the classical idea of reason. Much abstract painting and sculpture expresses this attitude. These various types of art vaguely symbolize a conception of reality, including the human mind, as irrational and chaotic, thus contradicting the main classic tradition of the West. Together with Existentialist philosophy, they are closer to the pessimistic tradition of Schopenhauer, who conceived of the cosmic will as nonrational.

9. Truth and realism in expository art.

The perennial questions of truth and realism have a special bearing on expository art. It has been pointed out in previous chapters that in judging a work of art as realistic or unrealistic, we apply our own assumptions as to the nature of reality. These change with the passage of years, and obviously we can not be sure that those based on twentieth-century science are entirely correct. The same can be said of the assumptions involved in mysticism. The cautious attitude, in estimating truth and realism in art, is to be aware of the conceptions which we use as tentative standards, and to make our estimates relative to these. On this basis, the expository factor in a work of art, such as Dante's conception of theological, eschatological, and moral truth on the highest spiritual level, can be judged as factually true or false, as either conforming or not conforming to reality. The poetic or figurative implications of a symbolic work are not necessarily true, any more than are its literal representations. Both can be judged, if we so desire, by comparison with our own conception of the facts. The judgment will express the ideology of the judge.

When the chain of reasoning in expository art is definite enough, as in Horace's *The Art of Poetry,* one can criticize it in terms of correct logical infer-

ence. But explicit inference is largely restricted to the more rationalistic types of exposition. One might say, for example, that the exposition was correctly reasoned from its premises though leading to a false conclusion, or that the premises were false and the conclusion true. In a great deal of mystical exposition, especially the more cryptic type, the reasoning involved is too obscure to be judged by logical standards. Only the problem or mystery may be stated or depicted; vague analogies may be suggested without specific demonstration or evidence.

Exposition in satire, humor, and sarcastic invective often involves a deliberate distortion of the rational component. Absurd or exaggerated premises and definitions may lead to literally false conclusions, as in Jonathan Swift's *A Modest Proposal for Preventing the Children of Poor People from being a Burden to their Parents or the Country* (by having the rich eat them). In such cases, as in mystic symbolism, one must look for deeper implications of the explicit statements, which may perhaps imply the direct opposite of what is said.

In mystic and other figurative poetry, there are many degrees of truth and logicality. Judgments as to the exact degree are often necessary. An assertion can be made arbitrarily which seems untrue and unrealistic at first sight, yet which discloses a kernel of truth on further consideration. Thus it is said, "'Tis love that makes the world go round." This is not intended, of course, to be taken literally. But metaphorically it is partly true, since love is one powerful motive in human affairs. When Dante speaks, at the end of the *Comedy,* of "the Love . . . that moves the Sun and the other stars," his statement can be judged (a) for its literal truth, as true, false, or partly true, or (b) for its symbolic or figurative truth—again as wholly, partly, or not at all true. How true it is on the symbolic level depends, in the final analysis, on the truth of Dante's religious and cosmological beliefs.

Modern poetry, including that which is based on a naturalistic world view, abounds in figurative expressions which are obviously false or exaggerated on the literal plane. Thus Keats can say, "Heard melodies are sweet, but those unheard are sweeter," and also, "'Beauty is truth, truth beauty,'—that is all/ Ye know on earth, and all ye need to know."

It would not be hard to quibble with the poet on the truth of these assertions, and literal-minded critics have done so; but readers accustomed to poetic discourse would realize that such an argument falls wide of the mark. The "Ode on a Grecian Urn," like countless other meditative lyrics, is not trying to demonstrate the strictly literal truth of some dubious assertions. On a deeper level, the Grecian urn symbolizes the eternal, changeless aspect of beauty, and more broadly the whole Platonic metaphysics in which Keats was trying to believe—the identity of goodness, truth, and beauty on the plane of eternal Ideas. The image of unheard music suggests the medieval belief in the silent music of the spheres, in contrast with the shortlived, sensuous beauty of heard music. The latter, though sweet, has the limitation of being ephemeral. In this it suggests what Keats wrote elsewhere about the poet's words and even his name as ephemeral, "writ in water."

Although the poem has a definitely expository factor, it would be a mistake to regard it as an attempt to demonstrate a philosophic theory. Serious poets like to play with ideas, and some like to play with philosophical conceptions. One way of doing so is to state them explicitly in rhythmic verse, thus lifting the train of thought out of the realm of ordinary prose. Another way is through developed symbolism. Here the symbol of the urn is expanded into a cluster of related symbols. The nightingale plays a similar role in the ode on that subject. In playing with theoretical ideas, a poem tends to develop an expository factor. In the present case, this is not carried very far. The expository development, which might easily become prosaic if carried far, is restrained by the wish to develop along other lines. These include picturesque imagery, representation (of the urn and the procession depicted on it), thematic word-sounds, and emotional expression ("Ah, happy, happy boughs! that cannot shed/ Your leaves . . .").

Another way to play with abstract ideas is to state them in exaggerated form, to heighten their emotive impact. Still another is to state as an existing fact something which the poet only wishes were true. Keats uses both of these devices here. A theoretical proposition, such as "beauty is truth," can be taken as a theme for multiple variation and free fantasy. So, also, the poet can play with assertions which he himself does not wholly believe, or believes only in a certain mood. Thus Shakespeare can make one of his characters express exaggerated optimism; another, equally extravagant pessimism. To the latter, life is "a tale/ Told by an idiot, full of sound and fury,/ Signifying nothing."

We look to science and philosophy as a rule, not to poetry, for attempts to state an abstract proposition cautiously and moderately, with all due reservations. The morphological description of a poem should recognize its particular way of treating an expository

theme. If this is unclear, illogical, or only partly true, that fact is not necessarily a fault in the poem. On both literal and symbolic levels, factual truth is not the only aim of art, and is often deliberately avoided for aesthetic or other reasons.

10. The expository schema of a particular work of art.

These are some of the points to be dealt with in a fairly detailed analysis. As in describing the other compositional factors, no particular order of steps is necessary, except that it is usually more enlightening to proceed from the general outline through intermediate groupings to the small details and subtleties.

(a) In what art or medium is the expository factor expressed? What is its provenance (period, place, people) and general style?

(b) To what extent is exposition combined with other compositional factors? Which ones? As framework or accessory? To what extent does it pervade the whole work? Is it confined to a few details or limited areas?

(c) What expository ideas, beliefs, attitudes, and trains of thought are expressed?

(d) What principal and subordinate subjects are discussed or hinted at? What problems, mysteries, or phenomena are to be explained? What persons or personages, natural or supernatural, oneself or others, are to be characterized? How and to what extent is this done in a clear and understandable way?

(e) How explicitly are these ideas expressed? In words (written or spoken), in visual images, or otherwise? Through linguistic symbols only, or through figurative, polysemous symbols? Through pictures, and if so, of what? Through metaphors and similes?

Through music and other sounds? How explicit or cryptic is this expression?

(f) To what extent is the expository factor logical and rationalistic? Mystical? Romantic? Naturalistic? Religious or secular?

(g) Are the symbolic images presented in part (as in printed or spoken words) or suggested only? What are the literal meanings of the chief symbols? (These are necessarily suggested.)

(h) How are these composed, as into spatial patterns, emblems, scenes, narratives, lyrics, or otherwise? How complex are these arrangements?

(i) What are some of their deeper, secondary meanings, individually? How are these indicated? What ground exists for attributing these meanings to them? To what extent is supplementary information needed for interpreting them? From what sources, such as reference works on iconology or symbology? To what extent is this interpretation certain or controversial?

(j) How are they composed into more complex forms, such as theological, philosophical, psychological, or other beliefs or theories? How complex are these arrangements of secondary meanings?

(k) What principal world view, ideology, or cultural stage is implied in this exposition? Is it one of mysticism, rationalism, empiricism, naturalism? Of magic, polytheistic religion, pantheism, monotheism? Of primitive or advanced science? What conception of reality, of the external world and the inner world of thought, is expressed? With what emotional attitude, if any?

(1) How is this ideological background expressed in the mode of arranging symbols and meanings?

Note: The following illustrations are particularly relevant to this chapter: Figures 3, 23, 40, 41, 43, 49, 52, 53, 54, 55, 56, 57, 59, 60, 62, 68, 83, 84, 87, 91, 92.

CHAPTER XV

Thematic Development: Simple and Complex Design

1. Trends to simplicity and complexity in design. The artist's procedure.

In Chapter VII, on modes of composition, a preliminary survey was made of the elements of design in all the arts. This included the nature of themes, thematic series, and thematic development, both presented and suggested. The possibility of developing themes into simple and complex patterns and designs through repetition, variation, contrast, and integration was briefly mentioned. Attention was given to the possibility of combining two or more compositional factors in a single work of art, and hence to the relation of design to utility, representation, and exposition. Thematic development, we saw, can proceed in various frames of reference, especially the spatial, temporal, and causal. It remains to amplify the account of these phenomena as manifested in different arts, and to show the chief lines of thematic development which lie open to the artist.

No opinion is expressed here, and no assumption is made, as to the relative value of simple and complex design. The ways of elaborating thematic form are described as actual and possible phenomena of art, with no recommendation that the artist pursue any particular one. The history of art shows a wide range of variation between extremely simple and extremely complex. Different degrees of complexity are preferred within the same art, period, and culture, even by the same artist, as being most suited to different needs and situations.

The account of thematic development in this chapter is not intended as a method for the practice of art. It is arranged in logical, theoretical order as a systematic survey of the principal types of design. It is related to the practice of art somewhat as a system of botany is related to the practice of horticulture. It describes some basic types of thematic development, from simple to complex. The artist must and does follow some of the lines of development we are considering, but usually without naming or distinguishing them theoretically. There is no one right order of procedure. The artist may look back and forth between the whole and some part or detailed relation. He may think synthetically at times, analytically at other times, and by sudden impulse or unsought inspiration at still others. In general, an artist's mental procedure in building design tends to go in one or more of the following directions, often shifting from one to another:

a. From the vague to the definite; from a rough, partial germ idea or sketch for a design to its clear-cut realization. This is not necessarily complex; the artist may prefer extreme simplicity, and hence may proceed from a complex germ idea to a simpler product, by eliminating what seems nonessential.

b. From definite, simple themes and small theme units to more complex forms, mainly by addition.

c. From definite, simple frameworks and larger units to more complex forms, mainly by division.

d. From an abstract design or thematic framework to one combining design with representation, utility, or exposition. An abstract, radiating pattern of lines within a circle can be developed into a picture of a wheel or chrysanthemum.

e. In the opposite direction, from an existing concrete object or event in art or nature, whose thematic aspects are undeveloped, unsatisfactory, or challenging to the artist. Here the development of design may proceed, not by creating a new object from the ground up, but by altering an already existent one so as to improve its design or decorative qualities. It may be a scene or sequence of actual events or a representation of one in visual, auditory, or verbal form. It

may be a utilitarian object such as a house, wheel, or garment. It may be an expository diagram or verbal explanation. In any case, the artist may take this as a starting point and as a tentative framework for thematic alteration. He may complicate or simplify it, throughout or in certain respects only.

A relevant question, but one outside the scope of morphology, is why an artist stops developing his design at a certain point. What makes him feel that the present state is not too simple or too complex but just right? No doubt the innate structure of the human organism and cultural conditions at the time set very broad, flexible desires and limitations in this realm as in others. Within these the current style and fashion, interacting with the artist's personal taste, further determine the decision.

At certain times and places, there is a widespread trend toward complication in the arts and other realms of culture. As we have noted, this occurred in the Baroque period in Europe, when concentrated power and wealth were enthusiastically poured into building huge, ornate churches, palaces, parks and pageants, theaters and dramas, ballets and musical productions, odes and epics. All four modes of composition were developed on a large scale, together and separately. Thematic elaboration in the form of applied ornament and in the basic structures of art was carried to impressive heights. This was associated historically with the power of grand monarchies, allied with a strongly hierarchical church.

At other times and places, there has been an opposite trend to simplification in various arts and modes of composition, including design. A thematic series must have at least some slight amount of development to qualify as a design, but a strong drive toward simplicity and economy may hold it down to the minimum, along with an effort to compress an adequate amount of form and content within a relatively small, plain product. Japanese *haiku* and brush drawings were mentioned above as examples. In Europe, the trend to simplicity was one of the main directions of Romanticism, as in the lyrics of Wordsworth and Heine, the songs of Schubert, and the plain furniture of William Morris.

The desire for simplicity in art has been motivated in part by the direct aesthetic appeal of that quality, in part by some of its historical associations. As the complex, strongly centralized political and ecclesiastical culture of Baroque Europe expressed itself in complex, strongly organized forms of art, so the Romantic revolt from that authority expressed itself in various traits suggesting freedom, passion, and revolt, the rejection of tradition and of rational control

and centralized authority. This attitude has remained influential in art until the present time. It has been manifested in various ways: in a regression to primitivism and archaism; in forms suggesting destruction and disintegration, the melting and dissolving of outlines; in forms which are simplified by the omission or weakening of unifying factors such as linear pattern, symmetry, balance, perspective, representation, plot, meter, melody, and definite frameworks. In painting and sculpture, large but simplified forms have been popular. When some representation remains, it often expresses a dislike for all traditional styles in art and for present civilization as based on machinery, science, and reason.

While these trends away from complex order have gained ground in painting, sculpture, poetry, and music, some other arts have continued to develop even more complex, large, and firmly structured forms than before, notably cinema, architecture, and community planning. Whether complex design is in or out of favor at a particular time, there can be no question of its importance in civilized world art as a whole.

One can only speculate on why ultracomplex designs arise at certain times in art history, and in certain arts. Why the cathedral, at its particular time? Why the Persian carpet and the symphony, in their respective eras? These are questions in the philosophy of history rather than in morphology.[1]

Let us remember that complex design is not the same as complex art form in general; a work of art may be simple in design and complex in other modes of composition. The complexity of single works or types of art does not necessarily mean that the culture in which it occurs is proportionately complex or advanced as a whole. It may mean only that social impulses toward thematic elaboration have become focused for a time on these particular vehicles of expression, carrying them to a high peak of complexity, while others at the same time are comparatively neglected. The lack of ultracomplex designs in a certain art at a certain time does not imply a low development of creative or decorative ability in the social group. It may mean that a general trend of simplification has set in, or has been diffused over a variety of artistic types.

Even in those contemporary expressionist works which try to reject all definite design, at least rudimentary thematic series tend to occur, willy-nilly.

[1] For further discussion of this question, and the philosophy of art history in general, see T. Munro, *Evolution in the Arts and Other Theories of Culture History* (Cleveland, 1963).

When the artist is content to express again and again in different images and symbols the idea that the world is absurd, meaningless, and chaotic, this idea is for him a theme, and he is producing variations on it.

2. Compound and component thematic analysis.

Analysis and synthesis, taking things apart and putting things together, both have a place in dealing with art. Physical analysis occurs in separating the chemical elements of medieval stained glass, and synthesis in combining the elements to make it. In aesthetic morphology, both analysis and synthesis are perceptual and intellectual processes, aimed at understanding the varieties of form in the arts. This book is mainly synthetic, in that it begins with an account of relatively simple ingredients and modes of transmission, then goes on to consider complex types of form.

Two kinds of analysis are especially revealing in the study of art. One we shall call *compound* analysis, the other *component* analysis. They are complementary, and both are necessary for an understanding of complex design. Any work of art as a whole is compound in that it involves a number of different components such as line and color, pitch and rhythm. But it will not develop all of them equally. The compound analysis of a particular work begins by distinguishing its main parts or sections, then goes on to describe the main parts within each of these, and so on. Objectively perceptible parts and divisions between them are to be sought, rather than those which may be arbitrarily made by the observer. In a symphony, the main parts are usually called "movements" and are given titles in Italian (sometimes English, French, or German) in terms of their tempo (as *adagio, allegro,* etc.); sometimes in terms of the kind of expression or performance required (as *con brio, cantabile, grave*); sometimes in terms of a conventional pattern (as *menuetto*). Analogous main parts in a novel are chapters; in a drama, acts; in a poem, stanzas.

Each of these main parts can be analyzed into smaller ones: the poem into lines, rhythmic phrases, and perhaps metric feet, words, and syllables. A movement in a sonata or symphony, if it is of the *sonata allegro* type, contains an exposition, a development, a recapitulation, and perhaps an introduction, coda, and other parts. A Gothic cathedral usually contains walls, roofs, towers, foundations, doors and windows, spires, piers, vaults, buttresses, aisles, balconies, chapels, and perhaps gargoyles and other features, large and small; some of these are within others, as a rose window and arches in a façade.

In observing each type of art, one arrives sooner or later at a point where further analysis is impossible or unrewarding. The individual stones of a wall can be analyzed into molecules and atoms, but these are not observable by normal aesthetic vision. It is important to see how each large or medium-sized unit, such as a window, serves as a framework for the smaller parts within it, e.g., as a window frame helps to organize the design of stained glass within it.

The parts distinguished in compound analysis are themselves compound, down to the smallest perceptible unit. Even the smallest, as a concrete thing or event, includes several component traits. It was mentioned above that the tone of middle C, struck on the piano, necessarily has not only a certain pitch but a certain timbre, loudness, and duration. A spot of red, cut out of a painting, necessarily has a certain hue, lightness, size, linear shape, surface shape, and texture. A spot of red in a motion picture also has a certain duration. A one-syllable word such as "I," the first person singular, as read aloud from a poem, necessarily has a certain timbre, loudness, pitch, and other qualities, whether or not these are determined in and by the poem itself.

When the framework of a complex design is provided by some other compositional factor, compound analysis may appropriately follow the structure of that factor. For example, in a landscape painting the main parts may be several groups of trees, groups of human figures, a building here and there, a sunset, and perhaps a harbor with ships, all distributed through foreground, middleground, and distant background. When design and representation are closely merged, they can be analyzed together, but thematic analysis calls for special emphasis on thematic relations among the objects represented, e.g., on the repetition of certain curves or colors in trees, clouds, and flowing drapery. This is often neglected by those whose main interest is in representation.

Let us say that a musical theme unit to be analyzed is traditional in form and contains two "periods," each of eight measures. These two periods are the main compound parts of the unit. (Two such parts are sometimes called the first and second *strains*. Each is usually a period or a phrase in length.) Each period may be divided into two phrases, an antecedent and a consequent.

Each phrase may be further divided into small groups of tones or "figures" (sometimes called motives or melodic germs). Each of these groups may consist of some two, three, or four tones or chords. A

single tone, rest, or audible beat is the ultimate stage of compound analysis in music. Each is a compound detail, involving several elementary components. A "figure" is a very short, simple, compound theme. It is usually repeated with variation, several times in the course of the whole passage or motif unit.

To describe how it is varied, we must speak in terms of components; the repetitions or units of this figure will differ as to pitch, rhythm, chord structure, and so on. This leads us to the second approach, *component analysis*. Beginning again with the whole passage, we can analyze it into several developed component themes and series. Each can be roughly indicated by common modes of notation. For example, we can indicate on one staff the *melodic* theme. This may omit chords, but include pitch progression, tempo, meter and rhythm (the durations, accents, and accentuations of each tone).

The melodic theme can be further analyzed into a *pitch progression* theme and a developed *rhythmic* theme. It is possible to write each of these separately, on a different staff. The former is shown by a succession of notes which indicate only key and position on the staff, with flats and sharps if any, but no durations, accents, or bar lines. The latter is shown by a succession of notes indicating only tempo, meter, durations, accents, bar lines, and rests, as if the tones were drumbeats without definite pitch. The pitch progression theme is an abstract melodic line in terms of pitch alone, but may be fairly complex in its ups and downs. The rhythmic theme may also be fairly complex in its varied succession of long and short, accented and unaccented beats.

We can now proceed to indicate the *chord progression* theme in terms of letters and numbers: for example, a sequence of cadences in G major and c minor.

There is also a theme in *orchestration:* for example, the timbre blend "clarinets and strings." This may remain unvaried throughout the unit, or involve some progression: for instance, to "clarinets, French horns and strings" in the second strain or period. In a "theme and variations" for piano alone, there would be one basic theme in timbre throughout the whole composition. Timbre would not be developed into orchestration. But a more limited development could be indicated, as in varying between legato, staccato, and other types of touch which are possible on the keyboard.

In addition, there is usually some direction for dynamics in the scoring. If it is *mf, mp, sf, mf,* this constitutes a slightly developed theme in dynamics. If it is *mf* throughout the passage, we can say that this component is undeveloped so far.

Each of the component themes thus isolated is capable of repetition and variation in itself, apart from the other component themes in the motif. (It can not be stated apart from other components, but can be stated apart from these particular themes.)

The theme of a "theme and variations" is usually regarded essentially as a short melody. It may be harmonized in a simple way, especially when written for piano, but that is not to say that the particular chords thus included in the first statement are essential to it as a theme. Some, or even all, of the other statements may contain different chords. The key, meter, and rhythmic details, and the timbre if the piece is orchestrated, are all likely to be varied. The details of pitch progression are variable. This may leave only the general approximate outline of the pitch progression and rhythmic beat as essential, relatively constant features, whose repetition links together all the statements.

Musical analysis is rarely carried down to elementary components and individual tones. But for purposes of comparison with visual design, it is well to see that this is possible. In static visual design, even the smallest details stand fixed for us to observe. Much visual design is extremely simple by comparison with music. Many vases and bowls contain only one color and texture, one or two simple shapes of line and surface. They can best be described in terms of elementary components, whose musical analogues are pitch and timbre, not melody or orchestration.

Any individual tone of the compound musical unit will possess a certain *pitch* (e.g., that of middle C). This is an *elementary component theme*, analogous to "blue" in a simple pottery form. It will also possess a certain *timbre* (a single kind of timbre like "violin," or a blend such as "clarinets and strings." The latter would constitute a slightly developed theme, the former a more elementary one). The tone will possess a certain relative loudness (e.g., *mf*). If it is harmonized as a chord, that chord will possess a certain *consonance or dissonance*. (We can not tell by the sound alone what *key* it is in, or the name of the chord. It takes more than one chord to establish a key.)

If we consider a slightly larger unit, such as a "figure" of two or three tones or chords, we may begin to discern some definite *key*, such as G major. We also find the rudiments of *rhythm*, in relative accent and duration (e.g., an iambic or trochaic foot).

Each of these traits, as it appears in a single tone, chord, or figure, can be treated as an *elementary component theme*. Through the repetition and variation of such themes, a considerable amount of complexity can be developed in the course of an eight-measure passage. This is why we can say that the theme of a

"Theme with Variations" is a little design in itself, a complex, compound motif unit.

In *visual* design, let us take a particular statement of a peacock motif. Let us imagine it as occurring in low relief, in polychrome tile on a wall surface. This unit can be divided into *compound parts,* such as head, body, and tail. Each of these will involve several elementary components.

The unit can also be analyzed into *component themes,* as follows. In *delineation,* there is a fairly complex developed linear theme, which we may call a "peacock-shaped" outline or pattern, as a whole. This can be isolated from the other components, as a developed component theme. In addition, there is a theme in *modeling,* consisting of certain distinctive convexities and hollows, grooves and ridges. In *coloration,* there is a certain distinctive chord, let us say of medium light, highly saturated blue, dark green of low saturation, black, and gold. From this, we can further abstract a *notan* theme, certain degrees of lightness, from black to medium light. In *texture,* let us say there is an embossed and spotted area in the tail, and a striped, grooved area in the body. Each of these component themes can be considered in abstraction, as something capable of being repeated and varied independently, apart from the compound peacock motif as a whole.

These developed component themes can be further analyzed into *elementary component themes.* These are, in the case of delineation, the various curves and angles of which the peacock-shaped outline is composed. They will doubtless involve a varied repetition of certain small curves and angles. (Compare the small "figures" of which a melodic theme is built up.) In the case of coloration and notan, they are the individual constituent hues, brilliances, and saturations. In the case of modeling they are the particular surface shapes involved. In the case of texture they may consist of all the above elementary themes, as stated in small, very closely packed details.

These methods of analysis can be applied also to any motif unit in *literary* design. There the large compound part might be called a "stanza" or a "canto" in verse, an "act" in a play, or a "chapter" in a novel. Compound analysis divides it into smaller parts such as "lines," "sections," or "paragraphs." Component analysis divides it into auditory components and their themes, both developed and elementary, such as meter, rhyme scheme, and assonance. It may go on to distinguish also suggested component themes under such headings as "emotion," "conation," and "reasoning." Thematic treatment of these latter components can also be found in visual and musical art.

Part of the total form of the peacock motif may be a set of symbolic meanings (e.g., as a symbol of immortality and the incorruptible soul). Part of the total form of a musical unit may be a certain emotional suggestion, and other meanings as well, as in the leitmotiv as used by Wagner.

Any complex design can be analyzed in several ways in terms of different components and of themes and series under each. One can thus describe an entire symphony with reference to its various melodic series only, again with reference to its rhythmic or dynamic series, and again in terms of suggested emotional series.

3. Component thematic development. Building series and patterns within the same component.

A single component such as hue can not exist by itself, and neither can a single component trait or theme, such as blue. In any work of art, they must occur along with others in a compound, concrete object or performance. But it is quite possible to focus our attention on a single component at a time, to notice what themes in that component are used, and how they are developed. It is possible also that only one component in a work of art may be developed to any great extent, the others remaining simple, indefinite, or constant, without variation. A particular drawing may develop only linear shape very far; a particular song, only pitch progression.

What is said in this section applies not only to such specialized forms, but also to those where many components are developed. For, even in the latter, one may observe the development of one component at a time. An artist may concentrate on developing one at a time, and return later to develop the same work in other respects, e.g., work out a linear pattern and then put a variety of colors within it.

4. Repetition, variation, and contrast within a single component. Two ways of varying a theme.

Any component theme, such as blueness or angularity, can be repeated almost exactly. It can be presented to the eye in about the same way at various places (as in a textile) or moments (as in a film). A bell tone or violin tone can be similarly repeated. So can any particular rhythmic configuration, such as a 3/4 meter with undivided quarter notes, or any pitch progression, such as g, e, f, c, in the key of C. To say that the theme is repeated without variation

means that each statement, unit, or occurrence of it is about like every other, so far as can easily be perceived. Doubtless no two statements will be exactly alike from the standpoint of scientific measurement, but that is not as important in aesthetics as the effect on ordinary perception.

It was mentioned in a previous chapter that art shows a widespread, persistent tendency toward slight irregularity, especially in romantic periods and in the mature stage of a civilization. Exact repetition and exact conformity to the basic geometrical types, such as the square, circle, triangle, cylinder, pyramid, cube, and sphere, are likely then to seem monotonous, frozen, and lifeless. When one of these types of series or pattern appears in a picture or statue, it often stops short of exact regularity, as if the artist wished to make it *almost but not quite* a perfect circle, triangle, or the like, or almost but not quite an exactly repetitive series. Of the major arts, architecture is most inclined to tolerate perfectly regular or repetitive forms, as in a row of columns, but even here, as in the entasis of Greek columns, the perfect cylinder is often avoided. Sometimes the musical score seems to call for exact repetition of a certain note or chord, especially in the bass and especially in early eighteenth-century music. But even here, and increasingly under Romanticism, there is a tendency to vary the units a little in performance, so that basic regularity is balanced with slight nuances of variation. In morphological description, this can be taken for granted, so that "triangular" or "repetitive" means "roughly or approximately" so.

There are two principal ways of *varying* a component theme. One is to vary it in *terms of the same component*. The second is to vary it *by combining it with various themes in other components*. The first may be illustrated as follows. Let us take the theme "blue." To vary it in terms of its own component (hue), we can make it a little yellowish in a second unit, and a little reddish in a third. The lightness (brilliance or value), intensity, and shape of the units can remain about constant. Take the theme "angle" under the component "linear shape." We can vary that in terms of linear shape, by making some angles a little more acute, others a little more obtuse. Or take the pitch progression theme g, e, f, c, in the key of C. We can state it several times without changing the rhythm, timbre, or key, but (on a violin) changing it slightly in pitch.

The second way is to combine the theme with various themes in other components. Blueness can be stated in unit 1, along with medium lightness and triangular shape; in unit 2, along with high lightness and circular shape; in unit 3, along with low lightness and square shape. Blueness is now being varied in terms of other components than hue, namely, lightness and linear shape. Hue may remain about constant. Nevertheless, the three units of blue will appear as variations, because of the different traits with which blue is combined in each of them. Likewise, one can vary the theme "triangle," by stating it in black on a flat surface, in blue on a convex surface, and in red on a concave surface: that is, by combining it in different units with different themes of the components hue and surface shape. The pitch progression theme above can be varied (while keeping the pitches constant) by playing it once with violins in 3/4 meter, and once with flutes in 6/8 meter. It will then be varied by combining it with different themes in the components timbre and meter.

5. Component thematic series. Theme-establishing units. Principal and secondary statements of a theme.

All the details or units in a particular work of art or part of one, which repeat a certain component theme exactly or with variation, constitute a *component thematic series*. A series may be an arrangement of things or events in space, time, or both. A *repetitive* series is one in which all the units are (or seem to be) approximately similar in respect to the theme under consideration; a *varied* series involves variations in that respect.

Within a component series, some one unit may stand out as the *theme-establishing unit* or *principal statement*. The first unit in a temporal series is often but not necessarily so. The largest, most complex, most intense, most complete, or most centrally placed unit in a spatial series is often so, but not necessarily. Others will be secondary or subordinate. Sometimes the various units of a theme can be graded into several levels of importance, activity, accentuation, emphasis, definiteness, etc., in relation to other units of the same theme. Sometimes one unit comes first in time and is thus theme-establishing, while a later unit is more important, dominant, or principal in other ways, e.g., as a climax.

In a picture of red roses, the largest, brightest, most central rose may be considered theme-establishing for the series of roses and for the whole form.

Now it may happen that we are interested for the moment in a series of yellow areas (component "hue"). We look around for units of yellow, finding them mostly in inconspicuous details representing faded stems, sunlight reflections, etc. The theme-establishing unit for yellow may be one of these details, which is very subordinate for the picture as a whole. It is perhaps a certain brushstroke where yellow appears most intensely. Often there is no such outstanding unit, or several are about coordinate.

6. Contrast of themes within the same component. Repetition and variation of each. Coinciding and diverging series.

To juxtapose (in space, time, or both) two or more very different themes in the same component is to produce a *contrast*. The compound units in which they occur do not need to contrast in all respects: indeed, they may be similar in all respects save the themes in question, e.g., as spheres identical except that some are red and some white. In the component linear shape, take the two themes "arc" and "angle." Juxtapose, in any order, a number of units definitely shaped as arcs and a number shaped as angles. In the component hue, take the theme "red" and the theme "blue," and juxtapose units containing these, in a definite, emphatic way. In the component pitch progression, take as a theme (in the key of C) the tones d, e, f, e, d, e, f, e (theme 1). Follow this by the theme c, c, g, g, c, c, g, g (theme 2). In each case, the themes are different enough to produce an effect of relative contrast.

In each component, the several units containing a single theme constitute a *component series*. Such a series may be repetitive or varied. The latter would be illustrated, in the component "line," by having all the angular units differ slightly in linear shape, some being acute, some obtuse, and some right angles. Likewise the arcs can be varied, some a little wider and some narrower; that is, they can be arcs of larger and smaller circles. Likewise the blues and the reds can be slightly varied in hue; and each of the pitch progression themes can be slightly varied in pitch, while preserving a basic difference from the contrasting themes. We now have, in each case, two varied component series which contrast with each other: the varied arc series against the varied angle series, and so on.

Two such different series in the same component can be combined into one *contrasting series*, one series containing contrast. This is a *bithematic component series.* For example, we can have a series of units involving arc, angle, arc, angle, arc, angle, and so on.

The order need not be one of alternation. In hue, it might be red, blue, blue, red, or, in pitch progression, theme 1, theme 2, theme 2, theme 1. The units can occur in any order and still form a single series, provided they are so presented as to be easily apperceived as a group or sequence. Units do not always occur in fixed series; the observer can group them so, in order to perceive them clearly and perhaps to describe their structure. He can regard the units of two different themes in the same component as two contrasting series, or as one series involving contrast. He will tend to do the latter if units of the two series are somehow interspersed and mingled, or contained in a single larger form: for example, if all the reds and all the blues are contained in a single picture of a peacock, or all the pitch progressions in a single, continuous song.

Two series in the same component may or may not *coincide* or interlock. There is some coincidence if red and blue units always come together. They are noncoinciding or divergent if some red units are combined with blue and others with green.

7. Coordinate, principal, and secondary thematic series in the same component.

Several contrasting themes may be used in a single component, red, blue, yellow, and green in hue, for example. Units of each make up a series. Hue, and the series of its units, would be polythematic in that form.

It usually happens that some of the themes in such a group or series are more important or emphatic than others. Often one will clearly preponderate and be unquestionably the dominant or *principal* theme in that component. Others may be secondary or coordinate in emphasis. The blue areas may be larger, more intense, more numerous, more extensive, and more varied than any of the others, while the yellows are least so. More question would arise if the blues were numerous and extensive but dull and in the background, while a few spots of bright red were conspicuously placed. One criterion of importance is power to attract and hold attention. This may be expressed in such terms as "emphasized" and "subordinate," "conspicuous" and "obscure."

8. Intermediate theme units, combining or midway between two or more contrasting themes of the same component.

However different and sharply contrasting two themes may be, it is usually possible to have a unit intermediate in nature between the two. Between the arc and the angle is a type of linear shape which resembles both; this may be called an angle with curving sides, or an intersection of two arcs. This often occurs in Gothic architecture. A façade will contain some pointed openings with straight sides, some arcs (as in the rose window and round arches), and some pointed arches with curving sides. These last are intermediate in linear shape between the first two contrasting series. Between red and blue, an intermediate violet may be found. Between any two pitch progression themes, one can make a unit which resembles both about equally. Such a unit will be a variant of both themes, and belong to both contrasting series. It does not contrast strongly with either of them. It can serve in design as a bridge or connecting link between the two series. *Intermediate units* have a function in integrating designs or parts of them, and in compensating for the partly disintegrative effect of contrast.

The effect of contrast itself is not entirely disintegrative, however. Two contrasting series may bind each other together. A series of small straight lines will serve (if suitably placed) to connect a series of circles, in an allover pattern.

9. Types of component series.

A component series may be extended mainly in one, two, or three dimensions of space, in time, or in space and time. A row of spots on a long, narrow ribbon or border is extended mainly in one dimension; an allover spot pattern on a rug is extended in two; the piers of a cathedral interior, in three. If a bell tolls once a minute it makes a series of events in time. If a ballet dancer makes rhythmic gestures on a stage, he produces a series of events in three dimensions of space and in time.

One type of component series, as we have seen, is *repetitive,* reduplicative, or uniform. In this, the units are all approximately alike in respect to the theme in question. It may be symbolized as A A A A A, etc. It is distinguished from a *varied* series, containing slight differences in respect to the theme, which may be symbolized as A, A^1 A^2 A^3, etc. A *contrasting* series, containing units of two or more radically different themes, may be symbolized as A, B, C, etc. A, B is a binary, contrasting series. The second unit more often answers the first. Both repetitive and varied component series are *monothematic,* containing one theme only. A contrasting series may be bithematic, trithematic, or polythematic, according to the number of themes it contains.

Types of series can be distinguished in terms of the *arrangement* of units within the series. A *periodic* series is one which contains approximately regular recurrence or repetition of a certain theme or trait, either continuously or with one or more different units intervening. A repetitive series is one type of periodicity. Let us say that blue is the recurrent theme, and that the series is extended mainly in one dimension as on a ribbon. The series would be periodic if every unit or every other unit (e.g., in half-inch squares) were blue, or every third, fourth, or fifth unit, or the like. The number of intervening units is not essential, nor is their nature, i.e., the extent to which they resemble each other. Some regularity or recurrence is usually implied, but if the interval varies slightly the series may be still called periodic. For example, the recurrent trait may appear sometimes after three units, or sometimes after four or five. A, B, C, A, C, D, E, A, F, G, A, etc., would be a periodic series, with A recurring at approximately regular intervals. Units of the recurring theme do not need to be exactly alike; the series would still be periodic if A came back with slight variations, at approximately regular intervals. The formula might then be A, B, C, A^1, C, D, A^2, D, E, etc. Intervening units do not need to be in strong contrast with the recurrent theme; they may be variations of it, coming between identical repetitions, as A, A^1, A, A^2, A, A^3, etc.

A special type of periodicity is the *alternate* or *alternating* series. This consists of two or more contrasting series combined so that a member of each recurs at approximately regular intervals. Blue, red, blue, red and arc, angle, arc, angle, are alternating series of the type A, B, A, B, A, B, etc. Two musical themes may alternate in this way, in temporal succession. Two or more units may intervene between each unit of a given theme, provided they also are regular repetitions of other themes, as in A, B, C, A, B, C, A, B, C.

The periodic series A, B, A, C, A, D, etc., is sometimes called alternating, since A recurs at alternate intervals, as in the refrain of a song. It would be more correct to call it *semialternating*, since only half the units recur. The *rondo* form in music arranges its

melodic themes in this way. Here the principal theme or first subject occurs at least three times in the same key, alternating with contrasting themes. This specification as to key involves another component, but any alternating series in a single component (A, B, A, C, A, D) can be roughly classed within the rondo type.

An alternating series may be highly regular and repetitive, as when all the units of A are alike, and all the units of B alike. This often occurs in architectural moldings and ornamental borders, such as the egg and dart or bead and reel. This is a convex molding with disks alternating, singly or in pairs, with oblong beads or olives.

Irregular approximations to these types are more common in other arts. In verse the rhyme scheme "sky, blue, high, new, fly, true," would be a regular alternating series. Most alternating rhymes involve sets of two rhyming syllables, such as "sky, blue, high, new, far, near, star, appear."

We can still apply the term "alternating series" to one in which the units of each theme are varied, for instance, with all the A units slightly different from each other and all the B units likewise. This is very likely to be true in music. That is, the scheme A, B, A, B, A, B may be followed on the whole, but with such variations as these: $A \rightarrow B \rightarrow A^1 \rightarrow B^1 \rightarrow A^2 \rightarrow B^2 \rightarrow A^3 \rightarrow B^3 \rightarrow B^1$. Certain variants may or may not reappear, exactly or approximately. Series of the *varied alternating* type occur in heroic cycles such as the exploits of Hercules, and in modern series of tales wherein the hero keeps getting into a different kind of trouble or difficulty, from each of which he emerges successfully.

We shall use the following signs to indicate theme relations. $A \rightarrow B \rightarrow A$ will mean that there is a determinate temporal succession from theme A to B and back to A. The signs A, B, A will not imply necessarily temporal order, but only that the units are fairly distinct, and that there is some tendency to present or perceive them in that order. The first is more typical of music and literature; the second, of painting and textile design, as in a bilaterally symmetrical pattern with a central mass and similar balancing figures at the sides. \widehat{AB} will indicate that A and B are combined in a single unit, or that the unit is intermediate between them.

The ideas of symmetry and balance are related to that of alternating series. An alternate series does not need to be symmetrical or balanced, but it will tend to be if bounded and so arranged that there is an equal number of units of each theme to right and left of a central point, or before and after a central moment. A, B, A is the beginning of an alternating series and is symmetrical. In music it is called "ternary

form." It is one of the most common series in music and lyric poetry, as in minuets and songs. If we prolong it to A, B, A, B, we destroy exact symmetry, but that can be restored by adding another A. A, B, A, B, A is alternating and symmetrical, and so is A, B, A, B, A, B, A. A, B, C, D, C, B, A is periodic and symmetrical.

A *gradual periodic* series is one in which the successive units recede or become different from the recurrent theme by continuously progressive stages, little by little, then return or regress to the theme or original state by similarly continuous stages. The series of steps or units between the two units of the original theme constitutes a *cycle*. When the series is one of rises and falls, or of changes which can be so regarded, the highest point in a cycle is the *zenith*, and the lowest the *nadir*. Many phenomena fall approximately into gradual periodic series, with alternate swings from high to low. The movement of a clock hand, or of the sun as seen from the earth, is cyclical. Each day and night, human activity rises and falls. Desires and emotions become more and less intense. Seasonal industries go through a longer cycle through the year. A colonnade in which successive columns from left to right are taller and taller, then shorter and shorter, then taller again, and so on by regular steps, is a gradual periodic series. A periodic series is *discontinuous* if it does not go through these regular gradations; its recurrences are more or less regular, but not its intervening steps.

A *continuously progressive* series is one which proceeds in a constant order through increasing degrees of the trait which constitutes the theme. A *regressive* series proceeds in opposite or diminishing order. (These terms have no evaluative implications here.) If blue is the theme, and we proceed (e.g., from left to right, or from first to last) through a series of units increasingly blue, the series is progressive. If circular shape is the theme, and we proceed through a series of units increasingly circular, the series is progressive. When the series is temporally determined, as in music, there is a definite difference between progressive and regressive series; but not when it is indeterminate in time.

A *periodic-progressive* series is on the whole progressive, but with partial returns toward the starting point or original condition. Imagine, for example, a series of mountain slopes, each ascending higher than the previous one, but with slight intervening valleys, no valley being as low as the previous one. Or imagine a series of sounds, as of a siren, which increase in loudness for a while, then grow a little softer, then louder than ever before, and so on. A tendency of the opposite sort would be a *regressive periodic* series,

if one kept the same point of view. Decreasing loudness is the same as increasing softness.

In a progressive or periodic-progressive series, the unit approached as terminus usually functions as a *climax*, or most accented unit. It is not necessarily theme-establishing, and in a temporal series can not be, since the theme has already been forecast by earlier units. It may be theme-fulfilling: the clearest and most forceful statement of the theme, which was approached in other units. But in a temporally indeterminate form, where one can look from part to part in any order, there is little or no difference; the climactic unit also tends to establish the theme. Again, it must be remembered that the type of climax we are considering here is limited and relative to one component series. It is a *relative climax*: a climax, for example, for a series of blues or of triangles in a design. The compound unit which is a climax for one component series is not necessarily so for others.

In a periodic series, which returns once or more to the starting point or original condition, there is usually no climax. There may be, however, a distinction of degrees of accent. The recurrent units may be more highly accented than the intervening ones, or vice versa. If the periodicity is gradual or cyclical, the successive zeniths may constitute accents. If there is but one departure from the original condition, and one final return to it, the farthest swing away from it (the apogee) may constitute a relative climax, especially if it is more intense, large, forceful, loud, or otherwise accented. For example, suppose a series of changes from dull gray to intense blue, and back to dull gray, or from short, slender columns at the left to large, massive ones in the center, then back to short, slender ones at the right.

The idea of a series implies some amount of definite order in the relative succession or position of the units. This may be a succession or sequence in time, as in music and poetry, where each unit is definitely put before, after, or simultaneous with each of the others. There may be a succession in one dimension of space, as in a row of letters from left to right along a line of print, or a row of circles along a molding or border. The series may be ordered mainly in two dimensions as in a series of towns on a map, to be visited by a traveler in a zigzag order of progress. It may be ordered in three, as in a set of different kinds of light placed around the walls and ceiling of a hall. In the latter case, there is definite spatial order but not definite temporal order. One could look from light to light in any order, and the result would be a somewhat different series.

When the order is indefinite spatially, temporally, or both, one may still call the units a series (using the term loosely). But a series cannot be recognized as periodic, alternating, progressive or regressive, unless its order is fairly definite. It can, however, be recognized as repetitive, varied, or contrasting, merely on a basis of the resemblance or difference between the units, without regard to their order of presentation.

Intermediate cases sometimes arise, as in pictorial design. Here the various series (e.g., of red spots, or of angular lines) are more or less indeterminate in temporal order; one can look around the picture in any order. Such a group of units may be definitely repetitive or contrasting, yet so irregularly scattered that one cannot call them definitely periodic or progressive. However, the picture may in certain places arrange a set of units so that one is led to perceive them as an ordered succession: e.g., the parallel rows of trees in Hobbema's *The Avenue*, which are regressive in size as one moves away and down the road; progressive as one moves from horizon to foreground. A picture may show a wall with panels alternately black and white, thus inviting us to perceive them as an alternating series. At the same time it may contain other black and white spots irregularly scattered, in no definite order. The latter would be a contrasting series, but not alternating.

We have seen how two or more different series can be combined into one contrasting series. There are many other ways of combining series in the same component. In the first place, a double, triple, or still more complex series can be produced by making two or more series run along together, concomitantly, so that a unit of each occurs with a unit of the others. Series can thus be combined in space, as in a rug border where a row of flowers runs parallel to a row of stars, thus forming a double series. They can be combined in time, as when a sequence of drumbeats is synchronized with a sequence of bell tones. The music of a string quartet can be regarded as a quadruple sequence of tones: a combination of the four sequences ("parts" or "voices") produced by the four different instruments. They are synchronized by a common meter and by the partial coincidence of the strong and weak beats in each voice. They can be further synchronized and made to resemble or differ from each other in any desired degree, as in counterpoint.

In space of two or three dimensions, the ways of combining series are numerous. Fitting together and extending series in two dimensions tends to produce various types of *allover pattern*. For example, if we put down a number of repetitive series parallel with each other from right to left at uniform intervals,

another group of repetitive series will also be formed, parallel with each other from top to bottom. This produces a *diapered* pattern, as in textile and wall decoration:

A, A, A, A
A, A, A, A
A, A, A, A
A, A, A, A

If the constituent series are of alternating squares from left to right, combined so as to produce alternating series from top to bottom also, the result is a *checkered* type of allover pattern. Here the formula would be

A, B, A, B
B, A, B, A
A, B, A, B
B, A, B, A

The combination of series in three dimensions can be illustrated by a number of beaded rods or strings of beads, placed so as to intersect at various angles from right to left, top to bottom, and near to far. Each row of beads would be a series, which might be repetitive, alternating, or of some other type. Placed together in definite orders, they would produce a three-dimensional pattern, as do the steel girders in an unfinished building.

10. Regularity, determinateness, and complexity.

Thematic series in nature and art vary greatly in respect to these attributes. Highly regular series in nature are the rotation of the earth and its revolution around the sun; somewhat less so are pulsebeat and respiration. Machine movements are usually regular in cycle. These are repetitive or periodic series. Business cycles and the alternation of war and peace are still less regular. The series or "rhythms" of life, especially in the more evolved civilizations, tend to be irregular and flexible, and so do those of art which seeks to express human feeling. In art, highly regular series appear in classic and Neoclassic architecture, ornament on furniture, formal garden design, textile design, verse, and music. Some recent painters, such as Mondrian and Albers, use regular series frequently.

Irregular and indeterminate series are more common in painting, sculpture, and prose literature, especially in romantic trends within these arts. Irregular-

ity is manifested in a thematic series as (a) dissimilar and perhaps incommensurable intervals between the units; (b) lack of exact recurrence or repetition, or much variation of theme; (c) lack of gradual progression; discontinuous leaps, starts, and stops; rambling tendencies; and (d) lack of conformity to any definite type of series or scheme.

Determinateness is partly a matter of regularity, partly of definite temporal order. It is also partly a matter of the definiteness of individual units, and partly of bounding or limitation. A series which goes on or might go on indefinitely in space or time is in that respect indeterminate: for instance, the ticking of a clock; the movements of the planets; a row of telegraph poles; a textile design on ribbon or dress fabric. We introduce a measure of determinateness into these forms if we bound them definitely in space or time. This does not mean merely to begin or end them, to start or stop the clock, to cut off a square of fabric. The internal nature of the form suggests a possible continuation, over and over as before.

Definite bounding is performed in various ways. One way is to put certain accented units at beginning and end, or all around in space, which resemble each other but contrast with much or all of what is in between. A red dot at left and at right of a row of blue dots would tend to bound it in one dimension. A red line about a field of blue dots would bound it in two dimensions. This is what a picture frame does or the border of a rug. A path around a garden does so in two dimensions; a high wall or roof does so in three. The rising and falling of the theater curtain bound a play, and each of its acts, in time. The stage bounds the presentation in space. At the concert, the conductor taps with his baton at the beginning, and the audience applauds at the end. The violinist comes out upon the stage, plays, and departs. These are not parts of the musical form, but they bound its performance temporally, by contrasting events. A boy's whistling, a shepherd's piping, the songs of birds— these have no definite beginning or end. Ballroom dance music can be played over and over, through repeating units, as long as the participants wish. In time, one can bound any process to some extent by putting contrasting events at or before its beginning and at or after its ending. If a piece of music is loud at the start, soft during the middle, and loud at the end, the contrast tends to determine it in time. A, B, A, is bounded in space or time, as the case may be; so is A, B, B, C, D, A, even though it is not internally symmetrical. Music is often of the latter type.

Another way of introducing determinateness is to arrange the internal units so that they obviously con-

form to some scheme which involves a definite beginning and ending. Then the first or last unit will not seem suddenly chopped off or abandoned. If the series is obviously progressive, tending toward a certain kind of goal or terminus, its achievement is foreshadowed as a kind of culmination and conclusion; no more need be said or done. A climax in music, the drama, or the novel thus tends to conclude the form in time, perhaps after some delay. Marriage is usually the culmination of a love story; the hero's death, the culmination of a tragedy. Such an ending need not be especially forcible, loud, or excited, if it appears as the consistent fulfillment of a previous main progression, as the occurrence of what one has been led to expect. It conforms to a definite internal scheme: that of a progressive or periodic-progressive series.

Another internal scheme is the *symmetrical periodic,* as in A, B, C, A, C, B, A. In a picture, the general conformity of figures to a triangular, pyramidal, or circular scheme tends to bound them in space, even without a frame. The boundary is suggested even if not actually shown. But conformity to a radial scheme bounds them less definitely, especially when outward movement is suggested; since it might conceivably continue outward indefinitely.

A *component pattern* is a comparatively definite and regular component series. No particular amount of these attributes is specified, but a series or set of details is not a pattern if it is extremely irregular, vague and indefinite, disorderly or unconnected. It may be very simple, however. A circle is a pattern, and so is a star, a diamond, a sphere, a triangle, a pyramid, a cone, or any other common geometric figure. A checkerboard is a simple pattern of alternating series of squares, light and dark, extended in two dimensions. A cycle of rotary movements, as of a machine, is a pattern; so is the normal cycle of life from birth to old age and death, and that of day and night, with its recurring sequence of light and color changes at sunrise and sunset.

A pattern does not have to be completely determinate in space or time. We speak of an "allover pattern" in textile or wallpaper design, even though it has no definite boundaries. But to call it a pattern at all implies a fairly definite internal structure. A pattern does not have to be absolutely regular; if the general outlines are approximately so, occasional details can be lacking or variable. A triangle with one side broken or slightly curving is still a triangular pattern from the aesthetic standpoint. Approximate, slightly irregular patterns are more common in art and life than exact or perfect ones.

A pattern does not have to be an abstract figure. It can be a representation of something, e.g., the linear outline of a peacock, a tree, a flower, or a human being. The subject does not matter, but the mode of treatment does. For example, a flower can be drawn in such a way as to present a very definite linear pattern of radiating petals, or by an Impressionist painter in such a way as to present only a blur of color, and no definite linear pattern at all. The shape of a utilitarian object can provide a pattern: e.g., a sword, vase, or windmill. A conventional symbol such as an initial letter can be treated as a pattern. Such letters have been developed into some of the most elaborate patterns in the world, as in the Book of Kells.

11. Complex component patterns. Frameworks and accessories.

Repetitive or varied series are ipso facto somewhat integrated, but not necessarily to any great extent. A number of similar units (e.g., of the letter X) may be scattered irregularly over a paper. Their resemblance will unify them somewhat, but not as much as if they were arranged in a definite way. Contrasting series, as we have seen, can be linked by intermediate units; but again, this is not enough to make a definite pattern. Another method of integration is through *subordination* or conformity to a common, basic series or pattern. The spokes of a wheel are all mutually related as radii of a circle; they are subordinated to the wheel shape as a whole.

A *complex pattern* may have a relatively simple underlying pattern, and also a number of different details or units which are not essential parts of the underlying pattern, but are fitted into it. For example, a circle whose circumference is made of smaller circles and crosses is complex by comparison with the underlying circle itself. The underlying, simpler pattern is not necessarily complete, explicit, or directly presented. It may be suggested or implied only in the general arrangement or tendency of the other details. Often the underlying pattern is used by an artist as a sort of preliminary sketch, diagram, or skeleton, to guide the disposition of details, but to be erased or covered up later on.

The underlying, simpler pattern, to which other details conform, is a *framework or skeleton pattern.* The other details, including patterns if any, are *accessory.* We have seen that a certain mode of composi-

tion, such as utilitarian or representative, can provide the framework for a whole, diversified form, with other modes as accessories. Here we are talking only of thematic composition, and of series built up within a single component. A certain pattern may be the framework for a more complex pattern in respect to linear shape only. A linear pattern may be drawn, and then colors may be smeared over it in no relation to the pattern, or in relation to some other pattern.

The distinction between "framework" and "accessory" is not the same as that between "conspicuous" and "obscure." A framework pattern may be obvious and emphatic, or a shadowy outline in the background, or may not be directly perceptible at all, and to be inferred only from the arrangement of details.

It was noted in a previous chapter that certain components are much more suited to the building up of complex thematic relations than others are. They are, in a special degree, the form-giving, architectonic components. These are, in the visual realm, *shape* (linear, surface, and solid); in the auditory realm, *rhythm* and *pitch,* especially *melodic pitch progression,* and *timbre,* the last especially in rhyming verse. Framework patterns tend to be constructed out of thematic series in these components. Other components tend to supply accessory development, enrichment, content, ornamentation, etc. They can be used to build up less complex series and patterns. Series of colors, textures, lights and darks, and of timbres, chord progressions, key progressions, louds and softs, can be arranged in fairly definite patterns. They sometimes act as frameworks. The same is true of lower-sense qualities. But on the whole it seems difficult to build one of these other components into a complex pattern by itself. Artists usually fit them as accessories into a framework otherwise constructed.

Any of the architectonic components, on the other hand, can be used not only to build a framework, but also to add accessory developments. Thus we can have extremely complex patterns in which line alone is developed. Surface shape can be developed highly, but this necessitates some linear development also. Solid shape development involves some development of both line and surface shape. There can be complex patterns in which rhythm alone is developed (e.g., patterns of drumbeats), and others in which melodic pitch progression alone is developed. What has been said so far of component thematic development applies in some measure to all components; but in pursuing the subject into complex levels, we shall limit it more to the few that are most architectonic.

12. Repetition, variation, and contrast of component patterns. Partial variation and anticipation.

Any component pattern, simple or complex, may be treated as a theme. When the same pattern (e.g., a six-pointed star) is embodied in several units, they constitute a component pattern series. In a row of six-pointed stars, that type of shape, considered abstractly, would be the theme. It would fall under the elementary component "line," and under the developed component "drawing" or "delineation."

Like any other component theme, a component pattern can be repeated exactly to form a repetitive series. From the standpoint of component development, and of the component "line," a row of stars would be repetitive if they resembled each other almost exactly as to linear shape and size, however they might differ in other components such as hue or lightness.

Like any other component theme, a component pattern can be varied in terms of its own component, or of other components. By the latter method, which is to be considered under "compound development," we could vary the theme "six-pointed star" by drawing it first in black ink, then in red. The component development of such a theme would involve varying it in terms of its own component only, in this case linear shape. Thus we could vary the theme "six-pointed star" by constructing one of equilateral triangles, then one of narrow, slender triangles; one of large and another of small triangles; one with lines all straight and another with some slightly curved or made of dots. If the difference between two nearby pattern units in the same component is great, they produce contrast. A six-pointed star would contrast with a set of concentric circles.

Partial repetition and variation of a component pattern are possible in any medium. For a visual illustration, let us say that the letter "A" is a linear theme. Then to follow it by any one of the lines of which it is made, diagonal or horizontal, would be to repeat it partially. If the lines were slightly altered in size or shape, they would be partial variations of the theme. "Partial variation" means here variation or varied statement of part of a theme. It does not specify the degree of alteration involved.

Classical music of the eighteenth and early nine-

teenth centuries is often pedantically careful and detailed in repeating themes in full. More modern music is full of fragmentary echoes, quick passing references, to themes previously stated in full. Often the last phrase of a theme, or part of it, is repeated several times in various altered ways, as a sort of echo, or as a detailed reconsideration of different parts of the subject. Usually such variations involve the use of several components, and hence belong under the heading of compound development.

In complex thematic development, as in a sonata, it is common to select portions of two or more themes, and to repeat, vary, and combine them in many different ways. Thus partial variations of two contrasting themes can be merged, either into a unit which resembles both somewhat, or into a unit which explicitly combines both—for example, through having one in the treble and one in the bass. In the sonata and symphony such variations, complete or partial, tend to be merged into continuous passages with units interpenetrating; not to be separated clearly by pauses or full cadences like beads on a string in the manner of the traditional "theme with variations." The "development" section of a sonata usually contains many partial variations of the principal theme or themes.

Temporally developed forms, especially in music, often make use of *partial anticipations* of a theme.[2] These are partial statements of a theme which come *before* the first complete, emphatic statement of that theme. (They are not the same as "anticipations" in the usual musical sense which refers to early, dissonant entry of a tone or chord.) One cannot call them repetitions, for that would imply that they came afterward. They are variations, in a broad sense, though not usually so called. They are *anticipatory* variations, whereas most variations in temporal series come after a fairly complete theme-establishing unit. For example, a sonata may begin with a rather vague, brief group of notes or chords. This is followed by another and another, each a little longer and more definite, with an effect of mounting suspense until the full theme is emphatically stated. Even this statement may not be absolutely full or complete, for subsequent development may enlarge it greatly. A similar kind of preliminary hinting often occurs in drama and fiction.

A *theme-establishing unit* often announces the main subject briefly but clearly as a whole, at or near

the beginning, as a speaker may announce his thesis at the start of a discourse. Different parts of a complex subject may thus be separately hinted in advance, only later to be assembled as a clear, organic whole. Frequent use of fragmentary anticipations or extended lingering upon them tends to give an effect of dreamy vagueness, hesitant, groping, perplexity, or mystery, which is characteristically romantic.

13. Thematic complication by division.

In Chapter V, on spatial, temporal, and causal development, a brief preliminary account was given of the methods of addition and division, as applicable to any mode of composition. Let us now consider them a little more carefully, especially as related to thematic composition and design.

By the method of division, it will be remembered, one begins with a simple pattern as framework; then divides and subdivides each of its parts; then differentiates these parts into varying and perhaps contrasting thematic series: always keeping the parts in approximate subordination to the original framework. Let us apply this method to the development of linear patterns in two dimensions.

Line or linear shape is inseparable from some extension in two dimensions. Visible line is always perceived as the shape or boundary of some sort of area: perhaps flat, as on a paper or cloth, perhaps solid and curving, as in the silhouette of a statue. Line may be perceived as a long, very narrow streak over a surface, straight or bent, contrasting with its environment in color, lightness, or some other respect. In this case, when we speak of line as a component, we tend to disregard the color or lightness which helps reveal it, and think only of the shape, size, and direction of the streak, as in a black letter on white paper. Line may also be perceived as the edge of an area, for example, of an inkspot on a white paper. A linear theme is the shape of such a streak or edge, or of a portion of one.

A single unit of line may be very simple, as in a dash or parenthesis, or very vague, as in wisps of cloud or foam. One would hardly apply the term "pattern" to these, for it implies something a little more definite and differentiated. A circle, square, or star is a pattern though still very simple. Each one involves some resemblance among the linear parts which make it up. Stars and squares are made of straight lines and angles. Circles and ellipses are made of curves. These figures also involve some differentia-

[2]Note, for example, the beginning of Brahms's Sonata for Violin and Piano, Opus 100.

tion, in the direction of the line which bounds or composes them. All of them bound a definite area of two-dimensional space, and are thus determinate. If one side of a square or star were missing, the figure would be indeterminate to that extent: that is, it would leave the figure unbounded on that side. However, we might still call it a partial or approximate pattern.

What does it mean to *divide* a line or a linear pattern? Thinking of a line as a long, narrow streak, we can divide it lengthwise, into two or more narrower streaks running side by side. We can divide it crosswise, into shorter lines. These can be made of the same shape as the first one: for example, a semicircular arc one inch in diameter can be roughly replaced by two semicircular arcs, each a half inch, thus putting two units of the theme where only one existed before. Thinking of a circle as the boundary of an area, we can divide that area, putting two or more smaller circles within the area covered by the first. It is not exact, geometrical division that we are concerned with here, but approximate, apparent division, which does not require a whole to be equal to the sum of its parts, or to the sum of the smaller units placed within it. Indeed, the framework pattern will remain more clearly perceptible if the new, small parts within it do not exactly coincide with its own outlines.

Thematic development by division is not merely cutting a thing into parts: a circle into arcs, or a star into angles. It involves marking off and altering the parts so that they will have a more distinct individual identity, separate and perhaps different from their neighbors. It involves placing two or more definite theme units in an area of space or time formerly occupied by only one.

In accordance with the above possibilities, a semicircular arc can be divided in many different ways. If the original line is broad, it can be split into two or three narrow, parallel arcs, as in a rainbow. It can be scalloped or divided into many short curves end to end. It can be divided into a wavy line, single or double (a guilloche) with curves in opposite directions. Instead of dividing it into curves, one can divide it into units of a contrasting theme, as in the angular teeth of a circular "buzz saw," or the rectangular cogs of a cogwheel.

One of the commonest linear framework patterns for division is the rectangle. Most rug designs, book covers, advertising pages and posters, formal gardens, and countless other types of design, are laid out as to their basic framework by subdividing a rectangle. The

design scheme of a painting is often sketched out in the same way, although usually complicated by three-dimensional representation. There are countless ways of dividing and subdividing a rectangular area, to produce a more or less complex pattern.

Greatest regularity and unity are produced by dividing it into equal, similar rectangles. This is done in the French tricolor flag, of three broad stripes. More parallel lines, horizontal or vertical, will divide the field into more stripes. Still more, at right angles to these, produce a tartan pattern (usually varied by having parallel lines at different distances apart). Subdivision in this way can be continued indefinitely. Likewise, one can put a smaller rectangle inside the larger one, giving the effect of a central field and border, then another inside the small one, and so on. Many rug designs are thus divided into an oblong central field surrounded by several borders of various widths.

The result of these types of division is to produce one phase in complexity: *multiplicity* of parts. But it lacks differentiation, which is necessary for full complex development. The American flag introduces some variation by dividing the field into a small rectangle, subdivided with stars, at the corner of a larger rectangle, subdivided into stripes. The British Union Jack also divides the rectangle diagonally into triangles, with acute and obtuse angles. The Japanese, Brazilian, and some other flags introduce contrast by putting a circle within the rectangle. Some rug designs place within it a vase-shaped pattern, a circular medallion, or other curving figures. Differentiation can be increased to any desired degree by thus dividing linear figures into smaller shapes which contrast with them. An early form of the American flag had more contrast in that the stars were arranged in a circle instead of straight rows.

For another example, let us take a wheel-shaped linear pattern as framework. This is itself a contrasting thematic series, whose units are arcs in the circle, straight lines and angles in the spokes. It is definitely bounded in two-dimensional space. The units are integrated by their common relationship as radii and circumference of a circle. Now each arc can be divided: say into small angles. This sawtooth series carries out the angular series of the spokes. Each spoke can be divided: say into small circles which repeat the main circle.

Filippo Lippi's *Madonna and Child* (Florence, Pitti Palace) is developed by division, the circular (*tondo*) framework being retained. The circle is divided by radii into a pie-shaped pattern whose sectors are dif-

ferent in size and shape. Their points do not converge exactly at the center, the largest and most emphatic sector being the lower central one whose apex is the head of the Virgin. Each sector of this framework is further subdivided.

It is not necessary to repeat framework themes in the division units, but that is one way to preserve unity. By repeating two or more themes in the division units, we preserve contrast or differentiation as well, and thus contribute to complexity.

If small figures of many different sizes and shapes are placed irregularly within the larger figures, differentiation and disorder will be suggested. (This is not usually desired in a flag or other institutional symbol.) Order throughout subdivision can be maintained in various ways. One is to preserve and interrelate the framework patterns clearly, including the framework of each constituent pattern as well as the largest, original one. Another is to make clear the relationship of the smaller, accessory parts to each other and to their frameworks, as to which is inside or outside, which are side by side, connected or unconnected, and so on.

Another is to subdivide systematically, step by step, in all or several parts of the total form together. That is, (1) to divide the original framework into main parts of about the same size; (2) to divide all or most of these into smaller parts of about the same size, and so on; and (3) to repeat this process until the desired complexity is reached. The result will be to facilitate clarity of perception and an appearance of order, through having all parts, small or large, on a few definite levels of subdivision, within a few definite ranges of size, and in a few definite groups, coordinate as to size, and mutual relationship. (Consider, by comparison, the political subdivisions of the United States: all states are coordinate in rank with each other, all counties with each other, etc.) This implies that the relationship of each part (detail or pattern, large or small) to each other part is clearly indicated, as to (a) what other parts it directly includes; (b) what part it is directly included within; and (c) what parts it is coordinate with, as being jointly included in a single larger part.

In certain types of painting, especially those of Matisse and the Persian miniaturists to whom he is indebted, a moderately complex linear as well as color design is achieved by the method of division. The rectangle is first divided into a few main sections of irregular size and shape. Then each is differently treated. Some are left plain, others further and further subdivided into striped, flowered, shaded, and other patterns and textures. The total effect as to linear pattern is somewhat free and loose.

14. Degrees of complexity in terms of the number of inclusions.

The first stage in the process of division is the original framework pattern; e.g., the circle, rectangle, peacock outline, or other linear figure before it has been divided at all. Any such pattern may include parts, a series of units such as arcs, sides and angles, the outline of head, legs, body, and tail. These parts will be somewhat differentiated as to direction, shape, or size, but somewhat integrated and determined in space or time. Such a pattern is more complex than a single straight line or arc. If left undivided, it will be on the *first stage of development* in terms of *levels of inclusion.* Being undivided means that the parts are not detached or marked off from each other, or given definite identity apart from the whole. It has no inclusions, in the sense that it includes no definite, individualized parts.

If the pattern is divided once, into a set of main large parts, each of which is directly included within the whole and not within a part of the whole, the pattern is carried to the *second stage of development* in terms of inclusion. Examples would be a rectangle divided diagonally into triangles, or a peacock outline in which the interior area is clearly marked off into head, wing, legs, etc. It has one inclusion: the whole and one set of parts.

If each of these main parts is divided again into a set of definite smaller parts, each of which is directly related to it as part to whole, the pattern is carried to the *third stage* of development. It has two inclusions: the whole framework includes a set of main parts, and these include another set. Further stages can be estimated likewise.

The end of the process has been reached when one encounters a set of parts which contain no definite smaller parts, no individualized units possessing a clear identity of their own.

If the circle were composed of thirteen small stars, as in the early American flag, one could look from the whole to a set of definite parts. But this would be the end; looking at an individual star with a magnifying glass, one would see only the texture of cloth. However many levels of inclusion a pattern contains, and whatever its material or medium, one's analysis will arrive sometime at such a set of undi-

vided parts. In a cathedral facade, one reaches it in going from a small detailed pattern (say the crown on a king's head) to a jewel in that crown. Looking closely at the jewel, one sees no definite details within it, only the texture of stone.

The number of divisions or inclusions is not a complete measure of complexity or development. A pattern may have many levels of inclusion, and yet be undeveloped in that it lacks contrast. All its units could be members of one thematic series, as in dividing and subdividing a rectangular cloth into a plaid pattern of crossed straight lines. There would probably be some variation, in that some units (e.g., rectangles) would be smaller than others (small rectangles fitted into larger ones). If there were also circles, wavy lines, and other different series, all integrated in the same framework, the total degree of complexity would be greater.

In most cases the whole pattern is not everywhere subdivided to the same extent. A single part near the center may be intricately subdivided, while the surrounding field or border is left plain. Details may be of so many different sizes, and so obscurely related to frameworks, that it is hard to say exactly how many subdivisions have taken place. In such cases, one may say that the greatest amount of division has been performed in a certain section or sections, and lesser amounts elsewhere.

Roughly speaking, we shall apply the adjective *complex* to patterns which contain some contrast and which have been carried, in one or more sections, to at least the second stage of inclusion. Below that, we shall regard them as *simple patterns,* even though they may appear complex as compared with a single detail, such as a straight line. Those carried to more than two stages we shall call *ultracomplex.*

We can now distinguish between two kinds of thematic framework. One is the *inclusive* framework series or pattern. The other is the *sectional* framework series or pattern, for any part, large or small, within this larger whole. As subdivision proceeds, areas in space or time which had been vague or undifferentiated come to include small framework patterns of their own, with still smaller details subordinated to them. Take for instance a Byzantine textile design of complex medallions, arranged in repetitive series from right to left and top to bottom, as an allover spot pattern. Each medallion, considered as to its linear shape only, has its own sectional framework, perhaps identical with that of all the others: e.g., a drawing of a charioteer and four horses within a circle. Within this are many accessory details, some of them comprising smaller patterns. The inclusive framework is the simple, repetitive series of medallions in two dimensions, indeterminate as to boundaries and theoretically capable of indefinite extension in all four directions. Each complex medallion is related to it as an accessory detail to a framework. So is the framework of that medallion; in other words, a given pattern may be a subordinate detail with reference to a larger, inclusive pattern, and a framework with reference to the smaller details within it.

We come now to the question of *size* and *scale.* It is evident that many subdivisions of a small framework pattern would quickly bring the details down to infinitesimal scale. If one starts with a gigantic framework, such as a cathedral façade, many levels of subdivision are possible before that point is reached. The practical limit is the point beyond which details cannot be manipulated by the artist or performer, or perceived in a manner regarded as adequate under the required conditions. Beyond this point, visual or auditory details appear as a vague texture, blurred and formless. Thus, if the artist desires an effect of clarity and complexity through this method, he must begin with a fairly large framework pattern, or else enlarge his framework pattern as he subdivides it. Thus the method of division tends to become a method of *enlargement and division.* If the original pattern is to be maintained, the enlargement must be in proportion, as an approximately uniform magnification. It constitutes an extension of the original pattern in space, time, or both, as the case may be.

The double process of enlarging and dividing the framework can be carried on indefinitely. Each stage of subdivision carries the pattern to a higher level of complexity through inclusion of part within part. Each tends to require, as a practical consideration, that the original framework be larger in space or time, so as to allow perceiving and manipulating the new set of small details.

One may start with any sort of simple pattern, involving any sort of themes in its units. They need not be arcs and angles; they need not be regular, geometrical, or definite. It is not necessary to divide and subdivide *all* the parts on a given level. One may subdivide only a portion of the original framework, for example, the rim or hub of the wheel. This would result in a type of pattern which was uneven in its development, more complex in some parts than in others, plain and simple here, and enriched with ornamentation there.

It is not necessary to follow the original framework exactly, or to preserve it as directly visible in the final

product. The artist is free to alter a first plan or basic scheme as he wishes, to decrease the subordination of details to the framework. He is free to loosen up the scheme, and make it as irregular and indefinite as he wishes. If he does so to any great extent, he may produce a romantic type of pattern, or no pattern at all, only a vague, irregular thematic series. To adopt so regular a framework as the wheel or rectangle, and adhere to it rigorously in the shape and subordination of accessory details, would result in an extremely regular, tightly unified pattern. Instead, one could start with an irregular, free-flowing pattern such as a naturalistic tree, subdivide it irregularly into more varied details, and avoid extreme subordination of these details to the framework. The method of division is flexible enough to fit into any style of art, any type of theme or pattern.

15. Subdivision and enlargement in one, two, or three dimensions of space.

We have been considering a framework which was originally extended in two dimensions, such as a flat, wheel-shaped pattern on cloth or paper. We also conceived of the subdivision as proceeding in two dimensions, e.g., between top and bottom and between right and left, on a sheet of paper held before the observer. As subdivision proceeded, there would be more and more internal parts, counting either vertically or horizontally. The result would tend to be an allover pattern of a spot, checkered, arabesque, or other type, within the framework area.

Suppose that the original framework is an alternate series of circles and crosses extending horizontally. The circle is A and the cross B, in the formula A, B, A, B, A, B, etc. Now we can divide each circle and each cross vertically, so that there are two units horizontally where only one occurred before, but leave the height of each unit the same and undivided. The result is to have two tall, narrow ellipses instead of each circle, and two tall, narrow crosses instead of each wide cross. Horizontally, we now have aa, bb, aa, bb, etc. These units can be arranged in any way, such as ababab, or aba, aba, aba, etc. The original framework can be kept visible, meanwhile, so that (for example) two narrow ellipses are superimposed on each circle. The original framework, A, B, A, B, A, B, is maintained if desired, but each A now includes two or more small units (similar to it or contrasting with it) and each B likewise. This process, continued, gives indefinite complication in one dimension. Meanwhile, the width of each unit in the framework can be

proportionately enlarged, if desired, so that the framework series is wider from left to right but the smallest units are kept constant in size.

Subdivision in three dimensions may be illustrated by imagining a cubical room, let us say, a hundred feet in each dimension. Run a floor and two walls above and below it at right angles through the central point, so as to divide the large room into eight small ones. Repeat the process, enlarging the rooms if desired. The result is a repetitive series in three dimensions, highly regular and uniform. It could be made complex if the rooms were different in shape: some, hollow spheres like soap bubbles; some, hexagonal prisms, like cells in a honeycomb. Now imagine these rooms of different shape and size arranged in different orders. The order from left to right might be, for example, cube, sphere, cube, sphere, etc.; that from near to far, sphere, hexagon, hexagon, sphere, etc. We are now producing definite, interlocking series of contrasting units: in other words, complex patterns of interior space or void. So far, such complex structures have seldom been found practicable in human art, though frequently achieved in the cellular structure of plants and animals. Buckminster Fuller's experimental architecture has produced a variety of complex, three-dimensional forms.

If we choose solid shape as the component, much the same course may be pursued. A solid sphere may be divided into smaller spheres, all being held up in space by rods and braces, or set in motion. Spheres, cubes, pyramids, and other themes in this component can be arranged in series and patterns in three dimensions. This has been done in art by Cubists and Constructivists. Scientists build models on this order, to demonstrate the structure of an atom. Some modern abstract sculpture, static and mobile (e.g., the work of Calder), follows it a little way, as a rule with the aid of other components such as color and texture variations.

16. Developing musical patterns by division.

Let us begin with a rhythmic theme of strong and weak, long and short beats. If it is fast and brief and we wish to subdivide it, we can magnify it in time. We can multiply each beat in duration, as by slowing the tempo, or making every eighth note a half note. The latter, of course, tends to alter the rhythmic pattern by redistributing accents. To develop the rhythmic pattern, we can then take each beat in the new, large framework, and subdivide it into fractional beats.

The same approach can be applied to melodic

pitch progression. A pitch progression or melodic line consists of a succession of single tones involving differences in pitch. It has a certain configuration of rises and falls which can be symbolized on a graph. Between any two tones there is an interval in pitch. There is an interval in time also between the first sounding of one tone and the first sounding of another. (Whether there is prolonged tone or a rest in between is not essential.) Any given melodic line, as a framework pattern, can be magnified in two ways. In other words, there are two dimensions or frames of reference along which enlargement can occur.

One is qualitative: that of *pitch*. Each interval in pitch between a note and its successor can be increased, as from a second to a sixth. (The increases do not need to be exactly uniform. The general melodic configuration can be maintained in spite of many small deviations.) As a result of the increases, more notes intermediate in pitch, more subdivisions of the scale, can be placed between these two notes. Theoretically, it would be possible to place just as many intermediate tones between them without increasing the interval first, for there are many intermediate wavelengths between any tone and a tone a second higher. By using such fractional intervals, one might complicate a melodic line which is to be sung or played on a violin, without enlarging the original pattern. But the traditional diatonic scale and the limitations of keyboard instruments prevent this. The interval of a minor second is indivisible on the piano. The situation is as if, in the wheel-shaped pattern, one were unable to subdivide the circle into parts smaller than an inch long. In that event, one would have to enlarge the whole circle in order to subdivide it further. Likewise with melodic line on the pianoforte, one cannot introduce intervals smaller than minor seconds. Thus complication of the melodic line in terms of pitch intervals soon requires enlargement of the original pattern.

The groups thus interspersed are, in this illustration, small repetitions of the original pattern. Again, this makes for unity without contrast. Slight variations in pitch, as by accidentals or brief modulations, would further develop the pattern and eliminate the monotony of exact repetition. Chopin often develops a melodic line by introducing rapid arpeggios between the tones of the melody. If we began with two contrasting melodic patterns, we could put a small repetition of each between the notes of the enlargement of the other, thus carrying on and reversing the contrast.

Practical conditions have tended to limit the enlargement of pitch intervals in music. If a melodic line is extended in pitch so that its high notes go much higher and its low notes much lower, it soon gets beyond the usual range or register of the human voice and of many instruments. Piano and organ allow extension to a greater range, but the music written for them is limited by traditional habits, so that melodic lines usually remain confined within an octave or two instead of developing through larger intervals. Moreover, the average listener's ear becomes confused by large leaps. He can follow a leap of an octave or less, but not so easily one of an eleventh or fifteenth. Long leaps are now more common in contemporary music, however.

The other frame of reference in which enlargement can occur is that of *time*. If the original melodic line is to be played at a rapid note speed (e.g., sixteenth notes, allegro), one cannot put many new notes between the ones it already contains, without taxing the technique of the performer and the auditory power of the listener. It may therefore be necessary to enlarge it in time: that is, (a) to slow down the tempo as from allegro to andante, or (b) to increase the quantity of each note as from sixteenth to quarter notes, or both. Increasing the quantity of each note will incidentally tend to alter the accent, meter, and rhythm of the original pattern. More and more *deceleration* (of one sort or another) in the note speed of the original pattern will tend to be necessary, in proportion as more and more notes are introduced between the original notes. In other words, the original framework pattern will tend to require enlargement in time, to allow increasing subdivision. With all its new notes, the complicated pattern may possess a note speed as fast as the original or faster, even if the tempo is now described as "adagio" instead of "allegro."

There are practical limitations here also, in the extent to which musical patterns can be magnified in time. If note speed is made too slow, the hearer is apt to lose the outline of the melody, and perhaps to lose patience with it. In our culture at least, listeners demand action, a rapidly changing flow of sounds. If the notes of the original framework melody are spread far out in time, and many others put between them, the hearer is again apt to lose the thread of the former. Most listeners have a rather short span of memory, and slight ability to grasp a long melodic line as a whole. They listen mainly to the few sounds which are reaching their ears at the moment; those which came a few seconds or minutes ago are soon forgotten. Thus they cannot clearly perceive the building up of a long, intricate melodic line, phrase after phrase.

In reading an ordinary story, on the other hand,

even the average reader remembers fairly easily what happened in the previous pages. He can see where the story is going, and follow the building up of an extended plot.

For reasons such as these, many types of thematic development which are theoretically possible turn out to be impracticable. Many kinds of musical development look well on paper—intricate fugues, for example—but are unsuited for actual performance or listening under present conditions. We are stressing certain types which have flourished in the art of the past and present, and certain limitations or obstacles in the way of others. No doubt future artists will find ways of surmounting many of these obstacles and of actualizing types of form which seem today as mere speculative possibilities.

Let us return to another example of the method of division in music, beginning this time with a fairly definite pattern or series, to act as framework. For example, let us take the familiar ternary form, A, B, A. Let us not, however, consider either theme, A or B, in its entirety as a compound theme, but only as to one of its component themes, melodic line. The pattern A, B, A could consist of contrasting rhythmic themes, timbre themes, dynamic chord progression, or any other type of component themes. In any case, it would imply starting with a certain theme A in that component, following it by a contrasting theme B, and then repeating theme A.

Let us say that the pattern A, B, A consists of two melodic line themes, A and B. There are three units or statements in this original pattern, two of A and one of B. They are comparatively brief, as in an ordinary song. As a first step, let us divide each unit into three units similar to it. We then have aaa, bbb, aaa. This contains three repetitive series, combined in ternary form. We can keep the total duration or time span constant by accelerating note speed or dividing the duration of each tone. But that would soon produce bewildering speed, and the usual course is to enlarge the total time span, as from one minute to three minutes. Instead of three units, we now have three groups of three units each. Each A group consists of three units of A, and each B group of three units of b.

Now let us complicate the pattern with some differentiation. This can be done in countless ways. For example, the units can be varied, as in the series, a, a^1, a^2, b, b^1, b^2, a, a^1, a^2 (or a^3, a^4, a^5, etc.). Or each group can be differentiated by introducing a unit of the contrasting theme, thus, aba, bab, aba. This is simple alternation, and can be further varied in some such way as this: aba^1, ba^2b^1, ab^2b^1, ab^2a^3.

For further contrast, add a new theme in each group: c in the A group, and d in the B group. This might give us: aca^1, bdb^1, a^2c^1a.

The essential point here is that we are retaining the original A, B, A pattern as a framework, but dividing each large part into differentiated groups of smaller units. The first and last groups are still dominated by the A theme, the second by the B theme. The groups can be small imitations of the framework pattern, which makes for unity, as in dividing A into a, b, a, or quite different, as in dividing A into a, a^1, c.

The next step is to divide each of the above small units (indicated by small letters) into several still smaller, again differentiating these smaller units from each other by variation, contrast, or both, and again preserving the main outlines of the original A, B, A pattern. That process can be continued indefinitely and tends to require at each step an enlargement of the whole in time. It can be carried to the stage at which the three original units have become three movements in a symphonic poem, lasting perhaps ten minutes each. To delimit the separate movements, and incidentally to give listeners a brief rest, the composer may indicate a short pause between the movements.

17. Visual component development by addition.

Taking a unit of the wheel or other circular pattern, let us repeat it several times over the surface available. Regardless of how these units are arranged, their resemblance constitutes them as a thematic series. To indicate that the units are individually somewhat complex, let us call them a *component pattern series.* Such a series may be repetitive or varied as to details or linear shape. It would be varied if some of the units were more or less oval, some with more spokes than others, some with a definite hub at the center. It could be progressive, e.g., if arranged in order of increasing number of spokes. The fact that each unit contains contrast (arcs and angles) does not make the pattern series thoroughly contrasting. It is still repetitive if the wheel units as wholes are repeated. If the wheels are irregularly scattered, they form a series, but not, as a whole, a new pattern. However, a number of them may be grouped more definitely, to form a large wheel-shaped pattern, a star, or any other kind of pattern.

Obviously, such a process of including simpler patterns and pattern series in larger patterns can re-

sult in stage after stage of inclusion and ultracomplexity. If wheels are included within wheels, those within other wheels, and so on, the resultant forms will have only a slight amount of differentiation or contrast. That can be supplied to some extent by including small units in a pattern which differs in shape from any of them, for example, stars within a circle.

Many degrees of contrast are possible, and contrasting patterns may be knit together in various ways. One is by making them embody units of the same thematic series of still smaller parts. For example, let us put beside the wheel a stylized, branched candlestick pattern.

Like the wheel, this is constructed of arcs and angles. When juxtaposed, the two patterns are different enough to be called contrasting. Yet they are linked by certain thematic repetitions, by possessing certain thematic series in common. The arc series includes certain parts of both patterns; the angle series also includes parts of both patterns.

Now let us repeat wheel, candlestick, wheel, candlestick, in a row of units from left to right. This is a contrasting component pattern series, periodic and alternating. If we scatter units of wheel and of candlestick over a surface irregularly, we still have a contrasting series, partly integrated by its arc-and-angle resemblances. But if we arrange wheels and candlesticks into a large framework pattern, we again produce a new component pattern, one stage higher in complexity than any of its units. Again, we may choose between achieving high unity and regularity, through adopting a large wheel or candlestick as the framework, and achieving more variety by adopting some other framework pattern.

Furthermore, at each stage of complication we may choose not to subordinate the present set of pattern units to any definite pattern at all. We may leave them as an irregular scattering of units, or as a simple series, repetitive, alternating, or otherwise. However complex the pattern units are, then, the series of them will as a whole be simple or indefinite, lacking in complexity. For example, let us suppose that a copper plate is engraved with a very complex linear pattern—say an initial from the Book of Kells. We may take that plate and print it several times at irregular intervals over a large sheet of paper. The result will be a simple, irregular pattern series. Regardless of how complex the units are, such a series may be arranged with any degree of definiteness, regularity, and complexity. "Allover" patterns, especially in textiles, are often highly complex as to individual units, but simple and indefinite as to general structure. We have seen (as in a Byzantine textile)

that this is especially so when (a) the complex units are merely repeated side by side, with no variation and no interconnections, and (b) there is no definite boundary in space, and the series of units is capable of indefinite continuation or reduplication. This is common in cloth woven in bolts, to be made into garments or upholstery.

There is no theoretical limit to the complication of pattern by repeated addition of units and subordination to new frameworks. But there are certain practical conditions to be reckoned with. Once more, we must consider *size* and *scale*. Each time a pattern is repeated enough to build up an extensive series, or each time a number of different patterns are assembled, the aggregate tends to expand rapidly in space or time. If we begin with a pattern an inch in diameter, and use it along with ninety-nine others of equal size to make a pattern one stage higher in complexity; if we then do the same with this new pattern, and again on a still higher stage of inclusion, we shall be greatly increasing the total size. Our task will encounter difficulties in technique and material, and in finding a place large enough to display the gigantic form.

On the other hand, it is possible to compensate for this expansion in size by *diminishing* the size of the constituent units. If we wish to keep the total size of the pattern constant, then we must diminish the size of the units as we increase their number, and as we go from stage to stage of inclusion and complexity. Thus the method of addition tends to become a method of *diminution* and addition.

Another practical question to be considered is whether the ultracomplex design can be perceived, once it has been made. Can any observer, regardless of his visual acuteness, see so vast a framework pattern in a comprehensive way? Have the details been diminished until too small to be perceived under the required conditions? In an architectural façade, where one can see the general framework from a distance and then move closer to see the details, a high degree of complexity is possible. There can be many levels of inclusion, yet the small details will still be large enough for ordinary observation from a nearby point.

Many types of complication are theoretically possible, which could not be clearly perceived. Suppose that we try to deal with solid, sculptural units, and to arrange them in three dimensions. Highly complex forms can be produced, as in the structure of plants and animals. But they cannot be seen all at once, or without cutting apart the form; the outer ones will at least partially conceal the inner ones, as in those carved ivory balls, one inside the other, which are

made in the Orient. The same could be done with room spaces in architecture, but the walls of the room one stood in (if opaque) would hide the outer rooms. An approach to such design is made in some cathedral and palace interiors, where partial vistas into inner and outer regions are given through gates and grills.

18. *Melodic development by addition.*

Addition means here producing more units of a theme or themes, fairly close to each other in time. The units may be successive, as in the verses of a song, or approximately concurrent, as in counterpoint.

Several simple pitch-progression units are added in sequence to make up the melodic line of a song, such as "Annie Laurie." These are brief figures, groups of a few notes, phrases, and periods. Sometimes a figure is repeated exactly or with slight variation; sometimes contrasting figures are introduced. The result is a series of simple pitch-progression units, which (if fairly definite and regular) will be complex enough to call a component pattern. This includes the whole song, considered in terms of pitch only (we are disregarding rhythm for the present).

This pattern can be repeated, as in playing a phonograph record over and over. "Repeat marks" in the score often indicate repetition of an extended passage. The result will be a *repetitive component pattern sequence.* Let us now vary the repetitions slightly in pitch, as by introducing accidentals, inverting melodic line, and placing the line on various levels of the scale. We thus produce a *varied* component pattern sequence. If we use "Annie Laurie" as a recurrent, long refrain, with other songs in between, we produce a periodic, semialternating sequence, as in the rondo form. If it alternates with only one other, e.g., as in "Swanee River," the result is a fully alternating series, A, B, A, B, A. A varied periodic sequence would be produced if "Annie Laurie" (B) were repeated with variations, as a refrain between different songs: A, B, C, B^1, D, B^2, E, B^3, etc. A varied *progressive* sequence would be produced if the variations tended consistently in any direction, as from smaller to wider leaps in pitch.

Let us suppose that "Swanee River" (A) and "Annie Laurie" (B) are played in their entirety as units in a sequence. Each is varied slightly in pitch intervals, every time it is played. Out of these units, we produce a regular sequence; let us say A, A^1, B,

B^1, A^2, A^3. (This is a development of the ternary form.) We have produced a new pattern, simple in its main outlines although possessing fairly complex units.

Now this pattern, as a whole, can again be treated as one single theme: a complex component theme or pattern, which again we may designate by a single letter such as X. The same process can now be repeated on a higher level of inclusion. Again, we can make a repetitive or varied sequence of units of X, as in X, X^1, X^2, etc. Each unit of X will include four units of "Swanee River" and two of "Annie Laurie."

Moreover, we can contrast X with another complex theme, to be called Y. Y can consist of two entirely different songs, in which the contrast with X will be great, or merely of A and B differently arranged, in which case the contrast will be slight (for example, arranged as B, A, A^1, A^2, A^3, B). Or it can include A but not B: "Swanee River" and "My Old Kentucky Home," arranged perhaps as A, C, A^1, C^1. Now our task is to arrange units of X and units of Y to make a sequence. Again, this may be of any type, simple or complex. Again, the resultant sequence or pattern can be treated as a unit. Thus the process of addition and subordination could, theoretically, go on forever.

But again we come back to the question of practical limitations. In music, or any art which unfolds in definite temporal order, the extent of duration is important. Adding and multiplying units extends the duration of the whole form at a tremendous rate. Before many levels of inclusion are reached, we have a total length which far outruns the time customarily allotted to a song or concert piece.

In music, we cannot do much to compensate for such enlargement by diminishing the parts, as we can in visual design. That would mean accelerating the note speed proportionately, so as to include more units within a given total duration. Doubling the number of units, we might also double the speed of each unit. But very soon the speed would be too great for the audience to follow, and the original character of the melodic themes would be lost.

Counterpoint is one way of avoiding these limits to some extent, while still providing more musical details. This proceeds by adding units of melodic line *simultaneously,* instead of adding them in succession only. It is, in a sense, extension into another dimension of music, that of simultaneity, in addition to the before-and-after sequence of a single melodic line. It is as though a visual designer had been limited to development in one dimension, as in narrow ribbons and borders, and was then permitted to extend his

patterns over a wide surface, interlacing two, three, and four lines in two dimensions. Counterpoint is a process involving attention to rhythm, chord structure, chord progression, and perhaps timbre, in addition to melodic line. But its main concern is the interweaving of melodic lines, and we may consider it for a moment from that standpoint only.

Let us say that we are to use four different voices, of similar timbre. Each voice is to play the same melodic line, on the same general level of pitch. This line is a simple pattern of the ternary type, A, A, B, B, A, A. The four voices now play it in an overlapping temporal succession, each one starting a unit later than the previous voice. The framework pattern of the whole belongs here to the general type known as a round or catch. Follow all four lines together from left to right:

Voice One: A A B B A A
Voice Two: A A B B A A
Voice Three: A A B B A A
Voice Four: A A B B A A

Each voice can of course repeat its line as soon as it finishes, instead of stopping as above, and thus continue the process indefinitely. But let us suppose that it does not, that each stops when its own pattern is finished. Suppose also that each unit of A and B takes the same amount of time as the others. We now have a complex pattern of melodic lines, which we shall call pattern X. It occupies nine units of time, nine times the duration of any one unit. We have compressed or telescoped four units of the pattern into the time which would be taken up by only one and a half units in homophonic succession. We have quickly presented a somewhat complex pattern of melodic lines, without necessarily accelerating the tempo or note speed of the whole process.

Any number of voices can theoretically be added, but again the limit of an audience's power and wish to follow them is soon reached. This can be somewhat increased by putting the voices on different levels, as soprano, alto, tenor, and bass, by instrumental contrast, etc.: that is, by the aid of other components.

The moderately complex pattern described above can be repeated as a unit in itself, to make a repetitive series. This is usually done in the framework type called a *round*. It may go on indefinitely, until the singers have had enough; in that case the total series is indeterminate in time. In fugues and other highly organized polyphonic works, the process is more definitely terminated, in ways which we shall notice later.

On the other hand, we may desire to introduce more *differentiation*. This can be done in a number of ways. It can be done internally, within the complex pattern X. Instead of repeating the A and B units exactly in each voice, we can vary them each time. Instead of making the four voices play the same melodic line, we can let them play variations of it, or even contrasting lines, as when people sometimes sing two different songs together. Instead of making each voice come in one unit after the preceding, we can make them come in at different times. When one goes up in pitch another can go down or stay on the same level. Instead of repeating pattern X exactly, we can vary it, to make the sequence X, X^1, X^2, X^3, etc. Inverting a melodic line is one way of varying it in terms of pitch alone. It is much used in traditional polyphony.

Instead of confining ourselves to pattern X, we can introduce a contrasting pattern Y. This may contain the theme A in some units or voices, which will be a means of integrating patterns X and Y. Or it may be composed of entirely different themes, in a different number of units, and in different sequences, which will heighten contrast. In the latter case, we should be developing the form somewhat as follows:

$$\overbrace{}^{X}\overbrace{}^{Y}$$

Voice One: A A B B A A C D C D
Voice Two: A A B B A A C D C D
Voice Three: A A B B A A C D C D
Voice Four: A A B B A A C D C D

If we alternate X and Y, we produce a new periodic sequence on a higher level of complexity; and as before, that sequence may be of any type. Again, we soon encounter the limits of perceptive power and interest in the hearer. Thus the theoretical possibilities of development are again sharply curtailed by practical conditions.

Estimates of complexity can be made from the standpoint of addition as well as of division, on a basis of number of *inclusions*. Here the starting point is the smallest definite, individualized unit. The smallest unit of pitch is a single tone; that of rhythm or meter, a single beat. But it takes more than one tone to state a melodic or pitch-progression theme; it may take a whole phrase of several measures. It takes more than one beat to state a type of meter, and it may take several measures of strong and weak beats to state a rhythmic theme, as a characteristic, perhaps irregular arrangement of accents and quantities. The smallest rhythmic unit may then be complex enough

to be called a simple pattern, analogous to a star or peacock in visual design.

One can begin to count levels of inclusion, then, with the smallest definite unit in the component under discussion. Then one observes how other units of coordinate size, repetitions, variations, contrasts, are added to it, and how these units are combined in a pattern of the second degree, perhaps a movement or a large section of a movement, in a sonata. One cannot say in general how many levels of inclusion a symphony or concerto will have; all depends on the internal structure. Different movements within the same sonata often differ in this regard, some being more complex than others.

19. Combined method; thematic complication by addition and division.

To use both tends to counteract and balance the opposing requirements of the two methods as to scale, of the requirement of one for enlargement and of the other for diminution. By choosing an original framework of moderate size, and developing it somewhat by division, somewhat by addition, the artist can achieve a considerable degree of complexity without having to change the size of his original framework, or of the original theme units with which he began to work.

Let us imagine a composer as having noted down some nine or ten melodic themes, which he wishes to build into a composition in four movements. We shall assume that the composition is to be of a rather free, romantic type, without definite prescriptions. Let us call the ten melodic themes A, B, C, D, E, F, G, H, I, and J. The composer assembles these roughly into four groups, perhaps on a basis of general resemblance, as materials for his four movements. So far the method is one of addition. He allots themes A, B, and C to a certain movement M. He may proceed along the line of addition, by simply stringing together units of A, B, and C, repeating and varying each as the impulse moves him. If his mood is that of an aimless, wandering fantasy or rhapsody, he may produce an irregular sequence: for example, A, A^1, B, C, C^1, C^2, and so on. As he proceeds, the conception of a total arrangement may gradually occur to him, and he may turn the sequence into a rondo. Or he may feel an impulse toward symmetry, and add B, A to the above sequence.

The method of division usually goes with a more planful, calculating attitude, and a desire for unity at the start. Thus our composer may at the start decide to organize this movement in a ternary pattern, A, B, A, with C as a minor accessory for contrast. If so, he may then produce an A group by division and enlargement, consisting perhaps of a, a, c, a^1, a; then a second group with B strongly dominant, as in b, b^1, c, b^2 c^1, b; and closing with another A group, such as a, a^1, a^2.

Each individual movement can thus be worked out in detail, by either method or a combination of both. The resultant composition as a whole may turn out to be an irregular, loosely assembled suite or cycle, especially if the method of addition has predominated. It may turn into a definite, inclusive framework pattern in itself. This will occur if the composer adopted at the start, or in the course of composition, some definite framework type such as the traditional sonata. Or he may produce a definite pattern which conforms to no traditional type.

As to visual design, it is easy and natural to use both methods by turns. Here also, the artist may begin with three or four patterns, group them either loosely or definitely, and repeat them enough times to cover the required area. Then looking over the whole design (e.g., a frieze around a room interior), he may decide that it calls for more enrichment. He then proceeds to subdivide a pattern unit until it reaches the desired complexity, and perhaps goes on to treat all other units of this pattern in a similar way.

When the artist proceeds by the method of division, his most inclusive framework is also his original, basic, rudimentary framework. This may be the simple rectangle, circle, or other shape which bounds the whole design. More broadly, we may include in it the first division into main, large parts. Thus the rectangle divided by diagonals into four large triangles, and the circle divided radially into a wheel, are basic frameworks for many designs. But when the artist proceeds by addition, this most inclusive framework is rather the end product of development than its origin or basis.

In any case, the *inclusive* framework remains distinct from the *sectional* frameworks of large and small internal units. Both are different from the *total* framework, which comprises the inclusive and all the sectional frameworks. From the standpoint of component development, we must distinguish to some extent between frameworks and accessory subdivisions. But a particular pattern unit may operate in either capacity: as an accessory in relation to the inclusive framework, and as a sectional framework in relation to still smaller details within it.

The method of division is most likely to be used

where there is a definite area to be filled with decoration or elaborated into a design, that is, where the area is bounded or limited in size, either by outside circumstances or by the arbitrary choice of the artist. The area may be a period in time, say half an hour to be filled with music or divertissements. Then the artist will tend to think in terms of dividing up the period, and allotting so many minutes to this item, so many to that. The area may be three-dimensional space, as in a theater interior of specified size, to be divided into auditorium, stage, balconies, etc. It may be a solid, such as a rough diamond or a block of marble to be cut. It may be a flat rectangle, as in a picture frame, wall panel, or book cover, to be filled with a design, or a flat circle, as on the back of a mirror. In such cases, the artist's first step is often to divide the total area roughly and tentatively into a few main sections; then he proceeds to subdivide each of these further.

When there is no specified area to fill, no boundary to limit extension, or when the artist does not take it clearly into consideration, then an additive approach is more likely. It is not imperative, for the artist may begin by arbitrarily marking off for himself an area to be subdivided. On the other hand, he may take a larger canvas, as Renoir is said to have done at times, and put a rose in one corner, then another rose and another, then additional objects as his fancy dictates, only gradually thinking out an orderly scheme for the whole and deciding on the eventual size of his picture, which may be only a small section of the whole canvas, to be cut off later.

In sculpture, again, the approach often depends in part on the extent to which the size and shape of the form are limited in advance. If the work is to be a carved relief, set as a panel in a wall opening of specified size and shape, then the sculptor tends to begin by dividing that area into parts. He feels the same need if he is to place a statue in a niche or other architectural setting of definite size and shape. But if he is planning a statue of unspecified size, to stand out in the open, then he can build it up more by addition, adding lumps of clay to swell the mass on his armature, bringing out projections at various angles from the mass, and then, perhaps, gradually organizing them into some consistent series (as of points contrasted with hollows) for the observer who walks around the design.

Let us say that a ribbon or border pattern is placed horizontally across a sheet of paper. Its width, between top and bottom, is fixed at two inches. Its length, between left and right, is indeterminate. Vertically, the development of the pattern is thus limited

to a definite dimension. Accordingly, the artist tends to treat it partly from the standpoint of *division*. Part of his development, as in complex Persian rug borders, may consist in dividing the area by horizontal lines into several narrower strips, say a half-inch strip at top and bottom (along the edges of the border) and an inch-wide strip in the middle. In this way, a ribbon-type pattern can be complicated to any desired degree by subdividing it into parallel strips of various widths. But when we come to consider differentiating it lengthwise, from left to right, there is no definite area to be subdivided. The artist may arbitrarily divide a portion of the ribbon by vertical lines, into sections of definite size, and continue to develop each one separately by further subdivision. But sooner or later, as the ribbon extends or promises to extend indefinitely on in one dimension, he tends to think in terms of *addition*, of adding an indefinite number of units until some outer circumstance provides a limit. Thus he produces, by addition, a series from left to right, which may be repetitive, varied, or contrasting.

Most border and molding designs are comparatively repetitious. If they involve some variation or contrast, the series is usually periodic and alternating. That is, each of the different themes recurs at a regular interval, after one or more units of the other themes (for example, rose-diamond-swan; or rose-diamond-swan; or ABC, ABC, ABC, etc.). If for any reason it is desired to attract attention to individual units, as in the Parthenon frieze, they may be treated with considerable variation, and avoid exact repetition even at periodic intervals.

An *allover* pattern, as we have seen, is characteristically indeterminate in size in two dimensions and in four main directions. These would be called "north, south, east, west" on a map, or "up, down, right, left" on a page. Unless arbitrarily cut off by a border or the edge of an object to be decorated, it can, theoretically, extend out infinitely in all directions. No particular termination is suggested by the inner nature of the pattern. As a result, the artist's attitude toward it tends to be partly additive. That is, he tends to regard its possible extension as consisting in the addition of unit after unit, upward, downward, to the right or to the left, as conditions indicate. There is no predetermined, overall size or area to be taken as a starting point and subdivided. But this does not mean that he is limited to the additive point of view in developing his design. He may be so limited as far as extension outward into space is concerned. But he has also a possible line of inward complication, which tends to involve division. This is the complication of

each individual unit in the pattern, by dividing it into smaller and smaller parts. Thus the development of a complex allover pattern usually involves both addition and division.

Sometimes an artist begins to compose an allover pattern by dividing up a piece of paper or other surface into rectangular (usually square) areas by intersecting vertical and horizontal lines, or into diamonds by intersecting diagonals. This guiding network of lines and areas is called a "web." Then he constructs a pattern unit, simple or complex, within one of the small areas thus formed. He has now made two steps by the method of division, or more if the pattern unit is complex. Even though there was at the start no definite, limited area to be subdivided, he began by accepting the sheet of paper as a field, and dividing it into parts; thereafter, he had the individual squares or diamonds to subdivide further.

Next, he may do one of two things. He may shift to the method of addition, by indicating that the first pattern unit is to be repeated in the other areas of the web, sidewise, up and down, or both. This produces a diapered pattern. (Division is still involved in regard to each individual unit, but extension of pattern consists in adding units.) He may, as an alternative, construct a different pattern in a neighboring space, also by division, then proceed to add units of the two patterns in alternating series, sidewise and vertically, until a checkered pattern is indicated. Then he can return, if he likes, to complicate the original pattern units further by additional subdivision and variation of internal parts.

One way of doing so is called "powdering": distributing minor units, much smaller than the main ones, at intervals between them. These serve to connect the main units and also produce subordinate series of their own. He can also link the main units together by connecting lines; and, if he likes, merge them still further by extending parts of each unit over the dividing line which separates it from neighboring units. This relaxes a little the rigid uniformity of intervals between the units, and tends to blend the individual parts into a single texture by obscuring the demarcations between them. Having thus indicated in a typical section of his pattern the structure intended for each unit, and the intended relations between them as to connecting parts, intervals, and order of arrangement, he is free if he likes to leave further extension to a process of automatic addition. This may be done by an obedient artisan or a machine, as in weaving bolts of cloth from an artist's pattern.

The preliminary web or network of guiding lines

is, in a very limited sense, a framework for the subsequent pattern. It is analogous to the basic meter of a piece of music or verse, which acts as a general guide or skeleton for the rhythmic development, but which is almost never followed exactly, being rather a starting point and limit for variation. In allover visual pattern, the network of guiding lines is commonly followed more closely, as a means of achieving regularity and perhaps exact repetition of the units and the intervals between them.

Variation among the individual main units is much less common in flat visual pattern (including both the ribbon and the allover type) than it is in music, verse, or pictorial design. Ordinarily, it is not intended that the observer's attention be attracted and held by individual units, or progress from one individual unit to another. He is expected to take in the whole decorated surface at a glance, or with casual attention to a few details; perhaps to perceive it only vaguely and marginally, as a general background of decorative texture. Hence there is less care to guard him against boredom by variation and contrast from unit to unit. There may be variation and contrast within each main unit, but usually there is little or none between the units, except in highly regular ways such as by inverting the direction of a line to left or right, up or down, in alternating sequence as in confronted animals.

The network of preliminary guiding lines, which usually does not appear in the final pattern, is a framework only in that it helps regulate the relative size and position of the main units, and the spatial intervals between them. It does not necessarily act as framework for the individual pattern units. Each of these may have a free-flowing, naturalistic linear framework, as in vines climbing over a trellis, or wallpaper designs repeating a small landscape scene.

To organize a pattern on a network of uniform lines and areas is to predispose it toward becoming a combination of strict repetitive or alternating periodic series, rather than a flexible, growing, irregular pattern. It is to give a fundamentally classical or even geometric quality to the general outlines of the form, even though detailed units (e.g., of a landscape motif) are romantic. Textbooks on design often err in making it seem that this is the only way of constructing an allover pattern.

A trend to romanticism tends to make the main units overflow the guiding lines, differ from each other in size, shape, and spatial interval, and thus abandon the regular network. Louis XV textiles tend to do this in each unit while conforming on the whole

with the web. Geometrical pattern is at the other extreme; not only does it tend to follow the regular network exactly as to size, shape, and interval, but it carries out the development of individual units on the same basis. For example, if the geometrical artist begins with a network of two-inch squares, he tends (a) to follow a rigidly diapered or checkered arrangement of the pattern units; (b) to use the square as an outside shape and framework for each individual pattern; and also (c) to proceed further into the construction of each individual unit by regular, proportional division: that is, to divide each square area into regular sections—smaller squares, rectangles, triangles, inscribed circles, etc.—which are obviously related and proportional to each other in size and shape. Many American Indian blankets are of this type.

Landscape, floral, and human figure patterns of the late eighteenth and nineteenth centuries show a romantic trend. Here the internal structure of the pattern unit often has no definite relation to the guiding web. It is sometimes a free, irregular pictorial composition, first made as an independent picture, without thought of being used in a repeat pattern. Such a unit can be produced by the method of addition, simply assembling flower after flower into a bouquet, or tree after tree into a grove. Then an all-over pattern can be produced, again by addition, through simply repeating this picture (reduced or enlarged to the desired size) over and over again, from right to left, upward and downward at regular intervals, or by alternating two contrasting pictures.

The romantic tendency toward greater variation and irregularity can be carried on to an extreme in which there is no conformity to a guiding web, no uniformity in the sizes and intervals of units, no exact repetition or periodic alternation: in other words, to a freely wandering succession of diversified units, extending outward until the edge of the surface is reached. Addition is then the dominant method of development. Such a form can be called an allover surface decoration, but scarcely a pattern, although it may involve highly organized individual pattern units, produced by division.

There are many intermediate stages short of such extreme irregularity, stages more analogous to those common in music. Though theoretically possible, they are rarely attempted in modern surface decoration. These may involve, first, the production of *varied* series between right and left, top and bottom, instead of confining the order to repetitive and exact periodic series. Instead of being restricted to the

formulas

$$A\ A\ A \qquad A\ B\ A$$
$$A\ A\ A \text{ and } B\ A\ B$$
$$A\ A\ A \qquad A\ B\ A,$$

the development would then assume, for example, such formulas as

$$A\ A^1\ A^2 \qquad A\ B\ A^1$$
$$A^1\ A^2\ A \text{ or } B\ B^1\ B^2$$
$$A^2\ A\ A^1 \qquad A^2\ B\ A.$$

Secondly, they may involve variation, without extreme irregularity, in the sizes and intervals of pattern units. Instead of being in uniformly straight rows at right angles to each other, or in rigid arcs and other geometrical arrangements, they can be placed in more varied, undulating, or zigzag rows. Their sizes and intervals can be, not exactly similar or completely dissimilar, but varied in more or less systematic ways. Examples of such development are not uncommon in the decorative arts of many non-European cultures, including those of India, and in Romanesque and Gothic decoration. Classical influences, as in the Italian Renaissance, operate to restrict such variation.

In the decorative visual arts, especially in flat surface design, thematic development is usually more regular and repetitive than it is in pictorial or sculptural design. In the former, there is commonly a stronger tendency toward systematic division into parts of uniform or proportional size; toward regular, often geometric themes in the details of linear shape; toward exact or approximate symmetry (bilateral, vertical, or both); toward exact repetition or periodic alternation of theme units; and toward the building up of complex and ultracomplex patterns. This difference between the arts is not necessary, or based on fundamental differences in medium. Design in any art can be made highly geometric, classic, or highly romantic.

In *pictorial* design, or in any decoration involving a considerable amount of representation, design is not the only mode of compositional development to be considered. Representational considerations have usually equaled or outweighed the thematic in painting. There has often been a persistent desire to make the whole composition look "lifelike," realistic in certain respects (e.g., as to anatomy and perspective, the shapes and colors of objects) even where the scene has been somewhat unrealistic in other respects (e.g., in fantasies of gravity-defying ascents to heaven). Thematic development has consequently been restrained or partly sacrificed, to compromise with such representational aims. Conversely, as thorough real-

ism ceases to be a compelling aim, the door is opened for more design in pictorial art.

In some of the arts called "decorative," thematic development has been similarly restrained by the requirements of another mode of composition: the utilitarian. In the designing of dishes, utensils, furniture, houses, and garments, the latter consideration often intervenes to cause restraint of thematic development in the interest of functional needs. From the decorative standpoint itself, the need to adapt design to a specified shape, usually three-dimensional, e.g., a cup or a spoon, can impose limits on some kinds of thematic development while suggesting others. Romantic and other influences making for simplicity and irregularity have also exerted a restraining effect on decorative complication.

Design has often flowered most elaborately when released to a large extent from representational requirements, as in Islamic textiles and other visual decoration. In the fugue and symphony, it was largely released from utilitarian as well as from representational and expository needs. In European textiles, especially brocades, laces, and other luxurious fabrics from the Renaissance through the Rococo periods, and in the sumptuous decoration of interior palace walls, decorative aims often prevailed over those of other modes of composition. Even when the object had utilitarian aspects, as a lace veil, a snuff box, or a paneled door, these were often comparatively simple and flexible, permitting much decorative elaboration. Even when some representation was introduced, as in the decorative use of flowers, animals, and human figures, conditions often favored its reduction to an accessory role.

20. Compound thematic development. Varying a component theme in terms of other components. Repetition and variation of compound themes.

If we take the theme "triangle," in the component "linear shape," we can vary it in terms of the same component by making a number of triangles which differ slightly in shape. We can vary it in terms of other components by making a number of triangles which differ as to hue (one blue, one red, one yellow); as to lightness (one light, one dark); as to surface shape (one flat, one convex); as to surface texture (one rough, one smooth), and so on. The linear shape of the triangle can remain approximately constant, and the units be varied only in that the triangu-

lar theme is combined with different themes from other components. Likewise, a pitch-progression theme in music can be repeated without alterations in pitch, but along with different effects of rhythm, dynamics, timbre, and so on.

By repeating and varying a component theme with the use of two or more components, we produce a *compound thematic series*. If we begin with the theme "triangle" and vary it in terms of hue, we can produce a series such as "red triangle," "blue triangle," "green triangle," etc. Varying each of these in terms of surface shape, we can produce the series "flat red triangle," "convex red triangle," "concave red triangle," etc. Thus the starting point of a compound series can be a component theme, provided each unit is developed in terms of traits from two or more components. (Actually, as we have seen, all concrete, material units and series are compound; it is only by abstraction that we consider the development of a single component by itself.) Types of compound series are often described in terms of some conspicuous component series (e.g., melodic) within them. Other series involved may be hardly noticed by the casual observer.

Any group of actual concrete objects or events which resemble each other in some respects is a compound series. A group of apples on a tree or a table is such a series; its units resemble each other to some extent in shape, size, color, surface texture, and other respects. Similar events such as the falling of apples from a tree, or the leaps of a rabbit across a field, if juxtaposed in space and time, also form a compound thematic series. If such objects or events are highly similar, we may regard them as a repetitive series. On close inspection, they are likely to show variations in detail. The apples will differ slightly in shape, color, texture, and so on, and thus constitute a varied compound series.

Any particular thing, person, or event, objective or subjective, real or imagined, if presented or suggested in art with respect to more than one of its components, is compound. To repeat it with or without variations, introducing traits from different components, is to treat it as a compound theme and thus produce a compound thematic series. It will be a contrasting series if some of its units are very different from each other, but not too different to invite comparison.

Not only all actual objects and events, but all detailed representations of them in art or elsewhere are compound. A component trait or series can not exist or occur by itself; it is always a product of

perceptual or intellectual analysis, as in regarding an apple or a picture of an apple with respect to its contour only or its redness only.

The units of a compound series can be arranged in one, two, or three dimensions of space and/or in time. For example, a collage by Picasso, Braque, or Schwitters of a still life, containing real cigarette stubs, streetcar tickets, bits of rope and burlap, is a contrasting compound series. It is thematic insofar as it contains resemblances among these objects and the ideas or feelings they suggest, as perhaps of refuse, destruction, and disintegration. It is probably developed in two dimensions of space with some extension in the third dimension, but with no temporal development. (A dated piece of newspaper would be a suggestion of such development.) The same series would be temporally developed if presented or represented, part by part, through the cinema.

Thematic development consists of emphasizing and systematically arranging such resemblances and differences. It is possible to produce a compound series which will be highly similar and repetitive. A grocer can arrange his oranges in a series of uniform pyramids. A painter can select or abstract a few component traits, omitting many others which would accompany the oranges in nature, and repeating the chosen ones with almost exact similarity. He can draw a simplified apple with characteristic rounded outline surrounding a flat red area, and repeat it several times in a horizontal row. This would be a repetitive compound series. To repeat a given passage of music exactly, two, three, or more times, would produce a repetitive compound sequence. Such a series, visual or musical, would contain several repetitive component series, exactly coinciding. In the picture we would have several units of apple-shaped line, several of redness, and several of flatness. In the music, we would have several units of a certain pitch progression, several of a certain rhythmic figure, several of a certain timbre or sequence of timbres, and so on. Thus a repetitive compound series can be analyzed into several repetitive component series, exactly coinciding. Each compound unit contains one or more units of several component series.

It is easy to introduce different, systematic variations into a compound series. Beginning with a red triangle, we can color other triangles in the row a little more bluish or yellowish. If bluish red alternates with yellowish red, they make a *varied compound series*, within which one component series (linear) is repetitive, while another (hue) is periodic and alternating. If the row of triangles begins at the left with a

very dark one, and if they become increasingly light as one moves toward the right, a progressive series will be involved in respect to the component "lightness."

In music, if unit 1 (the first statement of the compound theme) is played by flute, unit 2 by violin, unit 3 by flute, unit 4 by violin, and so on, the compound series will involve an alternating component series in respect to timbre. If each unit is a little louder than the previous one, the series will be progressive in respect to dynamics.

In such a varied compound series, the component series which make it up *do not necessarily coincide,* and need not even be of the same type. The more they do coincide, the more the compound units will tend to seem integrated and consistent: if, for example, the units from left to right become progressively more triangular and at the same time darker, redder, and smoother. But the variations may occur in different orders, or in no particular order at all.

Starting with a compound theme such as "red flat triangle," we have seen how it is possible to vary this theme in a compound way by repeating it with alterations first in one component, then in another and another. The original theme may be simple or complex: a red triangle or a complex, multicolored peacock design; a single bar of music or an extended orchestral passage. Taking a medallion or other motif unit from an actual textile, one may vary it first as to line and produce a series of units differing in this respect only, then another series differing in respect to hue only, and so on.

Beginning with a short musical theme such as the opening one in Beethoven's Fifth Symphony, one can produce a series of variations in regard to pitch progression or melodic line alone, then a series rhythmically varied, then one orchestrally varied, and so on. Variation of a musical theme in regard to speed gives an effect which is sometimes called *augmentation* (if the theme is slowed down) or *diminution* (if it is speeded up). Tempo may remain constant, and the change be produced by note speed, with changes in the time value of each note or rest.

If the original theme is thus repeated with variations in one component only, the result will be a new compound series containing several component series, one of which is varied while others are repetitive. The component series which is being varied can be made alternating, progressive, or otherwise regular; or it can be irregular if, for example, one produces a series of rhythmic variations which follow no particular order.

In actual musical composition, one would not

ordinarily confine a series of variations to a single component. Each unit might differ from the original in a different component, the first variation stressing rhythmic change, perhaps, the second key, the third melodic or chordal change, and so on. As a rule, changes would be introduced in regard to more than one component at the same time. Unit 2 might differ from unit 1 in regard to both melodic line and rhythm. The change in some one component at a time might be emphasized for the sake of clarity, but this is not the usual practice.

In analyzing actual musical variations, it is well to compare each variation with the original statement, to observe in what components and component traits it differs. By component analysis the original statement and each of the others can be dissociated into the several component series which make it up. Then one can readily see which of these series stay relatively constant and which are varied the most. Such analysis is a task analogous, on a small scale, to the comparative analysis of two or more complete designs. This approach can be followed, not only where the variations are distinct and separate, but in the course of a sonata or symphony. In the first movement of Beethoven's Fifth, the variations overlap and interweave in different voices and orchestral choirs, but each can be analyzed and compared as to the ways in which it differs from the first statement.

In complex thematic development, especially, the successive units do not necessarily repeat the whole of the theme. We have already noticed, under component development, how a part of a theme can be detached and varied, in units called partial variations of the original theme. A melody is often prolonged by varied repetition of its last few notes or measures (e.g., *Schéhérazade*, third movement). Partial as well as complete variations usually involve changes in more than one component.

Let us remember that the first statement of a theme or of part of a theme is not necessarily the theme-establishing unit in any full or definite way. Often the first unit and many thereafter are what might be called advance hints or foreshadowings of a theme, rather than theme-establishing units. They are partial anticipations of a theme whose first definite establishment is still to come. In this respect the conventional "theme with variations" is not typical of musical thematic variation in general. The early units may be slight, simple, fragmentary versions of a later theme. They may be considered as anticipatory variations, even though the theme-establishing unit comes later on. From this standpoint they should be compared with that unit, along with other variations which follow it, in terms of differences in the compo-

nents involved. Let us remember also that the theme-establishing unit is not necessarily the fullest or most emphatic statement of the theme, for that often comes near the end as a climax. Ordinarily, partial anticipations are not extended beyond a few measures, lest the hearer be confused or bored. Fairly soon his attention will probably be caught and directed by a definite preliminary statement. Taking this as theme-establishing, we can regard all other statements of that theme as variations, whether they come before or after it, and whether they are complete or partial. (Note as examples the beginning of Franck's Sonata for Violin and Piano, and Brahms's Sonata, Op. 100.)

21. *Contrast of compound themes and series.*

Some amount of contrast is usually involved in the variation of a compound theme: that is, there is usually contrast among component themes within it. For example, if we vary the theme "red flat triangle" by stating it in the second unit as "yellow flat triangle," and in the third as "blue flat triangle," we are introducing contrast—that is, marked rather than slight differentiation—in the component "hue." Red, yellow, and blue are contrasting component themes. But the compound units as wholes may still be similar enough to be regarded as variations, either of the component theme "triangle" or of the compound theme "red flat triangle." The same is true of other component contrasts which may be introduced. One unit can be made convex, to contrast with flatness, and if the first unit is smooth in texture, another can be made rough. But such component contrasts may still be regarded as mere incidental ways of varying the original compound theme.

Thus, the distinction between variation and contrast is relative. If we keep on differentiating unit 2 from unit 1 in more and more components, and by radical contrasts instead of slight variations in each, the two units may come to differ so much as to seem contrasting on the whole. Thus we can systematically build up a contrast between two or more compound units—e.g., parts of a textile design, rooms of a house, movements of a sonata, characters of a play or novel—by making them contrast more and more sharply, in more and more different components.

The total, net amount of apparent difference between the two units will not necessarily be proportional to the number of components in which they differ, or to the number of contrasting component themes. For certain components operate more power-

fully in this respect than others do, to determine a total effect of resemblance or difference. In determining a total effect of visual resemblance or contrast, *shape* is usually more influential than color or texture: not always, however, for the specific environment has much to do with it. Melodic line in music is usually more influential than timbre, dynamics, or chord structure. We are strongly accustomed, by ordinary perceptual habits as well as by art, to identify or discriminate visible things mainly on a basis of their shape, especially their linear outline or silhouette. Even if the thing is solid, as a statue or colonnade, we perceive it partly as a locus of varying linear outlines visible from different points of view. Light and dark variations, hue and texture, and consequent visual effects of surface shape tend to appear as incidental details rather than as defining the form. As a result, if a row of figures are all triangular in shape they will tend to be perceived as variations of the same basic theme, whatever their color or surface qualities. In music, if melodic line (including pitch and rhythm) remains about the same in a series of units, they will tend to appear as variations of the same theme, however much they may differ in chord structure or timbre. As we have seen, "melody" as a developed component involves both rhythmic and pitch-progression traits. But rhythm, including meter and accent, may remain fairly constant throughout long passages, leaving to melodic line the main task of establishing, varying, and contrasting themes.

Exceptions often occur. It is quite possible to have a wall covered with an allover pattern of units which are highly similar as to linear shape, yet which produce an effect of contrast through hue or lightness. A checkerboard has units similar in shape, but contrasted through light and dark. Likewise in music, an effect of total contrast might be produced among repetitions of the same melodic line, if they were sufficiently contrasted in rhythm, loudness, chord structure, and timbre. The resemblance in melodic line would tend to be obscured and overwhelmed by the combined force of other differences. This is not the traditional way of building up designs in music or visual art. As a rule, it is made fairly clear that the artist has conceived and contrasted his themes in terms of one of the architectonic components, and used the other components for incidental variation and enrichment; but stylistic trends can change these relations drastically.

Ordinarily, we recognize contrast as between two or more traits in the same component. We note a contrast between red, blue, and green because they belong to the same component, hue. We do not contrast redness with flatness because they are in differ-

ent components and therefore hard to compare. It is true that two traits from different components are sometimes found similar or different on the ground of their associations, meanings, or functions. Bright red and yellow can be compared to loud, brassy music on that ground.

What seems in art like the most striking contrast often turns out to involve only moderate differentiation if all components are considered. In a sonata, the first and second subjects are usually regarded as contrasting. As a matter of fact, they often resemble each other in meter, accent, chord structure, tempo, note speed, and other respects. In key they usually differ, as in going from a major tonic to the dominant, or a minor tonic to the relative major, but they are not ordinarily put in widely remote keys. How do they differ, then? Essentially in pitch and melody: the level and contour of pitch progression in the principal voice, and perhaps in rhythm and dynamics. Even these need not be utterly unlike. If we really set out to make the two themes as different as possible, we could put them in remote keys, give them different meters, tempos, and note speeds, different harmonic coloring, perhaps even different timbres, as those of the piano and violin. As we thus increased the total difference, the effect would probably be regarded as one, not of contrast but of incongruity, of a difference so great as to preclude combination in the same movement. The total difference between the movements of a sonata is usually greater, involving some contrast in several components. Even there, however, the composer sometimes achieves some amount of unity through pervasive resemblances.

The same may be said of visual design. Contrasting motifs in a textile design will usually preserve many traits in common, such as texture (e.g., brocade or velvet), flat pattern or suggested third dimension, and will often be fairly close or identical in hue, lightness, and saturation as well. Their contrast may lie only in some moderate difference in one component, especially linear shape. The difference between circle and square is enough to produce an effect of moderate contrast, but even regarding linear shape this is not extreme, since both are simple geometric shapes. A change from the square to an irregular floral motif would be more radical. If we produce a textile in which two units differed markedly in many components, e.g., from red to green, light to dark, smooth to rough, dull to shiny, flat to convex (as in appliqué or embroidery) and so on, the effect may soon be one of unrelatedness.

Suppose that, in a brocaded textile design, there is a conspicuous, colorful festoon of large flowers arranged in wavy lines. In it, red roses are contrasted

with dark blue iris. The background field is white, covered with straight, narrow lines of pale yellow. The whole background is much subordinated or "toned down," not only in color intensity but in linear development. It is less active, and less likely to attract attention. Now, broadly speaking, one may say that the flower series is contrasted with the pale background. Some effect of contrast between conspicuous and obscure series is always possible. But the most direct, outstanding contrast will be between the two conspicuous flower series, red and blue. The difference between the white field and the pale yellow lines may appear as a very minor contrast or variation. The observer may not notice the background details at all, or he may think of them in contrast with the flowers. Flowers and background may seem to be on two distinct *levels* of space and emphasis. The former are distinctly dominant (in one sense of the word), and the latter subordinate.

One function of such gradation in emphasis is to permit considerable development on both levels without confusion, competition, or distraction of the observer's attention. The background details may be complicated into an intricate filigree of lines, and yet not interfere with the main pattern, provided they are all kept relatively small, pale, dull, geometrical, or otherwise radically different from the flower series. The observer will notice them only vaguely and marginally; or, if he looks with more care, he can easily distinguish them *en masse* from the main flower series.

22. Types of compound series. Intermediate units. Interlocking and divergent series.

A red triangle and a blue circle, printed on a page, would stand in contrast because of two important differences in spite of their resemblance in other ways such as flatness, size, and texture. Let us say that both themes are repeated, with or without slight variations, thus producing two compound series which contrast with each other. Either a blue triangle or a red circle would now function as an *intermediate* unit, since it would partake to some extent of the nature of each contrasting series. As such, it would tend to link the series together perceptually, as a bridge or connecting link.

Or, let us say that two contrasting musical themes are repeated: one with melody A by the piano; one with melody B by the violin. A passage containing melody A for violin, or one containing melody B for

piano, would then be an intermediate unit between the two series. If this is repeated to form a series, the result will be an *intermediate series* with respect to the other two. It can function as a connection between them, or as a set of variations of either theme.

Two strongly contrasting series, both forcefully stated, may operate to produce an effect of conversational question and answer, or of dialectical sequence: the first as thesis, the second as antithesis. A third can act as synthesis in combining important features of both. Contrasting compound series can be combined in space or time to form a new single series, more diversified than either alone. Such a series can be of any of the types mentioned above under the heading of component thematic development. For example, if red triangle, blue circle, red triangle, blue circle were repeated in that order, they would produce an *alternating compound series*. The component series would be *interlocking*.

A compound series may be made definite, regular, and unified, or the opposite, by virtue of the relations between its component traits. (The spatial, temporal, and causal relations among its parts will also be influential in this respect.) A high degree of regularity and unity is produced by coincidence or similarity among the various component series of which it is formed. If red triangle alternates with blue circle, there is coincidence between the hue series and the line series. Both are alternating; theme A in one always coincides with theme A in the other. Such coincidence can be reinforced by the addition of several other alternating series in other components. For example, the red triangle units can all be made flat and smooth, the blue circles convex and rough. Then the effect of alternation will be cumulative, strong, and marked. However, if the process goes on and the A units are more and more differentiated from the B units in every respect, the tendency noted above may intervene: the two sets may no longer be grasped perceptually as making up a single series of any kind.

An extremely regular series may be considered too monotonous, and the artist may wish to vary its structure. He can do so by diminishing the amount of coincidence and reinforcement among the component series. An effect of freedom and irregularity will result from making one or more of the component series of a different type. This is usually the case in musical and literary, pictorial and sculptural designs, whereas architectural ornament and textile design are often highly regular in building up compound series. Suppose for example that we begin again by alternating red triangles with blue circles, and produce a row of ten units in all. But instead of having the red ones

flat and the blue ones convex, we make the units gradually more convex from left to right. Our compound series is now *progressive* as to one of its component series, while alternating in two of the others. In a fourth component, that of surface texture, we may arrange the traits quite irregularly: e.g., smooth in units 1, 2, 4, 7, and 10, rough in the other units.

How then shall we describe this compound series as a whole? We may regard it mainly from the standpoint of its framework pattern, and say that it is alternating on the whole, though with incidental deviations from this type. Or we may describe it more exactly, as a combination of several different types of component series, emphasizing certain ones.

Except for primitive and neoprimitive styles, concert music is almost always a combination of *diverse* component series; otherwise it would be regarded as extremely monotonous if long continued. Let us say that a composition for piano consists of a hundred measures in 4/4 meter. Considering each measure as a compound unit, we have a repetitive series in the component "meter." Each measure is, in respect to meter, like every other. In respect to timbre also (aside from small variations in piano tone) the measures are repetitive. As to tempo, the piece may be alternating in type: the first thirty or forty measures slow, the second fast; the third slow again, and the final part fast. As to dynamics, the order may be periodic-progressive, rising on the whole from a soft beginning to a loud climax, with partial diminuendos on the way. As to melodic pattern, the piece may be of the rondo or semialternating type (A, B, A, C, A, D). Rhythmic accents and modulations may be irregular and surprising. A stable backbone, making for continuity, is provided by the repetitive meter and timbre series. Climax is provided by the progression in dynamics. *Partial coincidence* among the series makes for unity, *divergence* and irregular component series for variety.

In literature, especially verse, the same possibilities exist. Keats's "Ode to a Nightingale," for example, is a repetitive series in regard to the structure of stanzas, including meter, length of lines, and rhyme scheme, but it is varied in detail and progresses to a climax in regard to emotional and volitional suggestions.

A compound series is interlocking to the extent that every component theme in every compound unit is repeated somewhere else in the compound series, thereby fitting into some component series instead of occurring only once. A single repetition to form two units, or an extensive prolongation, as in a drone bass or uniformly colored background, is enough to estab-

lish a series, and to prevent the trait concerned from appearing unrelated or isolated. Let us suppose that a contrasting series is composed of red triangles, red circles, blue triangles, and blue circles, arranged in any order or scattered irregularly. There are four component series involved here: the reds, the blues, the circles, the triangles. Any compound unit will fit into two component series and be linked thereby with other members of that series. Any given blue circle will fit into the blue series, and thus be linked with some blue circles and some blue triangles. Every other compound unit will thus be linked somehow with every other: with some by virtue of its hue, with others by virtue of its shape. The compound series is thus interlocking or dovetailing so far as the traits mentioned are concerned. The number of traits involved, and of possible combinations, can be increased to any number. Each compound unit will have an increasing number of thematic functions and interrelations, in that it helps to build up more and more thematic series. This is *plurality of thematic functions,* in the case of compound units or parts of a design. Each compound unit functions in several component series or patterns.

A repetitive compound series, as in textile designs, is automatically interlocking; each of its component traits is repeated exactly in each unit. An exactly alternating compound series, as of red triangles and blue circles, is also interlocking. It still remains so when we add the intermediate units, red circles and blue triangles. The order is not essential, and the interlocking condition can be maintained however the units are arranged. The various component series can still overlap and interweave completely, even if they do not coincide. There will be no "loose ends," since every detail is thematically tied up with others.

But let us say that one green triangle is introduced. It is still part of a component series as to its shape, but as to its hue it is unique and unrepeated. The series ceases to be interlocking to the extent that such unique examples of a trait occur. Now, instead of the green triangle, suppose we have a green square. This unit will be unrelated to the others in terms of both hue and shape. Suppose all the other units are flat, and this one convex, like a button pasted on a piece of paper. Now, in three ways, it is unrelated to the rest. We are building up a compound unit which appears incongruous or unrelated, and works strongly against the total unity of the design. This is not necessarily bad: we may wish to dissociate it and call separate attention to it. The more a design or compound series is interlocking, the more it tends to present a unified appearance, especially if each trait is repeated

about the same number of times, and in equally important positions.

In painting, suppose that a picture contains (a) a curving brown tree trunk; (b) a curving green drapery fold; (c) a rounded head of brown hair; and (d) a small, rounded, green treetop in the distance. Here are four compound units, of the many which the picture contains. As to its shape, the tree trunk fits into a series with the drapery fold and all other curving lines in the picture—arms, winding paths, etc. As to its color, it fits into a series with the brown hair and all other brown areas—leaves, leather, bread, etc. In shape, the head of hair is related to the treetop. In color, the treetop is related to the drapery fold. The brown series overlaps but does not coincide with the curving-line series. If every other important trait in the picture is thus repeated elsewhere, serving to tie up each unit with one or more of the others, it will be an *interlocking compound series,* and thus possess one of the attributes of highly organized design.

Of course, not all paintings are so highly interlocking thematically. Design is not the only consideration in painting, and is sometimes sacrificed in part or entirely to the interests of realistic representation or emotional expression. A highly interlocking design tends to appear somewhat formal and artificial; a few loose ends may increase the effect of naturalness and casual freedom. Almost any actual scene—landscape, portrait, still life, or other—will present a profusion of detailed component traits. Some will be obviously repeated, as in the eyes on a face or the leaves on a tree. Further observation will disclose many resemblances which occur spontaneously, as between treetops and cloud forms, a woman's body and the curves of a willow branch. There is no actual scene totally devoid of resemblance among its parts, and hence of some thematic repetition and interlocking. But most natural scenes will present occasional details which do not seem to have any definite resemblance to anything else nearby: a peculiar scar or wrinkle on a face; a single broken tree branch; a worm hole in an apple. The artist whose main interest is exact representation may set each down faithfully nevertheless. The one who seeks a highly definite, organized design will tend either to omit the unrelated detail or to find some way of repeating it with variation elsewhere. He will object to loose ends. If he introduces any emphatic trait even once, he will hunt for something elsewhere which could be altered so as to become a repetition of that trait. Thus he will heighten the red of a cheek so as to "pick up" and "carry out" the red of a flower, or curve a guitar more deeply to resemble a woman's figure somewhere else in the picture. This

can be done to a large extent and in regard to all emphatic traits, without being done completely. Occasional loose ends can be left for the sake of a casual or natural effect, along with a basic design of definitely repeating and interlocking traits. Thematic repetitions can be soft-pedaled, reduced to subtle hints and vague resemblances, or emphasized to make them strong and obvious. Such differences are largely matters of style and personal taste.

Comparative *unrelatedness,* as opposed to interlocking, is found in a realistic, suggestively three-dimensional painting in which one small area is completely flat and two-dimensional. In some early Renaissance painting, the whole picture is illusionistic, seeking to represent perspective with oils on a flat canvas, except for a few spots of raised gold ornament, surviving from the Byzantine style.

In music, the idea of unrelated traits can be grasped if we imagine a piano piece in which one or two measures were suddenly played by a violin with a different theme, the rest by piano again with no repetition of the second timbre. The violin passage would stand out as an interruption—perhaps intentionally so. The same would be true to a less extent of a peculiar melodic theme which occurred once and no more. The usual practice in music is to repeat each main theme. As to minor, incidental traits, especially in accessory components, it is common to leave many unrepeated as mere enrichments of the main ones. The fact that a certain modulation or chord progression is used once in the course of development does not mean that it has to be used again. But the total effect of interlocking and thematic unity would be increased if it were repeated somewhere, perhaps in the same melodic context or perhaps in different ones. A composer devoted to the ideal of unity would probably not build up a compound unit out of several traits, all of which were unrelated to any others elsewhere in the form. If such a passage were unique in melodic line, in key, timbre, rhythm, and chord progression, it would stand out as an extraneous interlude. The composer may seek to surprise his hearers by suddenly introducing a motif which seems radically different at first (e.g., the entrance of King Kastchei in the *Firebird* of Stravinsky). This is explained by the story of the ballet. Lacking this, the composer will probably repeat it and perhaps interweave it with others for the sake of unity. Contemporary experimental music goes a long way toward making sounds apparently unrelated as well as unexpected in nature and sequence. But even this (i.e., persistent surprises and unprepared transitions) can itself become thematic, building series of sounds related in just this

way. Extreme diversity, consistently followed out, can itself be a unifying factor.

23. Complication by division as a phase of compound development.

All that was said about the method of division under the heading of component development applies here also, and in the present section we need consider only the further possibilities which arise in manipulating several components at once. When two or more component patterns are developed in the same design, out of different components, each can be built up through division, addition, or both. They may coincide and reinforce each other to any desired extent and be carried to any desired degree of complexity.

It was pointed out that the method of division tends to be emphasized when a definite framework is adopted in advance, which limits expansion outward in space or time. Then development tends to go on as a process of involution, of internal complication within these limits, more or less in conformity to the framework. This is common in visual design within a given area or three-dimensional section of space. Let us suppose that a certain type of utilitarian framework is imposed in advance as a fundamental requirement. In two dimensions, it may be a prayer rug, the front cover of a book, the tympanum over a doorway, or the façade of a building. In three dimensions, it may be the building as a whole, or a chair, a cup, or a cigarette case.

Representation may set the framework, as in the case of a sculptural group in the round (three-dimensional) or a painting (two-dimensional). Let us say that representational requirements determine the general framework of the form, through demanding that a certain person or scene be portrayed from a certain viewpoint. Decorative development is then called for, to enrich and fill out this framework.

In any of these cases, the planning of the work will necessarily involve a division of the space or time span allowed, and of the general framework adopted, into a few main parts. These may be approximately determined in advance, as in the division of an armchair into legs, seat, arms, and back; or they may be optional, as in the decorative treatment of a book cover. In a portrait of Napoleon, the division will naturally tend to emphasize head, chest and shoulders, arms, hands, and background. A play about his life will tend to divide itself into the main stages of his career. Utilitarian or representational considera-

tions may go on to determine in a general way many of the details of the parts. In that case, thematic composition may be a minor accessory, limited to developing a few thematic series in the components then available.

Similar limitations may result from accepting a fixed, complex framework pattern which is thematic in nature, such as the sonnet, sonata, or fugue. This pattern itself involves main divisions, and perhaps subdivisions of these, as in the three or four movements of the sonata, and the division of the first movement into exposition, development, and recapitulation. Then the development of design in a given case will consist of working out detailed thematic series and patterns within these divisions. The visual artist, likewise, may accept a framework pattern which is nonrepresentational but fixed in terms of two or more components, such as the British flag, a heraldic shield bearing a red chevron on a gold field, or a family tree or other expository diagram to be decoratively developed.

The first step, as in component development, is to divide the framework into two or more main parts. To embark on the process of compound development, we now vary these parts in terms of one or more other components. One area can be black, another white, a third gray, thus developing brilliance or lightness. One can be red, another blue, another yellow, thus developing hue. One can be plain, another striped or dotted with paint or ink; one can be smooth, another crosshatched with grooves or ridges, thus developing surface texture. One can be flat, another concave, another convex, thus developing surface shape. Any or all of these variations in different components can be used at once. Each part is now regarded as a compound unit, to be differentiated from its neighbors to any desired degree, with a net effect of variation or contrast among them.

The next step, if development is to go on, is to subdivide one or more of these compound parts. Then these subdivisions, again, can be differentiated in terms of one or more other components. Such differentiation, as we have seen, usually tends to diminish the unity of the design. Any desired degree of unity is maintained by making units resemble each other, as by having themes in any component in common. For example, spots of red distributed over a complex design will serve to link together units of different shape. It is maintained by having clarity in the framework pattern and in the relation of each part (a) to the larger part which includes it; (b) to parts coordinate with it; and (c) to smaller parts which it includes.

If the framework is limited in size, the limit of development is reached when the parts become too small to subdivide further, or when the subdivisions would be too small to be seen effectively under the conditions involved. If the object is to be seen from different distances, as in case of a cathedral façade, the artist may wish to make his form "carry well," and present an interesting, complex design from each distance. As the observer approaches, he becomes able to perceive level after level of subdivision. What had seemed from far away to be a blurred, mottled surface now stands out as a set of organized pattern units on a smaller scale. This is achieved outstandingly in the late Gothic cathedral, and to some extent in Islamic wall tiles, carvings, and textiles. For that result, large carpets usually need to be hung upon a wall, or viewed from a balcony, to be seen at best advantage. Formal gardens are sometimes laid out so as to be visible from a tower or elevated terrace.

There is no one necessary order in the details of the process of division. One way is to carry out the subdivisions as far as desired with the use of one component only: the framework or other architectonic component. In many cases this is pitch or line. Thus the pattern can be developed to its maximum complexity in one component first of all. Thereafter, one component at a time can be developed, and used to differentiate parts on each level of subdivision. It is common to use lightness as the next component after line, and to distribute spots of light and dark over the whole pattern. Then hue or texture, or surface shape if the design is to be in relief, can likewise be separately manipulated. Such a method tends to make line extremely dominant, and to subordinate accordingly the components used later on. However, that effect will not necessarily show in the finished product. Its nature can be changed in the process, perhaps through melting the lines by flowing colors. The other way is to differentiate the parts on each successive level with the use of several components, then proceed to the next level and do the same thing.

Often the artist prefers to concentrate on one large part at a time: to subdivide, vary, and complicate that part by itself, in terms of several components, before going on to any of the other main parts. Suppose he is designing a rug, and divides the rectangle into a border and central field. The border is to contain many repetitive units of a certain floral motif, and the field many units of a certain heraldic motif. He may proceed by first sketching out the second division over the whole rug, that is, indicate the outlines of all the floral units within the border and all the heraldic ones within the central field. Then he may

proceed by elaborating one unit of each motif in full compound detail. After that, he will need to copy each elaborated unit several times within the appropriate outlines, or to let an assistant do so. This method involves both division and addition—the latter in adding one unit after another within a determined framework.

24. Analytic and synthetic observation of design.

To perceive design in a thorough, organic way, one must follow a course which is somewhat analogous to design construction. One way is analogous to complication by division, and this we shall call *analytic observation*. The other, *synthetic* observation, is related to addition, as in hearing a new symphony for the first time. The former goes from the whole to its main divisions, and from these to smaller and smaller parts within parts. The latter proceeds from noticing small parts and individual units to noticing their interrelations, how they fit together (if they do) into larger groups and sequences.

In observing analytically, one begins by noting the general framework of the design, whether it is actually presented or implicit in the arrangement of the parts. Then one tries to see the main parts individually and in their mutual relations. They may form a series or pattern of units which are approximately equal in size, or at least of coordinate rank as fitting directly into the framework. In observing a rug, one may notice first its division into central field and border, both rectangular units. Then one notices how each of these is divided, likewise into main large parts. Perhaps the border is divided into several parallel border strips, the field into repeated medallions. Then, taking up each border strip, one may find that each is subdivided transversely into many repeated units, as in a guilloche or fret. Taking up medallions, one looks to see if they are all alike; if not, one looks from one to another to note their resemblances and differences in internal structure; their combination in series and patterns.

The eyes will inevitably skip about, from whole to part and part to whole, from one unit to another at a distance. After following the internal subdivision of a certain part, one may return to a higher level, and begin again with the sectional framework of another part, to follow its course of involution. There is no necessary sequence to follow in looking from part to part of a rug, or of any other design which is not determinate in temporal order.

Certainly, one does not need to repeat exactly the order followed by the artist, and in most cases there is no way of knowing what it was. But there is a difference in general approach between the trained and the untrained observer of design. The latter is likely to have his attention held by some incidental detail, or to glance around at the whole in a vague, superficial way; in any case missing the structure of part within part and the subordination of details to frameworks. Trained observation is at least partly analogous to the procedure of the artist in that it seeks to follow this structure perceptually.

In looking at the exterior of a cathedral, analytic observation consists in noticing first, if possible from a distance, its main division into façade, roof, and walls; into nave, transept, and apse, if it is a cathedral; into stories or levels; into great towers and systems of buttresses, perhaps; into series of doors and windows. After that, and from a variety of nearer points of view, one seeks to penetrate the inner structure of individual main parts, and the relation of small parts to each other. Partly enclosed areas, such as a chapel from the apse or an aisle beneath a balcony, suggest the inclusion of space within space. In the *Arabian Nights* we read of vast palaces in which room within room is enclosed down to a small secret chamber, a symbol, perhaps, of the womb or "holy of holies."

In looking at the design of a statue in the round, analytic observation consists in taking a general view, first of the disposition of the main masses and surfaces, the direction of the main axes in space, and the series of such main parts presented from different points of view. To perceive these, it is usually necessary to walk around the statue. Afterward, one narrows down to small details such as grooves and ridges in the face or drapery.

In a picture, one looks for such main divisions as foreground, middleground, and background, for principal vistas down the center, left, or right, for the main groups into which the represented details fall. These may be mountain, valley, and forest in a landscape; vase, pile of fruit, and knife in a still life; head, shoulders, and background in a portrait. Within each of these represented groups one looks for subdivisions of a thematic nature, as of repeated, varied shapes and colors in the pile of fruit, or stripes and parallel folds in a textile. Sometimes it is a help to half-close the eyes at first, or if possible place the picture upside down, and thus ignore for a time the small details and their representational significance.

It is possible to glance over the score of a musical composition, or the text of a play or story, in somewhat the same way. Teachers and editors often do this when trying to get a quick grasp of the whole work. They read swiftly, skipping over details, then perhaps turn to the end and read backwards to see the main progression, the main division into chapters, acts, episodes, or movements, the outlines of plot or thematic framework, the general style. After that, they delve here and there into details of development.

Analytic observation is easiest when the whole design is presented at once, as in a rug or picture. Then the whole framework is disclosed and visible to the discerning eye, with all its ranks and levels of details in place. This is not to say that anyone, even the most highly trained, can perceive all the framework and its subdivisions clearly at a glance. The more complex, varied, and irregular it is, the more time and effort are required in perceiving it. But there is even greater difficulty in grasping structure when unfamiliar details are presented piecemeal, a few at a time, as they are in the temporal series of music and literature. There observation has to take a somewhat different course.

25. Compound development in temporal and static designs. Synthetic observation.

In a temporally developed art such as music, literature, dance, or cinema, there is always an appearance of addition in the way the small units are presented. They come one after another: word after word, gesture after gesture, tone after tone, or chord after chord. Unless we already know the piece or can look ahead rapidly in the score, text, or table of contents, we cannot discern the framework pattern in advance of the small details. On the first hearing of an unusual piece of music or literature, if we have no advance program or significant title to guide us, we must grasp the small details synthetically, one at a time, or in fairly small groups such as phrases or sentences.

When there is representational structure, as in a play or novel, it is comparatively easy to follow the story. But to follow an abstract temporal design, as in music, requires developed powers of perception. The untrained listener hears one chord after another, merging into a vague flow of musical sound. He groups them a little, into small bits of melody and chord progression. The trained listener can organize them into longer sequences, patterns within patterns. This is partly due to his developed power of musical memory. As he hears the successive tones, he does not forget them entirely, but fits them into place with previous ones. Thus he can recognize a sequence

of several phrases as an integral unit in a series, as one of several variations on a previous theme. He recognizes similarities and notes the extent of differences.

As he discerns the beginning of a sequence or pattern in what has already been played and is being played, he tends to generalize swiftly on the probable nature of what is coming. On the basis of his previous experience, he begins to expect and anticipate how the pattern will be completed. He may, of course, be surprised by an unusual turn of events. Some composers try to surprise the hearer frequently, but there is little possibility of surprise after the first hearing. In subsequent hearings, anticipation plays a larger role in perception. The hearer has some advance knowledge of what is going to happen. He understands the framework pattern more clearly, and as the music proceeds he fits each successive tone, chord, and phrase into the shadowy framework which he remembers from previous experience. Even at the first hearing, he can do this to some extent if told in advance that the piece belongs to some familiar type, such as a fugue for harpsichord. Knowing the composer's name, period, and usual style also helps one to anticipate the general outlines quickly.

Synthetic observation thus works from small details to larger and larger, more and more inclusive groups, until the structure of the whole is grasped.

Perception is more likely to be of this type when an unfamiliar form is presented in temporal sequence, either to eyes or ears. But it is not restricted to forms which are temporally determinate. In the extended study of any complex design, even a static one, there is sure to be something of this approach. Learning to perceive and understand the form of a cathedral is a long process, requiring many days or months of repeated observation from different viewpoints and at different times of day. Often one will notice apparently isolated details at separate times, and only later integrate them or see their connection in a single scheme.

The fact that an observer has to grasp the form synthetically does not prove that the artist produced it wholly by addition. The artist may have had a very clear-cut framework pattern of the whole to start with, not only in the back of his mind but on paper: perhaps a general sketch or outline of his intended building, play, or symphony. He may have complicated this plan a long way by division, before beginning to assemble any of the final, detailed units. Yet, if his form is temporally developed, he will not be able to disclose this framework all at once, even if he should wish to; he must give it out piecemeal, bit by bit, and not necessarily in the order of composition.

Neither analytic nor synthetic observation necessarily repeats the creative process.

In poetry, long epics have developed gradually out of folklore, separate tales, and ballads. At an early stage, tales of different heroes are told in different localities. They gradually merge as the peoples merge, and the various exploits are attributed to one hero, as a number of distinct stories. Through the work of various bards, they become strung together into a more or less definite sequence, as a heroic cycle. Finally, and perhaps at the hands of a single organizing genius, they may be thoroughly integrated into a complex epic like the *Odyssey,* with all the episodes woven together, plot within plot. A single writer may recapitulate this process to some extent by assembling anecdotes into a rambling novel or play. A composer, instead of adopting a fixed pattern in advance, may let his fancy wander aimlessly, improvising new themes or variations of the old as impulse directs. Romanticism, with its antipathy toward complex planning, often tends to favor this additive approach. The result may be called a rhapsody or impromptu fantasy, which implies no particular order of units, although it often falls spontaneously into a ternary or some other established type of periodic series.

In the additive approach, beginning with any compound unit, simple or complex, the artist can produce others which differ from it in more than one component. Let us say that the first unit is a peacock motif in several colors and textures. The primitive tendency in producing a border design from such a beginning is to repeat it exactly in a horizontal row, and in producing an allover design to repeat it also in parallel vertical rows. One or two contrasting motifs may be interspersed at regular intervals. But the repetition does not have to be exact; it can be more like the type of musical addition just mentioned. In that case, each successive unit of a motif can be partly differentiated from the previous ones in two or more components. To practice composing such variations on a compound theme is a useful exercise for students of design in any art.

One may go on to imagine a possible temporal development of abstract visual design in the future, in which a succession of complex units is presented, projected perhaps on a screen from a film or color organ, with one unit melting gradually into another. Thomas Wilfred's art of lumia, produced by the clavilux or color organ, made a beginning along this line. But so far the patterns projected at any given moment have had to be rather simple by comparison with those of textile design. Abstract films, using drawn and painted units, are easily capable of more complexity.

In pictorial design, compound series are usually varied a great deal, so much so that their thematic recurrences may be obscured. Any group of approximately similar objects in a picture may be regarded as a compound series, e.g., a number of pine trees in a landscape, of people in a room, of peaches on a table. The order of succession will not be definite, but may involve a general tendency to repetition or alternation, as well as conformity to a pattern. Two or more contrasting compound series can be interspersed, as in the case of curving human figures and rectangular panels, windows, picture frames, and floor tiles in a Dutch interior. It is not always possible to select any one as the theme-establishing unit. The important thing is to notice the similarities which link them all together as a series and the themes in various components which differentiate each one from the others. Also, one should look for intermediate units between any two contrasting series. For example, a curtain with vertical drapery folds, slightly curved, may be intermediate between a series of costumed figures and a series of rigid vertical columns.

When the additive approach alone is followed, design is not likely to achieve high levels of complexity. That usually requires the preliminary sketching of a framework, with some development through division into main parts. With this framework on paper or in the back of his mind, the artist can then proceed, in a more additive way, to feed one compound unit after another into it. There ceases to be any difference between addition and division when a particular area within a pattern is filled with similar units. One can say either that unit is added to unit within that area, or that the area is divided into a series of similar units.

26. Intermediate sectional frameworks. Inclusions.

In complex designs, unity is enhanced by showing clearly the relation of each part to each other, from the standpoint of inclusion. This implies that it is possible to see fairly easily, in regard to any particular part, (a) what sectional framework it fits directly into as a detail or subdivision; (b) what other parts are approximately coordinate with it as details in that framework or in other, coordinate sectional frameworks; and (c) what smaller details it includes, acting as their sectional framework.

Such relations are more likely to be clear and obvious if all the parts fall into a few main ranks as to size. For example, suppose that we are making a rug design by division. We first divide the rectangle into two main parts, a wide border and a central field. We divide the border into three strips, parallel and about equal to each other in width. We divide the central field into a row of four large diamonds, about equal to each other in width. Each diamond is studded with many small stars. Each border strip is filled with small details, one with leaves, one with flowers, one with palms. The stars, leaves, flowers, and palms are about equal in size. There are now four *main levels* in the design: (1) the outside rectangle of the rug; (2) the border and central field; (3) the border strips and diamonds; and (4) the stars, leaves, flowers, and palms. If the rug were hung on a large wall, and one approached it from a long distance, one would see clearly, at first, only the whole rug. All divisions would merge into a vague texture. Then, as one approached, the second, third, and fourth levels would successively become visible.

This is not to say that such clarity is always desirable. Many artists avoid it as too regular and obvious. It is approximated, or taken as a starting point, in many Persian rug designs, but there are usually some details intermediate between the various levels of size. This can be done without going to the other extreme and filling the original rectangle with a confusing mixture of large, small, and medium-sized parts, all in together, some subdivided and some not. The observer, trying to grasp the plan of a design, quickly makes use of any clues he can find to organize small details into groups and types. Here, he observes, is a set of details that fit together as parts of a large diamond. Now he can deal with them as a unit as well as individually. Here are a lot of details that are very small, though scattered; they are alike in requiring close inspection to be seen, and he can treat them as a group, apart from the larger shapes (for example, curving vines connecting large units). Various other component series, as in hue and notan, provide additional modes of perceptual grouping; and clarity (perhaps excessive) results from having all the groups in obvious conformity.

There are two notable series of engravings of the Apocalypse, one by Duvet and the other by Dürer. In the former, shapes of many different sizes—angels, humans, accessory objects, and landscape details—are mixed in together in a way which is comparatively hard for the eye to organize. In the Dürer engravings, there is studious care to make plain the relation of details to sectional frameworks. Main vistas and large figures stand out clearly, and small details (though not uniform in size) are clearly subordinated to them. The result is organized complexity.

The latter effect is more likely to be obtained if the artist follows a fairly continuous order of steps in subdivision: that is, if he first divides the whole area into a few main parts, then divides each of these a step farther, at least in a sketchy way, and thus carries the whole area from one level of subdivision to the next. If he goes immediately from the very large (e.g., the original rectangle) to the very small (e.g., an eye or a leaf here and there), it is hard to end up with a clear inclusion of part within part. There will probably be many small details which are not included within any subordinate, sectional framework, but only within the main outside rectangle itself. If there are many of these, along with some which do fall into groups, the observer will find organization comparatively difficult. His task of complex perception is aided if he can proceed step by step, back and forth between the very large and very small.

For this purpose, *sectional frameworks of intermediate size and scope* exert an important function. In an ultracomplex design, the artist may find need for several distinct sizes or levels of them, each containing a number of sectional frameworks coordinate with each other, at different places in the design. This is especially true of complex architecture, as in the cathedral. It is true of the symphony, where division into movements aids the observer to grasp the relation of many smaller units through hearing and remembering them one movement at a time. It is true of acts in a play, and of chapters in a novel. But it is true only if there is real internal organization in each movement, act, or chapter: if each has its own sectional framework, with details subordinated thereto. Otherwise the division is merely arbitrary, and does not necessarily help to organize details.

Clear relation to sectional frameworks can be achieved through either division or addition. In the latter case, the sectional frameworks will probably come first, before the comprehensive one, as small details are organized first into medium-sized, and then into larger groupings. It may turn out that the sectional frameworks are in the end clearer than the comprehensive one, and the sectional organizations more unified than the total design. This is often the result when a writer tries to join a number of short stories into a novel-length book, or when a composer tries to make a symphony or sonata out of three or four short pieces that he has written at different times. To merge the parts into one total design may require more alteration of them than the artist is willing or able to perform.

Many a well-known symphony or sonata reveals on analysis only a slight and tenuous interrelation between the movements, one of key and indefinite mood rather than of diversified thematic bonds. The hearer, nevertheless, is apt to assume in all reverence that every classical composition is perfectly unified. In complex temporal forms such as those of music, only listeners with developed powers of perception can clearly discern comprehensive unity of design if it exists, or miss it keenly if it is weak or absent. In others, the power to remember what has gone before, and compare it thematically with what comes afterward, is undeveloped. They grasp one short portion at a time, each for its own sake and without much reference to distant context, and vaguely sense a continuity in the musical flow. For such observers the smaller sectional frameworks are a more constant help in perception than the intermediate or comprehensive ones.

The ability to manipulate these intermediate frameworks in the production of genuinely complex design is a sign of artistic sophistication, and the ability to perceive them in relation to the whole is a sign of developed powers of observation.

27. Framework and accessory component series within a compound series or design. Degrees of component diversity.

Let us see how the terms "framework" and "accessory" apply to compound thematic development. We have used them in two other connections. The first was in the chapter on modes of composition, where it was shown that a single work of art could involve two, three, or four modes of composition at once. Each would operate as a more or less distinct compositional factor within the total form. In such cases one factor usually provides a determining general framework for the whole: e.g., the utilitarian factor in a house or chair. Others contribute accessories for reinforcement, enrichment, or versatility of function.

The second connection was that of *component thematic development.* Here we saw that, entirely within the thematic factor, one pattern might act as comprehensive framework, while other patterns, series, or component details fitted into it as smaller frameworks or accessories. Within a large linear or melodic framework, smaller patterns and details in the same component could be arranged. The large framework might be merely a shadowy, bare, and conventional web or skeleton, with all the emphasis placed on elaboration of detail.

It is easy to see how a component pattern can become the framework for effects in other components. Suppose we begin with a large initial A, as in medieval illumination. We then proceed to embellish it, not only with other linear shapes (component development) but with different colors, different shades and tints of lightness, and different surface textures such as burnished gold on vellum, striped and plain areas. The linear shape of the initial remains the framework, and other component series (e.g., spots of red) conform to it.

A great deal of painting has been little more than filling in with color the areas between definite linear outlines, as in most Egyptian art. Even when the outlines are obscured by more pervasive, melting color as in late Venetian work, something remains of the linear substructure in the axes and directions of principal masses, and in the edges (however blurred) of color areas.

In architecture, the shape of planes and masses (walls, roofs, floors, colonnades) usually provides a framework. It may be very simple and boxlike, while the principal development lies in variegated patterns of surface detail in carving and texture.

In music and regular verse, there are commonly two sorts of framework at once. Both arts may have a simple metrical framework such as 4/4 time or iambic pentameter, which acts as a temporal skeleton or trellis upon which to arrange all other effects. It may be very obvious, as when the actually sounded strong and weak beats correspond closely with the metrical basis. Or it may become shadowy and tacit, as when there is a great deal of incidental rhythmic variation and syncopation. Meter sometimes disappears in modern music through extreme diversification of the beat. Verse may have a second framework pattern in the ideas expressed, as in a narrative plot or lyrical exposition.

In music, melodic pitch progression commonly provides a second framework: what is usually called the thematic or melodic structure of the piece. It tends to develop a definite, emphatic pattern of its own, as in the fugue or sonata. Other component effects such as chord progression, dynamics, and timbre have usually been more or less subordinated to it. Theoretically, it would be quite possible to build up a framework pattern of orchestral timbres, and fit a few slight melodic and rhythmic series into this as accessories. But that is not the traditional way of building musical design. Ordinarily, the term "theme" is applied only to the melodic theme, or to a compound theme with special reference to its melody. More attention to the potential development of other components, as offering themes and patterns in their own right, would open the door to many new possibilities in music and other arts.

It is possible to develop a design on the basis of two or more frameworks at once, each in a different component. The two may then coincide completely or only approximately. Failure to coincide at all would result in considerable loss of unity. It may or may not be possible to say which is the most definite, basic framework; often, two seem nearly coordinate.

Often, but not always, the framework pattern and the component in which it occurs are the most conspicuous, emphatic, and highly developed. In a plain, striped, or checked textile design, the linear web on which the whole is organized tends to remain visible. In silk brocade designs, the web tends to disappear, and a second linear framework emerges in the outline of circular medallions, floral motifs, or the like. This usually remains the most complex of the component series in the whole. Color variations are fitted into it, and may be simple and inconspicuous. But they can become larger, more complex, bold, and conspicuous without losing their accessory status, being still fitted into a linear framework. One could then say that color was the most conspicuous, emphatic, and highly developed component, although accessory. This can be tested by seeing or imagining the design in a black and white photograph, and comparing it with the original to see how much of the distinctive total effect has been lost.

There is considerable difference between historic styles, and between individual artists, as to the status accorded the different components. In Egyptian and many later pictorial styles, line is preeminent as the framework component and as the most emphatic, highly developed one. In some late Venetian, Baroque, and Impressionist painting, it still remains as a shadowy, vague, and simple framework, but loses rank as to emphasis and complexity in favor of color, light, and texture. In early classical music, melodic line is most emphatic and highly developed in addition to providing a framework. Since then, it has tended to recede before the advance of modern harmony and orchestration.

Styles of design and particular designs differ as to how many developed components they involve. Some are highly specialized, some diversified in this respect. Any actual design must be compound; it is only through abstraction that we regard it as a component pattern. Even if only a black and white ink drawing or etching, and apparently "purely linear," it will

contain something besides line. But only the linear component may be highly developed, in which case the design as a whole will be low in component diversity. Let us now undertake to vary its strokes in lightness from black to light gray, and in texture from sharp to soft, as in Chinese brush drawing. Let us suggest rounded details and perspective, as in the flowers and columns of Renaissance design. Let us introduce a wash of brown color over certain areas. We are now increasing the design's *developed component diversity,* though not necessarily its total complexity.

Many past and present styles of design have been somewhat specialized in this regard. Horace expresses the classical spirit in disliking Persian luxuries, which included a love of elaborate ornamentation, rich color, and texture. Much emphasis upon color and texture at the expense of clarity in shape tends to accompany and suggest a voluptuous, sensuous, and emotional attitude in general, rather than one of moral and intellectual rigor. The same is true in music of developing chordal and orchestral effects, as opposed to the more severe emphasis on strict meter and melodic-line development, which reached a high point in the polyphonic and eighteenth-century neoclassical styles. The attempt to develop and emphasize many components at once may produce an effect which will strike the austere observer as lush, overloaded, and overdecorated. Unless carefully adjusted, the several components can compete with, confuse, and frustrate each other. It is a difficult task to handle the development of many components at once in such a way as to achieve unity and clarity along with variety. It is a task involving not only skill in handling each, but restraint in setting limits to the complexity and conspicuousness of each, and in subordinating accessory components to some definite, comprehensive framework. A symphony is not necessarily better than a piano sonata or a song; an oil painting is not necessarily better than a pencil drawing.

The size and complexity of the work of art have something to do with the problem. A very large, complex framework can more easily accommodate many different component patterns. It can, if desired, stress a certain component in one part of the work, another elsewhere, thus enhancing contrast between the parts and avoiding overloading in any one. Thus the Gothic cathedrals stressed line and mass in the piers, surface shape in the sculptural reliefs, color and light in the windows, void shape (empty space) in the nave and colonnades, but never exclusively, always with varying emphasis.

28. Other modes of composition regarded as providing frameworks for design. Thematic composition as accessory.

As we have seen, design is often fitted as an accessory enrichment into a utilitarian, representational or expository framework, as in the case of an armchair. Utility is the framework mode of composition. The form as a whole is determined in its general outlines by the functional and structural requirements of an armchair, comfort and security for the seated occupant, and strength of supports, durability, etc.

Now the general type of form called "armchair" is not only a type of utilitarian device; it can also be regarded from the thematic standpoint as a type of visual pattern. Regarded entirely aside from its utility, and merely as an arrangement of visible lines, planes, and masses, it presents a combination of several thematic series. Its four legs are usually repetitions of the same solid shape, roughly cylindrical; its arms and perhaps the frame of the back may repeat this shape further. The flat or slightly curving plane of the back is usually similar to that of the seat.

Utilitarian, rather than decorative, considerations determine this pattern in the first place. But, once produced, it operates also as a visual pattern. Indeed, the bare essentials of the form, which are functionally necessary for service as a chair, may be regarded as constituting a satisfying visual design in themselves, requiring no further decoration from the aesthetic standpoint. However, in case further decorative development is desired, the basic utilitarian structure is there to act as a framework pattern. The grain and natural coloring of the wood may be brought out by rubbing, or stains, paints, and varnishes be applied. Surface texture and color will thus be developed. Carving and upholstery fabrics may further elaborate the surface shape and texture. Whatever is added along these lines tends to be fitted into the main utilitarian framework to some extent. But, as in all design, it is possible for accessory details not to conform to the framework exactly. The carved incisions or upholstery patterns, for example, may or may not repeat the main lines of the legs, seat, and back. If they do, the thematic unity of the whole is to that extent increased. But some variation in this respect is often desired. Even though the carving or textile design is not in every detail subordinated to the utilitarian structure, it will still be fitted into it approxi-

mately. At the same time, the utilitarian traits of the form may be receiving development: e.g., the upholstery, for additional comfort.

To take another utilitarian example: an advertising poster may be thought out first in terms of commercial means and ends, of verbal and pictorial inducements to buy a certain product. Then the artist may be assigned to develop the form into a decorative design, within the framework thus determined. In the literary medium, an advertising argument may be turned into verse, and thus developed a little along thematic lines.

Let us say that a piece of literature (e.g., a Greek or Biblical text) is primarily expository. Taking as framework the verbal symbols necessary for clear exposition, the visual artist may add accessory decorative development, in the form of calligraphy, typography, or colored illumination. Or perhaps the expository basis is itself visual, as in the case of a diagram, map, chart, coat of arms, or genealogical tree. To a literary exposition, literary thematic development may be added, as by versification or rhythmic prose.

From the fact that a utilitarian or expository basis may come first, and thematic development later, let us not assume that the latter will necessarily be superficial or extraneous. That depends on how the artist develops the thematic accessories with the framework provided him. His efforts in design may not involve any adding of extra ornamental details at all, but only care in arranging the basic framework so that its intrinsic design aspects will appear to best advantage. This would be true of a text printed in simple type which is clear and plain and at the same time decorative, or of a text worded in prose at once terse, clear, and rhythmic, as Lincoln's *Gettysburg Address.* Here there are few thematic accessories; the utilitarian or expository framework itself functions as design with little thematic development. But even if many details are added for purely decorative reasons, they may still be integrated thematically with the utilitarian or expository framework, through echoing and elaborating its essential outlines.

Representation also provides a framework pattern for countless designs. The great majority of conventional shapes, used as bases for development into complex designs, have some representational significance: for example, the star, crescent, wheel, axe, and many varieties of tree and flower. Many that we commonly regard as abstractly geometric have had such meaning: the circle might represent the solar disc, and the cylinder the phallus or the tree of life.

Simplified outlines of animal and human figures often provide a framework pattern. As we have seen, the essential, distinguishing features in the outline of an eagle or peacock are drawn. At the same time, they may be drawn in such a way as to bring out a thematic series of repeated lines. Five or six repetitions of a flattened arc and a straight line, properly arranged, will serve to indicate the peacock, the eagle, the lion, or the unicorn; the palm tree, the lotus, the rose, thistle, or shamrock.

The artist may start to draw or model a subject from nature or imagination, perhaps a realistic landscape, still life, portrait, or a fanciful scene in heaven. If comparatively realistic in aim and working directly from the actual model, he may not think much about design until well along in the process. Then, having set down what he regards as the essentials of the scene, he may begin trying to rearrange or "touch them up" a little in the interests of design. This work may consist merely in trying to build up a few simple thematic series, as of repeated curves or angles, reds or blues, hollows or projections. Innumerable pictures and statues have no more thematic development than this; design is then a very minor accessory in the total form. Many go farther, through rearranging details in space so as to conform definitely to a thematic framework, such as one of radiation or bilateral symmetry (exact or occult), or through building definite and complex thematic series in various components such as line, color, texture, and surface shape, and subordinating them clearly to the framework pattern.

The framework can be primarily representational, as in the case of a picture of several persons, trees, or apples, and yet be at the same time a pattern from the thematic standpoint, as when the objects fall into similar groups, right and left, or into a triangular arrangement. This can be artificially imposed by the artist, as by arranging apples on a table, or by creating an ideal scene without an actual model. It can be selected from the spontaneous aspects of nature, as when a photographer stops and points his camera at a row of similar and equidistant trees. The framework does not need to be regular or symmetrical. The artist may be attracted in nature, as Cézanne often was, by some striking, accidental disposition of rocks or plants, a cross-hatching of branches against the sky, or a piling up of angular boulders in a ravine. This is what Cézanne called his *motif.* One might hesitate to call it a pattern because of its irregularity, but it would at least be a thematic series of more or less similar shapes in line, plane, and mass. Thus adopting a framework at once representational and thematic, the artist is free to maintain whatever balance he

chooses between realism and formal design in working out the details.

Other artists begin with some thematic conception and then try to find from observation or imagination some representative content to fill in this pattern. Utilitarian or other requirements may provide the framework. Suppose a sculptor is invited by an architect to fill in a triangular pediment with statues, or a semicircular tympanum with figures in low relief. For purely decorative reasons, or merely because he is interested in a certain abstract pattern, the artist may take it as his starting point. Suppose he begins with a wide, oblong area, and draws a wavy line across it from left to right. Then he asks himself, how could this be developed with representational content? Perhaps with vines, leaves, and grapes; perhaps with leaping fish or antelopes, waves or mermaids. Here, representation is not providing the initial framework pattern. It tends to be an accessory mode, with design as the framework. But if the details continue to develop along representative lines, with increasing realism and perhaps a tendency to alter or weaken the initial pattern, the end result may be much the same as in the other order of procedure. Whichever provides the original framework, the other may develop into a definite framework of its own, coinciding or competing with the former, or even replacing it.

Design and representation are often made to appear more different and irreconcilable than they need be. Design is often taught as a highly unrealistic procedure, much concerned with flat pattern and the exact repetition of units in allover patterns and borders. The student is not shown how, from any thematic framework, one can easily progress in the direction of representational realism. Conversely, when he studies pictorial and sculptural representation, he is not shown how a natural scene or figure can be taken as a starting point for design, or how, through the systematic alteration of details, to build thematic series. Consequently, neither discipline shows him adequately how it is possible to develop design along with representation, in a merged and balanced way, as in the great traditions of Classic, Renaissance, and Oriental art.

Literature also frequently adopts a representational framework and makes design accessory to it. This would not be the case if one started out to write a sonnet, for there a thematic framework would be accepted in advance. But suppose one starts out to tell a story. The framework of the whole is the narrative of events, such as a sequence of dynastic wars, in chronological order. At first, it may be told in prose, by storytellers around campfires. Then a bard, more gifted in poetic art, takes it in hand. He turns it into rhythmic verses and declaims them with the accompaniment of a lyre. The narrative framework thus becomes enriched with thematic auditory series, verbal and musical, including a metrical pattern.

Literary thematic structure, not being limited to the auditory components, may inhere in the order of narrated events themselves. Suppose for example that the story is one of a voyage, with home at the beginning and end. That introduces temporal symmetry, a bounding of the story in time with similar images. Moreover, the events may proceed in rhythmic, analogous episodes. Perhaps the hero struggles in each against a different kind of adversary, in a different place, but comes home after each to deserved reward and repose. In *Sindbad the Sailor,* there is a recurrent scene between each pair of voyages, in which the aged narrator gives the porter a hundred gold coins. This forms a repetitive series, marking off and connecting the other series of units consisting of the voyages themselves. Such a narrative has an inherent pattern to begin with, in this case periodic and alternating. Representation itself thus provides a framework pattern.

It is a short step to develop such a pattern into a ballad or song with a refrain, in which each exploit is the subject of a stanza or canto. This involves detailed thematic organization along auditory lines, in conformity with the alternating story pattern. Wagner's music dramas are outstanding examples of complex auditory design development within a dramatic libretto framework. They illustrate again the fact that it is often the accessory development, rather than the basic framework, which gives to a work of art its distinctive quality.

29. Different degrees of unity in design through amount of correspondence between framework and accessory series.

In considering component development we noticed how a complex pattern could be integrated through making details conform to a framework or skeleton pattern, and also that actual designs differ considerably in regard to the extent of such conformity. Extreme conformity (as in a circular plate decorated with concentric circles) makes for a tightly formal kind of pattern, with a degree of unity often felt as excessive. Some artists practically ignore the frame-

work, as in covering the plate with a naturalistic landscape.

We noticed also how series in various components may coincide to build up a *reinforced compound series:* e.g., a row of units which grows progressively more circular and convex in shape as well as darker and more intensely red in color, from left to right. Again, it was remarked that such extreme consistency is often avoided in actual designs, as being too monotonously regular.

To what extent should unity be achieved at the sacrifice of variety, or the opposite? If unity were the *sine qua non,* one might infer that all component series in a design should conform exactly to the framework pattern. Suppose, for example, that we are decorating the outside of a vase with lines and colors, dark and light areas. The framework is set up by the utilitarian structure of the vase. It may be of a conventional type, such as a lekythos or amphora. Shall all the surface lines, colors, dark and light spots be arranged so as to repeat or imitate the main contours of the vase? Sometimes this is done, but rarely. Both Greek and Chinese vases often contain freeflowing linear patterns, irregular color areas, even naturalistic flowers, birds, figure groups, and scenes, which repeat only slightly if at all the main contours of the vase. Geometric textiles, such as American Indian blankets, usually maintain an obvious conformity between the color areas and the basic, rectilinear structure of warp and woof. But in late Flemish tapestries the pictorial development obscures this framework.

Great divergence exists among actual designs with respect to the amount of coincidence between the component series, as well as between framework and accessories. Mature classic and romantic styles both favor some divergence as a rule, but romanticism tends to encourage it more. This suggests more freedom and variety, and sometimes an effect of casual relaxation. Romantic impulses often express themselves in a disposition to ignore the basic framework, to obscure it or wander far away from it, in developing accessory components. A lack of thematic relation between design and basic framework may result either from insensitivity on the artist's part or from a desire to avoid excessive unity. Some late Chinese vases and some Rococo snuff boxes, covered with naturalistic pictures, reveal very little thematic relation between utilitarian framework and decoration. It seems as if the artist was primarily interested in a certain kind of pictorial representation, and that he placed it indiscriminately on whatever surface came

to hand, with whatever materials and technique he happened to possess. He was not much interested in the shape or function of the vessel, or in the compound design of the object as a whole.

Along with such extremes, many intermediate types exist. Accessory ornament can be very free, departing widely from the framework, and yet provide a link between the two by some slight, occasional carryover of themes from one to the other. Here and there some details of an applied pictorial decoration can echo a basic contour line. The spacing of ornamental motifs, perhaps, can be regular enough to show that the basic shape was considered as a framework to be divided up, even though the individual units are quite different from the framework pattern.

30. Compound climaxes, reinforcements, accents, crises, foci of emphasis. Varieties of climactic series.

In the section on component thematic development we considered briefly the ideas of accent and climax, especially in relation to progressive and progressive-periodic series. The climax or most accented unit usually comes at or near the end in a series arranged in temporal or other regular order. Even where the order is indeterminate, as in a scattering of color areas graded in intensity throughout a picture, the most accented (e.g., intense in color) can be regarded as a climax. When the series is a component series, such a unit is a *component* climax. The compound unit containing the most intense red may not be the largest rose or the most conspicuously located, and hence not be a climax in all respects, but only in relation to the series of reds.

The term "climax" implies considerably more emphasis and gradual approach than does "accent." A complex work of art is likely to contain a great many *minor accents:* details which are slightly more emphasized than others. But it will contain relatively few climaxes: perhaps none at all or only one. Auditory rhythm involves constant contrast between accented and unaccented or less accented units which may result from differences in the loudness or length of beats or syllables. Such a series of strong and weak beats is a periodic series, involving more or less regular alternation, as in a, b, a, b (loud, soft, loud, soft); or a, b, b, a, b, b (loud, soft, soft, loud, soft, soft) or some other type of rhythmic foot or measure. Visual series can be similarly produced (and are often re-

garded as rhythmic also): for example, through alternating large with small units, rising with falling lines, light with dark spots, highly chromatic with dull, etc. Such accents may be very slight and incidental in the whole form, and attract little attention. Major accents, fewer in number, may involve a higher degree of the same trait—occasional spots of exceptional loudness, brightness, etc. A *climax* involves still greater emphasis; it stands out as most emphatic over a fairly extensive area.

The word "climax" came from the Greek word meaning "ladder," and was used in traditional rhetoric to include a whole progressive series of units, e.g., of figures of speech or steps in an argument, which gradually increased in force. Now it is commonly used to mean the culminating unit or apex only. A series with a climax is a *climactic* series. Without one it is *nonclimactic* or *level*. A climax may be a descent from the standpoint of fortune trend.

The climax is not necessarily the last unit in a temporal series. Often the most emphatic unit is followed by a decline in emphasis. If so, the series tends to assume periodic form, with an approach to temporal symmetry: a return to the starting point or original condition. In music and drama, the principal climax often comes, neither at the end nor in the middle, but somewhere between the two. There is often a scene of great excitement and decisiveness near the end of a play, followed by a gradual "letdown" in the closing moments. On the other hand, the climactic scene may come at the final moment, as in the disclosure and arrest or suicide of the guilty person in a detective mystery. In music consisting of a single movement, the point of greatest excitement may be reached at the end or shortly before it, in the latter case with a few quieter measures to relax tension and end with peaceful calmness. The main climax rarely comes as early as the middle of a temporal sequence, partly because the suspense and hence the interest of observers would tend to be lost too early.

The "letdown" after a climax cannot be called an "anticlimax," for this term has special and often unfavorable connotations. It is used of a disappointing or ridiculous letdown, as when ambitious efforts culminate in a weak fiasco, or when a pretentious climax is rendered absurd by some unintended and incongruous sequel—a squeaking false note in music, for example, at the end of a glorious cadenza. Of a different nature is the gradual, consistent return to a lower level of intensity which follows the climax in most tragedies and novels, and in many symphonies. We shall call this the *postclimactic descent*. "The rest is silence," says Horatio, after Hamlet's death.

Now cracks a noble heart. Good night, sweet Prince;
And flights of angels sing thee to thy rest!
Why does the drum come hither?

A few minor characters enter and discuss with Horatio the catastrophe, the succession to the throne, and honors for the dead prince, all with relaxing emotional tension as attention turns to the future and to the proper ceremonial observances.

It is common for strongly climactic art to end thus, with a gradual return to normal living, so that the observer is transported back again to something like the everyday world. Keen personal sympathy for the protagonist is succeeded by a more general, objective, philosophic view, consoling or moralizing. After hairbreadth escapes, the hero sails back into placid harbors, or settles down with his bride to "live happily ever after." Obviously, such a descent can occur only in a temporally ordered sequence. If there is more than one climax in a design, there can be a descent after each. Each minor, sectional climax (e.g., in a single chapter or scene) can have one after it. In that case, the sequence will be periodic or periodic-progressive. It is very common in long narratives or musical compositions, where the observer is given a breathing spell for relaxation after each exciting episode.

It is often possible to distinguish several degrees of emphasis or accentuation in a particular form. The strongest of these is the *main* climax; the others are *minor* or *secondary* climaxes. What is a main climax in a small form (e.g., a short story or a painted panel) may become a minor one if the form is included in a larger whole (e.g., a novel or a triptych). In a temporal form, a minor one preceding the main one is a *preliminary climax or pre-climax*. One following the main climax, and hence a part of the postclimactic descent, is a *post-climax*. After the main climax of a long story, play, or symphony, there is often a slighter flareup of tension and excitement before the final dying out of the flames; or, the whole piece may close on a level of moderate excitement.

If the main climax comes well before the end, it constitutes a kind of *crisis:* a *turning point* or decisive moment between rising and falling intensity or increasing and relaxing tension. It is then that forces definitely shape themselves to impel a change one way or another or a continuance of the present situation. However, a crisis or turning point is not necessarily a climax. A minor crisis may occur early in a story, as when a character is first shaken out of his normal routine by unusual events, and launched forth upon a series of complications. Later on, there may

be a true climax when these complications are resolved, after which he returns to uneventful normality. A turning point is not necessarily accented, and may be almost imperceptible. Any point or moment of definite change from one condition or thematic subject to another is a turning point, broadly speaking. It occurs in music when one main theme gives place to another. It occurs in "Cinderella" when the fairy first transforms the humble sister and sends her to the ball. The climax does not come until the prince discovers her as owner of the slipper, thus transporting her again, and permanently, from rags to riches and from abuse to love.

If the climax is followed by a drop all the way back to the original condition, and that by another and another rise and fall, the series takes on a *periodic, cyclical* nature. Then the question is whether all the high points or zeniths are about the same in emphasis. If so, no one of them is a climax for the whole series. The series as a whole is then a *nonclimactic* one, whether level or undulating. What constitutes a climax for a single section of the series is no more than a recurrent accent for the whole. However, if the successive high points reach higher and higher levels, the series becomes periodic-progressive, and as a whole may have a climax again. This may happen, for example, in adding together a number of short stories to make a novel or epic, or a number of short musical compositions to make a suite. Each may have a climax individually; but when they come together, the artist may feel the need of grading the emphasis so as to work up to a final, supreme climax for the whole.

There are various grounds for estimating the importance of climaxes. One is in relation to the various *compound units*. A certain area may be climactic in relation to a limited part or element in a design, in which case it is a *relative* climax. A *sectional* climax is relative to a single compound part such as a movement, act, chapter, or wall. A *serial* or sequential climax is relative to a single series within the whole: e.g., a series (a) of roses as distinct from lilies or (b) of statements of a single subject in music. A *total* climax is the most emphatic area of an entire design, approached and built up by all or most of its parts. A certain unit may be the *principal* climax in being the strongest climax reached anywhere in the design, and yet not be a total climax. In a sonata it may be reached near the end of the first movement, after which the remaining movements may have weak climaxes or none at all. In that case it could hardly function as climax to the whole composition. Remaining movements would be too long to constitute a

mere postclimactic descent, and the design as a whole would seem nonclimactic.

Another way of estimating the importance of climaxes is in relation to the various *component series and patterns*. As we have seen, a certain detail may be a relative climax with respect to linear shape only or color progression only. If so, it is a *component climax*. On the other hand, it may stand out as the most emphatic area in several component series at once, and thus be a *compound climax*. A certain rose in a picture may be the compound climax of a series of roses, as most emphatic not only in color intensity, but in size, position, and perhaps other respects as well. The yellow book in Vermeer's *Artist and Model* is climactic in regard to intensity of yellow, strong light illumination, and central position. It is reinforced by its context, being held by a pretty, richly costumed girl.

In painting, such an area is often called the center of interest. That term is misleading, since the observer's chief interest may be drawn elsewhere by other factors, and since the climax is not necessarily in the spatial center. It would be better to call it a *focus of emphasis*. In static forms, such an area often functions as a sort of pivot or fulcrum, a point of strength and stability, around which weaker and more unstable units radiate, converge, and balance. The observer's eye tends to be called back to it frequently, after wandering elsewhere. When the focus is near the center of the form (often a little above or below center, in a picture) the effect of stability and balance is heightened. When decidedly off center (eccentric focus), as it often is in late Renaissance, Baroque, and Mannerist art, the effect tends to be unstable, dynamic, strained, and agitated (e.g., in Veronese's *Crucifixion* in the Louvre and Tintoretto's *Last Supper* in San Giorgio Maggiore).

A *compound climax* is a compound unit containing two or more component climaxes. In music, for example, let us suppose that the sequence consists of varied repetitions of a certain theme (a, a^2, a^3, etc.). Each repetition is louder and faster than the previous one, and is played with richer chords and more instrumental timbres. The final repetition would be a compound climax. It would contain several component climaxes, those of the dynamics, note speed, chord structure, and timbre sequences. This would be an extreme and unusual example of *reinforcement* and *coincidence*. The coincidence of two compound climaxes is often enough to build up a fairly powerful compound climax. Sometimes the possession of one component climax alone is enough to make a compound unit function as a climax for a whole design.

In music, increasing loudness is often enough to accomplish this effect, while all other components continue with little or no increase. Increasing loudness contributes to the climaxes of Beethoven's *Waldstein* Sonata (Op. 53) and Ravel's *Bolero*. More components cooperate in the latter, especially orchestration. Bringing in all the resources of the modern orchestra, together and separately, is a powerful means of reinforcing the melodic progression.

A *continuously progressive component series* may be symbolized mathematically as follows: $a, 2a, 3a, \ldots na$ (n standing for the highest or culminating amount reached). Whatever it is, the unit containing that amount is the climax. In a *periodic progressive series,* the units would proceed approximately as follows: $a, 2a, 3a, 2a, 3a, 4a, 3a, 4a, 5a$, etc.

When we come to consider *compound* series, we must take note of more than one component theme in each unit. One theme (a) may increase, while a second (b) decreases and a third (c) remains constant, as follows: $a+3b+2c, 2a+2b+2c, 3a+b+2c$. This compound series combines a progressive, a regressive, and a repetitive component series. If reinforced and consistent, the compound series will progress more or less as follows: $a+b+c, 2a+2b+2c, 3a+3b+3c$, etc., to a climax where n or the highest point of emphasis for each component theme is reached.

In designs intended to attract and hold the attention, such as those of fiction, drama, and concert music, highly regular series, progressive or otherwise, are very infrequent. They are common in primitive geometric decoration, where they often accompany an interest in the intuitive, prescientific discovery of exact mathematical relations. They persist in certain phases of civilized design, as in architecture, where mathematical regularity is desired. Otherwise, the progressive series found in art are usually approximations to regular arithmetical or geometrical progression, abounding in discontinuity, and hard to measure in numerical units. Ravel's *Bolero* is of this type.

"Geometric" design, as a historic type associated mainly with primitive culture, is ordinarily nonclimactic, repetitive or periodic rather than progressive. However, there is no reason why it cannot become so. As the term "geometric progression" implies, increase can proceed by regular and exactly commensurate degrees. A climax can be reached through a series of increasing geometric shapes such as circles or triangles. Occasionally, a geometric style becomes very complex, as in Egyptian Islamic decoration. There it often develops progressive series (as of increasing angles) as well as accented areas. But it is usually employed for covering a surface or extending

a border, without strongly climactic emphases. Simple straight lines and arcs are apt to be too rigid and severe to suggest emotional excitement. More irregular themes as well as more irregular series tend to appear when that kind of suggestion is desired. So regular a progression as $a, 2a, 3a, 4a$ (arithmetical) or $a, 2a, 4a, 8a$ (geometrical) tends to lack the suggestion of struggle and conflict as well as that of contrast. It suggests an easy victory, a continuous and uneventful growth.

Beethoven, on the other hand, persistently tried to suggest conflict and struggle, sometimes with temporary defeat and depression, sometimes with laborious victory. He frequently combined a progressive and a regressive series (both compound, including two main subjects) to convey such effects. Says Douglas Moore in *Listening to Music* (p. 196), "Just as theme amplification suggests added power, theme disintegration is useful to indicate increasing weakness.... It is the progressive disappearance of features of a single motive so that its musical character becomes weaker and weaker. In the Beethoven development there are generally two themes selected for combat. One of them usually grows while the other loses in force. This makes the dramatic implications of the movement very clear." The end of such a combat is usually the disappearance of one theme (e.g., that of the adversaries or carping critics in Strauss's *A Hero's Life*) while the victorious hero's theme sounds forth in exultant fullness as the climax of the combat.

Western civilization has usually believed in the eventual triumph of good and of human aspiration, and has expressed this faith in progress in diverse artistic symbols. Ancient Persian thought, on the other hand, accepted the prospect of a long cyclical or periodic series of victories and defeats. Success went first to Ormuzd (goodness and light) and then to Ahriman (evil and darkness) with only a shadowy hope that good would finally prevail.

If there is no preparation at all for the highly forceful unit, it is likely to break away from its context entirely, and not appear as a culmination of anything. A thematic sequence may contain many minor surprises. Unexpected increases of force, as in the suddenly loud chords of Haydn's *Surprise* Symphony, are accents rather than climaxes. There is nothing necessarily wrong in having the most forceful area of the whole form come without progressive anticipation, as a total surprise; but such an area would not be a climax, strictly speaking. It might lose its intended effect through not preparing the hearer in advance.

Not many steps are necessary to give an effect of

progression. Two or three units increasing in emphasis may suffice. Forms which are not consistently progressive—which are more or less repetitive or periodic—are sometimes made to seem progressive by a sudden, brief ascent to climax near the close. This occurs in many examples of the fugue and of the "theme with variations."

Gradual rise to a climax is not entirely inconsistent with surprise. A climax which is too evident in advance may fail of its intent because the observer has foreseen it too clearly and has discounted its effects. He may even lose interest in a long approach to it. Surprise endings, as in de Maupassant or O. Henry's "The Gift of the Magi," may appear in retrospect to be quite logical and to some extent prepared, even when not completely inevitable or explicitly foreseen. In hearing great melodic development, as in Brahms and Tschaikowsky, we are frequently surprised when the melody does not go exactly where one would have predicted, where a less original composer would have sent it. Yet, as soon as played, it seems a continuous outgrowth of the previous passage. Subtlety and sophistication in art appear in avoiding obvious progressions, and in building series which combine some amount of surprise or discontinuity with some continuity.

Any component trait in which different degrees of intensity, force, or other means of emphasis are recognizable may be used to build up progressive series and climaxes. It may be presented or suggested. In music, loudness is an elementary component in which degrees of intensity are especially obvious. As developed into musical dynamics, it is a powerful means of building up climaxes, not only in a sensory way but through emotional suggestion. Degrees of loudness are closely associated in common experience with degrees of emotional excitement as expressed in outcries of fear, anger, joy, or mirth. Hence increase in loudness tends to express emotional excitement. If the loudness is prolonged, that effect disappears. Sometimes a sudden drop in loudness, as to a tense whisper, has similar suggestions. Increasing tempo and note speed, staccato, rhythm, and increasing irregularity in accent suggest an accelerated, jerky pulse and respiration during excitement. Rising pitch may also have this effect, partly because of its association with the common tendency to raise the voice in pitch during emotional stress. However, very high notes are thin and weak rather than forceful. Certain timbres in music suggest excitement, either through their similarity to other sounds with emotional associations, or through their irregular mixtures of overtones. Some are blaring, strident, piercing, especially the brasses.

Percussive sounds can be brisk or explosive; flutes and violins tend to be more gentle and flowing. All such effects are highly variable and dependent on accompanying factors.

In visual art, increasing lightness (i.e., nearness to white) or increasing luminosity (through more direct or reflected candle power) tends to impress the observer as a rise in general force or intensity. So does increasing chroma or saturation. A change from cooler to warmer hues, from smaller to larger shapes, from smoother to rougher, more variegated textures, may all have a similar effect. Zigzag or swirling lines tend to suggest more emphasis than straight lines or simple arcs; slanting lines, more than horizontals; convex, more than flat or concave surfaces. These tendencies, also, are extremely variable. Sudden darkness can suggest and cause excitement, fear, and suspense.

On the surface of a painting, a textile, or a wall, areas which are more developed through subdivision into small, differentiated parts tend to attract attention away from plainer ones, unless they are made very small and inconspicuous. The part most highly developed in this way may be the climax or chief focus of emphasis for the whole. Thus Spanish Baroque buildings often concentrate raised ornamental details about main architectural features such as entrances and altars, in contrast with large plain areas elsewhere.

The Baroque style in all arts was much given to grandiose climaxes, and this trend is notable in the transition from Renaissance to Baroque in Italian architecture. Early Renaissance Italian architecture was comparatively repetitive and nonclimactic in its long, uniform colonnades and arcades. Baroque churches undertook to develop the region around the main altar into a dramatic architectural climax, associated with the celebration of the mass. The tendency (not uniformly carried out) was to leave the interior comparatively plain near the entrance, so that the eyes and interest as well as the steps of the worshipper would be drawn toward the opposite end. In late Baroque churches, the region of the altar is loaded with all manner of emphatic shapes and colors—sunbursts of zigzag, sculptured light rays, actual brilliant illumination from windows and candles, gilt and richly colored paintings and intricately carved statues of twisting figures, divinities, saints, and angels with trumpets. A notable example is Bernini's Throne of St. Peter in the apse of St. Peter's in Rome.

By this means an approach to temporal sequence is introduced into the experience of the architectural interior. It is to be seen primarily from the entrance to the altar. Though the altars were somewhat em-

phatic in all Christian churches, those in styles other than Baroque allowed one to wander about more freely without feeling a drastic ascent or decline in excitement. The mass itself, in scenes of Baroque splendor, was the crowning climax in a temporal sequence. It fitted consistently into the architectural setting with magnificent vestments, music, ritual gesture, and burning incense.

Many lower-sense qualities—odors, tastes, tactile and kinesthetic sensations—are highly variable in intensity, and also carry powerful emotional associations. Rarely met with in art as presented ingredients, they are common as suggested images in literature. A series of such images, with suggestions of increasing intensity and emotional accompaniment, may involve progression and climax. So may emotion and conation, as in literary expressions of excitement, important success or failure, pleasure and suffering, love and hate, rage, pity, and terror.

Violent, decisive actions, such as physical blows producing death or surrender, often serve as climaxes if gradually approached in previous events. So does any final victory of one side and yielding of the other, as in war, intrigue, or love. In civilized narratives, the physical culmination is often omitted and merely symbolized by some expressive words or gestures. The result is usually to reduce the intensity of the climax, although climactic words or gestures may have intense emotional suggestions.

In tragedy, the climax is usually the final *catastrophe* or downfall of the chief protagonist. In a narrative involving plot with complication and resolution, the climax is usually the decisive step in the *denouement* or final step toward resolution, after which tension is relaxed. In a mystery or detective story, it comes in the solution or discovery of the hidden truth: e.g., of the perpetrator of the crime.

In expository literature, the climax may be reached in the final proof (Q.E.D.) or revelation of the central principle, cause, or explanation. In the mass or other ritual, it comes with the elevation of the host, the partaking of the Eucharist, or some analogous act of crucial symbolic meaning in worship.

The components most used for building up progressive series and climaxes are not necessarily the ones which we have listed in a previous chapter as "architectonic," not necessarily the ones most suited for building up framework patterns. Loudness, for example, is much used for climaxes in music, as color intensity is in painting and suggested emotion in literature. Whether architectonic components are used or not depends somewhat on the medium, however. The engraver may try to build his climaxes out of line

alone. Before the days of the pianoforte, when keyed instruments and even the orchestra had less dynamic range, there was much development (as in Bach) of definitely progressive series and sometimes climaxes, mainly through pitch—that is, through long chains of melodic lines, chord progressions, and modulations. Returning home to the tonic in a final cadence can be a kind of culmination, comparable to that of the *Odyssey,* but it may be a letdown emotionally, rather than a true climax.

When the artist has many components at his disposal, he can build different series with them simultaneously, and can choose whether to make them diverge or coincide. He may combine them in compound progressive series, or may—as often happens—build nonprogressive series out of his architectonic components (e.g., meter and melody) while relying mainly on others for his accents and climaxes.

In using any component to build up a progressive series, the artist is limited by its range of effective variations. In some components, this is much narrower than in others. The range is partly dependent on the medium and its physical properties, partly on the psychological characteristics of the normal observer. Oil paintings, for example, cannot establish a particular degree of luminosity, or increase in it, since the amount of light which will be reflected by a painting is indeterminate and seldom very great by comparison with electric lights or fireworks. High, prolonged luminosity, as that which comes from spotlighting a picture, stage, or cinema screen with extremely bright lights, would tend to dazzle the observer, hurting his eyes and making him unable to distinguish subtle details. Much the same can be said for very loud sounds. What we call "fortissimo" is never very loud in physical units, by comparison with cannon fire and factory whistles. If musical sounds become too loud, they are likely to arouse ridicule or irritation. In trying to increase the sensory or emotional intensity of any image, presented or suggested, the artist soon reaches a point of diminishing returns, where the observer either fails to grasp it as an increase or responds in some unintended way, perhaps by rejecting the stimulus entirely. Raising the pitch of musical tones may have an effect of raising tension and emphasis up to a point, more or less conforming to the normal range of human voices. Above that, it is likely to sound shrill and squeaky, or perhaps delicate and lacy. In any case, the series, although progressive toward a climax in terms of physics (e.g., loudness, highness, or brightness), is not at all sure to impress the observer as a progressive series either perceptually or emotionally.

Hence the artist is forced to devise clever and subtle expedients for making an image, presented or suggested, seem much more intense and powerful than it really is, or than it would appear under different circumstances. An effective means to that end is contrast with weaker, smaller, or less intense images, against which the ones he desires to emphasize will stand out forcefully. Thus a spot of moderately light, dull red in a Rembrandt painting often seems warm, intense, and glowing beside the very dull, dark browns and greens which surround it. When music has been hushed, slow, and low in pitch, the sudden entrance of a moderately high, loud, and fast trumpet solo will stand out with startling intensity by contrast. The St. Christopher in a tiny Flemish painting seems enormous beside the small Christ child whom he carries. Such *gradations* of relative size and emphasis are important in determining accent, dominance, and subordination in all the visual arts, especially painting and sculpture, theater, and architecture.

Since the effect of climax depends on contrast with adjacent, less emphatic areas, that effect cannot be greatly extended in time or space. The observer will soon become adjusted to the higher level of size, speed, loudness, or intensity, and cease to feel it as emphatic. It will no longer suggest excitement, stress, or heightened power, and may cease to hold his attention. Extremely loud passages in concert music are seldom prolonged beyond a few measures. (This is not true of marching and circus music.) Moderate plateaus of emphasis or tension and moderately deep valleys of calm relaxation can be more prolonged. One whole movement in a sonata, one chapter in a novel, or act in a play, can be more excited than its neighbors. Broadly speaking, it may function as a climactic area in relation to other large parts. But within it will be room for several briefer ups and downs, and one of the former may constitute the true climax of the whole design.

In a temporal sequence, if the artist were to progress steadily from less to more intense in any one component, he would very soon reach the physical and psychological limits of progression along that line. Going up the scale of pitches, even chromatically, one soon reaches the limit of any instrument. The same is true of increasing loudness, note speed, or any other component. In literature, a steady increase in images of pleasure, pain, or emotional excitement would soon arrive at the maximum of passion, ecstasy, or frenzy which language can express. The range of perceptible gradations in any one medium or component is always limited.

Hence the artist who wishes to build up a climax in a prolonged temporal sequence is forced as a rule to adopt a *periodic-progressive,* rather than a continuously progressive, type. By rising a little in pitch, loudness, or some other component, then dropping back a little, he has more room to rise on the next flight than if he had gone steadily up. Thus he can prolong indefinitely the general effect of rising. Moreover, as we have seen, a periodic-progressive series in art is not necessarily regular. It can drop back at times to a level lower than its previous drop, back as low as the starting point or lower, then begin the rise all over again. After a period of onward rush, it can pause as if for rest or in indecision; then press on to still higher levels. (The first movement of Beethoven's *Kreutzer* Sonata is a notable example of such irregular, almost spasmodically periodic progression. Notice also Wagner's "Liebestod" in *Tristan* and the "Prize Song" in *Die Meistersinger.*)

Another way of prolonging the progression toward a climax is to use sequences in various components, emphasizing different ones at different times. Now the melodic line can sweep a little higher, with the effect of approaching a peak; now the music can subside in pitch but grow a little louder; now grow soft but accelerate in tempo; and so on. The effect may be one of ever-renewed ascent, as if the attack were resumed in different ways, from different starting points. Various orchestral choirs can be effectively used in this manner, each carrying the ascent for a time.

31. Climactic and nonclimactic series in various arts. Their cultural associations.

In long temporal forms, any device for postponing a climax may fail to satisfy the artist. At times, impatient of any long ascent, he may prefer to reach his principal climax quickly, even at the risk of an excessive letdown afterward. In the *Kreutzer* Sonata, the principal climax comes at the end of the first movement. This, too, is not without analogy in life, where the greatest efforts and emotional climaxes often come in youth, to be followed by a middle and old age of more placid work and recreation. After an early main climax, the composer must rely on other types of development to sustain interest.

The contrast or suggested combat of two themes (mentioned above as frequent in Beethoven) is still another way of delaying ascent and developing design. With one theme only, and that rising steadily in strength, we should have a sort of "theme with varia-

tions" pattern, with increasing quantity specified for each unit: a, 2a, 3a, 4a, etc. But if a second theme is introduced, or several contrasting themes, we approach the rondo form: a, b, 2a, c, 3a, d, 4a. The otherwise steady increase of *a* is interrupted by other themes, which may be less emphatic. If sufficiently emphasized, 4a will function not only as sequential climax for the *a* units, but as sectional climax for the whole movement. By this means, the rondo pattern is often rendered strongly climactic. By an extended coda at the end of a sonata allegro movement, Beethoven often produces climactic effects with this pattern also.

In the literary narrative (drama, epic, or novel), the principal themes can often be reduced to two or three: to love or friendship and hate or antagonism, or, more concretely, to the personal hero (A), his friend and loved ones (B, B^1, etc.), and his hated enemies (C, C^1, etc.). In music, these three themes are clearly contrasted and alternated in Strauss's *A Hero's Life*.

In literature, they are elaborately developed in the *Odyssey*. The main framework pattern of the *Odyssey* is formed by a series of adventures of Odysseus (A), in which his craft and valor are shown (variations of A). He has many friends and loved ones, from the chief of whom (wife, son, and father) he is long separated (B, B^1, B^2). Other comrades accompany him, and temporary loves are met along the way. He meets occasional enemies, such as Polyphemus, on the journey; but his chief enemies are the suitors (C, C^1, C^2) who waste his substance and demand his wife at home. He has divine friends and enemies in heaven, as well. There are scenes at home and in heaven in which his friends (B) and his enemies (C) are contrasted while the hero is absent. There are scenes in which the hero takes part, aided by his friends and opposed by his enemies (AB, AC).

After many minor episodes, containing sectional accents and climaxes, the whole story works up to a powerful and carefully prolonged culmination through a series of minor, preliminary climaxes or *pre-climaxes,* in periodic progression. In Books XIV–XVI the home-coming Odysseus encounters first his old servant and then his son—two peaks of intensity through reunion of the hero with his loved ones. Then, in strong contrast, comes the battle with the suitors (Book XXII), *the main climax of hate and antagonism* (AC). Only after this victory comes *the main climax of love and joy* (AB) in the hero's reunion (Book XXIII) with his faithful Penelope, subtly prolonged through minor delays and misunderstandings. It is open to debate whether one of these two—

the climax of negative or that of positive feeling—is stronger than the other, and constitutes a true main climax for the whole form. Perhaps it is best to consider them together as a contrasting pair.

The postclimactic descent begins with line 300 of Book XXIII, where Odysseus and Penelope recount their trials and adventures in a mood of calm rejoicing. There is a *minor post-climax* of joy and love in Odysseus's meeting with his father (Book XXIV). Finally, near the very end of the poem, there is one of hate and destruction in the victory of Odysseus, his son, and his father, over some remaining enemies. There is a short final descent in the last few lines.

From the standpoint of climaxes, the *Odyssey* is thus very definitely and elaborately organized. As a highly evolved design, it is far from being "primitive," as it is sometimes thought to be.

One may consider the nature of these climaxes in relation to Freud's theory of the "eros" (love) and "death" instincts as the basic human motives, both conscious and unconscious. The eros motive receives its most complete satisfaction in sexual union such as that which constitutes the *Odyssey*'s climax of love and joy, just referred to. The death motive is satisfied by the killing of enemies in the other main climax. Similar satisfactions of both love and hate occur as sectional climaxes earlier in the story (e.g., the Calypso and Polyphemus episodes), but they are minor in relation to the main desires and interests of the hero and his family. The basic physical and emotional satisfactions of union with the beloved and death to the adversary provide, when adequately approached, extremely powerful climaxes. Modern works often lose this intensity, through substituting milder and more indirect, confused, cynical, or incomplete satisfactions or frustrations, and also by trying to maintain a high level of excitement too long.

When two or more important themes (B, C) are contrasted with the principal theme (A), the way is opened for two or more relative climaxes. Each of these themes may be made the basis of a progressive series, and thus there will be a relative, sequential climax for the B and C units as well as for the A. (This refers to *compound* themes, such as a whole character or type of character; a whole motif in music.) The three compound series, though overlapping somewhat along the way, can be kept fairly distinct; they do not merge as closely as component series do. At the end, the artist has several opportunities for building reinforced climaxes. He can combine in one scene, or in one musical passage, the climactic unit for the A series with that for B. He can

then combine the A climax with the C climax. He can distinguish these joint climaxes as the *Odyssey* does (hero and enemies; hero and beloved) or can join them in a single unit, as in stories where the beloved takes part in the final encounter between hero and adversary.

A total climax, reinforced as the culmination of several compound and component series, can function strongly as a *unifier of design*. It can hold together all parts of the form, reaching out into them through its component series as a city reaches out through the roads into the countryside. This integrative effect is exerted quite as strongly, and more subtly, if the various component series do not coincide elsewhere. Suppose that, in a painting, we follow a series of shapes from vague to clear, and finally reach a certain face as clearest of all. We trace another series of units as to increasing color intensity, and again arrive at the same face as most intense in color, though the route has been different. The climactic or terminal unit thus ties together two different series, and possibly many more.

In a similar way, many separate threads in a story—many life ambitions, mounting efforts, coalescing factions—can be made to converge upon one crucial event until a decisive trial of strength is reached, as in the Battle of Waterloo. Here the storyteller's imagination can heighten the effect of convergence beyond the power of strictly factual history, through selecting particular individuals from different localities and walks of life, with different motives and different processes of character development, bringing them all together in the final scene. In the process, the characters themselves had not realized this convergence and the reader, perhaps, had seen it but dimly. In retrospect the whole pattern stands manifest.

Such integration, whether climactic or otherwise, tends to develop suggested causal relations, ways in which people influence each other, as well as undergoing the influence of places, conditions, and other impersonal factors. Separate at first, these can flow together like contrasting, competing melodic sequences.

Beethoven inherited and at first followed with comparative fidelity the traditional sonata type of framework. He developed within it many more climactic progressions. In his later piano sonatas, chamber music, and symphonies, the conventional sonata framework is profoundly modified in many different ways. He did not constantly try to build up climaxes, or substitute regular progressive series, for that would have been too simple and uniform. Life is not always climactic, and Beethoven as a many-sided genius expressed all manner of sequences in mood, desire, and will. He liked the sonata pattern itself as Keats liked the sonnet and other strict patterns; but certainly the musical expression of mounting struggle, of onward rush against obstacles and toward a passionate culmination, was one of his dominant interests. Sometimes, as in the Ninth Symphony, he put the principal climax near the end. But often he put it earlier, and closed with a plateau of moderate intensity or calm resignation. In some ways, Richard Strauss's *A Hero's Life* develops more explicitly the romantic conception of a life struggle in music, with combat of themes along the way and a climactic battle to culminate it. Here the sonata pattern is subordinated to the programmatic representation.

Climactic series in music are not necessarily more programmatic or more romantic than others. Chopin, Schumann, and other Romanticists often chose other types of series, expressing gaiety, wistfulness, anxiety, or other moods in them. Any type of series or pattern can be made programmatic or definitely representational. Romanticism, like classicism, expresses many moods and ideas. In general, it has no definite preference for the climactic type, but rather tends to avoid or dissolve all conventional, regular patterns. Progression to a climax can become such a pattern, and as such irksome to romantics and other rebels in art. Climactic series are congenial to one aspect of romanticism: the heroic, grandiose type, often tragic, as in Byron, Tchaikovsky, Delacroix, and Berlioz. It is prefigured in Baroque painting, sculpture, and architecture. The pastoral, simple-life type of romanticism calls for more level, repetitive, or periodic series, or for very mild climaxes.

There was a phase in Baroque expression, also, which was antipathetic to climaxes. This was the conception of the world as orderly, lawful, governed by a rational deity who made the planets move in regular orbits: the philosophy of deism and the Enlightenment, of Newton and Spinoza. Some European music of the so-called classical period, especially that of J. S. Bach, expressed this sense of order and control. Also, some expressed the light, even gay or wistful sociability of Baroque and Rococo aristocracy, confident in the eternal rightness and stability of its regime. Against these, Romanticism and the Revolution surged into more turbulent struggles, rising at times to frenzied climaxes of destruction and at times to passionate assertion of the individual's right to freedom, beauty, and infinite adventure.

The early sonata pattern as a suite of dances grew directly out of late seventeenth- and eighteenth-cen-

tury thought and entertainment, aristocratic and bourgeois. It expressed this milieu, not only in the details of melody, rhythm, harmony, and orchestration, but in the framework pattern itself. The sonata allegro or first movement pattern was carefully organized in a neatly symmetrical way, with its exposition, development, and recapitulation, like a clever argument in pulpit or law court. Then, as a rule, there was a letdown in complexity and in the amount of attention required to follow structure: a suave slow movement, a graceful minuet, and a brisk, assured finale. The prevalence of the ternary or ABA series in many aspects of the pattern involves a tendency to periodic return, balance, and symmetry. It is easy to introduce progressive series and mild sectional climaxes here and there. If one movement is a theme with variations, it is easy to make the variations increase in speed, loudness, and broken rhythms, thus suggesting greater agitation.

When the first movement suggests a dialogue or struggle between two or more characters, it can easily lead to a dynamic climax with the victory of one. But it is hard to make the whole design, in three or four very different movements, work progressively toward any sort of climax, or in any continuous direction. The framework of the sonata as a whole often suggests diversified entertainment, rather than persistent march toward a goal. Compressing the movements into one continuous whole, as in Liszt's symphonic poems, makes a climactic progression easier.

Most sonatas (including symphonies, concertos, and related types) have no definite program. But the last movement is commonly so light and playful as to suggest, to some critics, a hero saying: "We have done our work; now let the children play in a world we have made more safe and happy for them." This applied, says Donald Tovey, to Brahms's great last movement in the B♭ Major Piano Concerto.

J. W. N. Sullivan finds in the sonata form in four movements an even more abstract analogy with the processes of life. It corresponds, he says,

to a very fundamental and general psychological process, which is the reason why it is found so satisfactory and has been so often employed. The general scheme of a first movement, usually representing a conflict of some kind, followed by a meditative or consoling slow movement, and that by a section easing the way to a vigorous final statement, to the conclusion won, is, in its main lines, admirably adapted to exhibit an important and recurrent psychological process. The life histories of many major

psychological processes can be accommodated within this framework.[3]

However, many composers would deny even this very general sort of program in the sonata as a thematic type. Certainly it does not fit all sonatas, or all the sonatas of Mozart, wherein there is often no discernible conflict.

The *fugue* usually marches steadily through its cycle of changes and on to a definite culmination. Many fugues build up to strong climaxes (e.g., Bach's A Minor Organ Fugue). They often begin with a rather diffuse, free-wandering prelude, after which the fugue itself begins somewhat mildly, with a thin, single voice, building up to a triumphant reaffirmation of the theme. But since it usually lacks strong contrast of theme, the fugue is limited in suggesting conflict. Its steady rhythm and melodic progress tend to suggest the assured exercise of control rather than a difficult, uncertain struggle to succeed or find the way. As such, it is akin to neoclassic deism.

Looking back to medieval music and the Gregorian chant, we are in a world still farther from the modern one of climaxes and conflicts. Although medieval thought is strongly dualistic and concerned with the warfare between good and evil, little expression of this theme finds its way into medieval music. Here the spirit is rather one of meekness, humility, self-effacement and devotion. Sensual enjoyments, including those of sound, are not to be sought for their own sake. Self-will or self-assertion on the part of an individual artist or singer is morally wrong. The attitude of humility is repeatedly expressed, in a slight diminuendo at the end of a phrase, and in the absence of climactic ascents. Strong ascents, together with the free expression of individual desire and struggle for power, were to develop in the Renaissance and later periods.

32. Partial divergence between different compound series in the same design. Climactic and nonclimactic series combined.

In discussing the relations between framework and accessory series, we have noticed a frequent tendency to avoid exact coincidence. Art often sacrifices some unity for the sake of more variety and freedom, for the avoidance of monotonous, excessively tight de-

[3] J. Sullivan, *Beethoven: His Spiritual Development* (New York, 1927), p. 230.

sign. This tendency to slight dislocation is found in the relations between design as a whole and other compositional factors (utility, representation, exposition) in the same work of art, and also in the relations between various thematic series and patterns within the design factor.

The lack of complete conformity is found especially in homophonic music of the eighteenth century and later. Instead of the careful, contrapuntal interlocking of voices in polyphonic music, there is a disposition to have one voice, usually in the bass, maintain a fairly regular meter while the higher ones ramble over and above the treble clef. (This is obvious in Schubert's songs and chamber music, such as the *Forellen* or *Trout* quintet.) The higher voices did not have complete freedom in the nineteenth century. They kept in touch with the bass on the whole, especially on strong beats and in the prevailing tonality. But the interrelation of treble and bass (right and left hands on the piano) was comparable, as we have seen, to that between a vine and trellis. Percussion instruments in the bass and flowing, often syncopated passages for strings and winds in the treble could develop this flexible interlocking to any desired extent. Later, from Wagner through Stravinsky, the metrical trellis has more often been concealed, while the lower voices wander still more freely, often losing their identity as continuous voices.

In discussing rhythmic phrasing in poetry, we have noticed its increasing freedom through the nineteenth century to wander over an implicit metrical framework. Literature has this obvious difficulty, however, that different verbal sequences cannot be well understood when sounded simultaneously. The silent reader is left to imagine both the metric and nonmetric sequences, and to notice how the phrasing deviates in part from the imaginary meter.

Relying on cooperative readers, the lyric poet has considerable leeway in such respects as working up to climaxes. He can do this with several components at once or with only a few, while others remain on a nonclimactic level. But in seeking a climax, he has an additional difficulty, which dramatists and composers do not have, that of presenting his word-sounds more or less intensely or emphatically. Aside from the poor help of italics or capital letters, he must rely mainly on the emotive meanings of the words for emphasis. In Shakespeare's sonnets these difficulties are fully overcome. Along with a steady, nonclimactic meter, some of them develop climaxes in suggested meaning while others do not.

Keats's "Ode to a Nightingale," a longer lyric, also develops two main sequences: one climactic and the

other not. In verse form or basic word-sound framework, it is repetitive and nonclimactic: a material series of eight identical ten-line stanzas. Each has nine pentameter lines and one (the eighth) trimeter, with prevailingly iambic feet. The rhyme scheme in each stanza is a b, a b, c d e, c d e. This small periodic series in rhyme and meter is involved within the large, repetitive stanza series.

Each line and stanza is varied from the rest, of course, in details of rhythm and verbal timbre. Many short, irregular series in these components are built up within the word-sound framework. For example, within the first stanza the long "a" sound of "aches" is repeated in "pains," "opiate," and "drains"; the "e" of "trees," in "green" and "ease." There is a series of words beginning with "d" and a series with "h" in the first stanza; other "d" series occur throughout the poem. Lines beginning with iambic feet are contrasted with those beginning with trochaic feet.

Coextensive with this nonclimactic framework is a framework in the realm of suggested ideas. It is very different in pattern, with divisions overlapping those of the lines and stanzas, and it rises to a climax. Here the main contrasting themes are the familiar moods of sadness and joy. The former (A) is developed with a cluster of images suggesting pain and depression, associated with the world of dreary actuality. The latter (B) is developed with images of song, warm summer, wine and dance, flowers and fragrance; it suggests the world of ideal beauty and happiness.

Theme A extends from the beginning through half the first stanza, where mention of the nightingale ushers in the first statement of B ("thy" is the turning point). This first flight of fancy, to a vision of summer suggested by the bird song, is not powerful; it soon gives place to renewed depression (note the periodic rise and fall). Theme B extends through the rest of stanza I, all of stanza II, and the first line of stanza III until the word "forget" turns the poet's thought back again to theme A, "the weariness, the fever, and the fret" of the actual, present world. It is longer and more specific than the first statement of A, and lasts throughout stanza III. "Away!" is the next turning point, at the start of stanza IV, which ushers in the second and longest statement of B: the most sustained flight of fancy, and the main developmental section of the poem. (Note in passing that the second main theme or subject is here given fullest development, whereas in the sonata pattern it is usually the first theme.)

This section, of flight to realms of ideal beauty, extends throughout stanzas IV, V, VI, and VII. It

works up to a climax of excitement in a way favored by many Romanticists: the desire for death at the moment of highest ecstasy, as a supremely voluptuous culmination. (Compare Wagner's "Liebestod" in *Tristan,* and again compare Freud's "love and death instincts." Here the death wish is turned inward as a suicidal impulse.) The climax is reached in stanza VI:

> Now more than ever seems it rich to die
> To cease upon the midnight with no pain,
> While thou art pouring forth thy soul abroad
> In such an ecstasy!

Stanza VII functions as a postclimactic descent, gradually lowering the emotional tension through a passage of more objective, generalized meditation. Here the poet develops the significance of the bird as an immortal symbol of beauty, appearing in all ages and opening magic casements to adventure. The last word of this stanza, "forlorn," is the final thematic turning point, back to A. Stanza VIII continues the emotional descent, and provides approximate temporal symmetry for the whole design, in bringing the poet back from the imaginary flight to consciousness of himself and of the actual world: "To toll me back from thee to my sole self!"

Retention of the strictly regular word-sound framework in Keats is symptomatic of an intermediate or transitional stage in this respect, between classicism and romanticism. In Whitman, a less classic, more thoroughly romantic poet, that framework dissolved into a freer, more rhapsodic pattern of irregular rhythmic phrases. "Out of the Cradle Endlessly Rocking" is a notable example, comparable in many ways to the example just cited. Whitman also expresses a romantic death wish.

In the *Oedipus King of Thebes* by Sophocles, progression to a powerful climax is direct and unwavering. It consists of the gradual, step-by-step disclosure of Oedipus's double guilt—murder and incest—leading up to the complete revelation and resultant catastrophe. It involves increasing understanding and emotional tension as this goal is inexorably approached.

At the same time, however, two very different sequences run along together in this drama. One is an alternation between passages of dialogue (A) and choruses (B). The former involve particular events, the works and actions of individualized characters. The latter are more general in tone, consisting of comments by a nameless crowd, uttering lyrical meditations, consolations, or interpretive comments. The former are mostly in long meter; the latter, in short. The choruses often involve partial relaxations of tension and thus tend to make the compound total sequence periodic-progressive. Along with this alternating sequence (A, B, A, B, etc.) goes the progressive sequence of steps in disclosure, which we may symbolize as x, 2x, 3x, etc. The sequence of choruses is less climactic, but rises to a peak of agitation after hearing of the double catastrophe.

The complete disclosure and Oedipus's full realization of his guilt occur in the fifteenth step of the series (verses 1182–85). This is a pre-climax, the most emphatic of all the directly acted events. It is exceeded in emotion only by the violent catastrophe narrated at second hand by the Messenger: the Queen's death and the King's self-blinding (step 16). The final descent includes further choruses and a minor post-climax in Oedipus's farewell to his daughters. The disclosure steps occur always in the A passages, so that the combined formula is somewhat as follows: Ax, B, A2x, B, A3x, B . . . A16x, B, (A5x), B. (The post-climax is in parentheses.)

33. Conventional types of compound framework pattern.

We have seen that the framework and materials for thematic development may come from any mode of composition: from a utilitarian type such as a church or armchair, a representational one such as a story or landscape, or an expository one such as an essay or diagram. It can also come from thematic composition itself. The sonnet is a kind of framework for poetic design and the sonata is one for musical design. Both can be defined in terms of themes and thematic relations alone.

Within such a framework, different kinds of composition may develop. A sonnet may tell a story or set forth a philosophical belief. A sonata may, incidentally, represent the sounds of wind and rain. These will be more or less accessory developments, fitted into thematic patterns. Such other compositional factors can be developed into subordinate frameworks of their own.

The sonnet and sonata are both compound framework types, each being defined in terms of more than one component. This distinguishes them from a component pattern such as a five-pointed star, as defined in terms of linear pattern alone. But the distinction between "compound" and "component" is always relative. Any actual five-pointed star, drawn or executed in any medium, can be analyzed into traits of several different components such as angularity, direction, size, color (including black), and texture of

line. The definition of a sonnet involves specifications as to number of lines, rhyme scheme, and the like. That of a sonata involves specifications as to melodic structure, key, and other components.

These concepts, like the types of art they signify, change through the ages. But, in spite of minor differences, there is much agreement on the general types and principal subtypes. Two poems may differ considerably and yet be sonnets, and the same can be said of sonatas. Only a few of the traits which any actual sonnet or sonata will contain are regarded as essential requirements. An account of these requirements will provide a skeleton pattern within which an artist can, if he so chooses, fill in the specific details.

Around the central definition of any important type there is a mass of associated ideas regarding what an example of that type is or ought to be. These develop from the works of influential artists and theorists. Full definitions of a type include: (a) a central core of supposedly essential requirements, without which a work can not be classed as an example of the type; (b) traits regarded as usual but not essential, without which the work may be considered somewhat atypical; and (c) traits recognized as frequent but entirely optional; nonessential to the type. In addition, any particular example will contain optional traits which are not specified in the basic concept. They are extremely variable and not especially associated with the type.

In analyzing an example of a type, it is quite as important to notice the optional as the specified ones—often more so, since they constitute a realm within which his original powers may operate more freely. Some optional traits may be socially regarded as appropriate to the type, cooperative with its other factors, and capable of adequate treatment within the limits of the type concerned.

What we are now calling "conventional framework types" are often called, simply, "forms." Thus the study of "form" in music is sometimes restricted to the study of the sonata, fugue, opera, oratorio, various dance types such as the waltz and mazurka, and so on. We have been using the word "form" in a much broader sense, and so must use a different expression here.

A conventional framework type such as the sonata is not identical with the whole form of any particular sonata, as here defined. The whole form includes not only the framework or frameworks used therein, but all the accessory details as organized within them. A *conventional framework type,* as distinct from a newly invented one, is an abstraction from many particular works, handed down as an artistic and cul-

tural tradition. It is subject to change throughout its history, as treated by successive artists.

34. The Crucifixion scene as a representational framework type for visual design. Expository factors.

The Crucifixion is the name of an event described in a narrative, primarily Biblical (John 19 and Matthew 27) but later developed by the imaginings of countless artists and theologians. As a favored subject in Christian art, it was shown with innumerable variations, some approved by the Church and some not. It achieved its greatest complexity in visual design in the late Renaissance and Baroque, in the hands of such men as Tintoretto, Veronese, and Rubens. This complexity was not achieved without some loss of religious fervor. It was deplored by the devout as turning the sacred scene into a mere dramatic spectacle, full of indifferent men and women, cavaliers and horses, whose only apparent function was to fill a large canvas with decorative details.

The social conception of the scene came to include a few enduring specifications, widely accepted as essential, and many optional, dispensable ones. Which of the latter to portray, and exactly how, was decided for each work by church officials and donors in the light of current styles and tastes, although more and more by the artist and his secular patrons as time went on.

One valuable source for the history of the Crucifixion in visual art, with reference to the features included at different times and places, is the work on Christian iconography by Louis Réau.[4] This and similar authorities provide a basis for inferring what traits have been regarded as essential or optional in the conception at different times and places. Réau refers to the story of the death of Christ as a "tragedy," which it is in some respects but not in the full classical sense: e.g., the protagonist does not have a tragic flaw. It contains three "acts": the carrying of the cross, preparations for the torture, and the crucifixion on Calvary. We shall consider only the third.

The image of Christ on the cross, says Réau, symbolizes the sacrifice of God the Redeemer and also the assurance of each Christian's own salvation.[5] These symbolic meanings form the core of a large

[4]*Iconographie de l'Art chrétien* (Paris, 1957), vol. 2, part II (Nouveau Testament), Ch. V.
[5] Réau, p. 475.

expository factor in the concept; others will be noted later.

Only in the fifth or sixth century, it is said, was Christ shown on the cross in human form. Before that the Crucifixion was indicated by symbols such as the mystic lamb (in the Catacombs) and a jeweled cross (in early Byzantine mosaics). Early Christians rejected the idea of an ignominious execution, but in the fifth century Christ is shown as nailed to the cross between the two robbers. Pictures of him as nude created a scandal and many varieties of garment were added, especially a simple loincloth. A Syrian type, adopted in Rome, clothed him in a long tunic and added several images destined to endure: soldiers drawing lots for another garment; the sun and moon; a spearman and a sponge bearer. In and after the sixth century, the Crucifixion was no longer regarded as ignominious. An attempt was made to emphasize the Savior's genuine sufferings in the flesh. Early representations show him as youthful or bearded, alive and triumphant, with large open eyes. Instead of the crown of thorns he has a royal diadem. His head is lifted and he stands with majesty.

From the eleventh century on, artists began to show him as dead, with eyes shut, head fallen on a shoulder, body bent and weighed down. In the Greek rite, the blood and water from his side are symbolized by heated wine, indicating the incorruptibility of his flesh. In and after the thirteenth century, under the influence of emotional mysticism, the main effort was to move the faithful by the sight of his sufferings. Grünewald, in his painting now at Colmar, carried this tendency to extremes of horror in showing the body of Christ as not only dead but putrefying: spotted with bleeding and greenish wounds. Rubens (1620) heightened the violence by showing Christ being pierced by the soldier's lance.

There are many variants, which we need not try to date, as to (a) the nature of Christ's garment; (b) a peg on which he sits or a board beneath his feet; (c) the location of the nails; (d) the position of his arms; (e) the precise form of the cross (trimmed into shape or left rough, tall or short, bare or leafy; the number and position of cross-pieces, etc.); (f) the color of the cross (green, red, or the color of dead wood).

As to symbolism, the Crucifixion is said to mean the union of the Old and New Testaments. Prophetic analogies from the former sometimes appear: e.g., Abel killed by Cain; the iron serpent on a column; the bunch of grapes from the Promised Land. The sun and moon (as New and Old Testament) are darkened at the moment of death and clouds darken the earth.

They also stand for the Church and Synagogue. Taken together, these build up a complex body of Christian exposition.

At the foot of the cross, in some versions, appears the skull or even the whole skeleton of Adam, the first man to sin, now revived and redeemed. God the Father is occasionally shown above. In some versions, angels catch the blood of Christ in chalices; the pelican tears its breast to feed its young; David and John the Baptist stand by the cross as forerunners.

Individuals who may or may not be present are classed as "actors" or "spectators." The actors include (a) the two thieves, sometimes distinguished as good and bad, one of whom repents and is carried to heaven; (b) the bearers of the spear and the sponge; (c) the soldiers casting lots for the garment. Spectators include the mourners, especially the Virgin, St. John, Mary Magdalen, and other holy women, as well as a scattering of "indifferent" persons, horses, and ornate costumes, helping to make the scene picturesque. For reasons noted above, this tendency was denounced by the Counterreformation. Charles Lebrun, under Louis XIV, called for fewer figures, with none but Mary, John, and the Magdalen, who knelt at the foot of the cross. Some austere persons objected to the presence of the sinful Magdalen.

Evidently, we have not one visual conception of the fateful scene, so focal in Christian art and thought, but many conceptions forming a complex, diversified tradition. What elements can we single out as comparatively essential? Primarily, of course, the main protagonist and the cross. But, as we have seen, even these central elements are imagined in various ways where the Bible leaves them unspecified. These include so important a point as whether Christ is to be shown alive or dead. The sudden darkness, mentioned in the Bible, is often but not always shown. Though mentioned there, the Virgin is not always pictured. She can be shown as strong and stoical or fainting.

From the early miniature style, unrealistic but complex in flat, linear design, there was a gradual trend to complex realism. From the aesthetic standpoint, this could be justified as contributing, not only to the human interest of the story by more characters and actions, but to the opportunities for visual design through arranging them in complex patterns. Some of these aesthetic pressures were more or less sanctioned by reference to the supposed prefiguring of the whole Messianic story in the Old Testament. Opposing them were the more severe authorities, artistic and ecclesiastical, who called for restricting the scene to the few details which were obviously sanctioned by the Scrip-

tures, and which would help produce the desired emotional attitude in pious observers.

In all the versions, even those restricted to fundamentals, the concept of the Crucifixion provides a range of possible frameworks for design. The more liberal the inclusion of supplementary details, the more the design could be elaborated. The number of figures present grew from that of Christ alone on the cross or between the two robbers to a group of five (including the Virgin and St. John), or sometimes to six with the Magdalen kneeling; then, to a small group of other actors and spectators, and finally to a crowd of miscellaneous men and women, some on horseback, richly dressed and paying no attention to so common a sight as a crucifixion. (It was the common Roman punishment for runaway and rebellious slaves.) Donors and officials responsible for the work sometimes added their portraits.

As the number of figures increased, the aesthetic effect of monumental, bilateral symmetry was usually preserved as befitting an event of transcendental solemnity, through regrouping and balancing the figures on both sides of the cross. Bright colors and graceful lines, as in the works of Fra Angelico, could give a sensuous charm to the scene which helped to soften its terrible aspects. A dark, stormy sky was contrasted with strange light on the main figures. In the high Renaissance, Mannerist, and Baroque periods, the taste for bilateral symmetry and balance gave way in part to that for oblique views and compositions heavily weighted on one side; the taste for linear sharpness gave way to that for painterly coloration.

These changes are evident in Veronese's *Crucifixion* (Louvre), in which the spotlight is shifted from the figure on the cross to the fainting Virgin and those supporting her. Rich color appears in the lighted faces and costumes, including some indifferent ones in the distance. The earlier version by Lucas Cranach is hard in texture and sharply linear, but ornate in its fanciful curves of windblown drapery, twisted limbs, and foliage. Picasso was inspired by Grünewald's terrible version to make a series of strangely expressionistic variations on the Crucifixion theme. These are semiabstract, with greatly elongated limbs and bony structures. As the interest in theological symbolism and exposition declined, the emphasis shifted (as in Rubens's versions) to the human drama of the scene with all its different emotions, and also to its possibilities of visual enrichment. The traditional framework insured a basic contrast between the rigid wooden crosses and the curving, sometimes writhing and contorted, bodies. These could easily be related thematically, in shape and color, to the secondary objects, such as clothed human figures, weapons, trees, rocks, and clouds.

Interest in the Crucifixion as a story proceeding in time led to its treatment as successive episodes, with depictions of the raising of the cross and the descent from the cross.[6] These were sometimes presented as a sequence of still pictures. Even when separate, they introduced variations on the central theme, as in the downward movement of bodies (living and dead) in the descent. But the main characters, and the contrast of rigid crosses with curving bodies, still remained.

35. The English sonnet as a conventional type of framework pattern. Its nature in terms of component themes.

The sonnet is a conventional type of verse, Italian in origin, consisting of fourteen lines which are typically in five-foot iambics, with a prescribed rhyme scheme. The English, Elizabethan, or Shakespearean subtype is distinguished from the Petrarchan and others by having its lines grouped in three quatrains and a final couplet, with the rhyme scheme a b a b, c d c d, e f e f, g g.

The general concept of a sonnet thus involves two components, meter and rhyme. As to meter, it specifies that the lines are "typically" five-foot iambics, and that the poem has fourteen of them. The normal or typical sonnet will have five feet to a line, many but not all of them iambic. Few sonnets are completely uniform in these respects. The nature of any particular foot is optional and some variation is almost universal. A poem with more than five feet per line may still be called a sonnet if it conforms in other respects, but fourteen lines are definitely prescribed for the English type.

To prescribe that a sonnet "must contain" fourteen lines is usually taken as a normative rule and a standard of value, implying that a sonnet with fifteen lines is a bad sonnet and a bad poem. Modern artists are inclined to treat such rules with scant reverence and to violate them when they wish to. Some would say that it is of the very nature of a sonnet to follow neoclassical rules with some precision; that to violate them is inconsistent with the spirit of the sonnet and inharmonious; that anyone who writes a fifteen-line poem should call it by some other name. One can say, at least, that a poem of fifteen lines, whether good or

[6] See, for example, Rubens's treatment of both subjects in the cathedral at Antwerp.

bad, is not a sonnet at all according to present established usage. A poet is free to write a fifteen-line poem and call it a sonnet, and if influential he may change the established usage.

Aesthetic morphology, like other sciences, must define its principal terms with some precision and stick to these definitions until there is reason to change them, but its present definitions are not necessarily right or permanent. A biologist might insist that an animal "must have" feathers to be a bird, while there is no such requirement as to its size or color. It is expedient in morphology to accept recognized, authoritative usage on the whole, though reserving the right to depart from it when advisable. This policy applies only to scientific usage in discussing, describing, and classifying works of art; no claim is made that it should govern the writing or critical judgment of poetry. In theory and practice, authoritative usage has often changed on such definitions, as in the case of "comedy," "novel," "romantic," and many other concepts.

In terms of thematic series, an iambic foot is a theme unit. Any actual iambic syllables, such as "believe," would be a compound unit, containing timbre also. But the abstract trait "iambic" is a theme in a single developed component, meter. One iambic foot is a unit of that component theme. A line of five iambic feet is a repetitive sequence of such units. If occasional trochaic feet were substituted, the sequence would be varied. Fourteen such sequences are added together in temporal succession to make the sonnet. In terms of meter, then, the sonnet is a repetitive or varied sequence of about seventy iambic feet, divided into fourteen smaller sequences of five feet each. The division is effected visually by printing each line on a separate level, with a capital initial letter. Audibly, it is usually effected by a slight pause (rhythmic variation), or by a dropping or raising of the voice in pitch. This, however, is not specified in the definition. It is taken for granted as a general convention of verse.

As to the English sonnet, it is further specified that the lines or five-foot sequences be grouped into three quatrains and a couplet, into four subordinate sequences within the total sequence of fourteen. The first three are to be of four lines each; the fourth, of two lines. This division into stanzas is sometimes indicated in print by putting double spaces between them; in reading, by a pause or inflection of the voice. Again this is not specified, and the division may be made only by rhyme scheme.

In terms of meter, then, we have in the English sonnet a moderately complex component pattern in-

volving at least three inclusions. The foot is included in a sequence called a line; the lines are included in a stanza, quatrain, or couplet; and the stanzas are included in the sonnet as a whole. If we analyze the feet into separate beats, each foot is a contrast of strong and weak, loud and soft, or both. An iambic line is an alternating sequence of such very small theme units as to accent, quantity (relative duration), or both.

The other specified component is *rhyme*. The rhyme scheme is to be a b a b, c d c d, e f e f, g g. Each of these letters stands for a theme in the component "rhyme," a development of timbre in word-sounds. In Shakespeare's Sonnet XXIX, the first *a* is exemplified by the syllable "eyes" and the second by "cries." Thus "cries" is a variation of "eyes" in respect to timbre. The first *b* unit, "state," is varied in the unit "fate." The first unit of each is a compound theme to be varied. One can abstract the "ies" sound from the first theme and the "ate" sound from the second, as being essential timbre themes which are varied by being combined with other letters or timbres. In timbre and its development, rhyme, there are thus two contrasting themes in the first quatrain, arranged to form an alternating series, a b a b. In the second and third quatrains there are different themes. The first is "hope" (theme c) and the second (d) is the last part of "possessed." But these are arranged in the same alternating order. The same is true of the third quatrain, e f e f.

Quatrains 1, 2, and 3 are themselves a sequence of similar units in respect to rhyme, in that each contains two contrasting themes, each of which is repeated once with variation, in alternation with the other. The quatrain units are varied in that each uses a different and contrasting set of timbre themes or rhyming syllables. The final couplet is similar to the quatrains in that it repeats a unique timbre theme once with variation. This makes it a fourth unit in the sequence of stanzas or main divisions of the sonnet. But it is varied in having only one theme, with no contrast and no alternation.

The two component series thus specified are complex enough to be called component patterns, one in meter and one in rhyme. They reinforce and partly coincide with each other. The metrical division into lines is reinforced by the rhyming syllables which mark the ends of the lines. The metrical division into stanzas is reinforced by the difference in timbre between the four sets of rhyming syllables. Having the rhymed couplet at the end tends to terminate the fourteen-line sequence definitely, bounding it temporally with a different unit. Otherwise it might

seem that the sequence of quatrains, rhyming alternatingly, was going to proceed indefinitely. The sudden change from alternation to repetition stops that sequence and the expectation of its continuance. It often suggests finality and a concise, definite conclusion to the line of thought.

The specifications as to the two components may be diagrammed as follows, to indicate the framework pattern of the English sonnet. The second unit in each rhyme series is marked with a superior number 1: e.g., as in a^1:

$$\text{U/U/U/U/U} \quad a$$
$$\text{U/U/U/U/U} \quad b$$
$$\text{U/U/U/U/U} \quad a^1$$
$$\text{U/U/U/U/U} \quad b^1$$

$$\text{U/U/U/U/U} \quad c$$
$$\text{U/U/U/U/U} \quad d$$
$$\text{U/U/U/U/U} \quad c^1$$
$$\text{U/U/U/U/U} \quad d^1$$

$$\text{U/U/U/U/U} \quad e$$
$$\text{U/U/U/U/U} \quad f$$
$$\text{U/U/U/U/U} \quad e^1$$
$$\text{U/U/U/U/U} \quad f^1$$

$$\text{U/U/U/U/U} \quad g$$
$$\text{U/U/U/U/U} \quad g^1$$

36. Unspecified, optional traits. Accessory traits in relation to the framework. Turning points.

What is left unspecified here in terms of components? In the first place, many features of the poem as to both rhythm and rhyme. As to *rhythm,* although the metrical pattern is specified in a general way, variations in the accent and quantity of individual feet are widely practiced. There is no specification as to possible developments of rhythm through varied *phrasing.* Something along this line is almost invariably done through the construction of sentences, clauses, and phrases. These involve pauses, long and short, which are indicated in print by punctuation marks. (E.g., "When, in disgrace.") Such divisions form small groupings or sequences of syllables, and of strong and weak beats, in their own right. One tends to speak or read together the sequence of words composing a clause or sentence.

Such divisions may or may not coincide with the metrical division into lines and stanzas. Often they do not, for such complete coincidence is sometimes re-

garded as monotonous and jingly. Subtle variations and complexities of rhythm are produced by the occasional coincidence and occasional divergence of rhythmic groupings. The beginning and end of a clause or sentence will sometimes correspond with the beginning and end of a line or stanza. Sometimes they will not, and the sentence will carry over into the next metrical unit. This may partly obscure the division into lines and quatrains. Exceptional stresses, as indicated by italics or exclamation points, are also optional. The reader, silent or audible, tends to imagine the regular metrical beat underlying the irregular rhythms of the actual words, and perhaps to hear the latter as variations of the former.

As to *rhyme,* the particular themes are of course unspecified. It is taken for granted that they will conform to the general usage of English verse, which bans rich rhymes: that is, which insists on variation in the sounds accompanying the main timbre theme. ("Prize" and "surprise" are not used together, being regarded as close repetitions.) There is latitude for invention in choice of rhyming sounds, and in the degree to which any rhyming pair will resemble each other.

These specifications leave open (a) the details of word-sound development in respect to assonance, alliteration, and internal rhymes, and (b) the whole of what is ordinarily called the "content" or "meaning" of the poem: its suggested imagery, emotions, desires, beliefs; its possible representational, expository, or utilitarian development. Series and patterns in these components may or may not correspond with the framework.

It is precisely in regard to the unspecified aspects that the principal differences will be found between one sonnet and another. These are the flesh and blood of any particular sonnet. The poet's handling of these may give his sonnet individuality, originality, variety and unity, power to interest and affect the reader. The study of sonnets and of other poems in fixed forms should not be confined to noting their nature as typical sonnets, the ways in which they are all more or less alike. One may do this first, but then include and emphasize the ways in which sonnets differ. This can be done, for example, by comparing the Shakespearean sonnets with each other. All of them conform substantially to the same skeleton framework, but they differ widely and significantly in other respects. These respects can all be noted and described in terms of components, component themes and series, and their integration in compound series and patterns.

By "unspecified" we mean here "unspecified in the

definition of the framework type." Some details are unspecified even in the finished poem as a printed visual form: for example, exact pitch inflections and tones of voice. These are directed only in part by the poet through punctuation and sentence structure. Otherwise, they are optional for the reader, and constitute a realm for his personal interpretation. They are not necessarily parts of the poem as an objective form, unless determined by cultural usage.

It has been said that the sonnet form is used especially for expressing a single emotion, sentiment, or reflection. This is often the case, but Shakespeare's Sonnet XXIX ("When, in disgrace with fortune and men's eyes") contains a contrast of two opposite emotions. It has been said that the final couplet of the English sonnet "is often epigrammatic or climactic" (Webster). This is true, but not all such couplets are so in Shakespeare or elsewhere. The sudden brevity and compression of the final couplet as a word-sound pattern often suggests a crisp finality in thinking, but such traits are optional and not essential to the sonnet as a conventional type.

In the sonnet, the framework is composed of a typical arrangement of meter and rhyme themes. Embroidered over it are several accessory sequences or patterns: some auditory, of various rhythms and verbal timbres, and some of other suggested images, concepts, desires, and emotions. These accessory sequences rarely if ever conform exactly to the framework. If they did, the result would be a monotonous jingle, and all Shakespearean sonnets would be much alike. Suggested images, concepts, desires, and emotions do not, as a rule, group themselves neatly into three quatrains and a couplet. They overflow such divisions, and form new divisions, in the midst of quatrains and even of lines. (Enjambed or run-on lines are often used.) The ideas form distinct sequences, and sometimes fairly regular patterns, different from the framework and different from those of any other sonnet.

Consider, for example, Shakespeare's Sonnet XXIX:

When, in disgrace with fortune and men's eyes,
I all alone beweep my outcast state
And trouble deaf heaven with my bootless cries
And look upon myself and curse my fate,
Wishing me like to one more rich in hope,
Featured like him, like him with friends possessed,
Desiring this man's art and that man's scope,
With what I most enjoy contented least;
Yet in these thoughts myself almost despising,
Haply I think on thee, and then my state,

Like to the lark at break of day arising
From sullen earth, sings hymns at heaven's gate;
For thy sweet love remembered such wealth brings
That then I scorn to change my state with kings.

Here the arrangement of ideas (other than suggested word-sounds) is one of contrast between two principal subjects: depression and elation. The first is developed with illustrative images, causes of sorrow and details of mood, through the first nine lines. Then comes a *turning point,*[7] in the words "Haply I think on thee . . ." The rest of the sonnet develops the second subject, showing how it results from this thought and illustrating it in turn with details of mood, including the simile of the rising lark. The sequence is a simple one, A, B.

Sonnet XXX uses very similar themes: sadness (at remembrance of things past) in contrast with satisfaction and the end of sorrow "the while I think on thee." But here the turning point and the second theme do not come until the final couplet. Sonnet XXXIII provides an alternating series of contrasting image clusters (A, B, A, B, A, B) around the ideas of "glorious sunshine" and "basest clouds." Each theme is a metaphor to contrast the beloved's opposite moods. Here the idea series coincide with the word-sound series, the first stanza being devoted to A, the second to B. The third gives two lines to each, the final couplet combines them.

Sonnet LXVI contrasts the poet's suicidal resentment toward life with his desire to live for the sake of his love. But here the second theme is postponed until the final line. The first thirteen lines form a strikingly repetitious pattern of similarly worded charges against life, bounded by two lines beginning "Tired with all these." The sonnet framework is in each case not a cramping mold but a foundation and starting point. Conformity of accessory sequences with it is not carried to extremes in the interest of unity.

In many poems the arrangement of ideas is so definitely patterned and at the same time so divergent from the basic word-sound framework, that it amounts to a second framework, equally clear and extensive. This can be said of Shakespeare's Sonnet XXIX. The almost symmetrical opposition of the two main, general themes in the simple sequence A, B is a framework in that accessory details are fitted into it: namely, the images which illustrate and explain both

[7] A turning point is a place or moment, usually in a temporal sequence, in which there is a more or less radical change in the direction of the action, and perhaps also in the principal theme, the mood and other components.

general themes, filling them out into consistently contrasted groups of specific ideas.

Such double frameworks, one of word-sounds and one of diversified meanings, are common in both classic and romantic verse. When they correspond almost exactly, to form a single compound framework, the effect is one of extremely tight integration. It is suited to brief, confident, clearly organized epigrams like that of Dryden on Milton:

> Three poets, in three distant ages born,
> Greece, Italy, and England did adorn.
> The first in loftiness of thought surpassed,
> The next in majesty, in both the last.
> The force of Nature could no farther go;
> To make a third she joined the former two.

Here the word-sound divisions correspond almost exactly with the steps in exposition of ideas. All the lines are end-stopped and the rhyme scheme is repetitious. When carried out into longer patterns, as in extended series of heroic couplets, such an effect is likely to impress modern readers as too artificial and monotonous, through the cramping of thoughts into tightly regular molds.

Long poems in any definite verse pattern tend to develop another framework of ideas which diverges more or less from the word-sound framework. In "free verse," the word-sound framework tends to become somewhat loose and irregular, and in prose even more so. The pattern of ideas can become the most definite framework, or the only one. Thematic word-sound series, in the shape of occasional, irregular phrases containing traces of rhythm and euphony, then become accessories, fitted into the structure of ideas.

37. Complex literary design and the role of intermediate frameworks.

We have been considering various types of *series and patterns of intermediate size,* between the largest and the smallest levels in a design. This section will deal with their literary aspects. In aesthetic perception and also in morphological analysis, their main function is to assist the observer's process of organizing the details of the object in his own experience. They help the artist to enrich the design with many details, while not producing an effect of confusion. Without these bridges between the very large and the very small, the task would be much harder. From the

standpoint of the artist, their function may be one of unifying and strengthening the work of art, so that it will not fall apart and will operate harmoniously.

One cannot well understand a complex utilitarian form such as a house or automobile if one looks directly from the smallest units, the nails, planks, bricks, and mortar of the house or the pieces of steel, glass, and rubber in the automobile, to the total operating form. One must see also how they are organized into subordinate systems such as rooms, walls, roof, wiring, plumbing, windows, and doors in the house; chassis, ignition, transmission, cooling system, body, doors, and windows in the car. The smallest parts do not, as a rule, directly serve the whole mechanism directly. A few of them cooperate with neighboring small units to make a certain subordinate system work; this system interacts with other systems of intermediate size to form still larger constituent systems which cooperate within the framework of the whole. Much the same can be said of any other complex mechanism, as in law and government, industry and education, rocketry and space travel.

It is significant that Near Eastern, Islamic culture produced not only ultracomplex rug and mosaic designs but also literary designs of remarkable complexity. To modern Western taste they have come to seem excessively complex: hard to follow from memory and perhaps not worth the effort. But storytelling by the hour, often without the aid of written text, has traditionally been a major art in the Near East. One heard the tales of *The Arabian Nights* over and over and learned to follow their multiple inclusions, which did not prevent their popularity.

Richard G. Moulton provides this typical plot scheme from *The Arabian Nights:*[8]

Frame Story of Scheherazade
 Story of the Hunchback, and the Four implicated in his Death
 Story (1) of the Christian Merchant—containing
 Story of the Handless Man
 Story (2) of the Mussulman Purveyor—containing
 Story of the Thumbless Man
 Story (3) of the Jewish Physician—containing
 Story of the Mutilated Patient
 Story (4) of the Tailor—containing
 Story of the Lame Guest

[8] G. Moulton, *The Modern Study of Literature* (Chicago, 1915), p. 147. What Moulton calls the "frame story" is only one part of a literary framework as described in the present book. The latter includes the inner structure of the stories on all levels. Accessories include the imagery, characterization, and incidents on all levels.

Story of the Chattering Barber
Of the Barber's first brother (hunchback)
Of the Barber's second brother (toothless)
Of the Barber's third brother (blind)
Of the Barber's fourth brother (one-eyed)
Of the Barber's fifth brother (no ears)
Of the Barber's sixth brother (harelipped)
Story of the Barber concluded
Story of the Tailor concluded
Story of the Hunchback concluded
Frame Story resumed

Beginning with the "frame story" of Scheherazade (which encompasses the whole of *The Arabian Nights*), we may count it as the first level going down. On the second level going down, the first inclusion is the Story of the Hunchback; the second inclusion is that of the Christian Merchant; the third inclusion is that of the Handless Man. That area of the work has four levels and three inclusions, but a little later the Story of the Chattering Barber (fourth level) is subdivided into the six stories of the Barber's brothers. They are all on the fifth level, and this part has four inclusions. Most of the stories can be still further subdivided into situations and brief incidents whose names do not appear in the above list of titles.

After a descent to lower levels of inclusion the order of telling (which we have called the transmissional order) rises again, step by step, to the main "frame story" of Scheherazade. This kind of fall and rise, or division and recombination, occurs many times in the thousand and one nights covered. The recombination on each level produces a temporally symmetrical frame. Also, it reverts to the compound theme which had been stated on that level previously. Thus we are reminded of the unfinished story of the Tailor and that of the Hunchback. We note their conclusions as completing those frameworks with a sort of cadence, after which we are carried into another set of complex frameworks. All the stories in the plot scheme as listed above are intermediate except that of Scheherazade, which is all-inclusive, and those of the Barber's six brothers, which do not include any other complete stories so far as this list indicates.

The *Odyssey* has been mentioned several times in previous chapters, most recently as an example of complex, climactic design. Let us consider it again as an example of intermediate frameworks and inclusions.

In the factor of word-sounds, the flowing hexameters provide as usual a steady undercurrent of even but varied rhythmic feet and phrases, together with the countless timbre series of the Greek words. They

diverge, of course, from the pattern of events. In the component of characterization, the epic hero himself, a mythical prototype of the Western ideal of resourceful, crafty, practical intelligence, unifies the whole story. Other figures, divine and human, more or less friendly and sympathetic, support or obstruct his actions.

The main plot divides itself, along lines which have become traditional, into complication and resolution, the former consisting of nine wonder incidents, most of which have obstructed the hero's return home. They are the incidents of the Cicones, the Cyclops, the Lotus-eaters, the cave of Aeolus, the Laestrygonian giants, Circe's isle, Hades, various prophetic incidents, and that of Calypso's isle.[9] These are balanced by nine episodes of adventure which constitute the resolution, whose subjects are the council of the gods, Odysseus's home in his absence, Telemachus in search of his father, the isle of Calypso, the Phaeacian wonderland, the cot of Eumaeus, Odysseus as the wandering beggar, catastrophe and triumph, and conclusion to the story. Complication and resolution form two main intermediate frameworks. But the resolution is divided in the middle into two equal parts: in the Phaeacian wonderland, after his rescue from shipwreck, Odysseus tells the story of the nine wonder incidents, his journey up to that point. After that, the rest of the resolution, comprising his journey and arrival home, is told by the omniscient observer.

The *Odyssey* as a whole begins *in medias res,* with a council of the gods to consider Odysseus's troubles. When we enter the story, Odysseus's fortunes are already beginning to improve, and we learn about the worst of them through his own account at the Phaeacian court.

These various parts of the complication and resolution, with the story of the former inserted in the midst of the latter, provide intermediate frameworks. In addition, many of the shorter tales, which Moulton describes as "incidents," themselves contain smaller incidents and therefore act as intermediate frameworks. Of this sort is the story of the Cyclops, which has its own little complication and resolution. After a situation of danger and fear, Odysseus and his men outwit and blind Polyphemus and escape to the sea.

The all-inclusive plot of the epic, seen in the large, is of the U type. But the resolution also develops a periodic-progressive sequence of intermediate units. Obstruction and danger from hostile forces provide one principal theme. It alternates repeatedly with suc-

[9] *The Modern Study of Literature,* p. 140.

cess, escape from danger, and resumption of the journey home. Both themes recur in varied form and contrast with each other. As the final stages of the journey are reached, the mood changes from one of frequent anxiety to one of relief and glad anticipation.

Shakespeare, whose love of complex plots was long considered a fault by neoclassicists, produced a wide range of plot types, both simple and complex. On the whole they are much more complex than those of Greek drama. The plot of *The Winter's Tale* is comparatively simple but neatly (some would say too neatly) symmetrical and regular. It is of the U type. Complication and resolution divide the play into a first and second half, separated by an oracle which constitutes the main turning point to rising fortunes. Each half is an intermediate framework combining the parallel fortunes of six characters. The first part tells of their fall: lost wife, lost friend, lost son, lost babe, lost minister (Camillo), and lost servant (Antigonus). It tells also of the strife between Sicilia and Bohemia. All these are due to the jealous madness of Leontes. The tone is tense and tragic. The oracle reveals the past sixfold descent and foretells a sixfold restoration. Symmetrically, step by step, Antigonus's widow is united to Camillo, the minister is restored, the lost daughter found, an old friend's son becomes a son-in-law, the friend is restored, and the wife also, as if from the grave. In this second half the tone and some of the scenes are pastoral, with relaxing tension and increasing happiness. The love of two young people unites the two states.[10]

On the other hand, *The Merchant of Venice* is an interweaving of four distinct stories: that of Antonio, Shylock, and the pound of flesh; that of Portia, Bassanio, and the caskets; that of Portia, Bassanio, and the betrothal ring; and that of the elopement of Jessica and Lorenzo. They are woven together as a main plot and underplot, the former including two main actions (the Shylock story and the casket story), each with a subaction (Jessica and Lorenzo are subordinate to the first, the rings to the second). The two main actions are connected by the character of Bassanio and by Jessica's link action. The first main action balances the second through the transfer of the Jessica interest to the second. There is a contrary motion between the two main actions, the first being resolved by the second. Complications recur, but Bassanio's choice brings together the four actions and the opposing forces. Portia's judgment brings success and rising fortunes to some, but catastrophe to Shylock.

Both of these recurring types of organization act as intermediate frameworks. Each distinct story or action, centering on one or more characters through all or part of the plot, provides a compound series developed in space, time, and causality. Each series provides one kind of framework, in which a number of incidents and situations, deeds, desires, and emotions are arranged. They are linked together by characters, moods, and actions which affect two or more of them at the same time.

Another kind of framework, even more inclusive, consists of the general movements toward complication and then resolution. Usually all or most of the action threads take part in both, not exactly at the same time, but with spreading repercussions from one to another. Suspense is preserved by having all or nearly all of them caught in some form of complication until a main turning point shifts the trend into resolution. First one and then another of the principal characters achieves his final status, good or bad. Accordingly, both the complicative and the resolving phase provide framework sequences to combine and interrelate the various action threads.

38. *Levels of complexity in visual design, especially in architecture.*

In discussing compound thematic development, we saw that it is possible to estimate the degree of complexity in a design through counting the number of inclusions of part within part. The "parts" referred to in this connection are compound parts which have some observable development (differentiation and integration), except for the simplest ones within a given area. These last are elementary parts within which no definite, smaller parts can be discerned. As one moves closer and closer to the façade of a cathedral, definite designs within designs come into view which, from a greater distance, seemed only uniform or variegated surfaces. A tower discloses different levels, openings, arches, colonnades, perhaps a belfry and a slender spire. What had seemed merely a circle in the façade is now a rose window with radiating traceries of stone between flatter areas of glass. This continues until one reaches, anywhere in the façade, a point of no further differentiation. One reaches, perhaps, a jewel in the crown of a queen which is a convex circle of uniform, smooth stone. The process can be reversed by moving away.

We have also noted that a certain design is often more complex in certain areas than in others, e.g.,

[10] *The Modern Study of Literature*, p. 192.

concentrates ornament around a door or window in a plain wall. It will have more inclusions in that part than in others. One may complicate certain components, as in adding colors to the architectural ornament around the openings. Thus to be more complex "on the whole" does not necessarily mean being more complex throughout or in all respects. Most very large designs, such as those of architecture and landscaping, involve some comparatively plain, simple areas to rest the eyes and to contrast with the more elaborate ones. Large, blank walls, unbroken lawns and courtyards have these functions.

In architecture, there can be small thematic series among the individual bricks or stones around a window: some dark, some light; some square, some oblong, combining into a pattern of small units. "Dark, square, red, rough" may be one compound theme, and "light, oblong, black, smooth" a contrasting one. Each is repeated many times, and perhaps varied. At the same time, the whole window may be treated as a theme in a larger series. The whole pattern of different stones around the window, and the casement, mullion, glass, etc., within it, may be treated as one motif and repeated several times along a wall. This motif as a whole may be contrasted with a different one, perhaps a much plainer type, in alternation with the ornate one. In other words, there is a set of themes and theme units on the level of the individual stone, and there is a larger one on the window level. (The word "level" is not intended here as meaning a floor or story of a building, but as degree of size or complexity.) Either set and either level can receive more development. The pattern of stones can be very complex while the pattern of windows is simple, perhaps with two or three units exactly repeated. A number of differently shaped windows can be arranged to make a complex pattern in a wall, while the individual stones around each are plain and repetitive.

It was mentioned in previous chapters that the observation of design can be *analytic or synthetic,* according to whether one goes from large to small or from small to large, from the whole to smaller and smaller details or in the opposite direction. According to the direction chosen, one may assign a different number to each level of inclusion, although the total will be the same in either case. Synthetically, beginning with the smallest units, the first level of development in music is the single tone or beat. The second level, and the first inclusion, occurs in the smallest figure or subfigure which groups together two or more tones or silent beats. From there one goes up, level by level, to the symphony as a whole. Analytically, the symphony as a whole is the first level. The

second, and the first inclusion, is encountered in the division of the symphony into movements. From there we can go down, level by level, to single tones.

In either case, one is moving up and down, as it were, along a path which may be figuratively called *vertical.* It is like looking up and down through a classified table, say of biological types, between the most broad and general at the top and the most narrow and specific at the bottom.

One can also look *horizontally,* along a certain level of classification: for example, to compare various biological genera with each other, or various species with each other. Thematic observation also can proceed horizontally. Staying on approximately the same level, we can observe thematic relations among units of that size. We can study the small-unit series by themselves, as if microscopically, or the large-unit series, or those of medium size. In a cathedral, we can compare the doorways with each other; or (moving to larger units) compare the façade and the side elevations with each other. In a rug, we can compare all the medallions of a certain intermediate size, noticing perhaps that some have blue figures against red backgrounds, some the opposite, and so on. Then, coming close, we may concentrate on the ways in which tiny leaves or jewels within each medallion are constructed throughout. For thorough perception, we must notice all the levels and their vertical interrelations. But it is often useful to stay on one level for a considerable time, if much development has taken place there. For example, one may compare the doorways of many different buildings, and use them as one criterion for distinguishing styles; the same for windows, for columns, and for other parts of intermediate size.

Division into levels is one kind of differentiation, that as to size. It is also a kind of integration, making large and small units conform to one framework. But there are other ways of differentiating units. A pen-and-ink drawing may be extremely complex as to number of inclusions, being divided and subdivided into infinitesimal, lacelike units. At the same time, an oil painting which has fewer inclusions may be more complex in another way, in having more differentiation among its units on the same approximate level, as to color, texture, deep space, etc. A thing can be compound and highly differentiated without being complex, if its parts are loosely and discontinuously assembled.

Most frameworks cannot be analyzed without bringing in more than one *mode of composition.* As we have seen, the basic framework of a design is often built up primarily in terms of some mode of composi-

tion other than thematic. If so, it may be convenient to observe and describe its inclusions primarily in terms of that mode. For example, one can notice panels within a door within a wall of a house, thus thinking in utilitarian terms. Or one can notice features within faces within figures within groups of figures in a painted crowd scene, thus thinking in representational terms. Since these levels and parts may also function as levels and parts in design, by virtue of their thematic relations, a description of them from a nonthematic standpoint may go far toward pointing out their thematic relations also.

What is the relation between "levels" and "parts" of a design? Musical phrases, movements, and the like are commonly regarded as parts of different length: a phrase as short, a movement as comparatively long. Either one can be comparatively simple or complex in its internal structure. The same is true of acts and scenes in a play. The length or size of a part, its mere temporal or spatial extension, does not necessarily imply any fixed degree of complexity. It may be large and yet very simple, if it is made up of comparatively uniform, undifferentiated units. A passage in music may, theoretically, be of movement length, and yet be a series of varied repetitions of one melodic theme. (In Ravel's *Bolero,* the units are individually complex but the series of variations into which they are combined is simple.) The stone blocks or tiles in a wall may have complex individual patterns, yet be combined in a simple, repetitive area.

In some designs, the small patterns are individually complex, the large ones simple; in some, the opposite is true. Both may be simple, or both complex. Broadly speaking, any design is complex if it contains complex units, but that does not take us very far in understanding its peculiar kind or degree of complexity. We must observe the kind and degree of complexity which exist *on each level of size:* the relative amounts of differentiation and integration which exist among the small units, and which exist among the large units. Then we shall discover on which level or levels of the design the chief development has occurred. Designs differ greatly in this respect, even within the same art, and this helps to distinguish historic styles.

39. *Intermediate frameworks in complex flat design in textiles and painting.*

In a complex work of art, the task of providing intermediate frameworks to organize the work and aid observers to perceive that organization is mainly one for the artist. It is the observer's task to notice these frameworks and to see their relation to smaller and larger units in the total design. An intermediate framework, moderately complex in itself, may result from dividing and subdividing a simple framework.

Let us say that a sketch for a *rug* design begins with a rectangular area of plain dark red, surrounded by a narrow border of yellowish brown. We may then divide and subdivide each of these areas. The border may be divided into five parallel strips of different breadth and coloring, some subdivided into leaf and flower motifs, some into geometrical motifs. The central field may be likewise divided, first by a diamond-shaped area, its corners touching the innermost border at the centers of the four sides. This leaves four corners of the central field to be colored and subdivided in one way, while the diamond-shaped area is differently developed. In the process, border and central field have become complex intermediate frameworks, containing as many subdivisions as the artist wishes to make.

The following main types of Persian rug design are commonly distinguished: compartmental, geometric, floral, garden, hunting, prayer, and medallion. Of these, the floral, garden, and hunting are defined primarily in terms of representational content; the prayer rugs, in terms of utilitarian form and function; the geometric and medallion, in terms of presented visual pattern. In all of them, the visual pattern usually constitutes the main compositional framework.

The representational factors contribute important intermediate frameworks to the total design. Some of these are symbolic and derived from ancient Near Eastern wall tiles and sculptural reliefs. They include the man on horseback (a hunter or warrior), the tree of life, the ibex (as symbol of the water from which life emerged), and the animal combat, as in the lion devouring a gazelle. The prayer rug often depicts the lamp and columns of a mihrab in addition to its religious meaning as pointing to Mecca. All these figures are highly stylized and usually small, being fitted as details into the main framework of central field and borders. However, they are not too small to be minutely subdivided. Simplified outlines of birds, flowers, palm leaves, and other natural phenomena, fancifully colored, serve as motifs on various levels of size. Leafy vines and arabesques connect them.

The main or comprehensive framework is usually symmetrical or approximately so, both vertically and bilaterally. (Prayer rugs are only partially so.) Slight variations of line and color can be found in compar-

ing the units of each series, and these may give a touch of free irregularity to the whole.

Such irregularity of shape and color is usually far less than that in contemporary abstract painting, with which the Persian rug is sometimes compared. The latter is sometimes abstract or nonrepresentational, but it differs in being extremely formal and tightly controlled by a preconceived plan. It is somewhat objective and impersonal. Contemporary abstract, action, and related schools of painting tend rather to emphasize the artist's individual, emotional expression and to avoid symmetrical patterns or other definite, complex plans.

Turning again to *painting,* let us recall the ultracomplex design of Seurat's *The Models.* Here the imaginary scene as a whole is the main framework. Within it the scene of the models in a studio corner, with another painting by the artist himself on the left wall, provides the principal one of two intermediate frameworks. Here we regard the painting as a painting: a framed, flat piece of canvas with pigment on it. The other is provided by the imaginary scene represented in that painting: the scene of bourgeois Parisians enjoying an outing near the Grande Jatte. Smaller intermediate frameworks are arranged (a) in subvistas of small figures in the distance of the same painting, and (b) groups of objects in the studio corner; two mounds of garments, each with parasol, hat, glove, and slippers; a group of pictures and an undergarment on the wall. As usual in an integrated design, the main compound parts and intermediate frameworks are held together by component series. For example, the arcs formed by the back of the girl at right, the yellow hat beside her, the white petticoat of the girl at left, and parts of the garment on the wall are echoed in the bosom and bustle of the woman in the Grande Jatte and in the open parasols within that scene.

The pervasive green of the grass and purple of the clothing in the *Grande Jatte,* the painting on the left wall, are carried on in smaller areas of the studio corner: greens in the stockings and objects on the wall at right. Varied tones of red, violet, orange, and yellow appear in both main parts. The series of curves does not coincide entirely with that of any one hue; we see it now with yellow, now with white, now with green, and now with purple. The same can be said of the angular series at left. We see it there with yellow, but with other hues in the parasol and the model's knee at right. Straight lines and angles are stated also in the intersection of the wall, the floor, and the picture frame; in the well-dressed man's cane and the distant tree trunks. Thus any particular component trait unit plays its part (a) in one or more intermediate frameworks and (b) in a component series linking some of these frameworks together.

Pictorial frameworks are not always regular, hard, or conspicuous. In Impressionist painting they are often quite the opposite. In Monet's *Antibes* (Plate I) many thematic relations exist, as they do in traditional landscape painting, but in a comparatively blurred, soft, and delicate form.

The basic framework here is representational: a view of a sunny springtime landscape on the Mediterranean coast. One is led to imagine it as if one were looking down from a hillside, across a pink-roofed cottage and a blue harbor, of which only a glimpse appears, to distant hills and sky. The house is firmly built, although the main emphasis is on its sun-bathed surfaces. Below the roof stands a series of rigid square-cut posts supporting the square roof. They combine with a small, rigid, vertical chimney and some tall, rigid, vertical buildings in the middle distance. These establish thematic series in line, surface, solid shape, and perspective. Contrasting with them is a softer series of young flowering trees with lacy, bending tops. They form a secondary grouping right and left, thus helping to bound the vista through which we look.

Trees and cottage combine to fill the lower, nearby half of the picture as an intermediate framework. A few dark areas in the foreground help to hold the floating vista together and down upon the grassy earth. The picture's upper, distant part has its own framework in the harbor view, which includes the rocks and vertical buildings. Like the foreground scene, they seem to float and shimmer on the blue water against the far-off sloping hills. Among the unifying factors are (a) the tinge of reflected pink in the blue sky and (b) the nearby treetops which overlap the distant view.

Within this framework are the accessory but powerful hues and tints which dominate the picture as representation and design. They provide contrasting series of intense, light rose and blue in roof and sky. Blues and reds blend to form intermediate connecting series of dark purple in the foreground shadows. Dots and streaks of light and intense color give an Impressionist quality of sparkling sunlight, but the older French landscape tradition of clarity, depth, and basic organization is not forgotten or ignored.

A few observations on a Sung Dynasty Chinese handscroll may help to show the partial analogy be-

tween this art and that of music. Both are temporal in operation, although the painting is a static object when not being shown. Both proceed by varied sequences of compound thematic units, large and small, inclusive and included. This landscape scroll is entitled *Streams and Mountains Without End* (Figs. 75, 76).

Again the main framework is representational, this time a broad panorama of rugged mountain scenery. We are made to perceive it as if we were high above the ground, on a level with some of the mountaintops, although the perspective is free. One feels at times as if flying through the air from right to left, and at times as if traveling forward and backward, in and out among the hills and valleys. An effect of temporal sequence is produced as the scroll is unrolled at the right-hand end (in accordance with convention) and rolled up again at the left. One sees only part of it at a time. The main framework sequence tends to assume a periodic-progressive form, rising as one moves from right to left, then falling a little, then rising again a little higher than before until the final climax is reached.

In this imaginary journey, one discovers the main repeated themes and theme-units. The basic framework series is produced by high and low, near and far hills and valleys. Theme A consists of low, blurred stretches of land with small vegetation, dunes and level shores in middle distance. Theme B consists of tall, dark pine trees, in the foreground but at some distance from our imaginary viewpoint. It is often combined with Theme C, consisting of tall deciduous trees. The pine trees have straight or jagged trunks. On a rocky promontory (Theme D) the trees rise as they recede from the eye to medium-high rocky bluffs. This ascent continues, right to left, in middle ground and foreground, with scattered pines on the cliffs. Meanwhile, in the foreground and in the gap between nearby rocky cliffs, small wooden houses, fences, a wall, and other structures appear (Theme E), many with thatched roofs. Far up and left (Theme F) appears a small human figure.

Units of each theme form a varied, compound series. The series differ somewhat in brushstroke and other stylistic traits. Taken together, they make up the diversified, periodic-progressive sequence just mentioned. This is interspersed with steep clefts which briefly arrest and reverse the prevailing movement upward and toward the left. As distant mountains in ascending ledges (Theme D) rise to a minor, preliminary climax, the tall pines and deciduous trees (C) come closer to us, thus developing that area down-

ward. It opens out into a clearing, wherein several human figures (F) are at work among extensive wooden structures (E), including more fences, huts, a large house, and a bridge.

As these complications develop in the middle ground, Theme G (a small boat) appears below and near to us. It is guided by two men, one with a pole, in the direction opposite to our main movement. This helps to suggest a circular movement toward the little bay formed by rocks, hut, and bridge. Beneath the bridge, we see a low waterfall (Theme H). As this complex, diversified area narrows, from top and bottom simultaneously, it brings an end to the minor climactic unit just passed. But then a smaller rise occurs in the background, along with a small thrust in the foreground. Thus our imaginary vision travels far and near, in and out of the landscape as it goes up and down in vertical space. In this minor postclimactic unit, one's attention is caught by the waterfall (Theme H), higher and narrower than before, at the center of the unit. The unit then dwindles in size and emphasis through dark and light, repeating several themes with variations (C, D, E). It is succeeded by a vaguely defined open space with little to catch the eye, stretching far away into wooded cliffs of medium height (B, C, D). Each group of diversified theme-units, marked off by clefts and ridges, becomes an intermediate section with its own minor framework, helping to link the very large and very small.

Now begins a long, jagged, undulating ascent to the main climax. It involves with variations all the themes above noted, bringing each one out somewhere in full force, distinctness, and diversity. The human figure theme (F) is augmented by a weary horse and rider on a nearby bridge. In the middle distance, clumps of deciduous trees are softened by the mist, while groves of pine stand out more darkly with their small green needles, delicately brushed, and the dark jagged outlines of their trunks.

Meanwhile, in middle distance, the theme of wooden structures (E) rises to lofty, complex architecture in a palace or temple above the mist, and then to a loftier, more ornate one with a double roof. The rocky heights, tree-crowned, now rise a little and jut forward, then sink away again as the waterfall (H) becomes a cataract over small rocks.

Now all the themes are recapitulated with mounting energy, up to a great main climax with cliffs and different trees rising and falling pell-mell from right to left. A few little human figures (one astride a donkey, another fishing from a small boat) appear in the foreground as they must do to avoid being lost in

distant woods and mountains. Even so, they seem small, weak, and inconspicuous before the towering grandeur of the hills and forests.

Passing another small boat, this time empty, and a low final statement of the falling stream, we enter another pause or hiatus of relative calm and emptiness. This is the postclimactic descent, and from here the action rises only briefly and partially through a sequence of low, undulating hills, meadows, and low, scattered trees.

40. The sonata as a conventional type of musical framework pattern.

One of the most complex of these recurrent framework types is the sonata. We have already considered it in general terms, and this section will examine it more closely as involving intermediate sectional frameworks.

There are several sources of confusion. On one hand, the term "sonata" is applied to a type of entire composition, especially to a fairly long work for one or two instruments, usually in three or four movements. Its framework pattern is commonly called sonata form. However, this form is used not only in pieces called sonatas, but also in the symphony, concerto, string quartet, and other kinds of orchestral and chamber music. We shall call it the *classical full sonata pattern*. It covers a sequence of movements, usually three or four.

On the other hand, the term "sonata form" is also applied to a certain kind of framework pattern for a *single movement,* often the first one of a sonata or similar work. It is sometimes called the sonata allegro form or the sonata first movement form, because the first movement of the neoclassical sonata is often written in that pattern and is often allegro in tempo. This is a poor distinction, because the pattern is not always used in the first movement of a sonata, and that movement is not always allegro. However, we shall call it the *sonata allegro pattern* for want of a better name. At least, it serves to distinguish a kind of framework used in a single movement from one used in a whole composition of several movements.

The two conceptions can be combined as the *total framework* of a sonata in three or four movements, the first of which is in the sonata allegro pattern. This will produce a fairly typical formula, much used or approximated but not universal in works called sonatas. (For example, it is not followed in Beethoven's last piano sonata, Op. 111.)

Some traits usually regarded as typical of the classical *full sonata* pattern are the contrast of movements (fast, slow, scherzo, fast) and the linking together of these movements by key relations, emotional expression, and other stylistic traits. In the *sonata allegro* pattern, the most typical feature is the division into three main parts—an exposition, a development, and a recapitulation—with the possibility of an introduction at the beginning and a coda at the end.

The typical full sonata pattern is approximately as follows:

First movement: usually fast and in sonata allegro pattern:
 Introduction (optional); slow.
 Exposition (theme-establishing statements of the two main subjects).
 First or principal subject, in tonic key.
 Transition: bridge to related key.
 Second or subordinate subject, in related but contrasting key (dominant if tonic is major; otherwise, relative major). Possible third or closing theme, ending in cadence or semi-cadence in key of second subject.
 Development.
 Recapitulation.
 First subject, in tonic key.
 Transition.
 Second subject, in tonic key.
 Coda (optional).
Second movement: slow; often adagio, largo, or andante; often in song (A, B, A) or variation pattern.
Third movement: minuet or scherzo; usually ternary.
Fourth movement: finale; may be rondo, sonata allegro, fugue, theme with variations, or other.

Obviously, the term "exposition" does not refer here to one of the four modes of composition, but to something entirely different. It refers to the first, theme-establishing statement of the main subjects. This is a small but important part of one kind of musical design. It was called the "enunciation" by H. A. Harding.[11] Donald F. Tovey calls it "First Group" and "Second Group."[12] But the term "exposition" seems most widely used today.

The first and second subjects are often treated, and regarded by listeners, as "masculine" and "feminine":

[11] H. Harding, *Analysis of Form as Displayed in Beethoven's Thirty-two Pianoforte Sonatas* (London, 1901), p. iii.
 [12] D. Tovey, *A Companion to Beethoven's Pianoforte Sonatas* (London, 1944).

the one as strong, firm, energetic, decisive, and perhaps serious; the other as gentle, soft, gay or wistful, and lyrical. This is especially true in romantic music. An example of such dualism is in Brahms's Sonata in C Major for Piano, Op. 1, No. 1. At times the dualism suggests a dialogue, sometimes gay and friendly, sometimes in opposition. Besides the main subjects, the exposition may contain one or more episodes, bridges, repetitions, and a coda. Each of these parts can provide a short, intermediate framework for the organization of still shorter figures and phrases.

We have been using "development" broadly to mean "complicative growth" in general, but here it refers to another section of the sonata allegro pattern. This is one in which the composer plays freely, in various keys, with bits of one or both subjects and other thematic material if he so desires. The development can be longer or shorter than the exposition. Schubert tends to spin it out to considerable length. In Beethoven's Sonata, Op. 10, No. 1, it is reduced to a single measure, while the exposition has forty-four, the recapitulation forty-five, and the coda twenty-two. His last piano sonata, Op. 111, has only two movements, but each is elaborately divided. The first contains an introduction and the three standard parts of the sonata allegro pattern, each of which is subdivided. The exposition has a first subject, a connecting episode, a second subject, a coda, and a double bar for repeat. The second movement, an arietta, is in "theme and variations" form, with seven sections and three codas.

As to comprehensive framework, these are some *varieties or subtypes of sonata.* Unless so regarded, their kinship in structure may be overlooked. They are often written in full sonata pattern, though not necessarily in the strict classic style as here defined. They are distinguished mainly on a basis of timbre or instrumentation, as follows.

1. The *piano sonata,* for piano alone. (Commonly omits the scherzo or minuet movement and contains three movements only; but traces of the dance movement may be left in passages within one of the other movements.)

2. The *sonata for violin and piano,* or the *violin sonata with piano accompaniment.* To use the former term implies that the piano part is emphatic and developed in its own right, and not a mere accompaniment.

3. The *chamber music sonata,* usually called a "string quartet," "quintet," etc., according to the number and kinds of instrumental timbres. It involves three or more, but many fewer than in a full orchestra. A "trio" as a sonata for three instruments must be distinguished from a trio as part of a minuet movement.

4. The *symphony:* the *orchestral* or *symphonic sonata,* for full orchestra, with no one instrument strongly emphasized throughout. Most fully developed examples of the sonata form, with four movements, are not called "sonatas" at all, but "symphonies." The nature of the orchestration is not specified as part of the definition of the symphony, and there has been much development in this respect since the classical period. Increase in the variety and power of instrumental timbres has gone along with a frequent tendency to blur and simplify the patterns once produced by other components. Thematic series and patterns in respect to timbre itself have been produced, but they vary greatly and are often not closely bound up with the sonata pattern. However, they may be so bound up. For example, in the history of the minuet (ancestor of the minuet movement of the classical symphony) orchestration sometimes followed the ternary structure of the melodic units. With the playing of the first minuet in the dance movement, the orchestration tends to fall into a ternary series, as in going from A (minuet proper, for full orchestra) to B (trio, for three woodwinds), and then back to A (first minuet repeated, for full orchestra).

5. The *choral symphony,* or *sonata for orchestra and voices,* such as Beethoven's Ninth.

6. The *concerto,* or *sonata for orchestra and solo instrument.* Such an instrument, usually piano, violin, or cello, is not solo in the sense of playing alone throughout the piece, but in being strongly emphasized and highly developed throughout most of the piece. Occasionally it is silent, subordinate, or merged with other instruments. The classical concerto usually has a double exposition: first one for orchestra, then one for solo instrument. In the modern concerto there is a tendency to compress the movements into two or one, to play them more continuously and partially merge them in form; to introduce the solo instrument more promptly at the start.

Some more specific expressive tendencies are frequently associated with the various movements:

1. First movement, if in sonata allegro pattern: usually brisk, energetic, lively; sometimes but not necessarily "merry" or "gay" (the literal meanings of the Italian "allegro"); sometimes agitated.

2. Second (slow) movement: usually more songlike, lyrical, often calm, meditative, grave, relaxed.

3. Third movement: if scherzo, often

sprightly, humorous; if minuet, more sweet and grace-
ful; sometimes dainty or stately.

4. Fourth movement, or third as finale: often
brisk, energetic. Tendency to light gaiety in Rococo
music; often serious and fiery in Beethoven.

41. Levels of complexity in various arts. Intermediate frameworks.

Among the types of art where highly complex designs
occur are the following: Celtic and Gothic book il-
lumination, Byzantine mosaics, Islamic arabesques of
carved wood and stucco, Persian rugs and miniature
painting. These are all static and subject to long, in-
tensive observation if one wishes to see them in de-
tail. Large and small designs, inclusive and included,
are spread out together before one's eyes for leisurely
perception. This is also true to some extent of early
Flemish painting such as that of the brothers Van
Eyck, Patinir, Van der Goes, and Van der Weyden.
All of these tend to organize small details in frame-
works of large and intermediate size, and thus to fa-
cilitate complex apperception of the design.

On the other hand, we have noted the fact that
music and dramatic enactment provide the observer's
organs of sense with a rapid flow of sensory stimuli
and suggested meanings. If the work is complex, un-
less he already knows it or has trained himself to fast
apperception, he may have all he can do to grasp it
thoroughly as it speeds along. Shakespeare's plots
have seemed too complex to many critics, who pre-
ferred the simpler forms imposed upon the drama by
the three traditional unities. Contrapuntal music in
the late seventeenth and early eighteenth centuries
produced elaborate polyphonic designs including a
variety of inversions and other thematic transforma-
tions, easy enough to follow on paper, but too hard
for many listeners to follow by ear. They lost favor in
competition with homophonic music and simple
counterpoint in the nineteenth century.

To perceive with ease the larger series and patterns
of musical design requires either help from printed
programs or strong powers of quick, organic percep-
tion, plus a retentive memory. To grasp an auditory
design of large proportions in a time art requires that,
while listening to the fleeting moment of symphonic
sound, one remember the general outlines of what has
just preceded it, and of what came before that. As
each moment rapidly sends more stimuli to the ears,

one must connect them with what went before. One
may be able to anticipate, from hearing a partly
finished, growing pattern of events, what the finished
series or pattern will probably be like. If the music
proceeds along unexpected lines, one must revise
one's expectation accordingly, with considerable
speed. All that the ordinary listener can perceive with
comparative ease is the fleeting moment of structured
sound, the blend of instrumental timbres, chords, and
bits of melody which is falling at the moment, excit-
ingly or soothingly, upon his ears. This is largely due
to the development, by composer and performers, of
the smaller units and series: in music, the figures,
phrases, periods, and cadences which he can grasp
without trying to follow the gradual development of
larger ones.

To a lesser extent, this is true of stage enactment
and the cinema also. Many observers are content to
grasp the passing images in the flow of words and
actions without trying to follow the long, gradual
working out of some elaborate complication and reso-
lution, some slow, profound change in character and
situation.

In symphonic music, one may expect to find rela-
tively simple, quiet areas, thinned-out textures, sus-
tained chords and rests, to contrast with the busier
passages, crowded with rapidly changing harmonies,
rhythms, and melodic figures. Some styles of archi-
tecture and interior design, especially the Islamic,
have shown a tendency to cover every available sur-
face with closely packed ornamentation. Some West-
ern music maintains a dense, complex texture through-
out, like a closely woven silk brocade. There are
types of Japanese Buddhist music, on the other
hand, with long silent pauses between the tones of a
bell or flute. A single bell stroke with many over-
tones, or a single, isolated tone on a flute, can func-
tion as a complete work of art.

Some primitive and Oriental music is complex on
the lowest levels only, in very small units. A complex
motif for drums or gamelan can be stated in a way
that would correspond to a rhythmic phrase in West-
ern music, comprising four or five measures. After
that, there may be a long repetitive or slightly varied
series which does not seem to go anywhere; it does
not build up large contrasting sequences or climaxes,
as in Western music. After many repetitions, the mu-
sic may suddenly stop with no cadence. This is espe-
cially true of Balinese music.

Differentiation and integration can exist on any or
every level, among small parts or among large parts.

In other words, there can be *different themes* and thematic series on *different levels* of the same design. Designs are not always organized so elaborately, but they can be. The common practice in musical theory of limiting the term "theme" to units of a certain approximate size (usually a phrase or period) tends to obscure the important fact that thematic relations exist among much larger units, and among much smaller units. A theme can be of figure length, or of movement length. A whole movement can be repeated as a theme, exactly (as by repeat marks at the end) or with variation. A large movement section can be played at the beginning of a symphony, and repeated with variation at the end, thus giving temporal symmetry. In Beethoven's Fifth, what is commonly called "the theme" (the famous four notes) is of short figure length. But even where the obvious principal theme or subject is longer, we can always analyze it into smaller units such as figures, and find that thematic relations exist among these also, even though they do not stand out in isolation as in the Beethoven Fifth. A certain figure is used as a miniature compound theme within the larger compound theme. The larger theme is a sequence of such figure units, repeated, varied, and perhaps contrasted.

Thematic series on the various levels in a complex design are often very different, and this tends to increase the total amount of complexity. The movement series in a sonata has no necessary analogy to any series of phrase units or smaller series. Let us say that, in terms of tempo and mood, it is A, B, A (fast and lively, slow and serious, fast and lively). Looking down into the phrase level of a movement, we may discover that it too contains an A, B, A or ternary series, in which case there is a unifying resemblance between small and large series. Or we may discover that the movement is internally constructed as A, A^1, A^2, etc., in which case the large and small unit levels differ from each other.

Complex musical design consists of temporal series within temporal series, of patterns within patterns. To be clearly grasped, it must be apperceived as presented on various levels of inclusion, as involving units and series of different sizes. The following list covers the chief types of compound unit in Western music, from small to large:

a. Single notes, chords, or rests.
b. Subfigures.
c. Figures.
d. Phrase sections.
e. Phrases.
f. Periods.
g. Subject parts (may be more or less than a period).
h. Subject statements (e.g., each variation in a "theme with variations").
i. Movement sections (e.g., the exposition in a sonata).
j. Movements.
k. Sonatas; symphonies; symphonic poems; acts of operas.
l. Concert programs; whole operas.
m. Cycles of concert programs or operas.

On each of these levels, some thematic development is possible. In other words, a unit of each type or level of size can be repeated, varied, and contrasted with others of the same type or level.

Not all these types occur in all music. There is probably no single musical composition which involves them all, distinctly and systematically. Most music is simpler, using few levels. Much is blurred and vague in structure, so that one level blends indistinguishably into the next larger or smaller. Only extremely clear-cut, complex music makes definite distinctions between many levels, and carries out systematic development on each. The above list is intended as a list of theoretical possibilities, of types occasionally found here and there in music, though never all together. By listing them together, we can gain a clearer idea of what musical design might become if extreme complexity were its main objective.

In terms of this list of levels and of relative unit sizes, where do the intermediate frameworks appear? That depends on which levels are included in a given composition. If we are thinking of a symphony (k), the symphonic type of form provides the all-inclusive framework. Within it, the movements (j) provide the largest intermediate frameworks. Looking upward on the list, the type of unit on each level can provide intermediate frameworks for the smaller ones above it. If that type of unit is distinctly realized in the composition concerned, it serves to organize any and all the smaller types. If the subject statement (h) is the highest level and the largest type produced in this case, then the subject statement is the inclusive framework. Within it, a phrase would function as an intermediate framework for whatever phrase sections, figures, subfigures, and single notes are definitely marked off. A subject statement by itself would be, of course, a comparatively short piece of music, such

as ordinarily constitutes only the chief, opening theme of a sonata. The terms "movement" and "movement section" are not ordinarily applied to a complete composition, but compositions of similar length and character are often presented as complete under other names.

On the lowest two levels mentioned above, there is wide variety as to degree of integration. Level (1), next to the last, ordinarily fills the time span known as an "evening," that is, an entertainment lasting some two to four hours, more or less. An opera of that length is usually a distinct, unified composition, but sometimes two shorter ones are provided, or an opera with a ballet interlude. A concert program, on the other hand, is usually more miscellaneous, often presenting a variety of instruments, performers, composers, and historic styles. But sometimes it is planned as a consistent whole: e.g., a Beethoven concert or a concert of eighteenth-century harpsichord music. In that case, whether so intended or not, the various compositions will probably contain some thematic recurrence, enough to constitute one or more loosely strung thematic series. With the whole concert program as inclusive framework, the total form of each constituent work becomes an intermediate framework. The type of form produced by Wagner in his cycle of music dramas called *The Ring of the Nibelungs,* each of which occupies a fairly long evening, is one of the largest unified musical (or musico-dramatic) forms yet achieved in Western art.

The temporal arts in recent years have, on the whole, tended to enrich each moment in their works with textures and small patterns easily grasped. These arts have often been content with simple patterns and irregular forms in the larger units, and with enriching passing musical texture through more harmonic dissonances, more instrumental timbres, more frequent changes and shorter series in meter and rhythmic phrasing.

This trend continues in the present vogue of mixed, noninstrumental timbres from "concrete" and "electronic" music. It has involved a tendency to eliminate or restrict the development of large traditional forms based on key relations, counterpoint, and sustained melodic line. But it is theoretically possible to organize the new types of ingredient into larger designs, new and old, whenever composers and the public wish to have them.

Works of art more complex than any yet achieved can, in theory, be produced by designing large, inhabited regions containing many cities, into unified spatial forms, or extending sequences of operas, bal-lets, or literary works to much greater length. The limits are not inherent in the nature of the design, but in the tastes and desires of human beings.

42. The thematic schema in design; an outline for descriptive analysis.

A. Is thematic development largely *presented? Suggested? Both?* (E.g., in poetry, through arrangement of word-sounds and also of meanings.)

B. *Type of presentation:* visual; auditory; audio-visual; visual and tactile, etc. (i.e., with definite thematic development so addressed).

C. *Dimensions* of space and time in which *presented* thematic development occurs (e.g., four-dimensional, in ballet).

D. Is *suggestive* development temporal, or spatial only?

E. Is the total thematic effect *conspicuous* and attention-holding, or inconspicuous, recessive? How? (E.g., through subdued color or sound, repetitious arrangement, lack of accents and climaxes, etc.)

F. Is emphasis strongly concentrated to form a *climax* of the whole, in space or time?

G. What general *types of theme and pattern* predominate? (E.g., geometric; biomorphic; classic; romantic.)

H. *What is the main thematic framework?*

1. If both presented and suggested thematic series exist, do they involve distinct frameworks, extending through the whole form? Is one series made to coincide with the other? (E.g., pattern of meanings with pattern of word-sounds.)

2. If distinct thematic frameworks exist, describe each in answer to the questions below. In what ways do they diverge? Coincide?

3. What type of *series or pattern* is constituted by each of these extensive thematic frameworks? Does it form a repetitive, progressive, or other definite type of series? A wheellike, pyramidal, or other pattern?

4. Does the framework involve gradual progression to a climax? What minor climaxes and principal accents occur?

I. Relations to *other compositional factors.*

1. Is main thematic framework provided by some other compositional factor? Are thematic arrangements accessory to such a framework? (E.g., as in a realistic painting or story.)

2. Is the design purely functional and structural, in having no thematic development in addition to that

necessary for utilitarian functioning? If such additions exist, are they subordinated to the utilitarian framework?

3. In a representational or expository framework, are thematic developments introduced which do not function, or are not necessary, from these other standpoints? (E.g., as applied, superficial decoration.)

4. Is the basic framework of the whole work of art thematic? (E.g., a fugue or an abstract textile pattern.) If so, to what extent are developments in other compositional factors fitted into this framework? (E.g., animal details in a rug pattern.) Is the design abstract or naturalistic?

J. *Compound thematic analysis.* What are the main compound *parts,* as shown in the basic framework of the whole form? (E.g., legs, arms, seat, back of chair. Border, field, central motifs in a rug design.)

1. How are these related thematically? (E.g., do they repeat certain component themes, as a cylindrical shape or mahogany texture? Certain compound themes, as a harmonized melodic figure or a colored linear motif?)

2. Is their detailed thematic development similar or different? (E.g., chair backs covered, some with silk, some with carving.) Slightly contrasting or radically different?

3. Do they combine to form a single, unified design? To what extent does their thematic arrangement diverge from the basic framework?

4. How are individual compound parts internally differentiated? Divided into smaller units and varied? How are these linked by resemblances and common frameworks?

5. What other compound themes and series exist? (E.g., decorative motifs which do not constitute main framework parts, such as applied surface pattern.) How varied, contrasted, integrated?

K. *Levels of complexity in design.*

1. On how many levels of inclusion, part within part, can definite thematic relations be distinguished? A different number in different compound parts? (I.e., are some compound parts more complex than others?)

2. To what extent and how do the thematic series

or patterns on these various levels resemble or differ from each other?

3. To what extent and how are they integrated by frameworks, comprehensive and intermediate?

L. *Component thematic analysis.*

1. What *components,* elementary or developed, are most actively used in the design as a whole? In each main part of it? (Analyze into either elementary or developed components, as convenient in this particular art and work of art. In music and literature, developed components such as melody and characterization, and in static visual design, elementary ones such as color and line, are usually more convenient.)

2. What principal *themes* are used in each of these components? What main *contrasts* of theme occur, within each component? (E.g., red and blue in hue; gay and solemn in mood.)

3. To what extent are other, *subordinate* themes and theme units introduced?

4. To what extent is the design *diversified* as to the number of different components actively used and developed? (Component diversity.)

5. Within each main component, how many different themes are actively used? (Monothematic, bithematic, polythematic types of series and pattern.)

6. What principal thematic *series and patterns* are produced in each main component, through repetition, variation, contrast and subordination to common frameworks?

7. *Types of series.* Are most of these series repetitive? Varied? Contrasting? Progressive? Periodic? Of different types?

8. To what extent do all components *cooperate* thematically, through reinforcing framework series, patterns, accents, and climaxes, thus building up a unified design?

Note: The following illustrations are particularly relevant to this chapter: Plates IV, V, VI, VII, VIII; Figures 2, 4, 5, 6, 7, 10, 11, 12, 13, 14, 16, 17, 18, 21, 22, 23, 24, 30, 34, 35, 37, 38, 39, 46, 47, 49, 50, 51, 52, 53, 55, 56, 59, 61, 62, 63, 66, 68, 69, 70, 71, 72, 73, 74, 75, 77, 79, 84, 86, 91, 92.

BIBLIOGRAPHY

Aristotle. *The Poetics*. Translated by S. H. Butcher, 4th ed. London, 1929. Translated by Ingram Bywater as *De Poetica* in Vol. XI of *The Works of Aristotle, Translated into English*. Oxford, 1924.

Arnason, H. H., and Pedro E. Guerrero. *Calder*. Princeton, N. J., 1966.

Arnheim, Rudolph. *Picasso's Guernica: The Genesis of a Painting*. Berkeley, Calif., 1962.

Beardsley, Monroe C., and Herbert M. Schueller, eds. *Aesthetic Inquiry: Essays on Art Criticism and the Philosophy of Art*. Belmont, Calif., 1966.

Cirlot, J. E. *A Dictionary of Symbols*. Translated by Jack Sage. New York, 1962.

Cleveland Museum of Art, The. *Selected Works: The Cleveland Museum of Art*. Cleveland, Ohio, 1966.

Daiches, David. *A Study of Literature*. Ithaca, N. Y., 1948.

de Givry, Grillot. *Witchcraft, Magic and Alchemy*. Translated by J. Courtenay Locke. London, 1931.

Dunbar, H. Flanders. *Symbolism in Medieval Thought*. New Haven, Conn., 1929.

Duncan, Elmer H. *Twenty Year Cumulative Index to the Journal of Aesthetics and Art Criticism*. New York, 1964.

Encyclopedia of World Art. Published by McGraw-Hill Book Co., Inc. London, 1959–64.

Fleming, William. *Arts and Ideas*. New York, 1955, 1968.

Green, Douglass M. *Form in Tonal Music*. New York, 1965.

Grohmann, Will. *Kandinsky*. New York, 1958.

Henning, Edward B. *Fifty Years of Modern Art*. Cleveland, Ohio, 1966.

Hesiod. *Poems and Fragments*. Translated by A. W. Mair. Oxford, 1908.

Holt, Rosa B. *Oriental and Occidental Rugs, Antique and Modern*. Garden City, N. Y., 1937.

Jacobsen, Charles W. *Oriental Rugs: A Complete Guide*. Rutland, Vt., 1962.

Janson, H. W. *History of Art*. Englewood Cliffs, N. J., and New York, 1962.

Kenton, Edna. *The Book of Earths*. New York, 1928.

Lee, Sherman E. *A History of Far Eastern Art*. Engle-wood Cliffs, N. J., and New York, 1964. (The painting *Streams and Mountains Without End* is discussed on pages 350–51.)

Lee, Sherman E. *Japanese Decorative Style*. Cleveland, Ohio, 1961.

Lehel, François. *Morphologie Comparée des Arts*. Paris, 1930.

Lucretius. *De Rerum Natura*, with an English translation by W. H. D. Rouse. Cambridge, Mass., 1924.

Maiuri, Bianca. *The National Museum, Naples*. Novara, Italy, 1959.

Moulton, Richard G. *The Modern Study of Literature*. Chicago, Ill., 1915.

Newman, William S. *Understanding Music*. New York, 1952.

Munro, Thomas. *Toward Science in Aesthetics*. New York, 1956. (Esp. pp. 18–47, 85–192.)

Olson, Eleanor. "A Tibetan Wheel of Existence." *Oriental Art*, Winter 1963, pp. 204–9.

Parker, De Witt H. *The Analysis of Art*. New Haven, Conn., 1926.

Prall, D. W. *Aesthetic Analysis*. New York, 1936.

Reti, Rudolph. *The Thematic Process in Music*. New York, 1951.

Rudrauf, Lucien. *L'Annonciation: Etude d'un thème plastique et de ses variations en peinture et en sculpture*. Paris, 1943.

Santayana, George. *The Sense of Beauty*. New York, 1896.

Tovey, Donald F. *Essays in Musical Analysis*. 6 vols. London, 1935–39.

Ueda, Makoto. *Literary and Art Theories in Japan*. Cleveland, Ohio, 1967.

Wellek, R., and Austin Warren. *Theory of Literature*. New York, 1942.

Whyte, Lancelot Law. *Accent on Form*. New York, 1954.

Wölfflin, Heinrich. *Principles of Art History: The Problem of the Development of Style in Later Art*. Translated by M. D. Hottinger. New York, 1932.

Wölfflin, Heinrich. *The Sense of Form in Art*. New York, 1958.

INDEX

Underlined Arabic numerals refer to figures in the black-and-white section; Roman numerals refer to color plates.

This book was set in ten-point Times Roman. It was composed and the text was printed by The Science Press, Inc., Ephrata, Pennsylvania. The illustrations were printed by Great Lakes Lithograph Company, Cleveland, Ohio. The book was bound by The Haddon Craftsmen, Inc., Scranton, Pennsylvania. The paper is Wescar Satinplate manufactured by the Oxford Paper Company, New York. The design is by Nan C. Jones.